ART AND ARCHITECTURE
OF SPAIN

ART AND ARCHITECTURE OF SPAIN

Edited by XAVIER BARRAL I ALTET

Contributions by

JAVIER ARCE, XAVIER BARRAL I ALTET, JOAQUÍN BÉRCHEZ GÓMEZ,
MANUEL BORJA VILLEL, JAIME BRIHUEGA SIERRA, FERNANDO CHECA, NÚRIA DE DALMASES,
CHRISTIAN EWERT, RAFAEL LÓPEZ GUZMÁN, MANUELA MENA MARQUÉS,
PERE DE PALOL, PILAR PARCERISAS, CARLOS REYERO, EDUARDO RIPOLL PERELLÓ,
JOAN-RAMON TRIADÓ, FERNANDO VALDÉS FERNÁNDEZ, AND GERMAIN VIATTE

A Bulfinch Press Book
Little, Brown and Company
Boston New York Toronto London

TABLE OF CONTENTS

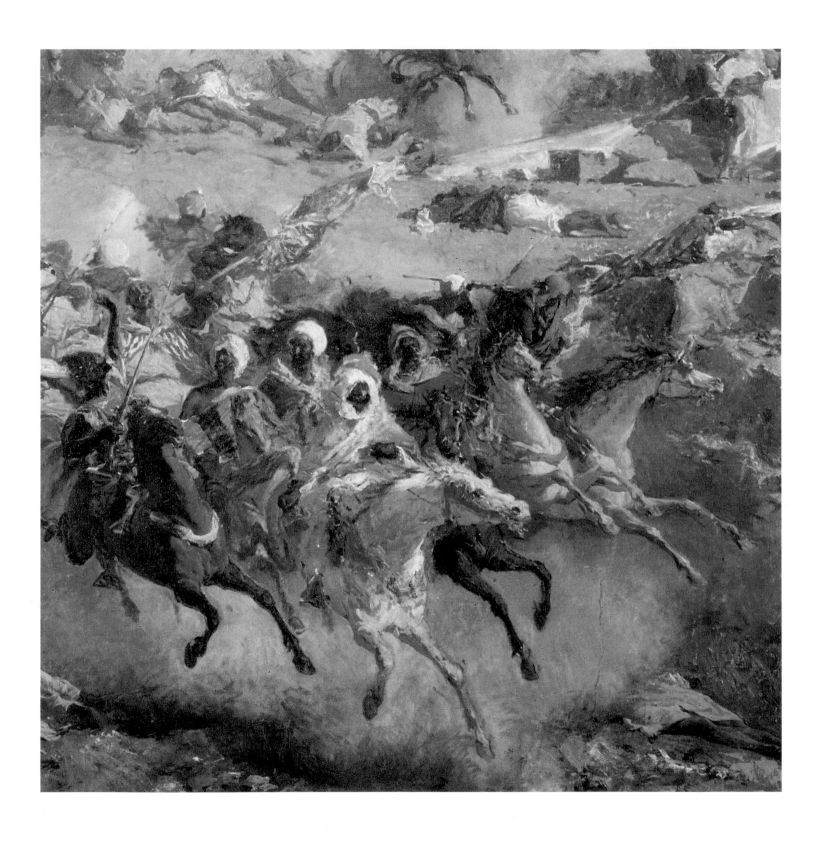

MARIANO FORTUNY: central detail of *The Battle of Tetuán*, 1863. Oil on canvas, 300 x 970 cm (ensemble).
Barcelona, Museu d'Art Modern del MNAC.

INTRODUCTION

Xavier Barral i Altet

The legacy of cultures and civilizations, both proximate and remote, set between North Africa and Europe, the Mediterranean and the Atlantic, constituted the essence of the art that Spain eventually exported to the other side of the Atlantic. Indeed, the Iberian Peninsula's location in the south-west corner of Europe has, since time immemorial, made it a cultural crossroads between north and south, leading it to become intensely involved in the development of world art. Hence, inherent in Spanish art is a constitutive blend of similarities and differences.

It is mainly abroad that the term 'Spanish art' is taken to refer to a consistent reality, in similar fashion to French, English or Italian art. Indeed, in the minds of many a foreigner, Castilian art and Spanish art are regarded as one and the same thing. However, the latter is often unacceptable to Latin Americans, as it is to Catalans, Basques and Galicians. Geography and history, which develop along the same lines as language, have determined clear-cut regional differences which Spain's democratic constitution enshrined in autonomous statutes just a few years ago. As a result, Spain's art history is now in the process of being rewritten in terms of official recognition of such differences.

Most of the earliest vestiges of artistic activity on the Iberian Peninsula, dating from the Upper Palaeolithic, consist of cave paintings found in two regions: Cantabria, which has its paradigm in the cave of Altamira, and the 'Levant' or eastern seaboard of the Peninsula. The first signs of Mediterranean culture *per se* emerged with the advent of the Iberians, as evinced in the emblematic find known as the *Dama de Elche* ('Lady of Elche'). Carthaginian, Greek and Roman colonisation laid the foundations for the first millennium of Hispanic civilisation. Classical, indigenous and imported culture flourished in the Roman villas scattered around the Iberian Peninsula, while bridges, aqueducts, triumphal arches and circuses were outward signs of belonging to Roman civilisation. Local traditions did, however, survive at specific points on the Peninsula, particularly in the field of sculpture, an upshot of ongoing cultural ties to the Greek, Phoenician and Punic worlds. Romanisation and, subsequently, Christianisation, were to be the first major pan-Mediterranean adventures on the Iberian Peninsula.

The western fringes of the Roman Mediterranean were Christianised at the same time as other provinces in the Roman Empire. The Hispanic territories later absorbed Germanic peoples, particularly the Visigoths, who established a powerful kingdom in which creative activity was prolific. While early Christian basilical architecture, based on both Italian and North-African models, was adopted and reworked by the Visigoths, their most notable achievements occurred in metalwork, notably in gold, as evinced in the crowns of the so-called 'Treasure of Guarrazar'.

In their endeavour to expel the Visigoths, the Moors drove them into the Asturian enclave, a region hemmed in by sea and mountains. This comparatively small but active kingdom established ties to the Carolingian world during the 9th century, while the Islamic presence led the Iberian Peninsula to adopt a new role as a place of symbiosis and transition between East and West. During the era of the caliphate, Cordova earned itself immense international prestige as a centre of culture, learning and science.

Ancient Roman Hispania thus became Moorish in the Middle Ages, a state of affairs that only came to an end when the Reconquest was completed with the fall of Granada in the late 15th century. The cultural activity of the Christians living under Islamic rule, known as Mozarabs, contributed to cross-fertilisation with the prevalent Moorish art forms, such as the horseshoe arch and decorative motifs found in illuminated manuscripts. Even so, theirs was a rather meagre artistic legacy.

From the 10th century onwards, the Christian Reconquest involved a series of military campaigns or crusades against the Moors in the south. Romanesque art developed in the Christian kingdoms in the north of the Iberian Peninsula, and was related to Romanesque art elsewhere in Europe. In its beginnings, it took the form of simple architecture, produced by monastic builders, which was homogeneous throughout southern Europe, from Lombardy to Navarre. Subsequently, the marked rise in pilgrimage to Santiago de Compostela led to exchange with other parts of Europe, especially France. In its most monumental form, this Romanesque architecture can be seen in such remarkable basilicas as San Isidoro at León, and the cathedral at Compostela. The latter, on which building

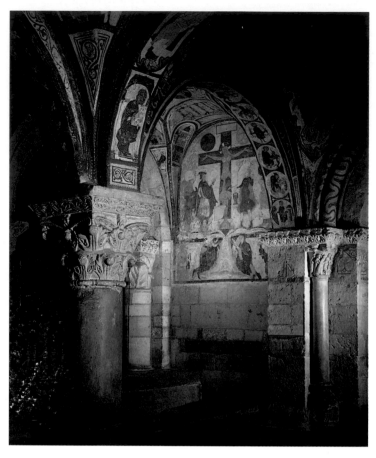

León: detail of the pictorial decoration on the Pantheon of the Kings, in the collegiate church of San Isidoro; first quarter of the 12th century.

work began in the late 11th century, is among the so-called 'pilgrimage churches', replete with ambulatories and galleries, like the ones at Conques, Limoges and Toulouse. The huge rise in popularity of pilgrimages to Santiago de Compostela brought northern Spain firmly within the European sphere of influence. Indeed, it was the earliest temporary mass migration of people and art forms to the Iberian Peninsula, and from there back to Europe.

Romanesque art, heavily based on imagery and the worship of relics, reached its height in the 12th century in the field of monumental sculpture, as borne out by the cloister of Silos in Castile, the facade of Ripoll abbey in Catalonia, and the Portico of Glory at Santiago de Compostela. Cultural exchange between Spain and Italy and the south of France had become more frequent by then. In painting, such relations extended as far afield as England, although the prime examples of Romanesque mural painting on the Iberian Peninsula—the Catalan paintings at Taüll—were highly representative of the consolidation of local styles.

This development further evolved at the time the Cistercian order was making inroads into the Iberian Peninsula and, as was the case throughout Europe, had a part to play in precipitating the birth of the Gothic style.

Gothic art was an urban phenomenon which, as all too often happens, emerged in opposition to the art of the Romanesque monasteries. Its central symbol was the cathedral. The Spanish Gothic is represented by the cathedrals of Toledo, Burgos and León, with their slender architecture reminiscent of northern France, or by the single, broad-naved Mediterranean basilicas, with their ribbed vaulting and side chapels, characterised by beautiful spatial unity. This internal unity prevailed in Mediterranean regions even when there were several naves, as seen in the church of Santa Maria del Mar in Barcelona, which was built as from 1328.

Gothic painting emerged in the Iberian Peninsula at the same time as the architecture. It is a decorative art geared to the service of princely courts, a fact which encouraged cultural exchange with Italy and France and, subsequently, Flanders. The chief exponents of the International Gothic were Lluís Borrassà and Bernat Martorell, active in the late-14th and early-15th century, while the Flemish influences of the second half of the 15th century were associated with figures such as Lluís Dalmau and Jaume Huguet, in Catalonia, and Bartolomé Bermejo in Castile.

Spanish Renaissance art, dating from the late-15th century, drew on the inspiration of the Italian Renaissance, the latest features of the flamboyant Gothic in France, and local Gothic tradition. The patronage of princely court circles looked to Italy, its artists and their styles. The Iberian Peninsula was then united as a result of the marriage of the Catholic Kings, Ferdinand of Aragon and Isabella of Castile. The new Renaissance art triumphed in Segovia and Salamanca, while the Mudéjar style continued to yield a mixture of northern architecture, forms and styles with an unmistakable taste for Islamic ornamentation. A specifically Spanish art style, known as Plateresque, evolved at the time. It was characterised by elaborately carved stone, resembling the work of goldsmiths. The style known in Spain as Isabelline, and as Manueline in Portugal, is defined by curves, reverse curves, drop arches, Solomonic columns and ornate, decorative exuberance. Mannerism of this kind is repeated *ad infinitum* in the colleges of Santa Cruz and San Gregorio, in Valladolid, and in courts, facades and towers in secular buildings.

From then on, Spanish art was represented by El Greco, and by the palace of El Escorial, commissioned by Philip II, a patron of the arts during whose reign (1556–1590) Spain lived out its 'Golden Age'. El Greco's markedly Italianate Mannerism, imbued with his own strong personality, was characterised by his elongated figural proportions and his tonal range of colour. Despite his Cretan origins, El Greco's art has become a symbol of Spain. On the Iberian Peninsula, the spirit of the Renaissance endured long after it had expired in the rest of Europe.

An artist who embodied the prevailing trends in wood and stone sculpture was Alonso Berruguete. Born circa 1480, he trained with his father, Pedro, and in Italy. The use of relief, observation of antiquity, realism and the dominance of lively polychromy gradually ushered in the religious art of the

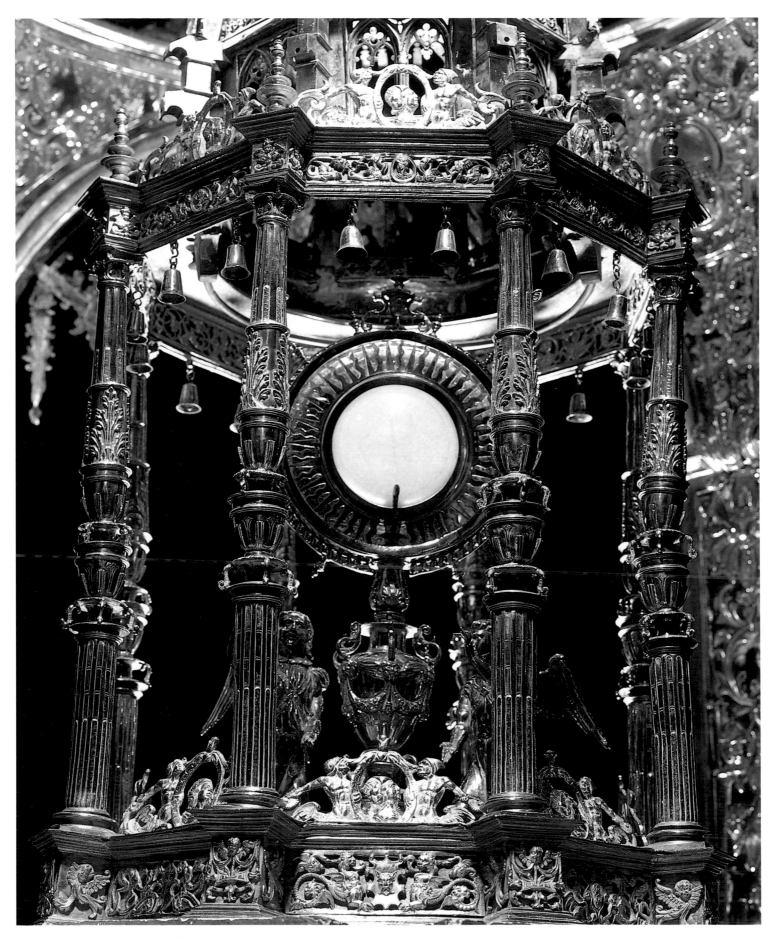

FRANCISCO PEDRAZA: *Processional Monstrance*, 1547. New Cathedral of Salamanca (the Gothic crest dates from 1450).

Spanish Baroque. Diego de Siloé, Bartolomé Ordóñez and Juan de Juni heralded the end of stylistic austerity and the rise of the Baroque.

This style emerged at the end of the 16th century, when Emperor Charles V (Charles I of Spain, 1516–1556) became an enthusiast and patron of the arts, prompted by his penchant for the works of Titian. The art of tortured figures that characterised the production of the religious orders and illustrated the 'Golden Age' of the Baroque in Spain responded to a need to externalise the misery and violence of the purportedly Hispanic spirit. Ribalta and Ribera were the leading tenebrist painters of the time, the latter as a result of his contacts with Caravaggio in Italy. The way Zurbarán used light to portray monks and clergymen contrasted, in its timelessness, with his taste for still-lifes and his evocations of idealised, everyday life. Murillo, an Andalusian at heart, painted a host of religious images, particularly feminine ones, with excessive facility.

Velázquez, who painted portraits in the court of Philip IV (1621–1665), including those of jesters and courtiers, earned international fame in the mid-17th century. His *Las Meninas* is perhaps the most universal Spanish artwork: it is admirable for his use of light, composition and a certain conceptual ambiguity, which make this painting emblematic of the height of the Baroque. A school of court painting developed around the figure of Velázquez in Madrid and continued, during the reign of Charles II (1665–1700), Philip II's son and successor, around the figures of Juan Carreño de Miranda and Claudio Coello.

The Spanish Baroque is even more pointedly defined by religious polychromed sculpture, as evinced in a wealth of retables, processional statuary and sculptural groups in churches. The Castilian school of Gregorio Fernández, based in Valladolid, was at the forefront in rendering the religious spirit of the new preachers, who sought to punctuate their sermons with scenes of pathos and violence.

The transposition to Spain of the Italian Jesuit style was accomplished by the figure of Churriguera. This architect (1665–1725), who designed the dome of the New Cathedral in Salamanca, also sculpted the retable in the church of San Esteban in the same city. His production straddles the Golden Age and the Enlightenment. After perpetuating the illusion of its 'universal empire' until the mid-17th century, Spain's decline was compounded in 1648 by the loss of the Low Countries and the outbreak of the War of Succession at the beginning of the 18th century. In 1738, the Obradoiro facade on the Cathedral of Santiago de Compostela marked the consolidation of Baroque architecture.

After Christopher Columbus reached the New World in 1492 and claimed it for Castile, the new continent was colonised by European settlers. All of Latin America, except for Brazil, was brought under Castilian rule. Throughout the Renaissance and Baroque periods, Spain exported its art to the Americas, where local art styles gradually developed. In the third decade of the 16th century, the religious orders, led by the Franciscans, Dominicans and Augustinians, embarked on a missionary drive in Spanish America. In so doing, they took with them architectural styles and figurative art. Subsequently, at the end of the 18th century, the Spanish Baroque found extremely fertile ground in Latin America. Castile, and the southern regions of Spain, which had taken part in the conquest of the Americas, suddenly had the opportunity to raise Spanish art to universal status.

During the 17th century, when Castile was losing its grips on its possessions in the Netherlands, the newly instated Bourbon dynasty made a break with the past. Given the political stability, Philip V, whose reign spanned the first half of the century, allowed art and architecture to develop in emulation of French models. The Rococo style was short-lived in Spain. The Enlightment was channelled into the Neoclassicism of the academies, a style which found its architectural expression in the Prado Museum building, designed by Juan de Villanueva, and Madrid's Alcalá Gate, by Francesco Sabatini. In painting, the presence in Spain of Giambattista Tiepolo, who had been summoned to complete the decoration of the Royal Palace, was largely instrumental in precipitating the development of anecdotal genre painting.

The most radical turning point in Spanish art was provided by Goya (1746–1828). This genius put into practice a new way of interpreting painting which was to be directly related to contemporary art. Social mutation, changes in mentality and the emergence of new class relationships were social themes that enabled Goya to stand out from his predecessors. After being summoned to court by Mengs in 1774, on the occasion of Charles IV's coronation in 1789, Goya was appointed chamber painter and his career was destined to have the backing of official patronage. His activity then centred on painting portraits of courtiers and cartoons for tapestries. Many years later, in a distinctly romantic mood, he painted or engraved the disasters of the Peninsular War. On a more critical note, filled with novelty, he produced his series known as the *Disparates* (1819). Through his art, he created a highly personal, ingenious and visionary world which culminated in the series known as the *Pinturas Negras* or 'Black Paintings' (1820–1821). His imagination, drawing skills and colouristic ability are crucial to an understanding of his personality and, to some extent, of modern character. In particular, he may be regarded as a forerunner of the Impressionists and Expressionists.

In Barcelona, Madrid and other cities in Spain, rising industrialism sparked steady growth in all sectors, principally from the mid-19th century onwards, when construction work boomed. Barcelona saw the implementation of Ildefons Cerdà's city-planning project, a symbol of the newfound industrial modernity. This consisted of a new urban district, the *Eixample,* based on a grid plan, which became an intermediate area linking the inner city to the peripheral suburbs. In Madrid, meanwhile, buildings such as the Teatro Real were decorated in an archaeologistic style based on a revival of ancient models, as evinced in the neo-Gothic Almudena Cathedral, begun by Francisco de Cubas (1826–1899). Catalonia's mediaeval past

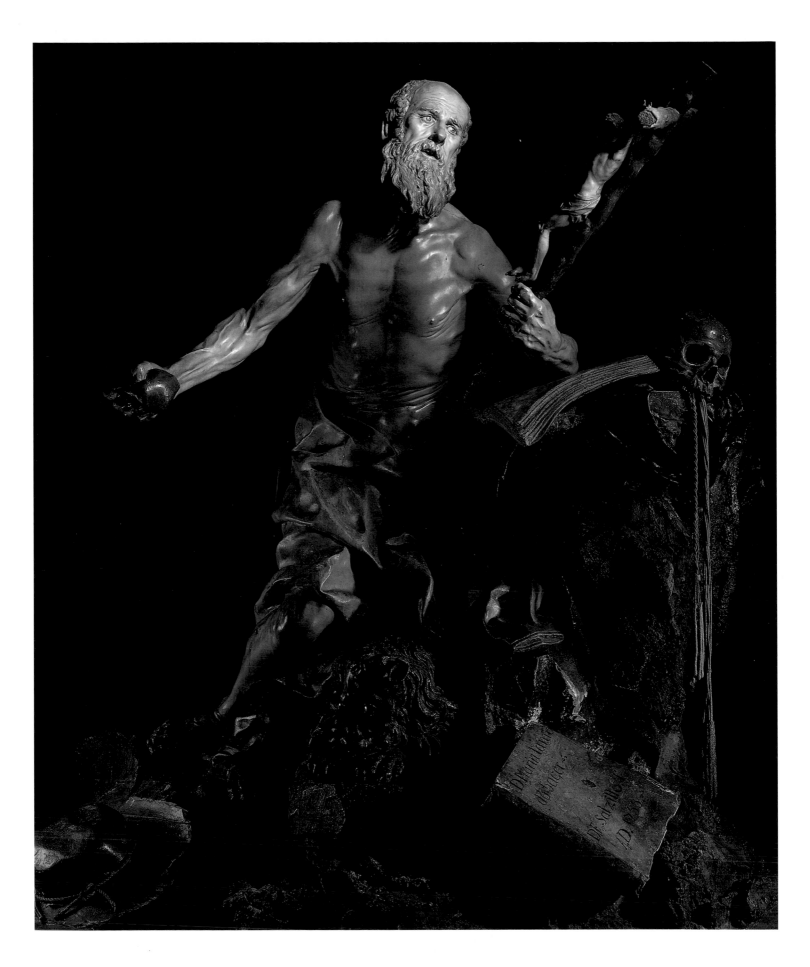

FRANCISCO SALZILLO: *St Jerome*. From the Hieronymite monastery of La Ñora. 1755.

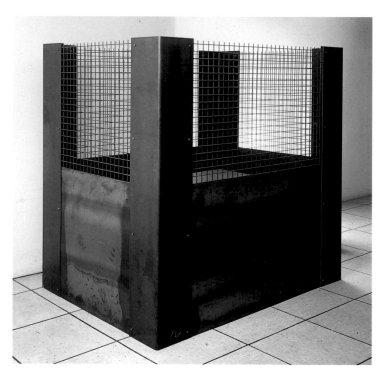

SUSANA SOLANO: *No te pases, nº3.* ('No Entry', no. 3) 1989. Madrid, Banco Central Hispano collection.

re-emerged in buildings such as the University of Barcelona, designed by Elies Rogent, while Madrid opted for a renewal of the Mudéjar in buildings such as the now defunct *Plaza de Toros* (bullring), designed by Emilio Rodríguez Ayuso, or of the Plateresque, in the offices of the Banco de España, by Eduardo Adaro.

In painting, the academic romanticism of Federico de Madrazo (1815–1894) fed official exhibitions and commissions for portraits and historical subjects, while landscape painters, *Nazarenes* and history painters worked in the regional schools which met demand in provincial capitals. Towering above them all was Mariano Fortuny (1828–1874), the 19th-century painter par excellence. Active in Rome and Paris, he was renowned for his highly original, Orientalist renderings. Europe discovered Spain in the 19th century, thanks to a brand of romanticism that exploited the picturesque genre and past tradition, led foreigners to visit the country and prompted works illustrated with plates of Spain's monuments and people.

Growing wealth in Catalonia, particularly of the Catalan bourgeoisie, as a result of industrialisation, and the fact that its prime-movers had not been involved in the long-standing Spanish business venture in Latin America, provided the resources for a renewed, beautifully redolent creative drive, which found its prime expression in architecture and the decorative arts. Around the year 1900, this materialised in the movement known as Modernism, paralleled in several other European countries: Art Nouveau, in France; Modern Style, in England, and Jugendstil in Germany. The leading exponents of

this style in Barcelona were Lluís Domènech i Muntaner, Antoni Gaudí (1852–1926) and Josep Puig i Cadafalch, who left a lasting influence on the city. The *Palau de la Música*, by Domènech, and Güell Palace or the church of the Sagrada Familia, by Gaudí, reveal the decorative opulence of a style tinged with reminiscences of its mediaeval roots.

While Modernism became broadly involved in contemporary European creative trends, each region in Spain produced its own, specific artistic manifestation. The resurgence of regional identity was accompanied by local revivals of regional culture. Painters such as Sorolla, in Valencia, Romero de Torres, in Andalusia, and Casas or Rusiñol, in Catalonia, responded to such trends. Ignacio Zuloaga, for his part, revived the traditional vision of a 'Spanish soul' in genre paintings of a reality that had long been grown out of. Bohemian circles in early-20th-century Barcelona—a city advanced in its concern for social issues—which featured artists such as Nonell and Casas and centred on the creative ambience at a locale known as Els Quatre Gats, yielded Spain's greatest art genius of all time, Pablo Picasso (1881–1973).

Picasso's art career unfolded mainly on French soil but falls wholly within the sphere of Hispanic art. Indeed, Catalonia and Spain come through as sources of inspiration throughout his oeuvre. From the Blue Period to the Rose Period, his painting is associated with Barcelona. His *Les Demoiselles d'Avignon* (1907), for example, reflects his experiences in that city, while another great canvas of his, *Guernica,* is now a worldwide symbol of Spanish history and the history of art. Picasso was the most universal artist to have been born on the Iberian Peninsula. His fundamental contribution to Cubism, Surrealism and the avant-garde art movements in general was decisive. In short, his work has marked the art of this century.

Spain's contribution to Surrealism was based mainly on such artists as Joan Miró, Salvador Dalí and Maruja Mallo. In Paris, Juan Gris, Manolo Hugué and Julio González were part of the century's art avant-garde, beyond all movements and trends. Joan Miró (1893–1983) developed an innovative, personal language, a mythology of line and colour, while Dalí (1904–1989), the most popular artist after Picasso, approached art as a spectacle through his 'critical–paranoiac method'.

From 1936 to 1939, Spain was ravaged by civil war, leaving its population deeply divided. Many went into exile or hiding, while others became collaborationists. The fratricidal struggle was to rack Spain for several decades, and it was not until the end of the nineteen forties that an innovative group of artists emerged. The short-lived movement sprang up in Barcelona around the journal *Dau al Set*. Inspired by Surrealism, its leading exponents in Catalonia were Brossa, Cuixart, Ponç, Tàpies and Tharrats.

In the nineteen fifties, Antoni Tàpies, who was born in 1923, embarked on an abstract Informalism in which the painting 'matter' became the subject. Tàpies is undoubtedly Spain's most important living artist. Throughout his consistent career, he has raised the humblest of commonplace objects to the

status of large-format painting, while simultaneously representing *arte povera* in its Catalan form.

In Madrid, Informalism was developed by members of the El Paso group such as Antonio Saura and Manuel Millares. Diverse avenues of artistic response were derived from those years which were to have a marked influence on Spanish art up until the death of Franco. The painting of Albert Ràfols-Casamada and Joan Hernández Pijuán, in Catalonia; the sculpture of Eduardo Chillida, in the Basque Country and, in Valencia, the *Equipo Crónico* group and the sculpture of Andreu Alfaro, ushered in the second half of the twentieth century. At the end of the sixties, the conceptual reaction in Europe to the ephemeral was cast in Spain by artists who opposed traditional art and social realism. New technologies and the return of large-format colourist painting characterised the production of the eighties.

Halfway between the historical masters and emerging artists, the generation which includes such painters as Miquel Barceló (b. 1957), and such sculptors as Susana Solano (b. 1946), is today representative of Spanish art as seen from abroad. The art of the last three decades is outstanding for its creative wealth, for the variety of ideologies it portrays, for the originality of the new artistic languages born of the hardships endured under the Franco regime, and for the new regional status quo it reflects. Nowadays, in view of the reigning political and artistic segmentation, it is rather obsolete to talk of 'Spanish art' in overall, unitary terms, as every one of the nationalities making up contemporary political Spain has in recent years been reconstructing its own unique cultural and art history. Madrid, Barcelona, the Basque Country and Galicia each speak and live in their own language, and are likewise developing art forms commensurate with their own history and lifestyle. Other regions, such as Andalusia and Valencia, are also striving to create their own, distinct forms of expression.

The above is a summary of the approach adopted in this title, which proceeds along essentially chronological lines. The work is broad-minded, open to a host of interpretations, while the rhythm is set by the major periods in art history.

Two factors stand out in that history: the sheer duration of the Moorish period, which lasted from the 8th to the 15th century and ran parallel to the Late Middle Ages and the Romanesque and Gothic periods, and the colonisation of the New World, which spanned the Renaissance and Baroque. Cultural originality is the hallmark of both phenomena, so that Islamic and Hispano-American art have been regarded as wholly separate manifestations. Thus, Moorish art follows the chapter on Gothic art, to avoid breaking the continuity running through mediaeval Christian art forms. Similarly, Hispano–American art has been placed after the chapter on the Spanish Baroque.

In structuring this title, Goya and Picasso, those forerunners of modernity, have been accorded greater importance than El Greco and Velázquez, on account of their contribution to the history of European art. Hence, both of them have been allocated a monographic chapter of their own.

The lack of knowledge about contemporary Spanish art, both outside specialised circles and especially abroad, has prompted us to devote a large portion of this book to contemporary art. Political, cultural, economic and global standardisation in Spain has led a large number of young artists to emerge on the international scene, and Spain's cultural sphere is rapidly expanding, on account of the many large contemporary art museums being opened in Madrid, Valencia, Las Palmas, Santiago de Compostela, Barcelona and Bilbao.

In the last few years, architecture, in particular, has led Spain to the forefront of international style. Architects such as Ricard Bofill, Oriol Bohigas, Santiago Calatrava and Rafael Moneo have become prominent international figures, while Spain has in turn attracted highly prestigious foreign architects such as Norman Foster, Frank Gehry, Arata Isozaki and Richard Meier. Moreover, architectural, industrial and graphic design were spotlighted at two magnificent showcase events in 1992: Expo 92, in Seville, and the Barcelona Olympic Games.

By retracing the history of artistic creation in Spain since its origins, and that of Spanish art abroad, while stressing historical continuity rather than rupture, this book will enable readers to come to grips with the true, yet many-sided picture of Spanish art as it evolved over the centuries. An attempt has been made to shed light on darker areas which other books have glossed over in their endeavour to focus exclusively on the major periods in Spain's art history. Art owes all to history, and to the economic, political and social climate in which it emerged. And, in general, it owes much to the dialectics of ideas, the prime mover behind change in civilisation.

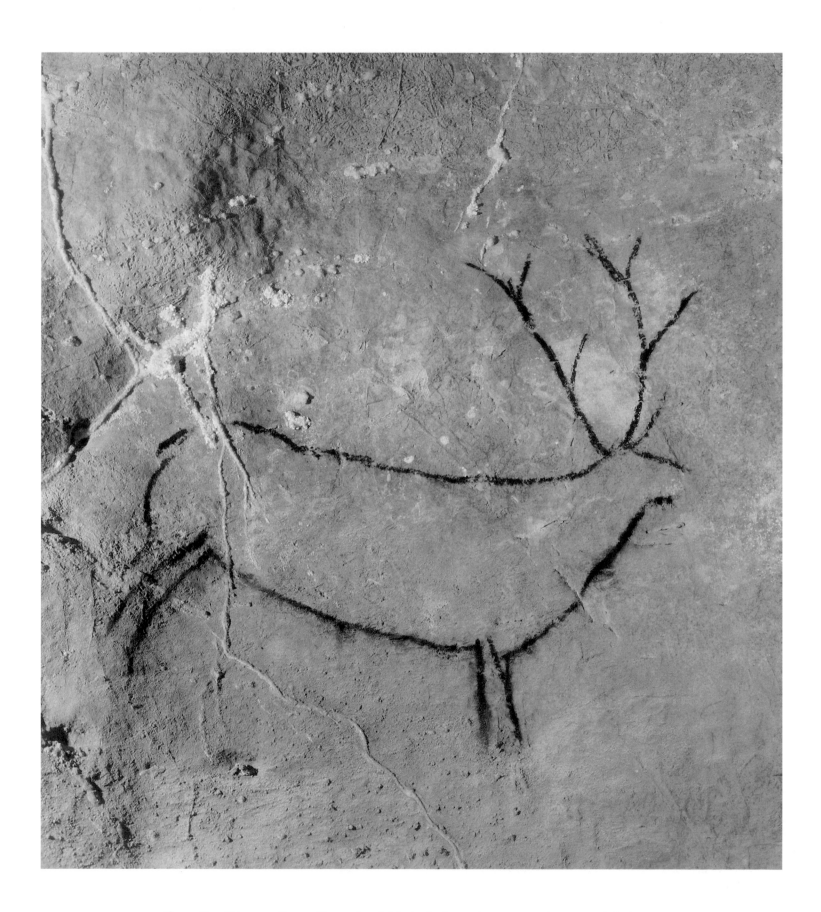

Cave of Las Chimeneas (Puente Viesgo, Cantabria): detail of a reindeer. Upper–Solutrian epoch (style III).

Prehistory and First Contacts with Mediterranean Antiquity

Eduardo Ripoll Perelló

The emergence of modern man—*Homo sapiens sapiens*—in southwestern Europe some 30,000 years ago was soon attended by a number of artistic manifestations. In the last hundred years or so, researchers have been instrumental in unearthing from caves some astonishing, vigorously realistic art, animalistic in the main, carefully applied to what for us would be an unusual support—cave walls. Similarly, the strata revealed through archaeological excavation have yielded objects with intrinsic artistic value. This is true of the Upper Palaeolithic, running from the Strait of Gibraltar to Lake Baikal, an area in which the Iberian Peninsula is the westernmost province, and France, the richest.

Subsequently, artistic manifestations specific to the Iberian Peninsula and dating from recent Prehistory and Protohistory have come to light. A noteworthy example is the unique expressionism of so-called Levantine cave painting, which was perpetuated in the form of hermetic, schematic art until the dawn of Protohistory. The evolution and aesthetics of both were complex, ranging from realism to abstraction, and taking in both stylisation and schematism.

As was the case in previous times, links with continental and Mediterranean Europe had their part to play in the Iberian Peninsula's Protohistory. However, the Peninsula had its unquestionably unique forms, as evinced in the art of the Iberians, prevalent in Mediterranean coastal regions and Andalusia, which even survived the Roman conquest.

The Art of the Palaeolithic Hunters

The men of the Upper Palaeolithic, who hunted large animals for nearly 20,000 years (from 30,000 to 9000 BC) in a harsh, icy climate, were highly accomplished artists whose legacy has partially survived to the present. Their predecessors may have engaged in similar artistic activity, using perishable materials that have now disappeared.

Palaeolithic art is particularly well known for the cave paintings and engravings found in Spain and France, with over two hundred documented sites. Some of the best known ones in Spain are Altamira, El Castillo, La Pasiega, Las Monedas, Las Chimeneas, Tito Bustillo and La Pileta, which are closely related to a large number of caves in France. They were religious sanctuaries whose significance remains a mystery. But, more importantly, the images they contain have survived on cave walls or in archaeological strata, pointing to the existence of reflective thought aesthetically akin to that of contemporary man.

So-called portable art, another distinctive feature of the Palaeolithic, refers to numerous objects sculpted or engraved on deer or reindeer horn, bone and mammoth ivory, among others, as well as stone slabs with engravings and, on occasion, paintings. The subjects depicted are similar to those found in cave painting. A magnificent example of this is the set of over 5,000 decorated plaques found in the cave of El Parpalló (Gandía, Valencia).

Portable art also includes the remarkable statuettes conventionally referred to as 'Venus'. Some one hundred objects of this kind are known, although, interestingly enough, none have been found on the Iberian Peninsula. Indeed, Spanish caves have yielded far

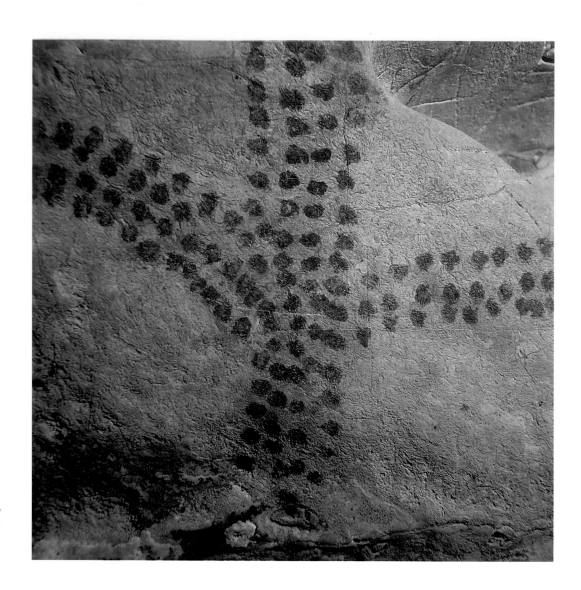

fewer examples of portable art than those in France, although a fair number have been unearthed in Cantabria, at sites such as El Castillo, Altamira, El Juyo, Tito Bustillo and others (Museo de Santander, Museo de Oviedo, and Museo Arqueológico Nacional, Madrid). Further afield, a carved ivory statuette depicting a glutton was discovered in Valdesotos (Guadalajara). A plaque from Villalba (Soria) is engraved with figures of horses and billy goats and may have been a ceremonial object. Similarly, there is the aforementioned collection of plaques, with engraved and/or painted animals and signs, from El Parpalló (Museo de Prehistoria, Valencia).

The main subjects portrayed were animals and human figures, in addition to isolated hands and signs. Animal subjects were prevalent and featured species such as the mammoth, which are now extinct, or those no longer found in Western Europe, like reindeer and bison. They are sometimes attended by anthropomorphic or humanoid figures, which would suggest an unresolved iconography as far as present-day research is concerned. What prompted Palaeolithic artists, who were adept at rendering true 'animal portraits', to shy away from a realistic portrayal of the human figure, which they left obscured, avoiding, above all, the depiction of facial features? It must be concluded that these artists were under duress not to represent the human figure in any recognisable form, and that the images they produced were most likely related to magic or religious concerns which involved masking the subject's identity and even merging it with animal forms. Some of the anthropomorphic figures are men disguised as animals and might therefore be identified as shamans or witchdoctors responsible for the socio-religious guidance of a clan or tribe. A clear-cut example of this is a painting and engraving applied to a natural surface in the cave of El Castillo.

Cave of Las Monedas
(Puente Viesgo, Cantabria):
detail of a horse. Upper Palaeolithic,
Magdalenian IV–V (style IV).

Also depicted are red or black hands, either separately or in groups. They are either 'negatives' (silhouettes, with an encircling halo), or 'positives' (a handprint painted over in colour). Hands of this kind can be seen in a score of French and Spanish caves, profusely so in the case of La Pasiega, El Castillo and Fuente del Salín (Cantabria) and Maltravieso (Cáceres). In this last instance, as in the Gargas caves in the French Pyrenees, the hands are mutilated. Their symbolism would suggest that these hands are a link between figurative representations and the enigmatic world of signs.

Palaeolithic ideograms present a wide typological variety, ranging from points and stick-like signs to rectangular shapes with complex internal divisions. They are found in all the caves and are still occasionally referred to as 'tectiform', as they are thought to have been used to depict dwellings. These signs highlight Palaeothic artists' capacity for abstraction, specific instances of reality being couched in symbolic forms somewhat reminiscent of written phonemes. That they had precise meaning is borne out by the fact that they were handed down over hundreds of generations and covered large distances. This is evident in the case of the club-shaped or 'claviform' signs—actually stylised female figures—found at sites in the Cantabrian region and the French Pyrenees, such as Cullalvera (Ramales, Cantabria) and Niaux (Ariège).

Geographically speaking, Palaeolithic art is concentrated in the Cantabrian region, running from Asturias to the Basque Country, with around eighty caves. Noteworthy examples in Asturias include the Tito Bustillo cavern (Ribadesella), with its huge plaque of horses and bichrome reindeer, and a diverticulum with female sexual signs; a number of small shrines in hollows on the banks of the river Nalón, and the El Pindal cave near Pimiango, which features paintings and engravings, including a silhouette of a mammoth.

THE PARAGON OF ALTAMIRA

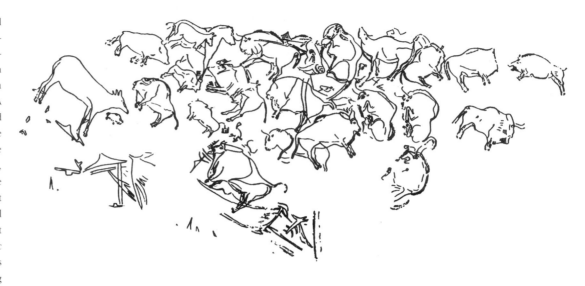

The name Altamira (Santillana del Mar, Cantabria) has cropped up several times on adjoining pages. The paintings in that cave were discovered in 1879 by Marcelino Sanz de Sautuola (1831–1888) and his daughter María. A few months later, Sautuola published a booklet in which he described the paintings in the celebrated ensemble known as 'the polychromed bisons', accompanied by a rough sketch of the composition. However, it was thought to be a fake, and rejected. The rebuffal was spearheaded by the eminent French prehistorian, Émile Cartailhac (1845–1921). Only a few researchers supported its authenticity, including the Spaniard, Joan Vilanova i Piera (1821–1893) and the Frenchman, Édouard Piette (1827–1906). In February 1877, the latter, then the world's leading expert in Palaeolithic portable art from sites in France, wrote: 'Don Marcelino de Sautuola sent me a booklet on prehistoric objects in the province of Santander and, above all, on the paintings in the cave at Santillana del Mar. I have not the slightest doubt that these paintings are from the Magdalenian period'.

Altamira's authenticity was not recognised until over twenty years after its discovery, thanks to the endeavours of the young abbot, Henri Breuil (1877–1961) and the aforementioned Émile Cartailhac, who by then had come around to the fact. The upshot of a memorable journey by the two in 1902 was the title, *La caverne d'Altamira à Santillane, près Santander (Espagne),* splendidly published in 1906 under the patronage of Prince Albert I of Monaco. The bibliography on Altamira, which included many minor works, was enriched in 1935 by a grand monographic title by Henri Breuil and Hugo Obermaier (1877–1946). The centenary of the discovery was celebrated in 1979 at a symposium, the minutes of which included a large number of research studies.

An inventory of the paintings and engravings in the various galleries of the cave, conducted for the monographic work of 1935, yielded the following figures: 38 bison, 10 bovids, 26 horses, 14 caprids, 63 cervids, 5 wild boar, 1 mammoth, 1 elk, 1 feline, 1 fish, 1 wolf, 10 indeterminate figures, 9 anthropomorphs, several hands and around a hundred more or less elaborate signs. The most fascinating feature of the caves is undoubtedly the grand vault in the so-called 'Polychromed Hall', measuring approximately 18 x 9 m., displaying seventeen large bison and other animals rendered in various shades of ochre, brown and black, with fine engravings and scrapings. The whole scene is painted on the cave ceiling over a pre-existing decoration, with the backing of rocky outcrops being used to advantage.

The pictures are no longer in the same condition as when they were first discovered. In the monographic title of 1935, Breuil and Obermaier laconically remarked: 'Originally, the distance between the ground and the painted vault was small. The height near the entrance was about 2 metres, dropping to between 180 and 190

centimetres in the centre and 100 centimetres at the back. These works of art were understandably at risk from visitors to the cave (careless use of lamps, surface rubbings, inscriptions, etc.). In 1928, the ground was lowered and a circular pathway built. Thanks to this improvement, the paintings can now be viewed comfortably, from a distance of about 2.5 metres, and may thus be preserved from deterioration'.

Abbé Breuil attributed the Altamira art ensemble to various moments during the Upper Palaeolithic: from the Perigordian (remains of early decoration) to the 'polychrome' Magdalenian VI, taking in the transition from the Solutrean to the Magdalenian (engravings, animals and black signs in the last gallery) and Magdalenian V (black figures on the ceiling, and most of the engravings). Recent datings using a variety of radiometric techniques have yielded eleven dates, ranging from 12600 to 11500 BC. In terms of the stylistic and chronological sequence, André Leroi–Gourhan classified the 'polychromes' within his Style IV (Middle Magdalenian). According to Leroi–Gourhan, the reading of the ceiling drawings is as follows:

	A	A				D
	C1b	C1b	B	B	B	B
C3	B	B	B	B	B	B
C1bC3	B	B	B	B	B	

Leroi-Gourhan explained his 'reading' in these terms: 'There are two horses. One of them, set along the central axis, is depicted in the form of a huge head. Most of the surface of the vault is covered by the 17 bison. This layer of bison (B) is delimited by the boar (D), the two horses (A) and the two hind (C1). The horses are on the boundary, but are part of the scene. Incidentally, the enormous horse's head, dominating the ceiling ensemble, is significant, as is the small bison on the edge, under the hind's neck. This arrangement recalls the interplay of dimensions between the horse, bison and ibex at Niaux, a contemporary, although on the other side of the Pyrenees.' This interpretation yields 18 female depictions (the bison), 2 male depictions (the horses) and 6 complementary ones (the cervids and boar).

That account might be compared to the explanation put forward by Leslie G. Freeman. For the professor from Chicago, the scene is one of a herd in a meadow, with the animals portrayed

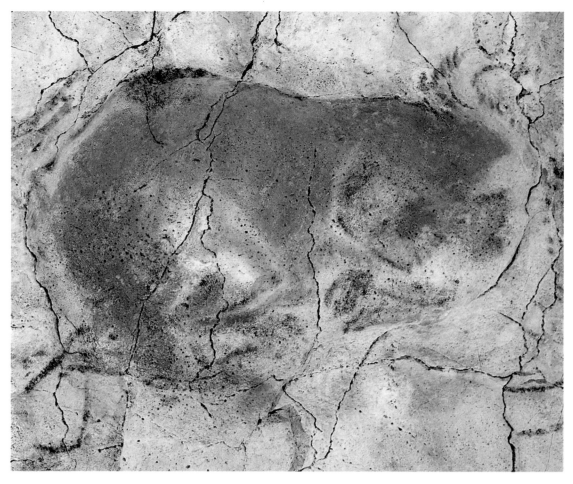

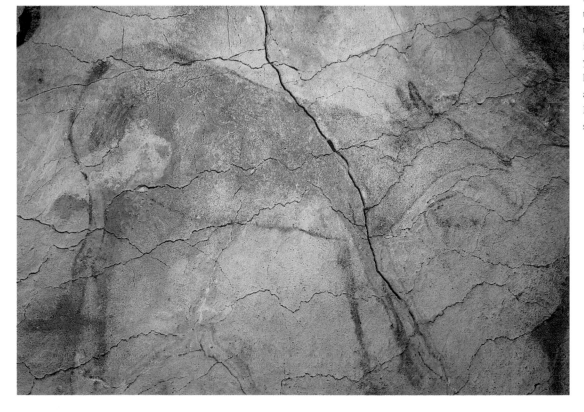

in the various positions they tend to adopt naturally. Moreover, Freeman rectified one of the attributions: the animal on the right, mistaken for a boar, was actually another bison.

Neither interpretation seems to take into account the fact that the artist had an 'ideal' view of the whole ensemble which was done away with when, as stated earlier, the floor level was lowered as a protective measure and for visitors' comfort. The original viewpoint will have only allowed the onlooker to see two or three figrues at once. Regarding movement, whereas the bison have been described as 'leaping', it is probably more accurate to say they are 'cavorting', as is customary with these animals and can be observed in a zoo.

Simón Pacheco, the old Altamira guide who knew the leading figures in this story and whom I had the privilege of meeting, once said: 'The paintings are talking to us. We can hear them, but we can't understand them.' Indeed, the key to unlocking the meaning of this magnificent, Upper Palaeolithic animalistic art, which lasted over 20,000 years, would seem to lie precisely here, in Altamira. The enigma remains and might one day be explained. Perhaps, in the future, some young researcher will manage to do so.

Cave paintings at Altamira (Santillana del Mar, Cantabria): details of a bison and a deer in the 'Polychromed Hall'.
Magdalenian (style IV), Upper Palaeolithic, between 12600 & 11500 BC.

Another Cantabrian site is Altamira (Santillana de Mar) which, together with Lascaux, near Montignac in the French Dordogne, is world famous for its cave paintings, notably the 'Hall of Polychromes' with its twenty bison, a large hind, a horse and various claviform signs. The deepest part of the cave has black paintings and engravings. The next most interesting site is the troglodytic ensemble of Monte del Castillo at Puente Viesgo, on the banks of the river Pas. The El Castillo cave itself contains some 150 zoomorphic figures, around a hundred hands and the same number of signs, dating from different times during the Palaeolithic. The same hill has three other sets of caves: La Pasiega, Las Chimeneas and Las Monedas, which all feature a large number of paintings and engravings. Among a host of minor sites is a complex with cave paintings in the vicinity of Ramales de la Victoria. The chief cavern here is that of Covalanas, with around thirty figures whose distinctiveness lies in the way the red silhouettes have been incised with a pointed implement.

The principal caves in the Basque Country are Santimamiñe (Cortézubi), Altxerri (Aya), and Ekain (Deva). The latter has, among other figures, some twenty horses which count among the finest depictions of horses in Palaeolithic art.

There are also cave–shrines at various places in Spain, although many boast only a few figures each. In contrast, Los Casares (Riba de Saelice, Guadalajara), features 118 engraved figures of large bovids, a mammoth, a glutton and some anthropomorphs, set in a scene. Another exception is La Pileta (Benaoján, Málaga), which has Palaeolithic figures interspersed with much later ones, from the time of schematic art.

One unusual variation on Palaeolithic art sites in Spain are open-air shrines with engravings, done in an unmistakably Palaeolithic style. These sites can be found at Domingo García (Segovia), Escuellar (Almería), and Siega Verde (Salamanca). Siega Verde is related to two other, not too far-off sites: at Mazouco (Bragança) and the newly discovered Vila Nova de Fozcoa, both in Portugal. Another open-air rock shelter is the large Ambrosio grotto (Vélez Blanco, Almería) with its painted and engraved wall frieze and rich Solutrean deposits, in which representations are buried under archaeological strata.

The long stylistic evolution of this artistic stage in Spain, paralleled by that of French Palaeolithic art, was slow-moving in the first half of its span, and based largely on crude animal protomes and female sexual signs. Zoomorphic outlines were subsequently perfected and greater plasticity achieved (Aurignacian & Gravettian phases, Leroi–Gourhan styles I & II). By the year 18000, the repertoire was completed, animal figures had acquired slight movement and signs had reached their height of complexity (Solutrean & Magdalenian phases, Leroi–Gourhan styles III & IV). By around 8000 BC, Palaeolithic art had disappeared altogether.

French and Spanish researchers have taken the same approach to interpreting those Palaeolithic art forms. For a long time they were thought to reflect religious beliefs in which magic played a part in the hunt and in fertility (Abbé Henri Breuil and his school). In 1960 and thereafter, André Leroi–Gourhan showed that the figurative associations were intentional and that the caverns were arranged in the form of shrines. Moreover, bearing in mind that over half of all the animals depicted were horses or bison, he concluded that they stood for two, linked themes. The first, embodied in the horse, responded to the masculine principle, while the bison stood for the feminine. Other animals were ascribed minor or complementary functions. Regarding the signs, they were thought to have an analogous or equivalent role. This theory tallies with the general feeling that the images are mythological stories associated with the hunt and based on a binary system. In this respect, 'myth' is taken to mean a complex but coherent system of a shamanistic type on which man's vision of the universe was based at that time.

Post-palaeolithic Art on the Iberian Peninsula

The advent of the Holocene, with its characteristic array of fauna and flora, gave rise to other pre-historic societies with their own artistic manifestations. Radical environmental

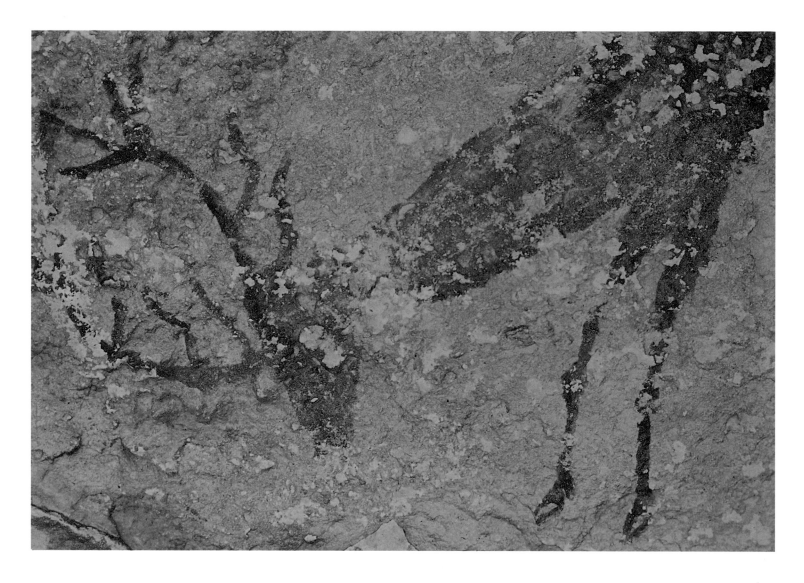

changes across Europe saw the rise of new societies of hunters–gatherers who were not long in adapting to Neolithic innovations in the course of a rapid process of acculturation (agriculture, animal domestication, group dwelling in settlements, etc.). Thus, peasant communities engaged in agriculture and livestock breeding had already emerged on the Iberian Peninsula by the year 5000 BC.

At the same time, and for three or four millennia, spanning the Epipalaeolithic, Neolithic and Chalcolithic, artists produced a naturalistic, expressive and complex form of cave painting known as 'Levantine'.

Their geographical distribution ran from the Pyrenees to the province of Almería, and inland as far as the mountain ranges of Cuenca and Teruel. Sites associated with such activity have come to light at Río Vero (Huesca), Cogul (Lleida), La Valltorta and La Gasulla (Tirig, and Ares del Maestre, Castellón), Santolea, Alacón and Albarracín (Teruel), La Araña (Valencia), and Alpera, Nerpio and Moratalla (Albacete). Together with some minor sites, they total about one hundred in all.

Characteristic of Levantine art are friezes with numerous figures painted on the walls of rock shelters exposed to sunlight. The paintings were virtually always done in 'pure ink'. Figures were generally small (10-cm-high, on average), although some animal figures were larger (as at Albarracín, where some bulls measure over 1 metre in length). They were invariably set in scenes, as it was the Levantines that first embarked on composition in the broad sense and, in so doing, added movement, which was highly dynamic at times. They were likewise instrumental in hitting upon a new way of conceptualising the human figure,

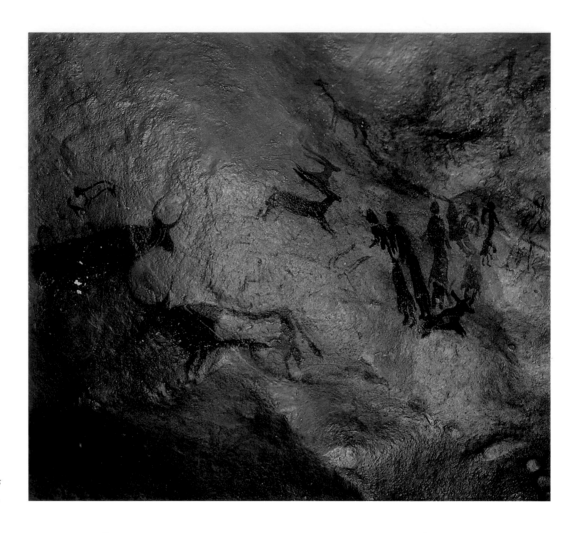

Cave of El Cogul or *Roca dels Moros* (Lleida): phallic dance scene.

the main subject in their compositions, which acquired a characteristic stylisation of aston-ishing vigour and movement. Prevalent were hunting scenes, although there are also scenes of gathering, dancing and even war. The zoormorphic figures depicted were species found in temperate climates—bulls, deer and caprids.

In the earliest phases, figures tended to be isolated, static and highly naturalistic. As they became stylised, they also acquired greater dynamism and started being grouped into scenes. In the later phases, details were gradually glossed over, heralding a move towards schematism. In classical times, men were depicted wearing a form of trousers, caps and other adornments, and armed with bow and arrow. Women were bare-breasted and wore huge, billowing skirts of the kind associated with certain parts of the Mediterranean and Eastern Europe.

Chronologically, this stylistic evolution has been described in relative terms. As a more specific date, Abbé Breuil put forward a time frame in the Palaeolithic, but it was later shown to take in the late Epipalaeolithic and early Metal Age. Although magico–religious factors cannot be ruled out, the art in question appears to have acted as a form of narra-tive, commemoration or reminder.

Wholly schematic figures were either superimposed on or added around the edges of the Levantine frescoes at a later date. They represent a completely different artistic stage, contemporary with the height of the Metal Age, which encompassed most of the Iberian Peninsula. The major centres of this art were concentrated in Almería, Cádiz, Sierra Morena, Extremadura and some parts of the Castilian meseta. Hundreds of rocks bear conventional, anthropomorphic or zoomorphic paintings which at times become so abstract in style as to resemble signs belonging to some archaic form of writing. The subjects portrayed were inherited from Levantine art which, in its final phase, was contemporary with schematic art styles. Other images—solar and stellar figures, idols, water symbols, and others—respond to the influx of a newfound religious mindset of Mediterranean or Eastern origin. These friezes must have been used to preside over funerary rites, kinship ceremonies, and propi-

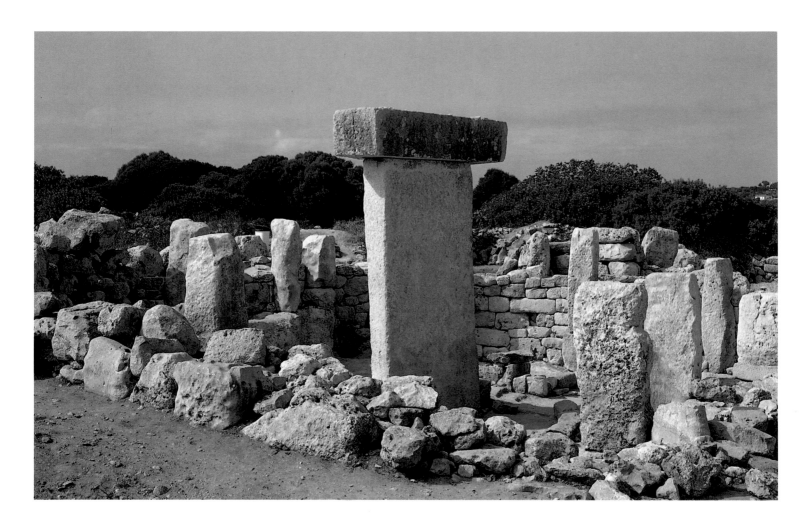

tiatory rites associated with the hunt, animal husbandry, the harvest, water and the preservation of other resources.

The sites of Tajo de las Figuras (Cádiz), La Graja (Jaén) and Cueva de los Letreros (Vélez Blanco, Almería) are characteristic of this style. Among the host of figures depicted at Cueva de los Letreros is that of a man wearing large goat horns and holding a sickle. He is regarded as a hunter–farmer, a symbol of this art, which survived until the dawn of Protohistory and even later. Extremadura features some interesting paintings of carts, while the Peña-Tú rock in Llanes (Asturias) has an engraved and painted idol, in addition to human figures, dashes of red colour and an engraving of a bronze dagger. This ensemble is related to so-called menhir-statuary, found at Tabuyo (León), Sejos (Cantabria), Preixana (Lleida), Hernán Pérez, Riomalo (Cáceres) and other sites. The 'eye-goddess', a recurring motif in Eastern Europe, the Balkans and the Middle East in Neolithic and Chalcolithic times, is also featured in schematic painting, and in such objects of a minor order as the ceramics of Millares (Almería) and a recent find, the 'Venus of Gavà' (Barcelona), most likely a ritual vessel associated with that goddess.

Another prehistoric form related to schematic art styles is evinced in engravings or petroglyphs in Galicia and northern Portugal. Rocks in that region are studded with thousands of figures, some semi-naturalistic and others wholly schematic and abstract, with a profusion of mazes. Campo Lameiro (Pontevedra) is one of the richest sites of this kind. The art form in question began during the Bronze Age and lasted for a long time, probably until the arrival of the Romans.

The Art of the Balearic Talayots

During the Bronze Age (the 2nd & 3rd millennium BC), the Mediterranean world with its islands was a complex mosaic of cultural phases. In the westernmost archipelago,

Taula & talayot at Torrauba d'en Salort (Minorca). Bronze Age.

Three types of megalithic construction were characteristic of talayotic culture: *talayots, navetas* and *taulas*. Talayots are known to have fulfilled a defensive purpose, and to be related to the Nuraghic culture of Sardinia. Navetas are so called as they are shaped like a ship's keel. They are thought to have served a funerary purpose, as they contain a hole and ornamental furnishings. In contrast, the function of taulas has not yet been established: they comprise two or three stone slabs placed in the form of a T-shaped upright and crosspiece. Some claim they were supporting structures for a larger complex, while others regard them as sacrificial altars.

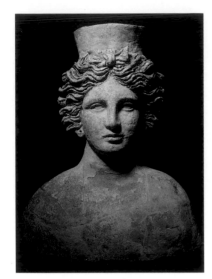

Punic terracotta, circa 500 BC.
Museo Arqueológico, Ibiza.

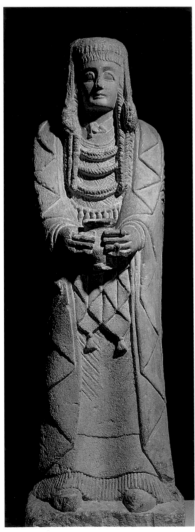

Votive offerer or *Gran Dama*
('Great Lady'): Shrine of Cerro de los
Santos (Montealegre del Castillo,
Albacete). 4th to 2nd century BC.
Museo Arqueológico Nacional, Madrid.

the Balearic Isles, Majorca and Minorca developed a megalithic culture that was to last until the Roman conquest in 123 BC, after which it went into decline. This culture is known as 'talayotic', from the characteristic monuments called talayots. They clearly reveal older influences from the Eastern Mediterranean, albeit removed in time. Talayotic culture did, at various times, adopt a number of Carthaginian, Greek and Roman objects.

Among the most outstanding examples of talayotic art are three bull's heads from Son Corró, Costitx (National Archaeological Museum, Madrid). Bronze and roughly life-size, they were found in an excellent state of preservation. They display some interesting features, such as regularity in the ears, and a tapering of the heads in the middle, making the snouts look globular. The same shrine, which remained active until Roman times, as well as others in Majorca, have yielded life-size bronze horns which appear to have fitted onto heads carved in wood. At one site, Son Mas, the horn is tipped with a small bull's head, while others bear Greek-style carved floral decoration. Other known objects include statuettes of bulls or doves inserted in a tubular bronze or iron rod, a kind of standard with Sard influences.

Evidence of progressive acculturation is provided by so-called 'Balearic Mars', which are Greek-style bronze warriors. The fruit of local production, they are thought to be archaistic. The warriors are shown naked, except for their helmets and weapons, and stand some 30 to 50 cm high. The best-known specimens came to light at Ses Pahisses (Artá, Municipal Museum). Some pieces are clearly imports, like the Greek warrior from Son Gelabert de Dalt, Sineu (Archaeological Museum of Barcelona), while the late period yielded a bronze Egyptian statuette of Imhotep, found at the village of Torre d'en Gaumés (Palma de Mallorca Museum). The Roman occupation, which took place in the years 123–122 BC, did not do away with indigenous culture, which only went into decline in the 1st and 2nd century AD.

The Punic Presence

During the second half of the 1st millennium BC and the centuries subsequent to the Roman conquests, the Mediterranean continued to seethe with different cultures, which often influenced one another mutually, although the Hellenic and Punic cultures held sway. Cultural and trade routes criss-crossed the Mediterranean and processes of religious syncretism were forged with Punic culture, as attested by art forms on the Iberian Peninsula, which then lay at the western edge of the known world.

Phoenician merchants settled in Andalusia around 900 BC, founding the city of Gadir (Cádiz). Written sources set the date as 1100 BC, while archaeological dating confirms the later date. They also founded factories on the Andalusian seaboard, before setting foot in Ibiza in the 8th century BC. In time, they had an influence on local Tartessian culture, established along the lower courses of the Guadiana and Guadalquivir rivers. They were superseded by the Carthaginians, whose cultural hegemony endured until the arrival of the Romans. Gadir had a famous temple consecrated to the god Melqart, who was later assimilated into the figure of Hercules. Its wealthier citizens purchased anthropomorphic sarcophagi for burial in the necropolis of Punta de Vaca, which dates from the 6th century BC The necropolis has yielded some fine specimens in alabaster, including a male figure with Greek influences and another female one, both archaistic in form (Museo Arqueológico, Cádiz), similar to sarcophagi in museums in Beirut and Istanbul, and in the Louvre. Another fine specimen from Cádiz is an 8th- or 7th-century Egyptiac statuette of a god, in gold and bronze, now housed in the National Archaeological Museum in Madrid. Phoenician finds have also come to light at inland sites, such as the figure of a goddess, possibly Astarte, seated on a throne between two sphinxes, found at Galera (Granada) and thought to date from the 7th century BC (Museo Arqueológico Nacional, Madrid).

The island of Ibiza was a commercial Punic outpost which exercised influence over the Iberian Peninsula and the Gulf of Lions. Punic terracotta statuary was a major activity

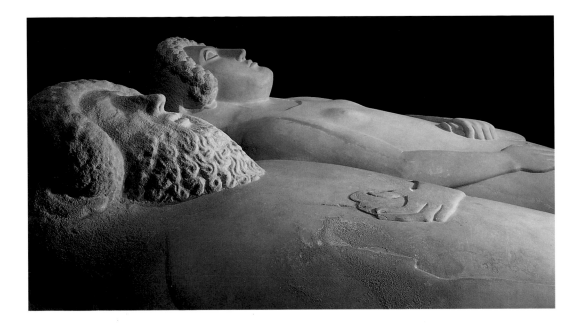

In 1980, an anthropomorphous female sarcophagus was unearthed in the necropolis at Punta de Vaca (Cádiz) which bore a striking resemble to a male one housed in the city's Archaeological Museum. Both in marble, they attest to a trade in luxury Eastern goods which served elite members of society in the south-west of the Iberian Peninsula. Both sarcophagi were imported from Phoenicia (present-day Lebanon), where they were crafted in the circle of the Sidonian workshops. Stylistically akin to Egyptian models, in both cases the image is wrought on the lid, while finer details are restricted to specific areas, such as the face, hair, hands and feet.

in Ibiza, as evinced in finds at Cova d'es Cuieram, Sant Vicenç (which yielded over 600 pieces), the necropolis of hypogea at Puig d'es Molins (with over 3,000 burials) and the remains of a temple to the god Bes in Illa Plana. They all date from between the 7th and 3rd century BC and are currently in the Archaeological Museum of Barcelona, the National Archaeological Musem of Madrid and a local museum in Ibiza.

The terracottas of Cova d'es Cuieram are bell-shaped, the figures swathed in broad tunics, with the pleats folded over, wearing a cylindrical tiara. They are bedecked with ornaments and symbols, such as the lotus flower, a crescent moon on a disc, necklaces and a rosette on the breast. Some are shown standing, while others are seated on a throne. They measure 15 cm-high, on average. All show the influence of Phoenician models. The cave might have been used for cult worship of the goddess Tanit, in similar fashion to places in Cyprus and Sicily.

The figures from Puig d'es Molins respond to a variety of types and influences. Funerary masks and female figures crowned with a tall headdress or *kalathos* are Hellenistic in form. They stand 40 cm-high, on average. Notable examples include the various *Damas de Ibiza* or 'Ladies of Ibiza', which probably came from the same workshop. The figures are naive in facture but full of charm, and wear large flowered tiaras and rich, complex earrings. A male figure, also crowned with a tiara, is depicted with his feet together, arms crossed, wearing a profusely decorated tunic. Some specimens show remains of paint. Genuinely Punic forms, which could be termed 'African', are the 6th–5th-century BC terracottas found at Illa Plana. There are also Egyptiac types, similar to the ones found in Carthage, Bitia and Mozia. However, the essental skills applied to terracotta modelling are attributable to local craftsmen, who had sound knowledge of existing models, including the Greek terracottas of the Tanagra type.

The Art of the Iberians

While the Phoenicians, Greeks and Carthaginians were making their influence felt on the Iberian coastline, Iberian culture had entered a phase of consolidation. Variations of Iberian culture, which sprang up on the eastern and southern seaboard of the Iberian Peninsula, reflected local adaptation and integration of those stimuli. On the whole, the Iberian civilisation was advanced, politically divided into tribal groupings ruled by a king, and had developed trade and techniques for metalworking, while religious practices were largely syncretic. The Iberian civilisation first became the object of study when sculptures were unearthed at the shrine of Cerro de los Santos at Montealegre (Albacete) in 1830.

The earliest nucleus of Iberian civilisation was the kingdom of Tartessus, whose material culture appears to have initially merged with colonial Phoenician culture (9th–7th

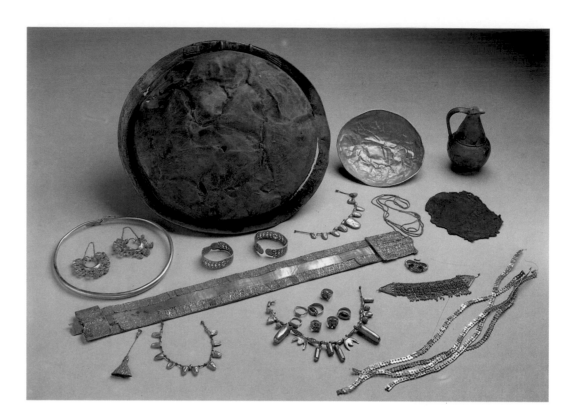

century BC, Eastern period) and subsequently acquired indigenous features (6th–3rd century BC). No Tartessian sculptures have come to light, but there are some splendid examples of toreutics, particularly bronze objects, such as the 15 cm-long 'Carriazo bronze' (Museo Arqueológico, Seville), a relief work depicting the goddess Astarte between two geese, and goldsmithing, as exemplified by the gold treasure troves of La Aliseda, Cáceres (Museo Arqueológico Nacional, Madrid), El Carambolo, Camas (Museo Arqueológico, Seville) and others.

The development of Iberian culture in the Levant and along the southeastern seaboard can be divided into three stages: it emerged in the 6th and 5th century BC, reached its zenith during the 3rd century BC and went into decline during the Roman occupation between the 3rd and 1st century BC. One of the defining elements was its ceramics, first decorated with geometrical motifs and, subsequently, with figures and even signs, becoming highly elaborate during its era of flowering. Statuary was of various types, the most representative of which will be referred to below. Major statues were made of limestone and sandstone, while bronze and terracotta was used for minor works.

One of the most outstanding Iberian monuments, based on Orientalizing models, is the turretlike burial mound of Pozo Moro, Chinchilla (Albacete). It has four recumbent, solid-headed lions with open jaws at the base, in a style reminiscent of neo-Hittite models. Several multifarious reliefs, once part of the quadrangular building, depict complex mythological scenes, likewise with Eastern overtones (circa 500 BC or earlier). The lions from Pozo Moro are similar in type to those found at Nueva Carteya and Baena (Córdoba, now in the Archaeological Museum of Córdoba), akin to Tartessian and therefore Phoenician iconography. The Pozo Moro monument is currently housed in the National Archaeological Museum of Madrid, as are most of the pieces mentioned below.

Another current in Iberian sculpture came to be known as 'Ibero-Greek', as it shows obvious Hellenic influences. A highly elegant, stylised example is the 80 cm-high sphinx of Agost (Alicante). Another, the so-called *Bicha de Balazote* (Albacete), is a recumbent, androcephalous bull with accurate proportions and smooth forms, measuring 93 x 73 cm. The head, large eyes, erect ears and small horns clearly indicate the figure's apotropaic function. Similar in style is an exceptional group of statues from ancient Obulco (present-day Porcuna, Jaén, Archaeological Museum of Jaén). All the sculptures in the ensemble were wrought in the same workshop, and were subsequently mutilated and buried shortly after 400 BC. Slightly smaller than life-size, they depict warriors—one of them on horseback,

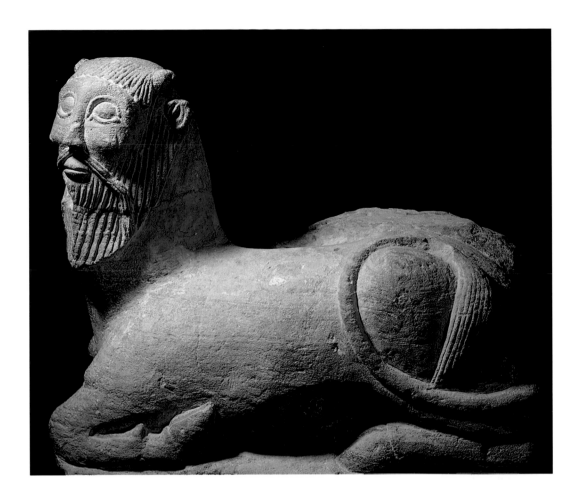

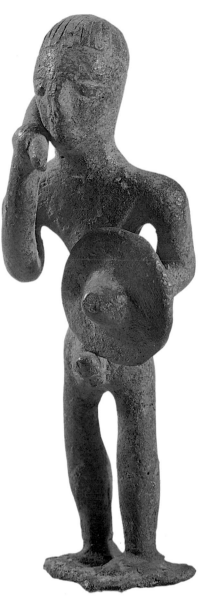

Androcephalic bull, known as the *Bicha de Balazote* (Albacete). First half of the 6th century BC. Museo Arqueológico Nacional, Madrid.

Figure of a warrior, an Iberian votive offering, from Despeñaperros. Early 4th century BC. Museo Arqueológico Nacional, Madrid.

with the enemy fallen at his feet—a person wrestling with a gryphon, a Greek motif, men and women in ceremonial dress—including a priest in an elegant tunic—an eagle, lions and bulls. Two high reliefs feature a battle scene and a hunt.

The finest example of Iberian statuary is undoubtedly the celebrated *Dama de Elche* ('Lady of Elche'), from the town known in Roman times as Ilici (Alicante province). The bust in question, measuring 56 cm high, is thought to have been part of a full-length figure. After being found by chance, it was acquired by Pierre Paris for the Louvre and later returned to Spain in 1941. The first striking feature of this figure is the contrast between the elaborate, sumptuous jewellery on the head and breast, and the simple, hieratic, yet beautiful visage. The woman's expression, particularly in the eyes and mouth, is one of serenity, as if her gaze were directed at the afterlife. Her garments fall into three sections: the outer layer is a robe which opens to reveal three large necklaces—tiny amphorae hang from two of them. The headdress is extremely elaborate: the head is covered with a veil, supported by a kind of back comb. The veil is surmounted by three rows of tiny spheres and two large discoids on either side of the face, separated by panels, also with minute hanging amphorae. These ornaments, most likely originally aureate, are also found on other Iberian sculptures. It is almost certainly a funerary statue, as suggested by the hole on the back, where the ashes of the deceased will have been placed after cremation. Although it was initially thought to have much earlier origins, the statue is now considered to date from the first half of the 5th century BC.

The excellently preserved *Dama de Baza,* unearthed in 1971 near the ancient town of Basti (Granada) in a tomb with rich ornaments, has most of its polychrome intact. Measuring 1.30 x 1.05 m, the 'lady' is shown seated on a throne, from the back of which spring large chestnut-coloured wings. She is wearing a blue robe and cloak, red footwear, and has her feet resting on a cushion. Her hands, bedecked with numerous rings, are set on her lap, and in her left hand she holds a blue dove. The breast is adorned with sumptuous necklaces. The oval-shaped face has small eyes and a broad nose, suggesting the portrait must have been done from life. A hollow under the throne was discovered to contain

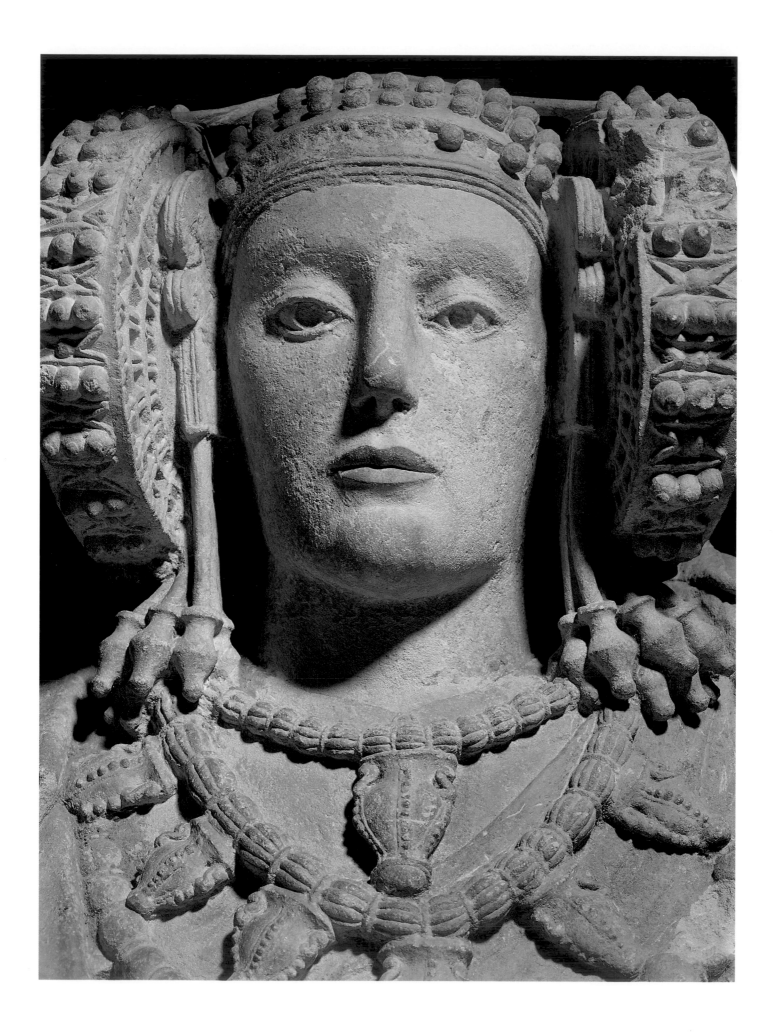

the ashes of a cremated body. It is thought to date from the first half of the 4th century BC, judging from the Greek ceramic ornaments found with it.

The shrine of Cerro de los Santos, researched by P. Paris and J.R. Mélida, is unique for the large quantity of statues it has yielded, numbering almost 500, between whole pieces and fragments, and for an unusual series of fake pieces. Sculpted in limestone, these statues usually depict figures at prayer or making offerings, and each of them holds a vessel. Unlike the works described above, these have markedly more indigenous features. The most representative piece is the full-length, hieratic *Gran Dama* or 'Great Lady', standing 1.35 m high. She is draped in rich garments and reverentially holds a votive vessel. The back has been left rough, as if the statue was intended to be attached to a wall. The same site yielded seated figures, 40 cm-high on average, and 20 cm-high beardless male heads. This rich collection was built up at the site over a period running from the 4th to the 2nd century BC. The latest figures are wearing Roman dress and even the odd Latin inscription has been found.

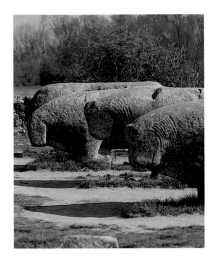

The *verracos* of Toros de Guisando (Ávila). Late 6th century BC.

The last period of Iberian sculpture is best exemplified by a set of reliefs unearthed at Osuna, the ancient Urso (Seville), dating from the 3rd to the 1st century BC. The most striking find here was an ashlar cornerstone bearing two female figures. One of them, an *Auletes* (who plays a double-piped flute), measuring 59 cm-high, wears a tunic with shallow pleats fastened by a broad, decorated cord. Noteworthy, too, is an ashlar featuring a 1.10 m-high soldier playing a large trumpet (*cornicen*), probably part of a scene depicting funerary rites, and a warrior bearing a falchion and shield depicted in an attitude of attack.

The minor arts spanned three main periods, and the largest set of stone statuettes in this category came to light at El Cigarralejo (Mula, Murcia; Municipal Museum). The site has produced some 150 statuettes of horses and 20 of human figures, which would suggests it was once a shrine consecrated to the worship of the horse goddess, *Pontia Hippo*. The site at La Serreta (Alcoy, Alicante) has yielded terracotta votive offerings, prominent among which is a composition of a goddess–mother shown breast-feeding two children seated on her lap. She is flanked by a mother and child, and a boy playing the double-piped flute, while a bird is placed next to them.

The most prolific group is made up of bronze votive offerings: over a thousand specimens are known, most of them located at the shrines of El Collado de los Jardines and Castellar de Santisteban, both in the province of Jaén, and Nuestra Señora de la Luz, in Murcia. Although varied in typology, the most realistic of them tend to be offerers: men dressed in short robes and a tight girdle, or women draped in long robes, measuring 7 to 10 cm high on average. Virtually all of them bear some distinctive item that sets them apart. Other figures are highly schematic, and some are reduced to a simple slab from which a head and legs emerge. A unique piece of this kind is the horseman wearing a helmet with an enormous crest that was unearthed at Mogente in Valencia. Although less abundant, animal statuettes have also come to light. Lastly, it is worth recalling the beautiful silver and copper Iberian coins, minted according to Punic and Greek models.

Turning to zoomorphic statuary of those times, Celtiberian culture on the central meseta of the Iberian Peninsula produced celebrated, near-life-size statues of bulls or wild boar known as *verracos,* most likely under the influence of Levantine and southern currents. They are simply rendered but vigorously realistic. The best known example is the group of four aligned bovids at Toros de Guisando in Ávila.

In short, the Iberian tribal groupings infused the cultural legacy of Greeks and Phoenicians with a new and extraordinary character. Instead of slavishly copying Hellenic proportion and harmony, or the forms peculiar to the Carthaginians, the Iberian artists replaced them with a new aesthetic, which attached value to detail and influenced the minds of society at the time.

Dama de Elche ('Lady of Elche'), from Elche (Roman Ilici, Alicante province). First half of the 5th century BC. Museo Arqueológico Nacional, Madrid.

MAJOR DISCOVERIES IN PREHISTORIC ART OVER THE LAST TWENTY YEARS

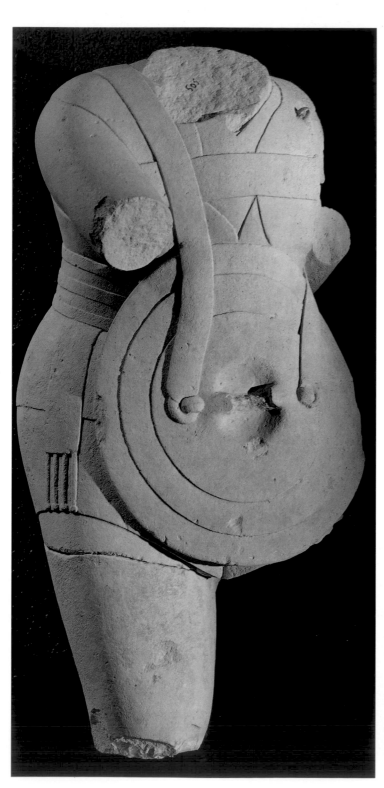

Venus de Gavà. Second half of the 4th millennium BC. Gavà (Barcelona), Museo Arqueológico Municipal.

This Venus, discovered in a variscite mine shaft in Gavà, near Barcelona, is one of the so-called 'gestating goddesses enthroned', characteristic of certain areas of the Mediterranean during the Neolithic, particularly the Balkans. It will have formed part of an earth fertility cult, both in the strictly agricultural sense and in a broader sense, including mineral wealth. This would account for it being found in a mine, and its relation to mining. This is the only modelled human figure that has survived from the Neolithic in Spain.

Torso of a warrior and horseman found at Obulco (Porcuna, Jaén). Museo Arqueológico, Jaén.

One of the most enthralling recent Iberian finds is the sculptural group unearthed in the vicinity of Porcuna in 1975 and following years. The ensemble comprises over 40 statues, hewn from local stone, which must have once adorned a funerary monument. The sculptures were part of various scenes: battles, struggles against mythical beasts, the hunt, the arena, gods, sphinxes, and so on. They seem to have come from a sacred precinct and were either funerary objects or votive offerings, like those displayed at contemporary Greek shrines. Greek influence, particularly that of Ionic art, is tangible in the composition and subjects, but the pieces were crafted locally. The scenes might in fact portray mythical battles rather than historical ones. This splendid group, which in part still remains a mystery, provides unique evidence of the heights attained by Iberian culture and of its marked Hellenisation in the 5th century BC.

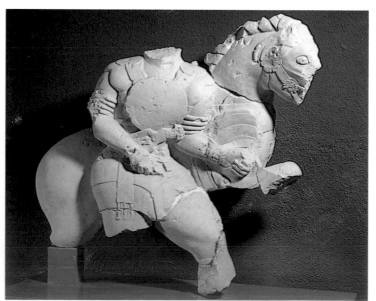

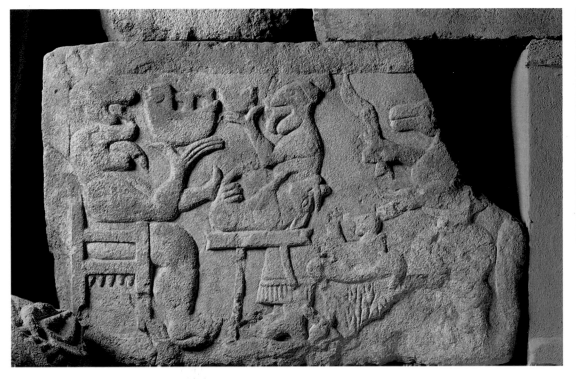

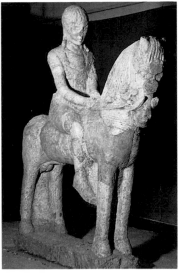

'Horseman of Los Villares'.
Museo Arqueológico, Albacete.

Siega Verde Grotto, Salamanca.

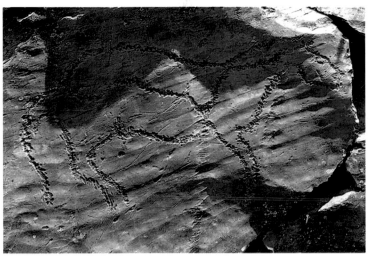

A novelty as far as Palaeolithic art is concerned was the discovery of sunlit, open-air shelters with rock engravings, similar to those found in caves, distributed all over the Iberian Peninsula. The major ones are at Domingo García (Segovia), Siega Verde (Salamanca) and La Fuente del Trucho (Huesca). The discovery of these grotto engravings, together with aniconic depictions predating the figurative age, have vastly broadened the chronological and geographical framework of the Iberian Peninsula's earliest artistic horizons.

Turretlike tomb at Pozo del Moro (Chinchilla, Albacete), dating from the transtion between the 6th and 5th century BC. Museo Arqueológico Nacional, Madrid.

The process of Orientalizing acculturation and the Greek presence on the Iberian Peninsula, precipitated by the colony founded at Empúries in the early-6th century BC, were paralleled in time by the consolidation of a complex, well-developed and well-stratified indigenous Iberian society, capable of producing a wealth of monumental sculpture. Many of the recently discovered pieces have been found in the tombs of dignitaries, whom they extol. They are either effigies of the hierarch himself or fantastical scenes in which he is depicted communicating with the gods and with infernal beings. The so-called 'Horseman of Los Villares' is of the former type, and the turretlike, monumental reliefs at Pozo del Moro, of the latter.

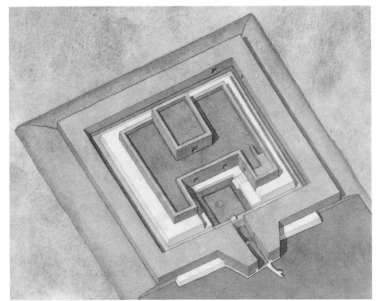

Palace–shrine of Cancho Roano (Zalamea de la Serena, Badajoz). Ideal reconstruction. Museo de Badajoz.

Much has been learned in recent times about 'Orientalizing art', which is art imposed on an indigenous people—particularly its elite—by a colonising culture. One of the finest examples of this is the palace–shrine of Cancho Roano, which is still being excavated. The building was probably in use between the 7th and 5th century BC, and its architecture reveals similarities to palatial buildings in northern Syria and their Grecian offshoots. Practically the whole precinct is an example of Orientalizing art, and of articles imported through trade or gifts sent by colonists, including Greek vessels, jewellery, ivories, bronzes and alabasters, in addition to clearly indigenous ornaments. Current research on this site may well eventually provide some crucial insight into the Orientalizing world on the Iberian Peninsula.

31

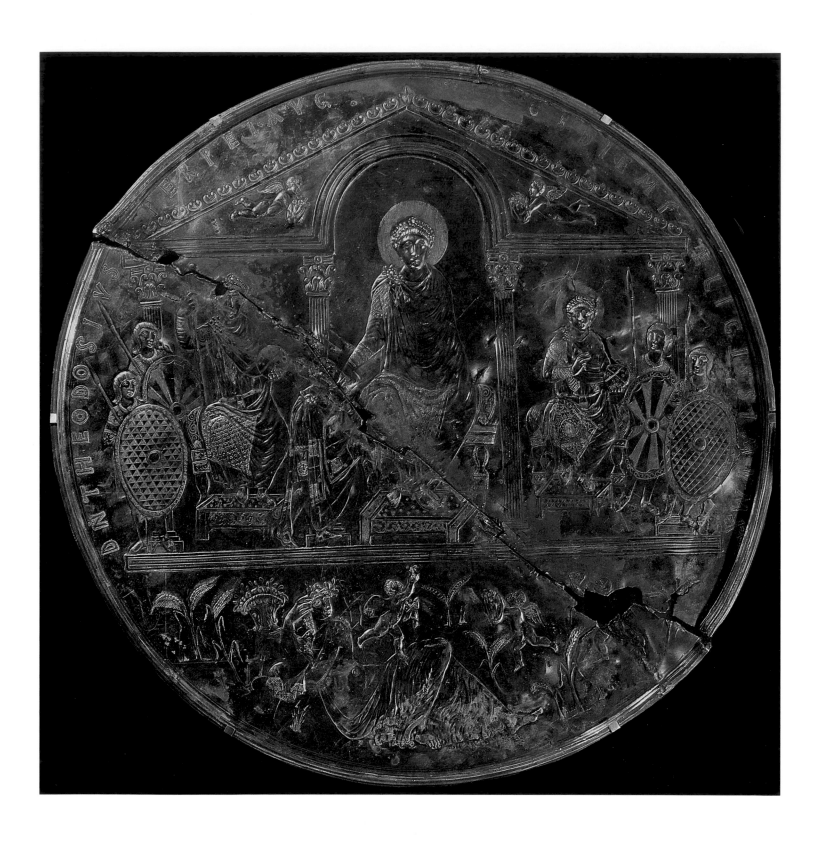

Theodosius' *Missorium, c.* AD 380. In repoussé silver, 74 cm in diameter. Found in the vicinity of Almendralejo (Badajoz).
Madrid, Real Academia de Historia.

Roman Art and Architecture in Spain

Javier Arce

In the late-4th century AD, around the year 380, when Theodosius was emperor, the governor of Rome's provinces in Hispania received an exceptional gift, sent to Augusta Emerita (present-day Mérida) from Salonika in Greece. The present was of a magnificent silver disc, measuring 0.74 m in diameter, which depicted the emperor seated at his *sella curulis* handing a book of instructions—known as a *mandata*—to a high-ranking official whom he had appointed to rule over Hispania. The object in question, now preserved in the Royal History Academy, Madrid, was found in what was presumably the governor's residential villa in Emerita, the capital of Roman Hispania. It is now known as Theodosius' *Missorium*.

Theodosius' *Missorium* is the most refined example of official Roman art of the time. The figures, seen from the front, appear withdrawn and hieratic, stylised and yet deeply expressive, set in a composition dictated by ancient imperial Roman conventions regarding relief work, as is the subject. However, the *Missorium* is not by any means an example of Roman art in Hispania; it is an example of craftsmen and craft tradition in the Roman Empire; in this instance, from its Eastern fringes.

It is worth clarifying this distinction from the outset: most of the Roman artworks, monuments, portraits and sculptures found in Hispania were *not* what might be termed 'Spanish' or 'Hispanic' art. They were imperial Roman works, either made by non-Hispanic artists or craftsmen or based on models produced by the latter.

Having said that, it must be admitted that local craftsmen and artists gradually started emulating Roman models and developing their own styles based on them. Hence, their production may be termed 'Hispano–Roman'.

Both tendencies come through in the artistic legacy bequeathed by Rome's presence on the Iberian Peninsula. They can likewise be assigned to a specific time span, which is the period running from the 1st century BC to the 4th century AD. Similarly, there were marked regional differences, which responded to: a) the contexts in which such artworks were found; b) the degree of local influence, presence and length of stay of Roman immigrants in Hispania, and c) the type of artwork considered. In the end, one of the basic issues involved in Roman art in Hispania is the question of who purchased, ordered or commissioned the works.

Bearing in mind these simple premises, this essay will attempt to address a rather more complex issue by resorting to a limited number of exemplary instances that might serve to draw general conclusions.

The World of Images

Roman society was enveloped by and crowded with images; indeed, public places were designed to accommodate them, from the forum to the thermae, basilicas, porticoes,

Meleager. 2nd century AD.
Museo Arqueológico, Seville.

***T**rajan of Italica.* From the area of the
Los Palacios Roman baths in Italica
(Santiponce, Seville). Flavian period,
second half of the 1st century AD.
Museo Arqueológico, Seville.

avenues, temples, theatres and archways. There was always a spot set aside for honouring an ancestor, a relative, a benevolent magistrate, a victorious general, a distinguished lady or an emperor, in addition to public deities and household gods. Some were individualised, free-standing effigies, while others were reliefs of an important figure, accompanied by an account of their deeds, and miraculous events or biographical histories. Citizens were kept informed of daily events in the world, and of the values it was based on and which made it their own. In short, they had visual access to their patrons, governors, heroes, poets, writers and philosophers.

That world of images was the first thing Romans took with them wherever they went, wherever they conquered or settled.

On the whole, very few images were displayed in public places when the Romans first set foot on the Iberian Peninsula. Following the Greek tradition, funerary monuments at necropolises were adorned with reliefs depicting mythological or battle scenes (Pozo Moro, Porcuna), or statues of immortalised male personages (Los Villares), but urban centres were all but devoid of images, with the exception of shrines or temples. Moreover, local deities usually lacked a visage. Thus, the arrival of the Romans heralded a revolution in local mores and customs.

As the Romans gained hegemony over and settled in Hispania, the first signs of their 'imagery' emerged, particularly in relation to funerary art and triumphal art.

Genuinely Roman models were imported from the Italian Peninsula. The practice of making an *imago* of a dead person, to be kept in the home or on a funerary monument, gave rise to the first known Roman 'portraits'. This Italic or Etruscan tradition is evinced in the head of a young man found at Emporion (present-day Empúries, in Catalonia), dating from the 2nd century BC and currently housed in the *Museo Monográfico de las Excavaciones,* or in the famous portraits from the city walls of Barcino (present-day Barcelona), dating from the 1st century BC, which were later re-used within the city precinct. The same is true of portraits from such other early-Roman settlements as Augusta Emerita, Tarraco (present-day Tarragona), Carmona and others. Interestingly enough, they were executed by Roman sculptors who journeyed with the soliders and settlers that arrived in Hispania, and they all exhibit the realistic, life-like quality, often highly expressive and masterfully executed, which so distinguished and ennobled Roman art. There is no dearth of coarse, but highly significant attempts at reproducing some local magistrate, this time in combination with local traditions, in somewhat Roman fashion. These were the first attempts at introducing the *togatus* into the visual arts in public or funerary areas at Roman settlements in Hispania. Production of this kind first appeared at Roman coastal settlements or in the provinces of Baetica and Lusitania, while the vast expanses of the Castilian meseta, Cantabria and the Atlantic seaboard remained practically oblivious to these initial forms of artistic expression.

Another issue to be determined is whether these rather flat statues, with imprecise, schematic features, were the work of local artists and craftsmen following their own Iberian tradition, or that of Romans using the techniques they imported into the Iberian Peninsula.

A highly illustrative example, which epitomizes the issue of the provenance of early Roman art in Hispania, is the famous funerary monument at Osuna, now in the National Archaeological Museum in Madrid. It is a frieze depicting the funeral of a notable from Osuna, in the Roman province of Baetica, which dates from the first half of the 1st century BC. It is commonly regarded as 'Iberian' in handling and execution, either because of the flatness of the reliefs or because its meaning has not yet been fully understood. However, the scenes, featuring someone playing the *cornu,* a jester heading the funeral procession, a female player of a double-piped flute, and gladiators locked in combat, are thematically wholly Roman, and belong to the well-documented Roman funerary ritual. In this respect, it is worth recalling that 'local' Italic art, which was transposed to the Iberian Peninsula by 'local' craftsmen, was an art form which, with few stylistic resources, attempted to reproduce the grand productions associated with Rome, and other places in the Empire with marked Greco–Hellenistic influences.

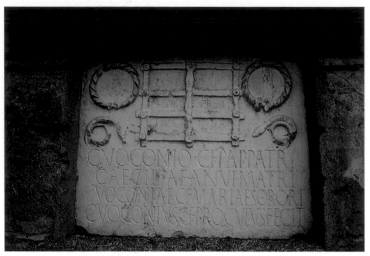

Relief with arms. First half of the 1st century AD. Mérida.

Relief of Voconios. Late-1st century BC & early-1st century AD. Mérida.

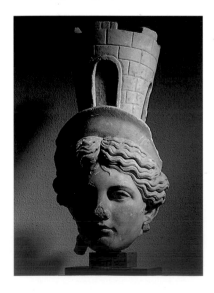

Turreted Head of Italica. Hadrianic period (1st quarter of the 2nd century AD). From the area of the Los Palacios thermae in Italica (Santiponce, Seville). Museo Arqueológico, Seville.

On the whole, these first, tentative manifestations of Roman art on the Iberian Peninsula emerged in response to individual, personal demand, rather than to official or public exigencies. They were later matched by more purposefully planned and designed forms of artistic expression by which the Roman conquerors gradually imposed their own pictorial conceptualisation and understanding on the vanquished, subject, allied or pacified peoples.

The Roman triumphal arch, Greco–Hellenistic in origin, was designed to enjoy immediate and preeminent status in local spheres, so that people would soon come to understand its symbolic charge.

Although there are few surviving examples of honorific statues on the Iberian Peninsula, as the Romans were initially more interested in commemorating their deeds and triumphs in Rome itself, their existence is suggested by literary sources. The first Roman triumphal monument intended for peoples of the Iberian Peninsula was prompted by Pompey's victories in the Pyrenees. The monument in question remains unknown but, judging from known contemporary models, it must have consisted of a pedestal, surmounted by *trophies* (effigies holding the arms of the vanquished), and a statue or portrait of Pompey the Great, which Pliny recalled as being very realistic and bearing a close resemblance to the victorious general. Pompey's trophies commemorated both his victory over the rebellious Sertorius and his subjugation of many peoples on the Iberian Peninsula. The monument was set in a strategically prominent position—*in summo Pyrinaeo*—beside a Roman way that ran from Gaul to the province of *Tarraconensis* via a Pyrenean crossing near the present-day town of La Junquera. The Romans used it to remind locals of the Roman presence and their power, and passers-by were enjoined to tarry a while and gaze at it before entering a land thus announced to be under Rome's control. Such monuments were raised wherever the Romans went—it was a novelty on the Iberian Peninsula and a highly effective, menacing reminder.

Imperial Cult & the Worship of Deities

In the late-1st century BC and early-1st century AD, Augustus embarked on a thorough, systematic colonisation of Hispania, and an administrative and fiscal reorganisation of the provinces that came under it. The changes he instituted were paralleled by a revolution in the use of images and decorative iconographic ensembles for public monuments. After his death, an imperial cult was established, associated with his relatives, successors, heirs, and his family as a whole, which spawned a host of commemorative statues, portraits and reliefs, as part of a propaganda campaign designed to reach all subjects of the

Empire. The emperor's portrait, which sprang up everywhere, became so omnipresent that its varieties were classed by type and sub-type, adapted to different settings and cast in various ways to stress different functions: the emperor as a priest, the Sovereign Pontiff, the emperor triumphant; as a soldier, hero or demi-god; naked or wholly resembling a god; as first citizen, consul, magistrate, legislator and emperor–god. His wife, children and relatives were portrayed in similar fashion. In this instance, art production issued from the seat of power, but it had a conditioned reflex in the ruling elite and the provincial authorities, who reproduced, consecrated and proferred effigies of the emperor as token of their loyalty, commitment and devotion.

Thus, Roman colonies and other municipalities in Hispania became peopled with a host of imperial portraits and statues, rendered in marble and local bronze. This situation lasted until the end of the 4th century AD, when the Roman Empire underwent a marked change. Some were produced locally, by local craftsmen; others were brought from Rome and finished or reworked in local workshops.

Hence, it was quite common to find a magnificent portrait of Augustus—the *capite velatus*—in the guise of a priest at Augusta Emerita, or to come upon series featuring his family members—Germanicus, Drusus, Livia, Trajan, Hadrian, Galba, Otho and Domitian— in other Hispanic colonies. They were all remembered and revered for their imperial presence, and for the favours they granted, as well as for their origins, and political events related to their person and their province. Imperial effigies were produced in Rome and then distributed across the Empire. Local copies of Roman models ranged in quality from splendid to poor. The *Trajan of Italica* and the *Hadrian* of *Italica* are magnificent examples of aulic art in Rome. The *Augustus of Mérida,* however, was probably executed by local craftsmen, as were the *Vespasian* in the Seville Museum, the *Domitian of Munigua* or the *Trajan of Belo,* made of local materials and therefore locally made. The one from Belo depicts the young emperor as provincial in appearance, and is thus untainted by the idealised tenets of Roman artists.

The emperor's image had to be omnipresent and it was therefore framed in settings in which the architectural adornment played a crucial role. Such decoration often took the form of historical reliefs, carved according to models prevalent in the capital or in neighbouring colonies.

Locally produced works which reveal accomplished style and technique include a relief of Agrippa at a sacrificial event commemorating the foundation of Emerita and, from the same city, reliefs of arms, recalling the triumphs and spoils offered to the victorious and avenging god, Mars.

Similarly, a great deal of effort and energy went into the production of images of gods and goddeses. Prototypes for this art form had already been established in Hellenic times and, in some cases, in the preceding classical period. Some of these deities were exquisite, and were probably executed by foreign artists. This is probably true of the *Venus of Italica,* an idealised work from the Hadrianic period, when the colony was living out its moment of greatest prosperity. This Venus may have been intended as an adornment for Roman baths. Its Egyptiac character is emphasized by the lotus flower (or *flabellum?*) held in the figure's left hand. Other examples of art from that period of flowering are a Diana and a Meleager—akin to the work of Scopas in style—also from Italica (near present-day Seville), and numerous statues and statuettes of the Romans' favourite deities: Hermes (Mercury), Venus, Hercules, Eastern patron gods of religious sects and associations, satyrs, nymphs and maenads.

Artistic production of this kind reached its height in the 2nd century AD, coinciding with a period of refinement, during which classical Roman models were held in great esteem. This phenomenon was echoed in Hispania, at a time when great, highly influential Roman aristocrats from provincial families rose to key positions in the imperial administration. The *Turreted Head of Italica,* which contains what appears to be a depiction of the city of that name, summarises all the above trends, and is conclusive proof of the national spirit, local pride and assimilation of allegorical concepts so frequent in Roman art.

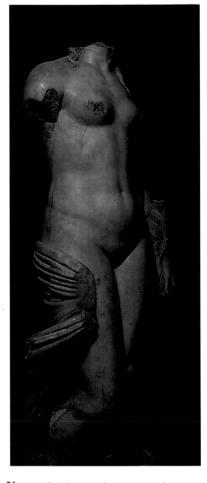

Venus of Italica. Hadrianic period (1st quarter of the 2nd century AD). Museo Arqueológico, Seville.

The *Venus of Italica* is one of the finest Roman sculptures to come to light on the Iberian Peninsula. Although mutilated, from its attitude, serene nakedness and iconographic attributes —the Lotus flower and dolphin's fin— it is related to the Greek *Aphrodite anadyomene.* It might even be derived from a currently unknown Alexandrian model. The statue was probably intended as an adornment for one of the wall niches ringing the Roman baths, not far from the theatre, in Italica, the Roman city discovered in 1940.

ROMAN PORTRAITURE

Strictly speaking, there is no such thing as Iberian portraiture. The Iberians borrowed the idea of personalised, recognisable physiognomic portrayal of an individual from the Greeks and the Romans. The latter, in turn, were heavily influenced by the Hellenistic Greeks. Iberian attempts at portraiture reveal a certain stiffness of form, a simplification of features, and an inability to sculpt well-defined traits on a marble or even stone or sandstone slab. Hence, the results they produced were comparatively inexpressive, with a marked angularity.

However, Roman portraits were essentially concerned with physiognomy and stark realism derived from death masks—*imagines maiorum*—yielding a plasticity which was full of character and expression. Roman portraits are extremely life-like: the sitter is readily identified, and his or her effigy accurately potrayed for posterity.

However, in the development and diversity of Roman portraiture, it was not always so. Another type of portrait which was not based on death masks was intended to 'identify' the sitter by highlighting his or her character traits. Such portraits display marked personality; they were somewhat more idealised, and more in line with Hellenistic portraiture.

Another Roman development was the 'ideal portrait', a stereotyped, dignifying rendering of gods or goddesses or, in the case of emperors, a deification of their effigy. These portraits are uniform, with common family traits being stressed to make them more easily identifiable. Rather than realistic portraits, they are a compendium of the subject's most salient features.

These three types can be roughly attributed to different periods. The early, Republican period was characterised by lively, more realistic portraits, which eventually coincided in time with those with stereotyped features produced for public display. Ideal portraits reached their peak of development in the Augustan period and that of the Julius–Claudia family. Image was emphasized in this type of portrait, to the detriment of accurate realism. In this respect, it is interesting to compare the numismatic portraits on coins with free-standing sculpted effigies.

The two trends that endured were idealised portraiture and the Hellenistic type of physiognomic portrait. They coexisted until the end of the 5th century AD, albeit with local variations.

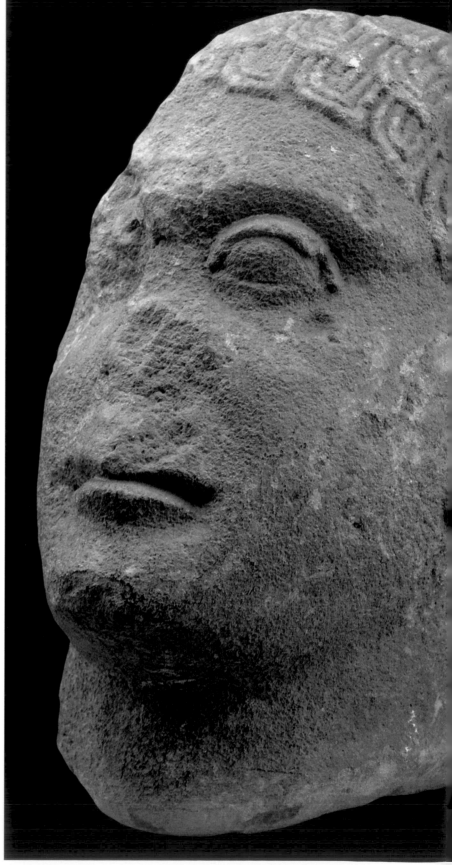

Iberian head. *1st century BC. From Cerro de los Santos (Montealegre, Albacete). Museo Arqueológico Nacional, Madrid*

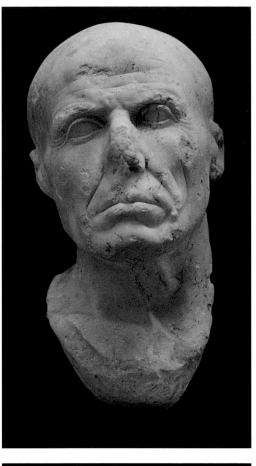

Portrait of a man. *1st century AD.*
From the Eastern Necropolis at
Mérida. Museo Nacional de Arte
Romano, Mérida.

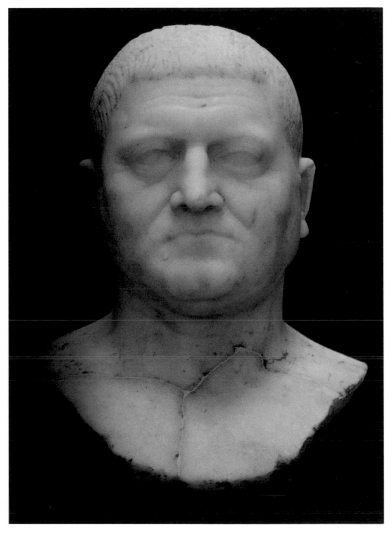

Portrait of a man. *1st century AD.*
From the Eastern Necropolis at Mérida.
Museo Nacional de Arte Romano, Mérida.

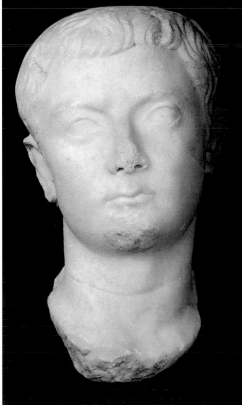

Tiberius. *1st century AD. From*
the Theatre at Mérida. Museo
Nacional de Arte Romano, Mérida.

Mosaico cosmológico or 'Cosmic Mosaic', from the *Casa del Mitreo* ('House of Mithraeus'). Mid-4th century AD; 462 x 356 cm. Mérida (Badajoz).

Drawing of the *Mosaico cosmológico* or 'Cosmic Mosaic'. Mérida, mid-4th century AD.

Drawing of the mosaic from the women's quarters at the La Olmeda villa in Pedrosa de la Vega. Achilles is exposed after disguising himself as a girl on the island of Scyros.

Private Artworks

Part of official, public art was occasionally reproduced in the private sphere for personal use, enjoyment and satisfaction. Some Romans regarded interior decoration or surrounding themselves with artworks as a means of displaying their wealth, which turned some of the wealthiest among them into patrons of the arts. Their villas were ideally suited to this purpose.

We know from Cicero and other writers that a large number of Romans were art collectors, to some extent as a result of pillage and the spoils of war after conquests in the Eastern provinces and in Greece itself, as borne out by salvage from sailing vessels that sank in the Mediterranean.

In Roman Hispania, art in the private sphere is evinced in the wealth of mosaic paving and the large variety of artworks that adorned rooms, gardens, fountains and porticoes. Houses and villas were studded with multicoloured mosaics, depicting a variety of scenes, which enveloped household members and visitors in cultivated and likewise *referential* atmospheres, in that their subject matter usually alluded to the area they were found in and the function of that area.

The residences of the well-to-do in Hispania relied for their decoration on an abundant supply of mosaics, churned out by intensely active workshops and, although the craftsmen that made them were, like sculptors, not regarded as artists, they sometimes achieved extremely beautiful results. Just as sculptors worked to established models, mosaicists used preparatory cartoons based on set subjects and iconographic repertories. Local variations were a matter of interpretation, the choice of certain subjects over others and, in time, of a crude adaptation of existing models due to lack of skill or incorrect interpretation of a model.

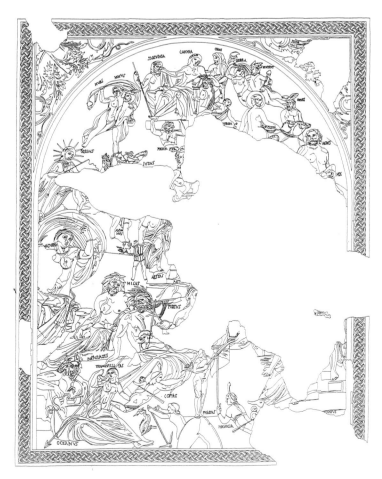

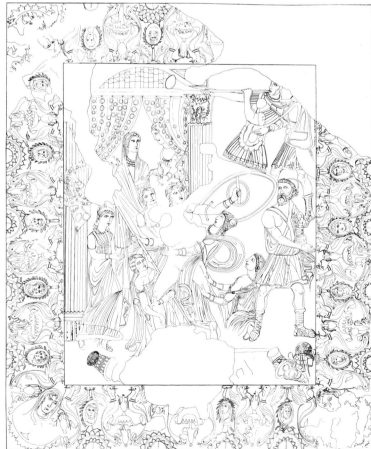

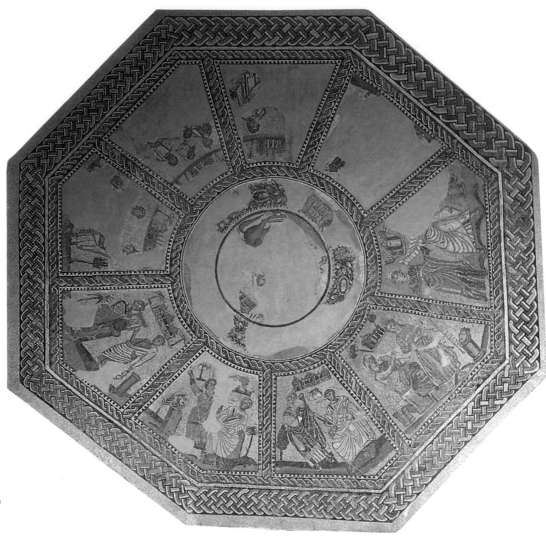

Mosaic of the Muses. *Circa* 310–330 AD; 490 cm. in diameter. Arroniz. Museo Arqueológico Nacional, Madrid.

In the case of mosaics, it is just as difficult to establish whether they were done by local workshops or by itinerant ones hailing from other parts of the Empire. Local workshops did obviously exist, but in some cases this can only be surmised. All that can indeed be determined is, for example, whether a particular motif was Alexandrian, Eastern or African.

The fact that many subjects appear repeatedly points to uniformity in taste and a certain imposition of style by mosaic workshops. Both Romans that settled in Hispania and Romanised Hispanics had a penchant for representations of such historical subjects as Dionysius–Bacchus, the triumph and return from India, Dionysius and Ariadne, Dionysius and his entourage of revellers, satyrs and maenads, the seasonal cycle, hunting scenes, seascapes, Hercules and his labours, and chariot or horse racing in the hippodrome. Each of these scenes was best suited to a particular setting, and was distributed accordingly in different parts of a house.

However, the most outstanding examples of Roman mosaic in Hispania are actually conspicuous exceptions to the rule of a standardised repertoire of motifs. In such instances it was indeed the landowner or patron that chose the subjects with which he wished to adorn his house.

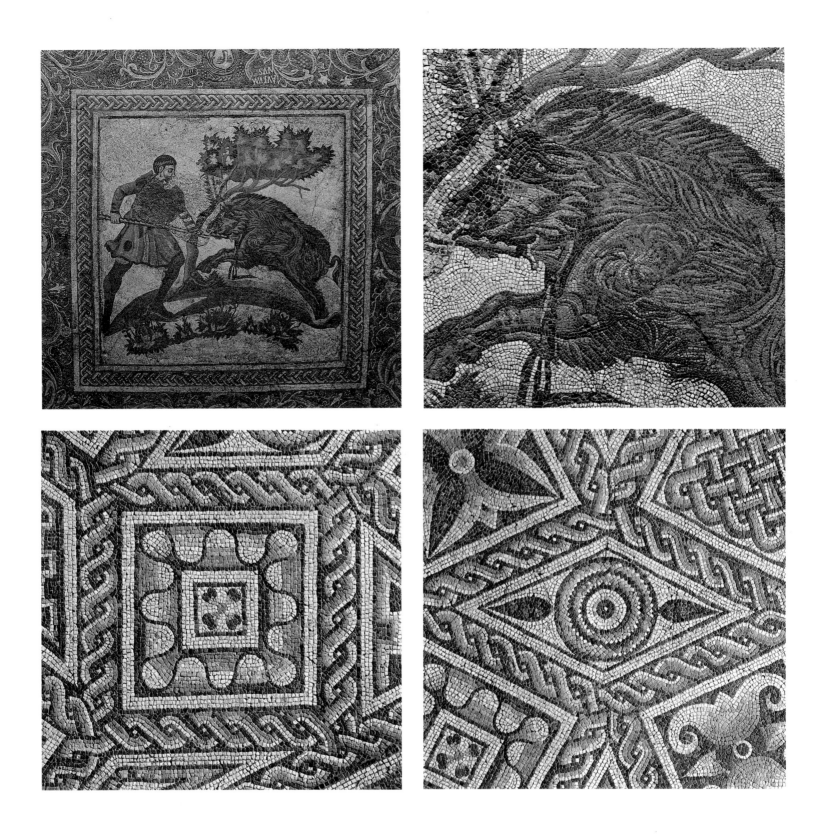

Mosaic of Annius Ponius. Late-4th or early-5th century AD.
Mérida (Badajoz); Museo Nacional de Arte Romano.

Perhaps the finest example of this kind in Hispania, and in the whole western Roman Empire, is the mosaic floor tiling in a suburban home in Augusta Emerita. The name of the owner of the residence remains unknown, but it was in all likelihood one of the governors of the province who lived in that city in the mid-4th century AD. I am referring to either Flavius Sallustius or Vettius Agorius Praetextatus, both great political figures of the time and pagans, who at various stages during their life were stationed in Augusta Emerita. The mosaic was discovered in a residence known as the *Casa del Mitreo* ('House of Mithraeus'), in Mérida, and its subject, style and originality would suggest it dates from the 4th century AD, although some archaeologists have even dated it in the late-2nd century or early-3rd century AD. However, one feature that remains undisputed is that the motif is Alexandrian in inspiration, as demonstrated by the Italian researcher, Luisa Musso. Now known as the *Mosaico cosmológico* or 'Cosmic Mosaic', it is an allegory of the cosmos, depicted in a number of scenes which are described in an explanatory legend in Latin. The lower part features the Earth; in other words, the Roman Empire which, by the emperor's *felicitas,* blossoms in its seas, rivers and ports.

The ensemble of earth and sky is overlooked by Aeon or 'recurring time', who is portrayed in the form of seasonal change. Aeon is also identified with *aeternitas.* The way these allegorical ideas have been developed, and the descriptions provided in modillions, would suggest that the mosaic dates from the later imperial period and that its owner possessed a complex philosophical and naturalistic ideology. It so happens that one of the aforementioned political figures set forward as the possible proprietor, Flavius Sallustius, once wrote an essay entitled *On the Gods and the Cosmos,* a subject which is physically echoed in this mosaic.

This, then, appears to account for the subject matter of the mosaic. Similarly, the fact that such a uniquely beautiful artwork should have come to light in Mérida tallies with the fact that this city was the capital of all Hispania during that period.

Another quite astonishing mosaic, which might have been based on a preparatory cartoon done in Asia Minor, came to light in a Roman villa at Pedrosa de la Vega, near Palencia. The villa, which dates from the later Roman Empire and continued to be used until the 7th century, is set in a large farming estate with hunting grounds on the Castilian meseta, and is ideally situated for a rich, powerful and presumably high-living landowner of the late 4th century. The scene depicted on the mosaic is full of vivacity and anecdotal value: Achilles, who has taken refuge on the island of Scyros and disguised himself as a girl to avoid going to war in Troy, is hiding in Lycomedes' gynaeceum. The astute Odysseus, who is charged with finding him and persuading him to lead them to war against Troy, resorts to a ploy: he sounds the trumpet, and Achilles, who cannot resist the call to arms, takes up his arms and gives himself away.

That is the moment depicted in the mosaic—Achilles taking up his spear. Odysseus looks on, wearing the expression of one who knows what he is doing. The beautiful women of the gynaeceum attempt to prevent the departure of the hero whose company has been a source of delight for them. Lycomedes' wife is shown dismayed on discovering the scene after pulling aside a curtain which conceals the secrets and delights of a woman's boudoir. The mosaic is framed in a richly adorned border which includes portraits of the landowner and his family, set between facing peacocks and lush vegetation. In short, magnificent colours and a splendid composition punctuate a beguiling, piquant escapade that might have been a topic of conversation at banquets.

Equally interesting is the mosaic in the adjoining room, which features a violent, brutal, brash hunting scene, more appropriate for male consumption.

Another mosaic, this time from a villa at Carranque, near Toledo (ancient *Toletum*), highly original in subject matter and iconography, turns out to be an invaluable aid to learning the techniques used by mosaic workshops. The subject is uncommon in mosaics on the Iberian Peninsula. Since the one in question was designed for the floor of a bedroom (*cubiculum*), it features love themes taken from mythology: Hylas devoured by voracious lake nymphs after falling prey to their beauty; Poseidon, who, disguised as a bull, chases

after the irresistible Amymone; Actaeon, a startled onlooker at the naked beauty of Artemis, who is torn to pieces as punishment for his indiscretion, and Pyramus and Thisbe, who come to a tragic end after arranging to meet in secret. These scenes are overlooked by a large medallion featuring Aphrodite, the goddess of love, both witness to and instigator of the passion and dalliance of the boudoir.

An inscription framed in a *tabula ansata* in the entrance enjoins the occupant to happily enjoy the pleasures of the chamber. It includes a reminder that a painter and workshop of *tessellarii* were instrumental in creating the artwork in question.

Numerous Roman mosaics have come to light on the Iberian Peninsula, including those depicting circus scenes in Barcino, Girona, Emerita and Italica. Mosaics portraying philosophers can be seen in Mérida, while marriage scenes, including a portrait of a married couple, were found in a villa known as 'La Malena' in Aragon, a splendid and highly original work. Indeed, mosaics were an extremely popular art form among the inhabitants of Roman Hispania, particularly landowners, and were developed to a high standard of artistry and expressiveness.

The passage of time has been harsher on paintings, which were also part of home decoration in Hispania, and few examples of Roman paintings have survived. Like mosaics, painting techniques and motifs, some of great beauty and refinement, were based on Roman models, and wealthy Romans or Hispano–Romans also collected artworks for personal enjoyment and for show. In this respect, Romans in the provinces emulated their counterparts in the metropolis, as they did classical models of refinement and luxury.

The Importance of Bronze

As mentioned earlier in passing, many of the finest surviving bronzes have been preserved as a result of a ship carrying the cargo of a wealthy nobleman having sunk in the Mediterranean. The objects in question were preserved by the sea and relinquished by it.

It was customary for Roman villas to be adorned with statues based largely on Greco–Hellenistic models. Bronze lamps of Ethiopian negroes, either in miniature or life-size, alluded to the role in real life of slaves brought from Africa. Other objects included

Mosaic of the Chariot Races. First quarter of the 4th century AD. 803 x 360 cm. Museu Arqueològic Nacional, Barcelona.

Mosaic of the Chariot Races. Late 4th century AD. 708 x 342 cm. From the Can Pau Birol villa in Bell-lloc del Plà (Girona). Museu Històric, Girona.

Both mosaics, set in a Roman circus, are of the so-called 'spatial type', whereby the chariot races are depicted within a complete architectural framework, which includes the arena, the spina with its ornamentation, the *carceres*, and the podium. The wealth of detail has enabled the setting in question to be identified as the Circus Maximus in Rome, rather than a local circus. Moreover, the way the horses and chariots have been emphasized, rather than the victors, suggests that the mosaics belonged to agricultural landowners who had commissioned the works for their villas to commemorate the games patronised by them in Rome. Similar examples have been found in Carthage, Capsa and Piazza Armerina, confirming the fact that the same models circulated around the Empire.

Ephebus of Antequera. 1st century AD. Museo Arqueológico, Antequera (Málaga),

tray stands, chamber pots and standing lamps. A beautiful statuette of an ephebus, known as the 'Melefebos of Antequera', has plaited curls and wears a festive garland. Another bronze, a *negrito* or statuette of an Ethiope, which might have once been used as a coaster, is housed in the National Archaeological Museum in Tarragona. Bronze statues of extraordinary facture, such as the Apollo of Pinedo or the Hypnos of Almedinilla, likewise attest to the export trade in artworks, to the high standards of craftsmanship in local workshops, and to the lavish tastes of their owners. It is not known exactly where local workshops were situated, although they may well have been housed in villas themselves, in addition to cities. What is known is that they generally produced small bronzes using the lost-wax technique.

Ornaments in humbler households tended to be made of ceramic or terracotta, while bronze objects would ordinarily be found only in wealthier homes. Perhaps the best example of how bronze objects were used to adorn interiors is provided by the ruins of Pompeii, which have yielded bronze lamp stands, candelabra, statues, tables and bedsteads. Some objects of this kind have survived from Roman Hispania, too, even though, in most cases, their specific archaeological context has not yet been determined. However, the base of a bronze candelabrum found in Mérida shows just how important existing Roman models were. The nielloed base in question features Apollo and the Muses in the form of small inlays, and the ornateness would suggest the client was probably an art connoisseur with refined taste. In particular, bronze was used to make statuettes of household deities for wealthy families.

Homes, taverns, marketplaces and the *collegia,* an association where members of a community met, were presided over by Lares, statuettes of a tutelary deity which were mass produced for public or private use. Set in shrine niches at the entrance to houses or public places, Lares became a speciality of bronzesmiths, as they were constantly in demand. Artisans were also commissioned to mass produce a host of other bronze deities, including Mercury, the god of abundance, commerce and wealth, in addition to a large number of other small or everyday objects. A noteworthy example is a situla unearthed in Buena (Teruel). The bucket-shaped vessel, used for female ablutions, is inlaid with silver and was most likely a gift brought from Alexandria.

While, during their lifetime, the well-to-do landowners, functionaries, retired senators and administrators surrounded themselves with sumptuous objects, they also provided for their death and burial, for which purpose they would import a sarcophagus and have it finished and decorated by local craftsmen. Imperial workshops specialising in funerary decoration also geared their production to models dictated by fashion, and a large proportion of the few sarcophagi found on the Iberian Peninsula are numbered among the finest, most outstanding works of Roman art in Hispania.

Monumental Architecture

Roman architectural services were contracted by both the State and private individuals, and major public works were usually designed by architects, surveyors and engineers in the employ of the military. The Aqueduct of Segovia, the Alcántara bridge and the Amphitheatre at Mérida were built in this way. Public works included functionally designed buildings, well-planned hydraulic and engineering works, and leisure or meeting places, which were often sponsored by the Emperor himself and bore an inscription to that effect, as a reminder of his grandeur and generosity. The idea of *public magnificence* was behind these major works, planned, designed and organised by Romans, but largely executed by local workforces. Many such projects, often related to town planning, can still be seen today. Such constructions were generally embarked on during the founding period of a colony or settlement and subsequently completed, enhanced or altered.

Roman theatres were possibly the most spectacular of public buildings in Roman Hispania. Apart from their function as theatres, these large-capacity constructions were used to

Ethiopian servant or *negrito*. Early Roman Empire. Museu Arqueòlogic Nacional, Tarragona.

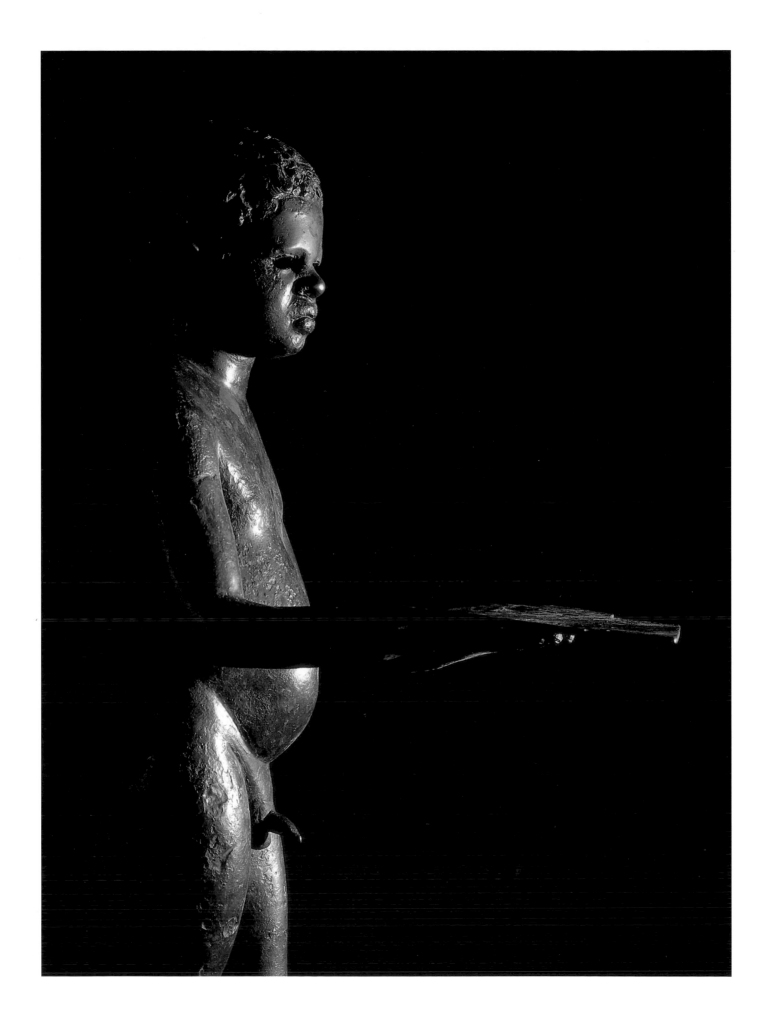

Alcántara bridge (Cáceres).
Early-2nd century AD.

The Alcántara bridge was a symbol of Rome's territorial and cultural dominion and its technical prowess in hydraulic works and engineering. It was part of a large network of roads and waterways which had its hub in *Augusta Emerita*. The latter, lying on the route linking the colonies of Metellinum (Medellín) and Norba (Cáceres), was connected to the south, north and north-west of the Iberian Peninsula. Measuring 194 metres long and 48 metres high in the middle, it is made up of six semi-circular arches resting on sturdy pillars, designed to offset the uneven terrain. In the centre rises a triumphal arch, which was fortified at a later date.

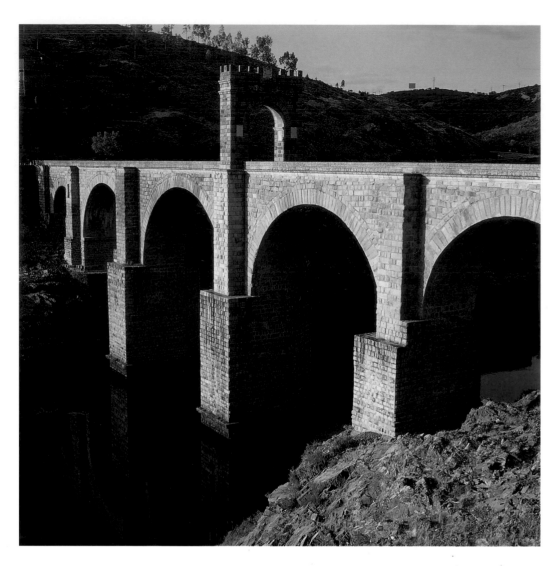

stage festivals, rites, processions, contests and political meetings, and their stage decoration rivalled adorning statues of deities and the imperial family.

Noteworthy Spanish examples include the theatre of Mérida, begun in the 1st century AD and completed under either Tiberius or Claudius; the one in Clunia, with a huge seating capacity in relation to the size of the site; another at Caesaraugusta (present-day Zaragoza), the tiers of which were originally wooden, later replaced by ashlar, and others at Sagunto, Segóbriga, Ronda, Málaga, Regina, Tarraco and Italica. The one in Italica, which reveals perfect, Vitruvian planning, was greatly enhanced during Hadrian's reign by the addition of Carystean columns (from Carystus, on the island of Euboea) and altar stones decorated with scenes of bacchantes and maenads. The various orders, styles, capitals and decoration, which adhered to Roman tenets and canons, with but a few regional variations, were probably the work of local stonemasons.

The Roman army raised walls and built aqueducts and bridges, especially when they first started settling on the Iberian Peninsula. The constructions were decidedly Roman, as were the engineering principles applied to them. In time, these walls and hydraulic works were repaired or overhauled and, on occasion, imitated by local inhabitants whenever the need arose. The walls of Tarraco, Mérida, Lugo, Barcino and Caesaraugusta are excellent examples of powerful, fortified enclosures. And, among the major hydraulic works, the Aqueduct of Segovia, thought to have been built under the emperor Domitian (second half of the 1st century AD), stands out as the most spectacular example, on account of its length, height and ashlars, pieced together without mortar.

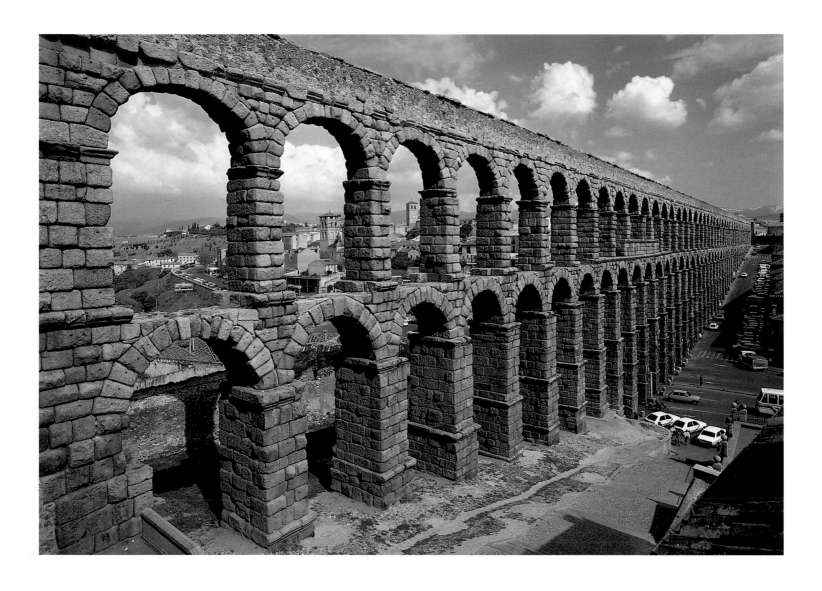

The Aqueduct of Segovia. Domitian period; last quarter of the 1st century AD.

Originally, Roman arches acted as both commemorative and triumphal monuments, adorned with one or more statues of the victor, and reliefs depicting his feats. Subsequently, they also acquired an honorific function, being built in honour of a particular personage. They were also used as funerary monuments, serving as a posthumous memorial to an important figure and his family. Lastly, there were arches used to demarcate territorial boundaries.

Few arches from Roman Hispania have withstood the test of time, but all the aforementioned types are represented by those that have survived. The Barà arch, for instance, is an honorific monument dating from the time of Augustus: it is simple and austere, and lacking any adornment, and was built during the early Augustan period. In contrast, the three-spanned Medinaceli arch was clearly built for territorial demarcation purposes. It is not known whether it was originally decorated in any fashion, as no adornment has survived to the present. The Capera arch, in Cáceres, is a funerary arch which was once adorned with statues of the deceased. There were several genuine triumphal arches, like the one dedicated to Septimus Severus in the Roman forum, but the only vestiges of such arches are remains of their decoration. They included one in Clunia, another in Tarraco—which was probably Augustan—situated in the upper forum, and one in Mérida commemorating the victories of Maximian Herculius, built in a later period. The Mengíbar arch, which survives only in epigraphic references and in a relief that might have once been part of its decoration, acted as a dividing marker between the Roman provinces of Hispania Citerior and Hispania Ulterior.

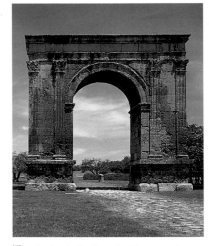

The Roda de Barà arch (Tarragona). Late-1st century BC.

49

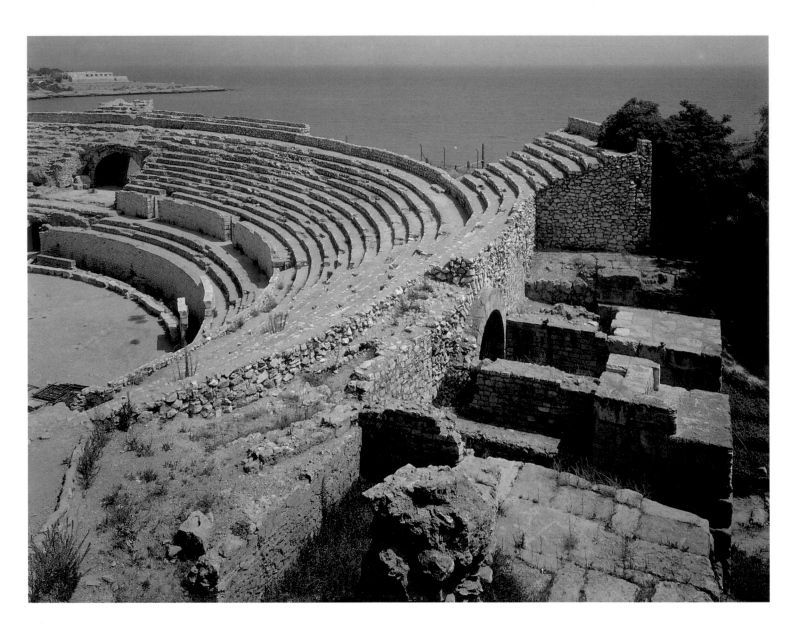

Roman Amphitheatre in Tarragona.
Second half of the 1st century AD.

Temples and tombs were an essential and deeply-rooted part of the Roman lifestyle and mentality. Temples presided over public squares and acted as a permanent reference point in civic life: they were used for sacrifices to mark the numerous events in the official calendar, as well as for holding meetings on their vast steps, or for processions and votive offerings. The few temples from Hispania that have survived, or have been rebuilt from remains, are classical in style, dimensions and arrangement.

The Temple of Diana in Emerita owes its good state of preservation to the fact that it was subsequently used as a palace in the Late Middle Ages. In Roman times, however, it probably served as a shrine for the imperial cult, and was set on top of a huge podium. Dating from the early years of the colony (the late-1st century BC), it had columns faced with stucco. Another comparatively well preserved Roman temple is the one in Cordova (Córdoba), dating from the Flavian period (second half of the 1st century AD). From its close resemblance to temples in Rome and southern Gaul (Vienne, Nimes), it must have also been used for imperial cult worship. One temple which has been magnificently preserved is the Temple of Diana at Évora (Alto Alentejo, Portugal), a town which in Roman times was a colony called Liberalitas Julia. Dating from the first half of the 1st century AD, the building was raised on a 3.5 m-high podium and had Corinthian columns. It bears resemblances to the Temple of Divus Julius in the Roman Forum, the Temple of Diana at nearby Emerita, and the temple at Barcino (Barcelona).

Vestiges of other urban buildings include basilicas and marketplaces. Noteworthy examples survive in urban complexes at Baelo Claudia (a site in present-day Tarifa, Cádiz),

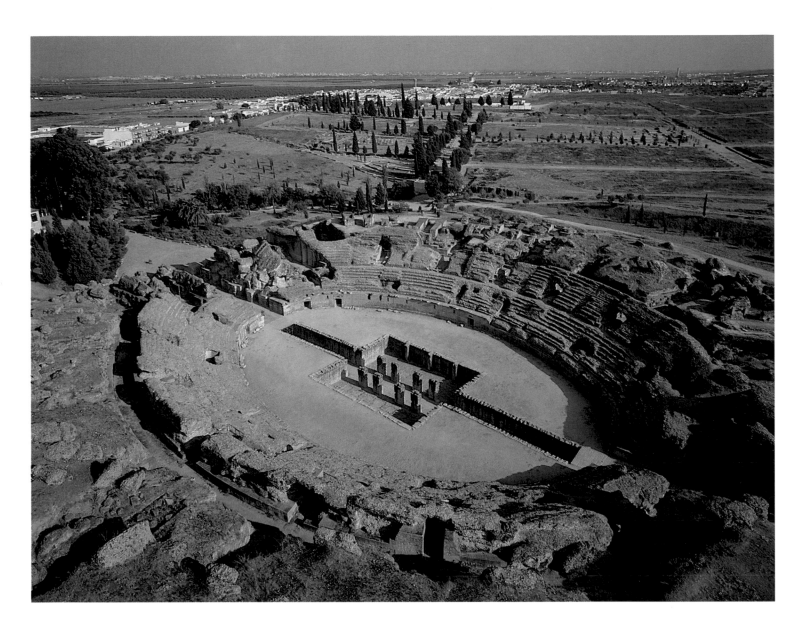

Empúries and Clunia. A gigantic building was the so-called Trajaneum of Italica, set in a similarly large forum modelled on Hadrian's Library in Athens.

In Roman times, the dead were buried in precincts resembling temples, particularly from the 1st century BC to the 2nd century AD, a period in which incineration became common practice. Chambers in the precinct known as loculi, where the funerary urns were kept, housed the mortal remains of an entire family, including parents, grandparents, children and freedmen, who were former slaves in the family home.

The dead could not be buried in the city, as it was believed that they would contaminate its citizens and wander about as spectres during the night. Instead, they were buried in necropolises that lined the Roman ways on the outskirts of a city or town. On occasion, they would be located in the vicinity of a villa.

Funerary architecture in Hispania has not yet been fully studied, and the results of detailed and regional research are only now coming to light. Regionally-orientated studies have focused on the variety of architectural customs and traditions relating to tombs and mausoleums. In this respect, Italic models are key to understanding the transposition of forms and monuments to Hispanic soil.

Early funerary monuments in the southern Roman province of Baetica adopted the form of towers surmounted by elegant pyramids, while in Tarraconensis the mausoleums consisted of temples with two or three columns on the facade. A magnificent and often overlooked example of funerary architecture is provided by the Fabara mausoleum, located on the boundary between the provinces of Zaragoza and Lleida. It features an under-

Roman Amphitheatre in Italica (Seville), built during Trajan's reign (98–117 AD), and remodelled and embellished in the Hadrianic period (117–138 AD).

The Trajaneum, in Italica (Seville). Reconstructed ground plan.

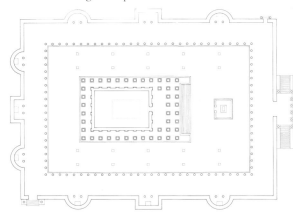

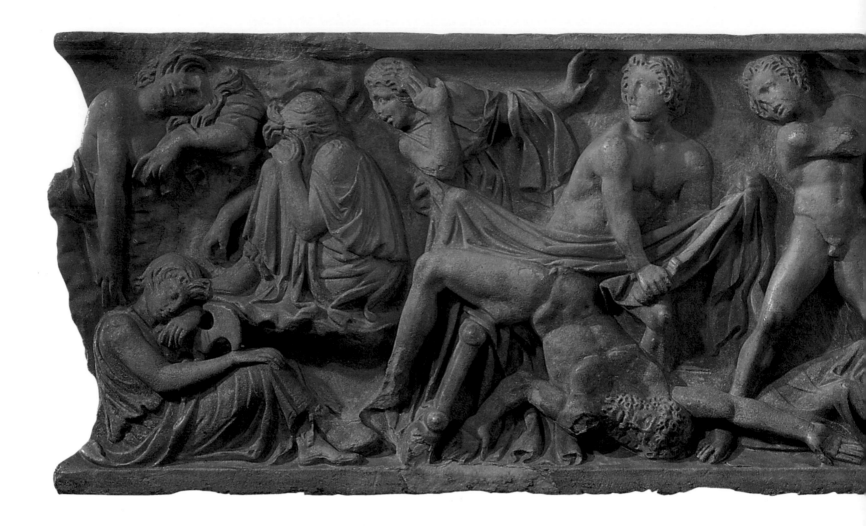

ground chamber which is thought to have been built during the reigns of Hadrian or Antonianus (2nd century AD).

Of the mausoleum of Atilius, in the district of Cinco Villas (province of Zaragoza), only part of the facade has survived. Architecturally, it is ornate and elegant in facture, and responds to models prevalent under the Severus emperors (late-2nd century and early-3rd century AD).

Some necropolises were highly original and local in style, like the one at Carmona, near Seville, where the loculi exacvated in the rock are reminiscent of Phoenician and Punic burials.

Another example of buildings designed for both public and private use is that of Roman baths or thermae, which usually covered large areas and had *ad hoc* decoration. They were common in Hispania and throughout the Empire, both in cities and in rural and suburban villas. In most instances only the walls and heating systems have survived, although some piscinas from the various chambers making up a Roman baths can still be seen.

The baths were profusely decorated wtih mosaics and statues, and the circular central halls covered with large vaults. Some noteworthy examples are the thermae at Alange (Badajoz), which are still used today and must have once been part of a resort with medi-

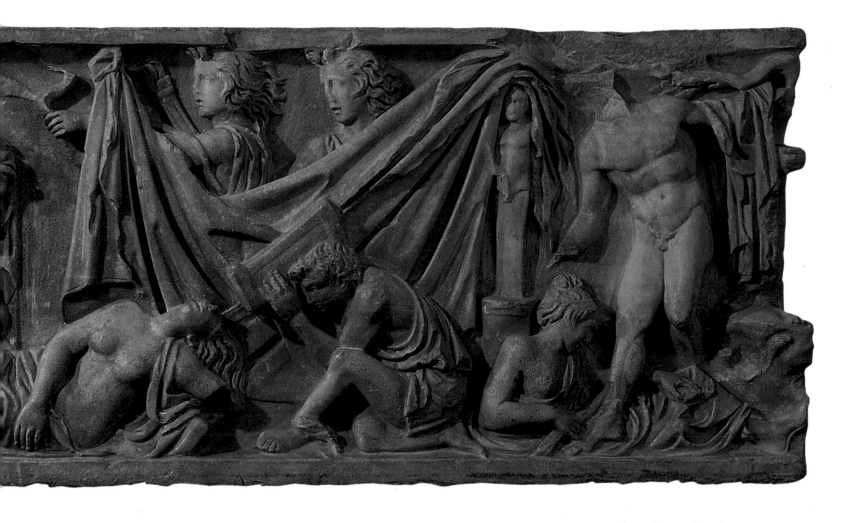

Sarcophagus of Husillos.
2nd century AD.
Museo Arqueológico Nacional, Madrid.

cinal waters, and the baths at Centcelles (Constantí), in the province of Tarragona, with a central dome that was decorated in the second half of the 4th century AD. The mosaic ornamentation features hunting scenes and a biblical representation of the ceremonial investiture of different Church offices, as the baths were owned by a high-ranking member of the ecclesiastical hierarchy, who eventually turned them into a prestigious mausoleum.

Roman Art in Hispania

The precepts of Roman art soon spread across the whole Iberian Peninsula. Classical and Hellenistic in tradition, such art forms and tastes took root wherever Romans settled. Simultaneously, local forms of artistic expression, which were by then impregnated with Mediterranean and Greek influences, were gradually superseded. It was only in areas where the Roman presence was negligible that artists and artisans managed to hold on to their local traditions and repertories. The desire to emulate—*aemulatio*—lifestyles in the new colonies led to *imitatio* and to the transformation of local art into visual art 'a la Romana'.

This phenomenon was only imposed on local inhabitants as far as official art was concerned, whereas in popular, everyday art, artists attempted to imitate Roman ideals of

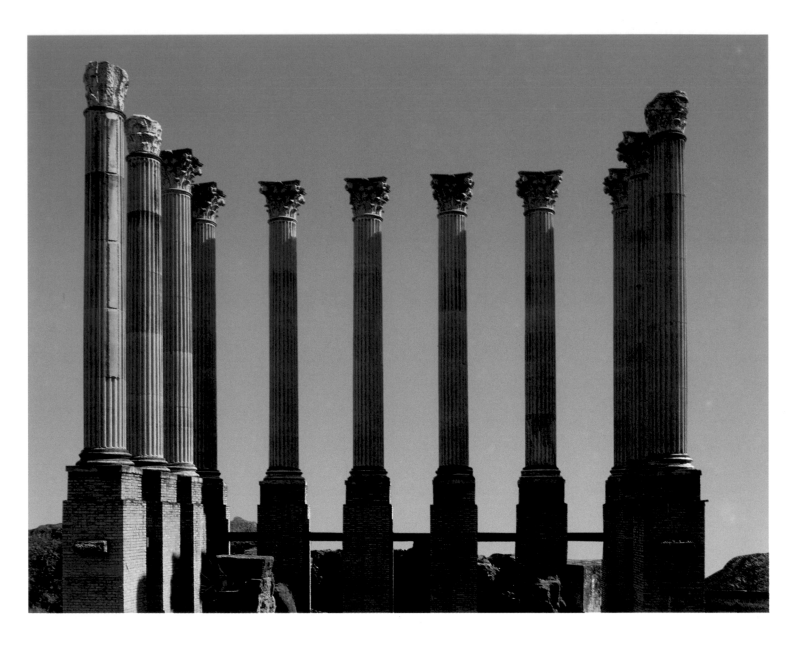

Temple of the Via Claudius Marcellus, Cordova. Flavian period, 2nd half of the 1st century AD, & Hadrianic period, first quarter of the 2nd century AD.

Sequence of figures from a frieze on a neo-Attic altar. The Theatre in Italica.

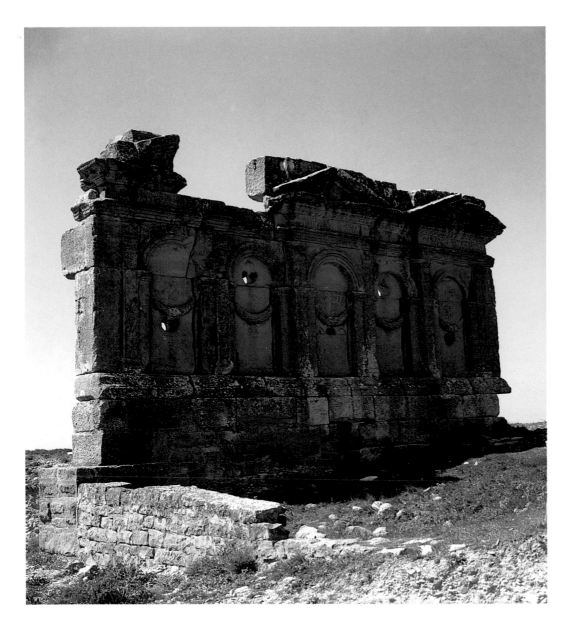

Mausoleum of Atilius, at
Sádaba (Zaragoza).
Late-2nd or early-3rd century AD.

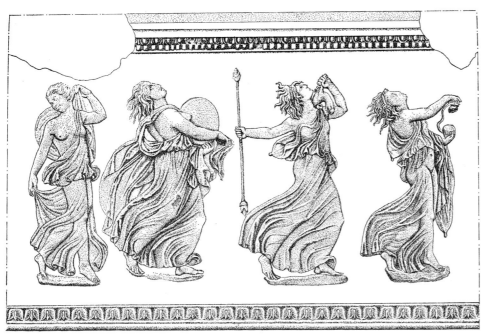

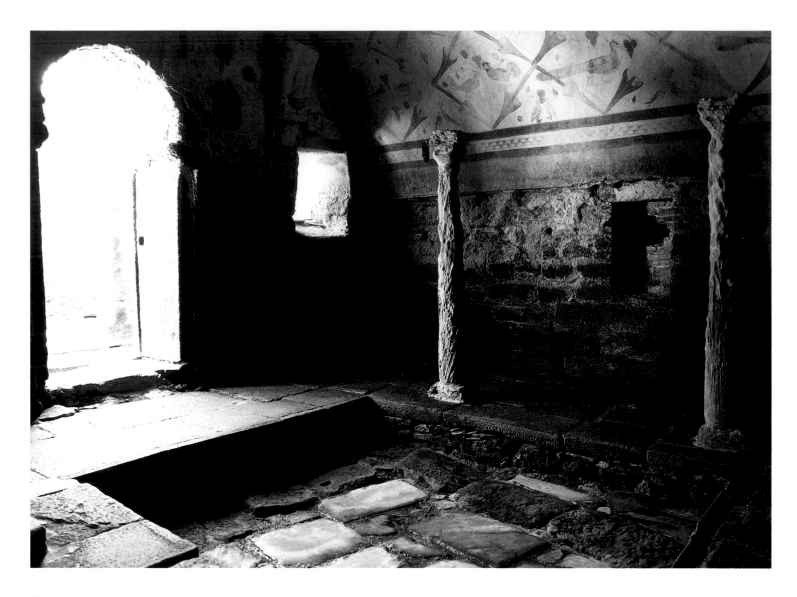

Roman baths at Santa Eulalia de Bóve-da (Lugo).

their own free will, and were not always successful in shaking off their local traditions. A well-known case in point are the funerary steles of the Castilian meseta, and certain reliefs or sculptures in north-western Spain; in other words, areas where the Roman presence had been less evident. The decorated funerary steles, made by local artists, are a combination of local motifs and ancestral techniques with classical Roman models and motifs. Figures, funerary banquet scenes, incised geometrical motifs and Latin inscriptions merge in highly original ensembles, bearing out the fact that local art attempted to assimilated Roman forms and ended up being overwhelmed by them. Those who commissioned steles were local citizens who aspired to achieve social status through assimilation by their colonists.

To conclude, it is worth addressing the question of what Roman art in Hispania really was. To all intents and purposes, it was the art of Rome transposed to an outlying province. Very little of it was actually *Hispanic,* apart from the fact that it was produced in Hispania. In essence, it reflected Roman tastes, interests, ideology and mentality and, subsequently, those of its provincial assimilators. As Roman art, it was highly uniform and monotonous.

At times, it attained great aesthetic and technical heights, depending on its purpose and the clients that commissioned it. It served the Roman State and fulfilled a wide range

of political, religious, funerary and practical exigencies in the Empire. It underwent the transformations and evolution that issued from Rome, and had the effect of superseding, quashing and stifling local trends. In short, it was additional proof of the Empire's regimented uniformity. It was an art that was cut short when Rome's creative drive went into decline, attended by the disappearance of art and architecture based on classical models. Its demise coincided with the rise of Christianity and the Christian suppression of anthropomorphic depictions of the gods, when pagan images were replaced by Christian iconography, and temples were turned into churches or cathedrals. The distant recollection of those classical models would later be recovered during the early Middle Ages in the form of monsters and other effigies adapted to Christian ends. Strangely enough, in many instances, that also prompted the reappearance of local, pre-Roman currents.

Roman art in Hispania was wholly reliant on a province or territory assimilating imported models, and was at times as expressive and vigorous as the Roman examples it looked up to.

Funerary stele, 2nd century AD. Museo de Burgos.

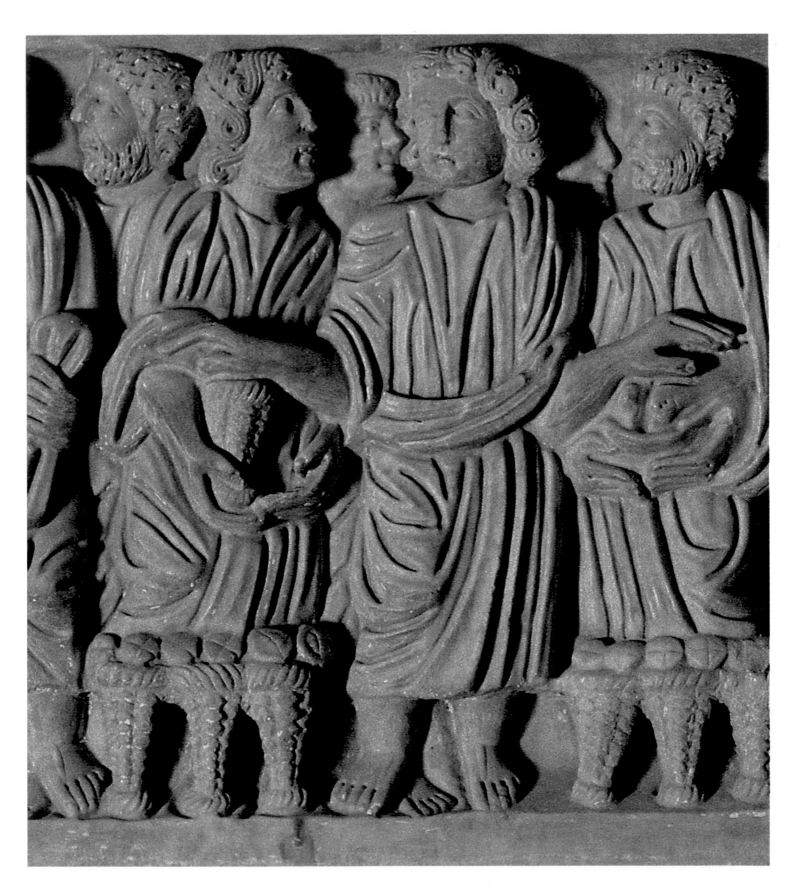

Sarcophagus with scenes from the Old and New Testament. 315-335 AD. Girona; church of San Félix.

From Antiquity to the Middle Ages, Christianity and the Visigothic World

Pere de Palol

The Christianisation of Roman society in Hispania is recorded as having begun in the mid-3rd century AD, once the apostolic origin of St Paul's teachings had been established, principally on the basis of his Letter to the Romans (Rm 15: 23 & 28). This is known from St Cyprian's reply (Ep. 67) to the Christian communities of Mérida, León and Astorga, who had written to him about the apostacy of the bishops Basilides and Martial. Around the year 259, St Cyprian confirmed the existence of organised communities in Saragossa, Mérida and León–Astorga. The martyrdom of the Bishop of Tarragona, Fructuosus, and of his deacons, Augurius and Eulogius, on 21 January 259, under the persecution of Valerian, and quotes from the martyrs, cited by the poet Prudentius in his *Peristephanon,* during the great persecution of Diocletian in the early-4th century, provide documentary evidence of certain urban communities, but it is not until the time of Constantine that any material remains of these came to light, owing precisely to that last, virulent persecution.

Thus, as in other Roman provinces, early-Christian art in Hispania dates from the 4th century AD. The earliest finds are liturgical, relating to worship and funerary objects, which are important for their ideology, in addition to those of a symbolic and narrative nature. The remains in question acccount for only a small portion of Roman and Christian monuments at the time, as they coexisted with pagan art. Together they make up the plastic arts characteristic of the Later Roman Empire.

Cities were the first areas to be Christianised, although the effect was only noticeable in the urban fabric after the edicts of Theodosius were passed at the end of the 4th century. Prior to that, it would have been politically unthinkable to establish places of worship within the urban precinct, whether in *municipia* or *coloniae,* where pagan worship of the emperor or the Capitoline Triad persisted, until it was suppressed by Theodosius following the triumph of orthodox Catholicism.

The major Christian necropolises, including Francolí, in Tarragona, San Antonio de Cartagena and one in Córdoba, have yielded some first-rate artworks. Vestiges have also been preserved in old cities such as Girona, which were Christianised at an early stage. The paramount and most beautiful artworks are sculpted sarcophagi made in Roman workshops. They were imported into Hispania from the early Constantinian period until the end of the 4th century. Later pieces were Theodosian in style. In all, they form a rich ensemble of high-quality workmanship, stylistically akin to the workshop or group of workshops that produced the famous Dogmatic sarcophagus of St John Lateran, and even the reliefs on the Arch of Constantine. The oldest sarcophagi date from the period AD 305–312 and include a beautiful specimen from Astorga, now in the National Archaeological Museum, Madrid, featuring cycles of narrative scenes from the Old and New Testament, as was customary in major Roman Christian sculptural groups. A fine set of sarcophagi of this kind is housed in the church of San Félix in Girona. Some of the works here are unique in their iconography, such as the sarcophagus of 'Christ Triumphant over the Dragon and the Lion', and another recounting the story of Susan.

Some late-Constantinian sarcophagi were also imported, including the colonnaded sarcophagus of Martos (Jaén), and one housed in the Provincial Archaeological Museum of Córdoba, in addition to those rendered in the so-called 'soft style', such as the finely worked

Santa Lucía del Trampal.
Plan of pre-Visigothic & Visigothic buildings.

Sarcophagus of the Good Shepherd & Daniel. 5th century AD. Church of Santa Cruz, Écija (Seville).

sarcophagus of Castiliscar. Sarcophagi were imported until the end of the 4th century AD. An example of the later period is the paradigmatic Besteda, with its depiction of the Entry into Jerusalem, housed in Tarragona Cathedral, or the strigilate sarcophagus in the Provincial Fine Arts Museum of Valencia. Imports from Rome were discontinued early in the 5th century AD, when the workshops there were closed down. Some claim this occurred when Rome was sacked by Alaric's Visigoths in 410. All 4th-century sarcophagi featured reliefs set in a continuous frieze, depicting scenes from both Testaments, invariably arranged for the purpose of conveying a particular religious message. There are no surviving examples from Hispania of the 'Christ presiding over the apostolic college' that emerged from Milan workshops in the late-4th century, with the sole exception of one sarcophagus from the Theodosian mausoleum of Pueblanueva (Toledo), which probably came from an Eastern workshop.

Subsequently, a wider variety of styles emerged from both local and foreign workshops. The sarcophagi of Écija either came from an Eastern workshop or, at the very least, were Greek in inspiration. They feature the Sacrifice of Isaac, and David in the Lions' Den, flanked by the Good Shepherd. This last subject also appears at Barba Singilia, in the province of Baetica. Another important group, housed in Tarragona, is known to have come from Carthaginian workshops. Further examples include the sarcophagus of Leocadius, one of the Apostles, and the frontal of Orantes, set against a double strigilate ground and featuring as subjects the Sacrifice of Isaac and the *Traditio Legis,* with a hybrid Peter–Moses image. A rough-hewn ensemble with marked character came to light in a workshop in La Bureb, in the province of Burgos, with an unusual iconography, quite different from anything preceding it. Interesting sarcophagi include one from Quintana Bureba, which portrays scenes from the visions of St Perpetua, martyred in Carthage, another from the same series, found at Poza de la Sal, showing the Adoration of the Magi, and a fragment from a sarcophagus lid from Cameno, adorned with other scenes. Iconographic features included a mixture of motifs from two of the Gospels, the *Traditio Legis,* and the Sacrifice of Isaac, on one side, and the story of St Perpetua's visions, on the other, with some examples from the Apocryphal Gospels, such as the *History of Joseph the Carpenter,* and the so-called *Protevangelium of James.* The series reveals rather coarse art forms, flat grounds and empty spaces, and its origins and dating have been the subject of debate: Perpetus dated it in the 4th century and claimed it to be African in origin, while other sources associated it with the early Middle Ages.

The few imports from Aquitanian workshops include two fragments found at the Empúries excavations and a sarcophagus, re-used in mediaeval times, from Villanueva de Lorenzana (Lugo). The magnificent lid of the Itacio sarcophagus, in Oviedo Cathedral, might be from Aquitania or Ravenna. The above examples round off the cycle of early-Christian funerary sculpture in Hispania, and practically bring to an end that of figural subjects, which did not reappear until the Middle Ages. It was canon number 36 of the Council of Elvira, held in the early-4th century which, as the source of Hispanic aniconism, banned all representation of the human figure in churches.

Mosaics & Painting

Like the other western Roman provinces, including Italy, north-western Africa and Gaul, during the later Roman Empire, the mosaics of Hispania had their own peculiar plastic beauty, a reflection of the now defunct painting of the time. The beautiful and iconographically rich groups of 4th- and 5th-century mosaics unearthed in aristocratic villas are not matched by anything similar in Christian basilicas on the Iberian Peninsula. Mosaic flooring in Christian churches only appeared in the Balearic islands, and from the 6th century onwards. It was lacking in any prior tradition or future continuity and formed part of the socio-cultural milieu of large landowners. Both secular and religious sites were supplied with the same type of mosaic by the same workshops, as was the case with paintings in the Rome catacombs.

It was against this backdrop that the unique Christian mausoleum of Centcelles (Tarragona) was built. The extraordinary mosaics on the cupola are comparable to those at Santa Constanza in Rome. Rebuilt in the 4th century, it was part of a large suburban villa which consisted of two interior areas topped with cupolas and joined externally by a single, rectangular section. The cupola faced with mosaic, the only one to be completed, is made of brick. The mosaic decoration is arranged in horizontal strips above a lower band of painting around the drum of the cupola. The iconography of these mosaics is a mixture of secular elements traditionally associated with the later Roman Empire, featuring a large cycle of deer hunting in the lower one, overlooked by a group of figures, including the possible *dominus* of the household. It is similar to other contemporary works, such as the ensemble at Piazza Armerina. The hunting cycle is consistent in its narrative discourse.

Mausoleum of Centcelles (Constantí, Tarragona): mosaics on the cupola. Mid-4th century AD.

The funerary character of the central chamber in the Centcelles complex is marked by the iconography of its mosaics. From 1959 to 1978, members of the German Archaeological Institute excavated the underground crypt, which was covered by a barrel vault and had an attached chamber designed to reduce humidity. Their endeavours led to the first iconographic and iconological interpretations of the mosaics. The Christian subject in the second frieze suggests the decoration dates from the period of Constantine onwards. According to H. Schlunk, the mausoleum was built for Constans, who was assassinated in Gaul on the orders of Magnentius around the year 350. This led to the enthroned figures being identified as the tetrarchy of Magnentius. A. Arbeiter concluded that the funerary complex was commissioned by the emperor's assassin, to legitimise the status quo and appease the deceased's brother, Constans II, Emperor of the East. Both hypotheses are the subject of debate.

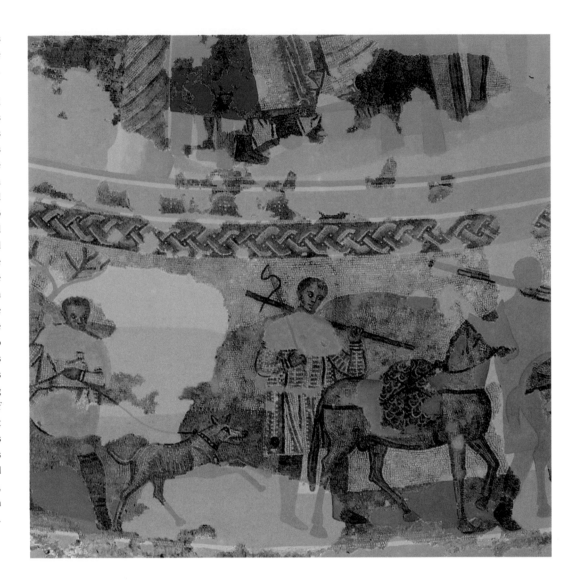

Above the aforementioned scene is a strip adorned with subjects of a funerary nature from the Old and New Testament, presided over by an image of the Good Shepherd, set against a gold ground and immediately above the *dominus* in the lower hunting cycle. There were once sixteen scenes in all, some of which are now missing, separated by Solomonic columns and Ionic capitals, after the fashion of the late-Constantinian sarcophagi mentioned earlier. To the right of the Good Shepherd are three scenes from the life of Jonah. A fourth scene, which has eluded conclusive interpretation, might well have depicted the weddings of Rebecca and Ezekiel. The following one, which is missing, might have been the Sacrifice of Isaac, Daniel in the Lion's Den, or Adam and Eve. The ornamentation continues to the left of the Good Shepherd with three scenes: Noah's Ark, the three young men who refused to worship the statue of Nebuchadnezzar, the resurrection of Lazarus, the youths in the furnace in Babylonia, and three missing scenes. As a whole, this ensemble is a veritable plastic representation of the Roman *commendatio animae*.

The upper frieze, with alternating subjects following a cruciform arrangement, features a classically inspired portrayal of the four seasons, with putti bearing fruit and flowers, as well as scenes of enthronement. Judging from their political and ecclesiastic attributes, the ornate garments appear to be those worn by officialdom, although the issue has not yet been definitively settled. These fine artworks all date from the mid-4th century AD. The mausoleum has been attributed to different personages, but the prevailing feeling is

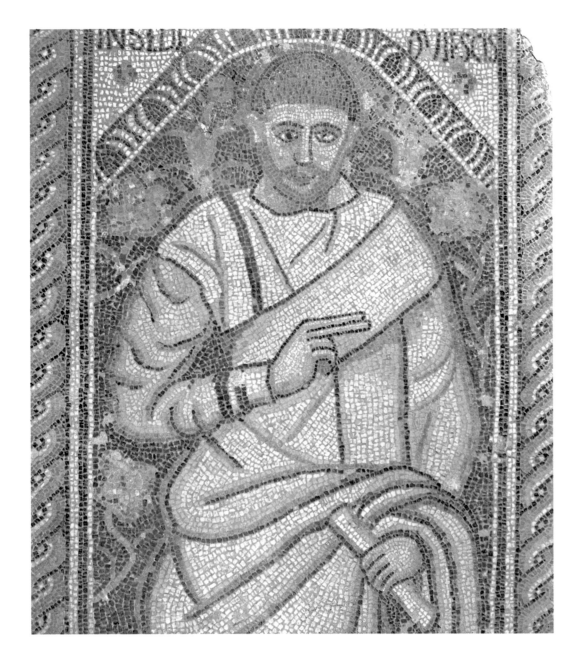

Mosaic on the sepulchre of Optimus.
Late-4th or early-5th century.
Museo Paleocristiano, Tarragona.

that it was the tomb of Constans I, the son of Constantine the Great, as the ensemble has a quasi-offical, academic-art character and includes certain ornamental attributes ascribable to Constans. It is an extraordinary example of plastic art in the milieu of the landed gentry, who had close ties to the Court and, given its overtones of *ludi venatorii,* it is more profane than religious in character.

Like their North-African neighbours, Hispanic Christians used inscribed mosaics to cover their tombs, a practice virtually unheard of in Italy or Eastern Christian countries. These popular works adhered to African trends and models. Tarragona has some fine examples of inscribed sepulchral mosaics, including one known as the *Optimus,* which bears metric inscription, dating from the late-4th or early-5th century. Other examples in the same city include one dedicated to The Good Shepherd and another to Ampelius and, further afield, at Coscojuela de Fontova (Huesca), Gracurris (Alfaro, Logroño), Denia and Italica, following the communication routes from the Mediterranean coast to the interior of Tarraconensis, and even along the river Ebro.

Church of San Juan de Baños
de Cerratos (Palencia); mid-7th century.

This section would not be complete without mention of mosaic paving in the Balearic islands, where mosaics were either inspired by models from North Africa or made in workshops there, as evinced at Santa María and Son Peretó, in Majorca, and in churches at Isla del Rey and Torelló, in Minorca. The mosaics of Santa María, which feature scenes from the Life of Joseph, are reminiscent of illustrated, Old Testament manuscripts such as the *Cotton Genesis,* which is Alexandrian in origin, while the iconography of Minorcan mosaics includes symbols from the Jewish tradition. These specimens mark the end of Hispanic mosaic as an art form, which had disappeared about a century earlier on the Iberian Peninsula. On the mainland, the finest examples sprang from the refined secular art of the rural aristocracy, the great landowners of the late Empire, and the influence of their milieu on the world of art in the subsequent, Visigoth period was considerable, too, on account of their demographic and economic continuity.

Hispano–Visigothic Art

The advent of the Visigoths marked the end of the great cycle of classical art in ancient Hispania. Early-Christian art was then augmented by new influxes, both from abroad and as a result of local development. However, with the Moorish invasion of the early-8th century, the development of Hispano–Visigothic art was cut short, and would never recover its former splendour.

The development of Hispanic art under the Visigoths was attended by a number of factors relating to the culminating moment of the Visigothic reign when, in 589, the religious and political unification of the country was decided at the III Council of Toledo. Thereafter,

Episcopal Centres in Hispania

Ever since the closure of pagan temples, once Christianity had been instated as the official religion by Theodosius, particularly in his edict of 8 December 392 (C.Th.XVI,10.12), Christian churches replaced the temples which had once been the pride and prestige of Roman cities. The churches became the core of episcopal sees, which were located either on the sites of martyria, outside the city walls, or within the city itself. In archaeological terms, they cannot easily be identified and defined, as there are few remains to go by in Hispania. In contrast, their importance can be gleaned from literary sources, particularly in the case of cities that were prominent politically in late-Roman or Visigothic times. As was to be expected, the episcopates continued the administrative tradition of Roman commercial centres, and sprang up in former Roman colonies and municipalities. The number of episcopal centres was enormous, particularly in the more intensively Romanised areas of Tarraconensis, Carthaginiensis and Baetica. Their names, and those of the clergy, are recorded in documents chronicling their attendance at provincial or national councils. Also recorded is the hierarchical structure prevalent at the time, from the city which acted as the seat of the primate down to metropolitan centres or small bishoprics. Signatures which have survived from the III Council of Toledo, held at the end of the 6th century, reveal the existence of six metropolitan sees, all of which dated from the late-Roman or early-Christian period. The order in which names have been signed is significant in terms of the Toledan Court. The first metropolitan signatory was Massona, the archbishop of Mérida and upholder of Catholic orthodoxy against the Arianism of King Leovigild, whose son, Reccared, was a convert. Next in line was Seville which, in the guise of the Sevilian prelates Leander and his brother Isidore, was the driving force behind the move to convert the whole kingdom. Tarragona featured in last place, as its metropolitan had not attended. Instead, the signature that appears is that of his representative, named Estephanus. Thus, the metropolitan sees had an order of importance. Absent from the Council was the metropolitan of Cartagonova, in the province of Carthaginiensis, which had come under Byzantine influence and was replaced by Toledo. Last came Narbonne and Braga, regarded as peripheral areas.

It is no easy matter to accurately determine the artistic and urban development of these cities. With the changeover, Roman buildings were modified, above all to accommodate churches and liturgical structural features such as baptisteries and episcopal residences. In this respect, three episcopal complexes, in particular, are noteworthy for their historical role, as documented in various literary sources and confirmed by archaeological finds. Firstly, Tarragona, which became an episcopal see at least as far back as the mid-3rd century, judging from remains of the martyrium. Documents concerning its ecclesiastic dignitaries, Bishop Fructuosus, and the deacons Augurius and Eulogius, point to the year AD 259. Mérida, the capital of Lusitania, was another important centre. It played a vital role in the conversion to Christianity, which was sealed at the III Council of Toledo in 589. The other major centre and capital of the kingdom was Toledo, which was important as both an episcopal and political centre. As a religious centre, it was the guardian of State religion; first, as the *de facto* see, following the national councils held in the city and, secondly, *de jure,* on the key date of 610 and, on a lasting basis, 687.

Tarragona, the *Colonia Julia Urbs Triumphalis Tarraco* and capital of Hispania Citerior, was one of the oldest episcopal sees in Hispania—by the 3rd century, it already had a consolidated social and ecclesiastic structure. There, the aforementioned Fructuosus, Augurius and Eulogius were martyred on 21 January 259, during Valerian's persecution, which left Christian Hispania without its leadership. A similar course of events ensued in North Africa, where Cyprian of Carthage was martyred, as was Sixtus II in Rome. The city of Tarraco was active as an imperial administrative centre until the later-Roman period, as evinced by the imperial dedi-cations made there, the last of them being to Carus and Carinus in 283.

A letter sent by the Hispanic writer Consentius to St Augustine in the year 419 or 420 (Ep. 11) bears out the existence of a set of buildings in Tarragona that formed the episcopal see of the metropolitan, Ticiano. The text refers to a meeting place, most likely part of the episcopate, as *secretarium in quo episcopi residebant*. The church is referred to as the *ecclesia,* while the official Roman residence of the *comes* Asterius is called the *praetorium*. Thus, there was evidently an episcopal building next to the church, with the praetorium some distance away. Frontón, a correspondent of Consentius', records that a *monasterium* was built in the city. Another important piece of writing is the *Oracional de Verona,* a *Liber orationum de festivitatibus* for the Tarragonan Church in the late-7th century. The cathedral of Santa Jerusalén, and the churches of San Fructuoso and San Pedro, are mentioned in a description of the processions held to mark the *dominica en carnes tollendas*. The church of San Fructuoso has been identified in connection with the necropolis of Francolí and, after its disentailment in the 6th century, with the Curia in the forum, prior to the excavation of the memorial to St Fructuosus in the amphitheatre, where the saint was martyred. The cathedral of Santa Jerusalén, which is probably where the present-day Cathedral is sited, was in turn most likely built on the former site of a temple dedicated to the Emperor Augustus, thought to have been located directly beneath the altar of the Gothic cathedral. The church of San Pedro is thought to have stood on the south side of the Roman circus, near the so-called Tower of Pilate. Thus, all the churches, except for Fructuosus' memorial and his martyrium in the necropolis, were located within the city walls. Recent archaeological excavations have unearthed an exceptional basilica with a large atrium on the north-west side of the necropolis, hard by the original church associated with Fructuosus. The church in question would have been well suited as a martyrium, but, for the time being, it has not been clearly identified. There were therefore three churches set outside the city walls: two purportedly related to St Fructuosus—the one at the necropolis and the memorial church in the amphitheatre—and a large third one which, in conjunction with that of Santa Jerusalén, make up the liturgical complex of the Tarragonan episcopal see. Chronologically, they span the period between Consentius' letter, in the early-5th century, and the Verona manuscript, from the 7th.

Mérida, Roman *Colonia Emerita Augusta,* the capital of Lusitania, had a large Christian community and bishopric for centuries, particularly in the 6th and 7th. Its three great bishops of the 6th century, the Visigoth Massona, and Pablo and his nephew Fidel, both of Greek extraction, led the community during the difficult period of conversion from Arianism to Catholicism, in which Massona was celebrated for his confrontation with Leovigild. A biography of the three prelates and details of the city are contained in a beautiful manuscript, the *Vitae sanctorum patrum emeritensium,* which documents the existence of a fully-fledged episcopate with its palace, which fell into ruin and was rebuilt by Fidel. The prelates used to meet in the atrium. Fidel's restoration involved raising the palace ceiling, enlarging the atrium, the addition of columns and marble facings *(parietes cunctos nitidis marmoribus vestiens),* and new roofing *(miranda de super tecta contexuit)*. He also rebuilt the *extra muros* martyrium of Santa Eulalia and its tower spires. Prudentius, in his collection of poems entitled *Peristephanon,* gives a beautiful account of the sublime martyrdom of St Eulalia. Documents from Fidel's era describe the cathedral—known as either Santa Jerusalén or Santa María—as separated from the baptistery or church of San Juan by a wall, while sharing the same roof. Thus, the episcopal ensemble of Mérida comprised three major buildings—the episcopal basilica of Santa María with its baptistery, the martyrium of Santa Eulalia and the episcopal palace or atrium. These, together with the churches of Santa Lucretia and San Fausto, *extra muros,* and those of San Cipriano, San Lorenzo and one dedicated to the martyrs, compounded a rich metropolitan religious ensemble, even though the Visigothic monarchy wrested some of these churches from Massona and ceded them to an appointed Arian bishop.

Apart from the church of Santa Eulalia, beyond the city walls, the exact sites of these churches is not

Barcelona: 5th- or 6th-century early-Christian cathedral baptistery.

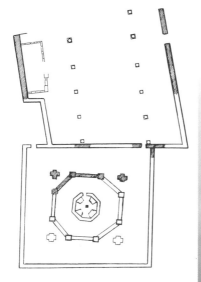

It is not known where those suburban buildings were sited, and excavations on the mediaeval church of Cristo de la Vega, known traditionally as the 'Church of Leocadia', have not yielded any remains from Visigothic times.

Also remaining to be determined is what the Roman urban constructions were like in Toledo, apart from the great circus in the Vega Baja district. The same is true of secular or religious palace architecture in the Visigothic capital, although it is known to have assimilated the plastic formulae of workshops active during the late-Roman period at Mérida, Cordova and others, which served as a model for artistic formulae in the Visigothic Court at Toledo.

Ground plan of the early-Christian cathedral baptistery in Barcelona.

known, although a wealth of unusual and rich architectural sculpture has come to light in the city, produced by a brilliant centre which, adopted by Toledo, may be termed Visigothic or Hispano–Visigothic.

Toledo under the Visigoths had two authoritative religious centres which were occasionally at loggerheads. There was the episcopal ensemble around the basilican cathedral, dedicated by Reccared to Santa María, and the palatial churches of the monarchs, in addition to a martyrium dedicated to Santa Leocadia. Overall, the religious complex was worthy of a royal or even imperial capital such as Rome or Constantinople. The buildings and their functions are recorded in the *Liber Ordinum* and in conciliar documents, as well as in other court and episcopal writings. Apart from the dual location of the religious complexes, the city is documented as having two separate episcopal authorities: the metropolitan and primate, on the one hand, and a court, palace or praetorian bishop on the other.

The church of Santa María marks the centre of the city, which is where the mediaeval cathedral must have stood. However, no remains of it have survived. The church was consecrated in the Catholic rite in 587, and the surviving inscription reads: *Flavi Recaderis regis in fide catholica potius quam in catholico loco,* and, from its consecration to Catholicism, it appears to be genuine. It is dedicated to Holy Mary, Mother of God, known as the *Theotokos,* a denomination approved by the Council of Ephesus in 431. The baptistery of San

Juan Bautista must have stood beside or near it, possibly on the former site of the church of San Juan, whose archbishop was described by Julian of Toledo in his *Historia Wambae Regis.* Nothing is known about the episcopal *palatium,* but the existence of other churches is documented, including the 7th-century San Vicente, and those of Santa Eulalia and San Miguel.

There was another church dedicated to SS Peter and Paul. The royal basilica was termed 'praetorian'—*in suburbio toletano pretoriensi sanctorum Petri et Pauli*—and was the venue for such ceremonies as the 'royal unction' of Wamba by the bishop Quirico on 19 September 672, and of Egica in September 687. Both are recorded in the manuscript *Laterculus regum visigothorum.* Witiza was similarly annointed in 711.

The third church, classed as 'praetorian', was a martyrium dedicated to Santa Leocadia. It was founded by the Visigoth king Sisebut on 29 October 618, according to the *Apologético* of St Eulogius. The Councils of Toledo were held in either of the three churches, according to a political hierarchy: up until the XVII Council of 694, all national councils were held in the praetorian basilica dedicated to the Apostles, or in the martyrium of Leocadia. Council venues are listed in the records of the proceedings—the church of the Apostles was outside the city—and Leocadia's status is clarified, as she was not executed: *in ecclesia gloriosae virginis et confesionis Christi sanctae Leocadie, quae est in suburbio toletano ubi eius corpus requiescit.*

Terrassa (Barcelona province): 5th-century piscina in the old baptistery at the church of Santa María.

Terrassa (Barcelona): mosaic pavement, with geometric motifs, in front of the church of Santa María; second half of the 5th century.

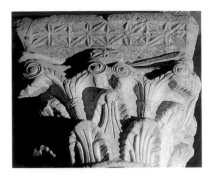

Details of the church of San Juan de Baños de Cerratos (Palencia).

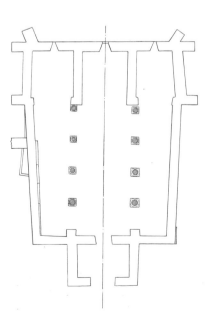

Plan of the church of San Juan de Baños (Palencia) in its present state.

the Court established its own standardised guidelines which were to influence art at that time.

At the beginning of the 5th century, when the situation in Hispania was in a state of flux, there was already a long-standing and solid base of secular and religious art in the country, the legacy of Roman colonisation and its subsequent consolidation. That artistic bedrock remained active, but it was augmented by a newfound creativity which can only be understood in the light of a historical review of the 5th and 6th centuries, both on the domestic front, concerning the nature of continuity, and abroad, with regard to human, ideological and trade relations, which were often the driving force behind innovation and creativity.

After an unsuccessful attempt to settle Narbonne and Barcelona by the Visigoths under Ataulphus, Alaric's brother-in-law and successor, the *foedus* subsequently signed by Constans on behalf of Emperor Honorius, and the Goth, Wallia, paved the way for the Visigothic kingdom of Toulouse to be set up in Aquitania. It also enabled Rome's Visigoth allies to explore Spain. Euric (466–484) occupied some areas of Hispania militarily and, according to his biographer, Jordanes, he regarded Hispania and Gaul as his possessions. That was most likely the time when the Goths made inroads into the Castilian meseta, where they settled, coinciding with the publication of the *Chronica Caesaraugustana* (494–497). The Frankish assault on Aquitania led by Clovis put an end to the Visigothic kingdom of Toulouse at the battle of Vouillé in 507, where Alaric II was killed. This event may have speeded up the migration of the Goths towards the Castilian meseta. Thus, in the late-5th and early-6th century, two distinct population groups inhabited Hispania: the Catholic Hispano–Romans, and the Arian Visigoths.

Throughout that period of religious and demographic duality, the Catholic Hispano-Roman population continued to produce its traditional artworks which, for study purposes, would still be classed as early-Christian art in the later Roman Empire. Similarly, the people continued to attend services in their basilicas, and at urban necropolises, as they had during the previous period, while sculpture, painting and mosaics adhered to the trends described earlier. In contrast, Visigothic artworks consisted solely of traditionally Germanic personal objects and ornamentation, including arched-bridge fibulae and a variety of embossed silver girdle brooches, sometimes studded with almandines. This state of affairs lasted throughout the 6th century.

Conventional religious architecture continued to serve the interests of a functional, early-Christian liturgical type. It is thus a difficult task to accurately define the early phase of Hispano–Visigothic architecture. Indeed, a great deal of Hispanic, early-Christian architecture was produced under the auspices of Visigothic power. Moreover, the religious unification of the country, prompted by the III Council of Toledo in the late-6th century, triggered a building spree in the Church, particularly in the province of Baetica, a vast region under Isidorian influence, while inscriptions attesting to the blessing and placement of relics in churches retained their currency as an art form. That period yielded some veritable 'builder bishops', such as the celebrated Pimenio of Cádiz.

In contrast, the 7th century was marked by new architectural forms, for which the common yardstick is taken to be the dedicatory inscription at the church of San Juan de Baños de Cerrato at Palencia. The basilical ground plan, generally consisting of a nave and two aisles, was retained in early-Christian architecture. The choir area was usually rectangular, divided into three sections, with the sanctuary set in the centre. There was sometimes a west choir placed at the back of the nave where the liturgy was read aloud. Occasionally, a fully-fledged *westwork* or second apse on the west side appeared, too, while baptisteries abounded.

A unique case is that of the church of El Bovalar in the town of Serós (Lleida), in which the baptistery is roofed with an exquisite canopy of horseshoe arches rising from imposts and resting on Corinthian columns. Baptismal areas were either placed at the west end of the building or in chambers situated in various parts of the church. Examples of this type of church include El Bovalar (Lleida), San Pedro de Alcántara (Málaga), El Germo (Cór-

doba), Gerena (Seville) and Casa Herrera (Mérida, Badajoz). Only the ground plan of these churches has survived, so that it is difficult to assess the original plasticity of their volumes. However, when appraised in conjunction with contemporary Balearic churches, such as the one at Son Peretó in Majorca, an analysis of modulation suggests their architectural style was eminently classical, and wholly consistent with their liturgical function.

This natural architectural development was paralleled in the larger episcopal centres by the emergence of a style of architectural sculpture now referred to as 'Visigothic', on account of it being readily accepted in Court circles at that time. This style is actually an adaptation of late-Roman volumetric forms, in which pictorial features tended to become plastic, while carving was rendered in two planes. At the same time, geometric motifs gradually replaced plant ones, and representation of the human figure was reduced to a minimum. These and other features imbued ornamental sculpture with a markedly 'Visigothic' character. There are, however, Roman precedents, which can be seen in the basilica plaques at Aljezarse (Museum of Murcia), or the aforementioned San Pedro de Alcántara, and in such secular work as the reliefs in the villa of Los Torrejones (Murcia), and the beautiful plaques at Mérida, particularly the plant motifs of the *Aesta,* now in the city museum.

The most creatively active and original centre of production were the workshops of Mérida, the wealthy provincial capital of Lusitania and a powerful, influential episcopal see. Two sculptural features were characteristic of Mérida. One was a type of pilaster bearing ornamentation on all four sides, which is thought to have been used in both religious and civil architecture in place of columns. One of these can still be seen *in situ* at a recently excavated outbuilding, identified as the *xenodochium* commissioned by Bishop Massona. Also characteristic was a variety of classical latticework partition screens which were surmounted by semicircular arches or corners. The latticework often consisted of simple chequers with birds set inside them, rather like the patterning on *ambos* in Ravenna. Other items characteristic of Mérida were wall niches used to shelter the triumphant Christogram, a basilican adornment probably found on altars. Still in Mérida, the councillorship of the bishops Paulo, Fidel and Massona is well documented, as is Massona's defence of Catholic orthodoxy against Leovigild's designs for unitary ambition based on the Arian confession. This, as well as the community work engaged in by those bishops, is documented in the manuscript, *Vitas sanctorum patrum emeritensium.*

Cordova was another centre of innovation in ornamental sculpture, particularly sculpted capitals. A large number of such capitals have survived in the Great Mosque. They lend themselves to a comparative study, particularly as far as the evolution of the Corinthian capital is concerned. The art of Mérida and Cordova, and the Levantine styles of Valencia and Cabeza de Griego, coalesced in the art of Toledo during the 7th century. Similarly, Eastern and Byzantine styles emerged in some works produced in Mérida and Lisbon (in the monastery of Chelos, or the Archaeological Museum), and at Saamasas in Lugo. The aforementioned *Vitas* also records the use of silk and Byzantine forms of decoration in liturgical ornaments in Mérida. In this respect, it should be recalled that Paulo and his nephew Fidel, a bishop–physician, were of Greek extraction, while Massona was of Visigothic stock.

A suitable starting point for any survey of the religious buildings classed as '7th-century Visigothic' is the church of San Juan de Baños in Palencia, which was dedicated by the Visigoth king Recceswinth to St John the Baptist. Originally thought to have dated from 657, the year 652 has now become widely accepted. The style of its ornamental friezes and capitals has been taken as a yardstick for evaluating other contemporary buildings, on the basis of the date of their dedicatory inscription. San Juan de Baños has a basilican ground plan, and three naves separated by horseshoe arches supported by Corinthian columns and capitals. The west end has a projecting portal, while the sanctuary at the other end is rectangular. The inscription is held aloft by a large triumphal horseshoe arch. Two chapels or chambers in the apse, separated from the sanctuary by an empty space, endow the chancel with a forked shape peculiar to Visigothic architecture. Only one other forked chancel has come to light, in the church of Santa Lucía del Trampal in Alcuéscar (Badajoz), which might be a later construction.

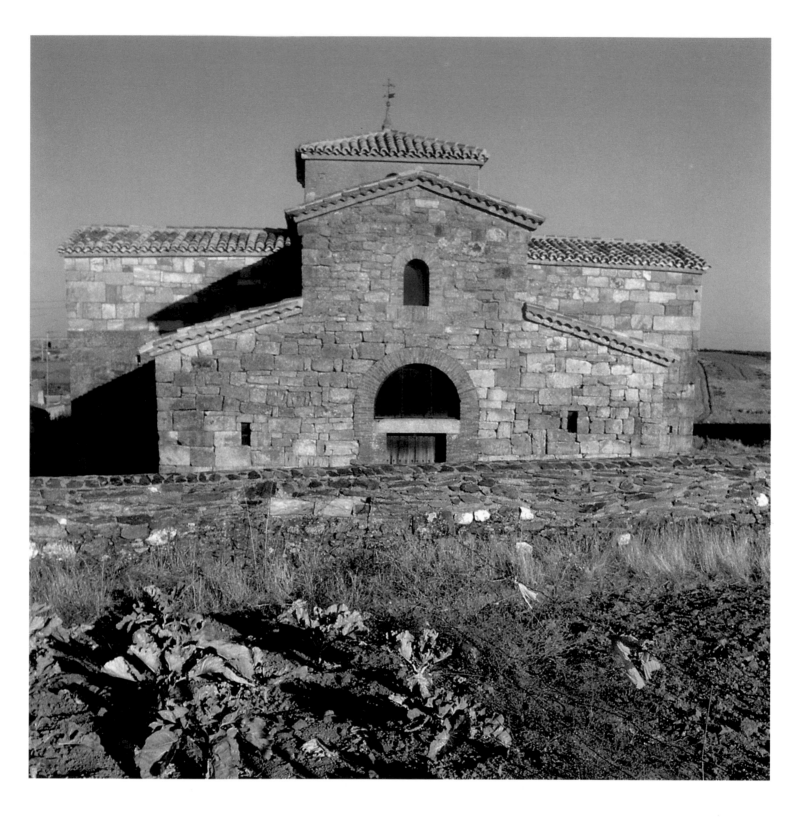

Church of San Pedro de la Nave (Zamora); second half of the 7th century.

Other central-plan buildings include Valdecevadar, in Olivenza (Badajoz) and the mausoleum of San Fructuoso de Monteliuos, in Braga (Portugal). The church in Olivenza has a cruciform plan with identical transepts, the cross being visible from the outside, and it features the peculiarity that access from the crossing to the transepts is via a double arch resting on columns. At Monteliuos, the arch is triple, with twin columns, and there is also a cluster of three arches set beneath a larger one, reminiscent of San Vitale of Ravenna. Also akin to Ravenna is the decorative arrangement on the outside walls, with arches and corners, while rectangular, vertically-set lesenes recall the decoration on the mausoleum of Galla Placidia, forerunners of the early-Romanesque blind arcades of Lombardy. A prominent feature of the surviving churches is the cruciform plan with a pseudo-transept near the

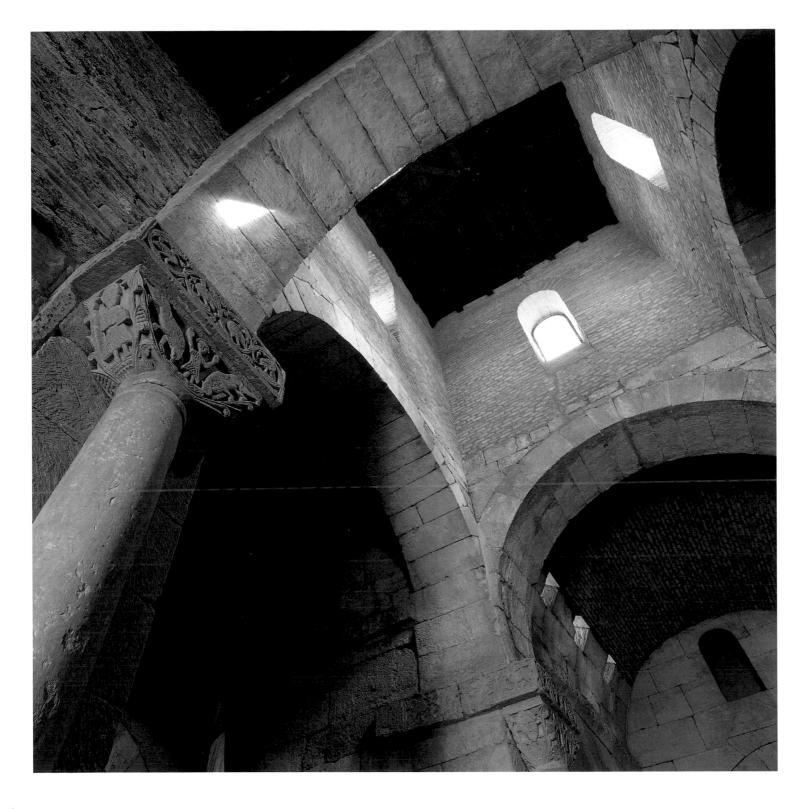

apse. The plan is therefore based on a Latin cross. The apses are rectangular and generally form a separate section, and either single or accompanied by a side chamber, as at Mata and Baños. At Nave and Quintanilla de las Viñas, structures have been added to the ends of the transept: a double chamber is set on both sides of the entrance portico at Viñas, while at Nave chambers have been superimposed over the structure of the apse and the crossing, with simple window openings. These arrangements are markedly compartmentalised, in functional, monastic terms, while the liturgical nave is single. Transepts can be classed into two different groups on the basis of their position. There are those placed close to the chancel, as at San Gião de Nazaré, near Lamego in Portugal. This church has a single nave, detached from two side aisles, which are in turn separated into two bays. The transept

Church of San Pedro de la Nave (Zamora), showing the roofing system with the capital of Daniel in the lions' den; second half of the 7th century.

crossing is split into three sections, following the arrangement of the nave and aisles. The transept is also set apart by a walkway with side windows. The structure has been widely studied, and its ground plan compared to those of later, Mozarab churches, and others in Asturias. Another church with the transept placed close to the apse is Santa María de Quintanilla de las Viñas, in Burgos. It has a single nave and two sets of side chambers in the aisle bays, which are subdivided into four areas. At the back of the nave is an entrance vestibule with the aforementioned side chambers. The decoration at Quintanilla and its dating have aroused considerable interest. The three exterior walls of the chancel and those of the aisles are adorned with friezes of birds in brambles. A series of medallions on the apse wall feature Byzantine-style anagrams which have eluded accurate interpretation. Gómez Moreno discerned the lettering FLAINVS DILANVS F (e)C(e)RVNT, among others. A frieze with richly plumed turkeys, partridges, pheasants and cocks led to a comparatively late date of construction being attributed. Dating was also based on an inscription on one of the capitals in the triumphal arch, where a female personage named Flamola appears in connection with the wife of the Conde de Lara, who restored the monastery in 879. The characteristic Visigothic iconography of friezes with plant and bird motifs even appeared on such objects as a 7th-century buckle from Jaén, and the church's large triumphal arch bears a large frieze of this kind. Two large capitals with imposts are adorned with depictions of the sun and moon set in a circle, supported by flying angels, in the fashion of Roman triumphal arches. There are also four cubes featuring Evangelists, which must have originally been placed at the spring of a transept vault. Also found were two sturdy imposts which depict Christ holding a cross and the Virgin Mary, supported by heraldic angels.

Other Visigothic churches have a large rectangular plan, with a free-standing chancel and portico, the transept crossing in the centre of the nave, and chapels attached either to the east end of the nave, west of the choir, or on the side of it. One major example of this arrangement is Santa Comba de Bande (Orense), to a large extent restored during a period of resettlement. Others include San Pedro de la Mata, in Toledo, with structures added to the chancel, and the most beautiful church of that period, San Pedro de la Nave, in Zamora. The latter is a large rectangle divided longitudinally into three areas: the centrally positioned transept sets apart the liturgical area, with its side bays connected by arches on columns. The sanctuary projects on the east side, and the transepts on the north and south, which form two chambers or porticoes just before the crossing. The crossing is set slightly east of the centre of the rectangle, and east of the crossing are two bays connected to the transepts via a door and a triple window. An interesting feature of such churches is the addition of chambers above the apse.

The church interior features some fine sculpted decoration which strikes a contrast with the delicately dressed flat stone surfaces, suggesting an absence of decoration in the form of mural painting. Two hands or workshops can be identified in the church: the coarser of the two was instrumental in sculpting the friezes running at mid-height along the choir walls and rising from the imposts surmounting the capitals of the lantern. The nave and the east wall of the transept are adorned with a frieze of circles tangential to double-cable moulding with Maltese crosses, wheels with curved spokes, tracery, and carved, undulating partition arches. Another hand, which might be termed the 'Master of San Pedro de la Nave', produced the four capitals in the lantern, and a delicate frieze surmounted by the nave vault, in addition to small friezes in the double, side windows. The most interesting feature is the figural decoration on the lantern capitals. One of them depicts Daniel in the lion's den, with an inscription based on handwriting which reads: UBI DANIEL MISSUS EST IN LAQUM LEONUM. Another, symmetrical scene depicts the Sacrifice of Isaac on an early-Christian altar, and bears the legend: UBI HABRAAM OBTVLIT ISAAC FILIVM SUUM OLO-CAVSTUM DNO. The two scenes are flanked by images of the apostles Peter and Paul, accompanied by Philip and Thomas, in a refined, smooth and incisive style. The capitals nearest the apse feature symmetrically placed birds shown picking at grapes. Large column bases also contain figural decoration, while the cubic imposts bear the same bird motifs, and the odd mask. A comparison of these subjects with slightly later Leonese miniatures,

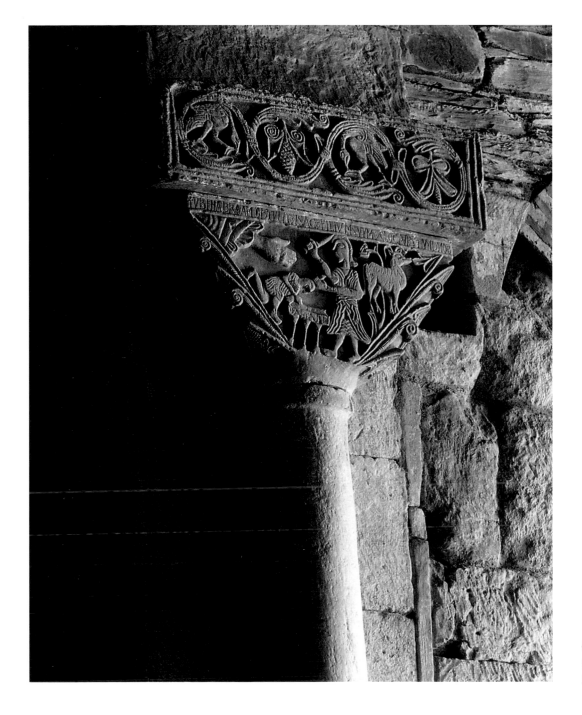

Church of San Pedro de la Nave
(Zamora): capital of the Sacrifice of
Isaac; second half of the 7th century.

or the 'Mozarab' miniatures of the *Beati* (Daniel, for example), raises a number of issues, from the idea that there might have been a Visigothic version of a biblical miniature, to the fact that this cycle and the church might belong to a later date: the 9th or 10th century.

In short, San Pedro de la Nave, Quintanilla de las Viñas and San Gião de Nazaré have proved difficult to date accurately, although they respond to what is known as the 'resettlement period' and a style termed 'frontier art' by some writers, such as Camón Aznar.

This chapter on Visigothic art would not be complete without reference to toreutics in the private sphere, and goldsmithing for the Court. In the case of the former, new fashions took root in dress accessories, ousting the traditional arched fibulae and large almandine-studded clasps. Small iris- or kidney-shaped bronze brooches became popular, in what was a Hispanic version of rich Byzantine or Sicilian goldsmithery. However, the finest and most beautiful pieces were wrought in gold for the Court. Indeed, the royal treasure of the Visigoths became renowned for its power and prestige. The collection had probably begun during the sack of Rome in the 5th century, and its importance even led it to be used as a currency of exchange with the Franks and the Holy See in Rome. One example, which most

Crowns and crosses in the Treasure of Guarrazar (Toledo); second half of the 7th century. Prado Museum, Madrid.

The peculiarity of Visigothic art is first gleaned from its goldsmithery. This art form evolved throughout the time of the Visigoths in Hispania, and the official, liturgical or representative function attached to metal objects gradually superseded personal or domestic functions. The most important finds are the treasures of Guarrazar (Toledo) and Torredonjimeno (Jaén). The Treasure of Guarrazar, which was buried after news of the Moorish advance, might have belonged to the Court of Toledo. Apart from eucharistic patenas and liturgical vessels, some noteworthy items are the replicas of crowns which the Visigothic kings commissioned as votive offerings for the saints of their devotion. The crowns of Recceswinth and Swinthilla reveal motifs of classical origin and semi-precious stones set using Byzantine techniques.

likely came from a Court workshop, is a set of crowns and crosses that were among the find known as the Treasure of Guarrazar, while other Visigothic treasure was unearthed at Torredonjimeno. An outstanding piece is the crown of Recceswinth (RECESVINTVS REX OFFERET), a large sheet of embossed gold with inlaid stones en cabochon, in Byzantine fashion. From it hangs a fibula, possibly a pectoral cross, from the same Byzantine workshop. Another noteworthy crown is that of Swinthilla, whose name is composed by a series of hanging letters, in the same way as that of Recceswinth.

The custom of offering crowns to the Church or to martyrs, in keeping with an early-Christian tradition, which Constantine followed at St Peter's tomb in Rome, is recorded in the literary document, *Historia Wambae regis*. The text also mentions the crown offered by Reccared to the martyr, Felix of Girona, which the rebellious Paulus of Septimania dared to wear on his head.

Proto-Romanesque Asturian Art

The first ensemble in Hispania of great plastic beauty and personality came from the Asturian Court. Its originality places it in a class of its own and sets it apart from the 7th-century Visigothic art we have seen, despite the fact that the Asturian monarch Alfonso the Chaste tried to emulate the Gothic order, as recorded in the *Albeldense Chronicle* (58. pp. 602). While there may have been a clear hereditary purpose related to the Visigoths, the artistic status quo was totally otherwise.

The group that held out against the Moorish advance in the Cordillera Cantábrica mountain range, centred around the figure of the legendary King Pelayo, established a court at which the most dynamic monarchs promoted a unique, highly original form of architecture. These were principally Alfonso the Chaste (796–842), Ramiro I (842–850) and Alfonso III the Great (866–889). By and large, the buildings in question have fortunately survived to confirm descriptions in chronicles and royal panegyrics, from the *Chronicle of Alfonso III* to the celebrated *Albeldense Chronicle,* written in Oviedo circa 883, which contains a wealth of information about Alfonso II and Ramiro. The original court was set up at Cangas de Onís where Fáfila, Pelayo's son and successor, had a church built above a large dolmen. Based on a cruciform plan, it still adhered to Visigothic tradition. However, Silo (774–783) moved the capital to Pravia, where he dedicated the basilican church of Santiáñez to St John the Baptist. The basilical ground plan broke with existing tradition. It consisted of three naves, each divided into two sections, with a portal on the facade, and the beginnings of a transept which was, however, not visible from the exterior. The choir section had three apses and altars, a liturgical innovation in relation to the early-Christian and Visigothic formula of a single apse and high altar.

It was under Silo that Oviedo became the capital of the Asturian kingdom. There, Alfonso II, who ruled from 791 to 842, commissioned large buildings to be erected. His was a long reign during which he was able to re-found the city, with a specific palatine design in mind, as heir and successor to Visgothic Toledo. The *Albeldense Chronicle* was, in this respect, the expounder of the monarch's desire to proclaim himself fully-fledged successor to the Visigothic throne: 'All Gothic order—*ordo gothicus*—existing in Toledo he established intact in Oviedo, both in the church and palace'. He reinstated the bishopric and restored the *forum iudicum,* the forerunner of the Castilian regional statutory code known as the *fuero juzgo.* The *Liber chronicorum* talks of Tioda, Alfonso II's architect, who was commissioned to oversee building work in the new city. The churches built included San Salvador, Santa María and San Tirso, the latter near the cathedral, in addition to the palace where the Holy Chamber, chapel–mausoleum and royal treasury are purported to have been housed. The whole complex is documented as being set within a walled precinct, with the palace in the centre and the churches of San Salvador and Santa María on either side of it. The basilica of San Julián de los Prados or 'Santullano' was apparently built outside the walled enclosure, at some distance from the palace. Of the buildings documented, the

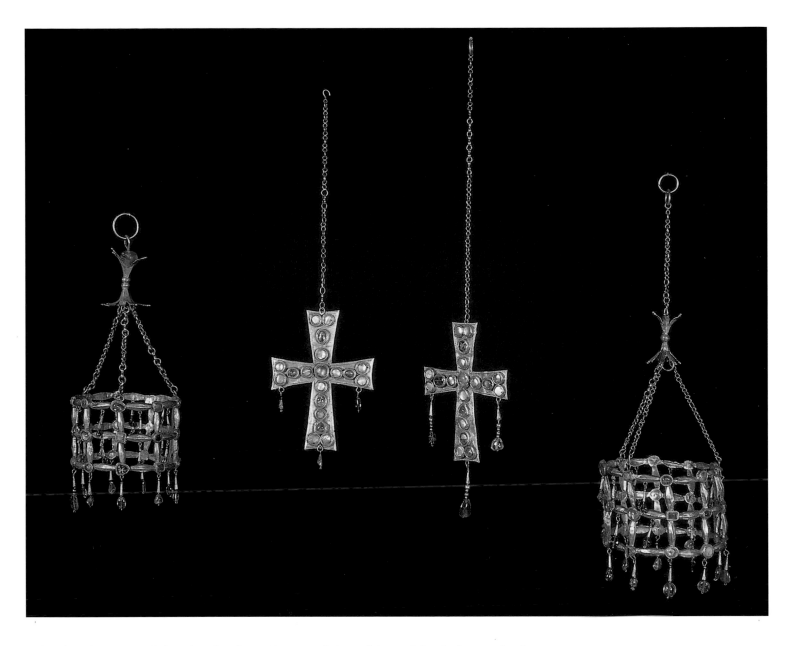

Holy Chamber, part of the church of San Tirso, and that of San Julián de los Prados have survived, the latter virtually intact. The Holy Chamber is a funerary chamber, along the lines of a large, classical *martyrium,* dedicated to St Leocadia. It has a funerary crypt with a vault which springs directly from ground level above an unbroken stone slab. Above it is a chapel, refurbished in the 12th century and dedicated to St Michael, of which the barrel-vaulted apse and a triumphal arch with half-columns are still intact. The structure responds to a well-known pattern, associated primarily with the Adriatic. Thus, the *martyrium* of Marusinac, at Salona (present-day Solin), or the tomb of Pécs, in Hungary, are related to the 4th-century mausoleum at La Alberca, Murcia, and to the funerary monuments of the Tarragona necropolis, which has a crypt or reliquary under the corresponding chapel.

The church of San Tirso, near the cathedral, must have been exquisite, judging from the praise lavished on it by contemporary chronicles. Only part of the back of the apse is still standing, and it is not known whether it was single or triple. According to the *Albeldense Chronicle,* it was a basilican building, *miro edificio cum multis angulis,* which would suggest it had side bays. The centre of the chancel wall, which has survived, has a window with three semi-circular arches, columns and capitals, topped by a moulded panel or *alfiz,* the date of which is unclear. The magnificent Corinthian capitals and other decorative items are indicative of a sumptuous building. However, the best preserved construction from that period is the church of Santullano, with its large basilica plan, measuring 28 by 24 metres. It has three tripartite naves, each section separated by semicircular arches on

Santa María del Naranco (Oviedo); mid-9th century (reign of Ramiro I, 842-850).

The monumental sculpture at Santa María del Naranco does not in any way detract from the church's architectural harmony. In the royal hall on the second storey, great plastic beauty is achieved through simple ornamental motifs. In the interior arcades, the shafts of the columns are cable-moulded, while the capitals display a rather coarse figural decoration. The spandrels are inscribed with medallions, framed in a double-cabled border, which hang from rectangles enclosing geometrical, plant or zoormorphic reliefs. In contrast, Corinthian capitals reappear in the beautifully structured exterior belvederes. This blend of decorative devices of varying origins, which re-emerges in the iconostasis in Santa Cristina de Lena, is characteristic of Asturian art.

sturdy pilasters. A large, free-standing transept is connected to the choir area via a triumphal arch. A noteworthy feature of the church is its spaciousness and light. This is a classical feature, in contrast to the multiple divisions and closed spaces characteristic of Visigothic churches. The chancel is tripartite, with a triple altar, and rectangular at the back. It has three portals: a single entrance portal and one on each end of the transept. The whole structure is an updated version of traditional basilican formulae, except for the tripartite character of the sanctuary. Part of the splendid painted decoration covering the whole wall space has survived. The pictorial subject is architectural, with classical devices, including false perspectives. The technique of applying the sinopia to the stucco with a burin has enabled the whole painting to be studied. It is possibly the finest painted ensemble from the 9th century, and marks a revival of the classical tradition associated with Pompeian or early-Christian frescoes, such as those in the oratory of Junius Bassus in Rome, or examples in Ravenna, Salonika and others contemporary with Breschia.

Recent modular analysis of the architecture and the painting arrangement has revealed extraordinary accuracy in the application of modules, pointing to mature, highly accomplished architectural design in this eminently aulic monument.

Ramiro (842–850) was a true builder–monarch. The works on Mt Naranco, designed by a brilliant architect, are the culmination of the aforementioned monuments and the epitome of court art in their uniformity and originality. The architect who designed them must have known all the major currents in contemporary architecture and all the latest techniques. He built a small palace in the form of a leisure pavilion, originally belonging to the Court, which was subsequently turned into the church of Santa María, and the palace church of San Miguel (St Miguel de Lillo). Another work undoubtedly by the same architect is the church of Santa Cristina de Lena, outside Oviedo.

Santa María is a large rectangular construction with facades on all four sides. It has two storeys: the lower one is roofed with a vault which springs from a stone slab, marking a renewal of the stuctural formulae applied to the Holy Chamber. Both floors have a central area and two end galleries on the short sides, with a broad view through an interplay of arches and columns. The entrance is monumental, with a double staircase on the main facade, symmetrical to a projecting belvedere on the opposite facade, which has not survived. The large nave is surmounted by transverse arches resting on wall brackets, the thrust being distributed on the exterior by a buttressing system attached to the wall facing. The volume of the nave is lightened by arcatures attached to the side walls, providing magnificent decoration, in conjunction with highly original figured circles on the spandrels which descend from the vault. The ensemble forms a marvellous interplay of volumes and ornamentation. Monumental, architectural sculpture has also been stressed, with sculpted figures similar to those which appeared in other European churches of that time. Transverse arches supported by clustered columns, series of blind arcades on a closed wall, and a buttressed barrel vault were innovative elements as far as Hispanic architecture was concerned, and forerunners of mediaeval design to come.

The building erected as part of the palace *habitaculum,* as it features in the altar inscription, was consecrated to Santa María, with the addition of an altar in the east portico during Ramiro's reign. The inscription gives the date of consecration as 848.

The palace church of San Miguel de Lillo was part of this royal complex on Mt Naranco. The *Albeldense Chronicle* records it having been built alongside the palace and dedicated to the archangel Michael. The ground plan is basilican, with nave and aisles measuring 16 by 10 metres. It has a tripartite chancel and two projecting side bays west of the choir. All that has been preserved is the interior tribune, a characteristic of Carolingian architecture, set near the facade. The arches separating the nave and aisles are supported by columns, rather than pillars, the bases of which are decorated with figural elements that have eluded interpretation. They end in prismatic capitals with cabled annulets, an element common to Asturian decoration, particularly around doors and windows. The large expanse of exterior wall sections amply accommodate large, beautiful windows, with two superimposed elements set above three-span arcades with columns. This is surmounted by open

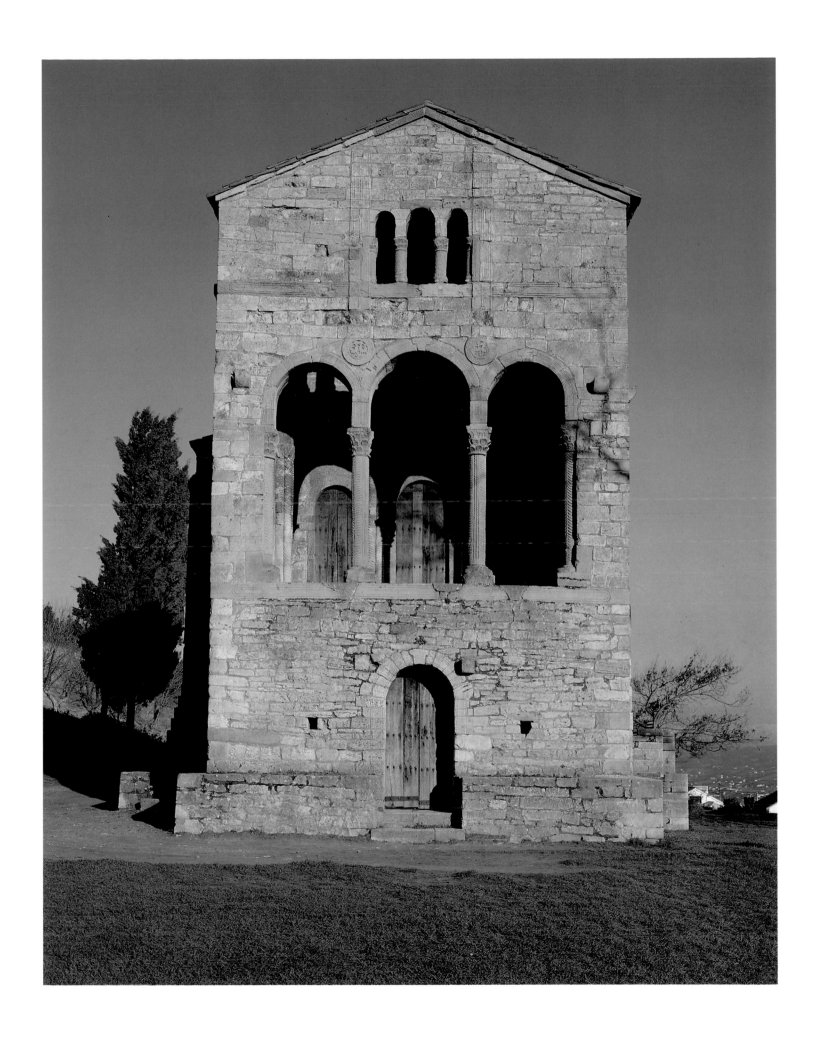

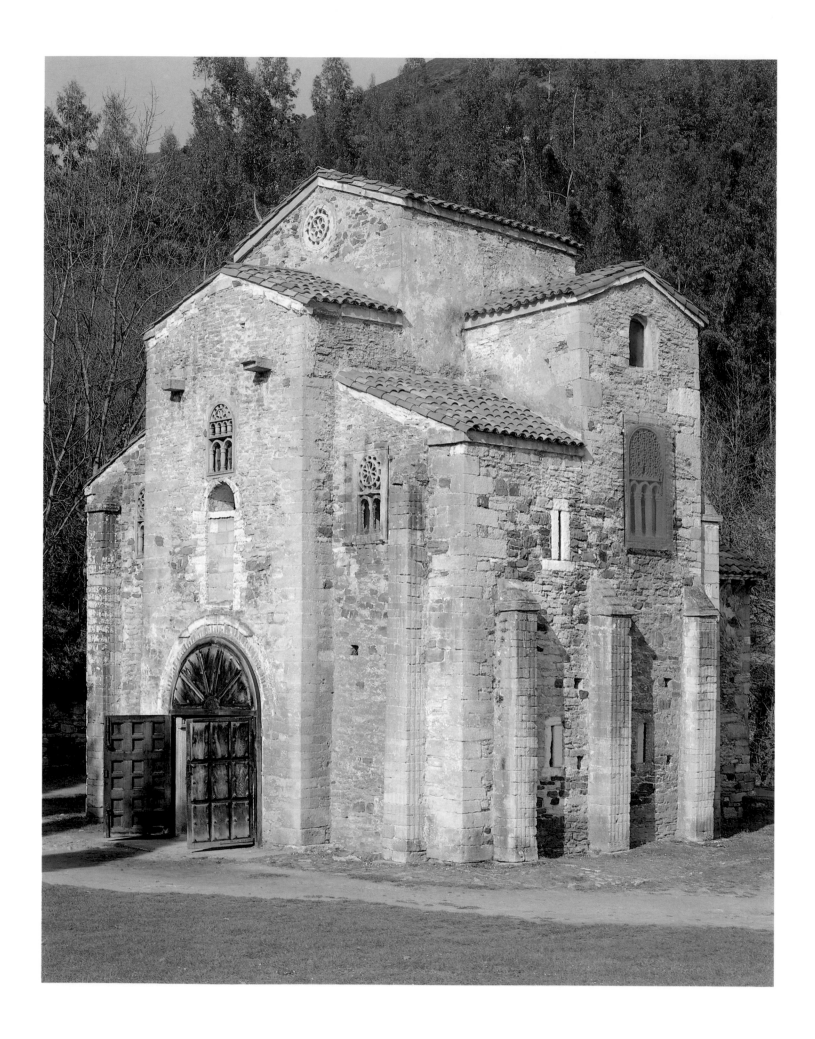

latticework with circular patterns characteristic of the Roman and early-Christian traditions. A classical feature, which was reinterpreted at San Miguel de Lillo, is the relief work on the entrance door jamb, inspired by the consular diptych of Areobindus, dating from 506, yet another sign of the marked classical influence on the contemporary Carolingian Court.

Santa Cristina de Lena, at Pola de Lena on the road to León, is another example of constructions built by a single master. The vaulted building is rectangular, and has four engaged chapels: on the sanctuary, vestibule and in the middle of the two side sections. As in San Miguel de Lillo, the vestibule has a vaulted inner tribune. The nave is similar to the one in Santa María del Naranco. The presbytery has two rood screens in the centre and two side staircases accessed from the penultimate section of the nave. Thus, an interior facade with three arches was built, the central one bearing sculpted rood screens akin to 7th-century Visigothic art, which it is sometimes classed as. The nave screen has prismatic capitals alternating with beautiful Corinthian capitals. The vaulting and buttresses endow this group of buildings with a harmoniously uniform exterior.

Alfonso III the Great (866–910) actively promoted resettlement and gave political impetus to the monarchy. The kingdom gradually spread towards León and the barren Duero river valley, and towards Galicia where, during the reign of Alfonso II, the body of the Apostle James had been discovered, leading to the construction of the first church there. Alfonso III had the basilica of Compostela rebuilt. His capital, Oviedo, had become too small and too far from the areas of resettlement. Hence, it was not long before the capital was transferred by his son, Ordoño II, to León, the seat of the *Legio romana* and an ideal spot for establishing the Court of a young and powerful kingdom. The new monarchy imposed changes through the art styles created in the new capital of León. However, the endurance of the architectural style forged under Ramiro was still evident, as evinced in the basilica of San Salvador de Valdediós, and in a number of isolated rural works, although building styles were starting to show departures from previous models.

Goldsmithing

Goldsmithing is an important part of Asturian art, and court ornamentation at that time must have been rich in gold and other materials used for both secular and religious purposes. Alfonso II's last will, dating from 812, also provides an inventory of the liturgical furnishings in the cathedral.

A few interesting pieces have survived among the cathedral treasure, kept in the Holy Chamber. The oldest is the so-called 'Cross of the Angels', which Alfonso II donated in 808. Its name comes from a legend featured in the Silos Codex, which recounts how the cross was made by pilgrim angels that had come from abroad. It is a splendid piece, technically akin to Frankish and Italian Lombardic specimens, with stones cut en cabochon and Roman-style incised stones set in gold filigree. The closest and most celebrated parallels are the Cross of Desiderius of Breschia (757–774), and the Cross of Aistulf, which was related to Byzantine goldsmithery. In the 874, during the reign of Alfonso III, a copy was made of the cross, although with some slight variations, for the basilica of Santiago de Compostela. Sadly, it was stolen in 1906. A third cross, known as the Cross of Victory, was donated by Alfonso III and his wife, Gimena, in 908. It had been made in Gozón Castle by royal appointment. This is the only surviving evidence suggesting the existence of a Court work-shop. The cross is similar to the Carolingian Cross of the Ardennes, now in the Nuremberg Museum. The crosspiece has lobulate ends and, interestingly enough, the cross is enam-elled, mainly in green, with plant and figural motifs of animals and birds. The piece is rem-iniscent of much older Byzantine models in the Carolingian world. A third piece is the so-called Agate Chest, also in Oviedo. It was dedicated by Fruela and his wife, Gimena, in 910 and features inlaid onyx set under a series of arches. The lid bears an extraordinary almandine plaque, and resembles the cover of the Gospel Book of Lindau, surrounded by enamelled plates with heraldic birds. The tetramorph stands out on an embossed ground.

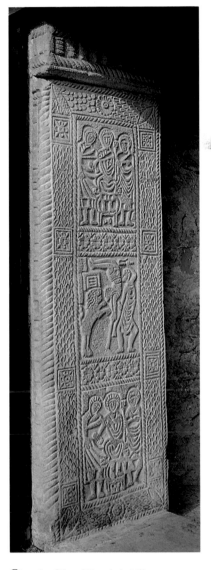

Church of San Miguel de Lillo (Oviedo): relief work on the entrance door jamb; mid-9th century (reign of Ramiro I, 842-850).

Church of San Miguel de Lillo (Oviedo); mid-9th century (reign of Ramiro I, 842-850).

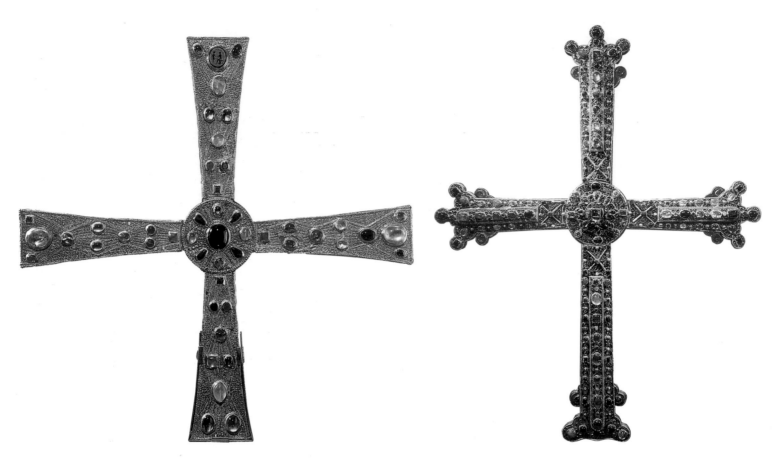

Cross of the Angels; early-9th century (reign of Alfonso II, 796-842). Holy Chamber, Oviedo Cathedral.

Cross of Victory; early-10th century (Alfonso III, 866-910). Holy Chamber, Oviedo Cathedral.

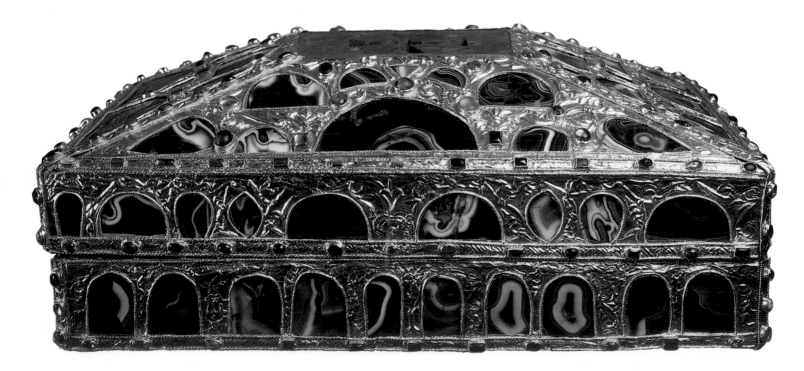

Agate Chest; early-10th century (Prince Fruela, 910). Holy Chamber, Oviedo Cathedral.

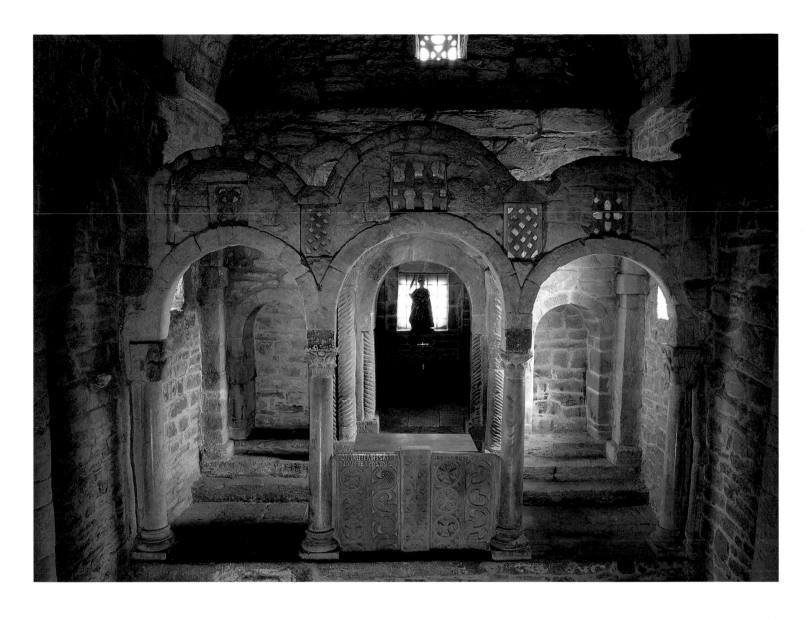

These are all exquisite works, although totally unrelated to the Visigothic gold-smithing tradition. Instead, they are associated with and even derived from the Lombardic, Carolingian tradition with its Byzantine roots, and the workshops in Charlemagne's empire. This fact is interesting in that it means there was some form of cross-fertilisation in the decorative arts at a political or Court level. The door jamb at San Miguel de Lillo, for instance, reveals knowledge of late-imperial ivories. Woven fabrics, goldsmithing and miniatures characterised both Asturian art and its successor, Mozarab art, which evolved in the Court of León, as opposed to the quite distinct forms of Cordova.

Christian art under the Romans and Visigoths brings to an end the great cycle of Romanist artistic influence in Hispania, with all its variations and innovations imposed by fashion and the natural evolution of classical Mediterranean art. This is true of both officially sanctioned architecture, painting and sculpture, and the applied arts, in the urban, royal, religious or strictly private spheres. This cycle ended with the last major works of the classical era, which included the beautiful production of the Hispano–Visigothic world. The imminent Arab occupation of most of the Iberian Peninsula, with the powerful Moorish settlement of former Roman Baetica and the withdrawal to the mountains of Asturias, where the Christian kingdom was established with Oviedo as its capital, ushered in new art forms and models, inspired by rising trends in Carolingian Europe, which were a far cry from the preceding Visigothic world, despite the fact that the Court in Oviedo declared itself to be the heir to Toledo. Cordovan influences, a tentative Visgothic revival, and ongoing ties to Europe marked the development of Mozarab art in the kingdom of León, from Alfonso III's time onwards.

Church of Santa Cristina de Lena (Pola de Lena, Oviedo), mid-9th century.

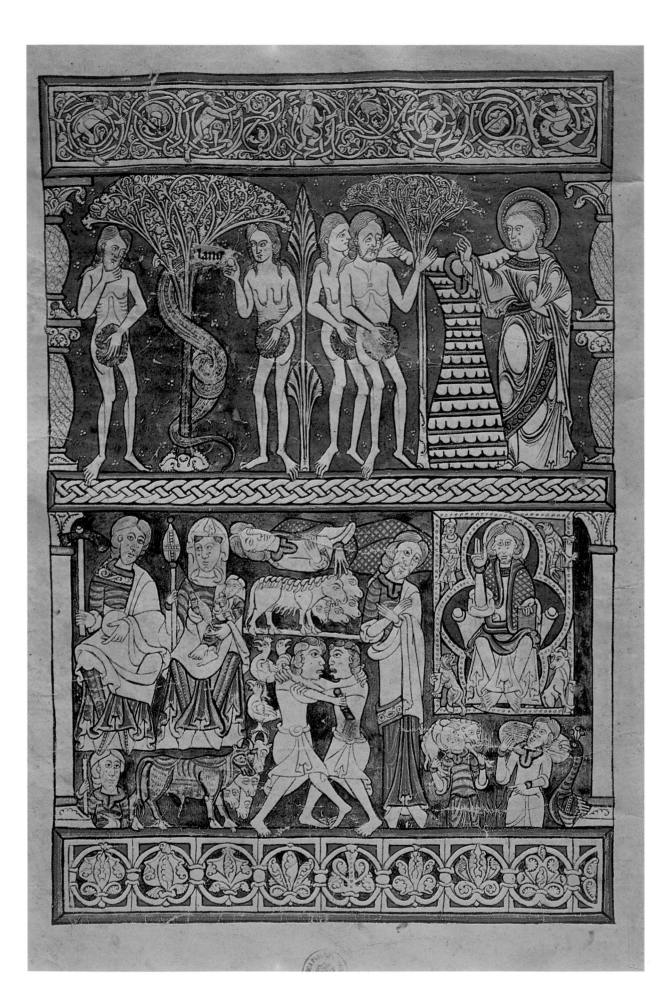

Pre-Romanesque and Romanesque Art

Xavier Barral i Altet

PRE-ROMANESQUE ART

In traditional historiography, the period between the break-up of the Carolingian Empire and the advent of the Romanesque is regarded as a 'dark ages', characterised by a new wave of invasions across Europe: those of the Moors, Normans, Slavs and Magyars. Nevertheless, the 10th century was a key moment in history which saw the demise of the historical processes associated with the ancient world and the dawn of mediaeval structures. Recent studies have revealed that the 10th century also witnessed the consolidation of power structures, economic recovery and a process of 'castling up' of the rural population.

On the Iberian Peninsula, enclaves opposed to Islamic domination were established from the 8th century onwards. These were the Kingdom of Asturias, founded in 718 by Pelayo, and the Spanish March (Catalonia and the French Roussillon), set up by Louis I the Pious in 795. At the end of the 9th century, the Kingdom of Asturias embarked on the reconquest and resettlement of territory in León (880), while the Spanish March became independent from the Franks under Wifred the Hairy, Count of Barcelona (874–898). The comparative stability and economic recovery of the Christian dominions was subsequently checked by the decline of the Asturian monarchy and the Catalan counties' inability to launch a joint assault on the Arabs.

The 10th century also saw the magnificent reigns of ʿAbd ar-Raḥmān III and his son, ʿAbd al-Ḥakam II. Indeed, the superiority and refinement of the caliphate of Cordova were admired even by Christians in all kingdoms. However, border security became a thing of the past during the raids of plunder mounted by al-Manṣūr and his son, ʿAbd al-Malik. This state of affairs, exacerbated by subsequent subdivision of the caliphate into ṭāʾifah or party kindoms, eventually prompted a slow but inexorable Christian reconquest and Romanesque reconstruction of the Iberian Peninsula.

The Peninsula was divided into Moslem and Christian kingdoms although, despite their differences and the antagonism between them, the two cultures had no alternative but to maintain some form of ongoing relationship. The term 'Mozarab' was applied to Christians who lived under Moorish rule until the fall of Granada in 1492. In the early period of their rule, the Moors tolerated the Christian religion and customs in return for payment of a tax. In 1919, Manuel Gómez Moreno was the first historian to refer to an ensemble of 10th-century architectural and sculptural works as Mozarab.

The use of this term might be objected to on the grounds that the artworks in question are geographically dispersed, and that only two examples have come to light in the territory of the former Al-Andalus. Thus, in the sixties, a number of specialists put forward the term 'resettlement architecture' for buildings in Christian territory with features attributable to Moorish influences. Even so, in a more conceptual sense, the term Mozarab applies solely to one particular trend that influenced original, 10th-century art, which also borrowed from late-Roman, Visigothic or Asturian art. In fact, acceptance of this term depends, to some extent, on the role of Islamic art in the formative development of Hispanic art. Luis

The Original Sin: late-12th century miniature from the Burgos Bible. Biblioteca Provincial, Burgos.

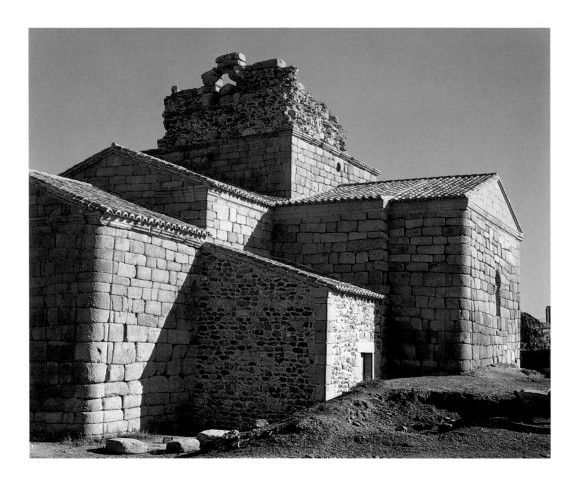

Church of Santa María de Melque, at
San Martín de Montalbán (Toledo).
Late-8th or early-9th century.

Caballero recently proposed a radically different use of the term: he claims that Visigothic
architecture *per se* was comparatively insignificant, as it was really a continuation of the
early-Christian basilica tradition. The break was triggered by the Moorish invasion, which
spawned an art form that has only recently come to be known as 'Hispano–Moorish',
charged with Syrian Umayyad overtones, as evinced in the Pla de Nadal in Valencia. This
trend eventually gave way to a recovery and renewal of classical forms and the transmis-
sion of a variety of styles that would come together as so-called Hispanic art in the early
Middle Ages.

The heterogeneous, eclectic nature of Mozarab art becomes apparent when com-
paring the two sole examples of Mozarab churches in the erstwhile Moslem dominions.
One is the church of Bobastro, in Málaga—once thought to be the fortress of ʿUmar ibn
Ḥafṣūn, which was subsequently located elsewhere. Carved out of the rock, it has a rec-
tangular basilica plan with a nave and two aisles, a symmetrical transept and three uneven
apses, the central apse projecting beyond the others. The only feature it has in common
with the other church, Santa María de Melque, in Toledo, is the fragmentation of the inte-
rior: the transept is divided into three small rectangles by partitions hewn out of the rock.
Santa María de Melque, for its part, is made of huge blocks of stone. Based on a Greek
cross, it has a horseshoe-shaped nave and two small, square apsidioles. The whole build-
ing is barrel vaulted except for the crossing, crowned with a truncated dome. This church
was classed as Mozarab by Manuel Gómez Moreno, but there are no surviving records to
assist in dating it. However, its ground plan, ashlar and vaulting, akin to those of Visigothic
churches—in particular, Santa Comba de Bande, in Orense—have led many historians to

question its date of construction and style. The discovery of a major decorative sculptural ensemble in the course of excavations during the seventies led Luis Caballero to label it as Visigothic, and he dated it in the 7th century. The latest theory, however, is that the form and technique applied at Santa María de Melque are derived from 8th-century Syrian Umayyad art, along the lines of Jirbāt al Mafjār, brought to the Iberian Peninsula by its Arab conquerors. This would involve a substantial extension to the time span of Mozarab art which, up until now, has applied only to Visigothic churches such as the aforementioned Santa Comba de Bande, as well as San Pedro de la Nave and San Juan de Baños de Cerrato, and the Asturian San Juan de Santiañes de Pravia.

The fact that Santa María de Melque is similar to various Visigothic churches is not unusual, considering that Toledo was the capital of the Visigothic kingdom. Furthermore, when the Mozarabs migrated northwards and repopulated the Duero river basin, their wanderings led them as far afield as Asturias, where their arrival coincided with late-Asturian art. They thus came upon existing Asturian religious buildings, as borne out by the few surviving records. It should be added that the Duero was also resettled by people from the north. Hence, it would be preferable to adhere to the term 'resettlement art', while keeping track of the various pre-Romanesque currents in the artistic cross-fertilisation that occurred across the Peninsula, and establishing the contribution of Moslem art and its influence in the Romanesque art to come.

It would be difficult to establish a standard architectural model for 10th-century 'resettlement churches'. One variation is based on a basilican ground plan, with certain Orientalising elements which reflect the influence of Cordova and are also reminiscent of late-Roman, African and Syrian basilicas. An example of this is the church of San Miguel de Escalada, in León, and São Pedro de Lourasa, in Portugal, as well as San Cebrián de Mazote and Santa María de Wamba, both in Valladolid. The other variety is based on a Latin or Greek cross, possibly due to the influence of Visigothic buildings, as evinced at Santa María de Melque and Santiago de Peñalba, in León. What is striking in both varieties is the tendency, more marked than in Visigothic churches, to break up interiors into small squares or rectangles, possibly in response to the progressively more hierarchised Hispanic liturgical rite. Thus, in the basilican churches, the apse and transept are physically separated from the nave and aisles. Small chambers isolated from the rest of the building sometimes appear, too. They are 'restricted areas', which can be seen in the churches of Santiago de Peñalba and San Cebrián de Mazote. The latter, for example, has a westworks with a rectangular exterior and circular interior, and was probably used for funerary or baptismal functions. This compartmentalisation of space inside churches using quadrangular units or cells, which is all the more noticeable on account of the small size of these churches, was likewise applied to the elevation and volume of each section. Similarly, roofing involved all types of combination.

Although some churches, particularly those based on the basilica plan, were still roofed with wooden frameworks, such as those at San Miguel de Escalada, São Pedro de Lourasa and San Cebrián de Mazote, all types of stone-based roofing, which would be subsequently developed during the Romanesque, were used on churches during the resettlement period. As in Visigothic and Asturian art, apses and transept arms were often crowned with a barrel or quadrant vault. However, the novelty was the addition of large lanterns over the crossing, and the way they were roofed and supported. The crossing at Santiago de Peñalba is surmounted by a tall cupola with eight-luned ovoli resting on four load-bearing arches with tiered wall brackets in the corners. The same system was used when reconstructing the cupola of San Cebrián de Mazote. In the latter, the apse, westworks and transept arms have ribbed vaulting similar to that of the 9th-century Great Mosque of Kairouan. It later became frequent in caliphal architecture in al-Andalus, as in the *miḥrāb* of the mosque in Cordova.

As a result of the studies conducted by Manuel Gómez Moreno, the horseshoe arch became the touchstone for identifying Moorish influences in such religious buildings. This led all churches with horseshoe arches to be classed as Mozarab, despite being located a

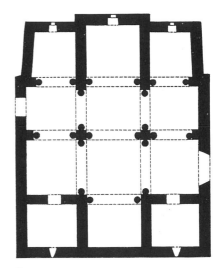

Ground plan of the church of Santa María de Lebeña.

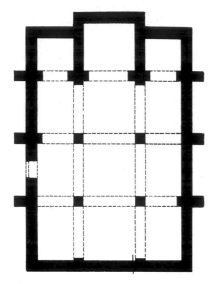

Ground plan of the church of Santa María de Wamba.

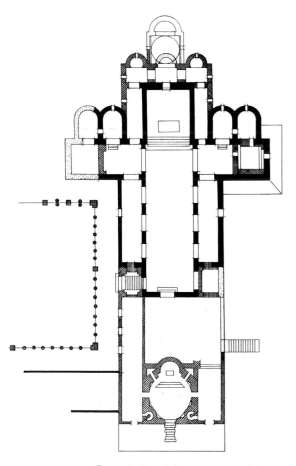

Ground plan of the monastery of Sant Miquel de Cuixà.

Baptistery in the 9th-century church of Sant Miquel at Terrassa (Barcelona).

long way from Andalusian territory. It should be recalled that some Visigothic churches already had a form of horseshoe arch, which had been developed from late Hispano–Roman architecture. The Islamic horseshoe arch differed in that it ended at two-thirds the radius; not one third, as in Visigothic architecture and, moreover, in that the extrados and intrados were not flush with each other at their base. Perhaps the finest examples in the Christian world are the arches in the portico and transept gallery at San Miguel de Escalada, for their refinement and slenderness, and those in San Cebrián de Mazote, for the way they blend harmoniously with the rest of the building.

A closer look at the capitals in resettlement churches, such as San Miguel de Escalada, reveals how in the 10th century they still adapted building materials from older buildings. In the aforementioned church, five Asturian capitals from the Ramiro period have been re-used. Mozarab capitals are, by and large, derivations of the Corinthian order, with greater flatness in the acanthus leaves and ornamentation on the basket, in addition to a mesh of various plant motifs, which have sometimes been worked with a boring tool.

The decorative array on friezes and partition screens included subjects adapted from Visgoth art, such as rosettes, palmettes, gammadia, grapes and birds feeding, which can be seen on the abacuses in San Pedro de la Nave and the triumphal arch of Quintanilla de las Viñas. A new motif was that of intertwining palm trunks, which appears to have been influenced by the minbar decoration at Kairouan. Moreover, they are all reminiscent of a particular kind of stucco and wood-carved ornamentation in Umayyad Syria. Thus, when precedents were not at hand in Moorish Spain, North Africa may be regarded as the mediator in the conveyance of such forms.

As a result of the research carried out by Manuel Gómez Moreno, the term Mozarab was also used to describe art forms in Catalonia in the period between late antiquity and the Romanesque. His conclusions even tempted such researchers as the architect, Josep Puig i Cadafalch. Nevertheless, the most appropriate term for early mediaeval art in the Spanish March is 'pre-Romanesque', as Mozarab objectives, just like Carolingian ones, arose in response to the socio-political status quo of those neighbouring regions and, while they might have found some echo in Catalonia, they certainly did not translate into the global art milieu there.

Little is known of architecture in Catalonia prior to the 10th century and, indeed, only a few isolated monuments have survived from those times. It is plausible that architectural styles were those characteristic of late antiquity, as evinced in the early-Christian basilica inside the Tarragona amphitheatre, or the church of Sant Cugat del Vallès, although it is not known to what extent the appearance of these buildings might have influenced the architects and architectural forms subsequently developed in the early Middle Ages. Also dating from that period is the complex of three churches in Terrassa, for which a specific time frame has not yet been clearly established. There, the sanctuaries of Sant Pere and Santa Maria, and the building of Sant Miquel, are contemporary in terms of their layout. Despite differences between historians who consider these churches to date from the 6th or 7th century, and those who place them in the 9th century, such as E. Junyent, P. de Palol and the author of this chapter, there is agreement as to the fact that they pre-date the 10th century. Surviving records and a few vestiges suggest that cities continued to play an important role in the early Middle Ages, as evinced in the episcopal group of Terrassa, and the lesser known ones in Vic and La Seu d'Urgell.

The yardstick for ascertaining what religious buildings were like in the 10th century is provided chiefly by rural churches, which are better known owing to the subsequent replacement of urban churches by Romanesque ones. Of the major buildings from that century, one of the most representative is Sant Miquel de Cuixà, which also give us some idea of what the large pre-Romanesque monastic buildings and cathedrals of Catalonia must have been like. Sant Miquel de Cuixà has a nave and two side aisles, a transept, a chancel with a rectangular-plan central apse, and four apsidioles opening onto the transept, with the nave separated from the aisles by large arcades of stunted horseshoe arches with protruding shafts.

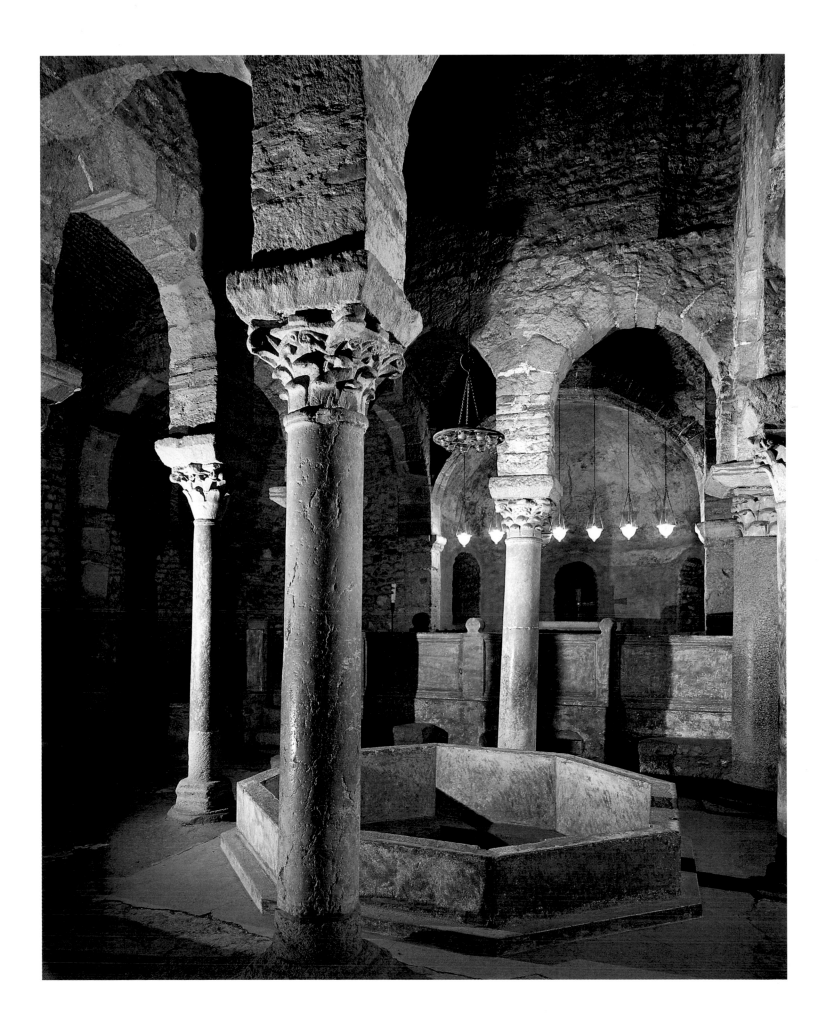

A Leonese Beatus in Girona

The Beatus of Girona is an illuminated commentary on the Apocalypse inspired by the miniatures of the Asturian monk whose name was given to this type of manuscript—the Beatus of Liébana. Written in Visigothic lettering on parchment, and set in two columns, it runs into 284 pages and features 114 polychrome miniatures, with gold and silver, many of which take up a whole page. It was most likely made at the monastery of Tábara (Zamora) in the kingdom of León. In 1078, it was conveyed to Girona Cathedral as part of a bequest, and is currently housed in the Cathedral museum.

The importance of the Beatus of Girona, in the context of 10th- and 11th-century Hispanic art, divided between the ancient, Islamic and Romanesque legacies, was that it acted as the model for the Beatus of Turin. The latter was probably copied in Girona, and is now housed in the Biblioteca Nazionale, Turin. It has been suggested that the iconography of the Beatus inspired relief work in the Cathedral cloister, although little evidence has come to light in support of this. However, it is one of the finest copies of the *Commentaries on the Apocalypse* by the Asturian Beatus, albeit incomplete, as some miniatures in the Beatus of Turin are missing from the one in Girona. The latter was bound, probably for the second time, in 1512, on the orders of Bishop Boïl, and restored and reinforced in 1974–1975.

Around the year 1000, the West was seized by apocalyptic terror, and fear of the 'hordes of evil' and the Antichrist of the end of time made itself felt in the Christian kingdoms in the north of the Iberian Peninsula, which were locked in a struggle against Islam. The illustrated manuscripts known as Beati echoed that atmosphere in rather crude terms, so that the anti-Christian forces of the Apocalypse are often identified with Islam, and Muḥammad with the Antichrist. This assimilation imbued the writings of St John with such currency that they were used as a spiritual guide in areas where the Christians placed their hopes on victory over the infidel.

The Girona manuscript, written by a presbyter named Senior, was illuminated by a woman—En or Ende—and the presbyter Emeterio. According to the last folio in the manuscript, the work was commissioned by an abbot called Domenicus, and completed in 975. Emeterio and Senior were presumably well-known figures in the areas where the major scriptoria flourished, as they are both recorded as having had a part in the production of the Beatus of Tábara in 968–970. The figure of Ende is interesting in that it proves that women were involved in the art movement that wrought the great Hispano–Roman transformation.

The Leonese origin of the manuscript is confirmed by both the presence of artists and craftsmen that had previously been active at Tábara, and the fact that the manuscript is rendered in Visigothic lettering, which by then had fallen into disuse in the former territories of the Spanish March. The reference in the manuscript to Fernando Flaginis, Count of Salamanca and governor of the Leonese region of Duero, lends further credence to the theory that it was made at Tábara. On the grounds of the aforementioned involvement of a woman artist, the minority who claim the work was executed in Catalonia point to the scriptorium of Sant Joan de les Abadesses as the centre of production, where scribes and illuminators from Castile and León are purported to have worked.

Illustrated in the late-10th or early-11th century, the manuscript must have been brought to Catalonia before the middle of the 11th century by the endeavours of a canon from Girona, who subsequently left it with the precentor of the Cathedral, named Juan. The latter, in his will, bequeathed the *Commentaries* to Girona Cathedral.

As was the case with the other Beati, despite the presence of the manuscript in Girona during the formative years of the Romanesque, it had little influence on local monumental art in the 11th and 12th century.

Beatus of Girona. Illuminated manuscript from the late-10th or early-11th century. Cathedral Museum, Girona.

ria quat entrum

e audi alium angelum ascen den den ab oratu solis habentem signum dei ui uicas .'
e clamabat uoce magna qua auor angelis quibus datum est po est aut ledere terram & mare dicens . Ne ledatis terram neque mare neque arbores donec signamus seruos dei nostri infrontibus eorum

EXPLICIT STORIA

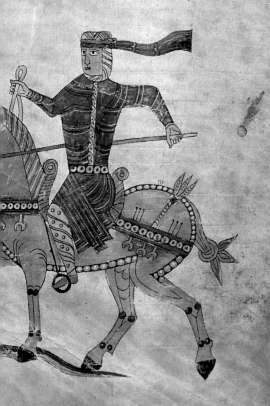

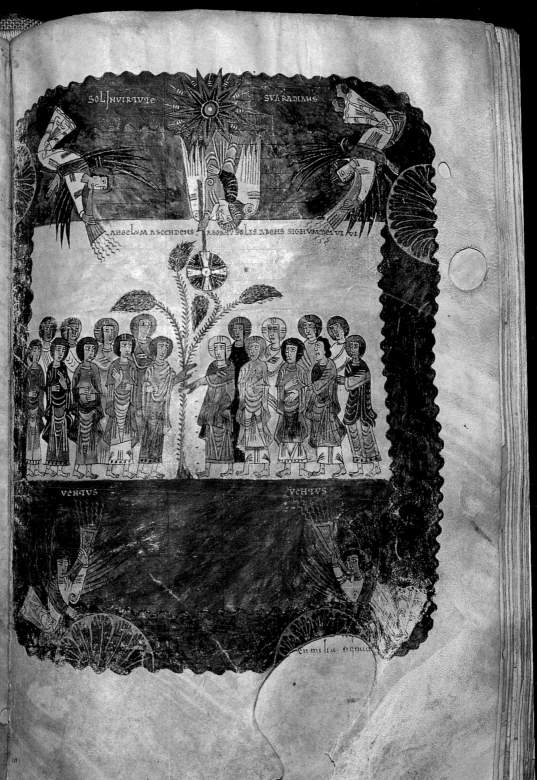

SOL IN VIRTUTE SVA RADIANS

ANGELVM ASCENDENS ABORTV SOLIS HABENS SIGNVM DEI VIVI

VENTVS VENTVS

Monastery church of San Miguel de Escalada, founded in 913.

Exterior of the apse of the collegiate church of Sant Vicenç at Cardona (Barcelona), consecrated in 1040.

Set on high ground, the church of San Vicenç is a landmark in Cardona. Its architectural forms, small, neatly-laid-out bonds and distribution of volumes makes this one of the finest examples of southern, early-Romanesque art. The architectural style and building technique applied to this church spread throughout Catalonia and the north-eastern Iberian Peninsula, linking up with the architectural trends prevalent in southern Europe at the time.

Other, more modest buildings are usually dominated by rectangular, wooden-roofed naves and aisles, as in Arles, Vilanant, Santa Elena de Rodes and Bellcaire de l'Empordà. The small, vaulted apse had a horseshoe-shaped interior profile and a square exterior. In line with tradition throughout the Mediterranean in the 5th and 6th century, apses were generally polygonal on the outside and semicircular or horseshoe-shaped inside. However, the major type was trapezoidal, that is, 'unevenly quadrangular'. This was superseded by apses with a horseshoe-shaped exterior, a device first applied to apsidioles of the kind found in Sant Quirze de Pedret and, at a later date, to a single apse (Llinars). A transitional Romanesque form is the apse which is horseshoe within and semicircular without (Santa Margarida de Empúries), which was superseded by a full semicircle, as in Sant Andreu de Sureda and Saint-Genis-des-Fontaines, which became the arrangement of choice in the Romanesque period. Although fairly logical, this evolution was not at all linear in time, since, apart from the first group of apses mentioned above, all the others were practically contemporary with one another. The transepts also showed variations: they could be higher than the nave, as in Canapost and Sant Pere de Terrassa, or lower than it, as in Saint-Genis-des-Fontaines. While the above typological description holds true for all parts of Catalonia, surviving pre-Romanesque churches in these areas cannot be classed into sufficiently consistent smaller groupings.

Pre-Romanesque sculpure in Catalonia was markedly architectural: imposts, cornices and capitals were ornamented, as were some bases and other structural elements. The cornices in some churches, such as Canapost, are decorated with geometrical or plant motifs. Imposts could either be devoid of decoration, have simple moulding or feature decoration which became progressively more figural, as in Sant Hilari d'Abrera with its series of human heads.

In addition to the decorative nature of sculpture during that century, major iconographic cycles were also undertaken in the field of illuminated manuscripts, a trend that lasted well into the Romanesque period.

It is not known whether Visigothic or Asturian codices were illustrated. Specific reference by the Beatus of Liébana to a miniature in his *Comentarios* ('Commentaries on the Apocalypse') reveal that this work was indeed illustrated, even though the oldest surviving illustrated manuscript, the Beatus of Silos, in Burgos, dates from the 9th century. With the exception of this profusely decorated manuscript from Silos, the earliest surviving illuminated codices contain rather scant decoration in the Concordances, consisting of linear patterns and images of the Evangelists. Examples of this kind include the *Biblia Hispalense* (National Library, Madrid) and the *Bible of Juan y Vimara* (Cathedral musem, León), which clearly reveals the influence of Asturian and Visigothic goldsmithing designs. In contrast, the so-called *Bible of León* (collegiate church of San Isidoro), dating from 960, marks a complete departure from the above in terms of the number of illustrations, and their size and style. This is the first example of an illuminator—Florencio, in this instance—displaying the full stylistic array associated with the early-mediaeval Hispanic miniature.

The characteristic style of the so-called Beati emerged in the mid-10th century in Leonese scriptoria. An illuminator named Magio may have first developed this style, with its deep, bright colouring, monochrome, banded background, structural types and architecture, lack of realism and archetypal figures. Magio has been associated with the Beatus of the Morgan Library (New York), and the Beatus of Tábara (National Historical Archive, Madrid), which had originally been housed in an abbey dedicated to St Michael, possibly San Miguel de Escalada. The Beatus of Tábara features a miniature depicting the scriptorium of Tábara inside the monastery tower—this provides a valuable clue as to the location of centres of illumination in the early Middle Ages. However, on the death of Magio, the text was completed by an illuminator called Emeterio, whose name also appears in the Beatus of Girona (Cathedral museum), alongside that of the female miniaturist Ende. This style spread across Castile, thanks mainly to the endeavours of Florencio, chief scribe in the service of Fernán González, who was instrumental in producing thirteen works between 937 and 978.

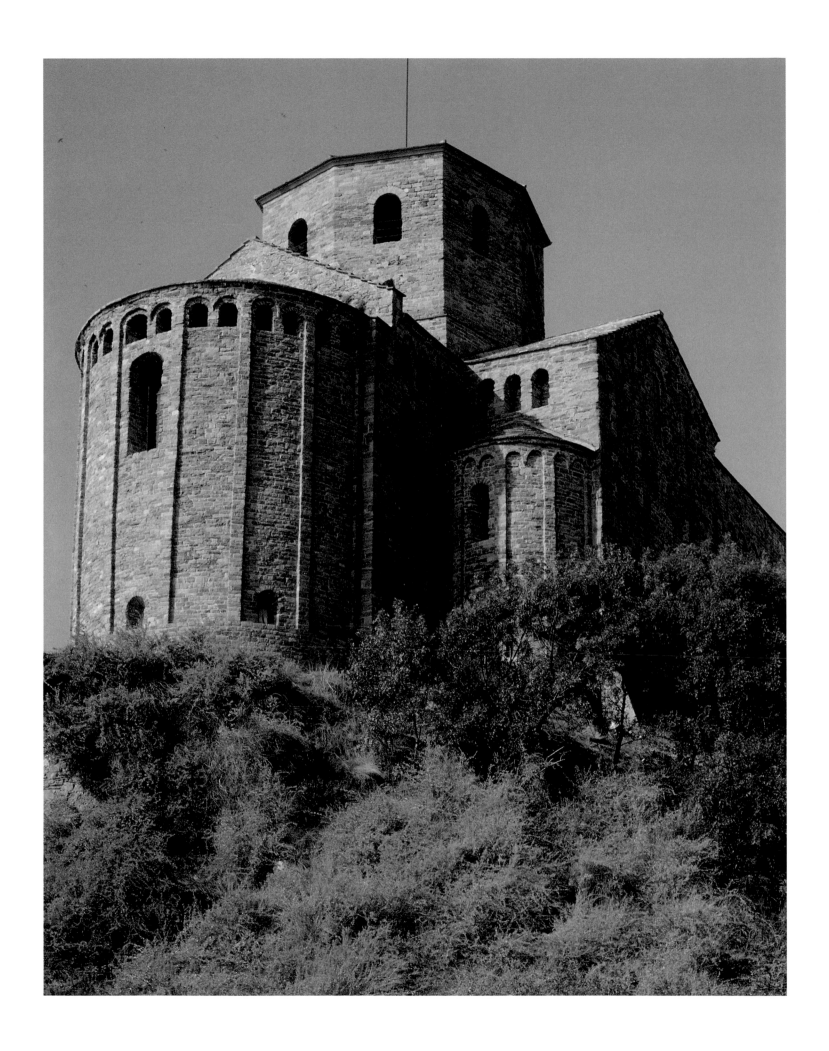

View inside the lantern in the collegiate church of San Vicenç de Cardona (Barcelona).

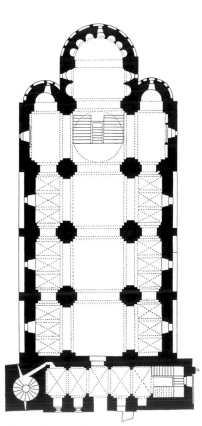

Ground plan of the church of Sant Vicenç de Cardona.

Moorish influence has traditionally been adduced to justify the term Mozarab as applied to early-mediaeval illumination of this kind. However, apart from a few decorative features, such as intertwining geometrical shapes and horseshoe arches in some of the architectural scenes depicted, there is no overall feature nor documentary evidence to support the claim that most of the illumination was produced by Mozarab monks that had emigrated from the south. On the contrary, the manuscripts contain a wealth of iconographic types or models derived from the ancient world. They may have been either part of local tradition or a borrowing from Carolingian art, and were used to ornament initials inherited from the late-9th century Frankish Insular script.

ROMANESQUE CHURCH ARCHITECTURE

Romanesque art on the Iberian Peninsula spanned over two centuries—from the 11th to the 13th—and was geographically distributed in terms of the advance of the Reconquest. The main periods are early Romanesque, mature Romanesque and late Romanesque, which is overlapped by the early Gothic.

Characteristic of the Christian kingdoms on the Iberian Peninsula in the 11th century was their spirit of freedom, and their independence from one another, and from both the Franks and Sarracens. Hence, each kingdom developed simultaneously but separately, and each fought its own battles against the Moors. History and early-mediaeval tradition led innovative Romananesque art to evolve in terms of the socio-political forces, technical advances and, above all, financial resources of each area. Thus, the earliest expressions of Romanesque art emerged in kingdoms with a specific political framework and stable frontiers.

The county of Barcelona, which came under the Carolingian territorial demarcation known as the Spanish March, won its independence from the Franks in the 9th century. This emancipation reached its height under Borrell II (950–992), and elicited indifference on the part of the Franks when the territory was raided by the Moorish leader, al-Manṣūr. Areas conquered by the Moslems were gradually recovered during the 10th century, including Cardona, Calders and Olèrdola, but the Catalan dominions were still restricted to 'Old Catalonia', in addition to Carcassone and Bèziers, which were annexed by Ramon Berenguer I (1035–1076). However, power was dispersed across separate counties, which precluded any joint action against the Moors. The Kingdom of Navarre also flourished during the first three decades of the 11th century, particularly owing to the endeavours of King Sancho III the Great (1004–1035). The Moorish presence in Navarre was short-lived, and the kingdom also fought off expansionist drives by the Franks and Normans. At a time when the Kingdom of León had become debilitated, and the Umayyad dynasty had gone into decline, Sancho the Great saw his chance to seize Castile through marriage to Doña Mayor. He also seized the counties of Sobrarbe and Ribagorça, while the county of Aragon had been incorporated into his kingdom in the mid-10th century.

In the first three decades of the 11th century, a proto-Romanesque architectural style emerged in the Catalan counties and the Kingdom of Navarre. Development of this style in Navarre was facilitated primarily by the monarch's outward-looking policies. The first scholar to define and geographically pinpoint the style in question was the architect Josep Puig i Cadafalch. His methodology was largely based on a direct study of the architectural features of Romanesque buildings in Catalonia, and he centred his research on the reappearance of the dome or cupola (see *L'arquitectura romànica a Catalunya, 1908–1919* in three volumes). In the course of his research, he noticed that certain features, including stone vaults, small-scale layout, and decorative arcatures and pilasters, were shared by buildings in Catalonia, northern Italy and southern France. Those features he termed 'early-Romanesque' in his subsequent publications.

The 11th Century

The major early-Romanesque churches were based on a basilica plan, with a nave and two aisles, which were separated from the sanctuary by a transept. The most outstanding monastic ensembles were similar to the extant Sant Miquel de Cuixà, which was remodelled, and its sanctuary enlarged, during the time of the celebrated Abbot Oliba. The refurbishment included the addition of a false ambulatory and two towers over the crossing, as well as the underground church of the *Pesebre* with its annular vault. An outstanding example of the Romanesque is the highly restored church of the monastery of Ripoll, with its five aisles, transept and seven apses aligned as in St Peter's in Rome. Others include the canonical church of Ager, the interior of which reveals the use of all the devices available to early-Romanesque art in southern Europe. The canonical church of Sant Vicenç de Cardona is noteworthy for its harmonious volumetric distribution and bold roofing, and that of Sant Pere de Rodes for its wealth of architectural features, including superimposed orders and an ambulatory, worthy of classical tradition, which must have coexisted with Lombardic styles during the 11th century. Unfortunately, the early-Romanesque cathedrals, such as Girona, Vic and Barcelona, were built over in the Gothic and Neoclassical periods, so that a picture of the original building can only be built up from a few surviving vestiges and the findings of archaeological excavations.

In the westernmost kingdoms of the Iberian Peninsula, building activity and the first distinctive signs of the early-Romanesque did not show through until those kingdoms had been politically united by Sancho III the Great, who was friendly with the Abbot Oliba and other clergymen of Catalan origin. Under the auspices of that monarch, the abbey of Leyre was rebuilt, and the church of San Juan de la Peña was enlarged. The fortified precinct of Loarre was built during the same period, while construction work began on Palencia Cathedral. Indeed, the concerted building activity at the time would suggest that all the churches enjoyed royal patronage or, at least, protection. Leyre monastery is regarded as the finest example of the early-Romanesque in Navarre. Built with huge blocks of ashlar, it has monumental proportions, accentuated by slender engaged columns offsetting the sturdy form of the crypt, a contrast which was possibly the result of structural demands. Conversely, in the Loarre fortress, southern-European Romanesque features are more in evidence, on account of its small size and the biforate windows of the so-called 'Tower of the Queen'.

The contradictory politics of Ferdinand I (1035–1065), who inherited the throne of Castile and subsequently that of León, was reflected in the artistic production patronised by him. On the one hand, tradition was brought to bear in his choice of León as his capital, and when he commissioned reconstruction of the monastery of San Pelayo y San Juan Bautista as a royal pantheon, in the purest Asturian style. On the other hand, in the church of San Pedro de Teverga, steeped in Visigothic style, innovation is evident in the capitals of the nave and portico. The southward drive of the Reconquest, begun by Ferdinand I with the occupation of Portuguese territory and party kingdoms such as Saragossa, Badajoz and Seville, was continued by Alfonso VI (1072–1109), culminating, in 1085, in the conquest of the legendary city of Toledo, where a Cluniac prelate was appointed to the episcopal see.

A number of factors were involved in the western kingdoms' rapprochement with Europe, which led to the influx of formulae from the mature Romanesque during the reign of Alfonso VI. These included acceptance of the Roman liturgy (1080) and the presence of French prelates, and matrimonial ties between the monarchs of Castile and León, and Navarre and Aragón, in addition to an influx of European pilgrims, for which the Road to Santiago was duly readied. In the light of these developments, the Renconquest was seen as a crusade. Thus, it would be a crude over-simplfication to conclude that Cluny was wholly instrumental in the introduction of the new style, or to consider Romanesque art as an import from France.

The first manifestations of the mature Romanesque emerged along the so-called 'French Road' or Road to Santiago in the last three decades of the 11th century, and sub-

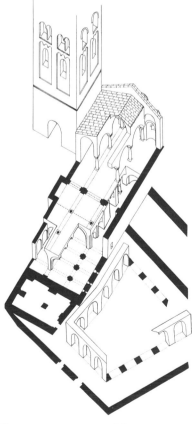

Isometric perspective of the monastery of Sant Martí de Canigó.

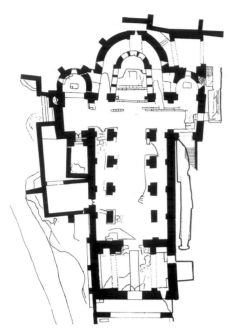

Ground plan of the monastery church of Sant Pere de Rodes.

Monastery of Sant Pere de Rodes, near Port de la Selva (Girona), consecrated in 1022.

The monastery of Sant Pere de Rodes is unique as far as pre-Romanesque and Romanesque buildings are concerned. This has led to uncertainty regarding its chronology, which ranges between the 10th and 12th century, depending on the source. The presence of an ambulatory, and the interior elevation, with two orders of superimposed columns, are uncharacteristic of the Catalan Romanesque. The exquisitely sculptured capitals in the nave date from the 11th century, while the facade, at least partially executed by the workshop of the Master of Cabestany, belongs to the late Romanesque.

sequently moved southwards with the advance of the Reconquest. For this reason, and thanks to the historiographic contribution of E. Mâle and A.K. Porter in the nineteen twenties, the term 'school' is now applied to all Romanesque vestiges on pilgrim routes. This is actually a transposition of literary methodology, according to which art skills were transmitted by pilgrims. For some, such as A. Mâle and E. Bertaux, the movement was born in the south of France. For others like A.K. Porter and M. Gómez Moreno, it began in Spain. However, all the religious buildings currently labelled as Romanesque could hardly be grouped together in a formal sense were it not for the survival of the celebrated itinerary guide known as the *Codex Calixtinus*. Similarly, it would be misleading to equate the great churches of pilgrimage—Santa Fe de Conques, Saint–Martial de Limoges, Saint–Sernin de Toulouse, Saint–Martin de Tours and Santiago de Compostela—with other examples of Romanesque architecture, and to regard them as having played an all-embracing role in the development and spread of each and every aspect of this style.

Construction work on the great basilica at Santiago de Compostela began under the auspices of Bishop Diego Peláez, between 1075 and 1078, although the major work was undertaken during the time of Bishop Diego Gelmírez, who died in 1140. The cathedral is based on a Latin cross, with a nave, two aisles and a large transept. The central nave is twice the width of the aisles and higher, and is surmounted by a barrel vault reinforced with transverse arches. The aisles have groin vaults over each bay. The uprights are clustered piers, with circular and rectangular bases alternating in the crossing. Attached to the bases are the shafts of supporting transverse arches and arch ribs. The aisles extend through the transept and link up with the ambulatory. Thus, the church has a complete secondary circuit which does not interfere with the central nave, set aside for worship. Above the aisles is a tribune gallery which overlooks the central area via an arcade and runs around the full girth of the building. From a description in the *Codex Calixtinus,* it appears altars were once placed in the gallery, although the fragile flooring and difficult access would suggest it would not have been able to hold a large number of pilgrims at any one time. The radiating chapels leading off the ambulatory have secondary altars corresponding to the different seasons of pilgrimage. The original Romanesque basilica had five radiating chapels in the apse: the central one was rectangular, the intermediate ones semicircular, and the end chapels polygonal, in addition to two semicircular chapels on either side of the east face of the transept. Santiago de Compostela was unprecedented as a Spanish basilica, and similar models could only be found in France, bearing out the international factor in the development of this type of Romanesque building.

Owing to the uniqueness of its structural features, the architectural model of Santiago de Compostela is not found anywhere else along the French Road. In the last three decades of the 11th century, the buildings flanking the Road on its way through Aragon, León and Castile were generally based on the Benedictine ground plan, which was rectangular, with a central nave and side aisles and three tiered apses, with a dome on squinches over the crossing and alternating types of upright. This type of architecture was also distributed across most of southwestern France, Gascony and Languedoc. Having ruled out the spurious documents and arguments once brought to bear, the fact is that Jaca Cathedral is now considered to be contemporary with Santiago on the grounds of two features: firstly, the two spires on the former, which were built circa 1075–1077 under the auspices of the Jaca diocese, from where the Aragonese Reconquest was mounted. The second clue is a donation made by King Sancho Ramírez's sister Sancha, in 1094, towards building work on San Pedro de Jaca.

Still on the subject of the aforementioned type of ground plan, another interesting feature characteristic of the mature Romanesque in Jaca is the careful articulation of wall interiors and exteriors, and the presence of sculptural groups. Apart from some significant examples of monumental sculpture, dealt with below, some noteworthy vestiges that have survived in Jaca Cathedral include one of its Romanesque apses, which served as a model for other contemporary religious buildings. The eaves in the circular apse are adorned with a billeted motif supported by modillions, ornamented metopes and two imposts, dividing

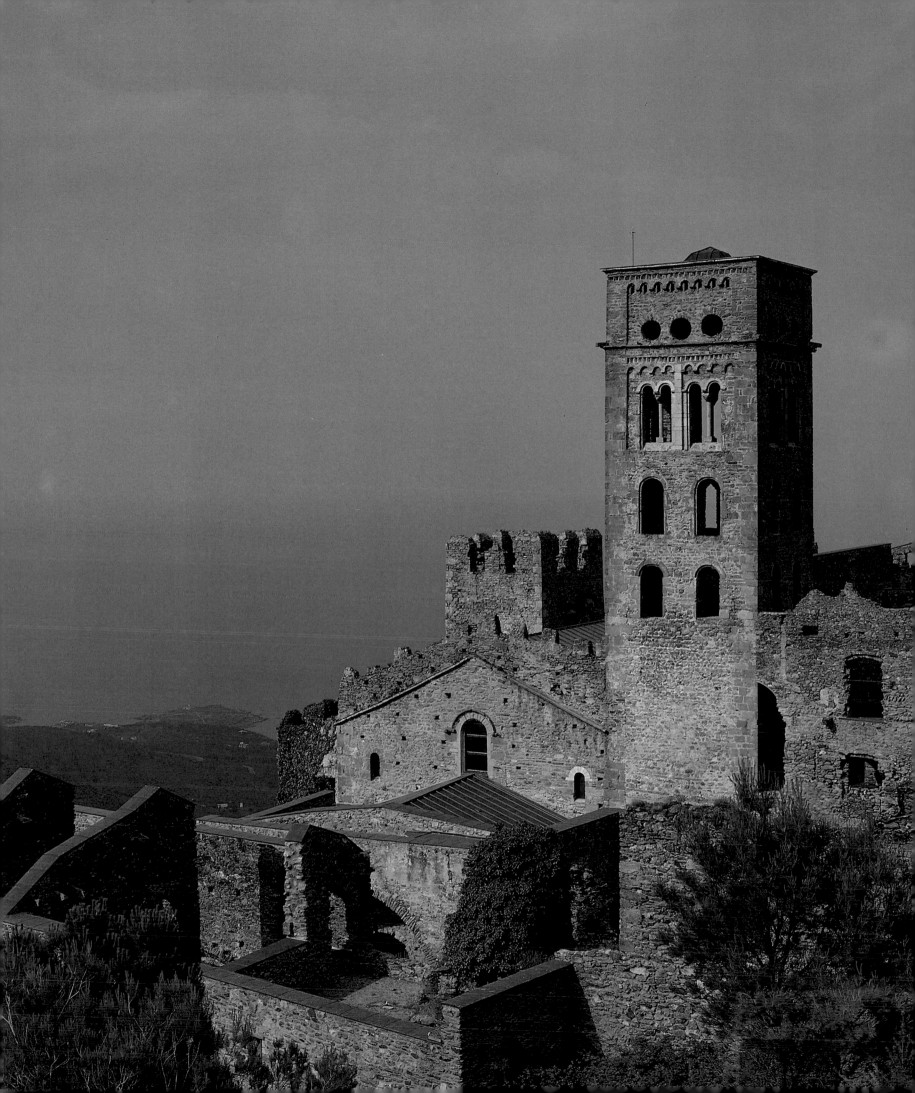

THE ROAD TO SANTIAGO

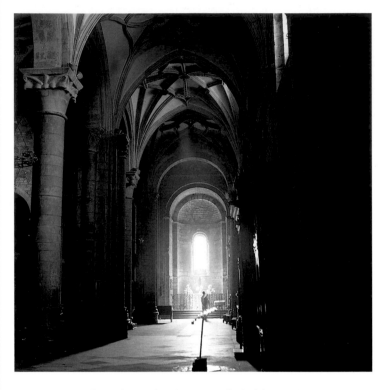

Aisle on the epistle side, Jaca Cathedral (Huesca).

*Frontispiece on the church of Santiago at Carrión de los Condes (Palencia),
dating from the late-12th or early-13th century.*

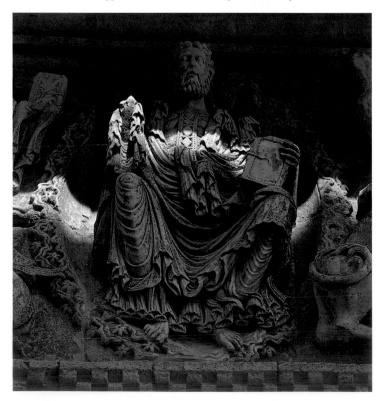

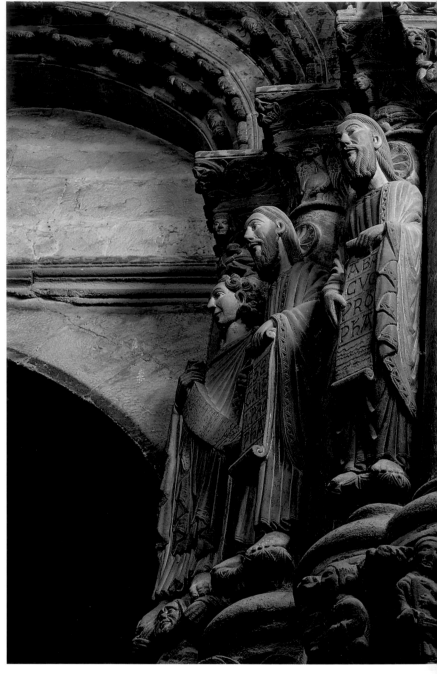

In the 11th century, Europe was gripped by pilgrimage fever, centred around the spot believed to be the last resting place of the Apostle, James—Santiago de Compostela. The pilgrim's guide described the four roads which traversed France and collected pilgrims on the way before converging on Santiago. One of these roads passed through Saint-Gilles-du-Gard, Montpellier, Toulouse and Somport. Another, through Puy, Conques and Moissac. The third, through Vézelay, the Limoges area and Périgueux. On the fourth and equally popular route, pilgrims gathered at Tours before passing through Poitiers, Saintes and Bourdeaux. All these roads are easily reconstructed, owing to the survival of records citing them, and to extant commemorative monuments. The major road led through Toulouse, while all of them met at Puente la Reina, and then proceeded through Estella and the region of La Rioja, before reaching Santiago de Compostela in Galicia.

The great basilicas that were built to serve the growing wave of pilgrims make up a homogeneous group, of which the major churches are Saint-Martin at Tours, Saint-Martial at Li-

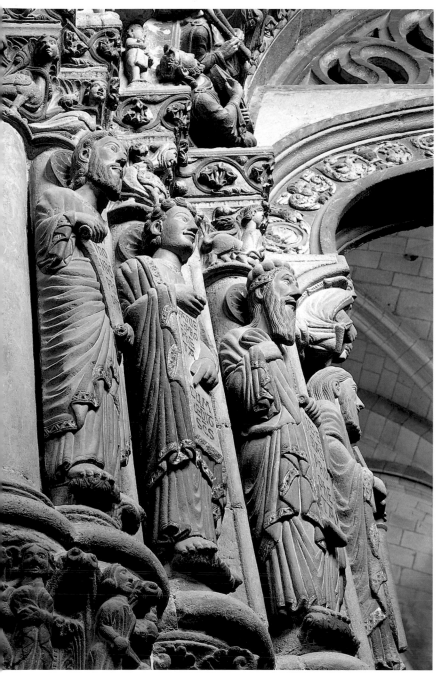

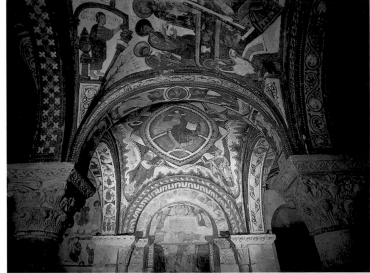

Early-12th-century mural on the Pantheon of the Kings, collegiate church of San Isidoro, León.

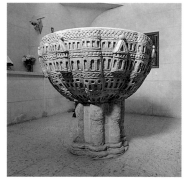

Baptismal font in the 12th-century church at Redecilla del Camino (Burgos).

moges, Santa Fe at Conques, Saint-Sernin at Toulouse and Santiago de Compostela. They are abbatial or collegiate cathedrals which, by the late-11th or early-12th century, had adopted a ground plan with three or five naves crowned by a projecting transept, with the apse extending into an ambulatory and radiating chapels. The exterior elevations at this eastern end of the church varied in terms of each architectural or structural liturgical element. In the interior, the addition of a first-floor gallery above the aisles shaped a standard three-storey elevation. Proportions could be huge, depending on the demand created by the crowds of pilgrims that descended on the churches to pray, usually only temporarily, and on the income for the religious communities which those pilgrims generated. The increasing tide of pilgrims led additional apses and altars to be built to cater for the worship of saints and relics, either of local or distant origin, a practice which became widespread.

The need to adorn the new churches along the pilgrimage routes led to the emergence of Romanesque sculpture, the chronology of which is still uncertain. Three great contemporary architectural works, at León, Toulouse and Compostela, all begun after 1070, reveal a parallel artistic development which is the focus of present-day studies. The undertakings were so vast that, for instance, Saint-Sernin at Toulouse contains over 260 Romanesque capitals in the church arcades. Monumental facades were then added: those in France and the facade of the Orfebres at Compostela, dated before 1112, and the Miègeville portal at Toulouse, before 1118, display the newfound Romanesque religious sensibilities in the form of a rich iconography that was to spread beyond the confines of the pilgrimage routes.

The basilica at Compostela, where construction work began with the apses during the time of Alfonso VI and Bishop Diego Peláez in 1075, is a synthesis of Romanesque religiousness and art. By 1102, the sanctuary had been completed and, three years later, in 1105, when eight altars were consecrated, building work had reached as far as the transept. In 1122, according to the *Codex Calixtinus,* or 1124, according to the *Crónica compostelana,* the last stone was laid.

The sculpture in this basilica can be classed chronologically into two groups, which roughly correspond to works on the north and south facades, in addition to that of Master Mateo on the west facade. The first two, highly characteristic of pilgrimage-plan churches, are both pierced by two doors of equal size. The facade of the Orfebres is set within a rectangular area in which all available space is studded with sculptures, such as scenes from the life of Christ, which appear on either side of the tympanum.

The Portico of Glory, executed by Master Mateo in 1183, marks the end of the creative cycle of the Romanesque at Compostela. This monument is a crowning achievement, in which the image of the Divine Majesty is flanked by elements based on the tenets of the new Gothic style, set in the heart of the Romanesque. At the end of the 12th century, the Romanesque was to receive renewed decorative impetus, which flourished simultaneously at various places in southern Europe, from Italy to the Iberian Peninsula.

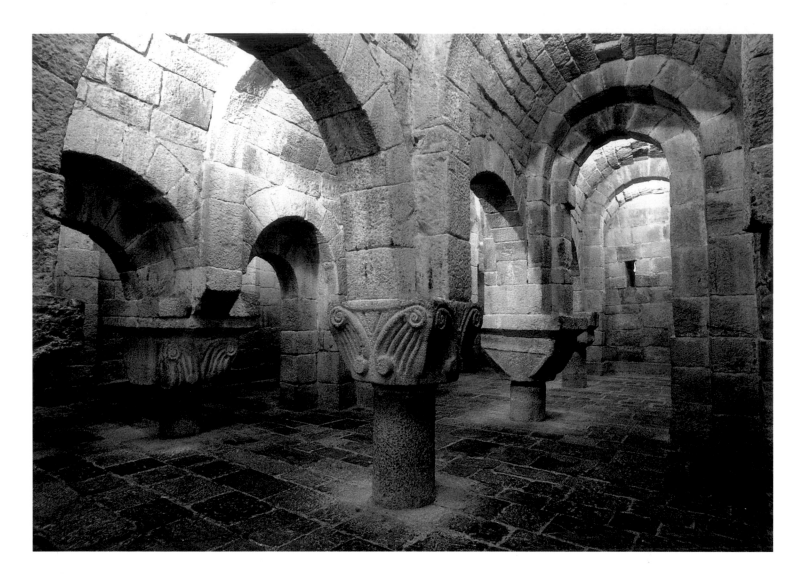

Monastery crypt at San Salvador de Leyre (Navarre), dating from the first three decades of the 11th century.

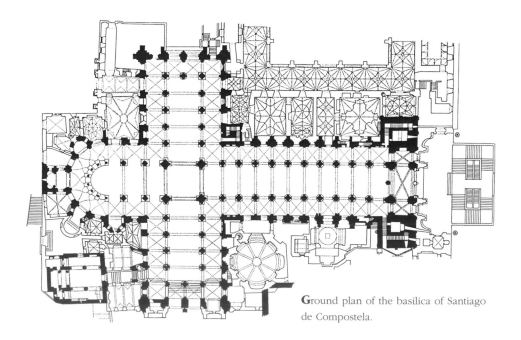

Ground plan of the basilica of Santiago de Compostela.

Cathedral at Santiago de Compostela, dating from 1075–*circa* 1120.

The central nave in the Cathedral of Santiago de Compostela is perhaps the most international example of the Spanish Romanesque. The elevation, with its huge arcades and galleries, is characteristic of pilgrimage churches. The galleries were thought to have been included in the design to accommodate the growing number of pilgrims that flocked to the Cathedral, but this theory does not agree with the narrow entrances to the building. The nave was adorned with sculptured capitals and rich, polychromed relief work.

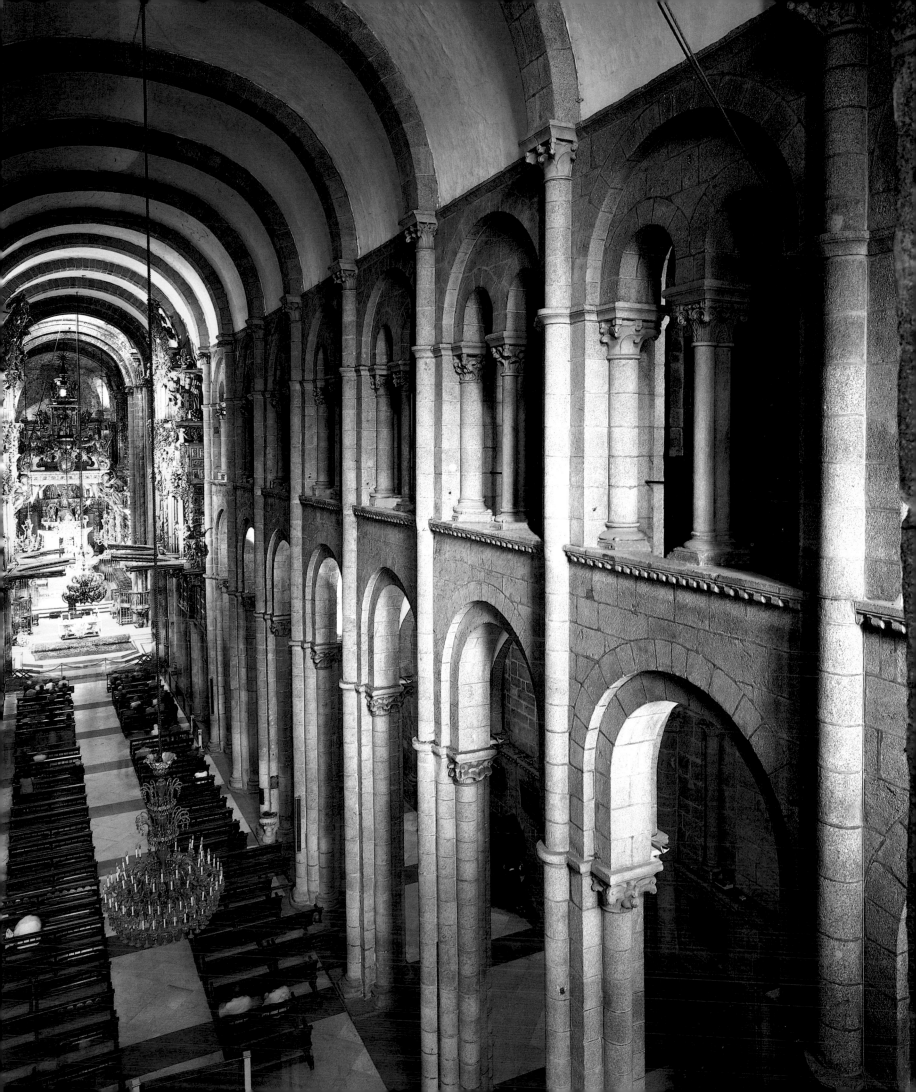

Interior of the monastery church of San Martín de Frómista (Palencia), dating from the second half of the 11th century.

Ground plan of the monastery church of San Martín de Frómista.

it into three horizontal registers with similar, chequered decoration. The window is framed by two engaged piers with capitals, joined by a semicircular arch with the same pattern on the extrados.

The chronology of San Isidoro de León is now also regarded as different from what was originally believed. The Pantheon of the Kings, which is architecturally reminiscent of entrance towers at such French churches as Saint-Benoît-sur-Loire, was built on the orders of Doña Urraca, the daughter of Ferdinand of León and Sancha of Castile, who died in 1102. The building is therefore contemporary with the sanctuaries of Saint-Sernin at Toulouse and Santiago de Compostela. However, the building that best exemplifies the mature Romanesque in Spain, both in relation to its plan and the sturdy treatment of its walls, is the church of San Martín de Frómista, which has unfortunately been thoroughly and repeatedly restored.

The 12th Century

The 12th century saw further development of both architectural systems—southern European early-Romanesque in Catalonia, and mature Romanesque in the territories newly conquered by the Castilian–Leonese and Navarrese–Aragonese crowns. Meanwhile, artistic novelties spawned in France gradually filtered into the Iberian Peninsula. During the reigns of Alfonso VII (1126–1157) and Alfonso VIII (1158–1214) of Castile, and Ramon Berenguer IV (1131–1162) of Barcelona, donations to the Cistercian order rose sharply, leading to the building of such complexes as Osera, La Espina, Las Huelgas, Poblet and Santes Creus. The

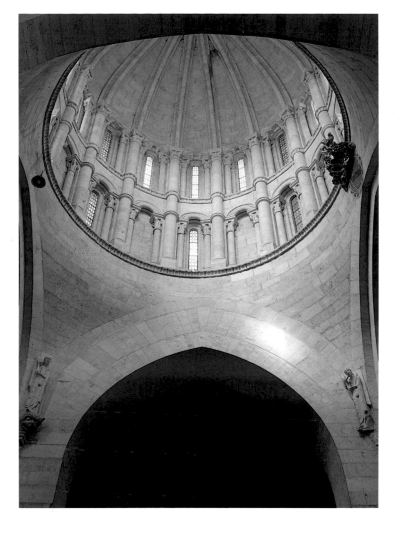

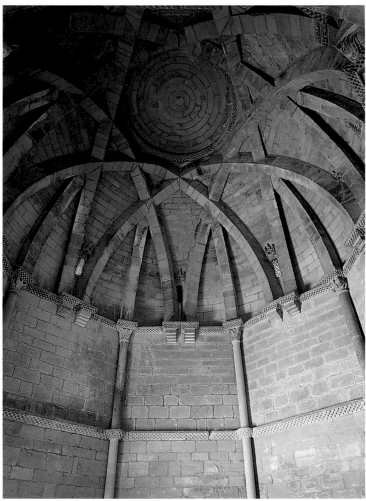

cathedrals of Salamanca, Zamora, Tarragona and Lleida incorporated Gothic structural elements for the first time, including the pointed arch and the rib vault, although without exploiting the structural advantages of such elements to the full.

The Romanesque architecture that developed in Catalonia in the course of the 12th century was inspired by the early-Romanesque experience. The major cathedrals—Girona, Barcelona, Vic, Tarragona and Lleida—were either built or refurbished at that time, as were the urban monasteries of Sant Pau del Camp, in Barcelona, and Sant Pere de Galligants, in Girona. The cathedral at La Seu d'Urgell, begun in 1131, is possibly the best example of Romanesque architecture in the local tradition with the admix of Italianate elements, as evinced in the exterior gallery surmounting the apse. In this respect, in 1175, an architect named Lambard, probably of Italian origin, was engaged by the cathedral chapter for a period of seven years. Foreign borrowings were superimposed on traditional architectural forms in many small or medium-sized buildings, which usually consisted of a nave without aisles, with or without a transept, and a semicircular apse. The building was often crowned by semicircular vaulting supported on transverse arches. The churches of Sant Joan de les Abadesses and Sant Pere de Besalú, for their part, reveal French influences, while the large basilicas of Tarragona, Sant Cugat and Lleida were forerunners of the Gothic.

During the 12th century, the ground plan of Jaca Cathedral served as a model for the churches built in the western kingdoms, as well as in León and Castile, as evinced at San Vicente de Ávila, and in Segovia and Salamanca. In Navarre, details of the origins of the Gothic cathedral of Pamplona came to light during excavations, which show that it was built under the episcopate of a French prelate in the period 1082–1114. In 1101, an architect named Esteban, who had directed building work on Santiago, is documented as hav-

101

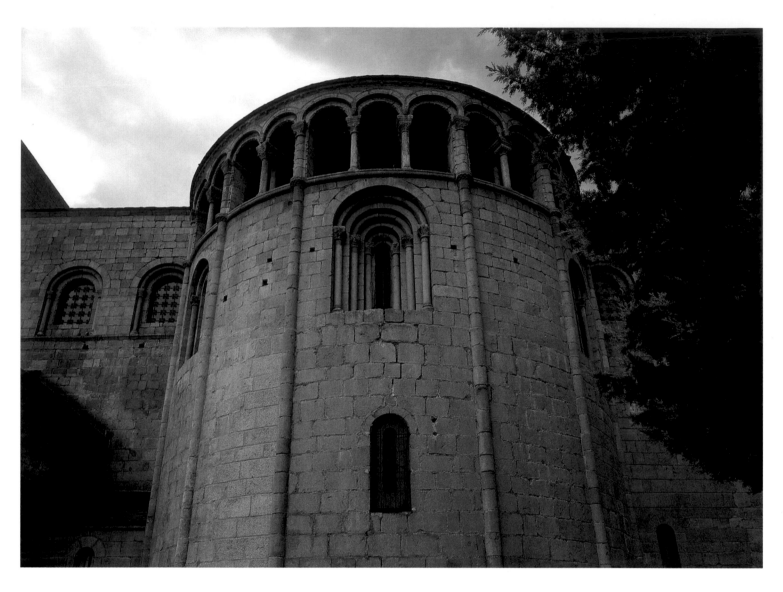

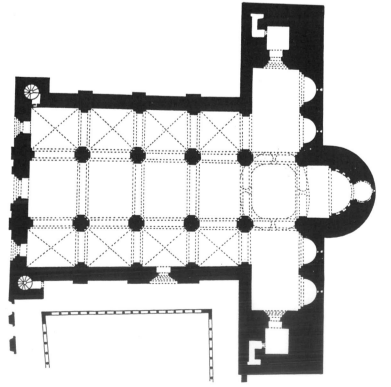

Sanctuary in the church of Santa Maria at La Seu d'Urgell (Lleida), built between the period 1092–1122 and the year 1195.

Plan of the cathedral of La Seu d'Urgell.

ing received donations relating to the construction of the cathedral, which was consecrated in 1127 in the presence of King Alfonso the Battler of Aragon. The most striking features of the building are in the choir, with a markedly projecting transept and three apses. The two semicircular side apses are set far apart from the central apse. The latter is unusual in that it has a semicircular plan within and a polygonal one without, while the buttressing was apparently added to support the vault, a formula that may have originated in southern France.

In Castile, the chronology of Santo Domingo de Silos has raised controversy in recent years. Traditionally, the church and the oldest part of the cloister (the eastern and northern galleries) were thought to have been built in the late-11th century. In this respect, a detailed account of the reconstruction of the monastery happens to be contained in a manuscript which narrates the life of St Domingo de Silos, written by a monk named Grimaldo, which mentions that the saint was buried in the cloister opposite the church entrance after his death in 1073. Subsequently, purportedly in 1076, his relics were moved into the church and deposited in front of the altar of San Martín. A consecration is recorded as having taken place in 1088, and this was attributed to the upper church. However, research carried out by I. Bango and J. Williams shows that it was the lower church that was consecrated on that date. Thus, the cloister must have been built after the saint's death. The south arm of the transept in the upper church, with its decorated capitals, marks the latest style in that section of the building, which also includes the Portal of the Virgins, dated in the period 1120–1130 by P. Klein.

Rural Castilian architecture displays frequent borrowings from the Islamic world. This can be seen in a host of decorative details and particularly in the baldachins and cloister arcades at the monastery of San Juan de Duero, in Soria, charged with reminiscences of Amalfi or Sicily. Another feature of 12th-century Castilian architecture are entrance porticoes, consisting of a covered gallery opening onto the exterior via a series of arcades, and sometimes containing tombs, as at San Isidoro de León. Presumably for liturgical reasons, these porticoes were also functional, and were often used for lay meetings. In short, the architectural style in question is unassuming at first sight, although actually closely geared to everyday life during the Romanesque period. Other purpose-designed porticoes of this type can be seen at San Miguel and Nuestra Señora del Rivero, San Esteban de Gormaz, Sepúlveda and Rebolledo de la Torre. The characteristic Romanesque dome of Zamora Cathedral, built in the late-12th century, is related to that of Salamanca's 'Old Cathedral', despite the fact that the one in Zamora is based on Byzantine models, while the source of inspiration for the latter is to be found in western France.

MILITARY AND CIVIC ARCHITECTURE

The following is a brief look at military and secular Romanesque architecture on the Iberian Peninsula. Although our knowledge of the subject is growing and being continually enriched by finds from current excavations, it is scant in comparison to that of religious and residential architecture, which has traditionally focused the attention of researchers to a greater extent.

Castles and Fortifications

On the western fringes of Catalonia, where the Catalan counties of Barcelona, Urgell and Pallars Jussà bordered on the shifting Moorish dominions, a number of unusual circular towers have been discovered. Indeed, they are architecturally unique in the context of the western European Romanesque. The tower walls had small bonds joined with mortar. Their thickness at the base was over one and a half metres, and they could be fairly high.

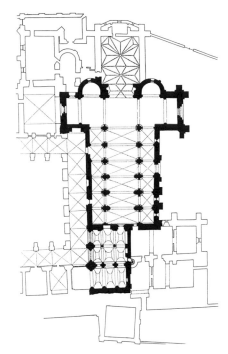

Ground plan of the collegiate church of San Isidoro de León.

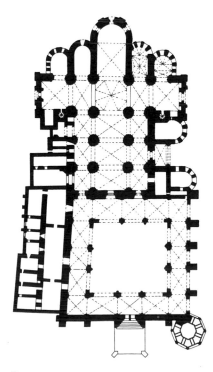

Ground plan of the Old Cathedral, Lleida.

Loarre castle (Huesca), dating from the 11th and 12th century.

Loarre castle is the clearest example of southern, early-Romanesque architecture as applied to secular and military constructions. Built to defend Aragonese territory, it comprises an outer wall, one of the finest of the early Romanesque, and an ensemble in which the keep and chapel are the most striking buildings. Built two-storeys high to offset sloping ground, the chapel was turned into canonical lodgings as from 1071. The exterior wall facings, built in tiers and pierced by decorative windows, make this the most representative of Romanesque fortresses in Aragon.

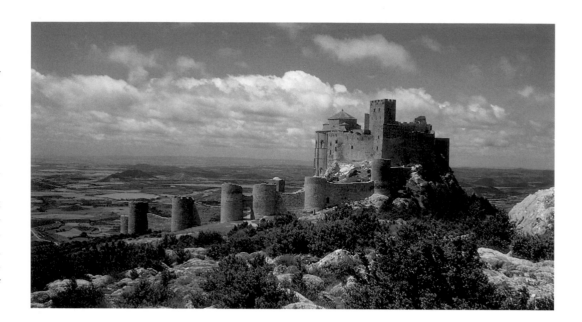

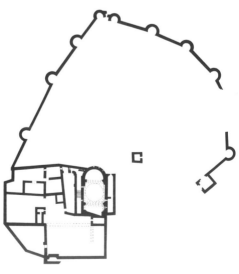

Ground plan of Loarre castle.

Wall facings were devoid of any adornment, and access was via a wooden door which led to an entrance set at a height of five to ten metres above ground level. Windows pierced the tower walls near the top. The interiors were divided into floors: the upper and lower floors were vaulted, while the intermediate ones were marked out by wooden rafters. Their isolated siting suggests they acted as watchtowers to give advance warning to castles in the event of impending danger. They were designed for this purpose, rather than as residences, although they did have the necessary facilities for being used as a keep. Their dating has proved to be a daunting task, as too few general archaeological studies have been carried out to enable their bond to be compared to that of other buildings. Moreover, they are hardly ever mentioned in any surviving documents. Watchtowers in the marches of Catalonia and Ribagorça have been classified into two groups: the first, with horseshoe arches, is termed Mozarab, and is dated in the period 1020–1035, when the borders were laid down, while the second group, dating from 1025–1070, is related to the southern Romanesque. When the areas where these towers were located ceased to be frontiers, they were either abandoned or gradually turned into residences, as shown by remains at Alsamora or Sant Oïsme de la Baronia.

Spain's castles, for their part, had diverse beginnings, so that a hard-and-fast taxonomic classification of castles on the Iberian Peninsula cannot be established. They were built in response to a variety of defensive, residential or territorial needs and within a number of different socio-political climates in the different kingdoms. In Catalonia, the first stone castles, which replaced the original wooden ones, are thought to date from the 11th century. Mur castle, in Lleida, is an example of what was originally a tower being remodelled as a castle. In the centre stands a circular tower around which a wall was erected. It was originally surrounded by a triangular perimeter, reinforced at the corners with rectangular works, and had an interior, open-air court that might have been used to house a garrison or as temporary shelter for people living in the vicinity. A third feature was the chapel, which in this instance was located outside the walled enclosure. This type of castle, characteristic of the early Romanesque, had been built in Arab territory ever since the 10th century, attesting, once again, to the influence of Islamic culture on Christian defence works. In time, castle structures gradually became more complex, and rectangular constructions

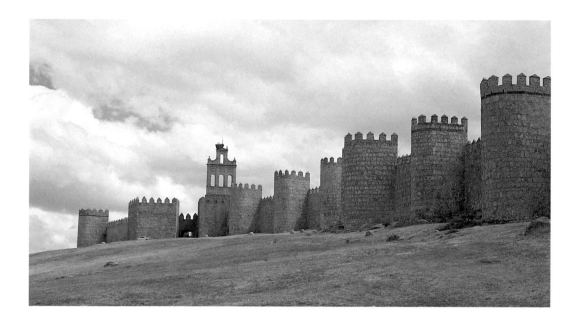

The walls of Ávila, built in the late-11th and early-12th century.

with either a military or domestic function appeared inside the aforementioned courts, as in Llordà castle. Remodelling work on the *castrum* in Terrassa, commissioned by the Count of Barcelona, Ramon Berenguer I, and his wife Almodis, reveals that the transition from the rock castle, based on an oval or irregular ground plan, to the square- or rectangular-plan castle with corner towers characteristic of the mature Romanesque, occurred in the period 1050–1070.

The emergence of common artistic traits in castles during the first three decades of the 11th century can be seen in the similarities between the first castle of Loarre, that of Abianza, in Huesca, and Torres del Oeste castle in Galicia. They feature the same stone-masonry techniques and, above all, the same tower ground plans and way of arranging the floors, which suggests that these 11th-century castles may have all been built on the initiative of King Sancho III the Great. All of them belong to the early Romanesque.

At Covarrubias, in Burgos, the so-called Tower of Doña Urraca, probably ancient in origin, is a good example of a keep. Prior to its incorporation into a more complex structure, it measured 15 m. long by 8 m. wide and 18 m. high, which are standard proportions for a Romanesque fortification. Such fortifications were probably smaller and fewer in number than those in France or England. However, the 13th century saw a marked rise in the number and consolidation of Hispanic fortresses, which included Peñíscola and the Alphonsine tower at Lorca, both among the series of fortifications built on the orders of Alfonso X of Castile. Dating from that Gothic period, but inspired in the Romanesque, is the exemplary quadrilobulate keep of Cotte, in Montellano (Seville).

Town Planning

New systems of defence and physical layout arose in the freshly conquered territories during the late-11th and early-12th century. Apart from walled cities, the epitome of which is Ávila, buffer cities were established to act as a line of defence and as newly chartered settlements. The city of Soria grew out of a frontier post between Castile and Aragon in 1119. Alfonso I granted privileges to all those who settled in that new, strategic town and

helped to defend it. At the same time, a number of military orders were founded, such as the Order of Calatrava and that of Alcántara, which strengthened the Christian reconquest of the Peninsula by contributing stringent methods of combat and organisation learned from the Almoravids. The fortress–monasteries of those warrior monks also became the nuclei of new settlements, as well as control centres for the surrounding farmland. Apart from providing safe havens and encouraging spiritual activity among the people by building hospitals and churches, successive monarchs also promoted the growth of strategically deployed towns such as Sahagún and Logroño. In some older towns, establishments were consolidated on either side of the newly laid pilgrimage routes. Castrojeriz, for example, was originally located at the foot of its castle, but, in the course of the 11th century, a second town centre sprang up around the road of pilgrimage. The same thing occurred in other towns, such as Estella and Lorca, both in Navarre.

In the same areas, new towns laid out in a regular grid pattern emerged on the basis of regional resettlement charters. The most representative examples are Puente la Reina and Sangüesa, which were founded on the initiative of Alfonso I the Battler. Both these towns were sited along a pilgrim route, on either side of which rectangular plots of land were distributed. In other instances, royal charters were granted for the purpose of grouping a number of villages into a single, larger defensive unit, a formula which was applied to cities such as Salamanca, Segovia and Ávila. The latter is undoubtedly the finest example of this type of charter. It was Raymond of Burgundy, the son-in-law of Alfonso VI, who in 1090 ordered the construction of city walls to protect the newly conquered area which eventually became the city of Ávila. The fortress is based on an irregular, rectangular ground plan. It lacks a moat, and the wall is set directly on the ground. It is 12 m. high and the entire stretch of wall facing is structurally reinforced, with semicircular towers placed every twenty metres. The top was built flat to support a walkway. Ávila Cathedral is attached to the wall and protected by it, as were the stately homes of the city's nobles. The walled precinct at Ávila was a symbol of the Romanesque in Castile, haughty and well defended during the times of the Reconquest.

The marked rise in urban activity triggered a demand for civic architecture. Building work began on a large number of hospitals, of which remains can be seen in towns such as Tortosa, Altafulla and Calaf, and public baths, which include the well-preserved and misnamed 'Arab' baths of Girona, restored in the 13th century.

Turning to private residences, it should be stressed that most homes were built with perishable materials until well into the 11th century. The sturdier stone constructions were usually several storeys high. A typical residence would have a basement store, an open ground floor used for commercial purposes, and one or two floors which served as living quarters. The so-called Paeria palace in Lleida, the residence of a noble family called the Sanahujos in the 13th century, is exemplary of a type of mansion which was gradually built to look like royal or episcopal palaces, particularly on the facade.

The residence of a monarch, count or Church authority was distinguished from the rest by the ornateness of its facade. The main facade of Estella palace in Navarre, which may have originally been a royal dwelling, is divided into two registers: the lower one has a portico with semicircular arches, and the upper one a gallery with biforate windows. There is a wealth of surviving documentation on princely and royal palaces in the Iberian Peninsula, such as those in Barcelona and Huesca.

Although cities survived well into the early Middle Ages, and Romanesque civilisation was to a large extent urban, the fact is that cities depended heavily on the countryside and vice versa. Diocesan synods, fairs, markets and public festivities were some of the occasions on which cities and countryside joined forces. This would account for the fact that, during the Romanesque period, the old road network was rebuilt and bridges were laid. Such tasks were often undertaken by celebrated architects, such as Petrus Deustamben, in León, and Master Mateo, who designed the famous Portico of Glory in Santiago de Compostela. Others, such as Domingo de la Calzada and Juan de Ortega, were sanctified for their endeavours.

Arab baths in Girona, built as of 1194 and rebuilt in 1294.

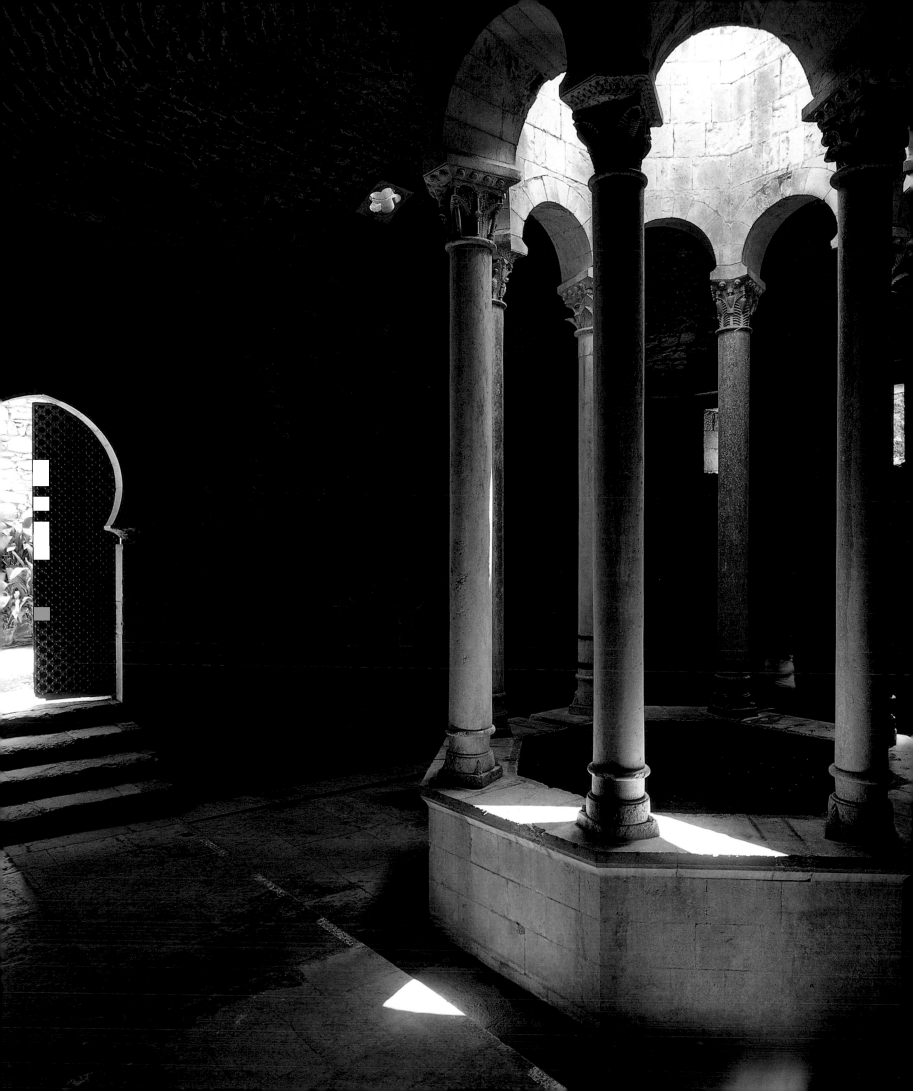

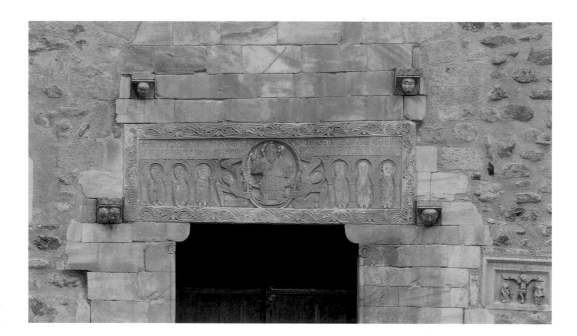

Lintel over the entrance to Saint-Genis-des-Fontaines (Roussillon). 1019-1020.

ROMANESQUE SCULPTURE

The first decorated facades to emerge tentatively during the first quarter of the 11th century mark the starting point for any study of Hispanic Romanesque sculpture. Monumental, sculpted facade decoration, part of the architectural renewal of the late-10th century, appeared in three Benedictine monasteries in Roussillon: Saint-Genis-des-Fontaines, Sant Andreu de Sureda and Sainte-Marie de Arles-sur-Tech. As with architecture, their development has close parallels to the whole of northern Italy as far as the Adriatic, owing to the deep-seated classical roots they had in common. Both reveal the use of the same techniques, siting and repertoire. However, in the case of Catalonia, the use of figuration was more accentuated, a fact which enriched the available iconography.

Depicted in the centre of the lintel over the doorway at Saint-Genis-des-Fontaines is a Christ in Majesty, set in a mandorla and supported by two angels. On either side of Christ is a set of three figures representing the Apostolic College, each one placed under a horse-shoe arch. A continuous border pattern of carved palmettes frames the whole marble lintel, which is flat and bevelled, related to goldsmithery and marble carving. The same technical and decorative features appear on the entrance door lintel, window frames and altar stone in the church of Sant Andreu de Sureda. Set in a similar border pattern, the lintel features the *Maiestas Domini,* flanked on either side by a seriph and two Apostles, surmounted by arcatures. The decorative motifs are completed in the window frame, with symbols of the Evangelists, three seraphim and two pairs of angels blowing a trumpet to celebrate the theophany. The iconographic repertory is similar to that of church altars, which has here been transposed to an exterior. This, and the fact that it looks as though it were part of a mounted setting, have led some authors to regard these pieces as fragments from a frontal or retable subsequently re-used on a facade, although this idea is rejected by others. What does comes through in the smooth modelling of the figures, the shallow angles in the bevelling and the rhythm generated by combining two patterns is the proximity to models from late antiquity. The same is true of the powerful figure of Christ in Majesty in the church of Saint-Marie de Arles-sur-Tech. Here, the Christ figure appears in the centre of a Greek cross, with symbols of the Evangelists in medallions at the ends.

The church of Saint-Genis-des-Fontaines is dated 1019–1020 in an inscription on the lintel, a fact which led all three buildings to be dated within the first three decades of the 11th century. They are regarded as consistent expressions of an art form that developed immediately after the pre-Romanesque and before the so-called Lombard style of architecture. The original portal at the church of Sant Joan el Vell, in Perpignan, is stylistically and iconographically akin to local sources and Byzantine models, prompting its classification within the same time scale, which tallies with its date of consecration, documented as 1025. Such details suggest that several workshops were active in Roussillon during the first three decades of the 11th century. Either some of these workshops were able to assimilated classical art forms to a considerable extent, or the older ones adopted a more classical style, while the more schematic styles were the result of reiteratedly reproducing the same model. The Perpignan decoration might also suggest a date closer to the late-11th or early-12th century. Indeed, the church became canonical in 1102, and its decorative features prefigured the classically-orientated sculptural renewal that occurred in Catalonia in the third decade of the 12th century, a current that began at Sant Miquel de Cuixà.

Sculptural ensembles incorporated into architectural elements were not a feature of the early Romanesque in southern Europe, and there are very few examples of such sculpture on the Iberian Peninsula from the mid-11th century. The only exceptions are sculpted capitals, derived from Corinthian and caliphal capitals, at Sant Pere de Rodes and Ripoll, while there were a few attempts at figural sculpture, as in the church of San Salvador de Leyre. In early-Romanesque buildings, exterior decoration took the form of panels and arcatures at structural wall joints, while interior decoration consisted of the occasional use of polychromed stuccowork, as in San Saturnino de Tavérnoles.

The chronology of French and Spanish Romanesque architecture has come under review in recent times, leading to a reappraisal of early examples of Romanesque monumental sculpture on both sides of the Pyrenees, and facilitating a better understanding of this art form. Thus, we now know that a revival of ancient forms and styles came into vogue in southwestern France and northeastern Spain at the end of the 11th century. This consisted primarily of reinstating both the Corinthian capital and monumental figuration. Thus, the human figure, which had previously been relegated to the odd portable piece, now came into its own once more. This phenomenon was prompted both by the discovery of late-Roman vestiges and small objects of goldsmithery and manuscripts transposed to a Christian context.

The Corinthian capital made a comeback in southern France in the middle of the century, the chronology being based on the date attributed to the portico of Saint-Benoît-sur-Loire, and the churches of Saint-Sever and Saint-Gaudens. A free interpretation of the old design was enhanced with Romanesque sturdiness, and the addition of animal motifs set among the acanthus leaves. On occasion, the Corinthian capital was used for displaying storied subjects, usually specific iconographic cycles, and placed in settings conducive to meditating on religious figures. This type of decoration appeared simultaneously in Saint-Sernin at Toulouse and Santiago de Compostela, as well as in the area adjoining the pantheon in the church of San Isidoro at León.

Despite the overall architectural similarity between Santiago de Compostela and Saint-Sernin at Toulouse, only one capital in Santiago specifically resembles those of Saint-Sernin, as the Languedocian decorative style appears to have entered a new phase after the first decade of the 12th century. However, a closer relationship has recently been adduced between Santiago, Conques and the southern Auvergne during the first decorative phase. The Compostelan capitals have their precedents in the oldest parts of Sainte-Foy, while some Jacobean devices, such as the theme of the miser's ordeal and angels sounding the trumpet, may have influenced the later typanum at Conques. Such cross-fertilisation was not exclusive to Santiago, as the capitals at San Martín de Frómista, featuring the subject of original sin, are stylistically akin to Saint-Gaudens. Influence of this kind might have extended to Sahagún and even Jaca, where it would have merged with the sculptural style of the Master of Jaca. Moreover, the beautiful capitals from the first workshop of Saint-Sernin, with

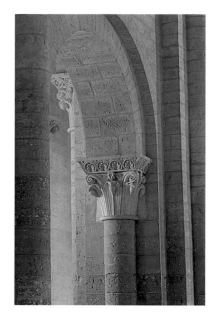

Monastery church of San Martín de Frómista (Palencia), dating from the 11th century.

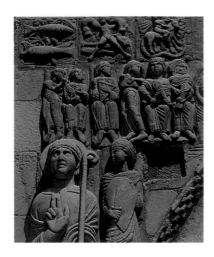

Door of the Lamb (detail), in the collegiate church of San Isidoro de León, built in the first three decades of the 12th century.

their leaves shaped into palmettes and fleurons bearing pine cones and balls, are echoed in similar designs at León, Jaca and Frómista.

It should be recalled that the Pantheon of the Kings, commissioned by Doña Urraca, who died in 1102, is roughly contemporary with the sanctuary of Saint-Sernin. Their capitals are thus similar in style, even though one of them is based on Saint-Sever. The dating of the pantheon is still under discussion: originally thought to have been consecrated in 1063, the new date that has been put forward is 1149. According to J. Williams, who has recently studied the subject, the *Puerta del Cordero* ('Door of the Lamb') and *Puerta del Perdón* ('Door of Pardon') date from 1130 and are thus much later than those in Compostela. However, a comparative analysis of sculptures on the portals and capitals suggets an earlier date, around 1110–1120, and that the Door of the Lamb is earlier than the Door of Pardon.

Jaca and Toulouse

Two celebrated exponents of archaising plasticity, who have at times been interrelated, emerged at the end of the 11th century at Saint-Sernin in Toulouse and at Jaca Cathedral. The men in question were Bernard Guilduin, who in 1096 completed the altar table at Toulouse, and the so-called Master of Jaca. The chronology of the latter was set at a later date, owing to the fact that construction work on the cathedral was postponed at one stage, and because the inscription purportedly attesting to his involvement in the church of Santa María de Iguácel in 1072 is regarded as commemorative. From the style of those two artists, it may be ventured that they both had classicist training. The French master drew his inspiration from the decorative arts, particularly ivory sculpture, as evinced in the flat, plane arrangement of sections in the ambulatory at Saint-Sernin. The Spanish master, for his part, appears to have been inspired by the ornamentation on late-Roman sarcophagi, particularly in terms of the volume, gesture and drapery of the figures on capitals, as evinced in the Sacrifice of Isaac, in Jaca Cathedral.

The style of the Master of Jaca made itself felt in Navarre and Aragon, which were then part of the same kingdom, and even spread to monasteries in Castile. Indeed, according to S. Moralejo, the origins of the Master of Jaca may be found at San Martín de Frómista, where the iconography of one of the capitals is based on a 2nd-century Roman sarcophagus which in the Middle Ages was housed in the church of Santa María de Husillos, just 25 kilometres from Frómista. The same style can be seen on one of the capitals at San Isidoro de León and in the entrance portico in the walled precinct of Loarre. In a recent paper, M. Durliat has taken a different approach, in that he attributes the origin of the style to Jaca instead of Frómista, and claims that the original master was succeeded by others, including the artificer of the south portal, and the later master of the great arcades in the nave. It then follows that the capitals at Iguácel are based on those at Jaca, as are those at Ujué, although more remotely so. The difference between Jaca and Frómista lies in the stylistic attitude of each master to ancient art. Moreover, a set of works have been associated with a possible disciple of the Master of Jaca, known as the 'Master of the Sarcophagus of Doña Sancha', who is attributed with the aforementioned sarcophagus of Santa Cruz de Serós, some of the capitals in the same church, a capital featuring the story of St Sixtus in the south portico at Jaca—which might have originally been in the now missing cathedral cloister—and the south typanum at San Pedro el Viejo in Huesca. This master, who was active in the second decade of the 12th century, produced his personal interpretation of the Jaca style, combined with formulae derived from the Platerías Portal at Santiago de Compostela and the Miègeville Portal at Saint-Sernin at Toulouse.

The formulation of a wholly Romanesque style was paralleled by the development of a monumental iconographic repertoire, applied to facades and cloisters, as shown by the similarities in the style and models used by the two classicist artists, Bernard Guilduin and the Master of Jaca, in the facade Platerías Portal and the Miègeville Portal.

Facades and Cloisters

The mature Romanesque saw the birth of sculpted portals and cloisters which, apart from being used to embellish a church, had an educational, pedagogical function. It has often been adduced that decoration was at times used to turn a church into a veritable illustrated Bible, designed to convey the essentials of Christianity to the common people. However, it may be assumed that different sets of religious or lay viewers would have had different capacities for understanding, and that the positioning of the various iconographic ensembles would have been determined by the audience they were directed at.

On facades, which acted at the divide between the temporal and spiritual worlds, the doctrinal themes portrayed were related to penitence, including the subjects of salvation, the Ascension and the Transfiguration, or to theophanic visions inspired by the Apocalypse of St John, or the Vision of Matthew.

Just as Saint-Sernin played an essential role in the development of Romanesque sculpture, it also became a structural, stylistic and iconographic yardstick for the subsequent development of monumental decoration on church facades. Its influence spread to various buildings erected along the Road to Santiago. An example of this is a portal in the south nave of Jaca Cathedral, arranged in similar fashion to the Door of the Counts at Saint-Sernin, with two small figures depicting the patrons of the church flanking the tympanum. Far more significant still is the influence of the principal iconographic motif of Saint-Sernin on the west facade at Jaca: the tympanum displays the Christogram, with the letter 'S' added, yielding trinitarian overtones, a device that appeared on many buildings in the kingdoms of Navarre and Castile. Further, the way the doors of the basilica of San Isidoro de León are positioned coincides exactly with those of Saint-Sernin: that of the Lamb opens onto the south nave, while that of Pardon features an iconographic ensemble that overruns the door frame. The Sacrifice of Isaac is depicted beneath the aforementioned type of Christogram on the tympanum. The story is completed on the capitals, but a number of reliefs overspill the edge of the last archivolt. These reliefs depict the patrons of the church, SS Isidore and Vincent, in addition to a set of images with narrative passages related to the subject of David and the musicians, as well as the signs of the Zodiac. These pieces were probably originally placed as metopes between the modillions supporting the cornice, while their current position dates from the Renaissance, when the portico was remodelled.

When, in 1105 and 1115, it was decided to open up the transept of Santiago de Compostela by piercing it with two monumental entrances, the Platerías Portal and the Francigena Portal, all the lessons learned from Saint-Sernin were taken into account. Their architectural structure was based on the biforate windows in the Door of the Counts, although it differed in that two small tympanums were added. The subject depicted on the Platerías Portal has so far defied interpretation, on account of fragments from three missing portals having been interspersed. However, it may be related to the dual nature of Christ, the Temptations (on the left-hand tympanum) and the Passion (on the right-hand one). The Platerías Portal also provides some definitive solutions as far as layout is concerned. Firstly, above the archivolts is a frieze depicting the Apostolic College, for which the oldest source appears to have been the entrance portal at Loarre. The latter is dated 1096, which would make the arrangement in question one of the most important indigenous models of Hispanic portal. It can also be seen in the imposing Jacobean frieze at Carrión de los Condes, as well as at San Salvador de Leyre, Santa Marta de Tera, Santa María la Real de Sangüesa and many other churches. Secondly, the monumental sculpture at Santiago de Compostela is not restricted to the upper portion of the facade, but extends down to the height of the jambs. Some of the columns are marble, adorned with series of superimposed figures set beneath arcades. Similarly, a device which first appears here involves setting religious figures, such as St Andrew or Moses, under the modillions supporting the lintel, a prefiguration of the statued columns to come.

As from the mid-12th century, the geographical location of the kingdoms of Navarre and Aragon led them to be infused with currents of renewal originating in France. The pres-

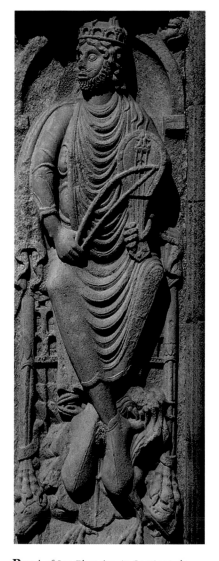

Portal of Las Platerías, in Santiago de Compostela Cathedral: detail of King David, 1105-1115.

ence of a master trained in France, possibly Aquitaine, is felt at the church of Santa María de Uncastillo in Aragon in the structure and decoration of the main portal. His work, and that of his disciples, can be traced into Navarre through the capitals in the west portal of San Martín de Unx, and those on the east side of Santa María la Real de Sangüesa. This master was evidently called upon to initiate the stonework at Sangüesa in 1131, even though the style of the church is predominantly marked by Burgundian influence. The south facade has a large portal punctuated by six statue–columns. One depicting the Virgin Mary bears the name of the sculptor, Leodegario who, judging by similarities in his stiff treatment of the figures and the lightness of the drapery, must have known the Royal Portal at Chartres. The same effect and style appear in the interior decoration of the apse at San Martín de Uncastillo, where the gallery arches are supported on pairs of statue–columns. The artistic importance of the Kingdom of Navarre in the 12th century also extended to other works, including San Pedro de la Rúa, which prefigured the Cistercian style, and the collegiate church of Tudela, which prefigured the Gothic.

A highly original artist who had no followers was the master of the oldest reliefs and some cloister capitals at Santo Domingo de Silos. In Romanesque times, the monks spent part of their resources on adorning the buildings they lived in. Cloister capitals usually bore sculpted stories from the Old and New Testament, sometimes set opposite each other, as in Pamplona Cathedral. They also featured hagiographic cycles on the founders of a building, as in the collegiate church of Tudela, or were used as a source of meditation, with visual symbols of the common sins and vices. In time, ornamentation of this kind spread to cymas, columns and angular pillars. The cloister pillars at the monastery of Silos reveal the hand of the above-mentioned master, who must have trained in ivory sculpture, with his flat, geometrically austere style.

In the second half of the 12th century, building activity in Castile was given renewed impetus by French influences. Indeed, it regained the vitality that had characterised late-11th century Castilian–Leonese monumental sculpture. The church of San Vicente de Ávila shows the marked influence of Burgundian art in the handling of drapery and rounded volumes, and in the arrangement of buildings. In fact, the area around Ávila had recently been conquered and resettled by people from Burgundy. The most striking part of the church is the magnificent portico, framed by two towers, reminiscent of the arrangement in the abbey church of La Madeleine in Vézelay, as is the structure of the sculpted portal. One of the few differences is the way the semicircular space has been divided up on two small tympanums. They recount the story of the rich man and Lazarus, and are related to the Pyrenean churches of Moarlas at Béarn and Sainte-Marie de Oloron. The style of the sculptor of the apostolate, with his elongated figures adopting a classical attitude and garbed in idealised drapery, has been associated with that of the sarcophagus of the patron saints in the same church, when it would have been more logical to regard it as a prototype. The classicist attitude of the figures has led this sculptor to be identified with the artificer of the superb frieze at Santiago de Carrión de los Condes. Admittedly, the rounded forms of the latter are admirably classical, particularly in the figure of the Pantocrator, but the solemnity and virtuosity in the handling of drapery distinguishes it from the idealism and linearity of the Master of Ávila.

The influence of the Burgundian Romanesque is striking in the most emblematic example of the Romanesque in Spain—the *Pórtico de la Gloria* or 'Portico of Glory' at Santiago de Compostela. Master Mateo is documented in Compostela in 1168 and, although nothing is known about his training, attempts have been made to define his complex artistic character in terms of both the Hispanic and French viewpoints. The structural formulae he applied to the portico are similar to those at San Vicente de Ávila and, consequently, those at Vézelay and Autun. But, unlike the latter, the decoration originally covered the whole portico. Despite the sytilistic uniformity, consisting of powerful volumes combined with a high degree of naturalism, the hands of several artificers can be seen, particularly on the tympanum, giving credence to the idea of a large workshop operating under the orders of Master Mateo. The work is so magnificent it is easy to understand subsequent attempts

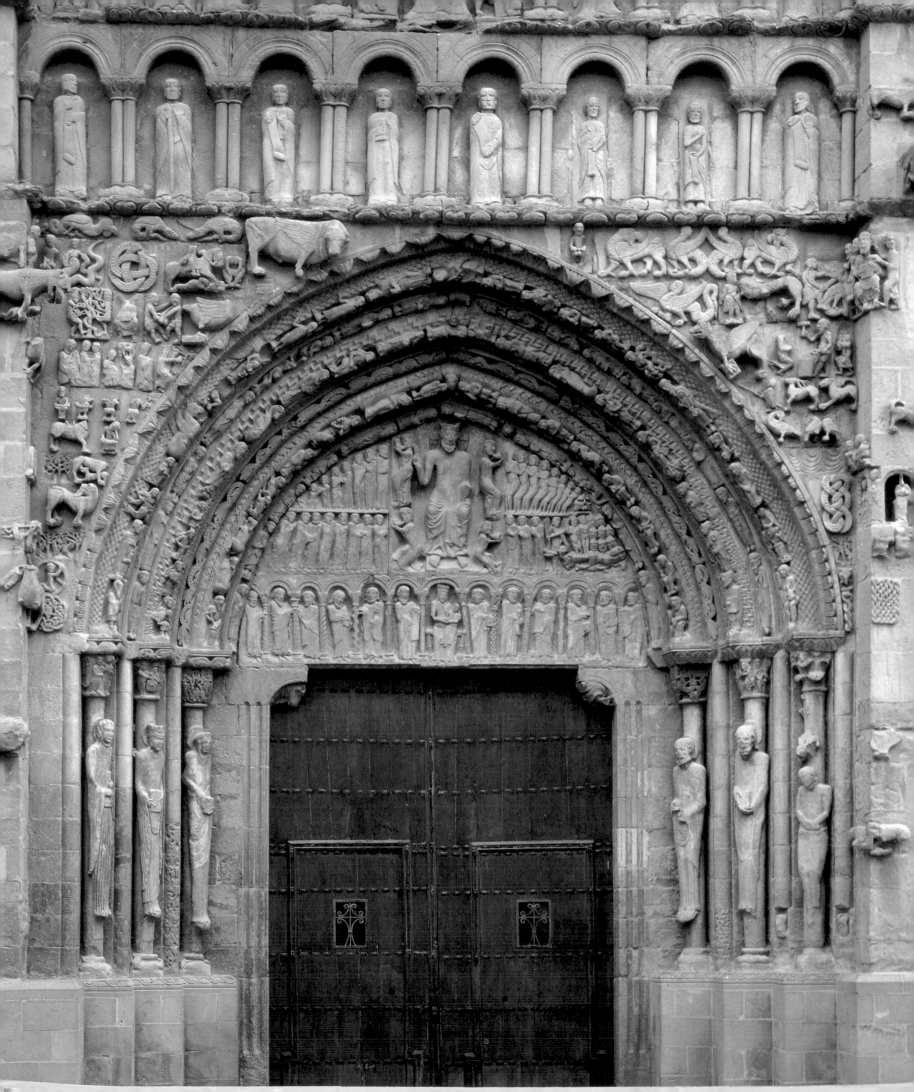

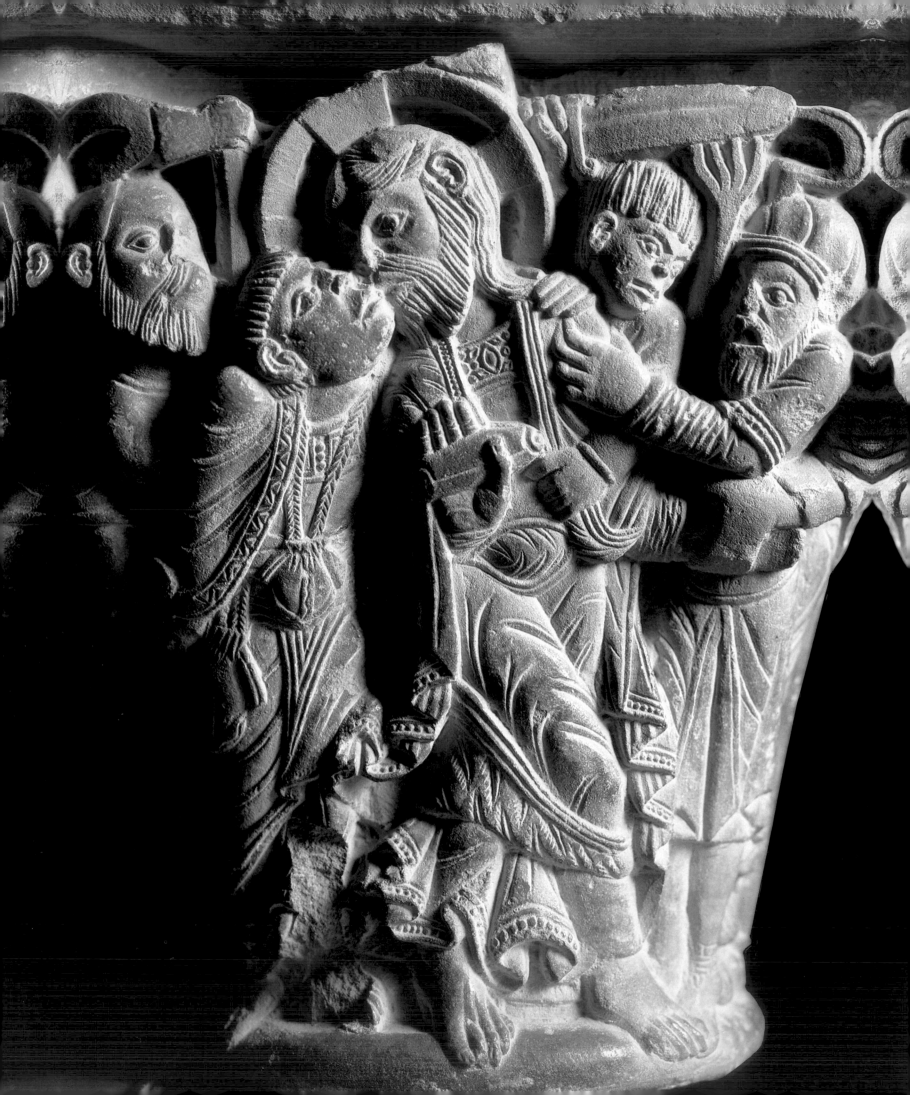

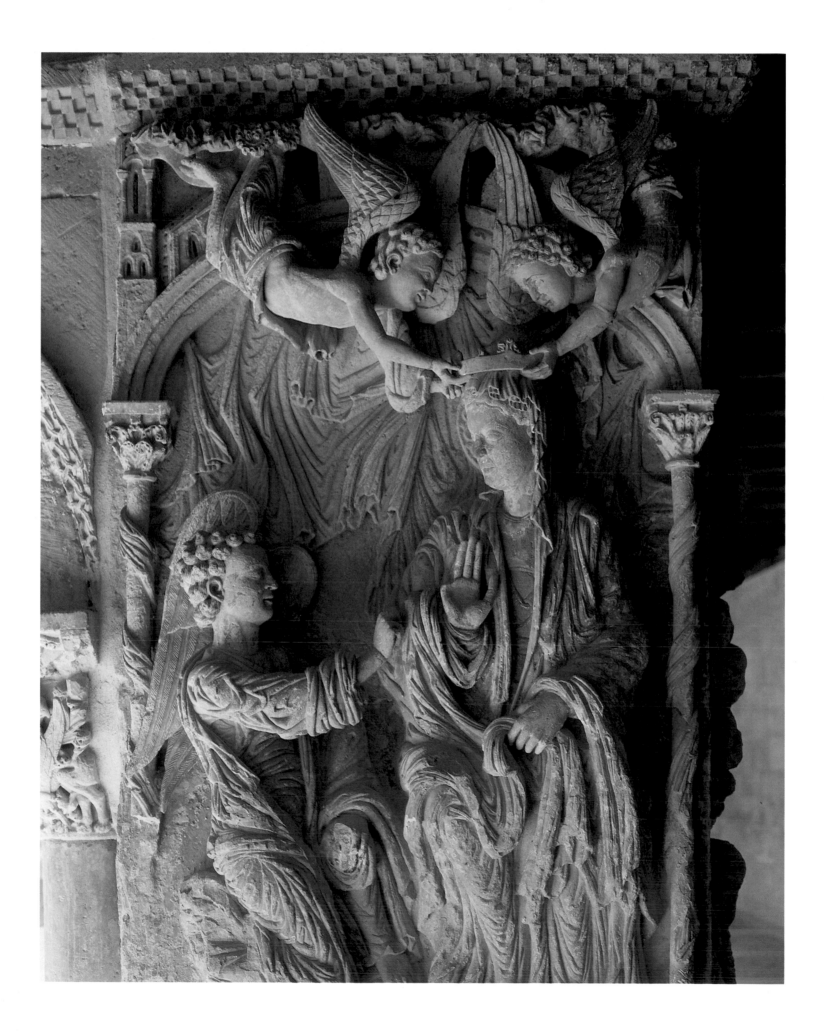

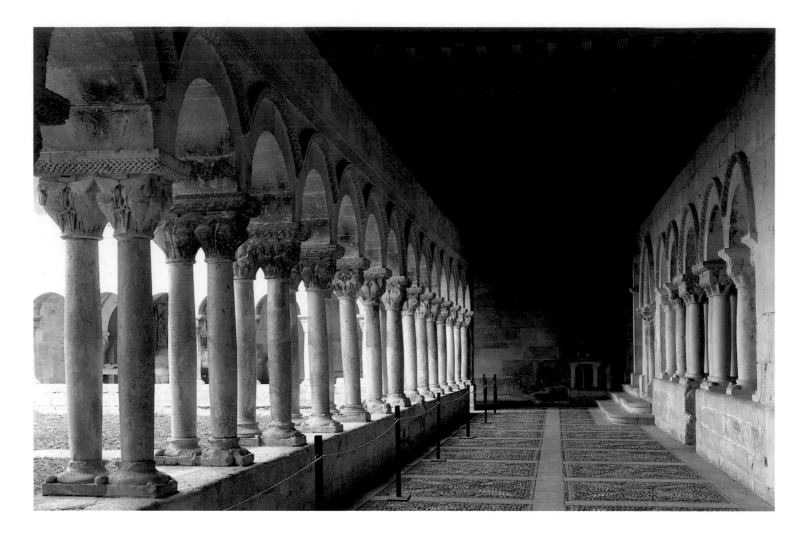

Cloister of the monastery of Santo Domingo de Silos (Burgos); late-11th and early-12th century.

at emulating it, as evinced in the Portico of Paradise in Orense Cathedral, or the apostles in the Holy Chamber, which some have even regarded as an early work by Master Mateo.

The example set by Compostela, and the redecoration of the monastery at Silos, which included the relief of the Coronation of the Virgin, appear to have coalesced in Soria with a new wave of Aquitanian influence. Much of the iconographic ensemble on the portal of the church of Santo Domingo is arranged radially over the voussoirs of the four archivolts. The ensemble consists of depictions of the elders of the Apocalypse, the massacre of the Innocents and, on the last two, scenes from the life of Jesus. This arrangement is also found in western France, at Angoulême, Poitiers and Périgueux, which is not surprising, bearing in mind that Alfonso VIII's wife, Leonor, hailed from Aquitaine.

Peculiarities of the Catalan Romanesque

Monumental sculpture in Catalonia, which was passing through a phase of isolation and endogenous evolution, was suddenly cut short in the early-12th century by currents of renewal which were to endure well into the following century. As had occurred in the first three decades of the 11th century, the renewal was spearheaded by the Benedictine monasteries in Roussillon, the first such works being the cloister at Sant Miquel de Cuixà and the gallery at Santa Maria de Serrabona. Around the year 1140, sculpture in these monasteries took the form of bevel-carved pinkish marble and the adoption of models from northern Italy. Their decorative repertoire, which included capitals with foliage studded with hybrid figures and animals of fable in an aggressive or ecstatic attitude, spread rapidly throughout Catalonia, as evinced in the cloister of La Seu d'Urgell and the portal of Espirà d'Agli. It has even been suggested that production was standardised for export to the other side of the Pyrenees.

Portal of the parish church of San Vicente (Ávila), dating from the third decade of the 12th century.

116

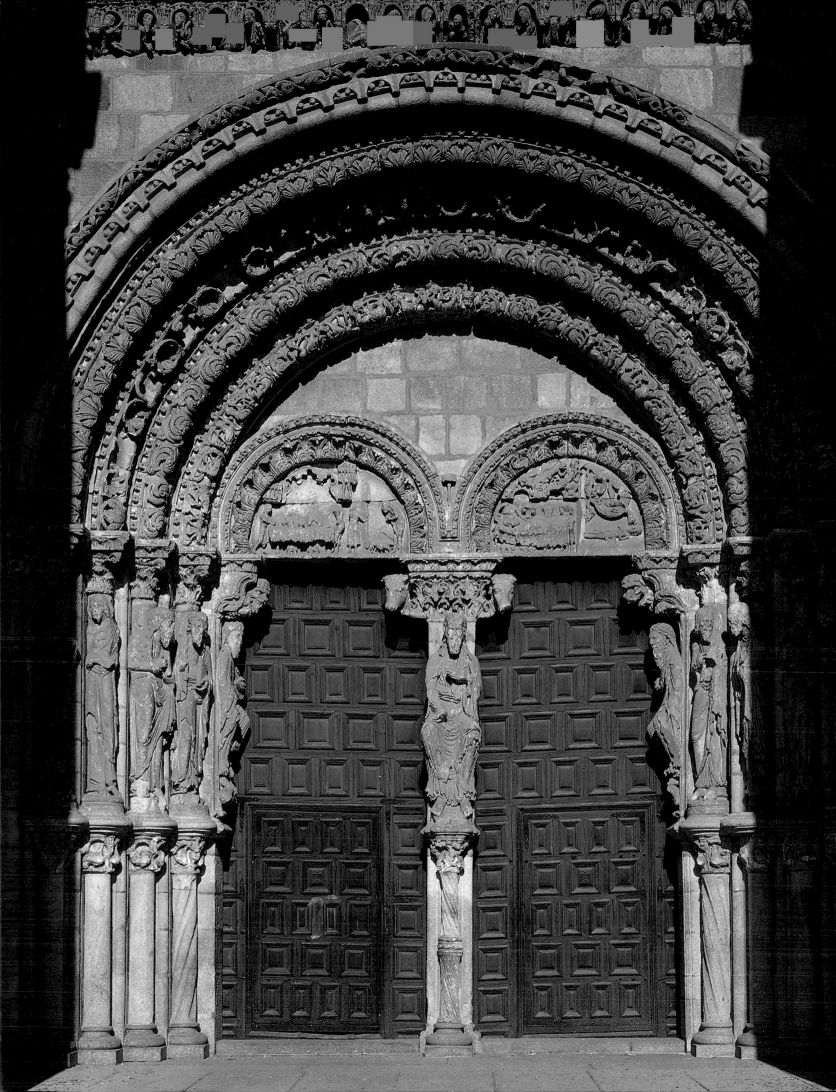

Detail on the portal of Santa Maria de Ripoll (Girona), dating from the third quarter of the 12th century.

The new currents, with their source in the Roussillon, continued to fuel activity at the Ripoll workshop, where features were also adopted from a new wave of classicism emanating from Italy. This would account for the emergence of the narrative trend visible in the emblematic portal at Ripoll abbey, which was designed as a triumphal arch, or in the cloister, where the Roussillon undertones are more conspicuous. The facade, which was executed well into the second half of the 12th century, displays a rich iconographic ensemble in which some reliefs appear to have been based on passages from the Bibles housed in the monastery scriptorium. The influence of the Ripoll workshop spread further afield, emerging in the cloister sculpture at Santa Maria de Lluçà, and on the portal of the church of Santa Eugènia de Berga. It may have even spawned a stonemasonry workshop in the city of Vic. The latter was commissioned to sculpt the portals of Vic's episcopal buildings, Sant Pere and Santa Maria, of which some fragments have survived in several local and foreign museums.

However, not all Catalan sculpture produced during the second half of the 12th century was related to the two aforementioned workshops. The cloisters at Sant Pere de Gallligants, Sant Cugat del Vallès and Girona Cathedral, for instance, have a style of their own. The tympanum at Santa Maria de Covet reveals iconographic ties to the church of Artaiz in Navarre, while the Gilaberto worshop, which left its mark in the cloister of Santa Maria de Solsona, was related to Toulouse. At the end of the century, against this background of vast production, two prominent figures emerge, both characterised by their marked classicism.

The Master of Cabestany, so called after the town of the same name in Roussillon where he sculpted the church tympanum, is one of the most enigmatic figures in the history of Catalan sculpture. His stylistic hallmarks include wizened faces with almond-shaped eyes, inordinately large hands, small bodies and classical drapery. Another of his characteristics was his internationalism, as he is associated with works ranging from northern Italy to Navarre. He drew considerable inspiration from late-Roman models, which he either reproduced (the portal at Sant Pere de Rodes) or copied (the sarcophagus of Saint-Hilaire de Aude).

The oeuvre of Ramón de Bianya was also infused with classical forms, particularly at Elna Cathedral and the portal of Sant Joan el Vell in Perpignan, although in this instance the classical features were probably borrowed from the work of a contemporary Italian master named Antelami.

In the last three decades of the 12th century and the first three decades of the 13th, a Romanesque sculptural tradition which gradually incorporated Gothic innovations evolved in the newly conquered lands that came to be known as 'New Catalonia'. Two clearly distinct workshops can be identified in Tarragona Cathedral: the mark of the first one, present in the cornices, capitals and abacuses in the cathedral interior, and in the door leading into the cloister, is reminiscent of Toulouse in its plant motifs, which include broad leaves, pearled frets and palmettes. The second, contemporary workshop makes its appearance in the magnificent marble frontal and in the cloister capitals, studded with profane iconography.

Catalan Romanesque sculpture is also a feature of Lleida Cathedral. Here, formal and technical devices associated with northern Italy have been integrated into an assimilation of the Languedocian ornamental style. The first master linked to this style emerged around 1210, his hallmarks being classical forms combined with powerful, energetic volumes, sculpted with a form of drill, as evinced in the east end of the Cathedral chancel. As construction work progressed towards the south transept, the master ceased to be involved, and work was continued by his followers, who decorated the two south apsidioles. At the same time, a second workshop produced the decoration in the Annunciata Portal, which was completed in 1215. The ornamental repertoire of this workshop was derived from the style of the Golden Cloister at Toulouse. It was applied to the traditionally structured portals in Lleida Cathedral, where it was blended with Languedocian, Moorish and even Norman styles, particularly in the patterning of the archivolts.

Portal of Santa Maria de Ripoll (Girona), dating from the third quarter of the 12th century.

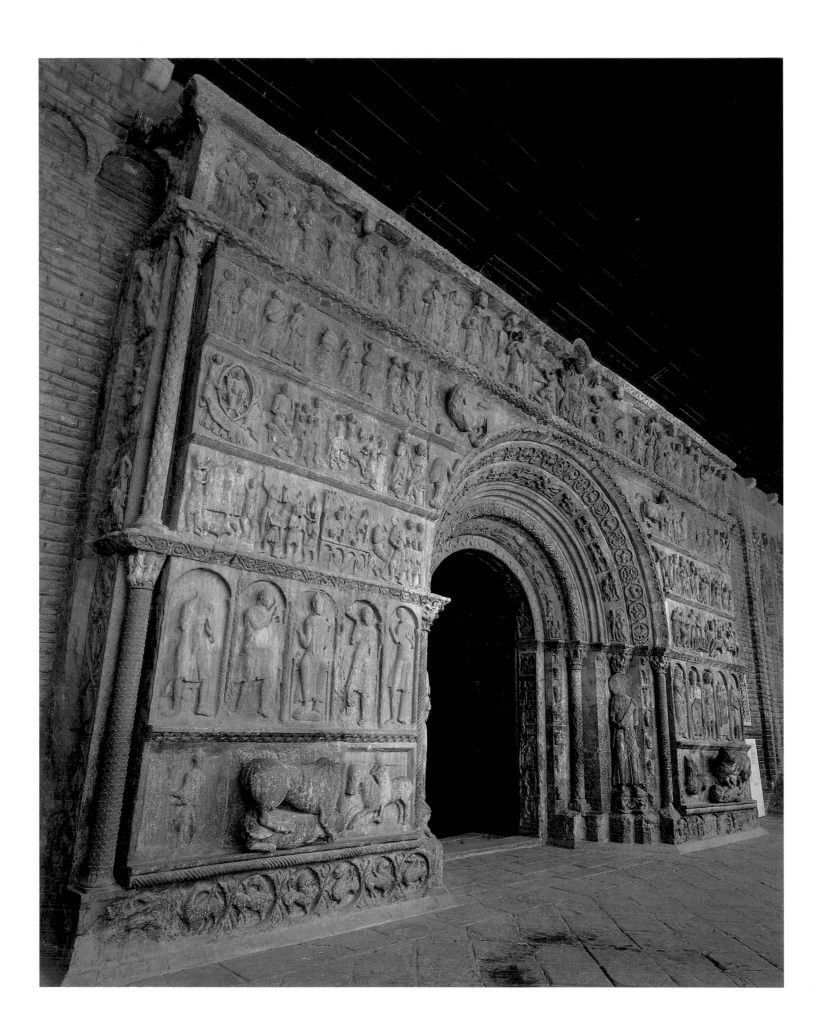

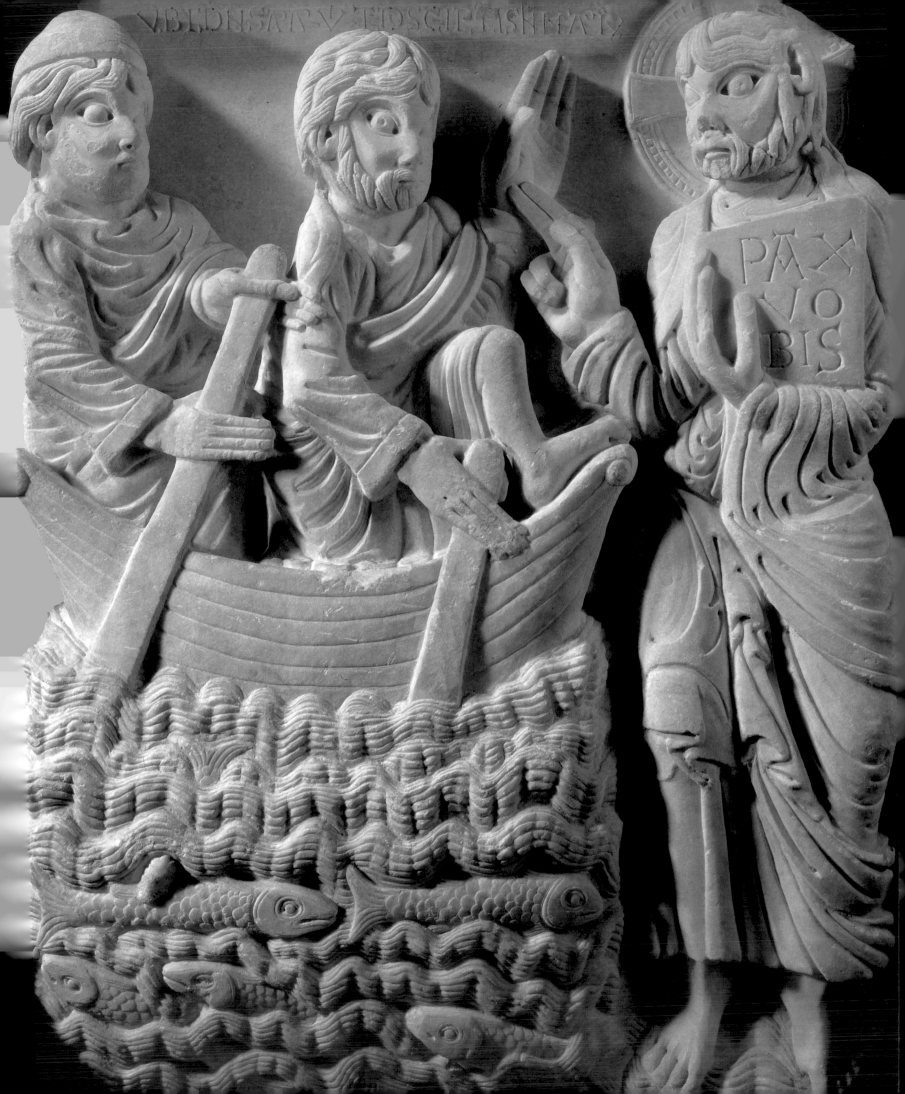

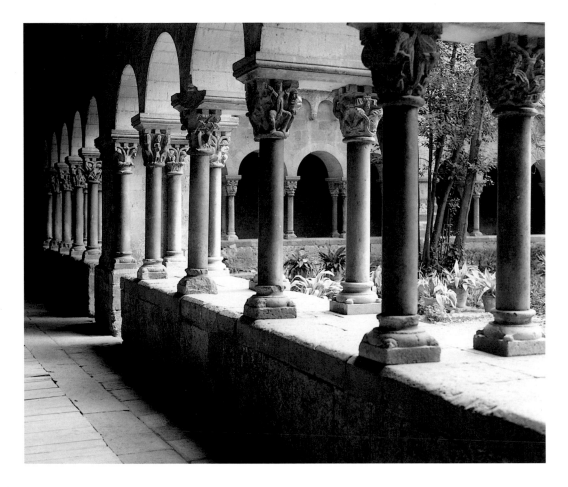

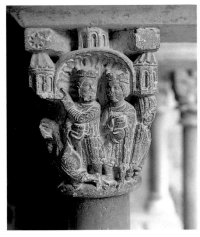

Cloister capital in the late-12th century monastery of Sant Cugat del Vallès (Barcelona).

Cloister in the monastery of Sant Cugat del Vallès (Barcelona), dating from the late-12th century.

Funerary Monuments

Another major genre of stone and marble sculpture during the Romanesque, particularly in the second half of the 11th century and throughout the 12th, was funerary sculpture. Churches became increasingly cluttered with ornamented tombs during that period, as did other cathedral or monastery quarters, particularly cloisters. Tombs usually took the form of a sarcophagus, for which purpose models from late antiquity were either adapted for contemporary functions or used as a source of inspiration for designing new ones. The artificers of facades and capitals frequently sculpted sarcophagi, too, so that funerary monuments had a direct influence on the overall development of the Romanesque sculptural styles and iconography.

A noteworthy example of funerary sculpture is the tomb of Alfonso Ansúrez (d. 1093) in Sahagún, now in the National Archaeological Museum in Madrid. Although it is the work of local craftsmen, it is stylistically related to Jaca. In Ripoll, as in many other monasteries, sculpted tombs were commissioned as memorials for counts, abbots and illustrious figures. That of Ramon Berenguer III, Count of Barcelona, who died in 1131, was originally housed in the cloister at Ripoll. It is rectangular, sober in appearance, with the frontal divided into six registers, depicting episodes which range from the death of the count, through the funeral ceremony and burial, to the moment his soul is taken into heaven. The tomb is interesting in that stylistically it is closely related to the sculpture on the church's Romanesque facade. Moreover, it has always been used as an aid to dating the facade, despite the fact that tombs of this kind were often commissioned in memory of the deceased and were therefore built at a later date, which is most likely the case here, too.

These tombs were sculpted in keeping with the traditions of late antiquity. They are burials which E. Panofsky defined as 'highly ceremonious tombs', a term also applied to the sarcophagi of Doña Sancha in Jaca, and the later one of San Vicente de Ávila. The latter, executed circa 1190, prefigured the scope of the Gothic funerary monuments to come.

*P*eter's Calling, by the Master of Cabestany, from the facade of the late-12th-century monastery of Sant Pere de Rodes (Girona). Museo Marès, Barcelona.

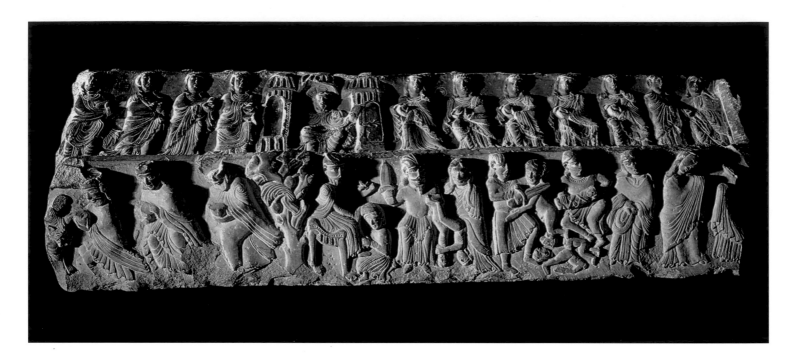

Sepulchre of Queen Blanca of Navarre.
Monastery of Santa María la Real
(Nájera). 1156-1158.

THE PICTORIAL ARTS

As with sculpture, Romanesque painting was channélled through figural and decorative ensembles capable of conveying the basic principles of Christianity to the common people, as well as the idea of social conformity within the established hierarchical order. Visionary subjects of a synthetic nature were featured in apses, while the walls of naves bore cycles from the Old and New Testament, sometimes juxtaposed. The customary theophanic vision portrayed was the *Maiestas Domini,* an enthroned Christ in the act of blessing, surrounded by the elders of the Apocalypse, the symbols of the Evangelists, or archangels and seraphim. However, in some Catalan churches the vision was that of the *Maiestas Mariae,* the Virgin and Child set in a mandorla, signifying the throne of wisdom. Another alternative was the Epiphany, in which the Virgin was depicted as participating in the mystery of incarnation and salvation.

Painting and Miniatures in the 11th Century

Catalonia boats the largest surviving collection of paintings and miniatures, primarily as a result of the endeavours of J. Pijoan, from the Institut d'Estudis Catalans, who in 1907 embarked on a project aimed at locating and preserving works of this kind. Despite such efforts, most extant specimens have rural origins, far from the great urban centres of production, and are thus rather conservative and traditionalistic in character.

Sepulchre of SS Vincent, Sabino and
Cristeta, in the late-12th-century church
of San Vicente, Ávila.
(Detail on the following page.)

The original paintings at Sant Quirze de Pedret, dating from the first half of the 11th century, are an eloquent example of early-mediaeval pictorial expression. A direct descendant of that work is the decoration in the circular church of Santo Sepulcro de Olèrdola. Executed shortly before the church was completed in 1061, the decoration is characterised by a predominance of line and large red and ochre brushstrokes, which would set it within the same tradition as the paintings preserved in the church of Naturno in the Tyrol. A stylistically exceptional specimen of early-mediaeval painting can be seen in the church of Marmellar castle. Here, the peculiar style is defined by the prevalence of form over line, and by simplicity in the handling of figures, and drapery based on large masses of colour. The

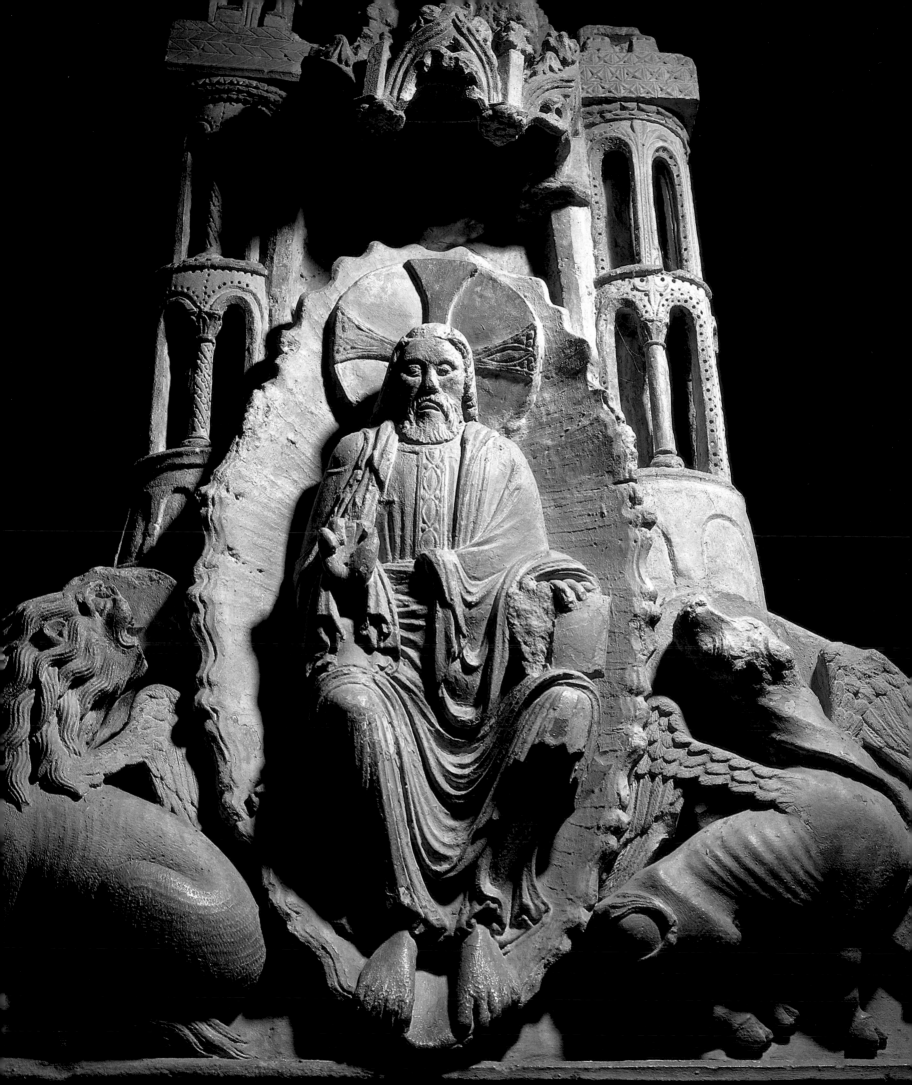

Romanesque Beatus of Burgo de Osma.
(1086). Burgo de Osma Cathedral
(Soria).

objective dating of mural painting is hampered by the dearth of available criteria, owing to the anonymous character of production during those times, and to the lack of specific chronological details. Thus, most studies are grounded exclusively in a purely formalistic methodology, in which information is gleaned from the relationship between painting and architecture, aided by a few clues provided by the nature of particular subjects, and inscriptions relating to images.

At the end of the 11th century, early Romanesque painting made inroads into Catalonia as a result of contacts with northern Italy, particularly Lombardy. The pictorial decoration in the church of Sant Joan de Boí, architecturally representative of the beginning of the late Romanesque, has long been thought to date from the late-11th or early-12th century. Surviving fragments have not yet enabled a chromatic affiliation to be established on the basis of the greys, whites, blacks, yellows and vermillions used. Determination of a stylistic relationship with contemporary works has also proved elusive. Some critics have suggested connections with French works, chiefly in the Poitou area, but the fragments in question have recently been shown to be more closely related to iconographic models in miniatures, such as the Bible of Sant Pere de Rodes, particularly in the scenes of jugglers and acrobats, which would derive from a much earlier tradition. Any reference, in episodes or details, to previous models is precisely what distinguishes a chronology prior to the late-11th century, owing to the absence of any illustrative historical or architectural detail. The aforementioned ensemble, then, appears to pre-date the Pedret group, and was probably executed in the 1080s, and not later than 1100.

A circle related to Italy, especially Lombardy, Gagliano and Rome, emerged at the end of the century in Catalonia. It centred around one or two artists with a strong character, heirs to the legacy of antiquity, known as the 'Old Master of Pedret', as they are iden-

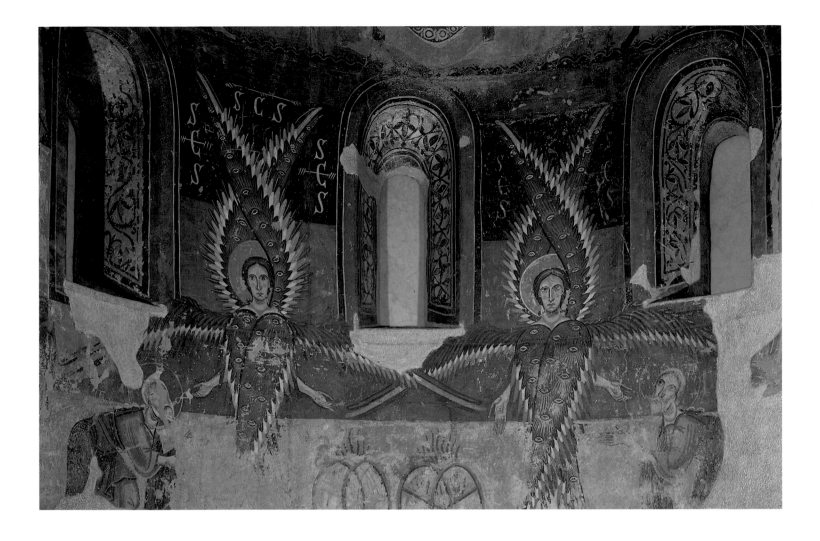

Seraphim: fragment of the mural in the apse of the early-12th-century church of Santa Maria d'Àneu (Lleida). Museu Nacional d'Art de Catalunya, Barcelona.

tified with the decoration in the central apse and absidioles in the church of the same name. In 1941, C. R. Post suggested they were influenced by local artists, instrumental in the decoration of Sant Pere de Burgal, Santa Maria d'Àneu, Sant Pere d'Ager, San Juan de Tredós, Orcau castle, the main apse at Saint-Lizier, and possibly San Saturnino de Baiasca, too. The essentially graphic style of the Burgal paintings, as well as their chromatic rigidity and their relationship with the Byzantine of Gagliano, would set them around 1081–1090. This would enable the time frame to be applied to the whole group, coinciding with the new dating that has been put forward for Saint-Lizier—circa 1065–1085. The linearity, hieratic attitudes and chromatic paucity probably reflect the endemic development of the group, which was active until the first decade of the 12th century. The paintings in the apse at La Seu d'Urgell, associated with the frontals at Ix and La Seu, are thought to date from just after 1100, when their activity was coming to an end.

Like the paintings at Sant Joan de Boí, a number of works by the circle of Osormort have proved difficult to date. The period in question spans the late-11th and first three decades of the 12th century. These works are at Sant Sadurní d'Osormort, Sant Martí de El Brull, Sant Joan de Bellcaire, Sant Pere de la Navata and Sant Esteve de Maranyà. To some extent, they are all related to the mural paintings in the crypt of Saint-Savin-sur-Gartempe in Poitou, and to the miniatures of the life of St Redegunda in Poitiers. Despite the unquestionable French ties, all the aforementioned works would not have been executed by the same hand, as they reveal some significant differences. The only fact that can be established is the existence of French influences in Vic and Girona in the late-11th and early-12th century.

The Catalan Romanesque miniature evolved along different lines from painting, at least in the beginning, as the style that emerged was unrelated to to the early-mediaeval

St John: fragment of the decoration in the apse at the 12th-century church of Sant Pere de La Seu d'Urgell (Lleida). Museu Nacional d'Art de Catalunya, Barcelona.

Hispanic tradition: the Beatus of Girona, for instance, was of Leonese origin. Palaeographic studies conducted by A. Mundó have shown that the Bibles of Ripoll and Rodes were actually made in the scriptorium at Ripoll. They reflect continuity in the Carolingian miniaturist tradition and feature among the most richly illuminated codices in Europe, as does the Bible of León, dating from 960. Although belonging to different cycles, the miniatures in the Ripoll Bible and those by the first Master of Rodes have been ascribed to the same workshop, characterised by its intense activity, marked narrative sense and concern for the human figure, attesting to the persistence of classical language in the 11th century. The second Master of Rodes, whose mark is first apparent in the *Libro de los Profetas* ('Book of the Prophets'), knew the work of the first master. However, he standardised images and made them stiffer, restraining their agility and spontaneity. The third master, who evidently embarked on a New Testament and an Apocalypse without completing them, was a fully-fledged Romanesque artist. His images are highly stereotyped, and can thus be dated around the end of the 11th century or the beginning of the 12th.

Unlike the status quo in Catalonia, in the western kingdoms the 11th-century miniature remained largely faithful to tradition, on account of both momentum and the opposition of local sectors to the reforms imposed by high-ranking Frankish Church authorities. The scriptorium that best illustrates this conservatism is that of San Millán de la Cogolla, which produced the Beatus of San Millán. The *Commentaries on the Apocalypse,* by the Beatus of Liébana, continued to be copied and illuminated throughout the Romanesque, as shown by examples surviving in Burgo de Osma and San Andrés del Arroyo, perhaps because the text in question was compulsory reading during Lent, in the Hispanic liturgy, or because of the resurgence of apocalyptic subjects, as evinced in monumental sculpture. This conservatism was countered by a 'royal scriptorium' thought to have been active in San Isidoro de León.

The *Beatus* and *Diurnal* of Ferdinand I were the first illustrated codices to include Romanesque features. The authorship of the Beatus, copied circa 1047, reveals the presence of two hands. Despite being traditional in composition, it shows Franco-Insular influences in the intertwined decorative patterns. The drawing is schematic and proportions are life-like. The prevalence of golds in the first few folios would suggest the work was a royal commission. Manuscript production during the Romanesque was gradually consolidated in religious centres—monasteries and cathedrals. This situation endured until the demise of the aulic trend characterising Carolingian and Ottonian illumination. Royal appointment of such codices becomes apparent in the aforementioned *Diurnal,* illuminated in 1055 by Fructuoso, as it features portraits of the monarchs, Ferdinand and Sancha, flanked by a figure thought to be either the illuminator or King David, whose psalms appear before the miniature.

The early-mediaeval tradition was also adhered to in 11th-century mural painting. Few examples have survived, which has led this genre to be interpreted in relation to Catalan art circles and international currents for the purpose of consistency. Two mural ensembles in late-mediaeval style have survived in Castile and Aragon. Dating from the mid- or late-11th century, they adorn the monastic church of San Bautista del Pano and the cemetery shrine of Castillejo de Robledo. In both, the geometrical shapes and the chromatic scale based on ochres and yellows recall some of the aforementioned Catalan examples, so it would be interesting to pursue a study of these 11th-century paintings jointly. Unlike Catalonia, in the western kingdoms wholly Romanesque paintings only appear in the 12th century, and often related to the masters who worked on the church of Sant Climent de Taüll.

Painting and Miniatures in the 12th Century

A group of fresco painters, led by the artificer of the central apse at Taüll, was active at the end of the third decade of the 12th century. The aloofness of the supernatural fig-

ures, their chromatic quality and variety, the geometrical rendering of shapes and, above all, the firmness of line and marked graphical abstraction are some of the hallmarks of this master, whose work was related to both Italian circles and the late-mediaeval Hispanic miniaturist tradition. What comes through in the less supernatural character of the faces, greater decorativeness and variations on a single tone, is that the artists at Santa Maria de Taüll were divided into two groups: those who worked on the sanctuary, and those who executed the side walls and the back of the facade.

W.W.S. Cook was the first critic to relate the magnificent mural paintings in the Maderuelo shrine and those at San Baudelio de Berlanga to the Master of Santa Maria de Taüll. However, in conjunction with J. Gudiol, he subsequently postulated the anonymous figure of the Master of Maderuelo, who would have trained in Italy and worked with the artificer of Taüll, the latter being attributed with the decoration at San Baudelio de Berlanga, together with other craftsmen. The style of this would-be Master of Maderuelo is characterised by linear stroke, a narrow range of colours, a certain tendency to monumentalism, statism and symmetry in figure portrayal, as well as by drapery with billowing folds wafting in the air. Some of these traits can also be seen in the biblical mural decoration at the church of San Baudelio de Berlanga. The authorship of the historical cycles in the upper register and the hunting scenes in the lower register is now considered to be different. They can be distinguished on a stylistic basis: the historical cycles are less narrative and have greater constituent value, while the hunting scenes are striking for the prevalence of a monochromatic background, against which the silhouettes of figures and animals stand out prominently.

The style attribution of the paintings in the churches of San Julián and Santa Basilisa de Bagües, dating from the first half of the 12th century, remains unresolved. They are clearly related to the south-west of France and the Master of Osormort, but they are also thought to have borrowed from Mozarab workshops, and to be associated with the Cistercian miniatures of Stephen Harding.

French influences are undisputed in a mural ensemble in Aragon—the paintings in the lower church of San Juan de la Peña, in the province of Huesca. Originally associated with San Isidoro de León, on account of the timelessness and weightlessness of the white grounds, they are currently deemed akin to the paintings in the apse of Berzé-la-Ville in Burgundy, albeit with obvious differences in the handling of backgrounds and the different degree of Byzantine influence, so that it would be hazardous to venture an accurate chronology for the Aragonese ensemble.

The murals in the pantheon at San Isidoro de León date from the first quarter of the 12th century. Traditionally, they were regarded as related to southwestern France, given the predominance of white grounds and the large number of nude figures. However, the paintings are now considered to be based on a Leonese workshop, identified through the illustrations in illuminated manuscripts, rather than on a foreign master.

Various scriptoria are documented in León during the 12th century, and the *Missal* of St Facundo alludes to the existence of a centre of illumination in an abbey in Sahagún. The presence of reformist monks from France would account for French influence in typefaces and miniatures, which have been related to the city of Limoges. The scriptorium at San Isidoro de León was active for a long period, during which its quality standards improved and its international projection increased, the opposite of what happened to the one at San Millán de la Cogolla. It was in León that the so-called Bible of San Isidoro was illuminated, and work on it is recorded in the year 1162. Its storied compositions reveal the legacy of miniatures from an older Bible, produced in 960, as evinced in some initials, which resemble the pictorial compositions in the pantheon, while others show an Eastern influence. The Bible of Ávila, so called for the place where it came to light, is from Italy, as attested to by its storied initials, which coincide with many of those found in Sicilian manuscripts. However, in the late-12th century, the New Testament was augmented by several folios with illustrations depicting the Passion cycle which reveal a Hispanic style with marked French influences in the type of figures and their drapery. The Bible of Lleida, pro-

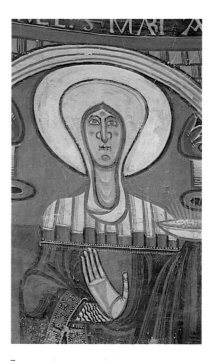

St Mary: fragment of the decoration in the apse at the church of Sant Climent de Taüll (Lleida), dating from the third decade of the 12th century. Museu Nacional d'Art de Catalunya, Barcelona.

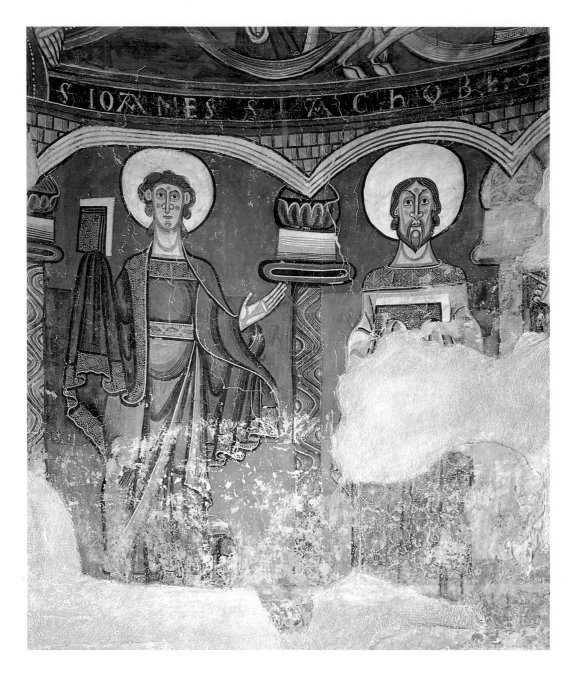

The Apostles: fragment of the mural in the apse at the church of Sant Climent de Taüll (Lleida), dating from the third decade of the 12th century. Museu Nacional d'Art de Catalunya, Barcelona

Christ in Majesty: from the church of Sant Climent de Taüll, possibly the most celebrated Hispanic Romanesque polychrome, which presides over an ensemble dated circa 1123. The iconography is characteristic of the murals found in Catalan Romanesque apses. In the early-20th century, they were stripped from the apse walls and taken to museums where they could be better protected. The figure of Christ in Majesty, with the symbols of the Evangelists, presided over all such scenes, which often featured the complete Apostolic College. Patterns, colours and arrangement are common to ensembles of this kind on both sides of the Pyrenees. The frontal pose of Christ symbolizes the relationship between the Divinity and the faithful in the Church during Romanesque times.

duced in Aragon, is also noteworthy for the fact that the numerous illuminators that worked on it included at least two who were associated with the Winchester Bible (1150).

Contacts with England and the 1200 Style

The arrival of English illuminators heralded the last stage in Romanesque miniatures and painting on the Iberian Peninsula. This period was characterised by the marked influenced of English artists in virtually all Christian centres of production, culminating in the 1200 style. Some Castilian scriptoria were known for their intense activity and high standards of workmanship, which could not be continued in the second half of the 13th century. The Burgos Bible, dating from the last quarter of the 12th century, first reveals the presence of English artists in the upper register of a folio illustrating passages from the Old Testament. The scenes dealing with original sin and the expulsion of Adam and Eve from paradise feature smooth, fluid, undulating graphics, a style that was to become highly successful in Castilian scriptoria. The same style emerges in the only surviving folio from the

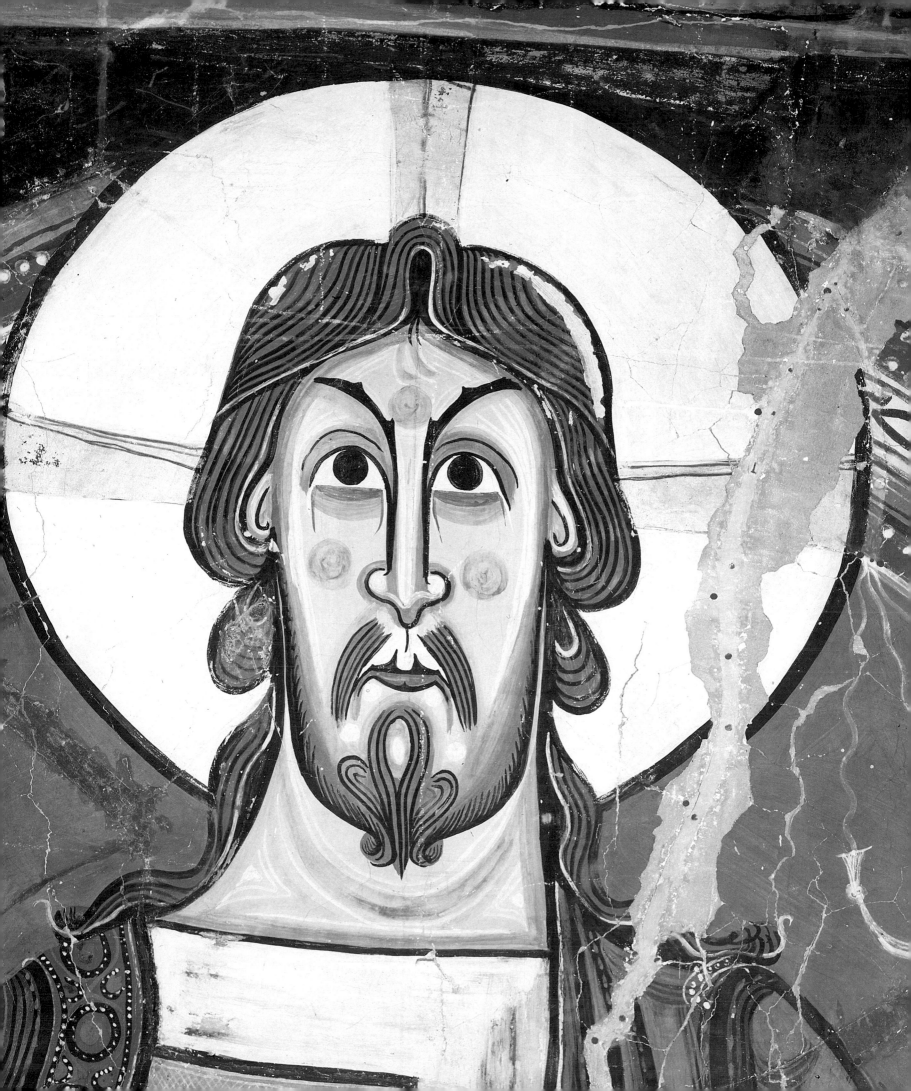

THE CREATION TAPESTRY

The Creation Tapestry, housed in the museum at Girona Cathedral and dating from the second half of the 11th century, is a wall hanging measuring 4.55 by 3.45 m. executed in coloured woollen thread on serge.

Together with the even more astonishing Bayeux Tapestry, it is one of the finest surviving examples of monumental Romanesque tapestries in Europe. It is not certain what its original function was in the Cathedral, although it is traditionally thought to have adorned the altar or the sanctuary walls.

The tapestry is an eloquent testimony to life and activity in the Girona chapterhouse during the 11th and 12th century. It is thought to have been woven in the city of Girona and to have been housed in the Cathedral right from the outset. Although it is first mentioned as late as 25 January 1538, on the occasion of a visit to the city by Emperor Charles V, some regard it as a source of inspiration for the Romanesque Beatus of Turin, a copy of the manuscript known as the Beatus of Girona.

It was discovered in the late-19th century in a poor state of repair, but soon aroused the curiosity of researchers on account of its uniqueness. The most comprehensive study of the piece to date was carried out by Pere de Palol.

Commonly known as the Creation Tapestry, at first sight the subject of the Creation indeed appears to be the iconographic focus. However, closer analysis would suggest that the subject is in fact related to salvation, with visions revealed of eternal contemplation of paradise and the Pantocrator, a Christ who is the creative and ordering principle in the universe.

Structurally, the composition comprises a circle set within a square.

The centre of the circle is taken up by the Pantocrator, around which radiate eight segments featuring scenes from the Creation, overlooked by the Holy Spirit above. Set in the area between the circle and the surrounding square are the four cardinal winds personified as winged genii blowing on two horns. The whole composition is framed by fret patterns. The rather deteriorated lower border strip affords a glimpse of the story of the Cross. The upper section and the two side sections, one of which is badly torn, are made up of framed squares in which the months and seasons are depicted, with the year in the centre of the upper section presiding over the ensemble.

The composition is classical in origin and has much in common with floor mosaics, while depictions of the winds, the year, the four seasons, the months, the rivers of paradise and the story of the Cross are well documented as Romanesque motifs. The tapestry is a grand cosmic and physical vision of the world as related to the spiritual sphere. The arrangement of a circle within a square is characteristic of mediaeval mosaics, devised in the form of the projection of a church dome onto the ground.

The lack of conclusive evidence has led some to date the tapestry in the 11th century, and others in the 12th. I would date it in the last quarter of the 11th century or the first quarter of the 12th.

Although traditionally regarded as having been made in Catalonia, when attempting to establish the intellectual and physical milieu of its origins, what must be taken into account is its synthesis of ancient Byzantine and Carolingian influences. Moreover, there are no parallels or specific clues to support the idea that it was made in a monastic or episcopal centre in Catalonia.

Indeed, everything appears to indicate a northern Italian origin: where parallels do indeed come to light is in the Romanesque mosaic paving at San Salvatore, Turin, and in the later Genesis Dome at St. Mark's, Venice, the latter dating from the 13th century. The tapestry is also reminiscent of examples in Cologne.

The Creation Tapestry, dating from the late-11th or early-12th century. Cathedral Museum, Girona.

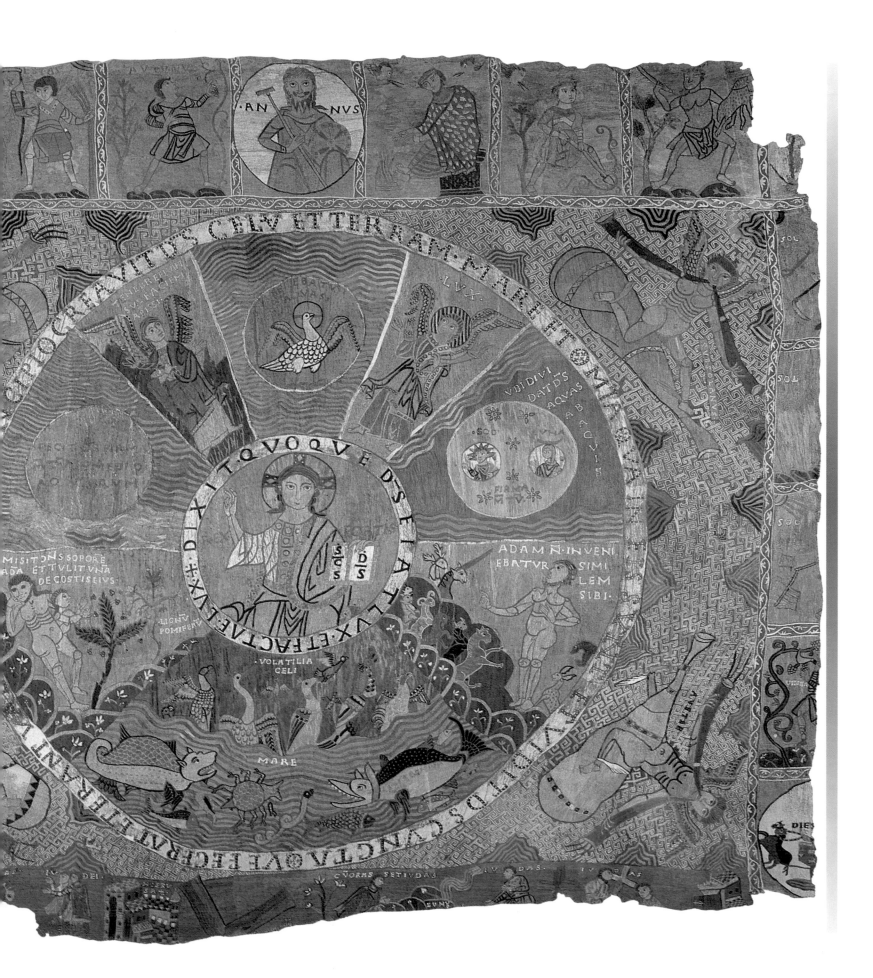

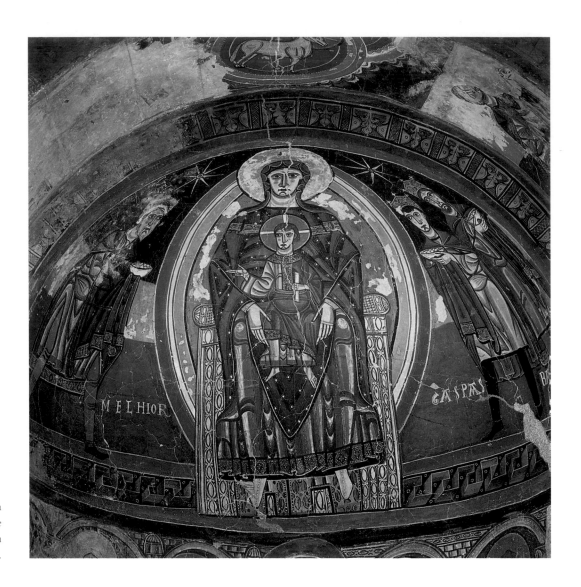

Decorated apse in the church of Santa
Maria de Taüll (Lleida), dating from the
first decade of the 12th century. Museu
Nacional d'Art de Catalunya, Barcelona.

Mural decoration in the shrine church
of Maderuelo, dating from the first half
of the 12th century. Prado Museum,
Madrid.

second volume of the Bible. Both volumes are thought to have belonged to the monastery of San Pedro de Cardeña, which is likewise associated with codices such as the Beatus of San Pedro de Cardeña, or that of San Pedro de Arroyo.

Some murals from the second half of the 12th century, including those in the churches of San Esteban in Andorra, San Pablo de Casserres and La Asunción in Navasa, tentatively display the European ambience characteristic of the 1200 style and the beginning of the 13th century. However, it is in the paintings in the chapterhouse of Sigena and of San Pedro de Arlanza that this Byzantinizing influence becomes most conspicuous.

The Sigena paintings, housed in the National Art Museum of Catalonia and unfortunately damaged by fire, reveal links to a master from the miniaturist school at Winchester, particularly in the full-scale decorativism of wall sections in the diaphragm arches. Murals in the upper chamber of a tower adjoining the monastery church of San Pedro de Arlanza feature as the main theme motifs ordinarily associated with illuminated manuscripts, such as plant and geometrical motifs, architectures, animals and hybrid figures facing one another. There are signs of a repertory common to Arlanza and Sigena, which would suggest the master of the former was related to English miniaturist workshops. Equally interesting is the apparent relationship between the paintings at Arlanza and activity at the aforementioned scriptorium at San Pedro de Cardeña, in addition to the recently discovered monastery of Las Huelgas. This all points to the existence of a large group of craftsmen active in Castile that was influenced by English circles, either directly or through northern France, during the reign of Alfonso VIII, whose Aquitanian wife, Leonor, might have acted as the vehicle of transmission.

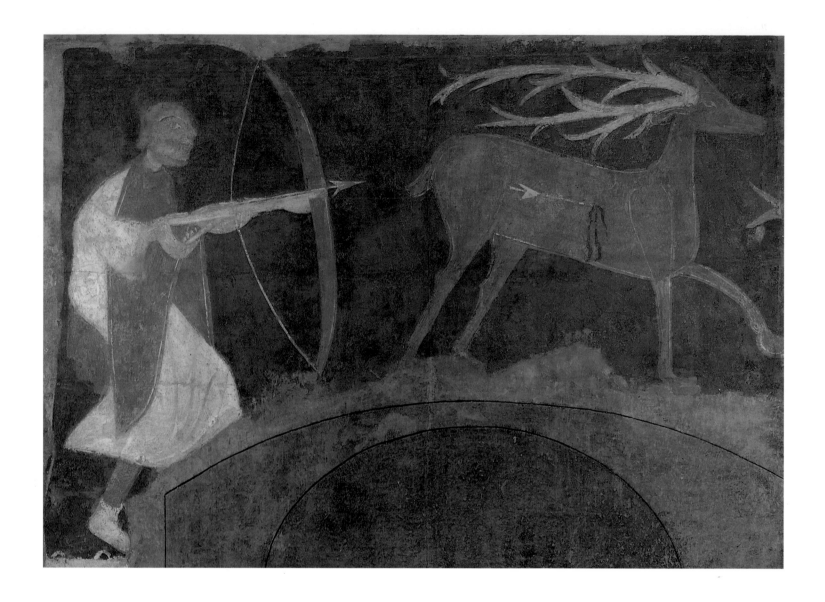

Hunting scene from the church of San Baudelio de Berlanga (Soria), dating from the first half of the 12th century. Mural painting transferred to canvas. Prado Museum, Madrid.

The murals from the Mozarab church of Casillas de Berlanga, part of which are preserved in the Prado Museum, are one of the gems of the Castilian Romanesque. The paintings of biblical scenes in the upper register are associated with the anonymous Master of Santa Maria de Taüll, while those in the lower register are more striking in subject and style. All the panels feature depictions of mundane subjects such as hunting and war. Prevalent are the monochrome grounds, made up mainly of reds and ochres, highlighting lively, dynamic colour figures in the foreground.

CHURCH TREASURE

During the Romanesque period, a church's treasure was its most valuable asset. It was safeguarded in strongboxes purpose-built of stone, which were either lodged in walls or outhouses attached to the church. An example of this was the so-called Holy Chamber in Oviedo Cathedral. Religious treasure was usually worth a great deal of money, as it consisted of reliquaries, urns and devotional objects made of precious metals which, if necessary, could be melted down and recast. In short, financial considerations cannot be ruled out when attempting to account for such an accumulation of precious metal in churches. In Romanesque times, if a religious community owned relics or housed a saint's body, it was able to attract pilgrimages, gifts and prestige, which all translated into increased wealth.

Two types of artwork formed the backbone of religious treasure on the Iberian Peninsula during the Romanesque: reliquaries and associated devotional objects, on the one hand, and chalices, liturgical ornaments and books, on the other. The latter, with their lavish illumination and binding, were in a class of their own. Treasure varied considerably from one church to another, depending on its status and, by comparing markedly disparate collections, such as the modest offering at Sant Feliu de Castellciutat (Urgell), and the marvellous treasure at Santiago de Compostela, it is easy to see how, in one instance, by providing the essential liturgical objects for the purpose of worship, a lay community was able to endow a church with a nest egg, while in another it provided the necessary relics for a church to become acclaimed throughout the Christian world. Treasure of this kind grew steadily as a result of ongoing donations and deeds of patronage.

Cathedrals and large monasteries owned treasure troves commensurate with their importance, but surviving vestiges from the Romanesque period are few and far between. Woven goods, for example, have mostly disappeared, although those that have survived include the Creation Tapestry at Girona Cathedral, and the Sant Ot Standard, from Urgell, now housed in Barcelona.

Metalwork in Navarre, Castile, León, Asturias and Galicia was produced to the highest European standards. Rooted in solid, early-mediaeval tradition, production was centred around San Millán de la Cogolla and León in the second half of the 11th century. Indeed, gold and ivory craft workshops were housed in the monastery of San Millán, near Nájera, ever since the late-10th century. A prominent Romanesque work produced there was the ark of San Millán, made up of various ivory sections currently distributed between various centres and museums, including the monastery itself, Washington, Florence, St Petersburg and Berlin. The metal casing and inlaid precious stones disappeared during the Napoleonic invasion. In León, a large treasure was built up on the initiative of Ferdinand I at San Isidoro. The collection includes gold pieces, such as the reliquary Ark of St Isidore and the late-11th-century Chalice of Doña Urraca, and ivory pieces such as a crucifix that belonged to Ferdinand I and Doña Sancha, in addition to various bindings.

The reliquary of San Isidoro is documented in the Leonese collegiate church from December 1063, the date when the saint's relics arrived from Seville. It consists of repoussé silver plates, gilded in some places, laid over a wooden corpus, with a wealth of figuration and ornamental decoration. The sides feature scenes from Genesis and images of the saint, while the lid contains depictions of the Last Judgement. However, the narrative was affected by restoration work in the mid-19th century. The iconographic association between Genesis and the saint, and the style in which the figures have been modelled, in addition to their attitude, would tentatively relate this reliquary to the artificer of the bronze doors of St. Michael's at Hildesheim, in Lower Saxony, dating from *circa* 1015. The interior and lid of the chest are lined with different woven fabrics of Islamic origin.

The *Arca de las Bienaventuranzas* ('Ark of the Beatitudes', National Archaeological Museum, Madrid) and the Reliquary of SS Pelayo and John the Baptist, executed by royal commission in 1059 and still housed in the collegiate church, both sustained damage during the Napoleonic invasion, so that their present appearance is the result of a reconstruction. Perhaps the finest surviving example of an ivory piece that was once part of a church's coffers, now housed in the National Archaeological Museum, Madrid, is the Crucifix of Ferdinand I and Doña Sancha, so called for the inscription that appears at the feet of Christ (FERDINANDUS REX SANCIA REGINA). It was probably one of the donations made by the monarchs to the palatine chapel when the body of St Isidore arrived in 1063. This is one of the earliest Hispanic examples of the customary Christ triumphant being superseded by the figure of Christ Crucified. A recent restoration revealed a cavity in Christ's back, confirming its function as a reliquary—it might have contained a fragment of the *Lignum Crucis*. One noteworthy feature of this piece is that the figure of Christ is wholly Romanesque in its rounded volume and disproportionate limbs; another is the painstaking figural and decorative work on the Cross, where a whole cycle of redemption is portrayed in images from the Last Judgement. The decoration on the back is more conventional, with the mystical lamb in the centre, flanked by the Evangelists.

The various specimens of ivory-bound manuscripts housed in the collegiate church of San Isidoro de León, and the numerous examples distributed between the Metropolitan Museum of New York, the Hermitage, and the Victoria and Albert Museum, pose the issue of just where the ivory workshops were located. The same riddle is posed by so-called 'southern enamels' or *champlevés,* rendered on gilded copper, preserved in Burgos and elsewhere, which point to the possible existence of a workshop at Silos. Among the most striking 12th-century Castilian enamels of this kind are some fragments from the Orense Frontal, the Frontal of San Miguel *in Excelsis,* the Throne of the Virgin of Salamanca, the front panel from the Urn of St Domingo (Provincial Museum of Burgos) and the matching lid panel (Silos), in addition to the side panels of the Reliquary of St Domingo (Burgos).

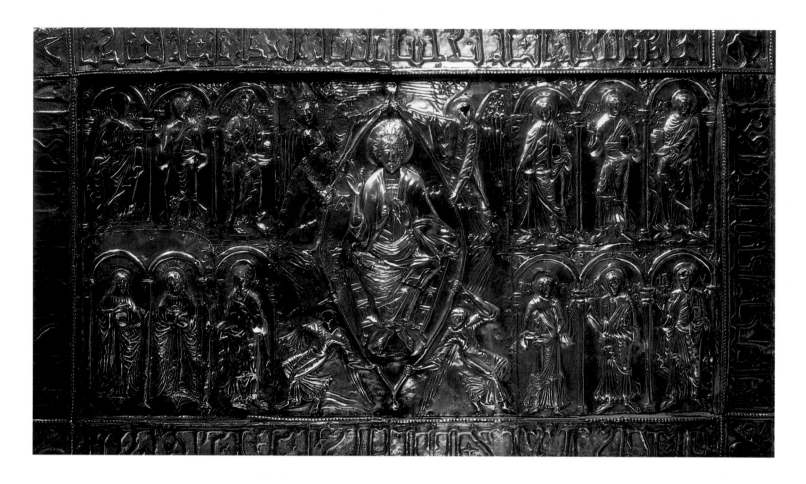

Reliquary ark in the Holy Chamber at Oviedo Cathedral, dating from the last three decades of the 11th century.

The latter also features magnificent ivory ornamentation from Morisco workshops active in the centre of the Iberian Peninsula in the first quarter of the 11th century. However, the finest ivory ornaments of all are the fragments thought to be part of a missal binding, of which the *Maiestas* is housed in the Instituto Valencia de Don Juan, Madrid, and the Crucifixion in the Cluny Museum, Paris. They display rich polychroned blue and green enamels, with the faces rendered in smooth relief, and marked volume in the architectural elements.

One of the boldest and artistically finest pieces in Spain is the Holy Ark of Oviedo, which Doña Urraca and her brother Alfonso VI donated to Oviedo Cathedral in 1075. It is a huge chest designed to hold all the relics in the church. The scenes rendered in repoussé silver depict Christ surrounded by the Apostles on the main side, while the ends feature scenes from Christ's childhood, the Ascension, St Michael, and the Apostles. The style of this ark is different from the one at San Isidoro de León, but the technique used appears to be based on the latter. The elegant figures and the style of drapery also recall the ties between the Romanesque of northern Spain and southwestern France. By all accounts, a gold-and-silver retable donated to Girona Cathedral by the Countess of Barcelona, a retable in Nájera, and the frontal in Santiago de Compostela, were comparable in scope and quality. Apart from raising the issue of the whereabouts of production workshops, all these pieces highlight the relationship with southern France, particularly in the realm of the Plantagenets, Aquitaine and the Limoges area.

CARVED IMAGERY

Detail of the late-11th-century Carrizo Crucifix. Museo de San Marcos, León.

Any study of Romanesque imagery should take in or at least be related to that of other liturgical objects found on an altar: painted or goldwork frontals, baldachins of dif-

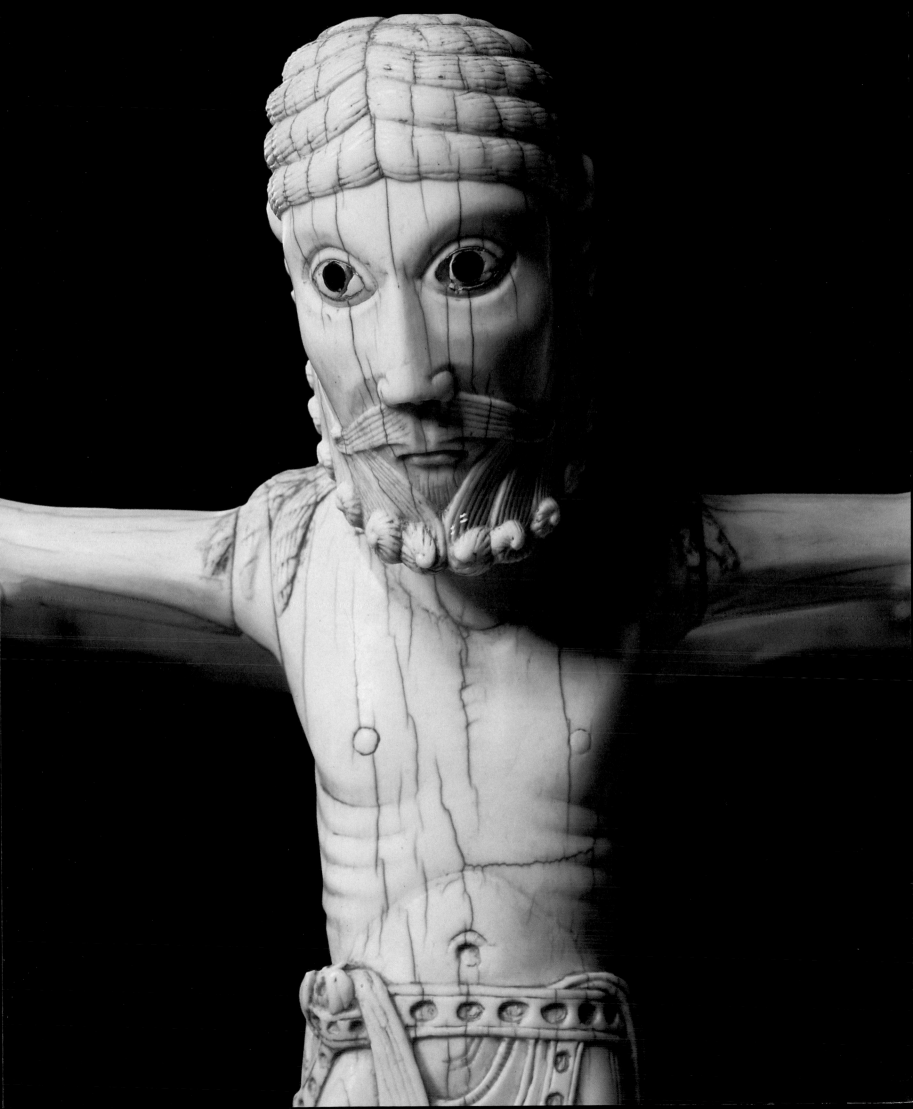

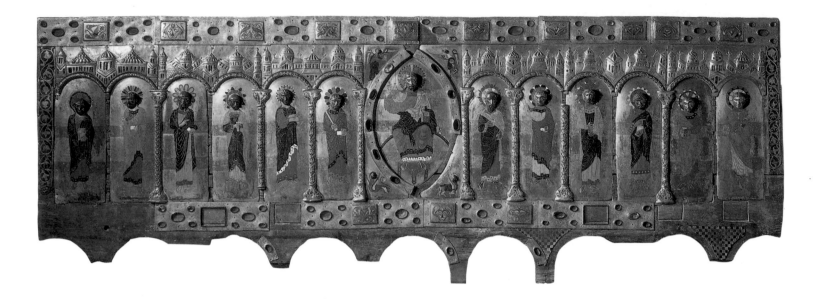

Urn of St Domingo de Silos, 1165-1175.
Museo Arqueológico, Burgos.

ferent structures and materials, liturgical decoration, crosses, reliquaries and wooden doors. Not much attention has thus far been paid to the origin, type and function of imagery in a liturgical context. The main subjects for wood carvings were the Crucifix, and the Virgin Mary as the throne of wisdom. Both were depicted most solemnly, with no hint of pathos or sentimentalism. Another image that occasionally featured was Christ triumphant over death, the crowned Christ figure depicted with large eyes, wearing a long robe. The epitome of such imagery is the Battló Majesty (National Art Museum of Catalonia), which reveals close links with Italian models. The seated Virgin, shown from the front, with the Christ child on her lap, is perhaps the most characteristic image of Western Romanesque art. On the Iberian Peninsula, a large number of such statues are preserved in each of the Romanesque regions. Notable examples in Catalonia can be seen at Cornellà de Conflent and Cuixà, both in the Pyrenees, but the most emblematic works are a stone carving at Solsona, and a wooden one at Montserrat. The latter is one of the widely distributed black virgins. The major production centre for Aragon and Navarre was Roda de Isábena. Castile, León and Galicia each had standardised series of carvings based on a local workshop, often metal-plated, such as the Virgen de la Vega in the Old Cathedral of Salamanca, or one in Toledo Cathedral.

Apart from single carved images, which performed a devotional function, and a liturgical one in processions, the middle of the 12th century saw the emergence of sculptural groups depicting Calvary and the Descent from the Cross as part of a dramatised final episode in the Passion. The Calvary group was made up of Christ Crucified, the Virgin Mary and St John. Hispanic Calvaries were all based on the same iconography, with comparatively stereotyped gestures, derived from 9th-century Eastern models: the Christ figure is depicted solemnly on the Cross, his only garment being a *perizonium,* with his head turned slightly to the right. The Virgin Mary is shown dressed in a long robe, wearing an expression of grief, with her head bent slightly forward and her hands crossed in resignation over her breast. The figure of St John conveys expression through the posture of his cheek resting in one hand, while holding the Gospel in his other hand. These attitudes became increasingly more life-like, as evinced in the later Calvary at San Antolín de Conques (La Coruña).

Portrayals of Depositions, for their part, usually consisted of a Christ Crucified, the Virgin Mary, St John, Joseph of Arimathaea and Nicodemus and, on occasion, the thieves that were crucified alongside Christ, Dismas and Gestas. Monumental examples would rarely be considered as dated earlier than the 12th century. The figure of Christ Crucified

Detail of the Urn of St Domingo de Silos, 1165-1175. Museo Arqueológico, Burgos.

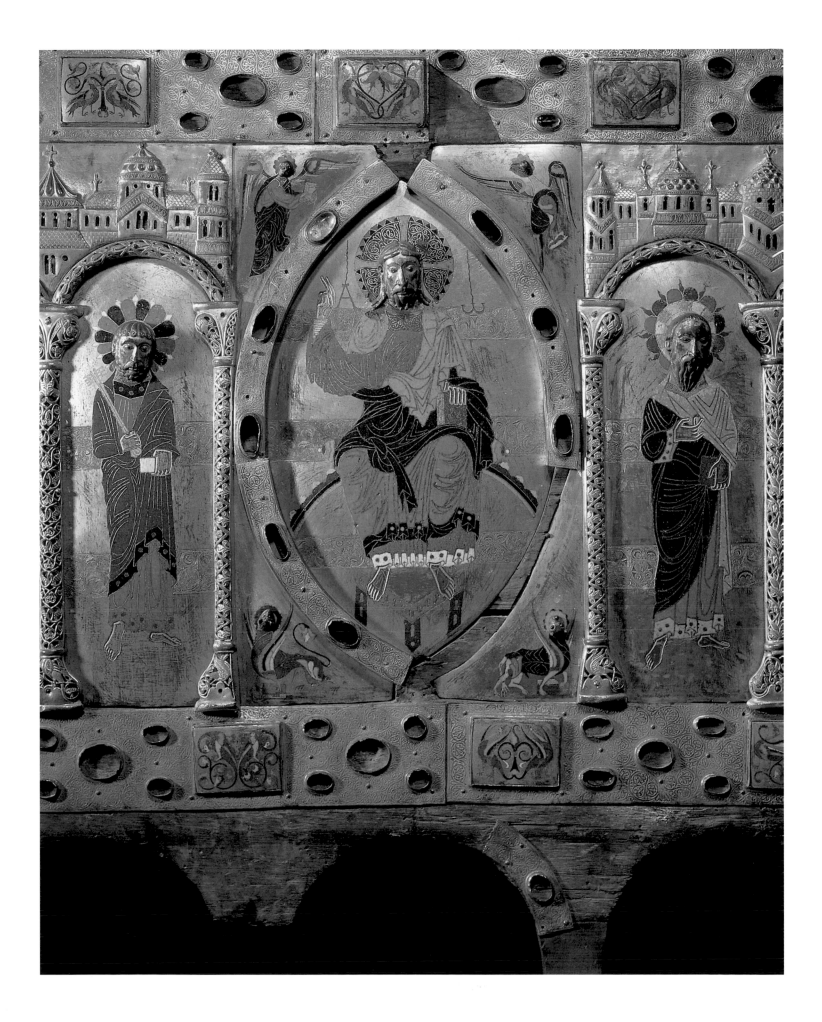

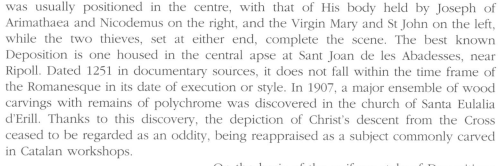

was usually positioned in the centre, with that of His body held by Joseph of Arimathaea and Nicodemus on the right, and the Virgin Mary and St John on the left, while the two thieves, set at either end, complete the scene. The best known Deposition is one housed in the central apse at Sant Joan de les Abadesses, near Ripoll. Dated 1251 in documentary sources, it does not fall within the time frame of the Romanesque in its date of execution or style. In 1907, a major ensemble of wood carvings with remains of polychrome was discovered in the church of Santa Eulalia d'Erill. Thanks to this discovery, the depiction of Christ's descent from the Cross ceased to be regarded as an oddity, being reappraised as a subject commonly carved in Catalan workshops.

On the basis of the uniform style of Depositions produced in the Pyrenean area, a workshop specialised in this type of carving is thought to have been located in the vicinity of Erill-la-Vall. It is associated with the Depositions of Erill, Taüll, Durro, Mitjaran and Boí. In all these examples, the Virgin Mary is attired in an unusual robe with large folds and a headdress which covers the neck. Other hallmarks of that workshop include the anatomical rendering of chest and legs in the figures of Christ on the Cross and the thieves, and the hair styles, consisting of a parting in the middle and wavy tresses. These features have of course come to light after comparing the aforementioned works with others which lack them. In this respect, another workshop, named after the town of Urgell, is thought to have produced the Christ housed in the Marès Museum, and another in the Isabella Steward Gardner Museum in Boston.

The aforementioned Depositions are difficult to date accurately, as they were produced in areas far from the major production centres, so that it is not easy to establish to what extent they were influenced by currents of renewal. However, similarities between the headdress of the Virgin Mary in the Taüll Deposition, and headdresses in the paintings in the apse of Sant Climent de Taüll, led A.K. Porter to regard the Taüll Deposition and other, similar examples as contemporary with the church, consecrated in 1123. However, the type of garment in question appears in a large number of Virgins found in that area, painted in the 12th and 13th century. Virtually all studies coincide in dating the production of the Pyrenean workshops in the second half of the 12th century, although J. Yarza recently opted for a later date within the 13th century.

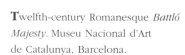

Twelfth-century Romanesque *Battló Majesty*. Museu Nacional d'Art de Catalunya, Barcelona.

These sculptural groups, both Calvary scenes and Depositions, occupied various places inside a church. The customary site appears to have been the main apse, either behind the high altar or raised on a crossbeam, out of the way of liturgical proceedings. However, they may very likely have also been used to mark off the areas set aside for clergy and laymen, as in the monastery of Las Huelgas (Burgos) and various German or Italian churches. Whatever the case, they were positioned according to their liturgical function, and each of them may have been used for a different ceremony in the liturgical Easter play.

The relationship between Romanesque wood carving and other genres, such as monumental sculpture, painting and goldsmithery, has caused considerable speculation. For instance, some hold that the sculptural groups were produced in areas which lacked stone statuary. Nevertheless, a comparison of the two techniques reveals some common features, suggesting that workshops specialising in wood carving and stone sculpture might have been enjoyed similar status in the Middle Ages.

* * *

Romanesque art in the Iberian Peninsula extended beyond the 12th century, a fact which did not detract from the quality of production or the conviction behind it. On the contrary, the end of the 12th century marked one of the most creative periods of the Hispanic Romanesque, in which artists, aware of the rise of Gothic art, consciously chose

Deposition. 1251. Church of Sant Joan de les Abadesses (Barcelona).

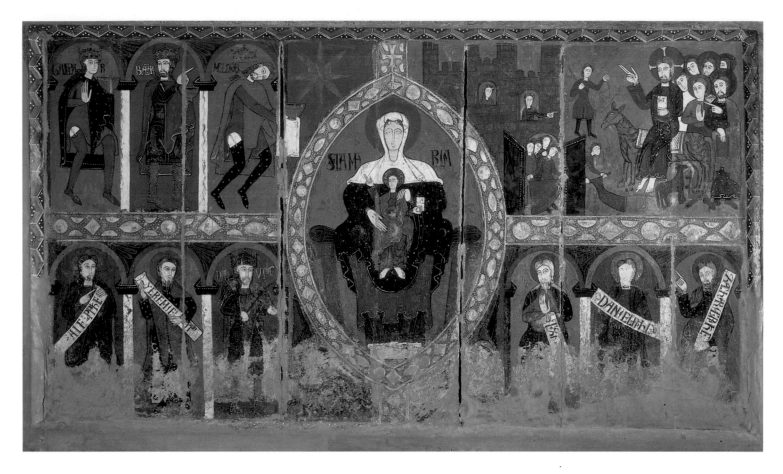

Frontal in the church of Sant Vicenç de Espinelves (Barcelona). Early-13th century. Museo Episcopal de Vic (Barcelona).

to further develop the Romanesque style to the best of their artistic ability and experience. This is the so-called '1200 style', which appeared in figurations in stained glass, enamels and manuscripts in an area running from northern France to the Meuse and Rhine. In Spain, however, it manifested itself mainly in sculpture and manuscripts.

The most important architectural phenomenon to emerge in the transition from the Romanesque to the Gothic, both in architecture and decoration, was Cistercian art, which actually grew out of a wholly Romanesque milieu. In the field of monumental art, strict, clear-cut guidelines for decorating monasteries were laid down by the chapter of the order in 1150: 'Painting and sculpture is expressly forbidden in our churches and all monastic quarters, for those paying attention to them might be distracted from their due sense of meditation and the discipline of religious solemnity'. Thus, in churches, cloisters and chapterhouses, artists in the service of the Cistercian order abandoned figural decoration in favour of a decorative refinement designed to lighten the austerity imposed by the new Cistercian foundations.

The unity and diversity of Romanesque art are paradoxical but nevertheless genuine features which came out most forcefully in regional and local interpretations of style. But the Hispanic Romanesque also faithfully mirrored the religious, political and social mores of the times. With an erratic pace of evolution, moments of brilliance and a grand finale in the early-13th century, more than fifty years after the facades of Saint-Denis and Chartres had been erected, the Hispanic Romanesque started to make its exit, reluctant to give way to the Gothic, a situation that obtained in many other regions in Europe.

The decline was inexorable, as was the attempt to perpetuate Romanesque feudalism *ad infinitum*, without realising that, as in art, it was a socio-political system commensurate with a particular moment in history.

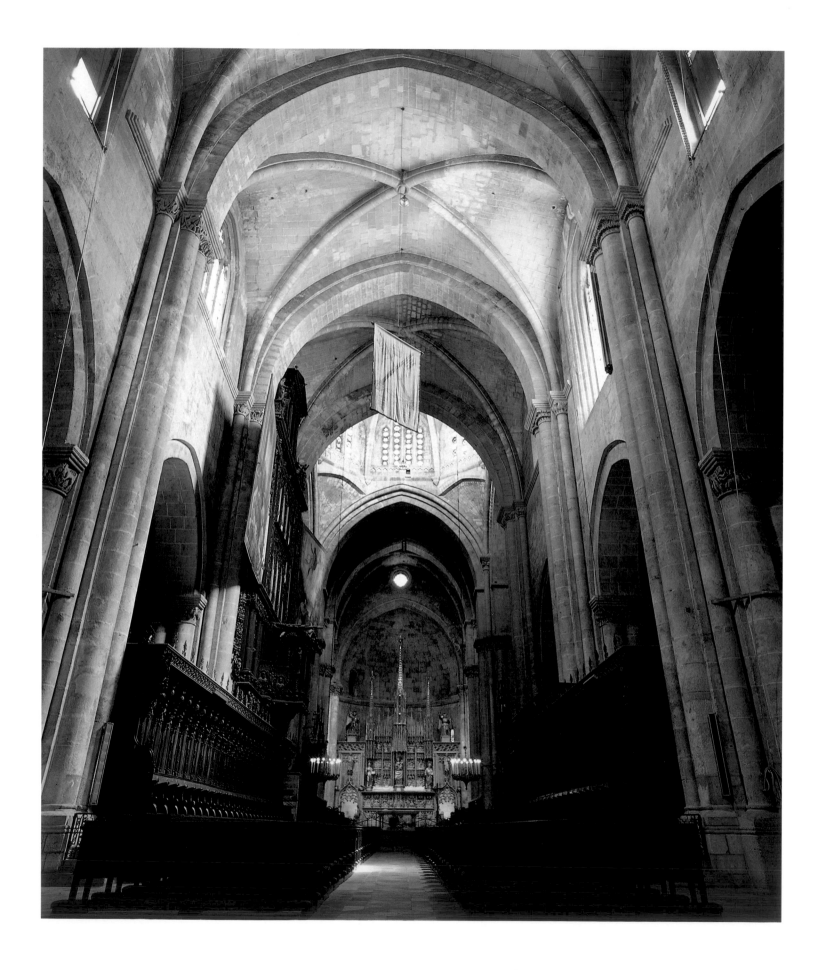

GOTHIC SPAIN

Núria de Dalmases

The Issue of Antecedents

As a result of the renewal sparked by Abbot Suger of Saint-Denis in the fourth decade of the 12th century, a crucial event in the history of art, innovative trends in art and architecture led to the spread throughout Europe of the *opus francigenum*. As far as the Hispanic world was concerned, the new, so-called Gothic style first emerged in the Iberian Peninsula with the construction of the Castilian cathedrals of Burgos, Toledo and León. Signs of change in the Peninsula became most conspicuous in the middle of the century, while the last three decades of the century saw architectural renewal in monasteries, cathedrals and churches, contemporary with the popularisation of the Romanesque in minor works in all the Christian kingdoms. In Castile and Aragon, this included the rise of the so-called Mudéjar style, adopted largely because of the economy and facility inherent in Mudéjar building methods and carpentry. The transforming experience of the Romanesque, although limited to particular instances, was based largely on the use of the ogival arch, a variety of roofing systems, and slight changes to pillars, invariably rendered within the prevailing context of space and volume. Although the appearance of the rib vault was key to the perception of Gothic architecture, it was not enough to determine the new style on its own. While the use of rib vaults became widespread, plans, layout, load-bearing systems and walls hardly underwent any change.

The first ribbed ceilings were built around the year 1170. The rib vault has traditionally been classified into two types: one of French origin, and the other considered to be a derivation of the Moorish caliphal vault. The use of the first type, together with square- or rectangular-section systems, was attended by the introduction of sexpartite systems (Cuenca Cathedral and the pilgrimage hospital church at Roncesvalles); Aquitanian ones, which involved reinforcement of the ribs (Zamora Cathedral); and the Plantagenet type, with liernes (Monastery of Las Huelgas and Cathedral of Ciudad Rodrigo). The second type, of Moorish origin, can be seen in central-plan buildings with a ribbed, polygonal structure in the centre, in which the ribs do not intersect at a boss (churches of Torres del Río and Almazán). A variation of the central arrangement featured ribs crossing at the centre, with the resulting segments shaped like ovoli (cathedrals of Zamora and Salamanca). Vaults were supported by compound piers with two kinds of attached shafts: the Hispano-Languedocian school had twin shafts attached to each face of the pier, while the other formula had them located at the corners. In both instances, they had the effect of lightening the pier.

A large number of the Cistercian monasteries built in the Iberian Peninsula from the last three decades of the 12th century onwards featured early-Gothic forms of this kind. They include Osera, Oya, Moreruela, Valbuena, La Oliva, Veruela, Poblet, Santes Creus and Alcobaça. However, they cannot be regarded as examples of the Hispanic early-Gothic, as that would be an oversimplification of their antecedents. The great Cistercian abbeys are contemporary with the crypt under the Portico of Glory at Santiago de Compostela, as well as with the cathedrals of Zamora, Salamanca, Ciudad Rodrigo, Santo Domingo de la Calzada, Lleida, Tarragona, Cuenca and Sigüenza, the basilica of San Vicente de Ávila, and

Interior of Tarragona Cathedral, begun in 1171 and completed in 1331 (the date of its consecration).

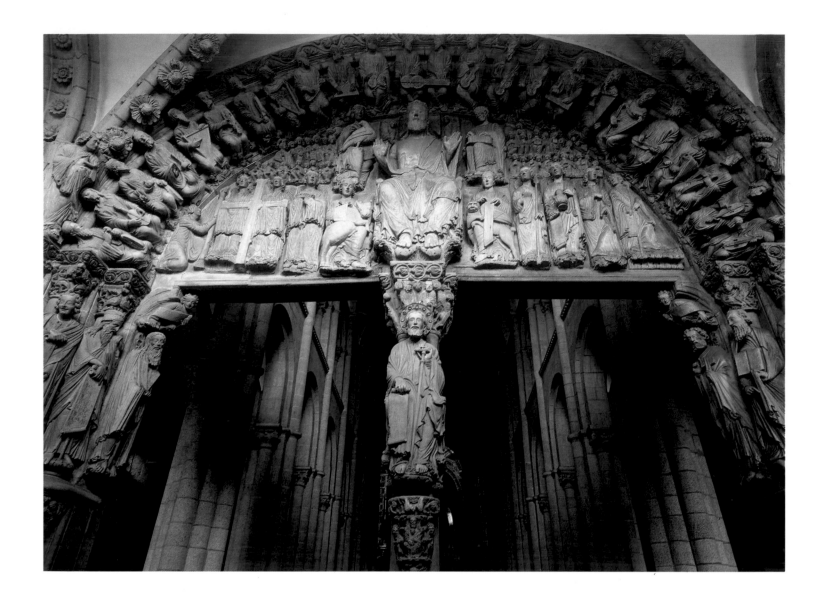

Pórtico de la Gloria ('Portico of Glory'), by Master Mateo, in the Cathedral of Santiago de Compostela. Last three decades of the 12th century.

monasteries such as Sant Cugat del Vallès, in addition to other, minor works. All of them were to some extent influenced by currents of renewal. The spread of the Cistercian order in Spain did not lead to full-blown Gothic architecture in religious and secular buildings until well into the 13th century, by which time cathedrals throughout the whole country, but particularly in Castile, were breathing a new artistic climate.

At the same time, the situation in fine art was undergoing similar changes, as evinced by compositions which, in keeping with the spirit of the times, gradually came to reflect the visible, natural world as the basis of intellectual knowledge. The symbolic and hieratic language associated with the Romanesque was to some extent abandoned, surviving only in the form of a structural support reflecting established values. That precocious awakening of a more or less idealised naturalistic milieu was especially marked in the field of sculpture, as from the mid-12th century, albeit still rooted in architectural forms. The new trends in art were promoted by celebrated masters with the artworks they created along the routes of pilgrimage, following the more decisive lead taken by artificers in the north of France. The cenotaph of San Vicente, by the Master of Ávila, the churches of Santa Sabina and Santa Cristeta, the second workshop at Silos, the apostolate in the Holy Chamber at Oviedo, the sculpture on the church of Carrión de los Condes, the typanum of the Virgin in Zamora Cathedral and the Portico of Glory at Santiago all bear witness to the sculpture that grew out of the highly skilled and well consolidated forms of the late Romanesque. Standing head and shoulders above his peers in that generation of sculptors was Master Mateo, best known for his Portico of Glory, thanks to the naturalism with which he endowed some of

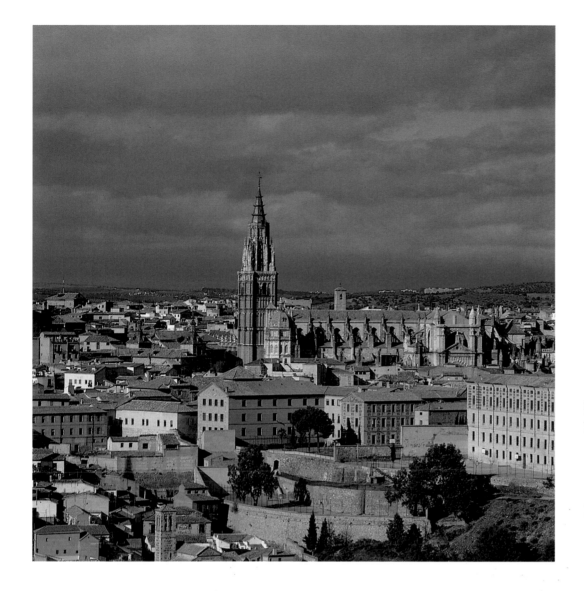

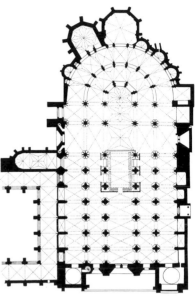

Aerial view of Toledo and its Cathedral, begun in 1226 and completed in the 14th century.

Plan of Toledo Cathedral.

his finest figures (SS Peter, Paul, John, James, Isaiah and Daniel), which have earned him the status of prime mover of early-Hispanic Gothic sculpture, despite the lack of subsequent continuity in his essential style.

The changes did not show through in pictorial art until the 13th century; indeed, to begin with, Gothic-inspired thematic and formal innovations only came to the fore in the illuminated manuscripts that appeared during the reign of Alfonso X of Castile (1252–1284). Meanwhile, formal Romanesque structure held firm in other pictorial genres, apart from the odd half-hearted attempt at portraying novel figures and subjects that would later be fully developed, although an initial tendency to restrain chromatic values is indeed noticeable. Research into the origins of Gothic painting has traditionally identified two sources of influence: the first of these, of Italian origin, is rooted in the Byzantine renewal of 1200, while the other is of French provenance. The latter, although more vaguely defined, is accepted as being more in line with the evolution of Western art. These trends often found eclectic forms of expression which become inseparable from the development of Romanesque painting, as exemplified in Catalonia by the frontals painted on panel at Valltarga, Orellà, Avià, Esterri, Ginestarre de Cardós, Bolvir and Sagàs. Noteworthy works in the '1200 style' include the murals in the chapterhouse at the monastery of Sigena in Aragon (partly preserved in the Museu Nacional d'Art de Catalunya in Barcelona), which feature a complete, Old and New Testament comparative biblical cycle, characterised by theological rationalism as applied to the genealogy of Christ. The marked Byzantinism in the illusionism of the scenes and the monumental feeling about the figures reveal a Siculo-Norman trend with

CISTERCIAN ART

In the context of structural developments in the history of mediaeval art, it is uncommon for a process of monastic ideological recovery and renewal to have quickly spawned a series of artworks eligible to be considered innovative and ahead of their time, particularly as this was not intended in the case of Cistercian art. Renewal of the order at Cluny, advocated by St Bernard of Clairvaux in the second half of the 12th century, marked the birth of an eminently architectural art style. Bernard called the order to rediscover its origins and strictly observe the Benedictine Rule, which led to the break with Cluny and the founding of Citeaux and four other abbeys: La Ferté, Pontigny, Clairveaux and Morimond. It was from here that the monks in white emerged to found other daughter abbeys.

The Cistercian renewal coincided in time with Suger's reconstruction of the abbey at Saint-Denis. As opposed to Romanesque cathedrals, which tended to be surrounded by episcopal art characterised by large municipal buildings adorned with grand, complex sculptural groups, Cistercian monastic art emerged in isolated spots located in untilled woodland which the monks set about cultivating, according to the Benedictine Rule, turning it into their prime natural resource for supporting the community.

The Cistercians first emerged in the Hispanic dominions in 1140, with the founding of the monastery of Fitero. According to the charter granted by King Alfonso VII of Castile—the patronage of Cistercian monasteries by the royal family and the aristocracy being a constant in Castile and Aragon—Fitero was the first Cistercian monastery on the Iberian Peninsula, even though this territory was not initially included in St Bernard's plans, as he himself asserts in a letter of 1127 or 1129, in which he describes it as a distant land where foundations could only be established at great expense and effort.

The typical Cistercian monastery was arranged around three nerve centres: the church, the place set aside for prayer; the cloister, surrounded by the monks' living quarters, and the ar-

eas used as working quarters and for converts. In all, the rationalised use of space can be seen in the way the various areas were distributed in terms of the monk's daily life and tasks.

The most salient feature of Cistercian art was its concern for striking a balance between the superfluous and essentials; in other words, just measure, and simplicity, in which line was prevalent and geometrical forms pure, as well as the aforementioned rationalisation. This conceptual austerity contrasts with the perfection and aesthetics lavished on the materials used and the way they were worked, based on the building traditions of Burgundy and Champagne, where the renewal of the order first took place. The architectural models which were transformed by the Cistercians through a process of selection and reduction to highly simple formulae were char-

acterised by a three-naved church bounded by a flat external wall, with a marked crossing, rectangular apses, and chapels in the transepts, pointed or semicircular arches, broad, smooth wall stretches, modillions and compact forms.

Many of the Spanish Cistercian monasteries built after the first three decades of the 12th century were in a similar position to early-Gothic forms, while other contemporary buildings, such as the crypt of the Portico of Glory in the cathedral at Santiago de Compostela, the cathedrals of Zamora, Salamanca, Ciudad Rodrigo, Santo Domingo de la Calzada, Lleida, Tarragona, Cuenca and Sigüenza, and the basilica of San Vicente de Ávila, also underwent a process of renewal.

The main features of Cistercian architecture in Spain relate to the load-bearing system and type of roofing used: compound piers were built by engaging twinned columns on the face of the piers (the crossing in the monastery of Fitero), with shafts set at the corners (monastery of Vallbuena).

As for roofing, the pointed barrel vault was developed from Romanesque architecture and supported either on a fully-fledged pointed arch (nave in the monastery church at Poblet) or on stilted arches (ambulatory in the monastery church of Melón). Around 1170, the groin vault was replaced by the rib vault, which consisted of two intersecting semicircular arches (monasteries of Poblet, Moreruela, San Salvador de Valdediós and La Oliva). After 1185, apses became polygonal without and circular within (monasteries of Poblet, Moreruela, Fitero and Gradefes), some of them containing chapels opening onto the crossing. Other buildings had chancels without an ambulatory but with three apses (monastery of Retuerta, Sandoval, Córcoles, Irache and Palazuelos), or straight chancels, such as those at Santes Creus, La Espina,

Monastery of Santes Creus (Aiguamurcia, Tarragona): chapterhouse, circa 1160-1191.

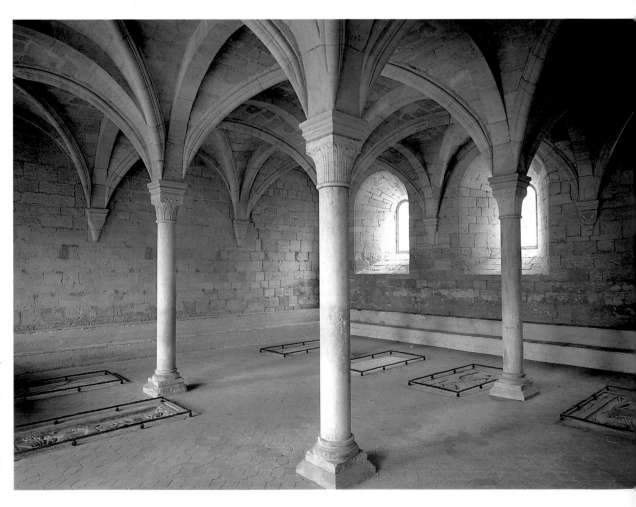

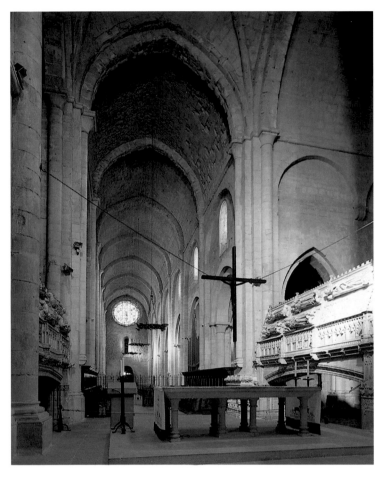

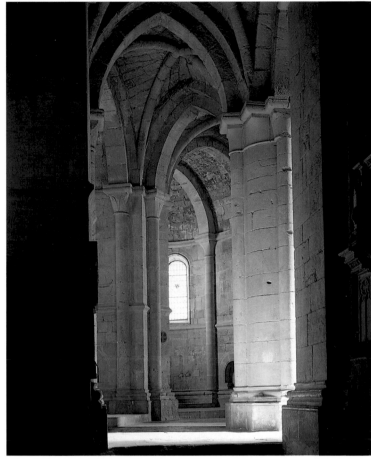

Monastery of Santa María de Poblet (Vimbodí, Tarragona): main church, circa 1170-1200.

Vallbona de les Monges, Montederramo and Iranzu.

In accordance with the precept that buildings best served religious needs when decoration was kept to a minimum, Cistercian art is striking for its luxurious nakedness. This did not, however, prevent cloister and chamber capitals, bosses, rose windows and cloister or dormitory modillions from being adorned with relief decoration, which generally consisted of geometrical shapes, strapwork, plant motifs and even figural compositions which blended in with the architecture.

In the province of Tarragona in Catalonia, the monasteries of Poblet and Santes Creus, which became the sites of the pantheon of the kings of Catalonia and Aragon, are the quintessence of Cistercian architecture. Their sober, refined, rectangular chapterhouses, roofed with simple rib

vaulting supported by walls and slender columns, are masterpieces of Hispanic art, as are the large dormitories with their pitched roofs resting on pointed diaphragm arches. These arches end in brackets with large ogee mouldings decorated with plant and other motifs.

Monastery of Veruela (Vera de Moncayo, Zaragoza): cloister. Last quarter of the 12th century.

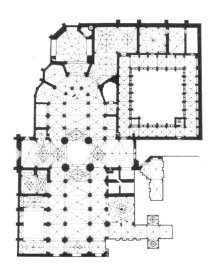

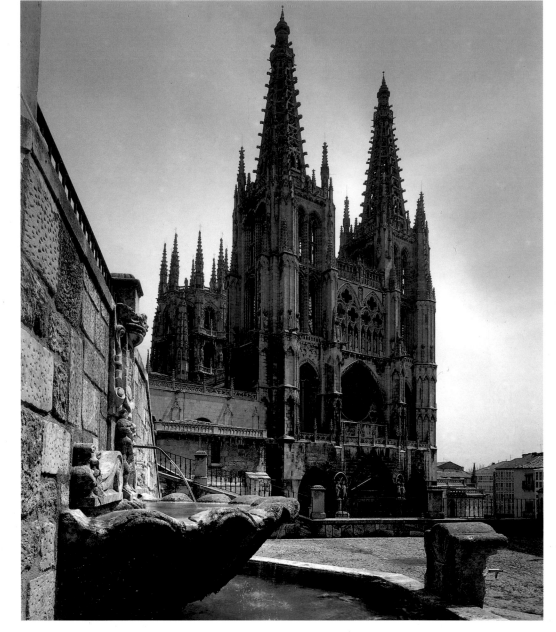

parallels in late-12th-century English miniatures, particularly those produced in the scriptorium at Winchester.

The Cathedrals of Toledo, Burgos & León, and 13th–14th-century Castilian Art

As mentioned earlier, the first phase of Hispanic Gothic art had its origins in France, although the transposition of French models did not involve any direct replica or copy. After tentatively probing into the currents of renewal, fully-fledged, classical Gothic art and architectural innovations were first seen in the Castilian cathedrals of Toledo, Burgos and León, belonging to the *ad triangulum* model; this refers to the church elevation being set in an ideal triangle, with the plan responding to a derivation of this geometrical shape. Construction work began on the cathedrals of Toledo and Burgos at about the same time, while that of León got under way some thirty years later. The first two were planned by Rodrigo Ximénez de Rada and Bishop Mauricio, while León Cathedral was promoted by Martín Fernández.

No newly planned Christian church had been built in Toledo, the capital of the kingdom of Castile and erstwhile capital of the Hispano-Gothic kingdom, since the peaceful sur-

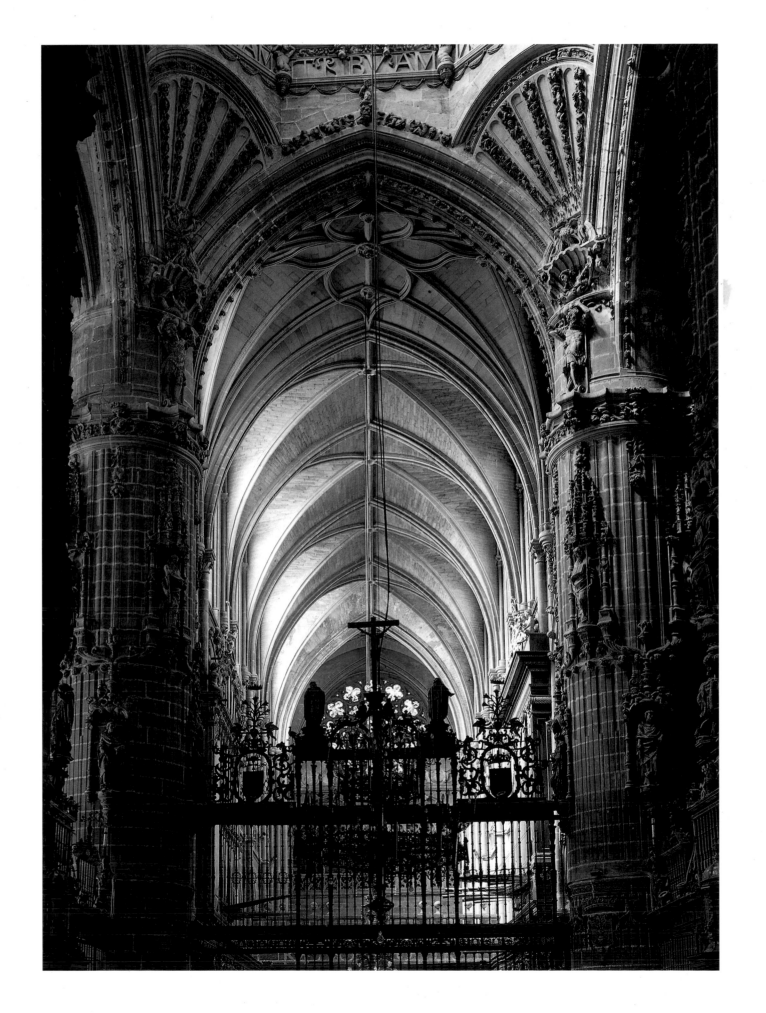

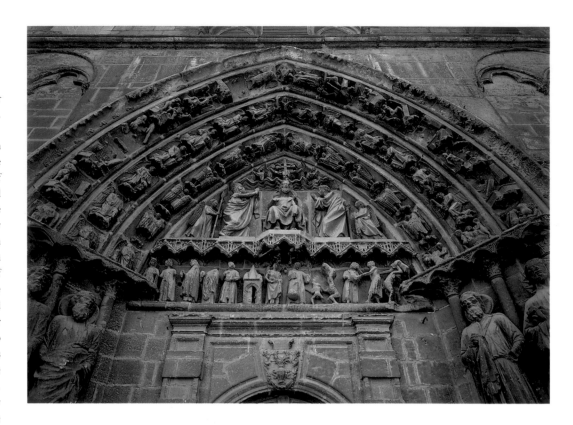

Burgos Cathedral: portal of the Cloister of the Apostles, circa 1295.

Gothic sculpture based on French models made definitive inroads into the Hispanic world via the cathedrals of Burgos, León and Toledo. Of all surviving portals, the Portico of the Sarmental is formally and thematically the earliest, and is deeply rooted in Romanesque iconography. Depicted on the tympanum is an apocalyptic vision of Christ the Judge, accompanied by the Evangelists, the twenty-four elders and the Apostolic College, making it similar to the Royal Portal at Chartres. It is also related to the workshop at Amiens Cathedral (the *Beau Dieu*) and the portals on the north transept at Rheims. The superb, poignant figure of the holy bishop or pseudo-Mauricio on the trumeau presides over the ensemble featured on the jambs, and beckons the faithful to enter. The influence of this door can be seen in the so-called Portico of the Revelation at León Cathedral, on which that of the church of Sasamón is directly based. The west portal of Burgos Cathedral must have been just as interesting: it disappeared in the 18th century, although some fragments of it are still preserved in the cloister. From documents dated before its disappearance, it was evidently dedicated to the glorification of Mary as the mother of God and queen of heaven.

render of the city in 1085. After the Christian victory at the battle of Navas de Tolosa in 1213, the archbishop of Toledo, Rodrigo Ximénez de Rada, deemed it a fitting moment to build a new cathedral to replace the old one, which was an adaptation of an earlier mosque. Having seen French architecture for himself, he must have thought it wiser to seek in France master builders and stonemasons capable of erecting an original building commensurate with a metropolitan see. The project was drawn up between 1222 and 1224 and, on 14 August 1226, a solemn ceremony was held before the king to mark the laying of the first stone. The first architect employed on the cathedral, recorded in documents dating from the period 1227–1234, was Master Martin, a Frenchman. He designed the cathedral and supervised building work. It appears that around the middle of the century he was replaced by Petrus Petri (Pedro Pérez) who, judging from the epitaph on his gravestone (1291), was regarded as an illustrious master of the cathedral. Construction work progressed rapidly, and by 1238 the radiating chapels had been completed, while the chancel was finished by 1247. However, progress slowed down following the death of Ximénez de Rada, and at the end of the 13th century the building had not been completed—this was achieved in the 14th century. The cathedral plan is based on a five-nave structure with a double ambulatory, the breadth of which is matched by that of the transept. It may therefore be classed in the group headed by the original cathedral of Notre-Dame in Paris where, as at Le Mans and Bourges, one of the main concerns was the distribution of thrusts and counterthrusts in the chancel.

Although not the official capital of the kingdom, Burgos was Alfonso VIII's *civitas regia*. Its strategic position on the Road to Santiago and in so-called Old Castile, together with its burgeoning commercial and financial activity, had turned it into the true business centre of Castile, so that in practice it shared capital status with Toledo. According to the *Cronicón de Cardeña,* on 20 July 1221, in the presence of the king and all his courtiers, the first stone was laid on the cathedral that was to replace the original Romanesque building. Bishop Mauricio, who had studied in Paris and was involved in diplomatic activity with France, must have first engaged a French master builder for his cathedral project. However, documentary sources only mention a master known as Enrique, also of French extraction, who, prior to his death in 1277, had worked on the cathedral around the middle of the century, after the death of Bishop Mauricio, as well as on the cathedral in León. The

building was consecrated on 20 July 1260, once the major part of the chancel had been finished, with only the vaulting and some upper areas awaiting completion. This first construction stage lasted throughout the 14th century and was directed by successive master builders who, apart from the aforementioned Enrique and his son, Juan, all hailed from Castile. A brief, rather abstract overview of the features added to the building that century, ruling out subsequent building stages, reveals Burgos Cathedral to have a fairly simple layout, comprising three naves with rectangular and square vaults, a single-naved transept projecting beyond the aisles, and an ambulatory. Broadly speaking, the chancel is reminiscent of the one at Coutances, in France, with five polygonal apsidal chapels and three rectangular ones reaching the crossing. The elevation of nave and aisles, set on three levels, has parallels in the cathedral of Bourges, both in the arrangement of piers and in the triforium, while the presence of flying buttresses confirms the French Gothic as the source of inspiration.

In León, the capital of the old Kingdom of León, talk of a new cathedral is documented in 1205, but it was not until circa 1255, in the time of Bishop Martín Fernández (1254–1289), that building work got under way. Work on the radiating chapels is recorded as being in progress in 1258, while most of the building was completed by around 1330. Of Castile's three great cathedrals, that of León comes closest to the diaphanous structure of the French cathedrals. Despite the conspicuously French influence in the cathedrals of Toledo and Burgos, in these two, horizontal architectural values are prevalent. Master Enrique of Burgos, who worked on both cathedrals up until his death, is likely to have also been instrumental in producing the original project design. The plan of León Cathedral, with three naves, a markedly projecting transept and an ambulatory, is essentially akin to that of Rheims, although with its proportions reduced to two thirds of the size. But its elevation reflects the innovations of Amiens, particularly in the way the triforium has been voided, practically dispensing with walls and allowing more light to flood in.

Contemporary with the great 13th-century Castilian Gothic cathedrals was Cistercian monastic architecture, which drew on Gothic structural innovations. Noteworthy examples are the chapterhouse at Las Huelgas, Burgos, and the refectory at Santa María de Huerta, in Soria. In the latter, dated around 1220–1230, the ceiling, which consists of sexpartite vaulting, and the back wall, designed to act as a transparent surface, bear out the new artistic trend associated with northern France and, in particular, Anglo-Norman architecture.

At the end of the third decade of the 13th century, the forms and images characteristic of Gothic sculpture made lasting inroads into the Hispanic world; specifically, in the great Castilian cathedrals, based on French artistic and ideological formulae. A language by which the Church communicated with its faithful in the form of vivid sculptural ensembles grew up on the entrance portals of those cathedrals, leading to a marked rise in popular devotion, a phenomenon that would spill over into following centuries. The first master builders in Castile were French, and wholehearted acceptance of things French meaned that the formal and iconographic tenets of stonemasons essentially came to echo contemporary trends in Île-de-France. A great workshop emerged as a result of building work on Burgos Cathedral and remained active until the end of the century, being superseded by that of León Cathedral. Both cathedrals were involved in a major circle devoted to funerary sculpture that emerged in the centre of Castile, of which some prominent examples are the tombs at the monastery of Las Huelgas, at the churches of Carrión de los Condes and Villalcázar de Sirga, and that of the precentor Aparicio in the Old Cathedral of Salamanca. In Toledo, owing to the death of Rodrigo Ximénez de Rada, the cathedral portals were only sculpted in the 14th century, except for the Clock, which was begun in the late 13th century.

With the west portal of Burgos Cathedral no longer standing, the evolution of sculpture in the Burgos workshops can only be gleaned from the three surviving porticoes: that of the south transept, known as the Sarmental, dated circa 1230–1240, the north portico of the Coronería, which is slightly later (1230–1257), ascribed to Master Enrique, and the cloister portico, dating from the last quarter of the 13th century (circa 1295). That of the Sarmental, thematically and formally the earliest, features an apocalyptic vision of Christ the

Cántigas de Santa María o de Alfonso X el Sabio (Canticles of Holy Mary or of Alfonso X the Wise): parchment, 13th century, 55.1 x 36.5 x 13 cm. Library at the Royal Monastery of El Escorial (Madrid).

A symbol of the intensity and, to some extent, novelty of Marian devotion, the *Canticles* is a literary, visual and musical record of Alfonso X the Wise's ideal for 13th-century Castilian society. It contains some four hundred poems, which reveal an undogmatic, humanistic and sensitive approach to religion, in which an attempt is made to account for and forgive human behaviour and its shortcomings through the figure of Mary. The moralistic tales are illuminated with miniatures which are outstanding for their colour and handling, and are accompanied by musical annotations. These, and other manuscripts produced by the Alphonsine scriptorium, including the *Grande e General Storia*, *Libro del saber de Astronomía*, *Lapidario* and *Libro de los juegos* were written and illustrated in the most innovative contemporary styles. Although they cannot be regarded as *Gothic* in the French sense, they did coincide with one of the great moments in 13th-century Europe, and reveal cross-fertilisation between the Byzantine, Islamic, southern Italian, English and possibly French currents, set within the context of contemporary Castilian life. The miniatures are arranged simply, in similar fashion to stained-glass windows, the page being divided into six compartments and edged with floral and geometrical motifs and heraldic subjects pertaining to Castile and León. The scenes are depicted within architectural settings with pointed arches and rib vaulting, resting on multicoloured columns and lobulate tracery, while crenellated crowns and stone and brick walls alternate with semicircular and horseshoe arches. References to landscape are frequent, and white grounds contribute to the overall tonal interplay. Even the most intimate details of everyday life in Castile at the dawn of the Gothic period are paraded across the pages of this manuscript.

Judge, surrounded by the Evangelists, the twenty-four elders and the Apostolic College, based on a model derived from the Royal Portal at Chartres. Certain differences between different areas on the portico have led it to be considered as related to Amiens Cathedral, where the *Beau Dieu* is portrayed as God in majesty on the tympanum, and to the portals on the north transept at Rheims on account of the handling of the Apostles on the lintel. In the centre, the figure of Christ of Sorrow is depicted as a judge with whom the Virgin Mary and St John of the Gospel are interceding, in a standing position, although about to genuflect—a Western transposition of the Byzantine *deesis*. A Judgement with a poignant central psychostasia is depicted on the lintel, presided over by St Michael. The group must have been produced by a workshop directed by a sculptor—possibly Master Enrique—who

Lower panel:

BARNABÁ DE MÓDENA:
Virgin of the Milk. Tempera on panel,
third quarter of the 14th century.
Murcia Cathedral.

knew the Chartres workshops. The door opening into the cloister, dedicated to Christ as the Son of God and Messiah, and the sculpture adorning the wings and chapterhouse, are in all likelihood the earliest major example of a great local workshop which, related to France and, in particular, the Coronería Portico, had widespread influence in Castile up until the early 14th century. The art of this workshop is characterised by marked naturalism and vivid emotional expressionism.

Ornamental sculpture at León Cathedral appears in the portal on the south transept, as well as on the north transept and in the triple portal on the west facade, which was probably designed by Master Enrique. The centre of the west portal is taken up by an apocalyptic vision of the Last Judgement, portrayed as a *deesis,* while the portals in the Epistle

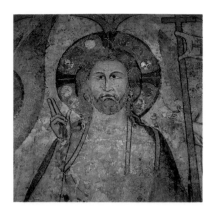

JOAN OLIVER: mural painting in the refectory, 1330. Museo catedralicio de Navarra, Pamplona.

Joan Oliver's linearity suggests he had knowledge of the miniaturist school at Westminster, and also reveals features in common with French and English works produced in territories that had then come under English rule as a result of the Hundred Years' War. This large-scale mural reredos is made up of three panels, featuring scenes from the Passion, centred by the Crucifixion, and scenes from the Passion and Resurrection depicted on the upper and lower panel respectively.

nave of St Francis, and that of the Gospel nave of St John, are dedicated to the Virgin Mary. The sculptors may have based their work on the model of the defunct portals at Burgos, as the subject of the Last Judgement is certainly derived from the Coronería Porticol, while the theme on the south portal is derived from the Sarmental Portico. Whereas formal eclecticism in relations with Amiens and Rheims was established at Burgos Cathedral, in León this is augmented by its direct relationship with Burgos, which is particularly noticeable in the Judgment Portal.

At Toledo Cathedral, the end-of-century Clock Portal heralded the beginning of the last architectural sculptural ensemble of the great 13th-century cathedrals. The door on the west side was sculpted in the 14th century, while the one on the south side was replaced in the 15th century by the magnificent Portal of Lions, by Annequin of Brussels and his workshop. The Clock Portal, also known as the Portal of the Kings or the Chapinería, features the detailed story of Jesus' childhood, ending with his emergence into public life at the Wedding at Cana. As in the most advanced French churches, such as the north portico at Rheims, the enormous tympanum is divided into four registers, like friezes, separated by some architectural feature.

Alfonso X the Wise turned his Court into a temple of learning precisely during the age of splendour of the Castilian cathedrals. He surrounded himself with Moorish, Christian and Jewish sages in an ambience in which the study of history, astronomy and physics coexisted with festivity, love and the commonplace. Such famous titles as the *Cantigas de Santa María* ('Canticles of Holy Mary'), the *Grande e General Storia* ('Great, General History'), the *Libro del saber de Astronomía* ('Book of Astronomical Learning'), the *Lapidario* ('Lapidary') and the *Libro de los juegos* ('Book of Games') were written in his scriptoria and illustrated using the most advanced pictorial techniques of the time. Although this art cannot be regarded as *Gothic* in the French sense of the term, the miniatures featured do reflect one of the crowning moments of 13th century art in Europe, with Byzantine, Moorish, southern Italian and possibly French influences coalescing within the framework of contemporary Castilian life.

Together with manuscript illumination, stained glass, which was essential to the lighting of French-style Gothic churches, was the major focus of line-based pictorial art during the 13th century. However, little is now known of that art in Spain's cathedrals, as but a few works and studies have survived the test of time. At León, for instance, restoration work, damage, removals and dismantling have left few examples ascribable to that century: the best known surviving stained glass is known as 'The Hunt'.

Textiles were likewise rendered in an eminently pictorial style associated with the luxury and sumptuousness of the Church and Court. They breathe an unmistakably Islamic influence, even though they may not have been produced in Islamic workshops, which were traditionally far more accomplished at this genre. Some fine examples are the brocaded robe of Fernando de la Cerda (Las Huelgas Museum, Burgos), the winding sheet of Ferdinand III (Seville Cathedral) and the waterproof cloak of Archbishop Sancho (Toledo Cathedral).

Castilian art of the 14th century did not match the intensity or monumental quality of the previous century. In this respect, it should be recalled that, as in Aragon, much of the production was Mudéjar, largely unrelated to trends in Christian worship in Europe, particularly as far as secular architecture was concerned. The Church was still the leading patron of the arts, and work on the three major cathedrals—Burgos, Toledo and León— continued unabated. By the second decade of the century, the cloister at Burgos had been completed, while work on the chapterhouse had begun, as had that of the Master Rodrigo Alfonso who, at the end of the century, had embarked on the cloister wings at Toledo Cathedral. New buildings were also raised, including the cathedrals of Palencia, Badajoz, Murcia and Oviedo.

The same was true, although to a lesser extent, of the figurative, sculptural and pictorial arts, although greater emphasis was laid on expressivenes and the heightening of anecdotal details, with a clear tendency towards symbology, while the expositional clarity

of the previous period was furthered. Artworks made by the Burgos and León workshops continued to be disseminated, while production associated with funerary rites, tombs and chapels was stepped up. Funerary art often entailed a combination of sculpture and painting, as in the cloister chapel and the tombs of Gonzalo de Hinojosa, Lope de Fontecha and Domingo de Arroyuelo at Burgos, while two major centres, in Toledo and Álava, were consolidated. Around 1337, the Toledo centre was employed on the west facade of the cathedral, one of the most monumental frontispieces in Hispanic art where, on the tympanum in the central portal, the customary 13th-century subject of the Last Judgement has been replaced by that of the Virgin Mary placing the chasuble on St Ildefonsus, the patron of Toledo. In Álava, the sculpture in the three porticoes of the main facade of Vitoria Cathedral is reminiscent of the Coronería at Burgos, and of the artisans who worked in Pamplona Cathedral. This is one of the last great works of Castilian monumental sculpture, matched by the portals at the churches of San Pedro and San Miguel in the same city and, above all, by that of Santa María de los Reyes de Laguardia.

In comparison with architecture and sculpture, pictorial art, as stressed by studies based on the enduring trend of line drawing in both murals and miniatures, started falling behind the rest of Europe, particularly Italy, being overshadowed by the rise of the so-called 'Italian current' in south-eastern Spain during the fourth decade of the century. The Italian presence in Castile was unassuming and restricted to but a few instances, judging from surviving examples. Indeed, renewal did not come until 1400, when the area was suddenly exposed to the fully-fledged 'International' style. Nevertheless, a noteworthy example was the frescoes in the chapel of San Blas at Toledo Cathedral (1395–1396), commissioned by Archbishop Pedro Tenorio and executed under the direction of the Florentine painter Gherardo Starnina, and the Hispanic Juan Rodríguez de Toledo. Others include the two retables in Murcia Cathedral, painted by Barnabá de Módena, related by the figures of the donors to the infante Don Manuel and his daughter Juana, the wife of Henry II of Castile, and the repainted Virgen de la Antigua in Seville Cathedral.

The Spread of Gothic Art in the Kingdom of Navarre

Throughout the 13th century and in the early 14th, the arts were heavily patronised by the French dynasty that had ascended to the throne after the death of Sancho the Strong in 1234. It reached its zenith during the reign of Joan II, the daughter of Louis of Navarre and Margaret of Burgundy, and her husband, Philip III the Noble, the son of the Count of Évreux. Navarrese court art of the time, which occasionally drew on contributions by the Church and even the bourgeoisie, was biased towards the plastic arts and centred on the capital, Pamplona, and its environs.

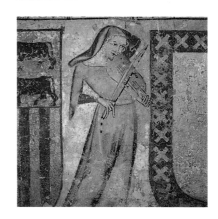

Navarre's artistic ties to France were already in evidence by the middle of the 13th century in the hospital church of Roncesvalles, founded by King Sancho, one of the most important churches on the Road to Santiago. The French associations could also be seen in the rib vaulting and arcaded porticoes on the church facades of Santo Sepulcro de Estella (1272), San Saturnino del Cerco, in Artajona, and Santa María la Real in Olite. Similarly, Navarre's contacts with southern France, particularly Languedoc, were attested to in the church of San Cernín in Pamplona, with its single nave and roofing supported by sturdy buttresses, dating from the last quarter of the 13th century, and at Santa María de Viana, dating from the end of the 13th century, with its three naves, and chapels set between the buttresses. The Navarrese Gothic reached its height in Court architecture, produced by royal workshops, as in the castles of Cortes and Marcilla, and the palace of the Prince of Viana in Sangüesa, the remains of the palace-castle of Tafalla and, in particular, the royal palace of Olite.

Gothic innovations in sculpture were introduced via the Road to Santiago, where they appeared in Romanesque buildings at towns along the route, such as San Pedro de la Rúa, San Miguel and the royal palace at Estella. Tentative change was visible at the colle-

giate church of Tudela, but did not become consolidated until the end of the 13th century, in architecture related to court circles. One of the first works of this kind was the portal at the church of San Saturnino del Cerco in Artajona, where the effigies shown kneeling before the saint have been identified as Philip the Handsome of France and Joan of Navarre. They also appear on the facade of Santa María de Olite, where the images of the Apostles have been shifted from the jambs and placed under arcatures with templets on either side of the portal, setting a precedent that would be taken up in Navarre the following century (Santo Sepulcro de Estella).

However, the epitome of Navarrese Gothic art is to be found in the Cathedral of Pamplona, the capital of the kingdom. The cathedral cloister was begun at the end of the 13th century, but the prime mover behind subsequent, major construction work on the building was Bishop Arnaldo de Barbazán (1318–1355). Several sculpture workshops were instrumental in carving the gossamer tracery in the galleries, in addition to the ornamentation of capitals, brackets and bosses, as exemplified in the funerary Barbazana chapel and in the refectory. This chapel, based on a central, square-plan hall, is surmounted by a huge, eight-pointed stellar vault which, together with that of the chapterhouse at Burgos Cathedral, is the first example of this type on the Iberian Peninsula. In 1330, Juan Pérez de Estella commissioned the refectory to be built, and Juan Oliver, who at that time was directing pictorial decoration in the cloisters, was appointed to paint it. The refectory is a vaulted, rectangular hall in which the back wall, which once bore a mural reredos by Master Oliver (now housed in the Museum of Navarre), was especially designed around the two glazed openings and rose window as the major source of light, with English-style tracery prefiguring the Flamboyant.

At about the same time as the refectory, or shortly before it, he directed work on the sculptural group on the portal of Nuestra Señora del Amparo, which leads into the cathedral cloister. The subject of this group is the Dormition of Our Lady, depicted as a girl being taken up to heaven by Christ, amidst incense-bearing angels and the expressively rendered Apostles. The highly dramatic treatment of this portal, matched by that of the statues of SS Peter and Paul on the door of the Barbazana chapel, is generally thought to be evocative of southern German sculpture dating from circa 1300. The presence of this door also gives credence to the iconography on the magnificent *Puerta Preciosa,* or 'Precious Door', which leads into the old dormitory. It is so called on account of the liturgical text that was once chanted when passing through it. It is dedicated to the death and crowning of the Virgin Mary and based on apocryphal writings. Its date and attribution remain unknown but, by extrapolating the dating put forward for the refectory, it would be later than the latter. Bearing in mind its similarity to the Epiphany sculptural group by Jacques Perut, in terms of its French conceptualisation, it is likely to date from the period 1340–1360. The polychromed refectory brackets, featuring naturalistic and mythical subjects and dating from circa 1330, and the magnificent reclining figure on the tomb of Bishop Barbazán, round off the remarkable sculptural ensemble of Pamplona Cathedral. When, in the late 14th century, building work on the cloister had reached an advanced stage, the Romanesque church collapsed, prompting the chapter, under the auspices of the Crown, to commission a new church to be built in 1393–1394. Work on the cathedral, in addition to the enlargement of the royal palace of Olite and the building of the archaistic and monumental church of Santa María de Viana, accounted for most of the activity in the building sector during the 15th century.

Pictorial art in Navarre, with mural painting as the major genre, initially took the form of an extension of the 1200 style far beyond its natural lifespan, as rendered by the master of the church of San Saturnino del Cerco at Artajona (circa 1300), and in its sequel in the apse of Artaiz (Museo de Arte de Navarra, Pamplona) and the frontal panels of Eguillor in San Pedro and Arteta (Museu Nacional d'Art de Catalunya, Barcelona), among others. This style was radically transformed through the aforementioned work by Master Juan Oliver in the refectory at Pamplona Cathedral and, as was the case with sculpture, was developed to high standards owing to the involvement of foreign artists. Oliver's linearity, which is purported to be an English derivation, would suggest he knew the miniaturist school at West-

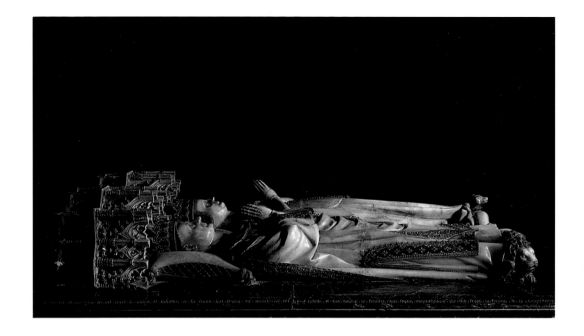

minster. His oeuvre also has points in common with French and English works executed in areas then belonging to the English Crown. Juan Oliver is also documented as having worked with Pierre del Pueg at Avignon in 1316, a fact which has prompted another line of identification. The great mural reredos in the refectory is divided into three panels, featuring scenes from the Passion—with the Crucifixion as the central theme—in the middle, a sequence from the Passion, above, and another from the Resurrection, below.

The architect and sculptor, Janin de Lome of Tournai, was instrumental in introducing the northern-European International style into the Court of Charles III the Noble in the first half of the 15th century. He supervised building work on Pamplona Cathedral, but is better known as the sculptor of the royal tombs of King Charles and his wife, Eleanor of Castile. His art was perpetuated in such sepulchral sculpture as the tomb of Bishop Sancho Sánchez de Oteiza, also in the Cathedral, and that of Chancellor Villaespesa in Toledo Cathedral.

In the second half of the 15th century, Navarre went through a period of marked strife and unrest, leading, in 1512, to its being annexed by the Kingdom of Castile. This was an unproductive period, as far as art was concerned, despite the endeavours of artists who continued to work in the service of the Church. A prominent example in this respect is the painter Pedro Díaz de Oviedo, who was also active and had a workshop in Aragon. One of his finest works, the reredos at the high altar in the collegiate church of Tudela (1487–1494), reveals affinities with the naturalism of Bartolomé Bermejo.

The 15th Century and the Resurgence of Architectural Enterprises in Castilian Crown Territories

The pluralism and diversification that characterised European art from 1400 onwards did not arise within the same time frame in the territories ruled by Castile. During the 14th century, the political crisis took its toll in the field of art, and it was not until full recovery was achieved in the mid-15th century that art began to flourish anew in the major towns and cities, although now it displayed two northern influences: Flemish and German. Seville, the erstwhile capital of a Moorish kingdom, was the first city to embark on major art projects, which began with the construction of a new, monumental cathedral. Toledo, Burgos and, to a lesser extent, León, followed suit, with changes being commissioned in the structure and ornamentation of their cathedrals. Their production coincided with what was the final stage of the Flamboyant Gothic in Europe. During the second half of the century, in Castile, this was fused with the coloured ornamentation of 14th-century Mudéjar, giving rise to the so-called Hispano-Flemish Gothic style.

Plan of Seville Cathedral.

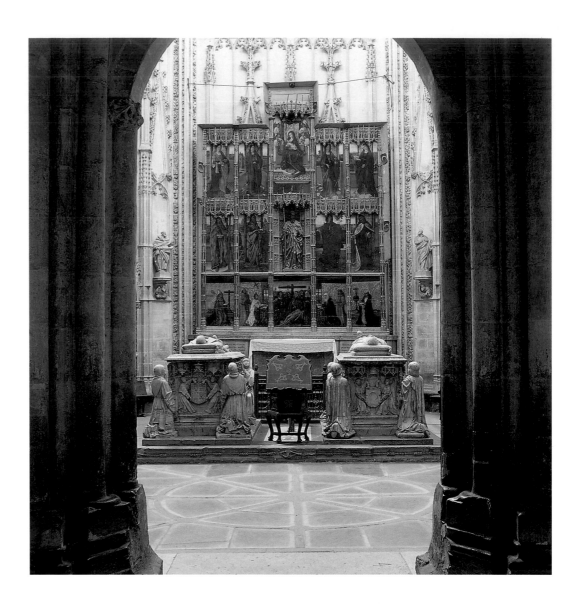

ANNEQUIN of Brussels & workshop:
Chapel of the Constable, Don Álvaro
de Luna, mid-15th century (after 1443).
Toledo Cathedral.

In 1401, the chapter of Seville Cathedral commissioned a new cathedral to be built, in what was a revival of the monumental sense attached to the construction of large-scale cathedrals, as embodied in the classical examples of Burgos, León and Toledo. Indeed, Seville is now regarded as the last of the great wholly Gothic cathedrals. The building then being used was an old, run-down Almohad mosque, prompting the decision to build a church of fine stonework that would break with local tradition, largely influenced by Mudéjar techniques at the time, which led to an influx into the city of a large number of outside artists. The building was erected on the site of the aforementioned mosque, of which the only part left standing was the court or *sha,* now known as the *Patio de los Naranjos* ('Court of Orange Trees'), which was put to use as a cloister attached to the north wall and the minaret. The latter, which was turned into a belltower and later became famous as La Giralda, is located on the north-east corner of the complex. Construction work began in 1402 on the west side of the building, designed in all likelihood by the Master Alonso Martínez, although this cannot be confirmed, as the plans were destroyed in the fire that gutted the Madrid Alcázar in 1734. In 1432, building work had reached the presbytery. The edifice was projected on a colossal scale, with huge arcades supported on large pillars. It consists of five naves, which run up to the transept without breaking the rectangular arrangement of the perimeter. Its enormous proportions led the building process to become comparatively sluggish, and progress was also hampered by damage sustained in an earthquake in 1431. The choir had not yet reached completion in 1494, and the cathedral was only consecrated in 1519.

The Court of John II at Toledo, which had close associations with that of Burgundy in its opulence and splendour, was renowned for its fine music and literature. And, with

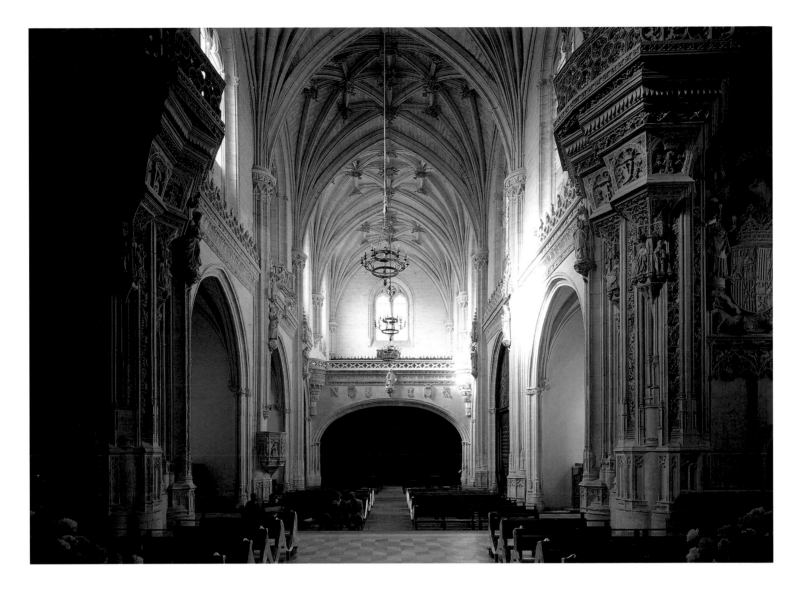

the arrival in that city of Annequin of Brussels and his assistants around the year 1443, the city embarked on a full-scale revival of the Flamboyant Gothic in art. Annequin of Brussels surrounded himself with a highly accomplished retinue of architects, engravers and sculptors, who brought with them Burgundian tastes, and who included Egas Cueman, Antón Martínez of Brussels and Pedro Guas. Annequin supervised the building of the octagonal-plan Chapel of the Constable, with its Flamboyant stellar vault, in the cathedral chancel. It served as the model for a similar chapel in Burgos Cathedral by Pedro Fernández de Velasco, and for the Vélez chapel in Murcia Cathedral. He is documented as master builder of the cathedral in 1448 and is attributed with the design of the Portal of the Lions, which he built and sculpted between 1445 and 1465. He also produced the octagonal finial on the belltower.

The style of Annequin of Brussels was furthered in Toledo by Juan Guas, a royally appointed architect who worked on the cathedral and the Casa Mendoza. His work is a fusion of the Flemish style, and decorative features and arrangements based on the Toledan Mudéjar. His career was far-reaching, as he was also active on the cathedrals of Ávila and Segovia, and was commissioned by Fray Alonso de Burgos to work on the college of San Gregorio at Valladolid. However, his undisputed masterpieces are his work in the monastery of San Juan de los Reyes at Toledo, founded by Isabella the Catholic, of which the original plans date from 1477, and the Palace of the Infantado at Guadalajara, commissioned by the Mendoza family.

Other artists associated with Juan Guas also emerged in the circle of Annequin of Brussels, notably the sons of the sculptor Egas Cueman, Anton and Enrique Egas. Anton originated designs based on the style of Juan Guas, such as the church of San Andrés in

JOHN OF COLOGNE: openwork spires on the facade towers; second third of the 15th century, Burgos Cathedral.

Toledo, and the exquisite church at Alcalá de Henares, while Enrique designed such major works as the Royal Chapel at Granada and the Royal Hospital at Santiago de Compostela.

At Burgos, which had been pivotal in the emergence and spread of the Gothic style in the 13th century, the last period was also ushered in by the arrival of a northern artist, Hans or John of Cologne. Through the mediation of Bishop Alonso of Cartagena, he designed the chapels of the Visitation and Santa Ana in Burgos Cathedral, the facade towers, with bold, openwork spires, and the original dome over the crossing (destroyed in 1539, and rebuilt along the same lines). Although less elaborate than Toledan style, that of John of Cologne nevertheless adhered to the decorative extravagance of contemporary Germanic art. His oeuvre was continued by his son, Simon, who started work circa 1480 and did justice to his father's name with the use of a style which combined northern and Islamic elements. His masterpiece, the octagonal Chapel of the Constable, also known as the Chapel of the Purification (1484–1494), set in the centre of the ambulatory in Burgos Cathedral, breathes the spatial grandeur associated with the Germanic Gothic, a harbinger of the spatial treatment of 16th-century Gothic architecture to come, with the use of Flamboyant forms and elements taken from the Islamic tradition, prominent among which is the openwork webbing in the rib vault. This is a characteristic of the Burgos school, which harks back to the models of Almoravid times. Simon of Cologne also worked in the environs of Burgos, notably at the church of Santa Clara de Medina de Pomar, the cloister of San Salvador de Oña and on two of the facades most emblematic of the Hispano-Flemish style: Santa María de Aranda de Duero, designed like a huge stone retable, with a profusion of scale ornamentation (one of the hallmarks of the Burgos school), and San Pablo de Valladolid, in which, in 1486, he designed the decoration and the lower scenes on the basket arch.

Activity in León was of a lesser order. Outside craftsmen are documented in the city's stained-glass workshops at the beginning of the century, while the full-blown Flemish renewal was introduced circa 1430 by William of Rohan, who worked on the Chapel of the Contador Saldaña at the convent of Santa Clara de Tordesilla (Valladolid). Another prominent figure was Master Jusquin, who directed work on the cathedral from 1440 to 1470, including the elevation of the southern tower or Clocktower, the pediment on the north gable of the crossing, and the tower known as the Queen's Chair. The relationship with Burgos is visible in the arrangement of the point and openwork spire on the Clocktower.

Lastly, Gothic cathedrals were also built in other important Castilian cities, including Palencia and Valladolid. These were begun in the 15th century and completed in the 16th, when construction work on the New Cathedral of Salamanca and Segovia Cathedral marked the continuation of Gothic style in the Renaissance period.

Burgundian and Flemish Sculpture in Castile

Throughout the 15th century and in the early 16th, Castilian sculpture lived out one of its finest moments, well abreast of events in Western Europe, with the sole exception of Italian models, which then responded to a different artistic conception—the Renaissance. The ties to Burgundy, the Low Countries and the Germanic world were evident in the work of a large number of accomplished masters and of run-of-the-mill workshops that drew on a wide variety of materials and techniques. They first worked to Burgundian tenets, but subsequently incorporated Flemish naturalism and Germanic expressionism, often in close collaboration with painters, becoming past masters in portraying the personalised expression of figures, and the relationship between them, while handling secondary themes and personality traits with skill and attention to detail.

The elegance, gestures and individuality characteristic of Burgundian forms are particularly forceful in the funerary sculpture of the third decade of the 15th century, and in the reclining images and those of saints in the chapel of the Contador Fernán López de Saldaña at the convent of Santa Clara de Tordesillas (1430–1435), as well as on the tomb of

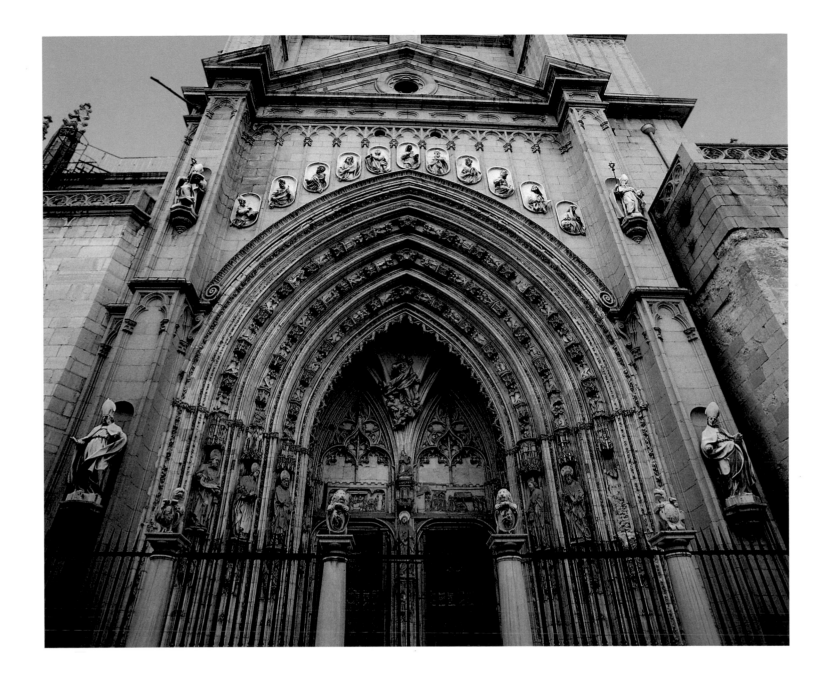

ANNEQUIN OF BRUSSELS & workshop: Portal of the Lions, 1445-1465. Toledo Cathedral.

Bishop Álvaro Carrillo de Albornoz (1434–1446) in Sigüenza Cathedral, and on that of the *Adelantado Mayor* of Castile, Don Gómez Manrique, and his wife Sancha de Rojas, in the monastery of Fresdeval. As the century progressed, the arrival of artists from abroad led to the emergence of new forms in the leading architectural and sculptural workshops, which were active at the great cathedrals of Toledo and Burgos and in their respective spheres of influence. Projects were first directed by the aforementioned Annequin of Brussels and Simon of Cologne, while in the second half of the century, Egas Cueman, Master Sebastián and Rodrigo Alemán worked at Toledo. The art of Annequin's brother, Cueman, who is thought to have arrived shortly before 1450, and who died in 1495, was closer to the Flemish style than the Burgundian. One of his first assignments was the choir seating in Cuenca Cathedral, which is now in the collegiate church at Belmonte. Commissioned by Bishop Lope Barrientos in 1454, it is considered to be the first in a series of similar undertakings in Castile. During that period, Cueman also worked on the Portal of Lions in the cathedral, in collaboration with Rodrigo Alemán, and in 1458 sculpted the tomb of Gonzalo de Illescas in the monastery of Guadalupe, followed in 1467–1468 by the tomb of Aldonso de Velasco and his wife, in which the deceased are depicted kneeling at prayer—an attitude that was new to Castile but which subsequently became very popular. A major workshop grew

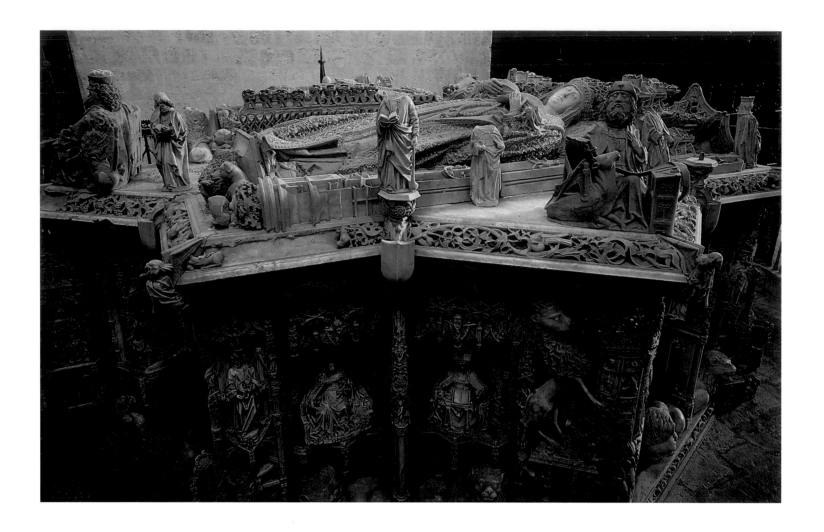

GIL DE SILOÉ: tomb of John II & Isabella of Portugal, 1486-1493. Miraflores Charterhouse, Burgos.

GIL DE SILOÉ (sculptor) & DIEGO DE LA CRUZ (gilder): retable, central detail, 1496-1499. Miraflores Charterhouse, Burgos.

up around the figure of Cueman. It was active in Toledo, Ávila and Segovia, and it is in this workshop that Master Sebastián is thought to have been trained. The latter sculpted the tombs of Álvaro de Luna and Juan Pimentel in the Luna chapel in 1489. Rodrigo Alemán was active during the last decade of the century. Regarded as the finest sculptor in wood, his masterpiece is the lower seating stalls in the choir at Toledo Cathedral, begun in 1489 and completed in 1495.

In Burgos, the close collaboration between architects and sculptors centred around the figure of John of Cologne and the continuation of his work through his son Simon who, simultaneously with his architectural practice, directed important sculpture workshops. Another pivotal figure in this respect was Gil de Siloé, known as Gil of Antwerp. The Cologne family sculpted ornamental works on the aforementioned buildings, their hallmarks being visible in statues on the towers and the upper part of the main facade in the cathedral, and in a number of tombs, retables and facades around Castile.

Gil de Siloé is regarded as the leading exponent of sculpture in the Burgos school during the last few decades of the 15th century. He had first-hand knowledge of contemporary German art, particularly that of the lower Rhine, and was exceptionally adept at sculpting wood and alabaster. He works were based on geometrical designs and lavishly adorned with architectures, figures and ornamentation, while in his compositions detail was sacrificed to the grandeur of the ensemble. Siloé's crowning achievement and one of the most unique works of late-Gothic art in Europe was at the Miraflores Charterhouse, where he sculpted the tombs of John II and Isabella of Portugal, the parents of Queen Isabella (1486–1493), in addition to that of the Infante Alonso, executed in 1493, and the retable at the high altar, dating from 1499. The tomb of the monarchs has a star plan, with the two figures reclining on a bed, both turned slightly outwards, while a novelty is provided by the depiction of the king reading. The altarpiece, for which he was commissioned together with the painter Diego de la Cruz in 1496, is a gilded, polychromed wood carving whose

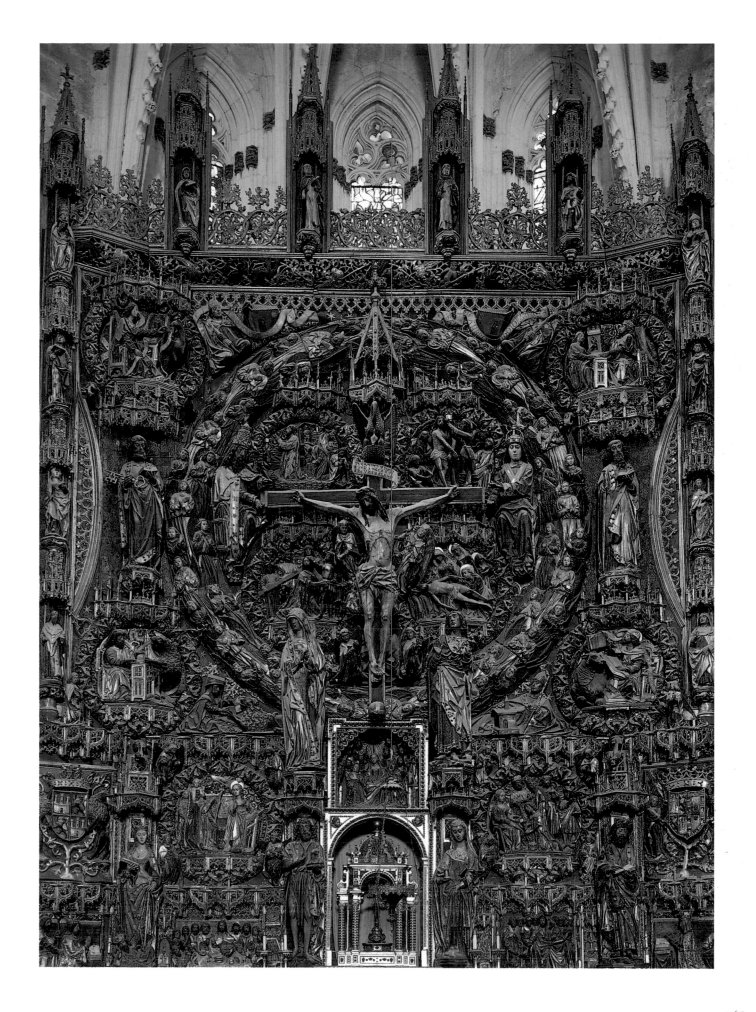

composition was inspired by a German rosary, with square and circular areas arranged around a central area dedicated to the Holy Trinity.

From the mid-15th century onwards, the sculptural work of the Castilian goldsmiths in Burgos, Valladolid and Toledo came into line with the aforementioned currents. The arrival, circa 1500, of the German goldsmith, Enrique de Arfe, born in Harff and resident in Cologne, brought about a qualitative change in Castilian gold and silversmithing. He produced monumental monstrances, of which the most prominent examples are the now missing monstrance of León (1501), that of Sahagún, one in Córdoba (1518) and another in Toledo (1515–1524), which marked the continuity of the Flamboyant ornamental tradition until well into the 16th century, although his figures and scenes were determined by the new classicist aesthetic.

In Andalusia, Seville first came to the forefront as a leading centre of sculpture when Lorenzo Mercadante of Brittany sculpted the *Virgen del Madroño* ('Virgin of the Strawberry Tree') and the alabaster tomb of Cardinal Juan de Cervantes, which was completed in 1458. Between 1464 and 1467 he worked on the fired clay sculpture on the west portals of the cathedral, known as the Portals of Baptism and the Birth. He is also attributed with the relief work on the tympanum of the latter. His figural imprint is decisive and, owing to the ductility of the material he sculpted, his volumes display a striking interplay of light. As of 1478, Mercadante's workshop found its continuity in the figure of Nufro Sánchez and, from 1487 to 1507, that of Pedro Millán. At the end of the century, this workshop was commissioned to sculpt a huge reredos at the high altar in Seville Cathedral, the design being attributed to Pieter Dancart (1482), on which Jorge Fernández Alemán also worked in the early 16th century.

Castilian Painting in the 15th Century: Between Eclecticism and Flemishness

During the first half of the 15th century, the situation of pictorial genres in Castile was, comparatively speaking, rather lacklustre, albeit influenced by the same innovative trends that prevailed in architecture and sculpture. The international current made late inroads into sluggish local tradition through the presence of foreign artists in several places. There was no Gothic painting to speak of prior to the arrival in León of Nicolás Francés, and the Delli brothers in Salamanca, although a few works did exist which suggest that certain Court forms might have been introduced into workshops before that time.

Nicolás Francés, who is thought to have been of Burgundian origin, was active in León from 1434 to 1468. His masterpiece was the altarpiece in the cathedral, of which only a few, rather dilapidated and reassembled fragments have survived on the high altar. He also painted the retable at La Bañeza (Prado Museum, Madrid), dedicated to the Virgin Mary and St Francis. His eclectic oeuvre was the result of a mix between Italian and Burgundian forms.

The reredos at the high altar of Salamanca Cathedral, executed by Dello Delli, who was active in this city in 1443, is an Italian variation on international styles with overtones of the work of Gentile da Fabriano. It features an extensive Gospel cycle portrayed on fifty-three panels, rounded off by a Last Judgement painted on the apse vault in 1445 by Nicolás Florentino, whose pictorial approach is akin to that of the Renaissance.

The presence of international styles in Seville is evinced in the panels executed by Juan Hispalense, which include a triptych of the Madonna and Child, flanked by SS Peter and Paul, now in the Museo Lázaro Galdeano, Madrid, and a retable by García Fernández which Alfonso de Fonseca, the archbishop of Seville, donated to the Ursuline convent in Salamanca. However, the finest example of cultured, refined art is to be found in the manuscripts illuminated by Pedro de Toledo, the old 'Master of the Cypresses', a writer, painter and humanist in the Hispanic tradition, who was in Rome in 1431. The storied narrative of his *Misal* (1428–1433) and *Comune Sanctorum* (1434–1436) are indebted to Italian decorative forms, with an admix of Franco-Burgundian origin.

In Castile, where neither Italian nor the International Gothic styles were ever quite to the liking of the art patrons, Flemish influences found their culminating and most homogeneous moment in painting, particularly in the late 15th and early 16th century. Triptychs and panels from northern climes became objects of devotion, and items to be collected and imitated in Castilian society, as attested to in Queen Isabella the Catholic's collection in the Royal Chapel at Granada. Melchor Alemán, Michel Sittow (of Baltic origin), John of Flanders (who knew the work of Gerard David and Hugo van der Goes) and the Picard painter and miniaturist Felipe Morras were among the painters employed by the queen. Shortly after the middle of the century, the nobility, particularly the Mendoza family, were also instrumental in promoting Flemish styles in Castilian workshops through the figure of Jorge Inglés, a painter and miniaturist who, in June 1455, completed his well-known retable of the Virgin. Commissioned by the Marquis of Santillana, Inglés executed this work for Buitrago Hospital. It is partly preserved in the Duque del Infantado Collection, Madrid.

The most popular exponent of Hispano-Flemish painting in Castile was Fernando Gállego, who was born in Salamanca in 1440. With his grounding in the expressive realism of early-Flemish art, Gállego subsequently adopted features of German engraving reminiscent of the work of Dirk Bouts and Vell Stross, tinged with pathos and the essence of drama, although his indebtedness to northern currents did not prevent him from developing a form of realism adapted to his Castilian milieu, as can be seen in his handling of physiognomy and in certain peculiarities of his landscape backgrounds. One of his most representative works is his first altarpiece, dedicated to St Ildefonsus and commissioned by Cardinal Mella for Zamora Cathedral (circa 1473), painted after a sojourn in Flanders. However, he was most active in Salamanca where, in the cathedral, he executed the retable of the Virgin, St Andrew and St Christopher, in which the dramatic tension of such earlier works as his Pietà (circa 1470, Prado Museum, Madrid) gives way to a penchant for landscape and other spatial features. From 1480 to 1490 he was commissioned to paint a tragic Calvary, now in the Prado, but his most famous work from that period is undoubtedly his contribution on the ceiling of Salamanca University library, in which he reveals a humanistic sentiment in his allegory of the stars and constellations, inspired by the Italian *Poeticon Astronomicum* of 1485.

The influence of the Castilian centres of Flemish painting, above all, Toledo, spread southwards. In Andalusia, the renewal brought by Flemish art merged with the tradition that had developed in 14th-century workshops at Córdoba and Seville. Bartolomé Bermejo was born in Córdoba and he is thought to have first trained there with Pedro de Córdoba, the most celebrated painter of the last decades of the 15th century, who executed the panel of the *Annunciation* in the mosque-cathedral, a painting with an intricate composition and iconography, commissioned by the canon Diego Sánchez de Castro in 1475.

The reign of Isabella the Catholic (1474–1504) was one of comparative splendour in Castile, as it gave impetus to artistic creation and spawned a host of workshops in Burgos, Segovia, León, Asturias and Galicia. To some extent, these workshops furthered the tradition of the aforementioned great artists, and others who also have a place in the vast panorama of Hispano-Flemish painting, attesting to the fact that this was one of the most eminently Hispanic of pictorial currents in the Middle Ages.

Early-Gothic Art in the Kingdom of Aragon

In the 13th century, the Romanesque tradition still endured in the kingdom of Aragon, and it was only in the second half of the century that innovations extraneous to the status quo there made tentative inroads in the field of architecture and fine art. Neither popular art, which had gained considerable ascendancy, nor monumental works, which echoed the more innovative features, showed any signs of ever wholeheartedly embracing the Gothic style, which was initially associated with France and, as described earlier, first made its appearance on the Iberian Peninsula in the great cathedrals of Castile.

LORENZO MERCADANTE OF BRITTANY: fired-clay figures on the Baptism Portal, 1464-1467. Seville Cathedral.

The northern origin of Lorenzo Mercadante, who came to Seville in 1454, apparently at the request of the cathedral chapter, is clearly reflected in the style of the figures adorning the jambs of the Baptism and Birth portals. Mercadante's unique style comes through in the affable, enigmatic hint of a smile in the female figures of SS Rufina, Justa and Florentina, and in their half-closed eyes and fleshy eyelids. Also apparent in the handling of drapery and the individuality of the faces is the influence of Burgundian realism. His work on the facade of Seville Cathedral became a veritable school for some artists, including Nuño Sánchez, who collaborated in the carving of the choir seating and in the dome, and Pedro Millán, who assisted the latter in the archivolts.

The eclecticism prevalent in Castilian painting during the first half of the 15th century is apparent in the central panel of this retable by Nicolás Francés. The strain of the International Gothic can be seen in the choice of an affable subject, lacking any dramatism, and in the gentle figures and lines. The central panel and eight other compartments making up this retable show great concern for space, which may be related to the presence of Nicolás Florentino in Salamanca. The baldachin over the Virgin Mary, which lacks any linear perspective, sets up an internal space containing both the main group and two kneeling angel musicians, in addition to a second plane, set further back, with two other larger angels, the two planes connecting via the openings in the architectural structure.

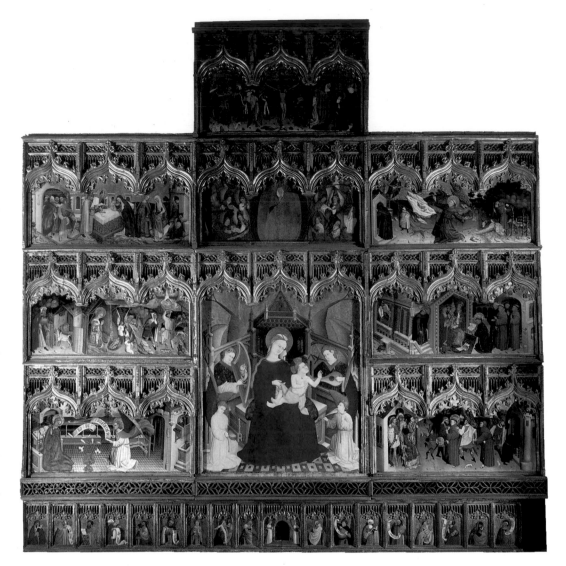

A notable exception to this was in Catalonia where, in the late 12th and early 13th century, Gothic structures were adopted by the Cistercian order in some parts of their monasteries, albeit set within the continuity of the walled enclosure and the horizontality of form characteristic of the southern aesthetic. The monasteries of Poblet and Santes Creus in the province of Tarragona, which were subsequently to house the pantheon of the monarchs of Aragon, are the finest examples of this trend. Their austere, refined chapterhouses, quadrangular in shape, with groin vaults resting on walls and slender columns, are masterpieces of Hispanic art, as are the great communal dormitories with their wooden, pitched roofing. The roof slopes are supported by huge, pointed diaphragm arches ending in large brackets with ogee moulding, decorated with intertwining plant and other motifs.

The wooden roofing of Poblet and Santes Creus, characteristic of Cistercian architecture and derived from a major Mediterranean tradition, was also used in Templar and Hospitaller buildings, and by the new mendicant orders during their expansion. It also featured in constructions erected during the resettlement of Valencia and Majorca, giving rise to an economical, utilitarian form of architecture based on single-naved buildings with square chancels—featuring side chapels on occasion—although such wooden roofing was gradually replaced by stone. The epitome of these so-called 'Reconquest' churches are San Félix, in Xàtiva, La Sangre, in Lliria, and El Salvador, in Sagunto, in the kingdom of Valencia, while in Majorca the most unique example is the church of Santa Maria de Bellpuig d'Artà, subsequently converted into a farmstead. This Levantine arrangement also appeared in some parts of Aragon, as in the churches of La Sangre, in Sarrión, San Fructuoso, in Bierge, San Miguel, in Barlluenga and San Valero, in Velilla de Cinca. Meanwhile, in Upper

FERNANDO GÁLLEGO: *The Vault of the Zodiac,* a mural from the last quarter of the 15th century, 1480-1490, University of Salamanca.

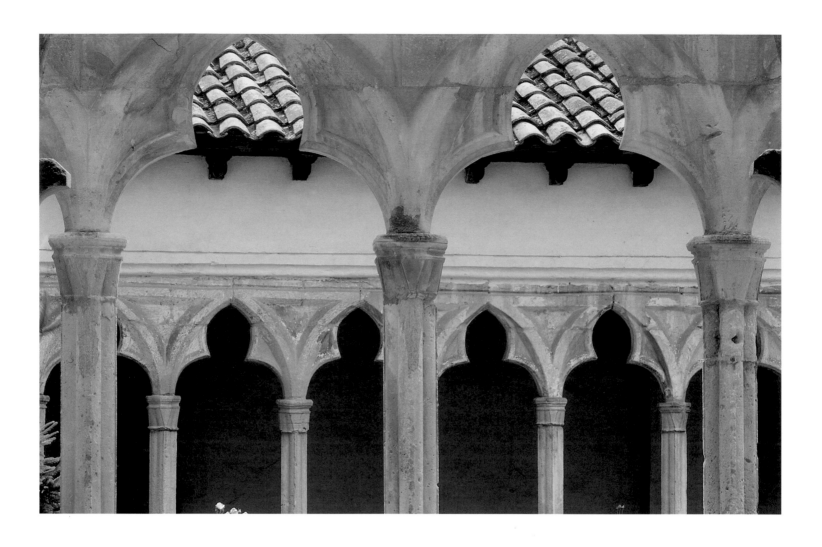

Cloister in the convent of San Francisco at Morella, circa 1280.

Aragon, ribbed vaults appeared in Lanaja, Zuera, Foces and Santa Cruz de la Serós. In Catalonia, the finest example of these constructions, in the province of Tarragona, is the church of San Miguel, in Montblanc, dating from the third quarter of the 13th century.

The earliest surviving building based on the combination of wooden roofing and pointed diaphragm arches in the Catalan sphere of influence is the church at the second Franciscan monastery of Majorca, consecrated in 1244 and now known as Santa Margarita. Probably similar in style was the Franciscan convent church of Barcelona, documented as having been founded in 1229, and enlarged in 1247, with the addition of groin vaulting. The style of these early examples was continued throughout the 13th and 14th century, and especially in buildings begun in the fourth decade of the 13th century. This is evinced in the Franciscan churches of Montblanc, with wooden roofing and diaphragm arches, and those of Vilafranca del Penedés, with groin vaulting, both dating from the last quarter of the century. Other examples include Santo Domingo at Perpignan, single-naved with side chapels between the buttresses, wooden roofing and rib vaulting in the apse and transept, the church and convent of Santa Clara at Tortosa, founded in 1267, and the cloister of San Francisco at Morella, circa 1280, the latter being related to the cloisters at Cotlliure and Majorca, dating from the 14th century.

Building work on the now defunct Dominican convent of Santa Catalina of Barcelona will have begun during the fourth decade of the century. Indeed, the church, cloister, chapterhouse, refectory and kitchen were built between 1243 and some time after 1275. Together with other quarters, they made up a well distributed complex, with church and cloister on the left side. The single-naved church with interconnecting side chapels and a seven-sided apse was rib-vaulted in the nave and chapels. In this instance, no diaphragm arches were used in conjunction with the stone vaulting. Instead, Gothic architectural tenets imported from other lands, probably northern France, were applied in such formulae as the

presbytery with two tiers of windows, although such innovations were adapted to an emerging 'southern' Gothic as from the mid-13th century. The cloister, probably begun circa 1260 and commissioned by Berenguer de Montcada, is also representative of the early-Gothic cloister in Barcelona. Most likely in a similar style, the richly carved portal, contemporary with the Gothic facade at Tarragona Cathedral, must have been a striking innovation in the austere tradition of Catalan facades.

Apart from Franciscan and Dominican buildings, the only other early-Gothic constructions were those commissioned by the monarchy, noteworthy being the quarters built on the orders of James I in this style in the palace-castle of Zuda, Lleida (documented in the *Llibre dels Feyts*), and early-Gothic chapels commissioned by James II of Majorca in the palace-castle of Perpignan. They are the only example of fortified chapels in Catalonia and are structurally related to models in southern France, such as the chapels commissioned by Bishop Pere de Montbui inside a tower in the episcopal palace of Narbonne, dating from 1273–1276, virtually contemporary with those in Perpignan, and reminiscent of palace chapels. The trend subsequently spread to Majorca, as evinced in the chapel of Santa Ana in the Almudaina palace, dating from the first decade of the 14th century, with the typology and structure reappearing in the facade.

Just when construction work on the Royal Chapel at Perpignan was reaching conclusion, a new cathedral was about to be built in Barcelona under royal patronage, the first stone being laid in 1298. It was followed a few years later by a series of buildings designed in the new southern-Gothic Catalan style.

As was the case with architecture, art in the dominions of the Crown of Aragon continued to be based on Romanesque formulae, which in some instances only became exhausted in the 14th century. The earliest Gothic sculpture in Catalonia appeared in Tarragona Cathedral at the hand of Master Bartomeu of Girona, whose oeuvre took a decidedly French turn when in 1277 he was commissioned to sculpt the frontispiece and rose window on the cathedral facade. Documented as active in Tarragona from 1277 to 1295, he also worked on the tomb of Peter the Great in the monastery of Santes Creus, and is attributed with the reclining figure on the tomb of Bernat Olivella in the cathedral chapel of Santa Tecla la Vieja.

In the field of painting, a prominent group of early exponents of a linear Gothic, with some Byzantinesque traces of formal and chromatic nuances adopted from the 1200 style, emerged in Catalonia and Aragon in the mid-13th century. Examples of this can be seen in the diocese of Huesca, where the murals at San Fructuoso de Bierge, dedicated to the life and martyrdom of St Fructuosus, are related to those at San Miguel de Barluenga. Dating from circa 1300 are the paintings in the crossing at San Miguel de Foces, and in the four tombs of the family of the founder of the church, Ximeno de Foces, depicting the Crucifix, the Virgin Mary, the Apostles, scenes from the Gospels and a vast iconography of angels, handled with linearity tempered by subdued colours and distributed between the stained glass windows.

In Catalonia, early-Gothic painting first adhered to Byzantine currents with naturalistic streaks. The leading exponent of this style was the Master of Lluçà, who executed the altar panels in the monastery church of Santa Maria de Lluçà (Museu Episcopal, Vic), the central theme of which is Marian devotion, characteristic of the Gothic. In the last quarter of the century, he painted the frontal in the church of San Miguel de Soriguerola (Museu Nacional d'Art de Catalunya), which observes the normative Gothic features in the portrayal of saints that can be found in other groups of related works. Features common to these are decorative colour contrasts, and trilobulate or ogival architectural frames. The mural paintings of contemporary epic subjects in the Royal Palace and Caldes Palace of Barcelona, both dated circa 1280, attest to the growing importance of the cities and, within them, that of the monarchy and nobility. Lastly, still in Catalonia, research by F. Avril has revealed that, in the second half of the 13th century, French-style illuminated manuscripts were produced on biblical, legal, theological and hagiographic themes. At a time when architecture in Barcelona was still early-Gothic, those manuscripts feature high Gothic forms.

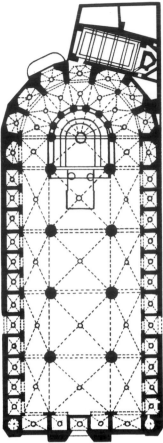

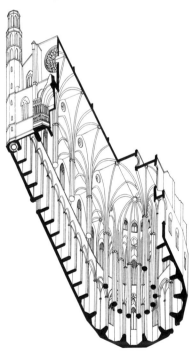

Plan & axonometric section of the church of Santa Maria del Mar, Barcelona.

MASTER BARTOMEU: main portal on the facade of the Apostles, last quarter of the 13th century (after 1277). Tarragona Cathedral.

The Unitary Concept behind Mediterranean Gothic Architecture

Within the framework of the Catalan-Aragonese confederation, in the 14th and part of the 15th century, Catalonia started steering its own political fortunes and, in so doing, also laid down its own guidelines in mainstream art. Aragon had been relegated to a secondary position at that time, despite the fact that Mudéjar architecture enjoyed a period of flowering there during the 14th century. As in Aragon, Mudéjar architecture was prevalent in the countryside in Valencia and Majorca, while in the cities styles came into line with Catalan cultural dictates, eventually bringing them wholly within the European Gothic sphere.

The 'Southern' style of Gothic architecture was first brought to Catalonia at the end of the 13th century by the itinerant mendicant orders, as mentioned earlier, so that by the 14th century their formulae had given rise to a common Mediterranean tradition whose roots actually went back to late-Roman times. Having developed through the Romanesque, when the tradition adapted to the new ideas and techniques established in northern France, it evolved into an indigenous southern, Languedocian style, of which Catalan architecture was an important part. Based on an *ad quadratum* model, the plans and elevations characteristic of Catalan architecture adhered to combinations of that geometrical figure, giving rise to marked horizontality with rectangular volumes in which buttresses were placed inside the walls and, when projecting upwards, tended to be stunted and rarely surmounted by pinnacles. This arrangement can be seen in the cathedrals of Barcelona, Girona, Tortosa and Palma de Majorca.

In interiors, stress was laid on integrating all elements into a unitary whole, in which light played an important part. In the finest examples, such as the church of Santa Maria del Mar, in Barcelona, and the *Llotjas* or commodity exchanges of Palma and Valencia, the concept that held sway was unfragmented space and marked decorative simplicity. Church plans consisted of one or three naves, while side chapels were designed as integral parts of a large hall. Octagonal, circular or helicoidal clustered piers were arranged so as not to impede a view of the whole, and the amplitude of the central nave was achieved through its vast width, rather than through any marked difference in height in comparison with that of the aisles. Rib vaulting was quadripartite, while stellar vaults lacking any superfluous ornamentation were common in chapterhouses and major chapels, as in the cathedrals of Barcelona and Valencia, and the Castelnuovo in Naples. The walls, which bore the thrust of two sets of arches, had infilling reduced to a minimum, and formed vast expanses pierced by glazing. Although used in some churches and monasteries, wooden roofing supported on diaphragm arches was usually reserved for secular architecture, in both public, utilitarian buildings and important civic constructions, whose interiors formed beautiful ensembles adorned with paintings and polychromed groups. Their structural consistency was also evident in polygonal lantern towers (Valencia Cathedral, and the monastery of Poblet), which were usually square, hexagonal or octagonal, as well as in engaged or free-standing belltowers (the Miquelet, in Valencia) and the sculpted portals of such walled enclosures as the monastery of Poblet, the portal of Serrans, in Valencia, and the church of Sant Miquel at Morella.

With the advance of the 15th century, the aforementioned architectural features, garnished with tracery, mouldings, sculptures, portals and rose windows, which helped to retain the spatial unity, were progressively enhanced by figurations and designs from the Burgundian and Flemish schools, as on the portals of the Apostles at the cathedrals of Majorca, Girona and Lleida, the Famboyant tracery in the chancel chapels of La Seo at Tortosa, the cloister of La Seo at Lleida, and the St George chapel in the Generalitat palace in Barcelona. In the 16th and 17th century, these buildings acquired additions on facades, and ornamentation derived from Renaissance and Baroque forms.

This type of construction was applied to both religious and secular buildings. Indeed, the profusion and diversity of such buildings were totally in keeping with the increasingly more consolidated social structures. They sprang up mainly in the major cities and district

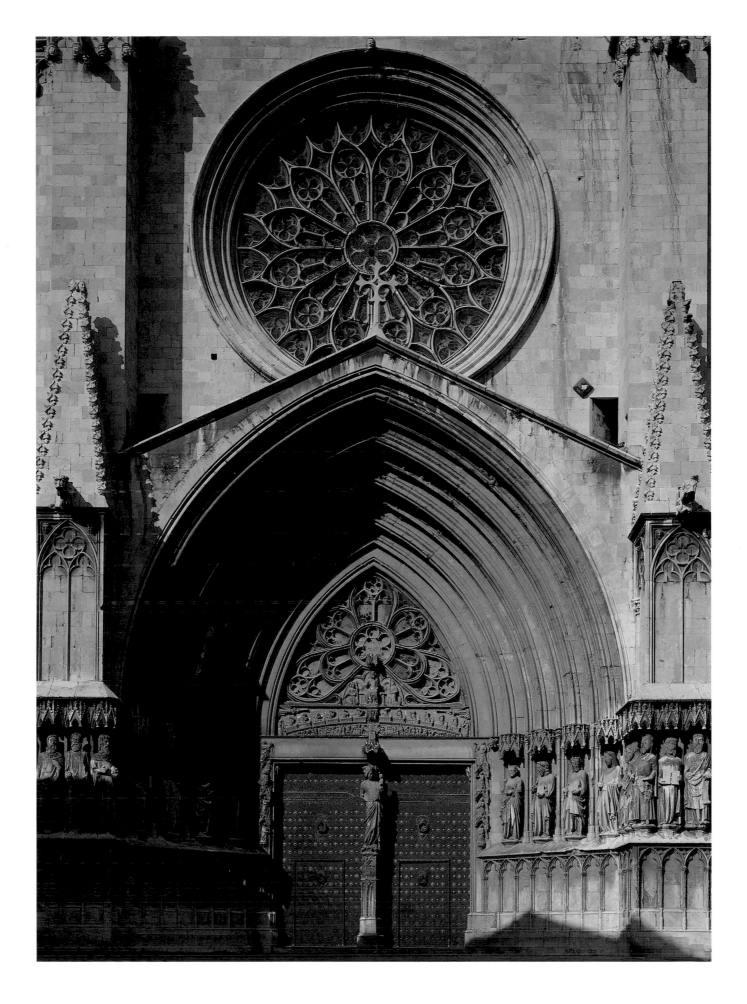

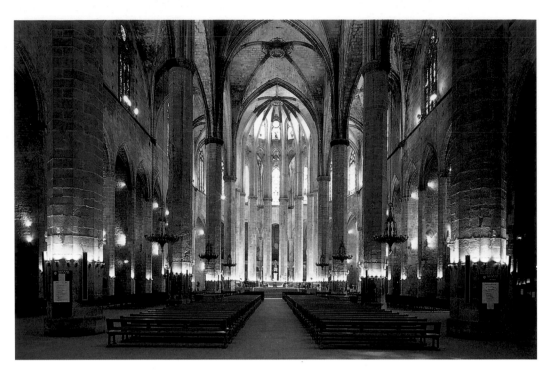

BERENGUER DE MONTAGUT: basilica of Santa Maria del Mar, 1329-1383, Barcelona.

The parish church of Santa Maria del Mar, commonly known as the *Catedral de Mar,* is a beautiful example of faithful adherence to the spatial unity that characterised the southern Gothic. Partly on account of all the powers-that-be becoming involved in the project, the church was built in just fifty years, a fact which contributed to the overall visual unity it displays even today. The diaphanous interior and the transparency of volumes are due to the negligible difference in height between the nave and aisles, which enabled large supporting arches to be erected over slender octagonal pillars. Similarly, the side chapels, set between the buttresses, do not impinge on the global vision of internal space.

capitals: the finest examples were built in Barcelona, Girona, Perpignan, Palma de Majorca and Valencia, while in Lleida and Tarragona, which had yielded the best examples of Romanesque architecture, Gothic constructions were usually found as adjuncts to Romanesque buildings. New cathedrals were built over the preceding Romanesque ones in Barcelona, Girona, Perpignan and Tortosa, or over former mosques, as at Palma de Majorca, Valencia and Orihuela, while the cathedrals begun in the 13th century were brought to completion (Lleida and Tarragona). At the same time, parish churches sprang up in urban precincts, including Santa Maria del Mar, San Justo y Pastor, Santa María de los Reyes or El Pino, in Barcelona; San Félix, in Girona, Santa Catalina, in Valencia, and Santa Eulalia, in Palma, in addition to those in large towns such as Castelló d'Empúries, Cervera, Manresa, Montblanc and Vilafranca del Penedès, in Catalonia; Morella, San Mateo, Burriana, Gandía, Sagunto and Requena, in the kingdom of Valencia, and Ciudadela and Ibiza, in the Balearic Islands. The Franciscans and Dominicans completed the buildings begun in the 13th century, and proceeded with their expansionist policy, while new monastic orders erected monasteries in the main population centres, including the new Poor Clare convent of Santa Maria de Pedralbes, built under royal patronage in Barcelona.

In civil architecture, the monarchy built and enlarged palaces that acted as the seat of an itinerant court. A surviving example is the Gothic refurbishment of the Moorish castle of Almudaina and the palace-castle of Bellver, both in Majorca, the extension to the Royal Palace of Barcelona (the great Saló del Tinell and the Santa Águeda chapel), the palace-castle of the kings of Majorca in Perpignan, Alfonso the Magnanimous' Castlenuovo in Naples and the palatial residences of Martin the Humane and James II in the monasteries of Poblet and Santes Creus, respectively. The monarchy also embarked on an extensive programme of walling cities: remains of city walls can be seen in Barcelona, the portals of Girona, and those of Quart and Serrans in Valencia. However, towns such as Montblanc and Hostalric, in Catalonia, Morella, in Valencia, and Alcudia, in Majorca, where the walls have survived more intact, provide a better example of mediaeval walled precincts. Peter the Ceremonious decided to protect the monasteries housing royal pantheons of the Crown of Aragon during wartime against his Castilian namesake, and even today the monumental gateway with its polygonal towers can be seen at the monastery of Santa Maria de Poblet.

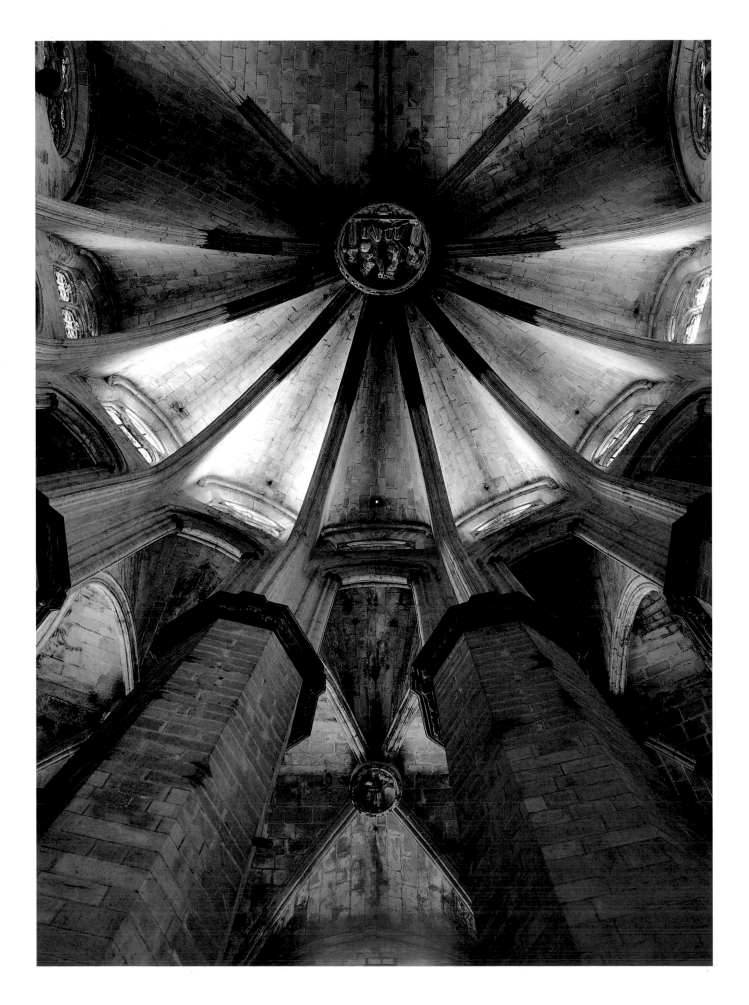

PERE BALAGUER: Portal of Els Serrans,
1392-1396, Valencia.

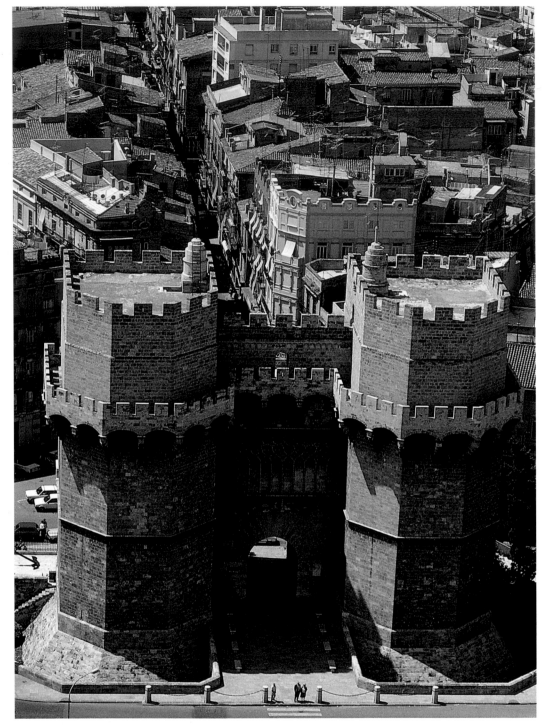

Palma de Majorca: plan & aerial view
of Bellver castle, circa 1300.

Most of the existing institutional buildings were erected during that period: the palaces of
the Generalitat of Catalunya, and that of Valencia, are the epitome of Catalan Gothic archi-
tecture, as is what has survived of the Barcelona City Hall after the 19th-century renovation.
The splendour and multifarious features of Catalan architecture, as part of the Southern
Gothic, are likewise evinced by such public works as enlargement of the shipyards in
Barcelona, commodity exchanges in Barcelona, Palma, Valencia and Perpignan, and hospi-
tals, particularly that of Santa Creu in Barcelona. Other examples include the mansions of
the nobility and bourgeoisie in Barcelona, Valencia, Majorca, Naples, Syracuse and Palermo.

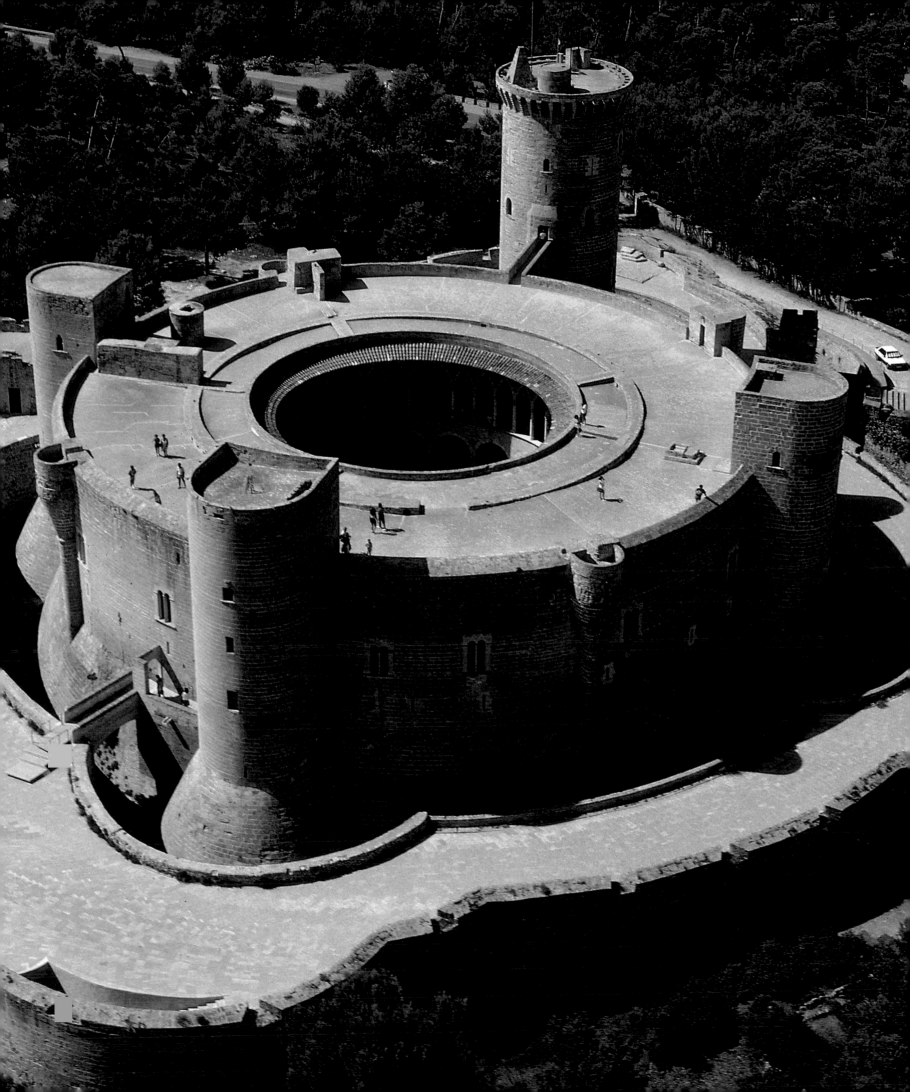

PERE COMPTE: detail of the ceiling of the *Llotja* (commodity exchange), begun in 1483 and completed at the end of the century. Valencia.

Apart from the master builders Enrique and Faveran, who both hailed from Narbonne and worked on Girona Cathedral, and the sculptor-architect Reinard de Fonoll, thought to be of English extraction, who worked on the monastery cloister at Santes Creus, all the known master builders of the 14th and 15th century were of local origin. These celebrated artificers of cathedrals, churches and civic buildings included Jaume Fabré, Bernat Roca, Antoni Canet, Guillem Carbonell, Berenguer de Montagut, Pere Arvei, Arnau Bargués, Marc Safont, Andreu Julià, Pere Balaguer, Martí Llobet, Pere Compte, Benet Dalguaire, Pere Sacoma, Bartomeu Gual, Pasqual de Xulbe, Pere de Vallfogona, Guillem Bofill and Francesc Baldomar. The greatest of them all, for the peculiarity and internationalism of his oeuvre, was the Majorcan sculptor and architect, Guillem Sagrera, who stands for one of the most brilliant moments of the Mediterranean Gothic. He worked on the Portal of the Mirador at Majorca Cathedral in 1397, and on the church of San Juan at Perpignan, from 1410 to 1425, but his most representative work is the Llotja or commodity exchange in the city of Palma de Majorca, which he began in 1426. Its rectangular structure, with towers set in the corners and in the middle of each stretch of external wall, and the spatial relationship between the helicoidal pillars and the rib vaulting, endow this building with a harmony, clarity and rationalism that speak of a great mastery of the art of building and that of stonecutting. In 1447 he was commissioned by King Alfonso the Magnanimous to direct building work on the Castelnuovo in Naples, begun in 1443 on the foundations of the old palace fortress which Pierre d'Agincourt had designed for Charles of Anjou. It was there, from 1452 until his death in 1454, that he supervised work on the base of the San Giorgio tower and the Council Chamber of the Barons. The latter is a huge, stellar-vaulted polygonal chamber lit by a central oculus, which replaces the boss, regarded as one of the most successful structural achievements of the late Middle Ages. It is also the crowning achievement of a master builder whose talent had already come to the fore in the chapterhouse of San Juan at Perpignan and in the Commodity Exchange of Majorca.

Sagrera's influence can be seen at the Silk Exchange in Valencia, directed by Pere Compte and begun in 1482, and in the arches, ribs and helicoidal mouldings that appeared in such places as Gandía, Orihuela and Utiel in the kingdom of Valencia. On the portal and in the nave of Santiago de Orihuela, and in the churches of El Salvador and Santa María in Requena, his influence merges with that of Castilian Hispano-Flemish art. Equally interesting is the Chapel of the Kings, at the old convent of Santo Domingo in the city of Valencia, built under the direction of Francesc Baldomar from 1437 to 1452, with ribless groined vaulting that displays a mastery of stonecutting, reminiscent of examples in the Germanic world.

The Gothic architectural concept of space, which became firmly rooted in the dominions of Catalonia, grew into a tradition that endured into the 16th and 17th century, when it was accommodated to the newfound tastes in ornamentation.

Sculpture Workshops in Catalonia and Aragon in the 14th and 15th Century

In Catalonia, the sober character of Mediterranean architecture, devoid of any penchant for monumental portals, together with a firmly rooted Gothic sculptural tradition, was crucial to the emergence of stable sculpture workshops at a comparatively later date than the highly active and widely distributed Castilian workshops of the 13th and 14th century. Despite the crisis of the second half of the 14th century, the comparative stability and economic prosperity in Catalonia facilitated the assimilation of European sculptural trends at their culminating moment, when commissions for statues, tombs and retables abounded. The scene was initially dominated by foreign masters, including Jaume Faveran of Narbonne, Alouns of Carcassonne, John of Tournai, Pere de Guines of Artois, the Englishman Reinard des Fonoll and Lupo di Francesco of Pisa, among others. It was not until the middle of the century, during a phase ushered in by Aloi de Montbrai, that Gothic art styles became firmly entrenched in Catalan sculpture. The relationship with French art was based

on technical and thematic Franco-Flemish features, with a tendency to assimilate the Italian corporeal and monumental sense and the legacy of the Mediterranean Romanesque, starting with the work of Jaume Cascalls of Berga, assistant to Master Aloi until 1361 and one of the leading figures of the period.

In the first three decades of the century, some outstanding works were executed by unknown artists, including a retable at the parish church of Anglesola (Museum of Fine Arts, Boston), the funerary monuments of the Counts of Urgell at the monastery of Bellpuig de les Avellanes (The Metropolitan Museum of Art, New York) and that of Ramon Folch de Cardona at the monastery of Poblet. Jaume Faveran, master of the cathedrals of Narbonne and Girona, is attributed with the tombs of Guillem and Bernat de Vilamarí in Girona Cathedral, that of Ramon Costa, the bishop of Elna, and that of the Infante Jaume of Majorca (Perpignan Museum). In these works, his formal treatment reveals an affinity with Languedocian currents. Around 1312, the royal tombs of James II and Blanche of Anjou were built at Santes Creus. The ensemble is actually a double pantheon, in Parisian style, with the effigies wearing a serene, idealised expression. In this instance, the project is thought to have been drawn up by Pere Prenafeta and Bertrán Riquer, the master builder of the Royal Palace at Barcelona, while Pere de Bonull and Francesc de Montflorit will have sculpted the figures of the monarchs.

As occurred in the field of painting, from the 1320s onwards, relations with Italy led to some unique creations, such as the tomb of Santa Eulalia in Barcelona Cathedral, sculpted circa 1327 by Lupo di Francesco, until recently the anonymous master of the pulpit at San Michele in Borgo, Pisa. Another example is the tomb of the archbishop Juan de Aragón in Tarragona Cathedral, begun in the period 1330–1335, which is directly related, in its formal handling and iconographic motifs, to the work of the Neapolitan Tino de Camaino and his workshop. These two works marked the arrival in Catalonia of the Gothic currents of Siena and Pisa, steeped in classicism. Despite the existence of other works associated with Italy, these forms did not endure in Catalan sculpture beyond the 1320s.

At the same time, major sculptural works were undertaken in silver. Examples include reliquary caskets at Sant Cugat del Vallès (Barcelona province) and Sant Patllari de Camprodón (Girona), the latter with some highly innovative relief work, and the retable and baldachin over the high altar at Girona Cathedral. Capitals and some reliefs were also probably sculpted in the east gallery of the Elna cloister. In 1332, Master Reinard des Fonoll directed work in the monastery cloister at Santes Creus, in which he introduced Flamboyant tracery in the arches and a fabulous, imaginary world in the reliefs on brackets and capitals, directly related to illustrations done in the margins of illuminated manuscripts at the time.

Aloi de Montbrai, who, from 1337 onwards, is recorded in connection with a design for the tomb of Teresa d'Entença, the mother of Peter IV the Ceremonious, was active in Girona as from 1345 (the Holy Burial, in the church of Sant Feliu) and Tarragona, as from 1356 (the retable in the Sastres cathedral chapel). After this, he is documented in relation to royal commissions, namely the royal pantheon at the monastery of Poblet (from 1340 to 1361), and nineteen statues of counts and kings in the Catalan-Aragonese royal bloodline adorning the Saló de Tinell in the Royal Palace of Barcelona, which subsequently went missing. Very little survives of the funerary monument of King Peter, which must have been one of his crowning achievements, and in which he was assisted by Jaume Cascalls (1349). This master, and his disciple, Jordi de Déu, completed the royal pantheon after 1361.

Historical documents covering the period 1345 to 1379 record Jaume Cascalls as having worked in Roussillon (on the retable at Cornellà de Conflent, 1345), Girona (the figure of Charlemagne), Tarragona Cathedral (the figures on the jambs, and part of the Last Judgement tympanum) and Barcelona, where he married the daughter of the painter, Ferrer Bassa, and was himself active as a painter. His major work, however, was the sculpture on the aforementioned tomb at Poblet. Nevertheless, what earned him most fame was his activity in the city of Lleida, particularly at the cathedral in that city, where he worked as master builder and, together with his assistants, set up a prestigious workshop which produced

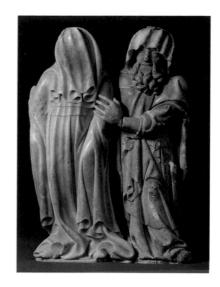

JAUME CASCALLS: *Plorantes* ('Weepers'), third quarter of the 14th century. From the royal pantheons at Poblet (local museum, Poblet).

Following page:

LUPO DI FRANCESCO: tomb of St Eulalia, 1327-1339. Crypt, Barcelona Cathedral.

The Italianism of the tomb of St Eulalia has never been called into question. The volume of the figures, the composition of scenes and even the spatial arrangement are all alien to local currents. Various episodes from the life of the saint are depicted on the coffin, while on the lid her relics are shown being conveyed, and her ascent into heaven on the back of the lid. A documentary source recently revealed that the Pisan embassy sent to Barcelona in 1326 to negotiate a peace treaty after the conquest of Sardinia included the sculptor, Lupo di Francesco. The tomb of St Eulalia, the original patron saint of the city, may have been presented as a gift to the sovereigns and the city.

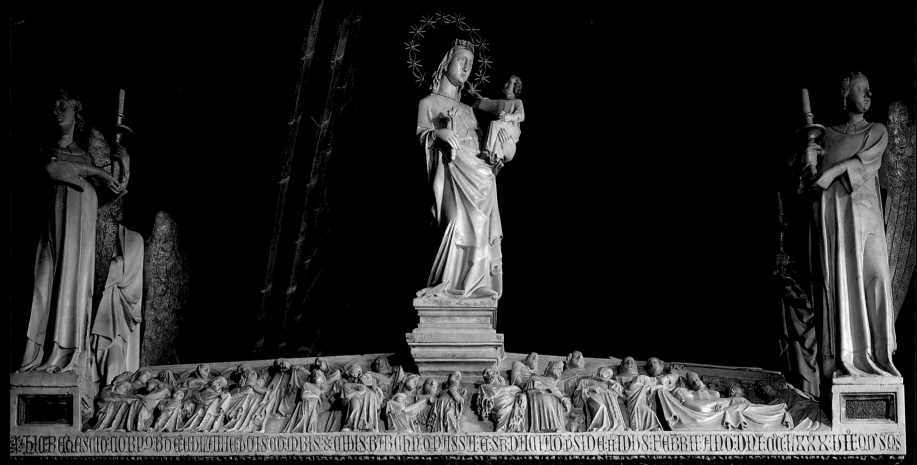

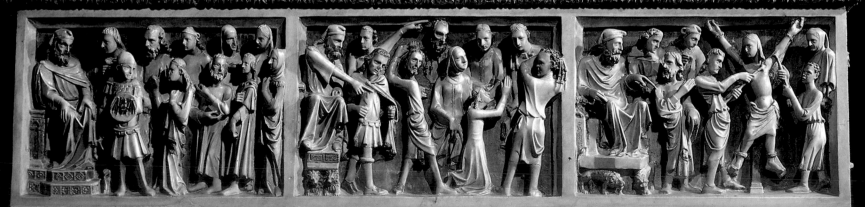

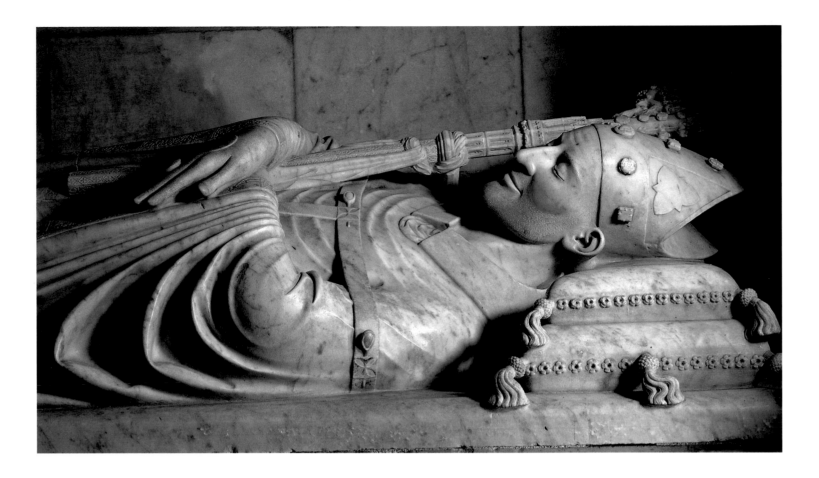

Tomb of Archbishop Juan de Aragón, in Tarragona Cathedral (detail of the lid), circa 1330-1335.

both innovative and stereotyped formulae that were applied in numerous parish churches in the diocese.

The styles characteristic of Catalan sculpture of this kind, which included a number of personal variations, were perpetuated until the last decade of the 14th century in the prolific production of masters active after the time of Cascalls. The leading exponents of that period were Jordi de Déu (the tomb of Ramon Serra in the church of Santa Maria de Cervera, and the retable of St Lawrence at Santa Coloma de Queralt), Bartolomeu Rubió (the retable at the high altar, Lleida Cathedral), Pere Moragues, a sculptor and goldsmith from Barcelona (tomb of Archbishop Lope Fernández de Luna, in Zaragoza Cathedral, and the monstrance of the Corporals of Daroca), and the Majorcan Guillem Morell (the tombs of Ramon Berenguer II and Countess Ermesinda, and brackets on the Portal of the Apostles, Girona Cathedral), whose work anticipated the assimilation of late-14th- and early-15th-century currents.

At the end of the 14th century, the sculptural techniques and formal repertoires derived from the work of Cascalls and his successors came to an end, ushering in a new period, known as the International Gothic, based on Flemish-Burgundian art forms, with a smooth, elegant realism that was applied to all subjects, from the happiest to the most tragic. The new style was applied to the choir seating at Barcelona Cathedral, sculpted most notably by Pere Sanglada, and used by artists who arrived from the north of France and Flanders, such as the Picard Pere de Sant Joan; active in Majorca, he was appointed master at Girona Cathedral, and sculpted the choir seating at the cathedral of La Seu d'Urgell. Other exponents of the International style were Master Françoy Salau, who knew Parisian sculpture well and worked on the decoration of King Martin's residential palace at Poblet, and Master Carlí (probably Charles Galtier, of Rouen), who designed a project for the facade of Barcelona Cathedral that never saw the light. The new style made itself felt in all existing

MASTER BARTOMEU, PERE BERNÉS & MASTER ANDREU: reredos at the high altar, 1325-1380, in gilded, carved & repoussé silver with enamel appliqué. 266.5 x 272 x 5.8 cm (ensemble). Girona Cathedral.

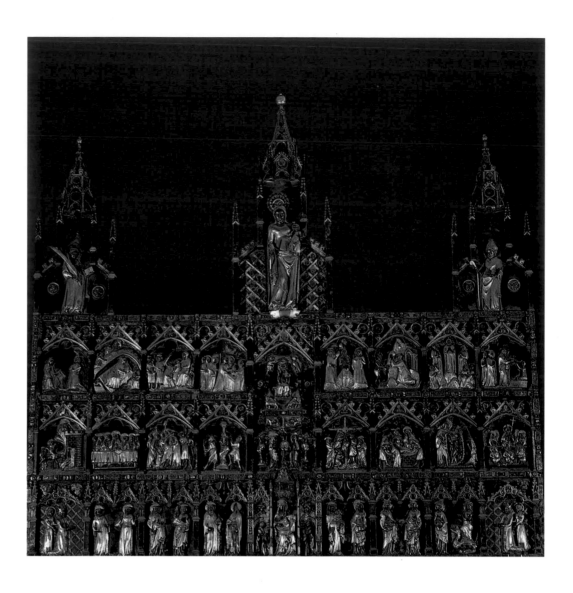

PERE OLLER: retable of St Peter, 1420-1426. Vic Cathedral, ambulatory.

The affiliation of Catalan sculpture to the International Gothic comes out clearly in this retable at the high altar in Vic Cathedral, which was subsequently moved to the ambulatory. The artificer, Pere Oller, reveals accomplished workmanship and polished skill in the details of every figure, particularly in the drapery and hair, and in the undulating, decorative architectures. However, the ensemble does suffer from over-repetition in the types and rhythms of the elegant but static figures, and from an awkward composition. Refined and elegant, but rather uninventive, Pere Oller adhered faithfully to the style of his master, Pere Sanglada, and was a worthy competitor of his contemporary, Pere Joan.

sculptural techniques and media, including stone, alabaster, carving, goldsmithing and silversmithing, the latter involving generous use of polychromy. A notable example of goldsmithery of this kind is the monstrance-retable in Girona Cathedral, crafted in Barcelona between 1430 and 1438.

Pere Sanglada, who is documented in Barcelona from 1386 to 1407, was the leading exponent of the initial stages of the new style, while Pere Joan, the son of the aforementioned Jordi de Déu, stood for the plenitude of that style—his was the greatest contribution to Catalan sculpture within the European milieu of the time. When commissioned to work on the choir seating in Barcelona cathedral in 1394, Pere Sanglada journeyed to Flanders to buy good-quality oak and to learn from models there that might help with his project. Throughout his oeuvre, whether carving wood or working in alabaster (the reclining image of St Oleguer at Barcelona Cathedral) or stone (assignments in the Barcelona City Hall, in collaboration with Master Arnau Bargués), the gracefulness of the International Gothic is superseded by the dynamic bodies of his figures and the folds of their drapery. His workshop, which sculpted the images in the retable at the high altar of Monreale Cathedral in Sicily, yielded a number of worthy successors, including Antoni Canet, who carved the tomb of Bishop Ramon Escales in Barcelona Cathedral (1409–411), and Pere Oller, whose most outstanding works were the mausoleum of Bishop Berenguer de Anglesola in Girona Cathedral (circa 1408), and the polychromed alabaster retable in Vic Cathedral (1420–1426).

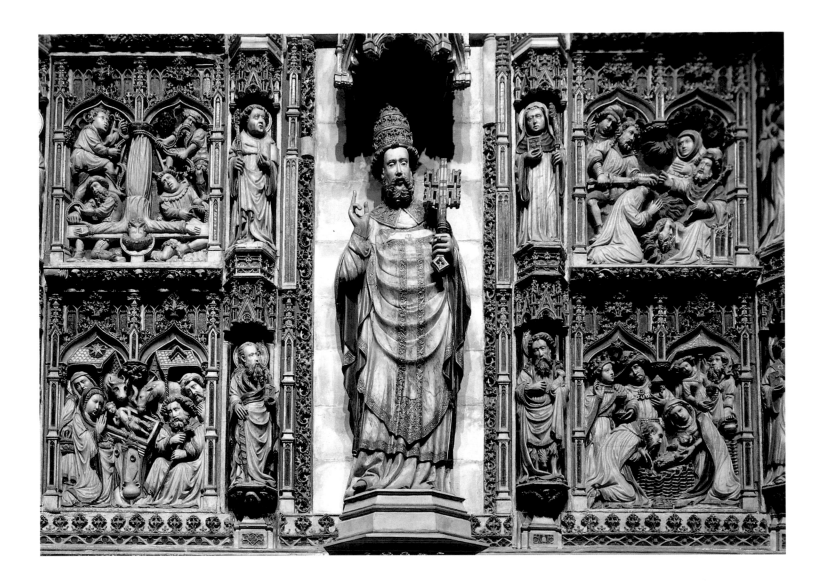

While international forms merged with the realistic trend in Pere Sanglada's work, Pere Joan captured the expressive sense of sinuous calligraphy associated with the pictorial arts. His was the most personalised style of the sculptors employed by the Crown of Aragon at that time, and he might be regarded as sharing pride of place with Gil de Siloé as the leading Hispanic sculptor of the 15th century. His statues and retables are wholly within the International Gothic style, but they provide a personalised vision of sculpture that sets them apart from other contemporary sculptors. In 1416, at a very young age, Pere Joan was commissioned to sculpt the figures and relief work on the palace facade at the Generalitat de Catalunya in Barcelona, prominent among which is the central medallion, with its allusions to the subject of St George, based on the seal which the Generalitat had previously commissioned to the German silversmith, Hans Tramer. Among the heads and gargoyles with human figuration making up the main scene on the facade is a princess, while the overall composition, arranged around the movement of the saint on horseback, reveals an incipient taste for dynamic, whirling forms. In 1429, Joan embarked on the great reredos in Tarragona Cathedral, under the patronage of Bishop Dalmau de Mur, which narrates the story of St Thecla and St Paul, wrought in polychromed alabaster. The modelling in this work, charged with a host of visual sensations, reveals a delicate sensitivity more akin to painting than sculpture, as evinced in the handling of the figures, and in the planes and material objects. In 1434 and under the auspices of the same bishop, he was commis-

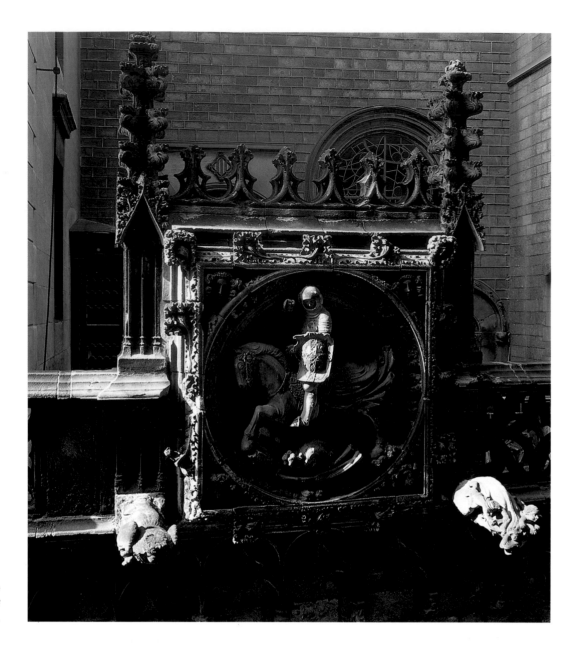

PERE JOAN: medallion of St George, 1416-1418. Barcelona, Palace of the Generalitat de Catalunya, side door.

sioned to sculpt the predella of the great reredos in Zaragoza Cathedral, the upper part of which was completed by Hans Gmund of Swabia as from 1467. He is thought to have ended his career in the court of Alfonso the Magnanimous in Naples, where he is documented as master builder in 1450.

Beyond Barcelona and its area of influence, the Lleida Cathedral workshop remained active, although on an irregular basis. Its major undertaking was the Portal of the Apostles, which Guillem Solivella had begun at the end of the 14th century. Around 1440, after a long period of inactivity, Rotllí Gautier was appointed master at the cathedral. This sculptor had worked with Guillem Sagrera at Perpignan. Jordi Safont and his disciple Bertran de la Borda worked at Lleida Cathedral two years later.

As the 15th century progressed, sculpture in Barcelona distanced itself from the major international currents, taking refuge in a tradition which in chronological terms might be regarded as Flemish realism, of which Antoni Claperós and his sons were prominent exponents. His son Joan, who died in 1468, was the artificer of the tomb of the Constable of Portugal, the illegitimate son of John II, on the templet boss in the cloister at Barcelona Cathedral, inspired by Pere Joan's St George. It was at this stage that Flemish realism emerged in a number of works, without setting any overall trend. Its principal exponents were such foreign artists as Enric de Birbar, Adrià de Suydret, Miquel Lochner, Joan Frederic de Cassel, William of Utrecht and John of Brussels. Despite the magnitude and quality

of such works as the tombs of Bernat de Pau and Dalmau Raset in Girona Cathedral, the retable on the high altar at Santa Maria de Castelló d'Empúries, and the late-16th-century works of Miquel Lochner, the current in question was never developed any further. Prominent among the few local sculptors that adopted this style to any advantage was Macià Bonafè, who specialised in choir seating. His major works were at Santa Maria del Mar in Barcelona (1434–1435), Santa Maria at Manresa (1438), Vic Cathedral (1454) and the lower choir seating at Barcelona Cathedral (1455).

The 14th-century Mudéjar architecture of Aragon, unsuited to sculptural ornamentation, did not, however, spread as far afield as Upper Aragon, where an Englishman known as Master William is documented as directing work on the west portal of Huesca Cathedral in 1333. He is attributed, almost exclusively, with the sculptures commissioned by Bishop Martín López de Arlor in the cathedral (1330–1331). Similarly, the collegiate church in the Aragonese town of Daroca features a French-style sculpted Portal of Pardon rendered in simple line, in addition to a Last Judgement on the tympanum. The much later Chapel of the Corporals, dating from circa 1430, is sculpted in an irregular, eclectic style which draws on both Burgundian forms and the gracefulness of the International Gothic. Another prominent work patronised by the aforementioned Bishop Dalmau de Mur is the choir seating and alabaster retable in Zaragoza Cathedral, begun by Pere Joan and completed by Hans Gmund of Swabia in 1467.

Master sculptors from Roussillon first introduced Gothic styles into Majorca at the beginning of the 14th century, bringing to an end the obdurate persistence of the Romanesque. One of those masters was Antoni Campredon, documented between 1309 and 1331, who specialised in angels. Pere de Guines, for his part, left his mark on the portal and bosses of the chapel in the Almudaina Palace, while a later workshop, also based in Roussillon and associated with work in the cathedrals of Elna and Carcassonne, is attributed with the decoration in the Trinity Chapel at Palma Cathedral. This sculpture merged with Catalan forms in the portals at the church of Santa Eulalia, and in the Portal of San Lorenzo at the church of Santa Cruz. Once the Balearic Islands had again been annexed by the Crown of Aragon, Catalan workshops, particularly those enjoying royal patronage, became more active in Balearic sculpture. The workshop of Jaume Cascalls sculpted the bosses in the church of Santa Eulalia, and the tombs of the bishops Ramón de Torrelles and Antonio Galiana. At the dawn of the 15th century, the Portal of the Apostles, also known as the Portal of the Mirador, one of the finest examples of Mediterranean architectural sculpture, marked the demise of Catalan styles, which were eclipsed by the ascendancy of Flamboyant ornamentation. During what was a time of social and political upheaval, the Flamboyant Gothic, introduced by Pere Morell around the year 1380, brought together a large number of artists who worked in the so-called Picard-Flemish style, including Juan de Valenciennes, Rich Alamant and Pere de Sant Joan, in addition to local artificers such as Antoni Sagrera and his son Guillem. Their work, most impressive when viewed as a whole, rather than in detail, is striking for the way the sculpture blends in with the architecture. Dating from that period is the portal at San Miguel, executed by Pere de Sant Joan, which is taken to be the start of the period he spent in Catalonia. Guillem Sagrera was commissioned to decorate the Llotja or commodity exchange at Palma de Majorca and, although he left for Naples without completing it, a large number of sculptures with Burgundian overtones bear his hallmark, including those of the Virgin and Child, St John, the angel guarding the entrance, and the gargoyles.

Gothic forms were brought to Valencia via Catalonia by foreign sculptors in the first three decades of the 14th century, and were soon adopted by sculpture workshops in the capital. One such contemporary follower of French currents, established in the city, sculpted the Portal of the Apostles at the cathedral. Dating from between 1360 and 1370 is the Portal of the Apostles and that of the Virgins at Santa María de Morella, plainly related to currents in Catalonia. Around 1358, Pere and Joan Llobet executed the statues of the Apostles and the original portal at the collegiate church of Gandía (Museu Nacional d'Art de Catalunya, and Museum of Copenhagen). Representative of funerary sculpture is the tomb

Murals from the Pía Almoina refectory in the Old Cathedral at Lleida, 14th & 15th century. Tempera & oil on a lime ground. (Diocesan Museum, Lleida).

Romanesque reminiscences are apparent in this painting, particularly in the geometry of the composition, linearity and handling of colour. However, several stages of execution have been identified, ranging from the early-Gothic to the Italianate period. These paintings once decorated the refectory of the Pía Almoina, a charity institution which operated under the auspices of the Cathedral chapter. Since charity was considered to wash away sin and secure one's place in eternity, it was common for nobles to make donations to the institution in their wills. Each compartment, which reveals the chronological evolution of the work, may reflect the number of poor people helped by each benefactor. The oldest plaques bear the sketchy remains of lettering, forming proper names.

of Margarida de Llúria, which the monastery of El Puig entrusted to Master Aloi in 1345. The same monastery features the burials of Bernat Guillem d'Entença and Roger de Llúria. Later examples, such as the double tomb of the Boïls, rebuilt in the chapterhouse at the monastery of Santo Domingo, Valencia, show the incorporation of international Burgundian forms, which have their culminating expression in the tomb of the Counts of Villanueva in Segorbe Cathedral.

Italianism, the International Style and Flemish Realism in Catalan-Aragonese Painting

Catalan painting in the first three decades of the 14th century followed the same trends as sculpture, characterised by flat models featuring an eminently narrative form of late-Gothic linearity, which first came to light in murals and panels painted in the last quarter of the 13th century. They include some unique ensembles, notably the decoration in the Pía Almoina refectory at Lleida Cathedral (currently in the Diocesan Museum), fragments of murals from the collegiate church of Cardona (Museu Nacional d'Art de Catalunya), those in the parish church of l'Arboç (Tarragona), some from one of the chapels on the Gospel side of the monastery church of Santo Domingo de Puigcerdà (Girona), and fragments from the cathedrals of Tarragona and Lleida, in addition to panel paintings from the same areas and the stained glass in the west end of the church at the monastery of Santes Creus, dated circa 1300.

The innovations ushered in by Tuscan painting soon made concerted inroads into the Mediterranean countries ruled by the Crown of Aragon, particularly Majorca and Catalonia. Related to the changes wrought in Castile, the new trends involved abandoning the abstract linearity of a flat pictorial world and embarking on a portrayal of the spatial volumes of bodies. As opposed to the continuity in sculpture of Franco-Flemish forms during the second third of the 14th century, painting and all the other pictorial genres, except for stained glass, started looking towards Italy.

In Majorca, the principal works of the early 14th century, including the Passion retable in the convent of Santa Clara (Diocesan Museum, Majorca), and the record of Matteo di Giovanni having been commissioned to paint stained glass windows for several churches in Palma, attest to the Sienese presence on the island. Indeed, between 1328 and 1348, an illustrious painter and miniaturist known as the Master of the Privileges, related to the figure of Joan Laert, is recorded as active in Majorca. He is attributed with the *Libro de los Privilegios* ('Book of Privileges') of Majorca, as well as the *Códice de Leyes Palatinas* ('Codex of Palace Laws') and the retable of Santa Eulalia in a chapel commissioned by Bishop Berenguer Battle in the cathedral apse. The retable of St Quiteria in the Diocesan Museum is also attributed to his workshop.

Active in Barcelona during the same period was Ferrer Bassa, regarded by critics as the most Italianising painter in Hispanic art in the first half of the 14th century. In terms of the ample formal Sienese repertoire, his style tended towards the Lorenzettis, but was also related to such painters as Niccolo di Ser Sozzo and Lippo di Vanni. Ferrer Bassa, whose activity is documented between 1324 and 1349, evidently travelled to Tuscany and other Italian regions, and, on his return, brought with him an air of renewal that found favour in Court circles. King Peter the Ceremonious commissioned him to paint retables in the royal chapels of Barcelona, Zaragoza, Lleida, Palma de Majorca and Perpignan, while in 1343 Abbess Francesca de sa Portella engaged him to paint the mural decoration in the chapel of San Miguel in the monastery cloister of Santa Maria de Pedralbes, Barcelona. This is the only surviving documented work of his, apart from the illumination of the *Libro de Horas de María de Navarra* ('Book of Hours of Maria of Navarre', Biblioteca Marciana, Venice), and that of the second part of the *Salterio anglo-catalán* ('Anglo-Catalan Book of Psalms', Bibliothèque National, Paris). His workshop, which also produced the *Llibre dels Usatges de Barcelona i Costums de Catalunya* (Municipal Archive, Barcelona), was where his son

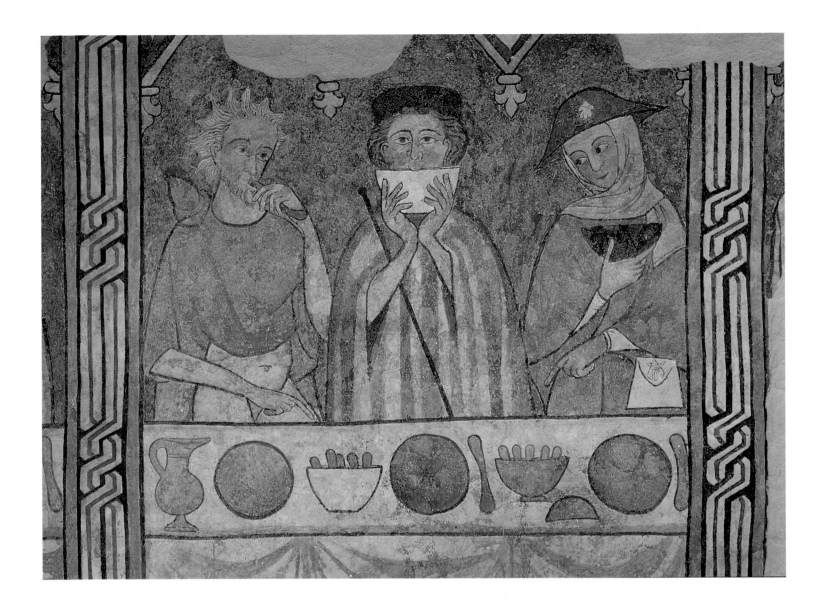

Arnau trained. Arnau is documented in 1346 in relation to the retable of the Shoemakers' Guild at Barcelona Cathedral, now in Santa Maria de la Aurora, Manresa, and appears to have succumbed to the plague in 1348 or 1349, a misfortune that might have been in store for his father, too. The painting of the Bassas may be regarded as a derivation of the Sienese current developed in Catalonia and, as occurred in sculpture with the synthesis of Cascalls, the second pictorial generation that grew out of Bassa's workshop generated an Italianate Catalan series, of which the leading exponents were Ramon Destorrents, the Serra brothers and Llorenç Saragossa.

Ramon Destorrents completed some royal commissions started by Ferrer Bassa, including the retable in the royal chapel at the Almudaina Palace in Palma de Majorca (the central panel is now in the Museo das Janelas Verdes, Lisbon, and the other parts of the central corpus in the Societat Arqueològica Lul·liana, Palma de Majorca). The workshop of Francesc, Joan, Jaume and Pere Serra in Barcelona was instrumental in consolidating the Italianate style outside Court circles. Their forms were more amenable but less innovative, and their activity lasted until the early 15th century, by which time the International Gothic had reached its zenith.

According to attributions and documents of the time, the production of that workshop covered a large part of Catalonia, and reached as far afield as Zaragoza and Alguer, in Sardinia. Among their most prominent works are the retable of the Virgin at the monastery of Santa Maria de Sigena (Museu Nacional d'Art de Catalunya), a retable which Fray Martín de Alpartir commissioned Jaume Serra to paint for the convent of Santo Sepul-

GOTHIC PAINTING

The transition from Hispanic Romanesque to Gothic painting was smooth and gradual. It was effected by compositional changes which, in keeping with the spirit of the times, attached increasingly more importance to the visible world and natural truth as the basis of intellectual knowledge. The changes began to take place in the 13th century, but it was not until the time of Alfonso X the Wise of Castile (1252–1284) that the new Gothic thematic and formal innovations came to the fore, which first occurred in illuminated manuscripts. The illustrated *Cántigas* or 'Canticles', which marked one of the culminating moments of 13th-century Europe, was an amalgam of Byzantine, Islamic, southern Italian, English and possibly French currents, set within the context of contemporary Castilian life. At the same time, stained glass, which became indispensable for lighting in the French type of Gothic cathedral, took its place beside illuminated manuscripts as the major genre of linear pictorial art. The best example of this can be seen in León Cathedral.

Linearity, prevalent in both murals and panel paintings, became widespread throughout the Hispanic kingdoms until the first quarter of the 14th century, as evinced in the work in the Pía Almoina refectory at Lleida Cathedral, and the paintings by Juan Oliver in Pamplona Cathedral.

In the 14th century, linearity endured in Castile, with only the odd, tentative and late Italian presence, as in the frescoes in the Chapel of San Blas (1395-1396), partly the work of the Florentine painter, Gherardo Starnina, and the Hispanic Juan Rodríguez de Toledo. In the territories ruled by Catalonia and Aragon, Italo–Gothic painting made concerted inroads as from the fourth decade of the 14th century. The Barcelona painter, Ferrer Bassa, introduced Tuscan-style painting in Church and court circles through his commissions from Peter IV the Ceremonious for royal chapels, and mural decoration in the chapel of San Miguel in the cloister of Santa María de Pedralbes. The work of this master and of his son, Arnau, may be classed as Sienese painting developed in Catalonia. Apart from a number of secondary, Italianate derivations, his influence spawned other workshops within a current headed by Ramon Destorrents, and the brothers Serra and Llorenç Saragossa, which was perpetuated through a number of followers in Catalonia until the early-15th century, once the International Gothic had come into its own.

Around 1400, painting gradually became dominated by the International Gothic, which had come to light in miniatures, painting and goldsmithery in Europe's court circles during the 1380s. A leading exponent of this trend in Castile was Dello Delli, at Salamanca, Nicolás Francés, in León, and Juan Hispalense and Pedro de Toledo in Seville, but, once again, it was in the courts and cities of the Kingdom of Aragon that pictorial art reached its peak of importance and scope. Its leading exponents were Lluís Borrassà and Bernat Martorell and his followers in Barcelona and its environs; Girardo di Jacopo, Marzal de Sax, Pere Nicolau, Miquel Alcañiz, Antoni and Gonçal Sarrià and Jaume Mateu, in Valencia, and the Levis, Bonanat Zaortiga and Blasco de Grañén in Aragon.

During the period of consolidation of the International style, which was manifold and brilliant in the Kingdom of Catalonia and Aragon, the realistic renewal of Flemish art, known as the Hispano–Flemish, gradually came into vogue. Based on the work of Jan Van Eyck, it acquired considerable importance during the later Gothic period in Europe, at a time when the Renaissance was in the ascendant in Italy. After a journey to Flanders in 1431, Lluís Dalmau was the first artist to paint in the Flemish style in Valencia and Catalonia. However, in Valencia, the most powerful and, at once, ambiguous figure was that of Jaume Baçó, Jacomart, who was summoned to Italy by King Alfonso the Magnanimous and appointed royal painter of all his kingdoms. Jacomart worked in Valencia in collaboration with Joan Reixach. At the end of the sixties, Bartolomé Bermejo, of Cordovan origin, travelled to the Low Countries and was active in Valencia, Daroca, Zaragoza and Barcelona, where he came into rivalry with Jaume Huguet, the most prestigious painter in the city. Bartolomé Bermejo was still active in Barcelona at the death, in 1492, of Jaume Huguet, which marked the decline of Catalan Gothic painting.

In Castile, where the Italian style had never gone down well with art patrons and where the International Gothic made few inroads, the period of greatest flowering and consolidation was achieved with the Hispano–Flemish style, particularly during the last quarter of the 15th century and the early 16th. Melchor Alemán and Michel Sittow, of Baltic origin, John of Flanders and the Picard Felipe Morras worked in the employ of Isabella the Catholic. Shortly after the mid-15th century, Jorge Inglés introduced the Flemish style in the workshops of Castile. The most popular artist working in this style, in the service of the crown, was Fernando Gállego, born in Salamanca, who adapted Hispano–Flemish realism to the Castilian environment. In Andalusia, Pedro de Córdoba was the painter of greatest renown during the last three decades of the 16th century, while Juan Sánchez de Castro was regarded as the pioneer of Hispano–Flemish forms in that region.

FERRER BASSA & workshop: murals in the chapel of San Miguel Arcángel. Barcelona, monastery of Santa María de Pedralbes, cloister, chapel of the Abbess Saportella, 1346.

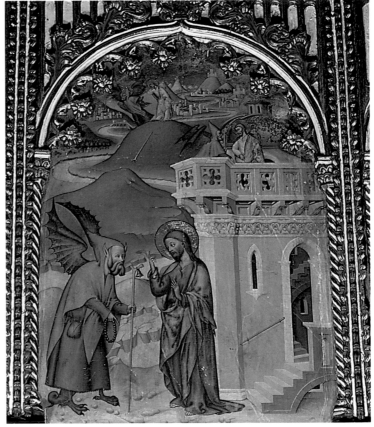

DELLO DELLI: detail of a scene from the reredos at the high altar in Salamanca's Old Cathedral; mid-15th century.

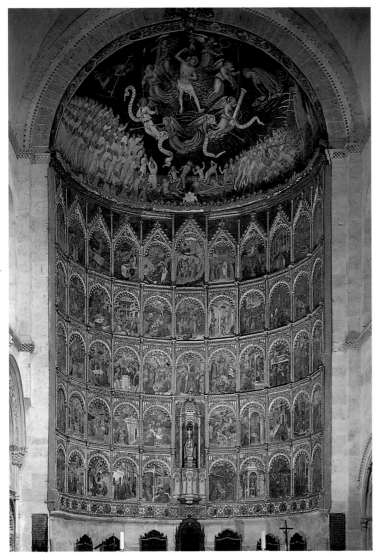

DELLO DELLI: reredos at the high altar in Salamanca's Old Cathedral; mid-15th century.

Stained-glass windows in a side wall at León Cathedral.

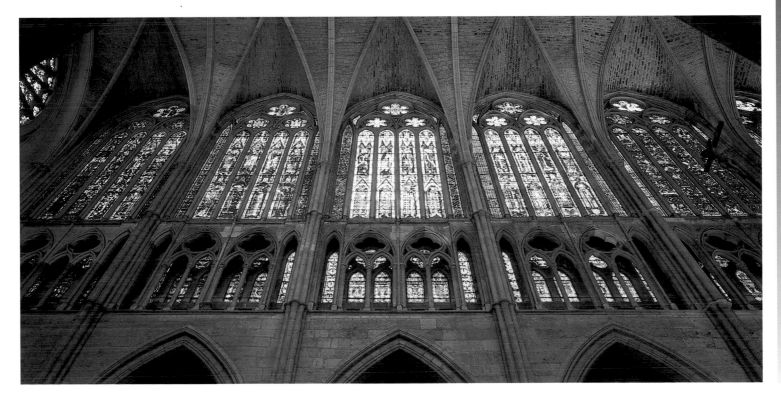

cro in Zaragoza (1361, Museo de Bellas Artes, Zaragoza), the Pentecost retable, executed by Pere Serra for the Guild of the Holy Spirit in Manresa (1394, Santa Maria de la Aurora, Manresa), and a panel of the Virgin and Child in Tortosa Cathedral (circa 1390–1400, Museu Nacional d'Art de Catalunya). No surviving works have been definitively attributed to Llorenç Saragossa, despite the fact that his activity was well documented in Barcelona between 1363 and 1374, and in even more detail after he moved to Valencia in 1374, where he worked until his death. Ferrer Bassa was active in Aragon in 1339, as was an extension of the Serra workshop, and Ramon Destorrents, who in 1358 executed some paintings, now missing, in the new chapel at the royal palace of La Aljafería. Recorded as active in Huesca in 1367 was Rómulo di Firenze, who some have associated with the retable in the church of San Vicente de Estopiñán (Museu Nacional d'Art de Catalunya).

Other pictorial arts, applied to either embroidered cloth or decorative enamels, likewise attest to Italianate forms in the Mediterranean area of Spain. Noteworthy examples are the great embroidered tapestry with scenes from the Passion by the Florentine Geri di Lapo in the church of Santa Maria de la Aurora, Manresa, and the Sienese-style enamels associated with the work of Peter IV's royal goldsmith, the Valencian Pere Bernés.

In the 14th century, the pictorial arts gradually migrated towards the International style which, starting with miniatures, painting and goldsmithing, had originated in European court circles in the 1380s. Acceptance of the new current was undoubtedly encouraged by the marriage, circa 1400, of King John I to Violante de Bar, the niece of Charles V of France, which turned the court of Catalonia and Aragon into one of the most opulent in Europe. Thereafter, the aesthetic of bright colours, striking harmonies and delicately expressive designs based on undulating motifs was consolidated in the territories of the Crown of Aragon.

This was the formative milieu of Lluís Borrassà, regarded as the first grand master of the International style, who worked primarily in the service of the Barcelona bourgeoisie. Documented between 1379 and 1426, Borrassà trained in his father's workshop in Girona, and in Barcelona after the time of the Bassas, together with miniaturists such as Rafael Destorrents (*Misal de Santa Eulalia,* Barcelona Cathedral). The courtly refinement of his art comes through in such works as the retables of the Virgin and St George (1390–1400, church of San Francisco, Vilafranca del Penedès), St Clare (1414–1415, Museu Episcopal, Vic), St Michael at Cruïlles (1416, Museu d'Art, Girona), St Peter at Terrassa (1411, Santa Maria church museum, Terrassa, and Fogg Art Museum, Cambridge-Massachussetts) and the retable in the monastery church at Santes Creus (circa 1411, Museu Nacional d'Art de Catalunya, partially preserved), on which he was assisted by his disciple, Guerau Gener, active in Barcelona, Valencia and Palermo. In addition to Joan Mates, Gener was one of Borrassà's most prominent followers.

Coinciding with the period of Borrassà's activity, some fine work in illuminating manuscripts was undertaken, including the *Misal* ('Missal') by Galceran de Vilanova, the bishop of La Seu d'Urgell (1396, Archive, La Seu d'Urgell), the *Misal de Santa Eulalia* ('Missal of St Eulalia', 1403, Barcelona Cathedral) and the *Breviario del rey Martín* ('Breviary of King Martin', circa 1398–1410, Bibliothèque National, Paris), commissioned by either the Church or the monarchy.

The second stage of the International style in Catalonia was ushered in by Bernat Martorell, active between 1427 and 1452. His forte was painting retables, but he also accepted commissions for decorative work, stained glass and embroidered tapestries. He was employed in the service of the Church and, in particular, various guilds. His art, which is characterised in such retables as the one in San Pedro de Púbol (1437, Museu d'Art, Girona), the *Transfiguration* (1449–1451 Barcelona Cathedral), and the illuminated *Libro de horas* ('Book of Hours', 1440–1450, Historical Archive, Barcelona), reached its height in his retable of St George (circa 1440, Louvre, Paris, and Art Institute, Chicago), where the combination of idealisation and realism culminates in the central panel, in which the refined, graceful figure of the princess stands in stark contrast to the aggressive bestiality of the monster, while the placid, expectant attitude of the maiden is offset by the dynamic and majestic

PERE SERRA: *The Pentecost Retable,* 1394. Tempera on panel. Church of Santa María de la Aurora, Manresa.

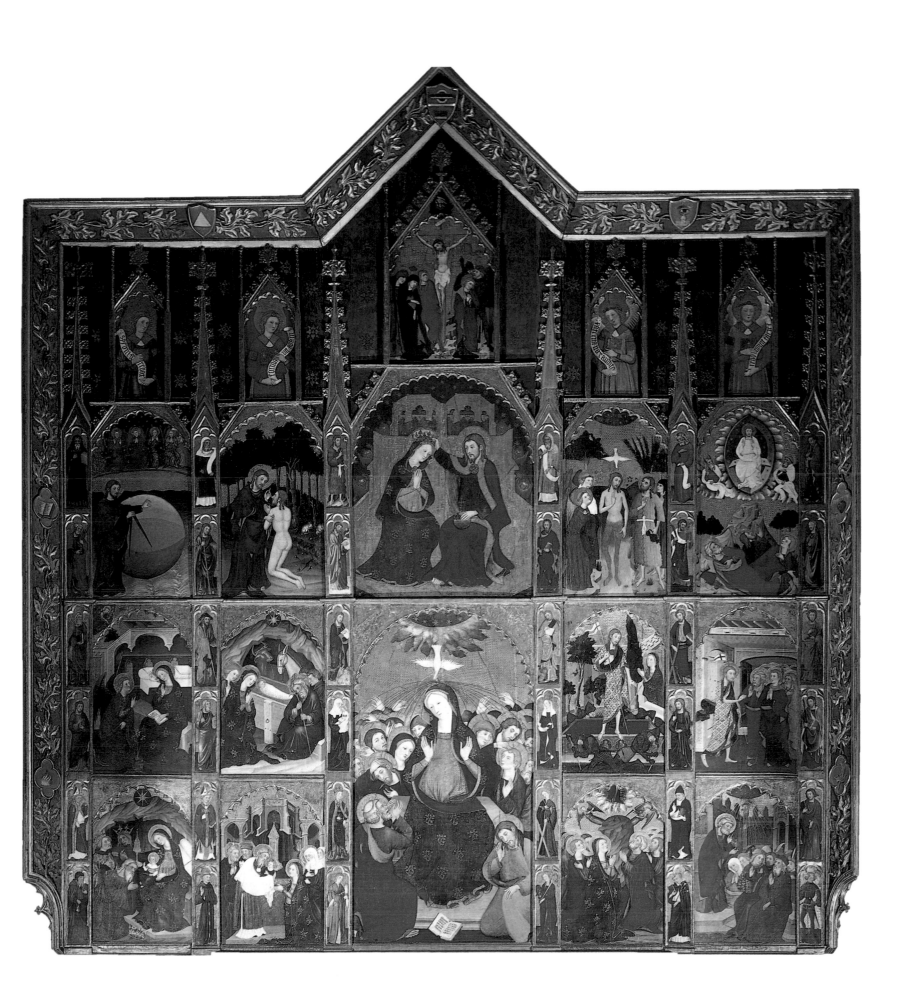

LLUÍS BORRASSÀ: *St Peter Retable* (details), 1411. Tempera on panel, approx. 4.5 x 4 m. Church of Santa Maria, Terrassa (Museum).

composition of St George on horseback. This work by Bernat Martorell is one of the crowning achievements of Mediterranean painting during that period. After his death, his workshop was continued by the Valencia painter Miquel Nadal and, subsequently, by the Aragonese Pere García de Benabarre. Martorell's oeuvre was highly influential in the cities of Lleida and Tarragona, while, in the province of Girona, the existence of workshops comparable in standard to that of Bernat Martorell in Barcelona is suggested by just two pieces: the retable of the *Virgen de la Escala* in the monastery of San Esteban de Banyoles, by Joan Antigó (1437–1439), and the panels of St Michael from the church of Castelló d'Empúries (1440–1450, Museu d'Art, Girona).

In Valencia, the zenith of Gothic painting was achieved after 1390, when a variety of the most refined contemporary European trends coalesced in the city's workshops. With its ascendancy as the commercial capital of the Kingdom of Aragon, Valencia lured increasingly more foreign artists, with highly successful results, reaching their apogee during the reigns of John I and Martin the Humane. Following the so-called Compromise of Caspe, Valencia became the city of choice for both Ferdinand I and Alfonso the Magnanimous, attracting artists from Italy, France and Central Europe, including two paramount figures: the Florentine Gherardo Starnina, who was also active in Toledo, and the Fleming, Marzal de Sax. These two figures were instrumental in laying down the guidelines for the International style of painting in Valencia. Girardo di Jacopo is attributed with a retable known variously as *The Seven Sacraments,* or *Fray Bonifacio Ferrer,* painted for the Portacoeli charterhouse (Museo Provincial, Valencia), which was executed in collaboration with other Valencian painters. Marzal de Sax is documented in Valencia from 1392 to 1410, and is regarded as the city's most celebrated painter. He decorated the City Council chamber known as the *Consejo Secreto del Ayuntamiento* ('Secret Council of the Corporation'), his only documented work, executed between 1392 and 1396 and now missing, and the panel, *The Incredulity of St Thomas,* part of the retable dedicated to that saint painted for the Cathedral circa 1400. If this retable was indeed painted by Marzal de Sax, it is difficult to see in it any parallels with another magnificent retable of St George, also attributed to him, commissioned by the society of crossbowmen known as the *Centenar de la Ploma* (circa 1405–1410, Victoria and Albert Museum, London). A controversial figure whose style was reminiscent of this retable is the little-known Pere Nicolau, a native of Valencia who was active between 1390 and 1408. His only documented attribution, albeit with some reservations, is the retable of *The Seven Marian Joys,* commissioned by the church of Sarrión, Teruel, in 1404, part of which is preserved in the Museo San Pío V in Valencia. The figure of Pere Nicolau, and the works ascribed to him, such as the retable of *The Holy Cross* (Museo San Pío V, Valencia), have posed some unresolved issues relating to another contemporary master, Miquel Alcañiz, documented from 1415 to 1447. This itinerant artist lived in Barcelona, Valencia (1415–1417) and Majorca (1434, and 1442-1447). One of his major works, the retable of the *Virgin Mary,* in the parish church of Alcudia (1442), and another in the church of El Puig at Pollensa, show a close affinity with the murals of Agnolo Gaddi in Santa Croce, Florence.

The generation of local artists that consolidated and further developed the innovations introduced by the originators of this current has proved elusive when it comes to defining them. Emerging at the beginning of the second decade of the century, its leading exponents were Antoni Peris, Gonçal Peris, Gonçal Sarrià and Jaume Mateu. Antoni Peris, documented between 1404 and 1422, became a major figure after the death of the masters of the first generation. His accomplished, yet eclectic style comes through in the retable of the *Virgin of Hope* at Pego (1405, Alicante) and the much later one of *SS Gregory and Bernard* at Alciza (1419). The other masters—Gonçal Peris (Antoni's son), Gonçal Sarrià and Jaume Mateu—are difficult to tell apart in terms of the evolution of 15th-century Valencian painting, although the first of them is thought to be the artificer of a retable of *SS Martha and Clement* (1412, Cathedral Museum, Valencia). One of the most all-embracing works of that period was a series of fourteen panels depicting Catalan-Aragonese monarchs, executed by Gonçal Sarrià, Joan Moreno and Jaume Mateu for the Valencia City Council in

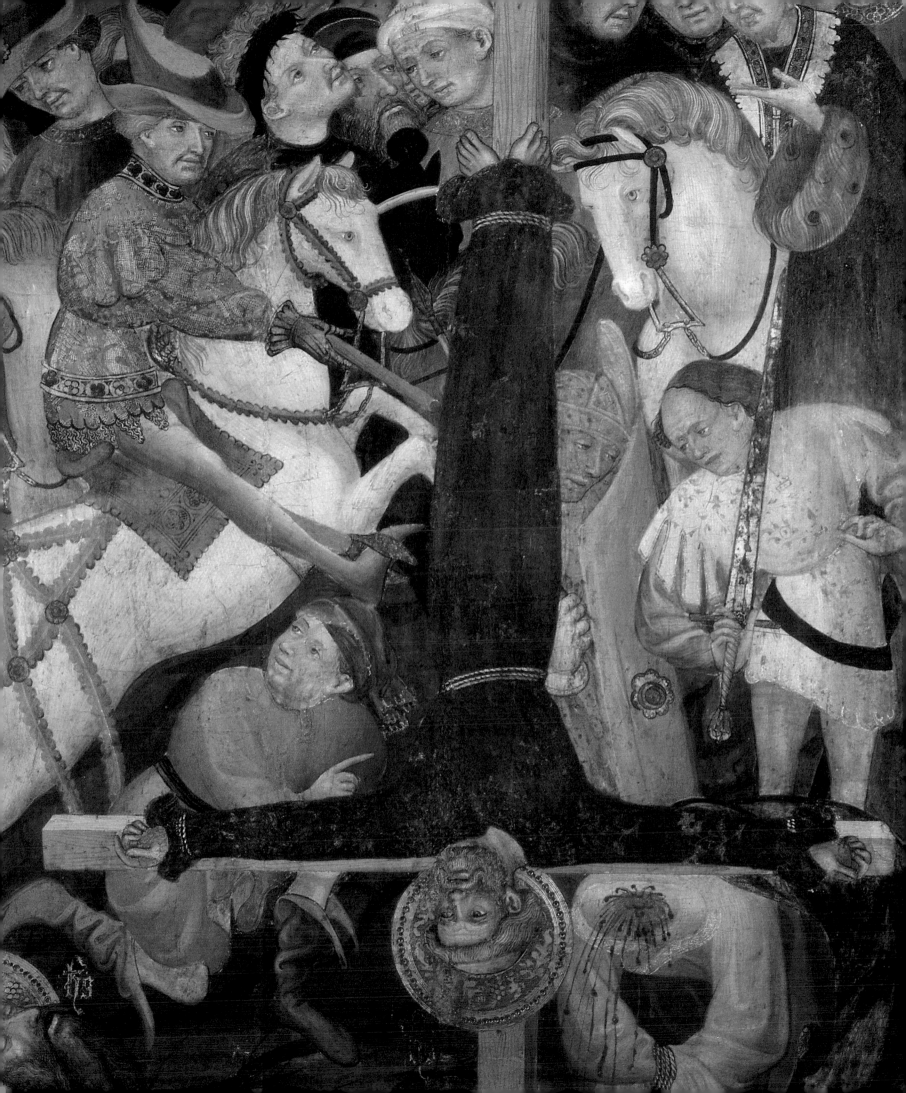

1427. The four, sole surviving panels are the would-be portraits of James I, Alfonso the Liberal, Peter the Ceremonious and Alfonso the Magnanimous (Museu Nacional d'Art de Catalunya). In Majorca, the International style was introduced by Francesc Comes, who trained in Valencia and is best known for his painting of the *Virgin and Child* in the museum at Pollensa.

Courtly art was most likely initiated in Aragon by two Jewish painters, Guillén and Juan Levi. Juan, documented between 1392 and 1407, is considered to have originated a style based on residual Italianate features, and more expressive, northern forms, which was popular for some years in the Aragonese school. His most outstanding work, a retable of *SS Catherine, Lawrence and Prudence* in Tarazona Cathedral (Zaragoza), was executed during the term of office of Bishop Fernando Pérez Calvillo (1392–1404).

Contemporary with the persistence of the International Gothic in pictorial genres, which showed variety and reached heights of brilliance in the Crown of Aragon, was the renewal heralded by the newfound Flemish realism pioneered by the work of Jan Van Eyck, highly influential during the last phase of Gothic painting in Europe, at a time when the Renaissance was gaining hegemony in Italy. Trade with Flemish ports, Van Eyck's sojourn in Spain with the entourage of Philip III of Burgundy (1428–1429), Lluís Dalmau's journey to the Low Countries in 1431, and Alfonso the Magnanimous' interest in Van Eyck's work, despite his Italianism, were factors that contributed to the introduction of the new style, which first emerged in Valencia.

After his return to Valencia in 1436, Dalmau was the first painter to reflect Flemish tastes. In 1443, when Bernat Martorell was still the leading light in Catalonia, councillors of the Generalitat de Catalunya commissioned Dalmau to paint the *Virgin of the Councillors* altarpiece for the Barcelona Council chapel (Museu Nacional d'Art de Catalunya), possibly out of a desire to have their portraits rendered by an artist of growing prestige. Completed in 1445, the work is conceptually more representational than interpretative. It features the Virgin and Child, and the councillors being introduced by SS Eulalia and Andrew, the patron saints of Barcelona. Nevertheless, Dalmau's art was never wholeheartedly accepted in either Barcelona or Valencia, where the aforementioned Gonçal Peris, an illustrious exponent of court painting, was still active.

The most powerful and yet disturbing figure at that time in Valencia was Jaume Baçó, known as Jacomart. In 1440, he was summoned to Italy by King Alfonso, who appointed him court painter of all his kingdoms. Jacomart lived in Valencia until 1451. His work, with which he was assisted by Joan Reixach, is a synthesis of Flemish currents, the International Gothic of Valencia, and features of Renaissance art, particularly in his handling of light. Nothing is known of his work in Italy, but in the Kingdom of Valencia he is attributed with the retable in the Cardinal Borgia chapel at Xàtiva, which he began in 1451 on his return to Valencia. The striking St Benedict, in the cathedral museum, is also ascribed to him. The only authenticated works of Joan Reixach are the retables of *St Ursula* at Cubells, and the *Epiphany* at Rubielos de Mora (Museu Nacional d'Art de Catalunya). He was active in the workshop purportedly headed by Jacomart in Valencia, which he continued after the latter's death in 1461. His style, which had the detail of Flemish painting and was closer and more comprehensible to the viewer than his predecessor's, often involved the use of gold leaf, which became fashionable and representative of Catalan-Aragonese painting of the second half of the century. By the time of his death, in 1484, Bartolomé Bermejo had already visited Valencia. After a sojourn in Flanders, in 1468 Bermejo painted the splendid panel, *St Michael of Tous* (Werner Collection, Luton Hoo, England), with reminiscences of Dirk Bouts.

The members of the last of the Netherlandish circles were trained in this climate of renewal. Their leading exponents were the Masters of Perea, Xàtiva, Artés and Martínez Vallejo, some of whom were also active in the 16th century. Simultaneously, within the complex fabric of Valencian art, the tradition laid down by Reixach's workshop continued to flourish. So did such pictorial trends as those of Rodrigo de Osona the Elder who, having captured in conceptual terms the essence of Flemish art, enhanced it with Venetian

BERNAT MARTORELL: central panel from the St George retable, circa 1440. Tempera on panel, 142 x 96 cm. Chicago, Art Institute.

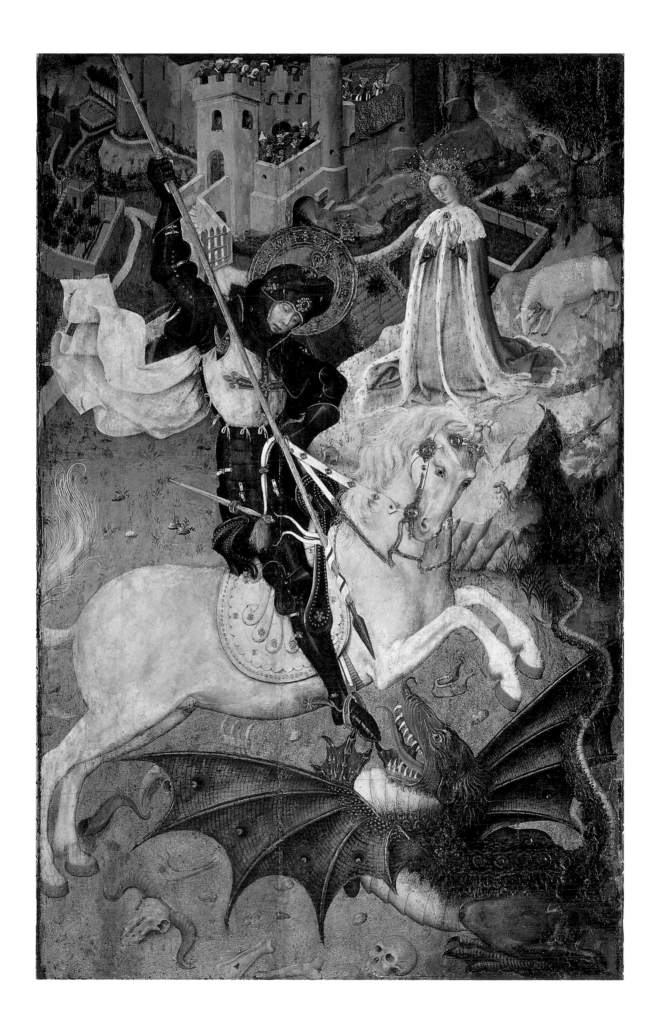

LLUIS DALMAU: *The Virgin of the Councillors,* 1443-1445. Oil & tempera on oak panel, 272 x 276 cm. Museu Nacional d'Art de Catalunya, Barcelona.

In the contract signed by the councillors and Lluís Dalmau, in keeping with customary practice at the time, it was stipulated that the ground should be rendered in gold leaf, as this material and the colour were symbols of the social and economic status of the sitters. In his endeavour to emulate Flemish models, Lluís Dalmau breached this clause in the contract. Through Gothic arcades with latticework, a broad, luminous landscape with singing angels appears, an arrangement reminiscent of a well-known polyptych by Jan Van Eyck in Ghent Cathedral. The Catalan painter must have seen this work during his trip to the Low Countries, as attested to by other details, both formal—the Virgin's throne, and the flooring—and technical, as this was one of the first Spanish works in which oil brushstrokes were applied over tempera.

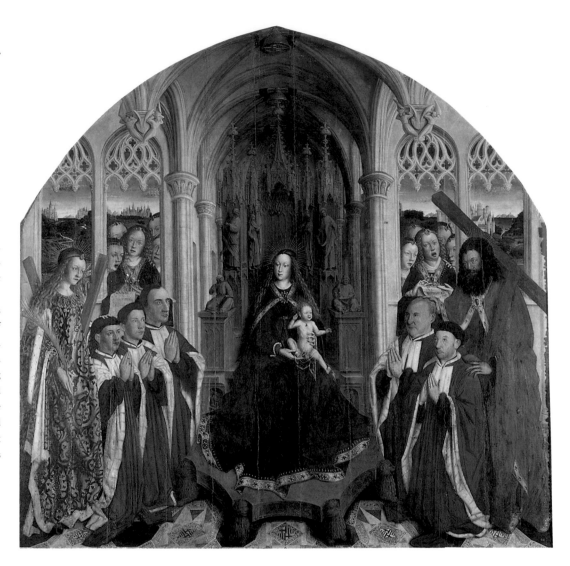

colourism, or Paolo di San Leocadio, one of the Italian painters in the entourage of the future Pope Borgia who first introduced early-Renaissance forms into Valencia.

After executing the *St Michael of Tous* altarpiece, in addition to the retable at Santo Domingo de Silos, commissioned by Juan de Bonilla, nothing is known of Bartolomé Bermejo's activity until 1474. The central panel from Silos (The Prado, Madrid), which revolves around the seated figure of St Domingo, reveals Bermejo to be highly knowledgeable of Flemish formulae and Italian geometrical composition, tempered by northern attention to detail and the glitter of gold leaf. While in his native Daroca (Aragon), he executed an irregular altarpiece of *St Engracia,* before moving to Zaragoza, where he collaborated with Martín Bernat. In 1486, he is recorded in Barcelona, where he competed against the ageing Jaume Huguet for the assignment to paint the organ door at Santa Maria del Mar. Huguet was awarded the commission, while Bermejo signed the panel of the *Pietà* painted for the archdeacon Lluís Desplà in 1490 (Cathedral Museum, Barcelona), a highly accomplished personalised interpretation of Flemish realism. Bartolomé Bermejo remained in Barcelona until the death, in 1492, of Jaume Huguet, which also marked the demise of the age of splendour of Catalan Gothic painting.

Jaume Huguet directed the most active workshop in Barcelona at the time Bermejo arrived there. Born in Valls in 1414, after a sojourn in Tarragona and some purported journeys, Huguet settled permanently in Barcelona in 1448, shortly before the death of Bernat

In the image:

RETABLO DE LA CAPILLA
LLAMADA DEL PAPA.LEVAN-
TADA POR CALIXTO III EN
EL SOLAR DE LA NAVE
CONTIGUA.DISPERSOS SUS
ELEMENTOS POR LUENGOS
AÑOS.REUNIERONSE EN 1924
PARA PERPETUA MEMORIA

JACOMART (JAUME BAÇÓ): *Triptych of the Virgin & Child with St Ann,* 1451-1455. Collegiate church, Xàtiva (Valencia).

Martorell. Huguet is regarded as the most outstanding Catalan painter of his time. One of his first works might have been the central panel in the *St George Triptych* (Museu d'Art de Catalunya), in which he has generated a climate of delicate, poetic elegance, still in line with the International Gothic. His works documented and preserved in Barcelona reveal him to be heir to the powerful Catalan tradition, with an admix of rigorous draughtsmanship and a spatial sense derived from Flemish currents. His work also shows the influence of Dalmau, that of the Master of Flemalle, and an Italian substrate which followed the Provence route and linked up with Piedmontese art of the second quarter of the 15th century. Prominent examples are are the retables of *St Anthony of Egypt* (1455–1458), destroyed in 1909, *St Vincent of Sarrià* (1450–1460, Museu Nacional d'Art de Catalunya), *SS Abdon and Sennen,* in Terrassa, those he painted for various guilds in the city, one in the convent of San Agustín el Viejo (1465–1486, Museu Nacional d'Art de Catalunya), with which he was assisted by several collaborators, and one of the constable, Peter of Portugal, elected King of the Catalans on 21 January 1464, in the Royal Palace chapel in Barcelona (1464–1465). The latter, dedicated to the *Epiphany,* features a highly refined figurative ambience uncharacteristic of his workshop.

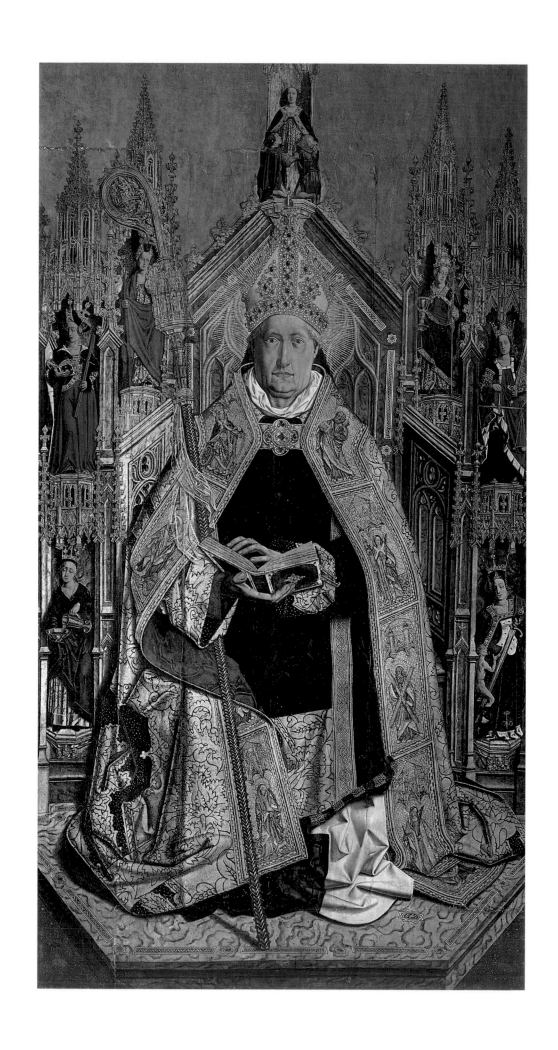

BARTOLOMÉ BERMEJO:
Santo Domingo de Silos, 1474-1476.
Tempera & oil on panel, 242 x 131 cm.
Prado, Madrid.

JAUME HUGUET: 'St Abdon before Emperor Decius'. Detail from the *Retable of SS Abdon & Sennen,*
1459-1460. Painting in tempera on panel, from the church of Sant Pere at Terrassa.
Santa Maria church museum, Terrassa.

JAUME HUGUET: 'St Sennen'. Detail of the *Retable of SS Abdon & Sennen,* 1459-1460. Painting in tempera on panel, from the church of San Pere at Terrassa.
Santa Maria church museum, Terrassa.

Towards the end of the century, a large number of artists slavishly followed Huguet's teachings and, to a lesser degree, those of Bermejo, including the Vergós family and the more creative Pedro García de Benabarre, documented between 1445 and 1496, who in turn founded a school of his own. Perhaps his most notable followers, however, were painters active in Girona, such as Ramon Solà II and the anonymous Master of Canapost, who prompted a renewal in pictorial tenets during the last quarter of the 15th century, after the transformation in Flemish realism headed by Jean Fouquet and other French painters. A prominent figure in Majorca was Pere Nisard who, circa 1470, painted the central panel of the *Cofradía de San Jorge* ('San George Guild') retable with its marked Eyckian influence. In Aragon, painting in the second half of the 15th century was largely based on art circles or even workshops set up around the figure of the young Huguet and, subsequently, that of Bartolomé Bermejo.

The status quo of art in the Hispanic kingdoms during the 13th, 14th and 15th centuries was complex and multifarious. While the 13th and 14th centuries saw the introduction of Gothic forms, and their subsequent spread and consolidation, and the coexistence of such forms with the Mudéjar in vast areas of Castile and Aragon, the overall picture is one of overriding French and Mediterranean (whether Italian or otherwise) influences, with the occasional influx of English and Germanic currents. During the 15th century, activity in the various kingdoms led to an increase in the prevailing diversity of trends, adopted by a host of centres, workshops and masters who, once relations had been established with the duchy of Burgundy and the county of Flanders, assimilated new artistic currents spawned by mediaeval European culture in its period of maturity and decline.

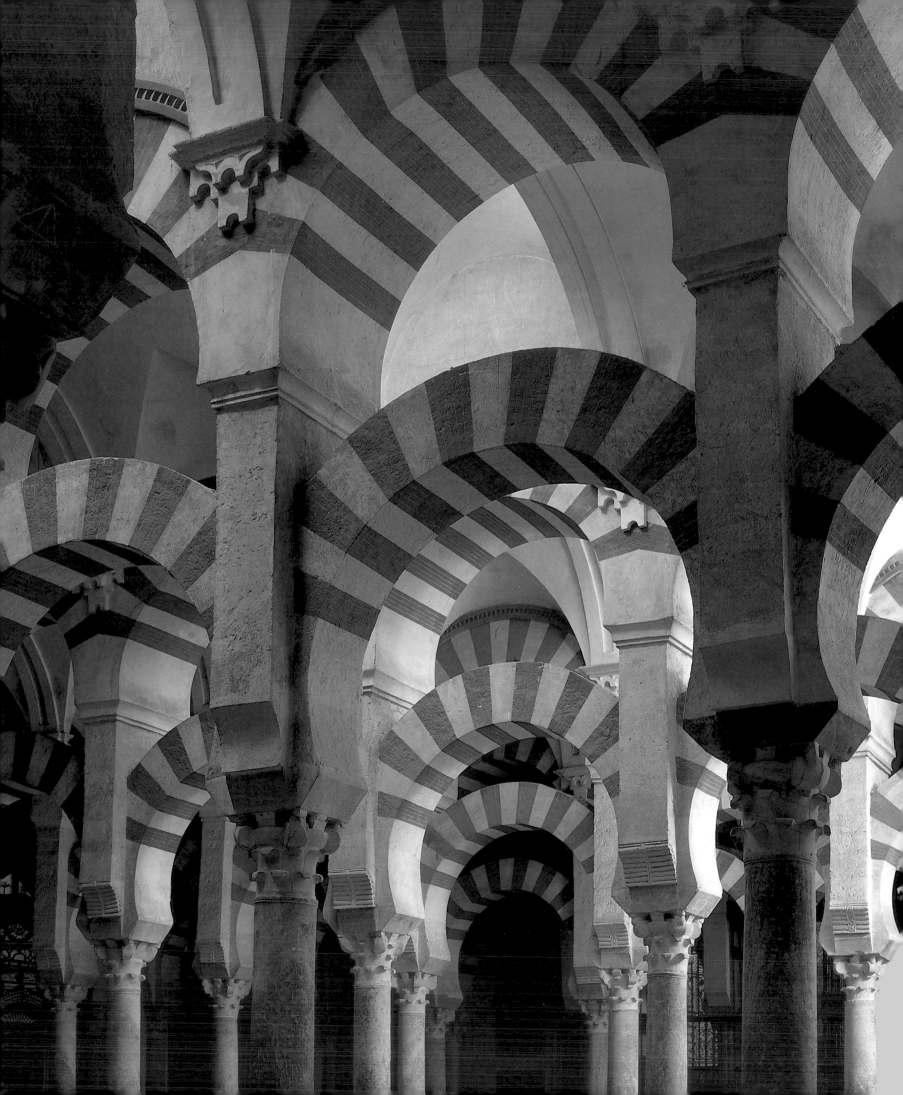

THE PRESENCE OF ISLAM AND ISLAMIC ART

THE CALIPHATE OF CORDOVA AND ITS WAKE

Christian Ewert

The political presence of Islam on the Iberian Peninsula lasted for nearly eight centuries, from 711 to 1492, yielding two periods of splendour separated by transitional phases of instability. Those culminating moments were the powerful Ummayad caliphate, transposed from Syria to the far West (*al-maghrib al-aqṣā*), and that of the Almohads, which sprang from the Berber environment.

The fall of the Ummayad caliphate of Cordova in 1031 prompted the emergence of a number of party kingdoms or *muluk at-ṭawā'if*, known in Spanish as *taifas*. They were often of dubious origin and questionable legitimacy. However, in the 11th century, the Almoravid Berbers, who invaded Spain from Morocco, did away with the party kingdoms and paved the way for the invasion of the Almohads, of similar origin, who brought to completion the political and cultural unification of the far West. The Almohad dynasty went into decline in the early 13th century, when the Christian advance or Reconquest was gaining momentum.

Islamic Spain produced a wealth of highly original architectural works. However, given the brevity of this essay, it seems reasonable to restrict ourselves to this field, taking the part for the whole, particularly when considering the need to extend the conventional concept of Spain. The historical and cultural facts described below must necessarily take in Morocco, too, bearing in mind that, in geographical terms, it acted as the natural southward extension of Al-Andalus across the Strait of Gibraltar during the culminating moment of Islamic Spain. Indeed, as I see it, it is not possible to separate the two. Moreover, it is not my intention to provide a complete inventory of monuments, but to focus on buildings which, in addition to their artistic value, are representative of the leading political and religious currents of those times.

In this respect, the crowning achievement of Islamic art in Spain is the Great Mosque of Cordova. Alone, it stands as a record of the decisive formative stage of Moorish Spain and its culmination in the Ummayad hegemony of the West. It reflects the modest beginnings of the emirate, and the developments that led up to the splendour of the caliphate, and even recalls the sudden, unexpected fall of the dynasty. This paradigmatic *opus magnum* of Islamic architecture will be examined right from the outset, as it is crucial to an understanding of the phenomenon of Islam on the Iberian Peninsula.

In Islamic architecture, decorative features are part and parcel of the architecture, and, in comparison with Christian art, the apparently vague borderlines between the various genres will enable us to have a brief look at the minor arts. In short, cross-fertilisation between architectural ornamentation and the minor arts is inherent in Islamic art.

Our brief analysis of architectural decoration will also serve to examine the various trends within the architectural typology.

Prayer hall in the Great Mosque of Cordova.

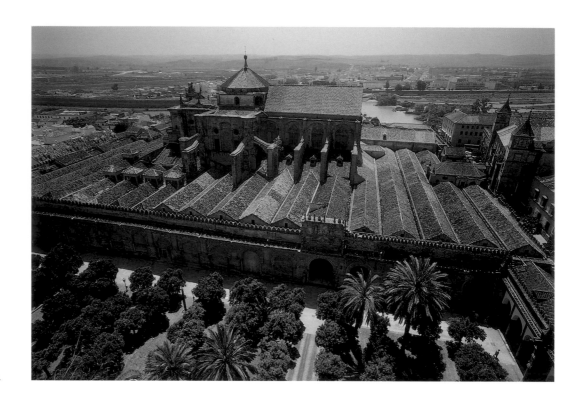

Cordova and its Early Expansion

In the beginning, Moslems worshipped in a building that formed part of a Church complex in the south of the Roman city of Cordova. Subsequently, 'Abd ar-Raḥmān I, the Umayyad emigré from Syria, persuaded the Christian community to make it over to the Moslems. Around 785, work got under way on a new building, which the sovereign sited on the west side of his palace complex, whose Visigothic origins are documented, giving rise to a combined central seat of political and religious authority, in similar fashion to well-known foundations in the Islamic East; the Great Mosque and Palace of Government (*dār al-imāra*) also formed a single unit in the Iraqi garrison towns of Kūfa and Wāsiṭ. At Cordova, the city layout inherited by the Moors was not only Visigothic, but Roman, too, and the core of the new Islamic city was built alongside a restored Roman bridge.

Construction was based on longitudinal naves perpendicular to the wall used for prayer (*al-qibla*), a style imported from Syria, from where the ruling dynasty had emigrated, and also found in the Umayyad al-Aqṣā Mosque in Jerusalem. This was actually a continuation of the early-Christian basilical tradition, with a markedly wider and taller central nave.

Moreover, continuity was also observed in the arrangement of arcades, with elevations revealing a deliberate relationship between Islam and the Roman legacy. A total of four building phases were characterised by the use of a dual load-bearing system, consisting of columns below and pillars above.

In the upper register, the pillars were set almost as far back as the adjoining main arches. The lower arches, which were far weaker, were about half as thick as the upper ones, and merely acted as props. Gómez-Moreno considered the superimposed arcades in Roman aqueducts to be the prototype of this structure.

Just half a century after the foundation of the mosque, the prayer hall had to be extended. This took a comparatively long time, from 838 to 848. Certain external parts of the building probably had to be demolished first. The naves set aside for women had then to be partitioned, and galleries built around the court.

During a second phase, the eleven naves were lengthened, while the depth of the building was enlarged on the south side from twelve to twenty spans. The new prayer niche (*miḥrāb*) also harked back to Roman times, while the four capitals on the double columns flanking the entrance were an Islamic creation. Its origins were only belied by certain details. It may now be asserted that its artificers faithfully copied Roman models.

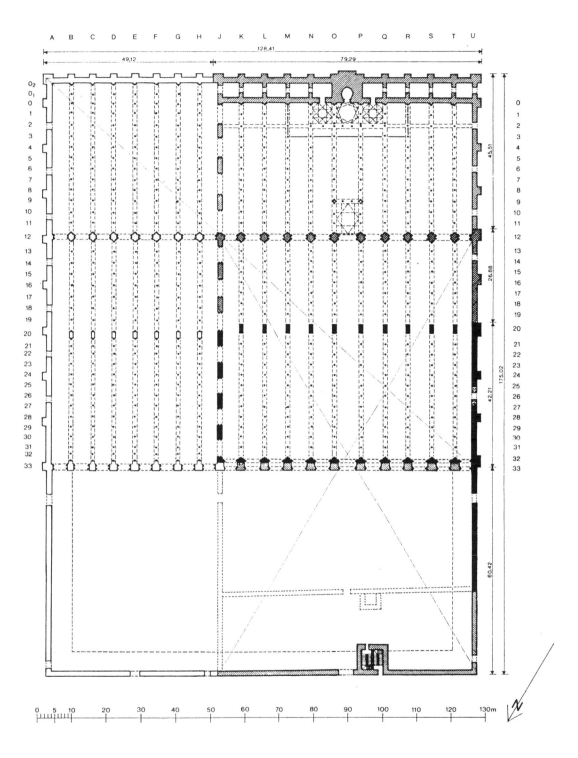

■ ʿAbd ar-Raḥmān I

▨ ʿAbd ar-Raḥmān II

▦ Muḥammad I

▦ 888-912

▨ ʿAbd ar-Raḥmān III

▨ al-Ḥakam II

☐ al-Manṣūr

Plan of the Great Mosque of Cordova after the final extension.
(Measurements by F. Hernández Giménez).

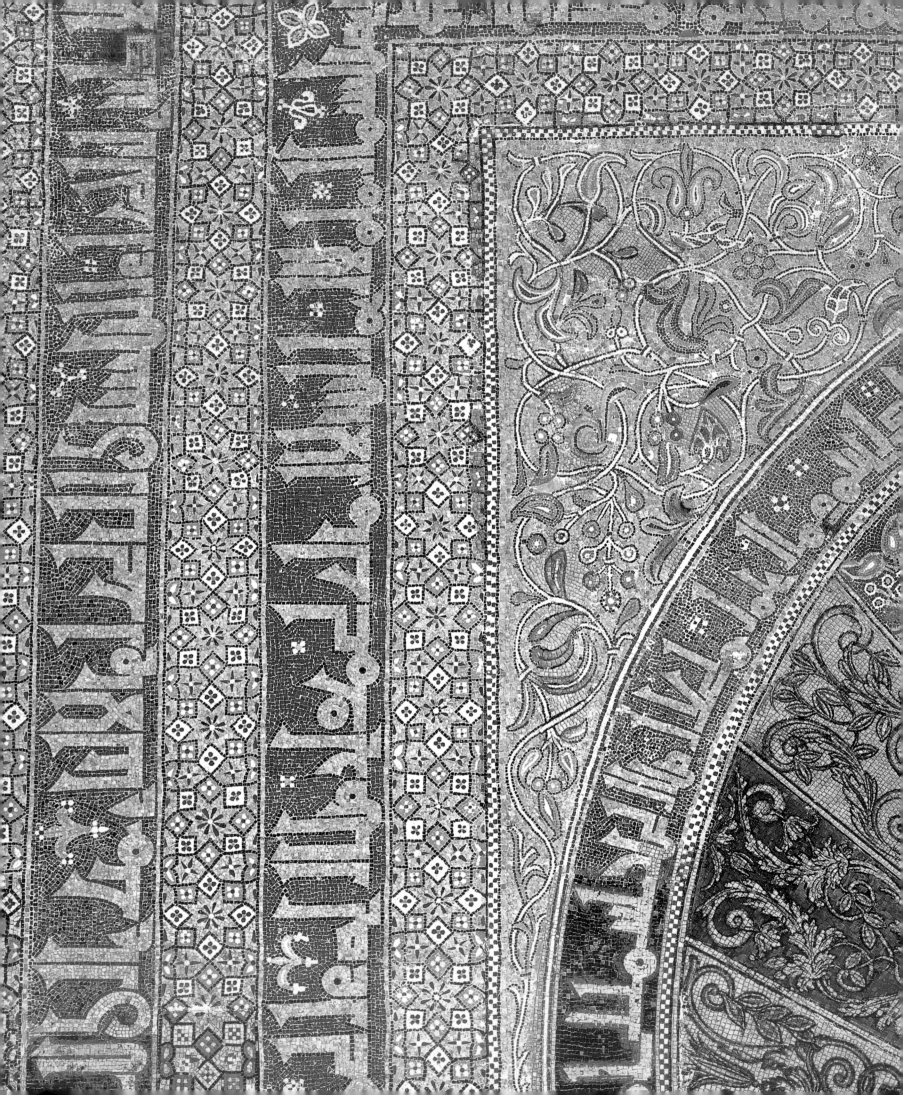

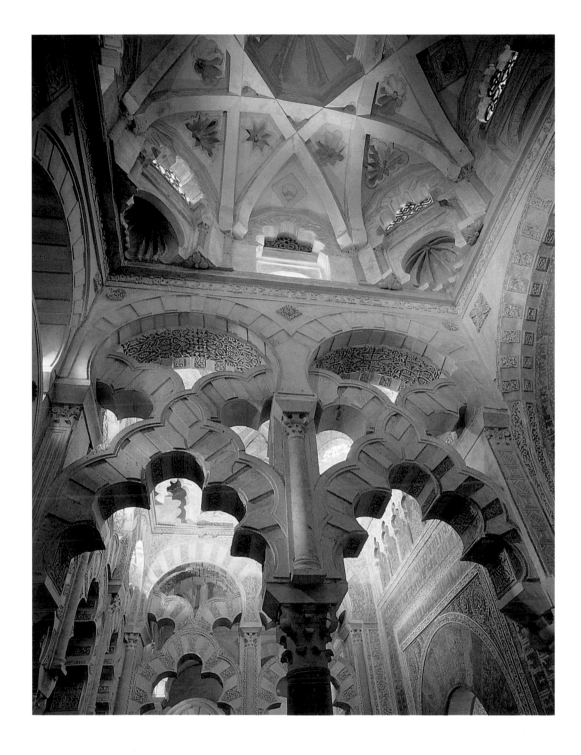

Great Mosque of Cordova: hall of prayer. Extension by al-Ḥakam II, third quarter of the 10th century.

The Umayyad caliphate recovered its splendour in the second half of the 10th century, when, in 929, ʿAbd ar-Raḥmān III proclaimed himself caliph, which might have been a reaction to the challenge posed by the Fāṭimid caliphate. The building programme undertaken in Al-Andalus was unprecedented in the western reaches of the Islamic empire, as evinced in the palatial complex at Madīnat az-Zahrāʾ and the extension to the Cordovan mosque. ʿAbd ar-Raḥmān III also had the mosque patio remodelled and, in 951, demolished the original minaret, dating from the late 8th century. A new tower was erected on the north side of the patio extension.

Immediately after acceding to the throne in 961, his son, al-Ḥakam II, undertook a magnificent extension to the prayer hall, which reduced the previous two building phases to the status of vestibules. When crown prince, Al-Ḥakam II had already supervised building work on the palace at Madīnat az-Zahrāʾ.

Great Mosque of Cordova: detail of the mosaics on the Sābat arch, third quarter of the 10th century.

The basic longitudinal structure and two-tiered arcades remained intact, although the mosque was again enlarged in length by twelve spans, without altering the overall arrangement. However, the rhythm of the naves perpendicular to the *qibla* wall was modified, as was the traditional longitudinal structure of the bay.

The T-shaped layout of the central nave—intersected at the *miḥrāb* by the nave parallel to the *qibla,* with the crossing crowned with a cupola, and all the aisles ending in a transept—still endured during the 9th century, as evinced in the new Aghlabid mosque of Kairouan (Tunisia). However, the Cordovan mosque appeared to have recovered many structural features of the far older mosque of al-Aqṣā, the arcades of which were altered during the foundation of the Cordova mosque and its two subsequent building phases. As in Jerusalem, the longitudinal arcades reach the *qibla.* Moreover, in Cordova, the bays flanking the area before the *miḥrāb* were covered with two cupolas, prefiguring the subsequent importance acquired by the *qibla*–transept duo. In the great 12th-century Almohad mosques such as Tinmāl, Marrakech and Seville, for example, these side cupolas were shifted to the corners of the building.

The new project was regarded as a two-tiered undertaking, one affecting the 'substrate' of the new prayer hall, and the other, a markedly distinguished 'superstructure', restricted to its central area. On a simple, lower level, two types of columns were set alternately: those with red shafts and simplified Corinthian capitals, and those with black shafts and composite capitals, probably based on the prototypes of Roman or Visigothic columns pertaining to the first two building phases, while parallel and oblique formations of identical columns converge on the central nave. The central nave is further distinguished by unique features in the upper arcades, and is characterised by the transverse rhythm of semicircular pilaster stuccowork and characteristically Islamic decoration on the shafts, in addition to the use of traditional Corinthian and composite capitals.

The major feature of the superimposed, transverse articulation of the new prayer hall is the arcade, which marked out the transverse nave of the *qibla.* This is the oldest example, in the Islamic West, of clearly differentiated arches set within a monumental hierarchy. It is only in the sanctuary area, formed by the three aisles on each side—that is, outside the enlarged *maqṣūra* area, which takes up five of the eleven naves—that double horseshoe arches were set across the whole nave. The *maqṣūra* was divided into three areas: the first of these was an outer bay covered with a pointed arch instead of a cupola, and edged with a frieze of volutes. Set beneath three cupolas and rising from the floor is a three-span, two-tiered understructure consisting of condensed variations of normal two-storey longitudinal arcades, enhanced with five-lobulate lower arches. A system of two-tiered intersecting arches stands in the centre of the arcade, running parallel to the *qibla* wall. Prominent in the aforementioned condensed form of arcade are the main points in the prayer hall, which are interjoined by the central nave. Each end of the bay, which acts as an antechamber leading into the *miḥrāb,* comprises a space surmounted by the two most richly adorned cupolas of the four in the mosque. The similarly condensed cupolas spring from the flat system of intertwining arches in the understructure.

The area opposite the *miḥrāb,* which forms the centre of the *maqṣura,* is covered with a single cupola decorated with mosaic. The chronicler Ibn ʿId̲ārī recounts how al-Ḥakam II 'ordered' the Byzantine emperor to send him a mosaicist and the requisite material to decorate the cupola. He was thereby following the example of his predecessor in the East al-Walīd I, associated with the mosque in Damascus, who claimed for the newly restored Umayyad caliphate universal sovereignty. Such a claim could hardly be substantiated by the decoration in an Islamic prayer hall. Al-Ḥakam II again clung to a pre-Islamic tradition, in similar fashion to his Eastern forbears: the familiar gold ground of Byzantine mosaics is considered to represent the sacred sphere.

The essence of the decorative ensemble on this cupola can only be briefly described: the umbrella vault looks like a kind of baldachin surmounting a network of ribs, giving rise to a plan of an eight-pointed star made up of two superimposed squares. The boss is formed by a celestial hemisphere, studded with a network of lozenges set around a central,

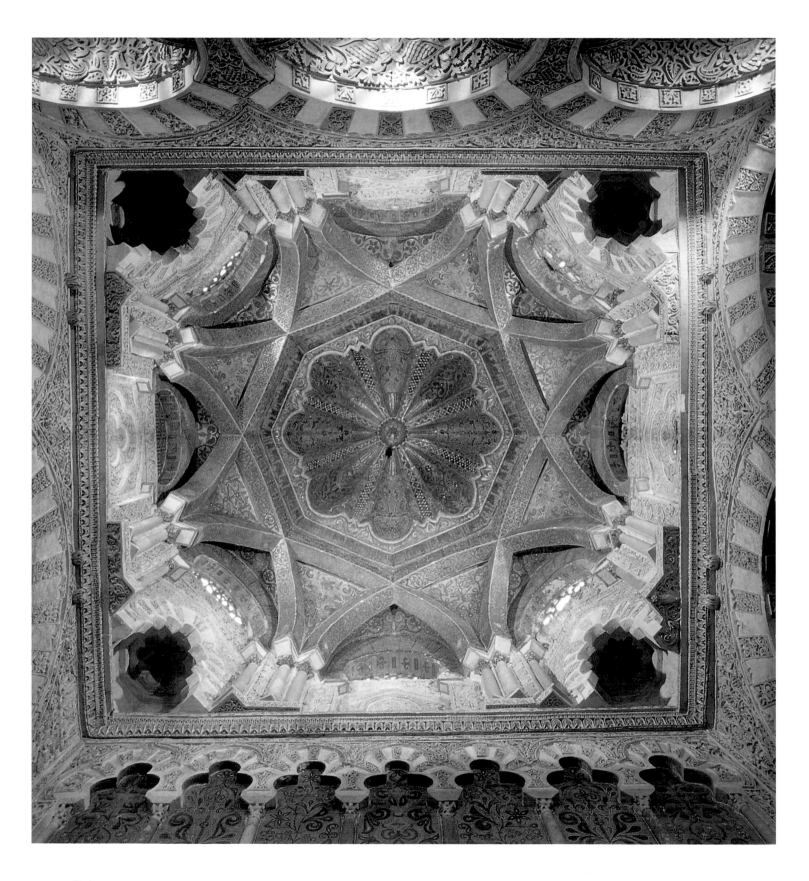

Great Mosque of Cordova: prayer hall, an extension commissioned by al-Ḥakam II. Central detail of the cupola located opposite the *miḥrāb*.
Third quarter of the 10th century.

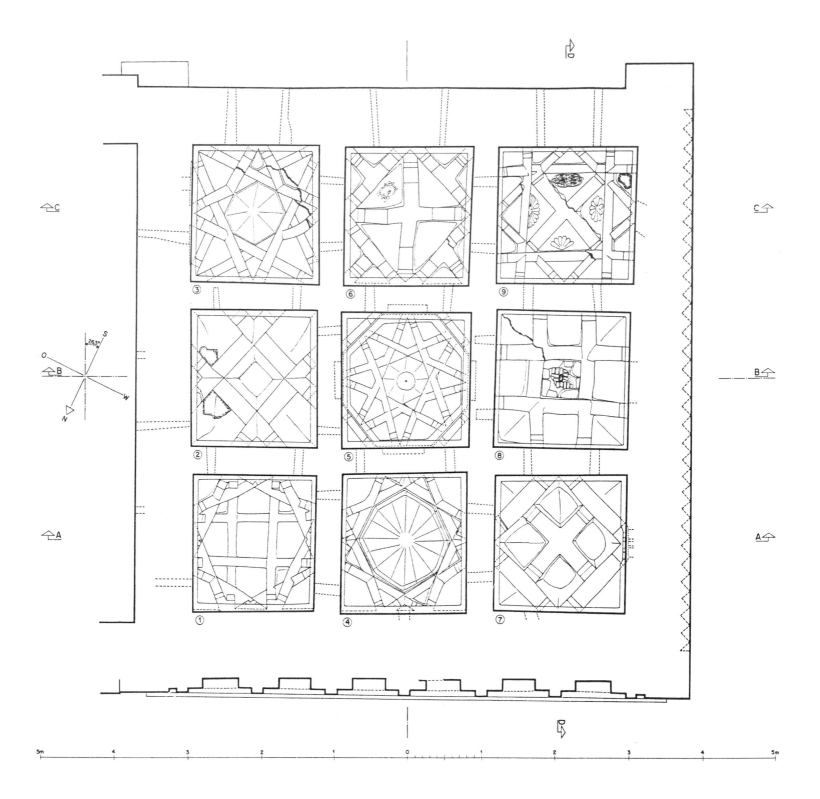

Sketch plan of the cupolas in the Bāb al-Mārdūm Mosque, Toledo.

ten-pointed star. The manifold problem of Al-Ḥakam II's religious and political building programme is exemplified in this prominent feature. It has been documented by K. Lehmann as the centre of a cupola from the Roman period until the 17th century. The characteristic reticular structure of the half-globe of Cordova reappears covering the vault of heaven in the celebrated Roman Mosaic of the Philosophers at Torre Annunziata. The vault of heaven of the scientists, also recorded in early Islam (Quṣayr ʿAmra), was regarded as a cosmic symbol. The philosopher Thales commented on the divine nature of the sphere, which has no beginning or end. This theory was used to advantage in Islam, which played an important part in the handing down of ancient philosophy, by virtue of its completely concealing the anthropomorphic representation of God. The Cordovan sphere, surrounded by a radiant gold halo, might be an allusion to the ancient association of sun and heaven.

inherently related to the worship of a sovereign consecrated as *Sol invictus*. The caliph, however, could not call up such a direct association, and could only hint at his presence as a minister of God, who had granted him his sovereignty.

The Last Extension & the Decline of the Caliphate at the End of the 10th Century

The last and greatest extension, which superseded the sum of all previous building phases, was undertaken by al-Manṣūr, the all-powerful minister of Hishām II, al-Ḥakam II's son, who had divested the caliph of all effective power. The growing attendance of the faithful, including the Berbers who had joined al-Manṣūr's raids on Christian fortresses, called for a further extension. Ibn ʿIdārī gives the date of construction as 987–988.

The proximity of the Guadalquivir precluded a southward prolongation of the Great Mosque. However, al-Manṣūr would have been loathe to impinge on the *qibla* in the caliphal hall of prayer. Public expendiency, accorded by his intelligent political restraint, will have prompted him to extend the mosque sideways, to avoid adding to the extensions undertaken by the Umayyad monarchs and being regarded as a usurper. In so doing, he might have actually been seen to pay homage to the Umayyad dynasty. Just as al-Ḥakam II had implemented his imperial programme, al-Manṣūr demonstrated his allegiance to the established order. He declined to build his own *miḥrāb* or central nave, but commissioned the still fairly recent caliphal prayer hall built under al-Ḥakam II to be enhanced. Similarly, he refrained from extending the arcade parallel to the *qibla,* opting instead to extend al-Ḥakam II's clearly subordinate entrance facade by building a single row of horseshoe arches.

Once again, the last extension consisted of a hall of longitudinal naves without transepts, although rows of pillars set crosswise mark the limits of previous building phases. A plan view reflects the refined articulation of all parts of the prayer hall, the result of two centuries of building activity. Spatial nuances were achieved with the use of the simple columns introduced by al-Ḥakam II, with shafts distinguished by two colour tones and three types of capital. Only the south side, coinciding with the extension undertaken by al-Ḥakam II, was endowed with a simple, longitudinally alternating rhythm generated by means of rows of identical columns set crosswise, while the oblique rows converging on al-Ḥakam II's central nave were left intact. The refined articulation of bays in the caliphal hall of prayer and its overall balance were also left untouched. Conversely, to the north of al-Ḥakam II's entrance arcade, any ordering principle in the columns was dispensed with. Instead, the chaos that had characterised the first two building stages was repeated in the deployment of re-used architectural elements.

Thus, Al-Manṣūr managed to come across to the faithful as a true servant of the Umayyad dynasty, as respectful of the architectural structure handed down by his masters, even in the minutest details, as if paying homage to their memory by preserving their inviolable legacy intact. He emulated the preceding building stages in the sanctuary enlarged under his direction, thereby sending out but one signal: the greatest mosque in the nation, ennobled by a building tradition of two centuries' standing, had achieved the status of role model worthy of emulation.

Emulating the Great Mosque of Cordova: the Bāb al-Mārdūm Mosque in Toledo and the Hassan Mosque in Rabat

The prayer hall in the Great Mosque of Cordova was emulated, particularly as far as the structural stages and Al-Ḥakam II's extension are concerned, during the time of the Western Umayyad caliphate, in the small Bāb al-Mārdūm Mosque (the present-day Cristo de la Luz) of Toledo, built at the end of the millennium. The two facades of the Toledan mosque and its internal, two-level articulation attest to endeavours to copy the paramount shrine of the Western Umayyad caliphate down to the very last detail.

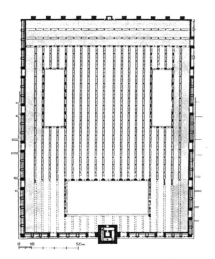

Reconstruction of the plan of the Mosque of Ḥasan (according to J. Caillé), Rabat.

The area set midway between the lower arcades and upper ribbed cupolas in all nine bays, and the very distribution of the vaults, reveal an architectural arrangement closely related to the T-shaped layout in al-Ḥakam II's Cordovan mosque, which consists of a broad central nave and a transept opposite the *qibla* forming the two arms of a 'T'. Just thirty years after the final stage of building work on the Great Mosque of Cordova had reached completion, sufficient expertise had been acquired to produce variations on the repertoire of such highly developed arches as those at Cordova. At Toledo, the hierarchical articulation of the Cordovan hall of prayer has been faithfully reproduced, albeit in a condensed form. Openings pierce the walls in the intermediate-level bays, with cascade-like echoes in the recesses of external walls, coinciding in plan view with the distribution of different arches. This differential of archivolts is also featured on the cupola level, and it is only in the cupola over the *miḥrāb* that trilobulate arches appear, as an exception to the horseshoe arches used in the other cupolas. They form a quadrangular area which becomes rhomboidal along the 45° line where the central ribs intersect. These are the main axes of the central and transverse naves in the small prayer hall. Both main naves are also accentuated by the horizontal line of the cupolas, which in the Toledan mosque are accurate copies of the arrangement used in the Cordovan ribbed cupolas. Superimposed planes were also used at Toledo, as well as in the Aghlabid mosque at Kairouan and the third building phase at Cordova, and are well documented in Islamic surface decoration, both in plant motifs rendered in plaster and in geometrical motifs.

However, it is worth drawing attention to the Eastern Islamic component in the architectural arrangement. It can be shown that the small, generally square mosques with nine bays (3 x 3) and cupolas are based on a layout imported from Asia in early-Islamic times, as evinced in the Masjid at-Ta'rīkh at Balkh, Afghanistan (probably from the ʿAbbāsid period), the Mashhad Sharīf Ṭabāṭabā at Cairo (probably circa 943), and the Aghlabid Bū Fatātā Mosque at Sousse, Tunisia (838–841). None of these places of worship, however, have two orders of superimposed arches, and none reveal the conflict, so characteristic in Toledo, between a central-plan building and one orientated towards the *qibla*.

At the end of the classical period of Western Islam, another 'copy' of the mosque at Cordova was built—the Hassan Mosque in Rabat. It provides a stark contrast with the small, intimate structural formula employed in Toledo: nearly two centuries after the Toledan mosque was built, the last major Almohad leader, Abū Yūsuf Yaʿqūb al-Manṣūr, wished to emulate the principal sanctuary of Islamic Spain—Al-Andalus—as he felt it would provide him with the spirit required to cut short the southward advance of the Christian armies. Moreover, he was not content to merely imitate the Cordovan forest of pillars, which were alone so different from the traditional Almohad mosque with its brick piers: he had the column drums set at very different heights and rendered in a rough-hewn fabric, marking a departure from local tradition. However, the overall measurements of the building are based on the frequently extended mosque at Cordova, including the last enlargement commissioned by al-Manṣūr shortly before the end of the milennium. Indeed, no other mosque in the Islamic West could match it for size.

The Great Mosque of Cordova also influenced other buildings. The prototype for the long eastern facade overlooking the valley at Rabat, with its powerful central minaret, relates to an Almohad mosque known as the Kutubīyah in Marrakech, a city founded by the Almohads in southern Morocco under direct Andalusian influence in the second half of the 11th century. Just as the mosque of al-Aqṣā in Jerusalem influenced the Great Mosque at Cordova, the latter and Marrakech in turn influenced Rabat as structural models developed in several stages.

The Hassan Mosque in Rabat shows, in its various stages of development, all manner of influences from various places in the western reaches of the Islamic empire: a direct provenance from the Islamic East, the transposition of Hispanic Islam from Spain to North Africa, and the migration of Andalusian art to the heartland of Morocco.

The New Caliphal Residence at Madīnat az-Zaḥrā', near Cordova

A third of all tribute levied by the
caliphate was used to defray the cost of
building Madīnat az-Zahrā'. Construction
work was undertaken by a force of
some ten thousand men, many of
whom were foreign, including some
Byzantines, which would account for
the fact that, in 945, just eleven years
after building work had got under way,
the complex was ready to accommodate
the court and its activity. The current
state of disrepair in which the
residential city finds itself, and the lack
of relevant documentation, make it
difficult to imagine the scope of its
former magnificence and the use to
which many of the rooms were put.
However, it appears that the numerous
living quarters set around courtyards
were connected via narrow, poorly-lit
corridors which, in contrast, enabled the
main areas to be more lavishly
embellished.

The cramped pre-Islamic palace of the emir at Cordova proved inadequate for the
representative needs of the caliphate. Thus, in 936, building work began on a palace com-
plex eight kilometres west of Cordova. This palace-city, and the extension to the mosque
in the city, were the two major projects embarked on once the caliphate had been instat-
ed. It is reasonable to assume that the same workshop was commissioned to carry out both
projects. The residential complex at Madīnat az-Zahrā' was supervised by al Ḥakam II, who
had been appointed heir to the throne and was to later provide the impetus for the exten-
sion to the mosque at Cordova.

The magnitude of the new palace-city cannot be accounted for on the basis of royal
requisites alone. There is no other princely residence in the Islamic West in any way com-
parable to Madīnat az-Zahrā' in size, and it is just possible that the idea was actually to build
something on a scale that would rival the achievements of the 'Abbāsids, arch-enemies of
the Umayyads, whose artistic and intellectual accomplishments were held in high regard
during the 10th century. Indeed, nearly half a century before the Western Umayyads
embarked on the construction of their new residence, the 'Abbāsids had already abandoned
their residence at Sāmarrā'. Moreover, the fame of that bold Islamic venture, on a scale
unheard-of at the time, was still fresh in people's minds. The conditions in which the two
palatial complexes were built were similar, at least at first sight, as in both instances the
royal family made its decision once their urban residence had become too small for them.
However, for the 'Abbāsid caliphs, Baghdad had become unbearable, as they had been
coming under increasing pressure as a result of friction between the inhabitants of the city
and the palace guard, of Turkish origin, whose growing influence had assumed disquieting
proportions. In contrast, at Cordova, the caliph was able to act with sovereign composure.
'Abd ar-Raḥmān III enjoyed unassailable authority and prestige at the time, and all powers
relating to his prosperous domains were vested in him alone.

Constructional parallels between Bagdad-Sāmarrā' and Cordova-Madīnat az-Zahrā'
were limited to the functional relationship between the two satellite residences and their
respective capitals. In terms of their common Eastern roots, the two projects also resembled
each other by virtue of the fact that they were both short-lived.

Madīnat az-Zahrā' lies at the foot of the Sierra de Córdoba and extends across its
southern slopes down to the plains below. Enclosed by two ringing walls, the complex
measures 2700x1500 cubits or 1520x745 m, according to Arab sources. On the upper side,

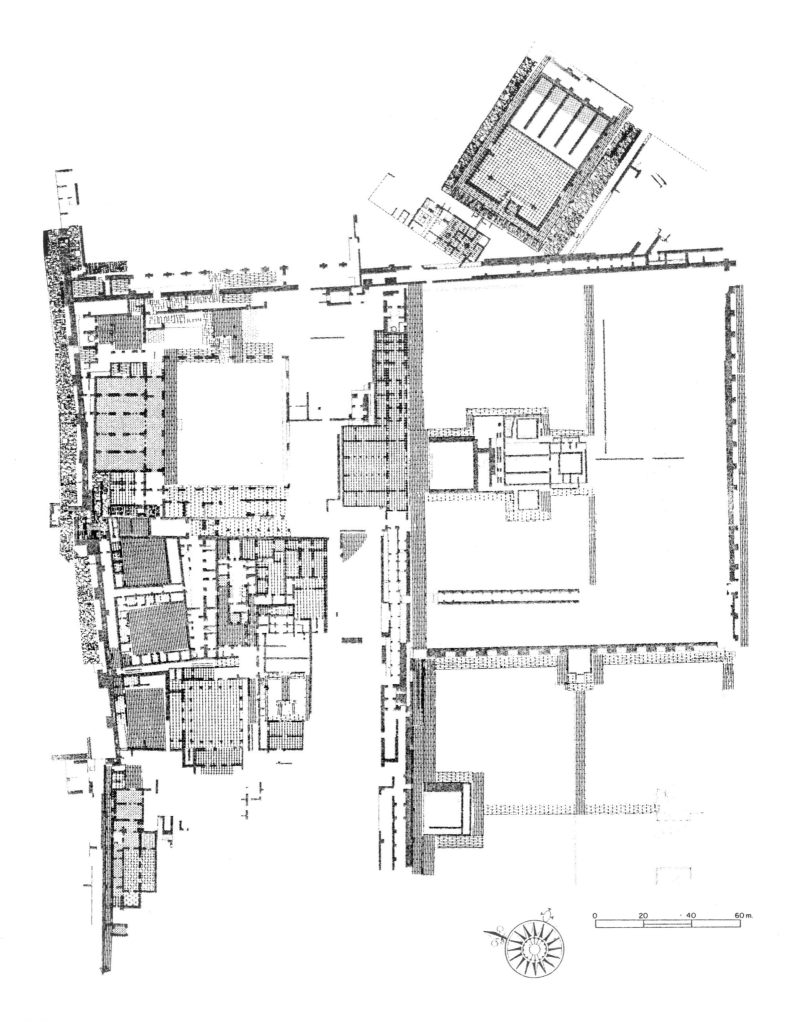

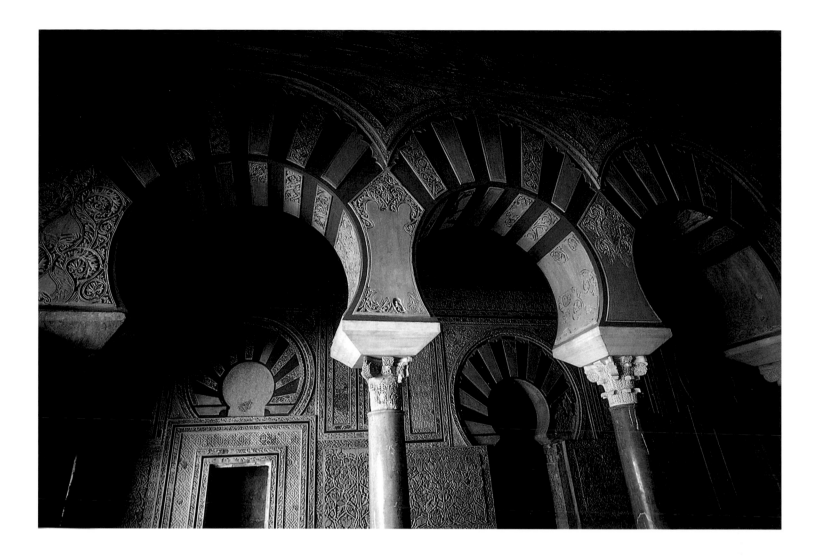

it ran smoothly into the mountain slope, forming a terrace. To date, only the central part of
the north wing has been excavated, revealing part of a vast palace complex attached to the
north wall.

The principal quarters in the great palaces of Sāmarrā' are connected via a rigorous
axial system. In contrast, at Madīnat az-Zahrā', there is no overall principle linking the var-
ious units. Even the two most significant quarters that have thus far been excavated—two
longitudinal halls and their entrance portico, set crosswise—only reveal an axial arrange-
ment in their respective forecourts. The three-naved nucleus of the southern hall is repeat-
ed in another free-standing pavilion. Attached to this complex is a series of axially placed
cisterns. A number of multi-naved halls are connected to family living quarters, the latter
being based on the model of Umayyad citadels in the Syrian desert, in which the chambers
are set around a square patio. The split-level floors are linked by a number of ramps.

The arrangement of the Moorish fountains suggests a terraced layout based on three
levels: palace, living quarters and gardens. The palace, the crowning feature of the resi-
dential city, must have determined its major axis. The so-called *Salón Rico* ('Rich Hall') and
a pavilion in front of it are set slightly west of this axis.

While the caliphate could obviously draw on the necessary resources to meet its
town planning needs in the capital, a palatial complex as lavish as Madīnat az-Zahrā' appar-
ently stretched those resources to the full. It reveals a certain reliance on ancient Eastern
structural influences, and it gives the impression that local craftsmen, who were heavily
dependent on the Umayyad tradition, had never received a commission of this magnitude

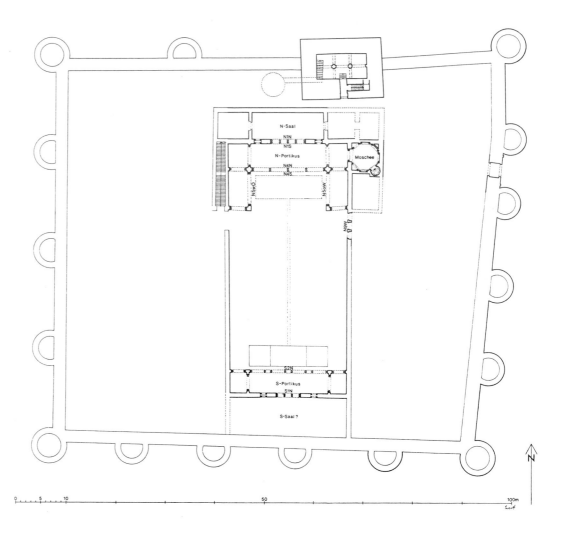

Hypothetical plan of the Aljafería
Palace, Saragossa.

and had not mastered the principle of axiality which the Eastern masters had perfected in
the enormous palaces at Sāmarrāʾ, built in response to elaborate ceremonial requirements
that reflect Persian influences.

The Party Kingdoms or Muluk at-ṭawāʾif: *the Aljafería of Saragossa*

During the 11th century, the second monarch of the Banū Hūd dynasty, Abū Jaʿfar
(hence al-Jaʿfarīya = Aljafería) Aḥmad I b. Sulaymān al-Muqtadir bi-llāh (who ruled in
1049/50–1081/82, according to numismatic sources, or 1051–1079/80, according to the
chronicle of al-ʿUḏrī) built a leisure residence on the scale of those used by the descendants
of the defunct Ummayad caliphate of the Islamic West. This monarch led the Kingdom of
Saragossa to its peak of political power and cultural achievement.

The palace is situated on the Vega del Ebro, near the capital, Zaragoza. La Aljafería
is the sole surviving *taifa* palace from the 11th century, of several on the Iberian Peninsu-
la recorded by contemporary Arab sources. The essential features of the palace have been
preserved, and bear inscriptions relating to its builders.

The ground plan of the building contains some of the major features characteristic of
Ummayad castles in the Syrian desert, dating from the first half of the 8th century. In this
respect, certain buildings in North Africa attest to the existence of intermediate stages in the

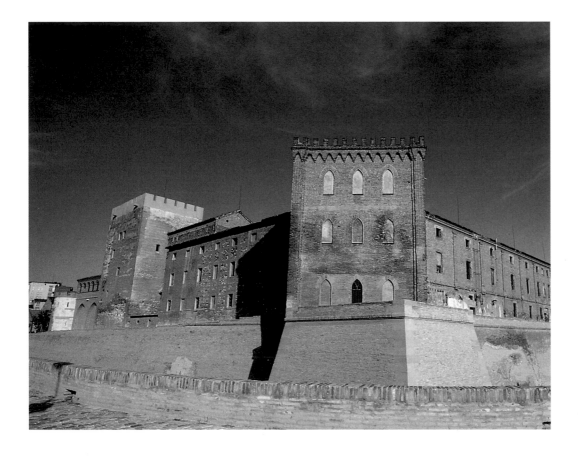

Zaragoza: Palace of the Aljafería.
Reconstructed Moorish wall.

spread of Islam to the Western Mediterranean. The best examples of this are the *ribāts* or holy fortresses of Sousse and Monastir, built by the Aghlabids.

The ground plan of the Aljafería, which is square, with a slight trapezoidal bias in the encircling wall on the east flank, recalls the Eastern Umayyad type in the horseshoe shapes of the towers. The east side of the Aljafería, where the only palace entrance is located, reveals the beginnings of a continuous tripartite devision of the kind Creswell demonstrated at Mshattā. The diameter of the flanking towers is equal to the breadth of the stretch of wall separating them, while division of each wall stretch into three parts yields the width of the entrance gate. In the palace interior, this traditional system of proportions is not only applied as merely a means of linear division, but, in strict observance of the Eastern Umayyad prototype, as an orthogonal turn in subsequent phases of subdivision into three north–south-facing areas, with an *īuān* or audience chamber in the centre, bounded by two sets of quarters on the north and south side, at the end of the central court. The aforementioned quarters consisted of a broad central area with two alcoves on the sides. This gradual articulation of the north block, where the throne room is assumed to have been located, has side alcoves projecting towards the alcoves of the portico, which extend into the court, giving rise to two open wings set around a cistern. The south side lacks any prominent wings of this kind, but has an imposing facade in six sections, with intersecting arches, characteristic of the Aljafería, running the breadth of the patio. The tripartite division can only be seen inside the portico, as the internal articulation of the south chambers is now missing.

The Aljafería of Saragossa is exemplary of a transitional period, as its architecture mirrors the political divisions of the time. Indeed, it has often been regarded as the epitome of an interregnal style. Characteristic Umayyad features coexist in the palace with others that would not be developed to the full until after political and cultural consolidation was attained in the 12th century.

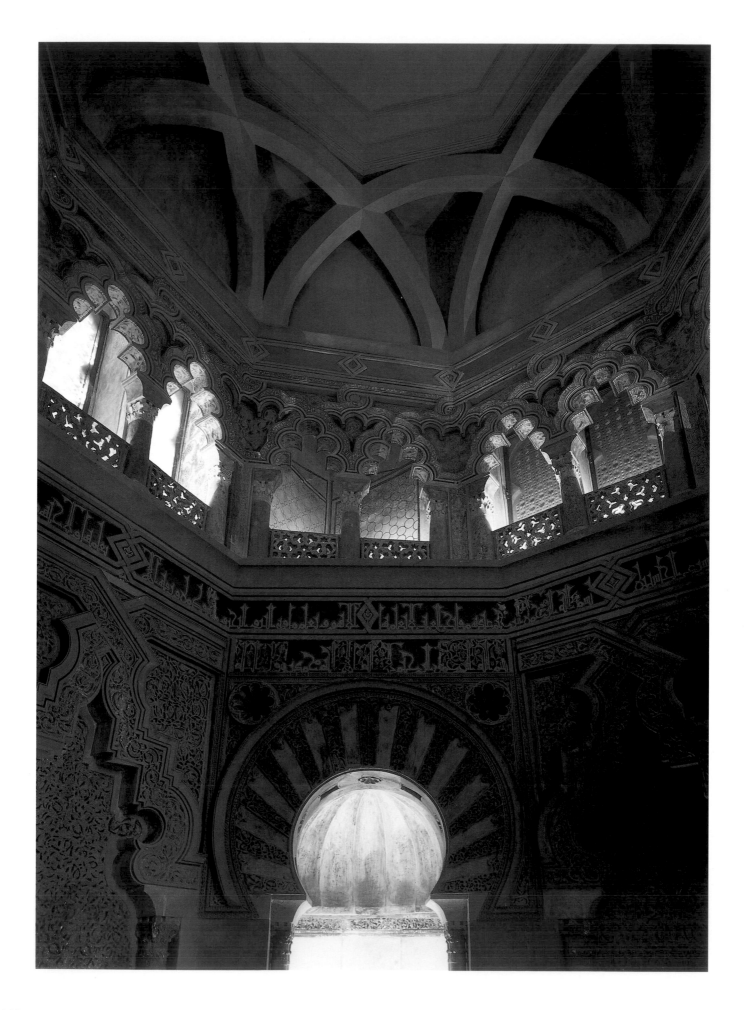

218

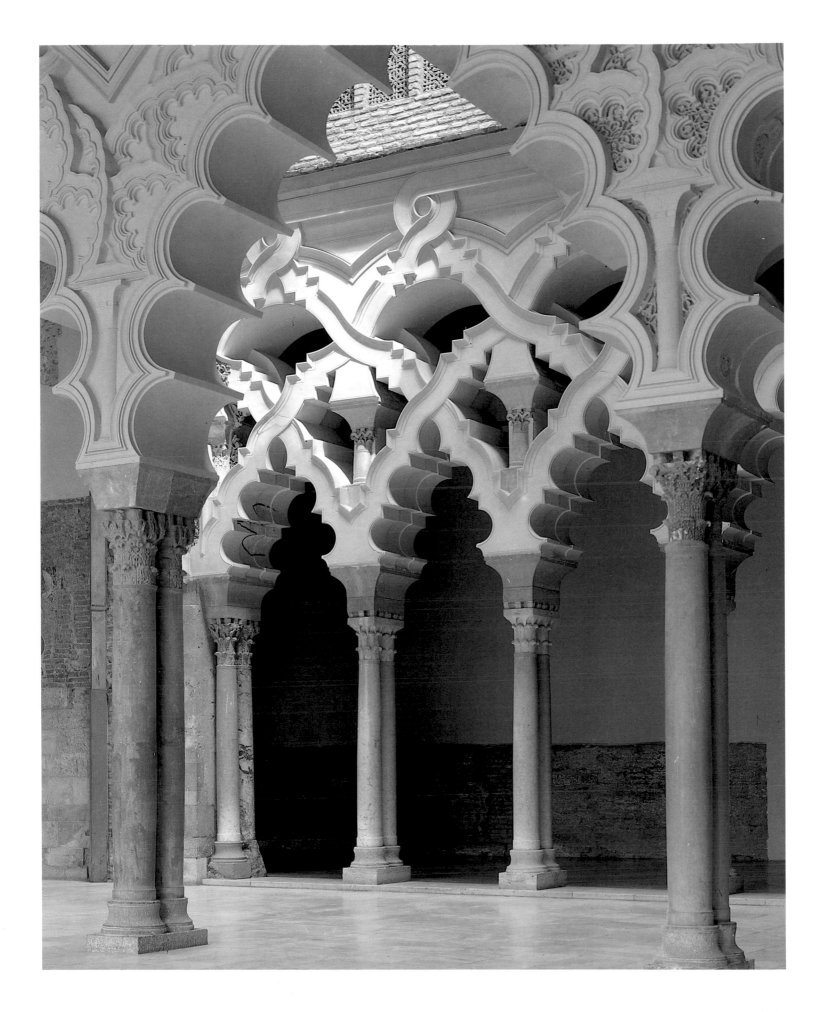

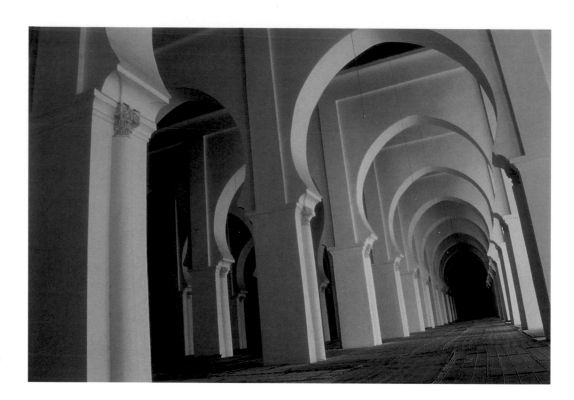

Kutubīyah Mosque, Marrakech: prayer hall; first half of the 12th century.

Previous pages:

Zaragoza, Palace of the Aljafería; third quarter of the 11th century.

The Palace of the Aljafería in Zaragoza (Roman Saragossa) is an excellent and beautiful example of the artistic developments that took place in the Hispano-Moslem territories as from the period of the party kingdoms or *muluk at-ṭauā'if*. With the political and economic impoverishment of the capital, the grand, incisive caliphal architecture disappeared, being replaced by more superficial, decorative and artificial values. The profusion and complexity of the arches in the small interior shrine are quite uncommon: horseshoe, lobulate, intertwining and mixed arches are so intermingled that they lose their tectonic value and become a framework for polychromed stucco ornamentation.

The Almohads and the Islamic Legacy of North Africa

Like their predecessors, the Almoravids, the Almohads were of Berber origin. The Almoravids had founded Marrakech at the foot of the Atlas mountains in 1062, and the Almohads set about embellishing it. At the end of the 11th century, the party kingdoms called on the Almoravids to help them check the inexorable advance of the Christian armies, and the Almovarids responded by doing away with the destitute states and uniting much of the Maghrib and Al-Andalus, the latter having been severely ravaged and reduced in size by the Christian Reconquest.

During the 11th century, the Maghrib had been exposed to the artistic influence of Moorish Spain, whose Umayyad legacy had overspilled its frontiers. Andalusian artists, and possibly entire workshops, emigrated southwards to Morocco, and Marrakech and Seville became the two major centres of art in the Islamic West. The formal artistic repertory was developed to high standards in those united territories, in which the Almohads, who were religious traditionalists, distilled their formal language in the mid-12th century.

The Almohads set their seal on architecture, particularly in mosques, as they were religious reformers. They clarified structural types and disciplined the decorative techniques of workshops in the Moroccan heartland, which were either predominantly Andalusian or followed the Andalusian tradition from then onwards.

Two works in the metropolitan area of Marrakech feature all the hallmarks of an Almohad building. The first is the Kutubīyah, built in two stages. The second stage was probably completed in 1158 and is structurally almost identical to the original one, against which it is placed and slightly offset. The second example is the building erected as a memorial to Ibn Tūmart, the founder of the Almohad movement, in the fortified town of Tinmāl, about 100 km south of Marrakech in the Atlas mountains, where he lived and died. This building, commissioned in 1153-1154, is much smaller than the one at Marrakech and its construction was probably assigned to master builders from the capital. Tinmāl is about

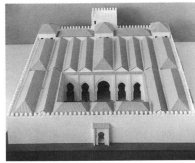

Tinmāl (southern Marrakech): model
reconstruction of the mosque, by
J. P. Wisshak.

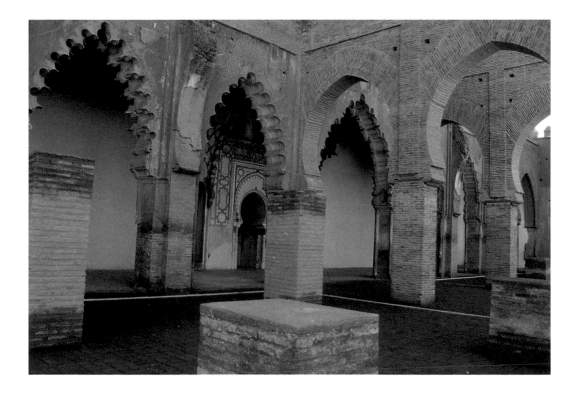

Tinmāl (southern Marrakech): mosque;
mid-12th century.

half the size of the Kutubīyah, consisting of nine naves, compared to the other's seventeen, in the main body, and two instead of four in the side wings.

The main mosque at Seville, the site of which is now taken up by the Cathedral, was based on the model of the Kutubīyah at Marrakech, and its famous tower, La Giralda, which was later turned into a belltower, is closely related to two other great Almohad minarets: those of the second Kutubīyah of Marrakech, and the Hassan Mosque in Rabat.

A number of examples of religious and palatine architecture have to be analysed in order to fully understand the significance of a 12th-century Islamic prayer hall, as a glance at these palace mosques reveals just how characteristically imprecise was the borderline between religious and civil architecture in Islam, which yielded an all-embracing system capable of absorbing all aspects of life.

The internal layout does not fit any preconceived typology, as far as religious architecture is concerned, and the number and arrangement of courts is uncommon in other mosques. The central court impinges on the characteristically shallow Almohad building and is flanked by four side courts arranged in pairs. The central and side courts are separated from each other by open arcades, while a transverse nave is placed between the two side courts in each pair. Set along a prolongation of the horizontal axis of the central court is the main nave, which is 'echoed' on the opposite side of the main court by a shallow, single-section nave. These four spatial elements, lying along the two axes of the central court, are signalled on each facade by a broad depressed arch. This arrangement is redolent with Eastern influences. Indeed, when in the central court, one has the feeling of being in a Persian mosque with four *īuăns* or audience chambers based on pre-Islamic palace models, such as the Parthian palace of Asūr. That might well be the source of reference for the two side courts flanking the central one, which can also be seen in North Africa, in the Zīrid palace of Ashīr (Algeria). It is as if the monarch had gazed at a plan of his palace mosque and, seized by a flight of fancy, decided to relieve it of its secular function. The arcades, the only dividing element in this mosque, provide the viewer with profound per-

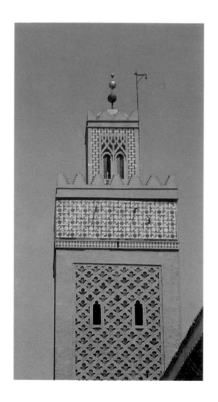

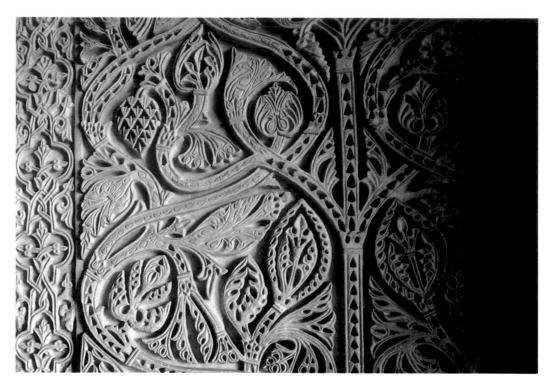

Minaret of the *Qaṣbah* Mosque in Marrakech; 12th century.

Caliphal residence of Madīnat az-Zahrā' (Cordova): decorative panel from the frieze in the *Salón Rico;* second third of the 10th century.

The *Salón Rico,* located on the south side of the palace, was divided into three naves by columns which supported horseshoe arches, with large, highly decorated limestone panels covering the walls. The *ataurique* ornamentation, a form of stylised plant motif, was worked in just two planes, the motifs standing out sufficiently against the neutral ground to set up a chiaroscuro. The capitals, derived from Corinthian and composite forms, were adorned in similar fashion and were a constant in caliphal art. This type of capital, and the information supplied by inscriptions, have led this hall to be dated in the period 953–957.

spectives of a virtually esoteric beauty. At a stretch, one might venture the more transcendental idea that the monarch's purpose was to heighten the diaphanous image of a paradisiacal, celestial palace by endowing it with a monumental spatially three-dimensional effect, possibly suggested in the earlier iconography of mosaics in the Umayyad mosque in Damascus.

The Development of Plant Ornamentation During the Almohad Caliphate in Cordova

The frieze on the walls of the *Salón Rico* at Madīnat az-Zaḥrā', which runs around both the main chamber and side alcoves above head height, is the most significant example of a closed decorative pattern in the Umayyad West. It was eventually pieced together by F. Hernández Giménez, after decades of painstaking work. As on the facade of the Great Mosque of Cordova, stucco has not been used in the architectural decoration. In the *Salón Rico,* the walls are lined with panels of soft limestone, which is as easy to work as stucco.

This decoration is akin, not in its constituent features but in its compositive arrangement, to the early 'Abbāsid period, the art of which is well known from Sāmarrā', a palace-city on the outskirts of Baghdad. In the Western Ummayad palatial complex at Madīnat az-Zaḥrā', what is also striking is the tension between developmental freedom and compositive discipline, in which the axial symmetry is marked by a stem placed in the centre, as was customary.

Highly elaborate *ataurique,* based on stylised plant motifs, usually rose from dense foliage below, with interspersed, stunted palm compositions, letting hardly any background show through. Simple and composite forms are rendered as closed, droplet-shaped outlines. On the whole, they must have been worked by Eastern masters, or masters who trained in the East and who worked as a team. Their style influenced all subsequent ornamentation in Al-Andalus.

The Party Kingdoms or Muluk at-ṭawā'if: Stuccowork Found in the Alcazaba at Balaguer and in the Aljafería at Saragossa

Fragments of stucco and painting unearthed in the Alcazaba of Balaguer (Lleida) are closely related to those in the Palace of the Aljafería at Saragossa, as they come from the same repertory. The pieces from the Islamic fort at Balaguer, most likely dating from the 11th century, include a distinguished, although highly fragmented, group bearing palmette designs. Their drop-like outlines, akin to those at Madīnat az-Zaḥrā', are still intact, and they reveal ʿAbbāsid influences even in the details, particularly the carved fragments, ringed by stark, typically Andalusian digitate leaves. Eastern influences appear to have streamed in throughout the 11th century, as borne out by the painted panels in the upper arcade in the oratory of the Aljafería, which reveal direct similarities to Eastern decoration down to the last detail.

Never before had forms of this kind been exalted to such an extent as, for example, in the almost arbitrary combination of a well-defined lower repertory with markedly schematic palmette and fruit motifs in the upper section. Both their 'syntax' and 'vocabulary' have been highly rationalised. Such lofty heights of development were bound to be exported.

Alcazaba of Balaguer (Lleida): fragment of stuccowork from a palace; 11th century (Museo de la Noguera, Lleida).

The Almoravids: Stuccowork Finds at Shīshāwa (Southern Morocco) and the Qubba of ʿAlī b. Yūsuf in Marrakech

In the course of excavations undertaken by P. Berthier on the site of ancient Shīshāwa, some 70 km west of Marrakech, on the *Maison de la Plaine,* numerous stucco fragments were unearthed, most of them from the Almoravid period. The proximity of Marrakech, founded by the Almoravids, would commend a comparison with the decoration in the hall of ablutions or *mihdā* at the major mosque in the city. H. Terrasse analysed this rich ensemble of stuccowork, in addition to that of the al-Qarawīyyīn Mosque at Fez. The Almoravid stucco of Shīshāwa reveals the evolutionary trend in Andalusian decoration, which was then in its second phase of development: after the demise of the caliphate of Cordova, followed by internal migration to the party states on the Iberian Peninsula in the late 11th century, migration to Morocco also got under way. It continued in the early 12th century, as a result of Yūsuf b. Tashūfīn's political unification of the Islamic West.

The decorative features of the Almoravid stuccowork at Shīshāwa and Marrakech are related to and complement one other, as they essentially respond to two variations on a single repertory: the stuccowork of ʿAlī b. Yūsuf's *qubba* breathes an elegance commensurate with Marrakech's capital status, while that of Shīshāwa might be considered a provincial offshoot.

The motif of digitate leaves proliferated even more than under the party kingdoms. Even the lower parts of the decoration, which by then had been highly simplified (chiselled, or with little digitation), were part of the Western Umayyad legacy. The *ṭā'ifah* tradition endured in the contrasts set up by digitate elements placed in opposite directions, while the principle of combining basic and more elaborate interchangeable parts was then applied to asymmetrical ensembles. Similarly, the principle of variation was exploited to the full, albeit within the limited dictates of a formal repertory.

The Almohads

The new demands imposed by the religious purism of the Almohads could only be met by a traditional artistic mindset based on rationalised norms. The digitation of plant elements was reduced or abstracted to a number of cursory notches, while the digitate palmette was turned into a virtually smooth half-palm leaf.

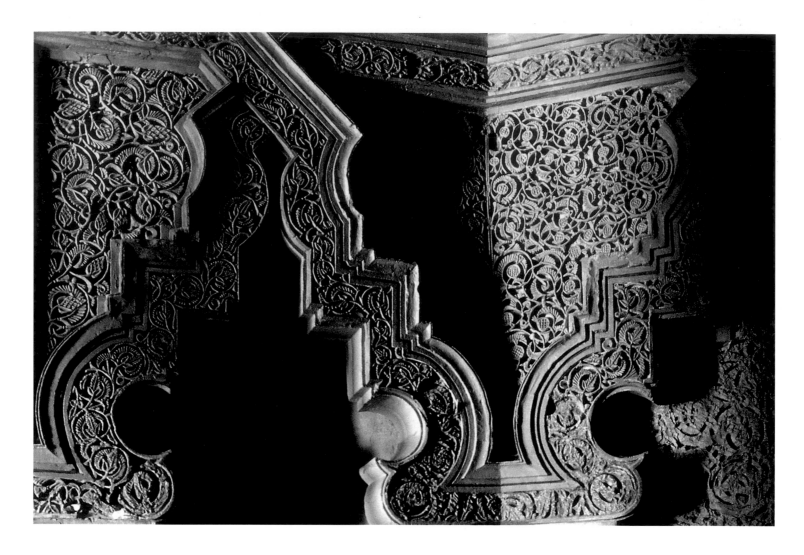

Saragossa: decorative arches in the oratory at the Aljafería; third quarter of the 11th century.

This reduction of ornamental motifs was, however, offset by a broader field of application. Structural arches became contaminated by plant forms or diluted altogether, and the Almohad masters decorated their minarets with huge reticular panels based on smooth palm motifs. Capitals were profusely decorated, although their ornamentation involved totally abandoning existing repertoires, remains of which survived in only a few isolated instances. Not only specific features but the overall decorative distribution in interiors was transformed. The scant or non-existent subdivision of leaves in ornamental detail was matched in pictorial decoration by smooth grounds on large surfaces.

Although this newfound formulation of decorative art should theoretically be regarded as a full-blown renewal, the reform was actually firmly rooted in the structural and formal principles of pre-Almohad Andalusian art.

MOORISH ART, FROM THE TIME OF THE ALMOHADS TO THE FALL OF GRANADA

Fernando Valdés Fernández

Almoravid Architecture

When the Almoravids incorporated Al-Andalus into their empire, during the last decade of the 11th century and first decade of the 12th, they brought about a marked political change. Indeed, it was the first time since the foundation of the Umayyad emirate that the Hispanic Moslems ceased to rule their own destiny, which now depended on an external, North African power. However, the political inferiority of Al-Andalus led its highly developed art to be propagated abroad on an unprecedented scale, a process which began before the territorial conquest had been completed.

The key to the decline of the ṭawāʾif, or party kingdoms, cannot be accounted for exclusively on the basis of their military weakness in the face of the aggressive Christian principalities of the north which, like their southern neighbours, endured political strife of their own. The reasons for the crisis of the ṭawāʾif lay in a complex set of economic factors related to their gold and silver currency being removed from circulation, and the shortage of metal for coining money, after the gold routes from the Sahara to the Strait of Gibraltar had been discontinued or diverted. In artistic terms, the shortage of hard currency drove the major architectural entrepreneurs, who had been active in the various kingdoms until the 1080s, out of business.

It appears that the court workshops which served the most powerful states were forced to emigrate after they stopped receiving commissions from their patrons. Having acted as the repository of art traditions purified by the Western Umayyads, and having developed those traditions to extremely high standards of formal variety and workmanship, they were now driven to seek new markets. Their fortunes abroad are only partly known, but it appears they journeyed mainly to the North African Maghrib states and the Norman kingdom of Sicily. Some might have even reached the burgeoning Cairo of the Fāṭimids. However, most of them found, in the Almoravid sultans, eager, acquiescent and affluent patrons who were well aware of their cultural inferiority vis-à-vis their Andalusian subjects. Thus, the art of Al-Andalus colonised the regions of the Islamic far West or Maghrib al-Aqṣā.

The greatest constructional achievement of the new dynasty was undoubtedly the foundation of Marrākush (Marrakech) in 1070, which first flourished under the sultan ʿAlī ibn Yūsuf (1106-1146). However, despite the documented monumental scope of the then capital of Morocco, precious few archaeological remains have survived to tell the tale. Perhaps the most important surviving building is the *Qubbat al-barūdiyyīn*, a small, rectangular-plan ablution pavilion raised above a cistern. It is roofed with a ribbed cupola adorned with lush, digitate vegetation, more luxuriant than the norm during the time of the party kingdoms.

Apart from the aforementioned building, the most representative constructions of the Almoravid period are the Great Mosque of Tlemcen (Algeria) and al-Qarawiyyīn, in Fez, one of the historic capitals of Morocco. The mosque at Tlemcen, built in 1135, is regarded as one of the greatest achievements of the Almoravid dynasty, although it is not clear just what the original building looked like, on account of subsequent structural alterations.

Plan of the Great Mosque of Tlemcen (Algeria).

According to G. Marçais, it consisted of thirteen naves perpendicular to the *qibla,* of which the central nave, divided into three sections, was the widest. The court was set in the centre of one of those sections, surrounded by the prolongation of the side naves of the oratory, giving rise to a triple portico on two sides. As in Cordova, the hexagonal *miḥrāb* was especially elaborate.

The dynasty's Great Mosque of al-Qarawiyyīn was substantially remodelled during the reign of the Umayyad ʿAbd ar-Raḥmān III (912–961), who enlarged the building and added a stone minaret.

It was at this sanctuary that the Almoravids undertook a major refurbishment during the last days of ʿAlī ibn Yūsuf. Of the Andalusian architects summoned for the purpose, the name of Salāma ibn Mufarrij has been recorded for posterity.

The floor containing the prayer hall was left intact in the renovation, although it was enlarged with the addition of three naves. The importance of the central nave—the one leading to the *miḥrāb*—was accentuated by retaining its greater magnitude, raising the ceiling above those of the other naves, and covering its bays with lavishly decorated vaults. Only four of these vaults have survived: three studded with stalactite work and one ribbed. These decorated cupolas are possibly the most striking feature of the mosque.

The evolution of plant decoration, which first appeared after the fall of the Cordovan caliphate, is cut short in this mosque, as the stalactite work on one of the vaults is surrounded by three rings of plant decoration in which the motifs are acanthus leaves in the purest classical style, a feature wholly alien to the art traditions vested in this building and out of keeping with its date of construction.

While it might be glibly conjectured that this decoration is a throwback to Roman prototypes, the issue is actually rather more complex. It relates to the practice, common to many Islamic dynasties, and evident from their very doctrinal origins, of re-using pieces of sculpture, or imitating styles and ornamental features from previous buildings, as a means of legitimising their own power base. This course of action is particularly conspicuous in newly conquered territories in the Mediterranean which were once part of the Roman Empire. There is no other way of accounting for such an abrupt, incongruous hiatus in decorative style. This is the period in which stalactite vaults first come to light in the Islamic West. Examples are documented in Almería in the 11th century, but the earliest surviving material remains, which predate those in Almería, are to be found in the Qalʿa of the Banū Ḥammad tribe in Algeria (1089-1105).

The earliest examples of stalactite vaulting which are preserved intact are, in this order: the Qubbat al-Barūdiyyīn, a vault in the Great Mosque of Tlemcen, and three in the al-Qarawiyyīn Mosque. Subsequently, during the Almohad period, this type of decoration was developed to great perfection, as evinced in the mosques of Tinmāl (1153–54), the Kutubīyya of Marrakech (1162) and the Alcázar at Seville, culminating in the unassailable splendour of the famous Court of the Lions in the Alhambra, Granada.

The overall impression of Almoravid buildings is one of the overwhelming influence of classical Andalusian models, with a tendency to accentuate the T-shaped transept. However, a closer look also reveals the influence of Eastern currents related to the Iraqi ʿAbbāsids and the Fāṭimids of Egypt. These telltale features include the prolongation of naves to encircle the court, and the use of pillars instead of columns, in addition to the decorative use of stalactite work. Judging from surviving examples, the style in question reached its peak under the Almohads.

In southeast Spain, in the present-day region of Murcia, stand a number of buildings from the Almohad period which are nevertheless fully Almoravid in style. The name recently coined for them is 'Mardanishid', as they date from the reign of ʿAbd Allāh ibn Mardanīsh (1147-1172), a prince whose kingdom emerged from the ashes of the Almoravid empire. For a quarter of a century, this princeling held out against the Almohad advance and retained his independence, symbolised in the continuity of a pure Andalusian architectural style, more archaic than that of the new lords of Al-Andalus, who ended up imposing their hegemony in art and politics.

Fez (Morocco): the al-Qarawiyyīn Mosque; mid-12th century.

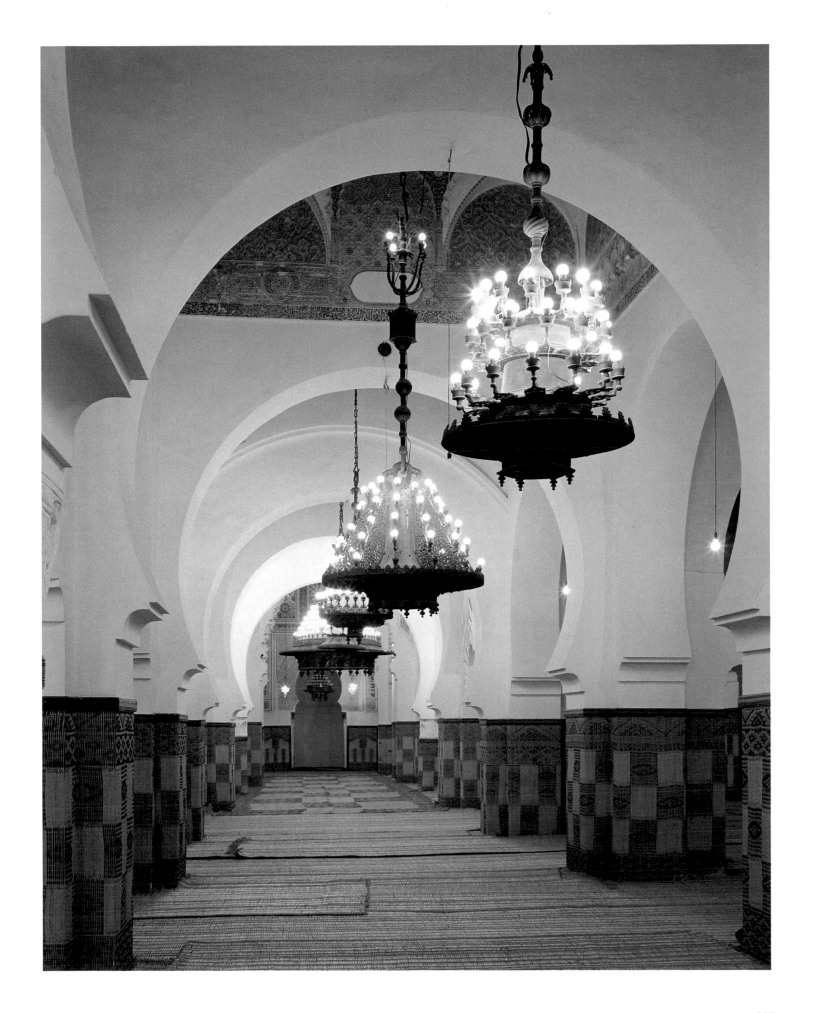

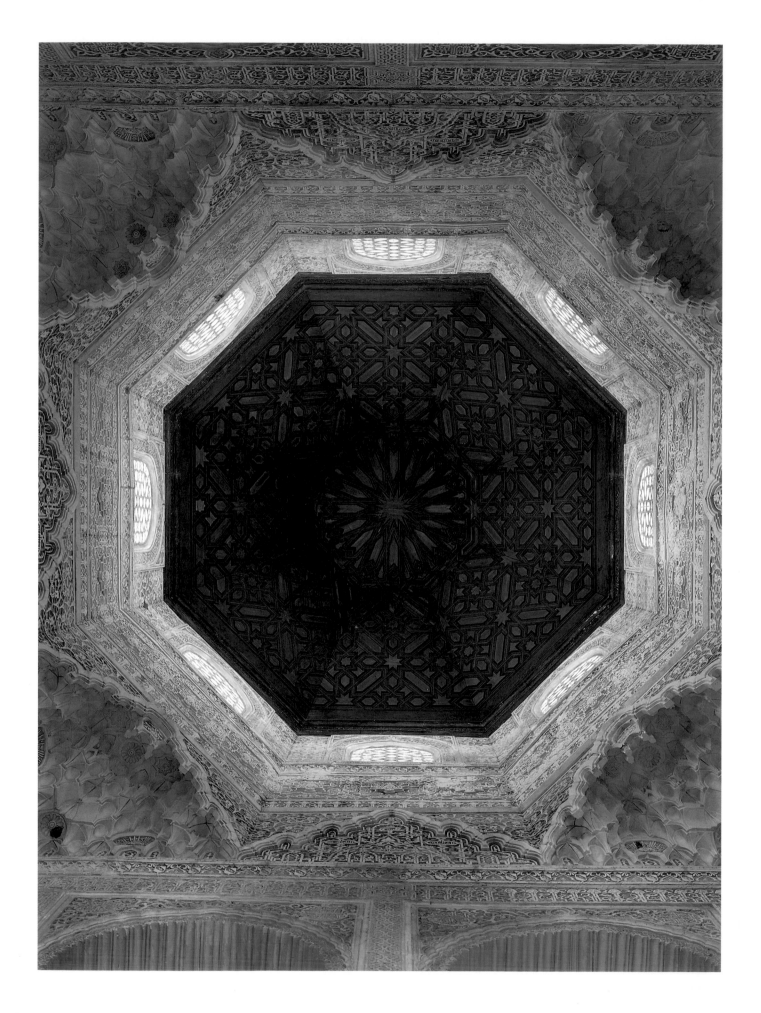

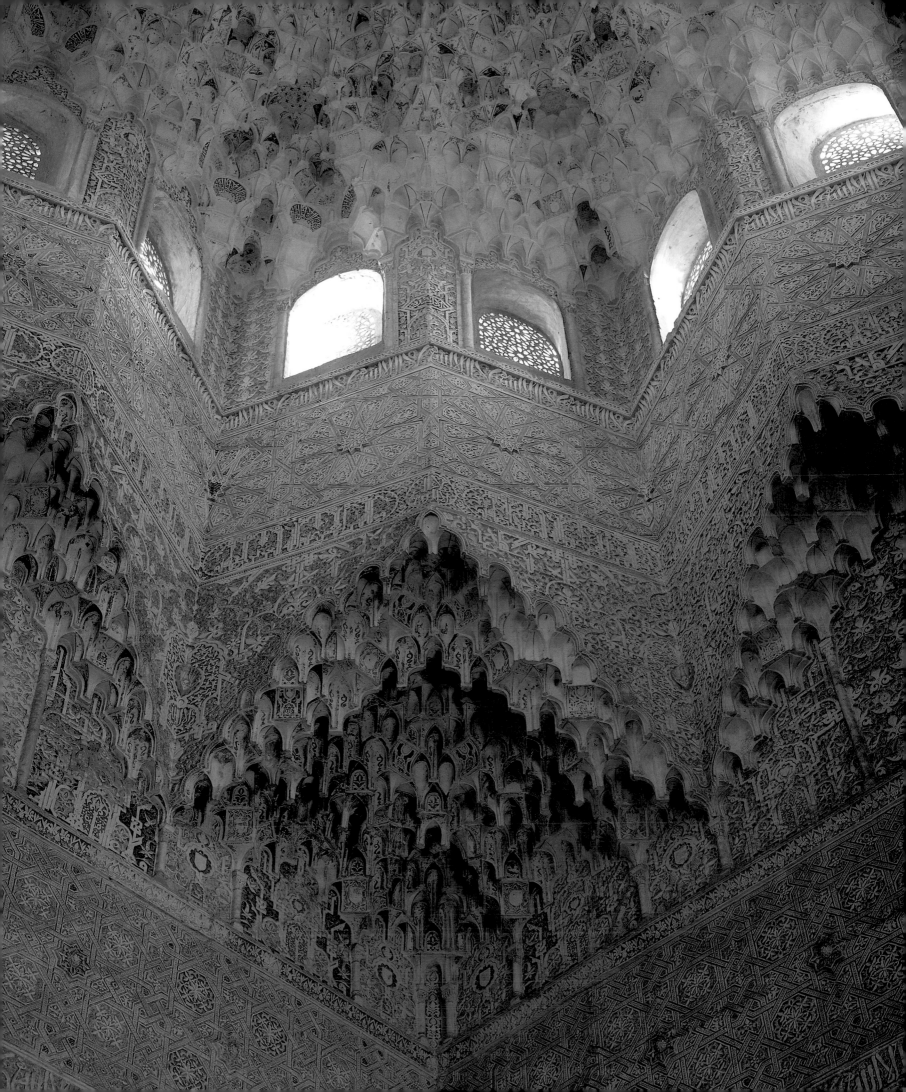

Previous pages:

Dome in the Hall of the Two Sisters; Alhambra, Granada. 1354-1359.

Detail of the stalactite vault in the Hall of the Abencerrajes; Alhambra, Granada. After 1363.

Plan of Castillejo de Monteagudo (Murcia).

Fragment of decoration from the convent of Santa Clara, the erstwhile Mardanishid residence of *ad-dār as-sugrāʾ*; second half of the 12th century.

The two most representative examples of the Mardanishid style are the Castillejo ('small castle') de Monteagudo, located in the environs of the city of Murcia, and the convent of Santa Clara, in the inner city. Both buildings appear to have once been the residence of Ibn Mardanīsh.

Other remains of this style include the palace of Pinohermoso in Xàtiva (Valencia), and at least three other military constructions, such as the castles of Monteagudo, La Asomada and El Portazgo, all in the vicinity of Murcia. All these buildings exhibit features closely related to the same grand architectural style that was only partly brought to completion on account of historical events. Perhaps their most distinctive hallmark is the receding corners of walled fortifications.

Castillejo de Monteagudo is a striking example of the Mardanishid style on account of its ground plan and comparatively good state of repair. Despite its fortified appearance, it was a leisure residence sited in a fertile valley, guarded by a castle not far away. It was set in farmland and drew its water from a cistern.

The most unusual feature of the building is its ground plan: it is rectangular, surrounded by chambered rectangular towers, while the west side is flanked by another wall, also with solid rectangular towers with shallow overhang, which mark off an area the purpose of which remains unknown.

The interior was taken up by a rectangular garden traversed along its length and breadth by walkways, with cisterns placed at each of the two shorter ends. The length of the garden was flanked by interconnecting rooms, and each corner of the enclosure was developed into an independent area set around a small, central patio. Overlooking the garden from each end was a chamber, with an apsidal alcove in each tower.

This architectural layout has its roots in the earliest known Islamic residences, although it also includes much later features reminiscent of buildings in North Africa, including the palace of Axīr and the fortress or Qalʿa of the Banū Ḥammad, both in Algeria. They are also akin to works at Zisa and Cuba in Palermo, Sicily, which both display marked Islamic influences.

The second noteworthy example of the Mardanishid style came to light in the course of excavations on the convent of Santa Clara in 1985. Known as *ad-dār as-sughrāʾ*, only part of it is still standing. From its large dimensions and rich ornamentation, it must have been the urban residence of Ibn Mardanīsh. It was apparently demolished around the year 1230 to make way for another residence in a later style.

Perhaps the most important aspect of this discovery, apart from a large court, is the large set of decorative plaster fragments that were unearthed. Some of them have been carved into the markedly digitate plantwork characteristic of the Almoravid style. Others, with geometrical shapes, must have been parts of socles and friezes. A third group consists of geometrical, floral and figural motifs painted on stucco, which belonged to a stalactite vault.

Among the painted figures is the top half of a woman playing the flute, and a man wearing a turban. They are characteristic of the figures in the Islamic decorative tradition in palaces, and are related to such contemporary works as the Palatine Chapel in Palermo (Sicily).

This constant affinity with Sicilian works, which in turn have ties to the Fāṭimid dynasty, is so palpable in the Mardanishid style of Almoravid art from southeastern Spain that it begs fresh overall consideration of Andalusian art during the second half of the 12th century. Although the style remained faithful to the old Umayyad tradition, and subsequently evolved from it, most of its content is redolent with borrowings from neighbouring regions which must have been facilitated by an ongoing commercial and political relationship with those states. With its patina of noble residual heritage, at a time when the Almohads were forging their highly original and imperial artistic precepts, the artworks of Ibn Mardanīsh stood for an attempt to maintain cultural independence in the face of the new and overwhelming North African power, in similar fashion to what transpired in the political sphere.

The Architecture of the Almohad Empire

The Almohad conquest of the Maghrib and their subsequent annexation of Al-Andalus in 1148 was characterised in the field of art by two phenomena: the rise of Andalusian influences throughout the territories under Almohad rule, and the unqualified imposition of an official style.

The Almohads instated a second Western caliphate, after the extinction of the Umayyad dynasty of Cordova. However, the political change did not involve any change of direction in the art trend set by the Almoravids. On the contrary, they followed that trend with renewed impetus, and broadened the artistic dimension originally forged by their Almoravid predecessors, as evinced at Marrakech. The Almohads knew how to exploit the propagandistic value of their state foundations, both religious and secular. Thus, each mosque they built was considered to be an assertion of *tauḥīd* or divine unity, which was at the heart of their faith, and each fortress a way of showing their readiness to defend the frontiers of Islam, guarding them against their enemies and extending them as far as they could.

This missionary purpose was enshrined in clear-cut architectural and decorative features, in keeping with the austerity preached by the movement. The style in question was not, strictly speaking, original, but rather a distillation derived from a pre-existing style. In the decorative field, the Andalusian plant repertory, which by then had strayed considerably from the original Umayyad prototypes, was distilled by the Almohads into a reduced set of forms commensurate with the new official directives. In morphological terms, Almohad decoration was characterised by the use of elongated, curved palms set on a smooth ground. Only in isolated instances were the lush, digitate leaves of the Almoravids preserved, almost symbolically, as in designs used to form the Arabic word *uāhid* ('oneness'). Thus, every floral motif that appeared in architectural ornamentation was used to proclaim the dogma of the new caliph.

For the rest, the Almohads were known for their endeavours to show continuity with their Umayyad forbears, just as the latter had done with the old Roman tradition. This accounts for the fact that the *miḥrāb* in the main Almohad mosques—Tinmāl, and the Kutubīyya of Marrakech—the windows in La Giralda, and the minaret at the great oratory of Seville, were adorned with capitals taken from Umayyad buildings. Once again, the reuse of major pieces of sculpture, taken from earlier buildings, became a symbol of continuity and legitimacy.

However, Almohad art does not merely stand for a period of continuity in Andalusian art. Although the latter had its origins in the East, the art and culture of Al-Andalus were periodically subjected to an influx of Orientalising currents from the opposite side of the Mediterranean, of which the Almohad style was one.

Despite its Berber origins, the pivotal doctrine of the Almohad movement undoubtedly took on renewed form and substance during the journey the *mahdī* Ibn Tūmart made to the East. The intellectual discourse that originated there was sustained at least throughout the prime of the dynasty. This fact is crucial to an understanding of secular and religious Almohad architecture.

One of the most astonishing examples of eminently Almohad plant and epigraphic ornamentation is found, of all places, in the monastery of Las Huelgas at Burgos. It was founded by Alfonso VIII of Castile (1158–1214), the North African dynasty's most ardent Christian enemy, who turned it into a residence and a pantheon for himself and his descendants. While the main religious area of the complex is rendered in austere Cistercian style, the palace area, taking in the San Fernando cloister and the chapel of La Asunción, is decorated with plaster vegetation in the most classical Andalusian style of the time. As if that were not enough, various places have signs up in Arabic alluding to Almohad dogma, which would have been incomprehensible to the Christian faithful in the monastery. In this respect, Las Huelgas was representative of the cultural environment prevalent in the mediaeval Hispanic world: a Castilian king, staunchly loyal to the Christian faith, builds a church

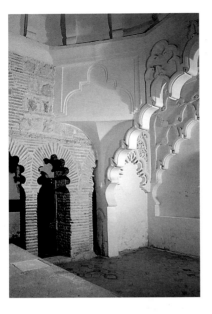

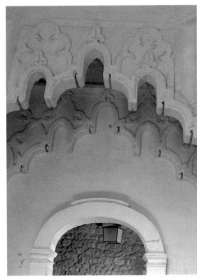

Chapel of La Asunción, Royal Monastery of Las Huelgas (Burgos).

231

to house his mortal remains in the most austere and up-to-date European style, but, when it comes to decorating his living quarters, he has no qualms about engaging the same Moorish craftsmen that work in the employ of his arch-enemies. Thus, the latest trends in Christian and Andalusian Almohad art come together in the same building.

Some of the most striking examples of Almohad architecture are their military constructions. Towards the end of the 11th century, the balance of military power on the Iberian Peninsula had begun to shift. The Christian kingdoms, which until then had been inferior in military might, started pushing back the frontiers they shared with the Moors, which had been established over a century before. The scope of the campaigns mounted by the Christians was stepped up, in keeping with changes in the northern kingdoms. While continuing with their sporadic raids of plunder on neighbouring territories, the Christian armies gradually embarked on a sustained, full-scale conquest in continual progression, despite the odd setback. Their armies grew in number and strength, so that fortifications had to be correspondingly more impregnable in order to withstand their assaults. An improvement in economic conditions and demographic growth played their part in this process, too.

Until that stage in history had been reached, fortification of city and castle precincts was still very rudimentary. Prevalent was the use of comparatively low, square towers, with shallow overhang and no internal chambers. Devices for shooting horizontal projectiles were crude, and practically none were available with a vertical trajectory. Doors had single or double leaves and, in the latter instance, a forecourt in between. However, with the decline of the party kingdoms, certain European influences became apparent, particularly during the Almoravid period, in the first half of the 12th century, when defensive arrangements purportedly of Christian origin were deployed as far afield as in North African fortifications, which appears to be the case at the Moroccan castle of Amergo.

Structural features at the time were manifold, becoming almost as varied as the number of places where they were applied, and the geological character of each site was decisive as far the building materials were concerned, which could be any combination of stone, ashlar, masonry or mud wall, for instance. However, in the late 11th and early 12th centuries, the so-called *enplecton* structural method, of Roman–Byzantine origin, became predominant: it consisted of facing both sides of a wall with well-bonded ashlar, while the core was made up of pebble and mortar masonry. In Al-Andalus, it was common to use lime of a high purity.

From that period onwards, a new type of structural wall became increasingly more common in fortifications. It was made of a mixture of sand, lime and gravel which, when pressed to remove air bubbles, yielded an extremely strong mortar. It was applied to the fortified walls of Seville, Badajoz and Cáceres during their final, Moorish building stages. Once the Almohads had completed their conquest of Al-Andalus, it became the principal type of walled fortification. An exception to this was the use of stone masonry, laid with the aid of wooden forms of the kind used for mud walls, which can be seen in certain parts of Trujillo castle in Cáceres. The weepholes between the cross-beams of loadbearing frames were disguised with a layer of daub, on wall curtains and towers, on which fake ahslar jointing was painted.

In terms of military technology, new structural features for defensive purposes made their appearance. Noteworthy features included posterns, with right-angled turns in their ground plan, turrets connected via a mobile walkway to the wall curtain, from which they could easily be detached, and polygonal towers, generally octagonal or dodecagonal, of manifestly Byzantine origin.

These elements of defence had not been used before, not so much out of ignorance but as a means of economising on resources when faced with a comparatively weak enemy. Technical innovations in both Moorish and Christian walled fortifications on the Iberian Peninsula did not evolve merely as a result of internal processes, which were often rather limited. Several external factors contributed to their development, including the arrival from abroad of people with greater experience in fortification techniques, and lessons learned from the Crusades.

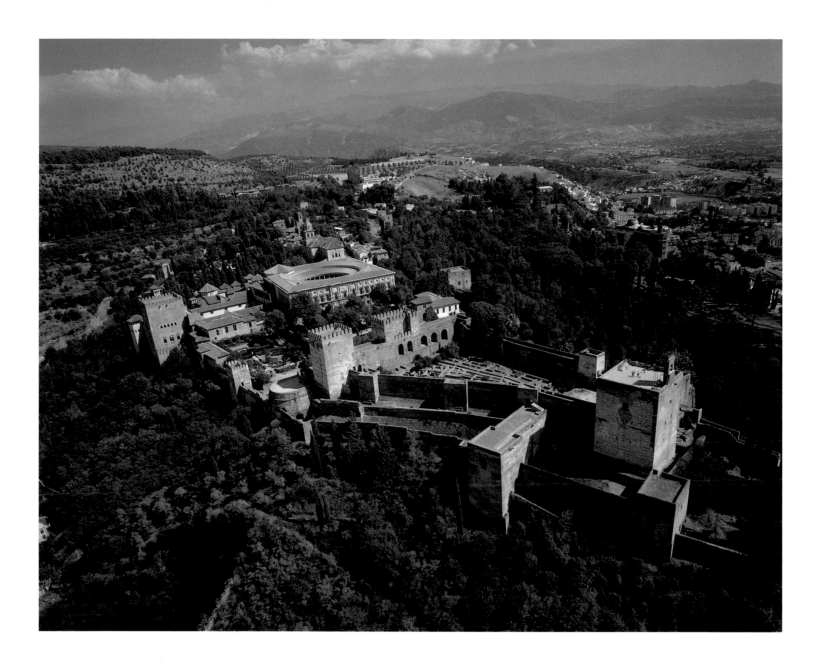

Naṣrid Architecture: the Alhambra of Granada

The founding of the small kingdom of Granada by Muḥammad I ibn Naṣr (1237–1273) marked the beginning of the end of the Moorish political presence on the Iberian Peninsula. It also ushered in the last great period of Andalusian art, which had by then become cut off from the major contemporary currents in the Middle East and reduced to mimetic reproduction of its own forms, except for the occasional arrival of some novelty. This repetition of forms and trends in palaces in the kingdom led to the emergence of a style distinguished by rare exquisiteness and refinement, and devoid of any of the Umayyad or Almohad power and sturdiness. The capital of this new kingdom was established in Granada, and the hill of the Alhambra became the seat of the ruling dynasty.

While what is known of the physical milieu of the Naṣrids is continually being expanded through the findings of archaeological research, the architectural style associated with that dynasty is admirably summarised and compended in the hill fortification known as the Alhambra, from the Arabic *Qalʿat al-Ḥamrāʾ*) or 'Red Castle'.

THE ALHAMBRA OF GRANADA

There were several gates leading into the Alhambra. Two of them, the Puerta de la Justicia and the Puerta de los Siete Suelos, were located on the south facade. They were built by Yūsuf I (1333-1354) and had greater monumental and status value than military value. When the Kingdom of Granada was nearing its end, they were reinforced with bulwarks to withstand artillery fire, being the first and last bulwarked fortifications in the whole of Al-Andalus.

The north wing also had two gates: the Puerta de las Armas connected the Alhambra to the city, while the Puerta de los Picos or Puerta del Arrabal led to the Generalife.

The interior was apparently divided up by three roads: the Real Baja, the Real Alta and the Calle de Ronda. The first of these was the main access route to the palace area and, in military terms, served to isolate the palace from the rest of the hilltop buildings. The buildings in the Alhambra complex, including the residences of public officials and service areas, were arranged along the major road, the Real Alta. The Calle de Ronda was a ring road used primarily for military patrols. At certain points it became an underground walkway to circumvent a number of buildings in its path.

There were two types of towers in the complex. Those used strictly for military purposes were set at regular intervals around the wall and connected by the ring road. The second type were tower residences, namely the Torre de la Cautiva and Torre de las Infantas. These were larger than the first type and had living quarters inside. The ring road passed underneath the private quarters, enabling patrols to operate normally without impinging on the private life of the occupants of the tower.

The oldest of the palace complexes making up the Alhambra appears to be the Partal, which is attached to the citadel wall. Building work on this palace was in all likelihood commissioned by Muḥammad III, and completed during the reign of Yūsuf I (1333-1354). At about the same time, the Great Mosque was erected on the present-day site of the church of Santa María. Adjoining it were baths, of which some remains can still be seen. The Mishwār or administrative and judicial quarters were built during the reign of Ismāᶜīl I (1314-1325), and later thoroughly remodelled by Muḥammad V (1354-1369; 1362-1391).

The other important buildings were commissioned by Muḥammad V and his predecessors, Ismāᶜīl I and Yūsuf I. The most prominent palaces among them are the Palace of Comares and the Palace of the Lions.

The Palace of Comares was the official and main residence of the Naṣrid sultans. In the centre of the complex is the Patio de los Arrayanes or 'Court of Myrtles', the main axis of which leads directly into the Hall of Comares, located inside a large tower, which is accessed via a room known as the Sala de la Barca ('Chamber of the Boat'), which is wider than it is long. It acted as a throne room or hall for large State receptions. It once had floor tiles painted in blue and gold, some of which bore the dynastic shield with the heraldic motto: *wa lā ghālib ʾilā Allāh taᶜ* ('there is no victor but God, praise be to Him') in the centre. The ceiling consisted of a polychromed wooden framework with intricate geometrical combinations based on knotwork motifs. In one of the most authoritative works ever written about the Alhambra, D. Cabanelas shows how the decoration was actually a schematic depiction of the seven heavens of the Islamic universe and the throne of God, as described in one of the *surahs* of the Koran (67,3). Private quarters were arranged around the court and in ringing galleries, as well as in the upper storeys of the tower.

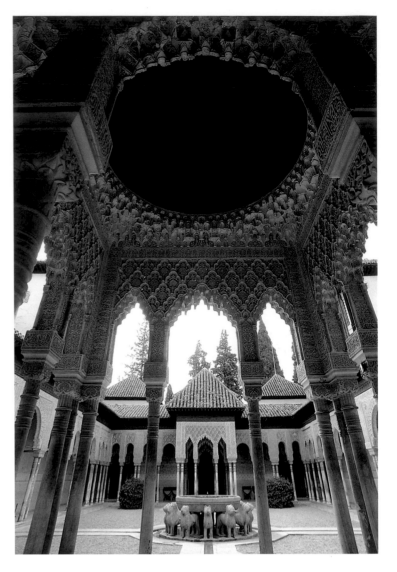

Stucco and stalactite work in the Court of the Lions in the Alhambra. After 1363. Granada.

Adjoining the east side of the Court of Myrtles and set on a lower level are baths built by Yūsuf I. All the chambers have marble floors with tiled wainscots. One of them is covered with an octagonal vault, while all the others have domical vaults, and all are pierced with stellar skylights, which once had coloured glass panes to illuminate the interior.

The ground plan comprises a central chamber surrounded by several corridors. The east and west sides lead through pairs of double arches into deep alcoves with beds faced in tiled brickwork.

The entrance to the palace leads through a small court with a marble fountain in the centre. The south facade, known as the Comares facade, is intricately decorated, and has carved wooden eaves. It is pierced with two lintelled doors, one of which leads to the large court in the centre of the palace. The doors are surmounted by a broad decorated strip, above which are three windows: two biforate windows vertically above the doors and a third, single window in the middle. This beautiful facade, a veritable frontispiece for the Palace of Comares, was unveiled by Muḥammad V on 4 October 1370 to commemorate the conquest of Algeciras. The Naṣrid sultans used to hold audience in the court, seated under the eaves opposite this veritable stuccowork tapestry.

The third palace complex, and the most famous of all in the Alhambra, is the Palace of the Lions, arranged around the similarly named Court of the Lions in the centre. The court is

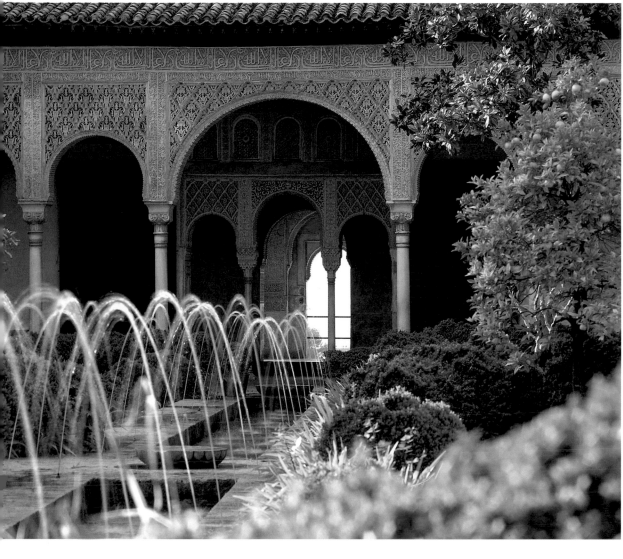

North portico of the Patio de la Acequia, Generalife. 1273–1302, remodelled in 1319. Granada.

flood into the room. The Rauda must have once been surrounded by gardens, which would account for its name, *rawḍa* ('garden').

The excavations unearthed a total of seventy-four tombs, all orientated towards the south-east, in keeping with the Islamic rite. They varied in size and none yielded any human remains, as, when the Castilian forces were securing their conquest of Granada, the last Naṣrid king, Muḥammad XII, called Boabdil in the Spanish chronicles (1482-1486/92), ordered the mortal remains of his ancestors to be exhumed and transferred to his new residence at Mondújar, where they might still rest today.

On the ground level just above the Alhambra stands the Generalife, a leisure pavilion set in orchards and gardens, with a commanding view over the royal citadel. It drew its water supply from the same channel that met the needs of the palaces on the lower level.

This small palace is made up of two forecourts, which lead into larger courts that acted as an enclosure for the gardens. A reservoir runs along the centre of the gardens. At either end stands a pavilion, porticoed on the inner side, the south pavilion affording a view of the surrounding landscape. The Generalife was probably built by the end of the 13th century or early in the 14th century, although it was subsequently refurbished on several occasions. After the Castilian conquest of Granada, remodelling work led to some alterations in the layout of the palace area.

laid out in cross-plan, with walkways intersecting at right angles in the middle. The centre is taken up by a stone fountain with a twelve-sided basin, inscribed around the edge, supported by twelve lions. The figures of the lions probably come from a 10th- or 11th-century palace which might not necessarily have been in Granada. At each end of the court stands a pavilion.

This central area is flanked on each side by axially placed chambers. Two of them—the Sala de los Reyes ('Hall of the Kings') and the Sala de los Mocárabes ('Hall of the Stalactite Vaults')—located on the east and west sides, respectively, are long and narrow, while the first of these is divided up into small alcoves. Opening onto the centre of the two long sides are two other areas: the smaller one, with a tripartite plan, is known as the Sala de los Abencerrajes ('Hall of the Abencerrages'), while the other, more complex area consists of several chambers set around a central hall known as the Sala de las Dos Hermanas ('Hall of the Two Sisters').

The architectural style of the Palace of the Lions, the monarchs' private residence, is noteworthy for its fine quality and delicateness. It is ringed by a portico with white marble columns, the shafts of which are cylindrical and adorned with rings. The lower part of the capitals is also cylindrical, while the upper part is cubic and adorned with highly stylised vegetation.

This complex as we see it today looks much the same as Muḥammad V left it in October 1370, at about same time as work was brought to completion on the façade of the Palace of Comares. The political situation affecting the Kingdom of Granada during the struggle between Peter I (1350-1379), who allied himself with the kingdom, and his illegitimate half-brother, the future Henry II (1369-1379), and the tentative victory of the former, gave the sovereign of Granada temporary respite to devote himself entirely to building work on the Alhambra. When, subsequently, the tables turned and Henry won a lasting victory, the situation ceased to be conducive to architectural pursuits.

The Rauda or royal pantheon of the dynasty, to the south of the Court of the Lions, was unearthed in the course of excavations carried out just over half a century ago. It is a rectangular-plan building and, like mosques, was built on a southeast–northwest axis facing Mecca. The sanctuary was divided into three small chapels, which were probably used to house royal burials. The shafts of the four pillars set in a square formation in the centre of the chamber suggest that it might have once been surmounted by a lantern, designed to allow light to

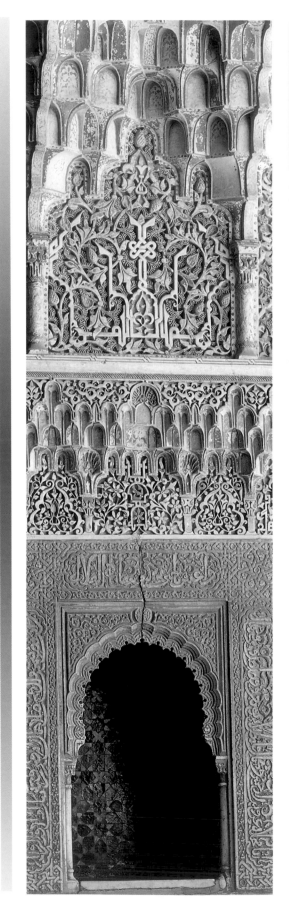

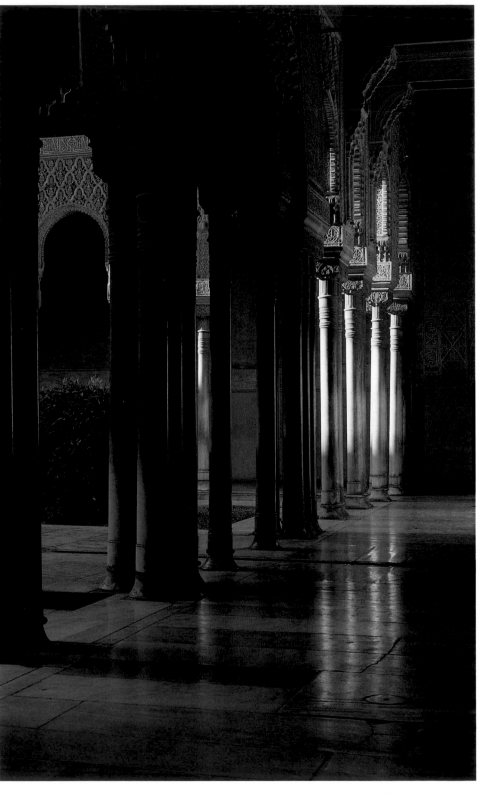

*Alhambra (Granada): detail of the walkway around the Court of the Lions.
After the mid-14th century.*

*Alhambra (Granada):
Detail of the Court of Myrtles.*

*Alhambra (Granada): detail of the Sala de las Camas
('Hall of Beds') in the royal baths; 14th century*

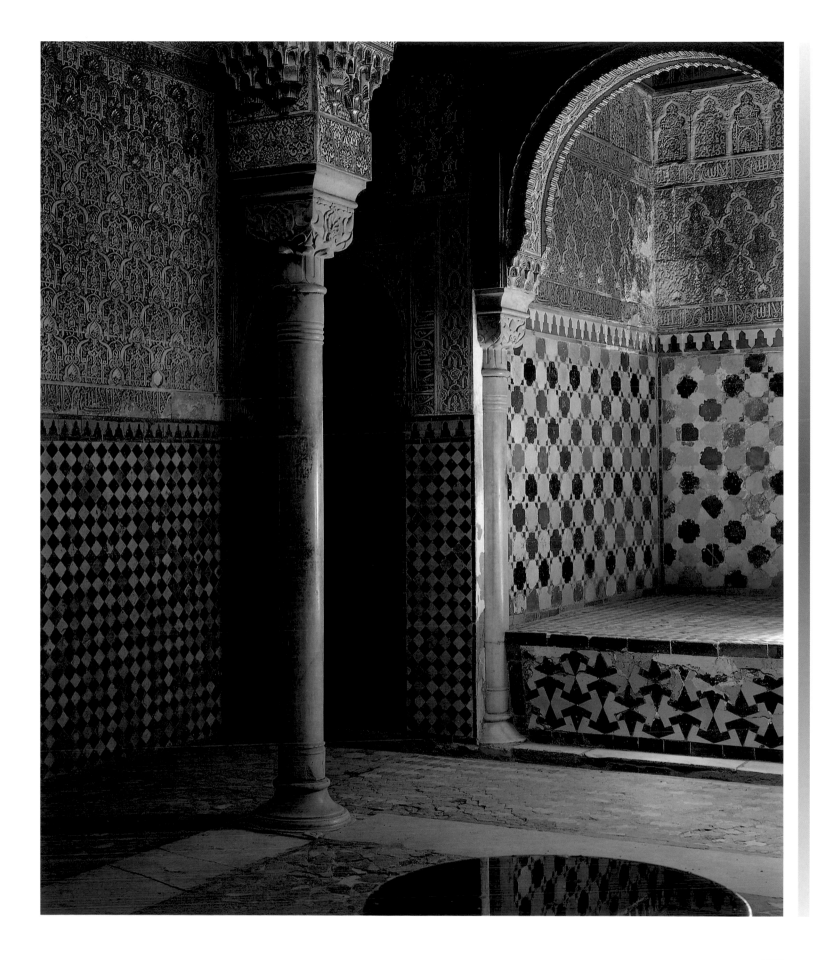

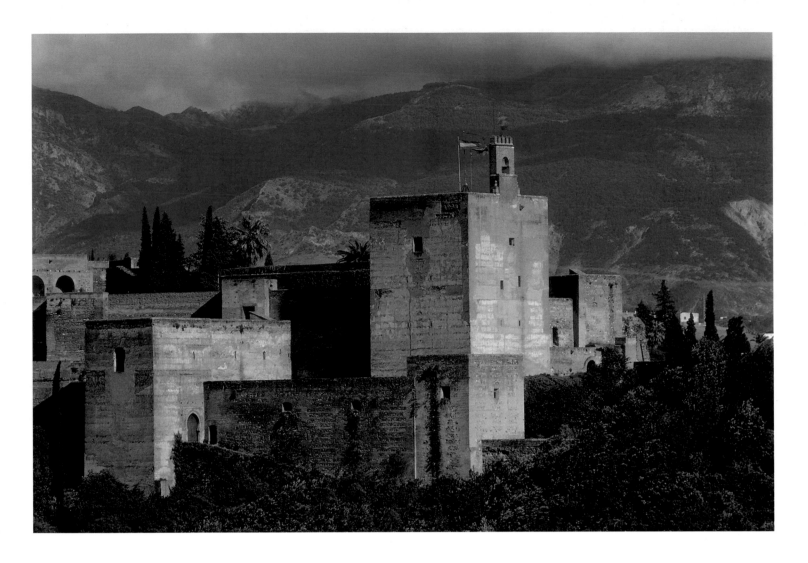

The Alcazaba: fortress tower and walls.
Alhambra, Granada; 13th century.

By shunning the old Zirid fortresses—or what was left of them—on the hill frontier of Albaicín, and instead choosing to live in the Alhambra and base his political power there, Muḥammad I was not only making a strategically sound, defensive move; on a modest scale, he was also following in the footsteps of of the great Islamic monarchs who built palace–cities as eloquent symbols of their grandeur. He was again calling up the paradigmatic examples of Sāmarrāʾ (Iraq) and Madīnat al-Zahrāʾ (Cordova), amongst others. In the palace at Granada, the sultan's seat of power, a host of private rooms and official chambers—both administrative and military—were confined within a very small space whose late-mediaeval origins were conditioned by an unknown, earlier architectural style.

The hill on which the Alhambra is perched, known as *as-Sabīka* in a later period, must have ceased to be barren land when Muḥammad I decided to locate his residence there. In the 7th century, it had been the site of a fortress, and buildings are reliably documented there in the second half of the 11th century. However, the claim that it was also the site of an 11th-century palace attributed to the Zirid minister, Samuel ibn al-Nagrālla, is clearly unfounded. The upper crust of society in Granada may have had country villas on the hill, but the relevant chronicles are vague on the matter and it cannot be stated categorically. If there had been villas there, they would have been affected by a water problem. In fact, the Alhambra only became a formidable palace-city thanks to the extraordinary irrigation system implemented by the Naṣrid sultans, who had water supplies channelled to

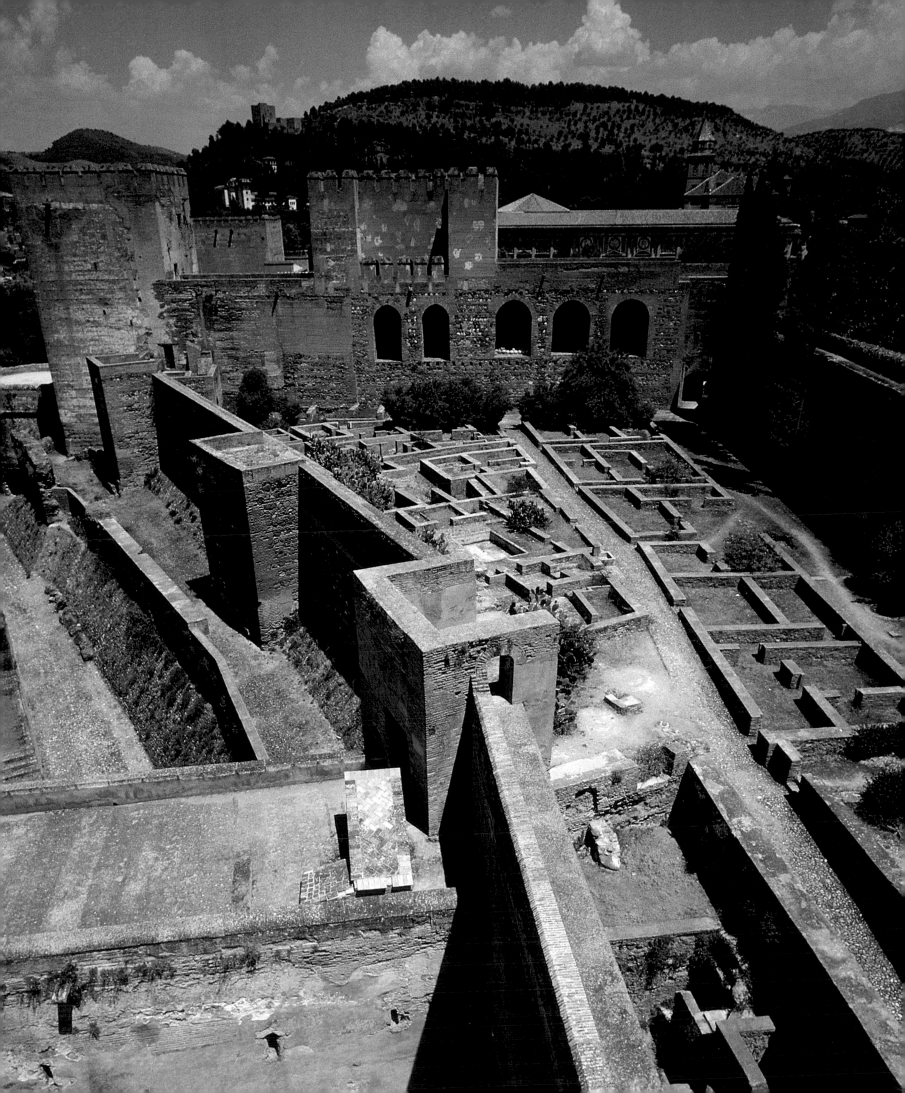

the hill from the nearby mountain range. They were thus able to support a comparatively large civilian population and turn barren land into a veritable garden. Ultimately, though, without a powerful, affluent and centralised political apparatus capable of providing such infrastructure, albeit on a modest scale, the Alhambra of the palaces would never have come into being.

The Alhambra is the result of a process of urban development in which the buildings that sprang up within the walled precinct did not always respond to a well-ordered plan, while existing buildings could be altered according to the needs of the court, or at the sultan's whim. In this respect, it has much in common with the Great Palace of the Byzantine emperors at Constantinople, or the Alcázar of Cordova, which was progressively enlarged by the Umayyad caliphs. Unlike these buildings, however, far more is known about the construction process of the Alhambra, although there are still considerable gaps in our knowledge and uncertainties relating to the building materials used, and the unaccounted disappearance of several buildings, particularly after Granada was incorporated into the kingdom of Castile. The decorative artwork in the Alhambra, and a large number of inscriptions, were wrought in stucco, which was often altered in subsequent years, so that stylistic and epigraphic analyses cannot go back further than the date of the material support itself. For instance, the buildings often date from one period, and their decoration from another.

The Alhambra was structured in the form of a miniature Islamic city. It was completed walled, and its western spur, the Alcazaba, operated as a fully-fledged, self-contained fortress, which included living quarters for military personnel and essential water supplies.

The purpose of the first phase of construction work on the Alhambra was to build solid fortifications, for which an existing wall was re-used, and new towers and wall curtains added. Some of the towers assumed enormous proportions and became forts in their own right, marking a departure from contemporary trends in Andalusian military architecture.

Perhaps the most striking of them all is the keep. Its internal distribution, based on three distinct areas with separate entrances—the storehouse, dungeon and guardhouse area, an audience chamber and living quarters—is a military, administrative and residential complex unprecedented in Al-Andalus, as far as we know from surviving records, paralleled only by buildings in the Middle East. Tracing the provenance of the architectural influences here is quite another matter: they might have come from Egypt, via North Africa. However, it is also plausible to assume a more circuitous route: either via Italy, as Genoa had excellent trade relations with Granada, or via Aragon or Castile, where the influence of the Crusades is palpable in religious architecture—the dome of Zaragoza Cathedral, and the church of Veracruz at Segovia—as well as in military architecture—the Vieja Puerta de Bisagra ('Old Hinged Gate') at Toledo.

Notwithstanding the chronological issues still to be settled, the fact is that the fortification ringing the hill was evidently detached from and unrelated to all other facilities, although it did affect their architectural structure. Access to the military area was separate from other entrances, and staggered sentry walks did not in any way impinge on official or private business conducted within the walled precinct, in observance of strictly utilitarian considerations commensurate with age-old Andalusian tradition and, further afield, those of the great Eastern empires.

However, it is not clear how the hilltop area was actually structured at the beginning of the Naṣrid dynasty. The first buildings erected by Muḥammad I were most likely interspersed with or, in the case of the Alcazaba, located alongside previous ones. Moreover, some older buildings will have been repaired and rehabilitated. It was only during the reign of Muḥammad III (1302-1309) that a clear-cut town planning project emerges.

The art of the Naṣrid dynasty had considerable contemporary influence on that of the Christian kingdoms, which was produced either by artists summoned from Granada or by local Mudéjar craftsmen, Moslems who lived in the Christian kingdoms. Some of the finest works commissioned under Christian auspices were done in territories that had been wrest-

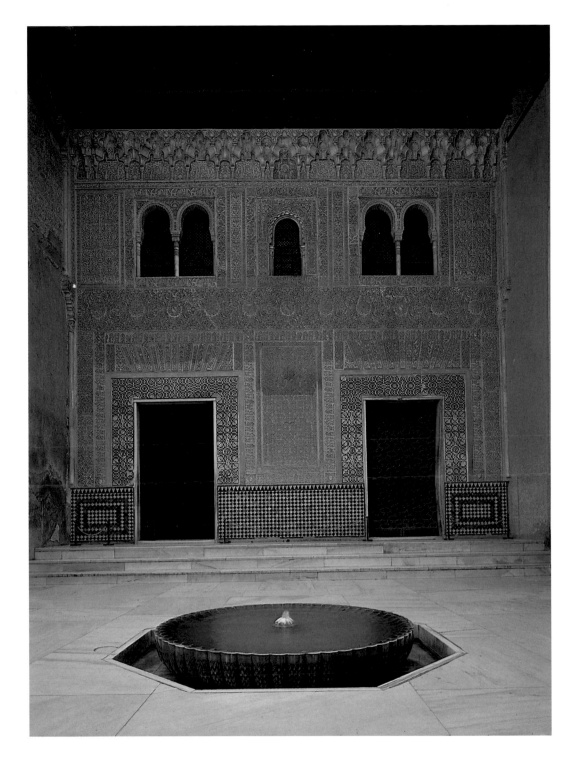

Tower or Palace of Comares.
Alhambra, Granada, 14th century.

ed from the Moors a long time before. Notable examples include the palace of Doña Leonor, at Tordesillas (Valladolid), and part of the Reales Alcázares in Seville, commissioned respectively by the Christian monarchs Alfonso VI (1312–1350) and Peter I. Granada also had a part to play in the industrial arts of Castile and Aragon, but the provenance of the latter is not always easy to determine, as the vast majority of craftsmen in the Christian areas were Mudéjars anyway. It is difficult to tell apart works based on the continuity of earlier Andalusian traditions, and those based on contemporary trends imported from Granada, although the difference can sometimes be gleaned from the use of a new technique, such as lustre pottery.

It is perhaps for these reasons, and because of the radical changes that swept the Hispanic world at the end of the 15th century, that our vision of the Alhambra is still tinged with romanticism.

The ensemble we see today is not quite the same as what the Castilian magnates first saw when they had managed to gain entry to the residence of the Naṣrid monarchs. Architectural alterations made by the conquerors were not immediate, nor lacking in criteria. From the very outset, the new owners showed great admiration for those palaces, and it is thanks to their care that they have survived virtually intact until the present. However, their sensitive respect for the ensemble did not detract from the ideology that for centuries had led them to combat Islam, until it had been divested of all political power on the Iberian Peninsula. It is worth recalling that the victory at Granada was a momentous occasion for the Christians who, ruled by one monarchy, had imperialist designs, and that the achievement should have come just thirty-nine years after the fall of Constantinople, when the Ottomans had dealt a severe blow to the military might of Christendom and the Eastern Roman Empire.

Might the palace of Charles V, erected over a Naṣrid building, not be the architectural product yielded by a combination of all these circumstances? The allure which the Alhambra had for Charles V should not be underestimated when accounting for his decision to construct such a magnificent palace there, although another factor should not be overlooked either: his station as sovereign of the Hispanic realms and as Holy Roman Emperor. Today, the delicate art of the vanquished Moors appears side by side with the power of the victorious Christians in the same complex. But the descendants of Muḥammad I were never able to see that for themselves.

Barring a priori assumptions about the Alhambra, coloured more by romantic illusion than historical fact, it has never been established whether the ensemble was ever brought to completion, or whether it is we who regard it as a unified whole.

Itemisation of all the buildings in the complex clearly reveals how additions were made on an almost continual basis, as were structural and decorative alterations and renovations to particular buildings. It cannot be conclusively asserted that the original Naṣrid monarchs had actually drawn up a plan, however vague, for structuring the hilltop building site. The Alhambra only began to shape under Muḥammad III, if we are to give credence to historical records and the results of modern research. And, as if the issue were not complex enough, we cannot, on the basis of available documentation, ascertain whether there were other buildings at that location, apart from military installations, regardless of whether they were built to a particular plan or formed an ensemble. Had they existed, we would still be left wondering to what extent they might have initially conditioned the Naṣrid construction project.

The upshot of all this is that the Alhambra is not just a work of art, but the best material evidence we have to piece together the world of the last Moorish dynasty on the Iberian Peninsula. It summarises, like an enormous architectural compendium, the evolution of Andalusian art. The palace of *Sabīka* is the conclusion of a long-drawn-out process which, enriched by diverse contributions across the centuries, evolved and ended up turning in on itself, acquiring an almost morbid delicateness and refinement. Its stature is in no way demeaned by this: after all, that is also the history of Moorish Al-Andalus.

Industrial Art in Al-Andalus

The urban culture of Andalusian Islam yielded a level of industrial development capable of meeting the needs of a complex society with a marked mercantile streak. Some domestic products were noticeably utilitarian, while others of a decorative nature served the demands of a refined oligarchy. Yet others, produced in palace workshops, were used to show off a dynasty's wealth and as genuine political propaganda, in the manner of the great empires of the Middle East.

However, a closer examination reveals that very few of the finest pieces produced by Andalusian workshops are comparable to those manufactured in Egypt, Syria, Mesopotamia or Persia. Only Naṣrid lustre pottery, some silk fabrics and, very especially, ivories

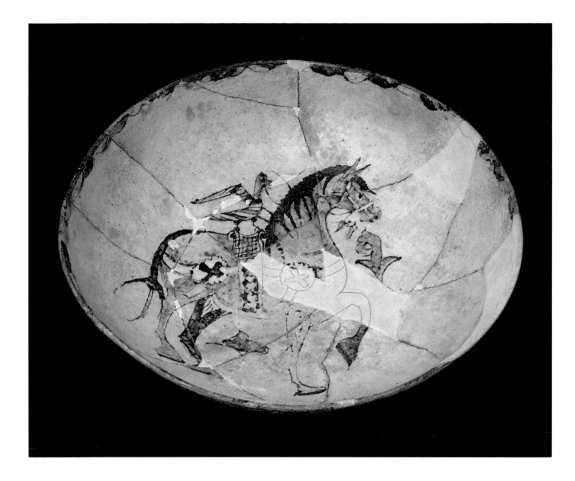

A taifor from Madīnat Ibīra; second half of the 10th century. Museo Arqueológico Provincial, Granada.

The austerity and simplicity of Islamic furniture, which was based on simple benches, was offset by the use of all kinds of fabric furnishings and a broad range of household crockery in bronze, glass and ceramics. The latter was made using such techniques as 'green and manganese' and *cuerda seca*, and could be glazed. The large number of crockery types used at table included the *ataifor,* a fairly deep dish for serving food.

from the caliphal school at Cordova, attained the highest stylistic and technical standards. Gold and silversmithery, woodwork and leather goods were not as widely known, although, judging from information gleaned from documents, and some surviving pieces, the quality of workmanship was high. The provenance of bronze objects, particularly large ones, is still the subject of debate today.

There is no doubt regarding ceramic production on the Iberian Peninsula: analysis and accurate dating of all surviving ceramics reveal poor technical standards of craftsmanship and point to a development process which, starting in late-Roman times, shortly before the Moorish invasion, involved gradually adapting the existing variety of objects to the strict dietary norms of the new Islamic religion. There is no evidence to support the claim that ceramic production ever met any high technical and artistic standards until at least the second half of the 10th century in Cordova and, some years later, in the remaining areas of Al-Andalus. The process substantially resembles the evolutionary trends in the main Middle Eastern centres, such as Damascus, Baghdad and Cairo. The only difference between them is their time frame. The great technological progress marked by the advent of white porcelain in Mesopotamia dates from the third decade of the 9th century, the finest example of this being the so-called Sāmarrāʾ–type ceramic, which was not among the ceramics featured in the palaces built at Raqqa (Syria) by Hārūn ar-Rashīd, the caliph of *The Thousand and One Nights*.

The late 10th century and, to a greater extent, the early 11th century, saw the introduction of decorative varieties of substantial artistic quality, although they fell short of the high technical and decorative standards of the East. The best known of these are the so-called 'green and manganese' and *cuerda seca* varieties. The former was a local imitation of Mesopotamian models and was first made at Cordova and Madīnat az-Zahrāʾ, and later spread to the whole of Al-Andalus. It remained popular for a long time and became the aesthetic prototype for late-mediaeval Levantine ware decorated in green and purple. The

A taifor with *cuerda seca* decoration; 11th century. Museo Arqueológico Nacional, Madrid.

Naṣrid gilded pottery *ataifor*. Museo Arqueológico Nacional, Madrid.

cuerda seca variety bore polychromed decoration and became popular in the East, particularly Egypt. It is archaeologically documented from the 11th century onwards, and remained in use, with ornamental variations, until the fall of the last Moorish state on the Iberian Peninsula.

Other pottery techniques were also developed to high standards: one of them was sgraffito, the best examples of which were produced in workshops at Murcia during the first half of the 13th century. The technique was only used in a limited area, however, and, at bottom, was never more than a spirited imitation of mainly metallic Eastern prototypes.

Gilded ware, the most luxurious and technically advanced type produced by mediaeval Islamic workshops, was also made in Al-Andalus. Nevertheless, the pieces classed as early-mediaeval are imports. The origins of this technique are currently being reviewed as a result of excavations under way in the Middle East. However, what seems clear is that the few examples that have come to light in the Iberian Peninsula have their origins in the Eastern Mediterranean, where researchers are still to determine their chronology.

A few reputable authors claim that late-11th- or early-12th-century Málaga was a gilded pottery production centre, but available evidence still leaves too many questions unanswered.

Gilded ware might have been produced in southern centres such as Málaga, Almería and Murcia as early as the late 12th century, but available documentation is rather incomplete. The finest examples of this pottery, which marks the peak of achievement in Al-Andalus, were made in the Naṣrid kingdom of Granada.

In the 13th century, workshops in Málaga embarked on the production of some extraordinary pieces on which a gold pigment appears on its own, or in combination with blue. This ware is thought by some to have been derived from local traditions, and the technique applied may well have been developed to high standards by potters in the area. However, the presence of pure cobalt blue, which was previously unknown in Al-Andalus, would point to the likelihood of Persian craftsmen having settled in Málaga, as combinations of gold and blue, based largely on cobalt, were common in Persia. These hypothetical potters may have fled from the invading Mongols. They set up their workshops in the kingdom of Granada, and either stimulated or ousted local industry. The assertion that the pieces from Málaga are purely the result of a local tradition is dubious to say the least.

Control of the trade routes that originated in central or West Africa, crossed the Sahara and the Strait of Gibraltar, and ended in the Iberian Peninsula, was one of the strategic priorities of the Umayyads of Al-Andalus, as those routes were vital for their supply of such raw material as gold and ivory, which were essential for the development of their advanced society.

Ivory soon became one of the financial standards of the Cordovan state and, as demand for large quantities of it was high, the capacity each Moorish state on the Iberian Peninsula had for intervening strategically along the North African trade routes became an indicator of its power status.

Ivory was not only a luxury article; it also played an important part in court etiquette. All state gifts to ambassadors or high-ranking officials used to include rich fabrics and ivories carved in royal workshops, a practice which had been enshrined many years before by the imperial Byzantine court.

Andalusian workshops were also famed for their fabrics, particularly silk. As so often happens, the available historical documentation is fragmentary and seldom tallies with archaeological findings. Various qualities of fabric will of course have been manufactured, especially those for which there was an abundant supply of raw material. Similarly, some workshops must have been based on traditions that pre-date the Moorish invasion.

To the emir ʿAbd ar-Raḥmān II (788-852) was attributed the founding of the *dār aṭ-ṭirāz* or 'House of Tiraz', a royal workshop which produced silk fabrics. Here again, the operation was based on Eastern practices: the cloth in royal workshops was made from the finest raw materials, and decorative motifs were usually proto-heraldic and, at times, propitiatory. They were used for luxurious court garments and given as distinguished gifts to

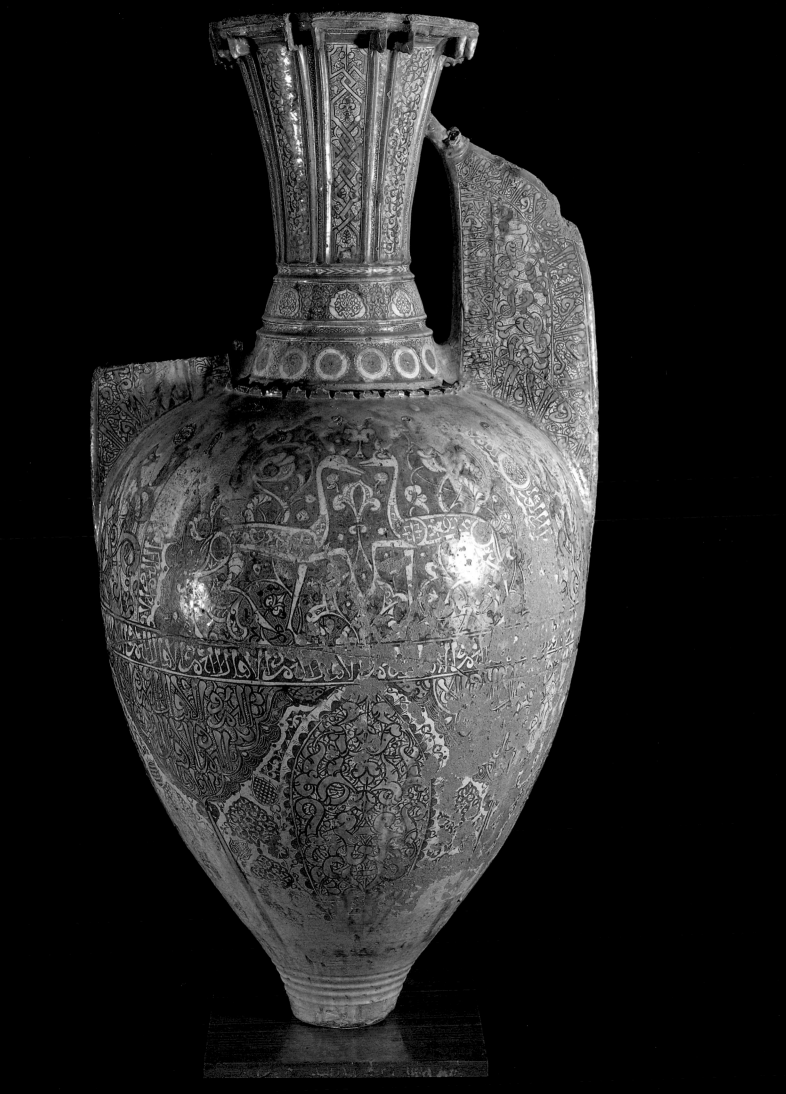

Pyrenean border pattern. Instituto
Valencia de Don Juan, Madrid.

Almaizar or humeral veil of Hishām II
(976-1013). Museo de la Academia
de la Historia, Madrid.

Previous page:

Vase of the Gazelles. Museo de la
Alhambra, Granada.

other monarchs, amabassadors, important figures and high-ranking officials. Like coins, the
lettering on fabrics was changed when a new monarch ascended to the throne.

Cordova was the first major textile centre in Al-Andalus, but not the only one. In
time, Almería became the most famous of all, with the largest production, particularly dur-
ing the 11th century and the first half of the 12th century. Other major centres were Seville,
Málaga and Murcia and, during the Naṣrid period, Granada.

On the whole, fabric decoration either set a precedent for, or was derived from, an
architectural feature, which has enabled them to be classified on the basis of stylistic simi-
larities. However, this principle becomes inoperative in the case of many designs, particu-
larly from court workshops, which were intentionally archaistic or imitative of prototypes
from a different period.

Some fine examples of Andalusian Moorish fabrics have been preserved in church-
es, cathedrals and monasteries. Noteworthy among them are the tapestry in the 11th-cen-
tury collegiate church at Oña (Burgos), the 12th-century chasuble of San Juan de Ortega at
the church of Quintanaortuño (Burgos), another chasuble, from the same century, embroi-
dered at Almería and now in Fermo (Italy), 13th-century funerary vestments in the mon-
astery of Las Huelgas (Burgos), and a 14th-century Naṣrid chasuble in the Burgos cathedral
museum.

For the purpose of re-classification, many of the pieces handed down to us would
have to be analysed by physical and chemical means, which are more accurate than stylis-
tic considerations. The frequent use within the same cloth of different fibres, including even
extremely fine gold thread, and of various qualities of dye, provides accurate clues that
would greatly broaden existing knowledge on the subject.

Turning to metalwork, the fact is that few specimens have survived to provide con-
clusive evidence of the activity in this field. Iron objects, whether weapons or tools, must
have undoubtedly been produced in large quantities, although without any major influence

as far as art history is concerned. All that we have to go on is a collection of swords and daggers, mainly parade weapons, from the late Naṣrid dynasty. The items in question are striking for the combination of excellent quality steel blades and magnificent goldsmithing and enamelling in the hilts. These weapons cannot have merely been an isolated instance of workmanship, but will have been based on long-standing industrial and craft traditions, which can be sensed rather than asserted.

The same is true of silversmithing, of which very few examples have survived. However, a prominent minor work is the wooden box, faced with repoussé and niellated silver, now known as the *Arqueta de Hishām* ('Casket of Hishām'), housed in Girona Cathedral. It was made in the workshop of either Cordova or Madīnat az-Zahrāʾ in 976 for Hishām II (976-1009), the son and heir of al-Ḥakam II (961-976). It is decorated with elegant silver plant motifs, based on double palms, with markedly Eastern flavour, which were highly fashionable at the time and adorned the walls of palaces at Cordova.

To end, it is worth taking a brief look at bronzes, of which some excellent examples have survived. Prominent pieces include a hind unearthed at Madīnat az-Zahrāʾ (Museo Arqueológico de Córdoba), the so-called Lion of Monzón (Louvre, Paris), some lamps in the mosque of al-Qarawiyyīn (Fez, Morocco), and a lamp in the Great Mosque of Granada (Museo Arqueológico Nacional, Madrid). On the whole, the bronze industry was not among the most highly developed in Al-Andalus. It did not emerge at an early date, and the size and quality of most pieces were only average.

Hind of Madīnat az-Zahrāʾ; second half of the 10th century. Museo Arqueológico Provincial, Córdoba.

Some pieces presumed to date from the period of the caliphate, including the Lion of Monzón and a cache of objects found in the village square of Chirinos (Córdoba), have had their chronology brought forward to the Almohad period. Lastly, the so-called Griffon of Pisa (Museo dell'Opera del Duomo, Pisa), which is larger than average, continues to arouse controversy among experts, owing to the marked disparities among several of its decorative features.

IVORIES

The ivories carved in Cordovan workshops are among the finest artistic achievements of Islam, and not only in Al-Andalus. However, any study of the subject comes up against several difficulties. The greatest mystery relates to the very origins of the technique in Al-Andalus. Although the ivories lack any precedents, and despite the foreign provenance of raw materials, it does not seem reasonable to assume that the Cordovan school has its origins in the Iberian Peninsula. However, the characteristically Andalusian Umayyad style of the work may well support that idea.

In all, thirty ivories have been preserved. Their dates of execution fall within the span of a century (circa 964–1060), while some of the later examples were produced by workshops wholly within the art world of the party kingdoms or *tauā'if.*

The oldest specimen from the period of the caliphate is the *bote de Zamora* ('Zamora cannister'), dating from 353 AH (the period from 19 January 964 to 7 January 965), while the latest one is a cannister housed in Braga Cathedral (Portugal), dating from 394–399 AH (30 October 1003 to 24 August 1009). In the period between those dates, there are two workshops documented in the two palace–cities of Cordova: Madīnat az-Zahrā' and Madīnat az-Zāhira. The workshop at Cuenca, a protectorate of the *tā'ifa* kingdom of Toledo, began production around the year 1010.

In the absence of any supporting archaeological evidence, it would not be too venturesome to suppose that a craft workshop, possibly from Fāṭimid Africa or Ikhshīdid Egypt, might have been induced to settle in the Western Umayyad capital. There is an evident parallel and proximity in time to the case of a master mosaicist who was summoned from Byzantium to decorate the *qibla* in the Mosque of al-Ḥakam II.

The style of the ivory carvings featuring geometrical and plant motifs is unequivocally Cordovan in tradition. It may well have been imposed by official ornamental regulations, in which Western Umayyad features will have merged with those rooted in the 'Abbāsid tradition. This tallies with dynastic imperial policy, which first became evident in the reception halls at Madīnat az-Zahrā', 'Abd ar-Rahmān III's greatest secular foundation.

Ornamentation on boxes and cannisters is usually based on plant motifs, figural scenes and inscriptions. Although a large part of such inscriptions is now missing, those which have survived are invaluable, not just as decorative items but for their documentary value, as they provide vital information about dates and places of execution, the purpose of the objects in question and the people they were intended for. In all instances, the epigraphic writings are in Kufic script.

Plant motifs form the most genuine type of Andalusian decoration. They were used, above all, to fill backgrounds. Animal motifs display the greatest variety, and are depicted either on their own or placed in pairs facing each other, set against lush vegetation, in keeping with Eastern tradition. They are portrayed at rest or moving, and the diversity of species includes gazelles, antelope, ibex and other cervids, lions, wolves, dogs, hares and some barely recognisable quadrupeds. Rarely are elephants or dromedaries depicted. There are also animals of fable, including griffons and unicorns. The array of birds is vast, although most of them are unidentifiable.

Motifs were often combined to form hunting scenes or animals fighting. The subjects portrayed on Moorish ivories were akin to those of Sassanid art, the repository of a large part of ancient Eastern traditions, as well as to Byzantine art, the icono-

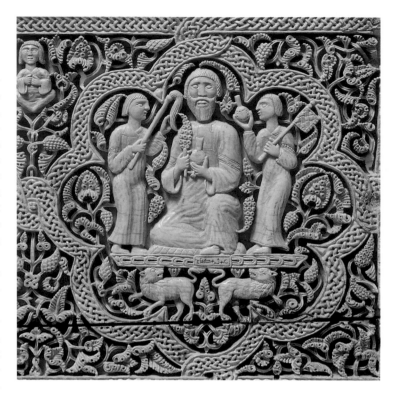

graphic prototypes of which may have been taken from fabrics.

There are also numerous scenes with human figures, set in the court circles of the great monarchs of the East, both pre-Islamic (the Sassanids) and Islamic (the 'Abbāsids). In addition to contravening the Islamic prohibition of animal representation, they plainly express the thirst for status of the burgeoning Umayyad caliphate. The repetition of iconographic motifs reveals a manifestly emulative intent, unheard-of until then in the Islamic West.

The ivories are Eastern in composition and iconography, but take on a character of their own in execution, with less attention to detail: in Andalusian pieces, large central motifs gain prominence over scrupulous *ataurique* decoration. In the oldest ivories, the whole surface is adorned with foliage speckled with small creatures. The so-called cannister of al-Mughīra, dating from 968 and housed in the Louvre, set a new trend in the arrangement of ornaments: the decorated surface is strung out in interlaced bands forming medallions in

Casket of Leyre. *Dating from the early-11th century (1005), this casket was commissioned by Zuhayr ibn Muḥammad for al-Manṣūr's son, 'Abd al-Malik. Detail of one of the medallions. Museo de Navarra, Pamplona.*

The Hispano–Moorish court workshops had a guaranteed supply of ivory from North Africa since the time of 'Abd ar-Rahmān III. The official character of the Leyre casket is evident in the iconography, and the inscription, which features the names of the patron, the beneficiary and even the artist. The larger figure in the centre of one of the medallions is probably the caliph Hishām II, as the ring, goblet and branch, and even the way the figure is seated with his legs crossed, are all attributes of that sovereign. The fact that the casket was Islamic in origin did not stop the Christians from subsequently re-using it as a reliquary for SS Nunilona and Alodia, as they attached considerable importance to the value and beauty of ivory.

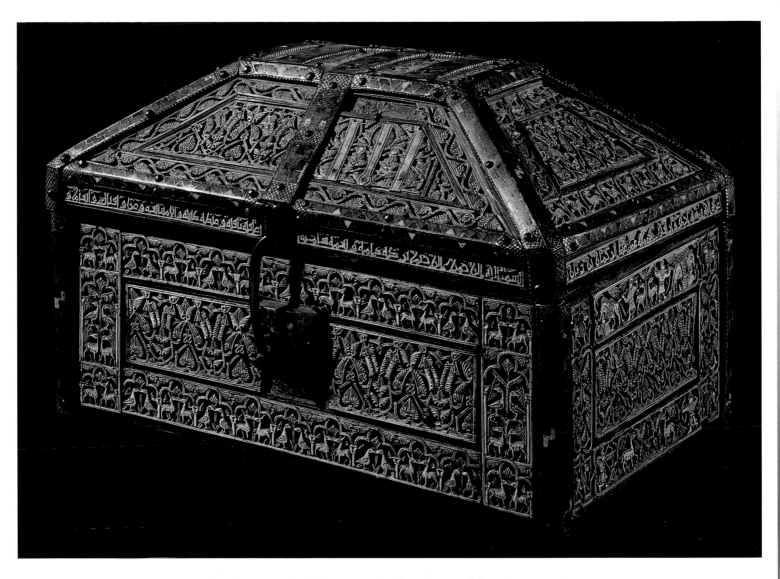

Ark of Palencia. *1049-1050. Museo Arqueológico Nacional, Madrid.*

which scenes are framed. During the last stage of production, around the mid-11th century, plant motifs again started prevailing over animal ones. Moreover, it became fashionable to paint reliefs blue, with grounds in red or even gold.

There may well have also been other workshops apart from official ones, but none of their works are known to us. We also know precious little about the craftsmen that carved these ivories. One of the few names that has been handed down is that of Khalaf, who produced several works, all totally devoid of zoomorphic ornamenta-

tion. One master that is documented is Faraj, who, together with his assistants, signed the *Arqueta de Leyre* ('Leyre Casket'), the culminating piece in a series, and one of the last from the caliphal period. It was presented as a gift to ʿAbd al-Malik al-ʿĀmirī, the son and successor of the famous al-Manṣūr, the caliph Ḥishām II's powerful minister, in the year 395 AH (18 October 1004 to 8 October 1005).

The last period of ivory production was centred at Cuenca, in the Toledan kingdom of the Banū Dhī-l-Nūn tribe. Although the Umayyad tradition endured until well into the 11th century, surviving specimens of carved ivory reveal a decline in standards of workmanship, both in the handling of mo-

tifs and in overall decorative composition.

The workshop at Cuenca was run by a single family, the Banū Ziyād. The inferior quality of their production, which nevertheless shows some original figurative features with Fāṭimid overtones, may simply have been part of a degenerative process in Cordovan prototypes, although possible ties to an independent workshop of the type described earlier, which might have continued active in the same place or elsewhere after the demise of the Cordovan centre, cannot be ruled out.

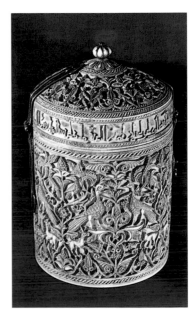

Zamora Cannister. *964. Museo Arqueológico Nacional, Madrid.*

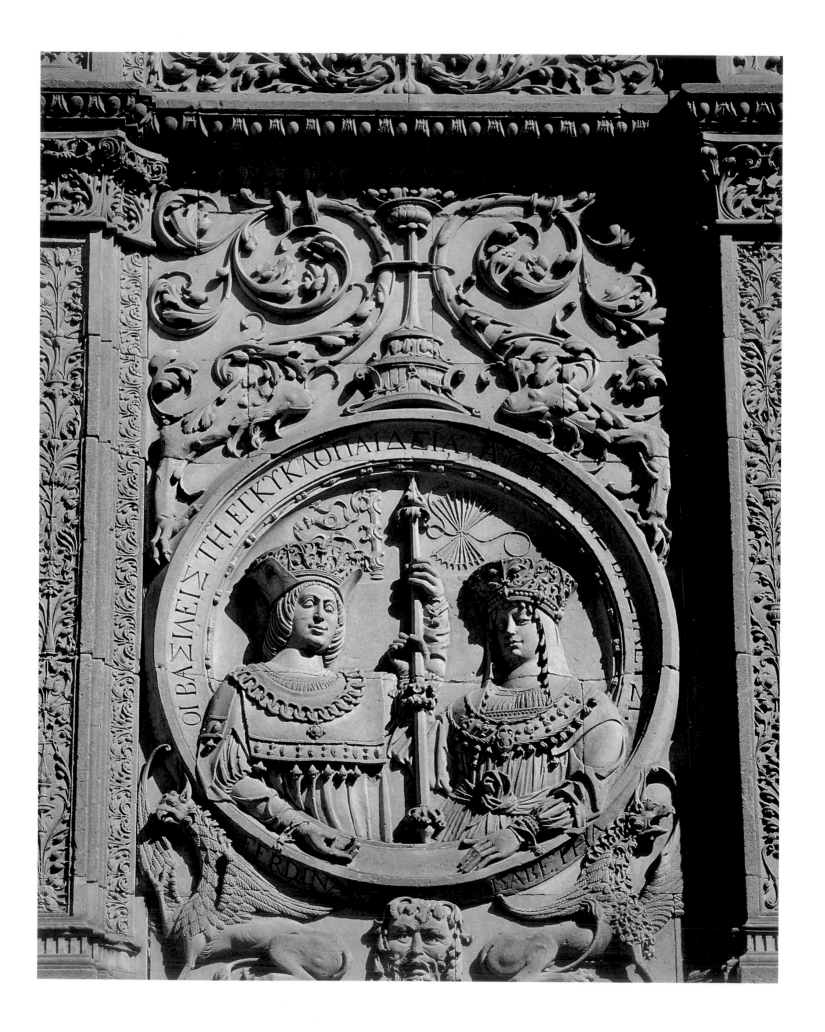

THE ART OF THE RENAISSANCE

Fernando Checa

TIME AND PLACE: THE PROBLEM POSED BY THE SPANISH RENAISSANCE

For decades, one of the essential problems faced by historiographers when dealing with the Spanish Renaissance was the crucial issue of whether it actually existed at all. Historians and critics of that period have been divided by two sources of fascination: on the one hand, the Italian Renaissance was regarded as having yielded a consistent, virtually seamless and even monolithic classical model which exerted a powerful formal attraction. On the other, Spain's turn-of-century historiographers were steeped in a cultural milieu in which specific, indigenous values prevailed, responding to Unamuno's categories of *castizo* and *intrahistoria*. 19th-century reminiscences, which considered Spain as 'a romantic country par excellence', did the rest.

Nowadays, we know that Europe's road towards the Renaissance was far more complex, that even in Italy itself there was not just one Renaissance, and that the brilliant model which Giorgio Vasari designed so effectively in his *The Lives of the Most Eminent Architects, Painters and Sculptors...* fell short of covering the whole Italian panorama in all its wealth and variety. As Peter Burke has pointed out, 'Italian customs' differed considerably in different parts of Europe, where deeply rooted local traditions held out against classicism and fostered diversity. In the 16th century, most of Europe adopted a form of eclectic art which cannot be accounted for merely on the basis of peripheral regions holding out against trends arising in the centre.

It should be recalled that, in the late-15th century and early-16th century, when the Modern Era was dawning in both Europe and Spain, the Italian model (which, as stated earlier, was actually far from monolithic, despite attempts to portray it as such) was not the only model that emerged as a guarantor of the renewal that would supersede the Gothic. From the early-15th century, changes in Flemish painting were so far-reaching that their influence was felt not only in Spain and Central Europe, but in Italy itself, including Florence. As Panofsky so rightly pointed out in *Early Netherlandish Painting,* the road to pictorial modernity did not only involve a 'rebirth' of antiquity, since an *ars nova* was perhaps equally feasible as a wellspring for such a renewal.

This is what occurred in Spain during the second half of the 15th century. Under the Catholic Kings, the country acceded to modernity in many respects. It adopted its own interpretation of Flemish influences in painting, which coexisted with magnificent late-Gothic architecture and sculpture, a sprinkling of Italianate features, and a marked Mudéjar substrate. The latter, for obvious historical reasons, was nonexistent in the rest of Europe. This eclectic artistic amalgam would endure until well into the 16th century, characterised by the absence of any paradigm, which did not appear to arouse any interest among the Spanish until the last few decades of the century.

The Renaissance has traditionally been regarded not only as an art of change, but as one of progress. This is also how it was perceived during the period itself. Indeed, the foreword to *La Celestina* speaks of *«aquel mudar de trajes, aquel derribar y renovar edificios y otros muchos afectos y variedades que desta nuestra flaca humanidad nos provienen»* ('that

Medallion of the Catholic Kings, on the facade of the University of Salamanca; end of the third decade of the 16th century.

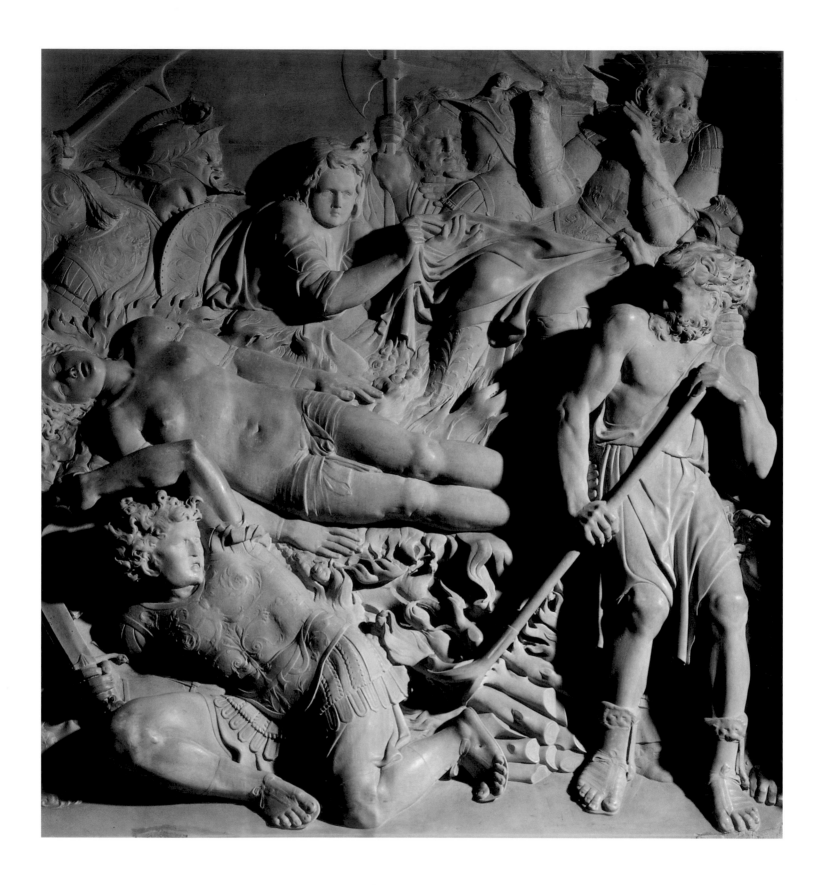

BARTOLOMÉ ORDÓÑEZ & workshop: scene from the martyrdom of St Eulalia in the retro-choir at Barcelona Cathedral, 1519.

change of garments, that pulling down and renovation of buildings, and of many other affects and varieties which come from our human frailty'). To return to Vasari, his model of the Renaissance was based on theoretical premises which would be untenable nowadays. Broadly speaking, they were based on a single Florentine (or classical) model, a contrary stance to the Middle Ages, the division of the Renaissance into a number of ages that influenced one another, and a prevailing idea of linear evolution. However, interestingly enough, particularly from a Hispanic viewpoint, this would suggest a negation of superimposed time frames, of a different *tempo* for each situation, as George Kubler has pointed out in his *Shape of Time: Remarks on the History of Things*. For him, determining the meaning and evolution of art forms involves adopting 'a criterion that is not merely a transference by analogy of biological science', as historical time is not something which is predetermined, but 'intermittent and variable'.

In addition to the lure of indigenous values, the existence of local or 'regional' schools was another impediment when it came to adequately appraising 16th-century Spanish art. In the 19th century, the classification of historical material on the basis of artists' biographies, undertaken by such pioneering Spanish historians as Palomino, Ceán and Llaguno, was paralleled by another division on the basis of regional schools or cities. The latter soon ceased to be regarded as a purely aseptic system of classification, which established a sorely needed order, and grew into a fully-fledged historiographic method, which is currently taking advantage of the new political structure known in Spain as the 'Autonomic States'.

In the 16th century, while there were indeed features of a formal nature common to particular cities or regions—owing to the coexistence of masters and workshops, and the emulative desire of patrons or clients—these features did not often come close to shaping genuinely consistent styles. Instead, they were most often mannerisms with no particular bearing on a deeper understanding of the phenomenon of art.

In his study of 16th-century art in the Baltic area, Jan Bialostocki appears to have touched on a sore point. In our times, neither the overly nationalistic and politicised *Kunstgeographie* of German historians of the thirties, nor the ideas of the Italian *Scuole Pittoriche*, seem to hold out much interest. The same may be said of Hegelian categories such as the romantic *Volksgeist*, or the Riegelian *Kunstwollen*, which Bialostocki describes as 'pseudo-explanations': the contemporary historian 'is interested in seeking historical reasons for specific choices, for similarities and dissimilarities, and for the contacts and factors which determined decisions'.

In this light, the old debate about what was specific to and 'indigenous' in Spanish art has given way to the recent controversy (which, as pointed out above, is actually age-old) over whether in fact Spanish Renaissance art ever existed, in terms of the univocal yardstick of the most classical Italian paradigm. This is not to mention the endless controversies about how and when to apply those subdivisions of the 'Gothic' and 'Renaissance', in contemporary historiography, that is, 'Proto-Renaissance', 'Pre-Renaissance' and even 'Post-Gothic', which seems pointless, long-winded and rather naive in terms of 16th-century Spanish art—at least until 1560—characterised, as it was, by linguistic diversity, a variety of trends and a paradoxical concurrence of styles.

Attitudes to an Artwork

Despite the reappraisal of worldly values and sentiments during the Renaissance, which was one of the cultural hallmarks of the period, most artistic creations were of religious subjects. However, as the century passed and the Renaissance took root, it became gradually more common to view artworks in a mundane light. On the whole, both attitudes tended to be mediatized by the functional value of artworks, and it was rare, apart from some highly significant exceptions, to come across a genuinely aesthetic approach to or appraisal of an artwork.

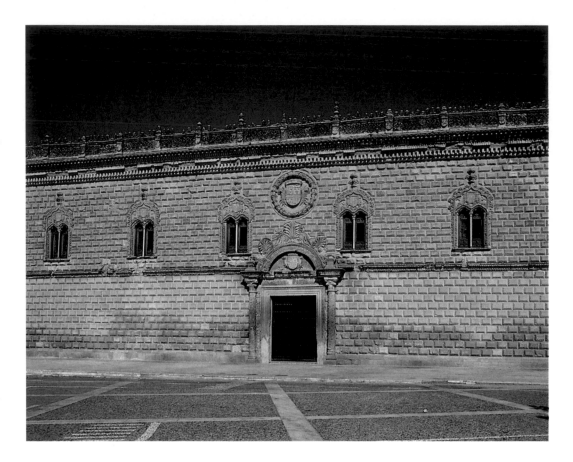

LORENZO VÁZQUEZ: facade of Cogolludo Palace (Guadalajara); Between 1492–1495 & 1502.

Lorenzo Vázquez was commissioned to design Cogolludo Palace (Guadalajara) for the Mendoza family in the period between 1492–1495 and 1502. Dispensing with the idea of a fortified residence, he designed the palace along Italian lines: cubic, a flat facade, and everything covered in bossage. The social status of the founders was displayed in heraldic devices set above the lintels of doors and windows. Despite the Gothic cresting and biforate windows, the palace is reminiscent of such Italian examples as the Palazzo de Piccolomini at Siena.

JUAN VALLEJO & FRANCISCO COLONIA: lantern in Burgos Cathedral; circa 1540–1568.

During the Spanish Renaissance, the principal form of assignment was commissions, which meaned that the presence of an artwork would be required in a particular place to fulfil a commemorative, educational, persuasive or status role for a certain person, group or institution that was financing the work.

Patronage, whether religious or secular, which had been a common form of sponsorship during the Middle Ages, became consolidated during the Renaissance. In this context, the issue of foundations had been an essential factor among the nobility and in court circles, from the time of the Catholic Kings to that of Philip II. Churches, monasteries and hospitals were built on the initiative of the king, particularly in the time of Isabella and Ferdinand, whose reign saw the foundation of San Juan de los Reyes (1477, the church was completed in 1494), Santo Tomás de Ávila, the Royal Chapel at Granada (the original design dates from 1506, although it was reworked in 1510), and the hospitals of Seville and Santiago de Compostela (completed in 1499). Patronage by the aristocracy included that of the Mendoza family, the Fonsecas and, during the reign of Charles V, the Dukes of Osuna and the Cobos family. These initiatives usually gave rise to a foundation as complex and many-sided as the Monastery of El Escorial, during the period of Philip II, and to subsequent foundations, such as the College of Cardinal Rodrigo de Castro at Monforte de Lemos which, as well as being a memorial to the piety of its founder, is associated with the subject of religious education, commensurate with the Counter-Reformation.

Patronage of this kind often went hand in hand with an artwork's funerary significance and value. From the end of the 15th century, this became increasingly more important as the individualistic ideas of the Renaissance gained ascendancy. Funerary achitecture was very often associated with central-plan areas, of which noteworthy examples include the still Gothic chapels of Álvaro de Luna, in Toledo, and of the Constable of Castile, in Burgos Cathedral, in addition to churches of a marked funerary tenor, such as that of El Salvador, at Úbeda, designed by Vandelvira for Francisco de los Cobos, and funerary church-

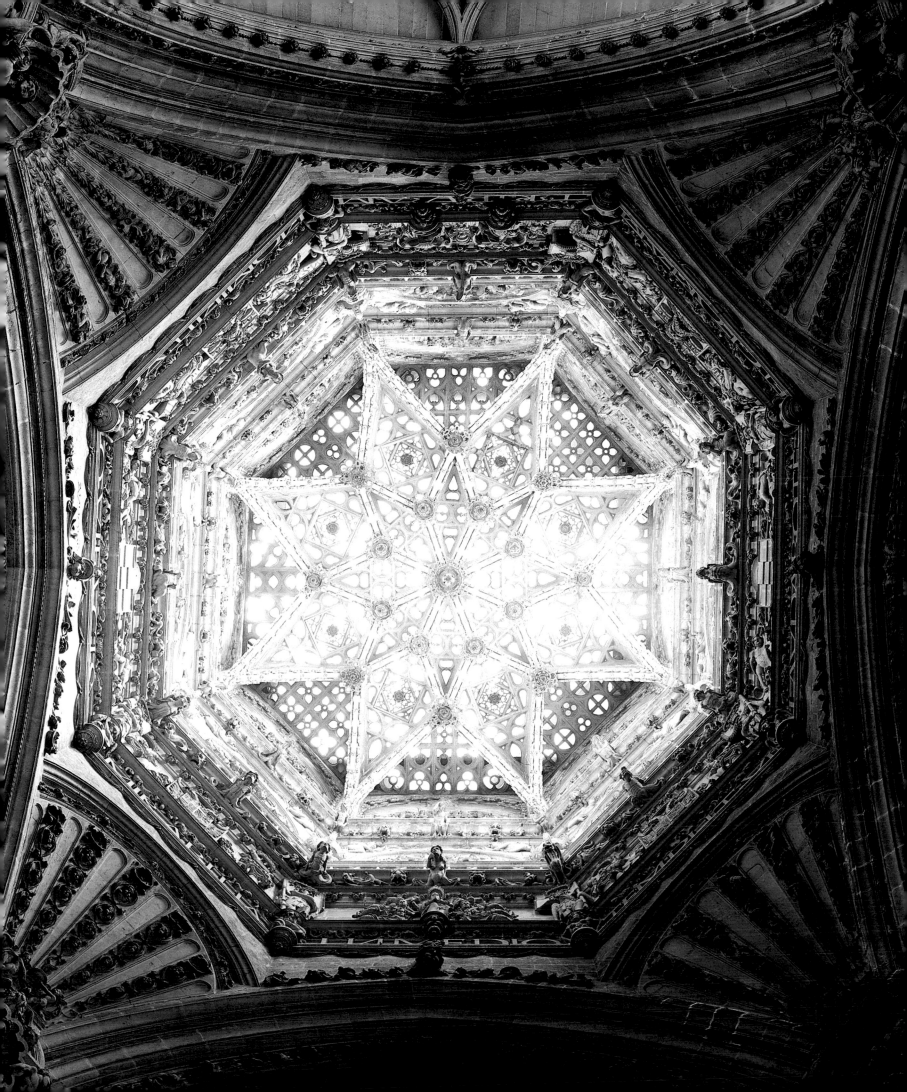

Plan of the church in the Hospital de la Sangre, Seville.

es related to the monarchy, including San Juan de los Reyes, Granada Cathedral and the Monastery of San Lorenzo de El Escorial. Some of these buildings have domed roofs, with El Escorial featuring the earliest dome on a drum of the Spanish Renaissance.

The commemorative value of these foundations is borne out not merely by the strikingly sumptuous, ornate architecture, but by the paintings and sculptures housed in them, from liturgical vessels to paintings and devotional retables, while, in the field of funerary sculpture, tombs were often carved by the leading artists of their time. In this respect, Cardinal Tavera commissioned Alonso de Berruguete to execute his tomb, which was placed at the crossing in the hospital church he had founded in Toledo, while the Constables of Castile built one of the most unusual and complex funerary ensembles of the period in their church at Medina Rioseco, featuring works by the Corral Villalpando family and Juan de Juni. Similarly, the aforementioned Rodrigo de Castro donated major works by El Greco, Andrea del Sarto and Hugo van der Goes to Monforte de Lemos.

As a form of sponsorship, patronage involved an attitude of considerable intensity and interest vis-à-vis the artwork on the part of the benefactor, who would take an artist directly under his wing. This practice had been customary since the time of the Catholic Kings and even earlier, as evinced in the case of the first Marquis of Santillana, who elected to adopt as his protege the painter and miniaturist Jorge Inglés. Inglés executed a splendid portrait of the Marquis and hs wife in his *Retable of the Angels* (1455), at the altar in Buitrago hospital. Patronage also applied to the activity of such artists as John of Flanders and Michel Sittow in the court of the Catholic Kings, and to Cardinal Cisneros' ongoing sponsorship of men such as Pedro Gumiel, Felipe Vigarny, the painter John of Burgundy, and the printers of Alcalá de Henares, and to the Mendoza's patronage of the architect Lorenzo Vázquez.

This type of relationship was consolidated further into the century, and the number of examples increased markedly, including artists such as Diego de Arroyo, who was active in the court of Charles V and the empress Isabella, and Alonso de Vandelvira, in the employ of Francisco de los Cobos. There was also the relationship between Luis de Morales and San Juan de Ribera in Valencia during the Counter-Reformation, and a host of Italian (the Leonis, Cambiaso, Zuccaro and Tibaldi) and Spanish (Sánchez Coello and Navarrete the Mute) artists in the court of Philip II.

A third approach, which may well be regarded as modern, was that of collecting artworks. The works assembled in specific collections reveal practically all as far as the collector's tastes were concerned, while the function assigned to the artworks tended to be one of pleasure rather than responding to practical considerations. This was a far more intellectual, rational approach to art, which was becoming increasingly more valued for its aesthetic character.

Art collecting came into its own under the Catholic Kings, although still a minority practice at the time. Examples of this are Pedro González de Mendoza's collection of antiquities, or Isabella's Flemish portrait collection, in which it is difficult to ascertain whether their function is religious—acting as a devotional stimulus to prayer—or purely aesthetic, as many of them are of a high quality and therefore a source of pleasure.

Similarly, it was during this period that artworks were often collected for their commercial value or material wealth. This new trend was ushered in at the start of the 16th century by men educated in foreign environments, as was the case with Diego de Guevara, a collector of Flemish painting of the highest quality. His palace was adorned with works by Sittow, Hieronymus Bosch and Van Eyck's *The Arnolfini Marriage*. He passed on his taste in art to his son Felipe, who became a painting collector and essayist and whose collection was eventually acquired by Philip II.

The love of painting grew during the 16th century, which featured such connoisseurs as the aforementioned Felipe de Guevara, Don Diego de Vich, Francisco de los Cobos, who collected works by Titian and Sebastiano del Piombo, and members of the royal family, including Maria of Hungary and, to a lesser extent, Charles V. The latter's son, Philip II, consolidated the trend, becoming one of Europe's leading Renaissance collectors: works by Tit-

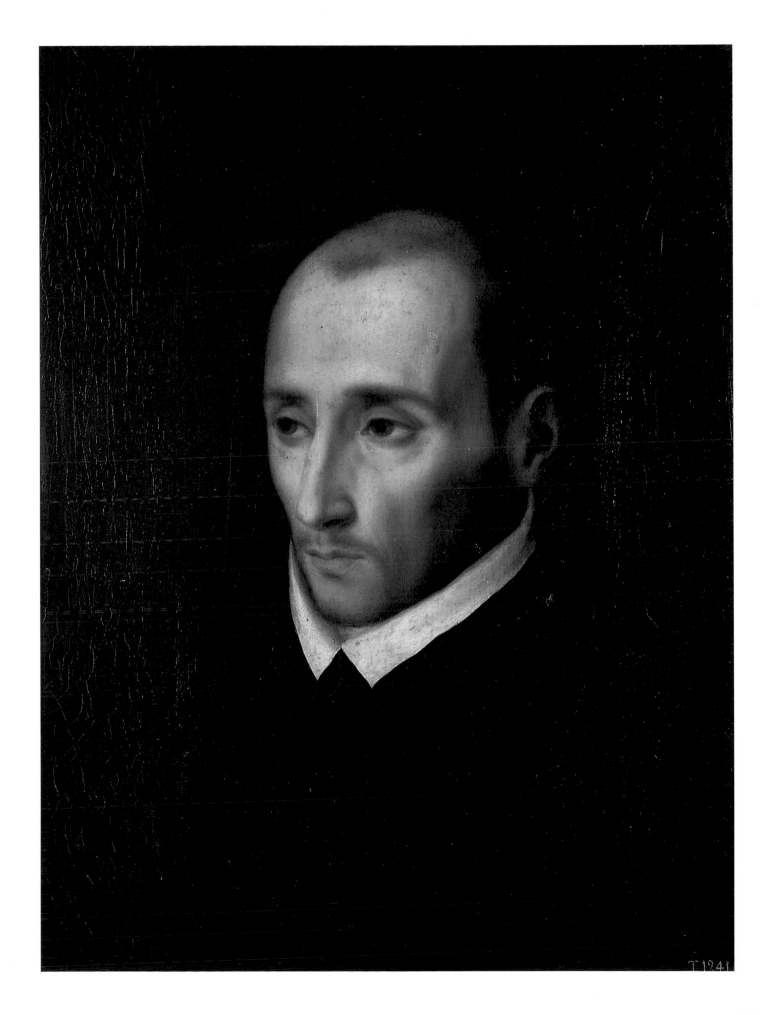

Previous page:

ian, Bosch, Van Eyck, Van der Weyden, Patinir and many others hung on the walls of his palaces and monasteries.

During the second half of the 16th century, some nobles and courtiers began to adopt a variety of approaches to art collecting. There was the scholarly approach, which focused on numismatics, epigraphy and antiquities, exemplified by the Duke of Villa-hermosa, in Aragon, Antonio Agustín, in Tarragona, the Dukes of Alcalá, in Seville, and the ambassador, Diego Hurtado de Mendoza. Others, who developed a taste for the exotic and the bizarre, pieces which might fill a 'hall of wonders', included the Duke of Priego, while yet others, such as Antonio Pérez, sought specifically pictorial works, or the works of El Greco, collected by Pedro de Salazar and Luis de Castilla.

Roman and Modern

In 1526, in his work entitled *Las Medidas del Romano,* Diego de Sagredo advised: *«E mira bien que no tengas presumpcion de mezclar romano con moderno; ni quieras bus-car novedades trastocando las labores de una pieça en otra; y dando a los pies las molduras de la cabeça»* ('And take heed not to attempt to mix things Roman and Modern; nor should you seek novelty by shuffling some pieces of work with others, and setting on the base the mouldings of the head').

In its proper context, this piece of advice from Sagredo refers mainly to the subject of columns, bases, capitals and other elements of an order, rather than to architecture as a whole. However, what is significant is that Joan of Castile's chaplain should have taken such an interest in architectural precepts which, at that late stage in time, still tended to be hybrid and contaminated.

In effect, despite the avant-garde nature of some architectural enterprises in the late-15th century, particularly those associated with the Infantado-Mendoza family's patronage of the master Lorenzo Vázquez, the architectural scene in the first few decades of the 16th century was dominated by a decorative, ornamental phase very much in tune with what was happening in most of Europe, and in whole regions of Italy.

Plurality, and the coexistence of different 'architectural times', was the prevalent trend. Late-Gothic architectural and decorative forms, imported from northern and central Europe from the mid-15th century onwards, had become pivotal and highly complex. They involved a major typological renewal cloaked in a Gothic ornamental and compositive language, as evinced in some palaces, typologically designed around an Italian-style *cortile,* but worked out in Gothic style, such as the Palace of the Infantado, designed by Juan Guas and, above all, the splendid series of hospitals, based on Greek-cross-plan Italian models, built by the Gothicist master, Anton Egas. Added to this was the spatial renewal which attempted to revive the unitary character of the large number of churches founded by the Catholic Kings, and the reiteration of central-plan models, as in the chapels of the Consta-ble, in Burgos, Álvaro de Luna, in Toledo, and Vélez, in Murcia.

Contemporary with this state of affairs was a current of 'Roman' renewal, evident in a number of works associated with the patronage of the Mendozas, such as the Palace of Cogolludo and that of La Calahorra, and the facade of the College of Santa Cruz at Valla-dolid, all of which flew in the face of the Modern or Gothic style still so much in vogue in court circles. However, the most significant aspect of the evolution of Spanish architecture at the time, which eludes any linear or strictly formalistic analysis, was the way that archi-tecture subsequently developed. Thus, during the first few years of the 16th century, so-called architecture 'a la Romana' entered an eminently decorative phase in which crude and even flawed interpretations often abounded. A case in point is the Portal of the Pellejería at Burgos Cathedral. However, interpretations could also often be harmonious and well articulated, as in the facade of the University of Salamanca, which features Italian orna-mental motifs rendered directly through drawings or engravings, or indirectly by stonema-sons from France.

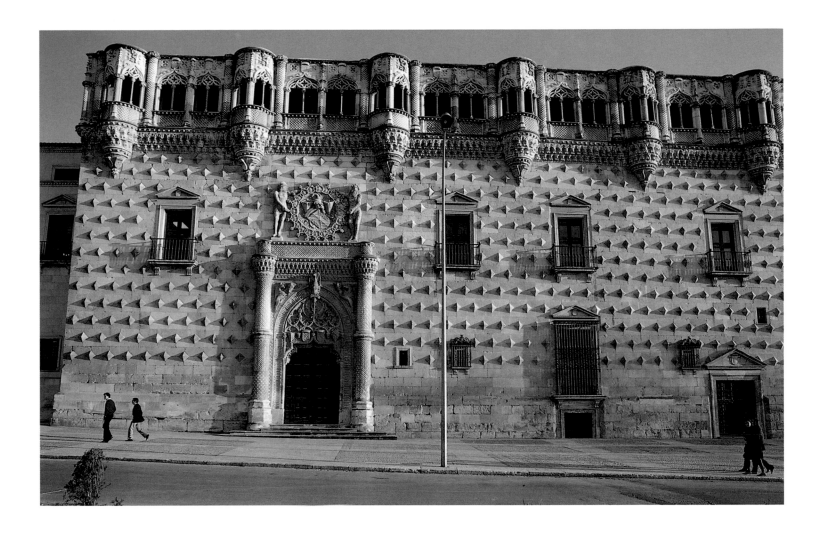

JUAN GUAS: facade of the Palace of the Duque del Infantado (Guadalajara); 1480.

Despite belonging to different architectural styles, there was nothing unusual about Italianate decorative motifs being used side-by-side with Gothic ones in the same building, as in the so-called Palace of Las Conchas in Salamanca. Similarly, 'Roman' features could be closely combined with 'modern' ones, as in the retro-choir of Palencia Cathedral, or the Gothic would be used on its own, as in the work of Juan Gil de Hontañón. However, this brand of Gothic was quite different from the Flamboyant style that had been popular in the 15th century.

In view of the above, it is difficult to summarise the position of the 'old' (Roman) and 'modern' (Gothic) in Spain during the first half of the 16th century. Different masters tended to use a completely different language in the buildings they designed. Perhaps the most noteworthy example is that of Rodrigo Gil de Hontañón, the son of Juan Gil, who, having trained in the Gothic style with his father, continued his father's work on Salamanca Cathedral. However, his style marked a significant departure from that of his father, as evinced in one of his paramount works—the superb cathedral of Segovia. The Gothic styles of the two buildings are unlike each other, and also differ in many respects from that of immediate predecessors: Juan Guas, the Egas family and the Flamboyant masters. However, the remarkable thing about Rodrigo Gil is the fact that he was also the artificer of thoroughly Renaissance buildings such as the Palace of Monterrey, in Salamanca, and the facade of the University of Alcalá de Henares, one of the first 'composite' constructions in terms of the new Italianate trends, although without being overburdened with ornamentation.

The work of other architects evolved from an initially decorative phase to a 'Roman' style regarded as a reflection on the principles of order, proportion, measure and typology. The career of Alonso de Covarrubias is an example of this: a comparison of his early works at Sigüenza—such as the tombs of St Librada and Don Fadrique of Portugal, or, at Guadalajara, the frontispiece of the convent of the Piedad—with those from his late period, such

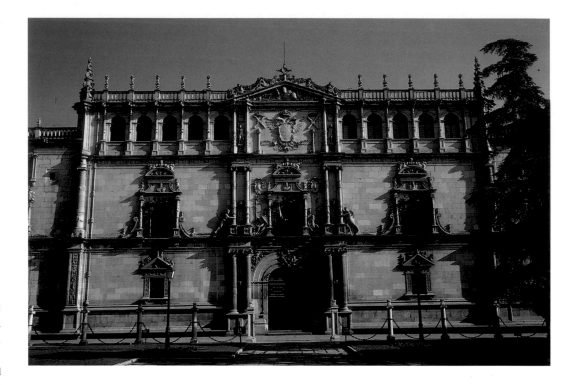

RODRIGO GIL DE HONTAÑÓN: facade of the University of Alcalá de Henares; 1537.

RODRIGO GIL DE HONTAÑÓN: sanctuary and ambulatory in Segovia Cathedral; circa 1525.

Of the numerous churches and cathedrals built in Spain during the 16th century, Segovia Cathedral is noteworthy for its harmony and transparent volumes, and has features in common with its contemporary in Salamanca. Charles V commissioned it to be built to replace the old cathedral, for which purpose he appointed Juan Gil de Hontañón as master architect. However, it was his son, Rodrigo Gil, who ended up directing building work, and whose design of the Cathedral, dated circa 1524, has survived to the present. The Cathedral is five-naved, with a transept and ambulatory. Twenty-five years later, the architect wrote a *Compendio de architectura y simetría de los templos* ('Compendium of Church Architecture and Symmetry'), which was compiled by Simón García in the late-17th century. In it, he sets out the ideal proportions governing the length, breadth and height of churches. However, in Segovia Cathedral itself, such technical precepts have not always been adhered to. The naves and chancel, for instance, have a staggered height, as was customary in Gothic buildings. A striking feature of the interior is the bilateral symmetry between the rib vaulting and the three central naves.

as the facade of the Toledo Alcázar, or the extension to the Alcázar of Madrid, helps to understand the trends prevalent in 16th-century Spain.

An interplay with Gothic styles is still noticeable in decorative and structural works on mediaeval buildings, as evinced in the lantern in Burgos Cathedral, designed by Juan de Vallejo, as well as in the work of Juan de Badajoz in León Cathedral, much of which was lost during a 19th-century renovation. This master was also the artificer of totally new designs, such as the cloister of San Zoilo at Carrión de los Condes. In short, that period was marked by composite styles, mixtures and eclectic heterodoxy, the hallmark of Spanish architecture during the times leading up to the advent of Mannerism.

It was in court circles that the approach to 'Roman' values was more concerted and far-reaching. Masters trained in Italy, or who had at least visited that country, were engaged for the purpose. Few works could have been more classicist or precocious than the architectural frames by Bartolomé Ordóñez in the retro-choir in Barcelona Cathedral, which can only be accounted for by the artist's sojourn in Naples.

However, the most emphatic and rigorous decisions, in terms of both ideology and formalism, which consolidated Spanish architecture within the domain of the Italian Renaissance, were taken in Granada, around the figure of Emperor Charles V. Granada had become representative of the new dynasty and it was there that Charles V decided to build a palace, egged on by such councillors as Luis Hurtado de Mendoza and, possibly, the Venetian ambassador, Baltasar Castiglione. To this end he commissioned Pedro Machuca, a master who had trained in Italy and had first-hand knowledge of some of the most up-to-date contributions to the classical debate, from the central-plan designs of Francesco del Giorgio, to Cesariano's editions of Vitruvius (1521) and the facades of Roman palaces designed in the circles of Raphael and Giulio Romano.

The design produced by Machuca is highly innovative for both the language of the palace facades, horizontally divided into two sections, the powerful bossage in the lower section, and the Serlian handling of one of them, and for the ground plan in which, with a symbolic purpose alluding to the imperial status of his patron, he mixed two of the figures regarded as perfect by the architectural ideology of the period, namely the square and circle, which coalesce in the extraordinary inner court with its double Ionic order.

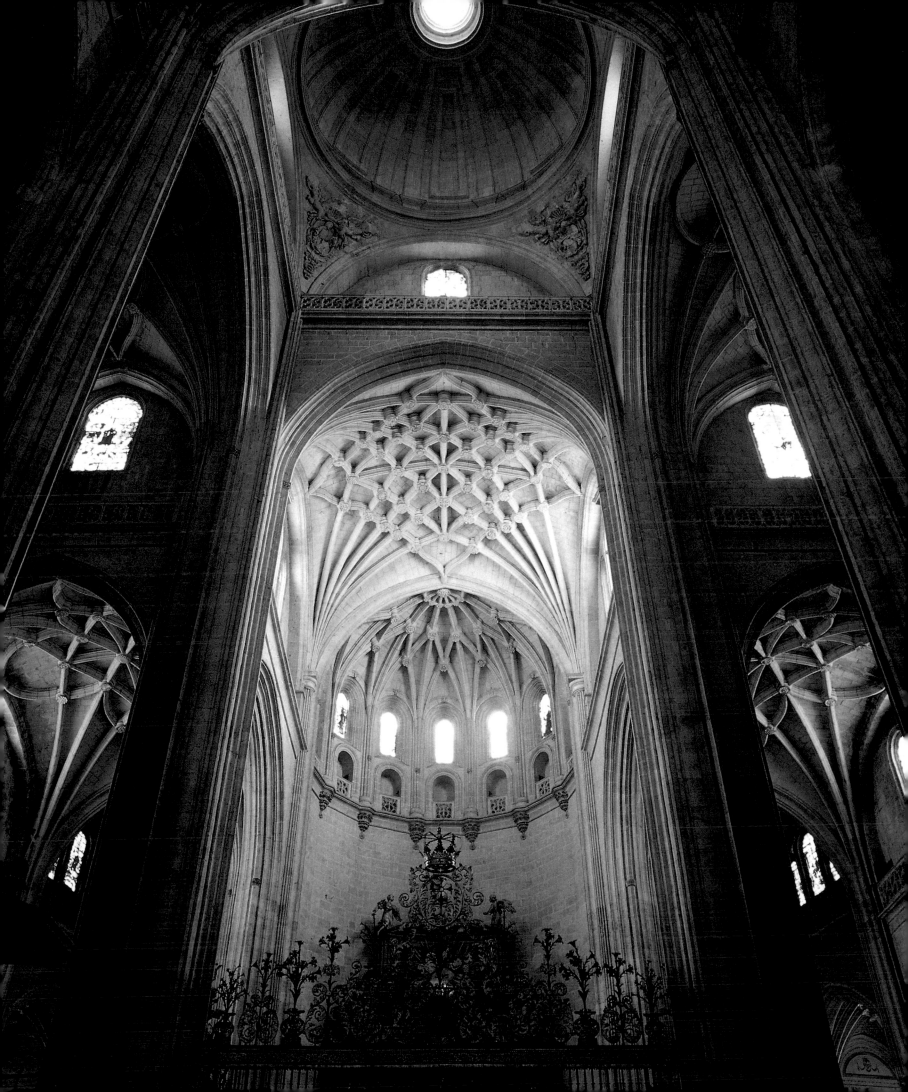

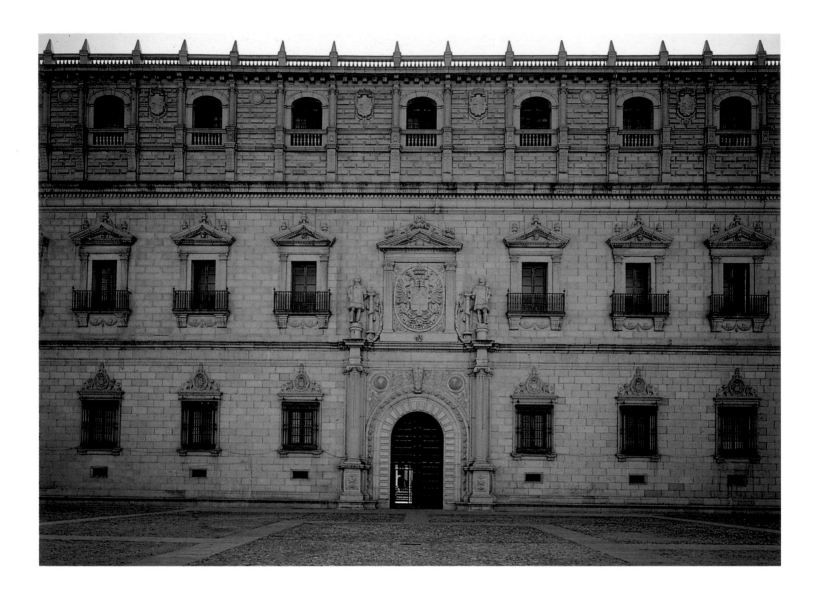

ALONSO DE COVARRUBIAS: facade of the Alcázar of Toledo; from 1537.

In 1537, Alonso de Covarrubias was appointed royal architect in charge of remodelling work on the old Alcázars of Madrid and Toledo. At Toledo, he was assisted by Francisco de Villalpando, who in 1552 translated part of Serlio's treatise into Spanish. The crown prince, who would later become Philip II, took an active interest in building and remodelling work on these royal palaces, in addition to those of El Pardo, Valsaín and, under the direction of Juan Bautista de Toledo, that of Aranjuez. The Toledo building is quadrangular, with corner towers. Its architectural purism, most evident in the court, must be due to Serlio's influence. The south facade, and the staircase begun by Villalpando, were completed by Juan de Herrera.

Also in Granada, Diego de Siloé was commissioned to continue building work on the Cathedral and to turn it into an imperial pantheon. Siloé had also travelled in Italy, and in his hometown, Burgos, had designed the Bramantesque Golden Staircase in the Cathedral, and the belfry at Santa María del Campo. Prominent aspects of his architectural language are pillars crowned with an enormous entablature, a centralising element in the chancel and, above all, his ability to creatively transform traditional and Italian models, a markedly innovative trend as far as 16th-century Spanish cathedrals was concerned.

This coexistence of different languages and widespread admiration for them all, is endorsed in an unusual book written by Diego de Villalón in 1539. Entitled *Ingeniosa comparación entre lo antiguo y lo presente* ('An Ingenious Comparison Between the Old and New'), it expresses equal admiration for such works as the College of San Pablo in Valladolid, that of Santa Cruz, in the same city, and the palaces of the Count of Benavente and Don Francisco de los Cobos. What is truly significant, however, is that, in praising the modernity of contemporary architecture, Villalón equates Gothic buildings with Renaissance ones, and makes no bones about his respect for the past. He asserts that the cathedrals of Seville, León and Toledo are all equally praiseworthy, and ends by extolling the virtues of the Renaissance College of San Ildefonso, founded in Alcalá de Henares by Cardinal Cisneros, all the above being laced with continual references to and comparisons with the wonders of the world.

In line with the penchant of Spain's art patrons during the first half of the 16th century, Diego de Villalón appeared not to frown on the coexistence and mixture of different styles. As far as most of them were concerned, he considered that the distinguishing fea-

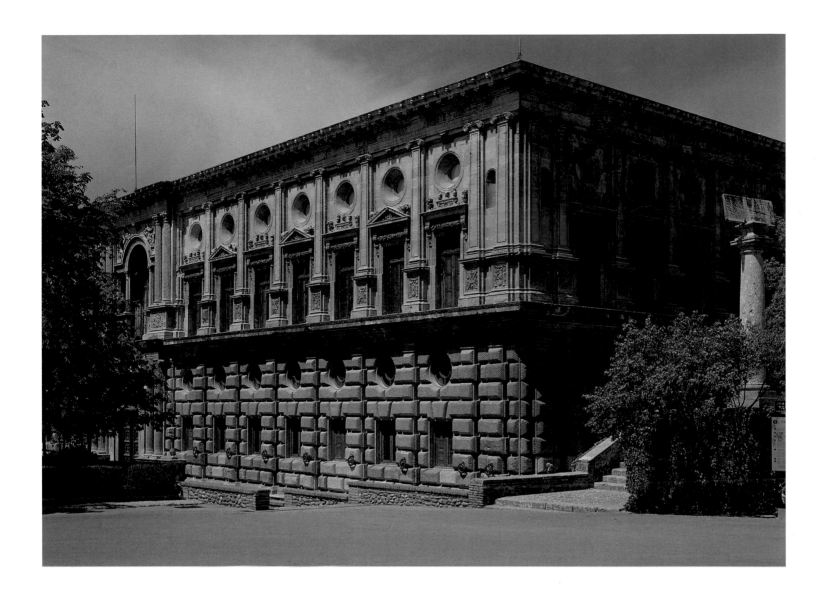

PEDRO MACHUCA: Palace of Charles V (Granada), facade. 1527–1568.

ture or mark of prestige afforded by the patronage of works executed in the new architectural language had a value which could be qualified by resorting to tradition.

Although this trend is most evident in the environment of Cardinal Cisneros, it also comes through clearly in other works. It involved blending elements of the new Italian style with others of Gothic origin or, above all, with those handed down by Moorish tradition, including stuccowork and coffered ceilings. An example of the revived stuccowork tradition can be seen in Master Bonifacio's door in the chapterhouse at Toledo Cathedral, while combinations with coffering are exemplified by the assembly hall in the Universidad Complutense, or in the aforementioned chapterhouse. The overall appearance of the latter, with its fresco paintings, portrait gallery of archbishops (the work of John of Burgundy) and classical mouldings, is vividly reminiscent of an Italian *studiolo*.

Decorative features continued to be very popular during the first half of the century. They could be charged with any type of language: Gothic and Roman, in the case of Juan de Álava, Renaissance, in that of Diego de Riaño and Martín de Gaínza, or with an admix of Mannerism, in that of Corral Villalpando, Esteban Jamete and Juan de Badajoz el Mozo.

However, the innovations in construction, structure, language and typology were not limited to masters close to court circles like Machuca, Siloé and Alonso de Covarrubias. The development of certain technical and aesthetic skills directly related to Italy, which arrived principally by way of France, was actually greatest in Andalusia. The abstract world of stereometry, which was yielding such excellent results in the 'French-style' architecture of Philibert de l'Orme and Du Cerceau, had its Spanish counterpart in some writings by Alonso de Vandelvira.

Plan of the Palace of Charles V.

263

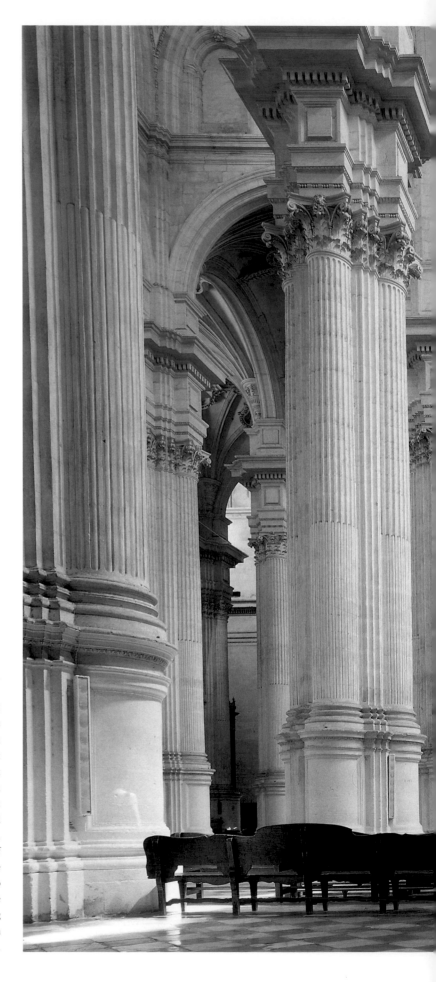

DIEGO DE SILOÉ: interior of Granada Cathedral; between 1528 & 1563.

In Granada, a symbol of the Reconquest of the Catholic Kings, and the short-lived seat of Charles V's imperial court, one of the most emblematic religious buildings of the Hispanic Renaissance was erected. After Enrique Egas had overseen construction of a new building on the site of a former mosque in 1521, the project was assigned to Diego de Siloé. Egas had produced a ground plan similar to that of Toledo Cathedral, with five naves and a vaguely defined transept. This design was altered substantially by Diego de Siloé in 1528. Although this architect, a native of Burgos who had travelled in Italy, died in 1563, before the building had reached completion, most of the architectural structure was built to his design, apart from the pre-existing foundations. His sojourn in Italy and his knowledge of architectural treatises enabled him to skilfully combine the centralised area of the sanctuary with the rectangular shape of the church, harmonising the church's two symbolic functions as an imperial funerary chapel and a place of worship. The former consisted of a lofty dome surrounded by an ambulatory and radiating chapels, set between buttresses, while the latter comprised five naves with unique, Italian-style pillars.

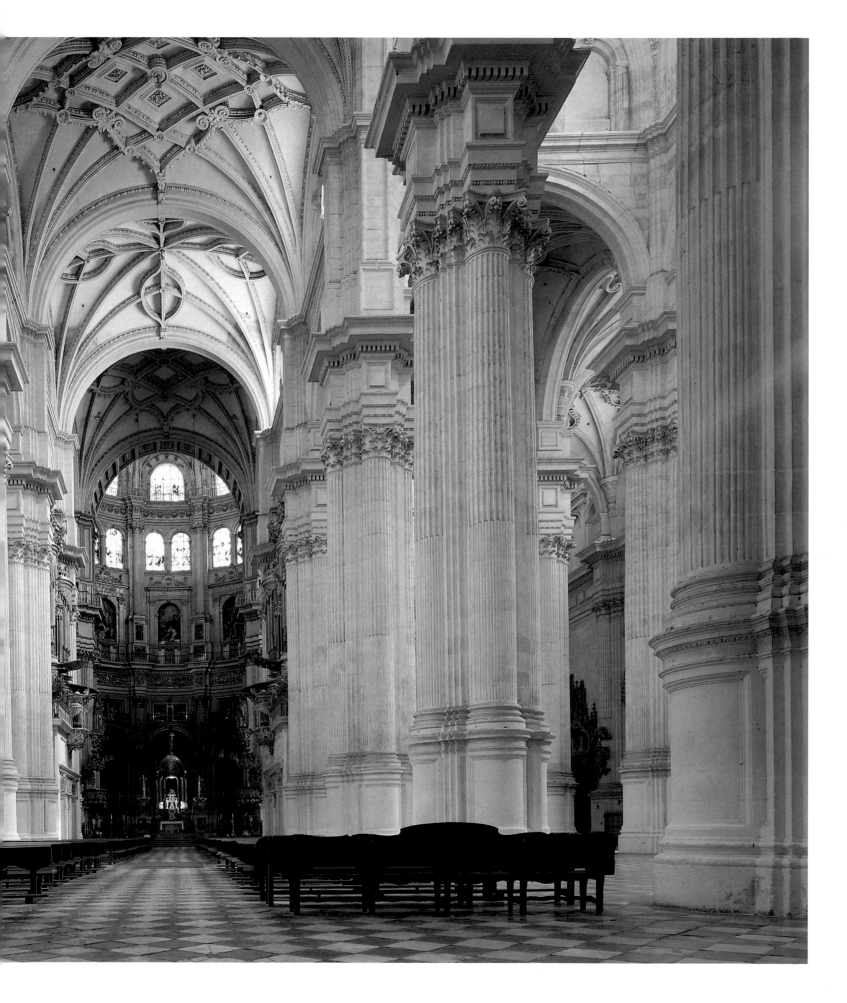

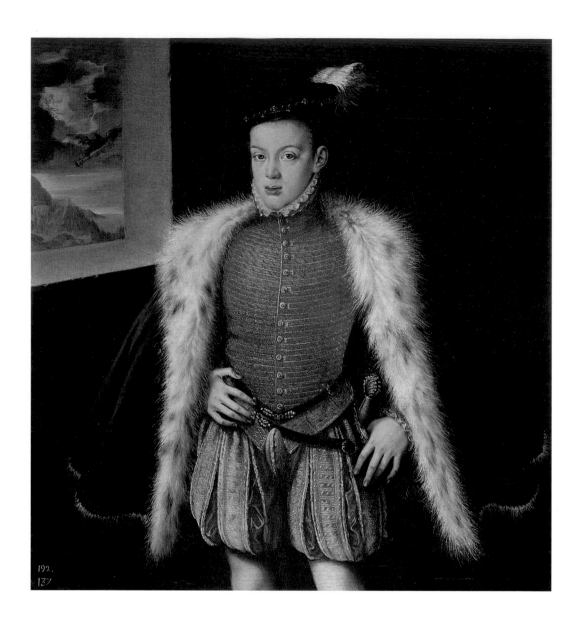

ALONSO SÁNCHEZ COELLO:
Portrait of the Infante Don Carlos, circa
1565. Oil on canvas, 109 x 95 cm.
Prado, Madrid.

In conjunction with Hernán Ruiz II and Jerónimo Quijano, Vandelvira developed an architectural style charged with classicist, Italianate wisdom. Ornamentation, and what on occasion has been termed an 'ornamented space', were replaced by experimental space and language, which often contravened the Renaissance system of orders and proportions in its transit to the complex, sophisticated world of Mannerism.

This comes home forcefully in such extraordinary interiors as those designed by Hernán Ruiz II in the corridor and chapterhouse at Seville Cathedral, with its oval ground plan, and in the reiterated use of *estípites* and other figural orders so frequent in the work of Vandelvira, not to mention Ruiz's perfect conjunction of opposing languages in his culminating work, La Giralda, in Seville. On other occasions, when Alonso de Vandelvira adhered more closely to the models of his master, Siloé, as evinced in the church of El Salvador in Úbeda, the use of the classicist repertoire is extremely ductile and free, like one who has mastered a language to perfection. This can also be seen in the Palace of Las Cadenas, in the same town, and in major religious buildings such as Jaén Cathedral.

The work of the leading Spanish masters in the mid-16th century reveals cultivated knowledge of Italian trends. The precepts of Vitruvius, Alberti and Serlio were fluently interpreted, and the first translations of their works appeared: in 1552, Villalpando translated Serlio's second and third book, while Lázaro de Velasco produced a translation of one of the Roman essayist's works.

Their cultivated knowledge of the problems inherent in classical architecture grew in depth and sophistication. This is borne out by such heated debates as one which took place

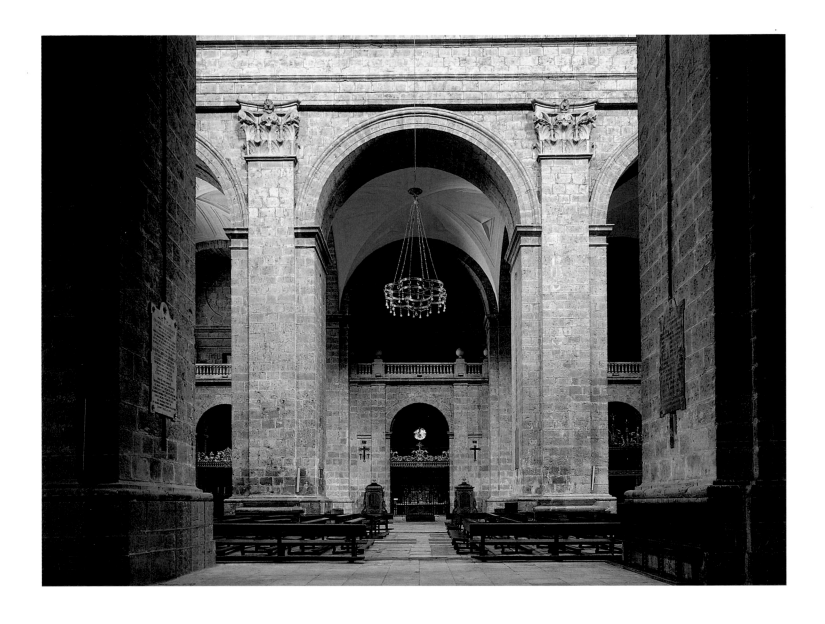

in Granada Cathedral in 1577, at which the erudition of such figures as Lázaro de Velasco came to the fore. Velasco clearly distinguished three types of building in Spain: those he considered to be designed 'in Roman fashion', those which responded to so-called Tudesque or 'German style, which they call Modern', and the Roman style 'which is practised now'. When qualifying his statement about 'modern' styles, he makes a distinction between 'Spanish'—which must refer to the decorative phases of Italianate origin—and ancient Roman, 'which consists of building around a circle or square, as Bramante and other Italian masters did'. This involved adopting Italian design procedures and showing due respect for the orders.

An appreciation of good architecture and, above all, its association with 'the old style'—and not merely because of the use of Italian-style ornamentation—is apparent in other assertions made during the aforementioned debate: Juan de Orea, for instance, remarked that 'architecture with the correct proportions is, in itself, ornate'. The same can be said of numerous assertions in the treatise written by Juan de Arfe in the eighties.

Architectural classicism was the dominant force during the last few decades of the 16th century, the time of the Counter-Reformation in Spain, marked by an obsession with rigour, decorum, order and restraint. This was evident in such far-flung areas as Toledo (Nicolás de Vergara), Catalonia (the Camp school), Andalusia (Alonso Barba and the Mannerist, Castillo) and, above all, Valladolid (Juan de Herrera, Diego de Praves, Nates and Juan de Ribero Rada, whose work even reveals Palladian overtones). This art was 'timeless', and 'beyond classicism' [indeed so]. According to Benedetti, 'synthesism' and 'typological reduc-

Following pages:

CESARE ARBASIA, JUAN BAUTISTA & FRANCISCO PEROLI: pictorial decoration on the staircase in the Palace of the Marquis of Santa Cruz; 1569–1586. El Viso del Marqués (Ciudad Real).

DIEGO DE SILOÉ: Golden Staircase; 1519. Burgos Cathedral.

267

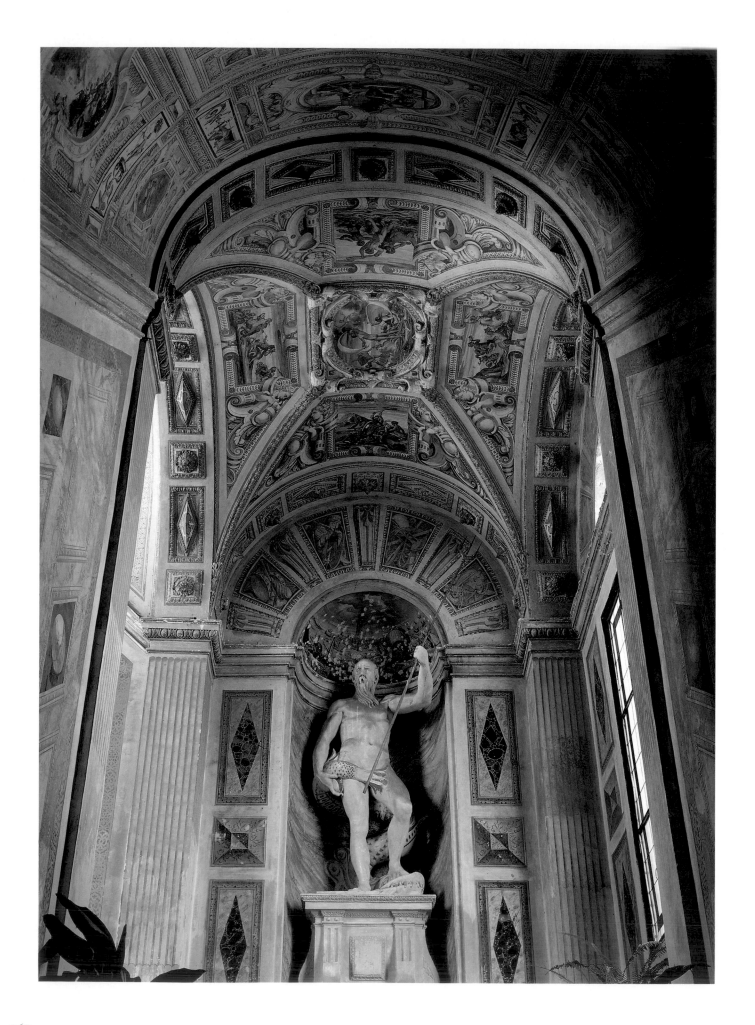

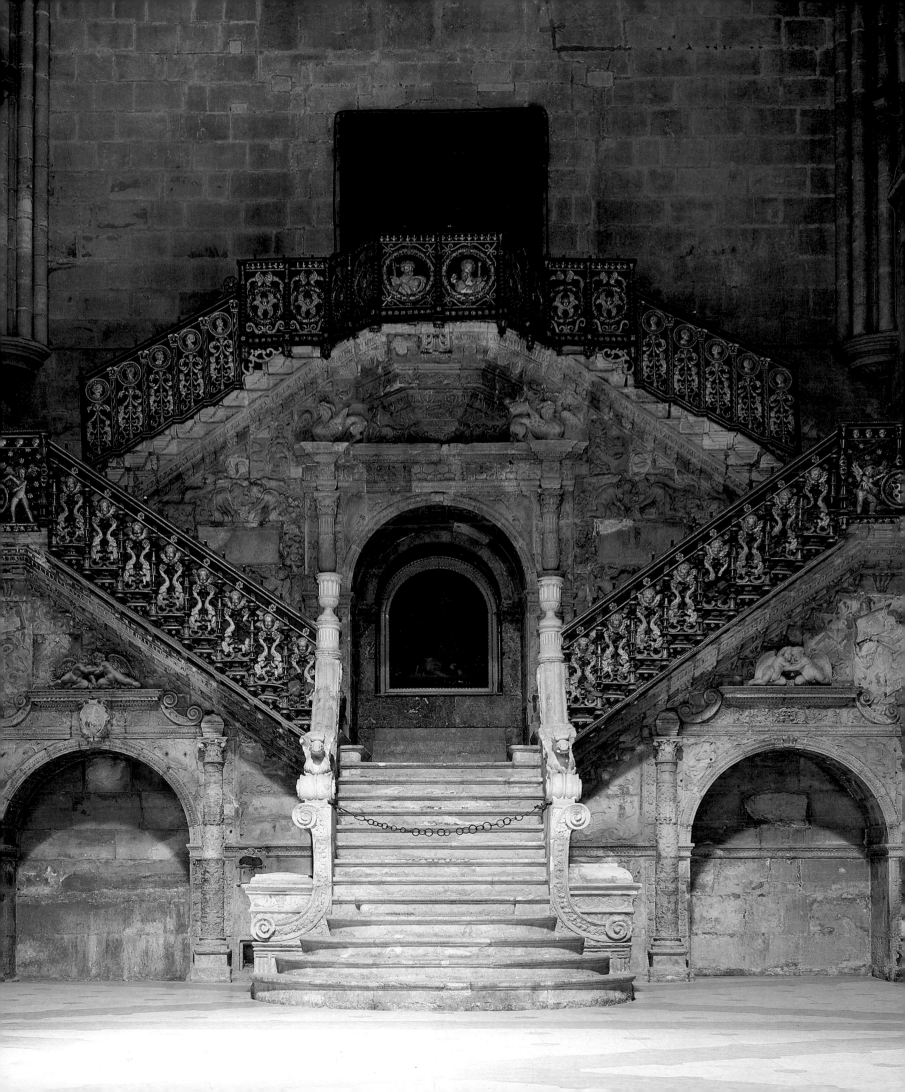

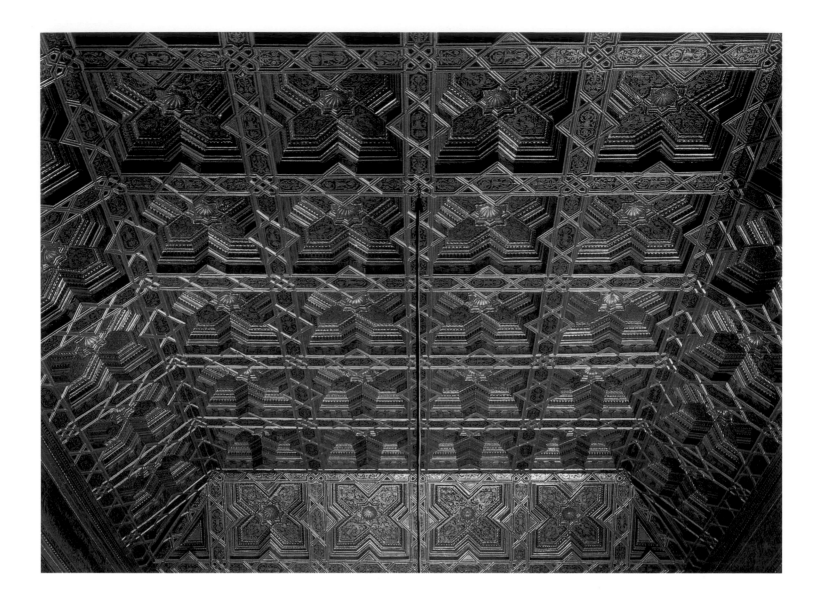

tion' were the genuine hallmarks of the period, which is best exemplified by its most conspicuous exception: the monastery of El Escorial.

Philip II's project for El Escorial was exceptionally complex in many respects, which makes it extremely difficult to pinpoint its influence elsewhere. In fact, such influence can only be identified in certain architectural mannerisms or language traits.

At the beginning of the seventies, Juan Bautista de Toledo came up with an idea which he called the *traza universal* or 'universal design'. It consisted of a huge quadrangular building structured by a network of courts set around a large basilica. This complex was devised to act as a pantheon, convent, palace, school and library, for which purpose there were to be funerary, dynastic, religious, culutural and political furnishings.

Juan Bautista de Toledo's project was built at great speed, the construction being completed in just twenty-four years. However, the original design was altered considerably as building work progressed: the number of towers was reduced, and the encircling wall was kept to a uniform height, while Pacciotto wrought changes in the proportions of the basilica and radically altered the nave ends by making them rectangular.

However, the essential features of the ground plan were retained by Juan de Herrera, Juan Bautista's successor, who saw the construction to completion. Like Philip II, Juan de Herrera was determined to bring about classicist, scholarly and technical renewal in architecture. To this end, he had founded the School of Mathematics in Madrid, and translated into Spanish the works of Alberti, Vitruvius, Euclid and Vignola. His work on El Escorial and the cathedral of Valladolid mark the peak of classicist achievement in 16th-century Europe.

ENRIQUE DE ARFE: monstrance; between 1514 & 1544. Toledo Cathedral.

Paramount among the numerous precious items to be found in 16th-century Castilian cathedrals were the monstrances, executed in carved and gilded openwork silver. Spectacular pieces of the kind shown marked the height of Spanish silverwork in the 16th century. Foreign craftsmen skilled in this technique were also active in Spain. They hailed from Flanders or Germany, like Enrique de Arfe who, between 1514 and 1524, executed the monstrances of Sahagún, Córdoba and Toledo. They include late-Gothic features in their architectural complexity and decorative sumptuousness, combined with Renaissance composition and the figures in the scenes on the base. The Toledo monstrance shown here is a veritable architectural miniature, comprising a twelve-sided base and a four-storey-high main body, which tapers towards the top. It is surmounted by a crown from which ribs spring to form a closed, bulbous form. The host is lodged in the ostensorium, covered with a tiny vault.

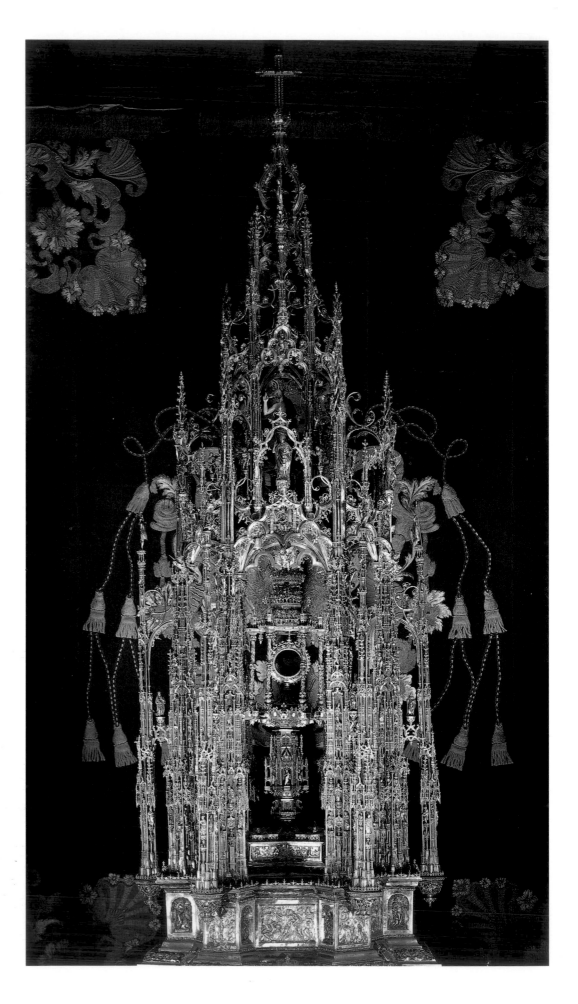

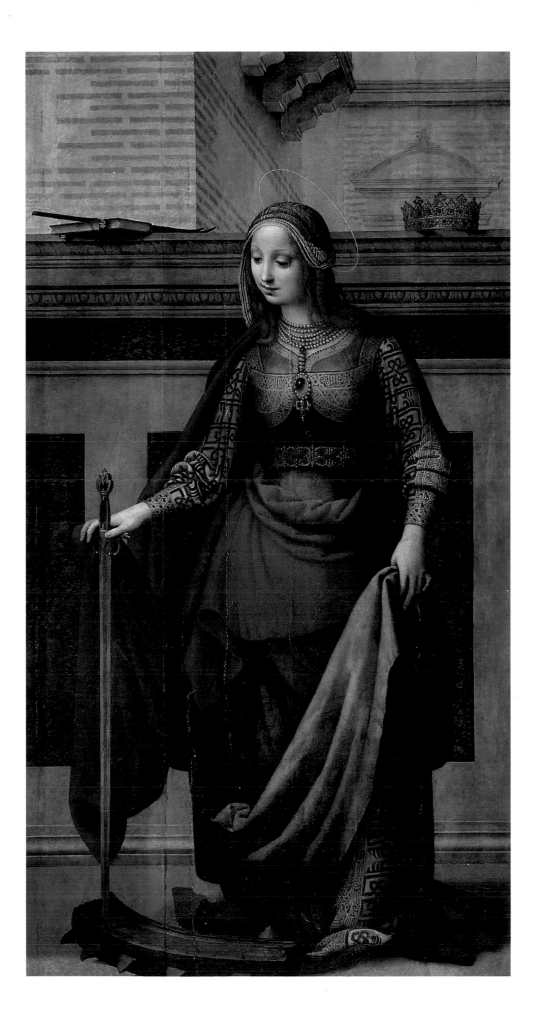

FERNANDO YÁÑEZ DE ALMEDINA:
St Catherine; circa 1510. Panel,
212 x 112 cm. Prado, Madrid.

Italianate forms appeared in Valencia at
the end of the 15th century, and a
clearly Leonardesque style of painting
was cultivated during the first decade of
the 16th century, as testified by the
panels in the Cathedral retable (circa
1507), as well as in this *St Catherine*
(circa 1510), now in the Prado. It was
painted by Fernando Yáñez de
Almedina, assisted by a collaborator,
Fernando Llanos. Both hailed from La
Mancha, and the latter is thought to
have trained in Italy. Vasari's mention of
Leonardo having paid one Fernando
Spagnuolo for his collaboration in the
fresco, *The Battle of Anghiari,* has
aroused considerable debate and
prompted various attempts at identifying
the Fernando in question, ever since the
dawn of Spanish art historiography. The
recent attribution of a painting in the
National Gallery of Art in Washington to
the Italian period of Fernando Yáñez
lends support to the identification of
this painter as the Tuscan master. For
the time being, pending confirmation
from other documentary sources, he has
been ascribed this *St Catherine,* with
her gentle, affable beauty, grand sense
of monumentality and spatial
coherence.

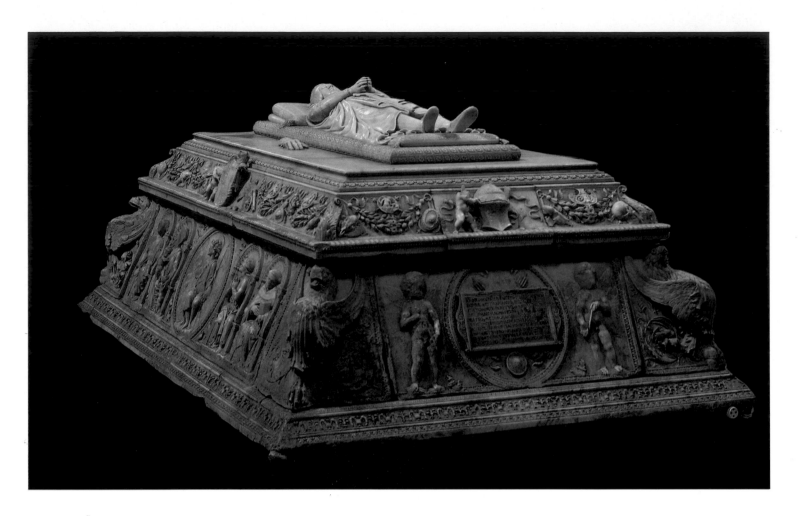

DOMENICO FANCELLI: tomb of the
Infante Don Juan, the son of the
Catholic Kings; 1510–1513. Convent of
Santo Tomás, Ávila.

However, El Escorial cannot be encompassed in its full complexity from the stance of the formal debates of the 16th century. Philip II used the building to express his personal vision of the world as King of Spain, the son of Emperor Charles V, Renaissance prince and supporter of the Counter-Reformation. In other words, his purpose was to Christianise the legacy of classical antiquity from an artistic, architectural and even intellectual point of view. El Escorial has to be understood in unison with intellectuals such as Ambrosio de Morales and his 'instructions', Gracián Dantisco and his symbolic arms design for the building, the archaistic patrimonial and Solomonic controversies of Benito Arias Montano, the Lullian, magic world of Juan de Herrera and the Augustinian interpretation of Fr Sigüenza. In short, in terms of a 'fabrication' of inordinately complex image and myth, which only recent studies are beginning to shed light on.

Court Circles

An understanding of Spanish Renaissance art is further complicated by another contraposition, namely, the divergence between court production and works commissioned by the rest of society.

While the average clientele placed greatest store by the functional—that is, religious—aspects of an artwork, and often accepted rough-hewn products, the monarchy and aristocracy promoted the world of art to the full. This had also been the case under the Catholic Kings, who sought accomplished artists such as John of Flanders and Michel Sittow for their portrait commissions. The same is true of the Count of Tendilla when he summoned to Spain a sculptor of the stature of Domenico Fancelli, who soon pioneered the Italianist trend in a number of royal tombs in Granada and Ávila. The difference between these and Gil de Siloé's original royal tombs at the Miraflores charterhouse, commissioned by the queen, could not have been greater, and his example was followed by Bartolomé Ordóñez in the latter's tombs of Cisneros, Don Felipe and Doña Juana in Granada.

JUAN DE JUANES:
The Martyrdom of St Stephen.
Panel from the altarpiece in the church
of San Esteban, Valencia; mid-16th
century, 60 x 123 cm. Prado, Madrid

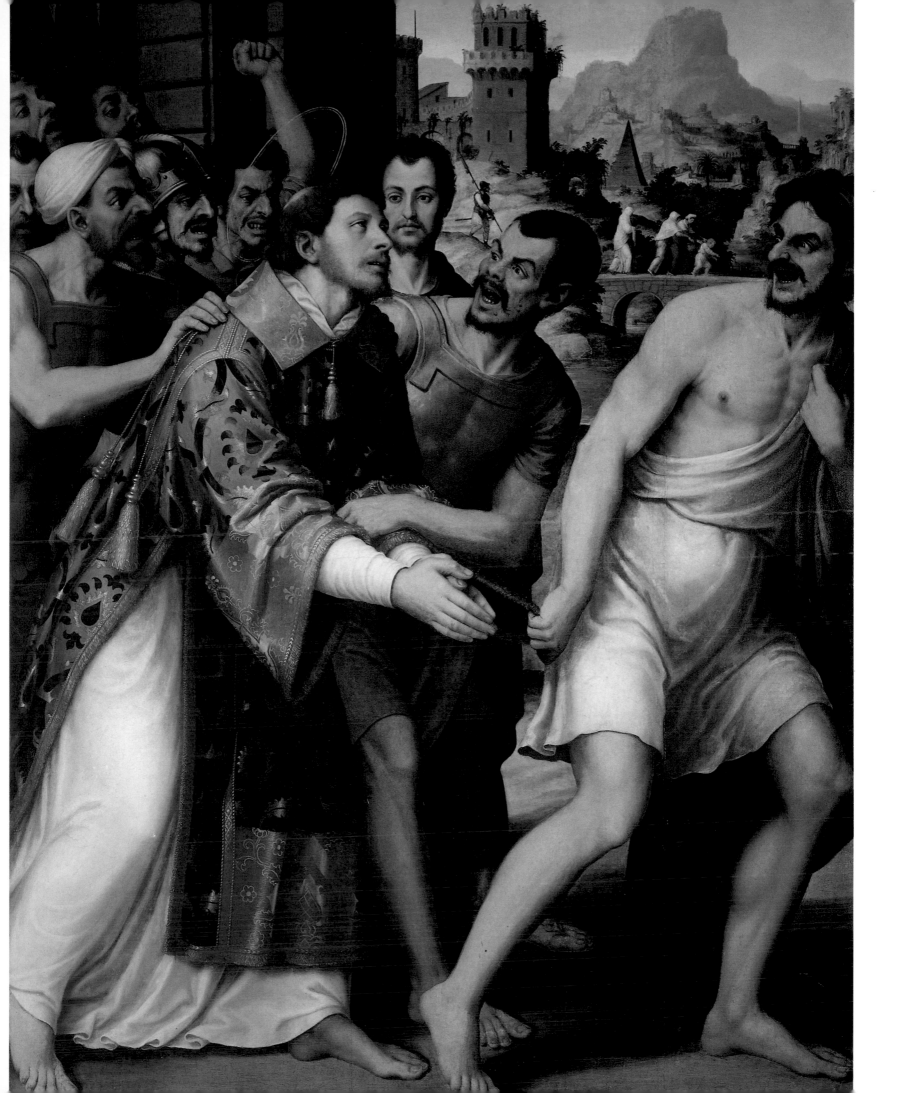

THE MONASTERY OF EL ESCORIAL

On his return from a second sojourn in the Netherlands (1559), Philip II, who by then had been crowned King of Spain, decided to restructure the building programme for palaces and residences first introduced by his father, Charles V, in the late 1530s.

Philip II took a decisive step by appointing Juan Bautista de Toledo as court architect. Having trained in Naples and Rome, Toledo's arrival in Spain forced out the artist, Gaspar de Vega, a follower of Flemish currents, and prompted the court to whole-heartedly adopt Italianate classicist forms. Apart from the unfinished Palace of Aranjuez, Juan Bautista's most distinguished commission was the design for El Escorial, where building work got under way in 1563.

Although Juan Bautista de Toledo produced the original design, this was substantially altered in 1564. While his original idea, and the size of the ground plan, were faithfully adhered to, more towers and campaniles than he had provided for were built. A further two were added to the chancel of the basilica, and another two midway along the north and south walls. Similarly, the rear section was raised to double the projected height, leading the basilica to protrude above the rest of the complex and acquire greater prominence.

However, an initiative to provide for twice the number of Hieronymite friars than had originally been intended, and Philip II's partial acceptance of flaws in Toledo's project, pointed out by the architect Pacciotto, led to a substantial change in the overall image of the ensemble. The untimely death of the first architect, in 1567, and the appointment of his disciple, Juan de Herrera, to take over his duties, did the rest.

Building work on the Monastery of El Escorial began with the monastery itself, and specifically, the southwest tower, known as La Botica. Progress was extremely slow under the supervision of Juan Bautista de Toledo, and it was only when his position was filled by Juan de Herrera, who proved to be both an excellent architect and an accomplished organiser of building work—which he expedited by implementing a highly effective system of piecework, and a set of ordinances he issued in 1572—that one of the king's most fervent wishes, that of finishing the complex as soon as possible, was fulfilled in 1586. Nevertheless, construction work on the basilica, a key building in the project, only began in 1575. The last section to be completed, the main facade, was designed by Juan de Herrera, and his was the decision to provide pitched roofing with slate tiles, as well as the celebrated spires of El Escorial.

From an architectural point of view, despite the uniqueness of this monumental complex, the principles governing its design should not be forgotten, as they involved keeping to a minimum the ornamentation associated with the classicism of certain architectural circles in Italy, such as those of Sangallo, which Juan Bautista de Toledo must have known. Another contributing factor was the rationalising influence of military architecture, in which Toledo, Pacciotto and even Juan de Herrera had experience. Moreover, the Herreran roofing owes much to Flemish architecture, which the king and many of his craftsmen greatly admired.

The austere classicism of El Escorial is most explicit—and most successful—on the famous south facade, which bears not the slightest trace of the classical orders and is supported on a monumental, Serlian plinth 'of Roman grandeur'.

The best guide to an understanding of this building is still the chronicle by Fray Sigüenza (1605), which gives a clear idea of the part played by the king and the Hieronymites in its construction, while the role of the architects is vague and deliberately biased. However, clarity is restored in his descriptions of all the sections in the complex, their pictorial and sculptural decoration, and the religious ornaments and relics they contain.

Such emblematic areas as the chapterhouses, the so-called 'Hall of Battles' and the library were decorated with paintings and frecoes by the Italian artists Luca Cambiaso, Granello, Peregrin Peregrini and Federico Zuccaro. Leone and Pompeo Leoni, and Jacopo da Trezzo produced the statues and other works at the high altar, in addition to the funerary sculpture. In this respect, it should be recalled that El Escorial was originally intended as a funerary monument, in memory of Charles V, and as the pantheon of the Habsburgs. This accounts for the importance of certain architectural features, such as the dome over the central basilica, the inclusion of ornamental pyramids, and certain iconographic touches, such as the groups shown at prayer on the high altar, the work of Pompeo Leoni.

The Renaissance painting collection assembled at El Escorial was one of the finest in Europe: it featured some splendid works by Titian, including such masterpieces from his late period as *The Martyrdom of St Lawrence* (El Escorial), *San Jerome* (El Escorial) and two versions of *The Agony in the Garden* (El Escorial and the Prado). Equally spectacular were a number of oils on panel by Hieronymus Bosch, including *The Garden of Earthly Delights*, *The Haywain* and *The Seven Deadly Sins*. Thus, in the plastic arts, it is quite clear that the 'prudent king' had a penchant for things both Italian and Flemish.

JUAN DE HERRERA: Monastery of San Lorenzo de El Escorial (Madrid); 1563-1584.

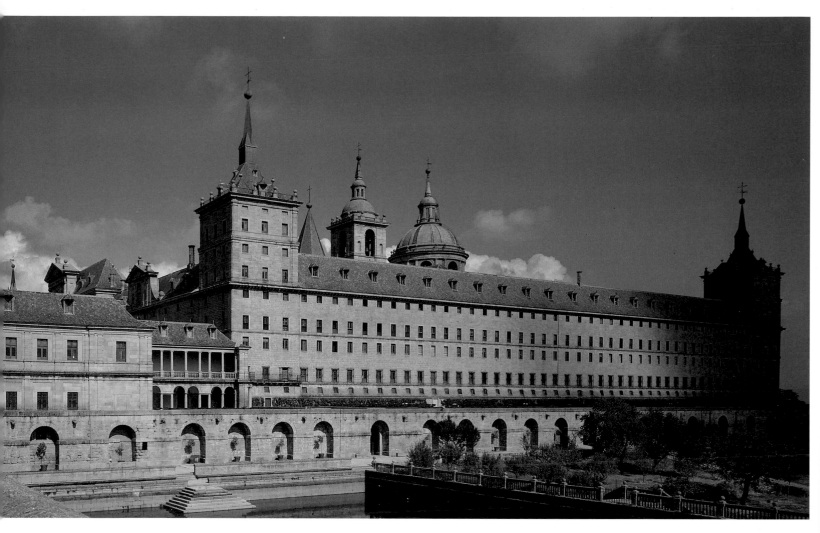

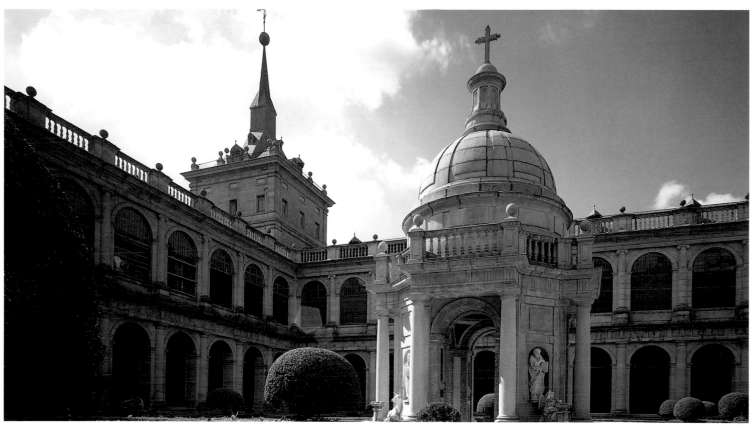

A prerequisite of court demand was that a sense of majesty, solemnity and grandeur had to be portrayed through the image, a trend that often clashed with the tastes of other clients, attracted more by the religious ideals of pathos and emotion. This is essentially why an artist of the calibre of Alonso Berruguete was rejected by Charles V, and, to some extent, El Greco by Don Felipe.

Despite some noteworthy architectural initiatives having been embarked on by the court of Charles V in Granada, Toledo, Seville and Madrid, it was not until the reign of Philip II that fully-fledged court art emerged in response to the needs of Renaissance court circles, with their penchant for restraint, solemnity and show. In this respect, the new king did no more than follow up his father's initiatives, and those of his aunt, Maria of Hungary, in the closing years of her reign in the Netherlands. It is precisely in the royal patronage of such distinguished artists as Titian, Leoni, Antonio Moro and Jacopo da Trezzo, pivotal to the development of Spanish Renaissance art, that the shortcomings of 19th-century historiography associated with nationalistic territorialism become so conspicuous, something which cannot, however, be said of Palomino. Apart from their immense value, the works of those masters were an example to all Spanish artists that were lucky enough to have access to them.

While Charles V commissioned men like Machuca and Ordóñez—who had trained in Italy—Flemings such as Jean Monne and, subsequently, the aforementioned Titian, Leoni and Moro, his son developed the trend further, and did not hesitate to summon to his court Italianate artists such as Juan Bautista de Toledo and Gaspar Becerra, or Italians such as Bergamasco or Pacciotto. In the Palace of El Pardo, decorated with frescoes by Italian artists, and views by the Fleming, Antonio de las Viñas, and hung with some of Titian's most important mythological works, Philip II set up a splendid, dynastically arranged portrait gallery based on paintings by Antonio Moro and Titian, whose self-portraits were considered worthy of being hung alongside such a regal ensemble. Lastly, the task of decorating El Escorial, undertaken by the likes of Tibaldi, Cambiaso, Zuccaro, Leoni and many others, became one of the major chapters of Italian art outside Italy.

Without the presence of those foreign artists, the Venetian-style development of Juan Fernández Navarrete would have been unthinkable. The same applies to the emergence of an indigenous school of court portraiture, headed by Sánchez Coello and Pantoja de la Cruz, who were indebted to that idea of the solemn, aloof image of the monarch, as depicted by Antonio Moro and the Leoni family of sculptors.

The resurgence of cosmopolitanism was welcomed by a number of more forward-looking nobles, as evinced in portraits executed by some of the aforementioned artists, or in fresco cycles such as those painted by Rómulo Cincinato—a native of El Escorial—for the Duke of El Infantado in Guadalajara, those by Pasini for the Duke of Alba, and those by the Perolis for Álvaro de Bazán in Viso del Marqués.

Debating the Arts: Controversy and Integration

If the traditional historiographic division between painting–architecture–sculpture and the decorative arts ever became inoperative in any particular society, it was in the *ancien régime* in which Spanish Renaissance art developed.

During that period, the arts became effectively and inexorably integrated, owing to the specific functions required of them. Moreover, the ongoing debate on Spanish art that took place in the 16th century lacked the abstract and intellectual intensity that characterised the Italian art scene. For instance, there was hardly any discussion comparable with the *paragone* between the various arts which the theoreticians of Italian art so enthused about, from Leonardo down to Benedetto Varchi. There were, however, some notable exceptions, including Francisco de Holanda, a Portuguese lover of Rome and friend of Michelangelo's, and Felipe de Guevara, an art collector and courtier who had lived in Flanders for many years. The latter never tired of drawing attention to the relationship between

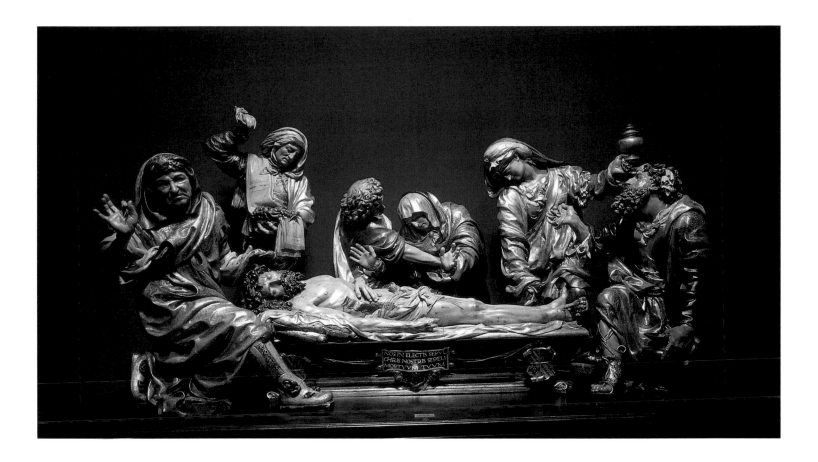

JUAN DE JUNI: *Holy Burial;*
between 1539 & 1544.
Museo Nacional de Escultura, Valladolid.

painting and poetry as a means of grasping reality, and as a way of achieving greater expressiveness in 'the movement and variety of moods', of 'attaining higher grandeur' or of thinking up 'more fabulous ideas about admirable things'. The interest in expressiveness and in endowing narrative images with a 'higher grandeur', 'fabulous ideas' or 'admirable things', as Felipe de Guevara put it, took the form of a search for an art style that was superlative primarily in a functional sense, in that it had an immediate and forceful impact on the viewer. This search for a relationship between artist and spectator, as it occurred in 16th-century Italian art, was the subject of a brilliant study by John Shearman in his recent work, *Only Connect Art and the Spectator in the Italian Renaissance*. In Spain, the issue was resolved in theory by insisting on pleasure and utility value as the twin goals of art activity, while in practice this was achieved by harping on a number of actions and an extremely unusual way of presenting images and areas given over to art.

In order to involve spectators, artworks had to be integrated into urban areas associated with everyday living, such as streets and public squares. This was achieved through the sort of triumphal entry and other urban ceremonies characteristic of court society and, very especially, by parading statues and paintings through the streets, in addition to the objects fashioned by goldsmiths, such as crosses and monstrances, and fine garments and other luxury items, ushering in one of the prime moments of the Spanish Renaissance. A noteworthy example of this were the processions held at Corpus Christi, in which monstrances were paraded through the streets. Production of these objects turned the Arfes into one of the most important families in Spanish Renaissance art, a status they enjoyed for a whole century.

Ceremonial areas in towns and cities were suitably embellished with architectural sumptuousness for the purpose. Initially, this took the form of decorative ostentation, as in the frontispieces on the facades of San Pablo and San Gregorio in Valladolid, and their

In the mid-16th century, the permanence of religious images, and the form they were to take, was the subject of heated debate throughout Europe. On the basis of its Catholic orthodoxy, Spain took a firm stand in favour of such images, and of them appealing to the senses of the faithful rather than to their intellect. This is evident in the sculptural ensemble, *Holy Burial,* executed by Juan de Juni between 1539 and 1544, both in the expressive and declamatory gestures of the figures, and in the vivid realism and rich chromatic values. This work was commissioned by Antonio de Guevara, the bishop of Mondoñedo, for his funerary chapel in the now defunct convent of San Francisco in Valladolid.

Renaissance extension in the University of Salamanca. Subsequently, as the Counter-Reformation gained ascendancy, it took the form of a manifold profusion of church facades. A similar process was at work inside churches and chapels, which thronged with architecture, painting, sculpture, goldsmithing and ornamented liturgical vessels. The sculpture on altars and in retables was often polychromed, while grillework became one of the most intensely experimental formal genres of the century, from the time of Juan Francés to that of the Roman master, Bartolomé, and the Mannerist, Villalpando.

Sumptuousness, and the Aristotelian category of magnificence, in conjunction with material wealth, became one of the mainstays of the aesthetics that prevailed at the end of the Middle Ages. In countries less given to intellectual reflection such as Spain, this trend extended into the early years of the 16th century. Places such as the Chapel of the Constable in Burgos Cathedral, or entire buildings like Toledo Cathedral, which were partly redecorated, cannot be understood without taking into account their ceremonial, ritual function. The sheer profusion and accumulation of art, and the integration of genres, would be meaningless without their processions, ornaments and tapestries: in this respect, it is worth recalling the series, dedicated to Our Lady, which Fonseca donated to Palencia Cathedral, used in a specific ceremony in which the donor took an active part.

The visual discourse of the period was grounded in a ritual, ceremonial sense of existence, which found greater and more intellectualised expression in court circles. It has often been shown how the layout of a building such as a palace had a lot to do with such ritual functions. The same can be said of the decoration, especially the places chosen to display paintings and other artworks in such royal palaces as the Alcázar of Madrid, the Palace of El Pardo or the Monastery of El Escorial. In palatial complexes of this kind, architectural elements are inseparable from the paintings, sculptures, tapestries and other objects they contain, as well as from the surrounding gardens, fields, fountains and ponds.

The integration in question took place not only between genres, but between styles, too. A case in point is the Mudéjar style, which was never overlooked, not even in refined, cultivated aristocratic ambiences of the kind found in the Hall of Lineage in the Palace of El Infantado, Guadalajara, the Moorish courts in some of Seville's stately homes, and the splendid stuccowork and roofing of the Palace of Peñaranda del Duero. The Mudéjar is also present in royal residences, as evinced in the ceilings of the Alcázar of Madrid, some works of rare perfection in the so-called Pavilion of Charles V, and the Royal Alcázar of Seville. Architectural features are matched by Mudéjar carpets, a large part of the furniture, ceramics and book bindings.

While the most striking features of Spanish cities at that time can be seen in the views in Anton van Wyngaerde's paintings, executed during the sixties—showing variegated, often fortified clutches of urban complexes, in which hardly any buildings in the new style can be discerned—and in the irregular street layout inherited from Moorish town planning—which still caught the attention of foreign travellers throughout the century—it should be recalled that towns and cities were being steadily Christianised. New palaces, public buildings, churches and cathedrals, often erected as isolated reference points in the city, were beginning to emerge as the dominant force in the visually eclectic, motley urban landscape in the throes of stirring from the Middle Ages.

'Modern Devotio', Christian Humanism and Christian Rhetoric

Not only in Spain, but in Europe, the 16th century was an intensely and deeply religious time. However, unlike the situation in Italy and, to a lesser extent, France, artistic expression of a more mundane kind earned far less acclaim in Renaissance Spain. As stated above, in Spain, the art of the Renaissance was primarily religious art. This first became apparent at the end of the 15th century, when Flemish and Burgundian innovations, and those derived from Italian painting, were making inroads into the country. From then on, clients focused their attention, and painters and sculptors their response, on the purchase

PEDRO DE CAMPAÑA: *The Visitation;* mid-16th century. Church of Triana, Seville.

ALONSO BERRUGUETE

The antiquarian and Renaissance scholar, Ambrosio de Morales, referring to the relief work on the Roman sarcophagus of Husillos, now in the Museo Arqueológico Nacional in Madrid, stated: 'Its sculptural excellence is best summarised by what Berruguete said after staring at it in astonishment for a while: "Nothing finer have I seen in Italy, and few things as good"'.

Alonso Berruguete was born at the end of the 15th century in Paredes de Nava (Palencia). The son of a celebrated painter, Pedro de Berruguete, he spent the first few years of the 16th century in Italy. There, according to Vasari, he was active in Florence, where he studied the work of Masaccio, and Michelangelo's cartoon for the *Battle of Cascina,* and in Rome, where he entered a competition organised by Bramante to produce the best wax copy of the *Laocoön.* These studies, the influence of Vasari and some of the works executed in Italy played an important part in his development as a painter and sculptor, and led him to become one of the artists instrumental in introducing Mannerism into Spain.

In 1517, he is documented working in Spain, in the court circles of the young Charles V. However, despite

having fulfilled such important commissions as the *Tomb of Chancellor Selvaggio* (only fragments have survived, Museo de Zaragoza), and decorative works such as 'sails, banners and flags and royal vessel', for the young emperor's boat at Corunna in 1519, his attempts at becoming court artist soon foundered.

Thus, after being assigned some paintings in the church of San Lorenzo at Valladolid in 1523, he decided to settle in that city. That same year, he was appointed clerk of the criminal court there, which involved compulsory residence in Valladolid, the most important city in Castile at the time.

It was there that his sculptural skills were developed to extremely high standards, making him one of the leading artists of Renaissance Spain. In 1523, he was commissioned to execute the retable known as *La Mejorada,* completed in 1526, while from 1527 to 1533 he produced the famous retable of *St Benedict,* which earned him lasting fame. In 1539, Cristóbal de Villalón said of this retable (now dismantled in the Museo Nacional de Escultura, Valladolid): 'Were the Princes Philip and Alexander to live now... no treasures would they find to pay for it'. In the late 1520s, Berruguete de-

signed a retable for the chapel of the Reyes Nuevos in Toledo Cathedral, and one for the Colegio de los Irlandeses in Salamanca. In 1537, he was engaged by a banker, Diego de la Haya, to design the retable of the *Adoration of the Magi* in the church of Santiago de Valladolid.

His last works were for Toledo, although he never moved from Valladolid, where he was granted, and then lost, two lordships: that of Villatoquite, and the more important one of Ventosa de la Cuesta. From 1539 to 1543, he was commissioned by the primate of Spain, Cardinal Tavera, to sculpt half the choir seating in Toledo Cathedral, the other half being done by Felipe Vigarny. In 1545, he executed the marble tribunes, with a magnificent finial of *The Transfiguration* in 1548. After some work for Úbeda and an unfinished retable for Cáceres, he produced one of his masterpieces, the *Tomb of Cardinal Juan de Tavera,* his patron, which was installed in the hospital church founded by the latter in Toledo. Berruguete died in that city in 1561. The figure of this artist is one of the landmarks of the Spanish Renaissance. His career developed throughout the reign of Charles V whom, as we have seen, he attempted to serve as court artist. Despite his

ALONSO BERRUGUETE: relief work in the choir at Toledo Cathedral. 1539.

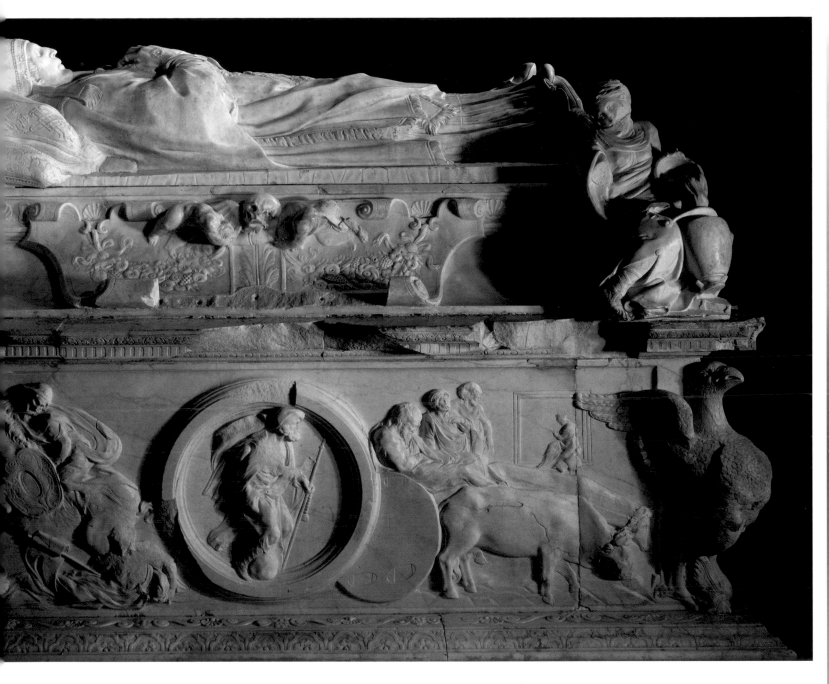

Italian training, the court did not take to the exalted Mannerism of his imagery, which did, however, appeal in intellectual and Church circles in Castile during the first half of the 16th century, as attested to by his engagements for such men as Diego de la Haya and Juan Pardo de Tavera. His Mannerist style, which he had begun to develop in Italy, comes through forcefully in the exceptional *St Sebastian*, part of the *Retable of St Benedict*, one of the finest *serpentinata* figures of the Spanish Renaissance. His style is impregnated with Gothicism tinged with pathos (as in his *Ecce Homo*, in the same ensemble), which was critically assimilated as one of the decisive elements of Mannerism. A similar trait, albeit not as skilful or conscious, is also found in the work of such artists as Juan de Valmaseda.

His final, Toledan, period marks the peak of his career, as borne out by the relief work in the Cathedral choir, a truly intellectual repertory of Mannerist attitudes and figures, and by the tomb of the cardinal. While the death mask of the cardinal reveals the moving aspect of Berruguete's style, his reliefs on the tomb-chest are among the finest examples of the conceptual intellectualisation of religious images in 16th century Spain.

ALONSO BERRUGUETE: Tomb of Cardinal Tavera, *1554–1561; Hospital del Cardenal Tavera, Toledo.*

and patronage of art rooted in religious images tinged with pathos and emotion, while artists built up relationships with patrons who were far more devout, and even ardent, than intellectual and aloof.

This is why Flemish art, which gave prominence to such values, was more acceptable to Spanish tastes than the intellectual currents of certain Italian schools. It also explains why, among the Italian schools, artistic expressions directed at the public, and the artists who worked in Spain, came from places such as Padua, Ferrara or southern Italy, that is, those furthest removed from the classicism of Florence. A similar claim can be made with regard to some Castilian masters who emulated the pathos of Flemish models, a noteworthy example being Fernando Gallego, who was influenced by the work of Dierick Bouts.

The choice of iconographic subject helped to reinforce this trend, as it was customary to favour scenes of pathos and emotion from the life of Christ, such as the Passion or the Nativity, or the most crucial, dramatic moments in the life of a saint. Other subjects of choice had once been iconographic standards during the Middle Ages, such as the *Imago Pietatis,* the Virgin and Child, the Ecce-Homo and the Pietà, which was particularly popular in sculpture. Despite the swift development of narrative content peculiar to the Renaissance, the iconic sense of images endured, as attested by such exatraordinary examples as the monumental, hieratic *Santo Domingo de Silos* by Bartolomé Bermejo. This iconic sense remained throughout the 16th century, as evinced in late examples, namely the work of Luis de Morales the Divine, and El Greco. This iconic predilection explains the penchant for small devotional panels featuring the aforementioned subjects, within the context of 'modern *devotio',* in which what mattered most was the relationship between the pious spectator and the image. This is borne out in numerous works by John of Flanders, Michel Sittow and Pedro Berruguete who, despite visiting Italy, never abandoned the Flemish aesthetic of his native Castile. This trend becomes apparent in the direct, religious impact of viewing such works as the *Diptych of Diego de Guevara,* by Michel Sittow, and the inclusion, in Bartolomé Bermejo's *Pietà,* of the canon Desplà.

Another feature that set Spanish religious images apart from Italian ones was the way in which the religious discourse was arranged. From the end of the 15th century, instead of the flat, single perspectives of the Italian altarpieces known as *palas,* the Spanish opted for the narrative sense of the retable, involving a number of small scenes in which the decorative and architectural elements of structure, painting and, above all, sculpture (usually polychromed) was combined in such a way as to immediately rivet the viewer's attention. Instead of having to make an analytical, interpretative effort, the spectator expected to take in a scene at a glance, to move from one scene to another, and to be moved and surprised by it all. There are countless examples of such works, from the large reredos in the cathedrals of Seville, Oviedo and Toledo, and those designed by Gil de Siloé in the late-15th century, to the gigantic stage-scenes of Damián Forment in Zaragoza, Huesca or Poblet, executed in alabaster in the early-16th century.

It was at this time and in this respect that choir seating came into its own. That of Toledo cathedral is a synthesis of some of the best, late-15th- and early-16th-century Spanish sculpture, from the still Gothicist burlesque *misericordias* and scenes commemorating the battle of Granada on the backs of seats in the lower choir, executed by Rodrigo Alemán, on assignment to Pedro González de Mendoza, to the Renaissance reliefs of saints and biblical figures by Felipe Vigarny, and those of Alonso Berruguete, which culminated in a magnificent *Transfiguration,* one of the finest examples of Spanish Mannerist sculpture.

In the early-16th century, the current of 'modern *devotio'* gradually gave way to humanistic ideas. Unlike the status quo in Italy, the new trend did not spawn a host of mundane, historic, mythological and portrait subjects, but involved the wide-ranging development of Christian iconography. Italian classicist forms, understood not as an all-embracing figurative model but as a formal stimulus, emerged in the work of such distinguished artists as Fernando Yáñez de la Almedina and Fernando Llanos, in painting, and Damián Forment, Felipe Vigarny and Diego de Siloé in sculpture. Thus, in early works like the retro-choir in Burgos Cathedral, Vigarny introduced distinctly Renaissance elements, while, in the early-

GASPAR BECERRA: reredos at the high altar in Astorga Cathedral; 1588.

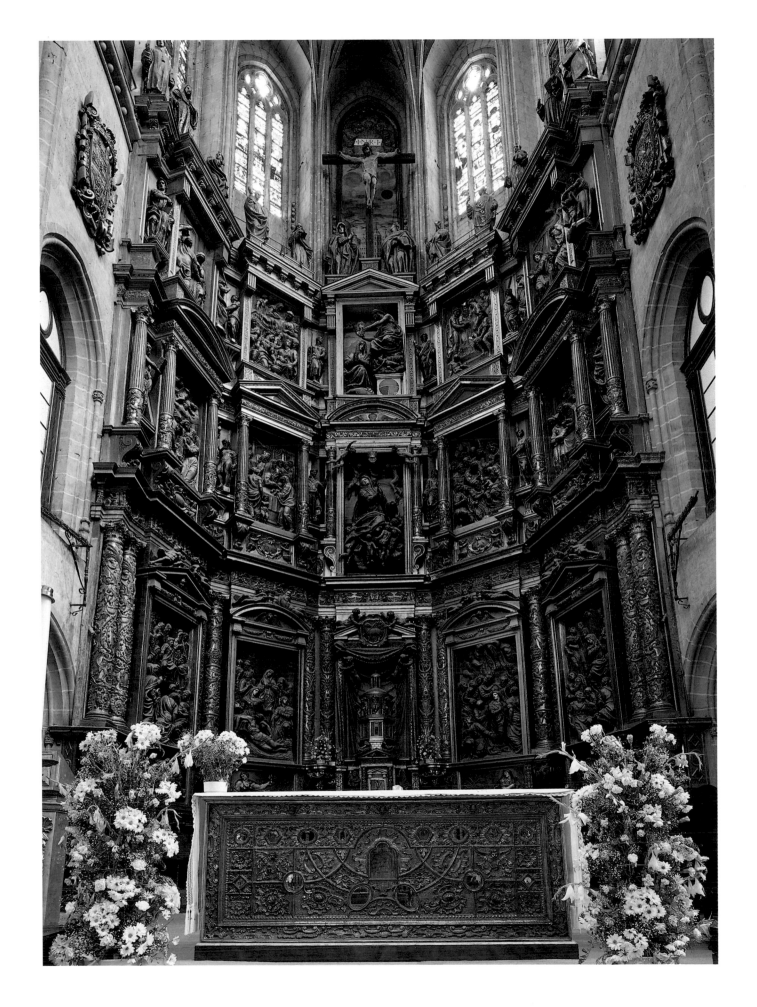

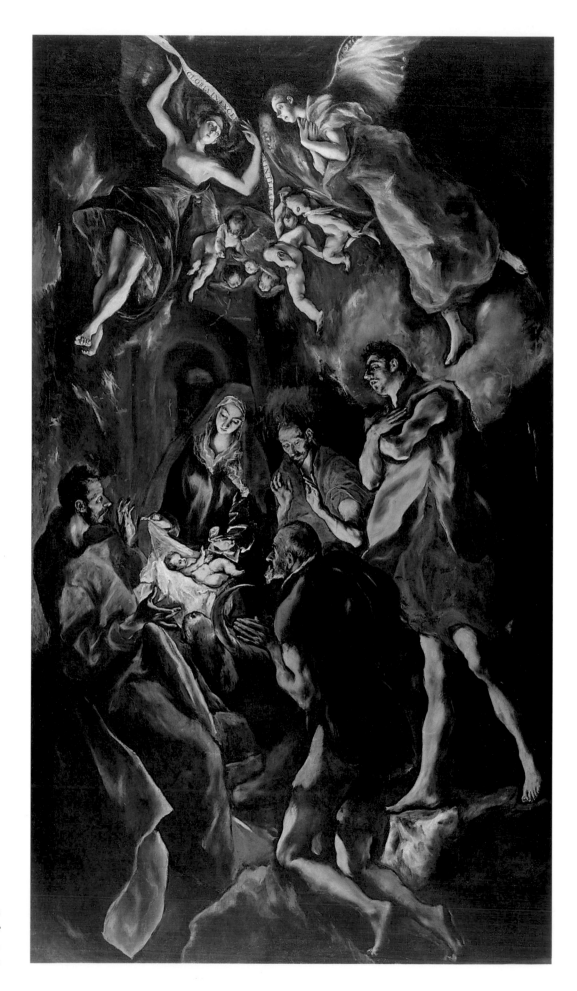

EL GRECO (Domenikos
Theotocopoulos): *Adoration of the
Shepherds;* 1612–1614. Oil on canvas,
319 x 180 cm. Prado, Madrid.

16th century, Fernando Yáñez executed clearly Italianate, monumental works in Valencia, such as a retable in the Cathedral, thereby eclipsing the 15th-century style that the Osonas and artists in the employ of Cardinal Borja had imported several decades earlier.

The situation was similar in the case of Mannerism, particularly in sculpture. Alonso Berruguete and Juan de Juni were two of Europe's greatest religious Mannerists during the 16th century. Their portrayal of holy images concertedly set out to elicit feelings on the part of the viewer who, consequently, was constantly expected to partake of the mysteries of religion, achieved through the use of polychromy, gold, exaggerated gestures and an unusual way of depicting reality.

The religious crisis of that century had a noticeable impact on religious images. In the face of events, Spain elected to side with and even passionately embrace Catholic orthodoxy. Clearly, this worked heavily in favour of religious imagery, which accounts for the proliferation of such work in church portals, retables, altarpieces, oratories, stained-glass windows, choir seating and grillework. Apart from the changes wrought in public places (a subject dealt with earlier), the architectural features of church buildings were continually being transformed, with the addition of broad iconographic and figurative cycles. This accounts for the importance of the aforementioned retables, of which the finest examples were produced by Berruguete, Juan de Juni and Gaspar Becerra and their followers. The *Retable of St Stephen,* by Juan de Juanes, is an excellent example of how to attract the viewer's attention through a narrative rendering of events, with studied gestures and attitudes, and careful arrangement of the various scenes, tinged with the same 'Christian rhetoric' preached from the pulpit and contained in treatises.

The influence of ideas decrying the image of the Erasmians, which emerged in such explicit writings as the *Diálogo de las cosas ocurridas en Roma,* by Alfonso de Valdés, had considerable repercussions in scholarly and theoretical circles. The Christian humanism they were grounded in developed into what was known as 'Christian rhetoric'. This was actually a religious adaptation of the classical rules for correct story-telling, as applied to religious figuration, which occurred in a number of variations, including the Italianate styles of Vicente Masip and Juan de Juanes, the Flemish Romanism of Pedro de Campaña, the Michelangelism of Gaspar Becerra, and the Mannerism of Alonso de Berruguete and Juan de Juni.

In the face of Protestant criticism, the positive value attached to images in Spain became a hallmark of the Renaissance there. This was admirably expounded in the writings of Fray Luis de Granada who, in his *Introducción del Símbolo de la Fe* (first edition, 1583), in which he compares the world and its beauty to painted retables, stated: *«Pues siendo tan grande la variedad y hermosura de las cosas deste mundo, ¿quién será tan bruto que diga haberse todo esto hecho acaso, y no tener un sapientísimo y potentísimo Hacedor? ¿Quién diría que un retablo muy grande y muy excelenetes colores y figuras se hizo acaso, con un borrón de tinta que acertó a caer sobre una tabla? Pero ¿Qué retablo más grande, más vistoso y más hermoso que este mundo? ¿Qué colores más vivos y agradables que los de los prados y árboles de primavera? ¿Qué figuras más primas que las de las flores, y aves y rosas? ¿Qué cosa más resplandeciente y más pintada que el cielo con sus estrellas?»* ('For so great is the variety and beauty of things in this world that, who would dare to say he had made all this, instead of there being an all-wise and all-powerful Maker? Who might say that a large retable with excellent colours and figures had been done with a blot of ink that happened to fall on a panel? And, what greater, lovelier and more beautiful retable be there than this world? What colours be there more vivid and agreeable than the meadows and trees in spring? What shapes more elegant than those of flowers, birds and roses? What thing more splendorous and painted than the sky with all its stars?').

The orthodox streak of Tridentine Catholicism, with its accent on religious images, found in Spain a country well-seasoned by the assertions of clergymen such as Fray Luis de Granada, and by provincial and other synods, but its influence prompted greater attention to decorum, and a clear, solemn presentation of stories and images. The closing years of the century saw a gradual decline in the penchant for pathos and emotion of the kind

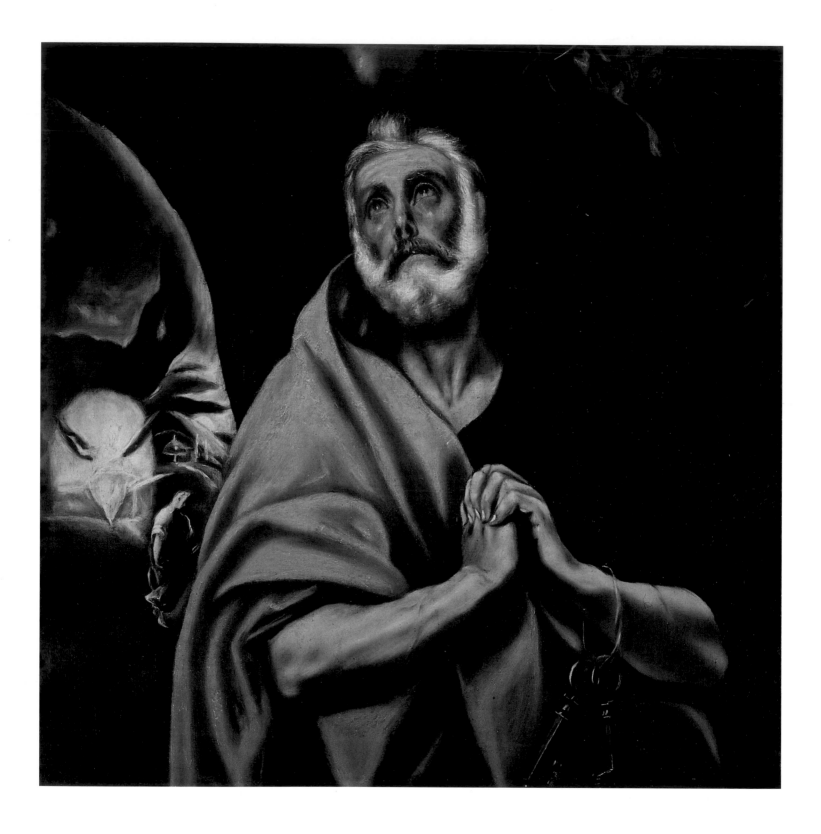

EL GRECO (Domenikos Theotocopoulos): *The Tears of St Peter*, 1603–1607. Oil on canvas,
102 x 84 cm. Cathedral sacristy, Toledo.

rendered by Alonso de Berruguete or Juan de Juni. However, the retables of the latter reveal a concerted endeavour to achieve greater clarity and readability in the way his scenes are hierarchically arranged. This development is further accentuated in the work of Gaspar Becerra, as evinced in Astorga Cathedral, and reaches a peak, late in the century, with Juan de Herrera's designs for Villagarcía de Campos and, above all, El Escorial.

Decorum, propriety and narrative clarity were essential ingredients of art during the Counter-Reformation. The devotional attributes of artworks, and their ability to persuade people to prayer, became the driving force and essential justification for Catholic images in the work of sculptors, and that of painters such as Luis de Morales and Juan Fernández Navarrete, leading into the earliest naturalistic tendencies, which first appear in the work of Francisco de Ribalta.

That is why El Greco's presence in central Spain, and his unqualified success, are all the more astonishing. He was unquestionably the greatest artist active in 16th-century Spain, but his activity continued well into the 17th century, during the height of the naturalistic reaction.

Born and educated in Crete, he trained in Venice and Rome during the seventies. When his *Martyrdom of St Maurice* was turned down by Philip II, he decided to settle in Toledo where, nurtured by the city's intellectual circles, its churches, Cathedral chapter and convents, he produced his fundamentally religious and portraitist oeuvre.

El Greco was a highly exceptional artist, as far as the Spanish Renaissance is concerned. His was an intellectual approach which reflected the specifically artistic issues in which the Italians were so engrossed. His sojourn in Venice, and his refusal to adopt the graphic line of Rome and Michelangelo, led him to become an ardent exponent of painting based on colour, and of decidedly Mannerist figural conceptualisations and compositional systems.

Nevertheless, while recognising his intellectual approach to art, a characteristic which should not be overlooked was his essentially religious subject matter, very much in tune with the Counter-Reformation. His religious scenes, series on saints and the Apostles, a predilection for pathetic subjects such as Mary Magdalene, the stigmata of St Francis, the Virgin and Child, or the tears of St Peter, lead us into the world of the emotions, of religion experienced with intensity. This was very much in keeping with the spiritual literature of the time, which expressed attitudes, forms and places of worship similar to those featured in his paintings.

The contraposition between the work of El Greco, and the cold religiousness of the Italians who worked in El Escorial, epitomises the Spanish Renaissance of the end of the century: its social and cultural diversity fostered varied and even opposing renditions of the Counter-Reformation, which still had many years to run. At the end of the 16th century, devotion was open to a wide variety of interpretations. According to Sigüenza, El Greco was rejected by the king because 'saints should be painted so as to avoid jading one's urge to pray to them; they should appear devout, as that is the main effect and goal of his painting'. At about the same time, San Juan de Ribera, in Valencia, had opted for the naturalism of Ribalta, the 'timeless' essentiality of Luis de Morales, and the narrative solemnity of Bartolomé de Matarana. Meanwhile, at El Escorial, under the sacrosanct laws dictated by the theory of decorum, the controversy of the century raged between the official classicism that characterised paintings and frescoes by Tibaldi, Cambiaso and Zuccaro, and the emotionally charged religious values of Navarrete the Mute. The latter's values come through both in the pairs of saints he painted in the basilica—where they stand with Raphaelesque solemnity, and the brushstroke of Titian—and in his religious scenes, of which Sigüenza wrote: 'In the end, these are the most decorous works of all, without their artistic excellence being in any way compromised; they stand above whatever has come from Italy, and are true devotional images, to which one may and does feel prompted to pray; for in many taken to be illustrious there is much carelessness, on account of the undue care they take to show off their art'.

El Greco

The figure of El Greco (1541–1614) towers above that of all other painters in Spain in the late-16th and early-17th century. He was active during the reign of Philip II (1555–1598), and the first fifteen years of that of his son, Philip III (1598–1621), at a time when the Counter-Reformation was at its peak.

Born in Crete, only the last part of his life on the island is known with any certainty. His first attributable work only came to light as recently as 1983. Known as the *Dormition of the Virgin* (Hermoúpolis, Syros), it confirms that he first trained as a painter of icons on his native island.

Modern historiographers rightly attach considerable importance to Domenikos Theotocopoulos' sojourn in Italy, which lasted from 1567 to 1576. He is documented in Rome and Venice, although the exact dates are not known. In a climate of controversy between the antagonistic geniuses of Michelangelo and Titian, the young painter developed into a fully-fledged Renaissance artist. Although he was influenced by *The Last Judgement* in the Vatican, he was mainly attracted by the way members of the Venetian school used colour, particularly Titian and Tintoretto.

In Rome, he was active in the circle of the Farnese family, to whom he was introduced by the Croat miniaturist, Giulio Clovio, and was commissioned by Fulvio Orsini, the family's librarian, to paint a number of unusual works, including *Boy Lighting a Candle,* based on an ecphrasis by Antiphilus. In view of the stiff competition in a place like Rome, thronged with Spaniards related to Toledo and court circles, he must have decided to travel to Spain in the hope of securing commissions from Church authorities or the court of Philip II, which was then involved with the project for decorating El Escorial.

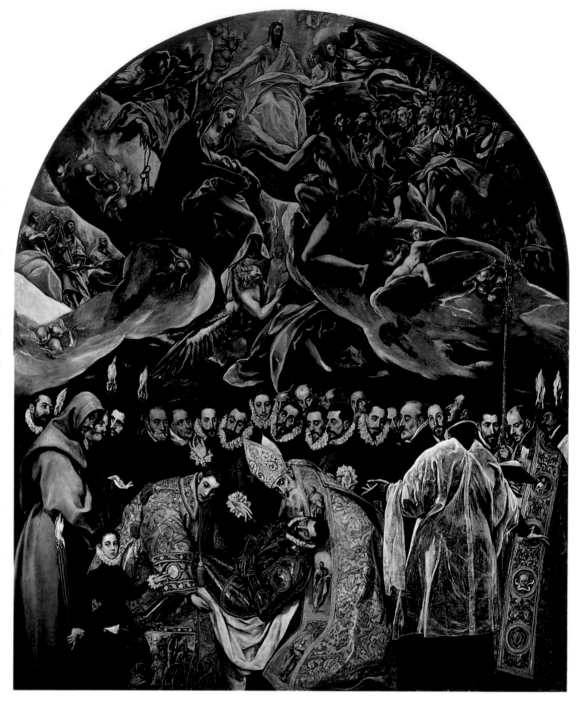

He arrived in Spain in 1577. After a brief sojourn in Madrid, he is documented as settling in Toledo at least as of July 1577, when the Cathedral chapter commissioned him to paint *The Disrobing of Christ.* However, he must have been in Toledo prior to that, when, with the mediation of Don Luis de Castilla, he was appointed to paint in the church of Santo Domingo el Antiguo.

This, his first commission in Spain, still has clearly Michelangelesque overtones and reveals the influence of Titian. *The Disrobing of Christ,* done in the sacristy at Toledo Cathedral, heralded the first of a series of lawsuits that were to become so characteristic of El Greco's career.

The *Allegory of the Holy League* might have been the painting he presented at his introduction to Philip II who, in 1580, commissioned him to execute the celebrated *Martyrdom of St Maurice* for one of the altars in the basilica at El Escorial. As is well known, the king later refused to have it on display there.

The litigation regarding *The Disrobing of Christ* and the king's rejec-

EL GRECO: Burial of the Count of Orgaz; 1586. Oil on canvas, 480 x 360 cm. Church of Santo Tomé, Toledo.

tion of *Martyrdom of St Maurice* are clear signs of how the unusual figure of El Greco clashed with the late-16th-century ambience in Spain. The problem with both works was related to the difficulty which the artist, aware of his individuality, had in adapting to an environment in which the Counter-Reformation idea of decorum was paramount, and to the prevailing art

directives, which required religious images to be styled so as to elicit a pious response in the spectator.

Despite these initial difficulties, and those apparently relating to the artist's lofty opinion of his own intellectual capacity, his career met with unprecedented success in the circles of monasteries, churches and collectors at Toledo. The wealth of commissions he received throughout his career, which ended in 1614, can only be accounted for by the fact that the artistic and cultural interests of his working environment concurred with those of the Counter-Reformation and the reigning exaltation of religious zeal. Moreover, the fact that his style subsequently remained impervious to the innovative trends that arose in Italy at the end of the 16th century, with the emergence of figures such as Caravaggio and Annibale Carracci, rather inappropriately aroused renewed enthusiasm over the markedly Mannerist work of the Cretan artist.

The relationship between El Greco and the religious climate in Spain lies behind the *Burial of the Count of Orgaz*, his most celebrated work, executed between 1586 and 1588. It is an exaltation of the 'good deeds' associated with the Counter-Reformation, a portrait gallery of contemporary personages, and a magnificent portrayal of the relationship between this world and the afterlife. Also along these lines are his works for the Colegio de Doña María de Aragón, dated 1596, in Madrid, coinciding with the most exultant period of his career, and the retable for the Hospital de la Caridad at Illescas, commissioned in 1603.

His portraits of contemporary figures, from the mythical *Nobleman with his Hand on his Chest* (emblematic of Spanish art), to those of *Fray Hortensio de Paravicino* (who wrote a celebrated sonnet in honour of El Greco) and *Cardinal Niño de Guevara,* in addition to his views of Toledo and the strange *Lacoön,* reveal him to be an artist of rare skills, and the leading exponent of Spanish Mannerist painting.

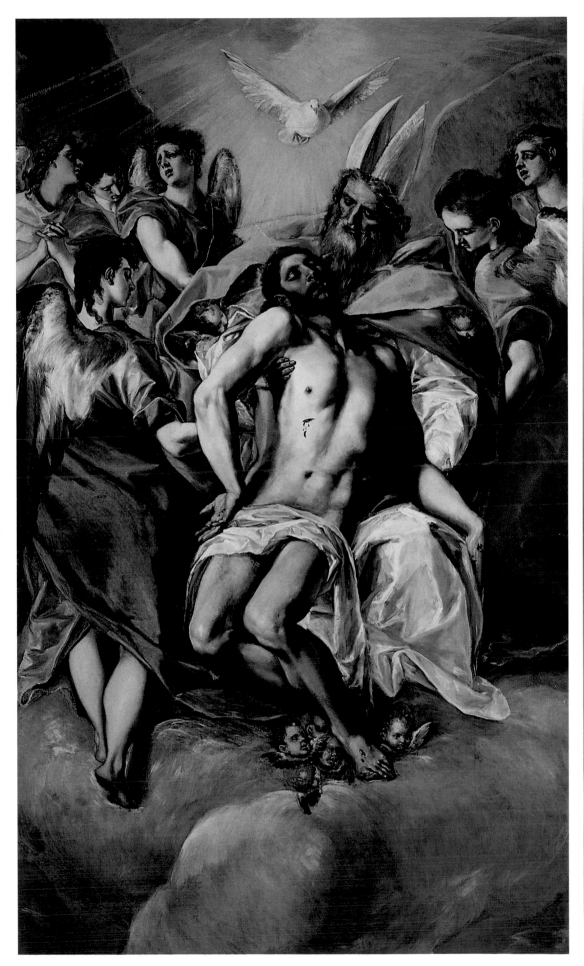

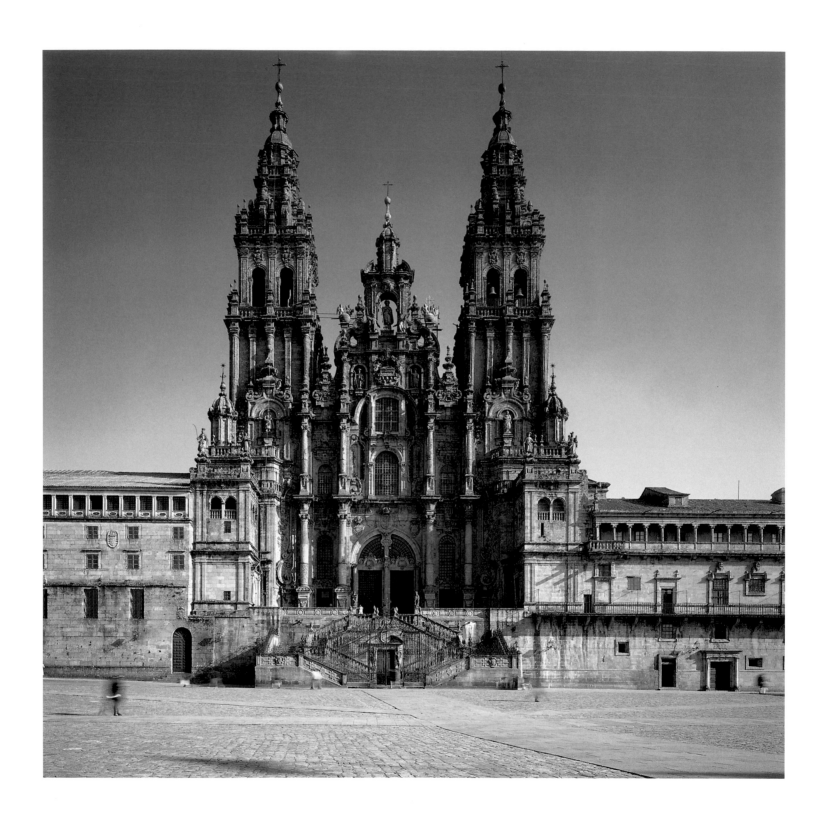

FERNANDO CASAS NOVOA: facade of the Obradoiro; 1749. Santiago de Compostela, Cathedral.

THE BAROQUE

Joan-Ramon Triadó

The Baroque, which spanned the whole 17th century and part of the 18th, is now considered to be a self-contained style. In other words, rather than being derived from the Renaissance, the Baroque style had its own complex language, providing a variety of aesthetic and formal solutions, with a contradictory yet unitary vision, born of what might be described as 'the spirit of the time'. Consequently, terms such as 'degeneration' or 'anti-classicism' should actually only be applied to intermediate phases such as Mannerism. As we shall see below, classicism was in fact part and parcel of the period in question. To adopt a linguistic metaphor, the words or forms were the same as those of the Renaissance; what changed was the syntax, that is, the composition.

During the Baroque period, architecture and the plastic arts were the hegemony of the Church, the monarchy and the bourgeoisie, and were used by them for purposes relating to glorification or self-assertion.

Indirectly, through its supporters, the Council of Trent, which ended in 1563, urged religious art to be simple and comprehensible, with the stress on its educational value. Moreover, it was to be realistic in depiction and stimulate piety through sensitivity, not reason. Thus, Baroque art started out with the emphasis on naturalism. However, the spiritual Church of the Counter-Reformation gave way to a Church of power in the political arena throughout Europe, and, in so doing, adopted more effective and persuasive methods of portraying art.

Thus, both the Counter-Reformation and absolutism were, in conceptual terms, the driving force behind Baroque art. Nevertheless, different aesthetic stances arose, owing to the vast area which it covered. I would not hesitate to assert that, in architecture and sculpture, Baroque art was fundamentally Italian, while in painting it was Flemish and Italian. Catholic Spain appropriated the ideological and theoretical principles of architecture and the plastic arts, although, as we shall see, it also enriched them with marked originality. Moreover, the Spanish Baroque borrowed heavily from foreign sources, particularly Italian and French, the former during the 17th century, and the latter during the 18th, after the new Bourbon dynasty had been established.

The Spanish Baroque spanned the comparatively long period of one and a half centuries, beginning at the dawn of the 17th century and lasting until 1752, when the Royal Academy of San Fernando was formally inaugurated. This marked the advent of restrained, academic art which tended to counteract the frivolous and decorative excesses of the late Baroque.

The Spanish Baroque may conveniently be divided into stages roughly coinciding with the ascent to the throne of successive Spanish monarchs. Moreover, the last three Habsburgs were succeeded by the Bourbon dynasty after the brief disruption caused by the interregnal War of Succession.

The period in question began during the reign of Philip III (1599–1621) and ended during that of Ferdinand VI (1746–1759), and took in the reigns of Philip IV (1621–1665), Charles II (1665–1700), Philip V (1700–1724), the short-lived Louis I (1724) and, in Catalonia and Valencia, the rule of the Archduke Carlos who, had he acceded to the throne,

FRANCESC GRAU: Details from tombs in the chapel of the Purísima Concepción, Tarragona Cathedral.

would have become Charles III. However, the late-Baroque and the Rococo yielded some works, particularly in the plastic arts, which spilled over into the reign of the Bourbon Charles III. This can be seen in Tiepolo's work in the Royal Palace, Madrid, the last works of the sculptor Salzillo, and those of Paret y Alcázar.

As we shall see, the change of dynasty in Spain had a marked influence on Spanish art. From then onwards, without relinquishing its Italian influence, it started to depend, too, on French tastes, due to the French origins of Philip V.

Another factor to be considered is that of the geographical areas in the Hispanic cultural sphere during the 17th century. It would be an error to limit this to what is now known as Spain: as is well known, during the 17th century, the territories ruled by the Spanish monarchy also took in Lombardy, the viceroyalty of Naples—in present-day Italy—Flanders and the overseas dependencies. Cultural and artistic ties between all these territories were intense at the time, as attested to by the continual toing and froing of artists and artworks between one area of production and another. Specific examples of this are the figures of Ribera, who was active in Naples in the service of successive viceroys, and Rubens, who worked for the crown and twice made his appearance at Court (in 1603 and 1628). Similarly, there was continual activity in assigning works to foreign artists and importing finished works. This accounted for the decoration of the Palace of the Buen Retiro in Madrid, adorned with works by the Neapolitans Aniello Falcone, Mico Spadaro and Massimo Stanzione, or the Torre de la Parada, designed by Rubens and executed by his assistants.

There were numerous production centres of varying importance on the Iberian Peninsula. The Court, once it had been established in Madrid, became one of the most productive centres, which engaged the largest number of artists. Seville, the centre of Atlantic trade between northern Europe and the Americas, and Valencia that of Mediterranean trade, became major centres of artistic production. Toledo and Valladolid declined in importance, while Salamanca and Granada held their position. Barcelona was important as a centre of secular art. Santiago de Compostela benefitted from the resurgence of the Road to Santiago and the power of the Church, while Murcia became important as the centre of the silk industry, and on account of the new agricultural policy implemented in La Huerta district. Other, noteworthy centres were Córdoba, Girona, Tarragona, Málaga, Vitoria, Manresa, Oviedo, Logroño, Orense, Zaragoza and Jaén, as well as many small towns, where the power of the local clergy or landed nobility led them to become active art centres. Such was the case of Monforte de Lemos, Lerma, Serradilla, Medina del Campo and Alfaro.

The Professional Status of Artists

From a social and theoretical standpoint, the esteem in which artists were held throughout the Baroque period is a fascinating subject. The basic issue was whether painting and sculpture were to be valued as a liberal or noble art, or as a manual craft (which would make an artist a craftsman). At the heart of the matter lay two, conflicting and likewise complementary interests. If the plastic arts were to be regarded as a liberal profession, artists would be on an equal footing with the nobility, and would therefore share their privileges and prerogatives. Moreover, they would then not be liable for taxation, as their art would be classed as the fruit of pleasure, not of work. Clearly, artists worked to make a living. They sold and traded their works, and constantly engaged in the struggle to earn lasting recognition.

From a practical point of view—that is, not having to pay the sales tax known as the *alcabala*—an illustrative example is the lawsuit in which Vincenzo Carducci defeated the Treasury official, Juan Balboa Magrobejo, a case studied by Julián Gállego. Tax exemption was based on virtually the same criteria as those adopted by 17th-century theoreticians to demonstrate the noble status of painting. The reasoning was classic: painting is exempted from taxation, as 'it is more liberal and scientific an art than the others; indeed, it includes all of the arts. This is how they regarded it in the first instance and, being so noble an art,

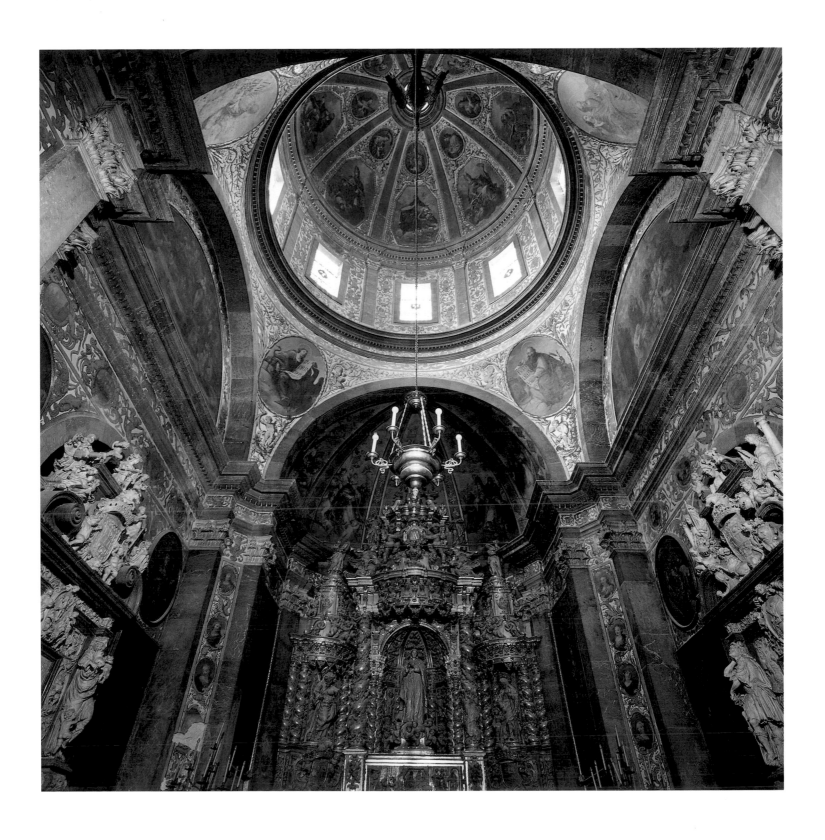

FRAY JOSEP DE LA CONCEPCIÓ (architect), FRANCESC GRAU & DOMÈNECH ROVIRA (sculptors):
Chapel of the Purísima Concepción; 1674–1679. Tarragona Cathedral.

ordered it not to be shown to slaves or people of low standing'. Similarly, 'because, from the very beginning, it has been a noble profession, and thus has it been practised by many a king, prince and lord, and regarded as an ingenious virtue, for its emulation of nature'.

As a liberal art, painting was extolled by Lope de Vega in his *Laurel de Apolo,* in which he compares it to poetry. The phrase *Ut pictura poesis* illustrates a sense of artistic assertion, and that was how Lope de Vega used it in his *Angélica,* in which he accords painting greater status than his own profession. His poem says it all:

> *Bien es verdad que llaman la Poesía*
> *Pintura que habla, y llaman la Pintura*
> *muda Poesía que exceder porfía*
> *lo que la viva voz mostrar procura;*
> *pero para mover la fantasía*
> *con más velocidad y más blandura*
> *venciera Homero Apeles, porque en suma*
> *retrata el alma la divina pluma*

Lope continues his argument in favour of such a noble art when, in *Los Ponces de Barcelona,* a character of his states:

> *Pintor era el padre mío,*
> *arte tan noble, que basta*
> *decir que a Naturaleza*
> *tal vez enmienda a las faltas*

Not only poets, but also most of the essayists of the period came out in defence of painting, including the Portuguese Felipe Núñez, the Italian Carducci and the Spaniard Pacheco. The noble status of painting prompted some artists to seek a knighthood. Diego Velázquez, to cite a well-known instance, used his favour with the king to have himself dubbed a Knight of the Order of Santiago. Judging from one of the Order's extant records, dating from 1563, the work of a 'silversmith or a painter by trade' was considered base, menial labour.

Despite the endeavours of artists to rise above their craft standing and guild associations, very few won any lasting social status. One who managed to do so through marriage was Antonio de Pereda, while Carreño de Miranda and Palomino achieved the same result by virtue of their noble origins. Diego Valentín Díaz won status through family connections in the Inquisition; Pereyra, as a member of the Order of Santiago, and the aforementioned Velázquez, as the king's protégé.

Lastly, an interesting case is that of Rubens, who painted for the monarchy and aristocracy in various parts of Europe. His patrons included Charles I of England, Marie de Médicis, Philip IV of Spain, the Duke of Mantua and the Duke of Lerma. Sent to Spain as a special envoy by Isabella Clara Eugenia, Governess of the Netherlands, and duly promoted to noble status beforehand, Rubens made Philip IV exclaim, enraged, that he was 'a man of few obligations', clearly referring to his condition as a painter.

Artists' struggle for self-assertion was not commensurate with their social and rather precarious financial status. Moreover, their standing in the world of culture was tenuous if not non-existent. There was, however, the odd exception, such as Poussin, a friend of Cassiano del Pozzo's, who arranged gatherings of philosophers and poets in his home. His was a fruitful relationship with the poet Marino, as evinced in his works inspired by Ovid's *Metamorphoses.*

These kinds of gathering were rare in Spain, but they did exist. The most celebrated of them were those held in Seville, in the home of Argote de Molina, a veritable 'academy' in the Italian sense. Every afternoon, a gathering would take place in the garden, attended by the leading Sevillian scholars, and foreigners who happened to be passing through. Sim-

ALONSO DE MENA: *St James, the Moor-slayer,* 1640. Granada Cathedral.

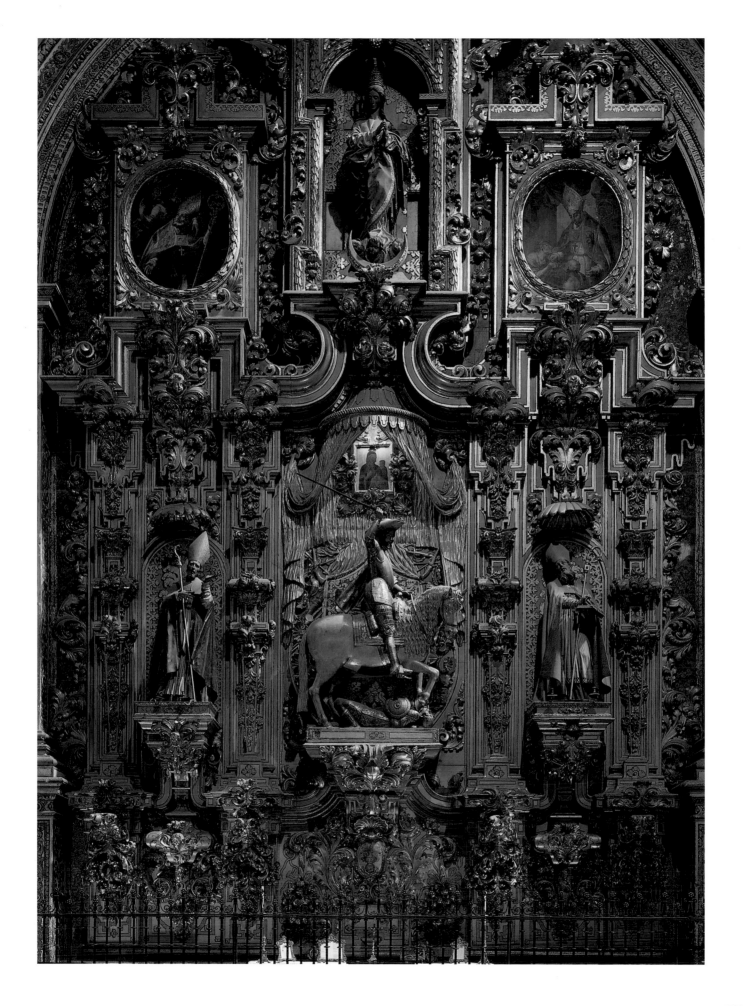

ilarly, Pacheco organised such meetings in his academy of drawing and painting, which was one of the most important in the early-17th century. They were attended by painters such as Herrera the Elder and Céspedes, poets such as Rioja, Caro and Argensola, and even Lope de Vega whenever he went to Seville. His *Libros de retratos de ilustres y memorables varones* has captured, for posterity, images of all the illustrious figures he met there. The young Velázquez also attended these gatherings, which helped him to acquire a sound knowledge of mythology.

Artists and their Audience

This state of affairs was not common, however. Artists were usually beholden to the public at large, operating in conditions more akin to a craft trade than to the milieu nowadays associated with an artist. What Haskell recounts in *The Mechanics of Seventeenth-Century Patronage,* when talking of Italian artists, is also readily applicable to Spain.

Commissions were negotiated at a fixed rate, which was paid in three instalments: the first, on signing a contract; the second, midway through the execution, and the third, on completion of the same. However, this system was onerous for sculptors, as they had to provide materials and engage assistants, which led them to run up debts with third parties from whom they would seek an advance payment. Very often, when a commission was publicly tendered, artists would accept low prices in order to secure it. Martín González, in his book, *Escultura barroca en España,* provides an eloquent example relating to a retable for the church of Santa Catalina in Seville: 'When it was announced in 1624 [...], it was stipulated that it should not be proclaimed in public, as bidders would be prompted to give discounts and deceive the parish'. This rueful scene was worsened by the prospect of inspections, commonly carried out once the work had been completed—if the finished product was not to the patron's liking, the contract could be rescinded.

Another factor to be taken into account was that artists were often asked to copy an existing work by another artist. In addition to being a test of the artist's skills, this was regarded as proof of his reliably fulfilling the demands made of him by a patron. In the case of painters, this merely involved executing an idea thought up by the members of a guild, community or even the king himself.

Another task assigned to painters was that of gilding retables or painting walls and balustrades, after the fashion of a house painter. Moreover, such commissions were not offered just to second-rate artists, as evinced in a lawsuit between Pacheco and Martínez Montañés over a painter's right to gild and incarnadine sculptural works.

When it came to fresco painting, the artist was not paid a lump sum for the finished work, but received a monthly stipend for the duration of the work.

Another practice which would be unthinkable nowadays was that of paying a particular sum of money for each figure painted in a composition. Haskell cites a highly illustrative example relating to a painter of the calibre of Il Guercino. On receiving a commission, the latter purportedly said: 'As my customary price per figure is 124 ducats, and as His Excellency has restricted himself to [handing over] 80 ducats, he shall have just over half a figure'.

Only architects were spared this ordeal, and it is no wonder that the finest Spanish Baroque painter, Francisco Herrera the Younger, on his return from Italy, should have laid down his paintbrush and devoted himself to architecture and ephemeral decoration, when faced with the situation of paintings being so poorly valued.

The Artist's Social Standing

The social status of artists was just as deplorable. When Velázquez, for example, was appointed chamber painter to Philip IV, he was granted an allowance of 'twenty ducats as

JUAN VAN DER HAMEN: *Flora;* 1627.
Oil on canvas,
216 x 140 cm. Prado, Madrid.

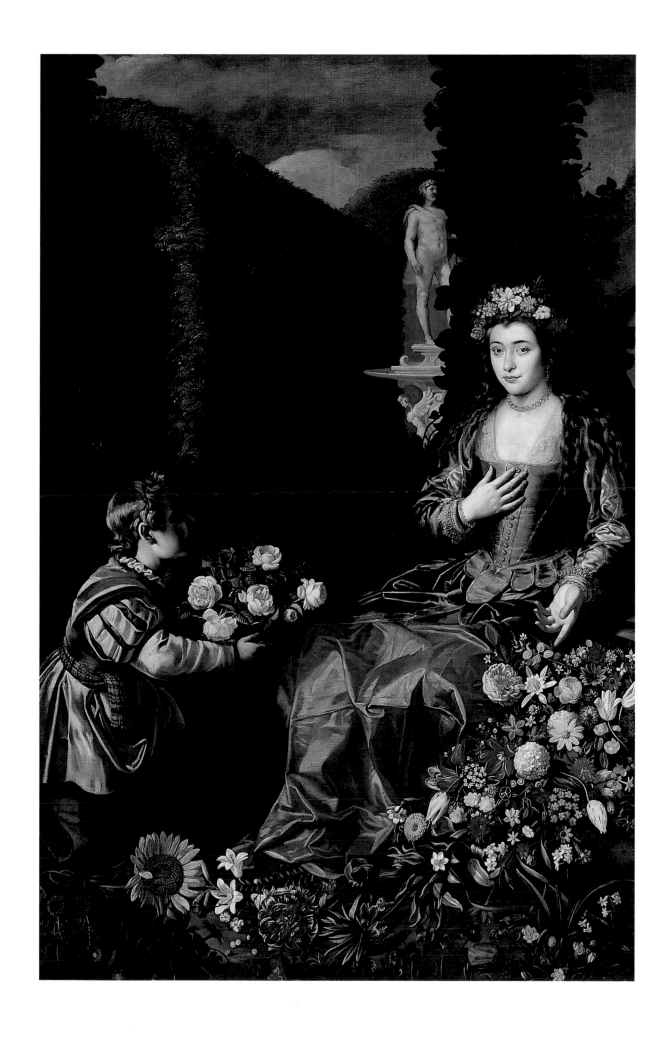

a monthly stipend, his works considered paid for in advance, including the right to a physician, a pharmacist and lodgings'. He was subsequently appointed chamber steward and wardrobe assistant; that is, the greatest Spanish painter of the 17th century performing a servant's duties! It would not, therefore, be unreasonable to assume that, once he had secured fixed employment with Pope Innocent X in Rome, on his second visit to Italy, he must have been loathe to return to Spain. His reasons will have had a lot to do with an artist's pride.

However, apart from a few exceptions, the situation in Italy was rather similar. For instance, Andrea Sacchi was employed in the household of Cardinal Barberini, together with three slaves, a gardener, a dwarf and an old wet-nurse, and it was only in the last year, once he had become famous, that he was promoted to the status of pensioner, on a par with writers, poets and secretaries.

The Art Market and its Protagonists

The destination of artworks, and the channels by which they were conveyed to purchasers and future owners, afford a fascinating study of the cultural milieu of the period and the personal tastes of the people involved, turning a purely artistic phenomenon into a socio-cultural one.

Firstly, it should be pointed out that the Spanish art trade, while not as active as in Holland, is, however, worth taking into consideration. During the 17th century, the trade was channelled through auctions and, judging from studies carried out on the subject, there was not much activity as far as art collecting in Spain was concerned. As in the rest of Europe, artworks were also sold in shops. Once an artist had passed an entrance exam for membership of a painters' or sculptors' guild, he was also entitled to open a shop and a workshop. Well-known workshops in Spain at the time were those run by a flower painter named Arellano which, according to Palomino, 'was one of the most celebrated workshops in the Court', and that of the still-life painter, Van der Hamen. The largest numbers of art stores were in Madrid and Seville, as Madrid had a highly developed services sector, while Seville was a major trade centre.

Artists arrived at Court in search of fame and fortune, to learn from the great masters, to view art collections, or to offer their services in the workshops. What is nowadays taken to be commercial art of dubious aesthetic value was commonplace during the 17th century. The Calle Mayor or 'High Street' in Madrid was the major shopping centre, lined with art stores and pedlars whose trade also spread into the neighbouring streets, including Toledo, Barquillo and Red de San Luis.

Art dealers also existed at the time, as did *corredores* or 'brokers'. This was the term used by Martín González, whose job it was to export artworks to the Americas, including some by Zurbarán, which were sent to Peru. However, the most interesting works were invariably those commissioned by patrons, as the leading artists were usually engaged for such assignments.

Art collectors both large and small are recorded in period literature. In *La Garduña de Sevilla* (1642), Castillo Solórzano commends the furniture owned by a dealer's widow, named Estefanía, who had 'a large collection of fine paintings'. Her daughter, Rufina, is mentioned as having seen 'a stable adorned with strange paintings' in the home of a *perulero* (an emigrant having returned from Peru) and, in the home of one Octavia, 'paintings executed with valiant brushes'. Hence, a fair number of paintings could be found in 17th-century Spanish homes. According to Ortega y Gasset, the Spanish public only took an interest in painting from 1600 onwards, following the example of certain aristocrats—mainly viceroys of Naples and ambassadors in Rome—who would return from Italy laden with paintings and a newfound interest in art. However, literary examples ought to be taken with a pinch of salt, as studies of the estates of deceased noblemen are rather more discouraging. This is evinced by a lawsuit relating to the arrival in Spain in 1626 of Cassiano del Pozzo, Cardinal Francesco Barberini's secretary, and certain art collections in Madrid.

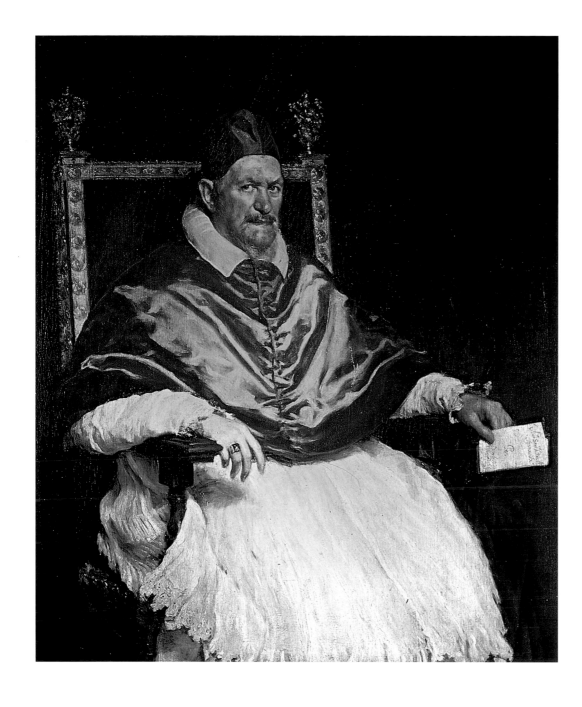

DIEGO VELÁZQUEZ: *Pope Innocent X;*
1649. Oil on canvas, 140 x 120 cm.
Galleria Doria-Pamphili, Rome.

The largest art collector was the Crown. It owned thousands of paintings and a large number of sculptures and furniture, distributed between the palaces of the Buen Retiro, the Alcázar and the Torre de la Parada. For the monarchs, it was not just a question of hoarding wealth, but of acquiring works to satisfy their cultural yearnings. The core of these collections can now be seen in the Prado.

The successive monarchs were the largest art consumers, and their tastes marked a departure from the general norm, as they commissioned works on subjects other than the customary religious themes that were invading Spanish homes. The last three Habsburgs and the first few Bourbons commissioned a large number of portraits and mythological subjects. Although they became great patrons, they did not monopolise the arts in the manner of the absolutist French king, Louis XIV. Indeed, from the time of Philip II onwards, other art circles outside the Court were free to develop unhindered. El Greco, in Toledo, Ribalta, in Valencia, Ribera, in Naples, and Murillo and Valdés Leal in Seville, had no need to resort to Court circles in order to become highly accomplished painters and earn recognition, as borne out by the large number of commissions they received and the positive appraisal of their work today.

Other great art collectors included the various governors of Flanders, who were all related to the royal family. In this respect, the painter David Teniers has bequeathed an invaluable pictorial legacy in his work, *Archduke Leopold Wilhelm in his Gallery*.

Other noteworthy patrons of the arts were Philip III's chancellor, the Duke of Lerma, and that of Philip IV, the Count-Duke of Olivares, in addition to Rodrigo Calderón, the Marquis of Siete Iglesias, the Counts of Fuensaldaña, the painter and essayist, Vincenzo Carducci, the architect, Juan Bautista Crescencio, who was awarded the title of Marquis of La Torre and, above all, the Count of Monterrey and the seventh Marquis of El Carpio. However, the magnitude of their patronage was surpassed by the successive viceroys of Naples.

The penchant for art collecting, predominant in Italy, was epitomised by the figure of Manuel de Fonseca y Zúñiga, the Count of Monterrey and brother-in-law of the Count-Duke of Olivares. He was appointed ambassador to Rome (1628–1631) and, later, Viceroy of Naples (1631–1637). On Velázquez's first journey to Italy, he acted as the latter's agent, sending his paintings to the Spanish Court, and his activity as an art collector and patron earned him considerable recognition in Neapolitan art circles. He was a man of refined tastes, with a predilection for the finest Italian art of the moment, including Il Domenichino, Artemisia Gentileschi, Lanfranco, Massimo Stanzione and, above all, the Valencian painter, Ribera. 'On his return from Naples in 1639', wrote Pérez Sánchez, 'he embarked on major building work in his house and garden in the Prado, directed by Gómez de Mora, which cost him 6,000 ducats. He had a large gallery built, overlooking the Prado, which he decorated with paintings and statues. Following his death in 1653, an inventory of his goods was drawn up. Noteworthy among his possessions was a collection of paintings. Although not excessive in number, they were all of the finest quality and included many Italian works. They were valued by Antonio de Pereda, and the inventory yielded a total of 139 paintings in his home and another 118 in the "Prado gallery and garden"'. The Count of Monterrey is associated with two magnificent landscapes by José de Ribera, rescued from oblivion by the current Dukes of Alba. The Viceroy may have commissioned the Valencian artist to paint them during his sojourn in Naples and, after the Viceroy's departure, the artist will have sent them back to Spain.

Part of Monterrey's collection was inherited by his nephew, Luis Méndez de Haro, the Marquis of El Carpio, who gradually added to it. Velázquez's *The Toilet of Venus,* now missing from Spain's national heritage, was found among his possessions in the course of an inventory taken in 1651. Gaspar Méndez de Haro y Guzmán, the seventh Marquis of El Carpio, who also served as ambassador to Rome and Viceroy of Naples, was both the greatest Spanish art collector of the period and a major patron of the arts. A cultivated man, he enthusiastically augmented his collection through transactions in Rome and Naples. In Rome, he purchased a large number of paintings that had belonged to the deceased Cardinal Camillo Pamphili, which included a portrait of the Cardinal himself, and another of Lady Olympia, both by Velázquez, as well as numerous antiquities which he had reproduced in engravings. A friend of Bernini's, he owned a small version of the latter's *Fountain of the Four Rivers* and a magnificent self-portrait of the artist. He continued his patronage in Naples, where he built up his collection from 1,100 paintings to 1,800. There he had his palace decorated by Luca Giordano, whom he appointed as his principal painter. On his death in 1678, it was said that 'Naples had lost a loving father and its artists their succour'.

However, in Catholic Spain, then in the grip of the Counter-Reformation, where the veneration of saints, founders of religious orders, martyrs and, above all, the Virgin Mary, was in the ascendant, most commissions were secured through either guilds and fraternities, with their retables and processional floats for Holy Week, or the religious orders with their monastic cycles, as in the Monastery of Guadalupe and the Charterhouse in Granada. Without them, there would have been no culture medium for the great painters of imagery—Gregorio Fernández, Martínez Montañés, Alonso Cano, Pedro de Mena and Salzillo—nor the magnificent retables adorning most churches on the Iberian Peninsula. Even painters such as Zurbarán would not have become so widely acclaimed had it not been for such powerful patrons.

Religious fraternities were important at the time. That of the Caridad, in Seville, founded by Miguel de Mañara, commissioned one of the most celebrated turn-of-century projects in Seville, assigned to Murillo, Valdés Leal and Pedro Roldán. Only a patron as powerful as such a brotherhood was capable of bringing together the two great geniuses of Sevillian painting. The two closing works, *Finis gloriae mundi* and *In Ictu oculi*, demonstrate how, faced with an important commission, Valdés Leal was capable of abandoning his sometimes hasty, lacklustre painting and rising above even Murillo himself. This bears out the fact that the price paid for a commission, and the urge to show off one's skills, are crucial when it comes to assessing artistic accomplishment.

VALDÉS LEAL: *Finis Gloria Mundi* & *In ictu oculi;* 1670–1672. Oil on canvas, 220 x 216 cm. Hospital church of La Caridad, Seville.

To conclude this section, the following quotation has been included as an example of an individual citizen's taste in art, expressed in the privacy of his home and free of official religious impositions. It also provides an orthodox argument which explains why certain mundane or genre subjects were shunned by the society of that period. In his *La esposa de Cristo,* Bernardino de Villegas says: 'I do not know why, for our sins, such tremendous abuse as profane paintings of naked men and women have appeared in our time, filled with such indecency as to disgrace Christian modest and purity, that there be no chaste eyes that might gaze upon them, even at a distance, to avoid impairing them with such obscene depictions that even the pen hastens to describe them. The galleries and boudoirs of many a prominent figure are filled with such works as these, resembling the chambers of a Heliogabulus, or some other coarse, dishonest heathen emperor, rather than those of a modest, religious and Christian gentleman or prince, as required by the faith they profess'.

Town Planning: Compilation and Originality

During the Baroque period, towns and cities took on a new lease of life. Residential buildings such as houses, palaces and convents, and meeting places such as churches, theatres and squares, were embellished. Similarly, streets were laid, infrastructure upgraded, with the addition of canals, water conduits and public fountains, while public works of a symbolic value were built, in the form of civic and religious monuments. Institutional buildings such as town halls, jails, hospitals and colleges were also erected. Without going to the extremes of Pope Sixtus V in the case of Rome, which led to a cardinal exclaiming that he did not recognise the city he had visited five years earlier, the fact is that urbanisation, pro-

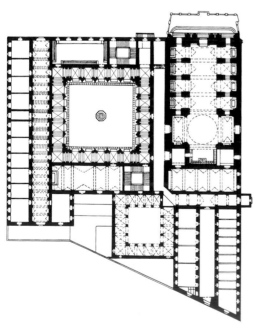

moted by either the monarch, municipality or Church, was advancing at a steady pace. In his comedy, *La villana de Getafe,* Lope de Vega was prompted to have one character say:

«¡No conozco Madrid! Va por instantes
poblándose de ricos edificios.
Ya sus enanas casas son gigantes
¡Qué portadas, qué ricos frontispicios!»

In the 17th century, public squares, which acted as a meeting place and venue for public events, became a unique town-planning feature. In its considerable uniformity, the Plaza Mayor of Madrid, designed by Juan Gómez de Mora in 1617, is reminiscent of the systematic town-planning projects implemented under Henry IV in France, particularly the Place Royale or the Place des Vosges (1603–1606) in Paris. The neighbouring streets, above all the Calle Mayor, were a meeting place and the true commercial centre of the great city. Poplar-lined promenades also appeared, replacing royal gardens as public recreational areas, in similar fashion to Parisian boulevards. The Prado promenade in Madrid, and the Hercules poplar grove of Seville, are specific examples of this. Meanwhile, public places in Madrid and other Spanish cities were embellished with additional chapels, votive altars, shrine niches, vantage points and such fountains as those in the Puerta del Sol and the Castellana in Madrid, or Santa Eulalia in Barcelona. The urban landscape also acquired a unitary appearance with the construction of new and stylistically uniform buildings, such as the facade of the Alcázar (1619–1627), La Corte prison (1629–1634) and the City Hall (1640), all designed by Gómez de Mora in Madrid. In the 18th century, Alberto Churriguera designed the Plaza Mayor of Salamanca (1728–1755), a monumental version of the more austere one in Madrid.

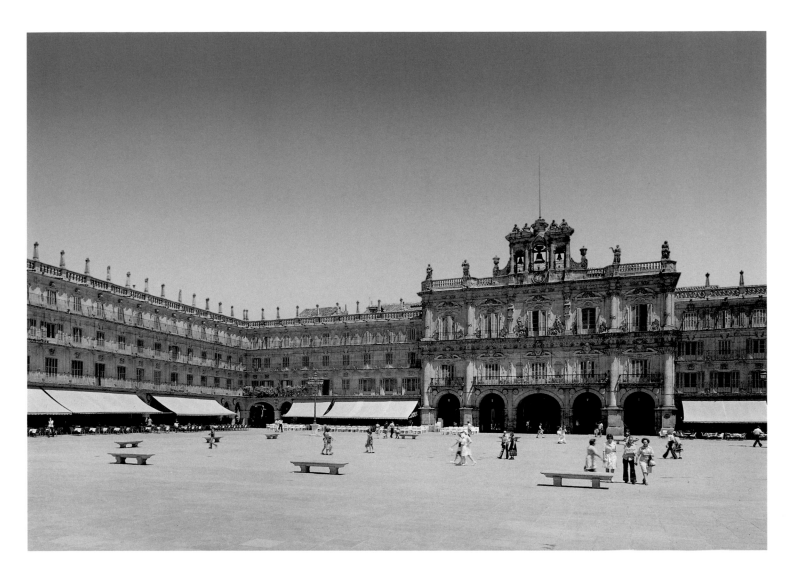

Another aspect of town planning which acquired certain currency during that period was the enlargement of existing towns and cities and the layout of new ones. Here again, Madrid provides an illustrative example, as its appearance was transformed by applying both conventional and picturesque criteria. The aforementioned Plaza Mayor became the epitome of uniformity, ringed by facades built to the same height and design. However, the capital as a whole grew haphazardly, a fact deplored by Gómez de Mora: 'In La Corte there are many buildings fashioned according to each owner's whim; some are too low, and others too high, some set within and others without, leading to marked deformity'. The disarray was partly caused by the city's rapid growth, as Salcedo Coronel observed: 'Buildings go up every day, and those which have just gone up last are now in the middle of the town'.

ALBERTO CHURRIGUERA & ANDRÉS GARCÍA DE QUIÑONES· Plaza Mayor; 1729–1755, Salamanca.

The Baroque *plaza mayor* or main square, for which the first model was the reconstruction of the main square at Valladolid, begun in 1561, endured well into the 19th century in Barcelona, from where it was exported to Spanish America. Unlike public squares in France, in Spain the civic function prevailed over symbolic considerations. Thus, in the Plaza Mayor of Madrid, the bakery or *tahona* was a prominent feature, while in that of Salamanca, pride of place went to the City Hall. Meanwhile, in Paris, the equestrian statue of the monarch ruled supreme. Public squares in Spain were used for communal events, from stage plays to religious ceremonies.

Elevation of the city hall in Salamanca.

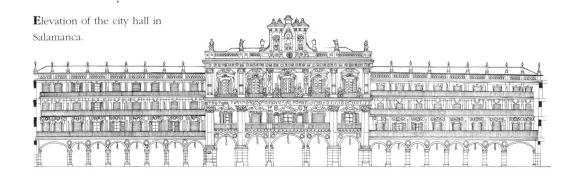

JUAN GÓMEZ DE MORA (architect) & TEODORO ARDEMANS (sculptor): facade of the Madrid City Hall. 1640 & 1670.

In contrast, Alcalá de Henares, Lerma and Nuevo Baztán were examples of highly regular urban layouts. An exemplary development plan was implemented at Alcalá de Henares for the building of convents, colleges and clerical residences to serve the prestigious university, and plots were triangulated according to a regular pattern, which is now considered characteristic of 17th-century Hispanic cities.

However, the town of Lerma, built on the orders of Philip III's chancellor, the Duke of Lerma, was the paramount example of 17th-century urban and architectural design, which closely matched similar models abroad. Here, the existing town centre was redeveloped by introducing architectural innovations. The street layout in the northern sector was re-aligned, and a number of small squares were placed so as to lead into the Plaza Mayor, where the Palace of Lerma was located. The Duke's unitary resolve also led him to commission the building of a raised walkway linking the palace to the old collegiate church and six newly built convents. In short, as Bonet Correa observed: 'Although lacking the symmetry and completely regular layout of Richelieu, designed by Lemercier in 1631, Lerma nevertheless built an admirable complex, turning the town into a both the seat of a ducal court and a Spanish conventual town.'

However, the palace of El Buen Retiro provided a poor example of 17th-century landscape gardening, although the influence of Italian gardens, such as the hunting lodge of Stupinigi de Juvarra, and the French designs of André Le Nôtre, were to yield more positive results in Spanish garden designs during the 18th century.

Architecture: Italian and French Models

Hispanic Baroque civil and religious municipal buildings were stylistically indebted to Italian and, subsequently, French models. The Italian current was adopted spontaneously, rather than meticulously emulated, which is apparent in the influence of Vignola and the spatial distribution in the church of Gesù. This formula was applied to most congregational buildings, including the Jesuit churches of San Isidro, in Madrid, designed by Pedro Sánchez, La Clerecía, in Salamanca, by Juan Gómez de Mora, and the church of Betlem in Barcelona, attributed to Josep Juli. Another, different spatial concept, revealing the influence of both Daniele Volterra and Vignola, can be seen in the church of the Bernardines at Alcalá de Henares, also by Gómez de Mora.

Spanish architecture poses problems when it comes to identifying specifically Baroque forms. Spatial ductility was not a hallmark of Spanish designers of the time, as they adhered to a classicism based on austere, 16th-century approaches, especially those of Juan de Herrera and his work on El Escorial.

In the 18th century, academic architecture made inroads into the Iberian Peninsula, brought by Bourbon military engineers trained in France. Their influence in civil and military architecture was crucial to subsequent developments, which culminated in the academic architecture of the Enlightenment, of which the maximum exponent in Spain was Ventura Rodríguez.

FRANCISCO DE MORA: Plaza Mayor of Lerma (Burgos); first third of the 17th century.

Plan of the Bernardine convent at Alcalá de Henares.

307

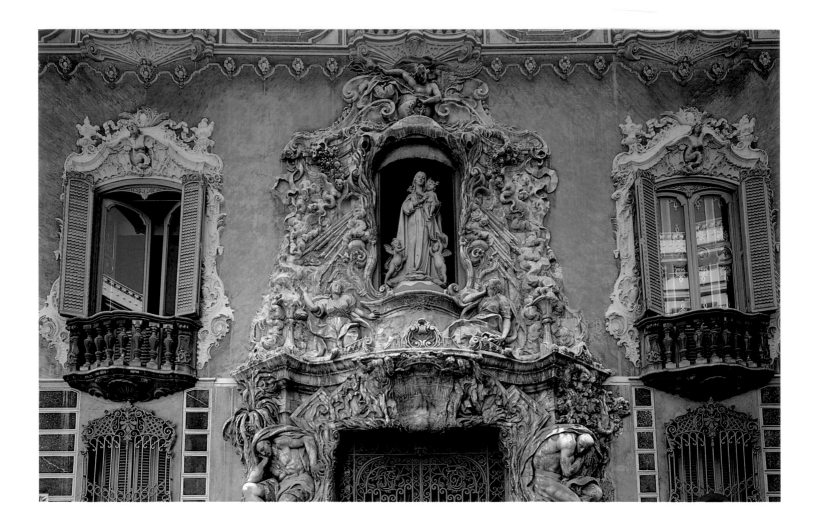

Facade–retables combined the lush
decoration of the Hispanic late-Baroque
and a universalistic depiction of the
Church and monarchy as the major State
powers. Ornamental entrances of this
kind changed the visual relationship
between the church and surrounding
urban precinct, and provided some
leeway for decorative variations within
what was a rather rigid overall design
scheme. On the facade of Valencia
Cathedral, for example, the decoration
still adheres to some architectural tenets,
and is restricted to certain areas, while
on the facade of the Palace of the
Marquis of Dos Aguas (shown above),
also in Valencia, the ornamentation
overruns the whole portal and
simultaneously acts as an interface
linking the interior and exterior.

This austerity was paralleled by the appearance of the classicist Italian style in major projects for palaces. Filippo Juvara (1678–1736) was the first architect to design for the Royal Palace of Madrid, the city he died in just a year after having arrived there. His design for the palace, a symbiosis of French and Italian influences, became the common denominator for the architectural style of other royal residences, such as Aranjuez and La Granja.

Having dealt with the formative influences in 17th-century Spanish architecture, it is worth looking at the hallmarks by which it is defined and identified. I am referring to such new or unique features as sacraria, shrine niches, frontispieces, false domes, spires, bell-towers and imperial staircases, and materials such as stucco. Moreover, during this period, it was common for improvised solutions to become lasting ones. Sacraria and niches were a 17th-century Hispanic creation which became most popular in the 18th century. The prototype for the former was the octagonal tower at Toledo Cathedral, begun under Nicolás de Vergara in 1595 and continued by Pedro de la Torre, his brother Bautista, and the marble worker, Bartolomé Zumbigo. It consists of two octagonal-plan chapels with marked verticality. The aforementioned chapel of San Isidro also fulfilled the purpose of guarding an image or relic. Its exterior is very simple—what Chueca calls the 'truth of volumes'—and has a square-plan interior with a formidable baldachin. When viewed from the church nave, the high niche, designed to hold an effigy, appears to be set in a retable. Niches appeared in the 17th century but, like sacraria, they reached their peak in the 18th century, particularly in Andalusia. They are noteworthy for their Baroque sense of complexity and mystery. To reach this inner sanctum, the faithful had to pick their way through narrow corridors and rooms and up staircases, that is, a journey in search of the divine. The first example of this was the church of Los Desamparados, in Valencia, designed by Diego Martínez Ponce de Urrana in 1647 and built between 1652 and 1667.

A typically Spanish feature was the facade-retable or frontispiece, a consummate external rendering of the retable, which turned church facades into a religious anteroom. As

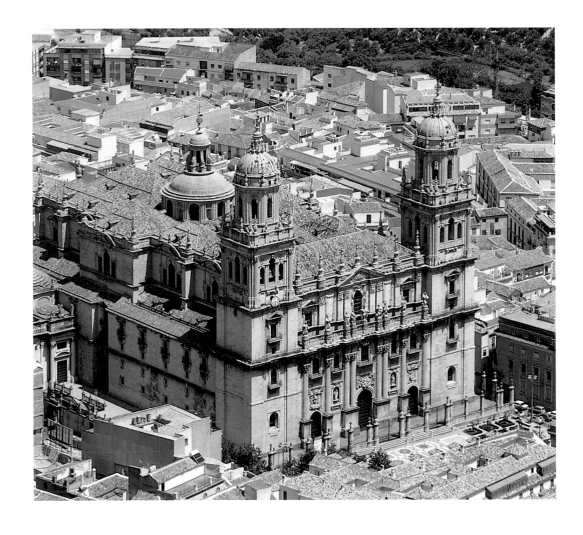

LÓPEZ DE ROJAS (architect) & PEDRO ROLDÁN (sculptor): Jaén Cathedral facade; 1694

with sacraria and shrine niches, such frontispieces reached their zenith the following century, particularly in Catalonia.

A unique feature introduced at that time was the false dome. Of French origin, it was based on Philibert de L'Orme's treatises on carpentry and consisted of a false cupola with plaster intrados suspended from a wooden structure concealed by a spherical extrados, which took the form of a dome or slate spire. These domes were described by Lorenzo de San Nicolás in his aforementioned treatise and widely used as they were economical and, as Bonet Correa pointed out, 'particularly owing to prevailing architectural tastes, as the form of the interior did not in any way correspond to that of the exterior'.

The spire was a common urban feature in 17th-century Madrid. Of Flemish origin, it consisted of a highly elongated, pyramidal wooden structure covered with slate and linked to a false dome. It was widely used to surmount flanking towers by Gómez de Mora and court architects of the time.

A feature peculiar to the Spanish style was the addition of belltowers flanking church facades, while in monastic churches bells were usually lodged in traditional bell gables. To reduce costs, occasionally only one tower was erected out of two in the original design project. This feature broke with Italian models, which lacked such elements—with the exception of Agnese in Piazza Navona, Rome—and linked up with the Gothic tradition, as did 18th-century Central European architecture.

Lastly, another characteristically Spanish creation was the imperial staircase, used in both civic and religious buildings. It usually consisted of a single flight of stairs leading up to a landing, after which it divided into two ramps. This architectural feature became extremely widespread in Spanish America, and in European architecture, particularly that of Genoa and Venice.

The materials used in Spanish Baroque architecture varied according to geographic location and time. Stone was originally used, but it was later replaced by the more eco-

Plan of the chapel of Nuestra Señora de los Desamparados, Valencia.

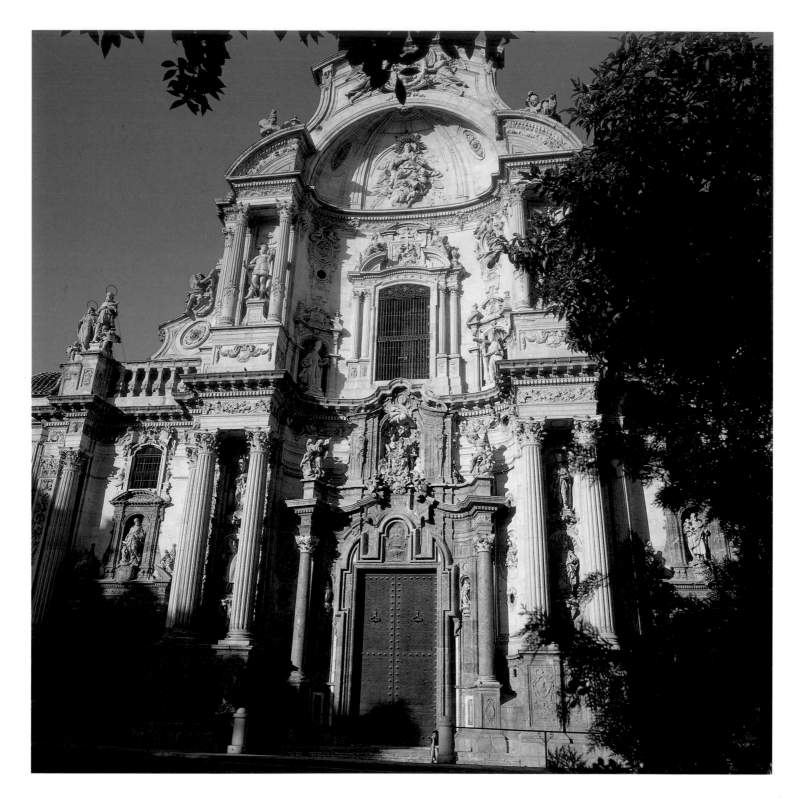

JAIME BORT MELIÀ: Murcia Cathedral facade; 1736–1754.

nomical brick. In Madrid, the use of granite from Colmenar, as well as brick and slate on roofs, yielded a rather unusual type of architecture. In Barcelona, stone from Montjuïc hill was used, in addition to marble from Tarragonan quarries. In Andalusia, prevalent was the use of stone and mock materials, primarily plaster-covered brick. Stucco, a traditionally Hispanic material, was used for all types of moulding and lush decoration. Expensive materials, reserved for major works, included marble and jasper, used on the walls of the Pantheon of the Kings at El Escorial, and on the octagonal tower at Toledo Cathedral. It was also common throughout the century to use materials imitating stucco and hard stone.

The colouristic and visual sense of architectural interiors was rounded off by the use of major fresco decoration and large altarpieces. Ceramics were also frequently applied to

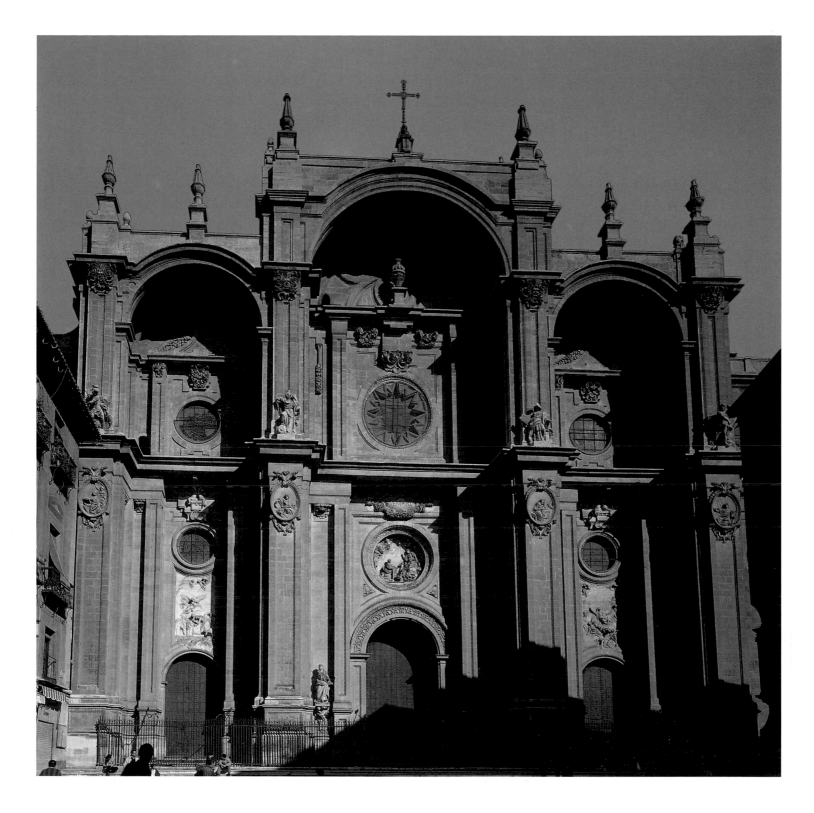

the walls of hospitals, convents and private homes for reasons of both hygiene and insulation. In the Levant and Andalusia, ceramic was used abundantly as an art material.

Lastly, there was a characteristic type of Spanish Baroque facade with marked vertical stress, a gable and a triple-arcaded entrance, as in the church of the Encarnación in Madrid, by Gómez de Mora. It has its forerunner in the church of San José de Lerma, by Francisco de Mora. Another unusual feature was the box-shaped ground plan of the church of El Sagrario in Seville Cathedral, begun by Miguel de Zumárraga and completed by Juan de Oviedo. Other peculiarities included the endurance of Gothic spatial arrangements, as evinced in the three-naved church of San Nicolás de Bari, in Alicante, with an ambulatory, the 18th-century New Cathedral in Lleida, and the importance attached to large reception

ALONSO CANO (architect),
DUQUE CORNEJO & JOSÉ RISUEÑO
(sculptors): Granada Cathedral facade;
1667.

311

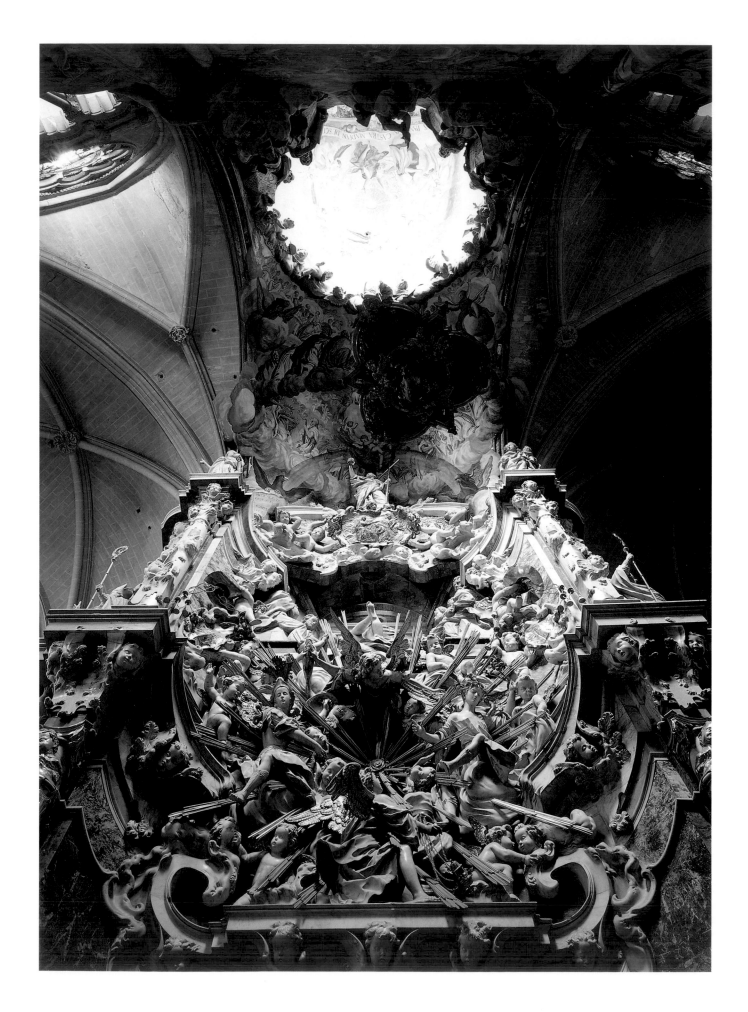

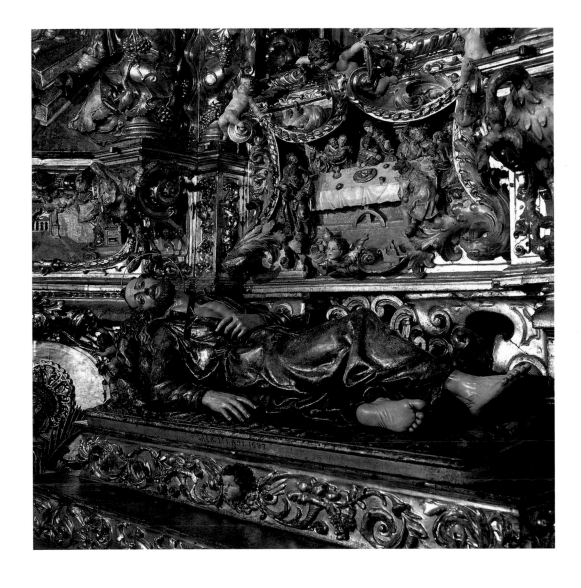

ANDREU SALA: *St Francis Xavier Reclining;* 1687. Barcelona Cathedral; retable of St Paciano y St Francis Xavier.

halls, as the one in Granada Cathedral, designed by Alonso Cano, or the magnificent facade of Murcia Cathedral, by Jaime Bort.

To end, the most decorative examples include the facade of the Hospice of Madrid—now the Municipal Museum—by Pedro de Ribera, a veritable master of ornateness bordering on paroxysm, and the magnificent *Transparent* in Toledo Cathedral, by Narciso Tomé. Together with the work of Churriguera, they are representative of the 18th-century decorative Baroque. Incidentally, the derogatory term *Churrigueresque* is a misnomer, as these works should, strictly speaking, be termed *Riberesque*.

The Originality of Baroque Sculpture

Unlike other genres, Spanish Baroque sculpture borrowed comparatively little from abroad. Noteworthy influences, however, include that of Neapolitan nativity scenes, and Bernini's theatrical sense and sensuality, which come through in the work of the Catalan, Andreu Sala, at the end of the 17th century. A worthy successor of the latter was Carlos Salas, who sculpted the reliefs in the Santa Tecla chapel in Tarragona Cathedral. Another is the design, by Pere Costa, for the presbytery in Girona Cathedral, which never saw the light.

The great mainstay of Spanish Baroque sculpture was religious imagery, particularly in polychromed wood. Virtually all workshops, schools and craftsmen produced unique pieces in their own original styles, with very few stylistic borrowings. An exception to this was *St Jerome,* by Martínez Montañés, indebted to the work of the same name by the Italian sculptor, Pietro Torrigiano.

NARCISO TOMÉ: *Transparent:* 1721–1732. Ambulatory of Toledo Cathedral.

The *Transparent,* in Toledo Cathedral, with its essential interplay of theatrical sense, free composition, polychromy and a fusion of all the arts, marks the zenith of the Castilian Baroque. As in Bernini's *Baldacchino* and *Cathedra Petri,* both in St Peter's, Rome, it is difficult to tell whether this work is primarily architectural or sculptural, or even a stage setting. Whatever the case, in the *Transparent,* ostentation becomes subordinate to the exaltation of the Holy Sacrament, the realistic apparition of which is achieved, in the Gothic ambulatory and the high altar, through a system of concealed skylights. In 17th-century Spain, Baroque chapels and altarpieces dedicated to the body of Christ are unequivocal signs of the Counter-Reformation.

Here, it would be in order to analyse Spanish sculpture of the 17th and 18th century in terms of the different production centres, the features peculiar to some of these, and the leading exponents.

The production of Court circles did not adhere to the mainstream subject matter in Baroque sculpture, that is, religious imagery, instead relying on portraiture and mythology associated with the monarchy. Most Court sculptors were foreigners, chiefly Italians. The late-Mannerist influence of Pompeo Leoni (circa 1533–1608) became prevalent in major funerary works, such as the praying figures of the Dukes of Lerma, cast in bronze. His followers were Giraldo da Merlo, Juan Antonio Ceruti, Rutilio Gaci, and Ludovico Turqui. These last two, in collaboration with the Catalan sculptor, Antonio Juan Riera, executed the fountain in the Puerta del Sol at Madrid, an allegorical ensemble centred around the figure of *Mariblanca,* a popular symbol of faith. However, the Madrilenian sculptural school was soon to adopt the tradition of religious imagery, as the Court tended to favour painting for its propaganda. Within the mediocre production that characterised Court circles, the only prominent figures were the Portuguese, Manuel Pereira (1588–1683), a faithful recorder of religious asceticism and mysticism, as evinced in his *St Bruno,* and Juan Sánchez Barba (1615–1670), a Baroque formalist.

Spanish Baroque sculpture is characterised by five major schools: those of Valladolid, Seville, Granada, Catalonia and Murcia. Prominent in the Valladolid school was the great Gregorio Fernández (circa 1576–1636), an artificer of religious imagery who evolved from late-Mannerist forms, in his early works, to eminently Baroque ones, such as the processional float of the *Deposition* (1624), in the church of Vera Cruz, Valladolid. He is also noted for a

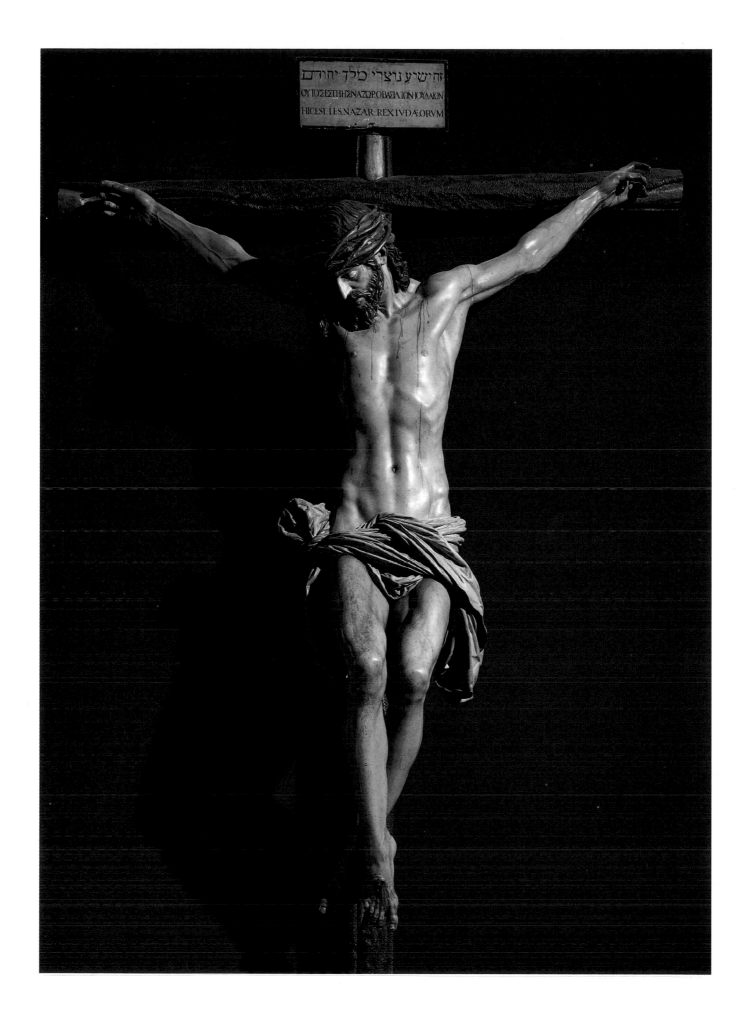

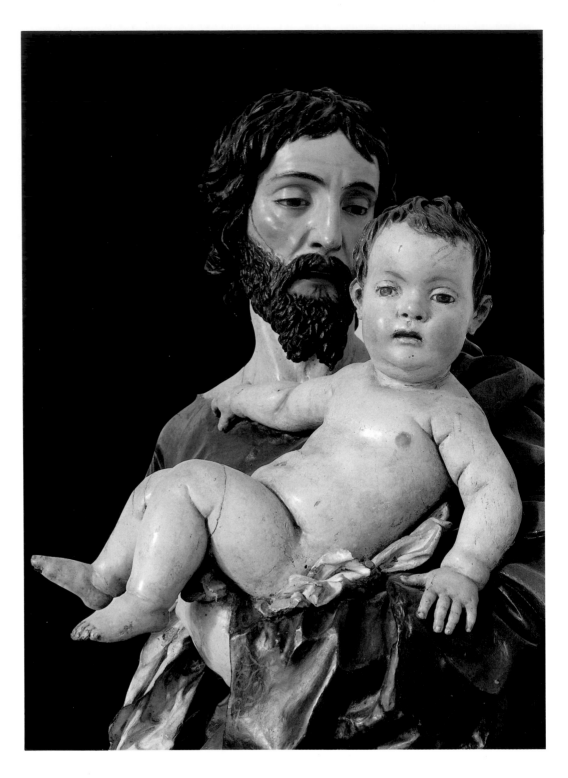

number of extremely life-like ensembles, particularly his *Reclining Christs,* one of which was commissioned by Philip III for the Capuchin church of El Pardo in 1614, and a *Pietà,* commissioned for the Augustinian monastery in 1617.

The early period of the Seville school was dominated by Juan Martínez Montañés (1568–1649), whose career paralleled that of his contemporary, Gregorio Fernández. From Mannerist beginnings, as in his aforementioned *St Jerome* (1600) and his masterly *Christ of the Chalices* (1603), inspired by Michelangelo (now in Seville Cathedral), his work took on a 'didactic realism' facilitated by a number of commissions for the Jesuits, such as *St Ignatius* (1609), *St Francis Xavier* (1619) and *St Francis Borgia* (1624), to commemorate their beatifications. The great *Retable of Santiponce* (1611–1614), rich in iconography, marks the peak of his middle period, which also included the magnificent wooden sculpture, *The Passion of Jesus.* The zenith of his career, by which time his work was formally Baroque, is exemplified

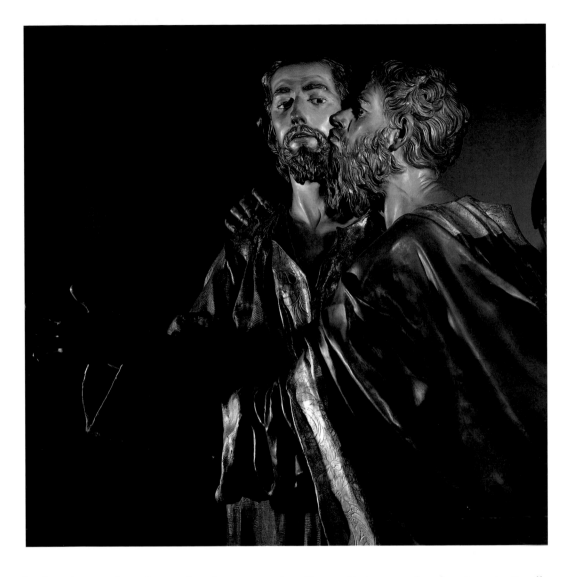

FRANCISCO SALZILLO: *The Arrest of Christ* or *The Kiss of Judas;* 1763. Church of Jesús, Murcia.

Following page:

JOSÉ RIBERA: *Death of Adonis;* 1637. Oil on canvas, 179 x 262 cm. Galleria Nazionale d'Arte Antica, Palazzo Corsini, Rome.

This work by José Ribera, signed and dated 1637, reveals the stylistic change he underwent during the period 1630–1640. Like his *Apollo & Marsyas,* the composition is divided into two distinct areas: the fallen body of Adonis—with its anatomy, facial features, hands, hair and flesh tones—is characteristic of the artist's early period, tinged with an invariably sober and sometimes even morbid naturalism, while the image of Venus—with her beautiful countenance—reveals aesthetic highlights which would become consolidated and more frequent in his subsequent work. The juxtaposition of the two areas in the same painting generates a dramatic tension expressed in the marked diagonal stress, as in the purest Baroque painting of Rubens or Van Dyck.

by his *Immaculate Conception,* known as the *Cieguecita* by popular devotion, in Seville Cathedral, which is striking for the smooth movement of the figure and the garment folds. Martínez Montañés' fame took him to Madrid, where he executed a bust of Philip IV, now in the Plaza de Oriente, cast in bronze by the Italian, Pietro Tacca. His immediate successor was Juan de Mesa (1583–1627), artificer of the imposing *Jesus of the Great Power* (1620).

Prominent sculptors of the last three decades of the century were Pedro Roldán (circa 1624–1699) and his daughter Luisa, known as 'La Roldana' (1656–1704), whose Baroque approach was crowned by Pedro Duque Cornejo (1678–1757) in the 18th century. The leading figure in Granada was Alonso Cano (1601–1667), whose style was one of formal classicism with marked expressive containment and radiant asceticism. His effigies of the *Immaculate Conception,* including a noteworthy example in the sacristy of Granada Cathedral (1655), became an archetype of female beauty, midway between reality and idealism. Alonso Cano reinforced a number of conceptually Baroque hagiographic subjects, his culminating work being the busts of *Adam and Eve* in Granada Cathedral. They are veritable paradigms of serene perfection and iconographic rareness. More Baroque still was his disciple, Pedro de Mena (1628–1688), whose *Dolorosas* ('Virgins of Sorrow') and *Magdalenas* ('Mary Magdalenes') were more expressive and dramatic than those of his master. The transition to the 18th century saw such outstanding sculptors as the brothers José de Mora (1642–1724) and Diego de Mora (1658–1729), in addition to José Risueño (1655–1732), who was to become the leading sculptor of religious imagery in 18th-century Granada.

Catalonia was distinguished for its retable sculpture, initiated in the early-17th century by Agustí Pujol (circa 1585–1624). He was succeeded by the Tramulles brothers, the Gran family, Andreu Sala, Pau Costa (1672–circa 1727) and Pere Costa, Josep Sunyer (d. 1751) and Carlos Salas (1728–1780), these last three wholly within the 18th century. The leading figure

in Murcia was Francisco Salzillo (1707–1783), the last exponent of Baroque asceticism and mysticism, as seen in his abundant figures of saints and amazing processional floats for Holy Week, notably *The Agony in the Garden* (1752), *The Fall* (1752), *The Supper* (1778), *Veronica* (1754) and *La Dolorosa* (1755), in addition to the approximately nine hundred nativity figures commissioned by Jesualdo Riquelme for the Cofradía de Jesús guild in Murcia.

Painting: Foreign Identity and Influences

A dependence on foreign models was prevalent in Spanish Baroque painting, despite a number of characteristic features that would rank it among the finest Baroque painting in Europe, particularly in the 17th century.

Italian influences were initially the legacy of Italian painters summoned by Philip II to work at El Escorial during the 16th century. Late-16th-century and early-17th-century Spanish artists adopted the markedly Tenebrist naturalism of their Italian counterparts, as in the work of the Catalan, Ribalta, the Sevillian, Roelas, and the Murcian, Orrente. However, a form of renewed Mannerism, which evolved into proto-Baroque, was consolidated in the

CLAUDIO COELLO: *The Holy Form;* 1685–1690. Oil on canvas, approx. 500 x 300 cm. Monastery of San Lorenzo de El Escorial, (sacristy).

PAINTING IN THE 17TH CENTURY: FROM NATURALISM TO THE BAROQUE

Spanish Baroque painting during the 17th century evolved from what is termed late-Mannerism or 'reformed Mannerism' during the reign of Philip III (1599–1621), through a period of great wealth and stylistic variety during the reign of Philip IV (1621–1665), to formal, conceptual Baroque under Charles II (1665–1700). An important factor in this respect is the great diversity of styles and, on occasion, of individual tendencies, which would be difficult to categorise.

Styles varied between two clearly defined trends under Philip III: reformed Mannerism and naturalism or realism. The Court attracted a number of artists, most of whom were indebted to the formulations of the late-16th century, dominated by the Italian group in the employ of Philip II. Painting likewise owed much to Mannerist forms, apparent in the work of such Court artists as Bartolomé Carducho (1560–1608), Vicente Carducho (1576–1638) and Eugenio Caxés (1574–1634). Other schools whose importance endured included the Toledan school of painting, imbued with the spirit of El Greco (who was active until his death in 1614). It featured such painters as Tristán (circa 1585–1634), and the Murcian Pedro Orrente (1580–1645), a follower of the Venetian forms of the Bassanos.

This initial period drew to a close with the schools of Seville and Valencia. Seville, as well as being a major commercial centre, had a brilliant artistic background, particularly in the pictorial field. The figures of Francisco Pacheco, Juan de las Roelas and Francisco Herrera the Elder were paramount during this period, which owed much to the northern realism of Pedro de Campania and Leonardo Esturmio. However, it was Diego Velázquez that adopted this realistic line most whole-heartedly.

A major pictorial school took root in Valencia, with the Catalan Francisco Ribalta (1565–1628). In his early period he was influenced by the Mannerists active at El Escorial, as evinced in his *Christ Nailed to the Cross* (1582, Hermitage, St Petersburg). He later acquired a naturalistic, tenebrist chiaroscuro charged with character, as in *St Bernard Embracing Christ* (1622, Prado, Madrid). His son, Juan (1597–1628), who died young, was an excellent painter who would have outshone his father, judging from his *St John the Baptist* (1627, Museo de Bellas Artes, Valencia).

The reign of Philip IV coincided with the great pictorial generation, also known as the 'generation of 1600', as most of these artists were born around the turn of the century. The exponents of this period were mainly active in the Court, in Seville and Granada, and in Naples. The Court attracted the leading artists, who either settled there or painted there sporadically, as in the case of Diego Velázquez.

Seville produced a painter with marked personality: Francisco de Zurbarán (1598–1664). His most characteristic works are those featuring only one figure, which he stressed through concise brushstrokes with a variety of nuances. Just one work—his formidable *St Serapion* (Wadsworth Atheneum, Hartford), painted for the *De profundiis* hall in the Mercedarian convent of la Calzada, Seville—makes him one of the great painters of 17th-century Europe.

The art milieu in Granada centred around the figure of Alonso Cano (1601–1667). Through his painting he sought classical ideals, as in *Christ Supported by an Angel* (Prado), a serene, triangular composition.

This period under Philip IV was seen out by the great José de Ribera (1591–1652). Born in Valencia, he moved to Italy at an early age. Although strongly influenced by the tenebrist naturalism of Caravaggio, his style was distinguished from the latter's by a certain heightening of reality and a search for the qualities of objects. From 1630, his work evolved towards increasingly more luminous compositions, which he achieved with a pasty, highly pictorial brushstroke. His realistic vision was always countered by an aesthetic sense, sometimes in the same work, like the precious boy who contrasts with the coarse *Portrait of a Bearded Woman* (Hospital Tavera, Toledo), produced on the whim of the Duke of Alcalá, or his various depictions of Mary Magdalene, which feature stunningly beautiful models, as opposed to the bare realism of *The Clubfooted Boy* (Louvre, Paris).

The reign of Charles II saw the triumph of the Baroque in an all-embracing sense, both formally and conceptually, Seville and the Court being practically the only noteworthy production centres.

After the death of Velázquez, Court painting centred around the figure of Juan Carreño de Miranda (1614–1685), Francisco Ricci (1614–1685) and Claudio Coello (1642–1692). Juan Carreño de Miranda was first and foremost a portrait painter. He was active at the Court as from 1669, the year in which he was appointed 'painter of the king' by the regent, Mariana of Austria. His portraits of the queen and the monarch are masterpieces of psychological portrayal and Baroque composition. His major achievement is undoubtedly the superb *Charles II and the Golden Fleece* (1677, Harrach Collection, Vienna), a symbiosis of Venetian and Flemish styles.

This same dual influence was active in Francisco Ricci, who painted mainly religious scenes, while Claudio Coello was the most fitting successor to Velázquez, to whom he owed some of his style, although his technique was more vaporous. Coello stands out primarily for his spatial conception, as in the eminently Baroque *Adoration of the Eucharist,* in the sacristy at El Escorial.

Francisco Herrera the Younger (1622–1685) stands midway between the Court and the Seville school. His Baroque leanings stemmed from his exposure to the work of Pietro da Cortona during a sojourn in Rome. His *Triumphs* or *Apotheoses* summarise the turn-of-century Baroque spirit, as in *The Triumph of St Hermenegild* (1654, Prado, Madrid) or the *Triumph of the Eucharist* (1655, Seville Cathedral).

Seville became an important art centre with the rise of Bartolomé Esteban Murillo (1618–1682) and Juan Valdés Leal (1622–1690), who were conceptual opposites. Murillo might be described as a painter of affable subjects, were that not in any way derogatory, while Valdés Leal tended to what might be termed the 'aesthetic of ugliness'. Murillo painted a number of themes, including religious scenes, genre and portraiture, and evolved from forms indebted to chiaroscuro naturalism to a vaporous art, apparent in his *Immaculate Conceptions* with their suave Baroque elegance. Valdés Leal was more impulsive, with inconsistencies in quality, but with wholly Baroque strength of brushstroke and compositional complexity. His *Sarracen Assault on the Monastery of Santo Domingo de Asís* reveals a fervour comparable only to Rubens, and admirably reflects the violent conceptualisation and *terribilità* of his style.

BARTOLOMÉ ESTEBAN MURILLO:
The Angel's Kitchen; *1646.*
Oil on canvas, 180 x 450 cm.
Louvre., Paris

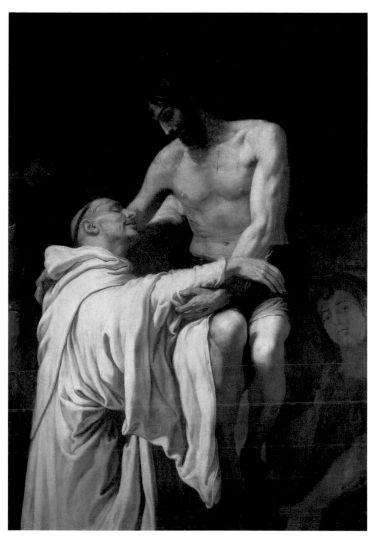

FRANCISCO RIBALTA: St Bernard Embracing Christ; *1622.*
Oil on canvas, 158 x 113 cm. Prado, Madrid.

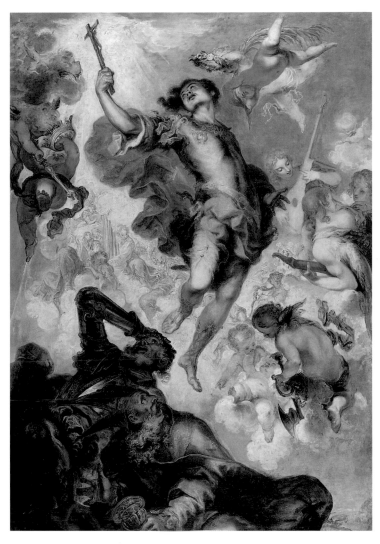

FRANCISCO DE HERRERA THE YOUNGER: The Triumph of St Hermenegild;
1654. Oil on canvas, 328 x 229 cm. Prado, Madrid.

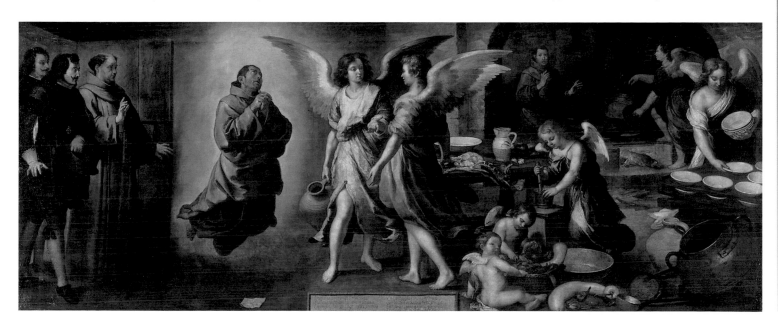

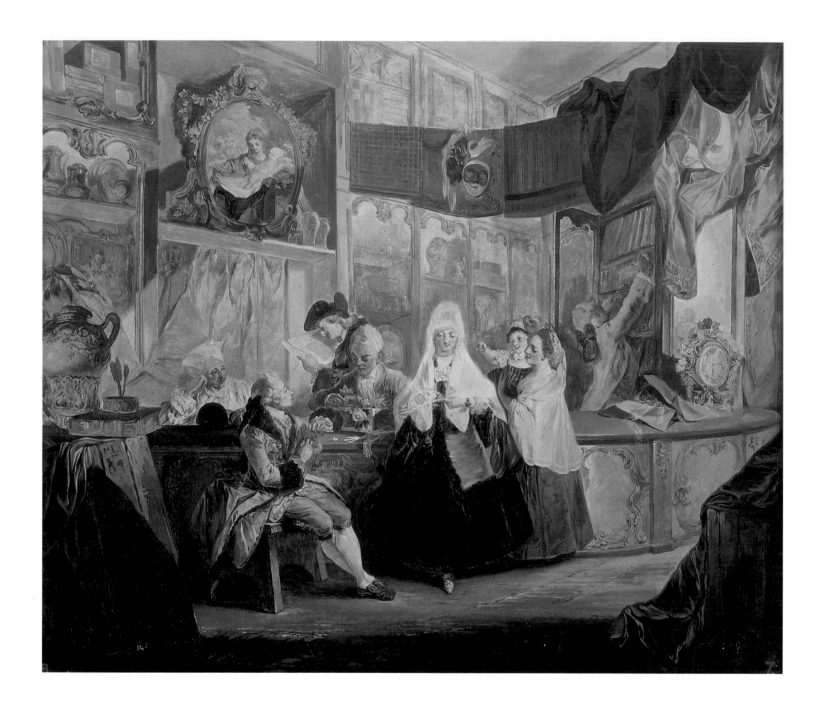

work of the Italian Bartolomé Carducho, and his immediate followers, Vicente Carducho
and Eugenio Caxés, while Tristán was a subdued pupil of El Greco's. The ascendancy of
Caravaggism and the classicist precedents of the Carraccis found their leading expression in
Spain in the figure of Juan Bautista Maíno, and their leading exponent in José de Ribera,
active in Naples. Conscious Italianism or Italianate overtones are apparent in the first 17th-
century generation: Velázquez, Zurbarán, Juan Ribalta, Jacinto Jerónimo Espinosa, Fray Juan
Rizi and Alonso Cano. The latter restored the paintings damaged in a fire that gutted the
Palace of El Buen Retiro in 1640, where he became familiar with the style of the Roman,
Neapolitan and Lombard artists.

Initially, engravings were also used as models for painting compositions, including
mediocre ones. Engravings by Dürer, Marcantonio Raimondi, Cornelis Cort and Raphael
Sadeler yielded a formal repertoire followed by Zurbarán, Cano, Carducho and other mas-
ters to varying degrees of success. The influence of Italian works, occasionally interpreted
by Flemish engravers, was augmented in the mid-17th century by that of Flemish masters,
particularly Rubens. His work was known from prints, copper reproductions and even
directly. A fact which is crucial to an understanding of Spanish painting under Charles II

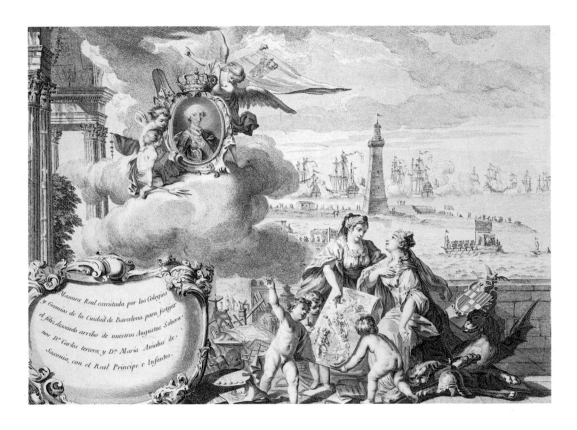

FRANCESC TRAMULLES I ROIG (draughtsman) and J.A. DE FEHRT (engraver): *Cover for 'Máscara Real';* 1769. Etching, 41.5 x 53.6 cm. Engravings Department, Biblioteca Nacional de Catalunya, Barcelona.

During the Baroque period, engravings became a popular medium for conveying culture. A form of artistic creation and pastime, they were also used as a documentary source. To mark the arrival in Spain of Charles III, all the guilds, egged on by the captain general, the Marquis of Mina, took part in a celebrated cavalcade known as the *Máscara Real.* All the events held in his honour were commemorated in an album containing 24 engravings and a profusion of ornamental motifs, a veritable gem of 18th-century graphics. The cover features two female figures, whose attributes symbolise the arts and industry.

was the copies that Rubens made of Titian's work during his second sojourn in Spain in 1628. The dual, Flemish and Venetian, influence was prevalent in most compositions by the strictly Baroque painters. At Court, these were Claudio Coello, Francisco Rizzi, Francisco Herrera the Younger and Carreño de Miranda. In Seville, Murillo and Valdés Leal, and in Valencia, Miquel March. At the end of the century, Italian Baroque decorative styles were introduced into Spain by Luca Giordano, whose work influenced the painter and essayist, Palomino. The change of dynasty in the 18th century ushered in French styles, as in the work of Paret y Alcázar, a disciple of La Traverse.

Full of character, 17th-century Spanish painting developed in this context of pictorial references. The work of some leading artists was highly personal, although with overtones of foreign influences. Diego Velázquez, for example, was unique, but his oeuvre does show the influence of older masters and even contemporaries, which might be defined as a form of 'cultural interference'. He was familiar with the plastic tradition of 16th-century humanism, but he was also a man of his time. Velázquez assembled a large amount of information, which he assimilated and refined. He studied different approaches, models and attitudes, all of which were incorporated into his art and updated. This compilation of information, and a stance contrary to the decadence and affectation of the plastic arts in the last quarter of the 17th century, were shared by a number of artists, bearing out the existence of cultural coincidence as translated into stylistic similarities.

Other painters with a markedly personal style were Zurbarán, Cano, Murillo and Valdés Leal, who captured the essence of 17th-century Hispanic pictorial art: Zurbarán, with his almost totemic depictions; Cano, with a classical spirit; Murillo, with his ethereal style, and Valdés Leal, with a searing and even overbearing forcefulness.

In contrast, the 18th century saw little in the way of pictorial originality, with the exception of the aforementioned Luis Paret y Alcázar, and the still-life painter, Luis Meléndez, who brought to an end the cycle of realistic still-life portrayal.

Drawing and Engraving

Engravings became a popular art form during the Baroque. Being readily portable and allowing a large number of copies of a work to be made, they were used by artists as graphic models for their pictorial and sculptural compositions. In some instances, they built up a veritable repertoire of such prints, most of which were 17th-century Flemish or 16th-century Italian. Originals were more highly valued at the time than reproductions, even more so than at the present time.

Drawings were very popular during the 17th century. Most of them have not survived to the present, owing to their fragility and the fact that they were not much sought after by art collectors. Moreover, they were often used merely as preparatory designs or studies for a larger composition. Those which have survived the test of time, however, are valuable in that they reveal the working methods of the period. Similarly, preparatory sketches for sculptured retables were submitted to a patron for his approval before embarking on the actual commission.

Lastly, engravings served two purposes: they were either original artworks in their own right, or reproductions of pictorial or sculptural works. However, most engravings were actually used in connection with printed text. Woodcuts and the various kinds of intaglio (on metal), such as etching, were common techniques. Loose prints, most of them of the work of foreign artists, helped to publicise their work and disseminate a new compositional style.

During the first three decades of the 17th century, prints of this kind were made by Flemish artists such as Diego de Astor, Cornelius Boel and Jan Schorquens, and the Frenchman Jean de Courbes and, subsequently, Jan de Noort and Pedreo Perete. Prominent among the Spanish engravers were Pedro de Vilafranca, Marcos de Orozco and Diego de Obregón, although they were also surpassed by the Valencian José de Ribera, who was active mainly in Naples, and the Sevillians Francisco de Herrera the Elder and Matías de Arteaga.

The outstanding engravers of the 18th century were Hipólito Rovira, Matías de Yrala and Juan Bernabé Palomino, who prefigured the great generation of Enlightenment engravers that were active during the reign of Charles III.

The Decorative Arts

Decorative objects should be studied in relation to the setting they are displayed in, be it a church or a private home and, in particular, as essential ingredients in the *modus vivendi* of 17th-century society. Inventories taken of the possessions of a deceased are useful in building up a picture of how people lived during a particular period, as this cannot be accurately gleaned from paintings alone, given that they never provide more than a restricted view of life, generally depicting merely Court lifestyles. Moreover, there was no genre painting to speak of in 17th-century Spain. In some cases, pinpointing the time when items such as furniture, hangings, glass and ceramic objects were used can prove to be an impossible task.

Although the decorative arts in Baroque Spain never reached the heights of the Gobelins in France, they do include some noteworthy ensembles. Wrought-iron was one area developed to notable standards. It furthered a tradition that had begun during the 16th century, as in the magnificent grillework by Juan Bautista Celma in the cathedrals of Burgos and Palencia, as well as the production of Bautista Rodríguez and Sebastián Conde in Seville.

Other noteworthy areas include armoury, goldsmithery and silversmithery, in which the leading craftsmen included Gaspar Arandas, in Tarragona, Rafael González, in Toledo, and Buenaventura Fornaguera and Juan Matons in Barcelona. The latter's elaborate candelabra in Majorca Cathedral are masterpieces in this genre.

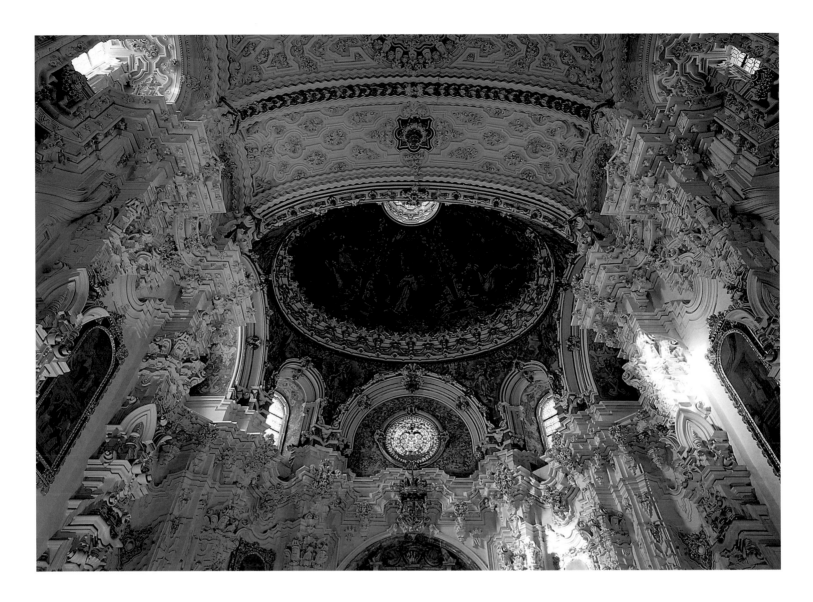

This brief account should also take into account furniture and the celebrated ceramics of Talavera. Characteristic of the Baroque period were pieces of furniture worked with a lathe, and the introduction of leather for chair seats and backs. Strangely enough, Spanish Baroque furniture was instrumental in fostering restraint throughout the decorative arts, in the name of Hispanic austerity, betrayed only by the ornamental luxury in some retables sculpted in wood.

The Major Subjects

A thematic study of the plastic arts should take into account specificity and visual appearance. Indeed, the great cultural expressions of the Hispanic 17th century were eminently visual. The powers that be, that is, Church and monarchy, publicised their message through theatre, the plastic arts and public celebrations. Furthermore, it should be recalled that artists often had their work made known to the public through engravings and the art trade.

The eminently visual character of the Baroque was exploited at public festivities as the ideal vehicle for transmitting an image of authority. The *fiesta* was summarised by Bonet Correa in the following terms: superlative, crowds, fun, popular response, tumult, repression, acclaim and panegyric, symbolic character and urban character. It should also be stressed that history and allegory were used to mythicise religion or the figure of the monarch.

FRANCISCO HURTADO IZQUIERDO (design): sacristy in the Charterhouse of Granada; 1713 & 1725–1764.

The Charterhouse of Granada is unsurpassed in beauty and substance, and the sacristy, built like a small church, displays the decorative wealth of the Andalusian Baroque. Its strapwork and *ataurique* plant motifs rendered in stucco hark back to the Hispano–Arab tradition. The images of the Virgin Mary and St Bruno at the altar, and the five hermit saints on the cupola, respond to the Marian and eucharistic theme of the Charterhouse, in which the principles of the Catholic faith, monastic life and the way of the hermit are interrelated. Some authors, including Alonso Ceballos, attribute the conceptual theme of this work to the painter and theoretician, Antonio Palomino.

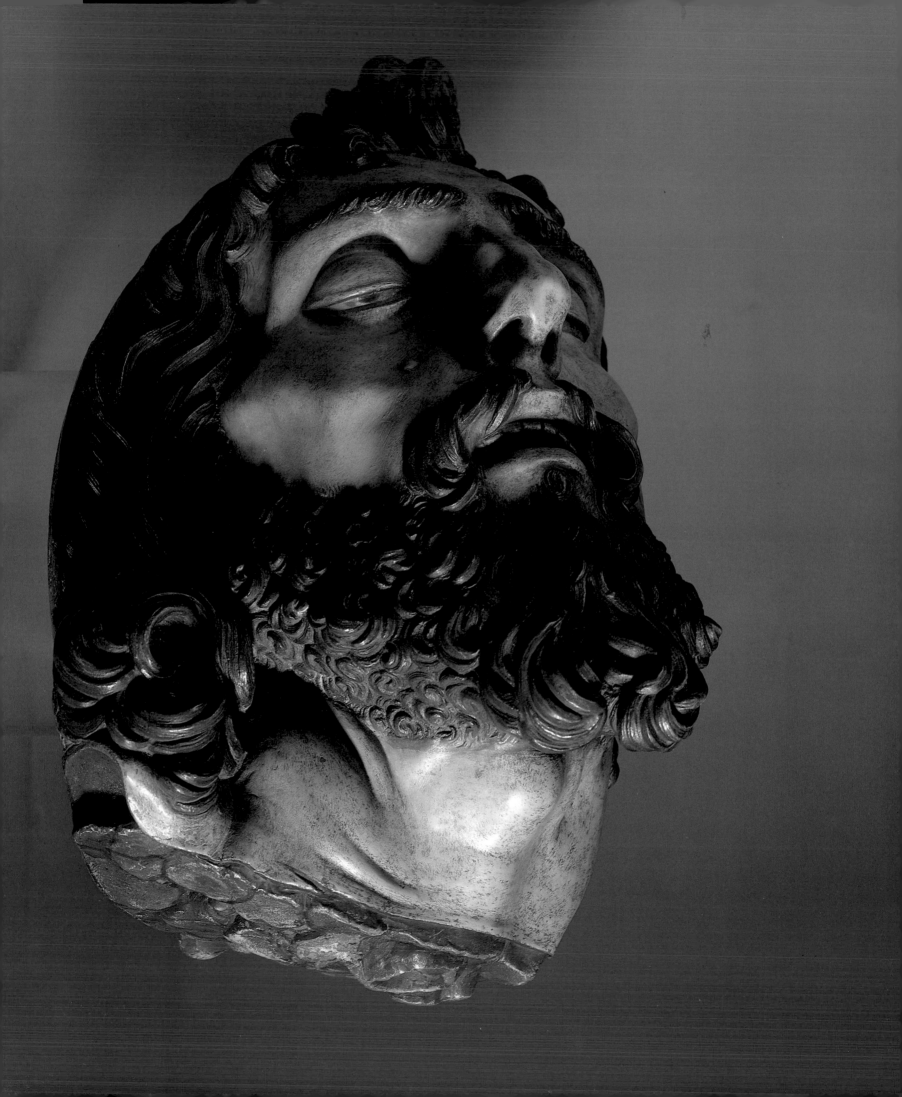

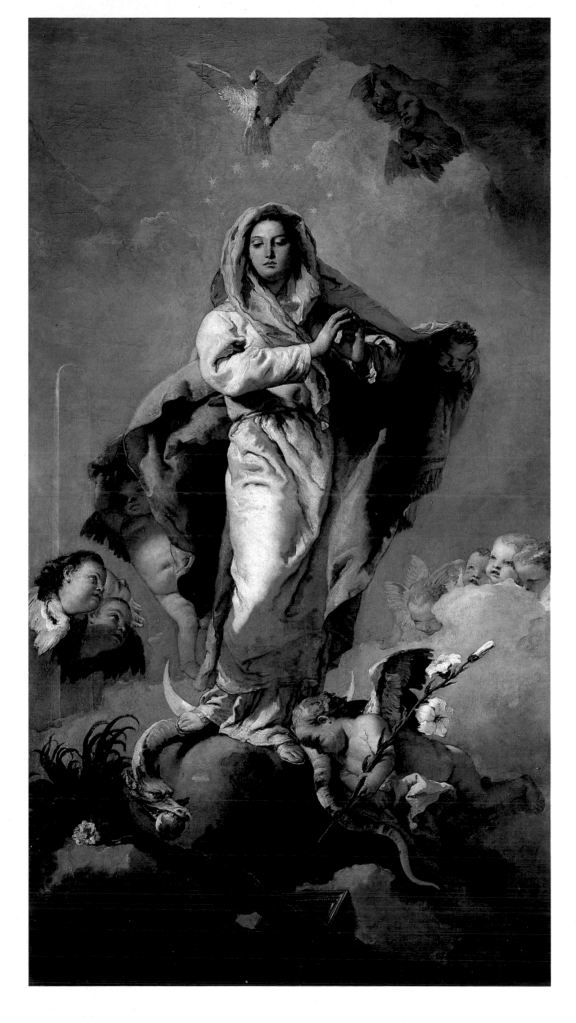

GIAMBATTISTA TIEPOLO: *Immaculate Conception;* 1769. Oil on canvas, 279 x 152 cm. Prado, Madrid.

JUAN DE MESA: *Head of St John the Baptist;* first three decades of the 17th century. From the Convent of Santa Clara in Seville. Museo de Bellas Artes, Seville.

History and allegory were at the heart of iconographic programmes in Court circles (Hall of Realms), hospitals (Hospital de la Caridad) and monasteries (Guadalupe and the Charterhouse of Granada). They were used to successfully convey the magnitude of royal power and of the supremacy of virtues such as charity and the clerical abnegation of worldly things. The message was brought home most forcefully in pictorial art. The great Baroque retables, dedicated to the Passion of Christ or the Virgin Mary in all her local and universal invocations—the Immaculate Conception, the Virgin of the Rosary, and so forth—are noteworthy examples. Others include large, painted altarpieces, of a marked scenographic character, Holy Week processional floats, with life-like action scenes, history paintings—reinforcers of power—portraits which stressed certain qualities in a monarch, and a long list of other pictorial variations.

Religious Subjects

Religious themes dominated painting and, above all, sculpture, throughout the 17th century and for much of the 18th. Subjects included references to passages in the New Testament, with the accent on the mysteries of Christ's Joy, Passion and Glory. The Annunciation, the Visitation, the Birth of Christ, the Adoration of the Magi and the Presentation in the Temple were rendered time and again, particularly in retables dedicated to the Virgin of the Rosary, an invocation actively supported by the Dominicans, who were opposed to worship of the Immaculate Conception. The list of painters and sculptors who executed these subjects is endless. However, it is worth mentioning the profusion of sculpted retables produced in Catalonia, particularly those by Agustí Pujol, with such works as *El Roser,* in both Barcelona Cathedral and the church of Sant Vicenç de Sarrià, dating from 1619. The Passion of Christ was the main subject of Holy Week processional floats in Valladolid, Seville and Murcia, the leading exponents of this genre being Gregorio Fernández, Martínez Montañés and Salzillo.

Apart from the so-called mysteries, paintings often dealt with episodes from the life of Christ and the Virgin Mary, most of them related to the Eucharist, such as the Wedding Feast at Cana and the Last Supper. Subjects from the Old Testament were chosen in terms of their relationship to the New Testament, as in the work of Orrente—*Rebecca at the Well,* (Museo de Arte Antiga, Lisbon), a forerunner of *The Annunciation*—and Murillo's *Laban Searching for his Household Gods in Jacob's Hut* (circa 1660, the Cleveland Museum of Art), clearly alluding to the tribulations endured by Christ's servants. Others were chosen to emphasize certain virtues, such as God's love for man, which comes out in Murillo's *Moses Striking the Rock* (1673, Hospital de la Caridad, Seville). The Immaculate Conception was a favourite among both painters and sculptors. The subject was profusely depicted by many artists, from Ribera to Murillo, through Zurbarán and Alonso Cano. Retables, in particular, featured Marian subjects, while the figure of St Joseph grew in popularity, to the point that, in some compositions, he steals the limelight from the Virgin Mary, as Murillo expressed so beautifully in *The Holy Family of the Little Bird* (circa 1650, Prado).

The Counter-Reformation and the attendant rise in saint worship led to a flood of hagiographic subjects in retables, in which saints were portrayed as an example to be followed. It is in these compositions that Weisbach's postulates regarding the Counter-Reformation were most successfully applied. That is, most of the works executed early in the century were tinged with asceticism, heroism, eroticism and cruelty. Bearing in mind the precedent set by El Greco's paintings of St Francis at the beginning of the century, the Toledan school (represented by Pedro Orrente and Luis Tristán), the Madrid school (Vicente Carducho and Angelo Nardi), the Sevillian school (Juan de las Roelas and Juan Martínez Montañés), the Valencian school (Ribalta), the Neapolitan school (José de Ribera) and that of Valladolid (Gregorio Fernández), provide a variety of depictions of ecstacy, martyrdom, asceticism and mystical embraces. At about that time a mainstream Counter-Reformation subject emerged: that of the apotheosis of the saints, partly replacing those of the Ascen-

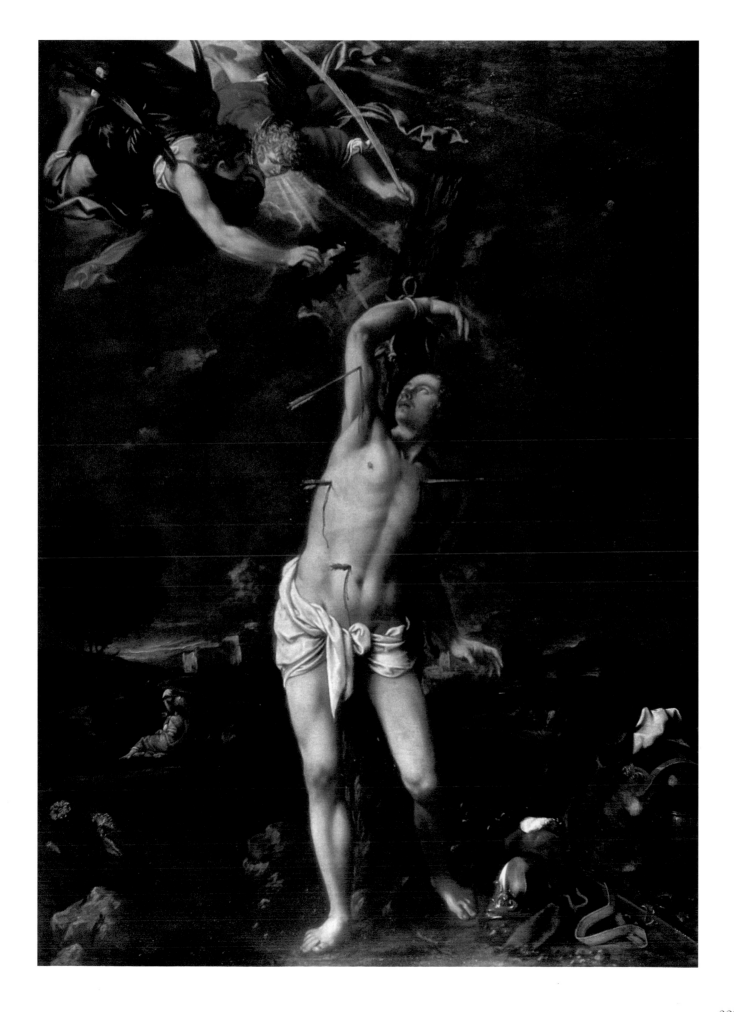

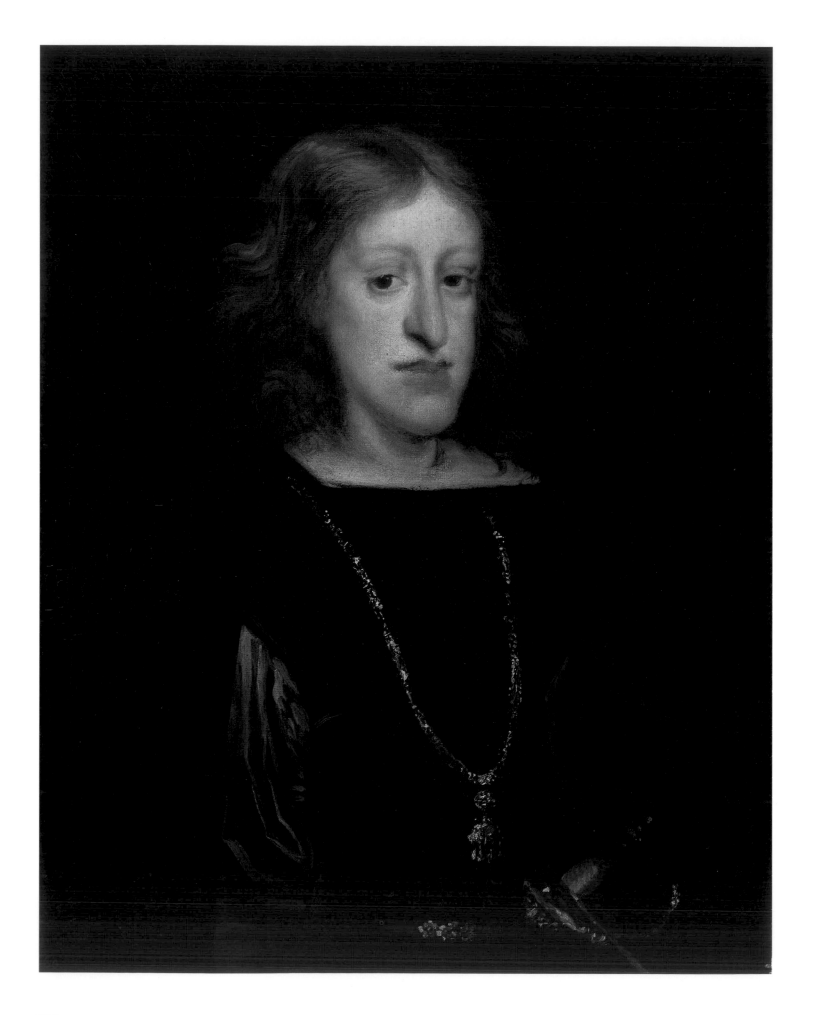

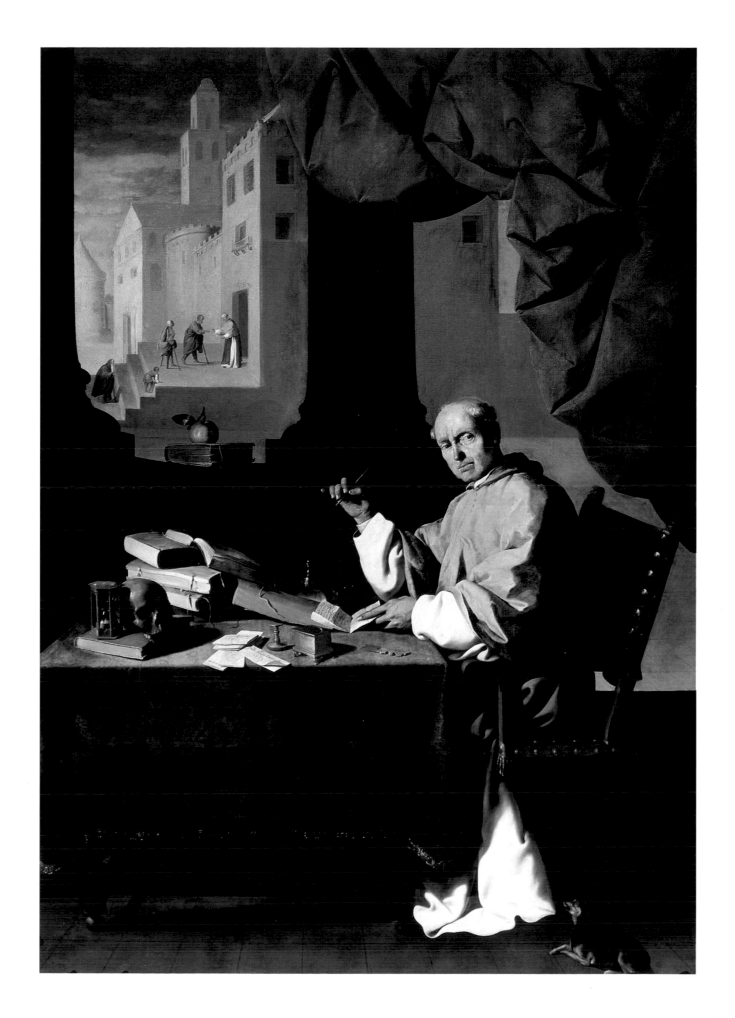

sion and the Assumption, which had not often been portrayed by Hispanic artists. Strangely, in time, the saints gradually lost the aforementioned traits and became more human, more in touch with the people, as evinced in Murillo's *St Thomas of Villanueva Distributing Alms* (1668, Museo de Bellas Artes, Seville). However, mystical embraces still endured, as in *St Francis Embracing Christ on the Cross* (circa 1668, Museo de Bellas Artes, Seville), by Murillo, as did the ascetic attitudes so successfully depicted by Valdés Leal in *The Temptations of St Jerome* (1657, Museo de Bellas Artes, Seville).

Noteworthy, too, are the great series painted for monasteries and hospitals. Vicente Carducho painted a number of works for the Charterhouse of El Paular (1626–1630), as did Sánchez Cotán for the Charterhouse at Granada (1615–1675), and Zurbarán for the Charterhouse at Jerez de la Frontera (1638–1639) and the Hieronymite monastery of Guadalupe (1638–1643). As far as hospitals are concerned, the series for the Hospital de la Caridad (1673–1675) in Seville deserves special mention. Murillo and Valdés Leal, and the sculptor Pedro Roldán, were commissioned by Miguel de Mañara to execute a number of works emphasizing the value of charity, which, according to St Paul, was the first virtue. Murillo depicted God's charity in the aforementioned *Moses Striking the Rock* and *The Multiplication of the Loaves and Fishes* (circa 1673), and the charity of man, in *St. Elizabeth of Hungary Tending the Sick* (circa 1673) and *St John of God Carrying a Sick Man* (circa 1673). Roldán depicted the supreme sign of love in his sculpted retable, *The Burial of Christ,* which was displayed together with two paintings by Valdés Leal, 'hieroglyphics' of death which remind us that, in death, all men are equal and wordly vanity is then worth nothing, that salvation can only come through good deeds, and that death can strike at any moment.

Portraiture

Portraiture was invariably restricted to painting, as portrait sculpture was executed almost exclusively by foreign sculptors, and only on the rare occasion. It was the second most frequently executed genre in Spanish Baroque painting, and the monarchy and nobility were the leading patrons in this field. Court portraits were usually executed by the king's protégés. In the early-17th century, this role was performed by Juan Pantoja de la Cruz (1553–1608) who, together with Bartolomé González (1564–1627) and Rodrigo de Villandrando (d. before 1621), covered the reign of Philip III. Diego Velázquez was practically the only chamber painter engaged by Philip IV, and Juan Carreño de Miranda (1614–1685) that of Charles II. In the 18th century, a French painter, Jean Ranc, became the portraitist of the new dynasty, while this genre reached its peak with Louis-Michel van Loo in his *King Philip V and His Family* (1743, Prado, Madrid). One characteristic of Spanish portraitists of the time was the extent to which they painstakingly and faithfully rendered the sitter. They did not indulge in mythisicising or idealising their model, as was the case with the French school under Louis XIV, and even the Flemish school. Thus, Velázquez painted the king and the royal family without adding any allegorical feature. He portrayed each of them realistically, unlike Rubens who, in his portrait of the *Cardinal Infante* (1634), depicts Fame and a two-headed eagle flying over the sitter, these being the symbols of victory and dynasty. In this respect, the *Libro de retratos,* by Francisco Pacheco, begun in 1599 (Museo Lázaro Galdeano, Madrid), is an important documentary source, as it deals with all the cultural figures who at some stage happened to be in the author's native Seville, and those who frequented the academy there. It was only in the 18th century that the French style of portraiture made inroads into Spain.

Individual and family self-portraits, a common genre in Flanders and Holland, were not often painted by Hispanic artists. Instead, they generally placed themselves in other compositions, as Velázquez did in *Las Meninas*. In this work, one of the few group portraits in 17th-century Spanish painting, the issue was masterfully resolved by the Sevillian artist, who placed the images of the monarchs as a reflection in the background mirror, an ingenious way of bringing them unobtrusively into the composition, presided over by the

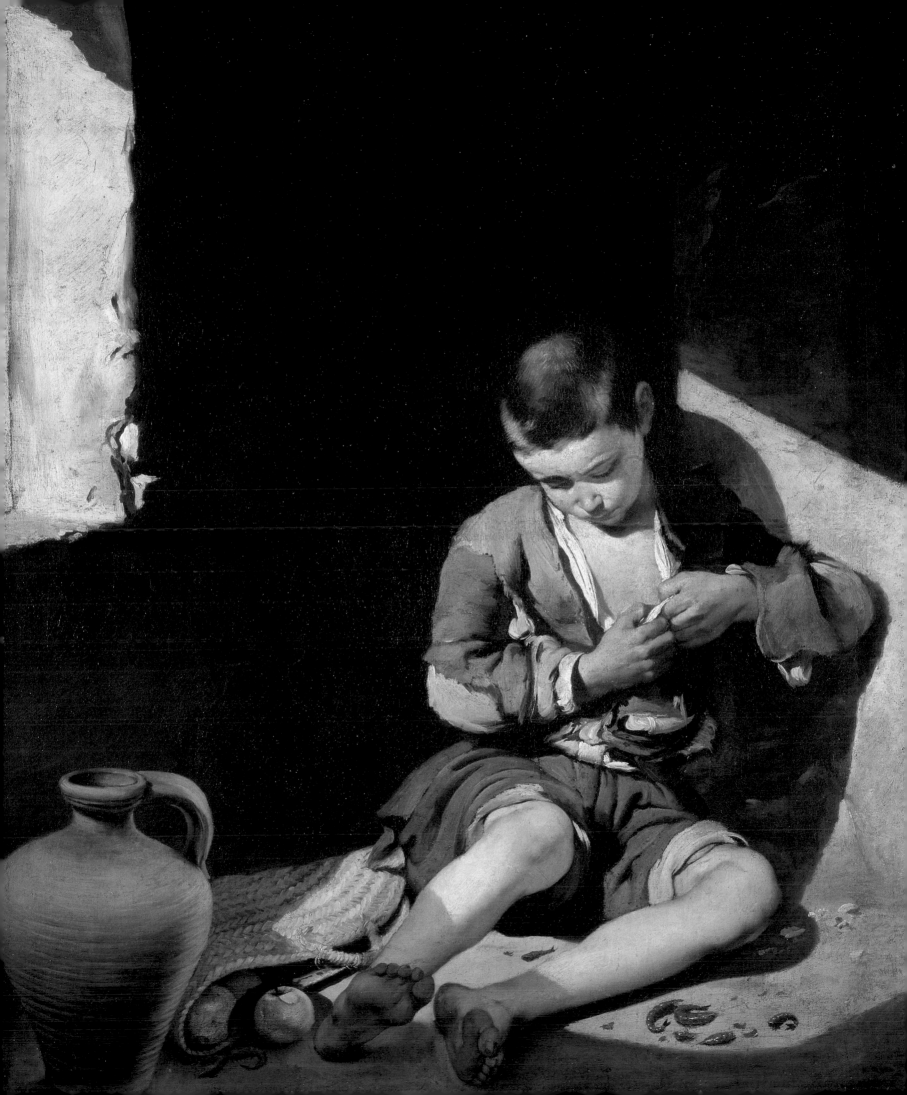

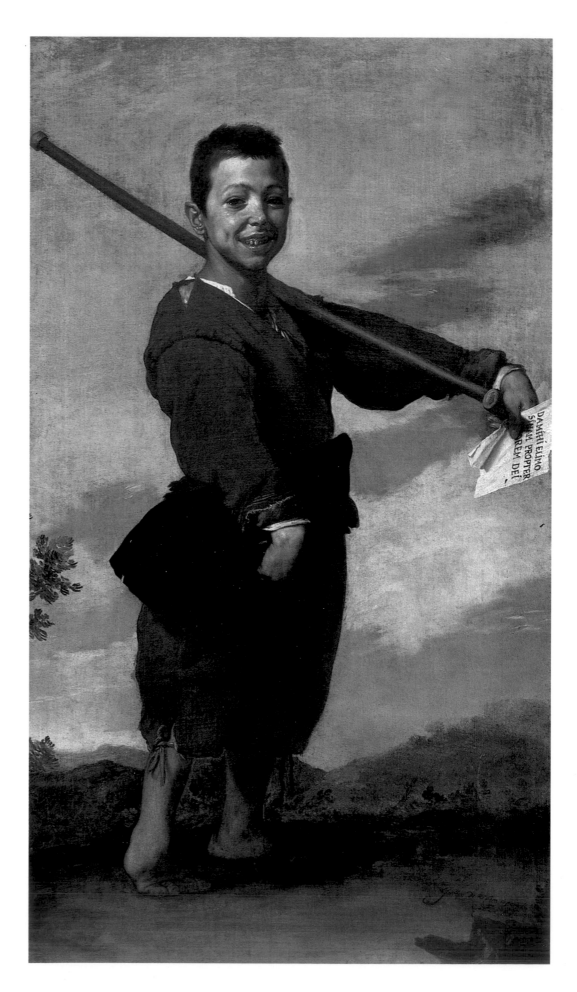

JOSÉ DE RIBERA: *The Clubfooted Boy;*
1642. Oil on canvas, 164 x 93 cm.
Louvre, Paris.

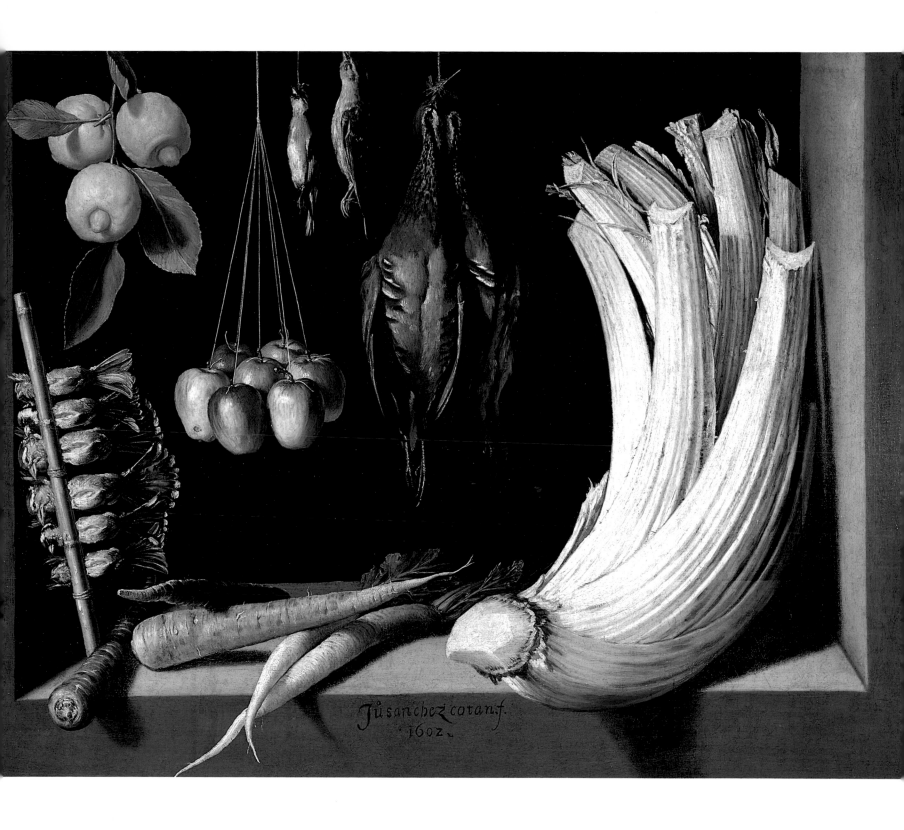

FRAY LUIS SÁNCHEZ COTÁN: *Still-life with Game, Vegetables & Fruit;*
1602. Oil on canvas, 68 x 89 cm. Prado, Madrid.

Infanta Margarita. As an example of an unusual painting, it is worth drawing attention to *Portrait of the Artist's Family* (circa 1660, Kunsthistoriches Museum, Vienna), by Juan Bautista Martínez del Mazo, which is interesting for its subject matter.

Lastly, brief mention should be made of what has come to be known as 'devotional portraits'. These took the form of portraits of cult figures in vogue at the time, epitomised by Zurbarán's portraits of women with saints' attributes.

Close to 'situational' portraiture was the so-called 'documentary' genre, rendered in paintings and prints. An example of this is the well-known *Auto da fe*, by Juan Rizzi (1683), those executed in the viceroyalty of Naples on such subjects as *The Plague of 1656* (1656, Museo de San Martino, Naples), by Domenico Gargiulo, and the hunting scenes of Philip IV by the Flemish Pieter Snayers, housed in the Prado.

Genre Painting: Popular Types, Still-Life and Flowerpieces

Genre painting, a subject popular among the public, rather than in Court circles, did not meet with widespread acceptance in Spain, with the exception of still-lifes and flower painting. A brief review of the various periods and geographical locations associated with the 17th century reveals that popular types and everyday scenes, so popular in Holland, was not a favourite subject among Hispanic painters. It was only in Seville, a highly commercial city, that this type of painting took root, with some excellent examples by Velázquez and Murillo. The former painted a number of works which, judging from the number of versions rendered of a single subject, show how popular this genre became with the people of Seville. His *Old Woman Frying Eggs* (1618, National Gallery of Scotland, Edinburgh), *The Water Seller of Seville* (1620, Wellington Museum, London), *The Breakfast* (1620, Hermitage, St Petersburg) and *The Musicians* (1618, Staatiches Museum, Berlin) reveal his predilection for portraying everyday scenes in true genre style. Moreover, such religious scenes as *Christ in the House of Mary and Martha* (1619–1620, National Gallery, London) and *Tavern Scene with Christ at Emmaus,* also known as *La Mulata* (1618, Beit Collection, Dublin), are depicted in a genre style, as the religious ensembles are set in one corner of the composition, while the emphasis is laid on the everyday scene.

In the case of Murillo, an exception as far as Spain is concerned, art dealers, presumably foreign ones, must have been involved. His paintings in the Alte Pinakothek, Munich—*Boys Eating Fruit* (circa 1670) and *Children Playing Dice* (circa 1670)—those in the Dulwich Picture Gallery—*The Pelota Game* (circa 1670) and *Three Boys* (circa 1670)—and those which make a social statement—*Boy Killing a Flea* (circa 1645, Louvre, Paris) and *Two Women at a Window* (circa 1670, National Gallery, Washington), the attribution of which is disputed—capture the type of scene that was reflected in literature, particularly in the so-called picaresque genre. Even in his religious works, Murillo brings viewers close to the social reality of Seville. Other exponents of genre painting include Antonio Puga—*The Knifegrinder* (Hermitage, St Petersburg) and *The Painter's Mother* (circa 1640, Prado, Madrid)—and the Sevillian Pedro Núñez de Villavicencio (1644–1700), a close follower of Murillo's genre style.

Still-life is one of the most widely studied genres, both in Spain and abroad. However, it was not well thought of during the 17th century, when theoretical values set greatest store by compositional painting and portraiture. Carducho and Pacheco frowned on still-life, although the latter, Velázquez's father-in-law, defended his son-in-law's use of this genre. In his *Arte de la pintura,* he wrote: 'Why should still-lifes not be highly considered? Of course they should, if they are painted as my son-in-law paints them. He has mastered the genre, leaving no room for others, and they are worthy of the highest esteem'.

Still-life or *bodegon* in Spain can be divided into three categories: realistic, speculative and symbolic. In realistic still-life, individual things took precedence over collective ones, and objects were rendered as faithfully as possible. The leading exponents of this current, which evolved from realism into Baroque, were Alejandro de Loarte (circa 1590–1626),

DIEGO VELÁZQUEZ: *The Gardens of the Villa Medici, Rome;* 1649. Oil on canvas, 44 x 38 cm. Prado, Madrid.

Antonio de Pereda (1611–1678) and Mateo Cerezo (circa 1626–1666), in addition to Juan Van der Hamen (1596–1631), the inequivocal pioneer of the great Hispanic *bodegon* tradition. In the 18th century, the survival of this realistic current in genre painting is represented by Meléndez.

The speculative current used objects as a pretext for conducting formal experiments, in which geometry and composition were the true purpose behind the painting. The leading exponent of this current was the Toledan Juan Sánchez Cotán (1560–1677), who produced such interesting works as *Still-life with Thistle* (1602, Museo de Bellas Artes, Granada). Lastly, symbolic still-lifes may be defined in terms of their international projection. Thus, as Julián Gállego rightly pointed out, Zurbarán's *Bodegón* (1633, Norton Simon Foundation, Pasadena) should be interpreted as a homage to the Virgin Mary.

On account of their ambiguity, special attention should be paid to *bodegones* with figures, as in Spain they are usually regarded more as genre paintings than still-lifes. They can often also be classed as allegorical paintings or *vanitas,* although I am reluctant to consider the latter category as a form of still-life.

Flowerpieces are also open to two different interpretations, one symbolic and the other decorative. Concerning the symbolic, Julián Gallego talks of a 'floral language' which was very much in vogue during the 17th century but has now been lost: 'They belong in a milieu of mottoes and emblems, with all their ambiguity and imprecision. The rose, a symbol of love, also stands for silence. The carnation, a symbol of human love, especially as related to marriage, likewise symbolizes divine love, a distinction it shares with the Virgin Mary. The daisy stands for mercy; the buttercup, celibacy; orange blossom, virginity, and the white lily, purity'.

Flowerpieces were occasionally set in place of fresh flowers on either side of an image, or used as a border framing a religious scene. Of course, they also served a purely decorative purpose in the interiors of palaces and wealthy homes. The leading exponents of this genre were Juan de Arellano (1614–1676), Bartolomé Pérez (1634–1693) and Juan Van der Hamen, of whom Lope de Vega, in his *Laurel de Apolo,* said:

> *«Sepa la envidia, castellano Apeles,*
> *que en una table de tus flores llena,*
> *cantó una vez burlada, Filomena,*
> *y libaron abejas tus claveles»*

> 'Envy should know, Castilian Apelles,
> That in a panel of your flowers filled,
> Philomena, beguiled, once sang,
> And bees from your carnations sipped.'

Landscape

Landscape, generally associated with the Dutch school and the early Italianate classicists, such as Claude Lorrain and Nicolas Poussin, was little cultivated in Spain. In effect, the finest examples of Spanish landscape were actually executed in the viceroyalty of Naples. They include two *Landscapes* (Monterrey Palace, Salamanca) by José de Ribera, signed in the year 1639, presumably commissioned by the Duke of Monterrey and now part of the Dukes of Alba collection. There are also two small landscapes of the Villa Medici (Prado, Madrid) painted by Velázquez during one of his two sojourns in Italy—either 1629–1630 or 1649–1650. Other examples include two landscapes in the Prado attributed to Murillo, and some views of Roman ruins executed in Naples, presumably for the viceroys. Ribera and Velázquez also produced some fine landscape backgrounds in their portraits and religious paintings. In Spain, the only noteworthy examples of this genre were executed by Paret y Alcázar, and Michel-Ange Houasse, with his magnificent *View of the Monastery of El Escorial* (Prado, Madrid).

Mythology, History, Allegory

Mythology, history and allegory were subjects related to worldly virtues, morals and institutions and, as such, were rendered in the service of the powers that be.

Mythological subjects were not frequently tackled by Spanish painters: there was no mythological tradition to speak of in Spanish art, and paintings of this type were usually assigned to foreign artists, chiefly Flemish. In this respect, it is worth recalling the decorative programme in the Torre de la Parada, for which Philip IV commissioned Rubens. The latter was assisted in this task by his closest collaborators, notably Jacob Jordaens. The earliest exponent of this genre in Spain was Francisco Pacheco (1564–1654), who painted a *Triumph of Hercules* (1604) for the Duke of Alcalá in the Casa de Pilatos in Seville. In it, he alludes to the virtues of his patron, who is depicted surrounded by the equally symbolic stories of Phaeton, Perseus, Icarus, Astraeus and Ganymede. This work, which is more interesting than well painted, reveals the artist's first-hand knowledge of art and literary academies and his literary erudition, as we shall see later.

Domínguez Ortiz's statement that, 'In his mythological subjects, which were com-

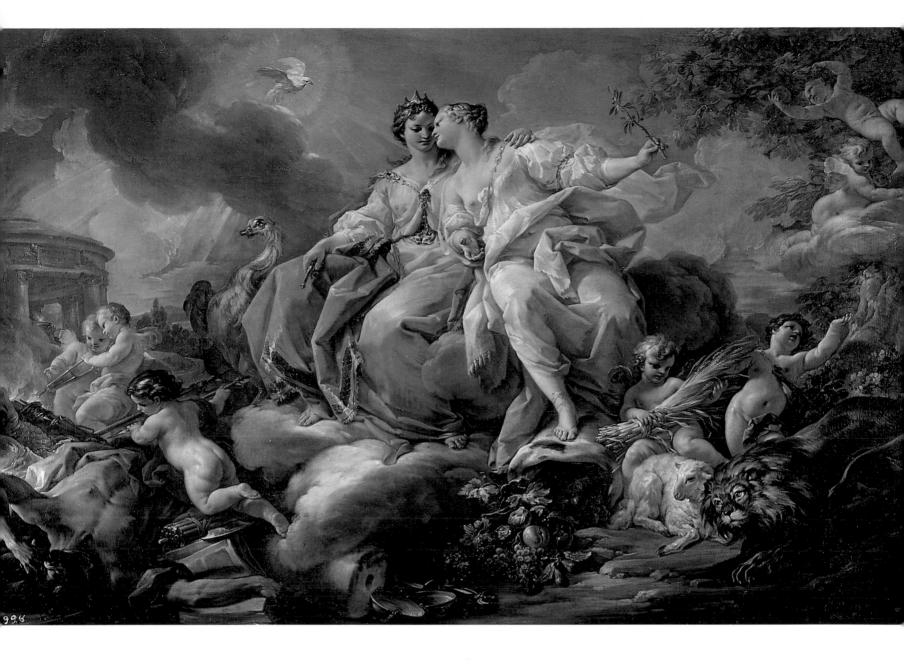

CORRADO GIAQUINTO: *Peace and Justice;* circa 1759–1760. Oil on canvas, 216 x 325 cm. Prado, Madrid.

missions, Velázquez was not quite on the mark', should be qualified. Velázquez was actually extremely knowledgeable about mythology, but he set out to demythicise it, as in *The Rule of Bacchus,* popularly known as the *Topers* (1628, Prado), in which he turns the story of Venus's unfaithfulness towards Mars into a defence of the noble arts—symbolised by Apollo—as superior to manual crafts, symbolised by Vulcan. In other words, he made use of myth, not the other way around. Moreover, interpreting his *Rokeby Venus* (1650, National Gallery, London) has posed enormous difficulties for art historians. This beautiful, mysterious and enigmatic nude prefigured the greater naturalism that was to come in the form of Goya's *Maja Desnuda* and the greater impudence of Manet's *Olympia.* In fact, it was the only nude in 17th-century Spanish painting, apart from *La Monstrua Desnuda* (1685, Prado) by Juan Carreño de Miranda (1614–1685), depicting the unsightly nude figure of Eugenia Martínez Vallejo with the attributes of Bacchus.

The artist that did, however, come to grief in his attempt to push his skills to the limit and, one might add, his scant knowledge of mythology and composition, too, was Zurbarán. His *Labours of Hercules,* part of the programme for the Hall of Realms, dating from 1634, is not quite *de rigueur,* to put it mildly.

When it came to historical subjects, however, painters in the service of the Spanish Crown, whether Spanish, Flemish or Italian, were highly prolific. Apart from the precedent of the Hall of Battles at El Escorial (circa 1590), executed by the Italians, Nicolas Granelo

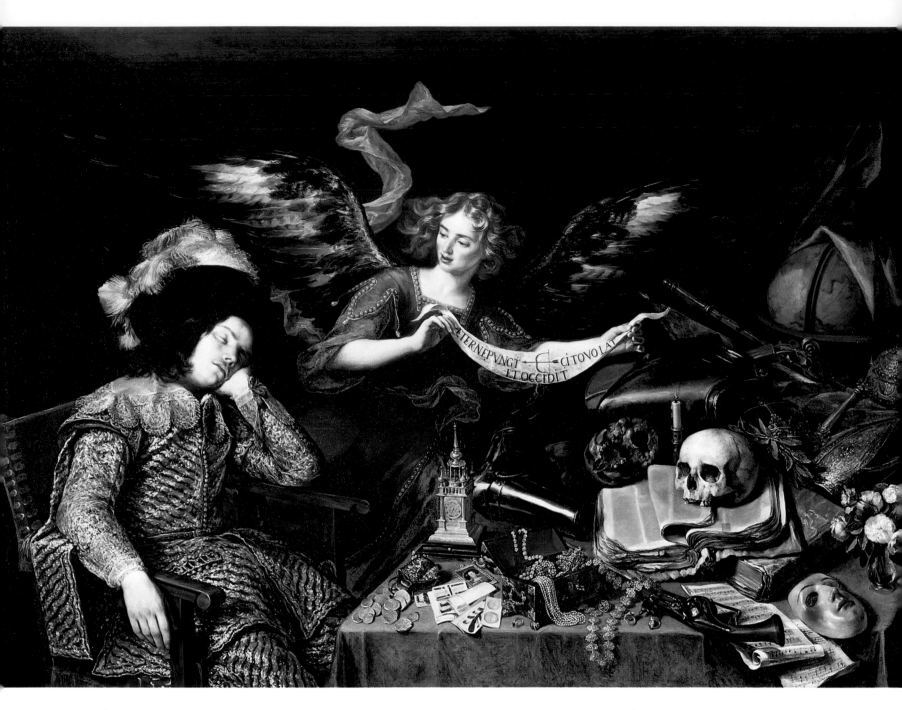

ANTONIO DE PEREDA: *The Dream of Life;* mid-17th century. Oil on canvas, 152 x 217 cm. Academia de San Fernando, Madrid.

and Fabio Castelo, the earliest history painting appeared in the so-called New Suite in the Alcázar in 1625. The works in question, which were Crown property, include Titian's *The Emperor Charles V at Mühlberg* (1548) and *Allegory of Philip II's Victory at Lepanto* (1572), and portraits of the Spanish kings since the time of the Reconquest, executed by Carducho and Félix Castelo, among others. This programme anticipated the larger and better known one in the Hall of Realms, initiated in 1634, purportedly based on an idea by the Count–Duke of Olivares, assisted by Velázquez. This ensemble is a veritable hymn to the Spanish monarchy, symbolised by Hercules (regarded as its founder), whose deeds and enterprises are lavished with praise in the work by Zurbarán. And, since those deeds of the Habsburgs had been clearly established, supported by the victories won by Spanish armies, they were explicitly portrayed in a series of canvases executed by the leading artists of the time: Antoni de Pereda, Francisco de Zurbarán, Eugenio Caxés, Jusepe Leonardo, Vicente Carducho, Félix Castelo and Diego Velázquez.

One of the outstanding works in this series is *The Surrender of Breda,* in which, despite the befuddled nature of the commission, Velázquez was able to turn the commemorative work into one of his greatest artistic achievements. His, too, are the equestrian portraits of Philip III and his wife, Margaret of Austria; that of Philip IV and Isabella of Bourbon, and another of the future king, Prince Baltasar Carlos. The rest of the palace was decorated by Italian painters, with works on the history of Rome, the first world empire, comparable to the Spanish empire. These paintings are now in the Prado, in a section known as the Sala del Museo del Ejército.

Another artist who made some fine contributions in this field was Pieter Snayers, a painter of Flemish origin in the employ of the Spanish monarchy. His battle scenes, most of which are now in the Prado, provide a magnificent sampling of his oeuvre.

To take a brief look at allegorical painting during the Spanish Baroque, we shall consider both strictly allegorical works and those of a more cryptic nature known as *vanitas,* charged with symbolism. Allegories with human personifications were common in 17th-century Spain, from those of Flora and Spring in Van der Hamen's *Flora* (1627, Prado), wrongly classed as a flowerpiece, to *Allegory of Messina's Incorporation into the Spanish Crown* (1678, Prado), by Luca Giordano. Other examples include *The Seasons* (1634, Comunidad Autónoma, Seville), by Francisco Barrera (circa 1600–1657), *The Senses* (circa 1650, Museo de Bellas Artes, Valencia), by Miquel March (circa 1635–circa 1670)—also wrongly classed as a *bodegon*—and allegories of *The Elements* (circa 1715, Prado) by Antonio Palomino (1655–1726), Jerónimo Antonio Ezquerra (1659–1733) and the Neapolitan, Andrea Vaccaro (1604–1670).

Vanitas works have a moralising significance, the term having been derived from a phrase in Ecclesiastes: 'Vanity of vanities, all is vanity!', taken by Thomas à Kempis as a maxim and reworked by Spanish artists into a plastic formulation which has a marked impact on the viewer. For Bialostocki, the symbols they used fall into three categories: worldy existence, the transience of life, and eternal resurrection. Those dealing with worldly things refer to the *vita contemplativa* (books, scientific instruments and equipment, literature, science and fine art), *vita practica* (jewels, crowns, sceptres and other symbols of power, weapons and all valuable things) and *vita voluptuaria* (vessels, fifes, playing cards and musical instruments). Inspired by the *Spiritual Exercises* of St Ignatius, the Jesuits evidently encouraged such depictions of death, on which one was supposed to meditate, and their public viewing. Antonio Pereda's *The Dream of Life* (Academia de San Fernando, Madrid), the aforementioned 'hieroglyphics' by Valdés Leal, as well as his *Vanitas* (1660, Wadsworth Athenaeum, Hartford) and *Repentance* (1660, City of New York Art Gallery), are the most significant and artistically most accomplished examples, although a better known, albeit mediocre, work by Juan Francisco Carrión, *Memento mori* (University of Indiana) is more representative of this genre, as it contains all the elements one would expect of these compositions: a skull, sand clock, books and others, in addition to a verse which runs:

> *O tu que me estás mirando*
> *mira vien i vivas bien*
> *que no çabes como o cuando*
> *te veras asi tanvien*
> *mira vien con atención*
> *este retrato o figura*
> *todo para en cepultura.*

Spanish Baroque art coincided with one of the most creative moments in the whole of Spain's art history. As we have seen, painting reached its peak during the 17th century, and went into decline in the 18th, while the highly original Baroque sculpture came into its own. Lastly, despite their originality, architecture and town planning did not attain the standards enjoyed by fine art. Thus, as in drama and literature, it may be said that Spain's so-called 'Golden Age' was brilliantly defined by painting.

DIEGO VELÁZQUEZ OR THE CULMINATION OF PAINTING

This chapter ends with a brief look at the figure of Diego Velázquez. Although an in-depth study of this artist is beyond the scope of this essay, I shall attempt to provide an overview of his stylistic development and an appraisal of his importance and uniqueness.

Diego Velázquez was born in Seville in 1599. He trained in the workshop of his future father-in-law, Francisco Pacheco, and most art historians believe he also spent a brief period in the workshop of Francisco Herrera the Elder. In his early work, known as the Seville period (1617–1623), he painted religious and genre subjects, and the occasional portrait. In 1623, he embarked on his period of Court painting. In 1628, after 'dabbling' in portraiture, he was commissioned to paint a mythological subject, now popularly known as *The Topers*. The following year, he made his first journey to Italy, where he visited Ferrara, Venice and Rome. These cities had a decisive influence in his ongoing artistic development, apparent in *Apollo in the Forge of Vulcan,* with its marked classicist accent, and *Joseph's Blood-Stained Coat Brought to Jacob,* with conspicuous Venetian overtones. On his return to the Court, he embarked on a period rich in pictorial production, ranging from such historical subjects as *The Surrender of Breda* to portraits full of character, particularly those of the royal family, and superb portraits of jesters, with brief forays into religious painting, such as *Coronation of the Virgin* (1642) and *SS Anthony Abbot and Paul the Hermit* (1642), both in the Prado.

In 1649, Velázquez went to Italy on official business: that of purchasing paintings for an art gallery Philip IV wished to open. Jusepe Martínez describes Velázquez's aesthetic leanings through the artist's reply to the king on how the gallery should be structured: 'If His Majesty gives me licence to go to Rome and Venice, I pledge to seek and purchase the finest works by Titian, Paolo Veronese, Bassano, Raphael, El Parmigianino and others of the sort. Very few princes have paintings of this kind, and in such quantities as Your Majesty shall acquire through my endeavours. Moreover, the lower floors must needs be adorned with old statues, and those that could not be made. They will be voided and the moulds brought to Spain, where they will be suitably cast.'

In Rome he painted the well-known portrait of *Pope Innocent X* (1650, Galleria Doria–Pamphili, Rome), which reveals his enormous facility in portraying a subject's psychological makeup. Also from this period, and in keeping with the traditional way of working up to a portrait of the Pope, is a bust of his Mulatto servant and attendant, *Juan de Pareja* (1650, Metropolitan Museum, New York), of which Palomino said: 'All the others look like painting; only this one is real'. Some authors claim that his two views of the Villa Medici date from this period, as does the magnificent *Rokeby Venus*. He stayed on in Rome for longer than the king had hoped, although this was not related to the acclaim he received from art lovers in that city: he was appointed member of the Academia dei Virtuosi al Pantheon, and of the Academia di San Luca. However, he was loathe to break off relations with the sovereign, as Poussin had done, and set off on the return journey in May 1651.

He then entered his late period, in which his brushstroke becomes abstract in the extreme, and his works filled with rich Baroque conceptualism. His portraits of the new queen, Mariana of Austria, and the ill-fated Felipe Próspero, led up to his best-known work, *Las Meninas* (1656, Prado, Madrid), a veritable synthesis of his entire pictorial conception, open to a host of interpretations. This period ends with the *Fable of Arachne,* better known as *Las Hilanderas* ('The Spinners'). Executed towards the end of his life, it appears to mark a return to the realistic style of his Seville period. As with *Christ in the House of Mary and Martha* or *Tavern Scene with Christ at Emmaus,* Velázquez sets the central theme—the fable—in the background, with everyday mores brought into the foreground. However, the closed, graphic forms of his Seville period have become a harbin-

DIEGO VELÁZQUEZ:
Christ Crucified; *circa 1630.*
Oil on canvas, 248 x 169 cm.
Prado, Madrid.

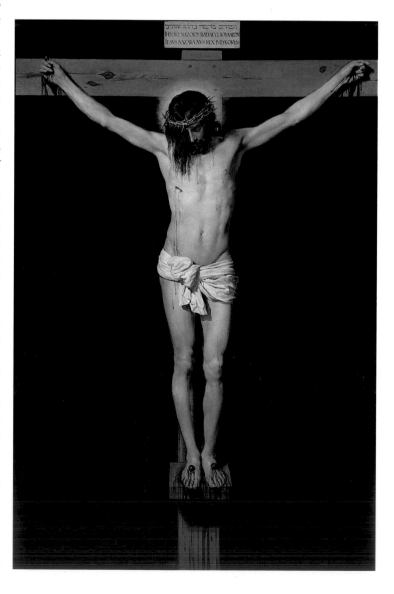

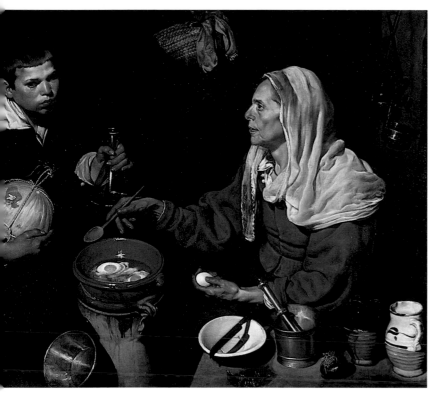

DIEGO VELÁZQUEZ: Old Woman Frying Eggs; *1618. Oil on canvas, 99 x 169 cm. National Gallery of Scotland, Edinburgh.*

DIEGO VELÁZQUEZ: The Surrender of Breda *or* The Lances; *1634-1635, Oil on canvas, 307 x 367 cm. Prado, Madrid.*

ger of light and atmosphere; of 'Impressionistic' execution and movement, which is evident in the spinning wheel, its spokes seemingly disappearing, while the circular daub of the hand that turns it is barely visible. This pictorial approach was not taken up by his successors, on account of the difficulty and character of his style, which involved a continual application of solutions suited to each case. One could talk of as many Velázquezs as the paintings he executed, as he never succumbed to affectation in his forms and never repeated himself. This is the truth of his art.

Velázquez's importance, aside from his personality, lay in his enormous capacity for mastering all the great pictorial genres throughout his long career. A portraitist *par excellence,* he was nevertheless able to uphold his standards when painting genre, mythology, landscape, religious and allegorical subjects.

The evolution in his portrait painting is astonishing, as all his portraits lack the affectation characteristic of the other artists that cultivated this genre. His first work of this type was the *Portrait of Madre Jerónimo de la Fuente* (1620, Prado, Madrid), the first abbess of the convent of Santa Clara in Manilla. In this portrait, Velázquez still reveals the influence of a dry, graphic style which came to characterise his Seville period. Before departing for the Court, he executed his *Portrait of the Poet Luis de Góngora* (1622, Museum of Fine Arts, Boston), in which he sounds the psychological depths of his sitter.

On his arrival in Madrid, the young Philip IV commissioned Velázquez to paint a large number of portraits of himself, the first of these being *Portrait of Philip IV in Armour* (1625, Prado, Madrid). Prior to that, he had executed a portrait of *Gaspar de Guzmán, The Count-Duke of Olivares* (1624, Museo de Arte, São Paulo), which he presented as his credentials before the Court. He subsequently executed portraits of members of the royal family, including the *Infante Don Carlos* and *Full-length*

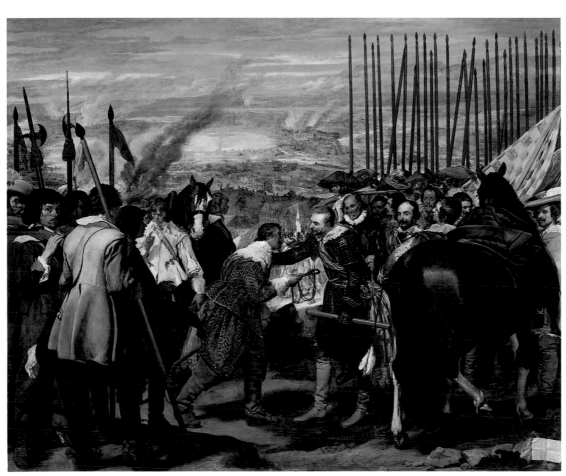

Portrait of Philip IV, both in the Prado, dated 1626 and 1628 respectively. The arrangement is practically the same in all of them, with visual depth being set up by the shadow cast by the body of the sitter.

After his return from Italy in 1629, his royal portraits became more realistic and less idealised. Contemporary with the Flemish portraits which Van Dyck painted for Charles I of England, his realistic characters were set on virtually abstract landscape backgrounds. Velázquez did not paint his models as he wanted to, but as he actually saw them. His series of members of the royal family in hunting dress, commissioned for the Torre de la Parada and the Hall of Realms, bear out Velázquez's penchant for realistic portrayal. The only work in that period which marked a departure from the artist's restrained approach and an approximation to the Baroque is *The Count–Duke of Olivares on Horseback* (1634, Prado, Madrid).

His second journey to Italy, in 1649, was a landmark in his art career, epitomised by two magnificent works: one of his servant, who also painted, *Juan de Pareja* (1650, Metropolitan Museum, New York) and *Pope Innocent X* (1650, Galleria Doria Pamphili, Rome), both masterpieces. The first of these was put on public display in the Pantheon. The papal portrait is a fine example of character portrayal and of pictorial and chromatic mastery in the history of art.

On his return to Spain, the aging monarch asked him to paint a portrait of his new wife, Mariana of Austria, and her offspring, from her previous and current marriage. Outstanding examples are those of the *Infanta Maria Teresa at the Age of Thirteen* (1651, Metropolitan Museum, New York) and, in particular, a succession of portraits of the Infanta Margarita, the protagonist of *Las Meninas,* and her sickly brother, *Prince Felipe Próspero.* The pinks, greys and reds in these portraits have been combined into a harmonious colour scheme with a plasticity above mere representation.

Velázquez's genre subjects were painted almost exclusively during his Seville period and for foreign collectors, so that, unfortunately, there are none of these works in Spanish museums or private collections today.

His mythological subjects were handled with a technique akin to the naturalist painters. Like Caravaggio, he humanised myth, turning it into something commonplace: he used each myth as the feature of a genre painting. The first of these paintings was *The Triumph of Bacchus* (1626, Prado, Madrid), better known as *The Topers,* in which the main character is overshadowed by the genre types. Velázquez was obviously very knowledgeable about mythology, which he had learned at the home of his father-in-law, Pacheco, where intellectuals used to meet and debate. Because he knew mythology, he dared to demythicise it.

His highly restrained classicist ideal is apparent in his rendering of Venus' unfaithfulness in *Apollo in the Forge of Vulcan* (1630, Prado, Madrid), in which he shows Apollo telling Vulcan—depicted as a mere mortal among his workers—of his wife, Venus' unfaithfulness with Mars.

The same approach can be seen in *Mars* (1640, Prado, Madrid), the *Rokeby Venus* (1650, National Gallery, London) and *Mercury and Argus* (1659, Prado, Madrid), while his handling of the celebrated *Fable of Arachne,* better known as *Las Hilanderas* ('The Spinners', circa 1657, Prado, Madrid) borders on the trivial.

His religious painting was more complex: he first embarked on this genre in Seville with *Epiphany* (1619, Prado, Madrid). While his *St John the Evangelist on Patmos* (1618, National Gallery, London) appears to be by his hand, there is some doubt regarding the attribution of *Immaculate Conception* (1618, National Gallery, London) and the *Apostolates.* In this respect, Jonathan Brown recently attributed to Alonso Cano the magnificent canvas *St Thomas Aquinas Comforted by Angels after the Temptation* (Museo Diocesano de Arte Sacro, Orihuela), the date of

which is uncertain. Another of his works now ascribed to Alonso Cano is the *Coronation of the Virgin* (Prado, Madrid), which is followed in the catalogue by the magnificent *SS Anthony Abbot and Paul the Hermit* (1642, Prado, Madrid).

Two outstanding works of his in the Prado are his *Christs Crucified,* particularly one known as the *Christ of St Placid* with its austere classicism.

Allegory is condensed in his emblematic composition, *Las Meninas,* Velázquez's only group portrait, which may be interpreted as a defence of the 'noble and liberal art of painting'. There has been considerable conjecture regarding its meaning. The Infanta Margarita appears to have just noticed the presence of her parents, Philip IV and Mariana of Austria, whose images are reflected in the mirror in the background. She is accompanied by her entourage, which includes, from left to right, María Augustina de Sarmiento, Isabel de Velasco, and the dwarfs María Bárbola and Nicolasito Pertusato. In the middle ground is Manuela de Ulloa, who was in charge of the maids of honour, and a figure thought to be Diego Ruiz de Azcona. In the doorway stands the palace steward, José Nieto de Velázquez.

The idea of this canvas advocating the noble bearing of painting is borne out by the Cross of the Order of Santiago which hangs from the artist's breast.

Velázquez's landscapes are summarised in two small views of the Villa Medici (Prado, Madrid), of uncertain date, a *Royal Boar Hunt* (circa 1638, National Gallery, London), and the impressive *View of Saragossa* (circa 1647, Prado, Madrid), executed in collaboration with his son-in-law, Juan Bautista Martínez del Mazo.

Velázquez also executed a noteworthy series on dwarfs and jesters, the first of which was *Juan Calabazas,* known as *Calabazillas* (1626, Museum of Arts, Cleveland). This was followed by *Prince Baltasar Carlos with a Dwarf* (1631, Museum of Fine Arts, Boston), and a series in the Prado,

which opens with *Pablo the Jester of Valladolid* (1633) and continues with *The Boy from Vallecas* (1634), *The Buffoon of Coria* (1639), *The Jester Don John of Austria* (1643), *'El Primo' the Jester* (1644) and *The Jester Sebastián de Morra* (1644).

Velázquez's treatment of this subject was extremely humane, his sitters being accorded the same highlights and realism as his royal portraits. These qualities are also apparent in his well-known work, *The Surrender of Breda.*

Although it is difficult to pigeonhole Velázquez in any particular aesthetic category, I would like to round off this essay with an apparently tautological statement which, in my opinion, defines his personality and his art: 'Velázquez's style was Velázquez'.

DIEGO VELÁZQUEZ:
Las Hilanderas ('The Spinners') *or* The Fable of Arachne; *1657, Oil on canvas, 220 x 289 cm. Prado, Madrid.*

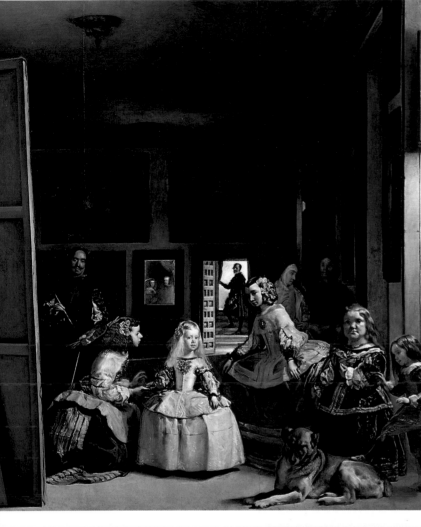

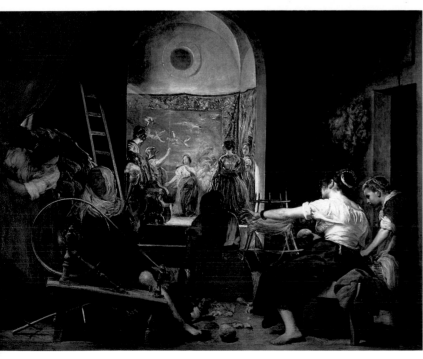

The Art of Colonial Spanish America

Joaquín Bérchez Gómez
Rafael López Guzmán

Geographical and Administrative Overview of Spanish America

Spain retained its possessions in the Americas for over three centuries, from the time of the discovery and conquest of the New World, in the late-15th century and the first three decades of the 16th century, to the independence of the colonies in the early-19th century.

Geographically, the former Spanish territories began at the Caribbean island of Hispaniola (present-day Haiti and the Dominican Republic) which, in 1512, was reclassified as the *Audiencia* of Santo Domingo, and acted as the springboard for mounting the conquest of and missionary drive into the mainland. Meso-America was the most important political, religious and cultural area in the Americas. It was in Meso-America that the Viceroyalty of New Spain (Mexico) was created in 1535, as a result of Hernán Cortés' conquest of the Aztec empire in the period 1519–1521. The Viceroyalty of New Spain took in all Spanish territory north of the Panama isthmus, with a population of nearly six million inhabitants at the end of the 18th century.

The Viceroyalty of Peru was founded in Andean America in 1542, following the conquest of the Inca empire by Francisco Pizarro in the central Andes. The conquest came to an end with the founding of the city of Lima, on the Pacific seaboard, in 1535. However, internecine strife between the conquistadors lasted until the middle of the century. The territories under Spanish dominion were also extended through other conquests, which took in the Colombian and Bolivian plateaux, Quito (1534), Paraguay (1537) and Chile (1541). The jurisdiction of the Viceroyalty eventually encompassed a vast swathe of land in South America, running from Panama to the Strait of Magellan. By the end of the 18th century, the territory in question had a population of one and a half million inhabitants.

The two major viceroyalties, based in Mexico and Peru, continued virtually unchanged until the 18th century, when the Spanish colonial administration was reorganised and the aforementioned viceroyalties reduced in size, particularly that of Peru. The Viceroyalty of New Granada emerged between 1717 and 1739. With Santa Fe de Bogotá as its capital, it included the present-day territories of Colombia, Venezuela, Ecuador and Panama. The Viceroyalty of La Plata, founded in 1776, took in Argentina, Paraguay, Uruguay and part of Bolivia and Chile. The administrative division of Spain's American possessions was brought to completion with the subsequent inception of the so-called Internal Provinces Command, set up in the north of New Spain, and that of the Captaincies General of Cuba, Guatemala, Venezuela and Chile. It was in this geographical and administrative context of Spain's American dominions that the various nations making up present-day Spanish America won their independence in the early-19th century.

The Architecture of Evangelization: the Hispano-American Mission Convents

During the early years of the conquest, the religious orders were instrumental in evangelizing the newly discovered lands. The Franciscans (1524), Dominicans (1526) and

Huejotzingo (Mexico): chapel or *posa* in the convent of San Andrés; 16th-century.

During the early period of colonisation and evangelization, Spanish American mission convents were based on a huge, free-standing church where the indigenous population could be evangelized in large numbers.
The forecourt, with a cross in the centre, became an important meeting place and an area from which the congregation could follow the religious services, held either in a chapel opening onto one side of the church or within the convent itself. In each corner of the courtyard was a chapel known as a *posa*, used both as a station for pausing during processions and for holding catechism. The *posas* of Huejotzingo and Calpan, with their cubic structure and pyramidal roofing, are among the most monumental chapels of this kind. Ornamentation was functional, serving the purpose of religious education. It was executed by mainly indigenous craftsmen applying local techniques, and generally lacked any specific stylistic intention, being a blend of Gothic and Renaissance repertoires.

Cholula (Mexico): Royal Chapel in the Convent of San Gabriel; 16th-century.

Axonometric view of the Royal Chapel in the Convent of San Gabriel, Cholula (Mexico).

Augustinians (1533) headed the missionary drive, which spread with the conquest of new territories and population centres. The lack of covered buildings, the need to indoctrinate a large indigenous population in a new religion, and the frontier character of territories which had not been completely pacified, were determining factors in the construction of churches and convents in rural areas. Architecturally, these buildings were based on secular monastic traditions adapted to the geographical and human reality of the times. Thus, convents were multi-purpose buildings, designed to meet a variety of needs associated with the first few years of colonisation. In time, their provisional character gave way to the more generalised, so-called 'moderate design', in which the first viceroy of New Spain, Antonio de Mendoza, evidently had a hand. The style in question was intended as a general blueprint for all constructions of this kind.

Initially, missionary convents (Mexico City, Texcoco, Tlaxcala, Huetjotzingo, Cuernavaca and Cholula) and cathedrals (Mexico City, Puebla, Oaxaca) were simple, three-naved constructions, with bays separated by pilasters, and wooden roofing with a layer of earth or thatch on the outside. From the mid-16th century, conventual buildings acquired greater consistency: the church usually consisted of a sizeable nave and chancel, with barrel or rib vaulting. Some were fortified with battlements on the copings (Huetjotzingo, Tepeaca, Cholula, Actopan) or surrounded with parapet walks (Tepeaca, Xochimilco). In addition to communal monastic areas such as cloisters and orchards, open-air forecourts became an important part of the complex. They were ringed by fortified thatch-topped walls and had a chapel or *posa* in each corner. The latter, which were often shaped like templets with pyramidal roofs, as in Huetjotzingo and Calpan, were used as areas for teaching catechism, as shown in a celebrated engraving by Fray Diego de Valadés (*Rethorica Cristiana*, 1579). Free-standing chapels built in the middle of these courts were used for holding religious services. The priest officiated in a covered area, and the service was followed by the cele-

Santo Domingo: Cathedral facade; between 1537 and 1540.

brants in the court. The variety of such chapels and, on occasion, their stylistic complexity, reveals just how important they were. Some, like those at Actopan, Acolman and Coixtlahuaca, consisted solely of an open apse, while others, such as the chapel at Teposcolula, were structurally more complex, with two naves and stellar vaulting in the centre, and diagonally placed buttresses. The Royal Chapel at Cholula, for instance, is a fully-fledged church, with pillars separating the various areas of the naves. Convent complexes were built along similar lines in other territories, including Guatemala, Colombia and Peru. In some cases, such as Copacabana (Bolivia), these buildings were still being erected in the 18th century.

Although these churches were generally single-naved, some were built to a three-naved basilical plan (Cuilapan, Zacatlán). In formal terms, entrance portals were rather archaistic, most compositions being derived from the architectural bilingualism prevalent in 16th-century Spain. This state of affairs resulted largely from the absence of professional architects during the first half of the century. Thus, the portal at the Franciscan convent of Huetjotzingo is late-Gothic, while those at Calpan and Xochimilco have Roman-style ornamental repertoires. The delicate portals of the Augustinian churches at Acolman, Actopan and Yuriria, dating from the second half of the century, are Renaissance.

Secular and Urban Architecture—Cathedrals

While the 16th century was characterised by the activity of the mendicant orders, and a perceived need for urgent evangelisation, which led to feverish convent-building activity in rural areas, the 17th was the century of the secular and urban clergy; that is, of episcopal sees. In the last three decades of the 16th century, the episcopal sees in the two largest viceroyalties—New Spain and Peru—were at pains to endow their churches, convents and other Church institutions with a monumental, exemplary status, in accordance with the contemporary needs of colonial cities.

In Spanish America, cathedrals were built to a more specific plan. That of Santo Domingo reflects the fleeting importance of the island of Hispaniola as the short-lived capital of the newly discovered Indies, prior to the conquest of the mainland. Built as from 1521, it has three naves, a polygonal chancel and rib vaulting, based on late-Gothic Sevillian models. The facade, erected in 1537–1540, clearly reveals the Roman-style language eschewed by Hispanic design, with splayed entrance bays. An unusual project was that of

Plan of the Convent of San Andrés. Calpan (Mexico).

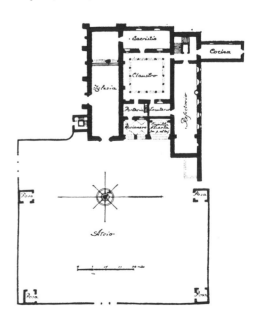

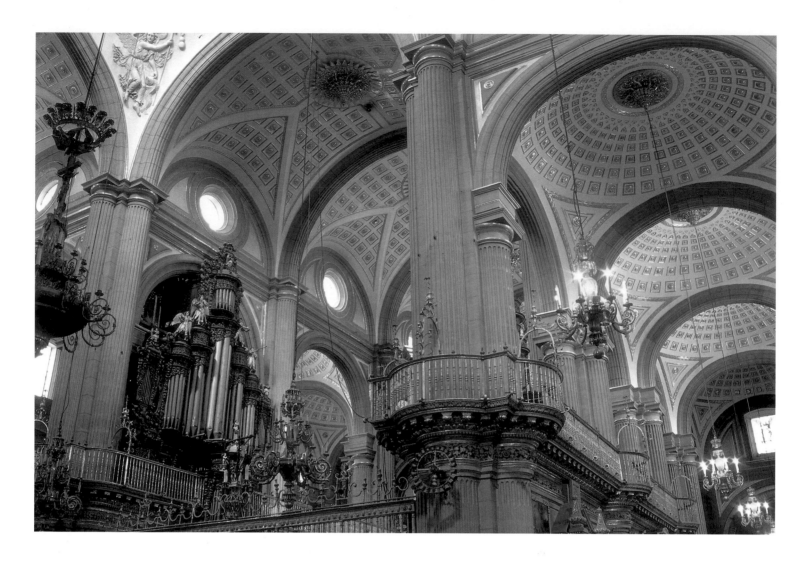

Puebla (Mexico): Cathedral interior; 16th- and 17th-century.

Section and plan of Mérida Cathedral (Mexico).

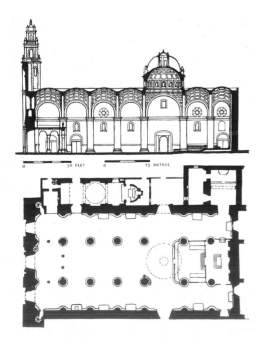

Pátzcuaro Cathedral (from 1541, Mexico City): designed according to the utopian tenets of Archbishop Vasco de Quiroga, and only partially known from hypothetical graphic reconstructions, it was apparently based on a pentagonal, stellar ground plan with five naves converging on an elevated chancel. Apart from this, the prototype generally applied to Hispano-American cathedral design in the second half of the century was that of a Roman-style hall church. This type of design, which allowed for large, uncluttered and well-lit bays, of the kind prevalent in Spanish cathedrals at the time, can be seen in the cathedrals of Mexico City, Puebla, Mérida and Guadalajara, in New Spain, and those of Lima and Cuzco in the Viceroyalty of Peru, the two most important Hispanic centres in the New World. Factors involved in such constructions included local terrain and the changes introduced when the building process lasted longer than originally expected.

Mérida Cathedral (1563–1598), in the Yucatán, is thought to have been designed by Pedro Aulestia, an architect who had previously worked at Seville Cathedral. Completed by Juan Miguel Agüero, it was based on the colonnaded hall-plan then in vogue in western Andalusia. Mérida Cathedral is characterised by the use of sail vaults, and a calotte with a coffered ceiling reminiscent of the Pantheon in Rome. As a whole, it is exemplary of the transposition to the New World of the on-site design prevalent in Renaissance Spain. The more conservative Guadalajara Cathedral (1571–1618) recalls prototypes in eastern Andalusia derived from the Siloesque style at Granada Cathedral, featuring rib vaulting and compound piers with half-columns raised by sections of curved entablature. Although the design for Mexico City Cathedral, by Claudio de Arciniega, and that of Puebla, by Francisco Becerra, both date from the 1570s, building work on the cathedrals did not reach completion until the mid-17th century. During the protracted building process, the original Roman-style hall-church plans were replaced by more up-to-date tiered, basilican pyramidal plans in the 1630s, in accordance with classicist, 17th-century prototypes and the implementation

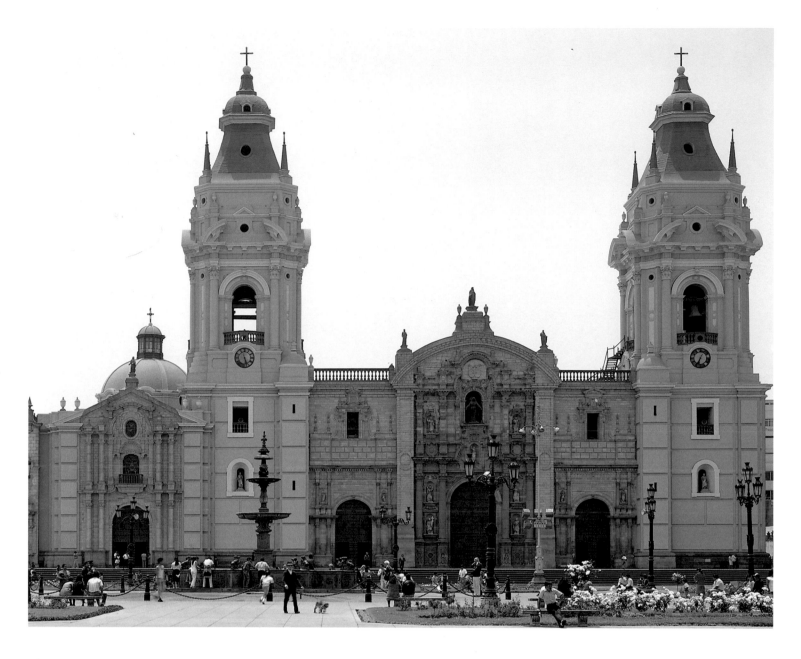

Lima Cathedral (Peru); between 1594 and 1604.

of lighter structural techniques, required by the marshy ground of Mexico City and the shaky ground of Puebla, which the master builder of Mexico City Cathedral, Juan Gómez de Trasmonte, was well aware of. These techniques included the use of brick cells in vaults and a type of volcanic rock known as *tezontle*. The cathedrals of Mexico City (inaugurated, although unfinished, in 1667) and Puebla (1648) are built on a three-naved rectangular ground plan, with absidioles, a dome on an octagonal drum, a barrel vault in the central nave, and sail vaults over the aisles. The classically ordered composite pillars are light, including a section of entablature in the case of Puebla. The monumentality of these two buildings was unprecedented at the time. Their clarity and luminosity were achieved by melding the hall-church style with the classical basilica, and are also the result of the materials used in their construction and geographical factors.

The cathedrals of Lima (1594–1604) and Cuzco (1594–1654) were both designed by the Extremaduran architect, Francisco Becerra. Based on the hall church, they are indebted to the cathedral of Puebla, with their rectangular ground plan and chancel, three naves of equal height and side chapels, although the style is more conventional and sober, with entablatures being retained and pillars arranged in Attic fashion. Lima Cathedral originally had groin vaulting but, as a result of an earthquake in 1609, it was replaced with more elastic rib vaulting, the example being followed at Cuzco. Another earthquake, in 1746, prompted the application of modern, mock rib-vaulting systems using quake-resistant timber. In

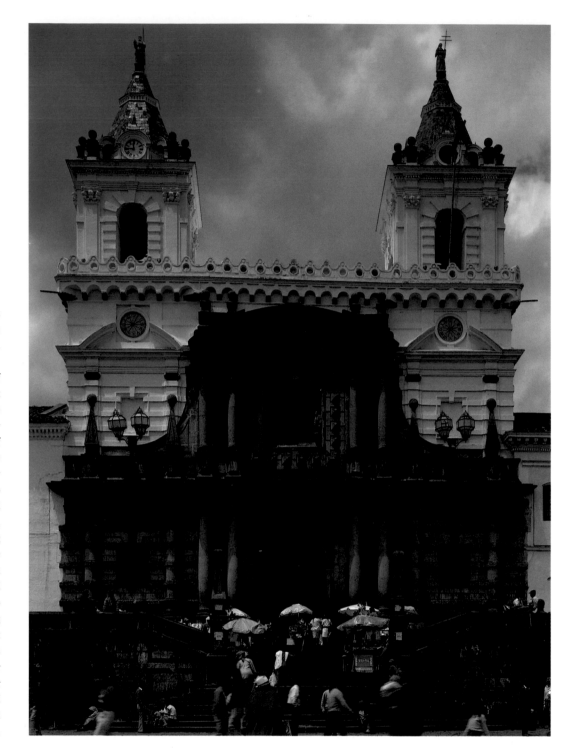

Quito (Ecuador): facade of the convent church of San Francisco; late-16th century.

The facade of the church of San Francisco de Quito is a magnificent example of the changes that took place among the mendicant orders as they became urbanised in the second half of the century, and of how the architectural ideals of late-16th-century classicism could be transposed to distant lands. The grandeur and monumentality of these city churches, suggesting cultivated art styles among the Spanish settlers, is a far cry from the rural mission churches associated with the early days of conquest and evangelisation, which were designed to facilitate the evangelical mission among the indigenous population. Refinement in the use of such formal details as rusticated bands, split gables or circular staircases is reminiscent of Serlio or Vignola; that is, of classicism combined with an innovative use of orders and scenographic treatment of the facade.

the 18th century, 16th-century hall-plan Spanish prototypes appeared with renewed architectural vigour, as they did in Spain. This rather stilted, late-Baroque style is apparent in the cathedral of Santa Fe de Bogotá, Colombia (1807), designed by the Valencian, Fray Domingo de Petrés, and that of Potosí, Bolivia (1809), by the Catalan friar, Manuel de Sanahuja.

An example of the urban monumentality that characterised late-16th-century conventual architecture is the facade of the convent church of San Francisco de Quito, Ecuador (1581). Its Serlian influence is evinced in the circular staircase—reminiscent of the convex–concave interplay in Bramante's Belvedere, reproduced by Serlio—in the way the facade has been divided up by sturdy, banded columns with diamond points, and in the overall interplay of light and shadow. A blend of classical tenets and the physical environment, the church is roofed with whitewood carpentry, which was damaged in an earth-

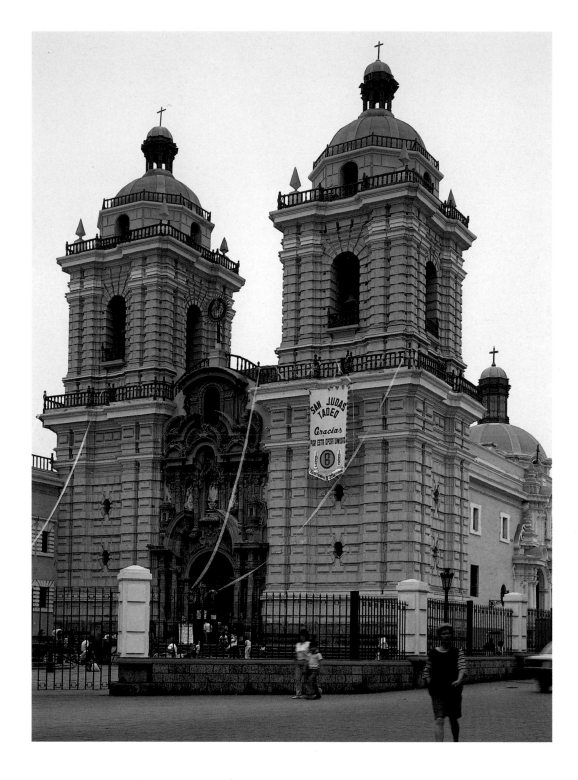

quake in 1757 and praised, in 1647, for its 'beautiful roof with interlaced designs and exquisite cedar, by way of a vault', attributed to Sebastián Dávila, an expert in *jumetría* who was familiar with Renaissance treatises such as the one by Serlio. This is also attested to in the frontispiece design on the facade.

It was then that facade-retables or frontispieces became fashionable on church exteriors. Their development throughout the century was determined by an increasingly more dynamic treatment of chiaroscuro in the stone registers, by cultivated, unbiased compositional articulation and by structural renewal in orders and decorative features. This late, 17th-century classicism, with its liberal admix of Serlian influences and Michelangelesque compositional devices, including projecting sections and clusters of columns, derived from the art of sculpted retables, reached its peak in the second half of the 17th century. This is apparent in cathedral facades built during that period, including Puebla, Mexico City, Lima

Tlaxcala (Mexico): roof frame in the
church of San Francisco;
late-17th century.

and Cuzco. With regard to those in Mexico City (1668), period documents talk of 'retables on the facades'. Architectural development in viceregal Lima was considerable. The finest example of this is the church of San Francisco (1657–1674), regarded as an architectural masterpiece of the period, featuring a curved gable with marked elliptical bulging, and striking chiaroscuro, with split planes and accentuated columns. Cloisters were treated in similar fashion. In Mexico City, that of La Merced (1693–1703), studded with diamond points in the arches and intertwining knotwork in the columns, heralded the Baroque liberties to come.

Whitewood Carpentry in Spanish America

An important milestone in the development of Spanish colonial architecture was the introduction of Hispano–Moslem or Mudéjar whitewood carpentry. The abundant supply of raw timber, the growth of craft guilds, the unstable terrain (with earth tremors and marshy ground) and expedient construction methods facilitated the use of wooden roofing for churches and other public buildings. Framework carpentry, which often went hand-in-hand with building and stonemasonry, enjoyed a period of great activity in the conquered territories until well into the 17th century. It provided a practical solution in construction and incorporated stylistic and technical innovations. Complex frames and knotwork decorative systems were used in conjunction with highly functional panelwork ceilings, roof trusses and carved or painted hip rafters. Contemporary poets and chroniclers described this woodwork with impassioned epithets, such as 'star-studded heavens', 'blue and gold bowls' or 'streaked gold bows'. The high standards of workmanship achieved in this field are borne out in the writings of Fray Andrés de San Miguel (1577–1644), active in New Spain, which describe how whitewood carpentry and the stereotomy of wood were actively studied with a view to their application in the architectural production of New Spain.

In the second half of the 17th century, the use of wood was gradually replaced by masonry. This, together with the erection of new churches over old ones, and the natural decay of wood, helped do away with many fine examples of this architectural element. Some examples of Hispano–American whitewood carpentry have, however, survived the test of time, while others are known from prints. The three-naved church of La Merced (1634–1654) in Mexico City, known from prints, was probably the greatest of these works. The church featured new groin-vaulted systems in the aisles, with traditional timber roof-

Puebla (Mexico): El Rosario chapel, in
the convent of Santo Domingo.
Detail of stuccowork; 1690.

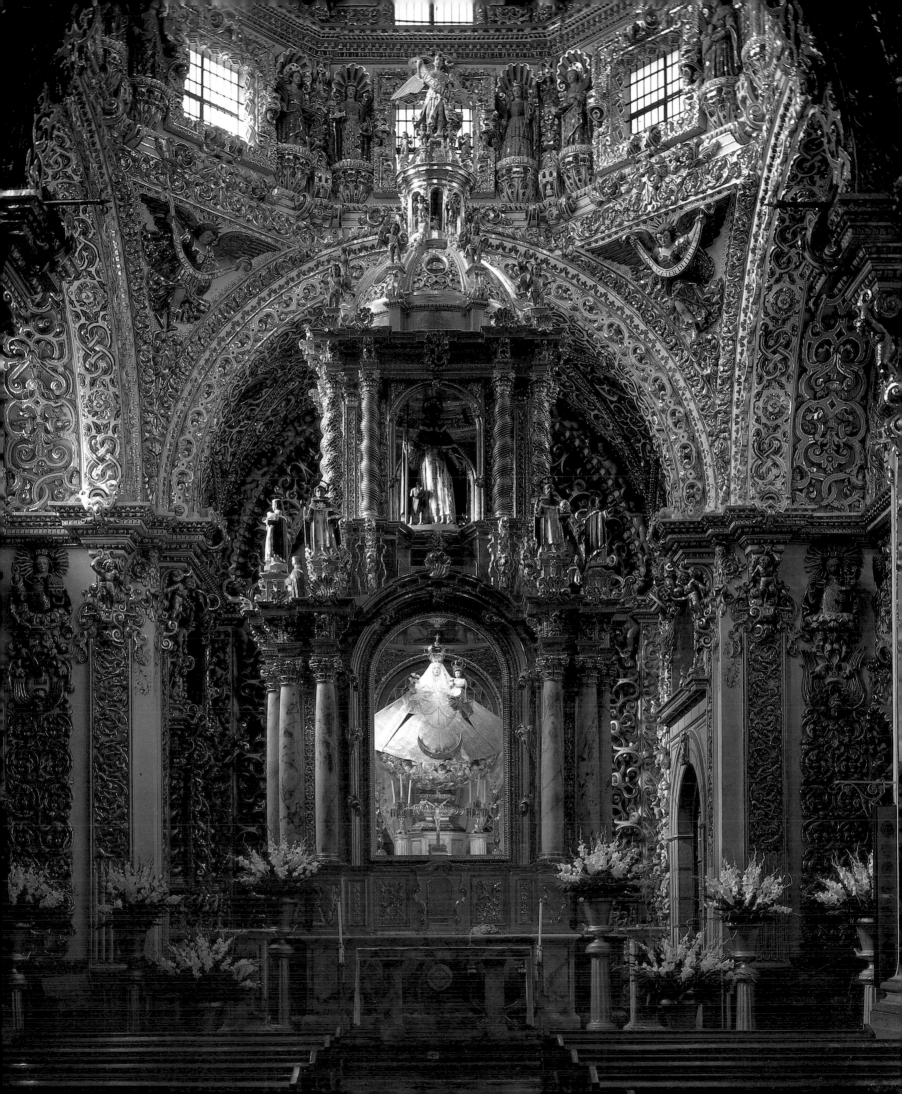

ing: an eight-sided gable roof in the nave, a sharp, pyramidal-section roof over the crossing, and a three-sided roof over the presbytery. A magnificent extant example of whitewood carpentry in New Spain is the church of San Francisco in Tlaxcala, dating from the late-17th century. The nave and sanctuary are roofed with trussed rafters and feature highly decorative knotwork on the ceiling and in the lower choir. There were also numerous examples in the Viceroyalty of New Granada: still standing in Tunja—which was the leading commercial and art centre of the viceroyalty throughout the 16th century and during the first half of the 17th century—is the Cathedral, dating from circa 1570, and the church of San Francisco (1595). Prominent in the *Audiencia* of Quito is the roof of the aforementioned church of San Francisco, damaged in the earthquake of 1775, that of Santo Domingo, dating from the early-17th century, featuring the finest example of whitewood framework in the area, and the original roofing of the same cathedral, described as 'a well-dressed wooden roof'.

In the Viceroyalty of Peru, whitewood frames were used for their resistance to earthquakes, significant examples having survived in the cloister of San Francisco in Lima, and in the parish churches of Huaro, Andahuaylillas and Checacupe in the Cuzco area. The lack of ready timber supplies in such territories as the *Audiencia* of Charcas did not, however, preclude the use of wooden roofing, as evinced in the church of Sucre, in Potosí. The material in question was, however, very costly, proof of the aesthetic and cultural value attached to whitewood carpentry in Spanish America.

Stuccowork and Architectural Decoration

Another distinguishing feature of 17th- and 18th-century Spanish colonial architecture was the use of polychromed stucco in church and chapel interior decoration, which yielded opulent ornamentation and an increasing sense of *horror vacui*. In consonance with similar trends in Spain, stucco was applied throughout the 17th century, with the emergence of modern techniques of Renaissance vaulting, based on the use of light materials. Formal compositions in stucco, derived from the geometrical patterns in wooden roof frames, went beyond the realm of purely decorative plasterwork. The call for ornamentation was also prompted by the growing tendency to apply European structural techniques (Roman-style sail vaulting, calottes or barrel vaulting) to local building materials, such as a volcanic rock known as *tezontle*, in Mexico, and limestone of coraline origin in New Granada, which required the skills of stonemasons and builders. This decorative activity was centred mainly in Mexico. Based on Andalusian tradition and involving the labour of Sevillian craftsmen, stuccowork soon developed in line with indigenous techniques, although with overtones reminiscent of Flemish, Italian and German engraving.

Outstanding stuccowork of Mannerist leanings can be seen in the convent church of Santo Domingo (1632), in Puebla, and in the chapel of the Jesuit college of Tepotzotlán and the church of Santo Domingo (1657), in Oaxaca. The chapel of El Rosario (1690), in Puebla, and the 18th-century churches of Santa María de Tonantzintla and San Francisco Acatepec, both near Puebla, display a Baroque-style decorative involution, with lush, affected ornamental meshes studded with polychromy. The results reveal how closely local craft tradition became interwoven with refined architectural motifs.

Baroque Splendour

The late-17th century and most of the 18th century saw steady growth in the use of extravagant Baroque ornamentation, which became a political, social and religious status symbol. A rich variety of local craft traditions played an important part in this. In addition to stuccowork, the interiors and facades of churches were covered with a profusion of decorative features, including creations fashioned from ductile mortar, multi-coloured ceramic

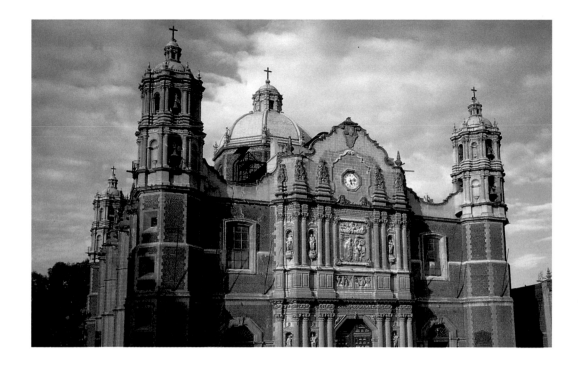

JOSÉ DURÁN, DIEGO DE LOS SANTOS
& PEDRO ARRIETA: Basilica of
Guadalupe, Mexico City; between
1694 & 1709.

facings, foliage and sculptural reliefs. In fruitful coexistence with this ornamentalism, there emerged a cultivated, Baroque-style architectural culture of a high standard, particularly in New Spain. A factor which contributed to this was the growing sense of Criollo identity, which gradually turned to such architectural manifestations as a vehicle for conveying distinctive values of local identity.

From the mid-17th century, the inception of the professorships of mathematics and astrology at the Universities of Mexico and Lima sparked a growing interest in modern mathematics, which soon had an influence in professional architectural circles. Innovative mathematicians such as Diego de Rodríguez and Carlos Sigüenza y Góngora in Mexico, or Juan Ramón Connick and Juan Rehr in Lima, became closely involved in the architectural production of both viceroyalties. Knowledge of the work of the Spaniard Juan Caramuel y Lobkowitz *(Arquitectura civil recta y oblicua,* Vigevano, 1678*),* and of the mathematical treatises of Claude François Millet Dechales (Chambéry, France, 1621–1678) and Tomás Vicente Tosca (Valencia, 1712), which comes through in a large number of works, fostered the development of a modern, mathematically-inclined culture. This often led to the erection of buildings based on the complex operations involved in on-site design and topographical considerations, rather than on classical norms. It also led to increasing research into technical disciplines, such as the stereotomy of wood, which would yield solutions for areas plagued by earthquakes. This accounts for the vast number of arcatures prevalent throughout Hispano–American architecture.

Church facades, naves and crossings, chapel elevations, and the cloisters and courts of monasteries and palaces, were inundated with a profusion of polygonal, pointed, elliptical, rampant, composite and polylobulate arches, and bosses 'suspended in the air', many of them indebted to mediaeval tradition but here set within classical morphology. In many instances, these elements formed complex syntactic and constructive ensembles. What also emerged was an untrammelled cultural attitude steeped in classical grammar, facilitated by the freely available reproductions of compositions by Michelangelo, Dietterlin and Rubens. Classical tenets were geometrically adapted or distorted to fit curved structures, while orders such as the Solomonic, Gothic and Attic were overhauled and used afresh to unsuspected limits, as in the case of inverted pyramids.

The shrine of Guadalupe, in Mexico (1694–1709), was initially built to the design of José Durán and Diego de los Santos, and completed by Pedro Arrieta. This is one of the most representative examples of the Baroque in Mexico, which also includes some precocious, modern innovations. The indigenous materials *tezontle* and *chiluca* were used in its construction. The church is based on a square basilican plan, with a central dome and Solomonic corner towers, and elongated, almost Gothic, compound piers. The shrine marks

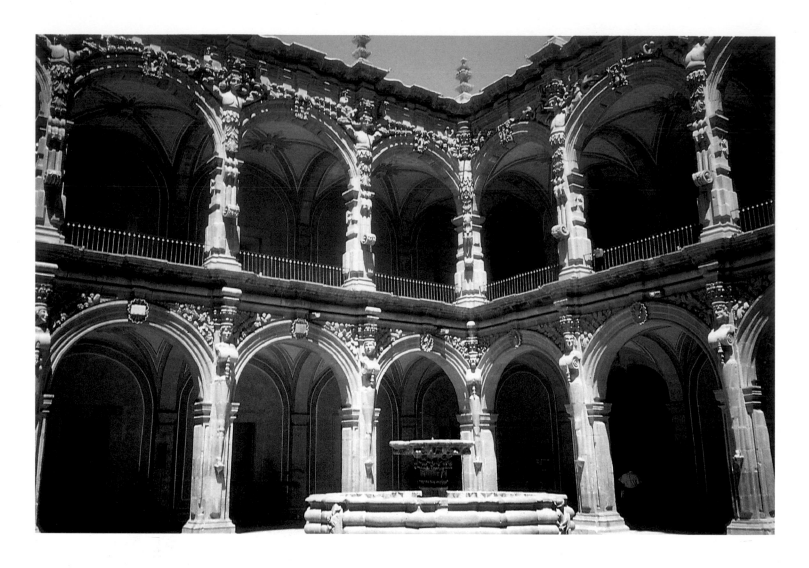

Querétaro (Mexico): cloister in the convent of San Agustín; 1731–1745.

the consolidation, in New Spain, of facades projected trapezoidally outwards, structured in triumphal classical fashion, but with semi-octagonal arches. Polygonometric architecture of this kind, which emerged as a viable alternative to the curvilinear architecture of the Italian Baroque, became very popular in Spanish colonial architecture. A large number of churches in New Spain were endowed with trapezoidal facades, to which classicist orders were adapted through structural logic. Concomitant features included polygonal, Gothic or trilobulate arches. Examples can be seen in the shrine of Guadalupe, that of La Soledad, in Oaxaca (1689–1718), the cathedral of San Luis de Potosí (1701–1729) and, in Guatemala, the church of Concepción, in Ciudad Vieja (1718–1732). The church of La Compañía de México (1714–1720), designed by Pedro Arrieta, has a modern, elegant, 'Gothic order' interior, with clustered piers. The so-called Palacio de la Inquisición (1733–1737) has an octagonal facade with bevelling, and a portal with polygonal arches resting on Gothicist bead mouldings. The inner court lacks columns in the corners and instead, in a show of constructional prowess, has crossed arches and a hanging boss. Within the context of Baroque culture in New Spain, the architect Miguel Custodio Durán exploited the possibilities of the undulating 'full Solomonic order', advanced by Guarino Guarini in his *Disegni* (1686), which introduced an element of curvilinear paroxysm in the treatment of pilasters, cornises and finials. This can be seen in the church of San Juan de Dios (1729), and the Medina Picazo chapel (1733) in the church of Regina Coeli, both in Mexico City. On the facade of San Agustín (1731–1736) at Querétaro, the logic of the 'full order' is transposed to polygonal forms, with an arch broken into sixteen sides or polygonal columns. In the cloister of the convent of San Agustín, one of the most interesting Hispano–American architectural works, articulated and gesticulating toys and dolls have been incorporated into classicist morphology with a freedom and even a sense of humour characteristic of indigenous culture in New Spain.

GERÓNIMO BALBÁS: *Retable of the Kings*, in the Cathedral, Mexico City; 1728–1737.

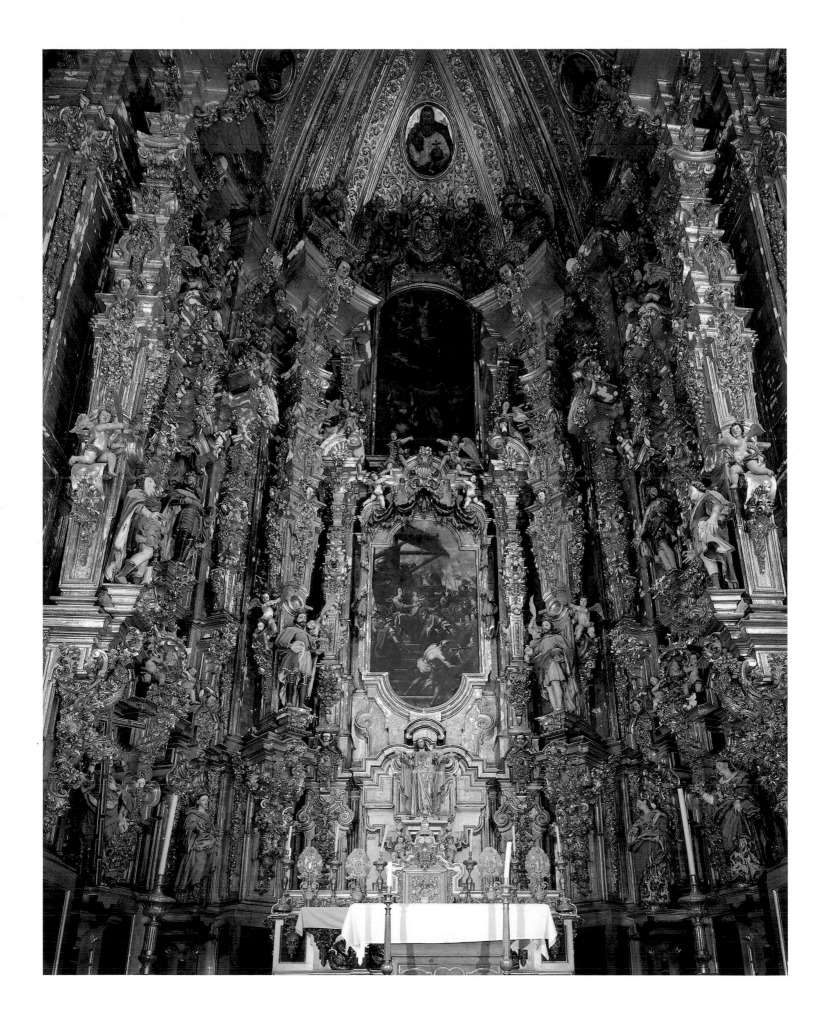

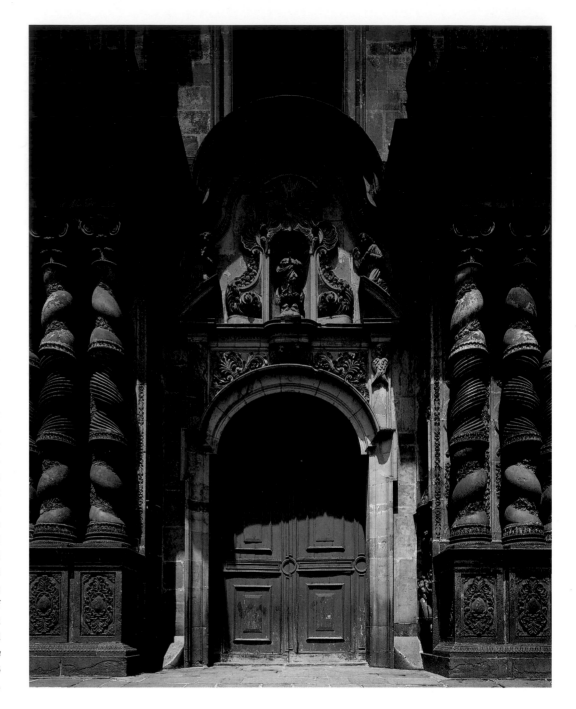

It was in this 'modern' architectural context that the Solomonic column emerged during the last few decades of the 17th century. At times referred to as a 'turbinate' column, in keeping with mathematical terminology of the time, it was joined, in the first three decades of the 18th century, by the inverted, tapering pilaster or *estípite,* introduced into New Spain by the sculptor of retables, Gerónimo Balbás. A form of mixed or composite order, it consisted of an inverted pyramid or truncated cone, surmounted by various superimposed cubic sections and a capital, arranged in Attic-like classical fashion. The *estípite* became extremely popular in New Spain. It often played a dynamic role in scenographic compositions of the type associated with Andrea Pozzo, and was a resounding success in the *Retable of the Kings* in the sanctuary of Mexico City Cathedral (1728–1737). In the tabernacle in this cathedral (1744–1768), an *estípite* used by Lorenzo Rodríguez acquires great forcefulness in the stone architecture, the facades being articulated in the manner of retables. Its gigantic proportions and compositional overtones are Michelangelesque, despite the corpuscular, fragmented impression of the laboriously worked structure. In Central America, particularly Guatemala, a wide variety of column shafts was used. They include the Solomonic col-

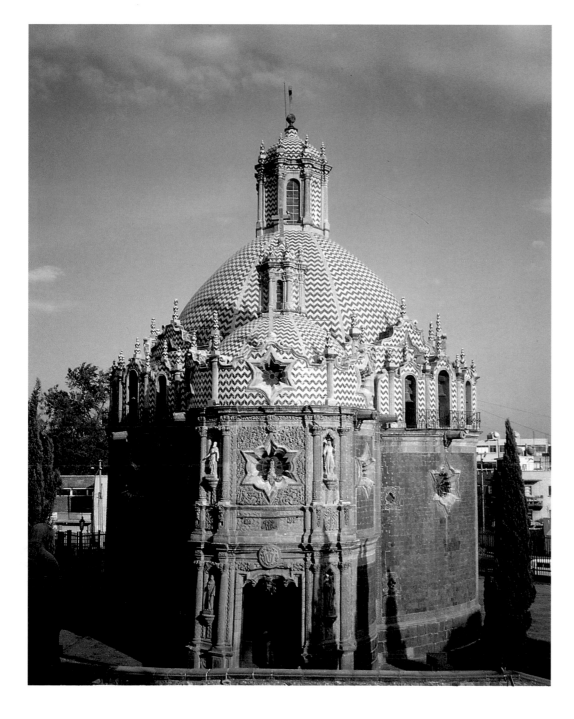

umn (entrance facade at the convent of La Merced, Antigua), the Serlian *estípite,* (facades of the churches of San Francisco and Santa Clara, Antigua) and the ringed pilaster (church of El Pilar, at San Vicente, El Salvador), with tight, lateral curvilinear rhythms setting up an undulating effect, reminiscent of Solomonic columns, on the facade. The monumental Solomonic orders on the facade of the church of La Compañía in Quito, Ecuador (1722–1765), respond to a cultivated Italianate design inspired by a treatise by the Jesuit, Andrea Pozzo. As from the early-18th century, church facades in Lima, Peru, also featured Solomonic columns of this kind, as evinced in the churches of La Merced, San Agustín and Trinitarias. Drawing on the possibilities afforded by the compositional legacy of the 17th-century Baroque, these facades throng with columns in two or more planes, pilasters with modillions, and cornises whose sides open abruptly into arches.

Polygonal arcatures, mixed and polylobulate arches—generally trilobulate—which by then had been developed to high technical standards, crowded the portals of numerous churches, covent cloisters and palace courts. Outstanding examples in the Puebla region include the court in the Casa de las Bóvedas (Puebla), the church of Santa María de

Tonantzintla and that of La Merced (Atlixco), and the portal of the church of La Compañía (Puebla) with its complex stereotomy. Other examples include the University courtyard in Antigua, (Guatemala), and the gate house of the monastery of San Francisco in Guatemala. Also in Guatemala, the facade of the church of La Merced, the cloisters of San Francisco Solano, San Agustín and Santa Teresa, and the court in the Torre Tagle palace, and, in La Paz (Bolivia), the portals of the churches of San Francisco and Santo Domingo. An innovation spawned by the increasing use of mathematics in architecture was a type of arch that discharged into bosses suspended in the air, as in the Casa del Alférez Cebrián y Valdés in Mexico (1762–1766).

Apart from the characteristic facade-retables, which projected polygonally outwards, 18th-century Spanish colonial architecture featured facades arranged in Roman style: two sections, linked by volutes, although interpreted in Baroque fashion, the cornices having mixtilinear profiles, undulating planes and obliquely angled columns, the most outstanding example of which is the facade of Havana Cathedral in Cuba (1748–1777). It is related to those of Guadix and Cádiz (Spain) and others in the Levant region of Spain, with which it clearly shares common cultural Hispanic Baroque origins. Another example is the facade of San Francisco de Popayán, Colombia (1775–1787), designed by Antón García, which features a rippled cornice with oblique outlines, classical columns and fascicles of Gothicist bead mouldings in the portal and niches, which contemporaries had no compunction about describing as 'modern architecture'.

The solid principles governing Spanish colonial Baroque architecture, particularly in New Spain, are best summed up by the figure of a Criollo architect, Francisco Guerrero y Torres (1727–1792). The chapel of El Pocito (1771–1791), the church of La Enseñanza (1772–1778), the Casa del Conde de San Mateo de Valparaíso, and those of the Condes de Santiago de Calimaya and the Marqués de Jaral Berrio, all in Mexico, make up a veritable showcase of architectural stonework, studded with examples of on-site design, which Guerrero y Torres executed to the highest formal standards within the deep-seated Mexican Criollo tradition. His work throngs with polylobulate, mixtilinear and polygonal forms, which coalesce in a fluid, undulating, mosaic-like movement that ripples through pilasters, ribs and cornises, conjoined with his peculiar chromatic elegance, achieved through the use of the local materials *tezontle* and *chiluca*. He applied Caramuel's principles of obliquity, with more than a hint of irony, to staircases (Casa del Conde de San Mateo de Valparaíso), and to dynamic, sloping plans, derived from ancient Rome (Chapel of El Pocito), enabling him to endow an overall structural composition of secondary areas, such as the sacristy in the above-mentioned chapel, with a remarkable polygonal syntax.

Painting and Sculpture: Images and Roads

From the very beginning of Spain's colonisation of the New World, painting and sculpture performed a prominent function in evangelisation, facilitated by the great capacity of the indigenous people for assimilating the various art forms. In this respect, it is worth recalling the pre-Hispanic art schools, known as *calmécac,* where American Indians traditionally acquired their skills. This explains why the arts and crafts schools founded by the missionary brothers were so successful. The first of these was founded by Fray Pedro de Gante at San José de los Naturales in Mexico. It was followed by the Augustinian school in Tiripitío (Mexico) and the Franciscan one in Quito (Ecuador). One local painter documented at that time was Juan Gersón, whose paintings on amate paper are housed in the lower choir in the convent church of Tecamachalco, Mexico (1562). Another was Marcos Cipac, to whom the original image of the Virgin of Guadalupe is attributed.

The walls and portals of convents teemed with catechistic motifs fashioned in reliefs and sculptures, murals in tempera with a gesso ground and, to a lesser degree, fresco. This repertoire was subsequently augmented by canvases, reproductions of prints and woodcuts depicting such fundamental Christian subjects as the Passion and the life of the Virgin Mary,

hagiographic themes associated with the various religious orders, and those relating to basic rituals (the sacraments), swiftly executed to meet the pressing educational and ideological needs and at little expense. The history of the Franciscan order is depicted in the Mexican convents of Cholula and Huejotzingo, featuring the arrival in Mexico of the first twelve Franciscans, under the guidance of Fray Martín de Valencia, shown congregated around the figure of Christ or the Cross, and in one of the *posa* chapels of San Andrés de Calpan, with its iconographic programme of the life of St Francis. The gate house at the Augustinian monastery of Actopan (Mexico City) features prominent mediaeval figures from the order. Similarly, pictures of Augustinian saints, including St Augustine himself, are arranged at different levels on the wall flanking the main staircase, the lower level being taken up by those of the prior at the time the programme was executed, and local donors. The Dominicans based their iconography on the Virgin of the Rosary, whose effigy adorns chapels attached to the major convents, particularly at Puebla and Oaxaca. The Jesuits elected to display cycles of the life of St Ignatius in the outermost cloisters and courts, although they can also be seen in the church of San Pedro de Lima, with a series executed by the Sevillian painter, Valdés Leal, and at the Novitiate of Tepotzotlán, by Cristóbal de Villalpando.

A noteworthy example of the early educational subjects designed to put the fear of God into the indigenous population is that of the Last Judgement, painted on a large number of convent walls (San Agustín de Acolman). Humanistic subjects were interspersed with religious ones, so that paintings of Plato, Socrates and Aristoteles are found side-by-side with such religious sages as Atotonilco. At times they were the subject of a complete programme, such as the triumphs of Petrarch in the Casa del Deán at Puebla. Another, highly original theme in Hispano-American painting was that of Indians, depicted in their racial diversity, insignia and death—portrayed on burials—and in portraiture.

European artists, particularly from Seville, played an important role in the development of Hispano–American painting and sculpture. Seville's monopoly over sea trade with the New World had a screening effect on whatever was exported to the Americas. Three painters from Seville who settled in Mexico were Cristóbal de Quesada (active in 1535–1550), Andrés de la Concha (active in 1583–1612) and Sebastián López de Arteaga (1610–1656), while Baltasar de Figueroa the Elder, who settled in Colombia, was also Sevillian. Others, of different extraction, included Melchor de Sanabria and Miguel Luis de Ramales, from Castile, the Italians Bernardo Bitti and Angelino Medoro, and the Fleming Simon Pereyns (c. 1530–c. 1600). The situation was similar in the field of imagery and retable sculpture. In New Spain, most commissions were awarded to artists from Seville, notably Diego de Pesquera and Martín de Oviedo, but other Europeans, such as Adrian Suster, were also active there. The leading Spanish figures were Pedro de Requena, who sculpted the retable of Huejotzingo, and Juan Rodríguez, the artificer of the retable sculpture at Yuriria. The brothers Claudio and Luis de Arciniega worked as architects, sculptors and engravers. Claudio was celebrated for his project in Mexico City Cathedral, and both of them were active in a number of areas: they are attributed with tomb sculpture, triumphal arches, Holy Thursday monuments, wooden retables and architectural sculpture. The Italian Jesuit Bernardo Bitti, a painter and sculptor, worked on the magnificent retable in the church of La Compañía at Cuzco, where his reliefs are clearly Mannerist inspired and reveal a blend of indigenous techniques—using such plant fibres as *maguey*—with Hispanic ones, including polychromy and sgraffito.

The presence in the New World of the aforementioned artists, and the direct influence of readily available prints of works by European masters, was accompanied by a flourishing art trade, with paintings and sculptures being sent to various points of Spanish America. The most important source of supply as far as painting was concerned was Andalusia. Zurbarán's *Apostolate* was sent to the church of Santo Domingo de Guatemala, and shipments to the New World also included works by Murillo, Pacheco, Herrera the Elder and Valdés Leal. Artworks were also sent from circles in Madrid (Bartolomé Román) and even Flanders (prints of works by Martin de Vos and copies of Rubens). Turning to sculpture, the work of Juan Bautista Vázquez, a product of the late-Mannerist school of

FRANCISCO GUERRERO Y TORRES: house of the Marqués de Jaral Berrio, or Itúrbide Palace, Mexico City; between 1779 and 1785.

Seville, had a decisive influence in New Granada at the end of the 16th century, as evinced in the retable in the chapel of Los Mancipe at Tunja, Colombia. Also extremely influential was the work of the Sevillian Juan Martínez Montañés, particularly in the Viceroyalty of Peru, either directly—as in the retable of St John the Baptist, executed for the monastery of La Concepción de Lima, and now in Lima Cathedral—or indirectly, through his followers, notably Martín de Oviedo and Alonso de Mesa. Another important aspect of the art trade was the export of Hispano–American artworks, shipped on the return voyage to Spain. Most of them were sent as part of donations or among the possessions of families returning to Spain. These works had considerable exotic appeal in Spain, but did not exercise any influence on Spanish art, with the exception of some specifically indigenous subjects such as the Virgin of Guadalupe and Santa Rosa of Lima.

Developments in Painting and Sculpture

In the 17th century, Hispano–American painting assimilated and interpreted European currents rather freely, from 'reformed' Mannerism and tenebrist naturalism, in the first half of the century, to the dazzling, colourful Baroque of the second half. In New Spain, the Flemish painter Simon Pereyns (c. 1530–c. 1600) imported an early Mannerist streak based on prints of works by Martin de Vos and Raphaelesque models (*Virgin of Pardon,* Mexico City Cathedral). Luis Juárez (active 1610–1639) and Baltasar de Echave Ibía (active 1625–1644) were the leading exponents of late Mannerism influenced by the Sevillian school, particularly the figure of Alonso Vázquez. Their style is characterised by idealised figures appearing in stark contrast to other, baby-faced figures with tousled tresses, as well as by stilted drapery and intense blue tones.

Also prominent in the field of painting was the Lagarto family, miniaturists active in the late-16th and early-17th century. Their precious compositions, executed on vellum and paper, have a decidedly Mannerist hallmark. Alonso López Herrera (active 1609–1650), known as 'the Divine', was celebrated for his bold foreshortening and the prevalence in his work of Flemish influences rather than Italian ones. In the Viceroyalty of Peru, two Italian painters, Bernardo Bitti and Angelino Medoro, were instrumental in importing a cultivated Romanist form of Mannerism, typified by elongated figures, affected postures and subdued colours with veils. Their workshops led to the spread of the Mannerist style throughout the viceregal territory, albeit tinged with some indigenous features. Angelino Medoro's *Immaculate Conception,* commissioned by the Augustinians, was acclaimed as a prototype until the end of the 18th century.

In the second three decades of the 17th century, Zurbarán's work, which was either publicly available or made known through his disciples, had a decisive influence throughout Spanish America. Sebastián López de Arteaga (1610–1656), a disciple of Zurbarán's, introduced and promoted a vigorous tenebrism in New Spain, as in *The Incredulity of St Thomas,* (Pinacoteca de México). An Aragonese lawyer, Pedro García Ferrer, was one of the leading exponents of tenebrism in Mexico. The 'art mentor' of Bishop Palafox, García Ferrer trained in the circle of Ribalta in Valencia. He was both a painter and sculptor, and is purported to have written essays on architecture. He painted the canvas, *Immaculate Conception,* which owes much to Ribalta, for the Retable of the Kings in Puebla Cathedral, based on a design ascribed to Juan Martínez Montañés. The influence of Zurbarán is apparent in such painters as Juan Tinoco, whose *Apostolate* (Galería de Bellas Artes, Puebla) features marked chiaroscuro. Works by Zurbarán and Francisco Herrera the Elder, shipped to Lima in 1630, were instrumental in arousing an interest in chiaroscuro in local art circles.

Censure of a Baroque nature emerged during the second half of the century, fostered to some extent by the dissemination of Flemish engravings and the presence of artworks by the Sevillian school, including Valdés Leal and Murillo. Baroque painting was consolidated in the late-17th and early-18th century, thanks to the work of Cristóbal de Villalpando and Juan Correa in Mexico, Miguel de Santiago in Ecuador, Melchor Pérez de Holguín in

Bolivia, and Diego Quispe in Peru. The most impassioned Baroque artist in New Spain was Cristóbal de Villalpando. He won fame in viceregal society during his lifetime, and held the posts of guild inspector and examiner. Prominent among his numerous works are the cycles based on the founders of the religious orders, including a set of twenty-two paintings on the life of St Ignatius of Loyola, based on prints of Rubens-Barbé (Rome, 1609), executed in the form of lunettes for the novitiate of San Francisco Javier at Tepotzotlán. Also by his hand is the cycle of forty-four oils on canvas, depicting the life of San Francis, in the Franciscan convent at Antigua, Guatemala, and the large-format canvases in the series executed for the sacristy in Mexico City Cathedral, comprising *The Apotheosis of St Michael, The Woman of the Apocalypse, The Militant Church* and *The Church Triumphant*. These compositions on a grand scale and their vivid colouring reveal the influence of prints of works from Rubens' circle.

Miguel Cabrera (1695–1768), an exponent of 18th-century Baroque painting in New Spain, produced work of such an exceptionally high standard that in the 19th century he was known as 'the Mexican Michelangelo'. He painted large-format works for churches in Taxco, Tepotzotlán and Santa Rosa de Querétazo, and his subject matter was varied, ranging from religious paintings and landscape to portraits and compositions for funerary works. His splendid *Portrait of Sor Inés de la Cruz* is a celebrated work.

In sculpture, the Mannerist period, brilliantly represented in Spanish America by the Italians Bitti and Pietro Santangelo in Peru, was succeeded in the first few years of the 17th century by a form of realism influenced by Martínez Montañés and his disciples, particularly in the Viceroyalty of Peru, where some of the leading figures were Martín de Oviedo, Alonso de Mesa and Gaspar de la Cueva. In the middle of the century, local workshops were set up to meet the rising demand for imagery. A school emerged in Quito with distinguishing features that marked a departure from the aforementioned realistic trend. Cuzco became a highly active centre of sculpture in the second half of the century. A technique that developed here involved attaching wooden heads, arms or hands to a sculptural backing of glued fabric. Various Indian sculptors were noteworthy at that time, including the Cuzco sculptor Tomás Tairu Túpac. His *Virgin of La Almudena,* housed in the church of the same name, reveals a tempered, sweetened variation on the realistic pathos that characterised contemporary Spanish sculpture. In the 18th century, the arrival in New Granada of the Andalusian Pedro Laboria marked the ascendancy of Baroque forms, characterised by theatrical affectation and agitated movement, as in *The Abduction of St Ignatius,* housed in the church of La Compañía at Santa Fe de Bogotá, Colombia. In the second half of the century, an indigenous artist from Quito, Manuel Chili, called 'Caspicara', produced statuary with graceful, mundane, inconsequential, almost Rococo forms, culminating in a large number of magnificent figurines for Nativities.

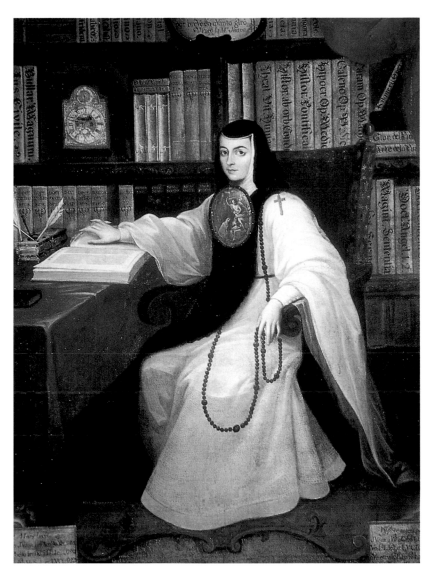

MIGUEL CABRERA: *Portrait of Sor Juana Inés de la Cruz;* 1750. Oil on canvas, 207 x 148 cm. Museo Nacional de Historia, Mexico City.

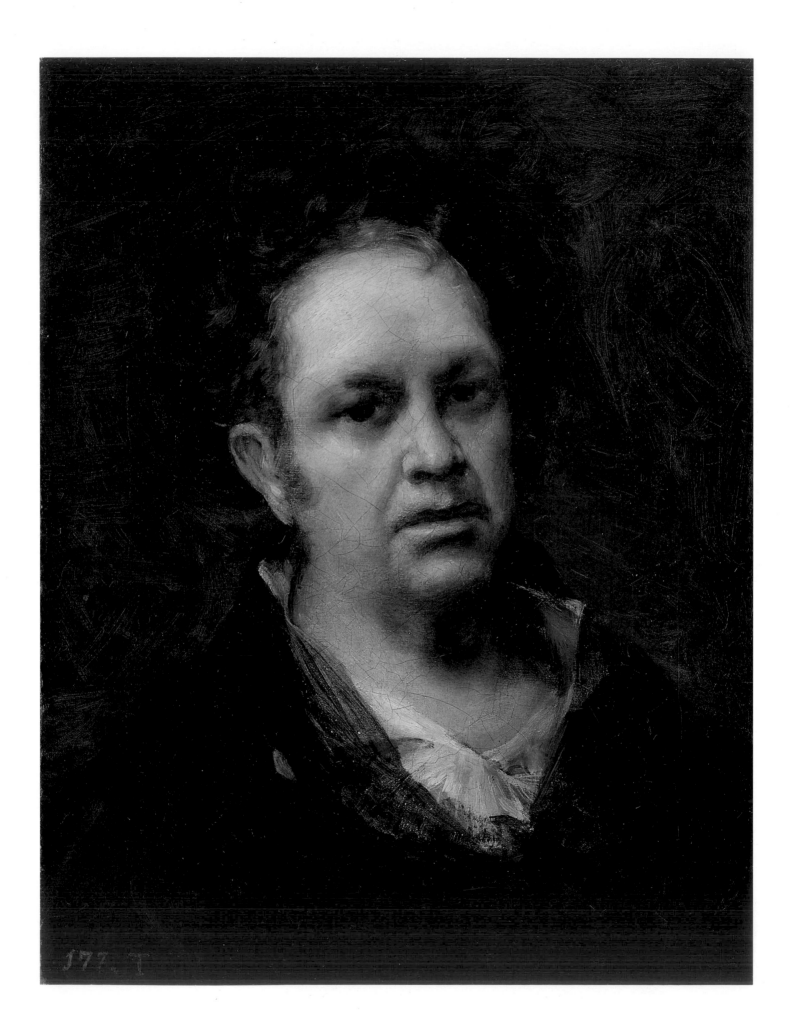

Francisco de Goya

Manuela Mena Marqués

Goya lived from 1746 to 1828, spanning one of the most interesting political, social and cultural periods in the history of both Europe and Spain. As a man of his time, like David in France, Goya was one of the artists most closely linked to contemporary political events: he was a key witness of major events during his lifetime and, in his capacity as friend and painter–confidant of leaders who had to take momentous decisions, had direct experience of them. This proximity to the figures who held the reigns of power and ruled the destinies of that period must have prevented him from adopting a completely neutral position and devoting himself solely to his work as an artist. Goya was highly intelligent and quick-witted. He had a wide variety of interests and saw through human nature. His close relationship with the king and the latter's ministers, as well as with Floridablanca, Jovellanos and the all-powerful Godoy, the intriguing queen, Maria Luisa, and the Duchess of Alba, among many others, meant he had first-hand knowledge of the important decisions taken in the corridors of power and in cultural circles. Although his political leanings were never as clear as those of David, his friendships in intellectual circles, particularly with Francophile and liberal politicians, led him to also be regarded as a Francophile. As the king's chamber painter, his close ties to the Court compelled him to keep up an appearance of restraint and ambiguity, so as not to jeopardise his position. This state of affairs lasted until he was forced to flee political repression under Ferdinand VII and seek exile in Bourdeaux. Even then, he could not afford to openly admit his condition as a political exile, saying he was travelling to a spa resort for health reasons. Indeed, his private correspondence, as when he wrote to his childhood friend, Martín Zapater, contains not a trace of any reference to things of a political or social nature, nor criticism of the powers-that-be or

judgements relating to historical events that took place during those critical years of the French Revolution. Yet his painting, and his art as a whole, including etchings and drawings, is profoundly political, and his oeuvre reveals a clear-cut political stance which has historically kindled debate and controversy regarding the figure of the artist.

Thus, Goya's political thinking, his critical attitude towards the society of his time and his association with historical events were issues he kept strictly to himself, his family circle and close friends, so that it must not have been easy to get close to him as a private individual. As a young man, he had already learned to tread carefully in his patrons' circles. More difficult still, he managed to keep up ties to the strange Court of the exiled Infante Luis de Borbón, while simultaneously being trusted in official circles and by King Charles III himself. This suggests an artist with a rare talent for tact and subtlety, and a mastery of intricate courtly etiquette. Years later, he also demonstrated his adroitness at circumventing a dangerous situation when, in 1803, he presented the plates and some of the prints of his etchings in the series, *Los Caprichos,* to the Royal Engraving Workshop. Dating from 1799, the series was critical of the monarchy and Godoy himself. It was known to the general public, for whom it was a subject of jocularity, but it had become a threat to the artist's personal integrity. Indeed, the affair led him to be denounced before the Inquisition.

While Goya's writings contain no references or criticisms relating to his political and social leanings, as that would have compromised his position, his complex work actually reveals both continual references to such issues and the artist's identification with certain ideals of progress and freedom then in vogue. However, we are probably still far from uncovering the intricacies of his innermost thought, which

Francisco de Goya: *Veiled Female Figure (Italian sktechbook);* circa 1771. Pen & sepia ink on black pencil strokes, 18.6 x 12.8 cm. Prado, Madrid.

Francisco de Goya: *Self-portrait;* 1815. Oil on canvas, 46 x 35 cm. Prado, Madrid.

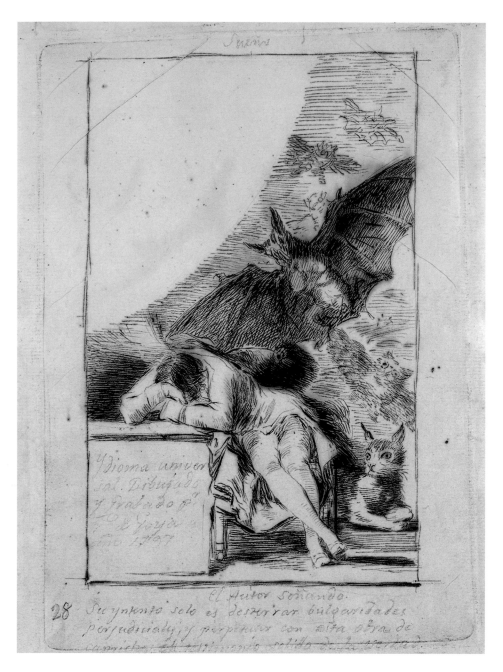

FRANCISCO DE GOYA: *The Sleep of Reason Produces Monsters,* or 'Ydioma universal'. Drawing and engraving by Francisco de Goya; c. 1797.
Los Caprichos, Plate 43, preparatory drawing for an etching, Prado, Madrid.

book drawings. His compositions are striking in their masterful simplicity and their power to communicate and move the spectator, while his drawings and etchings are often punctuated with concise, pithy, telling statements regarding the deeds of men and women. Contemporaneous references abound in Goya's work: clearly, he drew inspiration for his personal art world from Court circles, the Church and its sphere of influence, and from society. Nevertheless, he insisted that, in *Los Caprichos,* he used an *Ydioma universal* ('universal language') commensurate with true art, and refrained from criticising specific people or events, concentrating instead on a general satire of man and his vices, a claim that may be extended to other compositions of his.

Taken as a whole, Goya's work reveals the subjects that most concerned him, all of which were invariably related to man and his deeds. Unlike his contemporaries, Constable, Gainsborough and Turner, nature was not the main purpose behind his work, although the latter does feature details of landscapes of haunting beauty, expressive force and originality. Indeed, he may be regarded as one of the first modern landscape painters, if by that we mean portraying nature not necessarily as something benign, serene and classical, but rough and even inhospitable, harsh and real, like the Spanish countryside he ventured into so often. Similarly, he was not inspired by the genre painting tradition so widespread in Spain, yet his realistic portrayal of animals, flowers, drapery and other objects could have led him to become one of the greatest still-life painters of the century, possibly better even than Chardin. Although his oeuvre includes a few still-lifes, it cannot be claimed that he was attracted by the beauty of the abundant food he depicted, or by dead game, bearing in mind he was an avid hunter. He limited himself to capturing the poignant actuality of death, which he did so starkly that, judging from the few examples of his which have survived, it appears that he would not have been successful in a genre essentially regarded as pleasant and decorative. The same can be said of his portraits: unlike his contemporaries, Mengs, Batoni, Reynolds or David, he did not concern himself with stressing the most agreeable or noble aspects of his subjects, or highlight features suggesting their status, wealth or comfortable lifestyle. Each of his portraits reveals a story, a drama, bounty, intelligence, failings, disappointment, stupidity or even the evil in his sitter. Stories, whether dramatic or humor-

comes through in most of his known drawings and etchings. These works pose a number of riddles and double entendres, while certain figures and compositions with contemporaneous allusions have aroused the curiosity of art historians. A host of theories and hypotheses have been put forward to shed light on the depths of the Goyesque world, from popular sayings and satire to literary quotes and iconographic references, both past and present, including those associated with current events and the endeavours of contemporary figures to decipher the elements Goya featured in his works, particularly those of a personal, private nature—small cabinet paintings and the series of etchings known as *Los Caprichos* and *Los Disparates,* and, above all, his numerous sketch-

ous, tragic or burlesque, unfold in all their complexity in his compositions. They point up Goya's essential form of artistic expression, along the lines of the great classical painters of the past, and wholly within the grand tradition of history painting, which epitomises the work of this artist. In all his paintings, etchings and drawings, what comes through is Goya's concerted attempts to express his profoundly humane and artistic convictions. It is in these works that the artist shaped his heartfelt concern for moral, social and political issues, in an endeavour to move his contemporaries, and perhaps future generations, too, which is the most a genius can aspire to.

In a nutshell, Goya's work revolves around the major themes that have always affected humanity, from the ingenuous world of games and pastimes to the most frightful horrors of war. Between those two extremes, he showed an active interest in all aspects of life. Perhaps one of Goya's major concerns was how man is transformed by evil and vice: he considered that lust, greed and cruelty had the same ability to produce change in people as poverty and fear. Freedom in all its guises, from individual freedom and the right to be different, to social freedom, was another of his major concerns. He considered that a deep desire for freedom, an essential ingredient in the make-up of mankind, was behind the urge to put an end to child slave labour, to female prostitution and to male fanaticism and sloth. Goya denounced established power only when the latter enslaved people, which accounts for the invective he hurled at the Church, the aristocracy and the government whenever they compromised on their objective duty to serve society. Incipient democracy and democratic values emerge in his work: he praised the Liberal Constitution of 1812, one of the most progressive constitutions of the period, although it was abolished by Ferdinand VII before it had borne fruit. Bounty, tenderness, love, courage and heroism were interpreted with virtuosity by Goya, as were hate, fear and cruelty. He portrayed the feelings, passions, vices and crimes of his fellow men masterfully, but with profound humaneness and understanding, too.

Like all great artists, Goya can be studied from a strictly art historical viewpoint. As a painter of his time, his oeuvre has distinguishing features. His masters, as well as his travels, his sojourn in Italy and Madrid, his presence at Court and the nature of his patrons all contributed to determining the way he painted and his unique, personal style. Francisco Goya y

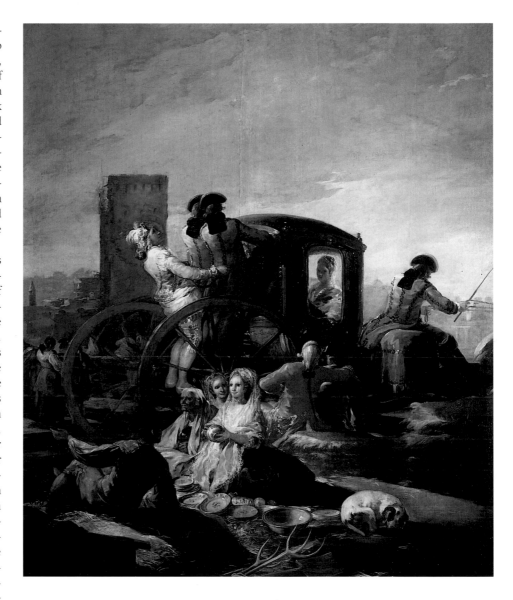

Lucientes was born in Fuendetodos (Zaragoza) on 30 March 1746. The son of a well-to-do master gilder with a smattering of art culture, Goya devoted his life entirely to the art of painting. He died in Bourdeaux, far from his place of birth, on 15 April 1828. He learned the rudiments of his art in the workshop of his first master, the modest José Luzán, where he copied Italian and French prints. From 1766 to 1771 he was in Madrid, where he made several unsuccessful attempts to enrol at the Academy of San Fernando. He was a disciple of Francisco Bayeu, a celebrated and accomplished painter whose academic approach was decisive in perfecting Goya's technique. At Court, he studied works in the royal collections, particularly those of the Venetian painters—especially Titian—and Velázquez who, according to Goya,

FRANCISCO DE GOYA: *The Pottery Seller;* 1779. Tapestry cartoon for the decoration in the Príncipes de Asturias Bedroom in the Palace of El Pardo; 259 x 220 cm. Prado, Madrid.

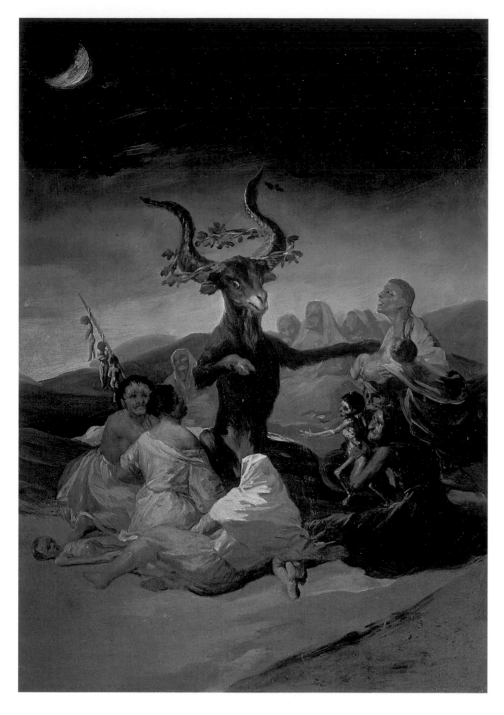

FRANCISCO DE GOYA: *Witches'
Sabbath;* 1795-1798, 43 x 30 cm.
Museo Lázaro Galdiano, Madrid.

was his principal master, 'in addition to Rembrandt and nature'. Two great Italian masters from the previous generation, Corrado Giaquinto and Giambattista Tiepolo, who had also been active in Madrid, had a substantial influence on the young Goya. At about that time he also met Anton Raphael Mengs, a leading exponent of Neoclassicism, painter to Charles III and promoter of the Academy of San Fernando. His sojourn in Italy in 1770 and 1771—recorded in the artist's *Italian Sketchbook* (Prado), which has recently come to light—led him to visit a number of major cities and to acquire first-hand knowledge of Renaissance and

Baroque painting and Roman antiquity, as evinced in the canvas he entered for the competition held by the Academy of Parma, *Hannibal looking at Italy from the Alps* (Selgas–Fagalde Foundation, Cudillero). Between 1772, when he returned to Spain, and 1786, by which time he was lecturing at the Academy of San Fernando, Goya executed works for religious benefactors, notably the frescoes in the basilica of El Pilar and the Aula Dei Charterhouse, both in Zaragoza, and commissions for Mengs in Madrid, including the famous series of tapestry cartoons for the Royal Workshop of Santa Bárbara. These cartoons feature an interesting and wholly new iconography, inspired by numerous sources, from everyday life in Madrid to classical motifs and compositions by the Italian masters, apparent in Goya's use of rich colours, in the forcefulness and freedom of his accurate brushstrokes, and in their harmony and grandeur. These scenes, which lead the viewer into a new world of infinite variety, include a number of symbols now identified as characteristic of Goya, such as the *Parasol* and the *Blind Hen*. During the decade from 1780 to 1790, when Goya first earned widespread public acclaim, he devoted most of his time to painting portraits. With his insight into human nature, Goya was well equipped to tackle this genre, which had become essential in court circles. His keen powers of observation and his sense of psychological introspection, together with an extremely delicate technique and compositions with irresistible charm, soon turned Goya into a fashionable portraitist. He was awarded commissions by several clients who were prominent figures in Spain's political and cultural life, including the Count of Floridablanca, the Dukes of Osuna and Medinaceli, the Infante Luis de Borbón, and the powerful promotors of the Banco de San Carlos. By then, Goya's work was characterised by expressive force and criteria of his own, a hallmark of his entire career.

This period, which saw Goya's rise to the pinnacle of public acclaim and enabled him to lead a comfortable life, was marred only by the successive deaths of his children, after which the sole survivor was his son Javier, born in 1784. At the end of 1792, his life took a sudden turn for the worse: Goya fell ill and was at death's door and, although he eventually recovered, the disease left its mark on him, principally in the form of deafness, which remained with him for the rest of his life. He then embarked on a remarkable series of paintings on tinplate which he presented to the Academy of

San Fernando in 1794. Known as *Los Caprichos,* this unique collection features such noteworthy compositions as *The Shipwreck, Assault on the Stagecoach* and *The Madhouse.* This series confirmed the attainment of complete, unfettered creativeness and attested to the free-flowing outward expression of the artist's inner world, far removed from the irksome trammels imposed by patrons and official commissions. In 1796, Goya became involved in a brief but passionate love affair with the young Duchess of Alba in the town of Sanlúcar de Barrameda, as borne out by the drawings in a sketchbook he kept there, known as the *Sanlúcar Album.* Together with the later *Madrid Album,* it provides further evidence of the deep-seated, creative freedom typifying the artist's work at the time, which culminated in the series of etchings also known as *Los Caprichos,* dating from 1799. This series is a biting criticism of man and his vices, as well as of society at large and the evils of his time. From 1796 to 1800, Goya took on a number of important commissions. In his portraits, he achieved absolute mastery. Indeed, some of them may be regarded as paradigms of the genre: *Portrait of Jovellanos* (Prado, Madrid), *The Duchess of Alba in Black* (Hispanic Society, New York), *The Actress* 'La Tirana' (Academy of San Fernando, Madrid), *The Countess of Chinchón* and *The French Ambassador, Guillemardet,* (Louvre, Paris). The culmination of all these works was his finest portrait, *King Charles IV and His Family* (Prado, Madrid), dating from 1801, which also marked the beginning of Goya's mysterious absence from Court, which has still not been accounted for. He also painted some more personal, large-format canvases of religious subjects, notably those executed for the church of La Santa Cueva, in Cádiz, *The Taking of Christ,* for Toledo Cathedral, and frescoes in the hermitage of San Antonio de la Florida in Madrid, all of which reasserted his exceptional skills in this difficult genre. During this period, he also painted a number of freely-executed cabinet works which, in terms of subject matter and creative freedom, are related to the world of *Los Caprichos.* Noteworthy among them are *Scenes of Witchcraft* (Museo Lázaro Galdiano, Madrid, and National Gallery, London), and small-format paintings on a variety of subjects in the Marquis of Romana private collection (Madrid). One of the compositions that was to subsequently acquire lasting fame was Goya's *La Maja Desnuda* (Prado, Madrid), originally owned by Godoy. A legend grew up around this painting which involved Goya's relation-

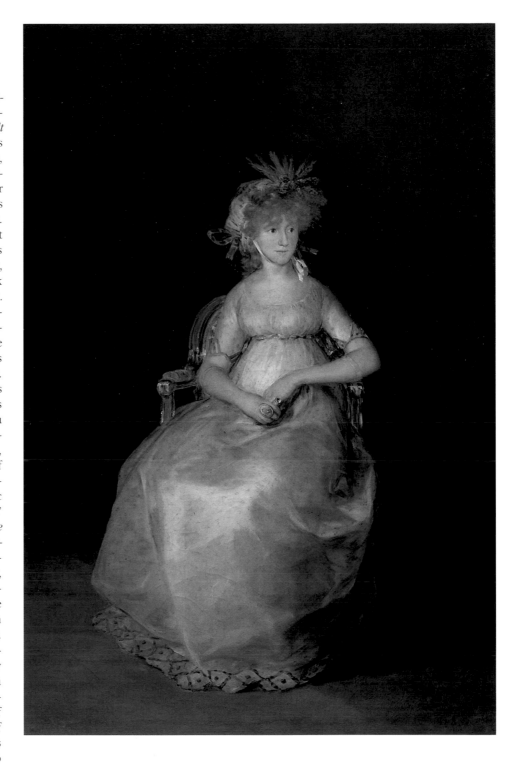

ship with the Duchess of Alba, and led the artist to again come up against the Inquisition some years later.

In the first few years of the 19th century, his life and work continued in much the same vein. His son Javier married in 1805, after which his grandson, Mariano, was born. The works he executed during that period include *Portrait of Godoy at a Military Encampment* (Academy of San Fernando, Madrid), *The Marchioness of Santa Cruz* (Prado, Madrid) and *The Condes de Fernán Núñez,* a blend of Neo-

FRANCISCO DE GOYA: *The Countess of Chinchón;* 1800. Oil on canvas, 216 x 144 cm. Duques de Sueca Collection, Madrid.

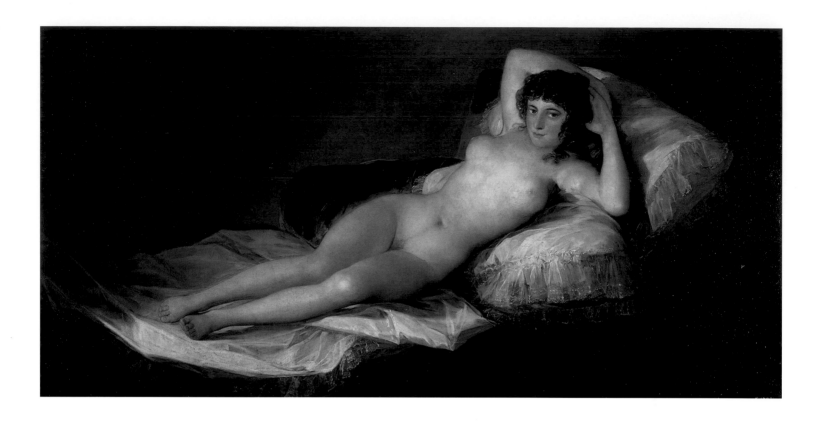

classical elegance and Madrilenian popular types or *majos*. He also continued to produce drawings at that time, although their date of execution is uncertain. They filled a number of sketchbooks, of which only fragments have survived, now distributed between various museums and private collections. Goya's life was then brutally disrupted by the outbreak of the Spanish Peninsular War, which estranged the artist even further from official circles and everyday life. For this reason, and despite having sworn loyalty to the new monarch, Joseph Bonaparte, and having befriended Francophile intellectual circles, the artist's activity became increasingly more dependent for its subject matter on his own creative sources of inspiration. His works at that time include an illustration of the defence of Zaragoza against the French siege, and a series of drawings that led to a collection of etchings known as the *Disasters of War*, a formidable series denouncing human cruelty and recounting specific episodes during the struggle of Spanish patriots against Napoleon's army. These etchings reveal how he had clearly adopted a stance condemning the cruelty and outrages committed by the very forces he thought would have have brought with them renewal and freedom for his country. This comes through most forcefully in his impressive canvas, *The Executions of 3 May* (Prado, Madrid), executed once the war had come to an end. The death of his wife in 1812, the ascent to the throne of Ferdinand VII and the abolition of constitutional freedoms were

undoubtedly determining factors in the bitterness and pessimism that pervaded his works during that period. Goya's drawings betray his feelings at the time, and a series of etchings—*Los Disparates*—present the spectator with a tragic world of deformity, siezed with fear and anguish, both personal and collective. They are matched in painting by a set of four views of the Academy of San Fernando, the gloomy *Last Communion of St Joseph of Calasanz* and, above all, the murals adorning what was Goya's last refuge in Madrid, a mansion known as the Quinta del Sordo. These murals, his so-called *Black Paintings* (Prado, Madrid), dated between 1819 and 1821, were executed immediately before he went into exile in Bourdeaux. He devoted the last few years of his life to his lover, Leocadia Zorrilla, the latter's daughter, Rosario, and his exiled compatriots. This period was characterised by a calm and optimism so sorely lacking during his latter years in Madrid. Moreover, the artist still had sufficient creative energy to turn his hand to new techniques, including lithography and ivory miniatures. The highly personal, liberated world of his drawings continued to come through in his well-known *Bourdeaux Albums,* prominent among which is the significant drawing of an old man, propped up on walking sticks, on which Goya wrote the legend: 'I'm still learning'.

Goya's art, despite having arisen in the narrow, isolated world of 18th-century Spain, subsequently became universal, and a decisive influence in European art, from Romanticism to

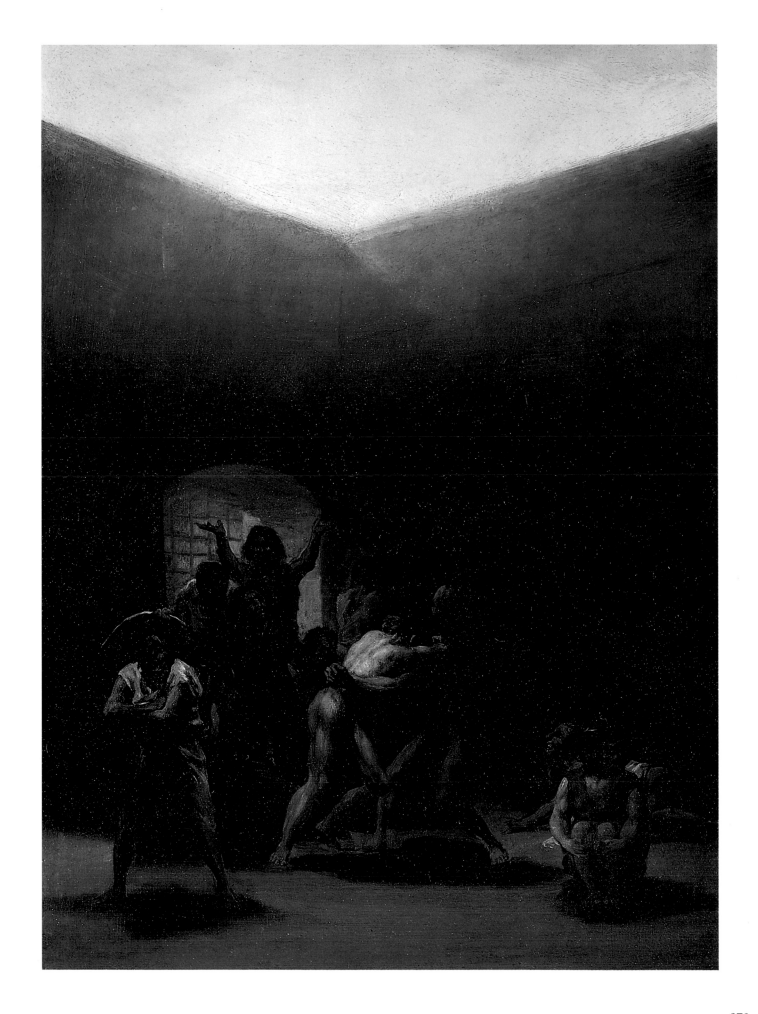

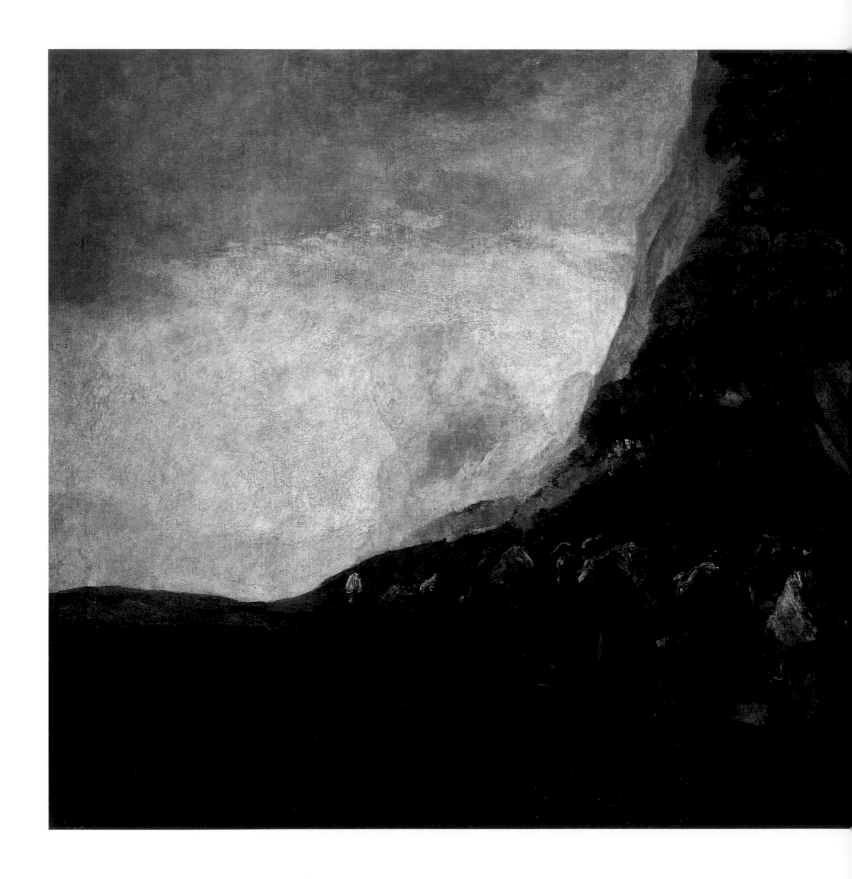

FRANCISCO DE GOYA: *Pilgrimage to the San Isidro Fountain (The Holy Office);* 1820-1823. Oil mural transferred to canvas, from the Quinta del Sordo, 123 x 266 cm. Prado, Madrid.

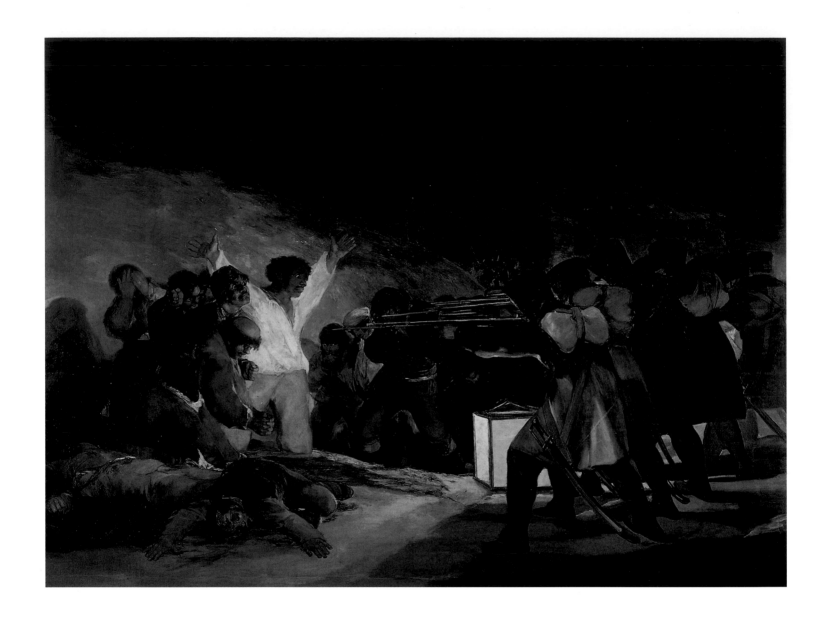

FRANCISCO DE GOYA: *The Third of May: the Executions on Príncipe Pío Hill*, 1814. Oil on canvas, 266 x 345 cm. Prado, Madrid.

the most modern forms of Expressionism. Goya was a source of ideas and knowledge for the artists that came after him. He bequeathed a unique way of viewing reality and stands for the artistic upsurge of expressive and creative freedom, and the freedom of man, which lie at the heart of all true art. As with all people of genius, his was a complex, varied and many-sided personality, and his art was conditioned by the same vital reality that made him, in human terms, a figure straddling two centuries. His early work was in line with 18th-century art, with its legacy of Baroque decorativism and exuberance and its indebtedness to intimate Rococo preciousness, like some of his French and Italian contemporaries, including Fragonard and Tiepolo. His sojourn in Italy exposed

him to the classical world, an experience shared by many other artists of his generation. This facet of Goya's oeuvre is still awaiting clarification, once the relevant research has been carried out. What is known, however, is that it brought him into contact with the novelties of Neoclassicism, even though they were never quite integrated into his work. In the closing years of the 18th century, which in Spain marked the demise of the *ancien régime,* he began to explore the subjects that most interested him and which had to do with an observation of human nature. The genuine revolution in Goya's art, which was to endure beyond his time, began with the new century, a diificult period in Spanish history, ravaged by revolution and change and the harsh realities of the

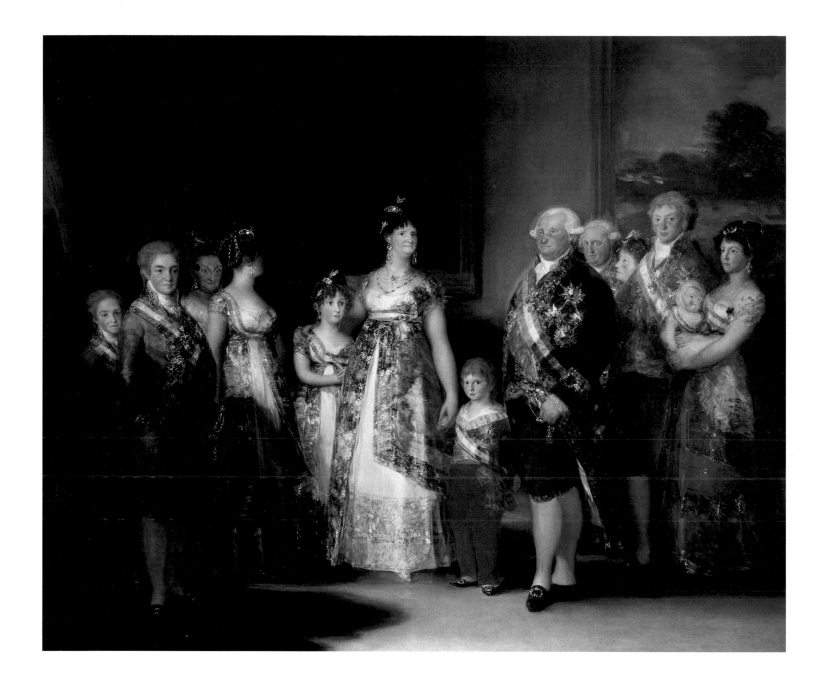

war sparked by the Napoleonic invasion. Goya's drawings and etchings then evolved towards the depressing intimacy of the frescoes adorning his refuge in Madrid, the Quinta del Sordo; paintings of dramatic intensity wholly unrelated to even the most visionary works by such contemporaneous artists as Blake or, in a different milieu, Delacroix and Géricault. Despite this far-reaching evolution, which would lead Goya from the Rococo to a personal, inner world removed from prevailing tastes, his work is profoundly consistent throughout, from his rich, delicate technique, with its balanced, calculated expressiveness, to the freedom and originality of the subjects he chose to depict, which were invariably related to mankind's fundamental, universal concerns.

FRANCISCO DE GOYA: *King Charles IV and his Family,* 1800.
Oil on canvas, 280 x 336 cm. Prado, Madrid.

DAMIÀ CAMPENY: *The Dying Lucretia* (detail); 1804
(marble replica made by the sculptor in 1834). Palau de Llotja, Barcelona.

THE NINETEENTH CENTURY:
FROM NEOCLASSICISM TO INDUSTRIALISM

Carlos Reyero

By and large, the development of 19th-century Spanish art was similar to that of other places in Europe, where the issues raised by the imposition of certain national political borders were constantly being challenged by the gradual integration of artists and their viewing public into an internationally based culture. In short, the weight of local tradition in Spain was offset by an ineludible 'foreign' yardstick. That tradition involved the subjects conventionally portrayed in painting and sculpture, Spain's subordinate position in the context of the European nations, and the features unique to the different cultural centres, such as Catalonia and the Basque Country. The aforementioned yardstick was, first and foremost, French, and involved assimilating the various art trends that emerged in that country during the 19th century—Neoclassicism, Romanticism, architectural historicism, realism, Impressionism, Art Nouveau and Symbolism. It also meant that France, particularly Paris, acted as the major venue where Spanish artists first came into contact with international trends, albeit with a certain time-lag. However, Italy was equally important in terms of academic prestige, as was Britain, at certain times, especially in the development of Romanticism and Art Nouveau. Thus, it may be asserted that aesthetic aspirations in Spain did not differ substantially from those of the rest of Europe.

As with so many other facets of its historical and cultural development, Spain's artistic creations in the 19th century were marked by profound contradictions—not always recognised by contemporaries—which conditioned both their appearance and their distinguishing features, so crucial to our understanding of them. The repercussions of those contradictions were so telling that even historiographers have become entangled in a web of value judgements, aesthetic preferences and biases towards certain artists and artworks whose place in the art-historical context tends to vary substantially, depending on the viewpoint adopted in any analysis. Even today, these considerations condition our fascination for or rejection of a period which, although different from our own, is not so far removed from our current concerns that we can stand back and judge it impartially.

The whole century was caught up willy-nilly in the enactment of history revisited: in architecture, this first materialised in a review of the classical world, and later of Romanesque churches, Islamic mosques and Moorish palaces, Gothic cathedrals and Renaissance motifs. In sculpture, it mainly took the form of Greco-Roman models, and, in painting, the Italian Renaissance, the Golden Age in Spain and, to a lesser extent, Goya. All this tended to be mythicised to such an extent that artists became overwhelmed, feeling themselves compelled to defend themselves or to fight, on unequal terms, in or against the shadow of the father figure. On occasion, this shadow became a sacralised doctrine of mimetic proportions, but it also proved to be a source of experiment and even a testing ground for those who chose to confront it in order to clarify their aesthetic identity.

However, this was not the only conditioning factor in Spanish creativity during the 19th century, although it was indeed one of the most decisive ones. Moreover, it introduced an interpretative ambivalence which became a source of contradiction. All artists were urged to become part of the official art establishment, and had their activity inexorably mediatised by institutional phenomena, which cramped their creativity and imposed limitations. Further,

Following page:

JUAN DE VILLANUEVA: Science Museum (now the Prado, Madrid), designed in 1785 and inaugurated in 1819.

As in Germany and France, 19th-century Spanish architecture was initially characterised by the prevalence of Neoclassical forms, as exemplified by the urban-design project for the Prado de San Jerónimo. The original idea dates from the time of Charles III, although some picturesque elements later crept into the project. Juan de Villanueva was commissioned to design this complex, intended as a science museum, which consisted of a botanical garden, an astronomical observatory and a building housing the royal natural science collection. For this collection, Villanueva based his design on a longitudinal plan to which several volumes were attached—one at each end and a third in the middle—which generated an interplay of light and shadow on the building. The central volume, which acted as the entrance to the main building, was designed in the form of a classical temple, with a magnificent Doric portico, while the cubic-plan side volumes faced north and south. All three volumes were joined by Ionic galleries set on top of arches and niches. The interior was thoroughly refurbished, with the exception of the magnificent roundhouse, when Ferdinand VII appointed the architect, Antonio López Aguado, to convert it into the premises for the royal painting collection.

as was the case in the rest of Europe, the growing importance attached to local values coexisted with an extraordinary admiration for contemporaneous international experiences, particularly in France and Italy, which in some instances took the form of restless cosmopolitanism or conceited snobbishness. Lastly, this multicultural situation was opposed by political State centralism, a legacy from the past century, so that artistic expression became increasingly enmeshed in a web of conflicting or superimposed national interests. This trend gradually gained momentum, and to some extent accounts for the overly favourable criticism of, or unjust contempt for, various 19th-century artworks.

The Desired Order, and Disordered Desire

Politically, the new century was ushered in during the reign of Charles IV (1748–1819), which lasted from the death of his father, the 'illustrated monarch' Charles III, in 1788, until his abdication at Bayonne in 1808, after which the Spanish Crown was briefly taken up by Joseph Bonaparte, an event which unleashed the Spanish Peninsular War. This state of affairs has clouded the perceived image of a king dominated by the ever-present Manuel Godoy, Charles IV's favourite and so-called 'Prince of Peace', and the watchful eye of his wife, queen Maria Luisa of Parma, caretakers of the kingdom's fortunes at the time of the *ancien régime's* demise. Those were the times of Francisco de Goya (1746–1828), whose larger-than-life figure was instrumental in prompting a reappraisal of contemporaneous artists. However, the Spanish court was by no means some remote point in Europe, oblivious to newfound aesthetic concerns in the international arena. Rather, it was just the opposite, a fact borne out by the presence in Spain of Anton Raffael Mengs (1728–1779), in the periods 1761–1769 and 1774–1776, who painted in the Royal Palace and had some of his writings published by the

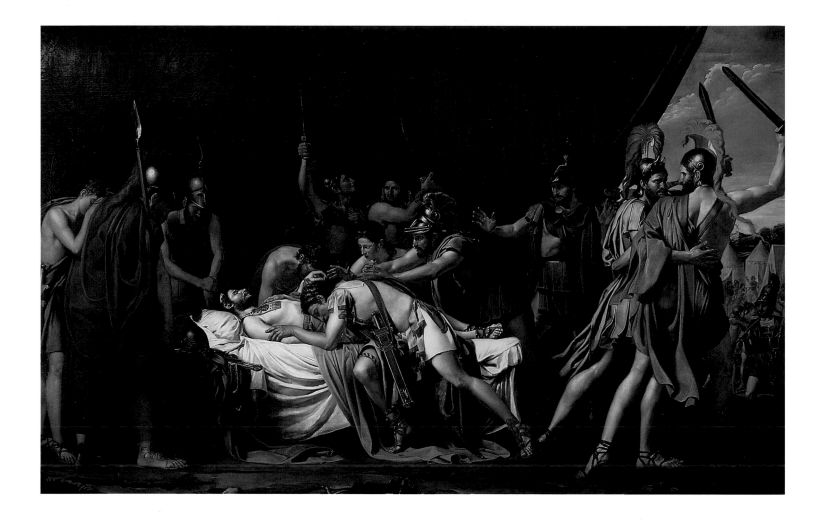

JOSÉ DE MADRAZO: *The Death of Viriathus;* 1806-1807. Oil on canvas, 307 x 462 cm. Casón del Buen Retiro, Prado, Madrid.

Royal Printworks in 1780. His presence in Madrid, in the late-18th century, sparked off a controversy over aesthetics, fuelled by the most avant-garde ideas, in which the contenders included such influential figures as José Nicolás de Azara, a friend of Mengs' and Winckelmann's and, like the latter, a lover of antiquity, and Esteban de Arteaga, whose *Investigaciones filosóficas sobre la belleza ideal* was published in 1789. While the controversy did make itself felt in the form of crises and struggles in the Fine Arts Academy of San Fernando in Madrid (founded in 1752), it had greater repercussions in the provincial academies. The latter, which had been founded after and modelled on the Academy in Madrid, were the scene of an uneasy and protracted coexistence between 18th-century classicist traditions and a reappraisal of the Greco-Roman world.

Charles IV surrounded himself with outstanding artists and artworks when still Prince of Asturias. It was he who employed the leading architect of the period, Juan de Villanueva (1739–1811). Villanueva, who had trained in the Academy of San Fernando, was an avid reader of Juan de Herrera's voluminous treatises on El Escorial, and copied ancient monuments in Rome, where he studied on a scholarship from 1759 to 1764. His first commissions were precisely at El Escorial, between 1768 and 1771. There, in 1771, he designed the Prince's Lodge in a palatial style with a gableless main facade, a style rare in Spain. His finest works materialised thanks to the enlightened policies of Charles III, who endeavoured to transform the old Madrilenian court of the Austrias into a splendid capital city, commensurate with the Age of the Enlightenment. In 1781, Villanueva designed the pavilion in the botanical gardens, after which he embarked on the huge Prado de Atocha complex, in which the main building was the Science Museum, first projected in 1785. Subsequently known as the Prado Museum, it was finally inaugurated in 1819 and commissioned to house the royal painting collections. Together with the New Royal Palace, which was also decorated during the reign of Charles IV, it became the major landmark in Madrid and the hub of a complex in which Villanueva also designed an astronomical observatory, in 1790.

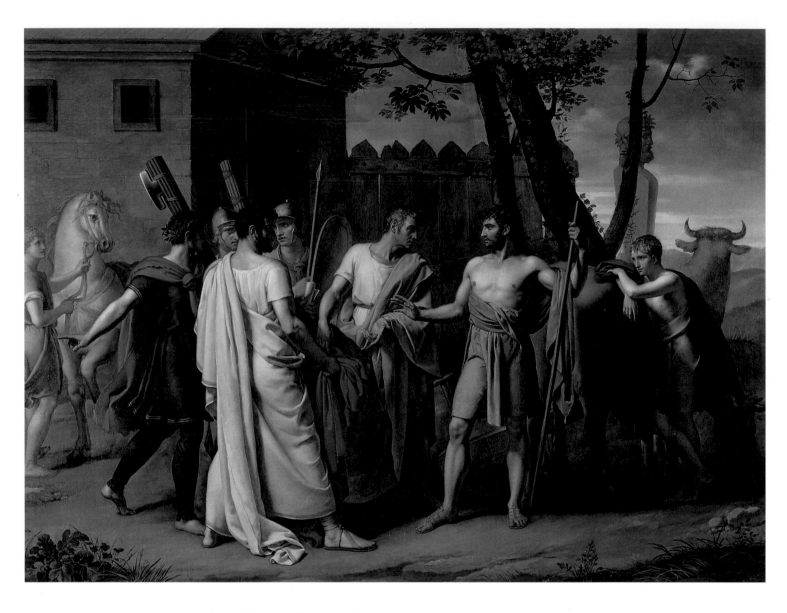

The Road to Neoclassicism

Charles IV was highly prominent as a patron and collector of painting and sculpture. In accordance with Bourbon tradition, major contemporaneous French and Italian works were sent to his court, providing Spanish artists with first-hand knowledge of the latest trends in both centres. A notable example was one version of Jacques-Louis David's *Bonaparte Crossing Mount St. Bernard,* which was hung in the Royal Palace, token of the esteem in which this French Neoclassical master was held. In 1799, a group of young artists journeyed to Paris with the aim of taking up further studies there. This episode, and the signing of the Peace of Basle in 1795, would suggest that relations between the two countries had not been irreparably damaged. The leading figures in the aforementioned group were the painters José de Madrazo and Juan Antonio de Ribera, and the sculptor José Álvaro Cubero. They were instrumental in introducing the Neoclassical currents, directly inspired by models from antiquity, that issued from Paris and Rome, even though the new style only achieved widespread acclaim in Spain during a later period. In effect, throughout their lives, both José de Madrazo (1781–1859), best known for his *Death of Viriathus* (1806–1807, Casón del Buen Retiro, Prado, Madrid), and Juan Antonio de Ribera (1779–1860), who painted the splendid *Cincinnatus leaving his plough to dictate laws in Rome* (c. 1806, Casón del Buen Retiro, Prado, Madrid), flaunted, as their credentials, the fact that they had trained with David. During the Peninsular War, they both had to remain in Rome, under the aegis of their patron and protector, Charles IV. The career of José Álvarez Cubero (1768–1827), known to his contemporaries as the 'Spanish Canova', developed along similar lines. A series of successes cul-

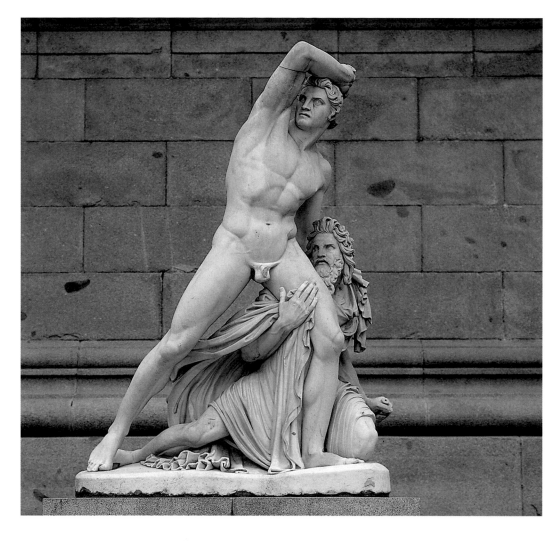

Juan Antonio de Ribera and José de Madrazo were the leading exponents in Spain of the clinical, synthetic Neoclassical current, with its blend of art and politics, represented by David. Episodes from ancient Rome were used as role models for contemporary artworks: this canvas depicts Cincinnatus being urged by his fellow citizens to leave his farm and restore law and order. The artist sent this work to Charles IV, possibly in recognition of the monarch's own sacrifices in the public interest. José de Madrazo's *Death of Viriathus* is quite different, in that its hero belongs to Spain's bygone history. The Lusitanian chieftain, who scored a string of victories over the Romans, is shown after being assassinated by three of his own men, who had been bribed by the Roman consul. The message conveyed by this subject contained allusions to the contemporary status quo in Spain, which had been invaded by the Napoleonic troops and required heroes to fight for its independence. The Neoclassical aesthetics of both works become markedly apparent when compared to contemporaneous works by Goya describing the Madrilenian uprising against the French, although the patriotism implicit in Madrazo's work is a harbinger of Romanticism.

minated in his group, *The Defence of Zaragoza* (1825, Casón del Buen Retiro, Prado, Madrid), a classical sculpture tinged with nationalistic overtones. The only artist outside the sphere of royal patronage who worked to comparable standards was the Catalan sculptor, Damià Campeny (1771–1855). His *The Dying Lucretia* (Cambra Oficial de Comerç, Indústria i Navegació, Barcelona), modelled in plaster in 1804, is possibly the finest sculptural interpretation in Spain of a calm attitude towards death.

Renewal in the arts was hampered by the Peninsular War against the French, which started in 1808, and the uncertainty that prevailed in subsequent years. This was later dispelled by the reinstatement of an absolutist regime under Ferdinand VII, who remained in power until 1833, a term of office broken only by a brief constitutional period. Throughout this period, artists and commissions were still governed by traditional, idealistic aesthetics, at a time when the Romantic spirit was shaking the foundations of the academic establishment in Europe.

After ascending to the Spanish throne, Napoleon's brother, Joseph I, commissioned town planning works in Madrid, although these were never brought to completion. Silvestre Pérez (1767–1825), who had designed the Villahermosa Palace in Madrid in 1789, subsequently completed by Antonio López Aguado in 1805, was appointed to oversee the ill-fated urban scheme. He had shown an active interest in a simple, radical and solemn form of Neoclassicism, bordering on the utopian, apparent in the churches of Motrico (Guipúzcoa) and Bermeo (Vizcaya), dating from 1798 and 1807, respectively. Pérez later went into exile in France, returning to settle in the Basque Country in 1815. There he produced several Neoclassical works, including designs for the city halls of Bilbao and San Sebastián, both located in porticoed squares, which were completed during a later period. However, the most striking complex undertaken in the Basque Country at that time was the Casa de Juntas y Templo de las Patriarcas in Guernica (Vizcaya), begun in 1827 by Antonio de Echevarría.

ANTONIO LÓPEZ AGUADO:
Toledo Gate; 1817-1827, Madrid.

DAMIÀ CAMPENY: *The Dying Lucretia*
(detail); 1804 (marble replica made by
the sculptor in 1834). Palau de Llotja,
Barcelona.

Built around a legendary tree, it became a kind of civic 'acropolis' to which a great deal of symbolic value was subsequently attached.

Another architect with a penchant for this austere brand of Neoclassicism was Torcuato Benjumeda (1757–1836), who was active in Cádiz. The Royal Prison, which he designed in 1794, shows a rationalised use of space and has a powerful Tuscan facade. It is the finest example of the cultural flowering of that city during the transition from the 18th to the 19th century. Benjumeda was appointed city architect in Cádiz in 1807 and his best known work there is the city hall, with its Palladian overtones. It was designed in 1816 and thoroughly refurbished in 1861. Cádiz was then a cosmopolitan city with an active cultural life. In the adjoining municipality of San Fernando, a marine observatory had been built in 1793 to a design by the Marquis of Ureña. It came as no surprise, therefore, that Spain's first constitution should have been drawn up in Cádiz, in 1812, and that it bears the name of this city.

In Madrid, the restoration of the Bourbon monarchy led to moves to resume urban planning projects, and to erect buildings and monuments commensurate with a State capital. In 1817, Antonio López Aguado (1764–1831) was commissioned to design the Toledo Gate to commemorate the return of Ferdinand VII. He also worked on the Alameda de Osuna, where his son, Martín López Aguado (1796–1840), designed one of the palace facades in 1835. A prominent feature of the Alameda is its picturesque, French-style garden. All in all, this was the finest villa complex of its time. The other great Madrilenian architect during the reign of Ferdinand VII was Isidro González Velázquez (1765–1840), who filled the vacancy left by Villanueva in the royal patronage. He also inherited much of the latter's skills, as evinced in his remodelling of the Plaza de Oriente, to which was added the Royal Theatre in 1816, in addition to the Royal College of Medicine and Surgery of San Carlos, built in 1831. He also designed Madrid's most important Fernandine monument, the Obelisco, a memorial to those who lost their lives in the events of 2 May. Built in 1822, it is a classical–romantic ensemble rendered in a variety of styles. Memorials of this kind were part of a

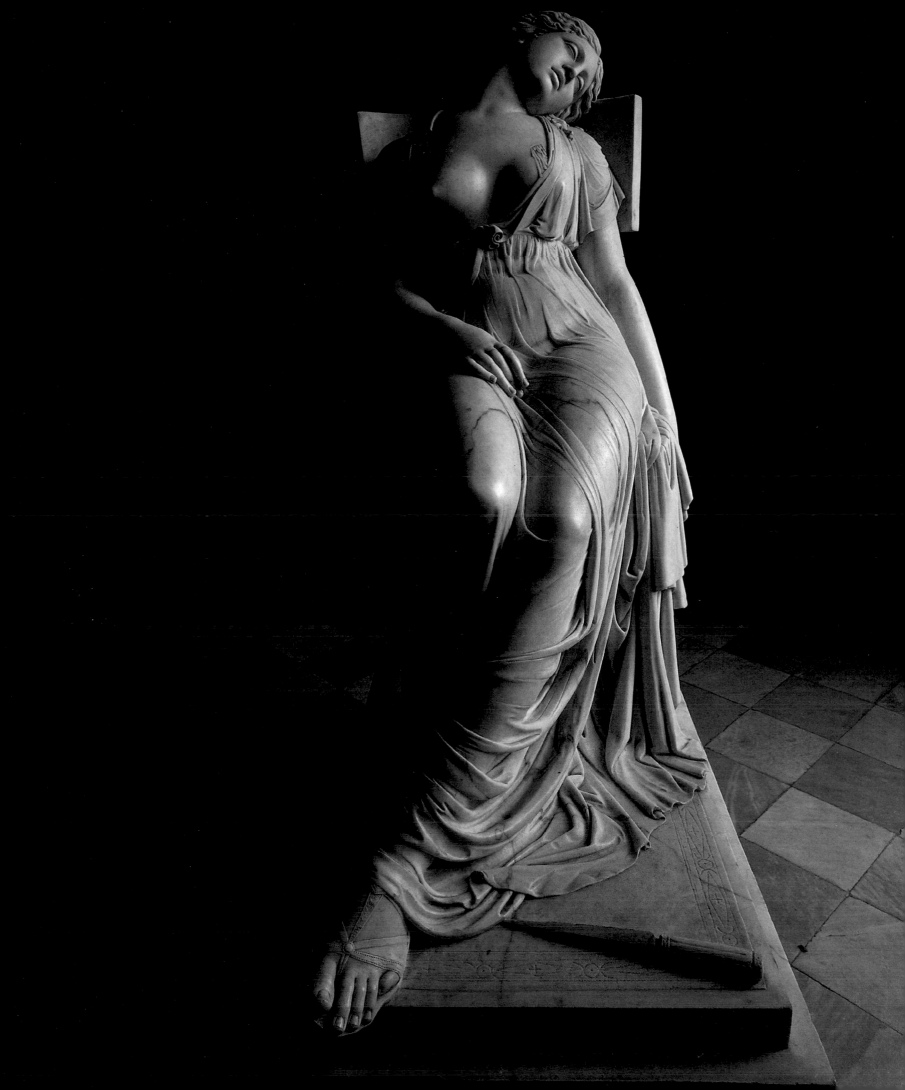

ANTONIO SOLÁ: *Daoíz and Velarde;*
1820-1830. Plaza del
Dos de Mayo, Madrid.

The work of Antonio Solá, who settled in Rome in 1802 but never lost touch with events in Spain, marked a departure from academic Neoclassicism, a contributing factor in his being one of the few non-Italian chairmen of the Academy of St. Luke. He was appointed to this office shortly after having designed this sculptural group, then associated with events in recent Spanish history. The figures, set in front of an artillery gun, are portrayed in a gesticulant attitude, dressed in period garments. Devoid of any allegorical references, this ensemble proved ideal for public display, in what is now the Plaza de Dos de Mayo in Madrid, at a time when monumental sculpture had come into fashion, in response to urban growth and the rise of democratic ideals. Years later, in 1835, the sculptor paid homage to Spain's most celebrated writer, Miguel de Cervantes.

trend that emerged in those years and involved dignifying historical figures and episodes from the Peninsular War, the purpose of which was to build up an awareness of national identity removed from any particular political ideology. An exponent of this trend in painting and sculpture was José Aparicio (1773–1861), who emerged from the circle of Davidian painters. In 1818 he signed his *Hunger in Madrid* (Municipal Museum, on loan from the Prado, Madrid), which illustrates the nation's heroic resistance against the invaders. Another such figure was Antonio Solá (1787–1861), who held the post of director of the Academy of St. Luke in Rome. His sculptural group, *The Massacre of the Innocents* (Academy of San Jordi, Barcelona), was executed shortly after having completed a work commemorating the military heroes, *Daoíz and Velarde* (Plaza del Dos de Mayo, Madrid), in 1830, which lacks the customary classical transfiguration.

Although there was less building activity of this kind in Barcelona, some interesting contributions did emerge from this city. In the field of landscape gardening, a noteworthy undertaking was that of a former chairman of the Royal Academy of Art and Science, Joan Desvalls, Marquis of Alfarrás, who remodelled his suburban villa in the district of Horta, then a village separate from Barcelona. He was assisted in this task by the master builder, Jaume Valls. In 1792, he commissioned the engineer, Domenico Bagutti, to design the staircases, pavilions and, above all, the cypress garden maze known as the *Laberinto,* which became the main part of the ensemble.

Barcelona: The Maze or *Laberinto* in
Horta; begun in 1791.

JOSEP BOVER: *James I;* 1841. City Hall facade, Barcelona.

JOSEP MAS I VILA: City Hall facade; 1831-1847. Barcelona.

Barcelona, Plaça Reial; 1848-1860.

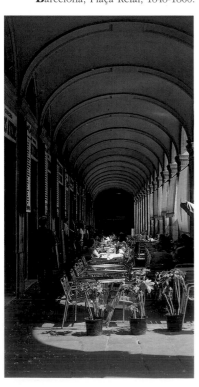

As far as city planning is concerned, in 1823 the new Plaça de San Jaume was completed and, on one side of this square, the facade of the Barcelona City Hall was designed by Josep Mas i Vila and built between 1831 and 1845. Once Ferdinand VII's reign had come to an end, the late-classical Casas Xifré were built in 1836, bringing to completion the area around the Plaça del Palau, which was remodelled at the turn of the century. Barcelona's Plaça Reial, designed in 1848 by Francesc Daniel Molina (1815–1867), was more akin in style to Parisian settings than to the classical world or the Spanish tradition.

In 1815, shortly after Ferdinand VII had been reinstated as absolute monarch, Vicente López (1772–1850) was appointed first chamber painter. During the reign of Ferdinand's father, López had executed the work, *Painting commemorating Charles IV's visit to the University of Valencia* (Casón del Buen Retiro, Prado, Madrid), markedly different to Goya's *King Charles IV and His Family,* painted shortly before that. Vicente López was intent on perpetuating the old academicism associated with the politics of that erstwhile period, in opposition to the Goyesque approach to art, which was still to yield a number of unique works. Curiously enough, Vicente López's masterpiece was precisely a *Portrait of Goya* (Casón del Buen Retiro, Prado, Madrid), executed in 1826. His outstanding technique, meticulous and objective, provided an implacably realistic visual record of the face of a society on the verge of collapse. His spectacular portrait of *Ferdinand VII Wearing the Regalia of the Order of the Golden Fleece* (Spanish Embassy before the Holy See, Rome), executed in 1831—in which he lavished all the praise he could possibly muster, and in which Baroque formulae proved to have retained their currency—conveys a sense of frailty in the sitter who, in order to justify his position of authority, was capable of going to great lengths to keep up appearances.

Despite concerted historiographic endeavours to recover this period of Spain's art history, the fact is that it yielded no one capable of matching the status of Goya or even López. However, apart from the aforementioned Davidian artists, one of the most interesting painters of the time was Zacarías González Velázquez (1763–1834). Trained in the 18th-cen-

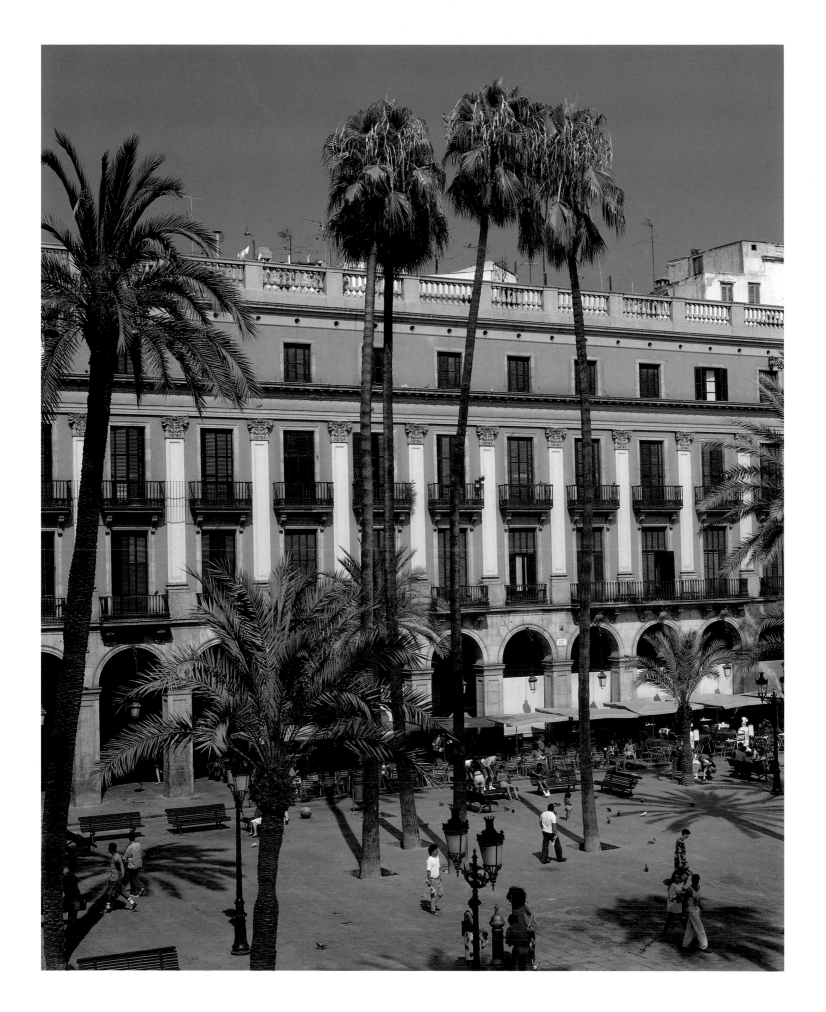

tury academicist tradition, he became a highly accomplished portraitist. A portrait of his niece, *Manuela González Velázquez* (Museo Lázaro Galdiano, Madrid), dated circa 1822, reveals his penchant for powerful modelling, precise, linear drawing, in keeping with contemporaneous French tenets, and a lyricism derived from an elegant, refined form of Neoclassicism. This was also the moment when Spanish landscape first emerged tentatively as an independent genre. Until then, Spain had not produced any major landscape painters of the kind to be found elsewhere in Europe. The Italian Ferdinando Brambilla (1763–1834) painted views of the city and the royal residences with the accuracy of a chronicler, as in *View of the Painting Museum* (Palacio Real, Patrimonio Nacional, Madrid), executed circa 1820. José María Avrial y Flores (1807–1891) painted more interesting works, although along similar lines. His *View of Cibeles Fountain and the Palace of Buena Vista* (Museo Municipal, Madrid), dating from 1836, reveals his interest in manifold aspects of his surroundings, imbued with all the features of incipient Romanticism.

Romanticism in Spain

Thus, while art during the first three decades of the 19th century was obsessed with presenting an orderly view of the world, historical events seemed intent on demonstrating just the opposite. The self-imposed exile of Francisco de Goya, who had been a key witness of those events, was overwhelming proof of the contradictions with which Spanish art was fraught, at the dawn of the Romantic period. The origins of Romanticism were related to the very spirit of the Enlightenment, which strove in vain to find a style that would be valid on a universal basis. Two, formally distinct currents coalesced to form the Spanish brand of Romanticism: one, of European origin, was developed by Francophiles—in the broadest sense of the term—who regarded developments in France as the source of regeneration. This current arose in Court circles, as well as in the Academy of San Fernando in Madrid, and at the Escola de Llotja in Barcelona. In its moderate character and marked eclecticism it was related to the official style of painting, architecture and sculpture, which was to prevail for the rest of the century. The other current, which manifested itself primarily in painting, stemmed from a revival of Hispanic art myths. In this sense, it may be regarded as a more indigenous trend, yet it cannot be fully explained without the decisive contribution made by foreign visitors, who envisaged Spain as a romantic country par excellence, so that, in the long run, it coalesced with the other current.

Chronologically, renewal of the pictorial traditions of Spain's Golden Age began in Andalusia where, at the same time, architectural, landscape and genre references became metonymically identified with multicultural Spain as a whole. This trend was nurtured by Spaniards and foreigners alike, and was to become more prominent as time went by. Despite its decline in the 18th century, the fact that the Seville school had been important during the 17th century led it to retain its aura of prestige, unrivalled in the rest of Spain. It should be stressed that both Spaniards and foreigners were aware of this, to the extent that they both exploited it for their mutual interests, which were often doomed to failure. These interests ranged from the sham, perpetuated by locals, by which they pretended to act as the repository of would-be past glories, to the demeaning role assumed by foreigners when trading in, forging or seizing works of art. An active pictorial centre grew up in Seville during the Romantic period. It was admiration for Murillo, professed by both locals and foreigners—particularly the English—that led to his work being copied ad infinitum. The aesthetically pleasurable, nostalgic sentiment aroused by viewing Murillo's mischievous scamps, the halo of divinity lighting up the saints, and the immaculate purity of those female virgins, with their currency and at once remoteness in time—as Seville was still Baroque in the mind's eye of visitors, and unconsciously timeless for its local inhabitants—formed an extremely powerful stimulus for budding painters. They endowed those models with a capacity for renewal, and indeed they were worlds apart from the 'common Raphaels' then imposed by European and even Spanish academies. This self-centred contemplation of itself was the chief allure of the

VICENTE LÓPEZ: Portrait of *Francisco de Goya;* 1826. Oil on canvas, 93 x 75 cm. Casón del Buen Retiro, Prado, Madrid.

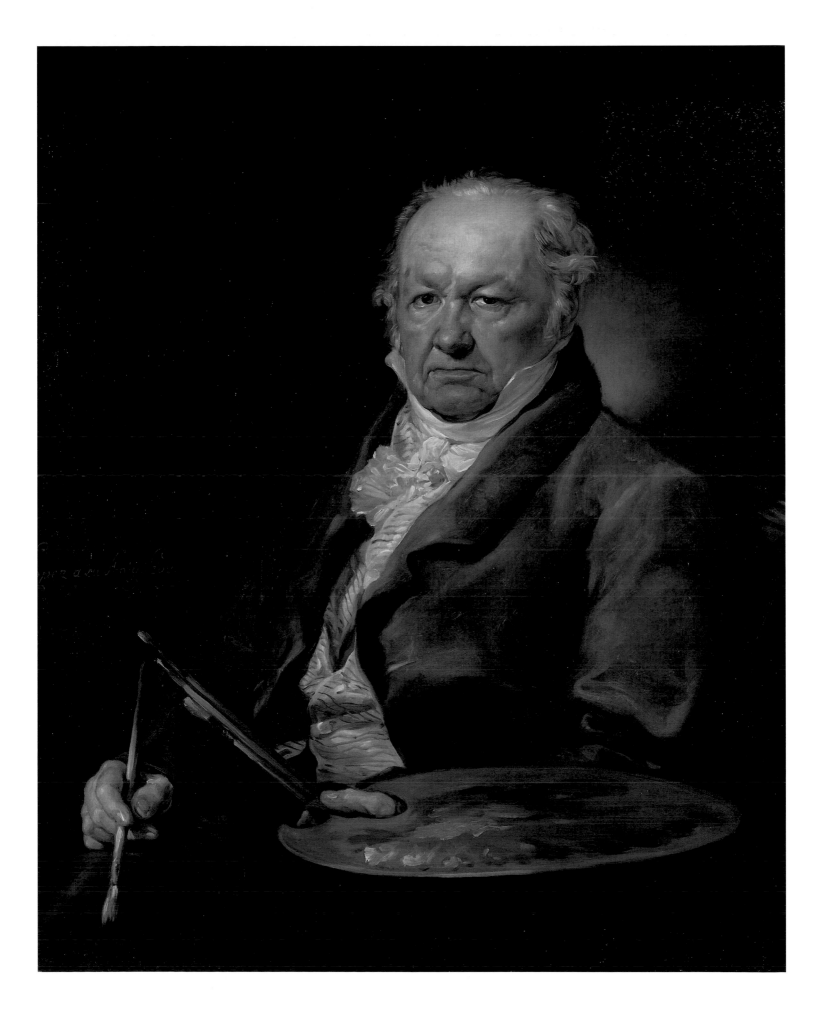

ANTONIO MARÍA ESQUIVEL: *Portrait of the Marquis of Bejons;* 1845. Oil on canvas, 126 x 95 cm. Museo de Bellas Artes, Seville.

Seville school, and also its most onerous burden, which it was forced to shoulder throughout the rest of the century.

The leading figure painters of that period were José Gutiérrez de la Vega (1791–1865) and Antonio María Esquivel (1806–1857). The former produced a large number of portraits, particularly of children, but he is best known for his religious subjects. The technique applied in his *St Catherine* (Casón del Buen Retiro, Prado, Madrid), executed circa 1850, reveals the use of delicate sfumato and vaporous brushstrokes, endowing the saint with extraordinary sensuality. This is also apparent in such mundane subjects as the *Maja Desnuda* (Casón del Buen Retiro, Prado, Madrid), dating from circa 1845. Esquivel, whose genre scenes are also tinged with eroticism, as in *Young Woman Removing Her Garter* (1842, Meadows Museum, Dallas), was above all a prolific portrait painter. A fine example of this is his *Marquis of Bejons* (c. 1845, Museo de Bellas Artes, Seville). His figures are depicted in fragile, elegant poses which convey a charming sense of primitive awkwardness.

However, the most characteristic hallmark of the 19th-century Seville school of painting was derived from the enormous popularity of its genre subjects. Although the depiction of popular types or traditions, associated with a particular place but not with a specific time frame, had its origins in the 18th century, this pictorial genre was stimulated primarily by the romantic attraction exerted by different places. Paintings of this kind usually involved a gratifying portrayal of a particular setting, in which the human presence was merely casual and colouristic, and not open to criticism. Many painters focused their attention on the fiesta, a village's mandatory festivity, as in *The Santiponce Fair,* executed in 1855 by Manuel Rodríguez de Guzmán (1818–1867), or on public religious celebrations, such as *Corpus Christi Procession* (1857, Casón del Buen Retiro, Prado, Madrid), by Manuel Cabral Bejarano (1827–1891). Such scenes were often located in easily recognisable places, which heightened their representative value, as in *View of Seville from La Cruz del Campo,* painted in 1854 by Joaquín Domínguez Bécquer (1817–1879). The most interesting painter of this genre was Valeriano Bécquer (1833–1870). He belonged to a generation that had learned to capture a new sense of reality, as applied to the depiction of popular types from other regions in Spain. This is evinced in *The Present* (Casón del Buen Retiro, Prado, Madrid), executed in 1866.

While Seville 'enjoyed'—as Gautier put it—basking in its own light and, to some extent, remaining oblivious to the vicissitudes of history, Madrid saw the emergence of a trend opposing the uniform, international academic taste. This trend was akin to genre painting in its subject matter, but far more bitter and scorching in its interpretation. Above all, its plasticity was tauter and more expressive, as it involved a tragic vision of life. Goya was the role model for exponents of the new current, particularly among the French Romantics, and remained so for several generations. The first Spanish painters of this kind were Leonardo Alenza (1807–1845) and Eugenio Lucas (1817–1870). Alenza stands for the misunderstood romantic, as portrayed in his *Self-portrait* (c. 1840, Casón del Buen Retiro, Prado, Madrid). He achieved renown through his keen observation of popular scenes, as in *Viaticum* (c. 1840, Casón del Buen Retiro, Prado, Madrid), in which he skilfully captures the mysteries of everyday life. Lucas was more superficially Goyesque, although inquisitorial scenes such as *Condemned by the Inquisition* (Casón del Buen Retiro, Prado, Madrid), or bullfighting scenes such as *Lancing the Bull,* dating from circa 1850, combine all the vitality of Goyesque pithiness with a brisk brushstroke and free handling, applied to a plethoric subject with rich colouring.

The Romantic infatuation with customs and popular types spilled over into landscape, which, as far as Spain was concerned, was only then becoming a genre in its own right and achieving academic status. As a result, Spanish landscape painting was initially closely associated with an admix of people and monuments, and thus took on a rather picturesque character. Spanish Romantic landscapes often feature figures or buildings designed to provide a literary rationale, as in *Gaucín Castle* (Casón del Buen Retiro, Prado, Madrid), dating from 1848, and *Procession at the Shrine of the Virgin of Covadonga* (National Heritage, La Moncloa Palace, Madrid), dated 1851, both by Jenaro Pérez Villaamil (1807–1854), who stood head

JOSÉ GUTIÉRREZ DE LA VEGA: *St Catherine;* 1850. Oil on canvas, 153.3 x 104.3 cm. Casón del Buen Retiro, Prado, Madrid.

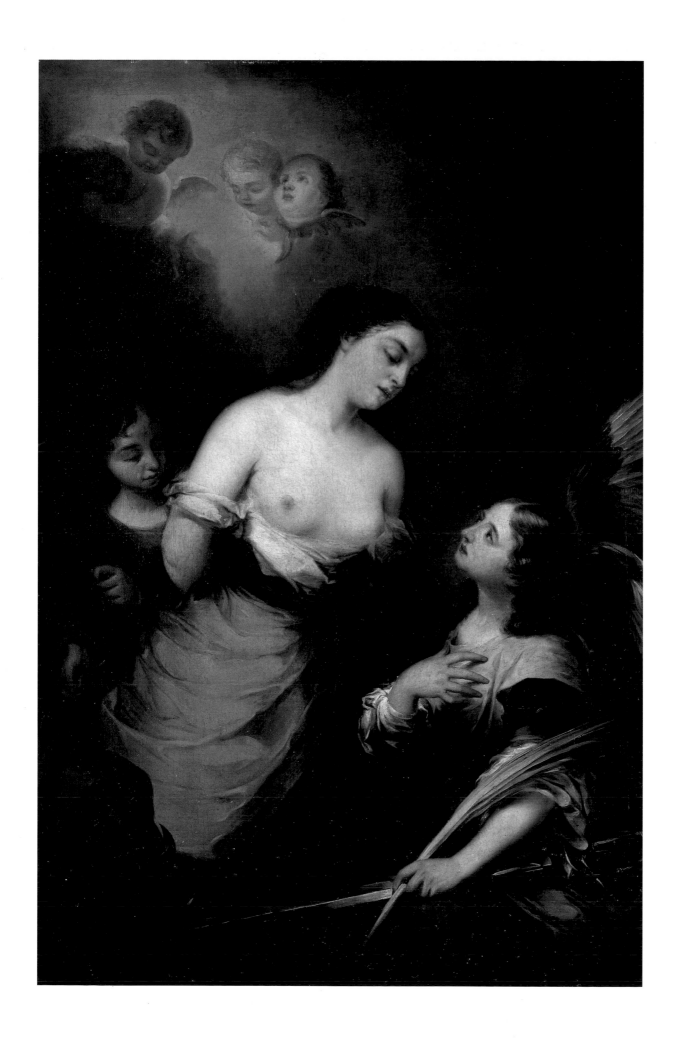

JENARO PÉREZ VILLAAMIL: *Gaucin Castle;* 1848. Oil on canvas, 147 x 225 cm. Casón del Buen Retiro, Prado, Madrid.

and shoulders above all others in this genre, and took pride in exhibiting his works in Europe. His landscapes are marvellous fantasies, poetically inspired by the geographical features of the Iberian Peninsula, in which he skilfully blended reality and illusion, undoubtedly adding considerable weight to the myth of romantic Spain. However, his style owes much to English painting: his brushstroke is rich and pastose, with subtle glazing and amber tones, steeping the viewer in an atmosphere of mysterious reverie.

Prominent landscape painters outside the Madrid circle included the Sevillian Manuel Barrón (1814–1884), a follower of Villaamil's style, as evinced in such works as *Smugglers in the Serranía de Ronda* (1860, Museo de Bellas Artes, Seville), and the Catalans Francesc-Xavier Parcerisa (1803–1876) and, above all, Lluís Rigalt (1814–1894). Rigalt's work reveals painstaking observation of his physical surroundings, while retaining the typically Romantic sense of nature's grandeur, apparent in his *Montserrat Seen from Roc Dreta* (1852, Casón del Buen Retiro, Prado, Madrid).

Meanwhile, sculpture was generally more beholden to classical tenets and, with the exception of those who modelled terracotta figures—notably the Andalusian Miguel Marín Torres and the Catalan Domènec Talarn—the great Spanish Romantic sculptors adhered to academic norms. Nevertheless, echoes of Spain's Golden Age were also felt in 19th-century sculpture. This is evident in *St Jerome* (1845, Casón del Buen Retiro, Prado, Madrid), by José Piquer, whose work reveals parallels with the meticulousness of López. The prevailing interest in revisiting history is attested to in a tendency to revive great figures of the past. One of the first to be revived was Murillo, a statue of whom, executed by Sabino de Medina (1814–1878) in 1861, was placed as a monument in front of museums in Seville and Madrid.

EUGENIO LUCAS: *Condemned by the Inquisition;* circa 1850. Oil on canvas, 77.5 x 91.5 cm. Casón del Buen Retiro, Prado, Madrid.

HISTORICISM IN 19TH-CENTURY SPANISH ARCHITECTURE

As in the rest of Europe, the use of historical styles alien to classicism in Spanish architecture was paralleled by renewed interest in antiquity as from the end of the 18th century. After all, having recourse to the models of one past era or another is just a question of time. However, this revival was heightened by the dissemination of Romantic ideas, becoming widespread in the second half of the 19th century.

The Neo-Renaissance was initially applied in residential urban architecture (particularly to decorative motifs, and in the articulation of storeys) and, above all, in palaces surrounded by gardens and in town mansions. One example, the Palace of the Marqués de Salamanca in Madrid, which has been compared to the Villa Farnesina de Peruzzi in Rome, was designed by Narciso Pascual y Colomer for a rich industrialist in 1846, during the reign of Isabella II. Another, the mansion known as the Palacio Gaviria, designed by Aníbal Álvarez Bouquel, also in 1846, recalls the architecture of Sangallo and Michelangelo. However, soon afterwards, a search for specifically Spanish Renaissance values ensued, with the result that the so-called Plateresque was singled out as a possible prototype for Spanish style. This comes through in the style of some Spanish pavilions at international exhibitions, such as the one built in Paris in 1867, designed by Jerónimo de la Gándara.

However, mediaeval styles in particular became the focus of a widespread revival. In this respect, it should be noted that considerable importance had traditionally been attached to both architectural thinking and historico-archaeological research, prompted by the upsurge of interest in historical styles. A sentimental attachment to historical things was aroused by a picturesque approach to romantically sited ruins, monasteries in which some fragment of historical memory had survived, and cathedrals or palaces majestically alive in each city, as reported by chroniclers and travellers to these spots. All this immediately became the subject of a more or less scientific debate. The curricula for the School of Architecture, drawn up in 1844, stressed the importance of both

art theory and history, which led future architects to become involved in a controversy over which were the most appropriate historical styles for each type of building.

Once the question of style, characterised simply by the use of certain formal elements, had been established as the determining factor in the buildings of all periods, its practical application was a simple matter. Of course, interest in one or other style implied identifying oneself spiritually with that style. Mediaeval styles, particularly the Gothic, were the first to be associated with a certain lifestyle whose values were deemed fit for modern society. The phenomenon swept through Europe. In Spain, the Middle Ages provided the degree of picturesqueness which the nascent industrial society needed as an evasion. That was when the various European nations were coming into being, so that the historical reawakening became identified with nationalism, one of the most cherished political ideas of the century. Moreover, it suited the sincere, emotional religious projections of the people and, to some extent, stood for the triumph of freedom over academic classicism.

Mediaeval Christian styles, which were generally related to the Romanesque or the Gothic, acquired a nationalistic identity in Catalonia, where the idea of nationhood and uniqueness, separate from that of the rest of Spain, reasserted itself forcefully. This philosophy was at the heart of such building projects as the University of Barcelona, designed by Elies Rogent in 1862. In Madrid, however, the Gothic was associated more with a religious discourse, as evinced in the work of Francisco de Cubas, who designed the Almudena Cathedral in 1883. The Gothic style was similarly applied to mainly religious buildings in other parts of Spain.

The Neo-Islamic style, which became very popular in Spain, was used in a different way. It emerged in connection with places of recreation, such as villas and mansions, spa resorts, bandstands, restaurants, theatres and bullrings. Indeed, this style came to embody the epitome of picturesqueness and frivolity, as opposed to the

gravity and bearing of other styles. While the Neo-Mudéjar cannot easily be distinguished from the revival of other Islamic styles, certain Spanish art traditions led the Neo-Mudéjar—and particularly its brickwork—to become part of the most characteristic national style in a large number of public and private buildings erected throughout the century.

EMILIO RODRÍGUEZ AYUSO:
Escuelas Aguirre. 1884, Madrid.

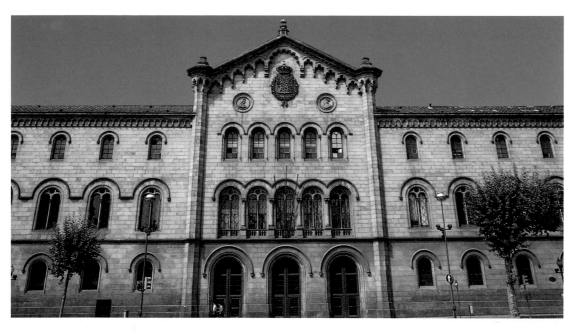

ELIES ROGENT: University of Barcelona, 1863-1868.

In the course of the historical style revision that marked Spanish architecture as from the mid-19th century, Catalonia clearly based its architectural revival on the Middle Ages, as expressed through the movement known as the Renaixença, for that was the period associated with the origins of Catalonia and the time when it achieved its greatest territorial expansion. This nationalistic attitude towards mediaeval art, shared by other European nations, including Germany, France and England, is embodied by the architect Elies Rogent, both in his restoration work—Monastery of Ripoll, and the cloister in the monastery of Sant Cugat del Vallès—and in his new designs, such as the University of Barcelona. The University has a U-shaped ground plan, that is, two side wings joined to a central section. The wings are set around a central court, in the manner of a cloister. The main facade, however, is perhaps the part most evocative of mediaeval styles, specifically the Romanesque. The central section has a pitched roof and is flanked by two quadrangular towers resembling Romanesque belfries, while most of the doors and windows are surmounted by semi-circular arches. Even so, the building reveals some eclecticism, as in the Tuscan-order cloister columns or the first floor with its domical vaults and Gothic tracery.

FRANCISCO JAREÑO: Palacio de Bibliotecas y Museos, now the National Library and Archaeological Museum. 1865, Madrid.

LLUÍS RIGALT: *Montserrat Seen from Roca Dreta;* 1852. Oil on canvas, 62 x 98.5 cm. Casón del Buen Retiro, Prado, Madrid.

Nationalistic Historicism and Cosmopolitanism

As from the mid-19th century, Spain's institutions began to assimilate the changes in all walks of life wrought by the Romantic movement. This process came later, or, at any rate, was slower, than in the rest of Europe. It was fraught with difficulties, and had to make more concessions to tradition than in other countries. The fact that Spain had been singled out as a 'romantic' country led to some confusion—often deliberately so—between tradition and novelty. Indeed, artistic creation, and the stylistic models this was based on, were characterised by a highly complex eclecticism. History was elevated to the status of supreme value, above all vested interests, becoming a permanent, dependable aesthetic and even moral criterion. But Clio is an ambiguous muse, as evinced by the fact that for decades all manner of innovations were bandied about, and their causes sacralised, shutting out all other alternatives, whereas, by the end of the century, they had all been discredited.

Despite appearances to the contrary, the nationalistic historicism that marked artistic production in Spain for much of the century cannot be understood in the context of the State alone. A cosmopolitan philosophy was inherent in this phenomenon, as nationalistic historicisms developed simultaneously in other countries, too. The fact that, in each case, the role models were different—although not as different as might be expected—was less important than the fact that, in all places and depending on prevailing circumstances, nationalistic or cosmopolitan connotations were attached to historical models in all the arts. The upshot of this is that to some extent these connotations determined the penchant for specific artistic currents that subsequently made their way into contemporary art.

The presence of a School of Architecture in Madrid, founded in 1844, led all learning related to architectural training to become rigorously systematised. Greatest importance was attached to history and art theory, the study of which involved making copies of buildings, both old and modern. If to that we add the representative values associated with the various historical types and styles, the powerful historicist charge implicit in the career of architecture becomes readily comprehensible. The aforementioned eclecticism is apparent in the work of one of the last architects to train in the Academy of San Fernando, Narciso Pascual y Colomer (1808–1870), whose activity as an architect coincided principally with his term of office as director of the Madrid school. His eclectic approach led him, for instance, to emulate the typology of an Italian villa with Renaissance motifs in the Palace of the Marqués de Salamanca, designed in 1846. Similarly, it allowed him to use the classical, Corinthian-order hexastyle portico in the lower house of Parliament, the so-called Palacio del Congreso de los Diputados, dating from 1850, or to 'restore' the church of San Jerónimo el Real in Gothic style in 1854.

In time, the diversity of historical styles applied in architecture became more accentuated. At times, this entailed an express commitment to slavish archaeological reproduction, while on other occasions historical styles were interpreted comparatively freely. In the second half of the 19th century, the constructional debate revolved principally around mediaeval styles, whether Christian or Islamic, depending on considerations of expediency and characterisation. The most important of these was the Neo-Gothic: as in the rest of Europe, Spanish theoreticians associated the Gothic revival with a renaissance of the Christian spirit and with sensitive and emotional aspects of architectural perception. Thus, an initial, superficial Gothicism gave way to the gradual assimilation of rationalistic ideas, primarily those of Viollet-le-Duc, and of more aestheticist interpretations, notably those of George Edmund Street. However, it was religious factors that actually conditioned a revival of both the Romanesque and the Gothic. A resurgence of the former characterised the collegiate church of Covadonga, designed by Federico Aparici (1832–1917) in the mountains of Asturias in 1874. It was there that, according to Catholic–nationalistic tradition, Divine Providence had been instrumental in King Pelayo's victory over the Moors at the beginning of the Reconquest. A similar sentiment was behind a larger project, this time Gothic, namely the Almudena Cathedral in Madrid. Until the 19th century, the cathedral had lacked its own bishopric or episcopal see, despite several attempts at establishing one over the centuries. The project in question, embarked on in 1883, was assigned to Francisco de Cubas (1826–1899), although he eventually built only the crypt. In 1888, shortly after being awarded a marquisate, he built the fabulous Butrón Castle in the province of Vizcaya.

By and large, however, the Neo-Gothic was not regarded as a 'national style' in Spain. Instead, the Neo-Plateresque won more widespread acclaim. It was the style in which the Spanish Pavilion was built at the Universal Exposition of Paris in 1867, designed by Jerónimo de la Gándara and modelled on the Palace of Monterrey in Salamanca, which actually spawned a whole building trend at the turn of the century. However, in Catalonia, buildings based to some extent on a revival of mediaeval styles were endowed with markedly nationalistic connotations. The University of Barcelona, for example, designed in 1862 by Elías Rogent (1821–1897), adhered to the canons of the *Renaixença,* a movement which was decisive in shaping modern cultural Catalanism, indissolubly linked to the drive for a unified language: *Pla-me encara parlar la llengua d'aquells savis* ('It still gives me pleasure to speak the language of those sages') wrote Aribau in 1832, in his ode to *La Pàtria,* the point of departure for the resurgence of Catalanism.

Interest in the Gothic style grew among praticising architects during the last few years of the 19th century, coinciding with a thirst for renewal in all genres. In this respect, the work of the architect Joan Martorell (1838–1906) is actually a proficient compilation of the Gothic language, as applied to modern, functional and representational needs. Examples of his include the church of Las Salesas, in Barcelona, dating from 1884 and, above all, the Sobrellano Palace, built in 1881 at Comillas (Cantabria) for the *Indiano,* Antonio López, who, like other *Indianos,* had returned from the Americas after making his fortune there. He was

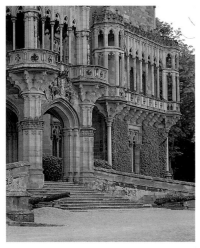

JOAN MARTORELL: Palace of Sobrellano. 1881, Comillas (Cantabria).

granted the title of Marquis of Comillas, and became one of the most influential figures in the world of finance at that time.

The forms characteristic of Moorish architecture also gained special currency in Spain during that period. Although echoes of the Orientalist phenomenon also reached other parts of Europe, the Neo-Islamic style exerted a particularly exotic, historicist influence in Spain, for which reason it was used in mansions, spa resorts, bullrings and urban fixtures. The fact that Spain had been under Moorish rule for so many centuries meaned that these forms could be regarded as part and parcel of national identity, albeit with certain picturesque overtones. In terms of that argument, the Neo-Mudéjar, in particular, became widespread and, as in the case of the Neo-Gothic, ended up becoming pivotal in modern architectural issues. A considerable number of architects specialised in the use of Mudéjar forms, and many more resorted to Mudéjar principles or materials from time to time. Lorenzo Álvarez Capra (1848–1901) was able to apply this style to the Spanish Pavilion at the Universal Exposition at Vienna in 1873, and to the monumental church of La Paloma in Madrid, begun in 1896. However, the leading exponent of this current was perhaps Emilio Rodríguez Ayuso (1845–1891), who designed the Escuelas Aguirre in Madrid, and numerous groups of brick housing units with their strikingly ornamented, intertwining facade patterns in various parts of the city, setting a trend that was often imitated. Moorish forms were also used in many places outside Madrid, particularly in Andalusia, with which they were obviously even more closely identified. In 1882, the Sevillian, Adolfo Morales de los Ríos, designed what would later be called the Teatro Falla in Cádiz, one of the largest buildings erected in this style.

The degree to which historical mediaeval styles were recovered and further developed as an alternative to the more stilted academic currents should, however, be viewed in the context of the marked growth of Spanish cities at the time, and the emergence of planned expansion districts. In Madrid, the engineer Carlos María de Castro was commissioned to draw up the draft project bearing his name for extending the city on the basis of an orthog-

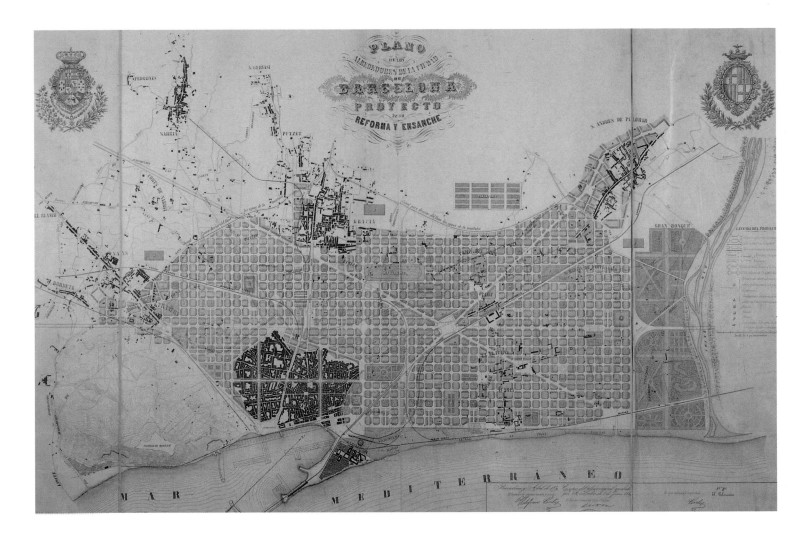

ILDEFONS CERDÀ: Plan of the Barcelona extension area, 1859.

onal plan projecting northwards and eastwards. It was approved by the government in 1860, the same year that Ildefons Cerdà (1816–1876) designed his celebrated expansion district in Barcelona. The area he designed, known as the Eixample, was a far more interesting project in that it included two large diagonal thoroughfares laid across the urban extension grid to speed up communications. Circumstances attending the execution of this enlargement project in the Catalan capital during the following decades helped to yield highly successful results. The expansion areas in San Sebastián, Bilbao, Alicante, La Coruña, León and Cartagena, which were based on similar principles, were among the most important urban design projects undertaken in the second half of the 19th century.

'Beaux Arts' Eclecticism

The growing State bureaucracy gave rise to new architectural needs, including larger and more ambitious buildings in which the architectural language, although richer, was applied more arbitrarily, depending on the representational interests these buildings had to serve. This led to a current of eclecticism known as *Beaux Arts* style, rooted in the growing complexity of classicist morphology. Of course, it can only be fully understood in a broader, turn-of-century European and American context in which urban monumentalism had become a widespread aesthetic aspiration. The architectural needs of Madrid as State capital were greater than those of other Spanish cities, so that it was here that this eclecticism with its marked academic leanings was developed most forcefully. Prominent in the first generation of characteristically eclectic architects was Francisco Jareño (1818–1892), who in 1865 designed the Palacio de Bibliotecas y Museos, now the Biblioteca Nacional y Museo Arqueológico (National Library and Archaeological Museum). The building is classicist, with Germanic reminiscences and restraint in the use of materials and architectural vocabulary,

although the facades, particularly that of the Archaeological Museum, display the full-blown presence characteristic of eclecticism. Outstanding figures in the following generation were Enrique María Ripullés (1845–1922) and Eduardo Adaro (1848–1906). Their designs, as far as eclecticism was concerned, were conventional, geared to the grandiloquence of the world of finance, but they were also successful as academic exercises. Repullés designed the Stock Exchange building, which was erected between 1884 and 1893. The facade was adapted to the semi-circular square in which it stands, and it has a Corinthian-order hexastyle portico and windows recalling the Renaissance. Adaro designed the Banco de España, built from 1884 to 1891, with its unassuming but familiar Italianate forms. Fernando Arbós y Tremanti (1840–1916) and Ricardo Velázquez Bosco (1843–1923) were more original in their approach, which was more akin to modern, turn-of-century architectural currents. Arbós designed several important buildings, including the church of San Manuel y San Benito, dating from 1902. It looks more like an Englishman's vision of the Italian and Byzantine world in the late Middle Ages, with its constructional clarity and luminous whiteness, wholly different from the Spanish tradition. Equally alluring is the oeuvre of Velázquez Bosco, whose major work is the Ministerio de Fomento, now the Ministry of Agriculture building, dating from 1893–1897. It was probably the most monumental building of its time, with an unmistakably French influence masking the pressing problems of integration of the arts so characteristic of *fin-de-siècle* culture.

The major cities in the Basque Country registered steep growth rates at that time. Luis Aladrén, who collaborated in the design of the Diputación Provincial de Guipúzcoa in 1885, and that of the Gran Casino in San Sebastián, built between 1882 and 1887, also designed the emphatic Diputación Provincial de Vizcaya in Bilbao. The architecture of all these buildings is reminiscent of the style of the Second Empire in France. Joaquín Rucoba designed the Bilbao City Hall, built between 1884 and 1891, and the Teatro Arriaga, dating from 1890, which were both intended to endow what was one of Spain's leading financial and industrial cities with the rather pretentious palatial monumentalism then in vogue.

One of the first eclectic architects in Barcelona was Josep Oriol (1815–1895). He was commissioned to remodel the Teatre del Liceu, which had been gutted by fire in 1861, although it was the World Fair of 1888 that gave the city its decisive impetus, on the eve of the boom it was to experience around the turn of the century. Many architects then active in Barcelona, including Gaudí, embarked on the style known as Modernism. Ciutadella Park was also remodelled in preparation for the aforementioned World Fair. A commemorative triumphal arch was designed by Josep Vilaseca (1848–1910) in the adjoining avenue, the Saló Sant Joan, where the most important project, the Palacio de Justicia, was entrusted to Josep Domènech (1858–1917) and Enric Sagnier (1858–1931) and built between 1887 and 1911. The building is large and complex, somewhat reiterative in its ornamentation, which reveals an attempt at originality within the restraints of established morphology.

Sculpture and Nascent Realism

During the second half of the 19th century, Spanish sculpture was also heavily influenced by historical models, both in the choice of subjects and in their treatment. Even the incipient realism noticeable in many works was invariably based on specific prototypes of this kind, and not on observation from life. Durng the Isabelline period, which ended with the forced abdication of Ferdinand VII's daughter in 1868, and up until the Bourbon restoration of 1874, sculpture played a preeminently social, aesthetic and political role. Indeed, its political importance actually increased in the last few years of the century, during the regency of Queen María Cristina of Habsburg. It was markedly conservative in all respects, and sculptors at the time had a reliable benefactor in the State and, in general, in public administration, for which their production fulfilled representational and ornamental needs.

National fine-arts exhibitions, the first of which was held in 1856 and which were convened at irregular intervals of two or three years, then became decisive events for promot-

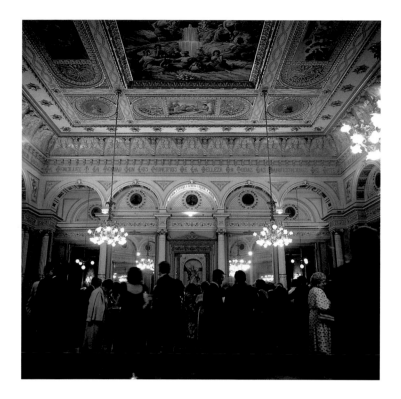 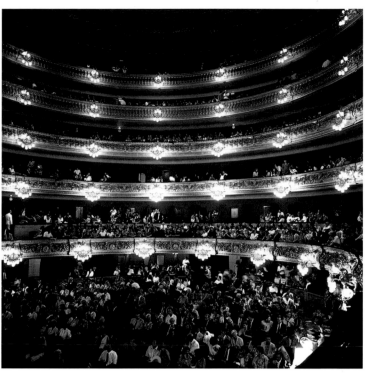

ing the work of both sculptors and painters. While these competitions were not quite comparable to the French *Salons,* like the latter they had the effect of prescribing majority tastes for several decades. They also acted as a source of supply of artworks for museums and major private collectors. In short, these nationwide competitions to some extent conditioned the development of sculpture, particularly in the appraisal of narrative aspects, leading to fierce competition in which technical skills were accorded the highest value, over and above other considerations. Moreover, the fact that artworks were then valued chiefly for their intrinsic aesthetic value led to a decline in functionality, which eventually affected all sculptural and pictorial creation during that period.

Sculpture was then dominated by artists of Catalan origin. The earliest generation featured such sculptors as the Vallmitjana brothers, Venanci (1826–1919) and Agapit (1833–1905). They were the first to incorporate elements of realism in their work, such as drapery folds, anatomy, expressions and other details that had been ignored until then, although, on the whole, their production adhered to the principles of historicist eclecticism. The Vallmitjana brothers worked in close collaboration, and their workshop received a large number of secular and religious commissions, including some large-scale works such as the *Birth of Venus* group, attributed to Vernanci, dated circa 1885, now in the Ciutadella Park in Barcelona. Agapit's most celebrated work is the *Dead Christ* (Casón del Buen Retiro, Prado, Madrid), whose delicate expression and profound sentiment riveted the attention of visitors to the Universal Exposition of Vienna, where it was displayed in 1873. A follower of the Vallmitjana brothers was Jeroni Suñol (1839–1902). His was a measured eclecticism, full of sobriety and elegance, with a sculptural conception characterised by great plastic vigour, as apparent in his best known work, the figure of *Dante* (Museu d'Art Modern del MNAC, Barcelona), which was admired by critics and historiographers alike when displayed at the national exhibition held in 1866. A contemporary of his was Rossend Nobas (1838–1891), whose *Wounded Bull* (Museu d'Art Modern del MNAC, Barcelona), dating from 1871, features both affected meticulousness and conspicuous realism, the result of studies of dying people, while also recognisably influenced by academic models.

Memorials proliferated at that time throughout Spain. They were built for a variety of purposes, from those associated with the rapid growth of cities—in which statues were used

JOSEP ORIOL MESTRES: Interior of the Gran Teatre del Liceu, 1861. Barcelona.

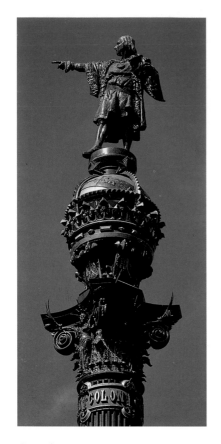

GAIETÀ BUIGAS (architect), RAFEL ATCHÉ (sculptor) et al: *The Columbus Memorial;* 1883-1888. Barcelona.

to adorn public places and to create a sense of identity in new towns or rehabilitated districts—to the prevailing passion for commemorating all kinds of events, whether related to civic pride or political propaganda. Perhaps the most ambitious *fin-de-siècle* public monument was the Columbus memorial in Barcelona, projected in 1881 and located on a privileged site where the city meets the sea. It was part of a scrupulous iconographic programme aimed at commemorating the part played by the Crown of Aragon, especially Catalonia, in the discovery of the New World, which was ultimately designed to extol the virtue of that society.

Unlike developments in the field of painting, which had suddenly been caught up in a process of radical renewal fuelled by the impact of Impressionism and post-Impressionism, most sculptural production continued to be conditioned by academic principles, even though it did, on occasion, absorb certain realistic or Modernist innovations dictated by fashion. In this respect, the founding of the Spanish Fine Arts Academy in Rome in 1873 marked a revival of classicist trends. This Academy produced a cultivated international artistic elite, representative of the most official creative current, and included such celebrated figures as Ricardo Bellver (1845–1924), Agustín Querol (1860–1909) and Mariano Benlliure (1862–1947), who were showered with honours at the various national and international exhibitions, and with commissions by public institutions. Bellver was highly praised for the success of his *Fallen Angel* (1878, Parque del Retiro, Madrid) with its Hellenistic and Baroque reminiscences, and a dynamism and fluidity that go beyond the limits of the narrative. Within the rhetorical eclecticism that dominated most of his oeuvre, Querol managed to overcome the material nature of sculpture, and indeed some of his best works breathe the energetic, palpitating expression of a live organism. One such example is the head of *Tulia* (Casón del Buen Retiro, Prado, Madrid), executed in 1895. Benlliure was a highly prolific sculptor. In his finest works, such as *The Tomb of Gayarre,* in the cemetery at Roncal (Navarre), dating from 1896, he achieved an extraordinary technical *trompe-l'oeil,* with a precious handling of details and great emotion.

Painting: the Influence of Ingres and the Nazarenes

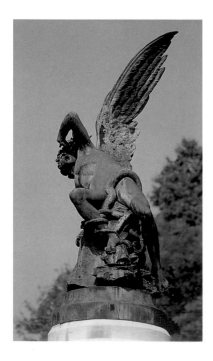

RICARDO BELLVER: *The Fallen Angel;* 1878. Parque del Retiro, Madrid.

In the field of painting, the second half of the 19th century was a time of profound change. Around 1850, the academic circles with the most markedly European leanings, namely those in Madrid and Barcelona, were dominated by the influence of the Nazarenes—brought to Spain by young painters who had studied in Rome on scholarships—and by the impact of Ingres and the most widely publicised Parisian fashions. The two currents were actually quite similar and acted as a thoroughly consistent, initiatory and formative grounding for all painters active in the third quarter of the century. In most cases, painters had only to use that grounding as a starting point for developing their skills.

The art world in Madrid came under the iron-fisted control of the painter Federico de Madrazo (1815–1894). As a young man he had made contact with the most conservative artistic elite in Rome and Paris, so that the principles of eclectic academicism, which bore comparison with the most widely disseminated international models, became entrenched as the prevailing taste among Spain's ruling classes during the Isabelline period. The seductive *Countess of Vilches* (Casón del Buen Retiro, Prado, Madrid), executed by Madrazo in 1853, was one of the finest examples of his talent. His male portraits, such as *Segismundo Moret* (Casón del Buen Retiro, Prado, Madrid), dating from 1851, reveal an exquisite elegance, with tonal ranges more in keeping with Spanish tradition. Carlos Luis de Ribera (1815–1891) was practically the only painter to rival Madrazo in official circles. After having trained under Paul Delaroche in Paris, his interest in history painting became apparent in a huge canvas, *The Granada of Ferdinand and Isabella* (Burgos Cathedral), which he first embarked on in 1853 and which he worked on for the rest of his life. Another of his most ambitious works was the decoration of the assembly hall in the Congreso de los Diputados, executed between 1850 and 1852.

CASADO DE ALISAL: *The Surrender of Bailén,* 1864. Oil on canvas, 338 x 500 cm. Casón del Buen Retiro, Prado, Madrid.

In Barcelona, the principles of the Nazarenes were assimilated on a strict although not exclusive basis, as borne out by the existence of Nazarene painters active outside the Catalan circle who were equally attracted by the style of the Germanic group. An example of this was the Murcian Germán Hernández Amores (1823–1894), who in 1862 painted the *Journey of the Most Holy Virgin to Ephesus* (Prado, on loan to the Museum of Murcia). In fact, after their Nazarene beginnings, the leading Catalan painters of the middle of the century subsequently developed an eclectic academicism which made fewer concessions to their formative style. This was true in the case of portrait painting, as splendidly exemplified by *Portrait of His Wife* (1853, Museu d'Art Modern del MNAC, Barcelona), by Joaquim Espalter (1809–1880), and in history painting, a genre for which Pelegrí Clavé (1811–1880) earned widespread acclaim, as evinced in his *Insanity of Isabella of Portugal* (Museo de San Carlos, Mexico), executed in 1855.

History painting became very popular during the second half of the century, partly due to State patronage of the genre, which involved purchasing such works to stock the Museo de Arte Moderno and to adorn institutional buildings. It was also given considerable impetus by national fine arts exhibitions, which practically guaranteed prize-winning painters a prestigioius, lifelong career and allowed them to practise their profession freely and even take up important teaching posts. The work of the Sevillian Eduardo Cano de la Peña (1823–1897), particularly his *Columbus in La Rábida* (Palacio del Senado, on loan from the Prado, Madrid), which won first prize at the national exhibition of 1956, contains a summary of all the formal and iconographic features of the first generation of history painters that emerged in the third quarter of the century. The eclecticism in question had as its main ingredients French academicism—particularly the form inherited from Paul Delaroche—the influence of the great Italian classicist masters—Raphael and Reni, among others—and some of

the better realistic contributions from Spain's 'Golden Age', particularly those embodied by Murillo and Velázquez. All of this was applied to subjects that extolled what were considered to be the most patriotic episodes in Spain's history, with a marked epic sense. Some artists, including Dióscoro de la Puebla (1831–1901), retained their original Nazarene and Italianate hallmark, as in *The Daughters of El Cid* (Casón del Buen Retiro, Prado, Madrid), dating from 1871. The work of others, such as José Casado del Alisal (1832–1886) and Antonio Gisbert (1834–1901), was more indebted to the international academicism learned in Paris, where both painters had been active. Casado del Alisal is best known for *The Surrender of Bailén* (Casón del Buen Retiro, Prado, Madrid), executed in 1864, and Gisbert for his masterpiece, *The Shooting of Torrijos and His Companions* (Casón del Buen Retiro, Prado, Madrid), painted in 1886. But the most outstanding painters of this generation were undoubtedly Vicente Palmaroli (1834–1906) and Eduardo Rosales (1836–1873), who had used their eclectic apprenticeship as a creative and experimental reappraisal grounded mainly in the Spanish painting tradition. In addition to producing several major compositions, Palmaroli was an excellent portraitist, as evinced in his *Hersilia Castilla* (Casón del Buen Retiro, Prado, Madrid), dating from 1865. Rosales, one of the greatest Spanish painters of all times, produced his major work in 1864, *Isabella the Catholic Dictating Her Will* (Casón del Buen Retiro, Prado, Madrid). In such works as his portrait of the *Countess of Santovenia* and *The Death of Lucretia,* both painted in 1871 and now housed in the Prado, he achieved a freedom of execution, chromatic richness, sobriety and mastery of impasto worthy of the best Manet.

The second generation of history painters emerged after the success, at the national exhibition of 1878, of the Aragonese painter, Francisco Pradilla (1848–1921), whose entry for that competition was *Joan the Mad* (Casón del Buen Retiro, Prado, Madrid). Like many other prize-winners in the following years, Pradilla had trained at the recently founded Spanish Fine Arts Academy in Rome, which had become the last line of defence of history painting at a time when the genre was generally falling out of favour. The genre was actually transformed in many respects, especially by adopting certain features of nascent realism. More

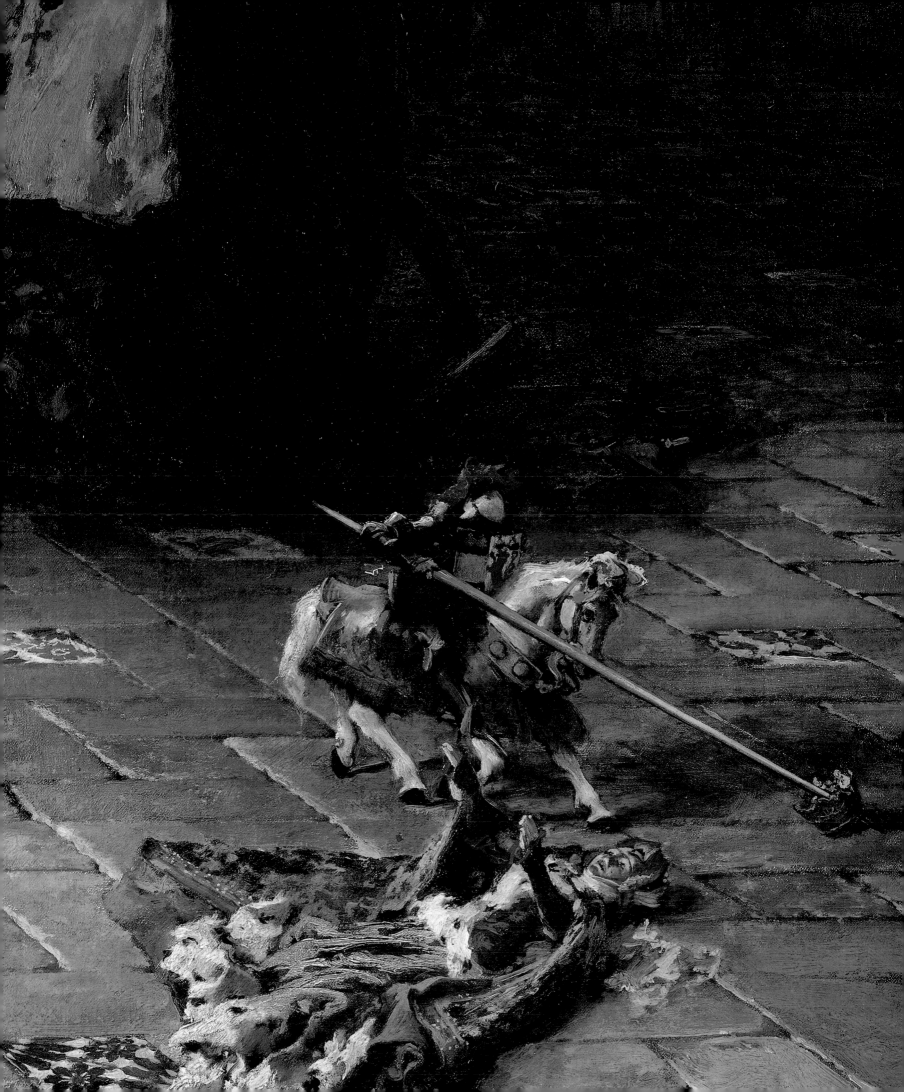

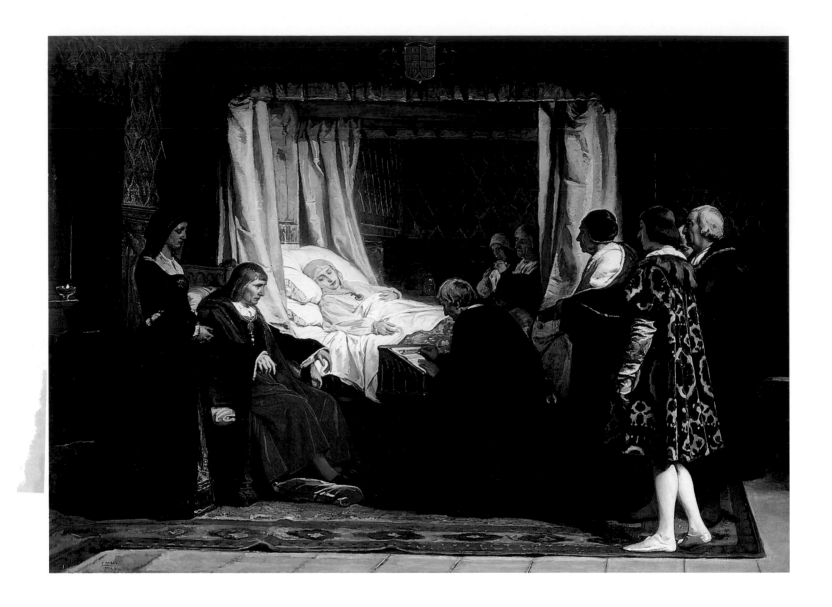

modest subjects began to be chosen, while emotions were portrayed on a more human level and the plasticity of the canvases acquired greater freshness. Things were interpreted with greater immediacy and candidness, and pictorial treatment became more colouristic and vigorous. Perhaps the best exponent of this new trend was the Valencian Antonio Muñoz Degrain (1840–1924). In 1884, he won a prize with his canvas, *The Lovers of Teruel* (Casón del Buen Retiro, Prado, Madrid), an exceptional work that steeps the viewer in a mysterious atmosphere, with sparkling brushstrokes and a profound symbolism that transcends objective perception.

Many painters visited Paris at that time, drawn by the burgeoning art market there, and began to spurn the thematic and formal demands imposed by the art establishment. For those who held major institutional posts, this rejection was the result of kowtowing to art dealers in the employ of the well-to-do bourgeoisie. They regarded the latter as ignorant in matters of art, as having rendered painting subject to the dictates of financial interests, and as having turned artworks into merely decorative objects. Of course, the issue was far more complex than that. Indeed, the fact that either group may have elected to operate within one socio-economic infrastructure or the other did not detract from their standing, and less so their modernity. The fact was that a growing, primarily foreign, clientele, which was in contact with the various art centres and major dealers in Europe and America, was demanding enormous supplies of paintings. The paintings most sought after were small-format canvases, known in Spain as *tableautin*, which usually depicted anecdotic, rather inconsequential subjects, often set in the 18th century, for which reason the genre was also known as *pintura de casacón* (literally, 'greatcoat painting'). They were generally painstakingly executed,

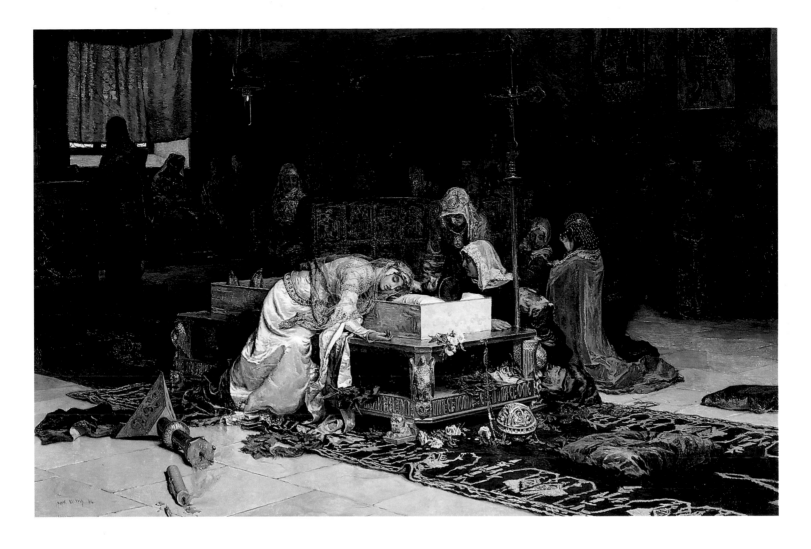

ANTONIO MUÑOZ DEGRAIN: *The Lovers of Teruel;* 1884. Oil on canvas, 330 x 516 cm. Casón del Buen Retiro, Prado, Madrid.

with small, bright brushstrokes, entailing considerable technical skill. The French models for this type of work were the Oriental subjects of Gerôme and the genre scenes of Meissonier, which inspired a large number of Spanish painters, headed by Mariano Fortuny (1838–1874), whose genius and uniqueness earned him an unassailable position in this genre. As a young man, when awarded a scholarship by the Diputación Provincial de Barcelona to paint as a 'pictorial chronicler' in the Moroccan war, he became passionately enthusiastic about Oriental subjects, as attested in his *Odalisque* (Museu d'Art Modern del MNAC, Barcelona), brimming with colour, exotism and pictorial facility. However, it was in Paris that he won lasting acclaim, with such paintings as *The Vicariate* (Museu d'Art Modern del MNAC, Barcelona), executed in 1870, which was exhibited in Paris *chez* Goupil, the art dealer who launched him to fame. However, Fortuny held out against such mercantilistic submission as best he could and, towards the end of his life, which ended with his untimely death, his work became highly personal and prefigured subsequent visual trends, closely related to the most avant-garde luminist currents of realism. During a sojourn in Granada in 1871, he painted bold landscapes and captured fleeting impressions of nature. One of his last Italian works was *Nude on Portici Beach* (1874, Casón del Buen Retiro, Prado, Madrid), a panel shimmering with all the radiance of light and water.

Fortuny attracted a legion of imitators who exploited 'Fortunesque taste' to the extent of triviality, a fad that actually lasted into the 20th century. Only a few of his friends understood the profound pictorial renewal at the heart of the Catalan artist's work. Prominent among these followers was Ramon Tusquets (1838–1904), who painted a moving canvas depicting *The Burial of Fortuny* (Museu d'Art Modern del MNAC, Barcelona) in 1874 and,

MARIANO FORTUNY: *Nude on Portici Beach;* 1874. Oil on canvas, 13 x 19 cm. Casón del Buen Retiro, Prado, Madrid.

above all, Martín Rico (1833–1908) who, in his mature period, which yielded the painting *View of Venice* (Casón del Buen Retiro, Prado, Madrid), developed a vivid, detailed technique for capturing reality, in which objects are so sharply defined they become poetic.

The Road to Modernisation

The 19th century saw a number of contradictions resulting from efforts at reconciling history and modern life, that is, the pragmatic sense of reality and the escapist urge of a romantic nature. Such contradictions had not been reconciled by the end of the century, but artists had at least become fully aware of the problems involved, and felt the pressing need to come up with specific answers to those problems. It was these answers that subsequently determined the various currents that were to be developed in Spain, during a particularly fertile and exciting period of artistic creation that would lead into the 20th century.

In architecture, the application of new materials and the emergence of new structural requirements asociated with trade and transportation produced considerable upheaval. To begin with, the new materials—iron and glass—and the new needs—markets, exhibition halls, bridges and railway stations—did not involve any rethinking of the theoretical principles on which architecture was based. Indeed, the fact that the new materials were suited to constructions of this kind merely amounted to adopting a form of eclecticism typologically consistent with the overall status quo. Nevertheless, a certain break with tradition had started to make itself felt. The siting of large markets in city centres was perhaps the most stimulating challenge: as complexes that were used contantly on a daily basis, these markets began to vie with other public buildings for space and status. Among the first to be erected in Barcelona was the Born market, designed by Josep Fontseré and Josep Maria Cornet in 1874–1876, in a style reminiscent of Baltard's old *Halles* in Paris.

RICARDO VELÁZQUEZ BOSCO: Crystal Palace. 1887, Madrid.

As for exhibition halls, it should be recalled that, with the exception of the Barcelona World Fair of 1888, which did not feature any iron and glass architecture comparable to that of Paris or London, the exhibitions held in Spain were not particularly large-scale events, so that pavilions of this kind had not yet posed any major issue.

To mark the occasion of the Philippines Exhibition of 1887, a pavilion was erected in the Parque del Retiro in Madrid. Designed by Ricardo Velázquez Bosco, it was known as the Crystal Palace and was conceived in the form of a greenhouse similar to those of Paxton. Despite its highly eclectic formal and spatial articulation, it is a unique example of this type of construction in Spain, with its lightness and transparency bordering on architectural dematerialisation.

Building needs related to transportation were far more pressing and led to the implementation of radically innovative designs. Bridge building developed on a scale unheard-of since Roman times. They were built over rivers, as in Seville, Logroño and Valladolid, and in the form of viaducts over low-lying obstructions and railways, as in Madrid, Cuenca and Alcoy. In all instances, constructions of this kind resorted to the use of the foreign technology applied to large metal structures raised on pillars. However, railway stations were undoubtedly the 'cathedrals' of modern times. A wholly new type of building, their design had to be directly derived from their function. The major urban stations were extremely complex constructions, which contained eclectic features of all kinds, depending on local needs. Two unique designs were produced by Alberto de Palacio (1856–1939): the ferry bridge over the Nervión estuary in Vizcaya, between Portugalete and Las Arenas, unveiled in 1893, and Atocha railway station in Madrid, which was erected between 1889 and 1892. It featured a spectacular roof spanning the various station buildings, on a larger scale than anything that had been built in Europe until then.

However, as in the rest of Europe, iron architecture did not provide a lasting solution for all the technical, aesthetic and functional problems that arose at the turn of the century.

GAUDÍ

The Catalan architect Antoni Gaudí (1852-1926) was the most powerful turn-of-century artistic figure in Spain. Universally acclaimed and constantly mythicised, Gaudí was the epitome of the solitary artistic genius, passionately involved with his ideas and his conception of beauty; full of energy and self-confidence channelled into his telluric and at once profound and spiritual work.

He was born in Reus in 1852. His father was a boilermaker, which enabled him to gain first-hand knowledge of craftwork at an early age. Throughout his life, he was to value craftsmanship as the fruit of man's action on matter. He began his training as an architect in 1873 in Barcelona, a city then undergoing cultural, social, economic and urbanistic transformation. In just a few years, it was to become one of Europe's great cities, with a skyline Gaudí himself helped to shape.

To begin with, Gaudí had progressive ideas. He was a confirmed Republican and atheist, but he soon migrated towards a form of Christian socialism which was conciliatory towards the status quo. However, he remained committed to the needy, although himself rubbed shoulders with powerful magnates and religious leaders. Subsequently, he became a strict and fervent Catholic. His friendship with the Marquis of Comillas and the latter's son-in-law, Eusebi Güell, was a decisive factor in his career as an architect, as were his ties to high-ranking members of the Catalan clergy, who gave him his first opportunity to demonstrate his genius.

He started out as a highly imaginative historicist, as exemplified by the Neo-Mudéjar Casa Vicens (1878–1883, Barcelona), which resembles some fabulous Oriental palace and, even more so, by the Palacio Güell (1885–1888, Barcelona), in which Gaudí's unique architecture become apparent, and which constitutes the first practical application of so-called Gaudian naturalism. For Modernism in general, and Gaudí in particular, nature was considered to be a provider of 'models' and 'resources' which man could use in construction. Gaudí used such devices mainly for structural purposes, although they were decorative, too. While his implementation of organic forms might, at first sight, seem whim-sical, it was actually the result of a rigorous preliminary study of nature, which he regarded as the unblemished testimony of God's deeds. This accounts for his use of the catenary arch, as well as sloping piers, columns—which, like trees, grow upwards and branch out—floral references and a cellular distribution of interiors reminiscent of the habitats of animals who live in colonies. He was fascinated, for instance, by the harmonious coexistence of bees in their hives.

His mature work shows a gradual development of essentially regenerative architectural principles shared by other Modernist movements in Europe. But, in Gaudí's case, they are radically and decisively transformed by a transcending inner force, so that his buildings, the work of a visionary, appear to have a life of their own. This idea of 'living architecture' means that Modernist naturalism eventually turns out to be a form of Expressionistic naturalism. His Casa Battló (1904–1906, Barcelona) reveals fluid spaces shaped by sinuous lines, but the overall effect elicits mixed feelings, as in a dream. The animalistic appearance, with cartilaginous forms in the balconies and rooftops, in conjunction with the fabulous blend of colours and forms, produces a surprising result which is both attractive and unsettling. The Casa Milà (1906–1910, Barcelona), resembling a giant pedestal or a mountain—indeed, it is known as *La Pedrera* (meaning 'stone quarry')—was initially built *merely* to support a large sculptural group, consisting of the Virgin of the Rosary, St Michael and St Gabriel, although the group was never placed there. Hence, seemingly emerging from the bowels of the Earth, the *telluric* construction looms up into the sky.

The unfinished church of La Sagrada Familia was the culmination of all Gaudí's efforts and experience. Much of his experience also went into a *minor* work which captured Gaudí 's imagination—the chapel at Santa Coloma de Cervelló, of which the first stone was laid in 1908. Here he explored Gothic structural devices in a 'natural' way: he built a model suspended on rope, with pieces of cloth and small bags to balance thrusts. When turned over, it became a full-blown model of the chapel, which produced amazing results. The interior of the crypt, with its rough-hewn finish conveying ancestral, primaeval values, sets up a disturbing feeling of mystical brutishness, despite its apparent coherence. All the aforementioned went into the utopian genesis of the Sagrada Familia, to which he devoted the rest of life, as from 1910. An expression of Gaudí's faith, this church, a prodigious, monumental prayer, which was to surpass all human proportion and anything imaginable, subsequently rose like some majestic forest of towers whose belfries were to resound incessantly, proclaiming the glory of God.

ANTONI GAUDÍ: Villa El Capricho; 1883-1885, Comillas (Cantabria).

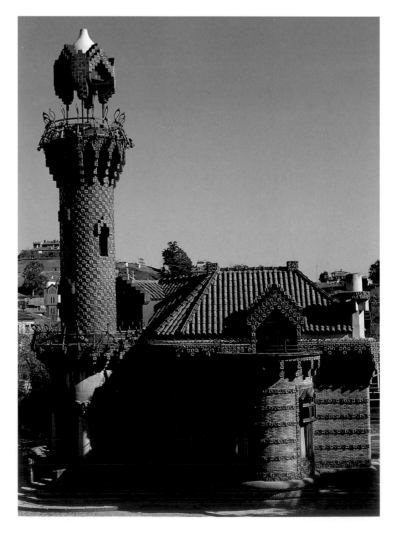

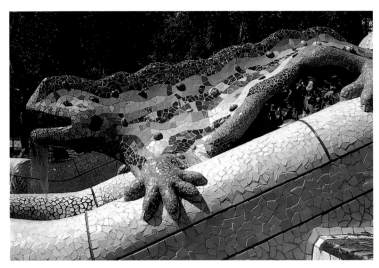

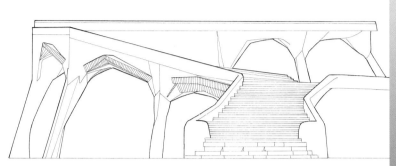

ANTONI GAUDÍ: elevation, plan and interior of the crypt in the chapel of the Colonia Güell (Santa Coloma de Cervelló, Barcelona), designed in 1898 and built from 1908 to 1915.

ANTONI GAUDÍ: Güell Park; detail of the monumental staircase leading up to the hypostyle. 1900–1914, Barcelona.

ANTONI GAUDÍ: Güell Park; detail of the winding bench in the square above the hypostyle. 1909, Barcelona.

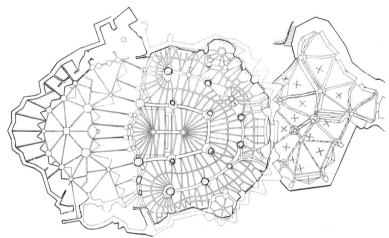

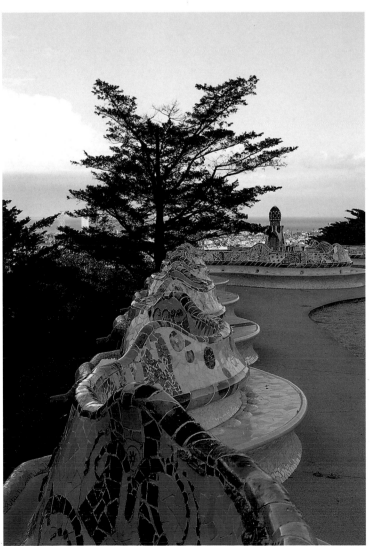

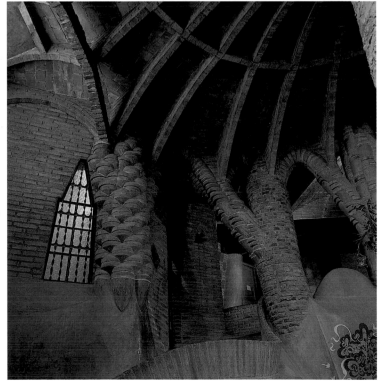

ALBERTO DE PALACIO: Bridge; 1887, Portugalete (Vizcaya).

A variety of solutions were put forward, until, in the end, the modern movement eventually prevailed everywhere. Until that time, so-called Modernism was the first art trend to adopt new design principles.

In Spain, the term 'Modernist' was applied to a whole range of artworks and types of architecture. On the whole, it implied renewal, a different, refined art form, but it inherited all the aesthetic and ideological problems of the 19th-century. Catalonia led this modern renewal, although there were parallel movements in other art centres in Spain, particularly in the Basque Country and Valencia. Artists at the time, positioned between indigenous values and cosmopolitan ones, between tradition and innovation, strove to break away from the official art establishment. This, coupled with the currents of renewal emerging in Madrid, an indispensable reference point for grasping the implications of many aesthetic attitudes, in addition to its global projection abroad, went to make up a new and wholly different art scene in Spain from what had gone before.

Modernist Architecture

In its origins, Modernist architecture was closely related to many contemporaneous historicist proposals, although it was opposed to the grandiose rhetoric of eclectic academicism. Paramount in that milieu was the work of Lluís Domènech i Montaner (1850–1923). His early work is inseparable from the Neo-Mudéjar style, even though this last tradition then began to be viewed in a different light. The erstwhile cafe–restaurant of the Barcelona World Fair of 1888, now the Zoology Museum, is one of his great brick buildings which, despite its picturesque features, with battlements and coats-of-arms, is not in any way historicist. His culminating architectural work was the Palau de la Música concert hall, built from 1905 to 1908, which shows the architect's firm intention to structure the building rationally according to Gothic principles. However, he endowed it with elements of fantasy, achieved through polychromy and ornamentation, both in its interior and exterior, yielding an almost pictorial result, with transparencies and luminous values. On a par with Domènech was Josep Puig i Cadafalch (1867–1956). His residential architecture, represented by such buildings as the Casa de les Punxes ('House of the Spikes'), built between 1903 and 1905, is characterised by an extraordinarily unfettered development of certain Gothic constructional principles and formal elements, studded with international connotations, particularly British ones, which were later associated with the historical identity of Catalonia.

LLUÍS DOMÈNECH I MONTANER:
Palau de la Música Catalana.
1905-1908, Barcelona.

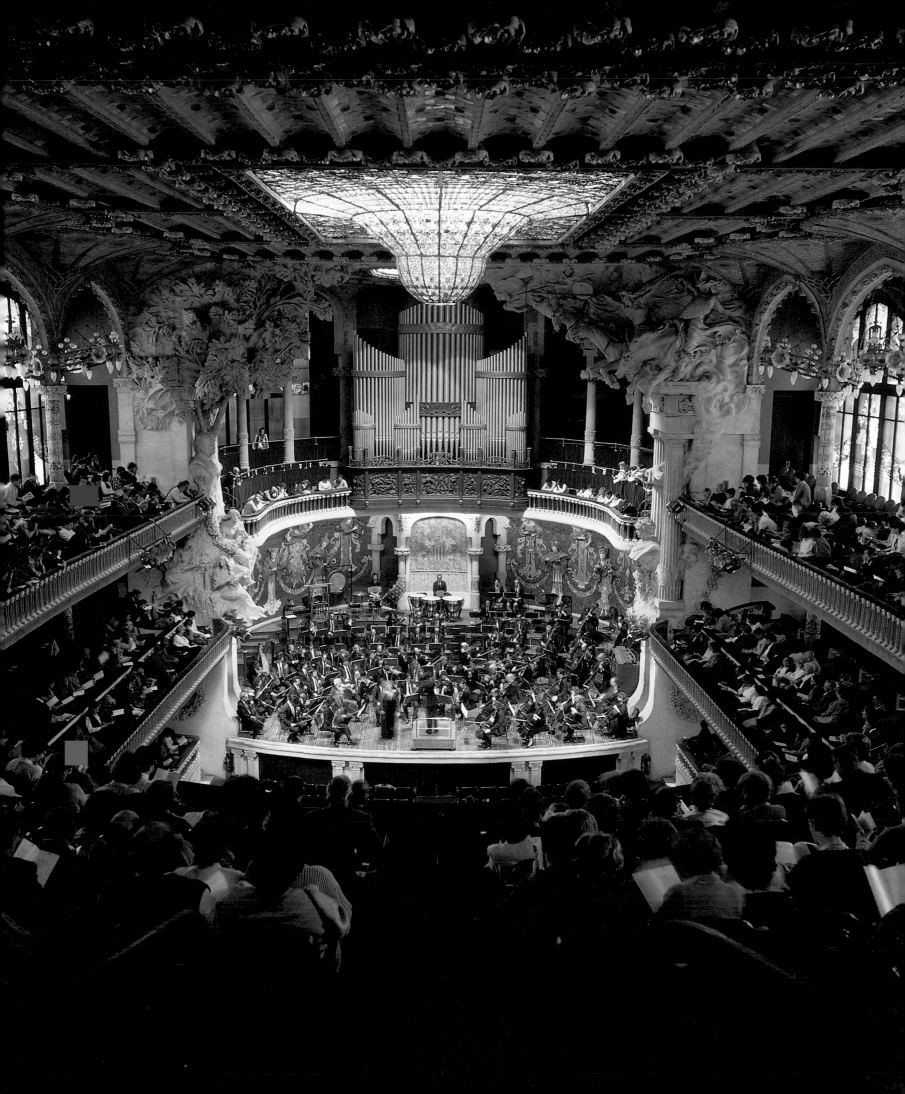

JOSEP PUIG I CADAFALCH: *Casa de les Punxes*
or *Casa Terrades*. 1903-1905, Barcelona.

ANTONI GAUDÍ: *Casa Milà* or *La Pedrera*.
1906-1910, Barcelona.

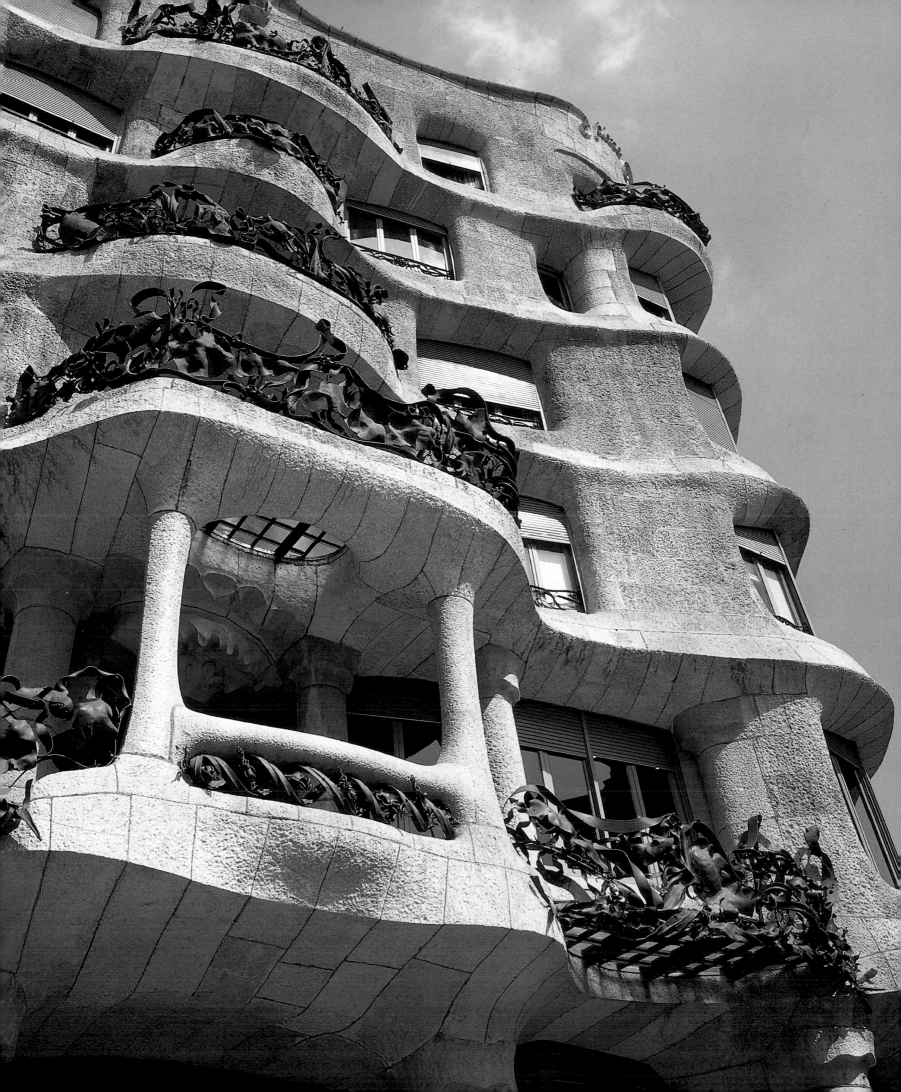

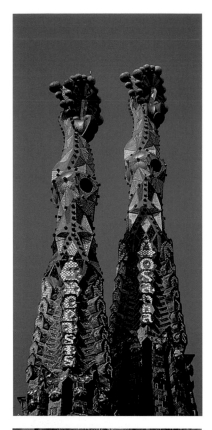

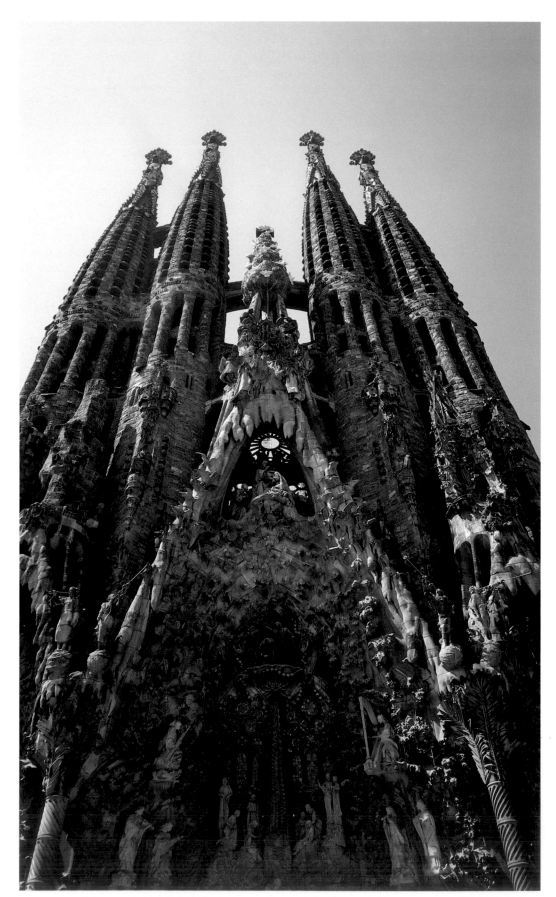

However, the crowning figure of this process of renewal, and one of the greatest architectural geniuses of all times, was Antoni Gaudí (1852–1926) who, having started out with a historicist background, ended up turning Modernism into a highly personalised style. The patronage of Eusebi Güell was decisive in launching Gaudí's career which, from the very outset, had shown him to be a highly imaginative architect, as evinced in the Casa Vicens in Barcelona, on which building work began in 1883. The Palacio Güell, built between 1885 and 1888, with its comparatively austere exterior, appears to lure one into an interior of tempting mystery. It swathes the viewer in what is virtually an aura of magic, an experience that was to reach its apogee in Güell Park, where building work got under way in 1900, and in which the various pavilions and other constructions in the park abound in fantasy. Gaudí's masterpieces of residential architecture were undoubtedly the Casa Battló and the Casa Milà, dating from 1905 and 1906, respectively, in which the initial, undulating decorativism was transformed into something organic, prefiguring Expressionistic emotionalism. This same inspiration was the guiding principle behind Gaudí's unfinished church of the Sagrada Familia, a veritable architectural explosion of tense, complex plasticity, pierced by openings and gravid with disturbing, fluctuating forms, the result of which resembles a mystical upsurge of superhuman dimensions.

Sculpture at the Time of Modernism

Just as Modernist architecture seemed to have been infused with a life of its own, sculpture at the turn of the century was undergoing a similar process of renewal. Even the most starkly realistic subjects—such as *Coal Mine* (Museo de Bellas Artes, Córdoba), by Mateo Inurria (1869–1924), and *The First Signs of Cold* (1892, Museu d'Art Modern del MNAC, Barcelona), by Miquel Blay (1866–1936), depicting figures dramatically burdened by resignation—contain figures which appear to emerge with vitality from matter with a rare plastic vigour. The sculptor who was most successful in achieving a poetic synthesis between the newfound subjects from everyday life, and the possibility of transcending them, was Josep Llimona (1864–1934). As occurred with most of his contemporaries, of which the most prominent figures were Enric Clarasó (1857–1941) and Eusebio Arnau (1854–1933), Llimona's work contains an acute decorative sense and a marked degree of idealisation, as a result of the spiritual sublimation prompted by his choice of subject, which in turn responded to his sincere and profound religious faith. In *First Communion* (1893, Museu d'Art Modern del MNAC, Barcelona), he surpassed the material boundaries of the descriptive and turned what is merely suggested into an essential part of the sculpture itself. In his most celebrated work, *Dejection* (Museu d'Art Modern del MNAC, Barcelona), executed in 1907, he created one of the ideal Modernist prototypes of delicate, languid feminine beauty.

Although many of these Modernist sculptures were of an intimist nature, they became widely known among the public and gratified the aspirations of the conservative middle classes, who fully identified themselves with the new movement. The figures in the Doctor Robert Memorial (Plaza de Tetuán, Barcelona), for example, are arranged around a rising spiral of force, which culminates in the effigy of the illustrious physician, surrounded by countryfolk and labourers, intellectuals and politicians, set under a huge flag which unites them symbolically through common ideals. The work is formally indebted to the stark realism of Meunier and the vital, plastic continuity of Rodin, which were the major international aesthetic role models at the time.

Perhaps even more interesting than the work of the Modernist Catalan sculptors was that of their Basque contemporaries. Francisco Durrio (1868–1940), of French origin, and a friend of Gauguin and Picasso, trained in Modernist decorativism until he had mastered part of the avant-garde languages. A sculptor who died young, Nemesio Mogrobejo (1875–1910), trained in Paris, where he assimilated the aesthetics of Rodin, as apparent in *The Death of Orpheus* (Museo de Bellas Artes, Bilbao), executed in 1905. This rhythmic relief work lacks the customary facile concessions to sensitivity, which makes his rendering of the mytholog-

ANTONI GAUDÍ: The Sagrada Familia. Barcelona, 1891-1893 (apse) & 1893-1903 (Nativity facade).

JOSEP LLIMONA: *Dejection;*
1907. Museu d'Art Modern del MNAC,
Barcelona.

ical drama particularly expressive, with essentiality in the forms and a very advanced creative conceptualisation.

European Influences in Painting

The pictorial renewal that took place at the end of the century was as complex a process as it was open-ended. It yielded a wealth of stylistic cross-fertilisation between the radical extreme of realism—consolidated throughout Spain around 1880—and the progressive absorption and reinterpretation of the major European pictorial movements, from Impressionism to Symbolism. As occurred in the other arts, all this took place in unison with a deep-seated redefinition of what it meant to be Spanish: *T'han parlat massa dels saguntins / i dels que per la pàtria moren: les teves glòries i els teus records, / records i glòries nomes de morts: has viscut trista / (...) que el plor et torni fecunda, alegre i viva: / aixeca el front, / somriu als set colors que hi ha en else núvols.* ('Too often have they talked to you about the Saguntins / and about those who die for the fatherland; your glories and your memories; / memories and glories relating only to the dead. Yours has been a sad life: / [...] may your weeping be fertile, joyful and lively; / lift your gaze, / smile to the seven colours of the clouds'.) That is how Joan Maragall's *Oda a Espanya* runs. It is a testimony, among so many others, of the thirst for renewal that was welling up everywhere and which became an indispensable cultural tool for grasping the ideological repercussions of the break that was being wrought with the most stereotyped academic tradition.

One of the first painters to embrace Realism with all its implications was the Catalan Ramon Martí i Alsina (1826–1894). Although he was initially interested in grand theme painting, he soon branched out into a variety of subjects. Thus, such paintings as *El Bornet* (Museu d'Art Modern del MNAC, Barcelona) reveal the beginnings of a break with the the-

RAMON MARTÍ I ALSINA: *The Siesta;*
circa 1880. Oil on canvas, 53 x 56 cm.
Museu d'Art Modern del MNAC,
Barcelona.

matic limitations of a descriptive approach within any particular genre. The first critic of this approach was Courbet, whom Martí admired profoundly. More mature works, such as *The Siesta* (c. 1889, Museu d'Art Modern del MNAC, Barcelona), no longer focus on some anecdotic scene but constitute a pictorial experience based on an inconsequential but real subject. Martí i Alsina was a prominent landscape painter and, as such, acted as a bridge between the emotional vision of the Romantics and the more naturalistic approach which, by the seventies and eighties, characterised a group of painters active in Olot, the town after which they were named. The motivation behind the so-called School of Olot was similar to that of the French Barbizon group, and was influenced by Corot. They felt the need to paint the poetic simplicity emanating from their vision of the Catalonian countryside by capturing the light at different times of day and seasonal changes. However, as in *The Harvest* (1876, Museu d'Art Modern del MNAC, Barcelona), by Joaquim Vayreda (1843–1894), they did include the occasional, subtle note of melancholy, as expressed in the odd anecdotic detail. This poetic streak can be found in many Catalan painters active before and even after the turn of the century, notably Francesc Gimeno (1858–1927), whose landscape, *Vallcarca* (Museu d'Art Modern del MNAC, Barcelona), executed in 1898, betrays his Barbizon training, although his work displays more vibrant, forceful brushstrokes.

Painters of Valencian origin, whose work became widely known through a series of national and international exhibitions, also interpreted reality in candid fashion. However, those belonging to the first generation still showed the signs of learned cultivation associated with academic realism, for which theirs turned out to be a connecting role between tradition—as represented by Eduardo Rosales—and modernity. Noteworthy artists in this generation were Francisco Domingo (1842–1920), Emilio Sala (1850–1910) and Ignacio Pinazo (1849–1916). Domingo's technical mastery of painting was comparable to that of Fortuny, whose career he followed to some extent. However, his best works were the result of reappraising the Spanish tradition: examples such as *The Shoemaker as an Old Man* (c. 1880,

Casón del Buen Retiro, Prado, Madrid) reveal his penchant for chromatic restraint and an almost tactile feeling for plastic description, with great freedom and ease of execution. Emilio Sala, in his finest works, which include the portrait of *Ana Colin de Perinat* (1874, Museo de Bellas Artes de San Pío V, Valencia), built up his compositions with forceful and austere luminous planes. He always avoided glibly resorting to superficially pleasing models or anecdotal motifs, although in his mature period he did dabble in Modernist-style decorativism. Pinazo, who was one of the best painters of his generation, sought a wholly intimate, personal style of poetics in the simplicity of his everyday life. He secluded himself in Godella, out of range of the public eye, and devoted his time to painting landscapes and scenes with astonishing pictorial freedom, which included the use of tonal mass and silhouettes to capture fleeting moments.

During the last decade of the 19th century, historical epic painting was replaced by the epic of everyday life as the subject matter at national fine arts exhibitions. This change marked the assimilation, by official institutions, of more compromising thematic concerns. The phenomenon in question is known as Social Realism, owing to the social denouncement implicit in the approach. However, this trend was soon ousted by the growing interest in light and luminosity in painting, an interest which was taken up by all painters who

JOAQUIN SOROLLA: *And they still say fish is expensive!* 1894. Oil on canvas, 153 x 204 cm. Casón del Buen Retiro, Prado, Madrid.

wanted to make a name for themselves at the time. This genre was actually the last form of academicism, in that it still involved a specific figurative standard, before the definitive demise of prescriptive art. Major exponents of this genre were Cecilio Plà (1860–1934), who painted *Bonds of Friendship* (Museo de San Telmo, San Sebastián, on loan from the Prado, Madrid), dating from 1895, and José María López Mezquita (1883–1954) with *Chain Gang* (Casón del Buen Retiro, Prado, Madrid), executed in 1901. Lighting effects play an essential part in both works, despite their melancholic charge. In the later work of both artists, an interest in subject matter was gradually superseded by an overriding concern for colouristic and luminous values, almost regardless of the subject chosen.

It was in this context that one of Spain's most international painters, the Valencian Joaquín Sorolla (1863–1923), achieved lasting fame. His enormous status led his images to become the most widely reproduced stereotypes of figurative culture at that time. His most prominent contribution to Social Realism was *And they still say fish is expensive!* (Casón del Buen Retiro, Prado, Madrid), executed in 1894. Over and above the tragic event portrayed, this painting reveals the artist's concern for setting up ambiences full of atmosphere and his interest in lighting effects, particularly highlights on objects, pointing up Sorolla's interest in capturing the purely visual. In 1895 he executed *The Mother* (Museo Sorolla, Madrid), which shows him to be an intimate painter with an extremely synthetic pictorial conceptualisation based on brushstrokes with a light material, which he used to build up spaces both decorative and poetic, after the fashion of Degas. Sorolla strove to render on canvas the enveloping feeling of the Mediterranean environment with such works as *Children on the Beach*

(Casón del Buen Retiro, Prado, Madrid), executed in 1910, in which light and movement become the dominant motifs of a fleeting, fragmentary reality. Sorollism or luminism, which consisted of capturing the radiant effects of light and colour in landscapes or inconsequential subjects, soon became fashionable throughout Spain, although the trend often strayed from the poetic sense that characterised the early Sorolla, in which enquiry held sway over a decorative result. The trend was also often related to the phenomenon of regionalism that emerged in the first few decades of the 20th century. One of the many artists who helped to shape this current was the Sevillian Gonzalo Bilbao (1860–1938) whose masterpiece, *The Cigarette Makers* (1915, Museo de Bellas Artes, Seville), is in fact a dignification of the working woman.

While the peripheral regions of the Iberian Peninsula bustled with creative activity, stemming from a need to reassert their own identity in the face of their lack of real political power, the centre of the Peninsula—specifically, Castile—was living out a no less radical process of renewal. A decisive factor in this process was the influence in Spain of Krausist ideas, channelled through the Institución Libre de Enseñanza, founded in 1877 by Francisco Giner de los Ríos, to which the painter Aureliano de Beruete (1845–1912) had close ties. Thanks to this institution, Spanish society achieved a greater degree of awareness in connection with the search for 'true Spanish personality', as expressed through character and landscape, rather than through glorious historical events. The shock caused by the loss of Spain's last colonies in the Americas led the contemporary generation to embark on a search for new roots: the aesthetic consequences of all this were immediate.

It was this cultural background that spawned the emergence of modern landscape painting at the Fine Arts Academy of San Fernando in Madrid. The first painter to bring a direct perception of nature into the focus of landscape depiction was an artist of Belgian origin named Carlos de Haes (1826–1898). His work still contains echoes of Romantic emotionality, particularly in his choice of subject and in his sense of composition. This is borne out by even his mature work, notably the canvas entitled *The Mancorbo Gulley in the Picos de Europa* (Casón del Buen Retiro, Prado, Madrid), executed in 1876. However, the way he sacralised nature was wholly innovative in terms of the Romantic tradition. His execution is fresh and brisk, with full-bodied impasto and rich pictorial material. Moreover, he played a fundamental role as mentor to some of the leading turn-of-century landscape painters. One of these was Agustín Riancho (1841–1929), whose infatuation with trees in the Cantabrian mountains led them to become both a descriptive motif and a live spectacle. His was a highly personal, expressionistic interpretation of nature, as evinced in one of his most celebrated works, *La Cagigona* (1905, Museo de Bellas Artes, Santander). However, de Haes' most important disciple was undoubtedly Aureliano de Beruete. He often chose subjects from the environs of Madrid, including *The Manzanares River* and *The Guadarrama River*, dating from 1908–1910 and now in the Prado. In these paintings, he attempted to preserve the essential austerity of the Castilian character, which he combined with the sovereign dignity of a Velázquez-like background, and a meticulous rendering of highlights and changing light effects in a crisp, tranquil setting.

Other landscape painters active towards the end of the century who did not share the naturalistic pragmatism of Carlos de Haes also contributed to the creation of a modern vision of the environment. Their work contains a poetic sediment of Romantic origin, so that the results they achieved resemble a sublimated essence, charged with emotionality, distilled from visible reality. The leading exponent of this current was Serafín Avendaño (1837–1906), who spent much of his life in Liguria. Such works as *Procession in a Village* (Casón del Buen Retiro, Prado, Madrid), dating from 1895, reveal a lyrical, mollified perception of the Italian countryside, redolent with a profound religious sense, and with an extraordinary wealth of nuances within the overall simplicity.

As opposed to the Spanish artists who chose to paint in Spain or Italy, a group of Catalan and Basque artists embarked on the difficult journey to Paris in the 1880s. There they gained first-hand experience of the avant-garde, which thereafter made gradual and hesitant inroads into Spain. However, in the end, these new trends became the core of the future

CARLOS DE HAES: *The Mancorbo Gulley in the Picos de Europa*; 1876. Oil on canvas, 168 x 123 cm. Casón del Buen Retiro, Prado , Madrid.

Spanish avant-garde. Chronologically, the first Spanish painter to adopt this trend was Adolfo Guiard (1860–1916). He met Degas in Paris and, on his return to Spain in 1886, caused a considerable stir in the art world of the Basque Country. In one of his works, entitled *Suburb* (Museo de Bellas Artes, Bilbao), his characters—the most prominent figure being a girl holding a carnation—are enveloped in a bluish atmosphere, a form of poetic emanation issuing mysteriously from an everyday scene. Another 'harbinger of modernity' was Darío de Regoyos (1857–1913), an Asturian by birth although associated with the Basque Country for much of his life. He was in Brussels in 1881, where he was actively involved in the *Cercle des Vingt,* and returned to Spain in 1888. In the works he produced around the year 1900, such as *The Shower; Santoña Bay* (Museu d'Art Modern del MNAC, Barcelona), he used what amounted to a Pointillist technique, with a host of small, juxtaposed brushstrokes of pure colour depicting highlights and iridescences, while his compositions characteristically consisted of colour banding, yielding tranquil decorative freedom.

Contemporaneous with these painters was an equally important Catalan group of artists who were in Paris in the early 1880s, from where they subsequently transposed the aesthetic interest that would lead Barcelona to become an exceptionally active centre of European culture around the year 1900. The first of these painters were Ramon Casas (1866–1932) and Santiago Rusiñol (1861–1931). Casas quickly digested all the technical and thematic novelties of French painting of the period, which are reflected in such works as *Plein air,* executed circa 1890–1891, and *Summer Studio,* dating from 1893, both in the Museu d'Art Modern del MNAC, Barcelona. In these works, what strikes the viewer is the rhythmic sense of the drawing, producing a pleasantly decorative visual effect, and the artist's use of the occasional frame, in photographic fashion, in addition to free handling and a sense of sobriety and austerity. Rusiñol's painting during that period was uncannily similar to that of Casas: both painted Montmartre, for instance, Rusiñol's version currently being housed in the Musée d'Orsay in Paris. Similarly, in the nineties, they were both interested in grey tones observed in exteriors and in capturing motifs which, while ungratifying in appearance, were suggestively enveloped in the dull winter light of Paris.

SANTIAGO RUSIÑOL: *Garden in Aranjuez;* 1908. Oil on canvas, 140.5 x 134.5 cm. Prado, Madrid.

All the aforementioned painters, every one of whom had adopted his own approach towards modernity, elected as the motif for their works the everyday world surrounding them, which was usually quite commonplace and at times even vulgar. This is what they had in common, as opposed to stereotyped academic principles, and all of them came up against an unfathomable poetic sense in the mundane world. At bottom, their works reflected their visual experiences of a Realistic–Impressionistic nature, an approach they remained fairly loyal to. However, some of them, including Casas and Rusiñol, those who had trained in an earlier tradition, such as Muñoz Degrain, and yet others who had made a name for themselves around the year 1900, were powerfully drawn at some stage by the Symbolist world, the mindset of which was radically opposed to the empiricism of early modernity, although less so in its results. As in the rest of Europe, in Spain, Symbolism was a rather heterogeneous art movement in terms of the forms of plastic expression adopted by its exponents, which ranged from the assimilation of Impressionist techniques to an attenuated form of academicism. At any rate, this escapist and markedly decorative approach contributed overall to an even more forceful break with tradition.

Despite his highly academic training, Muñoz Degrain acted as a nexus between a form of late Romanticism and the turn-of-century Symbolist renewal. His mature works, such as *Twilight in Magdala* (Museo de Bellas Artes de San Pío V, Valencia), dating from circa 1905, feature violent impasto and a vibrant, fragmentary technique. They are executed in delirious

tones with unreal lighting, producing a feeling of intensity and eeriness, as if they were the product of hallucination. In this respect, it may be asserted that an important part of Symbolism was engendered by the academic tradition. A similar case was that of Rogelio de Egusquiza (1845–1915). During a long sojourn in Paris, he became interested in the Wagnerian world of Fantin-Latour and even ended up exhibiting in the *Salon* of the Rosacrucians, founded by Sâr Péladan. His *Tristan and Isolda: The Life* (Museo de Bellas Artes, Santander), executed in 1912, reflects his passion for transcendental subjects, with figures swathed in illusory settings and symbolic colours alluding to primaeval human impulses.

The most interesting Symbolist painting emerged from turn-of-century Barcelona. The forerunner of this movement, who was instrumental in introducing into Catalonia the British Arts and Crafts aesthetic and Pre-Raphaelitism, which was to condition graphic art, poster design and interior design, was a man of many talents, the painter, poet and designer, Alexandre de Riquer (1856–1920). However, the most accomplished exponents of Modernist Symbolism in Catalonia were several years his junior, and were as receptive to French influences as Anglo-Saxon ones, or more so. Joan Llimona (1864–1934), the chairman of the Cercle de Sant Lluc, was the central figure in the more conservative, figurative current, which flourished in this art circle. His works feature pensive figures, set in interiors or landscapes evocative of a moralistic streak of intimism, which, paradoxically, end up becoming trivialised by reiteration. The paintings of Joan Brull (1863–1921), notably *Daydream* (c. 1898, Museu d'Art Modern del MNAC, Barcelona), also have an unmistakeable air of family, and tend to fall back on the sensibilities aroused by the solitary presence of female figures wrapped in thought, set in strange, mysterious and poetic places.

Curiously, the connection between Casas and Rusiñol and the Symbolist aesthetic developed from their empirical observation. It was as if some viewpoint, some unexpected glimpse, or the unusual way in which light impinged on something had transformed reality, to the extent that the symbolic suggestiveness of a motif should have begun to almost imperceptibly blur visual recognition of that motif. In effect, the portraits Casas painted in his mature period, such as *Dolors Vidal* (1911, Museu d'Art Modern del MNAC, Barcelona), are impregnated with the mysterious elegance of a Whistler. Rusiñol's interiors, as evinced in *Romantic Novel* (c. 1893, Museu d'Art Modern del MNAC, Barcelona), are almost as disturbing as those of the Belgian painter Khnopff although, in his mature work, this symbolism gave way to a much less profound decorativism, as in *The Arbour at Aranjuez* (1907, Casón del Buen Retiro, Prado, Madrid).

One of the most fascinating Symbolist painters was Joaquim Mir (1873–1940). In such works as *The Enchanted Cove* (Museu d'Art Modern del MNAC, Barcelona), painted on the island of Majorca around 1901, the artist captures a magical setting with an almost savage emotionality, aroused through contemplation of such an exceptionally beautiful spot. Outside the Catalan art world, another painter whose early work may be classed as Symbolist, although tinged with naturalistic perceptions, is the Cordovan Julio Romero de Torres (1880–1930). In his *Lovesick* (c. 1905, Museo de Bellas Artes, Córdoba), painted before he had developed the style characteristically associated with him, the alluring uncertainty of thought, which oversteps physical boundaries, has a subtly gratifying and yet unsettling effect on the viewer.

The approach involving direct visual experience, that is, reality analysed in a purely empirical sense, and the ancestral artistic urge to express the depths of the human soul, came together in the work of the leading turn-of-century Spanish artists in the form of two irreconcilable sentiments. This convergence sowed the fertile seed that to a large extent accounts for the development, along Expressionist lines, of artists in the following decades. Several artists found themselves caught between the meeting of the two centuries, and were liable to be seen either as the last exponents of a 19th-century process that was coming to an end, or as the outriders of new currents ushered in by the 20th century. The work of Regoyos, for example, an artist who made no effort to hide his Impressionistic leanings, lays bare the stark drama that was then being played out in Spain between tradition and progress. His *Holy Friday in Castile* (1904, Museo de Bellas Artes, Bilbao) constitutes a bitter metaphor in

which a huge, dark, industrial-age locomotive ploughs over a group of penitents trudging wearily and drearily under a bridge.

The work of Ignacio Zuloaga (1879–1945) also became well-known before 1900, particularly through national and international exhibitions. He was perhaps the most adept painter of all when it came to portraying—as far as the Spanish milieu is concerned—man's primaeval, untainted inner self, unscathed by the moral and aesthetic distortion arising from modern living. This aspiration, which left its mark on the lives of some of the leading international artists at the time, comes through in such works as *The Two Cousins,* dating from 1899, and *Portrait of Mercedes the Dwarf,* from circa 1900, both in the Musée d'Orsay, Paris. Although they strike the viewer as familiar characters, the figures portrayed are nevertheless infused with a great, almost timeless sense of human dignity. The artists of that generation inherited an atavic culture with a powerful racial factor, and they were mentally and pictorially indebted to El Greco, Ribera, Velázquez and Goya. However, they were also associated with the aesthetic leanings of the circles of Gauguin, Bernard, Toulouse-Lautrec and even Van Gogh, which is precisely what comes through in the work of Zuloaga.

This overtly or covertly Expressionist line had its leading exponent in the Catalan painter Isidre Nonell (1873–1911). He was possibly the most advanced painter of his time in terms of those whose work emerged from the dialectical relationship of passion and frustration that existed between Paris and Barcelona. The sinuous line of Modernism can still be found in his portraits of gypsy women, although it is used like some powerful whip to depict ghostly figures wrapped in profound, unfathomable thought. They are outlined in black and defined by the juxtaposition of small dark strokes. These sad, poignant and awesome beings, with their often inexpressive faces, swathed in dark, monochromatic light, are the same characters that attracted the attention of a young Andalusian, then living in Barcelona—Pablo Ruiz Picasso. After arriving in Paris, in the autumn of 1900, Pablo Ruiz moved into Nonell's studio, before he eventually became just Picasso. It was there that he embarked on one of the most fabulous adventures in contemporary art.

In the 19th century, the antagonism between Spanish tradition and the new currents from abroad, between history and the pragmatism of the times, or between consolidated values and the pressing need for innovation, helped to create a climate of inquiry which turned out to be highly enriching for Spanish art, despite the fragile political and economic status quo. Today, with our comparative perception of the art that emerged from the various centres in Europe, we are in a position to gauge the contribution of each artist to European culture as a whole. In this respect, the two geniuses that cast their impregnable shadows for several decades in the 19th century—Goya and Picasso—prove to be just as ordinary or unique, in the context of European historiographic myth, as the artists in any other country.

ISIDRE NONELL: *Profile of a Gypsy Woman;* 1902. Oil on canvas, 73 x 54 cm. Museu d'Art Modern del MNAC, Barcelona.

Following their respective visits to Paris, Ramon Casas and Santiago Rusiñol, together with the entrepreneur Pere Romeu, founded the tavern known as *Els Quatre Gats* in the Casa Martí, a building which had been remodelled by the Modernist architect, Lluís Domènech i Montaner. It soon became an intellectual coterie and the meeting place of avant-garde artists in turn-of-century Barcelona. Exhibits of its founders adorned the tavern walls, as did works by Miquel Utrillo, a second generation of painters (including R. Canals, J. Mir and I. Nonell, who were socially more critical than their predecessors) and the sculptors Manolo and Pau Gargallo. Also on display were the musical notes of Isaac Albéniz and Enrique Granados, and works by other artists who came to Barcelona, namely Darío de Regoyos and Pablo Ruíz Picasso. It was there, in February 1900, that Picasso, then a young, unknown figure, held his first exhibition of portraits, markedly influenced by Ramon Casas. In autumn that year he visited Paris, where he met the international avant-garde. Until 1904, he also kept in touch with the circle that continued to meet at *Els Quatre Gats.*

Spain's Pictorial Centres in the 19th Century

The main art centre in Spain throughout the 19th century was Madrid. Its Academia de Bellas Artes was the destination of artists from all over the country—although less so from Catalonia—and a compulsory reference point for all. Nationwide, State-run fine arts exhibitions were held there, too. Organised in the form of competitions, they were attended by artists from all parts of Spain, as they drew reviews and commentaries, and generated a thriving art market. Artistic activity in Madrid was synonymous with the official art establishment, which went into decline towards the end of the century, when academic principles became less and less fashionable. Even then, Madrid continued to attract artists, and sometimes acted merely as a recipient of work produced in other centres, the quality and quantity of which was rather assorted.

For the first three quarters of the century, Barcelona was not particularly important as an art centre, although its production was far from insignificant. However, more than anywhere else, it was open to foreign influences, which were subsequently conveyed to other parts of Spain by Catalan artists. Nevertheless, in the last quarter of the century, by then fully emancipated from Madrid, Barcelona rose to become one of the leading art centres both in Spain and Europe, and one of the most avant-garde on the continent.

Seville rivalled Madrid as the leading art centre during the first half of the 19th century. Several factors contributed to its importance: Spain's pictorial tradition was fundamentally Sevillian, and it was there that a small court sprang up around the figure of Luisa Fernanda (Queen Isabella II's sister) and her husband, the Duke of Montpensier. Seville also epitomised the myth that grew up among European romantics. Lastly, in terms of its population and its economic sector—albeit then in decline—Seville was one of the most important cities in Spain. However, its staunch traditionalism, a source of fascination for so many romantics, was what led it to become marginalised in the second half of the century.

At the beginning of the 19th century, Cádiz enjoyed a privileged position in Andalusia. It was there that the centre of trade with the Americas had shifted from Seville during the 18th century, leading Cádiz to become the second most important city in Spain around the year 1800, and the gateway for liberal ideas entering the Peninsula. At the end of the 19th century, Málaga also acquired considerable importance, and does not deserve to be classed as a remote, sleepy hollow in the south of Europe, as it was described by one of Picasso's biographers. On the contrary, it was quite a cosmopolitan city, with a School of Fine Arts where many accomplished artists studied.

While Valencia lagged seriously behind other cities in its artistic development during the first half of the century, by the end of the century many Spanish and European critics considered it to be yielding the finest Spanish painting of the period. In effect, Valencia's Escuela de Bellas Artes produced some of the country's most popular artists, both at home and abroad, so that, despite appearances to the contrary, part of Spain's national image was not Andalusian but Valencian. Moreover, marked urban growth around the year 1900 led Valencian architecture to rival that of Barcelona and Madrid.

Until the closing years of the century, the Basque Country hardly figured at all in Spanish art. However, thereafter, its production achieved local, national and even international acclaim. Together with Catalonia, it took its place in the avant-garde, and played an important part in the process of artistic modernisation south of the Pyrenees.

Artists in Asturias, Cantabria, Aragon (Zaragoza), Murcia, the Canary Islands and Castile (Valladolid) were active in the more restricted circles of regional schools kept alive by institutional support, and most of them attained rather short-lived acclaim.

This summary of art centres would be incomplete without mention of Rome, where Spanish artists were sent on scholarships awarded by the Academy of San Fernando in Madrid, under the supervision of a grants director. This eventually led to the founding of the Spanish Fine Arts Academy of Rome in 1873. Throughout the century, Rome also attracted many scholarship holders sponsored by other institutions, as well as artists who established themselves there by their own means. Similarly, many artists trained at the School of Fine Arts in Paris, the city that also lured many others in search of fame and fortune.

JOAQUÍN SOROLLA: Children on the Beach; *1910. Oil on canvas, 118 x 185 cm. Casón del Buen Retiro. Prado, Madrid.*

RAMÓN CASAS: Plein air; 1890. Oil on canvas, 51 x 66 cm. Museu d'Art Modern del MNAC, Barcelona.

VALERIANO BÉCQUER: The Gift; 1866. Oil on canvas, 85 x 65 cm. Casón del Buen Retiro, Prado, Madrid.

FEDERICO DE MADRAZO: Portrait of Amalia de Llano y Dotres, Countess of Vilches; 1853. Oil on canvas, 126 x 89 cm. Casón del Buen Retiro, Prado, Madrid.

Spanish Art from 1900 to 1939

Jaime Brihuega Sierra

In the first half of the 20th century, Spanish art was marred by a strident paradox regarding its identity. True, figures such as Picasso, Gris, Miró, Dalí and Julio González gave their names to important chapters in the artistic adventure that unfolded between the turn of the century and the Second World War, and were pivotal in the development of historic avant-garde movements. However, their brilliant protagonism took place in cultural mileus located on the other side of the Pyrenees. The context which Spain had to offer them during that first half of the century was that of a peripheral cultural framework, a scene buried under the burden of the past, which historical conditions of all types had rendered unsuitable for the development of the great whirlwind of innovation that was about to be unleashed. Whoever understood and internalised art as something more than a minutely pre-established destiny was forced to emigrate, and Paris was the preferred place of residence for such an exile.

Nevertheless, Spain still preserved a rich, variegated and passionate 'internal history' in the complex fabric of its cultural entrails. In effect, before lighting the way for international artistic creation, Picasso, Miró and Dalí had been steeped in the landscape of Spanish art. Even such foreigners as Diego Rivera, Rafael Barradas, Joaquín García-Torres, the Delaunays and Picabia had intense experiences in this respect. Alongside these, or in their circles, was a large number of creators who committed themselves to the difficult task of transforming the prevailing reactionary academicism. Prior to the formation of what is now termed the 'Spanish Paris school', Óscar Domínguez, Bores, Togores, Viñes and Cossío had been active in Spain, alongside others who were unknown beyond its borders and are only now gaining the recognition they deserve, such as Alberto Sánchez. Then again, there were those who, like José Gutiérrez Solana, Joaquín Sunyer and Emiliano Barral, cannot be appraised exclusively in terms of the dialectic between conservatism and renewal, but whose careers were extraordinarily interesting in that they were wholly consistent with the particular circumstances they operated in.

It is only in recent years that historiographers have become especially interested in studying these eccentric milieus of contemporary art, which had previously been relegated to the fringes. Indeed, it is edifying to explore that dual condition of Spanish art in the first half of the 20th century, tracing both its contribution in the international arena and the specific identity it assumed in Spain itself.

Overview of Art Culture in Spain

The long-drawn-out transition in Spain from the old to the new regime, which involved changes of an economic, political, social and cultural order, led progress in 20th-century Spanish society to fall seriously behind that of other European countries. As a result, the complexities of what may be termed the 'art institution' were also plagued by deficiencies. Apart from Catalonia and, to a lesser extent, the Basque Country, Spain's bourgeoisie lacked the protagonism of its counterparts in some other European countries, which played an essential

DARÍO DE REGOYOS: *The Chicken Coop;* circa 1912. Oil on canvas, 65 x 55 cm. Casón del Buen Retiro, Prado, Madrid.

part in fuelling the system of artistic production. Attempts were made to operate a small network of art galleries, but it proved to be incapable of replacing the old system of commissions and direct acquisition, which continued to be associated with official exhibitions, namely the National Fine Arts Exhibition and the Autumn Salons, on a State level, and a host of regional competitions slavishly modelled on the former. Only the Spring Municipal Exhibition, held in Catalonia, achieved a degree of independence and provided some access to information about the succession of innovations that were bringing about changes in the visual language of contemporary European art. Shielded by critics who generally acted as accessories, and backed by the conservatism that conditioned public art tastes, official exhibitions were a compliant forum for the consolidation of the prevailing ideology and art aesthetic.

Stodgy State art collections continued to be fed by works that had won prizes at these exhibitions, which also determined the bureacratic standards in market prices and tastes, and in turn gave rise to private collections unreceptive to modern trends. The upshot of this was the cut-and-dried rationale of a reactionary discourse impervious to change, by which the powers-that-be, as well as economic, social, cultural and 'artistic' forces, perpetuated themselves in a stale culture medium. Civil servants in the fine arts sector, academics, teachers, examiners, clients, officially sanctioned critics, and contenders for or winners of prizes compounded a dense mesh that forestalled all the attempts at modernising Spanish culture that emerged falteringly from the more progressive sectors of society. It was not until the proclamation of the Second Republic in 1931 that major changes began to be implemented from official quarters.

The art establishment thus yielded visual products associated with the most conservative aspects of tradition. With the exception of Catalonia and the Basque Country, which fostered the development of a plastic discourse of their own, the dominant trend in Spain was a form of naturalistic figurative art featuring anecdotal subjects, which covered a wide range of regional folklore or mythicised images of urban culture geared to public taste and symbolic requirements. With the eventual demise of the period of large-format 'compositional paintings' and sculptural groups that had nourished art models throughout the 19th century, the size of paintings and sculpture began to grow smaller, and their subjects more superficial, in order to fit comfortably in homes that were themselves becoming increasingly smaller. This process was similar to what had occurred in the rest of Europe, although in Spain it was slower and took longer. In short, the *ancien règime,* which had been practically wound up in most other cultural centres after the First World War, remained active in Spain until well into the 1930s.

The status quo described above refers mainly to official art in Madrid and its vast spheres of influence. Although official Spanish culture took in a host of regional features, particularities of the regions did not come through in art as a whole so much as in trivial details of a folkloric type. Nevertheless, as mentioned earlier, some regions did show a considerable degree of autonomy, particularly those now known as the 'historical communities', that is, Catalonia, the Basque Country and Galicia.

The most noteworthy case is, of course, that of Catalonia, where the industrial revolution, which came long before the rest of Spain, brought about marked changes in its socioeconomic structure as from the end of the 19th century. Thus, in the first three decades of the 20th century, Catalonia had a highly deveoped art culture of its own. This is true in terms of institutions (official exhibitions, a Modern Art Museum, artists' associations, art tuition, etc.), the art market, an incipient network of galleries, the aesthetic tastes acquired by the public and, of course, the local development of an artistic language, both the prevailing trend marked by the art establishment and the various alternatives soon to be offered by the Catalan avant-garde. A similar situation arose in the Basque Country, although on a much smaller scale and some decades later. However, apart from Catalonia and the Basque Country, features specific to the art cultures of say Galicia, Valencia, Asturias, the Canary Islands and Andalusia were gradually standardised to such an extent that their only remaining distinguishing traits were those which artists in the various cities were able to convey as far as their urban abodes and lifestyles was concerned.

JOAQUÍN MIR: *Terraced Village;* circa 1909. Oil on canvas,
121 x 164 cm. Museu d'Art Modern del MNAC, Barcelona.

PAU GARGALLO: *Maternity;* 1922.
Museu d'Art Modern del MNAC,
Barcelona.

From the end of the first decade of the century, efforts were made to set Spanish art on an equal footing with the leading international art centres. To begin with, these efforts were sporadic and limited in scope, and ended up getting bogged down in the dense inertia of the art establishment. Moreover, initiatives of this kind were unable to elicit the public response required to ensure their continuity. This state of affairs was aggravated by the fact that, sooner or later, the artists involved ended up leaving Spain for places more conducive to their activity.

In its beginnings, much of this process of renewal consisted of importing and emulating the poetics and languages of the international avant-garde. The innovations were either incorporated on a fragmentary basis into the bedrock of the visual languages prevalent in Spanish art, or else indiscriminately mixed with the latter. This gradually gave rise to a dialectical tension between the innovations introduced from abroad and the search for indigenous roots in which a process of renewal could be grounded. It was precisely this tension, fraught with contradictions and often biased interpretations, that led to the creation of an 'internal avant-garde'.

The international phenomenon of new realisms, which proliferated in the twenties and thirties, became a new and important yardstick for the movement of renewal in Spanish art. It also led to new paradoxes, in the sense that that the most forward-looking sector of the art world was beginning to notice a certain 'return to order'. However, the 'return' was negotiated from a position in which 'disorder' consisted solely of a few tentative moves that did not affect the art scene as a whole. Its fusion with such phenomena as the endurance of Catalan *Noucentisme,* and the lukewarm modernisation of traditional languages, created complex ideological and visual situations that require careful and thoughtful analysis.

In the thirties, a new factor arose that would take on explosive force during the Civil War—the political stance adopted by artists in their work. This new element triggered bitter controversy in Spain, and led the issue of avant-garde realisms—to which a veritable avalanche of Surrealistic art had been added—to assume even greater proportions. This would account for the brutal and at once alluring tension noticeable in works on display at the Spanish pavilion at Expo '37 in Paris, the universal emblem of which is undoubtedly Picasso's *Guernica.*

This all leads us back to the great paradox referred to at the beginning: while the development of art inside Spain was marked by contradictions and tribulations at that time, the great figures of contemporaneous Spanish art were setting the main course of 20th-century art before the expectant eyes of the world.

Picasso from 1900 to 1937

The turn-of-century atmosphere in Barcelona in which the young Pablo Ruiz Picasso (1881–1973) was active has been described in the chapter on the 19th century. The antithesis of optimistic Modernism, which stood for the Catalan bourgeoisie that had made its wealth from industrial development, was the bohemian, somewhat anarchical coterie that used to meet at such literary cafes as *Els Quatre Gats.* Encouraged by the enthusiasm that pervaded this milieu of alternative artists and intellectuals, figures such as Ramon Casas (1866–1932), Santiago Rusiñol (1861–1931), Joaquim Mir (1873–1940), Miquel Utrillo (1862–1934), Isidre Nonell (1873–1911) and, of course, Pablo Picasso paved the way for their first encounter with the poetic winds blowing from Paris. These they adapted to the ambience of Barcelona, nurturing the newborn seeds until they blossomed in a city ravaged by violent social strife. From the very beginning of the century, Picasso had built up a close relationship with Parisian circles which would eventually become permanent. Paris constellated in the young Picasso a flood of inspiration which he channelled through his work in many different directions. He would equally adopt the vigorous line of Toulouse-Lautrec, charge with provocative explosions of colour the broad chromatic repertory of the Post-Impressionists, or traverse the moving, sordid atmosphere of paintings by Munch and other early-Expressionist artists. In each of

JOAQUÍN SUNYER: *Landscape at Fornalux,* circa 1916. Oil on canvas, 100 x 125 cm. Museu d'Art Modern del MNAC, Barcelona.

these directions, Picasso's brushstroke went far beyond the mere assimilation of any particular influence.

From 1901 to 1905, Picasso concentrated on one particular line of development, characterised by the use of cold tones arranged into a highly expressive, vigorous and solid construction worthy of a draughtsman. A decisive moment for him was when he first saw El Greco's works on a trip to Madrid and Toledo. Equally decisive was his ability to recover the spirit of line drawing which had pervaded much of art at the end of the 19th century, although he divested it of all epidermal decorativism. All this went to make up what is known as his 'Blue Period'. His subject matter scoured the depths of the human condition through a veritable gallery of characters on the fringes of society. They compound a sort of theatre of the world in which, metaphorically speaking, all human species have their place. His poignant figures, starving in solitude, move the viewer to compassion, but they also prompt self-examination through the lucid distance imposed on emotionality by the mirror of frozen colour, in which reason acts to piece together our own desolate dimension.

From the end of 1904 and throughout 1905, his colours veered towards a tonal range which characterised what is know termed his 'Rose Period'. However, what was happening on his canvas was not merely a question of tonal changes. His figures ceased to be just an evocation on the fringes of the human landscape: their opposites were acquiring substance, in the course of a plastic deliberation on the autonomy of form. Cézanne, Ingres and the ide-

alist echoes of the ancient world acted as poles which Picasso now used to vault into the conquest of a self-defining universe, which was abstract despite its figurative concretion. It was therefore a harbinger of the powerful blow by which the development of Western art would be stopped in its tracks—*Les Demoiselles d'Avignon* (1907). From 1901 to 1907, Picasso had roamed across practically the entire horizon of trends making up contemporary art.

Preceded by a long and variegated series of trials conducted throughout 1906, the 'philosophical bordello' of the *demoiselles* reached out to the coarse sensibilities of primitive art and put paid to each and every fundamental principle of the visual language that had evolved since the Renaissance. Harmony, space and timeless beauty, which Picasso himself had pursued in works executed shortly before that, were smashed to pieces in order to draw up the most radical figurative manifesto ever seen. He had arrived at the beginning, from which painting would have to be developed from scratch. He himself was to take up that challenge.

Then began the process which went down in history as Cubism. It was implacable in its rigour and consistent in its development. As from 1908 and in close collaboration with Braque, Picasso began to break up surrounding forms and translate them into increasingly more autonomous geometrical units. The figure–background dialectic was subjected to self-criticism, so that things and beings were set in space and vice versa. By 1910, Cubism had achieved such levels of production and such a degree of identity that it was in a position to perpetuate itself, and to use reality as a simple archive of references which could be interpreted according to its own rules. In 1911, ties to that reality had been all but severed in the course of an intricate, hermetic game played out through lines, planes, units of shadow or ferrous compositional arrangements. Only then, once the independence of visual thought shone in all its finery, were virtual fragments of reality, or trim *trompe l'oeile,* affixed to the canvas, ushering in the possibilites of *collage*.

By 1912, Cubism was hailed as a solid alternative among the international avant-garde. It was fused with other movements and began to branch out in a number of directions. From then and until 1914, Picasso led Cubism to its epiphany, consisting of the purged plenitude of elementariness, through a synthesis of fragments of the endless vocabulary generated by the process that had gone immediately before, and those that would be generated *ex novo*. Colour burst forth in all its pictorial splendour, and forms moved in a fluid relationship of distance from and proximity to visibility, ranging across the flatness of a space which unabashedly flaunted its bidimensionality.

The First World War racked consciences and brought most processes to a halt. From 1917 to 1925, Picasso worked on the stage scenery for Diaghilev's Russian Ballets. His fame had soared and by then he was regarded as an undisputed genius. From 1915, coinciding with the last frontiers of Cubist development, his drawings recovered the rigorous balance of polished figuration. For the following ten years, this propensity inspired a period of grand pictorial compositions known as Neoclassicism. Parallel in time to large-format Cubist compositions, they impelled European sensibilities forcefully towards a veritable wave of 'return to order', which viewed tradition in a different light. Ancient Greece, Italy and Mediterranean fertility went into the piecing together of a world image which Picasso himself had previously pulverised.

But, with the insatiable appetite that had always characterised him, from 1925 Picasso turned in on himself and embarked on a writhing, distorting style which at times bordered on ferocity and monstruosity. The Surrealists saw Picasso as an 'inner urge' that deforms things and reconstructs them with the darkest human instincts, like some inexhaustible creative source that can never be cornered by the sure direction of any language. Symbolic beings, beings of flesh and blood, beautiful or deformed, peaceful or desperate, regained their virtuality on Picasso's canvas in all possible forms.

When, in 1937, Picasso had his *Guernica* put on display in the Spanish pavilion at the International Exposition in Paris, he was actually exhibiting a *summa* of over forty years of poetic experience, expressed through painting, graphics and three-dimensional works, bringing Spanish art of the first half of the 20th century to a resounding close.

Classicism and modernity coalesce in
the sculpture of Manolo Hugué and Pau
Gargallo, members of the international
avant-garde. Manolo Hugué settled in
Céret in 1910, and drew a group of
important artists into his circle, notably
Picasso, Braque and Gris. This did not
distract him from his own peculiar
approach to art, characterised by round
forms and Mediterranean subjects, but it
did lead him to introduce some Cubist
features into his work, particularly
geometrical forms. Gargallo, for his part,
applied his conceptualisation of space
to *Noucentiste* sculptures. From 1907, he
combined traditional materials—clay,
marble and stone—with metal. This is
apparent in the case of *Maternity*, in
which the concave hollows help to
shape the sculptural volume.

A Handful of Spaniards in Paris during the First Quarter of the Century

Darío de Regoyos (1857–1913), Francisco Durrio (1868–1940), Ramon Casas, Isidre
Nonell, Santiago Rusiñol, Ricard Canals (1876–1931), Joaquim Sunyer (1874–1956), Hermen-
egild Anglada i Camarasa (1871–1959) and Picasso had shown it was imperative to travel to
Paris in order to keep abreast of modern trends. Their lead was followed by virtually all the
significant figures in Spanish art, who paid visits of different lengths to what was then the
undisputed capital of world art. The members of that veritable flood of artists, who were
instrumental in shaping the 'extrauterine modernisation' of contemporary Spanish art, includ-
ed two highly talented sculptors, Pau Gargallo (1881–1934) and Manolo Hugué (1872– 1945).
The oeuvre of Pau Gargallo was positioned between Art Nouveau, a classicist renewal and
certain echoes of Cubism associated with Art Deco. The sculpture of the Catalan Manolo
Hugué featured a blend of earthy wryness and a spontaneous, sincere sense of form. Other
noteworthy artists, such as the painter Francisco Iturrino (1864–1924), Matisse's friend and
travelling companion, enjoyed greater fame in France than in their own country, despite the
fact their art moved halfway between the new sensibilities and their ancestral origins.

In 1906, Juan Gris (José Victoriano González, 1887–1927) went to Paris, where his
activity consisted of turning out satirical drawings for various publications. After making
inroads into avant-garde art circles between 1910 and 1913, he began to paint in response to
the fascination exerted on him by the proposals of Picasso and Braque. He soon adopted a
Cubist aesthetic, which he cultivated with almost mystical devotion until the twenties. His first
incursions into this language involved experimenting with the distillation of geometrical form,
with the stress on the structural potential of chromatic values and the communicative force of

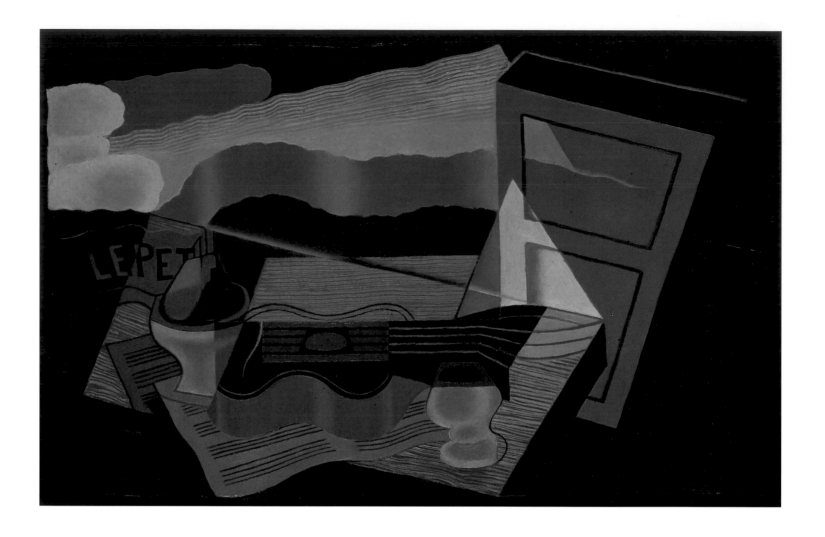

collage. His works gradually took on a cultivated sobriety in which reticular or rhomboidal compositive arrangements determined the continuity of a discourse that led from one painting to the next. He was deeply captivated by balance and by classical timelessness, which he distilled from the very essence of geometry. This led the number of devices used in his language to become reduced to more elementary sequences which, in his latter period, amounted to merely a wan vivification of visually recognisable images.

Another Spanish artist who was active in Paris from 1909 was María Blanchard (1881–1932). Her early work was based on a delicate primitivism, in tune with her sensibilities, but this painter from Santander soon adopted Cubist principles, which characterised her work until circa 1920. From then on, María Blanchard returned to figurative painting, caught up in the newfound current of Realism that was spreading across Europe. It was in this style that she found a decisive means of expressing form, roundly applauded by the critic Waldemar George.

Three References: Sorolla, Zuloaga and Romero de Torres,
and an Exceptional Figure: Solana

While some Spanish artists were competing on the front line in Paris, art culture on the Iberian Peninsula remained straitjacketed under the burdensome helmet of 19th-century tradition. Aside from the activity of Spanish artists involved in the avant-garde venture of the first two decades of the century, the public also looked on expectantly as other artists whose languages did not involve a radical break with prevailing tastes also triumphed in the international arena. One such painter was Joaquín Sorolla (1863–1923), who had become celebrated in Spain at the end of the 19th century and had earned international acclaim in the early-

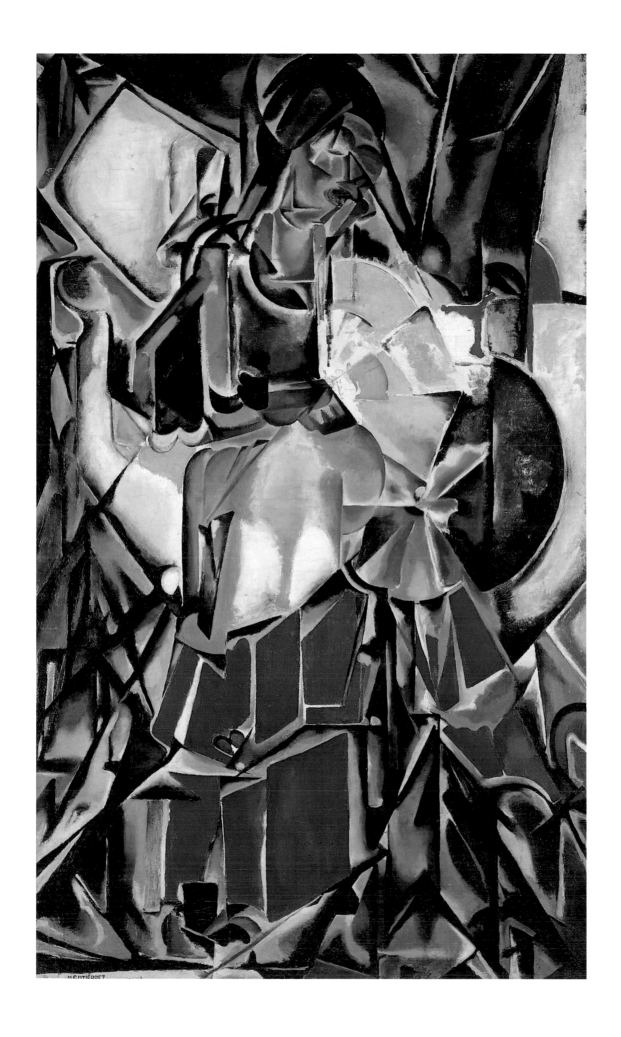

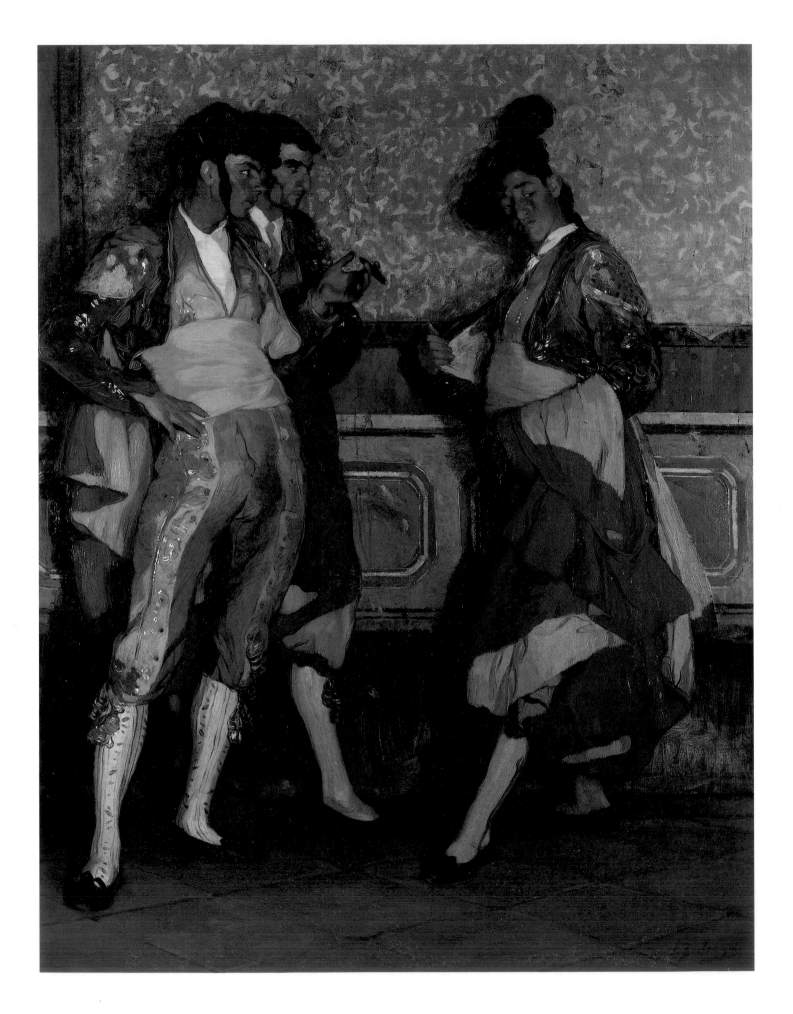

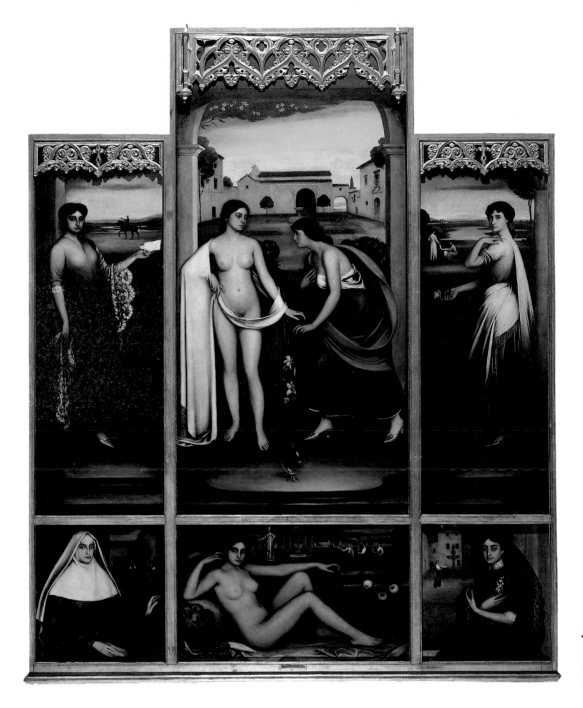

20th century, just when he was beginning to develop a plethoric, light-filled *pleinairist* technique, which was to have a marked influence on a large number of Spanish artists. His dazzling beach landscapes acted as an access route for the introduction of Impressionism, adapted to a regionalist subject matter which might be termed 'picturesque Spain'.

Ignacio Zuloaga (1870–1945) also achieved international fame and was held in great esteem in Spain. After initially immersing himself in the aesthetic morass of the turn of the century, he went on to develop the popular subject of 'the soul of Spain', spiced up with a lofty literary tone which led the traditional devices to become diluted in free, expressive brushstroke, a dramatic palette and vibrant drawing.

Julio Romero de Torres (1874–1930), for his part, was adept at exploiting clichés from Andalusian folklore through the use of a language combining Mannerist devices, morbid late-Symbolism and kitsch. His paintings aroused conflicting passions in Spain and drew a great deal of praise in Spanish America.

The international successes of some other artists, such as Josep Maria Sert (1874–1945) and Federico Beltrán Massés (1885–1949), were mostly related to the superficial sensibilities of certain mundane ambiences, so that in time their effect has waned.

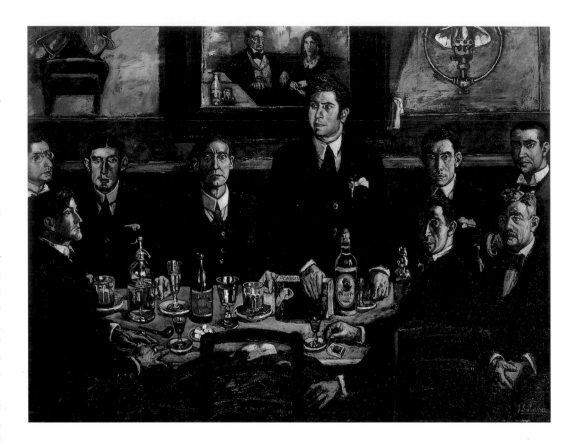

JOSÉ GUTIÉRREZ SOLANA: *The Coterie at the Café de Pombo;* 1920. Oil on canvas, 162 x 211.5 cm. Museo Nacional Centro de Arte Reina Sofía, Madrid.

Zuloaga and Solana have often been likened to two sides of the same coin. Both of them cultivated subjects associated with 'Black Spain'— processions, bullfights and prostitution. But, while Zuloaga's portrayal of matadors, for instance, is heroic and picturesque, Solana depicts them just as they are: bullfighters in all their grandeur and wretchedness. This distant atttitude, more the result of conformity and involvement than of criticism, is what sets Solana apart from the so-called 'Generation of 98' literary coterie, which he coincided with at the Café de Pombo in Madrid. In formal terms, both Zuloaga and Solana were quite alienated from the international avant-garde, but Solana's Expressionist Realism, his aloofness and his social portraiture marked a proximity to contemporaneous European movements, without detracting from his distinguishing Spanish features.

The Rise of the Avant-Garde in Catalonia: Joan Miró until 1937

At the end of the first decade of the 20th century, Catalonia began to forge a new cultural identity that came to be known as *Noucentisme*. The theorist behind this movement was Eugeni d'Ors, and its cause was promoted by regional political and economic powers. The aim of *Noucentisme* was to symbolise the ancestral roots of an eternal Catalonia, which was now called on to emerge in the present. The effect made inroads into all walks of cultural life. In the plastic arts, the Mediterraneanism put forward by Maillol and the modernised revival of the Greco-Roman tradition were the ingredients that went to make up an initial definition of *Noucentisme*, although it was never clearly delimited. Joaquim Sunyer's return to Catalonia, once his style had been steeped in the most classicist Cézannian vein, was hailed as a symbol of that encounter between tradition and modernity. The symbol was reinforced by the fact that the language used by Sunyer remained virtually unchanged thereafter. Other foundational influences in the movement included the mural decoration of various official buildings by the Uruguayan Torres-García (1874–1949), before he became associated with the avant-garde. Similarly, painters such as Xavier Nogués (1873–1941), Feliu Elias (1878–1948), Josep Aragay (1889–1973) and Josep Obiols (1894–1967), and the sculptors Josep Clarà (1878–1958) and Enric Casanovas (1882–1948), helped shape the various facets of this aesthetic, which remained latent until well into the thirties, when it re-emerged as a recurring tendency in the work of a large number of artists, and even among avant-garde militants.

In this context, various occurrences led small nuclei of Catalan culture to come together to form a more radical avant-garde. Of considerable importance in this respect was the activity of Josep Dalmau who, as from 1912, set about displaying some of the major innovations that were arising in different art centres in Europe. Also of paramount importance was the arrival in Barcelona of numerous members of the international avant-garde, prompted by the instability caused by the First World War. They included Artur Cravan, the Delaunays, Gleizes, Charchoune, Marie Laurencin, Olga Sacharoff and, above all, Francis Picabia, who in 1917 published the Dadaist journal *391* in Barcelona.

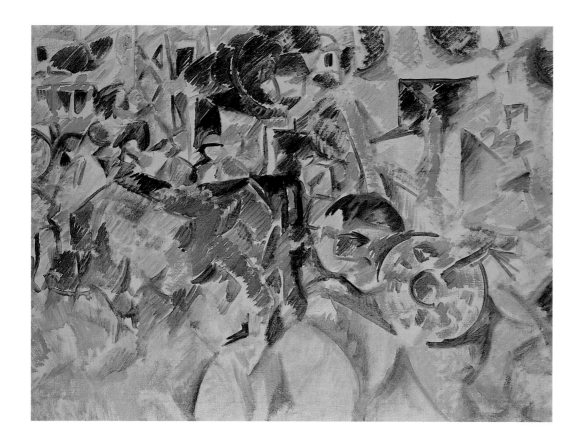

It was this culture medium that first led Spanish artists, or foreign artists living in Spain, to incorporate aspects of the avant-garde in their work. Such was the case of Celso Lagar (1891–1966) and Enric C. Ricart (1893–1960), who merged elements of Fauvism and Cubo-Futurism. Lagar called the language he developed 'Planism'. Others included the poets Joan Salvat-Papasseit, who published a large number of avant-garde journals, and Josep Maria Junoy, who produced calligrams. However, the process was most striking in the work of two Uruguayan artists, Rafael Barradas (1890–1929) and the aforementioned Joaquín Torres-García. Barradas, who settled in Spain in 1914, after sojourns in Milan and Paris, was a pivotal figure during the first stage of the avant-garde, initially in Barcelona and subsequently in Madrid. From 1917 onwards, he developed a style which he called 'Vibrationism', in which he blended aspects of Futurism and Cubism with the variety of interpretations into which these two movements had diversified internationally at the end of the nineteen twenties. Torres-García, captivated by Barradas' fervid commitment to the avant-garde, then abandoned *Noucentisme* and veered towards the direction set by Vibrationism. He also produced a wealth of theoretical writings which appeared in the modern publications that were then beginning to proliferate.

From within these nuclei of renewal, one figure began to emerge above the rest—Joan Miró (1893–1983). To begin with, his style of painting ranged across the seductiveness of Fauvist colour, the structural rigour of Cézanne, the geometrical fragmentation of Cubism and even the Futurist compositive upheaval of Barradas' Vibrationism. In 1918, he joined the first Catalan avant-garde group, the Agrupació Courbet, characterised by the aesthetic variety of such artists as Enric Ricart, Francesc Domingo (1893–1974), Josep Obiols, Torres-García, Rafael Benet (1889–1979) and the ceramist Llorens Artigas (1892–1981). However, Miró was to earn recognition as the leading exponent of the Catalan avant-garde as a result of a one-man exhibition organised by Dalmau in 1918.

As of 1919, his career became associated with Paris, where his work met with one success after the other. Miró then turned to a form of detailed, meticulous realism in which a setting was broken into fragments endowed with a naive, culturally unbiased quality, and in-

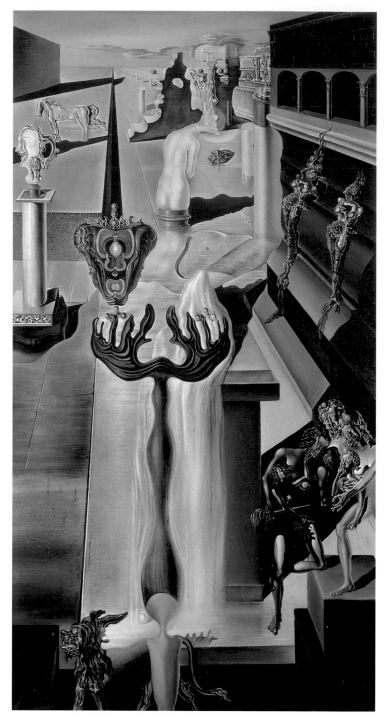

THE SPANISH SURREALISTS

In 1924, once the members of the Surrealist movement had determined their objectives and the strategy to be followed, they adopted the figure of Pablo Picasso as a role model for their artistic approach. This involved doing away with aesthetic and intellectual rules and preconceptions, and drawing inspiration from the inner landscape of their own consciousness, with its light and shadow, in order to shape an image of the world, a fusion of art and life, created through tireless exploration of the multifaceted human condition.

Picasso's *The Dance* (1925) heralded the start of a process of inspirational cross-fertilisation, in which the Surrealists held up the figure of Picasso as a living emblem of their ideology. Picasso, meanwhile, jealously guarded his artistic independence.

Joan Miró's relationship with the group headed by Breton was earlier and much closer, despite some fissures opening up temporarily between them. One such instance was when, in 1926, the Surrealists reproached him for having worked, together with Max Ernst, on the stage scenery for Diaghilev's ballet, *Romeo and Juliet*. Miró stood for the very essence of the creative freedom advocated by the Surrealists, that unswerving faith in unbiased ingenuousness as an instrument of unfettered, ongoing poetic genesis, a seductive amalgam of both triviality and substance, humour and profound meditation, candid enthusiasm and menacing transgression. The line they adopted was one of a continual, magical catharsis on the eyes, attained through experience and creative involvement.

Salvador Dalí was a different case. As he himself admitted in his profuse memoirs, he journeyed to Paris, then the art capital of the world, with the aim of taking his place among the avant-garde elite. He felt that there lay the culture medium for future hegemony of the art world. The same objective subsequently led him to New York. His prodigious pictorial capacity, boundless imagination and infallible instinct for provoking scandal seduced the Surrealists, who saw in Dalí a dependable translator of the movement's characteristic concerns into extremely suggestive images, and a dynamic showman capable of stirring the public. Initially, he behaved like any other disciplined militant and, subsequently, as a celebrity avid for public acclaim. Eventually, this deportment led him to break with the group altogether, particularly after some unfortunate statements concerning Hitler in 1939, and after having published his *Le Surréalisme au service de la Revolution!*

However, these three illustrious figures, in addition to Óscar Domínguez, from the Canary Islands, and sporadic forays (or aesthetic contamination) by Luis Fernández, Maruja Mallo and José Togores, merely represent Spain's contribution to Surrealism in the international arena. On the domestic front, prior to Dalí's departure for Paris in 1929, Surrealism had already taken root in Spain itself.

Its origins go back to 1925, when Dalí, Federico García Lorca and Pepín Bello met at the Residencia de Estudiantes in Madrid and indulged in what was an iconoclastic juvenile game that ended up as a project for a book to be called *Los Putrefactos* ('The Putrefied Ones'). Close to that group was the future film-maker Luis Buñuel, Spain's fourth great contributor to international Surrealism. Over the following two years, what had started out as a joke took on a rather more ambitious cultural dimension, which gradually came under the influence of Breton's group through books and illustrated journals. By 1927, Dalí and Lorca had formed a close relationship and were producing literary and pictorial works clearly related to the ideology and aesthetics of the Surrealist movement. From that time and until the outbreak of the Spanish Civil War, Surrealism was one of the most active avant-garde movements in Spain, and the first such venture on the Iberian Peninsula to harmonise with contemporary trends across Europe. These newfound currents eventually spread, to varying degrees of intensity, across the whole of Spain.

After his sojourn in Madrid, Dalí's return to Catalonia gave renewed impetus to a number of avant-garde movements there which were clearly linked to the literary and visual poetics of Surrealism. In 1928 and 1929, for example, activities were staged by the so-called *Anti-Art* Movement (Dalí, Sebastià Gasch, Lluís Montanyà, Lorca, Pepín Bello), for which the principal mouthpiece was the journal, *L'Amic de les Arts,* published in Sitges and subsequently produced in collaboration with *Gallo,* a journal

ÓSCAR DOMÍNGUEZ: *Guanche Cave; 1935. Oil on canvas, 82 x 60 cm. Museo Nacional Centro de Arte Reina Sofía, Madrid.*

published in Granada and directed by Lorca. As from 1932, *Amics de les Arts Nous* or ADLAN ('Friends of the New Arts') helped publicise the various Surrealist proposals, particularly the work of Miró. In the mid-thirties, ADLAN's activities spread to Madrid. In 1936, the so-called *Lógico-fobista* group emerged in Barcelona, a short-lived movement inspired by the principles of its counterpart in France. Through these collective experiments and other individual ones, the Catalan contribution to Surrealism materi-

ALBERTO SÁNCHEZ: Bull, 1958-1962. Banco Hispano Americano, Madrid.

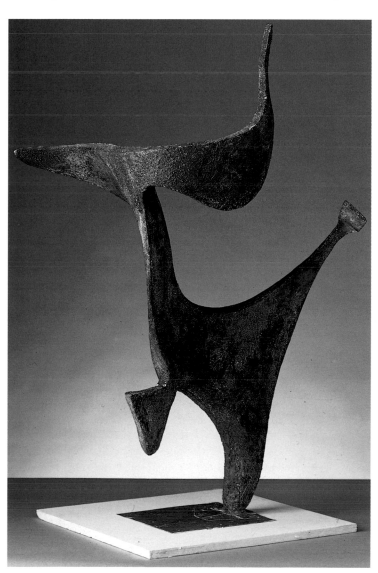

alised around such figures as A. Carbonell, A. Planells, L. Cristófol, A. García Lamolla, E. Serra, J. Sans, R. Marinel·lo, A. Ferrant, J. Massanet and E. Francés.

In the Canary Islands, a group which in theory was more solidly grounded and better connected to various international forums grew up after 1932 around the journal *Gaceta de Arte,* directed by Eduardo Wersterdahl. In 1935, this self-named 'Surrealist Faction of Tenerife' hosted a visit by Breton and his group, who arrived there from Prague as part of a European tour. This contact led to the emergence of new artists, including Juan Ismael, P. Niebla and the aforementioned Óscar Domínguez.

There were also other Spanish groups: the one in Zaragoza featured such artists as J.L. González Bernal, A. Buñuel and F. Comps. However, the most significant development of Surrealism in Spain was the so-called 'School of Vallecas', an experiment embarked on around 1930 by the sculptor Alberto Sánchez and the painter Benjamín Palencia. Their aesthetic approach was geared to the spontaneous, untainted sensibilities which Breton had spoken of when defining the idea of an 'inner model', that is, the subject's vital reaction to external circumstances, as expressed through works which act as testimony and as a thaumaturgical fetish, and are capable of leading the spectator to live out the artist's original, primordial experience. For Sánchez and Palencia, those 'external circumstances' were invariably substantiated in the impoverished landscapes of southern Madrid, against which they fashioned a kind of symbolic essence

of the Spanish cultural status quo, with its roots, its glories and its miseries. In this process of evocative juncture, their work bordered on abstraction, although it always featured morphological symbols with ties to the geological, organic matter of the inspiring landscape. The influence of the 'Vallecas aesthetic' spread to such artists as Maruja Mallo, José Moreno Villa, the Basque Nicolás Lekuona and Antonio Rodríguez Luna.

Lastly, Surrealism was at times combined with other aesthetic currents, including Magic Realism, new objectivity, Expressionism and even late echoes of the early avant-garde visual languages. Prominent figures in this variety of trends were Alfonso Ponce de León, Ángeles Santos, José Caballero, Isaías Díaz, Alfonso Olivares and Gregorio Prieto, together with artists from the School of Paris, notably Francisco Bores, Ismael González de la Serna and Manuel Ángeles Ortiz.

fused with experiences of fusion between the artist and the spectacle of reality. These works are captivating in their viewing facility, and in the way they beckon the spectator to delve further into their resourcefulness.

Throughout the twenties, Miró was carried away by the imaginative adventure of seeing things through the creative, enthusiastic candidness of a child's eyes. Having rid himself of the need to harmonise with the avant-garde which he had played a major part in, he was able to concentrate his efforts on the sublime act of fashioning a new universe, magical and convincing in its coherence, with a limitless capacity for breathing life into the incipient bud of sensitivity, which was both humorous and profound, ironic and yet earnest. Abstraction and figuration were now able to coexist with a clear-cut, common attitude, in a catharsis in which both the visible (tangible to the senses) and invisible (born of the imagination) coalesced in a single planisphere.

As happened to Picasso in the second half of the twenties, the Surrealists soon saw in Miró a living model of someone who had transformed art into a revolutionary experience, and into a way of penetrating the depths of outer reality by shamelessly exposing imagination and conscience. By the thirties, Miró's poetics had made inroads into scene painting, sculpture and just about any brash juxtaposition of objects. His work evolved from the absolute, untainted purity of abstract emotion to the frightful impact of monstrous entities capable of embodying all the violence of nature and humankind. After the outbreak of the Spanish Civil War, Miró exhibited in the Spanish (Republican) pavilion at the Universal Exposition in Paris. His exhibit was a mural asserting his commitment to the cause of freedom, which he was then prepared to externalise.

Artistic Renewal in Spain until the Iberian Art Exhibition of 1925

From 1918 to 1925, a number of factors led the centre of gravity of Spanish artistic renewal to shift from Barcelona to Madrid. Until then, the only experience of the avant-garde in Madrid had been some sporadic events promoted by the writer Ramón Gómez de la Serna: the publication of Marinetti's manifestos in 1909 and 1910, and an exhibition of Cubist works by María Blanchard and the Mexican Diego Rivera (1886–1957) in 1915.

The European avant-gardes began leaving Barcelona, while Celso Lagar, Barradas and the Delaunays moved to Madrid. In 1918, under the mentorship of the writer Guillermo de Torre, a literary movement known as Ultraism was founded in Madrid. It was a mixture of elements drawn from Dadaism, Futurism, Nunism and even Expressionism. The group staged events designed to cause a stir, and published a number of journals. It ended up drawing into its circle most of the artists who endeavoured to bring about cultural renewal. Among them was Barradas, who had then turned his hand to Cubism, and was to later embark on a schematic form of Expressionism which he called 'Clownism'. Another was Daniel Vázquez Díaz (1882–1969), who returned from Paris with a geometrical style of painting that managed to convey the illusion of Cubist assimilation, and who was to become an influential figure in a variety of circles during the following decades. The movement also included Robert and Sonia Delaunay, who continued to develop their Orphism, the Polish emigrées Ladislaw Jahl and Marjan Paszhkiewwicz, who disseminated aspects of Formism originating from Poland, and the Argentinian engraver Norah Borges (b. 1901) who, having previously been active in Switzerland, brought with her a marked Central-European Expressionist graphic art.

Ultraism, with its upbeat, provocative attitude and its radical onslaught on traditional languages, remained a force to be reckoned with until the twenties, after which the status quo began to show signs of a return to tranquility and 'order' and, in the plastic arts, a revival of calm representational art. This state of affairs ensued as a result of several factors: the personal situation of the artists involved, such as the beginning of Picasso's classicist period, and the advent of certain phenomena, namely the Italian *Novecento,* German New Objectivity and Magic Realism, and the complex 'return to order' that was taking place in France. In 1922, for example, figuration reappeared in Barradas' painting, and was to triumph among the new

generations of participants in the process of renewal. The overall register of this situation became apparent when the Exhibition of the Society of Iberian Artists (ESAI) was held in 1925, under the dictatorship of General Primo de Rivera.

The large number of exhibitors, and the sense of integration of trends that prevailed at that exhibition, turned it into a large-scale *tour de force* by the various art sectors committed to the process of renewal. In short, the new currents emerged as a genuine alternative to the official art establishment. This, the middle of the nineteen twenties, was therefore a major turning point in the status quo of Spanish art, and a time for taking stock of the new situation. Nevertheless, there were some noticeable absentees at the Exhibition of the Society of Iberian Artists (ESAI). Those missing included the majority of Catalan artists, who had opted instead to hold an exhibition of their own in Madrid some months later. Neither was there any official representation of Galician artists, which featured such painters as Alfonso Rodríguez Castelao (1886–1950), and sculptors like Francisco Asorey (1889–1961), Santiago Bonome (b. 1901) and Xosé Eiroa Barral (1832–1935), who had formed a movement of renewal in art associated with a reawakening of Galicia's regional identity. The movement

JOAN MIRÓ: *The Farm;* 1921–1922.
Oil on canvas, 132 x 147 cm;
donated by Mary Hemingway.
National Gallery of Art, Washington.

was to bear fruit some years later with the emergence of a number of figures, notably Arturo Souto (1908–1968), Luis Seoane (1906–1979), Carlos Maside (1897–1958) and Manuel Colmeiro (1901).

The Basque Country, however, maintained a high profile at the aforementioned ESAI exhibition. Among the participating artists were numerous members of the Association of Basque Artists of Bilbao, which had been working since 1911 towards the consolidation of regional art forms receptive to the initial trends of contemporary art. Commercial dealings among the Basque middle classes, and the geographical position of the Basque Country, on the border with France, facilitated direct contact between local artists and circles in France, Austria and other European centres. The upshot of this was the emergence of styles which extolled indigenous cultural and anthropological values and, at the same time, were open to the aesthetic developments of the first few decades of the century. Artists such as Juan de Echevarría (1875–1931), Aurelio Arteta (1879–1940), the Zubiaurre brothers (Ramón, 1882–1969, and Valentín, 1879–1963), Joaquín Tellaeche (1884–1958), José María Ucelay (1903–1979) and Antonio de Guezala (1889–1956) each stood for different points in the complex array of mixtures between modernity and ancestral roots. By the thirties, Basque painting was steering close to avant-garde Realism, as apparent in the work of Jesús Olasagasti (1907–1955) and Juan Cabanas Euraskin (b. 1906), or to Surrealism, as exemplified by Nicolás de Lekuona (1913–1937).

The Exhibition of the Society of Iberian Artists also featured veterans of the avant-garde, including Rafael Barradas and Norah Borges, and artists with a less radical language, such as the painters Cristóbal Ruiz (1881–1962) and Nicanor Piñole (1878–1978), and the sculptors Victorio Macho (1887–1966) and Emiliano Barral (1896–1976), in addition to unusual figures such as José Gutiérrez Solana. More importantly, however, the exhibition served to promote some comparatively unknown, up-and-coming figures in the process of renewal, prominent among whom were the painters Francisco Bores (1898–1972), José Moreno Villa (1887–1965), Gabriel García Maroto (1889–1970), Pancho Cossío (1898–1970), Joaquín Peinado (1898–1970), Benjamín Palencia (1894–1980) and Carlos Sáenz de Tejada (1897–1958), the sculptors Ángel Ferrant (1891–1961) and Alberto Sánchez (1895–1962), and a figure who was subsequently to win lasting fame—Salvador Dalí (1904–1989).

The Advent of Salvador Dalí

After training for several years in his hometown, Figueres, in 1922 Dalí moved to Madrid, where he enrolled at the prestigious Residencia de Estudiantes. There he made contact with one of the most actively progressive avant-garde circles of the twenties in Madrid and, in particular, the poet Federico García Lorca and the film director Luis Buñuel. He also struck up a friendship with Rafael Barradas, who had a decisive influence on Dalí's early work. He then began to experiment with a variety of languages: he would turn his hand equally to Barradas' 'Clownist' line, Expressionism, Fauvism or a Cézannian style, make forays into early Cubo–Futurism, adopt the line of the 'metaphysical' Cubists (that of Severini or Morandi, for instance), or make an approximation to the 'joyful' Cubism of Picasso in the twenties. Similarly, his interest in newfound realist currents, whether Italian or German in origin, and in Picassian Neo-Classicism, led him to execute a profusion of major works.

As of 1925, when he moved his headquarters to Catalonia, Dalí began to feel the call of experimental Surrealism—as represented by the work of Max Ernst, Tanguy and aspects of De Chirico—in which he found the qualities he needed to express his complex personality. During those years, his close friendship with Federico García Lorca became essential to his career. Indeed, it may be asserted that together they constituted one of the principal forums through which Surrealism earned its credentials in Spain, both in the fields of art and literature.

By 1927, the fundamentals of Dalí's visual language, which would become celebrated the world over, had been all but consolidated. In 1928 and 1929, in conjunction with the crit-

ics Sebastià Gasch and Lluís Montanyà, he became a leading light in the so-called Anti-Art movement, a set of Futuro-Dadaist strategies of provocation which successfully reactivated the Catalan avant-garde and drew heavily on increasingly more decisive Surrealist contributions by Dalí. After making preparatory contacts with art dealers, and having entered into a relationship with Gala Éluard, which eventually proved to be tortuously indestructible, Dalí began a veritable 'assault' on Paris.

He joined the Surrealist group amidst great expectation. His plastic language, which included a mastery of polished, persuasive figuration, capable of placing reality within reach of the senses, tended to disarm viewers before plunging them into the bottomless well of his obsessions, which turned out to be universal. *Eros and Thanatos,* Freudian immersions in which he began to question his own origins; arousing, inciting perversions eliciting feelings of both pleasure and rejection, the horror of rotting impotence leading up to the realm of death, and a merciless onslaught against the conventions of the intellect, morals and passions went into the making of Dalí's iconographic territory, which spread like wildfire and has today ended up becoming one of the clichés of mass culture. With his dazzlingly versatile *savoir-faire* in literature, painting, graphics, assemblage, cinema and the *mise-en-scène* of his own personality, Dalí became a living artifact which enabled the Surrealists to effectively augment their already explosive presence.

In the mid-thirties, he made no effort to conceal his *avida dollars,* which André Breton had set about exposing. Dalí was then expelled from the Surrealist group, after which he abandoned himself shamelessly to the ongoing spectacle that was to characterise the rest of his life.

Consolidation of the Spanish School of Paris. Julio González

Between the arrival in Paris of Miró, and that of Dalí, a host of Spanish artists went to that city, following in the footsteps of those that had made the journey prior to 1919. The first

SALVADOR DALÍ: *The Great Masturbator,* 1929. Oil on canvas, 110 x 150.5 cm. Museo Nacional Centro de Arte Reina Sofía, Madrid.

to arrive were Hernando Viñes (b. 1904), José Togores (1893–1970), Pedro Pruna (1904–1977), Ismael González de la Serna (1898–1968), Manuel Ángeles Ortiz (1886–1984), Pancho Cossío, José María Ucelay, Joaquín Peinado, Alfonso Olivares (1898–1936) and Luis Fernández (1900–1973). They were followed by Benjamín Palencia, Francisco Bores, Honorio García Condoy (1900–1953) and Óscar Domínguez (1906–1957), among others. Some returned to Spain from time to time, but the majority settled permanently in Paris, where there were better work prospects. Their production went through a number of phases, reflecting the influence of new developments in contemporary art as they emerged. The broad spectrum of Post-Cubist alternatives and the various options provided by Surrealism had the greatest effect on their work. Around 1926, many Spanish artists in Paris—notably Palencia, Cossío, Viñes, Bores, Ángeles and Ortiz—were active in the circle that formed around the critics Zervos and Tériade, and the journal *Cahiers d'Art.* A common aesthetic sentiment grew up among these artists which would subsequently have a considerable impact on artists active in Spain. The language they shared consisted of pure, autonomous plastic values of lyrical inspiration, in which line, distilled to utter simplicity, was used poetically to reconstruct the essence of form against full-bodied abstract backgrounds.

However, the leading figure in this second wave of Spanish artists to arrive in Paris was the sculptor Julio González (1876–1942). A wrought-iron craftsmen by trade, he worked in his father's workshop in Barcelona from 1891, and settled in Paris in 1900. He achieved the peak of his career late in life, despite his long-standing ties to art circles ever since his activity in

turn-of-century Barcelona. His early production was divided between decorative wrought-iron and painting. In 1918, he was an ironworker with the company Soudure Autogéne Française, where he mastered the technique of oxygen–acetylene iron welding. He first took up sculpture towards the end of the nineteen twenties. His approach was based on the creative proposals of his closest friends, namely Picasso, Brancusi, Gargallo, Luis Fernández, Edgar Varése and Manolo Hugué. Julio González was quick to master the fundamentals of contemporary creation: his ironwork from that period is extraordinarily expressive, based on an economy of plastic elements which combine the communicative value of form and that of its opposite—emptiness. Transposed to a reality running parallel to that of the senses, rugged and spontaneous, his world revolved around his works in a continuous, solemn and primitive process of genesis, becoming charged with memory as it evolved. From 1935, without straying from the road of abstraction, his work adhered simultaneously to the tenets of a profound, expressive realism. This was the style of exhibit he took to the Spanish pavilion in 1937, manifestly in tune with the pressing urgency triggered by the war in Spain.

JULIO GONZÁLEZ: *Lovers II;* 1932-1933. Institut Valencià d'Art Modern, Valencia.

Art in Spain, from 1925 to the Civil War

The impact of the Exhibition of the Society of Iberian Artists, held in 1925, resulted in significant changes in Spanish art culture. Despite the fact that many of the artists making up the front line had gone abroad, their places were taken by others. In the following ten years, the movement of artistic renewal spread across the whole of Spain, leading to a marked rise in the number of exhibitions and cultural journals, which became rife with the new artistic and literary creations, and with information on events in the international sphere. On the whole, the most widespread trends were associated with the variegated milieu of Post-Cubism, the myriad Surrealist expectations generated by the work of Dalí, and the various alternatives held out by 'new-fangled realisms'. Artists also began to experiment in the field of abstraction.

As from 1925, numerous artists in Catalonia became involved in this lively art scene. They included the painters Antoni Costa (1904–1965), Joan Sandalinas (1903–1991), Ángel Planells (1901–1989), Joan Massanet (1899–1969), Antoni G. Lamolla (1910–1981), Artur Carbonell (1906–1973) and Ángeles Santos (b. 1912), and the sculptors Jaume Sans (1914–1987), Eudaldo Serra (b. 1911), Ramon Marinel·lo (b. 1911) and Leandre Cristòfol (1908). By and large, the centre of gravity of their work was the Surrealist aesthetic with its various ramifications, dominated mainly by international Surrealism and the varieties that emerged in the work of Miró and Dalí. In Madrid, sculptors such as Francisco Pérez Mateo (1903–1936) and Emiliano Barral further explored their sobre, austere approach to representational art through the expressive realism of direct sculpting, which harmonised with the socio-political sensibilities of culture under the Second Republic. Notwithstanding obvious differences, a similar process obtained in the case of painters such as Alfonso Ponce de León (1900–1936), Rosario Velasco (b. 1910), Francisco Mateos (1884–1976), Isaías Díaz (b. 1898), José Caballero (1916–1991) and Luis Castelanos (1915-1946). In Murcia, Juan Bonafé (1901–1969), Ramón Gaya (b. 1910), Esteban Vicente (b. 1903) and Pedro Flores (1897–1969) illustrated the aesthetic aspects of Magic Realism, Expressionism and Surrealism. In Valencia, Genaro Lahuerta (1905–1990), Enric Climent (1887–1980) and Josep Renau (1907–1982) did likewise, as did Ramón Acín (1888–1936) and Juan J. González Bernal (1908–1939) in Zaragoza, and Juan Ismael (1907–1981) in the Canary Islands. All these artists exemplified, through a variety of formal approaches, the broad spectrum of ethical renewal that had emerged in Spain.

Similarly, a large number of avant-garde groups and platforms sprang up. Towards the end of 1929, for instance, the sculptor Alberto Sánchez and the painter Benjamín Palencia started the School of Vallecas in Madrid. This was an interesting experience in that it entailed developing a completely new visual language on the basis of essentially indigenous roots, attuned to the most innovative visual currents, although without resorting to any ethnographic or anecdotal clichés. Palencia knew the Parisian milieu, but Alberto Sánchez was from a rural

ANTONIO RODRÍGUEZ LUNA: *Birds in the Melon Patch;* 1932. Oil on canvas, 92 x 71.5 cm. Museo Nacional Centro de Arte Reina Sofía, Madrid.

ART DURING THE SPANISH CIVIL WAR

In July 1936, a group of army officers staged a military uprising against the democratically elected Republican government. With the same vested interests as sizeable sectors of the social right, and with political ties to Fascist groups, the rebels plunged Spain into a bloody civil war which lasted three years. Their eventual victory led all aspects of Spain's contemporary history to be abruptly cut short. In the cultural sphere, physical and ideological repression, caused by fear and the resulting desire to break with the past, laid waste to over three decades of modernisation.

Nevertheless, those three years of war were a time of intense cultural activity, both in the urban rearguard and at the front lines. Both sides in the conflict expressed their ideas and watchwords in the form of agitation and propaganda campaigns in which visual communication played an important part. Visual form and content ranged across the extremes of pure triumphalism, heartfelt distress at the horrors of war and confidence in the triumph of the cause defended by each side. The Republicans undoubtedly had the greatest cultural support, as most progressively minded people had sided with them. However, in all fairness, it should be noted that a large number of significant writers, artists and other intellectuals either sided with the rebels or were forced to collaborate with them. In art, this was true of such painters as Francisco Gutiérrez

Cossío, Pedro Pruna, Carlos Sáez de Tejada and Alfonso Ponce de León, who were either militant Falangists or openly sympathised with the rebels. There was also the case of the Surrealist and Republican sympathiser José Caballero who, in order to save his life, collaborated in the production of pro-Franco propaganda. Most of the artists who adhered to conservative academicist tenets refrained from committing themselves to any side. Instead, they sat on the sidelines and waited for a clear winner to appear before declaring their support. This became particularly apparent during the post-war period.

By and large, the subject matter of Spanish art during the Civil War was related to the historical circumstances. In formal terms, various types of realism took on a higher profile, clearly in order to sway large sectors of the population through a visual message charged with urgency or emotion. The Republicans prided themselves on retaining their hegemony over certain visual languages they had secured in the years preceding the war. This led to a major debate about the role of creative freedom during such times of tribulation. It was kept alive by such intellectuals as Ramón Gaya, Josep Renau, Antonio Rodríguez Luna and Alberto Sánchez through the articles of theirs published in the Valencian journals *Nueva Cultura* and *Hora de España* and, above all, in the speeches delivered at the International Congress

JULIO GONZÁLEZ: The Cry of Montserrat; *1937-1942.*
Museo Nacional Centro de Arte Reina Sofía, Madrid.

of Anti-Fascist Intellectuals held in July 1937 in Valencia, where the Republican government had moved for security reasons. The Spanish Civil War to some extent provided a channel for ideological and artistic formulations, in similar fashion to the U.S.S.R., Germany during the revolution, Fascist Italy and Nazi Germany, prompting debates like the one between Surrealism and Communism during the Congress of Writers for the Defence of Culture, held in France in 1935.

Specific institutional forums were set up by the Republicans to promote cultural activity, including the Ministry of Propaganda, the Propaganda Department of the regional Catalan government, the Generalitat de Catalunya, and the so-called cultural militia. In general, the various political parties, trades union and even the military had

their own propaganda sections. Other forms of cultural tuition and dissemination were also fostered, from literacy campaigns to cinema, theatre and poetry readings. Poster design became a major art form in military culture. It kept a host of artists active, prominent among whom were Renau, Ballester, Beltrán, Català Roca, Gaya, 'Goñi', Giralt Miracle, Helios Gómez, Monleón, Pérez Mateo, Rodríguez Luna, Arteta and 'Sim'. Many of these were painters and sculptors who had decided to help the Republican war effort in the field of mass communication. Political caricature or drawing, published in such magazines as *El Mono azul* and *Altavoz del frente,* also became more popular. Some of the aforementioned figures collaborated in this field, too, in addition to Miguel Prieto, Eduardo Vicente, Arturo Souto, Rafael Pérez Contell, Luis Bagaría, Ramón Puyol, Francisco Carreño and 'Yes'.

Of special interest were the albums of war sketches, published in Valencia and drawn by Rodríguez Luna, Aurelio Arteta, Solana, Souto, Alfonso R. Castelao, Enrique Climent, Servando del Pilar, Francisco Mateos and others.

However, the most representative symbol of Spanish art culture during the Civil War was the Spanish pavilion at the Universal Exposition of Paris, held in 1937.

ARTURO REQUE MERUVIA: Allegory of the Civil War; *1947.*
Oil on canvas, 1,370 x 300 cm.
Servicio Histórico Militar, Madrid.

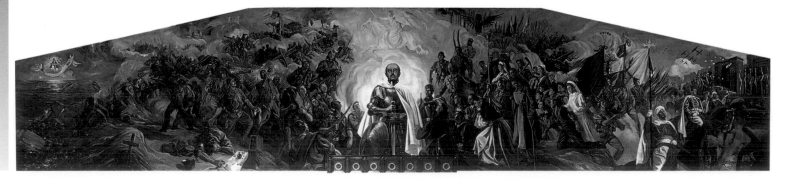

CARLOS SÁEZ DE TEJADA: The Northern Front. *Drawing. Private collection, Madrid.*

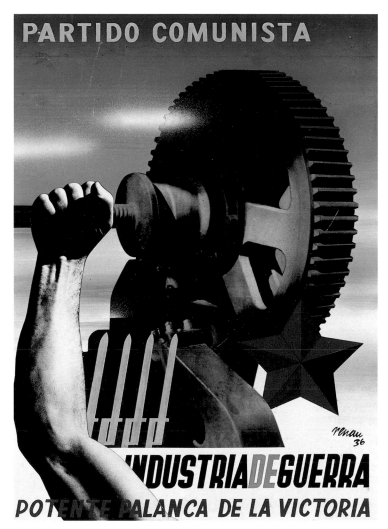

JOSEP RENAU: Leverage for Victory: the War Industry; 1936. *Photo-collage.*
Institut Valencià d'Art Modern, Valencia.

PERE CATALÀ PIC: Let us Squash Fascism!
*1936. Poster issued by the
Propaganda Department of the
Generalitat de Catalunya.
Institut Valencià d'Art Modern,
Valencia*

LEANDRE CRISTÒFOL: *Window;* 1936. Museu Nacional d'Art de Catalunya, on loan to the Barcelona City Council.

The figure of Leandre Cristòfol and his work have recently been rescued by Spanish contemporary-art historiography. His work is exemplary of avant-garde art developed far from official circles. Cristòfol, a native of Lleida, was prompted by a local, avant-garde journal, *Art,* and by his friendship with Viola, to take part in in a great 'logico-phobist' exhibition held in 1936 in the Galerías Catalonia in Barcelona, where the representation from Lleida exhibited alongside such figures of Spanish Surrealism as Remedios Varo and Maruja Mallo. The modelling of organic forms and the manipulation of commonplace objects brought their creations close to the poetic, dreamlike objects of international Surrealism. The outbreak of the Civil War cut short his highly orignal production.

background and, apart from being a close friend of Barradas', was comparatively unfamiliar with the cultural elites. Sánchez's sculpture was a major contribution to the 'domestic avant-garde' of the first half of the century. Other artists who became sporadically involved with the School of Vallecas included Moreno Villa, Antonio Rodríguez Luna (1910–1985) and Maruja Mallo (1909–1995), a Galician painter who achieved considerable success in Paris.

The instatement of the Second Republic in 1931 raised hopes of widespread renewal, for which purpose numerous forums were founded. The Association of Iberian Artists was reborn from its ashes and organised several exhibitions in Spain and abroad. It received some support from those in charge of the Republic's cultural policy, who were beginning to open up official institutions to the new trends in Spanish art. In Catalonia, however, the avant-garde was more radical in form and yet its influence was more restricted, as evinced in the activity of the association known as *Amigos de las Artes Nuevas* ('Friends of the New Arts') or ADLAN, as of 1932. Of major importance was a Canary-Island circle that gelled around the journal *Gaceta de Arte,* a level-headed upholder of Surrealism and rationalist architecture. The association kept close ties to other European forums, particularly Breton and his group. The Surrealists, who included Santa Cruz de Tenerife in their *International Surrealist Map,* actually made a journey to the Canary Islands in 1935. During the last few months of the Republic, the activity of ADLAN spread to Madrid, Valencia, Bilbao and Tenerife and took on the character of a 'common front', in similar fashion to the Association of Iberian Artists although more radically so.

The most striking feature of Spanish art culture under the Second Republic was the generalisation of a debate on the ideological commitment of art to society. However, since the early thirties, political stances had become increasingly more polarised, and social unrest more apparent. Tension was running high. From the political left, such platforms as the *Asociación de Escritores y Artistas Revolucionarios* ('Association of Revolutionary Writers and Artists') or AEAR were formed in Barcelona, Valencia and Madrid, while journals appeared with a commitment to the cause, as was the case with *Octubre,* in Madrid, and *Nueva Cultura* in Valencia. From the right, *La Gaceta Literaria,* until then one of the leading avant-garde journals, which had come into being in the late twenties, also repositioned itself politically, in this instance shifting towards a Fascist stance. The Canary-Island *Gaceta de Arte* was not to be left out of this debate, advocating freedom of artistic creation from a more flexible left-wing position.

The outbreak of the Spanish Civil War in July 1936 was the culmination of this process of radicalisation. Poster design and the art of agitation and propaganda then achieved unqualified success and involved most artists. The Spanish pavilion at the Universal Exposition of Paris in 1937 was the crowning moment for Spanish art of the first half of the 20th century. The pavilion, designed by Sert and Lacasa, housed an exhibition featuring Picasso's *Guernica,* Miró's *The Anti-fascist Peasant and the Revolution,* and Alexander Calder's *Fountain of Mercury.* But it also housed the works of all those artists who were committed to the democratic cause. In the entrance stood an eleven-metre-high monolith, sculpted by Alberto Sánchez, entitled *The Spanish people have a road leading to a star,* an assemblage of hope which would be cut short by the triumph of Fascism.

Spanish Architecture Becomes Part of International Modernity

With all its peculiarities, Catalan Modernism had scored a first by coinciding in time with similar international architectural trends. This movement endured in the rest of Spain for many years and, in some cases, lasted well into the nineteen twenties, both as far as architecture and the design of furniture and other objects were concerned. Indeed, it virtually connected up with the advent of Art Deco. In addition to its complex projection into literature and the plastic arts, *Noucentisme* also gave rise in Catalonia to a variety of architectural projects and achievements that lasted through the first two decades of the century. A host of elements were combined in spatial structures and the formal vocabulary of this style, including

Greco-Latin revivalism, Palladian remembrances and attempts to consolidate a traditionalistic Mediterranean morphology, often linked to rural values.

On the whole, during the first two thirds of the period in question, the architectural style of most of the buildings erected in Spain were designed in accordance with the principles of historicist eclecticism, with an admix of many elements drawn from traditional Spanish Renaissance or Baroque architecture. Historiographers have recently focused on the significance of figures who did not adopt a wholly modern style but nevertheless made a valuable contribution by endeavouring to break with the superficiality of indigenous historicism. Architects who fall into this category include Juan Talavera, Antonio Palacios, Antonio Flórez and Teodoro Anasagasti, who strove to harmonise with certain features of the Viennese Sezession.

The influence of the avant-garde architectural trends prevailing in Germany, Holland, England and France first came through in Spain in the so-called 'Generation of 1925', which included the figures that were instrumental in the architectural boom of the thirties: Secundino Zuazo, Fernando García Mercadal, Luis Blanco Soler, Luis Lacasa, Manuel Sánchez Arcas,

ALFONSO PONCE DE LEÓN: *Accident;* 1936. Oil on canvas, 158 x 188 cm. Museo Nacional Centro de Arte Reina Sofía, Madrid.

ALBERTO SÁNCHEZ: *The Spanish people have a road leading to a star;* 1937. Sculpture at the entrance to the pavilion of the Spanish Republic at the Universal Exposition of Paris (destroyed). Plaster replica. Museo Nacional Centro de Arte Reina Sofía, Madrid.

Rafael Bergamín, Carlos Arniches and Casto Fernández Shaw. These young architects made a number of journeys to complete their training and, at the end of the twenties, the first tangible results appeared, confirming the consolidation of architectural modernisation in Spain, which involved the assimilation of many functional and aesthetic principles of rationalist architecture. Examples of this were the Petróleos Porto Pi petrol station (Fernández Shaw, 1927, Madrid), the Casa del Marqués de Villoria (Bergamín, 1928–1929, Madrid), the Rincón de Goya (García Mercadal, 1927–1928, Zaragoza) and the Casa de las Flores (Zuazo, 1930–1931, Madrid). Subsequently, two much larger urban projects were undertaken: the Ciudad Universitaria de Madrid (Sánchez Arcas, Lacasa, Blanco Soler, Bergamín, 1927–1930s) and, also in Madrid, the residential housing complex Colonia El Viso (Bergamín, Blanco Soler, 1933–1936).

Architectural modernity was consolidated on a lasting basis in Spain through the activity of the *Grupo de Arquitectos y Técnicos Españoles para el Progreso de la Arquitectura Contemporánea* or GATEPAC ('Group of Spanish Architects and Technicians for Progress in Contemporary Architecture'). It was founded in 1930 in Zaragoza, although its scope was expressly nationwide, being divided into three sectors: North, Centre and East. It grew out of another association, the Catalan GATCPAC, a group of architects that sprang up around a disciple of Le Corbusier's, Josep Lluís Sert, and included Sixte Yllescas, Germà Rodríguez Arias, Ricard Churruca and Francesc Fàbregas. In addition to these, the group also included Madrilenian, Catalan, Aragonese and Basque architects, notably Francisco García Mercadal, Felipe López Delgado, Joaquín Labayen, Pére Armengou, Josep Torres Clavé, Ramón Aníbal Álvarez and José Manuel Aizpurúa. The group's aims, urban designs and architectural projects were published in the journal *AC. Documentos de Actividad Contemporánea*. As well as expounding on the theoretical and formal principles of architectural rationalism, GATEPAC adopted an ethical stance through its commitment to solidarity between architecture and society. It also built up a relationship with the powers that be. The Catalan group, for example, produced a number of community projects, prominent among which was one for a *Ciutat de Repós,* a complex of rest houses to be built in the towns of Gavà and Castelldefels, and various urban designs for remodelling Barcelona, all markedly influenced by the ideas of Le Corbusier. Noteworthy examples of GATEPAC's legacy is the low-rent housing complex known as Casa Bloc (GATEPAC, 1936, Barcelona), the Joyería Roca jewellery store (Sert, 1934, Barcelona), the *Dispensario Central Antituberculoso* ('Central Anti-Tuberculous Outpatients Clinic': Sert, Clavé, Subirana, 1934–1936, Barcelona) and the San Sebastián Yacht Club (Aizpurúa, Labayen, 1930). The group enjoyed international recognition, being a member of CIRPAC *(Comité International pour la Réalisation des Problèmes Architecturaux)* and a participant at CIAM (International Modern Architecture Congresses). The exhibition housed in the Spanish pavilion at the Universal Exposition of Paris in 1937, designed by Sert and Lacasa, was a compendium of the rich legacy of this process of modernisation.

JOSEP LLUÍS SERT: Model of the pavilion of the Spanish Republic at the Universal Exposition of Paris, 1937.

GUERNICA

For many reasons, *Guernica* is a key work in contemporary art history worldwide. On the one hand, like the last part of a symphony, it condenses many of the aesthetic exploits undertaken by the early avant-garde. On the other, built into it are its historical bearings, as it marks the chronological turning point between the historical avant-garde movements and the new world order that would prevail after the Second World War, determining both the structure of artistic production and the basic parameters of visual poetics. But *Guernica* stands for more than that—it is the last great testimony to art's commitment to history. Perhaps, too, it is the epitome of art merging with life, and not merely the particle of life of an individual, nor of an isolated group sympathetic to humanity and human destiny.

All interpretations of this kind, prompted by the painting's place in art history, tend to mask its original context. In effect, *Guernica* was, above all, a 'mural scream', an enormous poster displayed in the agitprop works and hustings that was the Spanish pavilion at the Universal Exposition of Paris in 1937. Together with other works, it formed a memorable collection that was designed to rivet world attention to the drama being played out in Spain—a ferocious confrontation between the democratic will of the people and Fascism—which was actually the first act of the greater world drama to come. Curiously, the Spanish pavilion was located near that of Nazi Germany, which was soon to start a world war and had been testing its military hardware in collaboration with Franco's troops. All this led the Spanish pavilion to become the focus of international attention.

The architectural style of the Spanish pavilion was among the most avant-garde of all the pavilions. It was designed by Josep Lluís Sert and Luis Lacasa, using a versatile, functional, tectonic language whose formal purity and economy of means showed just how far Spanish rationalism had developed under the Republic. It also revealed a conspicuous relationship between form and the war economy.

The architectural exterior and interior acted as a backing for displaying propaganda photomontages assembled under the direction of Josep Renau. They were changed periodically, turning the wall facings into a gigantic mural newspaper. The exhibits were divided between general information on politics, economics and culture under the Spanish Republic, and a sizeable collection of artworks. Alongside those signed by minor artists were works by all the major figures of Spanish art. The exhibition even featured contributions by a foreigner, Calder, whose glittering mobile, *Fountain of Mercury,* was placed in the centre of the ground floor. Joan Miró exhibited his mural, *The Anti-fascist Peasant and the Revolution,* and Julio González his poignant sculpture, *The Cry of Montserrat. The Spanish people have a road leading to a star,* a remarkable, 11-metre-high monolithic totem pole set at the entrance to the pavilion, was executed by Alberto Sánchez, who also designed the shelves holding collections of objects from grass-roots culture. Other participants included Solana, Barral, Pérez Mateo, Rodríguez Luna, Souto, Ángeles Ortiz, Horacio Ferrer (whose works ranged from searing Expressionism, through committed social realism, to Surrealism) and, of course, Picasso, who contributed five pieces of sculpture and his *Guernica.*

The enormous canvas, which took up a whole wall on the ground floor, opposite Calder's fountain, merged organically into the surrounding architecture. It blended seamlessly with the communicative subject matter of the photomontages, and with the notice boards and artworks. Indeed, its subject matter was literally welded to history, as it dealt with the brutal bombardment of the Basque town of Guernica by Hitler's Luftwaffe on 26 April 1937. Picasso had gleaned the scope of the tragedy from the extensive press coverage of the incident, and immediately decided to make it the theme of the commission he had received from the government of the Republic. (His first known preparatory sketches date from 1 May.) He used the episode to portray something which horrified the international democratic conscience— a civilian population being mercilessly bombed by the Nazis in the heat of open conflict between Fascism and freedom.

Very few artworks have had so much background information available about them. The eight stages making up the creative process involved in *Guernica* were recorded in a series of photographs by Dora Maar, and its genesis is also documented in about fifty sketches and preparatory drawings for the final canvas. Similarly, few artworks have had so much written about them, in an attempt to decipher the exact meaning of each form and image in the painting. In this respect, dead silence was the only re-

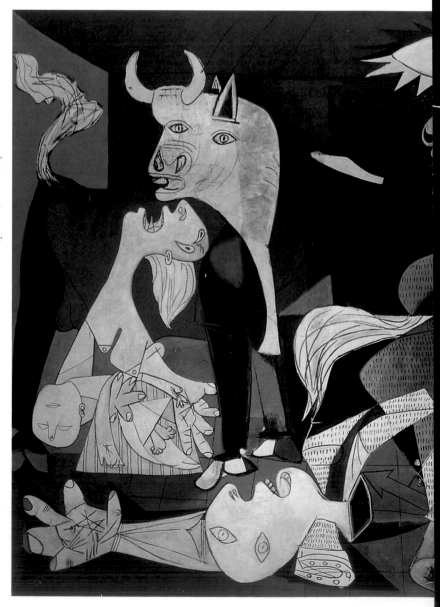

sponse from Picasso, who even gave out false leads. *Guernica's* impact is particularly powerful on account of its compact compositional balance, in which the moving scenes of the bombardment are portrayed. With its black, grey and white tones, and the occasional iridescence set up by colour glazing, it resembles a page of newsprint blown up to enormous proportions. Wailing, grief, death and cries for help rise amidst the deafening silence, with buildings in flames and light filtering through hesitantly, as if coming from the 'eye–sun-bulb' presiding over the canvas. Some have interpreted the figures of the horse and bull in tauromachian terms as symbolising the two sides in the conflict, whereas they are actually both victims of a fate determined by some force alien to them. This was exactly the plight of the Spanish people, pitted against one another by insurgents.

Guernica is heir to the legacy of a pictorial discourse which Picasso first embarked on in 1907 with *Les Demoiselles d'Avignon,* developed throughout his Cubist period and, as from 1925, brought to fruition when he became attuned to Surrealism. This work also has some tangible echoes of Goya's *The Charge of the Mamelukes* and *The Executions of 3 May.* Picasso's *Guernica* contains a judicious balance between ferocious expressiveness and a meditated creation process. And, despite dealing with a specific event, its subject matter is a painful, allegorical denouncement of war as a universal phenomenon.

PABLO PICASSO: Guernica. 1 May to 4 June 1937.
Oil on canvas, 349.3 x 776.6 cm. Museo Nacional Centro de Arte Reina Sofía (on loan from the Prado), Madrid.

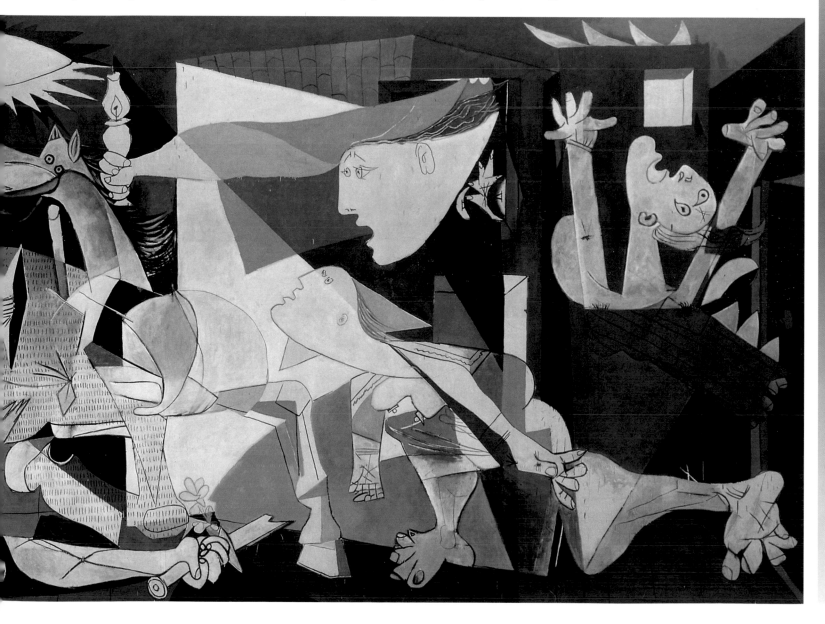

PABLO PICASSO: *Science and Charity;* 1897. Oil on canvas, 197 x 249.5 cm. Museu Picasso, Barcelona.

PABLO PICASSO

Germain Viatte

Picasso's Training, and His Place in Universal Art

When Picasso was thirteen, his father, José Ruiz Blasco, realised his son would eventually fulfil the ambitions he had once harboured for himself. Picasso gained access to academic expertise without ever having produced children's drawings. After attending his father's art classes at the Escuela de Bellas Artes in Corunna (1892), this enabled him to enter the Llotja in Barcelona in 1895, followed by studies at the Royal Academy of San Fernando in Madrid in 1897. In Barcelona, Picasso produced three works which would earn him instant recognition and reveal his potential for a brilliant official career: *First Communion* (winter of 1895–1896), *Mountain Landscape* (1896) and *Science and Charity* (early 1897).

In *Science and Charity,* this conventional approach to art is therefore the figure of the dying woman, whose pulse is being taken by her father, a hapless physician. Although the adolescent Picasso respected his father, he soon challenged the latter's principles, as he did those advocated by his academic masters, Antonio Muñoz Degrain and José Moreno Carbonero. It was not long before he decided to subject everything to radical examination. In the course of his inexhaustible drawing activity, and using as his mouthpiece the journals he wrote and illustrated, *La Coruña* and *Azul y Blanco* (1894), he turned his hand to caricature, a genre he would indulge in well beyond his Blue Period. For Picasso, it was a vehicle for social and aesthetic criticism, anarchic self-assertion and rejection of established values.

But it was also an instrument of pictorial liberation. As a throwback from his formative period, he was in the habit of proclaiming his progress by producing grand compositions which he sent to the various Salons, without actually taking part in them.

In 1898 he travelled to Horta de Sant Joan, where he stayed with a friend, Manuel Pallarès, before returning with renewed impetus to the Modernist ambiences of turn-of-century Barcelona (1898) and later Paris (1900). In both cities, surrounded by his Catalan and Spanish friends, he found himself in the middle of a post-Symbolist literary and artistic bohemian circle. As a brilliant colourist, he adapted his work to the prevailing influences of Isidre Nonell, Ramon Casas, Toulouse-Lautrec, Steinlen and Puvis de Chavannes. His insatiable thirst for inquiry led him to choose as his masters those he considered would favour his development. Thus, in homage to Velázquez, whose works he studied in the Prado in 1901, he painted *Woman in Blue* (Museo Nacional de Arte Moderno, Madrid) and, at the height of his Blue Period, *La Celestina* (1903, Musée Picasso, Paris), which has the stark verve of *The Venerable Mother Jerónima de la Fuente.* This same realistic vision, beyond the aloof, melancholic gracefulness of his Rose Period, is what pervades the lean gravity of *Portrait of Gertrude Stein* (1905–1906, Metropolitan Museum of Art, New York). At Gosol, where he spent the summer of 1906, Picasso searched for another direction, which would lead him to combine his interest in Greek statues (which led him to Ingres, who exhibited at the Autumn Salon in 1905) and the Iberian busts of Osona (which

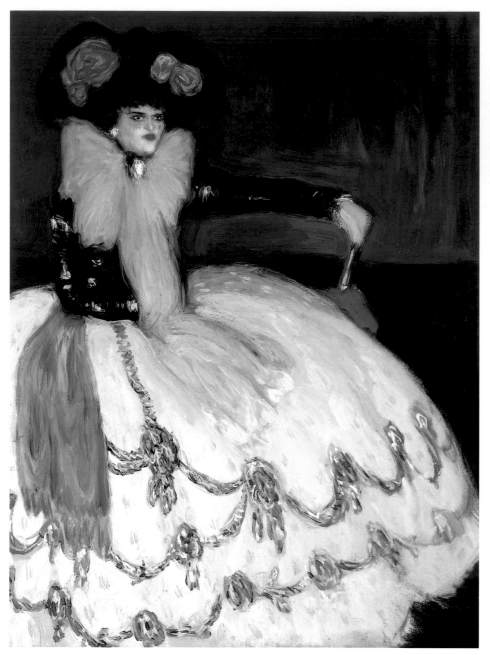

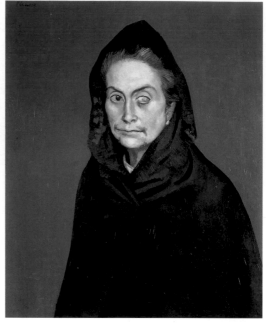

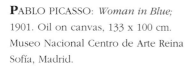
PABLO PICASSO: *Woman in Blue;*
1901. Oil on canvas, 133 x 100 cm.
Museo Nacional Centro de Arte Reina
Sofía, Madrid.

PABLO PICASSO: *La Celestina;* 1903.
Oil on canvas, 81 x 60 cm.
Musée Picasso, Paris.

had just been exhibited at the Louvre), with his deep-rooted admiration for El Greco, newly rekindled by a monographic retrospective of the latter's work organised by Miquel Utrillo. The interplay of contrasting light and shadow, and the complex, overwhelming presence of the figures and drapery in *The Peasants* (1906, Musée de l'Orangerie, Paris), paved the way for his initiatory access to the 'philosophical bordello' of *Les Demoiselles d'Avignon* (1907, Museum of Modern Art, New York), and to an enthralling retinue of drawings and studies which, like *Nude with Curtains* (1907, Hermitage, St. Petersburg), reveal the impact of the African works he had discovered in the Musée d'Ethnographie du Trocadero.

In 1907, after another retreat at Horta de Sant Joan, and as his work matured in the discourse between the influences of Cézanne and Rousseau (1908, *Three Women,* Hermitage, St. Petersburg, and *Table with Bread and Fruit,* 1909, Kunstmuseum, Basle) and was placed on an equal footing with that of Matisse, Picasso and Braque entered into a close collaboration that would lead to a more cerebral mastery of what would be known as Cubism. As if in need of ongoing aesthetic reappraisal, each phase of invention and transformation—of *finding* rather than seeking, as he once admitted to Marius de Zayas in 1923—was preceded or attended by a confrontation with the works that stood for universal art, taking the form of either a violent clash or redemption. In Picasso's works, this personal, imaginary museum was always associated with Apollonian or Dionysian phases, the frescoes at Pompeii (1917), Estruscan sculpture, the work of Ingres and Grünewald (1932), Romanesque art, the painting of Poussin (1944), El Greco or Courbet (1950), as well as with the art of ancient Greece, Africa and Oceania, prints of which frequently appeared in such journals as *Les Cahiers d'Art* and *Documents.* Whether surreptitious or explicit, these influences constituted a permanent, freely available source of stimuli and challenge. This comes through forcefully in his interpretative, almost cinematographic readings of Delacroix's *Women of Algiers* (1954–1955), Manet's *Le déjeuner sur l'herbe* (1959–1960), David's *The Inter-*

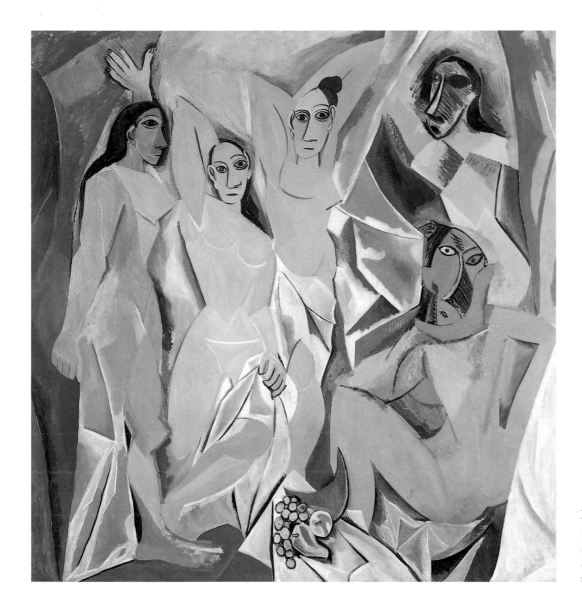

PABLO PICASSO: *Les Demoiselles d'Avignon;* 1907. Oil on canvas, 243.9 x 233.7 cm. The Museum of Modern Art, New York. Acquired through the Lillie P. Bliss Bequest.

vention of the Sabine Women (1962) and Velázquez's *Las Meninas* (1957, Museu Picasso, Barcelona), the latter described by Leiris as 'a subtle system of reflections, and reflections of reflections'.

Picasso's Revolution. The Scene of Discovery.

With *Les Demoiselles d'Avignon,* Picasso's work took a radical turn: after Realist and Symbolist beginnings, it had become a pictorial catharsis of creative ventures, capable of producing vertigo in a 'sacred image' (André Breton). Probably derived from a flurry of recollections from Barcelona, the *Demoiselles* compound in this dual perspective a theatre featuring every significant phenomenon in Western art that had emerged in the previous fifty years.

As from the winter of 1908, the history of Cubist milestones was written through his 'intense' relationship with Braque (the subject of an in-depth study by William Rubin) in Picasso's studio on the Bateau Lavoir in Paris (1904-1909), and during his summer sojourns at Horta de Sant Joan (1909), Cadaqués (1910), Sorgues (1912), Céret (1911, 1912, 1913) and Avignon (1914). The two artists worked jointly on the depersonalisation of painting, an anonymous collaboration in which their hands could not be told apart. They were openly challenging all hierarchy in genres and materials, as well as reality and all perception of it. In its analytical phase, (*The Guitarrist,* 1910, Musée National d'Art Moderne, Paris) Cubist multiplicity became semi-abstract, a shift which had an impact on other European avant-gardes and without which the work of Duchamp and Mondrian would not have been able to develop. Mean-

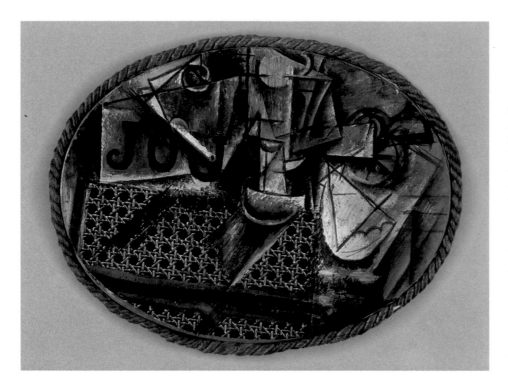

PABLO PICASSO: *Still-life with Wicker Seat,* spring 1912. Oil and oil-cloth on canvas framed with rope, 29 x 37 cm. Musée Picasso, Paris.

while, Picasso continued to dabble in all the genres of traditional painting. After completing an admirable series of portraits of his art dealers—Wilhelm Uhde, Ambroise Vollard and Daniel-Henri Kahnweiler, (autumn–winter, 1910)—he started incorporating collages into his still-lifes, as in *Still-life with Wicker Seat* (May 1912, Musée Picasso, Paris). However, he furthered Braque's idea in his *papiers collés* ('pasted paper') and in his cardboard constructions (model for *Guitar,* October 1912, Museum of Modern Art, New York), which influenced Tatlin and a whole area of 20th-century sculpture. As his international fame grew, Picasso found new freedom by diversifying in Rococo fashion his exercise of synthetic Cubism. Shortly before the outbreak of the First World War, when reactionaries associated Cubism with *art boche* ('Boche art'), that is, 'the art of German executioners', he took his experiments with illusionism to the extreme, moving from collage and construction to rounded, voluminous sculpture, as in *Glass of Absinthe,* (spring, 1914, Musée National d'Art Moderne, Paris). In the summer of 1914 in Avignon, he experimented with a host of poetic transformations of space and form, and combination of media, so freely that he appeared to be compiling an inventory: borrowings from Pointillism, a return to the organic form and then the preciousness of Ingres, the incorporation of real objects, coarse or artificial materials, and abstract simplifications (*Por-

trait of a Girl,* summer, 1914, Musée National d'Art Moderne, Paris). Through this decisive process of liberation, Picasso transformed and crowned Cubism to his own benefit, as a means of appropriation and invention that allowed him to simultaneously use a number of different styles. As was to be expected, this process was reflected in the only issue of *Cabaret Voltaire* (June 1916, Zurich). It was treated indulgently by the Dadaists when they sentenced Cubism to death, and was espoused by the Surrealists. Having become Neo-classicist at Juan-les-Pins in the summer of 1920, Picasso identified with the centaur of Mediterranean mythology, as in *Nessus and Deianeira,* while in Antibes, in the summer of 1923, he composed a masterpiece of Mediterranean poise, *The Pipes of Pan* (Musée Picasso, Paris). In December 1924, his metal construction of Cubist facture entitled *Guitar* (Musée Picasso) was featured in *La Révolution surréaliste,* while in January 1925 some apparently uncharacteristic drawings, done at Juan-les-Pins in 1924, were published in the second issue of the journal. These drawings and his work in Dinard four years later amounted to a renewal in sculpture, conceived of as a wire network of constellations and figures (*Metal Construction* 1928–1929, Musée Picasso, Paris), or as violent organic metamorphoses. His two lines of sculptural development—clay or plaster models, and iron constructions which he pieced together with *objets trouvés*—subsequently diversified at Julio González's workshop in Paris, and later at Boisgeloup (1930–1935). Sculpture constantly nourished his painting, as evinced both in *The Workshop* (1928–1929, Musée Picasso, Paris), for example, and his numerous renderings of Marie-Thérèse Walter during that period.

Throughout the war and the German occupation, Picasso's Paris workshop was at Rue des Grands-Augustins no. 7. There he produced a number of rather solemn works, marked by the utmost realism, comparable to *Woman Combing her Hair* (Mrs. Bertram Smith Collection, New York), painted in Royan in June 1940. His production during that period was either tinged with sorrow (*Dawn,* May 1942, Musée National d'Art Moderne, Paris) or timeless, peaceful effigies, such as *Man Holding a Lamb* (1944),

which the artist donated to the town of Vallauris after the war.

After the war, during the fifties and up until his death in 1973, Picasso was to pursue his previous experiments, grappling tirelessly with the surprises held in store by form, and the possibilities—whether conventional or otherwise—offered by all media. Picasso's home or rented workshops were permanently pervaded by an atmosphere of frenzied activity, until he had exhausted a particular line of inspiration, prompted by the discovery of new materials, or the uses to which they were put. It was in Fernand Mourlot's workshop, in 1945–1946, that he learned the various types of lithography. In Antibes, he painted modern versions of the monumental art inherited from antiquity on fibro-cement and plywood panels (Musée Picasso, Antibes) and, in the Madoura workshops in Vallauris (1947–1948), he cultivated ceramics as a personalised art form. He regarded this material as the unexpected, immemorial stuff of his fantasies.

At La Californie, Vauvenargues castle, and the house at Notre-Dame-de-Vie (Mougins), which he purchased in 1955, 1958 and 1961, respectively, Picasso executed to the point of obsession countless versions of the subject, 'the painter and his model', which he cast in numerous sets of drawings and engravings, and set in studio scenes in the form of 'work in progress' (*The Workshop in a Painting,* 2 April 1956, Museum of Modern Art, New York), a kind of forum for debates on painting, as in a series of variations on *Las Meninas,* executed from 17 August to 30 September 1957. He eventually approached the subject of erotic possession, tinged with growing pathos, mixing references to ancient art, the circus and tauromachia, in addition to deliberately grotesque allegories of similarity, beauty and decrepitude. For a long time, this production was infused with the earnest, sensual presence of Jacqueline, and was only interrupted by work on some new sculptures, including *The Bathers* (1956, Musée Picasso, Paris) and *Female Bust* (1961, Chicago). However, the process abruptly came to an end with his presentation in Avignon, in 1970, of an obscene, truculent finale, which subsequently turned out to be a harbinger of the nascent international painting of the eighties and nineties.

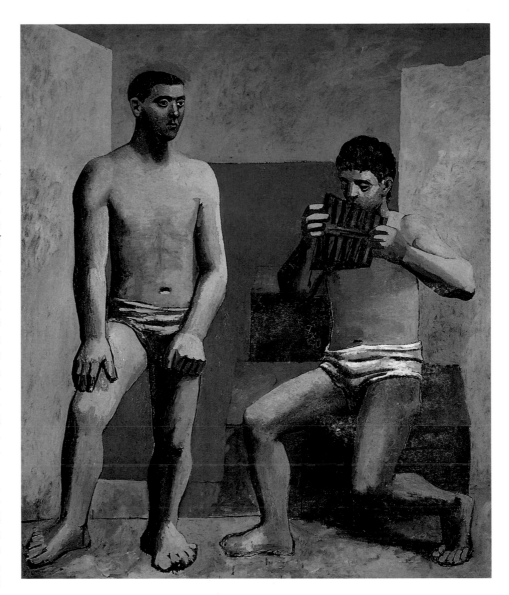

Friendship: Literature, Music and the Performing Arts

In 1899, in what Picasso described as 'beautiful, intelligent Barcelona', the young artist from Málaga discovered the intellectual vitality of his epoch. Prosperity in Catalonia had yielded a crucible of ideas in permanent cross-fertilisation with Paris. At the coterie that met in the tavern known as Els Quatre Gats, Picasso rubbed shoulders with Francisco de Asís Soler, Ramon Reventós and Eugeni d'Ors, and contributed on the journal *Pèl & Ploma,* before directing his own journal, *Arte Joven.* In Paris, the art dealer Pedro Mañach introduced him to Max Jacob. 'In a large workshop on the Place de Clichy, where some Spaniards were sitting on the floor and chatting away happily' (Mateo Fernández de Soto and Jaume Sabartés, and the

PABLO PICASSO: *The Pipes of Pan;* summer, 1923. Oil on canvas, 205 x 174 cm. Musée Picasso, Paris.

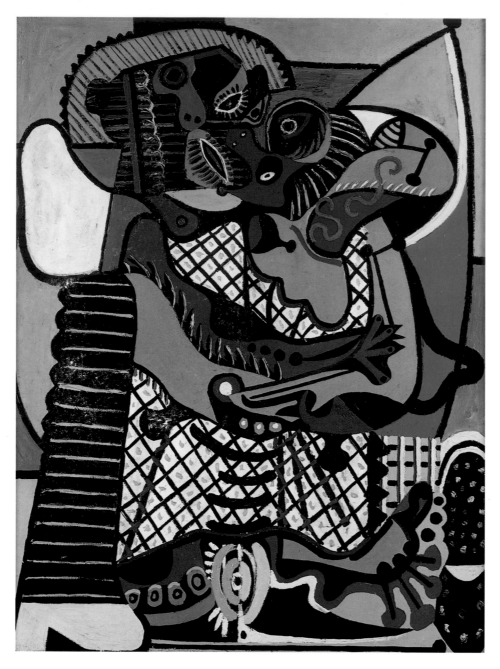

PABLO PICASSO: *The Embrace;* 1925.
Oil on canvas, 130 x 97 cm.
Musée Picasso, Paris.

amis (1909), while Apollinaire, whose book *Alcools* features a *Portrait of Apollinaire* engraved by Picasso on its frontispiece, speaks of *Méditations esthétiques* on *Les peintres cubiestes* in his book. Max Jacob dedicated *Saint Martorel,* published by Kahnweiler, to Picasso, who in turn had agreed to do some etchings for the book: 'It is you that lights the stars at night'. He produced three other engravings for *Le Siège de Jérusalem* in 1914. Together with Max Jacob and Apollinaire and between Cocteau and Reverdy, Picasso was on hand at the right moments and in the publications (*L'Élan, Sic, Nord-Sud*) that attested to the emergence of a new artistic stance during the war.

In 1916, Cocteau introduced Picasso into the ambience of Diaghilev's Russian Ballets, marking a turning point in his career. According to J. Cassou, Picasso found the true 'place' for his art—the theatre—while designing the stage sets for *Parade*. Based on a story by Cocteau and music by Erik Satie, it premiered at the Théâtre du Châtelet on 18 May 1917. Meanwhile, he frequented the company of Léonid Massine, Igor Stravinsky and Léon Bakst, and met his future wife, the ballerina Olga Koklova. The company took him to Barcelona, where Catalan artists paid homage to him on 12 July 1917. Amidst a continual stream of commissions and attendance at society events, in 1919 Picasso was entrusted by Diaghilev to design the stage set for *Le Tricorne,* based on *El sombrero de tres picos* by Pedro de Alarcón, set to music by Manuel de Falla, which was hailed by Salvador de Madariaga in these words: 'The thrill becomes exhilaration and the humour tends to caricature [...] Picasso has achieved a synthesis between dancing and painting'. Subsequently, he did successive designs for *Pulcinella* (1920), *Cuadro Flamenco* (1921, with music by de Falla), and the curtain for *Train bleu* (1924) and *Mercure.* The latter, with music by Satie, was produced for Count Etienne de Beaumont's soirées in Paris. In 1936, at the request of Jean Zay, Jean Cassou and Léon Moussinac, Picasso submitted to the Théatre du Peuple his house curtain design for *Le 14 juillet,* by Romain Rolland, directed by Luis Fernández, which would be re-used in 1939 for an adaptation of *Fuenteovejuna,* by Lope de Vega, produced by Jean Cassou. In 1936,

sculptors Emili Fontbona and Manolo Hugué), he befriended the man who, in 1915, was to become his 'dear protege Max'. It was then that he painted his portrait in the style of Ingres. In 1904, Picasso wrote the words 'the meeting-place of poets' on the door of his workshop in the Bateau Lavoir on Rue Ravignan. He met Apollinaire and André Salmon the following year. Their friendship was mutually stimulating: 'inspirers of Cubism, and inspired by it, Max Jacob, Apollinaire and Salmon were eager to have that formal precision born of clear-headed thought which established a new attitude in language' (Picasso to F. Fels, 1923). Marie Laurencin presented Picasso as the poet's source of inspiration in *Apollinaire et ses*

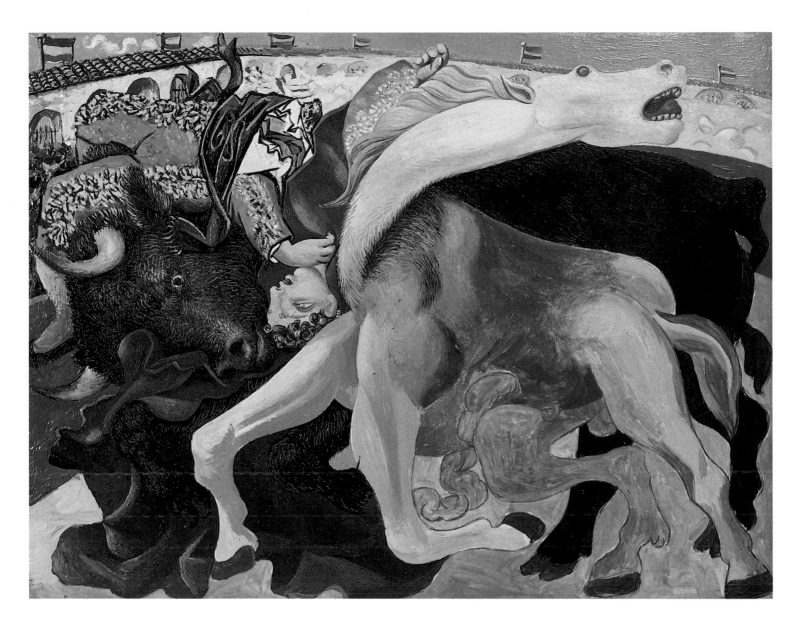

PABLO PICASSO: *Bullfight: the Death of the Matador,* September 1933. Oil on panel, 31 x 40 cm. Musée Picasso, Paris.

while the left-wing organisation *Amigos de las Artes Nuevas* (ADLAN) was organising a retrospective in his honour at the Sala Esteve in Barcelona, Picasso reached an agreement with Paul Éluard whereby he would illustrate the latter's books, *Le front couvert, La Barre d'Appui* and *Les Yeux Fertiles*.

By the early thirties, Picasso had positioned himself closer to the Surrealists. He illustrated the cover of the first issue of *Minotaure* (1 June 1933), which featured a study by Breton on assemblages entitled 'Picasso in his Element' (the maquette is housed in the Museum of Modern Art, New York). At about that time he turned his hand to writing and poetry, a conscious undertaking which undoubtedly had a calming effect in what was a period of serious upheaval. He narrated his visions in Spanish through stormy writing and unrestrained calligraphy, images without words and strokes linking up

like assemblages or storyboards, in the form of crudely grotesque satire or lyrical protest (*Poème avec tête de cheval,* 7 June 1936, Musée Picasso, Paris). This is the mark of his Ubuesque piece, *Le Désir attrapé par la queue,* written in 1941, in addition to some automatic poems written in French (with lithographs dating from 1949, published in 1954). The piece was read out in his studio on Rue des Grands-Augustins on 19 March 1944 by a group of friends, including some of France's most illustrious post-war intellectuals, notably Michel Leiris, Simone de Beauvoir, Jean Paul Sartre, Georges Hugnet, Raymond Queneau, Jacques Laurent Bost, Brassaï and Jacques Lacan. Picasso's circle of friends featured, in particular, the ongoing presence of Rafael Alberti and Michel Leiris, in addition to such Communist comrades of his as Éluard who, in 1945, made his dedication, *A Pablo Picasso,* some months after the

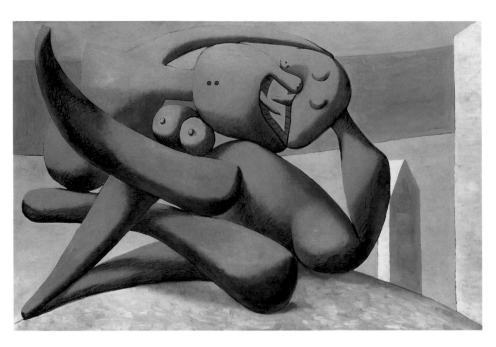

PABLO PICASSO: *Figures at the Seaside;*
January 1931. Oil on canvas,
130 x 195 cm. Musée Picasso, Paris.

homage paid him at the Autumn ('liberation') Salon. Another was Ilya Ehrenburg who, to mark Picasso's seventy-fifth birthday, organised an exhibition of Russian works in Moscow in 1956.

Picasso had been fascinated by the art of cinema ever since the turn of the century. Its black-and-white abstraction posed a challenge to painting both in its rhythm and time register and in its overall depiction of reality. All Picasso's work, including *Guernica,* reveals traces of that discourse with the seventh art. In the fifties, Picasso the spectator became an actor, one-time director and main character in *Le Mystère Picasso* (1955–1956), by Henri-Goerges Clouzot. Echoes of his proximity to cinema at that time are acutely apparent in such pictorial works as *Las Meninas* (1957), and in his graphics, particularly engravings done in 1970 in which a succession of different states appear in both a narrative sequence and a syncopated montage of light and shadow.

Sexuality and Death

In *La Tête d'Obsidienne,* André Malraux quoted Picasso on the Spanish Civil War: 'We Spaniards are like that: Mass in the morning, a bullfight in the afternoon, and a brothel at night'. From his first forays into art, between the ages of eight and eleven, he

had approached the subjects of bullfighting and the Crucifixion. From 1901 to 1903, his works were among the final offerings of international Symbolism, as in *Evocation, The Burial of Casagemas* (Musée d'Art Moderne de la Ville de Paris) and *La Vie* (The Cleveland Museum of Art), which deals with the subject of Eros and Thanatos, while in one of his most beautiful drawings, executed in Barcelona in 1903, the themes of the embrace and the Crucifixion come together. The self-portraits he did at the age of nineteen clearly broach the subject of erotism, which was ever-present thereafter in his parallel work and life, particularly in his tireless endeavour to portray, as he wrote in 1936, 'a body torn asunder by love bleeding from its nest of thorns'.

In *The Harem* (1906, The Cleveland Museum of Art) and in his depictions of Fernande Olivier, Picasso embarked on a theme he was to harp on considerably in the future—that of the mistress who is compelled to face decrepitude as she grows old before the viewer's eyes. Although intimist paintings of this kind were few and far between during his Cubist period—*Ma Jolie,* (1917, Museum of Modern Art, New York) in which the sitter is Eva Gouel—they again come to the fore in 1917, when Olga was becoming increasingly more embroiled in his iconography of erotic violence and death. Childhood tenderness (*Paulo as a Harlequin,* 1924, Musée Picasso, Paris) then gives way to figures of the kind that appear in *The Rape* (1920, Museum of Modern Art, New York), to Dionysian rapture (*The Dance,* June 1925, Tate Gallery, London, possibly inspired by the death of Ramon Pichot) and even ferocity (*The Embrace,* summer, 1925, Musée Picasso, Paris). The faces of his female subjects, which reflected his strained relationship with Olga, soon took on the menacing appearance of 'toothed vaginas'. The subject of *The Minotaur* (Musée National d'Art Moderne, Paris) appeared in 1928, following his liaison, the previous year, with the young Marie-Thérèse Walter, as did the works he executed in Dinard during the summer. It also reflects the emotional and sexual conflicts generated by that passionate affair. Ruth Kaufman has pointed out the influence of intellectuals close to Surrealism, notably Georges Bataille, in the primitive,

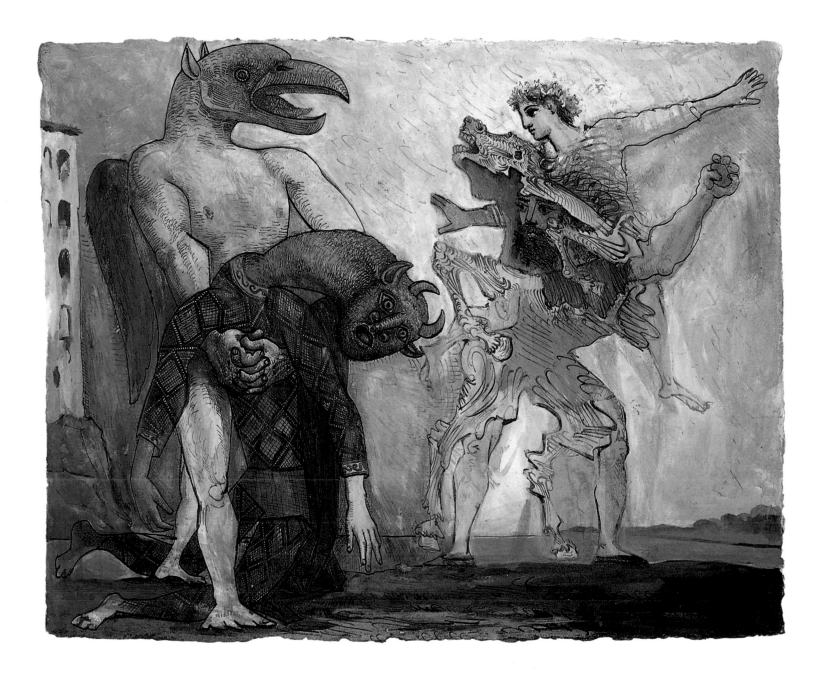

Mithraic iconography of *Crucifixion* (1930, Musée Picasso, Paris) and its fiercely sexual overtones, reminiscent of the cruel *Figures at the Seaside* (1931, Musée Picasso, Paris). Three subjects alternated in Picasso's work between 1932 and 1936: benign depictions of Marie-Thérèse Walter (*The Dream,* 1932, V. Ganz Collection, New York), the resurgent poignance of the Crucifixion according to Grünewald, and the Minotaur, which at times became linked to the world of tauromachia. While Spain was being ravaged by civil war, Picasso met a Yugoslav photographer, Dora Maar. This tragic figure, resembling an assemblage violently coloured with cruel metaphors (eyes–hedghogs, handkerchief–broken mirror, tongue–sex, tears–needle), would from then on embody in Picasso's work the suffering in Spain and the drama involved in his own fate (*The Weeping Woman,* 26 October 1937, Tate Gallery, London). His life with Françoise Gilot (*Flower Woman,* 1946, F. Gilot Collection), whom he met in 1943 and with whom he had two children, Paloma and Claude, appears in his work in such happy guises as Maya, a figure born of Picasso's love affair with Marie-Thérèse Walter. This period of contentment was disrupted when Françoise Gilot left Picasso in November 1953. In 1954, it led into a series of *caprichos,* 180 drawings on the subject 'the painter and his model', which acted as both a retrospective and new beginning. It gradually gelled in the form of a de-

PABLO PICASSO: *The Dead Minotaur in a Harlequin Suit;* 1936. Gouache and Indian ink, 44.5 x 54.5 cm. Musée Picasso, Paris.

PABLO PICASSO: *Poem with Horse's Head;* 1936. Mixed media, 33 x 17 cm. Musée Picasso, Paris.

vouring frenzy, with a heightened Baroque sensuality, in variations on Manet's *Le Dejeuner sur l'herbe* and, at the end of the year, Delacriox's *Women of Algiers,* dating from the time he met his final companion, Jacqueline Roque. In 1962, with his matching interpretations of Poussin's *The Massacre of the Innocents* and David's *The Intervention of the Sabine Women,* Picasso again took up the subject of abduction and rape which he had immersed himself in during the thirties. Other themes that were activated simultaneously in a profusion of drawings and paintings at that time were the nude, and the painter and his model. In his erotic drawings (1968) inspired by Ingres' *Raphael and La Fornarina,* those showing *Degas in the Brothel* (1971) and, above all, his subsequent works, the female figure appears broken, splintered and diffuse, portrayed using an ever more elementary visual code, revealing a timeless fusion between instinctive drawing and painting, 'movement become painting' (Octavio Paz), seen simultaneously from a multitude of angles, not as a sex machine but as a real object of desire, revealing a yearning for the mythical female who eludes the artist that has always sought her secret. The 'ecstacy' (José Bergamín) of this upsurge came to an end in the summer of 1972 with a number of self-portrait skulls and, in October 1972, a few months before his death on 8 April 1973, *Nude in an Armchair* (Musée Picasso, Paris), in which everything seems to have decayed, except for the subject's sex and the hand that draws.

Identity and Commitment

It is a well-known fact that for Picasso the allegory of passion was in the bullring, 'when the bull tears open the horse's belly' (Picasso, 13 November 1935). He always identified with his childhood recollection of a bullfight he witnessed one 'night locked inside the sun' (30 July 1940), and lived his whole life as a consummate Spaniard, which showed in his friendships and in his tastes in art and literature. In his *El entierro del conde de Orgaz,* the last of his writings, dating from the period January 1957–August 1959, his opening words are: 'There's nothing but oil and old clothes'. These 'trappings' of the

eternal Spain, which he perceives as indelibly Iberian, are the starting point from which Picasso makes a concerted attempt to come to grips with his century. This is what leads him to question the notion of painting and to ask what *Le Chef-d'oeuvre inconnu* might have been behind the concoction of nudes, bullfighting scenes and the painter at his easel, opposite his model, in 1927. They are what make Picasso ignore the First World War and yet respond with indignation at the wounds inflicted on Spain, siding for a long time with the struggle against the horrors of Fascism. His enthralment with the bull-horse dyad and its emergence in his work developed from the first prints for Pepe Illo's *La Tauromaquia* (1929) to those for *Minotauromaquia* (1936), and from his canvas *Bullfight: Death of a Matador* (1933, Musée Picasso, Paris) to his gouache house curtain, *Composition with Minotaur,* for Romain Rollard's *Le 14 juillet* (1936, Musée Picasso, Paris) and his definitive *Guernica* (May–July 1937, Centro de Arte Reina Sofía, Madrid). This evolutive process displays a moral shift in his use of metaphors, with antagonistic pairs of opposites: good and evil, tenderness and suffering, war and peace. After implicating the future dictator in his engraved comic strip, *Sueño y mentira de Franco* ('Franco's Dream and Lie'), dating from 8 and 9 January and 7 June 1937 (Musée Picasso, Paris), Picasso set an example with his contribution to the Spanish pavilion at the Universal Exposition of Paris and as the Director of the Prado: 'Artists who live and work with spiritual values cannot remain indifferent to a conflict that threatens the highest values of humanity and civilisation' (*New York Times,* 19 December 1937).

Picasso decided to remain in Paris during the Nazi occupation and dedicated his sculpture, *Bull's Head* (1943, Musée Picasso, Paris) to the memory of Julio González. He denounced the carnage Europe had just lived through in *The Ossuary* (1945, Museum of Modern Art, New York), and paid homage to the Spaniards who died in the French Resistance (*Monument to the Spanish,* 1945–1947, Centro de Arte Reina Sofía, Madrid). Far from Spain, he decided to join the French Communist party out of human solidarity, with no frontiers: 'Today I am no longer an exile' (1944). He journeyed

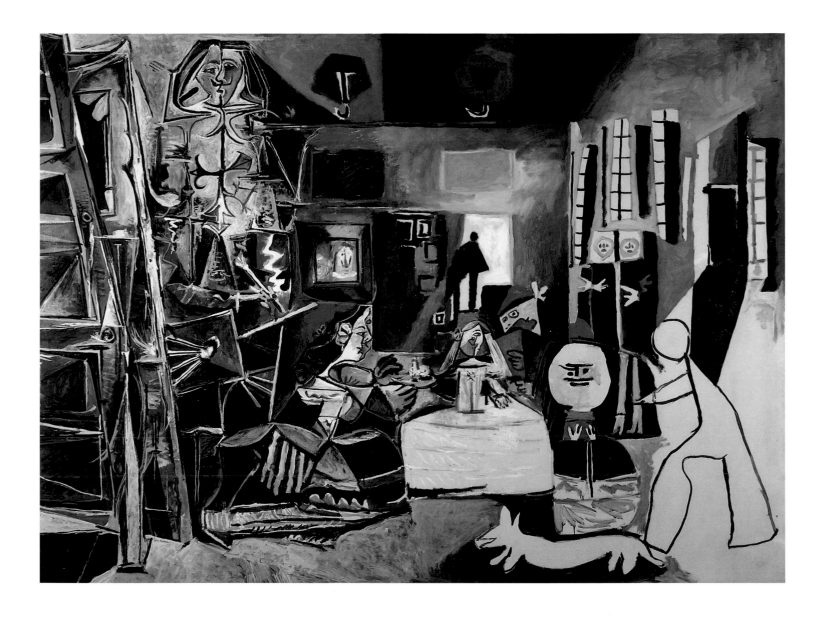

with Éluard to attend the Congress of Intellectuals for Peace, held in Wroclaw (Breslau) in August 1948 and defended Neruda during the latter's persecution in Chile. Deeply moved by the Korean War, in 1951 he painted *Massacres in Korea* (Musée Picasso, Paris) and the panels *War* and *Peace* for a deconsecrated chapel in Vallauris. On 22 November 1956, *Le Monde* published a letter he addressed to the French Communist party, in conjunction with Hélène Parmelin, Édouard Pignon and seven other public figures, in protest at the events in Budapest.

Picasso knew he would never again set foot in Spain. Once, on a visit to Céret, he climbed a hill to look at his country from there. In the fifties, in a show of optimistic indulgence, he became involved in an ongoing campaign in honour of tauromachia, which he promoted in the south of France, assisted by such friends as Jean Cocteau and

Luis Miguel Dominguín. As the testimonial of a militant *aficionado* and heir to Goya, he helped organise bullfighting festivals with almost documentary precision, which were also a delight for the eyes. On display were ceramics from Vallauris (*Corrida* wine glasses, April 1953, Musée de Céret), countless drawings and engravings for the final edition of Pepe Illo's *El cuaderno de la tauromaquia* (1959), Luis Miguel Dominguín's *Toros y toreros* (1961) and *Toros* (1960) by Pablo Neruda. In his *A los toros avec Picasso* (1961), his old friend and companion, Jaime Sabartés, wrote: 'Picasso takes us to the arena, where he used to go, holding his father's hand'.

PABLO PICASSO: *Las Meninas*; August 1957. Oil on canvas, 194 x 260 cm. Museu Picasso, Barcelona.

CONTEMPORARY ART, ARCHITECTURE AND DESIGN

Pilar Parcerisas
Manuel Borja Villel

POST-WAR ART. THE FORTIES

During the early years of the Franco regime, art was conditioned by the prevailing spirit of national reconstruction and its imperialist vision, tinged with an aura of triumphalism. This led to an architecture of monumental forms, a new approach to public sculptural works and commissions for commemorative monuments. Religious painting and statuary and mural painting were given renewed impetus, while painting survived within the confines of lacklustre academicism and picturesque or even downright folkloristic genre. The upshot of this was so-called *pintura de estraperlo* ('black-market painting'), particularly popular in Barcelona, where the middle classes that had grown rich during the Second World War bought up many works of this kind. Meanwhile, the artistic avant-garde had fallen silent.

Having lost touch with the avant-garde, post-war aesthetics showed a continuity with the trends that had prevailed before the war. This was particularly noticeable in the ongoing dialogue between tradition and modernity, which was inextricably linked with the Mediterraneism inherent in Catalan *Noucentisme*.

Chronologically speaking, the post-war period was not homogeneous. An initial stage, which was marked by the severity of the autarchic regime that emerged in the early forties, strove to create a 'national art'. The second stage, which ended with the 1st Hispano-American Biennial in 1951, yielded the first signs of recovery in the appearance of such innovative groups and initiatives as Pórtico (1947), Dau al Set (1948) and the Altamira school (1949).

The Spirit of Victory: Monumentality

In the absence of truly Fascist or National-Socialist art, of the kind that emerged in Italy and Germany, Spanish art was characterised by the development, along monumental lines, of pre-war classicism and a revival of the nation's imperialist past, for which the paradigm was the period of Charles V and Philip II. In short, this was an attempt to recover the essence of Spanish tradition, as epitomised by the architecture of the Habsburgs and their crowning achievement—the Monastery of El Escorial.

Franco's answer to El Escorial was a romantically inspired funerary monument, the Valle de los Caídos. Designed by Pedro Muguruza, it was quietly built in the rocky landscape of Cuelgamuros, in the Sierra de Guadarrama. In Franco's words, 'El Escorial is a monument to our past grandeur, and the church and adjoining buildings in the Valle de los Caídos the landmark and starting point for our future'.

Other projects associated with Francoist monumentalism include the Air Ministry building, designed by Gutiérrez Soto—a kitsch replica of El Escorial—an extension to the Casa Consistorial in Zaragoza, designed by Nasarre, Acha and Magdalena in 1942, the

RAFAEL ZABALETA: *Old Peasant Man;*
1957. Oil on canvas, 81 x 100 cm.
Private collection, Tamarite (Huesca).

remodelling of the Plaza de Oriente in Madrid in 1945, and the Universidad Laboral de Gijón (1946–1956), one of the most ambitious projects of the period, designed by Luis Moya Blanco.

In Barcelona, owing to the city's distance from the nerve centre of political power, official architecture was less influential. However, the city also had its 'memorials to the fallen', notably one erected in the Santa Elena cemetery on Montjuïc hill in 1940, designed by the architects M. Solà Morales, Josep Soteras, Baldrich, J. Ros and J. Mas, and the sculptors Miquel and Lucía Oslé. Another, sited on Barcelona's Avinguda Diagonal, was designed by Adolf Florensa and Joaquim Vilaseca and embellished with a sculpture by Josep Clarà. Monuments of this kind continued to be built until well into the sixties. In 1964, one was dedicated to José Antonio Primo de Rivera, while another, designed by J. Viladomat in 1963 and erected on Montjuïc, was dedicated to General Franco. Yet another, a monument to the infamous Condor Legion, was only dismantled in 1980.

Official Painting and Sculpture

The prevalence of monumentalist architecture led to commissions for commemorative sculpture, and for busts and equestrian statues of Franco. It also led to the restitution of religious sculpture and the appearance of reliefs and sculptures alluding to victory, work and the new ideal of beauty.

Juan de Ávalos (b. 1911), the artificer of the statues at the Valle de los Caídos, was the leading exponent of sculpture under the Franco regime. His style was somewhere between that of Michelangelo and the religious sculpture of the Castilian Baroque. Other sculptors active in his circle included Fructuoso Orduna, who executed the first equestrian statue of *El Caudillo* (1942), Pérez Comendador, Adsuara and Capuz. In Barcelona, official commissions were awarded to Josep Clarà, Frederic Marés, Enric Monjo and Josep Viladomat, who furthered the classical style of the 19th century by adopting a form of realism devoid of any archaism or primitivism.

The move to restore religious imagery in numerous churches created work for many sculptors. Architects, sculptors and painters were commissioned for the major task of renovating the facade of the Monastery of Montserrat, announced in 1942, an undertaking that lasted well into the following decade and constituted a stylistic extension of Catalan *Noucentisme*.

The national fine-arts exhibitions held from 1941 to 1948 in Madrid, and sporadically in Barcelona, were a showcase for the official art of the forties. To some extent, in the spirit of Ortega y Gasset, the idea was to create 'an art full of values', designed to cast out 'dehumanised art' and the avant-garde.

In the field of painting, the regime found wholehearted support among academic, genre and secondary painters, including Sotomayor, Zubiaurre and José Aguiar, although it also elicited some response from among a generation of painters fated to disappear during the forties, notably Ignacio Zuloaga, José M. Sert, J. Gutiérrez Solana and Gustavo de Maeztu, and the sculptor Mariano Benlliure.

Similarly, Daniel Vázquez Díaz (1882–1969), whose style stood midway between tradition and innovation, was to some extent won over by the regime. He painted subjects from the Civil War, folklore and genre, and in 1951 was awarded first prize at the First Hispanoamerican Art Biennial.

A unique case was that of the painter Pancho Cossío (Francisco Gutiérrez Cossío, 1894–1970), who had been active in the avant-garde Paris school in the twenties. After adopting the ideology of the *nacionalsindicalistas* or 'national unionists', he founded the Santander branch of the right-wing JONS movement and then took up painting again. However, his style was too modern, advanced and sensual for the regime, and unsuited to the official line in painting. Thus, his work has only recently been reappraised, and is no longer viewed in terms of his ideological stance.

JUAN DE ÁVALOS: *Pietà;* 1950.
Valle de los Caídos, Madrid.

Eugeni d'Ors and First Attempts at Renewal

Eugeni d'Ors, the prime mover behind the idealising classicism of turn-of-century Catalan *Noucentisme,* was to become the key figure in the new art policy of the forties. He made his first attempts at renewal from within the dictatorship, by methodically applying a dialogue between tradition and the innovation fuelled by *Noucentisme.* The effect was rather like Mediterraneanising the arid landscape of Castilian art.

In 1942, he founded the Academia Breve de Crítica de Arte, which drew its membership from among critics, artists and diplomats. Its principal aim was to establish a bond connecting pre-war and post-war art, and its statutes expressed its purpose of 'orientating and promoting modern art in Spain by all available means; fostering the publication of literature relating to modern art [...] and holding exhibitions and conferences'. In 1943, the Academia gave birth to the Salón de los Once which became Spain's showcase for modern art in the forties. Eugeni d'Ors' Salon ran into seven events, and the last of them, held in 1949, ended up acting as a genuine link between the great figures of the avant-garde and a new generation of artists: Dalí, Miró and Torres-García, alongside Ponç, Ciuxart, Tàpies, Bohigas and Zabaleta. Thus, within the framework of the Salón de los Once, the group known as the Dau al Set earned a measure of official recognition.

Only French and Italian art made inroads into Spain at that time, and offerings were restricted to the moderate avant-garde, mainly Post-Impressionism and Fauvism. In Barcelona, an exhibition entitled 'Modern French engraving, from Manet to our times', was staged in 1942. In 1944, the 'Exhibition of contemporary French artists' was held in Madrid. It included works by Matisse, Dufy, Vuillard, Roualt, Vlaminck and Laurencin. Other exhibitions included one in Barcelona of Italian engravings, held in 1945 and featuring the work of Morandi, a highly influential one in Madrid in 1948 entitled 'Exhibition of Contemporary Italian Art', which had metaphysical overtones and displayed works by Casorati, Campigli, Carrà, Marini, Modigliani, Sironi, Morandi, De Chirico and Gutuso, and, in 1949, an exhibition of 'Contemporary European Art', with works by Picasso, Matisse and Braque, held in the Galería Palma in Madrid.

HONORIO G. CONDOY:
Reclining Woman; 1945.
Colección Arte Contemporáneo, Madrid.

By the mid-forties, there was a noticeable penchant for Paul Klee's primitivism in art circles, and his work was praised in the collection of books entitled *Artistas Nuevos,* directed by Mathias Goeritz and published by the Galería Clan. Klee became the international banner for the Altamira school (1949–1950), and had a marked influence on the painting of Antoni Tàpies during the time of the Dau al Set group (1948–1951).

The Instituto Francés of Barcelona adopted a role as patron of the arts. In 1945, its director, Pierre Deffontaines, founded the so-called Cercle Maillol, a board which awarded scholarships liberally for young artists to further their training in Paris. In 1946, it organised an exhibition of works by Aristides Maillol.

Another attempt at renewal focused on the Castilian countryside, a return to rural aesthetics and suburban painting, which were approached in a fashion reminiscent of post-Fauvism and post-Cubism. Rediscovering the countryside had precedents in the solitary figures of Godofredo Ortega Muñoz (b. 1905), Juan Manuel Díaz Caneja (1905–1988) and Rafael Zabaleta (1907–1960). Ortega Muñoz, who hailed from Extremadura, imbued his landscapes with the austerity of the metaphysical spirit he had acquired during a sojourn in Italy in the years leading up to the war. Zabaleta, a protege of Eugeni d'Ors, and a native of Quesada (Jaén), painted landscapes of his natal countryside pervaded with Picasso's influence, striking a balance between primitivism and the avant-garde, Cubism and rural mores. Díaz Caneja also came from twenties' and thirties' avant-garde circles, and his Castilian plains reflect the sensuality of Matisse.

This revival of landscape painting in the forties yielded a paramount figure who had a considerable impact on young artists—Benjamín Palencia. Having been regarded as an accomplished Surrealist in the thirties, ten years later he turned with great impetus to harsh, rugged landscapes that bring out the austere essence of the Castilian and therefore Spanish countryside. A group of young landscape painters sprang up around the figure of Benjamín Palencia (1894–1980), forming the so-called Madrid school, which made its formal debut at an exhibition in the Galería Bucholz in 1945. This school, which took as role models the more moderate figures of the French avant-garde, included a wide variety of artists, including Álvaro Delgado, Carlos Pascual de Lara, Gregorio del Olmo, Francisco San José, Martínez Novillo, Redondela, Menchu Gal and Juan Guillermo. It eventually superseded the second Vallecas school, which lasted until about 1942, and was even joined by some members of the latter.

Just as Benjamín Palencia bridged the generation gap with his moderately avant-garde approach in Castile, a similar role was played in Catalonia by Ramon Rogent (1920–1958), whose paintings are Matissean in mood, full of *joie de vivre*. In Galicia, this transitional function was performed by Luis Seoane (1910–1979) who, during his exile in Argentina, joined the ranks of Picassian classicism. In his later work, he tended towards a radical approach to composition and sharp colouring, close to the teachings of Malévich.

Turning to the leading sculptors of that period, both Baltasar Lobo (b. 1910) and Honorio García Condoy (1900–1953) went into exile in Paris. The work of Baltasar Lobo

ÁNGEL FERRANT: *Fisherman of Sada;* 1945. Colección Arte Contemporáneo, Madrid.

reflects the influence of Picasso and Henri Laurens, particularly in his depictions of maternity, while the more stylised sculpture of García Condoy was closer to the Surrealist tenets of Alberto Sánchez and Angel Ferrant.

The course of post-war avant-garde sculpture was steered by prominent figures who had matured during the thirties, notably Ángel Ferrant (1881–1961) and Leandre Cristòfol (b. 1908). Ferrant, an artist and sculpture theoretician, became a key figure during that decade, in which he resumed work on his thirties' sculpture of *objets trouvés*, made up of randomly found objects—sticks, stones, roots and implements—in the spirit of the Surrealists and the sculpture of Joan Miró. His purpose was to use such objects or elements in the realm of 'the useless'. The exhibits he displayed at the Salón de los Once in 1946 reasserted his resumption of this genre, which was also present in the morphology of his *Esculturas ciclópeas y megalíticas* ('Cyclopic and Megalithic Sculptures') of that period.

Leandre Cristòfol produced a number of extremely beautiful drawings, his *Morfologías,* between 1932 and 1940. They heralded the end of his early avant-garde phase, and it was not until well into the fifties that he was able to resume work on a normal, ongoing basis.

Cristino Mallo (b. 1905) was another prominent sculptor in the post-war years who, like Ángel Ferrant, belonged to the *Alianza de Intelectuales Antifascistas* ('Alliance of Antifascist Intellectuals'). His sculpture reflects the austerity and humility of everyday life at that time, in the spirit of Marino Marini, and is unfettered by rhetoric, while retaining a classicist grounding.

Another interesting figure whose career began in the thirties was Eudald Serra (b. 1911), a pupil of Ferrant's. His work matured fully in the fifties and sixties, and is interesting in that it reconciles the anthropological and the artistic. From 1935 to 1948 he lived in Japan, where his passion for exotic and primitive cultures, and his assimilation of Giacometti's brand of Surrealism, led his work to develop along the lines of modern, ethnic monumentality. He was a key figure in the sculpture of the period of transition.

A sculptor whose work shows the influence of Moore was Plácido Fleitas (1915–1972). A prime mover behind the group known as LADAC or *Los Arqueros del Arte Contemporáneo* ('The Archers of Contemporary Art'), founded in the Canary Islands in 1951, his work became a reference for future artists in the archipelago, including Chirino and the painter Millares.

CRISTINO MALLO: *Female Head;* 1960. Private collection.

The Clandestine Avant-Garde

Towards the end of the nineteen forties, Spanish art began to renew its ties with the avant-garde, and newfound creative energy welled up among a generation of artists that came together in art circles or around journals.

The first of these groups was Pórtico, which saw the light in the bookshop of the same name in Zaragoza in 1947. It grew up around the figure of Santiago Lagunas, an architect and the first to support abstract art in Spain, together with Eusebi Sempere. The members of Pórtico included F. Aguayo, Baqué Ximénez, A. Duce, V. García, S. Lagunas, López Cuevas, Pérez Losada and Pérez Piqueras. Unlike the group Dau al Set, which was linked to the Surrealists, the aim of Pórtico was to introduce abstract painting into Spain.

In Catalonia, the resurgence of the avant-garde was not restricted to fine art. It took in the world of both art and literature and revolved chiefly around the figures of the poet J.V. Foix in literature, Joan Miró in painting and Josep Lluís Sert in architecture.

A figure that was in the ascendant at that time was the poet Joan Brossa (b. 1919), whose friendship with J.V. Foix, Joan Ponç and Joan Miró brought him into contact with the Dau al Set painters. As early as 1941, he had embarked on experimental poetry inspired by Apollinaire's calligrams. His automatic poems reflect hypnagogic images in the purest Surrealist style, and his first poem–object, *Escorça,* dating from 1943, is comparable to the ready-mades of Man Ray and Duchamp.

480

JOAN PONÇ: *Self-portrait;* 1948.
Mixed media on paper, 37.5 x 25 cm.
Fons d'Art de la Generalitat de
Catalunya, formerly the Salvador Riera
collection, Barcelona.

JOAN BROSSA: *Experimental Poem;*
1951. Mixed media, 25.5 x 15 x 3 cm.
The artist's collection, Barcelona.

Joan Brossa, a poet of words, images
and objects, assumed the role of
instigating a return to the avant-garde in
the post-war cultural sphere in Catalonia.
His invariably incisive work ranged from
lyricism to irony and the most caustic
criticism. He was a founding member of
the group Dau al Set, and exhibited this
Experimental Poem at the group's
exhibition in 1951 at the Sala Caralt in
Barcelona. The work establishes a
poetic, metaphorical relationship
between apparently disparate objects
through subtlety and forcefulness,
randomness and work, fabrication and
sincerity. Brossa's poem–objects provide
the spectator with an infinite number of
interpretations, achieved by
decontextualising and recontextualising
everyday objects.

ANTONI TÀPIES: *UGB;* 1949. Oil on canvas, 39 x 47 cm. Santos Torroella collection, Barcelona.

1948 was a memorable year, when the journal *Dau al Set* first came out and the Salones de Octubre were held for the first time. *Dau al Set* was a group, a journal of art and literature and a coterie committed to an innovative language, that is, to everything alien to academicism, *estraperlo* art and *Noucentiste* realism. In contrast, it was open to automatism, *ex novo* creation, Surrealist postulates and creative freedom. Its members admired Paul Klee, Max Ernst and the Surrealists and the group drew much of its inspiration from literary sources. Art was again to go through initiatory rites. The journal was published from September 1948 to December 1956, although its founders coincide in pointing to October 1951 as the time when the group ceased its collective activity, which ended with an exhibition at Barcelona's Sala Caralt in 1951. The group was founded by Joan Brossa, the painters Joan Ponç, Antoni Tàpies and Joan-Josep Tharrats, and the writer and theoretician Arnau Puig.

The first Salón de Octubre was held in the Galerías Layetanas in 1948. It was organised by a group of artists eager to promote new trends who would only go so far as to accept works which amounted to 'subsequent contributions to Impressionism'. The Salón featured less radical works than those associated with Dau al Set, but they did point to an interest in breaking away from realism and academicism and making inroads into more

abstract, geometrical or symbolic languages. This led to a figuration–abstraction debate in which Informal art ended up gaining the upper hand in Catalonia.

Among the new journals that attempted to promote avant-garde art was *Cobalto,* which appeared in 1949, at the time the Club 49 was founded. It was sponsored by the collector Joan Prats and the architect Josep Lluís Sert, former members of ADLAN. It later changed its name to *Cobalto 49.* The aforementioned club, which acted as a repository for works by Miró and members of Dau al Set, staged the first post-war exhibition of Miró's work in Barcelona (1949). It was followed by exhibitions of works by Ponç, Tàpies and Cuixart in the Instituto Francés.

Towards the end of the decade, the new art trends followed in the footsteps of the Altamira school, which had been founded during the *Conversaciones Internacionales* at Santillana de Mar in September 1949. It drew its inspiration from the leading exponents of primitivist art, on the basis of which its members advocated a form of prehistoric art, as in the Altamira caves, as a way of leading contemporary art back to its origins. Its mentor and the organiser of the school's encounters, Mathias Goeritz, an artist of German origin who settled in Spain after fleeing the Second World War, stated their aims as follows: 'Salvation for us and and our art lies in a new prehistory, without eschewing any existing

MODEST CUIXART: *Moonfisher II;* 1949. Oil on canvas, 81 x 100 cm. Fons d'Art de la Generalitat de Catalunya, formerly the Salvador Riera collection, Barcelona.

cultural experience or any so-called progress achieved by 20th-century civilisation' (letter from M. Goeritz to Eugeni d'Ors, 1 September 1949).

Another centre of avant-garde art sprang up in the Canary Islands, where the Surrealist painter Juan Ismael co-founded the group known as the *Pintores Independientes Canarios* or PIC in 1947, as well as the aforementioned LADAC, in 1950.

The fifties was characterised by a gradual acceptance in official circles of avant-garde art, which slowly came back into its own. This was to some extent prompted by the regime's decision to come out of its international isolation, particularly after the defeat of German and Italian Fascism in the Second World War.

P.P.

EXPERIMENTS IN INFORMAL ART IN SPAIN

Historically, Informal art emerged in Spain during the second half of the nineteen fifties, and soon became a fully-fledged social phenomenon. Indeed, the young people of the time were swept away by this trend. This was recalled by Cirici Pellicer, who made no bones about entitling one of the chapters in his book about 20th-century Catalan art, *Tots Informalistes* ('All Informalists'). A brief review of the salons, exhibitions and prizes of that period reveals just how forcefully the language of Informal art had made inroads. From Ràfols-Casamada to Guinovart, through Canogar, Hernández Mompó and Lucio Muñoz, this style affected everyone. It could not be otherwise as, following years of isolation, Spanish art's ties to the international avant-garde were established just as Informal art was in the ascendant everywhere, and had become the common denominator of art in the so-called 'free world'.

The popularity of Informal art in Spain was undoubtedly related to the political changes that took place there during the fifties. That period saw the end of post-war political autarchy and the return to normal of political and economic development, in which the regime was intent on opening up to the Western world. It built up an image of Spain as a democratised country in which artists and intellectuals were free to create unhindered, and promoting the most avant-garde Spanish art of the time became a declared government activity. Since the style in question was based on wholehearted Expressionism with existentialist leanings, and unfettered creative freedom lacking clear sources of inspiration, Informal art developed an ambiguous character which came to reflect the contemporary political situation in Spain. In spite of everything, it should be admitted that the country did open up, enabling exhibitions of works echoing the status quo in European and American art to be held ('Recent trends in French painting', 1954–1955, 'Contemporary Italian painting', 1995, 'Collections from the Museum of Modern Art of New York', 1955). Prominent among local exhibitions of international art, which have already been dealt with, was the first Hispano-American Biennial (1951).

Many critics in the mid-fifties felt that contemporary art in Spain was sorely lacking in national character, and the ensuing search for indigenous historical roots became widespread. The paintings of Saura, Millares and Tàpies, for instance, were regarded as genuinely Spanish. A number of clichés were then coined by critics and exhibition curators, both in Spain and abroad, in relation to local expressiveness and dramatism. The use of poor materials, such as hessian or earth, and a penchant for certain colours, particularly ochre, black and red, were immediately associated with the Inquisition, the mysticism of SS Teresa and John of the Cross, and overtones of romanticism and ruins, considered to be eminently Hispanic. Artists were not unscathed by this Hispanicisation of art in Spain. For these, references to the Spanish pictorial tradition was a chance to confront the history which official propaganda had been attempting to obfuscate. Saura's imaginary portraits, and his direct references to Velázquez and Goya, were exemplary in this respect. Similarly, it came as no surprise that allusions to cultural identity should have emerged in the work

MANOLO MILLARES: *Painting 122;* 1961. Mixed media on canvas, 162 x 130 cm. Private collection.

After painting in a figurative style with Surrealist roots in the forties, Manolo Millares turned to Informal art in the fifties and, together with Saura, he became one of the bulwarks of the Madrid-based group called El Paso. At this stage he used poor materials such as hessian, which he mauled, both physically and chromatically, although his handling is tinged with a form of Surrealist automatism inherited from an earlier period. His particular brand of Informal art may have been determined by his Canary-Island origins, and indeed his work reveals the influence of pre-Hispanic indigenous cultural vestiges. His hessians, for example, emulate the texture of local Guanche leather and cloth.

of Catalan artists, with harkings of the Romanesque, Ramon Llull and the Modernism of Gaudí and Jujol.

In any case, what is worth stressing is the widespread feeling that Spanish art was developing its own character, with distinguishable traits, while also assimilating a modern, international language. There was the feeling that the threat of mimicry and trivialisation had been averted, and that Spanish art was becoming part of what was considered to be the most dynamic avant-garde of the moment.

Informal art in Spain had one of its staunchest allies in the French critic Michel Tapié, an indefatigable promotor of this style. He contributed to its far-reaching acceptance and was instrumental in coining the term *informel*. Tapié's associations with Spain originated from the professional relationship he developed with Antoni Tàpies in 1954, when the latter, in addition to other painters, such as Antonio Saura, exhibited their work at the Galerie Stadler in Paris, where Tapié was the art director. His writings were highly influential in Spain at that time, and an essay of his entitled 'Esthétique en devenir', in which he put forward his aesthetic postulates, was published by the journal *Dau al Set*. It was also significant that the Madrid-based group El Paso should have supported the exhibition, *Art Autre*, for which the works were selected by Tapié, held in Madrid and Barcelona in 1957. It was a resounding success and gave considerable impetus to the careers in Informal art of many young painters.

Together with Jean Dubuffet, Tapié founded the Compagnie de l'Art Brut in 1948, and upheld the interests of a variegated group of artists who worked in the Art Autre style. He thereby propounded the possibility of a new avant-garde that would supersede both 19th-century Realism and part of modern art from the first half of the 20th century. He was searching for a new form of objective reality to replace the static, external reality that had characterised Western art and literature, and which would be free of all boundaries. With Informal art he attempted to eschew all systematisation. He was seeking an art form that would break through all established aesthetic confines and the matter–form polarisation; in other words, an art that would emerge from total ambiguity.

Since Informal art was supposed to avoid being labelled or categorised, it had to avoid becoming a regular art form. Tapié had no intention of starting a movement or school in the traditional sense. For him, the important thing was not schools but individuals. In *Un Art Autre,* Tapié did not talk of trends but of a common adventure in which each individual strove to transcend form. Paradoxically, the Spanish artists working along these lines won acclaim precisely because of this differentiating factor. This basically non-idealistic idea was also behind attempts to reconstruct a mythical view of art and history.

After reviewing write-ups of that period, it becomes clear that not only did critics pigeonhole Informal art; they actually constrained it further by regarding it as a new brand of formalism in which considerable importance was attached to technical aspects. Art was then categorised according to whether its exponents laid greatest emphasis on matter, gesture, tonal mass or spatial arrangement. This critical approach was shared by a fair number of scholars at the time, a fact which helped to mask and even cancel out the more radical aspects of Informalist experimentation. On the whole, Informal art was not regarded as a poetics that sought to transgress or bring down formal categories, but as a vocabulary of expressionistic or gestural forms or even as a sampler of textures. For most, the fact that it attempted to make a clean break and that it had its roots in Bataille and Duchamp, in Dadaism and Surrealism, passed unnoticed.

The part played by Surrealism in prefiguring and catalysing the first post-war avant-garde groups is widely recognised, particularly as far as Joan Miró is concerned. Its influence was apparent in many young artists at that time, notably those associated with the journal *Dau al Set*. The paintings Tàpies executed in 1948 and 1949, for instance, contain a characteristically Mironian space in which a number of small shapes appear to be floating. These works create an impression of continual movement and change, and show a clear turn towards automatism. In similar fashion and by a variety of means, artists in other parts of Spain were busy discovering the legacy of Surrealist automatism and appropriating

ANTONI TÀPIES: *White with Red Daubs;* 1954. Mixed media on cloth, 115 x 88 cm. María Luisa Lacambra collection, Barcelona.

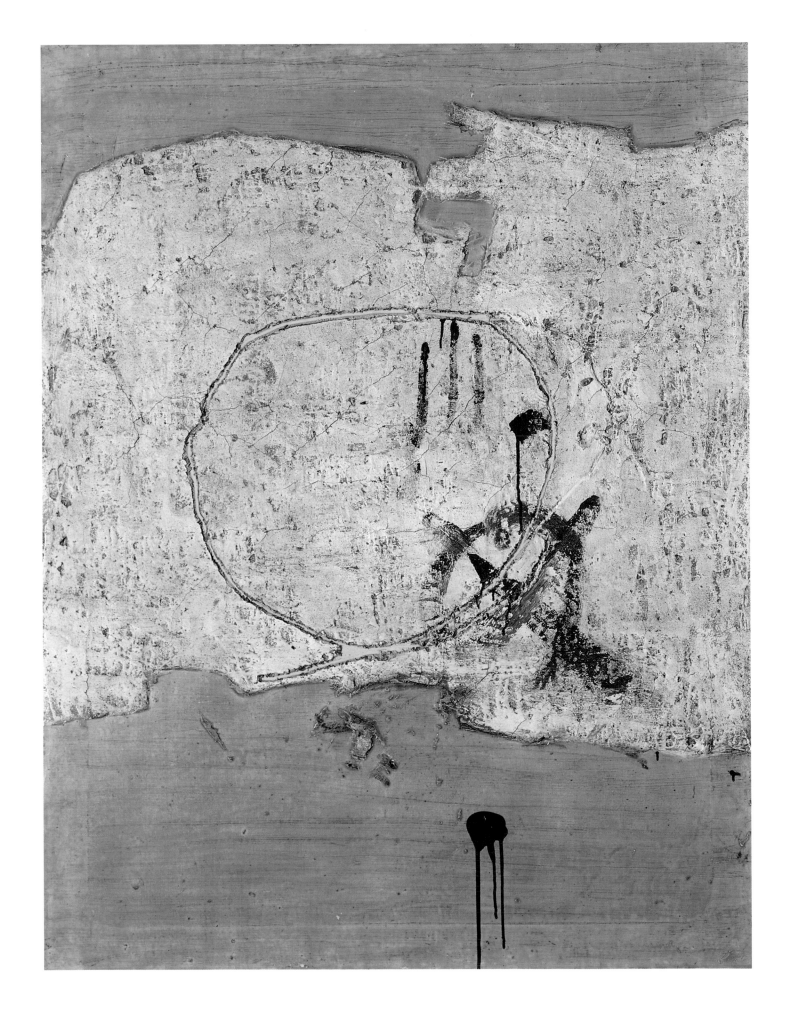

it for themselves. Such was the case of Millares and of Saura, who was a member of the Surrealist group of Paris from 1953 to 1955.

While both Miró and automatism had a widespread influence, not everyone realised that what André Breton had been talking about was not so much 'automatic painting' as 'automatic writing'. The distinction is important because, by nature, writing moves across a horizontal surface and is therefore detached from the vertical field of vision which, since Freud's time, became associated with construction and form; in other words, with civilisation. While Informal art sought to go beyond culture, which it took down from its pedestal and set on the same level as nature, one of the devices Informal artists used to achieve this consisted of driving their art towards the horizontal.

After a number of formative stages, once Informal art was at its height, there were artists who had managed to break with the vertical field of vision and others who had not. Many of the artists who had been unsuccessful resorted to blot drawing, particularly Tharrats. In such works as *Maculatura* (1954–1955), there is no trace of the spreading, horizontality and mark of some absent presence, features which would be associated with automatic writing. On the contrary, the conspicuous substantiality of the composition and its texture endow it with a plastic quality akin to an essentially traditional work. The brushstroke is less the result of the artist's action than a fairly hurried rough sketch of a particular image, such as a sun or some flames. Far from being indistinct, form is locked in. At no stage are we confronted with horizontal painting or anti-rhetorical, anti-compositional devices. The materiality of the work turns it into a texture sampler, rich in character and almost Impressionistic. Everything that could have been considered automatic writing has been 'raised up'.

Significantly, many paintings of that period include references to fire. It is apparent in Daniel Argimon's *Burnt Paper Collage,* dating from 1960, and in *Burning Landscape* by Normal Narotzky, an American artist who settled in Barcelona. What is striking, however, is that here fire stands for civilised things. Some works, such as Warhol's *Oxidation Paintings* (1978), are closer to Informal art than the production of artists associated with this movement, even though in formal terms they may appear aesthetically further removed from it. Urinating on something as 'cultured' as a canvas is associated with urinating on fire which, in Freud's interpretations, stands for a desire to break away from civilisation, from limits, from imposed form, leading us into limitless realms, to a boundless ocean. While it could be transposed to a vertical arrangement, Warhol's painting lies on a horizontal plane. This is borne out by the very manner in which it was produced. The action described in the *Oxidation Paintings* points to a presence which has vanished. In this respect, too, Warhol flouted the theories of expression that have prevailed throughout much of the modern period. As Rosalind Krauss put it, it was as if the artist were reflected in a mirror and then departed, leaving the reflection behind. It involves a violent act which attacks the idealism Bataille was opposed to.

Given the social impact of the atom bomb and recent discoveries in physics, a new world was unfolding before the eyes of painters and intellectuals of the time through the newly invented electron microscope. Those artists moved in circles where there was talk of such unheard-of phenomena as atoms and quanta, which to some extent accounts for their interest in experimenting with matter. In Informal painting, an upshot of this were the recurrent images suggesting explosions. For many artists, the Informalist poetics was no more than a kind of restricted naturalism in which nature revealed itself from either very close quarters or from a great distance, recalling cosmic or microorganic elements. In many instances, the fact that many of those paintings were thought of as landscapes shows just how conservatively they were approached, and how limited was the perception of Spanish critics at the time. Some were incapable of fathoming the more radical structural aspects of Informal art, which many took to merely involve a repertory of gestures, textures and materials used to endow academic rudiments with a modern appearance. The speed with which a sizeable number of these artists reverted to more traditional figurative art, once Informal art started going out of fashion in the early sixties, confirms this idea.

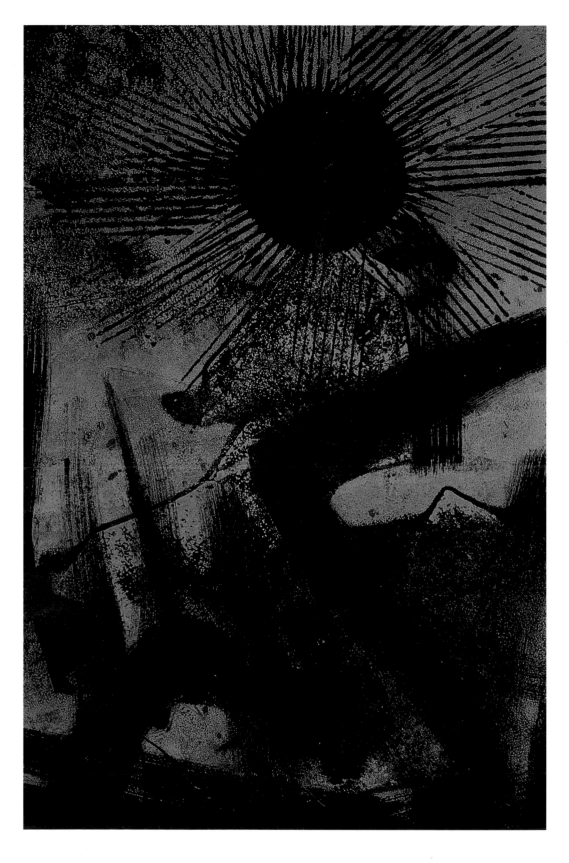

JOAN-JOSEP THARRATS: *Maculatura;*
1954-1955. Lithographic inks,
50 x 35 cm. Artist's collection.

Far from indicating a series of random gestures captured on canvas, the works of
the leading Informalist artists reveal an internal logic which was overlooked in formalist
analyses. The latter were even more incongruous if we consider that the leading Informal-
ists concentrated their efforts on pinpointing issues and relationships associated with
painting, rather than on settling them. It was not an ideal pictorial language they were

seeking, but confrontation and, rather than proclaiming the triumph of Informal painting, they asserted its impossibility.

M.B.V.

BREAKING WITH THE PAST, 1957–1975

By the end of the fifties, abstract art had consolidated its hegemony. The international success of Informalism enabled Spanish art to take its place in the international arena after a long post-war period of isolation. By that time, major exhibitions had been staged in Spain, including the Hispano-American Biennials of Madrid (1951), Havana (1954) and Barcelona (1955), while the first Spanish Museum of Abstract Art had been founded at Puerto de la Cruz in 1953.

The year 1957 marked a turning point in Spanish art's opening up to international influences. In the political sphere, the new technocratic government ushered in plans for consolidation and development which gradually led the country into the mainstream of the world economy, thanks to American aid programs. Spain was fast becoming an urban society, and 1957 saw one of the last mass migrations of workers from rural areas to cities, while the prevailing autarchy came to an end.

Informal art found its principal expression in the El Paso group (1957–1960), which stood for an expressionist, subjective, tragic, extravagant and existential brand of abstract art and drew its inspiration from sources close to Surrealist automatism.

At the same time, poetics advocating the prevalence of reason, order and the discipline of geometry emerged as a counterbalance to subjectivist irrationalism. This led to a staunch defence of pure abstraction by the Grupo Parpalló (1956) and the Equipo 57. The spread of the expressionist and geometric currents of abstract art reached their peak in the early sixties, just when newfound figurative and realistic trends had begun to emerge.

The Spanish government's firm intention to open up to outside influences in the late fifties was endorsed in the art world by an increase in the number of competitions and exhibitions held. Tapié's *Art Autre* exhibition at the Sala Gaspar in Barcelona was pivotal for Informal art in Spain. Oteiza won the sculpture prize at the São Paulo Biennial in 1957, as did Chillida at the Venice Biennial the following year. Antoni Tàpies was awarded the Carnegie Prize at Pittsburg in 1958, as well as the Bright Prize and the UNESCO prizes at the Venice Biennial that same year.

Foreign cultural institutes in Spain provided assistance in the form of allowances and scholarships which enabled artists to further their studies abroad, particularly in Paris, where they gained first-hand knowledge of American Abstract Expressionism, Op art and Kinetic art, and both American and European versions of Action painting and Tachisme.

Visiting exhibitions from abroad became a more frequent occurrence: in 1958, 'New American Painting' was held in Madrid. Similarly, Spanish artists started being sent abroad in an official capacity as part of the regime's newfound policy. In line with this policy, in 1960 the exhibition 'New Spanish Painting and Sculpture' was unveiled at the Museum of Modern Art, New York, and included works by Oteiza, Tàpies, Tharrats and Chirino.

The change also made itself felt in galleries, in the marketplace and among critics. In Madrid, Juana Mordó resigned as director of the Galería Biosca and, in 1964, opened her own gallery, where she held exhibitions of the work of Chillida, Palazuelo and members of the El Paso group, and of abstract painting and Spanish Informal art. The Galería Theo, which opened in 1967, became associated with artists of the classical avant-garde, notably Picasso, Miró, Dalí, J. González, Juan Gris and M. Hugué. It also promoted the figurative art of the Paris School, represented by Bores, H. Viñes and B. Lobo, among others.

Two years before that, in 1962, René Metras, publisher of the journal *El Correo de las Artes* (1958–1962), had founded a gallery on Consell de Cent street in Barcelona. From there he promoted a number of art currents, from the magical Surrealism of Dau al Set to

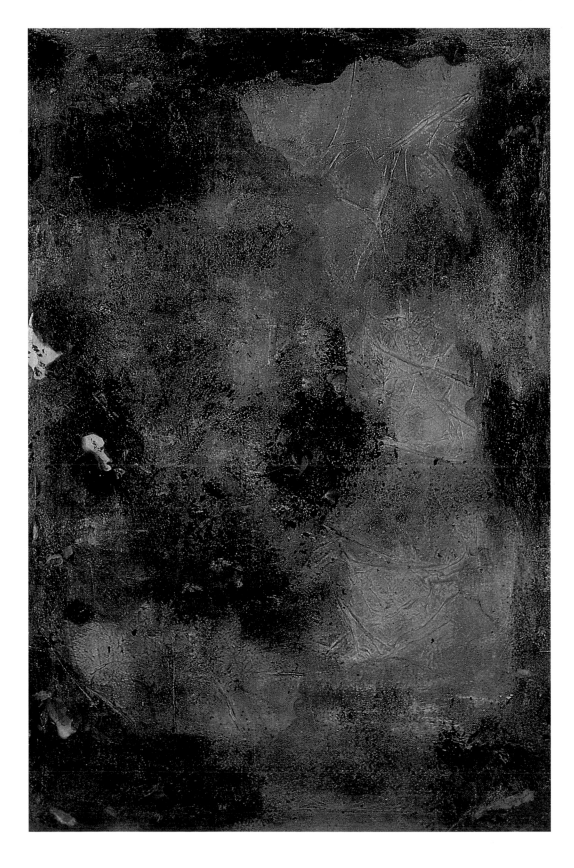

DANIEL ARGIMÓN: *Burnt Paper Collage*, 1960. Painting & collage, 162 x 114 cm. Artist's collection.

lyrical abstraction, Informal art and geometric Constructivism, thereby catering for artists on an international basis. His joint exhibitions featured works by Arp, De Chirico, Fautrier, Wols, Hartung, Dubuffet, Fontana and Vasarely, and he also displayed the work of Tàpies, Cuixart, Ponç, Millares and members of El Paso.

Foreign influences made gradual inroads into Spain in the early sixties. Spanish art was then embarking on a new struggle, that of shaking off the artistic and cultural dead-

weight of the Franco regime, and of preserving its identity. The sixties were characterised by the appearance and coexistence of a host of trends and alternatives, as well as by the apogee of Informal art and abstraction and the emergence of figurative art forms with only vaguely defined limits. That decade also saw the advent of social and critical realism, geometric construction and Kinetic art, atempts to popularise art, the first signs of Pop art and, towards the end of the decade, the emergence of new, poor, ephemeral, conceptual poetics, which enjoyed considerable popularity in the seventies. Meanwhile, the opening of new galleries and the tentative emergence of an art market and a new generation of critics, whose avant-garde affiliation was beyond all doubt, made up an art scene that was to endure until the mid-seventies.

The Survival of Informal Art and the Legacy of El Paso

In Catalonia, the influence of Tàpies paved the way for the emergence of 'matter' paintings, while a more Expressionist Informal Art thrived on the legacy of El Paso in Madrid. Tàpies (b. 1932), who had produced his first matter paintings during a sojourn in Paris in 1953–1954, enjoyed widespread international acclaim. In the sixties his work matured fully, being characterised by the objectification of matter and the emergence of somewhat figurative references to the wall motif he had developed during the previous decade. He began to use more base materials in his work, including cardboard and hessian, and to reflect on the creative process, with works stressing the bareness of the canvas frame. Signs such as ovals, crosses and arcs also crept into his paintings, and were gradually compounded into a graphic universe that has become a constant in his work.

There were many practitioners of Informal and abstract art in Catalonia at that time. Perhaps the most prominent of these were the direct descendants of the Dau al Set group, and those who managed to centre their whole career around abstraction. An example of this is Modest Cuixart (b. 1925), who in 1962 incorporated collage and certain destructive elements into his work. Another is Joan-Josep Tharrats (b. 1918), whose oeuvre benefitted from his background in graphic art. At some stage he adopted a technique he called *maculatura*, consisting of superimposed pictorial blots of lithographic ink, oil paint or watercolour, applied pure or mixed to sidereal, cosmic or astral landscapes. Joan Ponç (1927–1984), was never part of the Informalist current, neither during his Brazilian period, which began in 1935, nor subsequently. Instead, he ascribed to an evolved form of magical figuration.

Other painters that came under the influence of Informal art include August Puig (b. 1929), who practised gestual abstraction with cosmic and biological resonances, Joan Vilacasas (b. 1920), who painted some remarkable *Planimetrías,* and Enric Planasdurà (1921–1984), a one-time member of the Lais group (1949) who used extraneous materials such as coal and stressed gesture on dark grounds. Others were Romà Vallès (b. 1923), in whose work gesture becomes paramount—being applied in monochrome in his *White Series* (1960)—and Daniel Argimon (b. 1929), who developed a unique form of experimental collage using glitter.

Josep Guinovart, Albert Ràfols-Casamada and Joan Hernández Pijuán went through an initial Informalist period before developing styles of their own. In the case of the last two, this involved breaking free of any servitude to matter and approaching lyrical abstraction and the lessons learned from American painting.

Josep Guinovart (b. 1927) abandoned his early Expressionist figuration and embarked on unadulterated, out-and-out Informal art based on collage as his structural foundation. In the sixties he made use of both abstraction and figuration. He did justice to Informal art and Social Realism, as in his critical work, *Homage to Che* (1967). He produced assemblages on panel and re-created the material virtues of frames, always tending to three-dimensionality and to creating atmospheres. Burnt surfaces, doors, ovals, windows and graphic signs are hallmarks of his informal, tragic, primitive and extravagant painting.

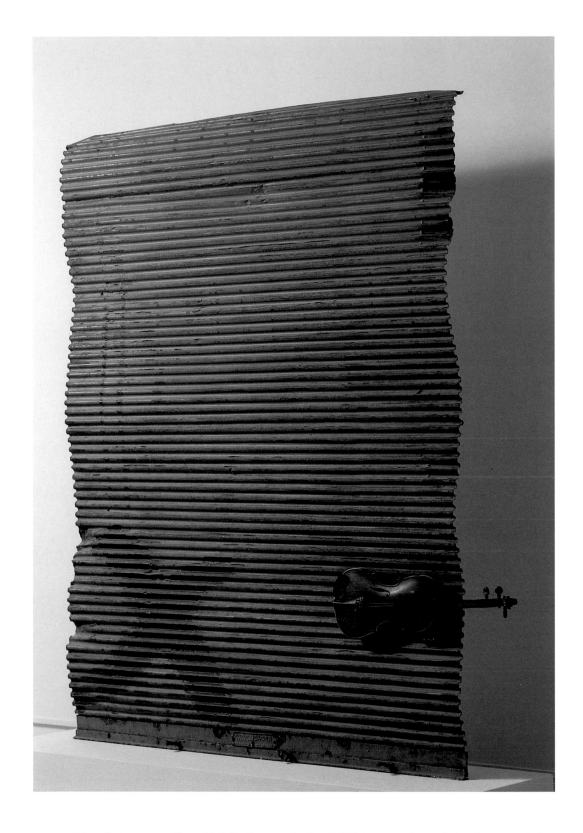

ANTONI TÀPIES: *Metal Door & Violin;*
1956. Private collection.

Like Guinovart, Albert Ràfols-Casamada (b. 1923) is a product of the Autumn Salons of the forties. Having started out with collages and the poetics of everyday objects in the manner of Schwitters and Cornell, his painting then became more spacious and luminous, reminiscent of Matisse's windows, linking up with the spatiality of Rothko and Motherwell. He succcessfully rendered Mediterranean landscapes with lyrical abstraction, in a synthesis between tradition and modernity.

Joan Hernández Pijuán (b. 1931), a painter and outstanding engraver, moved from an austere, gestual and spatial Informalism to the application of reductionist lessons drawn from the contemporary art of Malévich, Rothko, Morandi and Newman. By the turning point

ROMÀ VALLÈS: *Cosmogonies. B Series in White;* 1960. Acrylic, 130 x 162 cm. Private collection.

JOSEP GUINOVART: *Virgins;* 1962. Mixed media, 200 x 100 cm. Biblioteca-Museu Víctor Balaguer, Vilanova i la Geltrú (Barcelona).

of the eighties, his seemingly monochrome landscapes, which lack a horizon line, became vibrant with light. His work reveals Eastern sensibilities in abstract depictions of the Comiols highland landscapes, in the arid countryside of Lleida, where he doodled the odd profile of a leaf or the shadow of a cypress.

Picasso was an indispensable role model for artists of the Paris School both before the war and in the forties, and particularly for those who knew him. An example of this was Antoni Clavé (b. 1913), a Catalan who went into exile in Paris in 1941. An excellent engraver, he was extremely active in creating stage sets for theatre and ballet, although he gave up this activity in 1954 to devote himself exclusively to painting. He was initially inspired by collage and adopted an Informaist aesthetic which first comes through in his series on *Kings* and *Warriors,* executed in the fifties. Clavé exploited his knowledge of the Dadaist and Surrealist traditions when he subsequently reused all kinds of objects and materials in his baroque configurations of space. A peerless manipulator of matter, his *trompe l'oeil* devices create an optical illusion from the folds and creases of his painting surfaces. In the sixties he took up sculpture and relief work, producing cupboards and instruments, in a concerted move towards three-dimensional creations. His homages to El Greco and Picasso reveal his pictorial affinities. *Trompe l'oeil* became a permanent feature in his painting as from the mid-seventies, the decade of Baroque tenebrism that would eventually lead into a more spirited, luminous style in the eighties, influenced by Japanese calligraphy and urban graffiti.

ALBERT RÀFOLS-CASAMADA: *Homage to Schönberg;* 1962. Mixed media, 100 x 81 cm. Contemporary art collection, Madrid.

In 1962 and 1963, Ràfols Casamada paid homage to two of the figures instrumental in the modernisation of painting: in the international sphere, Schönberg, the father of dodecaphonic music and source of inspiration for Kandinsky's lyric abstraction, and Salvat-Papasseit, the leading figure in the literary avant-garde of Catalonia during the forties. For this purpose, Ràfols-Casamada used large swathes of colour, often set in vague outlines, to construct a sublime domain. These works show the unmistakeable influence of American spatialism, which he might have seen at the exhibition entitled 'New American Painting', held in Madrid in 1958. They also reveal the impact of Torres-García and his constructivist theory.

JOAN HERNÁNDEZ PIJUÁN: *Painting;* 1959. Oil on canvas, 116 x 89 cms. Biblioteca-Museu Víctor Balaguer collection, Vilanova i la Geltrú (Barcelona).

The El Paso group was disbanded in 1960, after which some of its former members continued to practise its principles: from an Informalist starting point with Expressionist overtones, they eventually evolved in different directions.

Manolo Millares (1926–1972) experimented with new materials, particularly hessian and, as from 1959, developed his 'homunculi', remains of human beings in crucifixion-like attitudes in which black and white hessians take on the major substance. His aesthetic is that of the 'deep Spain', a blend of existentialism and Surrealism.

Manuel Rivera abandoned conventional pictorial materials and adopted a spatial form of abstraction, achieved through the use of mirrors and metal fabrics. Luis Feito evolved from material Informalism to a geometrical approach which eventually became his hallmark. Manuel Viola, who had joined El Paso at a late stage, continued to practise gestual Expressionism, using enormous, fierce brushstrokes. His style is reminiscent of Tachisme, but more brutal, dramatic and decisive. Rafael Canogar, for his part, abandoned Informal art permanently to become a prominent exponent of the Social Realism and criticism associated with the sixties.

Antonio Saura (b. 1930) had a rich Surrealist background when he first joined the El Paso group, of which he became an active member. He has experimented with traditional painting from time to time throughout his steady, well-consolidated career. Within the conventional context of a painting, canvas and brush, and the occasional addition of photography and collage, he has examined the tragedy of man and the monstruous side of his existence.

Saura reacted against Surrealist automatism by reinstating the human figure, the body and the face as recurring, obsessive elements prone to manipulation: from the face to the mask, and from there to what he termed 'the decay of the purportedly true landscape of the subconscious'. His series *Damas* ('Ladies'), an extensive iconography of femininity, was both a way of keeping one foot in reality and a pretext for venturing into a new interpretation of the human figure, within the context of Spanish painting.

Saura then produced the series that conditioned his future development: *Imaginary Portraits of Goya, Nudes, Landscapes, Crowds* and *Shrouds*. His voluminous series entitled *Armchair Women,* featuring goddesses of love, erotism and destruction, portray woman in her guise as goddess–monster seated in a hierarchical arrangement that is the armchair–throne. Through his imaginary portraits of Goya he expounds on the effigy of the artist, while the Spanish Baroque comes through in his portraits of Philip II and his Crucifixions. His art and his critical spirit have survived the fluctuating fortunes of fashion and the aesthetic impositions of the last few decades.

Close to Saura was the Argentinian Alberto Greco (1932–1965). He took his vital, heterodox Informalism to the point of active commitment and connected up with the spirit of Flexus, Viennese Action painting and subsequently ZAJ.

The Informalist legacy is also apparent in the career of César Manrique (1920–1992), who hailed from the Canary Islands. He became engrossed in the material values of the volcanic landscape of his native Lanzarote, and later branched out into architecture, design, interior design, sculpture and landscape painting. Another exception within the sphere of Informal art but outside the El Paso group was Lucio Muñoz (b. 1929), whose friendship with realist painters did not detract from his panel work or from the importance he attached to the frames for his paintings. In the mid-sixties, Muñoz's work acquired a touch of the commonplace, when he incorporated portraits, objects, animals and dead men, revealing the influence of the realist saga of the Lópezes.

Despite a brief stint as a member of El Paso, Juana Francés (1928–1990) evolved from abstract landscapes with a Castilian atmosphere towards her 'hominids', in which she denounces the alienation and fragility of modern man, while the extravagant Expressionist spirit of El Paso left its mark on the painting of Josep Grau-Garriga (b. 1929) and, above all, on his contemporary tapestry-making.

The activity of El Paso also yielded a sculptural trend which came through in the mature work of Pablo Serrano (1919–1985) during the sixties and seventies, particularly in

ANTONI CLAVÉ: *Roi et reine;* 1957. Oil on canvas, 100 x 160 cm. Musée National d'Art Moderne, Centre Georges Pompidou, Paris.

his dialogue between abstraction and figuration or space and light, apparent in his depictions of human torsos with amputated limbs. Examples of such works include *Vault Men* (1963) and *Men with Door* (1965), which feature an inner light shining from their central void. Another instance is the work of Martín Chirino (b. 1925), a native of the Canary Islands, who trained in Italy and England, where he soon discovered the sculpture of Henry Moore and Barbara Hepworth and also took an active interest in African and Abo rigine art. His series entitled *The Wind* (1960), rendered in iron, especially wrought iron, led him to the spiral as a principle of tension, force and movement. He was to develop it further in the sixties, as in *Aeróvoros,* a continuous, horizontal spiral, and *Afrocán* (oval forms with vertical energy). The steles he made in the eighties were a hymn to Canary-Island primitivism and to the simplicity and infinitude of Brancusi.

Constructivism: the Cuenca School

The Cuenca school was characterised by a lyrical brand of abstraction. Its members were Fernando Zóbel, Gerardo Rueda and Gustavo Torner, whose work Zóbel defined as 'serene and orderly, tasteful and intelligent, sensitive and rigorous', although their painting was actually more sensual and emotional than intellectual. In 1966, they set up the Museo de Arte Abstracto Espanol in Cuenca.

After assimilating Rothko's spatial concept and concluding his calligraphic paintings *Saetas* and *Black Series* in 1963, Fernando Zóbel (1924–1984) sought Eastern bareness in transparency and luminosity, in nebulous pictorial effects and elegant, measured and vibrant gesture. The sensibilities of Gerardo Rueda (1926–1996) were akin to the Cubists and the constructive classicism of Morandi. With his restrained chromatism, spatialism and plane composition, influenced by Nicolas de Staël and Poliakoff, his style bordered on monochrome painting and Neo-Plasticism. Gustavo Torner (b. 1925) was more radical in his constructional approach. Like Rueda, he was interested in geometrical austerity, but his

work occasionally displays a Surrealist cast which sets it apart. His style became increasingly more minimalist and more full-bodied after abandoning canvas in favour of wood and metal.

The radical abstraction that characterised this group, which exhibited some features of American Abstract Expressionism, influenced a number of painters that emerged in the mid-seventies, notably Álvaro Delgado, Jordi Teixidor, Miguel Ángel Campano and José Manuel Broto.

The style of the Valencian painter, Manuel H. Mompó (1927–1992), could be described as an almost musical abstract lyricism, characterised by subdued blue, green and yellow grounds strewn with corpuscles seemingly floating weightlessly in space.

American abstraction was brought to Spain by two artists who spent much of their life in the United States: Esteban Vicente (b. 1903) and José Guerrero (1914–1991). Vicente became a naturalised American in 1940 and did not return to Spain until 1985. His work endeavours to achieve luminosity through the use of opaque colours, which are full-bodied. He avoided gesture and matter, and assimilated the work of Matisse and Cézanne, as he did that of Gorky and Rothko, whom he knew.

While Vicente sought objective lyricism, Guerrero reconciled background and form, space and colour, by using a specific tone of each colour—*Cerulean Blue* (1977), *Vibrant Red* (1977), *Violet Expansion* (1978)—or setting up contrasting relationships—*Ochre and Black* (1979), *Blue and Pink* (1977). He produced his first abstract paintings in New York, where he met numerous members of the New York school and was especially influenced by Rothko, Kline and Motherwell. He is regarded as the father of a generation of artists who embarked on a 'return to painting' in the late seventies and early eighties.

Analytical Abstraction and Normative Art. Kinetic Art

Geometrical constructivism has not had many followers in Spain, but it has yielded a few prominent figures who have been instrumental in preserving a pure form of abstract art. They followed the tradition of Constructivism and Concrete art of the sixties, as exemplified by members of the Grupo Parpalló (1956), and the tenets inherited from the Equipo 57. The latter, founded in 1957, consisted of José Duarte, Agustín Ibarrola, Juan Cuenca, Ángel Duarte and Juan Serrano. Their work was based on Neo-Plasticism and Suprematism and the trend set by Jorge de Oteiza who, together with Pablo Palazuelo, paved the way for Geometric art in Spain.

In 1960, the Grupo Parpalló organised the first exhibition of Spanish normative art in Valencia. On that occasion, one of the exhibitors, Eusebio Sempere (1923–1985), stated: 'I advocate an artistic appraisal of certain elements of reality; elements from the physical world, such as electricity, space, light and time'. Sempere had already staged his first abstract art exhibition in 1949 and his research into art as a dynamic object coincided with the promotion of Kinetic art on an international scale by the Denise René gallery in Paris in 1949, through an exhibition entitled *Le mouvement*. Without abandoning pictorial pigment, Sempere developed light effects in his work during the fifties. He introduced real movement into artworks by combining art and new technologies. Taking advantage of the findings of Constructivism and Kinetic art, he eventually incorporated light, sound and movement to create spaces and atmospheres.

Pablo Palazuelo (b. 1916) took up Constructivism early on in his career, producing his first abstract compositions in 1948. He studied architecture at Oxford in the thirties and, under the influence of Klee, practised a particular form of analytic abstraction in the period 1957–1970. After living in Paris for many years he returned to Spain in 1963. Palazuelo, who has turned his hand to painting, sculpture and engraving, differs from the followers of formalist Constructivism in his perfectionist approach and in an inner spirituality derived from Kandinsky's finest theories. His interest in Eastern philosophies, ancient geometry, symbols and numbers endows his work with a spiritual substance removed

ANTONIO SAURA: *Great Crucifixion in Red and Black;* 1963. Oil on canvas, 195 x 245 cm. Museum Boymans-van Beuningen, Rotterdam.

from purely formal speculation. As Claude Esteban once pointed out, Palazuelo's 'geometry' should not be confused with a quantitative weighting of figures. Rather, his work is, as he puts it, 'a trans-geometry; a melodic capture of the world's eurythmy'.

As from 1965 and under the influence of normative languages, José María Labra (b. 1925) developed an extremely hermetic Constuctivist style based on undulating lines in relief which meet in the centre of the canvas. The work of the Valencian José María Yturralde (b. 1942) connects up with the Constuctivist abstraction of the Cuenca school (Zóbel, Rueda and Torner), Italian spatialism and Vasarely. His early Kinetic work focuses on light and movement, while his *Impossible Figures* and non-Euclidean geometric projections are perhaps his most interesting offerings from the sixties. Kinetic art, Op art, Neo-Constructivism and new technologies applied to art earned widespread acclaim in Catalonia through the *MENTE* exhibitions organised in 1968 by the critic Daniel Giralt-Miracle.

Social Realism and Chronicling Reality. The Influence of Pop Art

Just as Informal art was gaining recognition and making inroads into the market, a crisis was brewing in the movement. During the sixties, the contemporary debate between art and society, the advent of Pop art, mass communication, the incorporation of Marxist thought into art analysis, and the rise of structuralism and semiotics began to pose a formi-

dable political and ideological challenge to the declining dictatorial regime. The upshot of all this was that art then adopted a socially committed stance: solidarity and joint effort emerged to replace Informalist subjectivism. The newfound ethos precipitated the formation of such movements as Estampa Popular (1960) and Grupo Hondo (1961), and art communities such as Equipo Crónica (1964) and Equipo Realidad (1966).

Directly inspired by the Mexican movement known as Gráfica Popular, Estampa Popular appeared in Madrid around the year 1960. Soon, other groups that adhered to similar tenets sprang up in Valencia, Catalonia, the Basque Country, Castile and Galicia. Their goal was to bridge the gap between art and society by creating comprehensible, popularised and economical images. It was an art form which involved social commitment and denouncement, as expressed through Social Realism. In technical terms, this was achieved by making prints, so that artists tended to resort to line engraving and short print-runs. It became a popular art form in Catalonia (E. Boix, J. Guinovart, C. Mensa and Artigau), the Basque Country (Ibarrola) and Valencia, and enjoyed the support of such critics as José M. Moreno Galván, Tomás Llorens and Vicente Aguilera Cerni.

The Grupo Hondo, whose members included Fernando Mignoni (b. 1929), José Paredes Jardiel (b. 1928) and Juan Genovés (b. 1930), came closer to triggering a resurgence of figurative art, as its aim was to make a break with the Informalist past. However, only Genovés managed to approach what Aguilera Cerni dubbed 'a chronicle of reality', that is, a form of painting that explored media images and messages and in which the painted object was replaced by its counterpart from real life. It was a mixture of Expressionist Informalism and Pop art, based on the realities of censorship and persecution in the Spain of the sixties, which was still ruled by the Franco regime. The objective was to reconcile art with the social status quo. Images of that period which became celebrated show crowds of people being chased on the street in broad daylight, viewed at microscopically close quarters, turning the spectator into a voyeur of his own social situation.

Rafael Congar abandoned Informal art in 1964 and adopted the spirit of the 'reality chronicle'. He added the third dimension to his work using wood, polyester and fibre glass, and enhanced the human presence, while reducing his palette to a bare black-and-white.

Another group with a critical standpoint that grew out of Estampa Popular was the Equipo Realidad (1966–1976), whose members included the Valencians Jordi Ballester (b. 1941) and Joan Cardells (b. 1948). Their painting involved critical opposition to the Franco regime, the capitalist system and the culture of wastefulness. Its sources of inspiration included mass communication, comics and children's magazines, and it took an anti-militarist stance in its series entitled *Hazañas bélicas* ('Deeds of War', 1973). Using a figurative language based on photography and Pop art, it conveyed candid messages intended to influence social conduct. The critic Aguilera Cerni regarded it as 'a way of apprehending real life as an awareness of what is required'.

Another spin-off from Estampa Popular was the group Equipo Crónica, founded in 1964 by Rafael Solbes (1940–1981), Manolo Valdés (b. 1942) and Joan A. Toledo (1940–1995), and continued by the first two after Toledo withdrew from the group. Their work was a genuine team effort which endured until the death of Rafael Solbes, after which Manolo Valdés continued on his own. The members of Equipo Crónica collaborated on joint projects as a deliberate artistic alternative to subjective individualism, and advocated a committed approach to reality, so that their painting might have a social part to play in a historical context.

They developed their own interpretation of Pop art and borrowed mass-communication techniques relating to optical distortion and repetition, which they used ironically as a way of critisizing the political status quo in Spain, a privilege which the leading American Pop artists could not boast of. In 1969, the idea of 'serial' production prompted them to create variations on a theme, enabling them to imbue their canvases with a cultural, social and political charge commensurate with the situation in Spain. Noteworthy was their series on Picasso's *Guernica* (1969), and *Autopsy of a Trade* (1969–1970), a reflection on

EQUIPO CRÓNICA: *Interior with New Suit;* 1980-1981. Oil on canvas, 217 x 170 cm. Museo Nacional Centro de Arte Reina Sofía, Madrid.

503

the practice of art, at a time of widespread crisis in the sector, as a way of bringing pressure to bear on the powers that be. Others include *Police and Culture* (1971), and the *Black Series* (1972), inspired by American underground films and detective novels. In the sixties, they introduced a number of portraits, still-lifes and landscapes rendered in an experimental technique involving visual recall. These were followed by *Game of Billiards, Autonomy and Responsible Practice* (1976–1977), *Urban Landscape* (1979), *Journeys* (1980) and *Chronicle of a Transition* (1980–1981), a set of allegorical essays on avant-garde scene painting.

The critical spirit of Eduardo Arroyo (b. 1937) is close to that of Equipo Crónica, although he anticipated the latter by one year, in an exhibition at the Galería Biosca in 1963. He was probably instrumental in introducing Critical Realism as a unique, individual art form into Spain. Arroyo is actually a journalist by trade, although he successfully transposed the critical approach of written journalism to painting. He moved to Paris in 1958, and returned to Spain in 1986, representing his country at the Venice Biennial of 1995. Arroyo is an exponent of narrative figuration and his subject matter is essentially Spanish: he is a past master at lampooning national clichés. His critical satire and derision of the Franco dictatorship infused his work with a seditious, irreverent streak that earned him recognition throughout Europe. Unlike Equipo Crónica, which advocated group projects, Arroyo's work is subjective and even autobiographical. He harangues such modern myths as Miró and Duchamp, and his painting is an ongoing homage to the irreverence of Picabia, with an admix of American Pop art. Arroyo has also painted stage sets and designs for theatre and opera.

From New Figuration to 'Gordillismo'

Informal art fell out of favour and went into decline in the early sixties, triggering a resurgence of figuration influenced by several factors: the work of Francis Bacon, Pop art and Superrealism. The new figurative trend was taken up by a broad repertoire of artists, notably Juan Barjola (b. 1919), Ángel Orcajo (b. 1934), José Hernández (b. 1944), Alfredo Alcaín (b. 1936), José Luis Fajardo (b. 1941), Alfonso Fraile (1930–1988) and Eduardo Sanz (b. 1928).

Two figures who deserve special mention are Jorge Castillo (b. 1933) and Darío Villalba (b. 1939). Castillo, who lived in New York for some time, resorts to a form of figuration influenced by such old masters as Velázquez, Goya and Picasso. His style borders on several currents, particularly Surrealism, although he is equally conversant with abstraction and classicism.

Villalba, whose vision of human frailty is influenced by photography, was fortunate enough to have seen the rise and flowering of American Pop art for himself. His critical dialogue with Pop art led to a series entitled *Encapsulated,* dating from the sixties and seventies. At the end of the seventies, he steeped himself in dark, rough, bituminous monochrome tones. His association with photography has parallels in Hamilton, Richter, Polke, Rainer and Appel.

The late sixties saw a reaction against both the lingering poetics of Informal art and the Critical Realism that had emerged just a few years earlier. The turning point came at an exhibition, 'New Generation', organised by José Antonio Aguirre at the Sala Amadis in Madrid in 1967, at which a number of disparate artists displayed their work. Artists who have since risen to prominence include Alexanco, Elena Asins, Teixidor and Gerardo Delgado, although the success of some of the tenets of this 'new generation' is largely due to Luis Gordillo (b. 1934), whose synthesis of figuration and abstraction, Pop art, Informalism and photography was to some extent instrumental in creating the freedom characterising Spanish painting in the eighties.

Gordillo abandoned his Informalist past to devote himself exclusively to Surrealist automatism, subsequently approaching the style of some English and American Pop artists

EDUARDO ARROYO: *Suit going down the Stairs;* 1976. Oil on canvas, 242 x 139 cm. Institut Valencià d'Art Modern, Valencia.

The journalist Eduardo Arroyo first embarked on his painting career during his exile in Paris. His work has always been characterised by his critical stance, initially vis-à-vis the Franco regime, and by his Informalist style. It is related to the narrative figurativism of American Pop art and the new European figuration. His ongoing criticism has also been directed at painters, as in a series of 'blind painters' executed in 1975 and 1976. They feature smartly dressed anonymous figures with the exposed parts of their body—hands and face— shown stained or tarnished. These 'masks', a recurring motif in his oeuvre, may symbolise alienation from society, while their impeccable grooming might refer to the mercantilisation of labour.

(Hockney, Kitaj, Rauschenberg), with a touch of Bacon and Giacometti. His is a hybrid oeuvre which reveals an interest in the chromatics of spot colours in silk-screen printing and in process colour printing. The four-colour separation process prompted him to develop his own range of colours in his painting, which also draws on photography and pictures published in newspapers and magazines. He is a painter of cold, distant tonal ranges who attempts to reconcile figuration with abstraction without resorting to Informalism or Expressionism. Gordillo's work has survived by indulging in its own contradictions and has exerted an enormous influence on younger artists, particularly those who were active in the late seventies and early eighties, notably his closest disciples, Carlos Franco (b. 1951) and Carlos Alcolea (1949–1992), who gradually evolved towards what may be termed 'Gordillismo'.

Everyday Realism

Apart from newfound figurative art, and the impact of Pop art and Superrealism, a school of realism emerged in Madrid which was typified by poetic introspection and a 'Franciscan vision', as applied to nature and to everyday life. This realism, rooted in the tradition of 17th-century Castilian painting, is distinct from both academic realism and Social Realism.

Virtually all the artists associated with the Madrid school trained at the Fine Arts Academy of San Fernando in the late fifties, while the term 'Spanish realists' is applied to the sculptors Julio (b. 1930) and Francisco López Hernández (b. 1932), Antonio López García (b. 1936), María Moreno (b. 1933), Isabel Quintanilla (b. 1938) and Amalia Avia (b. 1930).

The principal traits of these artists is the poetic, intimate and commonplace realism of their still-lifes and landscapes, and their technical prowess, as well as a pessimistic view of man which pervades many of their subjects with nostalgia, fatalism and Existentialist philosophy.

Prominent in this respect is the work of Antonio López García, who has achieved a greater measure of international success. A protege of his uncle's, the painter Antonio López Torres, his approach has been to stress the spirituality of humble things, in keeping with the mystic poetry of Castile. In his nudes, he emphasizes the painfulness associated with privacy vulnerated, in addition to the passage of time and the effects of ageing.

The international resurgence of such artists as Lucian Freud, Balthus, Edward Hopper and Andrew Wyeth in the seventies gave renewed impetus to Madrilenian realism and, in 1982, Antonio López García exhibited at the Vienna Biennial, alongside Lucian Freud and R.B. Kitaj.

The various Realisms have had their share of variations and followers, noteworthy among whom is Luis Marsans (b. 1930) and artists from younger generations, whose pictorial work has developed in the eighties, including Xavier Serra de Rivera (b. 1946), Raimon Sunyer (b. 1957), César Galicia (b. 1957), José Manuel Ballester (b. 1960) and the brothers Josep and Pere Santilari (b. 1959).

Sculpture. The New Generation

Two figures stand out in the development of post-war abstract sculpture in Spain—Jorge de Oteiza (b. 1908) and Eduardo Chillida (b. 1924). Oteiza's major achievements date from the fifties, when he developed his *Experimental Proposition* (1956–1957). His 'proposition' involved placing sculpture in the service of Basque primitivism and archaism, both for stylistic reasons and with the aim of creating a Utopia in which man would become one with nature, and art with religion. To attain this metaphysical goal, he adopted a form of essential reductionism, his 'spatial evacuations' in iron, which entailed decon-

LUIS GORDILLO: *Grey & Vinegar Trio;*
1976. Acrylic on canvas, 200 x 276 cm.
J. Suñol collection, Barcelona.

structing modular units such as a cylinder, cube or sphere. These 'evacuations' developed into his well-known series of *Metaphysical Boxes* or *Empty Boxes*.

Oteiza's preeminence over other sculptors was inexcusably conspicuous, particularly in the case of Eduardo Chillida, Néstor Basterretxea, R. Mendiburu and the whole new generation of eighties' Basque sculptors.

Chillida followed in Oteiza's footsteps in terms of developing the idea of Basque national identity in sculpture. His long and consistent career makes him the most prominent figure in Spanish sculpture during the second half of this century. His first work in iron, *Ilarik* (1951), led him to discover the archaic side of wrought-iron craftsmanship in the Basque Country, while his *Aranzazu Gates* (1954) epitomise the simplicity and austerity he imposes on his sculpture.

Chillida applied the dictates of nature to his work: wind, water, stone, rock, tides and waves—it is always the forces of nature that become trapped in his sculpture. This is perhaps more tangible in his monumental works, such as his series *Comb in the Wind* (1972–1977), on the cliffs at San Sebastián, or *In Praise of the Horizon* (Gijón, 1990). Whether using iron, cement, terracotta, wood, stone or alabaster, Chillida's sculpture emerges from the void—his 'raw material'—and from the abysmal force of the void its material presence is projected into space.

In the fifties and sixties, a sizeable new generation of organic, abstract sculptors emerged chiefly in Valencia and Catalonia. The Valencian Andreu Alfaro (b. 1929), a one-time member of the Grupo Parpalló, started out in the milieu of normative art with marked constructivist leanings. In 1959–1960 he hit upon the metal rod as a useful element of rep-

etition, and discovered the importance of axes for distributing space. At times he approached Kinetic art, and at others Minimalism, without relinquishing the classical order that prevailed in his work. In the sixties he developed his generatrices, leading him close to Op art. Many sculptures that can now be seen in cities and alongside motorways in Spain date from that period. He subsequently returned to classicism with his drawings 'in the air' and his filiform entities. His limestone and marble steles proclaimed his renewed espousal of classicism, although at times this revealed an underlying romanticism, as in his homages to Goethe.

In Catalonia, three currents of sculpture were emerging at the time: classicist-based figurative art, Expressionist-inspired informal abstraction, and experimental abstract sculpture based on the use of 'poor' materials. Josep Maria Subirachs (b. 1927) is an exponent of the first current. His early, post-19th-century classical approach gave way to a dramatic form of Expressionism, apparent in his facade of the Virgen del Camino shrine in León (1959). His sculpture later became more abstract after seeing the work of Julio González, whose art was the object of a revival in the sixties. Some of Subirachs' finest works belong to this abstract period, including *Monument to Monturiol* (Barcelona, 1963), *Monument to Mexico* (1968), the *Cross of St Michael* (1962) and *Monument to Ramon Llull* (Montserrat, 1976).

Another prominent abstract sculptor was Salvador Aulestia (1919–1994), who applied his effusive Expressionism to sheet-iron, as in *Sideroploide* (1960–1963), which can still be seen in Barcelona harbour.

Three sculptors whose work was dissociated from classicism were Xavier Corberó (b. 1935), Marcel Martí (b. 1925) and Moisés Villèlia (1928–1994). With Informalist aesthetics as his point of departure, Corberó migrated towards Expressionism, as evinced in his monumental bronze reliefs which he called 'volume-boxes'. His bronzes, marbles and basalts recall the influence of Brancusi, Arp and Noguchi. The work of Marcel Martí is imbued with an organicist spirit, which is occasionally anthropomorphic and invariably characterised by vertical growth, as in one of his most effective pieces, *Medas* (1970). Villèlia adopted the experimental line of Joan Miró, Calder, the Surrealists, Ferrant and Cristòfol in his use of poor, flimsy materials, while his concept of form was midway between Moore and Giacometti. In 1958, he incorporated reeds as a sculptural element, alongside other lowly materials, including wire, which he used to fashion organic, web-like pieces. Lastly, his discovery of bamboo and *gudúa* (which he found in Ecuador) enabled him to endow his work with a different dimension, which also drew on his knowledge of Oriental art.

This review of sculpture would be incomplete without drawing attention to the contributions made by Tàpies, and the Dadaist irony of Joan Brossa with his poem–objects, which have again become popular in the eighties and nineties. Experimental sculpture in the sixties was marked by the impact of Arte Povera conceptual poetics. Jordi Pablo (b. 1951) was the undisputed heir to experimental sculpture, in line with the morphology developed by L. Cristòfol, A. Ferrant and E. Serra, and the precedents set by Man Ray and Duchamp. His theoretical writings, *Cuerpos, formas y objetos en el espacio,* published in 1975, are a magnificent contribution to the theory of form.

Possibly the most remarkable exponent of Arte Povera poetics, however, was Noguera (b. 1941), a disciple of Eudald Serra's, particularly in his experimentation with the energy contained in matter and his sculptural vision of objects in space. The influence of French neo-Realism comes through in Miralda's (b. 1942) *Soldered Soldiers* (1965–1969) and *Cenotaphs* (1975), a concerted reflection on sculpture and the idea of monuments. Jaume Xifra (b. 1934), who is fascinated by the aesthetics of rites and ceremonies, worked as a sculpture poet in the sixties and seventies, producing luminous ritual objects and relics, and a series of 'impossible' and 'irreversible' objects. Lastly, Josep Ponsatí (b. 1947) endowed the repetitive structures of his monumental, inflatable sculptures, released to the whim of wind and terrain, with the grandeur and spirituality of dynamic Minimalism, midway between sculpture and Land art.

ANTONIO LÓPEZ: *Washbasin & Mirror;* 1967. Oil on panel, 98 x 83.5 cm. Private collection, Madrid.

Arte Povera and the Conceptual Poetics of the Sixties

A new and sizeable generation of artists broke with the tradition of Informal art, Social Realism and the figuration of the sixties, and embarked on a period of reflection on art as a language.

Echoes of all the movements that characterised the prodigious decade of the sixties reached Spain, including the yearning for freedom from prevailing political regimes, the ideological struggle marked by the writings of Marx, Lukacs and Marcuse, the rediscovery of Freud, the rise of the mass media, the theories of Max Bense and McLuhan's *The Gutenberg Galaxy.* The widespread enthusiasm over the new technologies enlivened the last few years of life under the Franco regime, as Spain became caught up in the mass movements for national, social, racial, feminist and student liberation. Pacifism, feminism, the hippies, the underground, beat rock, the beat generation and May of '68 were the cultural touchstones for that generation.

There was a return to the historical roots of the avant-garde, particularly its utopian attitude, geared to bringing about change in society. Morever, Dadaism came back into fashion, especially the figure of Marcel Duchamp.

During the closing years of the dictatorship, the experimental practices collectively known as Conceptual art gained most currency in Catalonia, where attitudes were more receptive to change and coincided with a concerted drive to reassert the Catalan identity as part of the transition to democracy, a fact that led art to become highly politicised.

The Spanish conceptualists shared Duchamp's ironical approach to objects, as well as the original avant-garde idea of art as attitude. Warhol's Pop art was admired for the way it presented the new mass media myths, while the influence of Dadaism and neo-Dadaism, epitomised by the way Duchamp and Warhol used images and found objects, also made inroads into Spanish art. To some extent, Fluxus' idea of art as an integral part of life also took root, as did his rejection of originals and his drive to popularise art through multiplicity and reproduction. Arte Povera, with its energetic vibrancy, material

EDUARDO CHILLIDA: *Comb in the Wind;* 1972-1977. Cliffs at San Sebastián, Guipúzcoa province (Basque Country).

mood and spatial penchant, came close to the sensibilities of Conceptualism, and considerable importance was attached to the material, objective Informalism of Burri, Millares and of course Tàpies.

The group known as ZAJ, which embarked on its pioneering activity in 1964 and lasted until 1972, led the new trend in Madrid. Its founder members were Walter Marchetti, Juan Hidalgo (b. 1927) and Ramón Barce. The first two met in Milan around 1956, and two years later Hidalgo met John Cage in Darmstadt.

ZAJ embodied the spirit of Fluxus in Spain as early as 1964. Directly influenced by Duchamp, Satie and Cage, their 'performance-concerts' ranged between the extremes of a musical concert and poetic action, and resorted to devices associated with art, music and drama. Ramón Barce left the group in 1967 and was replaced by Esther Ferrer (b. 1937). The group's activity was most productive betwen 1964 and 1972, the year of the 'Pamplona Encounter', an international gathering at which art was debated.

Nacho Criado (b. 1943), following a Minimalist period (1966–1970) which came to an end with his homage to Rothko, met Hidalgo and Marchetti in 1971. This marked a turning point in his work, related mainly to experiments involving nature and the human body, and revealing his interest in such artists as Manzoni, Beuys and ZAJ itself. In 1977, he even gave a Performance in conjunction with Hidalgo. His *Beats* and *Urban Route,* in addition to his participation in *Documents I & II* in the 'Four Elements' experience, were his major Conceptual works in the seventies.

ANDREU ALFARO: *Ethereal Work;* 1977.
Rose garden in the Parque Cervantes,
Barcelona.

JOSEP MARIA SUBIRACHS:
Female Torso; 1972.
Private collection, Madrid.

Noteworthy in Madrid were the offerings of Valcárcel Medina, Tino Calabuig and, above all, Alberto Corazón (b. 1942). In late 1969, Corazón published his portfolio of silk-screen prints entitled *Manipulating Images. 1st Proposal,* featuring an iconography combining Social Realism and politically orientated Pop art, to which he soon added a physical walk and the use of transparent plastic (Galería Redor, 1971). His *Documents,* executed in 1972 and 1973, epitomise how the language of Pop and Conceptual art can be transposed to graphic design, which he took up from 1976. In the nineties, he returned to sculpture.

In Catalonia, many artists of that period emigrated, particularly to Paris and New York, in search of newfound creative freedom. Those active in Paris at the end of the sixties, including J. Rabascall (b. 1935), J. Xifra (b. 1934), A. Miralda (b. 1942) and B. Rossell (b. 1937), engaged in a large number of joint ritualistic and ceremonial activities, culminating in Documenta at Kassel in 1977. F. Torres (b. 1948), A. Ribé (b. 1943) and E. Balcells (b. 1943) were the artists active in New York in the early seventies.

The Paris group was closer to Environment, Pop art, 'New Realism' and even happenings, while those that had emigrated to New York, primarily Muntadas and Torres, chose to work on media landscape and incorporate new techonologies, such as video and multimedia installations.

Thus, Conceptual art borrowed from matter, nature, landscape and all experiences relating to Land Art (J. Miralles, Noguera, C. Pujol, A. Ribé, F. Abad, J. Domènech and J. Ponsatí). In the field of Performance and Body art, prominent were the sensorial actions of

Muntadas (1971–1975), and the Performances of Jordi Benito, who followed an Expressionist line akin to Viennese Performance art. Carlos Pazos incorporated drag and the Star System into his work, while the activity of Francesc Torres focused mainly on behavioural art, as did that of Àngels Ribé. Lastly, Carlos Santos staged a form of Performance based on musical events.

Object art, widely practised by such artists as J. Pablo, J. Pazos, J. Cerdà, C. Pujol, J. Domènech, J. Xifra, F. Torres, B. Ferrer, E. Balcells, B. Rossell and Miralda, involved revisiting the distant precendents set by Dadaism, Pop art and New Realism, as related to popular Catalan tradition.

The most dematerialised form of Conceptual art, with philosophico-linguistic roots and a Wittgensteinian core, was prompted by the publication of *Art & Language,* the figure of J. Kosuth and, to a lesser extent, the activity of D. Graham, On Kawara and L. Weiner. At some stage, it influenced the Catalan Grup de Treball and F. García Sevilla, who used a rhetorical brand of this language on the basis of tautology as a provocative source of poetic images. Another interesting line of work was that of 'sociological art' and Mass Media, whose main exponents were J. Rabascall, Eulalia, Muntadas and F. Abad.

To recap, the initial, formative stage of Conceptual art in Spain lasted from 1964 to 1970 and took in both Pop art and Arte Povera. The year 1964 saw the exhibition entitled 'Machines', and the first 'worthless' sculptures by Antoni Llena, the first artist to adopt Arte Povera in Spain: his manifesto on poor, flimsy materials was published in the journal *Mosca* as early as 1968. He worked with extremely poor materials until 1969, after which his activity came to a halt and was only resumed in the late seventies. The experiments staged by S. Gubern, J. Galí and A. Llena in the Jardí del Maduixer in 1969 were described by Alexandre Cirici as the start of Arte Povera in Catalonia.

The second period, which ran from 1971 to 1975, was marked by the appearance of the Grup de Treball, the implementation of a radical, avant-garde programme, and endeavours to bring art into the mainstream of politics and society with the aim of overhauling the art establishment. The aforementioned group got involved in a bitter controvesy with Antoni Tàpies after the publication of the latter's article, *Arte conceptual, aquí* ('Conceptual Art, Here') in the newspaper *La Vanguardia* on 14 March 1973, in which he described the Conceptual projects of young artists as a trend and style. The Grup de Treball's riposte, published in the twenty-first issue of the journal *Nueva Lente* (November 1973), accused Tàpies of being a stylistic, apolitical avant-garde practitioner lacking social commitment and kowtowing to market forces.

The Grup de Treball organised the 'Informació d'Art' series of exhibitions and some political actions, notably one which denounced the arrest of 113 members of the Assemblea de Catalunya, which was influential in restoring Catalonia's autonomous status. The group also took part in the Ninth Paris Biennial, held in 1975 and, almost posthumously, in the exhibition entitled, 'The Artistic Avant-garde and Social Reality. Spain, 1936–1976', presented at the Venice Biennial and at the Miró Foundation in Barcelona. With the death of General Franco on 20 November 1975, art was depoliticised and returned to normal democratic channels of expression.

A third, post-Conceptual period, spanning the years 1976 to 1980, could also be established. From 1976, Conceptual artists withdrew into individual reflection, which led them to either adopt a belligerent Conceptual attitude or to devote themselves specifically to painting or sculpture.

THE ECLECTICISM OF THE EIGHTIES AND NINETIES

1976—The Return to Painting

Following the death of Franco, Spanish art aroused considerable interest abroad. The presentation of 'The Artistic Avant-garde and Social Reality. Spain, 1936–1976' at the

Venice Biennial was, for the international community, a review of the relationship between the artistic avant-garde and Spanish society from the Spanish Civil War until the end of the dictatorship.

By the second half of the seventies, a return to painting and sculpture as specific practices became noticeable, just when Conceptual artworks were most widely exhibited in newly-opened specialist galleries, and were becoming popular as collector's items. The return to painting was marked by a debate between those who advocated continued adherence to Conceptual languages and those who favoured a pictorial approach detached from all ideology and dogmatism.

When the introductory issue of the journal *Trama* came out in April 1976, with an article in which Tàpies heaped praise on the painters José Manuel Broto, Gonzalo Tena, Javier Rubio and Xavier Grau, it was taken as a decisive move in favour of an alternative to Conceptual poetics. Indeed, *Trama* came out in support of the line followed by M. Pleynet, *Support-Surface* and the postulates of the journal *Peinture Cahiers Théoriques,* directed by Louis Cane and Marc Devade.

Other signs of the resumption and of the coexistence of painting with Conceptual practices became clear at Documenta, held in Kassel in 1977. Meanwhile, in Spain, a number of exhibitions heralded the rise of Abstract Reductionism, as in '10 Abstracts' (Buades, Madrid, 1975) and 'In Painting' (Palacio de Cristal, Madrid, 1977).

This new approach to painting was partly derived from 'new figuration' (1967) and 'Gordillismo', and grew up in the circles around the Sala Amadís (1971–1972), Daniel (1972–1973) and Buades (1973–1974). These circles were consolidated in the seventies and eventually presented their work as a coherent grouping at the exhibition entitled '1980' in the Galería Juana Mordó in 1979. The exhibitors were Carlos Alcolea, José Manuel Broto, Miguel Angel Campano, Chema Cobo, Gerardo Delgado, Pancho Ortuño, Guillermo Pérez Villalta, Enrique Quejido, Manolo Quejido and Rafael Ramírez Blanco. This group, with its figurative roots, was subsequently superseded by the pictorial generation genuinely associated with the eighties, whose members were Barceló, Sicilia, Mira and others, and which ended up absorbing the former grouping. The trend in question was further asserted in an exhibition entitled 'Madrid D.F.' (Museo Municipal, 1980), although here the scope was broader.

The narrative style of Luis Gordillo, a transition figure between the sixties and seventies, is conspicuous in the work of Carlos Alcolea (1949–1992), who was also influenced by Hamilton and Hockney. It is also apparent in Carlos Franco (b. 1951), in which the commonplace fuses with psychoanalysis, and in Chema Cobo (b. 1951), whose work features a combination of the commonplace and allegory. Pérez Villalta (b. 1948) adopted a more extreme approach in his criticism of modernity and his revival of classicism, as well as in his neo-mythologies and ambiguous architectural styles reminiscent of Mannerist sensibilities.

The artists working along similar lines in Barcelona were José Manuel Broto, Javier Rubio, Gonzalo Tena and Xavier Grau, who were subsequently joined by Fernando García Sevilla. Together they organised a controversial exhibition entitled, 'Towards an Appraisal of Painting' (Maeght, 1976).

José Manuel Broto (b. 1949) removed the borderline between figuration and abstraction, leaving a shadow of reality behind as the only recognisable sign. Xavier Grau (b. 1951) and M.A. Campano (b. 1948) worked on the abstract gesturalism and expressionism of Action Painting. Grau's work is still tinged with reminiscences of Philip Guston, while Campano's work has echoes of Motherwell and Twombly.

Jordi Teixidor (b. 1941) and Santiago Serrano (b. 1942) were also adherents of this newfound abstraction, which was more Minimalist and initially more structuralist, linking up directly with the Cuenca school. Their work was tempered by chromatic lyricism and an expressive use of colour, borrowed partly from the American painting of Rothko, Newmann and Motherwell. Gerardo Delgado (b. 1942) and Soledad Sevilla (b. 1944) started out in cybernetic rationalism, and evolved towards a less structural form of painting with greater attachment to the surface. Soledad Sevilla went beyond the canvas and mastered geometric structures in real space with her highly interesting installations.

In the transition from the seventies to the eighties, other prominent Spanish artists included Robert Llimós (b. 1943), Zush (b. 1946) and Frederic Amat (b. 1952). With his formative background of late-sixties figuration and realism, Llimós subsequently discovered American abstraction and certain conceptually-based experiences. Zush (Albert Porta), who developed a psychedelic form of painting, produced a work entitled *Evrugo Mental State,* an ironic, stark, visionary and critical figuration with a liberal sprinkling of Surrealist automatism, which exposes the monstruous side of human nature. Frederic Amat initially went through a Mexican period, during which his work acquired great material and chromatic richness. In New York, he later hit upon such materials as wax with which he gradually fashioned a primitivist, mythological oeuvre marked by permanent metamorphosis.

The Eighties: a Time for Enthusiasm

The return to Spain of Picasso's *Guernica* in 1980 was a symbolic act marking the restoration of democracy. From then on, the State implemented institutional mechanisms

JOSÉ MANUEL BROTO: *Point of View;* 1986. Acrylic, 300 x 300 cm. Galería Maeght, Barcelona.

to promote the dissemination of world art in Spain, and Spanish art abroad. In 1980, Margit Rowell organised the exhibition, 'New Images from Spain' at the Guggenheim, featuring works by Sergi Aguilar, Teresa Gancedo, Miquel Navarro, Zush, G. Pérez Villalta, A. Muntadas and S. Pagán.

On the international scene, painting and figuration came back into fashion in various guises: Neo-Expressionism and 'wild painting' in Germany, the transavant-garde in

Italy, 'bad painting' in the United States and a whole range of denominations applied to various forms of Mannerism and anachronisms.

Since Documenta, held in 1982, Spanish art has been tuned into the spirit or *Zeitgeist* of the times, which was also the title of the exhibition staged in Berlin in 1982. From then on, Spanish art lived out its moment of splendour, drawing international attention and such reviews as the exhibitions 'Spain 87/Dynamics and Debate' (Paris, 1987) and 'Before and After the Enthusiasm' (Amsterdam, 1989).

The triumph of Miquel Barceló (b. 1957) at Documenta 1982 marked a turning point for young Spanish art. The Majorcan painter contributed Mediterranean light, the 'matter' genre of Catalan painting and the indigenous Baroque tradition to the inordinately dark and dramatic European neo-Expressionist scene. That was the time when Basquiat, Clemente, Schnabel and Salle were achieving acclaim in America, while Baselitz and Lüpertz were doing likewise in Germany, and Clemente, Chia, Paladino and Longobardi (with the aid of Achille Bonito Oliva) in Italy.

Barceló, initially promoted by Yvon Lambert, then by Lucio Amelio and finally by Leo Castelli, had unparalleled success on the international market with an oeuvre which explores the history of painting, its genres and myths, only to discover, in the dry African wastes of Mali, a tragic struggle between life and death—the *memento mori* that pervades his work of the nineties.

Fernando García Sevilla (b. 1949) and Juan Navarro Baldeweg (b. 1939) went beyond the Conceptual experience. The former, in particular, followed the international trajectory of his compatriot Barceló, carving out a figurative landscape thronged with graffiti, primitivism, traces of other civilisations, Expressionism, Eastern culture and a wild, brutal gesturalism which puts him in tune with the neo-Expressionism prevalent in Europe. The Aragonese Víctor Mira (b. 1949) was another of the great neo-Expressionist artists of the eighties: he developed a tragic style impregnated with Baroque mysticism.

The early eighties spawned a host of new artists, including José María Sicilia (b. 1954), who undertook a revision of pure abstraction, without abandoning all recognisable traces of the body or object, a legacy of Pop art. This revisionist line of abstraction has also been followed by Juan Uslé (b. 1954), a native of Santander, which came through in the work he presented at Kassel in 1992.

In Galicia, the 'Atlántica' movement, which first appeared at an exhibition in Bayonne in 1980, reflected on the Atlantic identity of Galician art, with an awareness of its antecedents and Galician emigration to the other side of the Atlantic, and a reappraisal of its forerunners, including Luis Seoane, Díaz Pardo and Raimundo Patiño. A new generation of painters and sculptors grew up around the Atlántica movement and the exhibitions it staged. Noteworthy is the neo-Expressionist painting of Menchu Lamas (b. 1954), the sculptural primitivism of Francisco Leiro (b. 1957), who adopted the sculpture of rounded forms associated with popular tradition, and Antón Lamazares (b. 1954), with his interesting organic and Surrealist approach to matter.

The Rise of Sculpture

The sculptors of the transitional period, interpreters of a post-Minimalist style, were Eva Lootz (b. 1940), Adolf Schlosser (b. 1939) and Carmen Calvo (b. 1950). They first came to public notice in 1976 in connection wih the Galería Buades. Eva Lootz adopted the elementary forms of post-Minimalism and its contrast between hard and soft materials, such as lead, paraffin and wool. Schlosser returned art to nature, and extracted it from nature, with his trees, stones and forests. Carmen Calvo, for her part, built an experimental laboratory of materials and forms, with registers directed either at painting, sculpture or Conceptual art. The Valencian Miquel Navarro (b. 1945), also from this transitional generation, used Minimalism to conquer space. His renderings of the city, executed in the mid-eighties, are perhaps his most representative work.

MIQUEL BARCELÓ: *Sistole, Diastole;*
1987. Mixed media, 398 x 400 cm.
CAPC-Musée d'Art Contemporain
collection, Bourdeaux.

The work of sculptors from this new generation, which emerged in the eighties, was first seen together at an exhibition organised by the Fundació la Caixa in 1984 entitled 'In Three Dimensions'. They were instrumental in reinstating iron as a sculptural material and furthered the tradition of Julio González and Pau Gargallo, although filtered through the sieve of Minimalism.

Sergi Aguilar (b. 1946), who first trained as a goldsmith, developed a geometrically-based style with a monumental calling. His approach to sculpture was elementary and perfectionist, with minute variations on a given subject. His work has reminiscences of Brancusi's infinitude, the purity of Palazuelo and the viewpoint of Anthony Caro.

Susana Solano (b. 1946) mastered space with her structures based on home fittings: boxes, cages, display cabinets, fireplaces, cupboards and tables. She combined the large-scale Object art of Tàpies with the mastery of space of Judd and particularly Robert Morris, whose sculpture her work shows most affinities with, as evinced in her offerings at the Venice Biennial of 1986 and at Documenta the following year.

Ángeles Marco (b. 1947) also moved close to Minimalism, while Agustí Roqué (b. 1942) established a dialogue between sculpture and architecture in his celebrated series on the balcony railings in Barcelona.

Jaume Plensa (b. 1955) and Juan Muñoz (b. 1953) pursued other objectives. Dispensing withi Minimalism, Plensa embarked on cast-iron sculpture which was distinct from the fusion-welding procedure recovered by his peers with their Minimalist leanings. His sculpture, totemic and primitive in its beginnings, was holistic rather than fragmentary, Conceptual rather than formal, a blend of Utopia and reality. In the work of Juan Muñoz, the theatrical character of his figures eventually yielded an ironical vision of contemporary man, caricatured in virtually empty settings.

Other Spanish sculptors of the eighties include Cristina Iglesias (b. 1956), who took part in the Venice Biennial of 1993 and highlighted the artifice of sculpture through the use of cement, and Joan Rom (b. 1954), who created some highly original pieces in an organic, structural style based on the use of rubber, leather, wool and glass, with allusions to the body and its imprint.

The nascent Basque sculpture of the eighties again took up the issue of Basque identity, in keeping with the spirit of Oteiza's boxes and his spatial evacuations. Exponents of this trend include Txomin Badiola (b. 1957), with his Minimalist-based sculpture, Ángel Bados (1945) and Pello Irazu (b. 1963), with a more constructional approach.

In Valencia, sculpture developed in the tradition of Alfaro and Miquel Navarro. A new generation of sculptors in the eighties emerged from local fine arts schools in search of a form of sculpture based on the object. Ricardo Cotanda and Maribel Domènech are prominent exponents of this current.

The eighties saw the appearance of artists whose work was midway between sculpture, painting and the poetic object. Having experienced Conceptual art with great euphoria during their formative period, they developed a unique style which overstepped the boundaries between painting and sculpture. This is attested to in the work of Pep Durán (b. 1955) and Jordi Colomer (b. 1962), more akin to sculpture, and Perejaume (b. 1957), with his reflections on painting.

In the nineties, Spanish artists from preceding generations have continued to thrive, producing works of great vigour and currency. Notable examples of this include Antoni Tàpies, Antonio Saura and Eduardo Chillida. However, numerous options have also emerged in unison: from the mid-eighties, a new Conceptualism arose unhindered by the political and ideological bias of the seventies. At the same time, multimedia installations were set up by artists who hailed from historical Conceptualism, such as Francesc Torres and Muntadas. Lastly, the work of younger artists active in Conceptual art was also consolidated, including that of Rogelio López Cuenca, Eugenio Cano, Marcelo Expósito and Pedro G. Romero.

The subjects of violence, homosexuality, marginalisation, AIDS, feminism and the human body were approached by the younger artists using poetics in which the medium was unimportant and all means considered legitimate, especially photography. The anatomical art of the nineties had its leading exponent in the figure of Pepe Espaliú (1955–1992), whose work is displayed posthumously in such thematic exhibitions as 'Rites of Passage' (Tate Gallery, 1995).

A concerted effort has been made in Spain during the eighties and nineties to promote art, as evinced in the opening of new museums. These include Madrid's Museo Nacional Centro de Arte Reina Sofía (MNCARS), the Instituto Valenciano de Arte Moderno (IVAM), which was opened in 1989, the Centro Atlántico de Arte Moderno (CAAM) in Las Palmas, the Centro de Arte Santa Mónica (Barcelona, 1988), the Fundación Tàpies (Barcelona), the Centro Gallego de Arte Contemporáneo in Santiago de Compostela, the Museo de Arte Contemporáneo de Barcelona (MACBA), the Museo Extremeño e Iberoamericano de Arte Contemporáneo (MEIAC) in Badajoz (1995) and the new Guggenheim Museum of Bilbao.

Expo 92 in Seville and the Olympic Games of Barcelona turned out to be ideal occasions for developing contemporary art programmes, while Barcelona is now implementing a large-scale project of public, monumental sculpture to match the architectural and urbanistic changes of the last few years.

ARCHITECTURE

Modernity Revisited

In the fifties, the need to recover Le Corbusier's avant-garde rationalism of the thirties became apparent in Spanish architecture. This opened up new horizons, which led

Spanish architecture to link up with the international spirit of the period. A new generation of architects in Barcelona rebelled against the autarchy of the forties. Their direct ties to such Italian architects as Bruno Zevi, Gio Ponti and Alberto Sartoris, and to the Finnish architect Alvar Aalto, opened up a new front for dialogue between functionalism, elementary rationalism, decorative organicism and the vernacular tradition, which had considerable influence on the 'Grupo R', founded in 1952 by Oriol Bohigas, J.A. Coderch, J. Gili, J. Martorell, A. de Moragas, J. Pratmarsó, J. Sostres and M. Valls, who were later joined by Giráldez, Balcells, Ribas y Piera and Bassó. Despite many individual differences, the group strove to reinstate the adventure of the avant-garde.

Four exhibitions at the Galerías Layetanas between 1952 and 1958 attested to the vigorous drive by this generation to impose organicism as a style. The declared aim of the 'Grupo R' was to prompt a far-reaching architectural debate, which eventually led to a form of realism with regionalist or vernacular overtones, the characteristic of what came to be called the Barcelona school, which dominated architecture during part of the fifties and all of the sixties.

FERNANDO GARCÍA SEVILLA:
Ruc 18; 1987. Mixed media on canvas, 290 x 330 cm. Galería Juana de Aizpuru, Madrid.

FRANCISCO LEIRO: *O Moucho ('The Owl');* 1983. Polychromed pinewood, 290 x 37 x 68 cm. Contemporary art collection, Madrid.

SUSANA SOLANO, *The Bridge*, 1986. MACBA Collection. On loan from the Barcelona City Council.

This work was executed just as Susana Solano was achieving international recognition in the second half of the eighties. Her career proved to be one of the fastest-evolving and best-consolidated of all Spanish artists at the time. Despite the monumental character of her work, on account of its sheer size and the materials used, her creations relate directly to the viewer and convey a degree of intimacy. Solano's formal mastery of space and her evocations of existential images from the past are factors that help to define both *The Bridge,* as part of her series on city features, and much of her oeuvre.

JAUME PLENSA: *Cloudy Box X.* 1994. Private collection, Barcelona.

A similar movement emerged in Madrid which included architects imbued with the spirit of El Paso. Some even contributed to its foundation and attempted to restore ties with rationalism. The movement's members included Antonio Fernández Alba, Javier Sáenz de Oiza, Miguel Fisac, Curro Inza, J.A. Corrales and R.V. Molezún, among others.

A. Fernández Alba (b. 1927) worked with Gio Ponti in Milan in the mid-fifties, and was awarded the 'Grupo R' prize in Barcelona in 1956. He combined his architectural practice with lecturing and theoretical writings. For him, architecture is a cultural phenomenon governed by constructional logic through the language of geometry. Prominent works of his include the Monastery of El Rollo (1960) and the Convent of the Discalced Carmelites in Salamanca (1970). He collaborated with Félix Candela on the Spanish Trade Centre in London (1974) and produced a number of projects for school and university buildings, a noteworthy example being the Faculty of Educational Science at Salamanca University (1970–1981–1983) and the Technical College of Industrial Engineers in Valladolid (1982–1985). He was also commissioned to restore and remodel the Astronomical Observatory of Madrid in 1981, for which he was awarded the National Restoration Prize.

Javier Maderuelo defined his notion of architecture admirably in an article entitled 'Sólida y lógica de la construcción. (El mundo de las ideas de Antonio Fernández Alba)', *Anthropos* 152, pp. 32: 'For Antonio Fernández Alba, architecture should also generate a place; that is, it should endow space with life and meaning, and include topological, cultural and historical references and identity traits, so that an area is transformed into a habitable place, in an emotional sense that goes beyond the idea of comfort and functionality'.

JOSEP-ANTONI CODERCH: residential blocks for fishermen in the Barceloneta quarter. Barcelona, 1954.

In 1952, José Antonio Corrales (b. 1921) and Ramón Vázquez Molezún (b. 1922) came together to form one of the most active and well-established teams of the fifties. They developed a rationalistic, organicist style, apparent in the Secondary School at Herrera de Pisuerga, Palencia, in 1955 and the Spanish Pavilion at the Universal Exposition of Brussels in 1958.

In the Basque Country, Sáenz de Oiza (b. 1918) applied his functional models to large, low-cost housing blocks, connecting up with the avant-garde that had been cut short by the war, including the Erillas (1955) and Batán (1955–1961) Housing Developments. His 'White Towers' (1962–1968), on the Barajas motorway, have been likened to Marina City in Chicago. Another Basque, Luis Peña Ganchegui (b. 1926), set out to reconcile modernity with traditional Basque architecture in terms of geography and society. His major environmental works of the sixties were in Motrico (Guipúzcoa province). An outstanding work of his from the seventies was the Unión Farmacéutica building in Eibar (1973–1975) and, in the eighties, the Parque de la España Industrial in Barcelona, by way of a homage to the bygone era of nascent industrialism.

In Galicia, Alejandro de la Sota (1913–1996) adopted some features of popular tradition. He applied technology and the quality of different materials to develop a structural architecture determined by the setting. This is apparent in the gymnasium of the Colegio Maravillas in Madrid (1962). His mastery of a project's structural features is also evinced in the Communications Centre in León (1983–1984) and in his refurbishment of the civil government building in Tarragona (1985–1987), executed with the assistance of Pep Llinás.

Both Sáenz de Oiza and de la Sota were key to a revision of the modern movement, a process they viewed from different positions, which were to influence the following generation, particularly Rafael Moneo, on the one hand, and Juan Navarro Baldeweg and Manuel Ignacio de las Casas on the other.

Two buildings in Barcelona epitomised the resurgence of rationalism: the new Faculty of Law (1958), on Barcelona's Avinguda Diagonal, designed by the team of Subías, Giráldez and López Iñigo, and the College of Architects building (1958–1962), by Xavier Busquets.

Three figures were emblematic of the transitional period characterised by the recovery of rationalism and modernity: Antoni de Moragas (1913–1985), Josep Maria Sostres (1915–1984) and Josep-Antoni Coderch de Sentmenat (1913–1984).

Antoni de Moragas, who was influenced by Alvar Aalto and Bruno Zevi, was, perhaps more than anyone else, instrumental in introducing organicism into Spain, as evinced in the undulating facade and the construction of the Cine Fémina in Barcelona. Moragas also restored ties between Catalan and European architecture, particularly Italian and Scandinavian, and was a pioneer in introducing the idea of design in the fifties, when he founded the Agrupación de Diseño del Fomento de las Artes Decorativas (ADI-FAD) in Barcelona. His Italo-Finnish brand of organicism was manifest in the aforementioned cinema, as well as in the Park Hotel housing development and the church of San Jaume in Badalona (1957). From then on, his work acquired a more personally distinct style: he strove to recover vernacular structural values, which he interpreted in rugged fashion, while committing himself to an analysis and recomposition of structural elements.

Josep M. Sostres was more of a theoretician and educator—qualities he developed as a professor of architectural history in Barcelona—than a practitioner of architecture. He studied the figures of the transition to modernity, namely Gaudí, Van de Velde and Frank Lloyd Wright, and advocated an 'acritical' form of rationalism, a stance that marked the demise of architecture as a personal form of expression and placed it within an anonymous context of overall design. His major works are the Casa Agustí (1955) in Sitges, the Hotel María Victoria (1956) in Puigcerdà, the MMI building (1958) on the Diagonal in Barcelona and the headquarters of the newspaper *El Noticiero Universal* (1956).

J.A. Coderch produced most of his work in conjunction with Manuel Valls (b. 1912). His headstrong character soon led him to abandon the 'Grupo R' and embark on a radical solo career. His architectural style is a clear example of reconciliation between modern

SÁENZ DE OIZA: 'White Towers'. Madrid, 1962-1966.

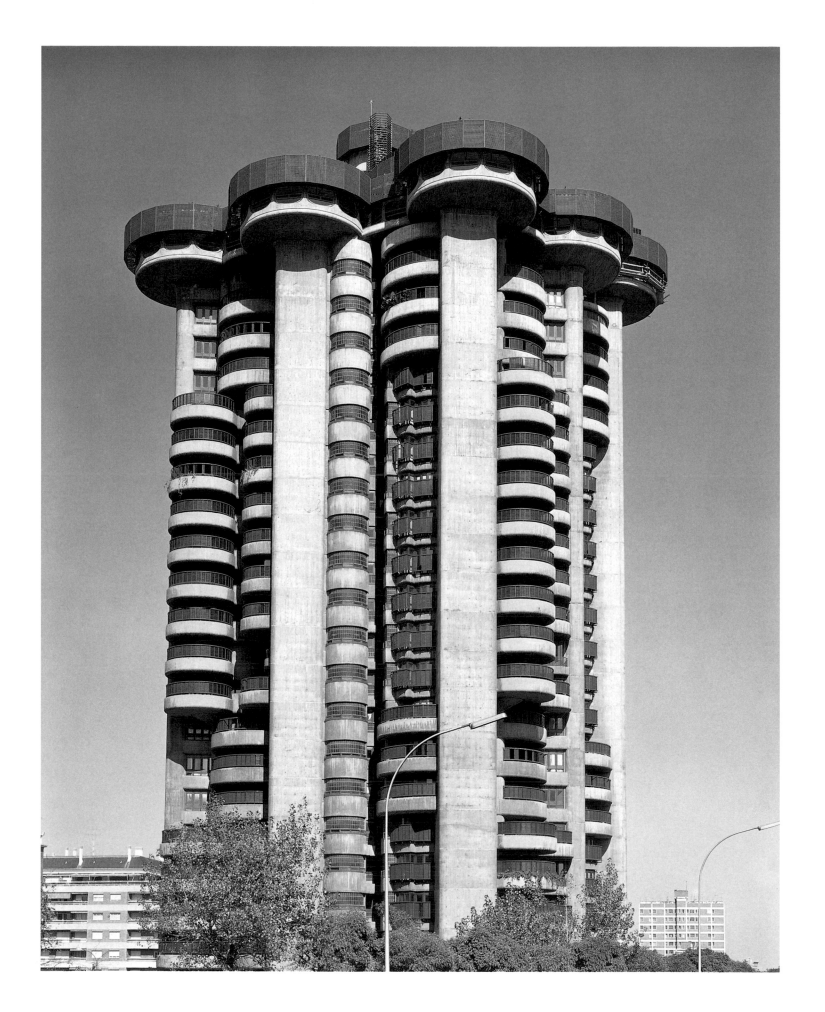

rationalism, regionalism and Mediterranean style, using vernacular organic materials such as brick, roof tiles and wood. In his early period he designed single-family housing units such as the Casa Ugalde (1951), which exemplifies the prime of grass-roots Mediterranean architecture. His finest work during that period, for the dynamic relationship between the interior spaces, was the housing block for fishermen (1954) in Barcelona's Barceloneta quarter. He also designed the home of the artist Antoni Tàpies (1964) and, in the late sixties, adopted Mies' curtain-wall, as in the Trade buildings (1968–1973). A prominent example of his late period is the French Institute building in Barcelona.

Coderch's mastery was taken up in Barcelona by the team consisting of Federico Correa (b. 1924) and Alfonso Milà (b. 1924). They developed a meticulous style for interiors, both in their remodelling of middle-class flats in Barcelona's Eixample quarter and of houses on the Costa Brava, and their interest focused on methodological aspects of project and design. Their painstaking, aristocratic style led to some celebated interiors, such as those of the Reno (1962) and Giardinetto (1973) restaurants, while their rugged Atalaya building (1966–1970) is reminiscent of BBPR studio's Velasca Tower in Milan. Federico Correa has also taught at the Elisava and Eina design schools in Barcelona.

Realism and Tradition in the Sixties' Debate

Labour migration from the countryside to the cities and the consequent urban growth in the sixties led to intense social and architectural development. The new groups of architects that sprang up were highly successful in adapting international rationalism to designs for low-cost housing, prefabricated and industrial units. The groups included the aforementioned Subías–Giráldez–López Iñigo and Fargas–Tous teams and Xavier Busquets, although the architects that most clamoured for architectural realism and thus a return to traditional, vernacular craft values were the members of the MBM team (Martorell–Bohigas–Mackay). This revival of grass-roots tradition entailed recuperating architectural and decorative Modernism as part of an overall design strategy, and therefore rescuing from the past such figures as Domènech i Montaner and Jujol.

In May 1962, Oriol Bohigas (b. 1925) published what amounted to a manifesto: an article entitled 'Towards Realism in Architecture' which appeared in the journal *Serra d'Or*. It was a call to architects and artists in general to recognise their commitment to society. The housing developments on Barcelona's Avinguda Meridiana (1959–1965) are patent examples of that realism adapted to local tradition. MBM's rationalism was derived from Italy and the figure of G. Terragni, while interest in design and the quality of local materials and craftsmanship was Aalto's legacy.

For Philip Drew, 'MBM's architecture is a mixture of Catalan realism and fantasy: it is decidedly rational, at times rigidly so, but, for all that, inclined to sculptural gestures and an intense identification with the region' (Gustavo Gili, Barcelona, 1993).

The members of the MBM team have fuelled an architectural debate lasting from the fifties until the present, particularly Oriol Bohigas who, from the Barcelona City Council and since the eighties, has promoted a town-planning programme culminating in the architecture of 'Olympic Barcelona'.

The return to the urban precincts characteristic of the historical city, to its parks, patios, streets and squares, and to the traditional urban district demarcations, is the guiding principle behind MBM's architectural approach, in which the revival of the grass-roots Mediterranean tradition is apparent in their use of patios, balconies and streets as a natural extension of the dwelling, gallery, pergola, terrace, bay window and tribune, all of which make for architecture on a human scale. Other hallmarks of their projects include the use of the diagonal as a sculptural gesture, breaking with the monotony of a plane, endowing facades with volume and introducing an interplay of light and shadow.

Part of their prolific output has centred on school architecture, as in the Garbí (1962–1973), Thau (1972–1974) and Sant Adrià (1981–1988) schools. Other noteworthy

works by this team include the Can Sumarro library in L'Hospitalet (1982–1984), the Nestlé building in Barcelona (1983–1987), the 'Future Pavilion' at Expo 92 in Seville, with its socially-oriented design, the Nova Icària housing development in Barcelona's Olympic Village, and the Creueta del Coll park, also in Barcelona.

By the late sixties, when a move was afoot to come up with a definition of the Barcelona school, the latter had practically disappeared. Many of its would-be members, including Correa, Milà, Tusquets, Cirici, Pep Bonet, Ricard Bofill and Lluís Domènech, had embarked on separate careers.

MBM (MARTORELL–BOHIGAS–MACKAY),
Housing block on the Avinguda Meridiana.
Barcelona, 1959-1965.

Crisis, and a Revision of Modernity

A crisis in the modern movement was detected in the mid-seventies, while the need for critical revision was tinged with Post-Modernism and eclecticism, with a trend towards the preeminence of individuality over currents. The influence of Aldo Rossi and his 'city architecture', as well as the Post-Modern theories of Robert Venturi, were decisive in braving the crisis. One of the upshots of this was a return to historicism.

Ricard Bofill's (b. 1939) entry into the architectural scene of the times prompted a renewed dialogue with space and a consideration of architecture as an all-encompassing art form. In 1960 he founded his *Taller de Arquitectura* ('Architecture Workshop'), a many-sided, interdisciplinary team which, in its early phase, focused on creating new types of housing. A second phase yielded widespread recognition, with the team's designs for the Expressionist, Gaudian Barrio Gaudí in Reus (1964–1970) and the Walden-7 building in Barcelona (1970–1975). In its late period, following disappointment over losing the Halles project in Paris, Bofilll's team devoted its endeavours to transforming entire cities, an approach which retains much of Spain's Baroque grandiloquence. The results can be seen in the Parisian villas known as Les Arcades du Lac (1981–1985), Le Viaduc (1972–1982) and Les espaces d'Abraxas (1978–1983), and the Antigone project in Montpellier.

Bofill's architecture takes in a wide variety of styles, which he himself sees as follows: 'I have traversed different civilisations, from Alvar Aalto to Antoni Gaudí, and from vernacular Mediterranean architecture to the derelict cities with no architecture on the fringes of the Sahara [...] They are important, consecutive references in my way of thinking, conceiving and feeling space; the relationship between space and solids, which in my view defines the essence of architecture'.

In Catalonia, the crisis was averted through a move away from the realism of the Barcelona school. This departure, which Ricard Bofill had himself undertaken to achieve, also characterised some teams of architects that emerged in the seventies, including Studio PER—Lluís Clotet, Pep Bonet, Óscar Tusquets and Cristian Cirici—the Garcès–Soria team and that of Helio Piñón and Albert Viaplana. That was an austere generation, which advocated a bare form of architecture with Conceptualist overtones.

With the aid of Venturi's theories, the Studio PER soon went beyond the norms of the modern movement and adopted a sphere of limitless proposals in the context of the history of architecture. The joint projects undertaken by the Studio PER (1965–1975) to some extent perverted the architecture based on design tenets, creating a kind of 'anti-design', apparent in Belvedere Georgina (1970–1972), by Clotet–Tusquets. At times, they also elected to adopt certain traditional forms, such as the classicism in ruins of the Casa Vitoria on the Italian island of Pantelleria (1975), also by Clotet–Tusquets.

The separate development of the team's members eventually led to conceptual variations in their careers. Cristian Cirici (b. 1941) used design to remodel historical architecture, as in the BD Ediciones de Diseño areas in Barcelona. He accepted the more industrial aspects of architecture and their relationship to engineering, as in the hydraulic power station at Estany-Gento Sallente. Pep Bonet (b. 1941) seemingly locked himself up in structural Minimalism, as evinced in his home in San Antoni de Vilamajor (1985) and, to a more radical degree, in the outpatients clinic at Parets del Vallès (1983–1985). Lluís Clotet (b. 1941) went into partnership with Ignacio Paricio. Together, they explored the options provided by technology and produced some of the most significant works in recent times in Catalonia, notably the Banco de España building in Girona (1983), the water-storage plant in Cuidadela Park (Barcelona), the remodelling of the Convent of San Agustín, which was turned into Barcelona's Central Art History Library, and the new School of Architecture in the Vallès district. Óscar Tusquets (b. 1941), for his part, managed to apply experimentation to tradition and accepted certain conventions as an architectural language. Outstanding works of his over the last ten years include the Auditorium in Las Palmas, the low-cost housing development in Reus and the housing project at Premià de Dalt (1983–1984) in the Maresme district. A noteworthy example of his restoration work is the Palau de la

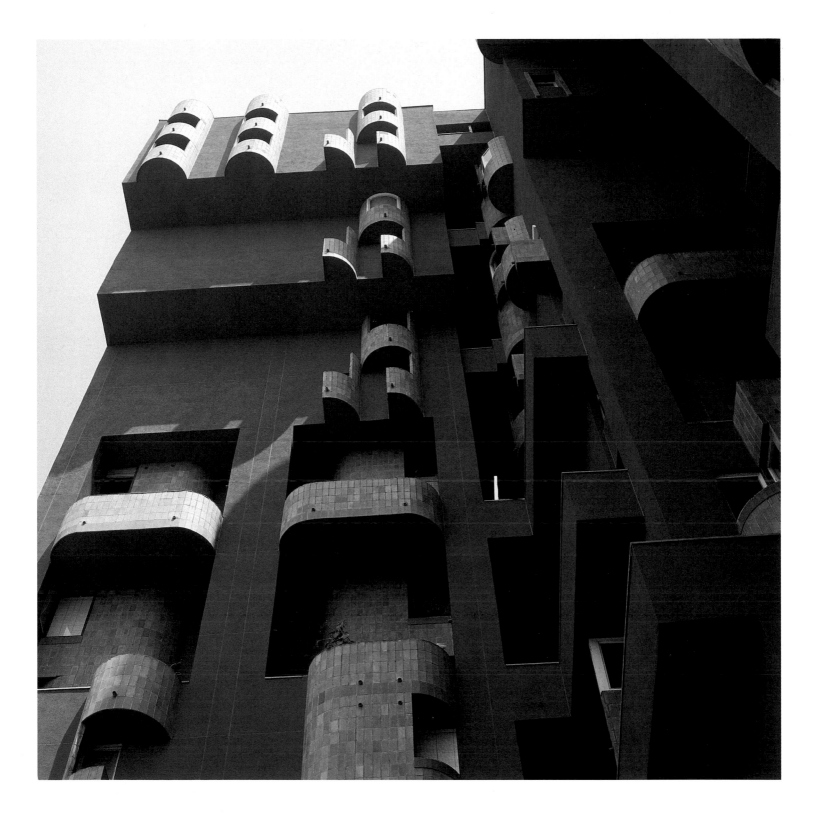

Música Catalana concert hall, a Modernist building originally designed by Lluís Domènech i Montaner.

The Minimalism of Jordi Garcès and Enric Sòria was conspicuous in their early work, such as the groundwater depot at Santa Maria de Barberà (1971). Their architecture is composed of clearly separate elements, each of which is different from the others and becomes an entity on its own. In the sixties, their works were bare, conceptual and critical, as in the Resintex factory at Gavà-Castelldefels (1973–1977). Examples of the team's restoration work include the renovation of the Museu Picasso of Barcelona in the early eighties and the private home of Josep-Antoni Salgot at Sant Feliu de Guíxols, dating from the mid-eighties.

RICARD BOFILL: Walden-7 building. Sant Just Desvern (Barcelona), 1975-1979.

RAFAEL MONEO: detail of the interior
of the Museo de Arte Romano, Mérida.

Another radically-oriented partnership to emerge in the seventies was the one made up of Helio Piñón and Albert Viaplana which, until 1976, also included Gabriel Mora. They made their debut on what was by then the controversial home of Jiménez de Praga (1967), and subsequently concentrated mainly on urban design, in which they adopted a truly provocative attitude. In a conceptual, self-analytic, projectional and almost transparent style, they tend to the radical abstraction of forms and to Minimalism in urban design, which is artificial, with a sculptural and technological gesture. This is the spirit they breathed into two projects in Barcelona: the controversial Plaça dels Països Catalans (1983), and the remodelling of the Centro de Arte Santa Mónica, with a ramp added to its exterior, false arches in the interior, and a sloping grille dividing the upper space into a diagonal.

A disciple of Alejandro de la Sota's modernity is Juan Navarro Baldeweg (b. 1939). From the same generation as Rafael Moneo, he has devoted special attention to the topography of sites, and his 'House of the Rain' was one of the first examples of Minimalist architecture in the seventies. The old city has always been a source of inspiration for him, as a place where he conceives of buildings providing the setting for the theatrical aspects of social life. His floating cupolas, like the one in the Conference Hall in Salamanca (1985), his overhead lighting and his recurrent rows of seats and tiers reveal how he views a building as a place for social interaction. Some of his finest works include the Segura River Mills (1984), the Festival Hall in Santander (1984) and the Conference Hall of Cádiz (1988).

As a young man, Rafael Moneo (b. 1937) was a direct disciple of Sáenz de Oiza, whom he collaborated with on the 'White Towers' project in Madrid. He also contributed to the Sydney opera house project, alongside Jörn Utzon in Denmark (1961–1962). His *A la conquista de lo irracional,* published in 1966, became a highly influential reference work. He held a professorship at the Barcelona School of Architecture from 1970 to 1980 and was a contributor on the journal *Arquitecturas bis,* which aroused considerable interest among the new generation of architects in Barcelona. Renouncing typology, he adapts his style eclectically to the physical, cultural, historical and ideological context of a project: he searches for the basic profile of the form to be used and then projects it into space. For Moneo, architecture is communication, and should both respect and take advantage of the cultural tension of its own historical memory. His leading works include the Drieste factory in Zaragoza (1965–1967), the Bankinter building in Madrid (1973–1976), the Museum of Roman Art in Mérida (1980–1984) and, in the nineties, Seville airport (1992), the remodelling of Atocha station in Madrid and the Illa shopping complex on the Diagonal in Barcelona.

The emergence of Santiago Calatrava (b. 1951) in the eighties had a powerful impact on the architectural status quo, as not since the 19th century had there arisen such an integrating, aesthetic cross-fertilisation between architecture and engineering. Calatrava trained in Valencia and Zurich and is Spain's most international architect. His organic approach leads him to devise structural solutions based on nature, as in the movement of joints in the skeletons of vertebrates. His architectural style is one of sculptural, anthropomorphic, organic, Expressionist and symbolic gesture. Arboreal, alveolar, Gaudian spaces, but infused with new technologies. It is perhaps his bridges which provide the most syncretic paradigm of the functional with the symbolic. Prominent works of his with an engineering bias are Stadelhofen station in Zurich (1982), Bilbao airport and the Calatrava communications tower on Montjuïc hill in Barcelona (1989–1992).

Another contemporary architect who has produced interesting work is Guillermo Vázquez Consuegra. His major achievement has been his renewal of residential architecture in an urban context, without relinquishing rationalism, rendering apartment blocks with an elegance worthy of the classical avant-garde, as in the Ramón y Cajal housing development in Cádiz. Other figures include the team of José Antonio Martínez Lapeña (b. 1941) and Elías Torres (b. 1944), whose rationalist, geometric sobriety is undoubtedly influenced by Coderch and Scarpa. Torres, a native of Ibiza, has contributed Mediterran-

RAFAEL MONEO: Museo de Arte
Romano. Mérida, 1980-1984.

JAVIER MARISCAL: *Duplex Stool.* Barcelona, 1980.

Just as members of GATCPAC —particularly Torres Clavé—designed some of the furnishings in the Spanish Republic's pavilion at the Universal Exposition of 1937, after the Spanish Civil War it was architects that were called upon to renew interior design. Thus, F. Correa and A. Milà, for example, were commissioned to promote the 'Barceloneta' armchair for J. A. Coderch's building in the urban quarter of the same name. In Barcelona, a major city with thriving craft trades, and a large industrial capacity, new business and teaching infrastructure was created during the fifties, sixties and seventies, prompting the emergence of industrial designers and leading to the boom of the eighties. BD Ediciones de Diseño, founded in 1972, was commissioned to market the *Duplex Stool,* which led its creator, Javier Mariscal, to join the Post-Modern group Memphis, characterised by its rather outlandish, fantasy creations.

ean plasticity to the team. His Minimalist, austere and brilliant architecture is amply borne out in the Church of Hospitalet in Ibiza (1981–1984), as well as in the outpatients clinic in Gandesa (1982–1986), the hospital at Mora de Ebro and the Villa Cecilia park in Barcelona.

A large number of architects have contributed their grain of sand to these last two decades of the 20th century, a period of splendour and vigor in Spanish architecture and urban design. It is worth recalling such buildings as the Olympic Cycle Track in Barcelona's Horta district, by Esteve Bonell and Francesc Rius, the Raventós Cavas in Sant Sadurní, the university railway station at Bellaterra, the school architecture of the team consisting of Jaume Bach and Gabriel Mora, and the Provincial Trade Pavilion in Jerez de la Frontera, by Javier Vellés.

In the eighties and nineties, the architectural approach has centred on the city as a field of action. More building and renovation work has been undertaken in these two decades than in the preceding four. The fledgling democratic regime has turned architects

ÓSCAR TUSQUETS: *Varius Chair.* Barcelona, 1984.

into personal advisers, public works have been given renewed impetus and a host of teams have emerged to meet the newfound social needs and to implement institutional plans.

Restoration work, reconditioning and inventorying items in the National Heritage requiring protective measures have been the priority tasks. The dialogue between past and present has been settled with dignity, without giving in to the temptation of Post-Modern pastiche. However, excessive attention to design details and concern over external image have often led functionality and structural order, as well as balance in an overall, integral idea, to be neglected in favour of a sensorial appeal for materials.

Restoration and reconstruction have been accorded pride of place: suffice to recall the brilliant rehabilitation of the Mies van der Rohe Pavilion (1929), completed in 1986 by Ignacio de Solà-Morales (b. 1942), who has also been commissioned to restore the Barcelona Liceu.

The idea of the city–monument or museum–city was born, admirably embodied by post-Olympic Barcelona, with its aesthetic counterpoint in the valuable contribution made by foreign architects. This blend of local and foreign design is evinced in the Collserola communications tower, by Norman Foster, the Sant Jordi indoor stadium, by Arata Isozaki, the aforementioned communications tower by Santiago Calatrava, the Barcelona airport remodelling project, by Ricard Bofill, the Olympic Village tower, by S.O.M., the I. Pei tower in the old harbour, the reconditioned National Art Museum of Catalonia, by Gae Aulenti, and the new premises of the Contemporary Art Museum, by Richard Meier, an example which has been followed in the Basque Country with the new Guggenheim Museum of Bilbao, by the American Frank O. Ghery.

The meteoric rise and development of architecture in the eighties has helped to modernise industrial and graphic design, decoration and interior design, and has made a major impact in the field of publicity and advertising. The impact has been less spectacular in the field of large-scale technology, even though the Barcelona underground railway system and that of the Ferrocarriles Catalanes were the object of major renovation work.

Catalonia, with its deep-seated craft tradition and a large pool of Modernist resources to draw on, has been gripped by veritable design fever. The pioneers in this field were A. de Moragas, Miguel and Leopoldo Milà, Yves Zimmerman and Rafael Marquina, whose work overlaps that of the new generation of graphic designers, many of whom have trained at the Eina and Elisava schools or at the decorative arts institution known as FAD (Fomento de las Artes Decorativas). The latter was founded at the turn of the century and has industrial and graphic design departments. Among the activities it sponsors is the Delta prize, a yardstick in the history of contemporary Spanish design.

This new period of flowering has yielded industrial designers of the calibre of Josep Lluscà, the Gemman Bernal and Ramon Isern partnership, Eduard Samsó, Alfredo Arribas, Alberto Liévore, Jorge Pensi, the Estudio Quod, Ramón Benedito, Pete Sans, Carlos Riart, Gabriel Teixidó, Luis Morillas and Josep Puig, with contributions by the architects Tusquets, Cirici, Bonet and Lluís Pau.

Prominent figures from Valencia include Vicente Martínez and Javier Mariscal. The latter soon became fashionable in the world of graphic and industrial design, in conjunction with Pepe Cortés, after being commissioned to produce the Olympic mascot. Other noteworthy graphic artists include Enric Satué, América Sánchez, Claret Serrahima and Peret.

Progress and renewal in architecture, urbanism and design in the last two decades have translated into a better quality of city life. At this cusp of the 21st century, other challenges have to be met and new problems solved, such as demographic overcrowding, privacy in the city, new technologies, information highways, trans-national disease, and the dialogue between local and worldwide values, between physical and virtual reality, and ecology and life on this planet.

P.P.

SANTIAGO CALATRAVA: Montjuïc Tower, Barcelona. 1989–1992.

ADDENDA

JAUME HUGUET: St Sennen: detail from the *Retable of SS Abdon & Sennen;* 1459-1460. Tempera on panel; from the church of Sant Pere at Terrassa. Santa Maria church museum, Terrassa.

1000 BC TO AD 300

Kings and Rulers		Socio-political & Scientific Context		Art Context		Art Fact File	
Spain	Rest of World	Spain	Rest of World	Spain	Rest of World	Spain	Rest of World
From 1100 BC to 901 BC	Palestine: 1006-966 BC. David, king. Palestine: c. 966-926 BC. Solomon, king.	1100 BC. Traditionally, the date when Gades (Cádiz) was founded by the Phoenicians.	945-712 BC. Egypt: decline of the New Kingdom, XXII dynasty.	Urnfield culture. Late Bronze Age III.	1000-933 BC. Temple of Solomon. C. 1000 BC. The Phoenicians invent alphabetic writing.		
From 900 BC to 801 BC	Assyria: 883-859 BC. Ashurnasirpal II, king. Assyria: 858-824 BC. Shalmaneser III, king. Assyria: 810-805 BC. Semiramis, queen.	Arrival of the Illyrians and Celts. The Tyrians found Malaka (Málaga), Sexi (Almuñécar) and Abdera (Adrá).	Phoenician trade flourishes. Period of the great Assyrian empire. 814 BC. Traditional date of the founding of Carthage by the Phoenicians.	Urnfield and barrow culture. South-western Spain: glazed, reticular pottery. Majorca and Minorca: megalithic constructions.	C. 850-800 BC. Greece: Homer. Greece: Archaic period. Italy: Villanovan civilisation. Greece: Geometric pottery.	El Carambolo: glazed reticular pottery. 850 BC. 'Carp's-tongue' swords' in the Huelva estuary.	C. 900 BC. Gold objects in the royal burials at Tanis. 883-858 BC. Palace of Ashurnasirpal II.
From 800 BC to 701 BC	Assyria: 722-705 BC. Sargon II, king. Assyria: 705-681 BC. Sennacherib, king.	Splendour of the kingdom of Tartessus, in present-day Andalusia. Celtic invasion from Westphalia and the Netherlands.	753 BC. Founding of Rome (Romulus). 734 BC. Founding of Syracuse. 712-332 BC. Egypt, Late Period.	Indigenous culture becomes Orientalised. Andalusia: legendary kingdom of Tartessus.	C. 800 BC. Greece: Hesiod. C. 800 BC. Central Europe: Hallstatt civilisation. 800-700 BC. Italy: Etruscan civilisation.	Palace–shrine of Cancho Roano (Zalamea de la Serena, Badajoz).	C. 750 BC. Funerary vase, Athens. 722-705 BC. Palace of the Assyrian Sargon II. 705-681 BC. Palace of Nineveh.
From 700 BC to 601 BC	Assyria: 680-669 BC. Ashur-Dan, king. Assyria: 668-626 BC. Ashurbanipal, king. Babylonia: 605-562 BC. Nebuchadnezzar II, king.	C. 700 BC. Greek colony founded on Rhodes. The Greeks found Mainake and Hemeroscopium. Waves of Celts from Frisia and eastern France. 654 BC. Founding of Ebusus (Ibiza), a Carthaginian colony.	671 BC. The Assyrians conquer Egypt: their empire reaches its largest size. C. 640 BC. Greek colony of Naucrate (Egypt) is founded. 626-612 BC. Fall of Assyria. 625-539 BC. New Babylonian empire; Nebuchadnezzar II.		C. 680 BC. Assyria rebuilt by Ashur-Dan. C. 650 BC. Zenith of Assyrian art. C. 630 BC. Greece: beginnings of the recent Proto-Attic. 625-540 BC. Europe: Middle Hallstatt.	Terracotas from Illa Plana. Turret-like burials at Pozo Moro (Chinchilla, Albacete). End of century. Treasure of Aliseda.	668-630 BC. Palace of Ashurbanipal, Nineveh. C. 630 BC. Lady of Auxerre. 605 BC. Babylonia: Ishtar Gate.
From 600 BC to 501 BC	Greece: 560 BC. Pisistratus, tyrant of Athens. Persia: 558-528 BC. Cyrus II the Great, founder of the empire. Persia: 512-484 BC. Darius I, emperor. Italy: 509 BC. Lucius Junius Brutus & Lucius Traquinius Collatinus, first consuls of Rome.	550 BC. Emporion (Empúries). The Carthaginians conquer the south-eastern seaboard. 509-480 BC. The Carthaginians destroy Tartessus.	C. 594 BC. Solon's reforms in Athens. 550 BC. Peloponnesian League. 539 BC. Conquest of Babylonia by Cyrus II. 525-404 BC. Persian domination of Egypt (XXVII dynasty). 509 BC. The Republic is founded in Rome. 508-507 BC. Cleisthenes' democratic reforms in Athens.	End of century. Beginnings of Iberian culture.	600-590 BC. Greece: Attic Black-Figure ware. C. 590 BC. First Kouroi at Samos. C. 550 BC. La Tène culture in central Europe. C. 545 BC. Early, Attic Red-Figure ware. C. 520 BC. Pythagoras, Greek philosopher. 516-513 BC. Building commences at Persepolis.	Lady of Elche. Anthropoid sarcophagi at Cuerna Vaca (Cádiz).	C. 600 BC. Kouros of Sounion. Beginning of century. Cleobis & Biton of Delphi. C. 570 BC. Hera of Samos. C. 570-550 BC. François vase. C. 550 BC. 'Rampin Horseman' (Athens). C. 540 BC. Funerary Black-Figure amphora.
From 500 BC to 401 BC	Persia: 485-464 BC. Xerxes I, emperor. Greece: c. 462 BC. Pericles rises to power in Athens.	500 BC. Voyages of Hanno and Himilco.	499-304 BC. Median wars in Greece. 449 BC. Callius makes peace with Persia. 431-404 BC. The Peloponnesian War between Sparta and Athens.	5th century: age of splendour of Iberian culture. Obulco deposits.	C. 498 BC. First Ode to Píndaro. 496-406 BC. Sophocles: Greek dramatist. C. 460-440 BC. Voyages of Herodotus, Greek historian.		C. 500-475 BC. Capitoline Wolf. C. 478-474 BC. The Charioteer, Delphi. C. 470-465 BC. Temple of Zeus at Olympia.

1000 BC TO AD 300

Kings and Rulers		Socio-political & Scientific Context		Art Context		Art Fact File	
Spain	Rest of World	Spain	Rest of World	Spain	Rest of World	Spain	Rest of World
			404-403 BC. Tyranny of the Thirty in Athens and restoration of democracy.				C. 450-430 BC. Warrior of Riace. Ictinus & Phidias, Parthenon of Athens. Myron, *Discus Thrower*. Polyclitus, *Doryphorus*. C. 420 BC. Temple of Athena Nike.
From 400 BC to 301 BC	France: 396 BC. Brennus, leader of the Gauls. Persia: 380-335 BC. Darius III, emperor. Macedonia: 359-336 BC. Philip II, king. Macedonia: 336-323 BC. Alexander the Great, king. Egypt: 304-30 BC. Dynasty of the Ptolemies. Mesopotamia: 304-64. Dynasty of the Seleucids.	After 348 BC, the Carthaginians settle near Mastra, the capital of the Iberian tribe of the Mastrenes.	399-394 BC. War between Sparta and Persia. 387 BC. The Gauls march against the Romans. 348 BC. Treaty betwen Carthage and Rome. 337 BC. Confederation of Greek cities under Philip of Macedonia. 333 BC. Alexander the Great occupies Egypt. 323 BC. Alexander's empire crumbles; the Hellenistic kingdoms emerge.	Site at Cerro de los Santos.	399 BC. Death of Socrates, the philosopher. 386 BC. Plato founds the Academy. 384-322 BC. Aristotle, philosopher. C. 306 BC. Epicurus founds his school in Athens.	Lady of Baza.	C. 360 BC. Praxiteles, *The Aphrodite of Cnidus*. C. 350 BC. Mausoleum of Halicarnassus. C. 340 BC. Skopas: Aphrodite or Capitoline Venus. 340-310 BC. François tomb at Vulci. C. 330 BC. Theatre at Epidaurus. C. 310 BC. Sarcophagus of the Amazons in Tarquinia.
From 300 BC to 201 BC	Macedonia: 279 BC-AD 168. Dynasty of the Antigonids. Carthage: 247-183 BC. Hannibal, general. Syria: 223-187 BC. Antiochus III, king. Macedonia: 221-179 BC. Philip V, king.	237 BC. Hamilcar Barca lands at Cádiz. 228 BC. Founding of Cartago Nova (Cartagena). 226 BC. Treaty of the Ebro, between Carthage and Rome. 220 BC. Hannibal attacks Sagunto, a city allied to Rome. 218 BC. The Scipios land at Empúries. 211 BC. Defeat and death of the Scipians at Cástulo (Linares). 210 BC. Arrival of Publius Cornelius Scipio and Marcus Junius Silanus. 206 BC. Fall of Cádiz; end of Carthaginian domination. 206 BC.-205 BC. Uprising against Rome by the Ilergetas, Indibil and Mandonio.	298 BC-290 BC. Rome: third war against the Samnites. 285-282 BC. War between Rome and the Celts. 264-241 BC. First Punic War. 263-133 BC. The Kingdom of Pergamum is founded. 229-228 BC. First Illyrian War. 223-222 BC. Campaign against the Gauls of the Cisalpine. 218 BC. Outbreak of the Second Punic War. 212 BC. Syracuse sacked by the Romans. 202 BC. Roman victory at Zama; end of the Second Punic War. 200-197 BC. Second Macedonian War.	Reliefs of Osuna. Iberian culture goes into decline. 207 BC. The Romans found Italica.	300-280 BC. Euclid's *Geometry*. C. 290 BC. Founding of the Library and Museum of Alexandria. 270-184 BC. Plautus, a comic Latin poet. 212 BC. With the fall of Syracuse, the Romans seize Greek works of art, which influence their own production.		C. 290 BC. Temple of Athena in Pergamum. 285 BC. Colossus of Rhodes. C. 230 BC. Temple of Horus at Edfu. 220 BC. Construction of the Circus Flaminius.

1000 BC TO AD 300

	Kings and Rulers		Socio-political & Scientific Context		Art Context		Art Fact File	
	Spain	Rest of World	Spain	Rest of World	Spain	Rest of World	Spain	Rest of World
From 200 BC to 101 BC		Macedonia: 179-168 BC. Perseus, king. Syria: 175-163 BC. Antiochus IV Epiphanes, king.	197 BC. Hispania divided into two provinces, Citerior & Ulterior. 153 BC. First Celtiberian War. 139 BC. Death of Viriathus, leader of the Lusitanians. Second Celtiberian War. 133 BC. Conquest of Numantia; end of the Celtiberian Wars. 123 BC. Roman conquest of the Balearic islands.	192-188 BC. War against Antiochus III of Syria. 168 BC. Third war against Macedonia; the Romans defeat Perseus. 149-146 BC. Third Punic War. 147 BC. Rome occupies Asia Minor, and Egypt annexes Macedonia. 133 BC. Death of Attalus III; Pergamum ceded to the Romans. 133-123 BC. Agrarian reform of the Gracchis. 118-105 BC. War with Jugurtha.		174 BC. Cato starts writing his *Origines*. Golden Age of Latin literature: Cicero, Catullus, Virgil, Horace, Ovid, Livy. La Tène III culture.		*C.* 190-185 BC. Victory of Samothrace. *C.* 180 BC. The great altar of Zeus is built at Pergamum. *C.* 130 BC. Delian group of Aphrodite, Eros and Pan.
From 100 BC to 1 BC	Italy: 82-79 BC. Silius, dictator of Rome. Italy: 60 BC. Pompey, Caesar & Crassus, first Triumvirate of Rome. Italy: 46-44 BC. Julius Caesar, dictator of Rome. Egypt: 37 BC. Cleopatra, queen. Egypt: 30 BC. Alexandria falls to the Romans. Italy: 27 BC–AD 14. Augustus, first emperor of Rome.	82 BC. Civil war between Sertorius and Pompey in Catalonian territory. 56 BC. Conference of Lucca; Pompey; triumvirate in Spain. 45 BC. Decisive victory of Caesar over Pompey's allies at Munda. 27 BC. Augustus' administrative reform: Baetica, Lusitania & Tarraconensis. 19 BC. Cantabrians & Asturians submit to Agrippa.	88-84 BC. War against Mithridates; outbreak of civil war. 63 BC. Cicero exposes the Catiline plot. 58-51 BC. Caesar conquers Gaul. 49-46 BC. Civil war between Caesar and Pompey. *C.* AD 33. Crucifixion of Christ.	26 BC. Founding of Emerita Augusta.	*C.* 100 BC. Italy: first style of Pompeian painting. *C.* 80 BC. Italy: second style of Pompeian painting. 50 BC. Caesar writes *Commentaries on the War in Gaul*. *C.* 31 BC. Vitruvius' *De architectura*. 29-19 BC. Virgil's *Aeneid*. From 25 BC. *Terra sigillata* ware. *C.* 15 BC. Rome: third style of Pompeian painting.	25 BC. Construction of the Aqueduct of Tarragona. Construction of the Aqueduct of Segovia. Construction of the Berà Arch.	*C.* 100 BC. Venus de Milo. *C.* 55 BC. Frescoes in the Villa dei Misterii, Pompeii. *C.* 40 BC. The Laocoön group. 30-25 BC. The Villa Farnesina: painting and stuccowork. *C.* 27 BC. Pantheon of Agrippa. 21 BC. Arch of Augustus in the Forum of Rome. 13-9 BC. Ara Pacis.	
From AD 0 to AD 99	Italy: AD 14-37. Tiberius, emperor of Rome. Italy: AD 41-54. Claudius, emperor of Rome. Italy: AD 54-68. Nero, emperor of Rome. Italy: AD 69-79. Vespasian, emperor of Rome. Italy: AD 81-96. Domitian, emperor of Rome. Italy: AD 98-117. Trajan, emperor of Rome.		AD 53. Birth in Italica of the future emperor, Trajan. AD 73. Roman law concession.	AD 43. Conquest of Britain. AD 46. Thrace, Roman province. First persecution of the Christians. AD 70. Titus destroys Jerusalem. AD 77-84. Conquest of Scotland. AD 79. Vesuvius erupts, destroying Pompeii and Herculaneum.		AD 77. Publication of Pliny the Elder's *Naturalis Historia* ('Natural History'). Italy: fourth style of Pompeian painting. St Paul preaches in Asia Minor & Greece. *C.* AD 90-96. St John's *Apocalypse*.		AD 14-29. Statue of Augustus at Prima Porta. AD 64-68. Construction of the *Domus Aurea*. AD 70-82. The Colosseum, Rome. AD 81. Arch of Titus. Temples of Bacchus & Venus at Baalbeck. House of the Vettis, Pompeii.

Kings and Rulers		Socio-political & Scientific Context		Art Context		Art Fact File	
Spain	Rest of World	Spain	Rest of World	Spain	Rest of World	Spain	Rest of World
From AD 100 to AD 199	Italy: 117-138. Hadrian, emperor of Rome. Italy: 138-161. Antoninus Pius, emperor of Rome. Italy: 161-180. Marcus Aurelius, emperor of Rome. Italy: 180-192. Commodus, emperor of Rome.		100-107. The Roman Empire at war with the Dacians. 132-135. Uprising of the Jews. 162-165. War against the Parthians. 175. Wars against the Sarmatians and Germans.				125-135. Hadrian's Villa at Tivoli. C. 128-188. The Pantheon, Rome. 132-139. Hadrian's mausoleum. 161-162. Column of Antoninus Pius and Faustina. 179. Equestrian statue of Marcus Aurelius.
From AD 200 to AD 300	Italy: 211-217. Caracalla, emperor of Rome. Italy: 260-284. Period of the 30 Tyrants. Italy: 284-305. Diocletian, emperor of Rome.	New provinces are created: Nova Asturica & Gallaecia. 297. New division of Hispania: Baetica, Lusitania, Gallaecia, Cartaginiensis, Tarraconensis & Baleares.	212. Roman citizenship granted to the inhabitants of the provinces. 230. The Goths invade Moesia. 267. The Goths invade the Balkans and Greece by land and sea. Diocletian divides the Empire.		Christians persecuted in the Roman Empire.		203. Arch of Septimus Severus. 216-212. Caracalla Baths. C. 245. Catacomb of Domitilla; chapel of the Good Shepherd. C. 245-250. Frescoes in the Villa Doura-Europos. C. 298-305. Diocletian's Baths.

Kings and Rulers		Socio-political & Scientific Context		Art Context		Art Fact File	
Spain	Rest of World	Spain	Rest of World	Spain	Rest of World	Spain	Rest of World
From 300 to 349	Italy: 306-337. Constantine the Great, emperor of Rome. Italy: 337-361. Constans II, emperor of Rome.	304. Martyrdom of SS Eulalia, Vincent and Felix.	303-304. Persecution of the Christians. 313. Edict of Milan, recognising Christianity. 324. Constantinople, capital of the Eastern Empire. 325. Nicaea, first Ecumenical Council of the Christian Church.	Sarcophagi from Roman workshops imported to all the provinces in Hispania.			315. Arch of Constantine (Rome). Beginning of the century. Statues of the Tetrarchs. C. 320. Helen's porphyry sarcophagus. C. 326. Episcopal church of Letran & baptistery (Rome).
From 350 to 399	Italy: 379-395. Theodosius, emperor of Rome. 394-410. Alaric, first Visigoth king. 395-423. The Roman Empire is divided: Honorius I, West & Arcadius I, East (395-408).	384. Council of Zaragoza, at which Priscillianism is condemned.	365. The Alamani invade Gaul. 367. Picts, Scots and Saxons invade Britain. 375. The Huns occupy the Ostrogod kingdom. 380. Edict of Theodosius.			C. 350. Mosaics on the dome of the Centelles mausoleum (Tarragona). 388. Theodosius' *Missorium*.	359. Sarcophagus of Junius Bassus. C. 383-386. Church of San Ambrosio (Milan).
From 400 to 449	East: 408-450. Theodosius II, emperor.	409. Invasion of the Suevi, Vandals & Alani.	404-476. Ravenna, capital of the Western Roman Empire.		405. St Jerome finishes the *Vulgata*.	Palaeochristian baptistery in Barcelona.	C. 425. Mausoleum of Galla Placidia.

Kings and Rulers		Socio-political & Scientific Context		Art Context		Art Fact File	
Spain	Rest of World	Spain	Rest of World	Spain	Rest of World	Spain	Rest of World
	410-415. Ataulf, Visigoth king. 419-451. Theodoric, Visigoth king. Papacy: 432-440. Sixtus III. France: 448-458. Merovech, Frankish king.	411. The Suevi settle in Galicia. 415. Ataulf conquers Barcelona. 425. Independence of the Visigoths. 428. The Vandals seize Seville and Cartagena.	406-409. the Vandals sack Gaul. 410. Alaric sacks Rome. 418. The Visigoths settle in Toulouse. 432. St Patrick founds the Catholic Church in Ireland.		426. St Augustus finishes *The City of God.*	Basilica of El Bovalar (Serós).	432-440. Church and mosaics of Santa Maria Maggiore (Rome).
From 450 to 499	453-466. Theodoric, Visigoth king. East: 474-491. Zeno, emperor. France: 481-511. Clovis, Frankish king. 484-507. Alaric II, Visigoth king. East: 491-518. Anastasius I, emperor.		451. Schism between the Western and Eastern Churches. 455. Rome is sacked by the Vandals. 476. Rome is sacked by the Goths. 493. Theodoric founds the Ostrogothic kingdom at Ravenna. 496. Clovis converts to Christianity.		*C.* 470. *Codex Euricianus.* 480-490. Large-scale building work in Syria.		*C.* 450. Alahan Monastery Church (Cilicia). *C.* 480-490. St Simeon Stylites (Syria).
From 500 to 549	France: 511-558. Childebert, Frankish king. East: 527-565. Justinian, emperor.		507. Alaric II is defeated at Vouglé: end of the Visigothic kingdom of Toulouse. 529. St Benedict founds his Order. 533-555. Reconquest of Italy & Africa by the Byzantines.	506. Alaric's *Breviary.*	Constantinople reaches its cultural apogee under Justinian. Cultural & artistic apogee of Ravenna under Theodoric.		Before 526. Mausoleum of Theodoric the Great at Ravenna. 532-537 & 558-562. Santa Sophia (Constantinople). *C.* 532-547. S. Vitale (Ravenna).
From 550 to 599 Spain: 573-586. Leovigild, Visigoth king. Spain: 586-601. Reccared, Visigoth king.	France: 558-561. Clotaire, Frankish king. 570-632. Muhammad. Papacy: 590-604. Gregory the Great.	Toledo becomes the capital of the Visigothic kingdom. 572. Leovigild reconquers Cordova and Málaga. 587. Reccared converts to Catholicism. 589. Third Council of Toledo; Catholicism the official religion.	568-650. The Lombards settle in Italy. 584. The exarchate is founded at Ravenna. 590-604. Gregory the Great unites the Western Church.		*C.* 550. Cosmas Indicopleustes, *Christian Topography of the Universe.*		*C.* 550. Barberini diptych. 586. Syriac Rabulla Gospels (Florence).
From 600 to 649 Spain: 621-631. Swinthila, Visigoth king. Spain: 643-653. Chinsdaswinth, Visigoth king.	East: 602-610. Phocas, emperor. France: 613-629. Clotaire II, Frankish king. France: 629-639. Dagobert, Frankish king. Papacy: 642-649. Theodorus I.	620. The Visigoths subdue the Vascons & expel the Byzantines. 633. Fourth Council of Toledo, elective monarchy. The Visigoth kingdom achieves unity throughout the Iberian Peninsular.	622. The Hegira: Muhammad flees from Mecca to Medina. 642-732. The Byzantines lose their provinces in the Near East & Africa to the Muslims. 646-653. Writing of the *Koran.*	621-631. Isidore of Seville, *Historia de Regibus Gothorum.* The Beatus of Liébana writes his commentaries on the Apocalypse of St John.			*C.* 600. Monastery of St Catherine on Mount Sinai; apse mosaics. 630-680. Founding of Jouarre.

Kings and Rulers		Socio-political & Scientific Context		Art Context		Art Fact File	
Spain	**Rest of World**	**Spain**	**Rest of World**	**Spain**	**Rest of World**	**Spain**	**Rest of World**
From 650 to 699 Spain: 653-672. Recceswinth, Visigoth king.		650. Promulgation of the *Liber judiciorum*. 683. Onset of the decline of the Visigothic kingdom.	653. The Lombards convert to Christianity. 661. The Umayyads seize the caliphate.		672-735. Venerable Bede: *History of the English Church & People.* Artistic flowering of Merovingian Gaul and Lombardic Italy.	San Juan de Baños (Palencia, consecrated in 661). Santa Comba de Bande. San Pedro de la Nave (Burgos, second half).	654. Founding of the Abbey of Jumièges. 671-675. Construction of the Great Mosque at Kairouan. C. 680. Book of Durrow (Dublin).
From 700 to 749 Spain: 702-710. Witiza, Visigoth king. Spain: 710-711. Roderick, Visigoth king. Spain: 718-737. Pelayo, Asturian king. Spain: 739-757. Alfonso I, Asturian king.	France: 743-751. Childeric III, last Merovingian king.	711-718. Moorish invasion of the Iberian Peninsula. End of the Visigothic kingdom; battle of Guadalete. 718. Founding of the kingdom of Asturias. The Reconquest begins.	709. Pepin's expedition against the Alamani. 716-719. Charles Martel defeats the Neustrians. 732. The Moors are driven out of Gaul.		726-843. Byzantium: Iconoclastic period.	C. 700. Church of Quintanilla de las Viñas (Burgos). 737. Favila orders a church of the Holy Cross to be built.	
From 750 to 799 Spain: 756-788. 'Abd ar-Rahmān I, emir of Cordova. Spain: 774-783. Silo, Asturian king. Spain: 792-842. Alfonso II, Asturian king. Spain: 796-822. Al-Hakam, emir of Cordova.	France: 751-768. Pepin the Short, Carolingian king. Italy: 757-774. Didier, king of the Lombards. 768. Coronation of Charlemagne at Noyon, & of Carloman at Soissons. France: 771-814. Charlemagne, Carolingian king & emperor.	756. The independent emirate of Cordova. The Asturian king Silo moves his capital to Santianés. 795. The Spanish March is formed. Alfonso II moves the capital of the Asturian kingdom to Oviedo.	751. End of Byzantine rule in central Italy. 752-759. Pepin the Short reconquers Septimania. 774-887. Italy under Carolingian rule. 785. Charlemagne conquers Saxony.		754. Crodegang: *Regula canonicorum.*	Church of Santianes de Pravia. 785. Building work commences on the Great Mosque of Cordova. Palace complex of Alfonso II in Oviedo; Holy Chamber.	760. Great Mosque of Baghdad. 775. Consecration of the abbey church of Saint-Denis. 781-783. The 'Golden Gospels'. 789-805. Palatine chapel at Aquisgranum.
From 800 to 849 Spain: 822-852. 'Abd ar-Rahmān II, emir of Cordova. Spain: 842-850. Ramiro I, Asturian king.	France: 814-840. Louis the Pious, king. Papacy: 827-844. Gregory IV. France: 840-877. Charles the Bald, king.	801. Charlemagne reaches Barcelona. 809-812. Conquest of the Spanish March.	800. Charlemagne is crowned emperor. 805. Charlemagne conquers Bohemia. 843. Treaty of Verdun: break-up of the Frankish empire.	Cultural peak of the kingdom of Asturias, during the reigns of Alfonso II, Ramiro I and Alfonso III.	800. *Renovatio Imperii* in the West. Major ivory workshops in the Carolingian empire.	808. Cross of the Angels. 812-842. San Julián de los Prados (Oviedo). 838-848. The Great Mosque of Cordova is extended for the first time.	C. 800. Book of Kells (Dublin). 820-830. Psalter of Utrecht. 842-852. Construction of the Great Mosque of Samarra. 842-869. Psalter of Charles the Bald.
From 850 to 899 Spain: 850-866. Ordoño I, Asturian king. Spain: 866-910. Alfonso III, Asturian king. Spain: 870-905. Fortún Garcés, king of Navarre.	Papacy: 858-867. Nicholas I. England: C. 871-899. Alfred the Great, king. France: 877-879. Louis II the Stammerer, king. France: 898-922. Charles the Simple, king.	859-860. Norman expedition in the Pyrenees. 874-898. Rule over the Spanish March permanently instated.	856-861. Normans raze Ile-de-France. 865. First Danish raid into England. 870. Treaty of Mersen: the Frankish empire is carved up.		843-1204. Artistic renaissance in the Byzantine empire (Macedonian and Comnenian dynasties).	Mid-century. Church of San Miguel de Lillo (Oviedo). Mid-century. Church of Santa María del Naranco (Oviedo). 866-910. Ark in Astorga Cathedral. 893. San Salvador de Valdedios.	852-876. Construction of Hildesheim Cathedral. C. 869. Second Bible of Charles the Bald. 871. Foundation charter of Saint-Benigne de Dijon.

10TH, 11TH & 12TH CENTURIES

Kings and Rulers		Socio-political & Scientific Context		Art Context		Art Fact File	
Spain	Rest of World	Spain	Rest of World	Spain	Rest of World	Spain	Rest of World
From 900 to 949 Spain: 911. Sunyer I, count of Barcelona. Spain: 912-961. 'Abd ar-Raḥmān III, emir and first caliph of Cordova. Spain: 914-924. Ordoño, king of León. Spain: 920-970. Fernán González, count of Castile. Spain: 926-970. García Sánchez, king of Navarre.	Germany: 911-918. Conrad of Franconia, king. Germany: 936-973. Otto I the Great, emperor. France: 936-954. Louis IV d'Outremer, king.	912-961. Height of the Ummayad dynasty. 914. Founding of the kingdom of León, with Galicia, Asturias, León & Castile. 926. The county of Aragon is absorbed by the kingdom of Navarre. 929. 'Abd ar-Raḥmān III proclaimed Caliph of Cordova.	911. The Franks surrender the future Normandy to the Normans. 926. The Hungarians cross the Ardennes to Rome. 927-942. Odo, abbot of Cluny. 940. Lorraine is annexed to the Germanic empire. 948-994. Mayeul, abbot of Cluny.		910. Founding of the abbey of Cluny.	908. Cross of Victory, Oviedo. 910. Reliquary in Astorga Cathedral & Agate Chest. 913. Church of San Miguel de Escalada (León). C. 915. Church of San Cebrián de Mazote (Valladolid). 920. Mozarab Bible of León.	920-940. Extension to the crypts at Saint-Pierre-le-Vif (Sens). 925-950. Gospels of Essen. 946. Building of Clermont Cathedral.
From 950 to 999 Spain: 950-992. Borrell II, count of Barcelona. Spain: 961-976. Al-Ḥakam II, caliph of Cordova. Spain: 970-994. Sancho Garcés II, king of Navarre. Spain: 976-1009. Hishām II, caliph of Cordova. Spain: 992-1018. Ramon Borrell, count of Barcelona. Spain: 999-1028. Alfonso V, king of León.	France: 954-986. Lothair, king. Germany: 973-983. Otto II, king. England: 973. Edgar, Archbishop of Canterbury, crowned king. East: 976-1025. Basil II, emperor. France: 986-987. Louis V, last Carolingian king. France: 987-996. Hugh Capet, first Capetian king. France: 993-1031. Robert II the Pious, king. Papacy: 999-1003. Gerbert of Aurillac (Sylvester II).	960. Hereditary succession in the county of Castile. 967. Sojourn in Catalonia of Gerbert, the future Sylvester II. 977. Al-Manṣūr destroys the basilica of Santiago de Compostela. 985. Al-Manṣūr sacks Barcelona. 988. Count Borrell II of Barcelona breaks away from Hugh Capet.	980. The Danes embark on the conquest of England. 994-1049. Odilo, abbot of Cluny.	961. Cordova becomes the main cultural centre in Europe.	952. Flocloard: *History of the Church of Reims*. 965. Windukin: *History of the Saxons*. Sixties and seventies. Cultural apogee of Byzantium. 991-998. Richer: *History*. 993-1022. Hildesheim workshop.	C. 952. The Beatus of Morgan Library. 961-976. Great Mosque of Cordova. 974. Consecration of Sant Miquel de Cuixà. 975. The Beatus of Girona (Cathedral). 977. Consecration of the monastery of Santa Maria de Ripoll.	955-981. Building of the Cluny II church. 963-980. Magdeburg ivories. 969-976. Crucifix of Archbishop Gero. Cologne Cathedral. 972-1008. Church of Saint-Jean de Liège; replica of the chapel at Aquisgranum. 975-1009. Construction of Mainz Cathedral. 980. St Pantaleon, Cologne. 990. Lectionary of Limoges.
From 1000 to 1049 Spain: 1000-1035. Sancho III the Great, king of Navarre. Spain: 1017-1035. Berenguer Ramon I, count of Barcelona. Spain: 1035-1076. Ramon Berenguer I, count of Barcelona. Spain: 1035. García Sánchez III, king of Navarre. Ramiro I, king of Aragon & Ferdinand I, king of Castile. Spain: 1037-1065. Ferdinand I, king of Castile & León.	Germany: 1002-1024. Henry II, emperor. Germany: 1024-1039. Conrad II, emperor. France: 1031-1061. Henry I, king. Germany: 1039-1056. Henry III, emperor. England: 1042-1066. Edward the Confessor, last Anglo-Saxon king.	The caliphate breaks up into party kingdoms or *ṭauā'if*. 1018. Abbot Oliba, bishop of Vic. 1027. The 'Assemblies of Peace & Truth' begin. 1029. The counties of Aragon & Castile become part of the kingdom of Navarre. 1031. End of the Ummayad caliphate of Cordova. 1035. Division of the kingdom of Navarre.	1013. The Danes conquer England. 1033. Burgundy becomes part of the Holy Roman Empire. 1035. William I, Duke of Normandy, embarks on the Norman expansion. 1040. Proclamation of the 'Peace of God'. 1049-1109. Hugh, abbot of Cluny.		1009. Destruction of the Church of the Holy Sepulchre in Jerusalem. C. 1040. Ralph Glaber: *Chronicle*.	1001. Wifred II of Cerdagne founds the monastery of Sant Martí del Canigó. 1022. Consecration of Sant Pere de Rodes. 1031. Dintel at Saint-Genis-des-Fontaines. 1040. Consecration of the church of Sant Vicenç de Cardona, 1040–1100. Bible of Sant Pere de Rodes.	1000. Crucifix of Lothair. 1002-1024. Pulpit at Aquisgranum. 1003. Reconstruction work begins on Saint-Martin de Tours. 1037. Consecration of Chartres Cathedral. C. 1040-1050. Building of the belfry portico at Saint-Benoit-sur-Loire.

10TH, 11TH & 12TH CENTURIES

Kings and Rulers		Socio-political & Scientific Context		Art Context		Art Fact File	
Spain	Rest of World	Spain	Rest of World	Spain	Rest of World	Spain	Rest of World
From 1050 to 1099 Spain: 1054-1076. Sancho Garcés IV, king of Navarre. Spain: 1065. Sancho II, king of Castile; García, of Galicia, & Alfonso VI, of León. Spain: 1072-1109. Alfonso VI, king of Castile & León. Spain: 1094-1104. Peter I, king of Aragon. Spain: 1097-1131. Ramon Berenguer II, count of Barcelona.	Germany: 1056-1106. Henry IV, emperor. France: 1060-1108. Philip I, king. England: 1066-1087. William the Conqueror, king. Papacy: 1073-1085. Gregory VII. England: 1087-1100. William II the Red, king. Papacy: 1088-1099. Urban II. Papacy: 1099-1118. Paschal II.	1060. Fall of the caliphate of Cordova. 1065. Division of the kingdoms of Ferdinand I of Castile. 1076. County of Barcelona divided between Ramon Berenguer II & Berenguer Ramon II. 1060-1091. Norman conquest of Sicily. 1085. Conquest of Toledo by Alfonso VI of Castile. 1086-1145. The Almoravids halt the Christian expansion. 1094. El Cid conquers the Moorish kingdom of Valencia. 1096. Huesca occupied by Peter I of Aragon.	1054. Schism of 1054: Michael Cerularius; permanent division of the Eastern and Western Churches. 1057. Rise of the Comnenian dynasty in Byzantium. 1059-1082. The Almoravids conquer Morocco and Algeria. 1060-1091. Norman conquest of Sicily. 1071. Jerusalem occupied by the Turks. 1076. Synod of Worms. 1084. Henry IV seizes Rome & is crowned emperor by the anti-pope Clement III. 1096. Urban II inspires the first Crusade. 1099. Jerusalem falls to the Crusaders.	1055. Council of Coyanza: the Rule of St Benedict is adopted in Spain. 1069. Diego Peláez, bishop of Santiago de Compostela. 1073. Death of St Domingo de Silos. 1080. Council of Burgos: the Roman rite is adopted throughout the Iberian Christian territories. 1085. Sahagún awarded 'villa' status. Start of pilgrimages to Santiago de Compostela.	C. 1050-1060. The illuminator, Ingelard, active at Saint-Germain-des-Prés. 1087-1106. Goldsmithing & enamelling workshops at Conques, under the abbacy of Bégon III. 1090. *The Song of Roland.* 1098. Founding of the Cistercian Order.	1055. Crypt of the Monastery of Leyre. After 1066. Building work begins on San Martín de Fromista. 1075. Holy Ark of Oviedo. Building work begins on Santiago de Compostela. 1080-1090. Murals at Sant Quirze de Pedret. 1086. Beatus of Burgo de Osma. 1090. The wall of Ávila built. 1093. Tomb of Alfonso Ansúrez. Before 1100. Construction of Loarre castle.	1063. Consecration of the church of Moissac. 1063-1096. Saint-Martial de Limoges rebuilt. 1063. Founding of Saint-Étienne de Caen. 1065. Building work commences at Westminster Abbey. Antes 1072. Beatus of Saint-Sever. 1077-1082. Bayeux tapestry. 1079-1120. Work on Winchester Cathedral. 1096. Consecration of the sanctuary of Saint-Sernin de Toulouse. Completion of the cloister at Moissac, under the abbacy of Ansquitil.
From 1100 to 1149 Spain: 1104-1134. Alfonso I the Battler, king of Aragon. Spain: 1126-1157. Alfonso VII, king of Castile. Spain: 1131-1162. Ramon Berenguer IV, count of Barcelona. Spain: 1134-1137. Ramiro II, king of Aragon. Spain: 1134-1150. García V, king of Navarre.	England: 1100-1135. Henry I, king. Germany: 1106-1126. Henry V, emperor. France: 1108-1137. Louis VI the Fat, king. France: 1137-1180. Louis VII, king. Germany: 1137-1190. Conrad III, emperor. Portugal, 1139-1178. Alfonso I, king. East: 1143-1180. Manuel I, Comnenus, emperor.	1106. Seville falls to the Almoravids. 1111. Saragossa falls to the Almoravids. 1117. Ramon Berenguer II seizes the county of the Cerdagne. 1118. Sargossa conquered by Alfonso I the Battler. 1137. Union of the county of Barcelona & the Crown of Aragon. 1146-1147. Onset of the Almohad expansion.	1117. Rome falls to the emperor Henry V. 1122. Concordat of Worms, between Calixtus II & the emperor Henry V. 1122-1126. Byzantium at war with Venice. 1130. Start of Almohad domination of North Africa. 1139. England: civil war between supporters of Matilda and Stephen of Blois. 1141-1144. Normandy conquered by Geoffrey Plantagenet. 1147-1149. Second Crusade.	1119. The city of Soria is founded. 1130. The Templars establish themselves in Catalonia. Founding of the School of Translators at Toledo. 1135. Aymeric Picaud, *The Pilgrim's Guide.* C. 1140. Production of pink marble in the Catalan Pyrenees. 1147. The city of Salamanca is founded.	1101. The Carthusian Order is founded. 1109. Stephen Harding, abbot of Cîteaux. 1113. Founding of the military order of the Knights of St John of Jerusalem. 1122-1151. Suger, abbot of Saint-Denis. 1122. Peter the Venerable, abbot of Cluny. 1125-1153. St Bernard, abbot of Clairvaux.	1104. Portal of Las Platerías (Santiago de Compostela). C. 1120. Murals in the church of San Pedro de Burgal. 1123. Consecration of the churches of Sant Climent & Santa Maria de Taüll. 1126-1129. 'Book of Testaments' of Oviedo Cathedral. 1130. Murals in the churches of Maderuelo and Berlanga.	Portal of Miègeville in Saint-Sernin at Toulouse. 1120. The portal of Moissac is begun. 1130. Consecration of Cluny III. 1133. Consecration of Durham Cathedral. 1139-1147. Cistercian church of Fontenay. 1140-1144. Saint-Denis. 1145-1155. Royal Portal, Chartres.
From 1150 to 1199 Spain: 1150-1194. Sancho VI, king of Navarre. Spain: 1162-1196. Alfonso II, king of the Crown of Aragon.	Germany: 1152-1190. Frederick I Barbarossa, emperor. England: 1154-1189. Henry II Plantagenet, king.		1154-1155. Fresh Germanic campaign in Italy. 1173. War between Louis VII of France & Henry II of England.	1150. Founding of the Cistercian monasteries of Poblet & Santes Creus. 1175. Contract with Pietrus Lombardus at La Seu d'Urgell (Lleida).	1167-1169. First mention of Limoges as an enamel production centre. 1175. *Tristan and Isolda*	C. 1150. Bibles of Lleida and Ávila. 1151-1174. Building of Zamora Cathedral. C. 1170. Portal of Santa María de Ripoll.	C. 1150. First domes at Puy-en-Velay Cathedral. C. 1160. Building of Saint-Étienne de Périgueux.

10TH, 11TH & 12TH CENTURIES

Kings and Rulers		Socio-political & Scientific Context		Art Context		Art Fact File	
Spain	Rest of World	Spain	Rest of World	Spain	Rest of World	Spain	Rest of World
Spain: 1188-1230. Alfonso IX, king of León. Spain: 1194-1234. Sancho VII, king of Navarre. Spain: 1196-1213. Peter II, king of the Crown of Aragon.	France: 1180-1223. Philip II Augustus, king. England: 1189-1199. Richard I the Lionheart, king. Germany: 1190-1197. Henry IV, emperor. Papacy: 1198-1216. Innocent III. England: 1199-1216. John I Lackland, king.	1188. Saladin conquers the Levantine kingdoms.	1177. Peace of Venice: Frederick I submits to the papal authority of Alexander III. 1183. Peace of Constance. 1187. Saladin seizes Jerusalem. 1189-1192. Third Crusade.	1188. Master Mateo at Santiago de Compostela. 1200. Ramón de Bianya active in Roussillon.		C. 1171. Building work starts on Tarragona Cathedral. 1180-1190. Chapterhouse at Sigena. 1180-1190. *Liber Feudorum maior*.	1162-1176. Building work starts on Coimbra Cathedral. 1172-1177. Newcastle: the 'New Castle' is rebuilt by Henry II. 1178-1223. Construction of the abbey of Alcobasa. 1185-1208. Construction of the Cistercian abbey of Pontigny.

13TH, 14TH & 15TH CENTURIES

Kings and Rulers		Socio-political & Scientific Context		Art Context		Art Fact File	
Spain	Rest of World	Spain	Rest of World	Spain	Rest of World	Spain	Rest of World
From 1200 to 1249 Spain: 1213-1276. James I the Conqueror, king of the Crown of Aragon. Spain: 1217-1252. Ferdinand III the Saint, king of Castile. Spain: 1238. Muḥammad I ibn Naṣr, establishes the Naṣrid kingdom of Granada.	England: 1216-1272, Henry III, king. France: 1226-1270. Louis IX the Saint, king. Papacy: 1227-1241. Gregory IX.	1203. The Almohads conquer the Balearic islands. 1212. Battle of Navas de Tolosa; the Almohads defeated. 1228. The leader, Banū Hūd, proclaimed king of Murcia. 1229. James I the Conqueror occupies Majorca. 1230. Alfonso IX of León occupies Badajoz. 1235-1245. James I conquers Valencia. 1248. Ferdinand III the Saint occupies Seville.	1202. Fourth Crusade. 1204-1261. Sack of Constantinople; founding of Latin states. 1215. The Magna Carta is drawn up, limiting the powers of the English monarchy. 1228. Fifth Crusade, inspired by the emperor Frederick II. 1229. Treaty of Paris; end of the crusade against the Cathars. 1245. Confrontation between the papacy and the Empire. 1248-1254. Sixth Crusade under Louis IX de France.	Castile: building work starts on the first Gothic cathedrals. Romanesque art formulas survive. 1244. Publication of the *Llibre dels feits*.	1210. St Francis of Assisi founds the Franciscan Order.	1203. Building work starts on Lleida Cathedral. 1220. Construction of the Tower of Gold (Seville). 1221. Building work starts on Burgos Cathedral. 1226. Building work starts on Toledo Cathedral. 1230-1240. Portal of El Sarmental in Burgos Cathedral. 1230-1257. Portal of La Coronería in Burgos Cathedral. 1243-1275. Convent of Santa Caterina (Barcelona).	1212. Building work starts on Rheims Cathedral. 1220. Building work starts on Amiens Cathedral. Church of St Francis of Assisi founded in 1228 & consecrated in 1253. 1239-1246. Sainte-Chapelle, Paris. 1240-1245. 'Visitation of Rheims' workshop. 1248-1268. Choir & sanctuary of Cologne Cathedral.
From 1250 to 1299 Spain: 1252-1284. Alfonso X the Wise, king of Castile & León. Spain: 1253-1270. Theobald, king of Navarre. Spain: 1274-1304. Joan I, queen of Navarre. Spain: 1276-1285. Peter III the Great, king of Catalonia, Aragon & Valencia. Spain: 1291-1327. James II, king of the Crown of Aragon.	France: 1270-1285. Philip III, king. England: 1272-1307. Edward I, king. Germany: 1273-1291. Rudolf I, emperor. France: 1285-1314. Philip IV the Handsome, king. Germany: 1298-1308. Albert I of Habsburg, emperor.	Moorish uprisings in Andalusia and Murcia (in the sixties). 1265. Creation of the Consell de Cent in Barcelona. 1266. James I the Conqueror subjects the kingdom of Murcia and cedes it to Castile. 1273. Mesta regulations drawn up by Alfonso X. 1276. Death of James I: his domains are divided between Peter the Great and James II of Majorca.	1256. Johannes de Sacrobosco: *Tractatus sphaera mundi*. 1261. Michael VIII Palaeologus recaptures Constantinople for Byzantium. 1270. Seventh Crusade; St Louis sails to Tunis. 1284. England annexes Wales. 1294. War between France and England, after France had seized the county of Guyenne.	1250. Gonzalo de Berceo: *Vida de Santa Oria*. Castile: development of sculptured frontispieces. Castile: Gothic features appear in illuminated manuscripts (reign of Alfonso X). 1283. Bernat Desclot: *Chronicle*. Crown of Aragon: rise of the concept of 'southern architecture'. 1289. Ramon Llull: *Llibre de meravelles*.	1258-1267. St Thomas Aquinas: *Summa Theologica*. 1267. Iaccoppo da Varazza: *Legenda sanctorum*.	1255. Building work starts on León Cathedral. *Cantigas de Santa Maria* ('Canticles of Holy Mary' or 'of Alfonso X the Wise'). Portal of the Lions in Toledo Cathedral. 1280-1290. Murals in the Royal Palace & Caldes Palace (Barcelona). 1298. Building work starts on Barcelona's Gothic Cathedral.	1265-1268. Nicola Pisano: pulpit in Siena Cathedral. 1280-1285. Cimabue, *Crucifix*. 1280-1300. Building work starts on the west facade of Strasbourg Cathedral. C. 1290. Pietro Cavallini: decoration of the apse at S. Maria in Trastevere. 1294-1302. Arnolfo di Cambio: Florence Cathedral. Master Honoré: Breviary of Philip the Handsome.

13TH, 14TH & 15TH CENTURIES

Kings and Rulers		Socio-political & Scientific Context		Art Context		Art Fact File	
Spain	Rest of World	Spain	Rest of World	Spain	Rest of World	Spain	Rest of World
Spain: 1295-1312. Ferdinand IV, king of León and Castile.		1296. James II occupies the kingdom of Murcia.	1297. Philip IV the handsome occupies Flanders.				
From 1300 to 1349 Spain: 1312-1350. Alfonso XI, king of Castile. Spain: 1327-1336. Alfonso IV, king of the Crown of Aragon. Spain: 1329. John II and Philip III, kings of Navarre. Spain: 1336-1387. Peter IV, king of the Crown of Aragon.	England: 1307-1327, Edward II, king. England: 1327-1377. Edward III, king. France: 1328-1350. Philip IV, king. Germany: 1346-1378. Charles IV, emperor.	1309. Ferdinand IV of Castile occupies Gibraltar. 1311. The Catalan Company occupies the duchies of Athens & Neopatria. 1323. The Infante Alfons, the future Alphonse the Good of Catalonia & Aragon, occupies the island of Sardinia. 1348. The Black Death ravages the Iberian Peninsula.	1303. Peace between France and England. 1309-1377. Papacy exiled in Avignon. 1314. Scotland independent; the House of Stuart. 1337. Outbreak of the Hundred Years' War between England and France. 1339. Venice seizes Treviso & embarks on its territorial expansion.	1325. Ramon Muntaner begins his *Crónica*. Crown of Aragon: artistic ties with Italy (end of the third decade). Endurance of pictorial linearity in Castile. 1330-1343. Juan Ruiz (archpriest of Hita): *Libro del Buen Amor*.	1309-1320. Dante: *The Divine Comedy*. 1343. Boccaccio: *The Decameron*.	1326-1327. Monastery church of Santa Maria de Pedralbes (Barcelona). 1327. Lupo di Francesco: tomb of St Eulalia (Barcelona Cathedral). 1329-1393. Berenguer Montagut: Santa Maria del Mar. 1337. West facade of Toledo Cathedral.	1302-1311. Giovanni Pisano: pulpit in Pisa Cathedral. 1304-1313. Giotto: frescoes in the Scrovegni chapel (Padua). 1330-1336. Andrea Pisano: doors of the Florence baptistery. 1333. Simone Martini: *Annunciation*. 1338-1339. Ambrogio Lorenzetti: *Allegory of Good Government*.
From 1350 to 1399 Spain: 1350-1369. Peter I the Cruel, king of Castile. Spain: 1379-1390. John I, king of Castile. Spain: 1387-1396. John I, king of the Crown of Aragon. Spain: 1387-1425. Charles III, king of Navarre. Spain: 1398-1410. Martin I, king of the Crown of Aragon.	France: 1350-1364. John II, king. France: 1364-1380. Charles V, king. England: 1377-1399. Richard II, king. France: 1380-1422. Charles VI, king. Portugal, 1383-1433. John I Avis, king. England: 1399-1413. Henry IV, king.	1356-1369. War between Peter the Ceremonious & Peter I the Cruel of Castile. 1369. Victory of Henry of Trastámara over Peter I of Castile. 1385. Portugal wins independence from the Crown of Castile.	1354. Gallipoli, first Turkish possession in Europe. 1360. Treaty of Brétigny: Edward III of England withdraws his claim to the French throne. 1377. The papacy reinstated in Rome; Gregory IX. 1378-1417. Great Schism in the West. 1394. Pedro de Luna proclaimed Pope as Benedict XIII in Avignon.	1350. First versions of *Amadís de Gaula*. 1370. Pedro López de Ayala: *Rimado de palacio*. 1382. The *Chronicle* of Peter I the Ceremonious. 1386. First synod of architects for the completion of Girona Cathedral. 1396. Francesc Eiximenis: *El llibre de les dones*.	1387. G. Chaucer: *The Canterbury Tales*. The courtly style becomes international.	1359-1362. Construction of the Saló del Tinell in the Royal Palace, Barcelona. 1394. Pere Serra: retable of the *Holy Spirit*. 1394-1399. Pere de Sanglada: choir seating in Barcelona Cathedral. 1395-1396. Frescoes in the chapel of San Blas in Toledo Cathedral.	1351-1412. Cloister galleries in Gloucester Cathedral. Bonino da Campione: equestrian monument to Bernabo Visconti (before 1363). *C.* 1380. Jean de Liège: bust of Mary of France. 1396-1405. Claus Sluter: *Well of Moses*.
From 1400 to 1449 Spain: 1412-1416. Ferdinand I of Trastámara, king of the Crown of Aragon. Spain: 1416-1458. Alfonso V the Magnanimous, king of the Crown of Aragon. Spain: 1425. John and Blanche, king and queen of Navarre.	England: 1422-1461. Henry VI, king. France: 1422-1461. Charles VII, king. France: 1431. Coronation of Henry VI of England. Italy: 1434-1464. Cosimo de Medici in Florence. Portugal: 1438-1481. Alfonso V, king. Germany: 1440-1490. Frederick III, emperor. Papacy: 1447-1455. Nicholas V	1412. Compromise of Caspe. 1420. The Infante Juan, the future John II of Catalonia & Aragon, marries Blanche of Navarre. 1421. Alfonso the Magnanimous succeeds Queen Joan II of Naples. 1441. War of Succession in Navarre. 1442. Conquest of Naples by the Catalan–Aragonese Crown.	Florence defeats Pisa & reaches the sea. 1413-1566. Rise of the Ottoman empire. 1414-1418. Council of Constance to settle the Great Schism. 1431. Joan of Arc burned at Rouen. 1431-1449. Council of Basle. 1438. The 'Pragmatic Sanction', cornerstone of the Anglican Church. 1446-1450. Gutenberg invents the printing press.	1416. Second synod of architects at Girona Cathedral. 1431. Lluís Dalmau visits the Netherlands. Nicolás Francés active in León between 1434 and 1468. 1441. The Marquis of Santillana: *Serranillas*. 1443. Annequin of Brussels & his team arrive in Toledo. John of Cologne arrives in Burgos.	1401. Florence: contest for decorating the doors of the baptistery. 1418. Masaccio sets up in Florence. First generation of the *Quattrocento*: Brunelleschi, Ghiberti and Masaccio. 1441-1505. Pictorial school of Ferrara (Leonello, Borso and Ercole d'Este).	1402. Building work starts on Seville Cathedral. 1414-1415. Lluís Borrassà: retable of Santa Clara (Vic). 1426-1436. Pere Joan: retable at the high altar in Tarragona Cathedral. Guillem Sagrera: *Llotja* (commodity exchange) in Palma de Majorca (from 1426). 1443. Dello Delli: retable at the high altar in Salamanca Cathedral. 1445. Lluís Dalmau: *La Verge dels Consellers*.	1415-1416. Jean Limbourg: the *Belles Hueres* (for the Duc de Berry). 1420. Brunelleschi: dome of Florence Cathedral. 1423. Gentile da Fabriano: *Adoration of the Magi*. 1424-1452. Ghiberti: *Gates of Paradise*. 1425. Massaccio: *Trinity*. 1432. J. van Eyck: retable of the *Adoration of the Lamb*. 1446. Donatello: *Gattamelata*.

13TH, 14TH & 15TH CENTURIES

Kings and Rulers		Socio-political & Scientific Context		Art Context		Art Fact File	
Spain	**Rest of World**	**Spain**	**Rest of World**	**Spain**	**Rest of World**	**Spain**	**Rest of World**
From 1450 to 1499 Spain: 1451-1479. John, king of Navarre. Spain: 1458-1479. John II, king of the Crown of Aragon. Spain: 1469. Marriage of Ferdinand of Aragon and Isabella of Castile. Spain: 1474-1504. Isabella, queen of Castile. Spain: 1479-1516. Ferdinand II, king of the Crown of Aragon. Spain: 1483-1516. Catherine, queen of Navarre.	England: 1461-1483. Edward IV of York, king. France: 1461-1483. Louis XI, king. Russia: 1462-1505. Ivan the Great, czar. Italy: 1469-1492. Lorenzo Medici of Florence. France: 1483-1498. Charles VIII, king. Papacy: 1484-1492. Innocent VIII. England: 1485-1509. Henry VII Tudor, king. Portugal, 1495-1521. Manuel I the Fortunate, king. France: 1498-1515. Louis XII, king.	1462. Outbreak of civil war in Catalonia. 1469. Unfication between the kingdom of Castile and the Catalan–Aragonese Crown. 1475-1479. Civil war in Castile. 1479. Sicily annexed by Aragon. 1492. Conquest of Granada. Coloumbus discovers America. 1494. Treaty of Tordesillas. 1500. Forced conversion of Moriscos in the Alpujarras mountains.	1451. End of the Hundred Years' War. 1453. Fall of Constantinople; end of the Eastern Roman empire. 1455. War of the Roses in England. 1463-1479. Turko-Venetian war. Rise of Portugal as a trading power. The Germanic empire in decline. War in Italy between the French and Spanish Crowns.	1460. Castile: the Hispano-Flemish style prevails. Joanot Martorell: *Tirant lo Blanc.* The Court collects Flemish paintings. 1476. Jorge Manrique: *Coplas por la muerte de su padre.* 1499. *La Celestina.*	1452-1485. L. B. Alberti: *De Re Aedificatoria.* 1456. A. Mantegna in the employ of Ludovico Gonzaga, Duke of Mantua. 1461-1464. Filarete: *Trattato d'Architteture.* Florence relinquishes its hegemony over Italian painting. Rome re-emerges as a major art centre. 1485. Alberti's treatise on painting.	1450-1460. Jaume Huguet: retable at Sant Vicenç de Sarrià (Barcelona). 1474-1477. Bartolomé Bermejo: retable of Santo Domingo de Silos. 1480-1490. Fernando Gállego: ceiling in the library at the University of Salamanca. 1484-1494. Simon of Cologne: chapel of the Condestable (Burgos Cathedral). 1496-1499. Gil de Siloé: retable at the high altar in the Miraflores charterhouse.	1452. Piero della Francesca: *Legend of the True Cross,* Arezzo. 1468. Mantegna: ceiling of the Camera degli Sposi, Mantua. 1471. Verrochio: *The Baptism of Christ.* 1475. Botticelli: *Primavera.* 1492-1494. Decoration of the Borgia apartments. 1493. Dürer: *Self-portrait with a Flower.*

16TH CENTURY

Kings and Rulers		Socio-political & Scientific Context		Art Context		Art Fact File	
Spain	**Rest of World**	**Spain**	**Rest of World**	**Spain**	**Rest of World**	**Spain**	**Rest of World**
From 1500 to 1519 Spain: 1516-1554. Charles I, king.	Papacy: 1503. Julius II. England: 1509. Henry VIII, king. Papacy: 1513. Leon X. France: 1515. Francis I, king.	1512. Annexation of the kingdom of Navarre. 1518. Cortés lands on the Mexican coast.	1513. Machiavelli: *The Prince.* 1515. Francis I conquers the duchy of Milan. 1516. Thomas More: *Utopia.* Ariosto, *Orlando Furioso.* 1517. Wittenberg: Luther's theological theses.	Plateresque style. 1516. B. Ordóñez and D. de Siloé active in Naples. Arrival of Italian artists: F. Torni, P. Torrigiano.	Rome: a major European art centre. Italy: architectural monumentalism. England: Gothicism endures. Venetian school of painting.	1502. L. Vázquez: Palace of Cogolludo. 1504-1514. J. de Egas: Hospital de Santa Cruz. 1509-1510. F. Llanos & F. Yáñez: retable of St Eloi. 1512. John of Burgundy: frescoes in the chapterhouse at Toledo Cathedral.	1502. Bramante: San Pietro in Montorio. 1503. Leonardo da Vinci: *Mona Lisa.* 1507. Giorgione: *The Tempest.* 1509. Raphael: The Vatican *Stanze.* 1512. Holbein: *Christ in the Sepulchre.*
From 1520 to 1539 Spain: 1530. Coronation of Charles V.	Papacy: 1521. Clement VII. England: 1533. Anne Boleyn, queen. Papacy: 1534-1550. Paul III.	1524. Cuauhtémoc, the last Aztec emperor, is executed. 1529. Peace of Cambray between Charles V & Francis I. 1531. Pizarro conquers Peru. 1538. L. Vives: *Del alma y de la vida.*	1521. Diet at Worms: Luther is excommunicated. 1526. Erasmus: *Dialogus...* 1529. Colloquy of Marburg, between Zwingli and Luther. 1532. Calvin embarks on Protestant reform in France.	1526. Diego de Sagredo: *Medidas del Romano...* Cisneros style. 1534. Garcilaso: *Églogas.*	1528. Dürer: *Theory of Human Proportions.* Italy: Mannerism develops in Rome, Florence and Parma. 1530. G. B. Rosso arrives in France. Fointainebleau school.	1520-1523. Diego de Siloé: golden staircase, Burgos Cathedral. 1529. D. Forment: retable at Poblet. 1535. V. Macip: *The Baptism of Christ.* 1537. Covarrubias: The Toledo Alcázar. 1539. R. Gil de Hontañón: Monterrey Palace.	1526-1530. Correggio: frescoes on the dome of Parma Cathedral. 1530. G. Romano: Hall of the Giants, Palazzo del Tè (Mantua). 1532. G.B. Rosso: Gallery of Francis I, Fointainebleau. 1537. Sansovino: library of San Marco.
From 1540 to 1559 Spain: 1556. Philip II, king.	Scotland: 1542. Mary Queen of Scots. England: 1547. Edward VI, king. Papacy: 1550-1555. Julius III.	1540. Valdivia conquers Chile. 1546. St Ignatius of Loyola: *Spiritual Exercises.* 1557. Battle of San Quintín.	1543. Copernicus formulates his heliocentric theory. 1545. The Council of Trent opens. 1555. Religious Peace of Augsburg.	Emotionalism and pathos in religious imagery. 1552. F. Villalpando translates Serlio's architectural treatise.	1550. Vasari: *The lives of modern painters, sculptors and architects.*	1540. P. Machuca: Palace of Charles V. 1544. J. de Juni: *The Holy Burial.* 1547-1563. P. de Campaña: *Deposition,* Seville Cathedral.	1540. Clouet: *Portrait of Francis I on Horseback.* 1546. Michelangelo: dome of St. Peter's. 1550. Palladio: Villa Rotonda, Vicenza.

16TH CENTURY

	Kings and Rulers		Socio-political & Scientific Context		Art Context		Art Fact File	
	Spain	Rest of World	Spain	Rest of World	Spain	Rest of World	Spain	Rest of World
		England: 1553. Mary I Tudor, queen. England: 1558. Elizabeth I, queen. France: 1559. Francis II, king. Papacy: 1559-1565. Pius IV.	1559. Peace of Cateau-Cambrésis between Philip II and France.		1554. Publication of *Lazarillo de Tormes*.	Italy: architectural illusionism and ornamentalism.	1554-1561. A. Berruguete: tomb of Cardinal Tavera. 1556-1577. A. de Vandelvira: Jaén Cathedral.	1554. Michelangelo: *Rondanini Pietà*. 1557. Bruegel the Elder: *The Fight between Carnival and Lent*.
From 1560 to 1579 Spain: 1570. Philip II marries Anna of Austria.		France: 1560. Charles IX, king, with regency of Catherine de' Medici. Papacy: 1566-1572. Pius V. Papacy: 1572-1585. Gregory XIII. France: 1574. Henry III, king.	1564. St Teresa of Ávila: *The Way of Perfection*. 1571. Battle of Lepanto.	1572. Night of St Bartholomew, France. 1575. St Philip Neri founds the Oratory, Rome.	Counter-Reformation.	1563. Debate on religious imagery (last session of the Council of Trent).	1562. Sánchez Coello: *Prince Don Carlos*. 1563. Building work starts on El Escorial. 1564. Luis de Morales: *El Beato Juan de Ribera*.	Il Vignola: Villa Farnese, Caprarola. 1568. Building work starts on the church of Gesù, Rome. 1574. Ammanati: *Neptune fountain*. Florence.
From 1580 to 1599 Spain: 1598-1621. Philip III, king.		Portugal, 1580. Philip II, king. Papacy: 1585-1590. Sixtus V. France: 1589. Henry IV, king. Papacy: 1590-1591. Gregory XIV. Papacy: 1592-1605. Clement VIIII.	1582. St John of the Cross: *Spiritual Canticle*. Fray Luis of Granada: *Introduction to the Symbol of Faith*. 1588. The Spanish Armada defeated by the English.	1580. T. Tasso: *Gerusalemme Liberata*. 1582. The Gregorian calendar introduced. 1587. Montaigne: *Essais*. 1597. Irish uprising against England. 1598. Edict of Nantes.	1583. Fray Luis of León: *La perfecta casada*. 1585. Cervantes: *La Galatea*. 1593. P. Cajés, translates Serlio's architectural treatise.	Italy: dynamic, graceful sculpture. 1585. Urban plan for Rome. 1592. Ruins of Pompeii discovered. 1594. G. P. Lomazzo: *Trattato dell'arte della pittura*, Milan. 1595. Shakespeare: *Romeo and Juliet*.	1580. Juan de Herrera: Valladolid Cathedral. 1582. F. Ribalta: *The Crucifixion*. 1586-1588. El Greco: *Burial of the Count of Orgaz*. 1587-1591. Tibaldi: frescoes in the library at El Escorial.	1581. Giambologna: *Heracles, Deianeira & the centaur Nessus*. 1580-1585. Germain Pilon: *The Virgin of Piety*. 1595. Carracci: paintings in the Palazzo Farnese, Rome. B. Spranger: *Hercules and Omphale*.

17TH CENTURY

	Kings and Rulers		Socio-political & Scientific Context		Art Context		Art Fact File	
From 1600 to 1619		England: 1603-1625. James I, king. Papacy: 1605-1621. Paul V. France: 1610-1643. Louis XIII, king. Ferdinand II, Holy Roman Emperor (1619-1637).	1600-1605. Fray J. Sigüenza: *History of the Order of St Jerome* (Madrid). 1604. Peace of London, between the Spanish and French monarchies. 1609-1610. Expulsion of the Moriscos.	1600. G. Bruno is burnt as a heretic in Rome. 1609. Maximilian I of Bavaria founds the Catholic League. Galileo invents the telescope. 1618-1648. Thirty Years' War. 1619. J. Kepler: *Harmonice mundi*.	1603. Rubens visits Spain and makes copies of the Italian masters. 1604. P. de Céspedes: *Discurso de la comparación*. 1605-1616. Cervantes: *Don Quijote*. 1606. Quevedo: *Los Sueños*. 1619. Lope de Vega: *Fuenteovejuna*.	1600. Rubens visits Italy. 1601. Shakespeare: *Hamlet*. 1607. Monteverdi: *Orfeo*. F. Zuccari: *L'idea de' scultori, pittori et architetti* (Turin). Followers of Caravaggio in Flanders and Holland.	1605. G. Fernández: *The Dead Christ*. 1609-1613. J. Martínez Montañés: *St Jerome*. 1610. El Greco: *Fray Hortensio Paravicino*. 1612-1613. J.B. Maino: *Adoration of the Magi*. 1617. La Clerecía, Salamanca.	1606. Caravaggio: *Death of the Virgin*. 1611. Guido Reni: *The Slaughter of the Innocents*. 1618. Rubens: *The Rape of the Daughters of Leucippus*. 1619-1622. I. Jones: Banqueting House, Whitehall, London.
From 1620 to 1639 Spain: 1621-1665. Philip IV, king.		Papacy: 1621-1623. Gregory XV. Papacy: 1623-1644. Urban VIII. England: 1625-1649. Charles I, king.	1621. Count-Duke of Olivares, favourite of Philip IV. 1627. Treasure of New Spain captured.	1624. The Dutch found New Amsterdam (N. York). 1624-1642. Richelieu, French prime minister. 1633. Galileo forced to recant before the Inquisition.	1623. Velázquez sets up in Court. 1628. Rubens' second visit to Spain. 1629. Velázquez's first visit to Italy.	1624-1650. Classicism emerges in France. Major realist school established in Holland. 1632. Van Dyck settles in England.	*C.* 1625. F. Ribalta: *St Bernard Embracing Christ*. 1629. Francisco Herrera the Elder: cycle of *St Bonaventure*. 1632. J. Ribera: *Tizio*.	1624-1633. Bernini: *Baldacchino*. 1625. G. La Tour: *Mary Magdalene*. 1630. B. Longhena: Santa Maria della Salute, Venice.

17TH CENTURY

	Kings and Rulers		Socio-political & Scientific Context		Art Context		Art Fact File	
	Spain	Rest of World	Spain	Rest of World	Spain	Rest of World	Spain	Rest of World
				1637. Descartes: *Discourse de la Méthode*.	1633. V. Carducho: *Diálogos de la pintura...* (Madrid).	1636. P. Corneille: *El Cid*.	1634-1635. Pictorial programme in the Hall of Kingdoms in El Buen Retiro.	1631. Poussin: *The Empire of Flora*. 1632. Rembrandt: *The Anatomy Lesson*.
From 1640 to 1659		France: 1643-1715. Louis XIV, king. Papacy: 1644-1655, Innocent X. England: 1649. Cromwell's government. Papacy: 1655-1667. Alexander VII. Leopold I, Holy Roman Emperor (1658-1705).	1640-1652. War of *Els Segadors* ('The Harvesters'). 1647. Uprisings in Naples and Sicily. 1648. Peace of The Hague: Spain recognizes the republic of Westphalia. 1652. Native uprising in the Yucatán. 1659. Peace of the Pyrenees.	1642. Civil war in England. 1642-1661. Mazarin, minister of France. The Pope condemns Jansenism. 1651. T. Hobbes: *Leviathan*. 1658. B. Pascal: *Lettres provinciales*. Restoration of the Anglican Church. French absolutism.	1642. Calderón de la Barca: *El Alcalde de Zalamea*. 1648. Velázquez's second visit to Italy. 1649. F. Pacheco: *Arte de la pintura...* 1651. B. Gracián: *El Criticón*.	1647-1660. France: Atticism. 1648. Founding of the Royal Academy of Painting & Sculpture in France. C. Le Brun, director of the French Academy and art dictator. Start of the French 'Grand Manner' period.	1640. Alonso de Mena: *Santiago Matamoros*. J. Gómez de Mora: City Council (Madrid). 1654. F. Herrera the Younger: *Triumph of St Hermenegild*. 1656. Velázquez: *Las Meninas*.	1641. C. Lorrain: *The Embarkation of St. Ursula*. 1642-1651. F. Mansart: Château Maison-Laffitte. 1642-1660. Borromini: S. Ivo della Sapienza, Rome. 1655-1661. L. Le Vaux: Château Vaux-le-Vicomte. 1658. Vermeer: *View of Delft*.
From 1660 to 1679 Spain: 1665-1700. Charles II, king. Spain: 1679. Marriage of Charles II to Marie-Louise d'Orléans.		England: 1660-1685. Charles II, king. France: 1661-1715. Louis XIV, effective government. Papacy: 1670-1676. Clement X. Papacy: 1676-1689. Innocent XI.	1660-1697. France invades northern Catalonia. 1668. Treaty of Lisbon; Portugal becomes independent. 1672-1678. War with France over Dutch territory.	1666. French Royal Academy of Natural Science. 1667. New Holland falls into English hands. 1668. Peace of Aix-la-Chapelle. 1672. Newton: laws of gravity.	1669. Carreño de Miranda, chamber painter. Religious piety increases in Seville. 1678. J. Caramuel: *Arquitectura civil, recta y oblicua* (Vigevana). J. Martínez: *Discursos practicables del nobilísimo arte de la pintura*.	1664. The Trappist Order founded in France. 1665. Bernini in the employ of Louis XIV. 1667. Milton: *Paradise Lost*. 1669. Molière: *Tartuffe*. 1677. Racine: *Phèdre*.	1664. P. de Mena: *Mary Magdalene*. 1667. Alonso Cano: Granada Cathedral facade. 1672. J. Valdés Leal: *Finis Gloria Mundi & In ictu oculi*. B.E. Murillo: *The Multiplication of the Loaves and Fishes*.	1661. Versailles. 1664. F. Hals: *Regentesses of the Old Men's Alms House*. 1666. Urban design of London after the fire. 1668-1680. G. Guarino Guarini: S. Lorenzo, Turin. 1675-1710. C. Wren: St Paul's, London.
From 1680 to 1699 Spain: 1690. Charles II marries Maria Anna of Austria.		England: 1685-1688. James II, king. Russia: 1689-1725. Peter the Great, czar. Papacy: 1689-1691. Alexander VIII. Papacy: 1691-1700. Innocent XII.	1689-1697. Third war with France. 1693. Birth of D. Torres de Villarroel. 1697. Peace of Ryswick: Louis XIV returns Flanders, Luxembourg and Catalonia.	1683. William Penn founds Philadelphia & Pennsylvania. 1684. France occupies Luxembourg. 1685. The Edict of Nantes repealed; exodus of French Protestants. 1687. Dual, Austro-Hungarian monarchy.	A school of portraiture grows up around Charles II. Decorativism and conceptualism in Hispano-American architecture. 1685. Sánchez Coello appointed chamber painter.	1680. Founding of the Comédie Française. France: the so-called 'minor genre' grows. 1698. Vauban: new town design: Neuf-Brisach.	1680. J. Carreño de Miranda: *La Monstrua Desnuda*. 1685. C. Coello: *Adoration of the Holy Form*. 1693. J. Churriguera: retable at the high altar in the church of San Esteban. 1694-1709. Sanctuary of Guadalupe (México).	1685-1691. Andrea del Pozzo: ceiling decoration in the church of S. Ignazio, Rome. 1687-1688. J. H. Mansart: The Grand Trianon. 1693-1724. J. von Hildenbrandt: Lower & Upper Belvedere, Vienna.

18TH CENTURY

	Kings and Rulers		Socio-political & Scientific Context		Art Context		Art Fact File	
	Spain	Rest of World	Spain	Rest of World	Spain	Rest of World	Spain	Rest of World
From 1700 to 1719 Spain: 1700-1746. Philip V, king. Spain: 1705. Archduke Charles of Austria proclaimed king in Barcelona. Spain: 1714. Marriage of Philip V and Isabella Farnese.		Papacy: 1700-1721. Clement XI. Austria, 1711-1740. Charles VI, emperor. Prussia, 1713-1740. William I. England: 1714-1727. George I, king.	1703-1714. War of Succession. 1704. English troops occupy Gibraltar. 1714. Philip V seizes Barcelona.	1707. Act of Union: the kingdom of Great Britain is formed. 1709. Peter the Great founds St Petersburg. 1713. Great Britain annexes Terra Nova & Nova Scotia.	Spain enters the French art sphere. 1713. Founding of the Real Academia de la Lengua. 1715 y 1724. Palomino: *El museo pictórico y la escala óptica* (Madrid).	France imposes court tastes throughout Europe. 1704. Roger des Piles: *Cours de Peinture pour Principes*. Flowering of Baroque architecture in Central Europe.	1715. H. Rovira: Palace of the Marquis of Dosaguas. *Risueño, Ecce Homo & Dolorosa* (Royal Chapel, Granada).	1701. J. Rigaud: *Portrait of Louis XIV*. 1707. Fischer von Erlach: church of San Carlos Borromeo. 1713. Hildebrandt: Daun-Kinsky Palace (Vienna).

Kings and Rulers		Socio-political & Scientific Context		Art Context		Art Fact File	
Spain	Rest of World	Spain	Rest of World	Spain	Rest of World	Spain	Rest of World
	France: 1715-1774. Louis XV, king.	1719. Conquest of Sardinia and Sicily.	1718. Sardinia falls to Victor Manuel II of Savoy.	1717. Founding of Cervera University.	France: birth of the Rococo style. 1719. D. Defoe: *Robinson Crusoe*.		1716. Le Blond: Peterhof palace. 1717. Watteau: *The Embarkation for Cythera*.
From 1720 to 1739 Spain: 1724. Interregnum of Louis I.	Papacy: 1721-1724. Innocent XIII. Papacy: 1724-1730. Benedict XIII. Russia: 1725-1740. Catherine I, czarina. England: 1727-1760. George II, king. Papacy: 1730-1740. Clement XII.	1720. Peace of the Hague: Philip V forfeits Sardinia and Sicily in exchange for Parma, Plasencia & Tuscany. 1729. Founding of the Academia de Buenas Letras, Barcelona. 1739. War between Spain and Great Britain.	1733. Voltaire: *Letters on the English*. 1739. Treaty of Vienna. Charles III forfeits his Italian dominions in exchange for Naples and Sicily. Peace of Belgrade: Austria loses Serbia and Walachia.	Survival of Baroque classicism in Court commissions. Moves to improve Spain's cultural status quo.	1721. Fischer von Erlach: *Entwurf einer historischen Architektur*. 1726. Swift: *Gulliver's Travels*. The Rococo spreads to England. 1738. Excavations at Herculaneum.	1721-1732. N. Tomé: *Transparent*, Toledo Cathedral. 1722-1765. Facade of the church of La Compañía (Quito). 1729. Churriguera: Plaza Mayor, Salamanca. 1736. F. Salzillo: processional floats.	1729. F. Juvarra: Stupinigi Palace (Turin). 1730. W. Hogarth: *Before and After*. 1736-1739. G. Boffrand: Hôtel de Soubise, Paris.
From 1740 to 1759 Spain. 1746-1759. Ferdinand VII, king. Charles III, king of Spain, forfeits his dominion over Naples (1759).	Papacy: 1740-1758. Benedict XIV. Austria: 1740-1780. Maria Theresa, empress. Papacy: 1758-1769. Clement XIII.	1756. French seize Minorca. 1762. War between Spain and Great Britain. 1763. England recovers the island of Minorca.	1745. Frederick II of Prussia defeats Austria. War against the Prussian empire. 1748. Montesquieu: *De l'esprit des lois*. Peace of Aix-la-Chapelle. 1752. Benjamin Franklin invents the lightning conductor. 1756-1763. Seven Years' War: England & Prussia against Austria & France.	1747. E. Flórez: *España Sagrada*. Arrival of Italian artists: Solimena, Giaquinto... 1752. Founding of the Real Academia de Bellas Artes de San Fernando. 1755. Gonzalo Velázquez, chamber painter. Urban plan for Madrid.	1742. Handel: *The Messiah*. 1748. Excavations at Pompeii. 1751. Diderot & d'Alambert: *Encyclopédie*. Rome: centre of attraction for artists and theoreticians. 1756. A. Gerard: *Essai sur le goût*.	1740. Charterhouse of Granada. 1752. A. González Velázquez: decoration in the chapel of El Pilar.	1740. Chardin: *The Lesson*. 1743-1772. J. B. Neumann: *Vierzehnheiligen* (Germany). *C*. 1745-1750. Canaletto: *View of Venice (Il Bucintoro)*. 1757-1792. J. G. Soufflot: Pantheon, Paris. 1758. Boucher: *Mme. de Pompadour*.
From 1760 to 1779	England: 1760-1820. George III, king. Russia: 1762-1796. Catherine II the Great, czarina. Russia, 1762, adds the Black Sea to its dominions. Papacy: 1769-1774. Clement XIV. France: 1774-1789. Louis XVI, king.	1766. Uprising against Esquilache. 1768. Aranda' 'census'. 1774-1776. F. de Cevallos: *La falsa filosofía*. 1778. Free-trade between Spanish ports and the Americas.	1762. Rousseau: *The Social Contract*. 1769. Watt patents the steam engine. 1771. Russia conquers Crimea. 1773. Abolition of the Society of Jesus. 1775. American War of Independence.	1761. Arrival in Madrid of the painter Mengs. 1762. Tiepolo decorates the Royal Palace (Madrid). 1768. Founding of the Academia de San Carlos, Valencia. 1775. Campomanes: *Discurso sobre la educación popular de los artesanos*.	Spread of Neoclassicism. 1764. J.J. Winckelmann: *History of Art in Antiquity*. 1768. The Royal Academy is founded in London. 1774. Goethe: *Leiden des jungen Werthers*. 1776. Gibbon: *Fall of the Roman Empire*.	1765. F. Bayeu: decoration in the palace of El Pardo. 1771-1791. Chapel of El Pocito (Mexico). 1772. L. Paret y Alcázar: *The Antiquarian's Shop*. 1778. F. Sabatini: Alcalá Gate.	1762-1768. J. A. Gabriel: The Petit Trianon. 1768. Fragonard: *The Swing*. 1775-1779. C. N. Ledoux: ideal city of Chaux. 1776-1780. W. Chambers: Somerset House (London).
From 1780 to 1799 Spain: 1788-1819. Charles IV, king.	United States: 1789. George Washington, first President. France: 1792. Proclamation of the First Republic. Austria: 1792-1835. Francis II, emperor.	1781. Charles III recovers the islands of Minorca. 1787. Floridablanca's 'census'. 1792. Godoy, prime minister. 1793. War between France and Spain.	1781. Kant: *Critique of Pure Reason*. 1783. Treaty of Versailles: England recognizes the United States of America. 1789. American constitution. Storming of the Bastille.	1786. F. de Goya is appointed painter to the king. 1788. A. Ponz: *Viaje por España*. 1792. L. Fernández Moratín: *La Comedia Nueva*.	France: Louis-XVI style. Germany: *Sturm und Drang*. 1787. Mozart: Don Juan. England: Adam style. Neoclassicism becomes militant in France.	1785. Juan de Villanueva: Museo de Ciencias Naturales (now the Prado Museum, Madrid). 1789. Goya: *Portrait of Jovellanos*. 1794. T. Benjumeda: Royal Prison, Cádiz.	1784. David: *Oath of the Horatii*. 1789-1791. Langhans: Bradenburg Gate. 1792. A. Canova: *Monument to Clement XIII* (Rome).

18TH CENTURY

Kings and Rulers		Socio-political & Scientific Context		Art Context		Art Fact File	
Spain	Rest of World	Spain	Rest of World	Spain	Rest of World	Spain	Rest of World
	France: 1793. Consulate of Bonaparte. Russia: 1796-1801. Paul I, czar. Prussia: 1797-1840. Federico-William III, king.	1795. Peace of Basel. 1796. Outbreak of war with England.	1791. Paine: *The Rights of Man* 1793. The Reign of Terror.	Young artists train in Rome: J. de Madrazo, J.A. de Ribera and J. Álvarez Cubero.	Germany: classical monumentalism in public buildings. 1797. F. Milizia: *Fine Arts Dictionary*.	1800. Goya: *King Charles IV and His Family*.	J. Soane: Bank of England. 1796. Wyatt: Fonthill Abbey.

19TH CENTURY

From 1800 to 1819 Spain: 1808. Charles IV and Ferdinand VII abdicate in Bayonne. Spain: 1808-1814. Joseph I Bonaparte, king. Spain: 1814. Ferdinand VII restored to the throne; absolutism reinstated.	Russia: 1801-1825. Alexander I, czar. France: 1804-1814. Napoleon I, emperor. France: 1814-1824. Louis XVIII, king.	1802. Peace of Amiens. 1805. Battle of Trafalgar. 1808-1814. Spanish Peninsular War. 1811. Paraguay and Venezuela, independent. 1812. The Cádiz Constitution. 1816. Argentina, independent. 1818. Chile, independent.	1801. Formation of the United Kingdom. 1805. Battle of Austerlitz: France defeats Austria and Prussia. 1812. Napoleon invades Russia. 1814. Congress of Vienna. 1815. Battle of Waterloo.	Persistence of academicism. Pockets of Neoclassical purism. 1812. Rome scholarship-holders active in the service of Charles IV. 1815. V. López, chamber painter. 1816. J. Ginés, chamber sculptor. Ferdinandine style in decorative art.	1802. Chateaubriand: *Génie du christianisme*. 1804. Beethoven: *Eroica*. 1810. The Nazarene association formed in Rome. 1816. Rossini: *The Barber of Seville* (premiere). 1819. Lord Byron: *Don Juan*.	1802. I. González Velázquez: Farmer's Lodge (Aranjuez). 1804. D. Campeny: *The Dying Lucretia*. 1806-1807. J. Madrazo: *Death of Viriathus*. 1814. Goya: *The Executions of 3 May*. 1817. A. López Aguado: Toledo Gate.	1806. B. Vignon: church of La Madeleine (Paris). 1808. A. J. Gross: *Napoleon at Eylau*. 1810. F. Overbeck: *Portrait of F. Pforr*. 1814. Ingres: *La Grande Odalisque*. 1815-1820. Leo von Klenze: Glyptothek, Munich. 1819. Géricault: *The Raft of the Medusa*.
From 1820 to 1839 Spain: 1833-1868. Isabella II, queen.	Great Britain: 1820-1830. George IV, king. France: 1824-1830. Charles X, king. Russia: 1825-1855. Nicholas I, czar. Great Britain: 1830-1837. William IV, king. France: 1830-1848. Louis-Philippe, king. Austria: 1835-1848. Ferdinand I, emperor. Great Britain: 1837-1901. Victoria, queen.	1820-1823. Liberal Triennium. 1821. Mexico & Peru, independent. 1823-1833. The 'ominous' decade. 1828-1830. Uruguay and Ecuador, independent. 1833. Carlos María Isidro, pretender to the Spanish throne; outbreak of the First Carlist War. 1834. Abolition of the Inquisition. 1837. Liberal constitution.	1822. Independence of Brazil. 1822. Independence of Greece. 1823. The Monroe Doctrine is formulated. 1829. Stephenson invents the locomotive. 1830. France: July bourgeoise revolution. 1830-1842. A. Comte: *Curso de filosofía positiva*. England leads world industry. 1837. First Opium War between Great Britain and China.	1820. Goya, in exile in Bourdeaux. Local and regional art traditions come under review. 1832. P. Milà i Fontanals establishes contact with the Nazarenes. A romantic image of Spain emerges. Catalonia: the Renaixença cultural movement. 1836. Disentailment of Church property.	Germany: the Biedermeier style. Oriental taste spreads throughout Europe. England: Victorian style. 1836. Rousseau founds l'École de Barbizon. 1837. C. Dickens: *Oliver Twist*. 1838. Stendhal: *La Chartreuse de Parme*. 1839. Daguerre builds a photographic machine.	1823. J. Álvarez Cubero: *The Defence of Zaragoza*. 1827. A. Echevarría: Casa de Juntas and Templo de las Patriarcas. 1835. A. Solà: Monument to Cervantes.	1822. C. D. Friedrich: *Moon Rising over the Sea*. 1822-1826. K. F. Schinkel: Berlin Museum. 1824. J. Constable: *The Hay-Wain*. 1827. W. Thornton & C. Bulfinch: the Capitol, Washington. 1830. E. Delacroix: *Liberty Leading the People*.
From 1840 to 1859 Spain: 1843-1868. Effective rule of Isabel II. Spain:, 1854-1856. Espartero, prime minister.	Prussia: 1840-1861. Frederick-William IV, king. Papacy: 1846-1878. Pius IX. Austria: 1848-1916. Franz Joseph I, emperor. France: 1848-1851. Proclamation of the II Republic.	1844-54. Start of the 'moderate decade'. 1846-60. Second Carlist War. 1848. Barcelona-Mataró railway. 1854-1856. Progressive Biennial.	1846. Mexico at war with the United States. 1848. France: February Revolution. Marx and Engels: *Communist party manifesto*.	1842. Federico de Madrazo settles in Madrid. 1844. J. Zorrilla: *Don Juan Tenorio*. 1854. The Barcelona city walls demolished.	1843. Wagner: *Der fliegende Holländer*. 1848. Founding of the Pre-Raphaelite Brotherhood. 1851. J. Ruskin: *The Stones of Venice*. Universal Exposition of London.	1840. L. Alenza: *Viaticum*. 1843. C. Lorenzale: *Creation of the Coat-of-Arms of Catalonia*. 1846. A. M. Esquivel: *Lectura de Zorrilla*.	1844. J. M. W. Turner: *Rain, Steam & Speed*. 1848. D. G. Rosetti: *Girlhood of Mary Virgin*. 1850. J. Paxton: Crystal Palace (London).

19TH CENTURY

Kings and Rulers		Socio-political & Scientific Context		Art Context		Art Fact File	
Spain	Rest of World	Spain	Rest of World	Spain	Rest of World	Spain	Rest of World
Spain, 1856. General O'Donell's coup.	France: 1852-1870. Napoleon III, emperor. Russia: 1855-1881. Alexander II, czar.	1856-1868. Second moderate period. 1859. War in Africa.	1850. S. A. Kierkegaard: *Training in Christianity*. 1854-1856. Crimean War. 1858. Suez Canal. 1859. Darwin: *The Origin of the Species*.	1856. First National Fine Arts Exhibition. 1859. I. Cerdà designs the Eixample new town project in Barcelona.	1852. Haussmann; town planning. 1855. International Exposition of Paris. Pictorial realism in vogue in France.	1848. J. Pérez Villaamil: *Gaucín Castle*. 1850. Teatro Real (Madrid). 1853. Federico de Madrazo: *La condesa de Vilches*.	1852. J. E. Millais: *Ophelia*. 1855. G. Courbet: *The Painter's Studio*. 1858-1859. J.-F. Millet: *The Angelus*.
From 1860 to 1879 Spain, 1868. provisional government under generals Serrano, Prim & Topete. Spain, 1870. Assassination of General Prim. Spain, 1870. Amadeus of Savoy appointed king by the Cortes. Spain, 1873. First Republic. Spain, 1874-1885. Bourbon restoration. Alfonso XII, king.	Italy: 1861. Victor Emmanuel, king. United States: 1861. Abraham Lincoln, President. Prussia: 1861-1888. Wilhelm I, king. Austria: 1867. Franz Joseph I crowned King of Hungary; birth of the Austro-Hungarian empire. Germany: 1871. Wilhelm I of Prussia, emperor. France: 1871. The Paris Commune.	1868. The September Revolution. 1868-1874. Liberal Six-Year period. Constitution of 1869. 1872. Third Carlist War. 1873. Cantonalist Uprising. 1874. Pronouncement of General Martínez Campos.	1860. Garibaldi conquers Sicily and Naples. 1861. American Civil War. 1864. The First Internacional. 1865. Abolition of slavery in the U.S.A. 1867. K. Marx: *Das Kapital*. 1869. First Vatican Council. 1871. Bismarck proclaims the II Reich.	History painting in the ascendant. 1866. B. Pérez Galdós: *Fortunata y Jacinta*. 1869. Barcelona's Ciutadella partially demolished. 1873. Founding of the Spanish Fine Arts Academy in Rome. Monumentalism in sculpture. The Olot school of landscape painting is formed.	1862. Victor Hugo: *Les Misérables*. Italy: the Macchiaioli. 1863-1872. Viollet-le-Duc: *Entretiens sur l'architecture*. 1867. Verdi: *Don Carlo*. 1869. Tolstoy: *War and Peace*. 1874. First collective exhibition of the Impressionists (Paris). 1879. Ibsen: *A Doll's House*.	1862. E. Rogent: Barcelona University. 1863. E. Rosales: *El testamento de Isabel la Católica*. 1866. Jareño: Palacio de Bibliotecas y Museos (Madrid). 1870. R. Martí i Alsina: *El Bornet*. 1871. M. Fortuny: *Marriage in the Priory*. 1873-1876. Fontseré: El Born market design.	1861-1875. J.L.C. Garnier: The Opéra, Paris. 1863. E. Manet: *Le déjeuner sur l'herbe*. 1865-1867. G. Mengoni: Galleria Vittorio Emmanuele (Milan). 1867-1869. Carpeaux: *The Dance*. 1875. Degas: *Ballet Rehearsal*. 1876. G. Moreau: *The Apparition*.
From 1880 to 1899 Spain, 1886-1931. Alfonso XIII, king.	Russia: 1881-1894. Alexander III, czar. Germany: 1888-1918. Wilhelm II, king & emperor of Prussia. Russia: 1894-1917. Nicholas II, czar.	Political parties take turns in government. 1890. Inception of universal male suffrage. 1891. Protectionist measures approved. 1897. Assassination of Cánovas del Castillo. 1898. Spain's loses its last colonies (Treaty of Paris).	Triple Alliance: (Germany, Italy & Austria) against France. 1885. Berlin Conference; division of Africa. 1886. F. Nietzsche: *Beyond Good & Evil*. 1889. The Second International. 1895. Lumière: first cine camera. 1898. The Curies discover radium.	1880. Advent of pictorial realism. 1884. L. Alas Clarín: *La Regenta*. 1887. Discovery of the Lady of Elche. 1888. Universal Exposition of Barcelona. Catalonia: Modernism.	1884. I Salon des Indépendents (Paris). 1885. Zola: *Germinal*. 1888. Van Gogh settles in Arles. England: *Arts & Crafts* movement. France: the Post-Impressionists. 1890. Gauguin in Tahiti. 1892. The Sezession founded in Munich. 1897. Advent of the Viennese Sezession.	1880. Comillas Seminar (Cantabria). 1887. Gaudí: episcopal palace, Astorga. 1889-1892. A. Palacio: Atocha station. 1890. R. Casas: *Plein Air*. 1894. Sorolla: *And they still say fish...* 1897. Josep Llimona: *Primera Comunión*.	1880. Rodin: *The Thinker*. 1886-1888. P. Cézanne: *Mont Sainte-Victoire*. 1889. G. Eiffel: The Eiffel tower (Paris). 1893. E. Munch: *The Cry*. 1896. V. Horta: Casa Solvay. 1899. Sullivan: Carson, Pirie & Scott Store. Monet: series on Rouen Cathedral.

20TH CENTURY

Kings and Rulers		Socio-political & Scientific Context		Art Context		Art Fact File	
Spain	Rest of World	Spain	Rest of World	Spain	Rest of World	Spain	Rest of World
From 1900 to 1909	Great Britain, 1901-1910. Edward VII, king.	1904. Echegaray: Nobel prize for literature. 1909. War in Morocco. The 'Tragic Week' in Barcelona.	1900. G. Puccini: *Tosca* (premiere). 1901. T. Mann: *Buddenbrooks*. 1905. Einstein: Theory of Relativity. 1906. Mahler composes the sixth symphony.	1900. Picasso exhibits at Els Quatre Gats in Barcelona. 1903. Antonio Machado: *Soledades*. Spanish artists in the Paris avant-garde. 1907. J. Benavente: *Los intereses creados*.	1900. Universal Exposition of Paris. 1905. Salon d'Automne: *Les Fauves*. Die Brücke formed in Dresden. 1908. Picasso & Braque, Cubism. 1909. Futurist manifesto.	1901. Gaudí starts work on Güell Park. 1905. L. Doménech i Montaner: Palau de la Música Catalana. 1907. Picasso: *Les Demoiselles d'Avignon*. I. Zuloaga: *The Dwarf Gregorio el Botero*.	1905-1911. J. Hoffmann: Palais Stoclet (Brussels). 1905-1906. Matisse: *Bonheur de vivre*. 1909. P. Behrens: turbine factory, Berlin. E. Nolde: *The Last Supper*.

	Kings and Rulers		Socio-political & Scientific Context		Art Context		Art Fact File	
	Spain	Rest of World	Spain	Rest of World	Spain	Rest of World	Spain	Rest of World
From 1910 to 1919		Great Britain: 1910-1936. George V, king. Austria: 1916-1918. Charles I, emperor.	1911. The CNT trade union is formed. 1914. The *Mancomunidad*, Catalonia.	1914-1918. First World War. 1917. Bolshevik Revolution. 1919. Gandhi advocates India's independence.	1911. Catalonia: *Almanach dels Noucentistes*. 1914. J. R. Jiménez: *Platero y yo*. 1915. Falla: *El amor brujo*. 1917. Publication of the journal *391*. 1918. Ultraism founded in Madrid.	1910. W. Kandinsky: first abstract watercolour. 1912. Der Blaue Reiter. 1913. I. Stravinsky: *The Rite of Spring*. 1916. Kafka: *Metamorphosis*. 1917. Malévich: Suprematism. Dadaist movement. Mondrian: Neo-Plasticism. 1919. Gropius: the Bauhaus (Weimar).	1910-1911. J. Sunyer: *Pastoral*. 1912. Picasso: *Still-life with Wicker Seat*. 1913. Torres-García: *Catalunya eterna*. 1914. Juan Gris: *The Anis Bottle*.	1911. F. Marc: *Blue Horses*. 1913. E. L. Kirchner: *The Street*. 1914. Duchamp-Villon: *The Horse*. 1917. Egon Shiele: *The Embrace*.
From 1920 to 1929 Spain: 1923. Primo de Rivera, dictator.		Stalin's rule (1924).	1922. J. Benavente: Nobel literature prize. 1926. End of the Moroccan war.	1922. Mussolini rules Italy. Fleming discovers penicillin. 1929. Crash of the New York stock exchange.	1925. Exhibition of the Association of Iberian Artists. 1928. L. Buñuel: *Un chien andalou*. F. García Lorca: *Romancero gitano*. 1929. International Exposition of Barcelona. The Vallecas school.	France: the return to order. Germany: *Die Neue Sachlichkeit*. 1922. J. Joyce: *Ulysses*. 1924. Surrealist manifesto. 1924. A. Schoenberg: Piano Suite Op 25. 1925. S. M. Eisenstein: *The Battleship Potemkin*. Art Deco.	1920-1921. Joan Miró: *The Farm*. 1922. E. Barral: *Portrait of the Artist's Mother*. 1926. Solana: *The Bishop's Visit*.	1920. Otto Dix: *War Invalids playing Cards*. 1923. M. Duchamp: *The Large Glass*. 1928. A. Martini: La Pisana. 1929. Le Corbusier: Villa Savoye (Poissy).
From 1930 to 1939 Spain: 1931. Proclamation of the Second Republic.		The United States: 1932. F. D. Roosevelt, President. A. Hitler, Chancellor of Germany (1933) Great Britain: 1936-1952. George VI, king.	1930. Unamuno: *San Manuel bueno y mártir*. 1933. A. Lerroux, president of France. 1936. M. Azaña, Spanish prime minister. 1936-39. Spanish Civil War.	1933. Roosevelt proclaims the 'New Deal'. 1938. Hitler annexes Austria. 1939-1945. Second World War.	1930. Formation of GATEPAC. 1932. Formation of ADLAN. 1936. 'Logico-phobist' exhibition. Advent of Surrealism. 1937. Pavilion of the Spanish Republic in Paris.	Italy: *Novecento* style. Mexican muralists: Rivera, Orozco, Siqueiros & Tamayo. 1938. J. P. Sartre: *La Nausée*. Many European artists emigrate to the United States.	1931. Salvador Dalí: *The Persistence of Memory*. 1932. A. Sánchez: horizon sculpture. 1935. O. Domínguez: *Guanche Cave*. 1937. J. González: *The Cry of Montserrat*.	1930-1935. D. Rivera: fresco on the National Palace, Mexico. 1933. J. Arp: human concretion. 1934-1936. F. Lloyd Wright: Falling Water. 1937. Picasso: *Guernica*.
From 1940 to 1949			1940. Franco meets Hitler at Hendaya. 1945. Spain barred from the United Nations.	1941. Japanese attack on Pearl Harbor. 1944. Allied landing in Normandy. 1945. The first atom bomb dropped on Hiroshima. 1949. NATO is formed.	1940. Joan Miró settles in Majorca. Development of the avant-garde cut short. C. J. Cela: *La familia de Pascual Duarte*. 1945. Founding of the Mailloll Circle (Barcelona). 1948. Publication of the journal *Dau al Set*.	New American painting: Action painting, Abstract Expressionism, etc. 1948. Cobra group.	1942-1958. P. Muguruza: El Valle de los Caídos (monument). 1943. J. Brossa: first poem–objects. 1946-1956. L. Moya: Universidad Laboral (Gijón). 1948. J. Ponç: *Self-portrait*.	1942-1945. J. Fautrier: *Hostages*. 1945. J. Dubuffet: *Coffee Machine*. A. Gorky: *Table Landscape*. 1948. M. Pollock: *Untitled*. K. Appel: *The Cry*.

20TH CENTURY

	Kings and Rulers		Socio-political & Scientific Context		Art Context		Art Fact File	
	Spain	*Rest of World*	*Spain*	*Rest of World*	*Spain*	*Rest of World*	*Spain*	*Rest of World*
From 1950 to 1959		Britain: 1952. Elizabeth II, queen. United States: 1953. Eisenhower, President. Yugoslavia: 1953. Marshall Tito, president. Papacy: 1958. John XXIII.	1952. End of rationing in Spain. 1956. Spanish Morocco becomes independent.	1950-53. Korean War. 1955. Warsaw Pact. 1959. Fidel Castro enters Havana.	1951. Formation of the 'Grupo R'. 1956. Grupo Parpalló. 1957. Formation of the El Paso group. 'Other Art' exhibition in Barcelona and Madrid.	1952. Rise of Informal art. New Dadaism, U.S.A. 1958. Pop Art in England. 1958-1967. Germany: Zero Group. Pop Art in the U.S.A.	1951. Florensa/Clarà: Monument to the Fallen (Barcelona). 1954. J. A. Coderch: fishermen's quarters. 1958. A. Saura: *Imaginary Portrait of B. Bardot*.	1950. W. de Kooning: *Woman I*. 1956. L. Fontana: *Spatial Concept*. 1957. A. Giacometti: *Woman of Venice*. 1958. J. Jones: *Three Flags*.
From 1960 to 1969		United States: 1960. J. F. Kennedy, president. United States: 1968. R. Nixon, President.	1968. ETA starts its campaign of violence.	1961. Erection of the Berlin Wall. 1963. J. F. Kennedy assassinated. 1965. American intervention in Vietnam. 1968. May, France. Assassination of Martin Luther King. Soviet invasion of Czechoslovakia. 1969. First manned lunar landing.	1964. Equipo Crónica. 1964-1972. ZAJ movement. 1966-1976. Equipo Realidad. 1966. Museo de arte abstracto, Cuenca. Realism in architecture.	France: GRAV. France: New Realism. 'Happenings': Kaprow and Fluxus. 1964. Consolidation of Pop art. 1965. Minimalism. 1967. Arte Povera. 1968. Cybernetic art.	1961. A. Tàpies: *Inverted T on Black Ground*. 1962. Ràfols-Casamada: *Homage to Schoenberg*. 1966-1968. J. A. Coderch: Edificios Trade (Barcelona). 1969. Equipo Crónica: *The Banquet*.	1963. T. Wesselmann: *Bathroom: collage no. 3*. Niki de Saint-Phalle: *Crucifixion*. 1967. A. Warhol: *Marilyn Monroe*. 1968. Mario Merz: Igloo at Giap. 1969. V. Vasarely: *Ambiguous*.
From 1970 to 1979 Spain, 1973. Juan Carlos I, king. Spain, 1976. Adolfo Suárez, first democratic prime minister.		Chile: 1970. Salvador Allende, president. Chile: 1973. Pinochet, dictator. Papacy: 1978. John Paul II. Britain: 1979. Margaret Thatcher, prime minister.	1973. Assassination of Carrero Blanco (December). 1975. Death of General Franco. 1978. Democratic constitution. 1979. Catalan and Basque statutes of autonomy.	1971. Pablo Neruda: Nobel literature prize. 1973. Vietnam War ends. 1974. Nixon resigns. 1976. Mars landing. 1979. Soviet invasion of Afghanistan.	1971. The Conceptual movement emerges in Catalonia. 1975. Founding of the Museo Español de Arte Contemporáneo. Inauguration of the Miró Foundation.	1972. Hyperrealism debuts at Documenta in Kassel. 1976. New Subjectivism. 1977. France: inauguration of the Centre Georges Pompidou. 1979. The transavant-garde in Italy.	1970-1975. R. Bofill: Walden-7. 1972-74. O. Bohigas: Escuela Thau (Barcelona). 1972-1977. E. Chillida: *Comb in the Wind*. 1975. C. Pazos: *Becoming a Star*. 1976. E. Arroyo: *Suit going down the Stairs*.	1973. F. Bacon: *Self-portrait*. 1974. Adami: *Intolerance*. 1979. Aldo Rossi: The World Theatre.
From 1980 to 1995 Spain, 1982. Felipe González, prime minister.		United States: 1980. Ronald Reagan, President. France: 1981. F. Miterrand, president of the Republic. Germany: 1982. H. Kohl, Chancellor of the Federal Republic. URSS: 1985. M. Gorbachev, Soviet leader. United States: 1988. G. Bush, President. Russia: 1991. B. Yeltsin, President of the Federation.	1981. Aborted coup attempt. 1982. Spain joins NATO. 1985. Accession to the EEC. 1987. Mayor Zaragoza, director general of UNESCO. 1992. Olympic Games in Barcelona and Expo 92 in Seville.	1986. Nuclear accident at Chernovil. 1987. Reagan and Gorbachev adopt the demilitarisation plan. 1989. Gorbachev's Perestroika. 1989. The Berlin Wall comes down. 1990. Iraq invades Kuwait. 1990. German reunification. 1991-95. Civil war in Yugoslavia.	1981. *Guernica* arrives in Spain. 1983. J.L. Garci: Oscar for the best foreign film. 1984. V. Aleixandre: Nobel literature prize. 1989. C. J. Cela: Nobel literature prize.	Graffiti art. Bad Painting. 1982. G. García Márquez: Nobel literature prize. Highest prices ever on the art market. Italy: the Anachronists. Internationalisation of architecture.	1981. F. García Sevilla: *Untitled*. 1984. M. Barceló: *L'amour fou*. 1986. J. M. Broto: *Point of View*. 1987. F. Leiro: *Bench-Man*. 1988. S. Calatrava: Bac de Roda bridge (Barcelona). Plensa: *Dawn*. 1990. Solano: *Acotación*.	1982. F. Clemente: *Fortune*. 1983. Blade: *Oh Yes*. 1986. Arata Isozaki: San Jordi Stadium project (Barcelona). 1987. J. Schnabel: *Portrait of Eric*.

PREHISTORY AND ANTIQUITY

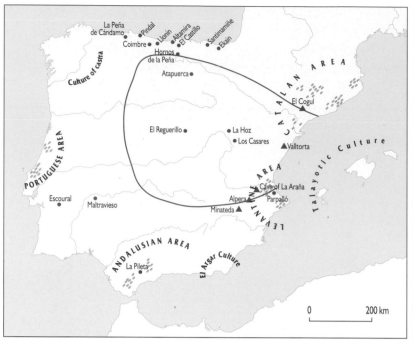

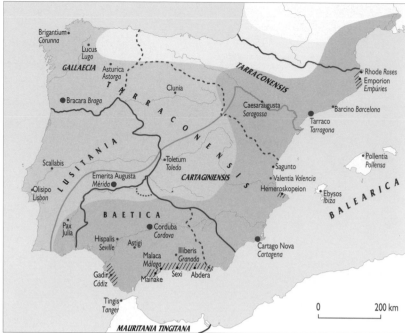

Palaeolithic cave art
(17th–10th millennium BC)

▲ Levantine art

• Franco-Cantabrian art

LEVANTINE AREA Main agricultural settlements during the Neolithic

🗘 Cardial pottery
(6th–3rd millennium BC)

— Approx. boundary of Megalithic culture
(4000–1800 BC)

Talayotic Culture Bronze Cultures (2nd millennium BC)

Peoples:

▨ Iberians

▨ Celts

▢ Cantabro-Vascons

Colonizations:

▨ Greek

▨ Phoenician

— Limits of
Carthaginian
(3rd C. BC)

— Provincial boundaries until Diocletian (284-313)

- - - Provincial boundaries set by Diocletian

● Provincial capitals

• Major towns

BAETICA Provinces until Diocletian

GALLAECIA Provinces created by Diocletian

THE CALIPHATE IN THE 10TH CENTURY

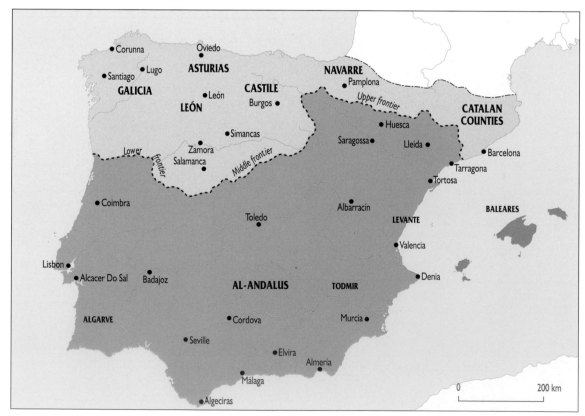

▨ Christian territory

- - - Approx. frontier line

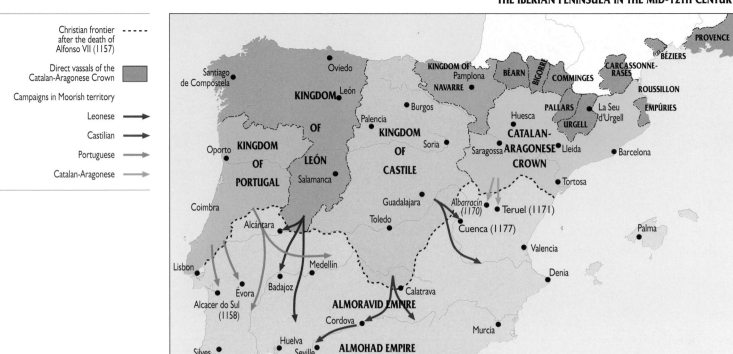

Christian frontier
after the death of
Alfonso VII (1157)

Direct vassals of the
Catalan-Aragonese Crown

Campaigns in Moorish territory

Leonese

Castilian

Portuguese

Catalan-Aragonese

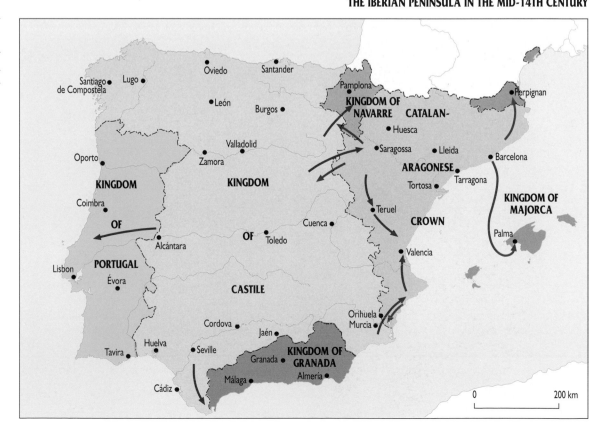

Lines of assault and penetration:

Castilian

Catalan-Aragonese

EUROPE DURING THE REIGN OF PHILIP II

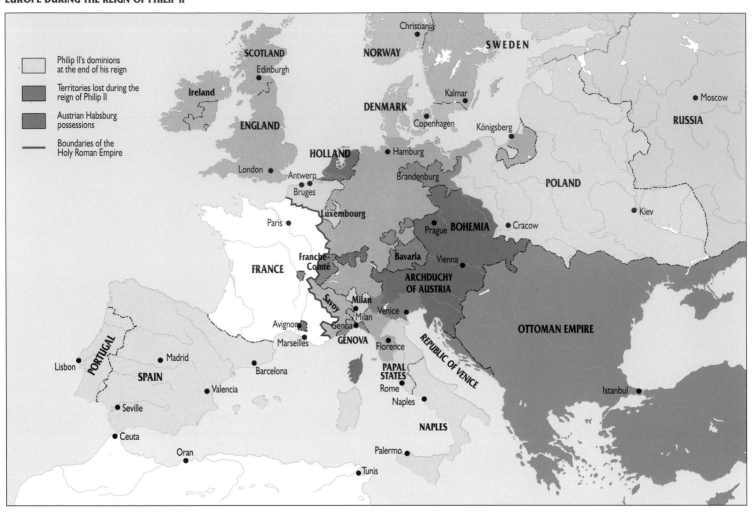

Philip II's dominions at the end of his reign

Territories lost during the reign of Philip II

Austrian Habsburg possessions

Boundaries of the Holy Roman Empire

Christiania

SWEDEN

NORWAY

SCOTLAND
Edinburgh

Ireland

Moscow

Kalmar

DENMARK
Copenhagen

Königsberg

RUSSIA

ENGLAND

London

HOLLAND
Antwerp
Bruges

Hamburg

Brandenburg

POLAND

Kiev

Luxembourg

Paris

Prague

BOHEMIA

Cracow

FRANCE

Franche-Comté

Bavaria

Vienna

ARCHDUCHY OF AUSTRIA

Savoy

Milan

OTTOMAN EMPIRE

Avignon

Marseilles

Genoa

Milan

Venice

GÉNOVA

Florence

REPUBLIC OF VENICE

PORTUGAL

Lisbon

Madrid

SPAIN

Barcelona

PAPAL STATES

Rome

Naples

Istanbul

Seville

Valencia

Ceuta

Oran

NAPLES

Palermo

Tunis

SPAIN'S COLONIAL EMPIRE IN THE 16TH CENTURY

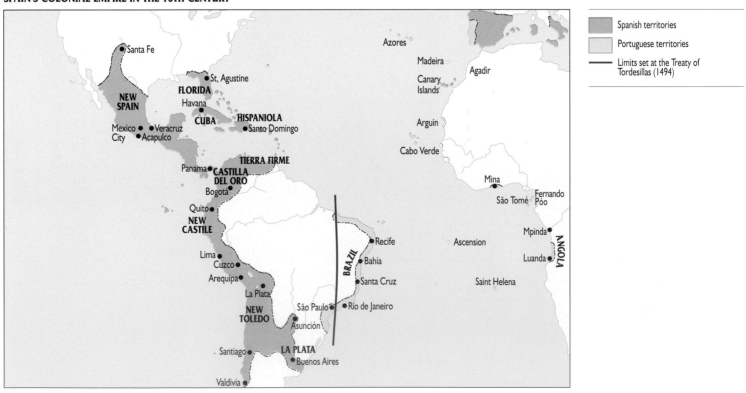

Spanish territories

Portuguese territories

Limits set at the Treaty of Tordesillas (1494)

Santa Fe

Azores

Madeira

St. Agustine

Canary Islands

Agadir

FLORIDA
Havana

NEW SPAIN

CUBA

HISPANIOLA

Arguin

Mexico City
Veracruz
Acapulco

Santo Domingo

Cabo Verde

TIERRA FIRME

Panama

CASTILLA DEL ORO

Bogotá

Mina

Fernando Póo

São Tomé

Quito

NEW CASTILE

BRAZIL

Recife

Mpinda

ANGOLA

Lima

Cuzco

Bahía

Luanda

Arequipa

Santa Cruz

Ascension

La Plata

Saint Helena

NEW TOLEDO

São Paulo
Rio de Janeiro

Asunción

LA PLATA

Santiago
Buenos Aires

Valdivia

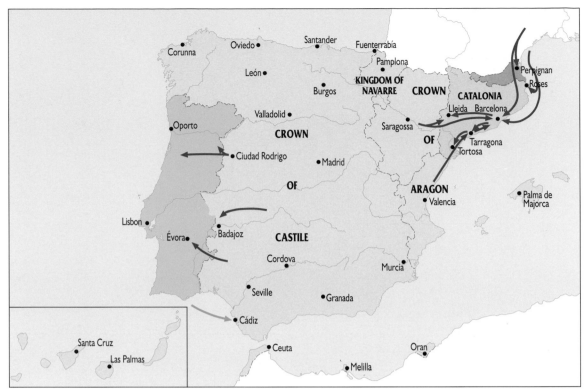

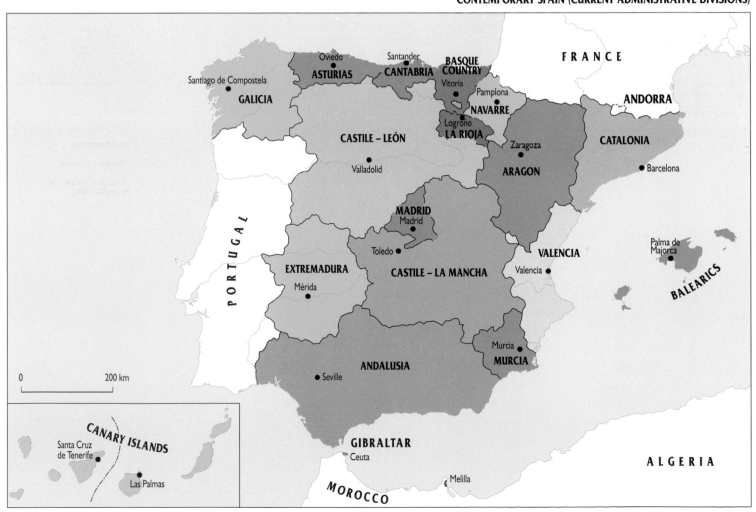

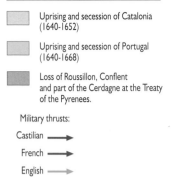

Uprising and secession of Catalonia
(1640-1652)

Uprising and secession of Portugal
(1640-1668)

Loss of Roussillon, Conflent
and part of the Cerdagne at the Treaty
of the Pyrenees.

Military thrusts:

Castilian

French

English

GLOSSARY OF TERMS

Abacus

Top, slab-like part of a capital on which an architrave or arch rests.

Alfiz

Moulded panel acting as a lintel and framing an archway in Moorish architecture.

Ambo

Raised stand set on either side of the altar in some churches, at the entrance to the sanctuary.

Ambulatory

In some cathedrals and churches, a semicircular aisle behind the main altar with radiating chapels enclosing the apse. It is usually an extension of the side aisles.

Archivolt

Splayed arch moulding found on a portal.

Ataurique

Decorative motif of Islamic origin consisting of a compratively stylised plant leaf based on the classical acanthus. One of the essential motifs in Hispano-Moorish decoration.

Atrium

An open or partly enclosed and generally colonnaded entrance vestibule in early-Christian churches.

Barrel Vault

One produced by the longitudinal prolongation of a semicircular arch.

Barrow

A mound of earth and stone placed over a tomb.

Basket Arch

Quasi-elliptical in shape, and made up of three, five or more arch segments whose combined circumferences add up to 180 degrees.

Beaux Arts Style

From the École des Beaux Arts. A term used in 19th-century architecture to refer to a rich, rhetorical and grandiloquent classical form of eclecticism. It survived during the first half of the 20th century in some public buildings and urban designs.

Bell Gable

Belltower consisting of a single wall perforated by openings in which church bells are placed.

Bevel

Obliquely cut angle forming the edge of two adjoining surfaces, as distinct from a right-angled edge. Bevelled edges can be applied to stone, wood or other materials, and are found in mouldings.

Biforate Window

A window divided into two openings or lights by an upright.

Boss

Projecting, knoblike ornament, often adorned with foliage, placed over intersecting ribs in a vault.

Bracket

An architectural supporting element projecting from the vertical plane.

Buttress

Type of reinforcing pilaster attached to a wall at various points in order to counteract lateral thrust.

Cable Moulding

A Romanesque moulding resembling a twisted cord or rope.

Cabochon

Precious or semi-precious stone cut into a rounded, unfaceted shape with a polished finish.

Calotte

A cup-shaped vault or semicircular dome lacking a drum.

Canopy

Ornamental hood suspended above a statue, chair, choir, etc.

Choir

Part of a church where the clergy congregate to sing the religious service. Its location has changed over the centuries: in Spain, it is traditionally placed in the nave, separated from the transept by a screen and enclosed on the back and sides by the retro-choir wall.

Churrigueresque

Late-Baroque style of architecture associated with José Churriguera and his followers in the late 17th and early 18th century. Characterised by over-elaborate ornamentation, the Churrigueresque style was decried by early Neoclassical critics.

Coffering

Sunken or recessed panelling used to adorn ceilings and vaults.

Cresting

Ornamental, generally openwork finish running along the edge of a roof.

Cyma

A double-curved moulding used on cornices, entablatures and coronas. Also known as ogee moulding.

Diaphragm Arch

A form of transverse arch dividing a nave into sections, used to counteract the thrust of side walls and wooden frames.

Diptych

Painting divided into two hinged sections or panels which could be opened like a book. In the late-Empire style, diptychs were often made entirely of ivory.

Dome

Large, evenly curved external vault rising from a circular base.

Domical Vault/Cloister Vault

A dome rising directly on a square or polygonal base, with curved surfaces separated by groins.

Entablature

Upper member of a classical architectural order comprising an architrave, frieze and cornice.

Estípite

An inverted, tapering pilaster used as a supporting member, although mainly a decorative element. A common feature of Spanish Baroque architecture and retables, they were sometimes placed one on top of another, separated by a ring, or combined with balustrades.

False Dome

A framework of reeds or wooden rods and other light materials faced with plaster.

Fibula

Metal clasp (of iron, bronze, gold or silver) with a pin, used until the Middle Ages as a safety pin for fastening garments.

Float

Each of the tableau images or scenes depicting the Passion of Christ or the Virgin Mary carried aloft in Holy Week processions throughout Spain. It is a specifically Hispanic form, which first appeared in the 16th century.

Flying Buttress

Raking arch which transmits the thrust of a vault to an outer buttress.

Framework

In an art-historical context, it can refer to either the generally metal supporting members of a statue, or a structural building frame of members and joints used for roofing a building, taking the form of hip rafters, roof trusses, etc.

Frontispiece

Main (front) facade of a building. Also, the illustration opposite the title page of a book.

Gable

Triangular upper section on a facade, portal or window.

Gablet

Gothic decorative motif found above the arcades of a church facade, consisting of two lines rising to form a steep pointed arch.

Grille

Wooden, metal or stucco grating or partition screen through which one can observe others without being seen.

Groin Vault

One produced by the intersection at right angles of two barrel vaults of identical span.

Grotesque

Decorative motif, based either on fanciful figures or plant motifs arranged strictly around an axis of symmetry. Originating in Roman times, it was revived during the Renaissance, with which it is generally associated.

Hessian

Open-weave fabric traditionally used for making sacks and packing goods. In the various currents of contemporary Informal art, it is used as backing for pictorial works and as an expressive item.

Horseshoe Arch

Pointed or round, horseshoe-shaped arch widely used in Islamic architecture.

Iconostasis

In Byzantine or Orthodox churches, a screen separating the sanctuary from the nave, covered with icons or statuettes, used to conceal the officiant from the congregation when blessing the host. By extension, the rood screen in some churches prior to the Romanesque.

Impost

Row of projecting ashlars supporting an arch or vault.

Kufic Script

Arabic script based on rigidly angled characters. It was used for early versions of the Koran, and in inscriptions on buildings, monuments and coins. Embellished with intertwining strokes and plant-motif terminals, it became a highly decorative script.

Lantern

Cylindrical or prismatic section of a dome which rests on pendentives or squinches supported on arches. It is usually placed over the crossing between the nave and transepts and projects above the roof of a church.

Lesene

Elongated pilaster-strip set close to the wall and arranged in series, usually surmounted at the top by blind arcades.

Lintel

Horizontal member bridging the upper part of an opening.

Lonja

Building used as a commodity exchange where merchants met to conduct their business transactions. The first examples in the Hispanic kingdoms appeared at the end of the Middle Ages in the Crown of Aragon.

Lunette

Small semicircular vault bounded by a vertical arch and its intersection with a barrel vault, perforated to allow light through.

Maqṣūrah

In mosques, an area near the *miḥrāb* setting the sovereign apart from other worshippers.

Metope

Square space between two triglyphs in the frieze of a Doric entablature, generally polychromed or with relief carvings.

Miḥrāb

In mosques, a niche, chamber or slab in the *qibla* wall indicating the direction of Mecca, towards which prayer is focused.

Minaret

The tower on a mosque from where the muezzin calls the faithful to prayer.

Modillion

Projecting stone, iron or wooden member supporting a cornice, an arch or a gallery. Found in conjunction with a particular type of decoration, particularly roll moulding.

Mortar

Mixture of lime, sand and water used as a building material. By extension, a material used for jointing and binding.

Mudéjar

Term coined in the 19th century to describe the Moslem inhabitants of areas seized by the Christians during the Reconquest, particularly from the late-11th century onwards.

Mullion

Wooden or stone upright which divides a window opening into two or more lights.

Niche

Wall recess, crowned with a quadrant vault, used for housing a holy image.

Niello

Black alloy (usually of sulphur and silver) used as a decorative inlay on incised metal surfaces. The term also refers to the process of inlaying.

Noucentisme

Catalan cultural movement which emerged around the year 1910. It revealed an attempt to stress culture over nature, Mediterranean values over northern European ones, order over anarchy and reflection over spontaneity. It may be interpreted as a reaction to Modernism.

Ogee Arch

Shaped like an upturned keel, it consists of four arcs, with concave exteriors and convex interiors.

Ovolo

Convex, ovoidal or spherical segment used to adorn architectural surfaces, including domes and niches.

Pendentive

Each of the four curved triangles set between supporting arches on which the drum of a cupola rests. Used as a means of supporting a circular dome over a square ground plan.

Peristyle

A range of columns set around a court or a building. It has its origins in Greek houses.

Pinnacle

Pointed terminal crowning buttresses, flying buttresses, spires or walls, often decorated with floral or plant motifs.

Plateresque

Renaissance style used in architecture and the applied arts in Spain and Spanish America. It is characterised by the decorative repertory of the Renaissance with an added sense of ornamentation. The adjective Plateresque stems from the belief that it was first adopted by silversmiths or *plateros*.

Presbytery

Often semicircular in shape, that part of a church lying east of the choir and nave. Its name stems from the presbyters who gathered there to assist the bishop in officiating at Mass.

Retro-choir

The space in a church behind the altar or choir.

Rib Vault

One in which the groins are reinforced with ribs. Depending on the number of ribs, they are termed quadripartite, sexpartite, etc.

Rood Screen

A screen made of stone, wood or metal separating the chancel of a church from the nave, choir or chapels.

Rose Window

Circular, stained-glass, perforated opening in the west wall of a church.

Sail Vault

Spherical or cup-shaped dome placed over a square-, polygonal- or rectangular-plan base, with the protruding part of each side truncated by a vertical plane.

Sfumato

From the Italian for 'smoke'. A painting, sculpture, engraving or other artwork with imperceptibly blended outlines.

Shaft

The trunk of a column, between the base and the capital.

Sinopia

Drawing executed with a reddish-brown chalk used for the underdrawing of a fresco.

Solomonic Column

One with a spirally fluted shaft.

Splayed Arch

One in which the span of one opening is larger than that of the opposite opening.

Squinch

Conical architectural element, with its apex running along the angle between two walls, from which it projects. Used to fit an octagonal structure to a square plan.

Stalactite Work

A ceiling ornament in Islamic architecture consisting of a geometrical arrangement of corbelled squinches scalloped out to resemble stalactites. Used to adorn vaults, cornices, capitals and panelled ceilings.

Statue Niche

A recess in the wall behind the altar where the image of a saint is kept. It can also take the form of a sacrarium or chamber, set behind the altar and often raised, where the image of a saint and other devotional objects are housed.

Stele

Vertical slab, usually of stone, marking the site of a tomb or funerary monument.

Strapwork

Geometric motif made up of a number of interlaced lines forming a variety of star-shaped or polygonal figures. The fret which is repeated to make up a strapwork pattern is usually a regular, four-, six- or eight-sided polygon.

Stuccowork

Decorative work in plaster; specifically, stucco, gypsum or a variety thereof. Characteristic of Hispanic art, stuccowork was used profusely during the caliphate of Cordova and, subsequently, in Naṣrid and Mudéjar art.

Supporting Arch

One set parallel to the longitudinal axis of the nave, separating the latter from the aisles. Used to support a sail vault.

Tabernacle

An altar receptacle for the consecrated host. A shrine niche or recess with an architectural facade for housing a holy image. Often incorporated into a retable.

Talayot

Megalithic structure found on the Balearic Islands consisting of a large, square- or circular-plan tower resembling a pyramid or truncated cone in section. The hollow interior is roofed with a false dome and has rough-hewn courses. It is supported in the centre by a monolithic column or pile of stones. The talayot was a defence work and was also used as a tomb for chiefs and patriarchs.

Tracery

Architectural decoration consisting of geometrically arranged lines and figures in stone. Specifically, pierced stonework applied to openings in a building, particularly above windows.

Transverse Arch

One placed across a nave and separating one vault bay from the next.

Triforium

A pierced wall-passage running above the aisles in a church. Its principal function was to prevent the pillars of vaults from warping, although it was also used to let in natural light.

Triptych

Painting or relief in three adjoining hinged sections, so that the outer panels could be closed over the central one.

Trompe L'oeil

A pictorial device intended to deceive the eye by creating the initial optical illusion of a painted object being real.

Volute

Spiral scroll ornament found on Ionic and Composite capitals.

BIBLIOGRAPHY

GENERAL WORKS

Proceedings of the XXIII Congreso Internacional de Historia del Arte: España entre el Mediterráneo y el Atlántico (Granada, 1973), 3 vols., Granada, 1976-1978.

Ars Hispaniae. Historia Universal del Arte Hispánico, 22 vols., Madrid, 1957-1977.

BABELON, J., *L'art espagnol*, Paris, 1963.

BARAÑANO, K.M., GONZÁLEZ DE DURANA, J., & JUARISTI, J., *Arte en el País Vasco*, Madrid, 1987.

BARRAL I ALTET, X., *Les catedrals de Catalunya*, Barcelona, 1994.

– *Tresors artístics catalans*, Barcelona, 1994.

– (dir.) *Prefiguració del Museu Nacional d'Art de Catalunya* (cat. exp.), Barcelona, 1992.

BOZAL, V., *Historia del arte en España*, Madrid, 1972.

CARRETE PARRONDO, J. et al. 'El grabado en España (siglos XV al XVIII)', *Summa Artis. Historia General del Arte*, vol. XXXI, Madrid, 1987.

Colección de documentos para la historia del arte en España, 7 vols., Madrid, 1981-1991.

CHUECA GOITIA, F., *Historia de la arquitectura española. Edad Antigua y Media*, Madrid, 1965.

DALMASES, N. de, & GIRALT-MIRACLE D., *Argenters i joiers de Catalunya*, Barcelona, 1985.

GAYA NUÑO, J. A., *El Arte Español en sus estilos y sus formas*, Barcelona, 1949.

– *Historia de la crítica de arte en España*, Madrid, 1975.

GUDIOL, J., *Hispania. Guía general del arte español*, 2 vols., Barcelona, 1962.

HARVEY, J., *The Cathedrals of Spain*, London, 1951.

Historia del Arte Español (edited by J. SUREDA I PONS), 10 vols., Barcelona, publication in progress.

Historia del Arte Hispánico, 6 vols., Madrid, 1978-1980.

LAFUENTE FERRARI, E., *Breve historia de la pintura española*, Madrid, 1953.

LOZOYA, Marqués de, *Historia del Arte Hispánico*, 5 vols, Barcelona, 1949.

MIRALLES, F. (coord.), *Història de l'Art Català*, 8 vols., Barcelona, 1983-1988.

Monumenta Cataloniae, Materials per a la Història de l'Art a Catalunya, 13 vols., Barcelona, 1932-1966.

MORALES Y MARÍN, J. L. et al., *El Prado, Painting Collections*, Barcelona, 1994.

PAREJA LÓPEZ, E. (ed.), *Historia del Arte en Andalucía*, 7 vols., Seville, 1988.

PÉREZ SÁNCHEZ, A., *Tres siglos de dibujo sevillano* (cat. exp.), Seville, 1995-1996.

POST, C. R., *A History of Spanish Painting*, Massachusetts, 1930-1958.

Thesaurus. L'Art als bisbats de Catalunya, 1000-1800 (cat. exp.), Barcelona, 1985-1986.

Thesaurus/estudis. L'Art als bisbats de Catalunya, 1000-1800, Barcelona, 1986.

WORKS BY CHAPTERS

PREHISTORY AND FIRST CONTACTS WITH MEDITERRANEAN ANTIQUITY

ALCALDE DEL RÍO H., BREUIL, H. & SIERRA, L., *Les cavernes de la région cantabrique (Espagne)*, Monaco, 1912.

ALMAGRO BASCH, M., *Las estelas decoradas del Suroeste peninsular*, Bibliotheca Praehistorica Hispana, VIII, Madrid, 1966.

– & FERNÁNDEZ MIRANDA, M. (eds), *Altamira Symposium*, Madrid, 1981.

ÁLVAREZ OSSORIO, F., *Catálogo de los exvotos de bronce ibéricos del Museo Arqueológico Nacional*, Madrid, 1941.

BELTRÁN MARTÍNEZ, A., *Arte rupestre levantino*, Zaragoza, 1968.

BLÁZQUEZ, J. M., *Tartesos y los orígenes de la colonización fenicia de Occidente*, Salamanca, 1975.

BOSCH GIMPERA, P., *Etnología de la Península ibérica*, Barcelona, 1932.

BREUIL, H., & OBERMAIER, H., *La cueva de Altamira en Santillana del Mar*, Madrid, 1935.

CABRÉ AGUILÓ, J., *El arte rupestre en España*, Madrid, 1915.

CARTAILHAC, E., & BREUIL, H., *La caverne d'Altamira à Santillana près Santander (Espagne)*, Monaco, 1906.

CHAPA BRUNET, T., *La escultura zoomorfa ibérica en piedra*, Madrid, 1985.

GARCÍA BELLIDO, A., *Arte ibérico en España*, Madrid, 1980.

HERNÁNDEZ PACHECO, E., *La caverna de la Peña de Cándamo (Asturias)*, Madrid, 1919.

NEGUERUELA, I., *Los monumentos escultóricos ibéricos del Carrillo Blanco de Porcuna (Jaén)*, Madrid, 1990.

NICOLINI, G., *Les ibères, art et civilisation*, 2 vols, Paris, 1903-1904.

OBERMAIER, H. & WERNER, W., *La Pileta à Benaojan (Málaga)*, Monaco, 1915.

PARÍS, P., *Essai sur l'art et l'industrie de l'Espagne primitive*, 2 vols, Paris, 1903-1904.

PERICOT GARCÍA, L., *La cueva del Parpalló (Gandía)*, Madrid, 1942.

RIPOLL PERELLÓ, E., *La cueva de Las Monedas en Puente Viesgo (Santander)*, Barcelona, 1972.

– *El Abate Henri Breuil (1877-1961)*, Madrid, 1994.

SAUTUOLA, M. S. de, *Breves apuntes sobre algunos objetos prehistóricos de la provincia de Santander*, Santander, 1880.

ROMAN ART & ARCHITECTURE IN SPAIN

ABAD CASAL, L., *La pintura romana en España*, Alicante, 1983.

ACUÑA, P., *Esculturas militares romanas de España y Portugal*, Rome, 1975.

ARCE, J., 'Arcos romanos en Hispania. Una revisión', *Archivo español de Arqueología*, no. 60, 1987.

– 'El *missorium* de Teodosio I: una interpretación política', *España entre el mundo antiguo y el mundo medieval*, Madrid, 1982.

BALIL ILLANA, A., 'Mosaicos circenses de Barcelona y Girona', *Boletín de la Academia de la Historia*, no. 151, 1962.

– 'De la escultura romano-ibérica a la escultura romano-republicana', in GONZÁLEZ, Julián (ed.), *Estudio sobre Urso*, Seville, 1988.

BLANCO, A., 'Arte de la Hispania Romana', in MENÉNDEZ PIDAL, R. (ed.), *Historia de España II, vol. 2º, España Romana*, Madrid, 1982.

Los bronces romanos de España (cat. exp.), Madrid, 1990.

La ciudad hispanorromana (cat. exp.), Barcelona, 1993.

Cuadernos de Arquitectura romana, no. 1, 1992.

DUPRÉ, X., *L'Arc Romà de Berà*, Rome, 1994.

FERNÁNDEZ CASTRO, M. C., *Villas romanas en España*, Madrid, 1992.

GARCÍA Y BELLIDO, A., *Esculturas Romanas en España y Portugal*, Madrid, 1949.

– 'Esculturas Hispanorromanas de época republicana', *Mélanges d'archeologie, d'epigraphie et d'historie offerts à J. Carcopino*, Paris, 1966.

Hispania Antiqua. Denkmäler der Römerzeit, Madrid, Mainz am Rhein, 1993.

LEÓN, P., 'Die Übernahme des römischen Porträts in Hispanien am Ende der Republik', *Madrider Mitteilungen*, no. 21, 1980.

– *Traianeum de Itálica*, Seville, 1988.

PUIG I CADAFALCH, J., *L'arquitectura romana a Catalunya*, Barcelona, 1934.

SALCEDO, F., 'Los relieves de armas del Teatro de Mérida', *Lucentum*, no. 2, 1983.

SCHLUNK, H., & HAUSSCHILD, T., *Hispania Antiqua. Die Denkmäler der Frühchristlichen und Westgotischen Zeit*, Mainz am Rhein, 1978.

El Teatro en la Hispania Romana. Proceedings of the Simposio de Mérida (1980), Badajoz, 1982.

TED'A, 'L'Anfiteatre romà de Tarragona, la basílica visigòtica i l'església romànica', *Memòries d'Excavació*, no. 3, Tarragona, 1990.

TRILLMICH, W., & ZANKER, P. (eds.), *Stadtbild und Ideologie. Die Monumentalisierung hispanischer Städte zwischen Republik und Kaiserzeit*. Kolloquium, Madrid, 1987 (Abh. München, 1990).

FROM ANTIQUITY TO THE MIDDLE AGES

ARIAS PÁRAMO, L., *Recursos geométricos y de proporción en la arquitectura prerrománica asturiana*, Centro de Cultura de Cangas, Museo Antón Candas, 1990.

BANGO TORVISO, I., 'Arquitectura prerrománica en los reinos occidentales de la península', *Simposio Internacional de Arquitectura en Cataluña. Siglo IX y primera mitad del XI*, Girona, 1994.

BONET CORREA, A., *El arte prerrománico asturiano*, Barcelona, 1967.

CABALLERO ZOREDA, L., *La iglesia y el monasterio visigodo de Santa María de Melque (Toledo). Arqueología y Arquitectura. San Pedro de la Mata y Santa Comba de Bande*, Madrid, 1980.

CAMPS CAZORLA, E., 'El arte hispanovisigodo', *Historia de España* de Menéndez y Pidal, vol. III, Madrid, 1963.

CORZO SÁNCHEZ, R., *San Pedro de la Nave. Estudio Histórico y Arqueológico de la iglesia visigótica*, Zamora, 1986.

ELBERN, V. H., 'Die fränkische Emailplatte von der Caja de las Ágatas in der Cámara Santa zu Oviedo', *Symposium sobre la cultura asturiana de la Alta Edad Media*, Oviedo, 1961.

GODOY, C., *Arqueología y liturgia. Iglesias Hispánicas (siglos IV al VIII)*, Barcelona, 1995.

GÓMEZ MORENO, M., *Las iglesias mozárabes*, Madrid, 1919.

PALOL, P. de, *Tarraco hispanovisigoda*, Tarragona, 1953.

– *Arqueología cristiana de la España romana. siglos IV al VI*, Madrid-Valladolid, 1967.

– *El arte hispánico de la época visigoda*, Barcelona, 1969.

– *El arte paleocristiano*, Barcelona, 1969.

– 'Arte y Arqueología', in MENÉNDEZ PIDAL, R. (ed.), *Historia de España III*, vol. 2., Madrid, 1991

– y G. RIPOLL, *Los godos en el Occidente europeo. Ostrogodos y visigodos en los siglos V al VIII*, Madrid, 1988.

SCHLUNK, H., 'The crosses of Oviedo. A contribution to the History of Jewelery in north-ern Spain in the ninth and tenth centuries', *The Art Bulletin*, XXXII, 2, 1950.

– & HAUSSCHILD, T., *Die Denkmäler der frühchristlichen und westgotischen Zeit*, Hispania Antiqua I, Mainz am Rhein, 1978.

– & BERENGUER: *La pintura mural asturiana de los siglos IX y X*, Oviedo, 1985.

– *Die Mosaickkuppel von Centcelles*. Madrider Beiträge, Mainz am Rhein, 1988.

SOTOMAYOR, E., *Sarcófagos romano-cristianos de España*, Granada, 1975.

PRE-ROMANESQUE AND ROMANESQUE ART

Proceedings of the International Symposium on 'O Portico da la Gloria e a Arte do seu Tempo' (Santiago de Compostela, 3–8 October 1988), La Coruña, 1992.

AINAUD DE LASARTE, J., *La fascinació del romànic. La pintura catalana*, Geneva-Barcelona, 1989.

The Art of Medieval Spain (a.d. 500-1200) (cat. exp.), New York, 1994.

ASTORGA, M. J., *El Arca de San Isidoro: Historia de un relicario*, León, 1990.

AVRIL, F., MENTRÉ, M., SAULNIER, A. & ZALUSKA, Y., *Manuscrits enluminés de la Peninsule Ibérique*, Paris, 1982.

BANGO Y TORVISO, I., *El Arte románico en España*, 1992.

BARRAL I ALTET, X., *La catedral románica de Vic*, Barcelona, 1979.

– *Les pintures murals romàniques d'Olèrdola, Marmellar, Calafell i Matadars*, Barcelona, 1980.

– *L'art pre-romànic a Catalunya. Segles IX-X*, Barcelona, 1981.

– *Compostelle, le grand chemin*, Paris, 1993.

BASTARDES I PARERA, R., *Els davallaments romànics a Catalunya*, Barcelona, 1980.

BOHIGAS, P., *La ilustración y la decoración del libro manuscrito en Cataluña (Período románico)*, vol. 1, Barcelona, 1960.

BORRÁS, G., & GARCÍA GUATAS, M., *La pintura románica en Aragón*, Zaragoza, 1978.

BUCHER, F., *The Pamplona Bibles*, 2 vols., New Haven-London.

CABAÑERO SUBIZA, B., *Los castillos catalanes del siglo X*, Zaragoza, 1996.

CAMPS CAZORLA, E., *El románico en España*, Barcelona, 1945.

CAMPS I SÒRIA, J., *El claustre de la catedral de Tarragona: l'escultura de l'ala meridional*, Barcelona, 1988.

Catalunya i la França Meridional a l'entorn de l'any Mil. La Catalogne et la France meridionale autour de l'an mil (Barcelona, 1987), Barcelona, 1991.

Catalunya Romànica, 26 vols., Barcelona, publication in progress.

The 'Codex Calixtinus' and the Shrine of St. James, Tubinga, 1992.

COOK, W. W. S., *La pintura mural románica en Cataluña*, Madrid, 1956.

– *La pintura románica sobre tabla en Cataluña*, Madrid, 1960.

DURLIAT, M., *L'art roman en Espagne*, Paris, 1962.

ESTEBAN LORENTE, F., GALTIER MARTÍ, F. & GARCÍA GUATAS, M., *El Nacimiento del arte románico en Aragón*, Zaragoza, 1982.

ESTELLA, M., *La escultura de marfil en España. Románico y gótico*, Madrid, 1984.

FERNÁNDEZ AVELLÓ, M., *La Cruz de la Victoria*, Oviedo, 1982.

– *La Cruz de los Ángeles y la Caja de las Ágatas*, Oviedo, 1986.

GAILLARD, G., *Premiers essais de sculpture monumentale en Catalogne aux Xè et XIè siècles*, Paris, 1938.

GARCÍA GUINEZ, M. A., *El arte románico en Palencia*, Palencia, 1975.

GÓMEZ MORENO, M., *Iglesias mozárabes. Arte español de los siglos IX y X*, Madrid, 1919.

– *El arte románico español. Esquema de un libro*, Madrid, 1934.

GONZÁLEZ-GARCÍA, V. J. & SUÁREZ SUÁREZ, G., *La Cámara Santa y su tesoro*, Oviedo, 1979.

GUDIOL, J., *La pintura mig-eval catalana*, 3 vols., Barcelona, 1927, 1929 & 1955.

MORALEJO, S., 'Cluny y los orígenes del románico palentino. El contexto de San Martín de Frómista', *Jornadas sobre el arte de las órdenes religiosas en Palencia* (24 to 28 July 1989), Palencia, 1990.

PALOL, P. de, *El Tapis de la Creació de la catedral de Girona*, Barcelona, 1986.

PÉREZ CARMONA, J., *Arquitectura y escultura románicas en la provincia de Burgos*, Burgos, 1975.

PÉREZ DE URBEL, J., *Sancho el Mayor de Navarra*, Madrid, 1950.

PLADEVALL, A. & ADELL, J.A., *El monestir romànic de Sant Llorenç del Munt*, Barcelona, 1980.

PORTER, A. K., *Romanesque Sculpture of the Pilgrimage Roads*, Boston, 1923.

– *Spanish Romanesque Sculpture*, 1928.

PUIG I CADAFALCH, J., *Le premier art roman. L'architecture en Catalogne et dans l'Occident méditerranéen aux Xè et XIè siècles*, Paris, 1928.

– FALGUERA, A. de, & GODAY, J., *L'arquitectura romànica a Catalunya*, 4 vols., Barcelona, 1909-1918.

RIU I RIU, M., *L'arqueologia medieval a Catalunya*, Barcelona, 1989.

SCHLUNK, H., *Las Cruces de Oviedo: El culto de la Vera Cruz en el reino asturiano*, Oviedo, 1985.

SICART, A., *La miniatura medieval en Galicia*, Santiago de Compostela, 1978.

SILVA, S. de, *La miniatura medieval en Navarra*, Pamplona, 1988.

Simposio para el estudio de los códices del Comentario del Apocalipsis de Beato de Liébana (Madrid, 1976), 3 vols., Madrid, 1978-1980.

SUREDA I PONS, J., *La pintura románica en España*, Madrid, 1985.

Los Tumbos de Compostela, Madrid, 1985.

VÁZQUEZ DE PARGA, L., LACARRA, L. & URÍA RIU, J., *Las peregrinaciones a Santiago de Compostela*, 3 vols., Madrid, 1948-1949.

Vida y peregrinación (cat. exp.), La Rioja, 1992.

WEITSTEIN, J., *Le fresque romane. Italie-France-Espagne. Études comparatives*, Geneva, 1971.

WHITEHILL, W. M., *Spanish Romanesque Architecture of the Eleventh Century*, Oxford, 1940 (reprint, 1968; trans. of part of Catalan architecture, Barcelona, 1974).

WILLIAMS, J., *Early Spanish Manuscript Illumination*, New York, 1977.

– *The Illustrated Beatus. A Corpus of the Illustrations of the Commentary on the Apocalipse*, Introduction (I), London, 1994.

YARZA, J., *Arte y arquitectura en España, 500-1200*, Madrid, 1979.

GOTHIC SPAIN

AZCÁRATE RISTORI, J. M., *El protogótico hispánico*, Madrid, 1974.

– *Arte gótico en España*, Madrid, 1990.

BORRÁS, G. M., *Historia del Arte en Aragón I. De la Prehistoria al fin de la Edad Media*, Zaragoza, 1986.

CAAMAÑO, J. M., *Contribución al gótico en Galicia*, Valladolid, 1962.

CAMPUZANO, E., *El gótico en Cantabria*, Santander, 1985.

Catalunya Medieval (cat. exp.), Barcelona, 1992.

COMPANY, X., *El gòtic valencià i Europa*, Valencia, 1989.

COMPANYS I FARRERONS, I., *Embigats gòtico-mudéixars al Tarragonès*, Tarragona, 1983.

DALMASES, N. de, & JOSÉ PITARCH, A., *L'Epoca del Cister, segle XIII*, en *Història de l'Art català*, vol. II, Barcelona, 1984.

– '*L'Art Gòtic, segles XIV-XV*', en *Història de l'Art Català*, vol. III, Barcelona, 1984.

DURLIAT, M., *L'art en el Regne de Mallorca*, Majorca, 1964.

Las Edades del Hombre. El contrapunto y la morada (cat. exp.), Salamanca, 1993.

Las Edades del Hombre. El arte de la Iglesia de Castilla y León (cat. exp.), Valladolid, 1985.

Las Edades del Hombre. Libros y documentos de la Iglesia de Castilla y León (cat. exp.), 1990.

FREIXAS I CAMPS, P., *L'Art Gòtic a Girona. Segles XIII i XIV*, Barcelona, 1983.

HERIARD DUBREUIL, M., *Valencia y el gótico internacional*, Valencia, 1987.

LAMBERT, É., *L'art gothique en Espagne aux XII et XIII siècles*, Paris, 1931 (Madrid, 1977).

LIAÑO, E., *Contribución al estudio del gótico en Tarragona*, Tarragona, 1976.

LLOBREGAT, E. & IVARS, J.F., (coords): *Història de l'art al País Valencià*, vol. I, Valencia, 1986.

MARÍAS, F., *El siglo XVI. Gótico y Renacimiento*, Madrid, 1992.

MARTÍNEZ DE AGUIRRE, J., *Arte y monarquía en Navarra 1328-1425*, Pamplona, 1987.

MARTÍNEZ FRÍAS, J.M., *El gótico en Soria, arquitectura y escultura monumental*, Salamanca, 1980.

Pallium. Exposició d'art i documentació: de la memòria de Sant Fructuós al triomf de Santa Tecla (cat. exp.), Tarragona, 1992.

Pulcra. Centenari de la creació del Museu (cat. exp.), Lleida, 1993.

SUREDA I PONS, J. (coord), *La España Gótica*, 12 vols., Madrid, 1987.

– *Un cert Jaume Huguet. El capvespre d'un somni*, Barcelona, 1994.

YARZA LUACES, J., *La Edad Media* (Historia del Arte Hispánico, II), Madrid, 1992.

– *Baja Edad Media. Los siglos del Gótico* (Introducción al arte español), Madrid, 1992.

– *Los Reyes Católicos. Paisaje artístico de una monarquía*, Madrid, 1993.

VV.AA., *Signos, arte y cultura en el Alto Aragón Medieval*, Huesca, 1993.

THE PRESENCE OF ISLAM
THE CALIPHATE OF CORDOVA AND ITS WAKE

BASSET, H. & TERRASSE, J., *Sanctuaires et forteresses albohades*, Paris, 1932.

CAILLÉ, J., *La mosquée de Hassan à Rabat*, Paris, 1954.

CRESWELL, K.A.C., *Early Muslim Architecture*, I², Oxford, 1969; II, Oxford, 1940.

EWERT, C., *Spanisch-islamische Systeme sich kreuzender Bögen. I. Córdoba*, Berlin, 1968.

– *Islamische Funde in Balaguer und die Aljafería in Zaragoza*, Berlin, 1971.

– 'Die Moschee am Bâb al-Mardûm in Toledo - eine "Kopie" der Moschee von Córdoba', *Madrider Mitteilungen*, 18, 1977.

– '*Spanisch-islamische Systeme sich kreuzender Bögen, III. Die Aljafería in Zaragoza*', 2 vols., Berlin, 1978-1980.

– 'Baudekor-Werkstätten im Kalifat von Cordoba und ihre Dispersion in nachkalifaler Zeit', *Künstler und Werkstatt in den orientalischen Gesellschaften*, Graz, 1982.

– 'The mosque of Tinmal (Morocco) and some new aspects of Islamic architectural typology', *Proceedings of the British Academy*, 72, 1986.

– 'Elementos decorativos en los tableros parietales del Salón Rico de Madinat al-Zahrā', *Cuadernos de Madinat al-Zahrā*, 1, 1987.

– & WISSHAK, J.P., *Forschungen zur almohadischen Moschee*, I: Vorstufen, Mainz, 1981.

– *Forschungen zur almohadischen Moschee, III, Die Qasba-Moschee in Marrakesch*, in Madrider Mitteilungen, 28, 1987.

HAMILTON, R.W., *The structural history of the Aqsa Mosque*, London, 1949.

HERNÁNDEZ JIMÉNEZ, F., *El alminar de Abd al-Raḥmān III en la mezquita mayor de Córdoba*, Granada, 1975.

– *Madinat al-Zahrāʾ. Arquitectura y decoración*, Granada, 1985.

JIMÉNEZ MARTÍN, A. & ALMAGRO GORBEA, A., *La Giralda*, Madrid, 1985.

JIMÉNEZ, A. & CABEZA, J.M., *Turris fortissima*, Seville, 1988.

PAVÓN MALDONADO, B., 'Estudios sobre la Alhambra', I, 1975 (Anexo I to Cuadernos de la Alhambra).

STERN, H., *Les mosaïques de la Grande mosquée de Cordoue*, Berlin, 1976.

TERRASSE, H., 'Le Grande mosquée almohade de Séville', *Mémorial Henri Basset*, Paris, 1928.

– *La mosquée al-Qaraouiyin à Fès*, Paris, 1968.

MOORISH ART, FROM THE TIME OF THE ALMOHADS TO THE FALL OF GRANADA

BERMÚDEZ LÓPEZ, J., 'Una introducción a la estructura urbana de la Alhambra', *Al-Andalus. Las artes islámicas en España*, Madrid, 1992.

BEYLIÉ, G. L. de, *La Kalaa des Beni Hammad*, Paris, 1909.

CABANELAS, D., *El techo del Salón de Comares en la Alhambra: decoración, policromía, simbología y etimología*, Granada, 1988.

CASAMAR, M. & VALDÉS, F., 'Origen y desarrollo de la técnica de cuerda seca en la Península Ibérica y en el Norte de África durante el siglo XI', Al-Qanṭara, 5, 1984.

ETTINGHAUSEN, R., 'Notes on the Lusterware of Spain', *Ars Orientalis*, 1, 1943.

FERNÁNDEZ-PUERTAS, A., *La fachada del palacio de Comares I. Situación, función y génesis*, Granada, 1980.

FERRANDIS, J., 'Espadas granadinas a la jineta', *Archivo Español de Arte*, 16, 1943.

FLORES ESCOBOSA, I., *Estudio preliminar sobre loza azul y dorada nazarí de la Alhambra*, Madrid, 1988.

GOLVIN, L., *Essai sur l'architecture religieuse musulmane*, T. IV, L'Art Hispano-musulman, Paris, 1970.

KÜHNEL, E., *Die Islamischen Elfenbeinskulpturen, VIII-XIII. Jahrhundert*, Berlin, 1971.

MARÇAIS, G., 'Sur la Grande Mosqué de Tlemcen', *Annales de l'Institut d'Etudes Orientales d'Alger*, 1949/50.

MASLOW, B., 'La Qubba Barudiyyīn à Marrakus', *Al-Andalus*, 13, 1948.

MEUNIÉ, J., TERRASSE, H. & DEVERDUN, G., *Recherches archéologiques à Marrakech*, Paris, 1952.

– *Nouvelles recherches archéologiques à Marrakech*, Paris, 1957.

NAVARRO, J. & JIMÉNEZ, P., 'Arquitectura mardaniší', *La arquitectura del Islam occidental. El legado andalusí*, 1995.

– 'El Castillejo de Monteagudo: Qaṣr ibn Saʿd', *Casas y Palacio de Al-Andalus. Siglos XII y XII. El legado andalusí*, 1995.

PANTEARROYO, C., 'Tejidos almorávides y almohades', *Al-Andalus. Las artes islámicas en España*, New York–Madrid, 1992.

PAVON, B., *Estudios sobre la Alhambra I. La Alcazaba, el palacio de los Abencerrajes, los accesos a la Casa Real Vieja, el palacio de Comares. El Partal*, Granada, 1975.

TERRASSE, H., 'La Forteresse almoravide d'Amergo', *Al-Andalus*, 18, 1953.

– *La mosquée al-Qaraouiyin à Fès*, Paris, 1968.

TORRES BALBÁS, L., 'Paseos por la Alhambra. Una necrópolis nazarí: la rauda', *Archivo Español de Arte y Arqueología*, 2, 1926.

– 'Monteagudo y el Castillejo en la vega de Murcia', *Al-Andalus* 2, 1934.

– 'La Alhambra de Granada antes del siglo XII', *Al-Andalus*, 5, 1940.

– 'La alcazaba almohade de Badajoz', *Al-Andalus*, 6, 1941.

– 'Arquitectos andaluces de las épocas almorávide y almohade', *Al-Andalus*, 11, 1946.

VALDÉS, F., *La alcazaba de Badajoz I. Hallazgos islámicos (1977-1982) y testar de la Puerta del Pilar*, Madrid, 1985.

– 'La fortificación islámica en Extremadura: resultados provisionales de los trabajos en las alcazabas de Mérida, Badajoz y Trujillo y en la cerca urbana de Cáceres', *Extremadura Arqueológica*, 2, 1991.

– 'Die Zisterne der islamischen Festung von Mérida und die Islamisierung des westlichen al-Andalus', *Akten des XXVIII. Internationalen Kongresses für Kunstgeschichte*, Berlin, 1993.

– 'La edad oscura de la Alhambra', *Arte islámico en Granada. Propuesta para un Museo de la Alhambra*, Granada, 1995.

– 'Aspectos arqueológicos del Tibyan: el Puente del Cadí', *Proceedings of the XVI Congreso de la Unión Europea de arabistas e Islamistas*, Salamanca, 1995.

VALOR, M., *La arquitectura militar y palatina en la Sevilla musulmana*, Seville, 1991.

THE ART OF THE RENAISSANCE

ÁLVAREZ LOPERA, J., *El Greco*, Madrid, 1990.

ANGULO ÍÑIGUEZ, D., *La mitología y el arte español del Renacimiento*, Madrid, 1952.

– *Pintura del siglo XVI*, Madrid, 1952.

AZCÁRATE, J. M., *Escultura del siglo XVI*, Madrid, 1958.

– *Alonso de Berruguete. Cuatro ensayos*, Madrid, 1963.

BENITO DOMÈNECH, F., *Pintura y pintores en el Real Colegio del Corpus Christi*, Valencia, 1980.

BROWN, J. et al., *El Greco de Toledo*, Madrid, 1982.

BUSTAMANTE GARCÍA, A., *La arquitectura clasicista del foco vallisoletano 1561 1640*, Valladolid, 1983.

CAMÓN AZNAR, J., *La arquitectura plateresca*, Madrid, 1945.

– *La escultura y la rejería españolas del siglo XVI*, Madrid, 1961.

CERVERA VERA, L., *Las estampas populares y el sumario de El Escorial por Juan de Herrera*, Madrid, 1954.

COMPANY Y CLIMENT, X., *Pintura del Renaixement al Ducat de Gandia. Imatges d'un temps i d'un país*, Valencia, 1985.

COSSÍO, M. B., *El Greco*, Madrid, 1908.

CHECA, F., *Pintura y escultura del Renacimiento en España*, Madrid, 1983.

– *Carlos V y la imagen del héroe en el Renacimiento*, Madrid, 1987.

– *Felipe II mecenas de las Artes*, Madrid, 1992.

– *Tiziano y la monarquía hispánica*, Madrid, 1994.

CHUECA GOITIA, F., *Arquitectura del siglo XVI*, Madrid, 1953.

– *Andrés de Vandelvira, arquitecto*, Jaén, 1971.

DÍEZ DEL CORRAL GARNICA, R., *Arquitectura y mecenazgo. La imagen de Toledo en el Renacimiento*, Madrid, 1987.

GÓMEZ MORENO, M., *La escultura del Renacimiento español*, Florence, 1931.

– *Las águilas del Renacimiento español*, Madrid, 1941 (1983).

GUTIÉRREZ RODRÍGUEZ DE CEBALLOS, A., *Bartolomé Bustamante y los orígenes de la arquitectura jesuítica en España*, Madrid, 1961.

Herrera y el clasicismo (cat. exp.), Valladolid, 1986.

HOAG, J. D., *Rodrigo Gil de Hontañón. Gótico*

y Renacimiento en la arquitectura española del siglo XVI, Barcelona, 1985.

KAGAN, R. (ed.), *Ciudades del Siglo de Oro*, Madrid, 1986.

KUBLER, G., *La obra de El Escorial*, Madrid, 1983.

LAMPÉREZ Y ROMEA, V., *La arquitectura civil española de los siglos XV y XVI*, Madrid, 1922.

LLEÓ CAÑAL, V., *Nueva Roma: mitología y humanismo en el Renacimiento sevillano*, Seville, 1979.

MARÍAS, F., *La arquitectura del Renacimiento en Toledo (1541-1631)*, Madrid, 1983-1984.

– *El largo siglo XVI. Los usos artísticos del Renacimiento español*, Madrid, 1989.

– & BUSTAMANTE, A., *Las ideas artísticas de El Greco*, Madrid, 1981.

MARTÍN GONZÁLEZ, J.J., *La arquitectura doméstica del Renacimiento en Valladolid*, Valladolid, 1948.

– *Juan de Juni*, Madrid, 1954.

MORALES, A., *La Capilla Real de Sevilla*, Seville, 1979.

– *La obra renacentista del Ayuntamiento de Sevilla*, Seville, 1981.

– *Hernán Ruiz 'El Joven'*, Madrid, 1996.

MORÁN TURINA, M. & CHECA, F., *Las casas del Rey. Cazaderos, casas de campo, jardines. Siglos XVI y XVII*, Madrid, 1986.

MULCAHY, R., *A la mayor gloria de Dios y el Rey. La decoración de la Basílica de El Escorial*, Madrid, 1990.

NIETO, V., MORALES, A. & CHECA, F., *Arquitectura del Renacimiento en España, 1488-1599*, Madrid, 1989.

OSTEN SACKEN, C., *El Escorial. Estudio iconológico*, Madrid, 1984.

Reyes y mecenas. Los Reyes Católicos, Maximiliano I y los inicios de la Casa de Austria de España (cat. exp.), Toledo, 1992.

ROSENTHAL, E.E., *El palacio de Carlos V*, Madrid, 1988.

– *La catedral de Granada. Un estudio sobre el Renacimiento español*, Granada, 1990.

SALAS, X. de, & MARÍAS, F., *El Greco y el arte de su tiempo. Las notas de El Greco a Vasari*, Madrid, 1992.

SAN ROMÁN, F. de B., *El Greco en Toledo*, Madrid, 1910.

Splendeurs d'Espagne et les Villes Belges (1500-1700) (cat. exp.), Brussels, 1985.

WETHEY, H. E., *El Greco y su escuela*, Madrid, 1967.

WILKINSON ZERNER, C., *Juan de Herrera. Architect to Philip II of Spain*, Brown, 1993.

THE BAROQUE

ANGULO ÍÑIGUEZ, D., *Murillo*, 3 vols., Madrid, 1981.

El Arte en tiempos de Carlos III, IV Jornadas de arte del CSIC, Madrid, 1988.

BEDAT, C., *La Real Academia de Bellas Artes de San Fernando (1744-1808): contribución al estudio de las influencias estilísticas y de la mentalidad artística en la España del siglo XVIII*, Madrid, 1989.

El Barroc català. Actes de les jornades celebrades a Girona..., Barcelona, 1989.

BÉRCHEZ GÓMEZ, J., *Arquitectura y Academicismo en el siglo XVIII valenciano*, Valencia, 1987.

BONET CORREA, A., *Andalucía Barroca, arquitectura y urbanismo*, Barcelona, 1978.

– 'La arquitectura y el urbanismo'. Separata from *El Siglo del Quijote (1580-1680). Las letras. Las Artes.* vol. XXVI, vol. II, *Historia de España* MENÉNDEZ Y PIDAL, Madrid, 1986.

– *Fiesta, poder y arquitectura. Aproximaciones al barroco español*, Madrid, 1990.

BOTTINEAU, Y., *L'art de cour dans l'Espagne des Lumières (1746-1808)*, Paris, 1986.

– *El arte cortesano en la España de Felipe V (1700-1746)*, Madrid, 1986.

BROWN, J., *Imágenes e ideas en la pintura española del siglo XVII*, Madrid, 1980 (New Jersey, 1978).

– *Velázquez. Pintor y cortesano*, Madrid, 1986.

BUSTAMANTE GARCÍA, A., *El siglo XVIII. Clasicismo y barroco*, Madrid, 1993.

Carlos III y la Ilustración (cat. exp.), 2 vols., Madrid, 1988

Catalunya a l'època de Carles III, Barcelona, 1991.

GALLEGO, J., *Diego Velázquez*, Barcelona, 1983.

– *Visión y símbolos en la pintura española del Siglo de Oro*, Madrid, 1984.

GALLEGO, J. & GUDIOL, J., *Zurbarán, 1598-1664*, Barcelona, 1976.

MARAVALL, J. A., *Velázquez y el espíritu de la modernidad*, Madrid, 1987.

MARTÍN GONZÁLEZ, J.J., *Escultura barroca en España, 1600-1770*, Madrid, 1983.

– *El artista en la sociedad española del siglo XVII*, Madrid, 1984

PÉREZ SÁNCHEZ, A. E., *Pintura barroca en España, 1600-1700*, Madrid, 1992.

PÉREZ SÁNCHEZ, A. E. & SPINOSA, N., *La obra pictórica completa de Ribera*, Barcelona, 1979 (Milan, 1978).

RODRÍGUEZ G. DE CEBALLOS, A., *El siglo XVII: entre tradición y Academia*, Madrid, 1992.

STIERLIN, H., *El Arte Barroco en España y Portugal*, Madrid, 1992.

TOVAR, V., *El Arte del Barroco*, Madrid, 1990.

VALDIVIESO, E., *Juan de Valdés Leal*, Seville, 1988.

Velázquez y el arte de su tiempo, V Jornadas de arte del CSIC, Madrid, 1991.

Venezia e la Spagna, Milan, 1988.

VOSTERS, S. A., *Rubens y España: estudio artístico-literario sobre la estética del Barroco*, Madrid, 1990.

WETHEY, H. E., *Alonso Cano. Pintor, escultor y arquitecto*, Madrid, 1983.

THE ART OF COLONIAL SPANISH AMERICA

ANGULO ÍÑIGUEZ, D., MARCO DORTA, E. & BUSCHIAZZO, M.J., *Historia del arte hispanoamericano*, 3 vols., Barcelona, 1945, 1950 & 1956.

BAYÓN, D. & MARX, M., *Historia del arte colonial sudamericano. Sudamérica hispana y el Brasil*, Barcelona, 1989.

BÉRCHEZ GÓMEZ, J., *Arquitectura mexicana de los siglos XVII y XVIII*, Mexico City, 1992.

BERNALES BALLESTEROS, J., *Historia del arte hispanoamericano. Siglos XVI a XVIII*, Madrid, 1987.

BONET CORREA, A., GÓMEZ PIÑOL, E., BERNALES BALLESTEROS, J. et al., *Arte, Gran Enciclopedia de España y América*, tomo IX, Madrid, 1989.

BOTTINEAU, Y., *Baroque ibérique*, Friburg, 1971 (Spanish ed., Barcelona, 1971).

BUSCHIAZZO, J., *Historia de la arquitectura colonial en Iberoamérica*, Buenos Aires, 1961.

CASTEDO, L., *Historia del arte iberoamericano*, I, Madrid, 1988.

EARLY, J., *The Colonial Architecture of Mexico*, Alburquerque, 1994.

GASPARINI, G., *América, barroco y arquitectura*, Caracas, 1972.

GUTIÉRREZ, R., *Arquitectura y Urbanismo en Iberoamérica*, Madrid, 1983.

KELEMEN, P., *Baroque and Rococo in Latin America*, New York, 1961.

KUBLER, G., *Mexican Architecture of the Sixteenth Century*, New Haven, Conn., 1948 (Spanish ed., Mexico City, 1983).

– & SORIA M., *Art and Architecture in Spain and Portugal and their American Dominions (1500 to 1800)*, Baltimore, 1959.

LÓPEZ GUZMAN, R. et al., *Arquitectura y carpintería mudéjar en Nueva España*, Mexico City, 1992.

MARCO DORTA, E., *La arquitectura barroca en el Perú*, Madrid, 1957.

MARKMAN, S. D., *Colonial Architecture of Antigua Guatemala*, Philadelphia, 1966.

MAZA, F. de la, *La ciudad de México en el siglo XVII*, Mexico City, 1968.

NIETO, V. & CÁMARA, A., *El Arte Colonial en Iberoamérica*, Madrid, 1989.

SAN CRISTÓBAL, A., *Lima. Estudios de la arquitectura virreinal*, Lima, 1992.

SARTOR, M., *Arquitectura y urbanismo en Nueva España. Siglo XVI*, Mexico City, 1992.

SEBASTIÁN LÓPEZ, S., MESA, J. de, & GISBERT, T., 'Arte iberoamericano desde la colonización a la Independencia', *Summa Artis*, vols. XXVIII-XXIX, Madrid, 1985-1986.

TOVAR DE TERESA, G., *México barroco*, Mexico City, 1981.

– *Pintura y Escultura en Nueva España (1557-1640)*, Mexico City, 1992.

TOUSSAINT, M., *Arte colonial en México*, Mexico City, 1948.

WEISS, J. E., *La arquitectura colonial cubana*, Havana, 1972.

WETHEY, H. E., *Colonial Architecture and Sculpture in Peru*, Cambridge, 1949.

V.V.AA., *Simposio Internazionale sul Barocco Latino Americano*, Rome, 1982.

V.V.A.A., *Pintura en el Virreinato del Perú*, Lima, 1989.

V.V.A.A., *Escultura en el Perú*, Lima, 1991.

V.V.A.A., *Mudéjar iberoamericano: Del Islam al Nuevo Mundo*, Madrid, 1995.

FRANCISCO DE GOYA

ÁGUEDA, M. & SALAS, X. de, *Francisco de Goya. Cartas a Martín Zapater*, Madrid, 1982.

BOZAL, V., *Imagen de Goya*, Madrid, 1983.

CANELLAS LÓPEZ, A., *Francisco de Goya. Diplomatario*, Zaragoza, 1981.

CARDERERA, V., 'Biografía de don Francisco de Goya', *El Artista*, vol. II, Madrid, 1835.

Catálogo ilustrado de la exposición de pinturas de Goya, Madrid, 1928.

La década de los Caprichos. Dibujos y aguafuertes (cat. exp.), Madrid, 1992.

DESPARMET FITZ-GERALD, X., *L'Œuvre peinte de Goya. Catalogue Raisonné*, Paris, 1928-1950.

GASSIER, P. & WILSON, J., *Vie et œuvre de Francisco de Goya*, Friburg, 1970.

– *Dibujos de Goya. Los Álbumes*, Friburg, 1973.

– *Dibujos de Goya. Estudios para grabados y pinturas*, Friburg, 1975.

GLENDINNING, N., *Goya and his Critics*, London, 1977 (Spanish ed., Madrid, 1982).

Goya. Das Zeitalter der Revolutionen. Kunst um 1800 (1789-1830) (cat. exp.), Hamburg, 1980-1981.

Goya y la Constitución de 1812 (cat. exp.), Madrid, 1982.

Goya y el Espíritu de la Ilustración (cat. exp.), Madrid-Boston-New York, 1988-1989.

Goya. El Capricho y la Invención: cuadros de gabinete, bocetos y miniaturas, Madrid-London-Chicago, 1994-1995.

GUDIOL, J., *Goya 1746-1828. Biographie, étude analytique et catalogue de ses peintures*, Barcelona, 1970 (2nd ed., Barcelona, 1984).

HARRIS, E., *Goya. Engravings and Lithographs*, Oxford, 1964.

HELD, J., *Die Genrebilder der Madrider Teppichmanufaktur und die Anfänge Goyas*, Berlin, 1971.

HELMAN, E.F., *Trasmundo de Goya*, Madrid, 1963.

LAFUENTE FERRARI, E., *Antecedentes, Coincidencias e influencias del arte de Goya*, Madrid, 1947.

LICHT, F., *Goya: The Origins of the Modern Temper in Art*, London, 1979 (New York, 1983).

SÁNCHEZ CANTÓN, F.J., *Goya*, Paris, 1930.

– 'Cómo vivía Goya. I.- El Inventario de sus bienes. II.- Leyenda e historia de la Quinta del Sordo. III', *Archivo Español de Arte*, 1946.

– 'Vida y obras de Goya', Madrid, 1951.

SAYRE, E. A., *The Changing Image: Prints by Francisco Goya*, Boston, 1974.

TOMLINSON, J.A., *Francisco de Goya. The Tapestry Cartoons and Early Career at the Court of Madrid*, Cambridge, 1989 (Spanish ed. 1993).

TRAPIER, E. du G., *Goya and his Sitters. A Study of his Style as a Portraitist*, New York, 1964.

VIÑAZA, Conde de la, *Goya. Su tiempo, su vida, sus obras*, Madrid, 1887.

YRIARTE, C., *Goya, sa biographie, les fresques, les toiles, les tapisseries, les eaux-fortes et le catalogue de l'œuvre*, Paris, 1867.

ZAPATER Y GÓMEZ, F., *Goya, noticias, biográficas*, Zaragoza, 1868.

THE NINETEENTH CENTURY:
FROM NEOCLASSICISM TO INDUSTRIALISM

ARIAS ANGLÉS, E., *El paisajista romántico Jenaro Pérez Villaamil*, Madrid, 1986.

ARIAS DE COSSÍO, A.M., *José Gutiérrez de la Vega, pintor romántico sevillano*, Madrid, 1978.

ARNAIZ, J.M., *Eugenio Lucas, su vida y su obra*, Madrid, 1981.

ARRECHEA, J., *Arquitectura y Romanticismo. El pensamiento arquitectónico en la España del siglo XIX*, Valladolid, 1989.

BEDAT, C., *L'Académie des Beaux-Arts de Madrid, 1744-1808*, Toulouse, 1974.

BERUETE MORET, A., *Historia de la pintura española del siglo XIX. Elementos nacionales y extranjeros que han influido en ella*, Madrid, 1926.

BOHIGAS, O., *Reseña y catálogo de la arquitectura modernista*, Barcelona, 1973.

CASADO ALCALDE, E., *La Academia Española de Roma y los pintores de la primera promoción*, Madrid, 1987.

COLL MIRABENT, I., *Santiago Rusiñol*, Sabadell, 1992.

L'Escola d'Olot. J. Berga, J. Vayreda, M. Vayreda, Olot-Barcelona, 1993.

Federico de Madrazo y Kuntz (cat. exp.), Madrid, 1994.

FONTBONA, F., *El paisatgisme a Catalunya*, Barcelona, 1979.

FREIXA, M., *El Modernismo en España*, Barcelona, 1986.

GARCÍA FELGUERA, M.S., *Viajeros, eruditos y artistas. Los europeos ante la pintura española del Siglo de Oro*, Madrid, 1991.

GONZÁLEZ, C. & MARTÍ, M., *Marià Fortuny*, 2 vols., Barcelona, 1990.

HENARES CUELLAR, I, *La teoría de las Artes plásticas en España en la segunda mitad del siglo XVIII*, Granada, 1977.

HEREU, P., *Arquitectura i ciutat a l'Exposició Universal de Barcelona 1888*, Barcelona, 1988.

HERNANDO CARRASCO, J., *Las Bellas Artes y la revolución de 1868*, Oviedo, 1987

JARDÍ, E., *Nonell*, Barcelona, 1969.

Juan de Villanueva, arquitecto, 1739-1811 (cat. exp.), Madrid, 1982.

LITVAK, L., *El tiempo de los trenes. El paisaje español en el arte y en la literatura del realismo (1849-1918)*, Barcelona, 1991.

MARÈS DEULOVOL, F., *Dos siglos de enseñanza artística en el Principado*, Barcelona, 1974.

MARÍN MEDINA, J., *Escultura española contemporánea (1800-1978). Historia y evaluación crítica*, Madrid, 1978.

El Modernismo (cat. exp.), Barcelona, 1990.

NAVASCUÉS PALACIO, P., *Arquitectura y arquitectos madrileños del siglo XIX*, Madrid, 1973.

– & QUESADA MARTÍN, M.J., *El siglo XIX. Bajo el signo del Romanticismo*, Madrid, 1992.

OSSORIO Y BERNARD, M., *Galería biográfica de artistas españoles del siglo XIX*, Madrid, 1883-1884 (re-edition, 1975).

PANTORBA, B. de, *El paisaje y los paisajistas españoles. Ensayo de historia y crítica*, Madrid, 1943.
– *Historia y crítica de las exposiciones nacionales de Bellas Artes celebradas en España*, Madrid, 1954.
PARDO CANALIS, E., *Escultores del siglo XIX*, Madrid, 1951.
PENA, C., *Pintura de paisaje e ideología. La generación del 98*, Madrid, 1983.
La pintura de historia del siglo XIX en España (cat. exp.), Madrid, 1992.
RÀFOLS, J.F., *El arte romántico en España*, Barcelona, 1954.
REYERO, C., *La pintura de historia en España. Esplendor de un género en el siglo XIX*, Madrid, 1989.
– & FREIXA M., *Pintura y escultura en España, 1800-1910*, Madrid, 1995.
SAMBRICIO, C., *La arquitectura española de la Ilustración*, Madrid, 1986.
SOLÀ-MORALES, I., *Eclecticismo y vanguardia. El caso de la arquitectura moderna en Cataluña*, Barcelona, 1980.
SALVADOR, S., *La escultura monumental en Madrid: calles, plazas y jardines públicos (1875-1936)*, Madrid, 1990.
SUBIRACHS I BURGAYA, J., *L'escultura commemorativa a Barcelona fins el 1936*, Barcelona, 1986.
VALDIVIESO, E., *Pintura sevillana del siglo XIX*, Seville, 1981.

SPANISH ART FROM 1900 TO 1939

ANTÓN CASTRO, X., *Arte y Nacionalismo. La vanguardia histórica gallega (1925-1936)*, La Coruña, 1992.
Arte y artistas vascos de los años 30 (cat. exp.), San Sebastián, 1986.
BALDELLOU, M. A. & CAPITEL, A., *Arquitectura española del siglo XX*, Madrid, 1995.
Barradas (cat. exp.), Zaragoza-L'Hospitalet-Madrid, 1992-1993.
BOHIGAS, O., *Arquitectura Española de la segunda República*, Barcelona, 1970.
BONET, J. M., *Diccionario de las vanguardias en España. 1907-1936*, Madrid, 1995.
BOZAL, V., 'Pintura y escultura españolas del siglo XX. 1909-1939', *Summa Artis. Historia General del Arte*, vol. XXXVI, Madrid, 1991.
BRIHUEGA, J., *Las vanguardias artísticas en España. 1909-1936*, Madrid, 1981.
Cinco siglos de arte español (cat. exp.), Paris, 1986.
COMBALÍA, V., *El descubrimiento de Miró. Miró y sus críticos. 1918-1929*, Barcelona, 1990.
Dalí joven. 1918-1930 (cat. exp.), Madrid, 1995.
Escultura española 1900-1936 (cat. exp.), Madrid, 1985.
FONTBONA, F. & MIRALLES, F., 'Del Modernisme al Noucentisme', *Història de l'Art Català*, vol. 7, Barcelona, 1985.
GARCÍA DE CARPI, L., *La pintura surrealista española (1924-1936)*, Madrid, 1986.
GRIMAU, C., *El cartel republicano en la Guerra Civil*, Madrid, 1979.
KAHNWEILER, D-H., *Juan Gris*, Madrid, 1971.

MUR, P., *La Asociación de Artistas vascos*, Bilbao, 1985.
Pabellón español. Exposición Internacional de París. 1937 (cat. exp.), Madrid, 1987.
PÉREZ CONTEL, R., *Artistas en Valencia 1936-1939*, 2 vols. Valencia, 1986.
PÉREZ ROJAS, J., *El Art-Déco en España*, Madrid, 1990.
Picasso, Miró y Dalí y los orígenes de la vanguardia en España (cat. exp.), Frankfurt-Madrid, 1991-1992.
SAMBRICIO, C., 'La Arquitectura', *Historia del arte hispánico. VI. El siglo XX*, Madrid, 1980.
SANTOS TORROELLA, R., *Dalí residente*, Madrid, 1992.
La Sociedad de Artistas Ibéricos y el arte español en 1925 (cat. exp.), Madrid-Bilbao, 1995-1996.
J. Solana. Exposición-homenaje (cat. exp.), Madrid, 1985.
SUREDA I PONS, J., *Torres García, la fascinació del clàssic*, Barcelona, 1993.
Surrealismo en España, Madrid, 1994.
Surrealismo en Cataluña, 1924-1936 (cat. exp.), Barcelona, 1988.
Torres García (cat. exp.), Madrid-Valencia, 1991.
VIDAL Y OLIVERAS, J., *Josep Dalmau. L'Aventura per l'art Modern*, Manresa, 1986.

PABLO PICASSO

APOLLINAIRE, G., *Les peintres cubistes: méditations esthétiques*, Paris, 1965 (Barcelona, 1993).
BAER, B., *Picasso peintre-graveur*, Berne, 1986-1989
BALDASSARI, A., *Picasso photographe 1901-1916*, Paris, 1994.
BERNADAC, M L., *La corrida de la guerre. Génèse de Guernica*, Paris, 1991.
– & BRETEAU SKIRA G., *Picasso à l'écran*, Paris, 1992.
BLOCH, G., *Pablo Picasso, catalogue de l'œuvre gravé et lithographié*, 4 vols., Berne, 1968-1979.
BRASSAÏ, *Conversations avec Picasso*, Paris, 1964 (Madrid, 1966).
CABANNE, P., *Le siècle de Picasso*, 2 vols. Paris, 1975 (Madrid, 1982).
COMBALÍA DEXEUS, V., *Estudios sobre Picasso*, Barcelona, 1981.
COWLING, E. & GOLDING J., *Picasso: sculptor/painter*, London, 1994.
CHIPP, H.B., *Picasso's Guernica: history, transformations, meanings*, Los Angeles, London, 1988 (French ed., Paris, 1992; Spanish ed., Barcelona, 1991).
CIRICI PELLICER, A., *Picasso antes de Picasso*, Barcelona, 1946.
CIRLOT, J-E., *Picasso: el nacimiento de un genio*, Barcelona, 1972.
DAIX, P., *La vie de peintre de Pablo Picasso*, Paris, 1977.
– *Les Demoiselles d'Avignon*, 2 vols. Paris, 1988.
– & BOUDAILLE, G., *Picasso, 1900-1906, catálogo razonado de la obra pintada*, Neuchatel, 1966.
– & ROSSELET, J., *Picasso, 1907-1916, catálogo razonado de la obra pintada*, Neuchatel, 1979.

GILOT, F. & LAKE, C., *Vivre avec Picasso*, Paris, 1965.
GOEPPERT, S. & GOEPPERT-FRANK, H., *La Minotauromachie, Pablo Picasso, peintre, graveur, esculpture, céramiste et poète*, Ingelheim am Rhein, 1981.
– GOEPPERT-FRANK H. & CRAMER, P., *Pablo Picasso, catalogue raissoné des livres illustrés*, Geneva, 1983.
KAPLAN, T., *Red city, blue period: social movements in Picasso's Barcelona*, Berkeley, 1992.
LEIGHTEN, P., *Re-ordering the universe: Picasso and anarchism, 1897-1914*, Princeton (New Jersey), 1989.
LEYMARIE, J., *Picasso, Métamorphoses et Unité*, Geneva, 1971.
MALRAUX, A., *La tête d'obsidienne*, Paris, 1974.
OCAÑA, M. T. et al., *Picasso. Paisajes 1890-1912*, (cat. exp.), Barcelona, 1994.
– *Picasso & Els 4 Gats* (cat. exp.) Barcelona, 1995.
Pablo Picasso, a retrospective, New York, 1980 (Spanish ed., Barcelona, 1980).
PADIN, A., *Los cinco años coruñeses de Pablo Ruíz Picasso (1891-1895)*, La Coruña, 1991.
PALAU I FABRE, J., *Picasso vivent (1881-1907)*, Barcelona, 1980 (Spanish ed., Barcelona, 1980).
– *Picasso cubiste (1907-1917)*, Paris, 1990 (Spanish ed., Barcelona, 1991).
PENROSE, R., *Portrait of Picasso*, New York, 1957.
Picasso, œuvres reçues en paiement des droits de succession, Paris, 1979-1980.
Picasso, jeunesse et genèse: dessins (1893-1905), Paris, 1991.
PERUCHO, J., *Picasso, el cubisme i Horta de San Joan*, Barcelona, 1993.
PICASSO/APOLLINAIRE, *Correspondance*, edición de Pierre Caizergues y Hélène Seckel, introducción de Pierre Caizergues, Paris, 1992.
RAMIE, G., *Céramique de Picasso*, Paris, 1974 (Spanish ed., Barcelona, 1974).
RICHARDSON, J., *A life of Picasso. Vol 1: 1881-1906*, New York, 1991.
RUBIN, W., *Picasso et Braque: l'invention du cubisme*, Paris, 1990 (Spanish ed., Barcelona, 1991).
SABARTÈS, J., *Picasso, Portrait et souvenirs*, París, 1946 (Spanish ed., Madrid, 1953).
SCHIFF, G. (ed.), *Picasso in Perspective*, Englewood Cliffs, 1976.
SÉCKEL, H., *Max Jacob et Picasso*, Paris, 1994.
SPIES, W., *Picasso, Das Plastische Werk (catalogue of the sculptures, in collaboration with Cristine Piot)*, Stuttgart, 1983 (Spanish ed., Barcelona, 1989).
UHDE, W., *Picasso et la tradition française: notes sur la peinture actuelle*, Paris, 1928.
WARNCKE, C-P., *Pablo Picasso 1881-1973*, 2 vols., Cologne, 1992.
WARNOD, J., *Le Bateau-Lavoir 1892-1914*, Paris, 1975.
ZERVOS, C., *Pablo Picasso*, 34 vols, Paris, 1932-1978.

CONTEMPORARY ART, ARCHITECTURE AND DESIGN

AGUILERA CERNI, V., *Panorama del arte nuevo español*, Madrid, 1966.
– *Textos, pretextos y notas: escritos escogidos, 1953-1987*, 3 vols. Valencia, 1987.
BARRAL I ALTET, X. (dir.), *L'Art de la victòria. Belles Arts i Franquisme a Catalunya*, Barcelona, 1996.
BOZAL, V., 'Pintura y escultura españolas del siglo XX, 1939-1990', *Summa Artis*, vol. XXXVII, Madrid, 1993.
– & LLORENS, T. (eds.), *Vanguardia artística y realidad social* (cat. exp.), Barcelona, 1976.
CALVO Y SERRALLER, F., *España. Medio siglo de arte de vanguardia, 1939-1985*, 2 vols, Madrid/Santander, 1985.
– *Del futuro al pasado. Vanguardia y tradición del arte español contemporáneo*, Madrid, 1988.
– *Pintores españoles entre dos finales de siglo, 1880-1980*, Madrid, 1990.
CIRICI, A., *La estética del franquismo*, Barcelona. 1977.
CIRLOT, L., *La pintura informal en Cataluña, 1951-1970*, Barcelona, 1983.
– *El Grupo «Dau al Set»*, Madrid, 1986.
Equipo 57 (cat. exp.), Madrid, 1993.
FONTCUBERTA, J., *Contemporary Spanish Photography*, Alburquerque, New Mexico, 1987.
GAYA NUÑO, J.A., *La pintura española del siglo XX*, Madrid, 1972.
JULIÁN, I., *El arte cinético en España*, Madrid, 1986.
LLORENTE, A., *Arte e ideología del franquismo, 1936-1951*, Madrid, 1995.
MARCHÁN FIZ, S., *Del arte objetual al arte del concepto. Epílogo sobre la sensibilidad postmoderna*, Madrid, 1986.
PIÑÓN, H., *Nacionalisme i Modernitat en l'Arquitectura Catalana Contemporània*, Barcelona, 1980.
RYKWERT, J., *Arquitectura española contemporánea. La década de los 80*, Barcelona, 1990.
RODRÍGUEZ, C. & TORRES, J., *Grupo R*, Barcelona, 1994.
SOLÀ-MORALES, I. de, *Eclecticismo y vanguardia. El caso de la arquitectura moderna en Cataluña*, Barcelona, 1980.
Tàpies, Colloque, Paris, 1995.
TOUSSAINT, L., *El paso y el arte abstracto en España*, Madrid, 1983.
UREÑA, G., *Las vanguardias artísticas en la postguerra española, 1940-1959*, Madrid, 1982.
VV.AA., *Arte para después de una guerra* (cat. exp.), Madrid, 1993-1994.
VV.AA., *Anys 90. Distància zero* (cat. exp.), Barcelona, 1994.
VV.AA., *Col·lecció Riera. Anys 40* (cat. exp.), Barcelona, 1994.
VV.AA., *Arte en España, 1918-1994*, in the *Arte Contemporáneo* collection (cat. exp.), Madrid, 1995.

ALPHABETICAL INDEX

The numbers in italics (e.g. *48, 307*) refer to illustrations.
The numbers in roman (e.g. 512, 514) refer to the main text.

571

PHOTOGRAPHIC CREDITS

Luis Agromayor: 306, 400 below, 418 above left.

AISA: 19 above, 512.

Francisco Alcántara: 329.

ORONOZ Photographic Archive: 19 below, 21, 27 right, 30 left, 32, 34, 46, 54, 55, 82, 84, 87, 105, 166, 167, 195, 197, 206, 227, 274, 281, 290, 301, 305, 331, 345 above, 370, 371, 373, 414, 454, 455 above right, 474, 503, 505, 509, 513, 521, 525.

Joaquín Bérchez Gómez: 348, 349 below, 350, 357, 358, 361, 363, 365.

Biblioteca Nacional de Catalunya, Barcelona: 323.

Lluís Bover: 523.

Matías Briansó: 56, 64, 65, 68, 76, 77, 78, 79, 81, 400 above, 412.

© Girona Cathedral Chapter. All rights reserved. 88-89 (Marc Llimargas); 130, 131 182, 247 above (Ramon Manent).

CAPC Musée d'Art Contemporain, Bordeaux: 519.

Joaquim Castells: 388 below, 389.

Colección Arte Contemporáneo, Madrid: 478 right, 479, 520.

Colección Banco Hispano Americano, Madrid: 12, 447 below.

Colección J. Suñol, Barcelona: 507.

Col. Archives Photeb, Paris: 464 right.

Col. Archives Photeb, Paris (J.J. Hamte Feville): 469.

Joaquín Cortés: 243, 245, 246 right, 247 below, 248, 478 left, 496.

Jordi Cuxart: 71, 307, 530, 531.

Koldo Chamorro: 217, 224.

Ediciones Encuentro, S.A. (Marc Llimargas): 346, 351, 352, 353, 355, 359, 360.

Fons d'Art de la Generalitat de Catalunya, Barcelona: 481, 483, 515.

Fundació Antoni Tàpies, Barcelona (Gasull): 482, 487, 489, 491.

Fundació Joan Miró, Barcelona: 449, 459.

Fundación Lázaro Galdiano, Madrid: 322.

Galería Maeght, Barcelona: 517.

Galleria Corsini, Rome: 318.

Gasull: 445, 446, 480, 485, 487.

Gasull & Giralt: 494.

Guerendiain: 183.

Institut Valencià d'Art Modern, IVAM: 453 right, 455 above left and below right.

Instituto Valencia de Don Juan, Madrid: 246 left.

Legado Andalusí, Granada: 230.

Pablo Linés: 477.

Xurxo Lobato: 97 below right, 98, 100, 109, 111.

Rafael López Guzmán: 220, 221, 222 left, 349 above, 354.

Lunwerg Editores: 29, 49 below, 50, 67 above, 70, 73, 90, 91, 96 above, 104, 144, 154, 169, 176, 177, 213, 215, 222 right, 234, 238, 239, 271, 279, 309, 378, 383, 384, 385, 387, 388 above, 397 below, 404, 411, 413 below right, 415, 418 below left, 534.

Marc Llimargas: 8, 9, 11, 23, 24, 25, 27 left, 28, 35, 36 below, 37, 43, 47, 48, 52-53, 57, 80, 95, 97 above right and left, 99, 101, 102, 110, 113, 114, 115, 116, 117, 120, 122, 123, 136, 137, 138, 139, 146, 147, 148, 149, 150, 151, 156, 157, 159, 160, 161, 162, 164, 165, 170, 173, 175, 180, 181, 189, 191, 202, 218, 219, 228, 229, 231 below, 235, 236, 237, 241, 255, 262, 263, 264-265, 267, 269, 270, 272, 282, 283, 285, 288, 292, 294, 297, 308, 312, 314, 315, 316, 317, 319, 325, 326.

Marc Llimargas Pons: 199, 200, 268, 276, 277.

Ramon Manent: 6, 22, 45, 58, 61, 62, 63, 67 centre and below, 92, 108, 118, 119, 121, 127, 132, 140, 174, 178, 179, 184, 188, 192, 193, 196, 295, 397 above, 401, 418 right, 421, 422, 429, 431 above, 462, 473, 483, 493, 495, 497, 510, 522, 524, 527, 529, 532, 533.

Óscar Masats: 124, 209, 260, 386, 396.